Feminism--Art--Theory

To mum and dad,
Olive and Ivor:
binding to reading,
word to cover.

Feminism–Art–Theory

An Anthology 1968–2000

Edited by Hilary Robinson

BLACKWELL
Publishers

Copyright © Blackwell Publishers Ltd 2001
Editorial matter, selection and arrangement copyright © Hilary Robinson 2001

First published 2001

2 4 6 8 10 9 7 5 3 1

Blackwell Publishers Ltd
108 Cowley Road
Oxford OX4 1JF
UK

Blackwell Publishers Inc.
350 Main Street
Malden, Massachusetts 02148
USA

British Library Cataloguing in Publication Data

A CIP catalogue record for this book is available from the British Library.

Library of Congress Cataloging-in-Publication Data

Feminism-art-theory : an anthology, 1968–2000 / edited by Hilary Robinson.
 p. cm.
 Includes bibliographical references and index.
 ISBN 0-631-20849-6 (hb : alk. paper) – ISBN 0-631-20850-X (pb. : alk. paper)
 1. Feminism and art. 2. Feminist art criticism. 3. Art, Modern – 20th century.
 I. Robinson, Hilary.

 N72.F45 F442 2001
 704′.042 – dc21 2001025974

Commissioning Editor: Andrew McNeillie
Development Editor: Ally Dunnett
Desk Editor: Sue Ashton

Typeset in 10.5 on 12.5 pt Ehrhardt
by Best-set Typesetter Ltd., Hong Kong
Printed in Great Britain by T. J. International, Padstow, Cornwall

This book is printed on acid-free paper

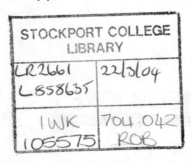

Contents

x Contents

Preface

This book is the result of much research in the UK, Ireland, the USA and Canada, and has been made possible by the generosity of the women's movement, the libraries and archives of many institutions, and the support and debate of numerous friends and colleagues. There are countless people with whom I have had conversations, ranging from five minutes to several hours, in conference halls, restaurants, bars, universities and private homes or through e-mail contact. Owing to the theft of a lap-top and disks at an advanced stage of research, I no longer have the list of those to whom I spoke. So, to all those who know they contributed their thoughts and knowledge, please accept my apologies and sincere thanks. No matter how brief, it was valued.

Beyond this, there are individuals and institutions who have given very particular support and input to this project. First is Andrew McNeillie of Blackwell, to whom I offer a big thank you for saying yes to the idea, understanding my aims, and supplying wise editorial guidance when I needed it. Thanks go also to the rest of the team at Blackwell for their support and professionalism. Also crucial was the University of Ulster. The library staff of the School of Art and Design, in particular Olivia Fitzpatrick and Marion Korshidian, have been a constant source of help; without their good-natured efficiency, this project would have foundered before it began. I would also like to thank the School of Art and Design for its research support, including funding for crucial research trips.

I have worked in many other libraries during this time. Warm thanks go to Ferris Olin of Rutgers University, who alerted me to the feminist art archives and papers in their special collections. Working with this remarkable resource affected both the content and shape of this book. Thanks are due too to the Institute for Research on Women at Rutgers for granting me a visiting scholarship to get the work done, and especially to Beth Hutchinson for providing a safe haven in the nick of time! Other libraries which have provided help during my research trips include: in Los Angeles, CalArts (with thanks to Coco Halverson and her colleagues); in the Bay Area, the Art Institute of San Francisco and the University of California, Berkeley; in Washington, the Archives of American Art; in Montreal, Concordia (with thanks to Janice Helland) and the archives at Artexte and the Musée d'art contemporain; in Toronto, the Matriart archives; in London, the National Library of Art and Design at the Victoria and Albert Museum, the library of the Tate Gallery and the Women Artist's

Library; in Oxford, the Bodleian Library; and in Dublin, the library of the National College of Art and Design.

Several friends and colleagues have been remarkably generous in opening up not only their thoughts but the material fruits of their labours – their personal archives, libraries and collections – to my searching. This includes, notably, Amelia Jones, Katy Deepwell, Moira Roth and Whitney Chadwick; discussions with all – even where there was disagreement – proved most fertile. To Whitney is due deep and special gratitude: she and Bob Bechtle were gracious hosts during my times in San Francisco: warm thanks to them both.

The Feminist Art History Listserve has been a real boon when searching for archives and for individuals: sincere thanks to Robin Masi for keeping it going, and to all who responded to my requests for information. The Tyrone Guthrie Centre, Co. Monaghan, has provided a haven for work at key moments – like nowhere else: thank you to the centre, and to all the unsuspecting residents on whom I tried out the shape and substance of this book.

And to Alastair MacLennan – who knows when to offer the bottle of vitamin pills and when the bottle of wine – thank you, and love, always.

Acknowledgements

The publishers gratefully acknowledge the following for permission to reproduce copyright material. Every effort has been made to trace copyright holders, but in some cases this has proved impossible. The publishers would be happy to hear from any copyright holder who has not been acknowledged.

Extract from *The Dialectic of Sex* by Shulamith Firestone, published by Jonathan Cape Limited. Reprinted by permission of Laurence Pollinger Limited.

'Is Female to Male as Nature is to Culture?' by Sherry B. Ortner from *Women, Culture and Society*, edited by Michelle Zimbalist Rosaldo and Louise Lamphere. Copyright © 1974 by the Board of Trustees of the Leland Stanford Junior University. Reprinted with permission of the publishers, Stanford University Press.

'Tape no. 2 for "Kitch's Last Meal"' (super 8 film) by Carolee Schneemann, 1973, 74, 75; 'Statement' (untitled) found in *Shrine for Everywoman* by Betsy Damon, 1972; 'Consciousness-raising Rules' by West–East Coast Bag, published in WEB West–East Coast Bag, June 1972; extract from 'Minutes: Heresies Collective', October 7th, unpublished, from Lucy Lippard Women's Art Registry Collection, Special Collections and University Archives, Rutgers University Libraries. Reprinted with permission of Rutgers University Libraries.

'Waiting' by Faith Wilding from *Through the Flower* by Judy Chicago, published by Anchor Books, 1977. Reprinted with permission of Faith Wilding.

Extract from 'The Straight Mind' by Monique Wittig. Copyright © 1992 by Monique Wittig. Reprinted by permission of Beacon Press, Boston.

Extract from 'In the Shadow of Contemporary Art' by Isabelle Bernier, in *Feministe toi-même, feministe quand même*, published by La Chambre Blanche in 1986. Reprinted by permission of La Chambre Blanche.

Extract from 'Writing as a Woman: Luce Irigaray' interviewed by Alice Jardine and Anne Menke, in *Je, tu, nous: Towards a Culture of Difference* by L. Irigaray, published by Taylor and Francis Inc., reproduced by permission of Taylor and Francis Inc. (http://routledge-ny.com).

'To the Viewing Public for the 1970 Whitney Annual Exhibition', self-published handout for Women's Ad Hoc Committee/WSABAL. Reprinted with permission of Faith Ringgold.

'The Triple Negation of Colored Women Artists' by Adrian Piper found in *Next Generation: Southern Black Aesthetic*, ed. Devinis Szakacs and Vicki Kopf. Reprinted by permission of the author Adrian Piper.

'Art Conferences: Passification or Politics?' by Val Walsh in *And: Journal of Art and Art Education*, 25, 1991, pp. 40–42. Reprinted with permission of the author.

'Bodies of Theory, Bodies of Pain: Some Silences' by Jody Berland, published in *Harbour*, 6, 1993, pp. 14–21. Reprinted with permission of the author.

'Lesbian Art Project' by Terry Wolverton, in *Heresies*, 2, no. 3, 1979, pp. 14–18. Reprinted with permission of the author.

'Well, *is* the Personal Political?' by Martha Rosler. Reprinted by permission of the author.

'A Theoretical and Political Context' by Anne Marsh, from *Difference: A Radical Approach to Women and Art*, published by Women's Art Movement, Adelaide, 1985. Reprinted with permission of the author.

'In Mourning and in Rage . . .' by Leslie Labowitz-Starus and Suzanne Lacy, in *Frontiers: A Journal of Women*, 3, no. 1, 1978, pp. 52–55. Reprinted with permission of Suzanne Lacy.

'Touch Sanitation' by Mierle Laderman Ukeles. Reprinted with permission of Ronald Feldman Fine Arts, New York.

'Hot Potatoes: Art and Politics in 1980' by Lucy Lippard, in *Block*, 4, 1981, pp. 2–9. Reprinted with permission of Lucy Lippard.

Extract from *Monuments and Maidens: The Allegory of the Female Form* by Marina Warner, published by Weidenfeld and Nicolson. Reprinted with permission of the Orion Publishing Group Limited.

'Silence as a Vigil' by Gail Bourgeois, Carole Brouillette, Barbara McGill Balfour, Suzanne Paquet, programming committee members, 1990–91, La Centrale/Powerhouse Gallery Canada. Reprinted with permission.

Extract from 'The Education of Women as Artists: Project Womanhouse' by Miriam Schapiro, from *Art Journal*, 31, no. 3, 1972, pp. 268–270. Reprinted with permission of the author.

Extract from 'The First Feminist Art Program: A View from the 1980s' by Paula Harper, from *Signs*, 10, no. 4, 1985, pp. 762–781. Reprinted with permission of the University of Chicago Press.

Extract from 'Art, Art School, Culture: Individualism after the Death of the Artist' by Griselda Pollock, in *Block*, 11, 1985, pp. 8–18. Reprinted with the kind permission of Griselda Pollock.

'Teaching Modern Art History from a Feminist Perspective: Challenging Conventions, my Own and Others' by Moira Roth, from *Women's Studies Quarterly*, 15,

no. 1–2, Spring–Summer 1987, pp. 21–24, special issue, 'Teaching about Women and the Visual Arts', ed. Thalia Gouma-Peterson. Copyright © 1987 Moira Roth. Reprinted by permission of the Feminist Press at the City University of New York.

'A Conversation on Censorship with Carolee Schneemann' by Aviva Rahmani, first appeared in *M/E/A/N/I/N/G*, 6, November 1989. It appears in *M/E/A/ N/I/N/G: An Anthology of Artists' Writings, Theory, and Criticism* (Duke University Press, 2000). M/E/A/N/I/N/G retains the copyright. Reprinted by permission of Mira Schor and Susan Bee, M/E/A/N/I/N/G.

'The Flesh Dress: A Defence' by Sarah Milroy, in *Canadian Art*, 8, no. 2, 1991, pp. 71–72. Reprinted by permission of Canadian Art Magazine.

'Where Do We Draw the Line? An Investigation into the Censorship of Art' by Anna Douglas, from *New Feminist Art Criticism*, ed. Katy Deepwell, 1995. Reprinted by permission of Manchester University Press, UK.

'Art Hysterical Notions of Progress and Culture' by Valerie Jaudon and Joyce Kozloff. Copyright © Valerie Jaudon and Joyce Kozloff/Licensed by VAGA, New York, NY. Reprinted by permission of VAGA, New York, NY.

'No Matter How Unreasonable (review of *Rape*, edited by Sylvana Tomaselli and Roy Porter)' by Susanne Kappeler, in *Art History*, 11, no. 1, 1988, pp. 118–123. Reprinted by permission of Blackwell Publishers, UK.

'On the Road Again: Metaphors of Travel in Cultural Criticism' by Janet Wolff, in *Cultural Studies*, 7, no. 2, 1993, pp. 224–239. Reprinted by permission of Taylor & Francis Limited, PO Box 25, Abingdon, Oxfordshire OX14 3UE.

'The Women's Art Magazines' by Corinne Robins, in *Art Criticism*, 1, no. 2, 1979, pp. 84–95. Reprinted by permission of Stony Brook University.

'Framing Feminism (letter)' by Griselda Pollock, from *Women Artists' Slide Library Journal*, 26, 1988, pp. 22–23. Reprinted by permission of Women's Art Library.

'Critical Reflections' by Meaghan Morris, originally published in the April 1992 issue of *Artforum*. Copyright © Artforum April 1992. Reprinted by permission of Artforum.

Extract from 'In Search of a Discourse and Critique(s) that Center the Art of Black Women Artists' by Freida High (Wasikhongo Tesfagiorgis), in *Theorizing Black Feminisms: The Visionary Pragmatism of Black Women*, ed. Stanlie M. James and Abena P. A. Busia, published by Taylor & Francis. Reprinted by permission of the publishers.

'The Art Criticism and Politics of Lucy Lippard' by Stephanie Cash in *Art Criticism*, 9, no. 1, 1994, pp. 32–40. Reprinted by permission of Stony Brook University.

'Courbet's *L'origine du monde*: The Origin without an Original' by Linda Nochlin. In *October*, 37, Summer 1985, pp. 77–86. Copyright © October Magazine Limited and the Massachusetts Institute of Technology. Reprinted with permission of MIT Press.

'Modernist Art History: The Challenge of Feminism' by Lisa Tickner, from 'Feminism: Art History and Sexual Difference', *Genders*, 3, 1988, pp. 92–128. Reprinted by permission of the author.

'Frida Kahlo: Marginalization and the Critical Female Subject' by Joan Borsa, in *Third Text*, 12, Autumn 1990, pp. 21–40. Reprinted by permission of the author.

'Getting Down to Get Over' by Judith Wilson, from *Black Popular Culture: A Project by Michelle Wallace*, ed. Gina Dent. Copyright © 1992. Reprinted by permission of The New Press.

'The Creation (of a) Myth' by Pamela Allara, in *Pictures of People: Alice Neel's American Portrait Gallery*. Copyright © 1998 by the Trustees of Brandeis University. Reprinted by permission of the University Press of New England.

'Some Thoughts on Feminist Art' by Marjorie Kramer, in *Women and Art*, 1, 1971, p. 3. Reprinted by permission of the author.

Extract from 'Woman as Artist' by Judy Chicago, from *Everywoman*, 2, no. 7, 1972, pp. 24–25. Copyright © Judy Chicago 1991. Reprinted by permission of the author.

'A Feminine Sensibility?' by Pat Mainardi, in *Feminist Art Journal*, 1, no. 1, 1972, pp. 4, 25. Reprinted by permission of the author.

Extract from 'For a Truly Feminist Art' by Judith Stein, published in *The Big News*, 1, no. 9, 22 May 1972, p. 3. Reprinted by permission of Judith Stein Coleman.

Extract from 'Feminism and the Definition of Cultural Politics' by Michèle Barrett, from *Feminism: Culture and Politics*, ed. R. Brunt and C. Rowan, published by Lawrence and Wishart, London, 1982. Reprinted by permission of the publishers.

Extract from 'Is There a Feminine Aesthetic?' by Silvia Bovenschen, in *Feminist Aesthetics*, ed. Gisela Ecker. First published in the German language in 1976. Reprinted by permission of the author.

'How Can We Create our Beauty? by Luce Irigaray, in *Je, tu, nous: Towards a Culture of Difference* by L. Irigaray, published by Taylor and Francis Inc., reproduced by permission of Taylor and Francis Inc. (http://routledge-ny.com).

Extract from 'Where is the Woman in Feminist Theory? The Case of Aesthetics' by Hilde Hein, in *Philosophic Exchange*, 21–22, 1990, pp. 21–36. Reprinted by permission of the author.

'Black Aesthetics, Feminist Aesthetics, and the Problems of Oppositional Discourse' by Belinda Edmondson, in *Cultural Critique*, 22, 1992, pp. 75–98. Reprinted by permission of the University of Minnesota.

'Issues of Feminist Aesthetics: Judy Chicago and Joyce Wieland' by Lauren Rabinovitz, in *Woman's Art Journal*, 1, no. 2, 1980, pp. 38–41. Reprinted by permission of the author.

Extract from 'Beyond the Family Album' by Jo Spence, in *Ten-8*, 4, Spring 1980, pp. 8–10. Reprinted by kind permission of Terry Dennett.

Extract from *Art in Everyday Life* by Linda Montano, published by Astro Artz, 1981. Reprinted by permission of the author.

Extract from 'Looking Backward in Order to Look Forward: Memories of a Racist Childhood' by May Stevens, published in *Heresies*, 15, 1982, pp. 22–23. Reprinted by permission of the author.

Extract from 'Anthropology into Art' (Susan Hiller interviewed by Sarah Kent and Jacqueline Morreau), in *Women's Images of Men*, ed. Sarah Kent and Jacqueline Morreau. Reprinted by kind permission of Sarah Kent.

Extract from *In Conversation at the Vancouver Art Gallery* by Mary Kelly and Griselda Pollock. Reprinted by kind permission of Griselda Pollock.

'Of Monitors and Men and Other Unsolved Feminist Mysteries: Video Technology and the Feminine' by Nell Tenhaaf. This article was first published in *Parallélogramme* (Toronto), 18, no. 3, 1992–3, as part of the inter-magazine publishing project entitled *The Video Issue/Propos Vidéo*, ed. Renee Baert, and sponsored by Satellite Video Exchange Society, Vancouver, 1992–3. Reprinted by permission of Nell Tenhaaf.

Extract from 'Paint Stripping' by Katy Deepwell, in *Women's Art Magazine*, 58, 1994, pp. 14–16. Reprinted by permission of the Women's Art Library.

'Plan: Large Woman or Large Canvas? A Confusion of Size with Scale' from 'On Viewing Three Paintings by Jenny Saville: Rethinking a Feminist Practice of Painting', by Alison Rowley, in *Generations and Geographies in the Visual Arts: Feminist Readings*, ed. Griselda Pollock. Reprinted by permission of Taylor & Francis.

'Where is the Feminism in Cyberfeminism?' by Faith Wilding, in *n.paradoxa*, 2, 1998, pp. 6–12. Reprinted by permission of the author.

'The Ties that Bind: Here We Go Again' by Kass Banning, from 'The Mummification of Mommy: Joyce Wieland as the AGO's First Living Other', in *C Magazine*, 13, 1987. Reprinted by permission of the author.

'The Floozie in the Jacuzzi: The Problematics of Culture and Identity for an Irish Woman . . .' by Ailbhe Smyth, in *Circa*, 48, 1989, pp. 32–38. Reprinted by permission of the author.

'Five Terms, Two Letters' by Hung Liu. Originally published as part of a forum, 'Contemporary Views on Racism in the Arts', in *M/E/A/N/I/N/G*, 7, May 1990, pp. 17–18. It appears in *M/E/A/N/I/N/G: An Anthology of Artists' Writings, Theory, and Criticism* (Duke University Press, 2000). M/E/A/N/I/N/G retains the copyright. Reprinted by permission of Mira Schor and Susan Bee, M/E/A/N/I/N/G.

'We Wear the Mask' by Coco Fusco, from *Talking Visions: Multicultural Feminism in a Transnational Age*, ed. Ella Shohat (New York/Cambridge, MA: The New Museum and MIT Press, 1998). Reprinted by permission of MIT Press.

'Reinventing the Nude: Fiona Foley's Museology' by Diana Losche. Reprinted by permission of the author.

'On Shows' by Sally Potter. Copyright © Sally Potter. Reprinted by permission of Alexandra Cann Representation on behalf of Sally Potter.

'Images of "Woman": The Photography of Cindy Sherman' by Judith Williamson. Copyright © Judith Williamson. Reprinted by permission of the author.

'Sexuality and/in Representation: Five British Artists' by Lisa Tickner, from *Difference*, ed. Kate Linker (London: ICA, 1985), pp. 19–30. Reprinted by permission of the author.

'Sexuality in the Field of Vision' by Jacqueline Rose, published by Verso in 1986, pp. 225–233. Reprinted by permission of Jacqueline Rose and Verso.

'Mapping the Imaginary' by Jo Anna Isaak. Reprinted by permission of the author.

'Framing the Questions' by Jan Zita Grover, in *Stolen Glances: Lesbians Take Photographs*, ed. Tessa Boffin and Jean Fraser, published by Pandora Press, London, 1991. Reprinted by permission of Rivers Oram Press Limited.

Extract from 'Feminism and Modernism: Paradoxes' by Nicole Dubreuil-Blondin, published by The Press of the Nova Scotia College of Art and Design, 1983. Reprinted by permission of Nicole Dubreuil-Blondin and Serge Guilbaut.

'"Post-feminism": A Remasculinization of Culture?' by Amelia Jones. First published in *M/E/A/N/I/N/G*, 7, 1990, pp. 29–40. It also appears in *M/E/A/N/ I/N/G: An Anthology of Artists' Writings, Theory, and Criticism* (Duke University Press, 2000). M/E/A/N/I/N/G retains the copyright. Reprinted by permission of Mira Schor and Susan Bee, M/E/A/N/I/N/G.

Extract from pp. 225–242 of *Risking Who One Is: Encounters with Contemporary Art and Literature* by Susan Rubin Suleiman, published by Cambridge, MA: Harvard University Press. Copyright © 1994 by the President and Fellows of Harvard College. Reprinted by permission of the publishers.

'Le Café des Artistes (The French Collection, Part II, no. 11)' by Faith Ringgold. Reprinted by kind permission of Faith Ringgold.

'Negotiating the Feminist Divide' by Whitney Chadwick, in *Heresies*, 24, 1989, pp. 23–25. Reprinted by permission of Whitney Chadwick.

Extract from 'The Risk of Essence' by Diana Fuss, from *Essentially Speaking: Feminism, Nature and Difference* by Diana Fuss, pp. 1–21. Copyright © 1989 Diana Fuss, published by Routledge, New York in 1989. Reprinted by permission of Taylor & Francis, Inc./Routledge, Inc. (http://www.routledge-ny.com).

'Desire in the Politics of Representation' by Shonagh Adelman, in *Matriart*, 3, no. 3 1993, pp. 21–25. Reprinted by permission of the author.

'Lesbian Identity and the Politics of Representation in Betty Parsons's Gallery' by Ann Gibson, in *Journal of Homosexuality*, 27, no. 1–2, 1994, pp. 245–270. Reprinted by permission of the author.

'Against Cultural Amnesia' by Harmony Hammond, in *Art Papers*, 18, no. 6, 1994, pp. 9–13. Reprinted by permission of Art Papers Magazine, Atlanta.

'Disability, Differentness, Identity' by Mary Duffy, in *Circa*, 34, May/June 1987, pp. 30–31. Reprinted by permission of the author and Circa.

'Framing the Female Body' by Lynda Nead, in *The Female Nude: Art, Obscenity and Sexuality*, published by Routledge, London, 1992. Reprinted by permission of Taylor & Francis, UK.

Extract from *Body Art: Performing the Subject* by Amelia Jones, published by the University of Minnesota Press, 1998, pp. 5–9. Reprinted by permission of the publishers.

'Vaginal Iconology' by Barbara Rose, originally published in *New York Magazine*, 7, 11 February 1974, p. 59. Reprinted by permission of the author.

'Feminism' by Joanna Frueh. Reprinted by permission of the author.

'I Don't Have to Expose my Genitalia' by Buseje Bailey, in *Matriart*, 3, no. 3, 1993, pp. 16–19. Reprinted by permission of the author.

Extract from 'Objections of a "Goddess Artist": An Open Letter to Thomas McEvilley' by Mary Beth Edelson, in *New Art Examiner*, 16, no. 8, April 1989, pp. 34–38. Reprinted by permission of the author.

'I Found God in Myself and I Loved Her / I Loved Her Fiercely' by Michelle Cliff, from *Journal of Feminist Studies in Religion*, 2, no. 1, 1996, pp. 7–39. Reprinted by permission of Michelle Cliff.

Extract from 'The Laugh of the Medusa' by Hélène Cixous, translated by Keith Cohen and Paula Cohen, in *Signs*, 1, no. 4, 1976, pp. 875–893. Reprinted by permission of the University of Chicago Press.

Extract from *Art on my Mind* by bell hooks. Copyright © 1995. Reprinted by permission of The New Press.

Introduction: Feminism– Art–Theory – Towards a (Political) Historiography

This anthology aims to indicate the main strands of thought, debate and politics in the spaces where the women's movement has intersected with the practices of making and writing about art. It is not, therefore, a history of that movement as such, but rather an archive of one set of discourses in the politics of culture. The chapters are constructed as exemplars of different areas where feminism has focused, and the texts within them are presented to index the differing positions developed over time in each. The title of the volume suggests this complexity. I did not wish to name something called 'feminist art' as a reductive term, suggesting a style of art; nor to propose 'art theory' as a pre-determined academic focus with attendant structures; nor, indeed, to propose 'feminist theory' as a potentially de-politicized academic exercise. Instead I wished to show the productive, if still tense, engagement of the three terms of the title: *feminism*, as a set of politics; *art*, as a set of cultural practices; and *theory* as a set of ideas and knowledge that can be used in analysis.

In addition to the main aim, I had a number of further objectives in my selection of texts: to disrupt the orthodoxy of a canon of feminist writings, to complicate the USA/UK axis often taken as given, to reprint texts demonstrating the eclectic, polyphonic publishing that feminism has developed or in which it has intervened, and to collect as diverse a set of voices and positions as possible. Further, I recognized that within feminist activity, the term 'theory' is neither straightforwardly defined, nor contained in certain types of academic discourse alone.

It is a commonplace in the introductions of anthologies for the editor to state that one volume cannot be totally inclusive, and that it cannot do more than scratch the surface of a complex and diverse field. While this book brings together ninety-nine texts, it was clear from an early stage in my research that I would have to make some difficult decisions about the parameters within which texts were selected and excluded. Two decisions in particular have had a far-reaching effect on the overall content of the book. First, an early decision was to include only texts that feed into Western English-language debates, either by being written in English or by having been translated. To attempt to include not previously translated German-language texts, or English-language texts from India, or texts from elsewhere in Asia (to give just three examples), would have been tokenistic. Such a transnational group project must remain, at present, an aspiration for the future.

Secondly, with a few exceptions, I have excluded texts that have been widely used elsewhere in anthologies, or that appear in books which are frequently found on university art course reading lists and are thus easily available through college libraries. In preference, I have made full and flexible use of the Bibliography and reading lists which are an intrinsic aspect of this volume. As an alternative focus, and to increase the usefulness of the book as an archival resource, I have instead selected texts by well-known writers that have not as yet been widely reproduced, texts that have appeared in less-accessible or little-known publications, and texts by writers who are less widely published. The initial objectives, in conjunction with these two decisions, have determined the types and provenance of the texts I have chosen.

As a result, some readers may be surprised by the omission of certain texts and writers here, and also at the modest selection of work from prominent writers such as Whitney Chadwick, Lucy Lippard and Griselda Pollock. It would be hard to overestimate the significance of Laura Mulvey's essay 'Visual Pleasure and Narrative Cinema', but, precisely because it has been so significant, it has been reprinted many times and is currently available in a number of publications. Another example of this is Linda Nochlin's 'Why Have There Been no Great Women Artists?' Neither essay is reprinted here. Such texts are instead included in a short list of essential reading following the introduction to each chapter, thus freeing space for material that develops these debates, but has not previously been reprinted. Similarly, there are writers without whose body of work it is hard to imagine these debates at all. Lucy Lippard and Griselda Pollock have been particularly prolific, and without their tireless moving and questioning feminist art criticism and history would lack its trajectory and energy. Work by both writers could have been included in virtually all of the chapters in this anthology. However, I have taken the difficult decision to restrict the number of texts by these writers, while being as thorough as possible in including their work in the appropriate bibliographies. This again is in order to broaden the diversity of writers represented here. Those of us who have been researching this area for some time will have books by both Lippard and Pollock on our bookshelves; if not, and for those just starting out on research, then their books are either currently in print or easily accessible in university and college collections, or through inter-library loans, and I would urge all readers to consult them.[1] Bibliographical details are given where such texts are listed as essential reading or in the other bibliographies. Continuing this strategy with other well-known writers, I have included texts by them that may not be considered the most obvious choices where particular texts have become popular by being included in anthologies elsewhere.

It is not by chance that the collection begins with an extract from Valerie Solanas's *Scum Manifesto* and ends with an essay by bell hooks, writers whose work, overall, intersects tangentially with contemporary art practice: neither has practised foremost as an art critic nor as an art historian. While researching in libraries, public and private archives, and in discussion with artists and writers, it became clear that many of the texts that had been most influential for them were not from within the art arena as such – novels, feminist theory, activist polemics, and so forth, were also mentioned. While it is beyond the remit of this collection to do justice to all such influences upon feminist practices in art, none the less it is important to recognize that feminist theory has always held up to scrutiny patriarchal structures of culture, existing cultural

practices and women's potential for making culture. These two texts, and others, attest to that.

Beyond this, there is a further significance to these two texts: they are both from the US. Half of the texts in the book come from the US, nearly a quarter from Great Britain, and an eighth from Canada. The remaining texts come from Ireland (both Northern Ireland and the Republic) and Australia, with some previously translated material from continental Europe. The amount of material from the US acknowledges both the huge mass of work produced there and its significance. There is a certain problematic in this, however. Those of us who are not from the US have to work with this amount of material as a reality in our political and academic lives, while struggling with the fact that our own political, artistic and cultural histories are at odds with those taken as read in the US. Our analyses, strategies and practices will as a result be different from those of American writers. One of the constant tensions within feminist writing comes from the need to talk with and for a collectivity of women, and the conflicting need to recognize and articulate difference between women. Feminists outside the US, with their different national political and cultural histories, should not be seduced by the seemingly universal discourse of work produced in the US, published by US companies, written for a US audience, but rather be alert to this limitation, even when it is not marked as such. An author – even a feminist author, it seems – feels no need to mark specificity when her audience is assumed to be of the same identity as herself. (This problem of an unmarked identity masquerading as the universal authoritative voice is, of course, found widely, and across different categories, but I remark upon it here because of the particular impact of universalizing in a body of work to which deference is given internationally.)

A further difficulty is that such a feminist author feels no need to analyse the cultural and political histories of that identity. When national identity *is* marked – as with *The Power of Feminist Art: The American Movement of the 1970s, History and Impact*, edited by Norma Broude and Mary D. Garrard – it is often done, as in that book, in a manner that charts the events of that national history rather than a more self-reflective (or deconstructive) analysis of that very identity.[2] Thus the processes of identification and the national politico-cultural specificity of the author remains veiled, while the chronology of events is presented as an apparently floating set of symptoms, seemingly available as identificatory signs to be related to by any reader. This is very different from, say, *Past Present: The National Women's Art Anthology*, edited by Joan Kerr and Jo Holder, from Australia.[3] In the introduction, Joan Kerr states:

> But *Past Present* is not simply a chronicle of the 1995 exhibitions plus samples of recent feminist approaches to Australian art history, theory and practice. Alongside the emphasis on fundamental continuities over time, these essays evince a new and fuller understanding of the interdependence of the historical and the contemporary that results when basic changes are made to the definition of Australian art generally, its history, criticism, presentation and interpretation.

Thus the political structure of *Past Present* is one that recognizes the change wrought by feminism upon Australian art, is conscious of the construction of that national identity, and seeks to be part of the continuing national analysis of culture. In an increasingly transnational environment, attention to the local is ever more important

if art is not to be reduced to some bland international mainstream, and if artists and feminists are to speak across their differing identificatory processes and histories.

In significant contrast to Kerr's comments, Broude and Garrard's introduction to *The Power of Feminist Art* states that 'The goal of feminism, said early spokeswomen, was to change the nature of art itself, to transform culture in sweeping and permanent ways by introducing into it the heretofore suppressed perspective of women', adding 'Twenty years later we may smile at so utopian a vision.'[4] Tellingly they add a quote from Lucy Lippard: 'In endlessly different ways the best women artists have resisted the treadmill to progress by simply disregarding a history that was not theirs.'[5] Broude and Garrard then argue out the inappropriateness of modernist discourse for feminism and the exclusions of high modernism. The prime reference here is Abstract Expressionism. In this the construction of their identity as products of US art historical discourse becomes particularly significant. An important element in the discourses of Abstract Expressionism is the conflicting manner in which the art form was claimed as the premier American (or New York) art form, on the one hand, and as a universal art form, on the other. This is not to suggest that these discourses did not happen or have effect elsewhere: they have dominated, particularly in those countries that have also practised political or cultural imperialism. However, the discourses from the US were always privileged, and provided the models for practice in other countries that aspired to a modernist high culture. One of the interesting aspects to emerge from US feminist criticism from the 1970s to date is its relationship to these high modernist discourses, which overtly have US artists and their work as their subject, but retain a US identity as an unmarked category.[6] While the concept of the national as a category and its discourses are fraught with problems (and nation-states themselves are historically both a recent invention and also contingent), national categories form a key defining order of academic art history – Dutch golden age, Italian Renaissance, and so forth. They should therefore be subject to constant feminist critical scrutiny and evaluation. Doubtless the specificity of US feminist criticism will be an area of art historical investigation in this changing global environment.

The significance of placing an essay by bell hooks at the end of the collection indicates also the difference and diversity at play within the US – and the difference of difference elsewhere. Work by African-American women and other women of colour in the US, in part because of its attention to its clear political specificity, may have more to teach those of us who live outside the US about our political strategies of identification than some work of our white US sisters. This suggestion might at first seem ludicrous: an analysis of the structures of racism transnationally would dismiss it out of hand. But still, from where I sit writing this, in Belfast (a city which has for three decades suffered from low-grade civil war, currently being played out as issues of nationality, cultural heritage and the 'authentic voice'), reflection upon the universalizing discourses of the (white) US art world, and upon the models available for the analysis of local difference within global indifference, suggests that the aspiration to learn from this work seems fitting. This is not to suggest any simplistic structures of identification: as I argue in the introduction to chapter 6, the histories, constructions and symbols of otherness and imperialism differ hugely between places – the struggles between white, working-class, English-speaking Christians of different national identity from Belfast and between people of different races, lands and languages in Los Angeles cannot be understood as the same. Similarly, the art historical theories

and subsequent methodologies developed by writers such as Michelle Cliff, Freida High (Wasikhongo Tesfagiorgis) and Judith Wilson cannot be shifted regardless of geographical location, national identity and so forth. However, their texts do provide exemplary models of practice for those who wish to be rigorous about the politics of identification in art historical and critical discourses.

Feminist activity has worked extremely hard to disrupt the notion of the canon. Few feminists other than those who advocate complete separatism have been content to leave patriarchal structures untouched. Some have wanted to add to, mix up or displace the content of various canons; typically, in this context, by wanting to add the names of women artists to the current histories of art.[7] Others, as indicated by the comment from Lucy Lippard quoted above, have attacked or dismissed the very notion of the canon. Recognizing that the content of a canon is always historically and geographically contingent, and that the fundamental problem is the ideological structure that forms it, others still have deconstructed the premises which establish it. This approach analyses the gendered way in which the canon produces meaning and exposes the patriarchal underpinnings that must be mined out if women artists and their work are ever to receive more than a token gesture that leaves the masculinity-supporting mainstream fundamentally intact.[8]

In the field of art historical research, the danger of replacing a patriarchal canon with another of women artists has often been implicit within the debate. Within academia, the privileging of theoretical research over archival research has led to an uneasy political position: doing the slog of archival work can mean that the feminist art historian remains marginalized by the institution she works in, and her work is ignored as it focuses on artists who are not regarded as part of the canon. She and her work, therefore, have little or no impact upon the content and structures of teaching and research. On the other hand, the desire to unpick the structures which marginalize women artists produces a necessity for theoretical work, and theoretical work can go straight to the heart of the (academic) matter, producing publications which are viewed as respectable academically, rather than populist. However, this may have to be outside traditional art history departments, and the archival work which is so important remains undone.

In my introduction to the panel 'Historiography/Feminisms/Strategy' at the 2000 College Art Association conference, I asked 'is discovering and assessing the work of "forgotten" women no longer seen as urgent? Or is it just not "hip" enough? Is there now a case for doing some of this work on the 1970s as well as on work from earlier centuries?' These questions were discussed in differing ways by a number of the panelists.[9] The tendency of publishing houses to maintain a canon through 'coffee-table' publications and monographs rather than risk supporting primary research was evoked, but Whitney Chadwick observed that:

> critically surveying the state of literature on gender and post-minimalism, I was surprised to discover how thin was the pile of monographs and scholarly catalogues for a very important group of women artists, when compared to their male colleagues and to theorizations of more contemporary practices . . . Working on women artists may not have much intellectual caché at the moment in some quarters, but it seems to me that our failure to attend to the realities of women's production, and to add to its record, risks knocking the history out of feminism and art history.

One conclusion is that the strategy should be 'both/and' rather than 'either/or', but how the individual feminist art historian might achieve this in relation to the pragmatics of both universities and publishing is not straightforward. Clearly, however, the production of work on women artists requires the unwriting of patriarchal structures of art history – including the monograph as its mainstay genre of publication – even as we simultaneously write the histories of women artists and the analyses of their work. A handful of feminist monographs, such as Mary Garrard on Artemisia Gentileschi or Griselda Pollock on Mary Cassatt or Pamela Allara on Alice Neel, indicate different theoretical approaches to this, and differing stances in relation to the canon; their existence is testimony both to the impact of feminist scholarship upon publishing, and to how much work still remains to be done.[10]

In a position related to its critique of the valorizing monograph as the mainstay of traditional art history, the women's movement has been wary of any 'star-system' emerging from its activity.[11] Early collective action and authorship were intended as a means of avoiding the replacement of patriarchal authority-figures with their matriarchal equivalent, leaving the structures intact while simply changing the sex of the players. Taking turns in speaking, writing or representing a collective position aimed at encouraging and training those who had possibly never before been asked to express an opinion, and to make real an egalitarian mode of operation in an anti-oppressive movement. The fondness for anthologies found within feminist publishing can be related to this formative move by the women's movement of the 1960s and 1970s, and I am happy to contribute to this tradition.

While I am now employed full-time in academia, I think it important to recognize the limitations of the academy for feminism. The strictures of the Research Assessment Exercise in the UK system, for example, or the iniquitous tenure system in the US, might devalue certain forms of writing and encourage individual feminists to publish pragmatically, compromising their politics. But feminism is after all a matrix of political positions, not an academic category, and the aim of a political struggle is to win. In this instance, the struggle is against the patriarchy of the art world. By this I mean the structures within visual culture which use markers of gender, race and nation above all else in maintaining hierarchies of forms of production and consumption, of categories of artists, and of representation. It is in this spirit of struggle, and as an item of intellectual armour, that this present book is offered.

USING THE BOOK: A NOTE FOR TEACHERS

This anthology will be of use for teachers at both BA and postgraduate level, in studio-led art courses and art history, in women's studies and cultural studies. Its scale and structure make it flexible to use. The collection has come to fruition at a particular historical moment – not only after the turn of the millennium, but also after the turn of three decades of feminist work in the field of art practices. Those of us who teach are now teaching many young women for whom the 1970s – and even a good part of the 1980s – predate their own birth. While some of us have a stake in the debates outlined in this book and hold the times, events and ideas as intellectual and emotional personal memory, many of its readers will approach these texts as art history. Archiving at this

transitional moment was a crucial task, and forming the book to aid teaching was a necessity. If archives help support the construction of our histories, they have peda-gogical purpose. However, as I have stated above, the aim here is not to provide a history of the movement, its chronology, events and people: to do so in such a context would be to run the risk of reasserting the monolith suggested when Art History is accorded its capital letters. Instead, the aim has been to chart the strands of debate and the areas of concern for feminists. Thus it is the interrelation of the texts that is intended to be productive for the reader. The book's structure promotes this.

The book has nine chapters, five with subsections. Each section has no fewer than three texts, and sometimes many more, in order to avoid the binary oppositions that have appeared in some accounts of the history of feminist work (particularly decon-structivist versus celebratory or theoretical versus essentialist feminism). The debates have been more complex than such binaries allow, and teaching them can also be complex. It is intended that each chapter (or subsection, if required) can be pre-sented as a subject for study. The Introductions to each chapter are designed for both general and undergraduate readers, and provide a descriptive summary of the discussion in the texts. The texts can be used in conjunction with the various bibli-ographies in a number of ways. The lists of Essential Reading given in each chapter can be used as a basic introduction to the library research which is such an indis-pensable part of undertaking feminist academic work; selected essays and books from these reading lists can be used as set texts, depending upon the level that the students have reached or the depth in which each topic is to be studied. Each chapter then has a further, extensive listing for more advanced research in the main Bibli-ography at the end of the book, which also includes three further lists: general books, journal special issues, and books which document the history of the movement. Students who are at top BA or at MA level, and those who are researching the move-ment as a whole or the broader context for each chapter, will find these bibliographies of most use.

Notes

1 Books by Lucy Lippard include: *From the Center: Feminist Essays on Women's Art* (New York: E. P. Dutton, 1976); *Overlay: Contemporary Art and the Art of Prehistory* (New York: Pantheon Books, 1983); *Get the Message? A Decade of Art for Social Change* (New York: E. P. Dutton, 1984); *Mixed Blessings: New Art in a Multicultural America* (New York: Pantheon Books, 1990); *The Pink Glass Swan: Selected Feminist Essays on Art* (New York: The New Press, 1995); *The Lure of the Local: Senses of Place in a Multicentered Society* (New York: The New Press, 1997); *On the Beaten Track: Tourism, Art, and Place* (New York: The New Press, 1999). Books by Griselda Pollock include: (with Rozsika Parker) *Old Mistresses: Women, Art and Ideology* (London: Routledge and Kegan Paul, 1981); (with Rozsika Parker) *Framing Feminism: Art and the Women's Movement 1970–1985* (London: Pandora Press, 1987); *Vision and Difference: Femininity, Feminism and the Histo-ries of Art* (London: Routledge, 1988); *Avant-garde Gambits 1888–1893: Gender and the Colour of Art History* (London: Thames and Hudson, 1992); *Generations and Geographies in the Visual Arts: Femi-nist Readings* (London: Routledge, 1996); (with Fred Orton) *Avant-gardes and Partisans Reviewed* (Manchester: Manchester University Press, 1996); *Differencing the Canon: Feminist Desire and the Writing of Art's Histories* (London: Routledge, 1999).

2 *The Power of Feminist Art: The American Movement of the 1970s, History and Impact*, ed. Norma Broude and Mary D. Garrard (New York: Harry N. Abrams, 1994).

3 *Past Present: The National Women's Art Anthology*, ed. Joan Kerr and Jo Holder (Sydney: Craftsman House, 1999).

4 Broude and Garrard, *The Power of Feminist Art*, p. 10.

5 Lucy Lippard, 'Sweeping exchanges: the contribution of feminism to the art of the 1970s', *Art Journal*, 41 (1–2) (1980): 362–5, quoted in Broude and Garrard, *The Power of Feminist Art*, p. 10.

6 At a panel entitled 'Towards a Non-sexist, Non-racist, American Art History' at the College Art Association Conference (New York, February 2000), Nicholas Mirzoeff joked – but was serious in his point – that if sexism and racism were removed from American art history, it would no longer be American art history. His comment highlighted the lack of analysis of what constitutes American identity in such discourses.

7 For example, Eleanor Tufts, 'Beyond Gardner, Gombrich and Janson: towards a total history of art', *Arts Magazine*, 55 (8) (1981): 150–4.

8 For a recent, excellent analysis of the concept of the canon and feminism's response to it, see Griselda Pollock, *Differencing the Canon: Feminist Desire and the Writing of Art's Histories* (London: Routledge, 1999).

9 Hilary Robinson, 'Introduction to historiography/feminisms/strategy', *n.paradoxa* (online), 12, 2000 (http://web.ukonline.co.uk/n.paradoxa/panel.htm). This links to the full texts of the panel contributions from Whitney Chadwick, Deborah Cherry, Katy Deepwell, Phoebe Farris, Dori G. Lemeh, Marsha Meskimmon and Janet Wolff.

10 Mary Garrard, *Artemisia Gentileschi: The Image of the Female Hero in Italian Baroque Art* (Princeton, NJ: Princeton University Press, 1988); Griselda Pollock, *Mary Cassatt* (London: Thames and Hudson, 1998); Pamela Allara, *Pictures of People: Alice Neel's American Portrait Gallery* (Hanover, NH: Brandeis University Press, 1998).

11 See Susan Brownmiller, *In our Time: Memoir of a Revolution* (London: Aurum Press, 2000) for accounts of this in the early US activist movement.

1

Gender in/of Culture

INTRODUCTION

All through the twentieth century, from the suffrage movement, through writers such as Virginia Woolf, then Simone de Beauvoir, to the writers in this collection, feminists have not been content to allow political and economic analysis to stand alone, but have always provided it in conjunction with critiques of cultural structures and production. In the second half of the century Simone de Beauvoir's ringing words have been echoed and quoted in a large amount of feminist writing: 'Representation of the world, like the world itself, is the work of men. They show it from their own point of view, which they confuse with absolute truth.'[1] De Beauvoir argues that culturally woman is constructed as 'other' to man, who is the norm. While most, if not all, of the texts in this book may be said to engage with this assertion in some manner, the ones in this chapter directly address the gendered nature of culture – how representational practices *in* culture and the representation or mediation *of* culture can be said to be gendered.

Valerie Solanas's *Scum Manifesto* is read today sometimes with great veneration and sometimes with utter derision. The passage cited here as the opening text of this collection has been selected for another reason. It shows how the *Manifesto* is also a funny and trenchant tract on gender roles and cultural production. Solanas turns masculine and feminine roles upside down, suggests that male artists are weak individuals and thus have feminine roles[2] and that women are heroic and creative. Her involvement in Andy Warhol's Factory provides added interest to her analysis (she is often remembered today as the woman who shot Warhol). 'The true artist is every self-confident, healthy female, and in a female society the only Art, the only Culture, will be conceited, kookie, funkie females grooving on each other and on everything else in the universe', she writes, betraying the date of her writing and providing a utopian rallying call.

Shulamith Firestone was an art student in Chicago when she became active in the women's movement. In the chapter '(Male) Culture' (here edited) from her book *The Dialectic of Sex* she indicates and analyses the lack of women artists. Women who are artists 'have had to compete *as men*, in a male game' – our culture has no room for a female viewpoint to be accorded respect. Those who endeavour this 'must achieve and be rated by standards of a tradition she had no part in making'. These standards are biased: a woman's viewpoint is no less limited than a man's viewpoint and until women's voices are accorded their proper place we should not speak of our culture as universal.

Sherry B. Ortner's paper argues the necessity for a rigorous methodology when defining terms and determining the questions to be asked: 'we must be absolutely clear about *what* we are trying to explain, before explaining it.' Coming from an anthropological background, she defines culture as 'human consciousness and its products'. She then develops her theory that if every known society both accords women certain cultural roles but devalues them overall, then the issue is not that women are nature, but that 'women are seen "merely" as being *closer* to nature than men.' The reasons for this subtlety are argued through the complex cultural structuring of activities such as child-rearing and cooking.

The following two texts are both from performances. Carolee Schneemann used hers for both her super-8 film 'Kitch's Last Meal' (1973–5) and for two performances titled 'Interior Scroll' (1975 and 1977). Photographs by Anthony McCall documenting this latter performance are much in circulation in histories of performance art and of feminist art, and have also been commodified on the art market as if the photographs themselves were the artworks.[3] The moments represented are those at the end of the performance when Schneemann stands naked, body smeared with 'expressionist' brush marks, and has extracted a scroll from her vagina from which she is reading out the text reproduced here. In her own collected writings,[4] Schneemann was careful to supply a number of photographs juxtaposed with the full text; one still image alone can re-enforce the issue she addresses in the text as a problem: the representation of women as artists and their work as art.

Faith Wilding's performance 'Waiting', done while she was a student at the Feminist Art Program at CalArts, Los Angeles, is in a tradition of performance art that is found much more in the US than in, say, Europe – a tradition that builds upon theatrical modes and literary representation more than visual representation and a more conceptual approach to time and duration. Sitting in a rocking chair on stage, Wilding acted out with her voice and body posture the ageing of a woman from infancy to old age and death. The text demonstrates the passivity of women in their allotted roles of relationship to other family members.

In the extracts from 'The Straight Mind' reproduced here, Monique Wittig revisits both de Beauvoir's concept of the 'Other' and the anthropological differentiation of nature and culture investigated by Ortner (she links her concept of the straight mind to Lévi-Strauss's *The Savage Mind*). Her aim is to expose 'the obligatory social relationship between "man" and "woman"' – what Adrienne Rich would come to call 'compulsory heterosexuality'.[5] While Wittig would concur with Ortner that the relation between nature and culture is itself a cultural construct, she turns to the very language used to mediate these concepts. Language is not neutral, but embodies straight ideology. 'Thus lesbianism, homosexuality, and the societies that we form cannot be thought of or spoken of . . . The transformation of economic relationships will not suffice', she argues: language itself must be worked upon in order to shift concepts. Language is also addressed by Isabelle Bernier. Drawing upon work done by Rozsika Parker in *The Subversive Stitch*, and by Parker and Griselda Pollock in *Old Mistresses*, she attends to the shifting and gendered hierarchies of differing materials: those which connote 'masculinity' ('art') and those which connote 'femininity' ('craft').[6]

The interview given by Luce Irigaray concerns the identification 'as a woman', the position of women in institutions, and of their works in the twentieth-century canon.

Running through Irigaray's answers are her theories that subjectivity is sexed, and that it is articulated in writing and elsewhere. She understands a culture where a woman might say 'I do not write as a woman' as one which has 'contempt for the value of women'. For Irigaray, cultural processes and products are never neuter. She questions the veracity of the interviewer's assessment of women's progress, indicating that women who gain 'success' have had to pay highly for it, and suggests that progress will only be found in a culture which recognizes the links between sexed subjectivity and language: it is an argument for recognition of difference in culture, rather than the erasure of difference suggested by the neutrality of equality and sameness. The final text in this chapter, statistics gathered by the New York based Women's Action Coalition in the early 1990s, backs up Irigaray's scepticism about women's progress in today's institutions. The readings in this chapter provide differing analyses of why this might be so, and differing strategies for righting the situation. These are radical (going back to the root) or revolutionary in different ways, whether it be the supremacist separatism of Solanas, the revolutionary egalitarianism of Firestone or the radical linking of subjectivity, cultural structures and difference argued by Luce Irigaray.

Notes

1 Simone de Beauvoir, *The Second Sex* (Harmondsworth: Penguin, 1972; first pub. France, 1949), p. 175.
2 A thread later taken up by June Wayne in a more orthodox manner in 'The male artist as a stereotypical female', *Art Journal*, 32 (4) (1973): 414–16.
3 See Amelia Jones, *Body Art: Performing the Subject* (Minneapolis, MN: Minnesota University Press, 1998), pp. 36–7 and passim, on the problematic of documenting performance.
4 Carolee Schneemann, *More than Meat Joy: Performance Works and Selected Writings* (New Paltz, NY: Documentext, 1979; 2nd edn, 1997).
5 Adrienne Rich, 'Compulsory heterosexuality and lesbian existence' (1980), in *The Signs Reader: Women, Gender and Scholarship*, ed. E. Abel and E. K. Abel (Chicago: University of Chicago Press, 1983), pp. 139–68.
6 Rozsika Parker, *The Subversive Stitch: Embroidery and the Making of the Feminine* (London: The Women's Press, 1984); Rozsika Parker and Griselda Pollock: *Old Mistresses: Women, Art and Ideology* (London: Routledge and Kegan Paul, 1981).

Essential reading

de Beauvoir, Simone, 'Dreams, fears, idols', in *The Second Sex* (Harmondsworth: Penguin, 1972; first pub. France, 1949), pp. 171–229.
Butler, Judith, *Gender Trouble: Feminism and the Subversion of Identity* (London: Routledge, 1990).
Figes, Eva, *Patriarchal Attitudes* (London: Faber, 1970).
Greer, Germaine, *The Whole Woman* (London: Doubleday, 1999).
Haraway, Donna, 'A manifesto for cyborgs: science, technology, and socialist-feminism in the 1980s', *Socialist Review*, 15 (2) (1985): 65–108; reprinted in *Feminism/Postmodernism*, ed. Linda Nicholson (London: Routledge, 1990).
hooks, bell, *Yearning: Race, Gender, and Cultural Politics* (Boston, MA: South End Press, 1990).
Jardine, Alice and Smith, Paul (eds), *Men in Feminism* (London: Methuen, 1989).

Kristeva, Julia, 'Women's time' (1979), *Signs*, 7 (1) (1981): 13–35; reprinted in *The Kristeva Reader*, ed. Toril Moi (Oxford: Blackwell, 1986), pp. 187–213.

Plant, Sadie, *Zeroes and Ones: Digital Women and the New Technoculture* (London: Fourth Estate, 1997).

Probyn, Elspeth, *Sexing the Self: Gendered Positions in Cultural Studies* (London: Routledge, 1993).

Riley, Denise, *Am I that Name?: Feminism and the Category of 'Women' in History* (London: Macmillan, 1988).

Valerie Solanas, 'Scum Manifesto' (1968)

From *Scum Manifesto* (London: The Matriarchy Study Group, 1983; first pub. 1968), pp. 23–6.

[. . .] *'Great Art' and 'Culture'*: The male 'artist' attempts to solve his dilemma of not being able to live, of not being female, by constructing a highly artificial world in which the male is heroized, that is, displays female traits, and the female is reduced to highly limited, insipid subordinate roles, that is, to being male.

The male 'artistic' aim being, not to communicate (having nothing inside him, he has nothing to say), but to disguise his animalism, he resorts to symbolism and obscurity ('deep' stuff). The vast majority of people, particularly the 'educated' ones, lacking faith in their own judgement, humble, respectful of authority ('Daddy knows best' is translated into adult language as 'Critic knows best', 'Writer knows best', 'PhD knows best'), are easily conned into believing that obscurity, evasiveness, incomprehensibility, indirectness, ambiguity and boredom are marks of depth and brilliance.

'Great Art' proves that men are superior to women, that men are women, being labelled 'Great Art', almost all of which, as the anti-feminists are fond of reminding us, was created by men. We know that 'Great Art' is great because male authorities have told us so, and we can't claim otherwise, as only those with exquisite sensitivities far superior to ours can perceive and appreciate the greatness, the proof of their superior sensitivity being that they appreciate the slop that they appreciate.

Appreciating is the sole diversion of the 'cultivated': passive and incompetent, lacking imagination and wit, they must try to make do with that; unable to create their own diversions, to create a little world of their own, to affect in the smallest way their environments; they must accept what's given: unable to create or relate, they spectate. Absorbing 'culture' is a desperate, frantic attempt to groove in an ungroovy world, escape the horror of a sterile, mindless existence. 'Culture' provides a sop to the egos of the incompetent, a means of rationalizing passive spectating; they can pride themselves on their ability to appreciate the 'finer' things, to see a jewel where there is only a turd (they want to be admired for admiring). Lacking faith in their ability to change anything, resigned to the status quo, they *have* to see beauty in turds because, so far as they can see, turds are all they'll ever have.

The veneration of 'Art' and 'Culture' – besides leading many women into boring, passive activity that distracts from more important and rewarding activities, from cultivating active abilities and leads to the constant intrusion on our sensibilities of pompous dissertations on the deep beauty of this and that turd. This allows the 'artist' to be set up as one possessing superior feelings, perceptions, insights and judgements, thereby undermining the faith of insecure women in the value and validity of their own feelings, perceptions, insights and judgements.

The male, having a very limited range of feelings and, consequently, very limited perceptions, insights and judgements, needs the 'artist' to guide him, to tell him what life is all about. But the male 'artist', being totally sexual, unable to relate to anything beyond his own physical sensations, having nothing to express beyond the insight that for the male life is meaningless and absurd, cannot be an artist. How can he who is not capable of life tell us what life is all about? A 'male artist' is a contradiction in terms. A degenerate can only produce degenerate 'art'. The true artist is every self-confident, healthy female, and in a female society the only Art, the only Culture, will be conceited, kookie, funkie females grooving on each other and on everything else in the universe. [. . .]

Shulamith Firestone, '(Male) Culture' (1970)

From *The Dialectic of Sex: The Case for Feminist Revolution* (London: The Women's Press, 1979; first pub. 1970), pp. 148–60.

> Representation of the world, like the world itself, is the work of men; they describe it from their own point of view, which they confuse with absolute truth.
>
> *Simone de Beauvoir*

The relation of women to culture has been indirect. We have discussed how the present psychical organization of the two sexes dictates that most women spend their emotional energy on men, whereas men 'sublimate' theirs into work. In this way women's love becomes raw fuel for the cultural machine. (Not to mention the Great Ideas born rather more directly from early-morning boudoir discussions.)

In addition to providing its emotional support, women had another important indirect relation to culture: they inspired it. The Muse is female. Men of culture were emotionally warped by the sublimation process; they converted life to art, thus could not live it. But women, and those men who were excluded from culture, remained in direct contact with their experience – fit subject matter.

That women were intrinsic in the very content of culture is borne out by an example from the history of art: men are erotically stimulated by the opposite sex; painting was male; the nude became a *female* nude. Where the art of the male nude reached high levels, either in the work of an individual artist, e.g. Michelangelo, or in a whole artistic period, such as that of classical Greece, men were homosexual.

The subject matter of art, when there is any, is today even more largely inspired by women. Imagine the elimination of women characters from popular films and novels, even from the work of 'highbrow' directors – Antonioni, Bergman, or Godard; there wouldn't be much left. For in the last few centuries, particularly in popular culture – perhaps related to the problematic position of women in society – women have been the main subject of art. In fact, in scanning blurbs of even one month's cultural production, one might believe that women were all anyone ever thought about.

But what about the women who have contributed directly to culture? There aren't many. And in those cases where individual women have participated in male culture, they have had to do so on male terms. And it shows. Because they have had to compete *as men*, in a male game – while still being pressured to prove themselves in their old female roles, a role at odds with their self-appointed ambitions – it is not surprising that they are seldom as skilled as men at the game of culture.

And it is not just a question of being as competent, it is also a question of being *authentic*. We have seen in the context of love how modern women have imitated male psychology, confusing it with health, and have thereby ended up even worse off than men themselves: they were not even being true to home-grown sicknesses. And there are even more complex layers to this question of authenticity: women have no means of coming to an understanding of what their experience *is*, or even that it is different from male experience. The tool for representing, for objectifying one's experience in order to deal with it, culture, is so saturated with male bias that women almost never have a chance to see themselves culturally through their own eyes. So that finally, signals from their direct experience that conflict with the prevailing (male) culture are denied and repressed.

Thus because cultural dicta are set by men, presenting only the male view – and now in a super-barrage – women are kept from achieving an authentic picture of their reality. Why do women, for example, get aroused by a pornography of female bodies? In their ordinary experience of female nudity, say in a gym locker room, the sight of other nude females might be interesting (though probably only in so far as they rate by male sexual standards), but not directly erotic. Cultural distortion of sexuality explains also how female sexuality gets twisted into narcissism: women make love to themselves vicari-ously through the man, rather than directly making love to him. At times this cultural barrage of man/subject, women/object desensitizes women to male forms to such a degree that they are orgasmically affected.[1]

There are other examples of the distorting effects on female vision of an exclusively male culture. Let us go back to the history of figurative painting once again: we have seen how in the tradition of the nude, male heterosexual inclinations came to empha-size the female rather than the male as the more aesthetic and pleasing form. Such a predilection for either one over the other, of course, is based on a sexuality which is in itself artificial, culturally created. But at least one might then expect the opposite bias to prevail in the view of women painters still involved in the tradition of the nude. This is not the case. In any art school in the country one sees classrooms full of girls working diligently from the female model, accepting that the male model is somehow less aesthetic, at best perhaps novel, and certainly never questioning why the male model

wears a jock strap when the female model wouldn't dream of appearing in so much as a G-string.

Again, looking at the work of well-known women painters associated with the Impressionist School of the nineteenth century, Berthe Morisot and Mary Cassatt, one wonders at their obsessive preoccupation with traditionally female subject matter: women, children, female nudes, interiors, etc. This is partially explained by political conditions of that period: women painters were lucky to be allowed to paint anything at all, let alone male models. And yet it is more than that. These women, for all their superb draughtsmanship and compositional skill, remained minor painters because they had 'lifted' a set of traditions and a view of the world that was inauthentic for them. They worked within the limits of what had been defined as female by a *male* tradition: they saw women through male eyes, painted a male's idea of female. And they carried it to an extreme, for they were attempting to outdo men at their own game; they had fallen for a (lovely) line. And thus the falseness that corrupts their work, making it 'feminine', i.e. sentimental, light.

It would take a denial of all cultural tradition for women to produce even a true 'female' art. For a woman who participates in (male) culture must achieve and be rated by standards of a tradition she had no part in making – and certainly there is no room in that tradition for a female view, even if she *could* discover what it was. In those cases where a woman, tired of losing at a male game, has attempted to participate in culture *in a female way*, she has been put down and misunderstood, named by the (male) cultural establishment 'Lady Artist', i.e. trivial, inferior. And even where it must be (grudgingly) admitted she is 'good', it is fashionable – a cheap way to indicate one's own 'seriousness' and refinement of taste – to insinuate that she is good but irrelevant.

Perhaps it is true that a presentation of only the female side of things – which tends to be one long protest and complaint rather than the portrayal of a full and substantive existence – is limited. But an equally relevant question, one much less frequently asked, is: Is it any more limited than the prevailing male view of things, which – when not taken as absolute truth – is at least seen as 'serious', relevant, and important? Is Mary McCarthy in *The Group* really so much worse a writer than Norman Mailer in *The American Dream*? Or is she perhaps describing a reality that men, the controllers and critics of the Cultural Establishment, can't tune in on?

[. . .]

In order to illustrate this cultural dichotomy in more objective terms, we don't need to attack the more obvious paper tigers (all senses implied) who consciously present a 'male' reality – viz. Hemingway, Jones, Mailer, Farrell, Algren, and the rest. The new Virility School in twentieth-century literature is in itself a direct response, indeed a male cultural backlash, to the growing threat to male supremacy – Virility Inc., a bunch of culturally deprived 'tough guys', punching away to save their manhood. And though they get more credit, these artists write about the 'male' experience no more perceptively than Doris Lessing, Sylvia Plath, Anaïs Nin have written about the female experience. In fact they are guilty of a mystification of their experience that makes their writing phony.

[. . .]

And what about women artists? We have seen that it has only been in the last several centuries that women have been permitted to participate – and then only on an individual basis, and on male terms – in the making of culture. And even so their vision had become inauthentic: they were denied the use of the cultural mirror.

And there are many *negative* reasons that women have entered art: affluence always creates female dilettantism, e.g. the Victorian 'young lady' with her accomplishments, or the arts of the Japanese geisha – for, in addition to serving as a symbol of male luxury, women's increasing idleness under advancing industrialism presents a practical problem: female discontent has to be eased to keep it from igniting. Or women may be entering art as a refuge. Women today are still excluded from the vital power centres of human activity; and art is one of the last self-determining occupations left – often done in solitude. But in this sense women are like a petty bourgeoisie trying to open up shop in the age of corporate capitalism.

For the higher percentages of women in art lately may tell us more about the state of art than about the state of women. Are we to feel cheered that women have taken over in a capacity soon to be automated out? (Like 95 percent Black at the Post Office, this is no sign of integration; on the contrary, undesirables are being shoved into the least desirable positions – Here, now get in and keep your mouth shut!) That art is no longer a vital centre that attracts the best men of our generation may also be a product of the male/female division [. . .] But the animation of women and homosexuals in the arts today may signify only the scurrying of rats near a dying body.[2]

But if it has not yet created great women artists, women's new literacy has certainly created a female audience. Just as male audiences have always demanded, and received, male art to reinforce their particular view of reality, so a female audience demands a 'female' art to reinforce the female reality. Thus the birth of the crude feminine novel in the nineteenth century, leading to the love story of our own day, so ever-present in popular culture ('soap opera'); the women's magazine trade; *Valley of the Dolls*. These may be crude beginnings. Most of this art is as yet primitive, clumsy, poor. But occasionally the female reality is documented as clearly as the male reality has always been, as, for example, in the work of Anne Sexton.

Eventually, out of this ferment – perhaps very soon – we may see the emergence of an authentic female art. But the development of 'female' art is not to be viewed as reactionary, like its counterpart, the male School of Virility. Rather it is progressive: an exploration of the strictly female reality is a necessary step to correct the warp in a sexually biased culture. It is only after we have integrated the dark side of the moon into our world view that we can begin to talk seriously of universal culture.

[. . .]

Only a feminist revolution can eliminate entirely the sex schism causing these cultural distortions. Until then 'pure art' is a delusion – a delusion responsible both for the inauthentic art women have produced until now, as well as for the corruption of (male) culture at large. The incorporation of the neglected half of human experience – the female experience – into the body of culture, to create an all-encompassing culture, is only the first step, a precondition; but the schism of reality itself must be overthrown before there can be a true cultural revolution.

Notes

1 Female inability to focus on sexual imagery has been found to be a major cause of female frigidity. Masters and Johnson, Albert Ellis, and others have stressed the importance of 'sexual focusing' in teaching frigid women to achieve orgasm. Hilda O'Hare in *International Journal of Sexology* correctly attributes this problem to the absence in our society of a female counterpart for the countless stimulants of the male sexual urge.
2 However, women's presence in the arts and humanities is still viciously fought by the few males remaining, in proportion to the insecurity of their own position – particularly precarious in traditional, humanist schools, such as figurative painting.

Sherry B. Ortner, 'Is Female to Male as Nature is to Culture?' (1972)

From *Feminist Studies*, 1 (2) (1972), pp. 5–31.

Much of the creativity of anthropology derives from the tension between the demands for explanation of human universals on the one hand and cultural particulars on the other. By this canon, woman provides us with one of the more challenging problems to be dealt with. The secondary status of woman in society is one of the true universals, a pan-cultural fact. Yet within that universal fact, the specific cultural conceptions and symbolizations of woman are incredibly diverse and even mutually contradictory. Further, the actual treatment of women, and the relative power and contribution of women, vary enormously from culture to culture, and over different periods in the history of particular cultural traditions. Both of these points – the universal fact, and the cultural variation – constitute problems for explanation.

It goes without saying that my interest in the problem is more than academic: I wish to see genuine change come about, the emergence of a social and cultural order in which as much of the range of human potential is open to women as to men. The universality of female subordination, the fact that it exists within every type of social and economic arrangement, and in societies of every degree of complexity, indicates to me that we are up against something very profound, very stubborn, something that can not be remedied merely by rearranging a few tasks and roles in the social system, nor even by rearranging the whole economic structure.

First, it is important to sort out the levels of the problem. The confusion can be enormous. For example, depending on which aspect of Chinese culture we looked at, we might extrapolate entirely different guesses concerning the status of women in China. In the ideology of Taoism, *yin*, the female principle, and *yang*, the male principle, are given equal weight; 'The opposition, alternation, and interaction of these two forces give rise to all phenomena in the universe.'[1] Hence we might guess that maleness and femaleness are equally valued in the general ideology of Chinese culture. Looking at the social structure, on the other hand, we see the strong patrilineal descent principle,

the importance of sons, and the patripotestal structure of the family. Thus we might conclude that China is the archetypal patriarchal society. Next, looking at the actual roles played, power and influence wielded, and material contributions made by women in Chinese society, all of which are, upon observation, quite substantial, we are tempted to say that women 'really' are allotted a great deal of (unspoken) status in the system. Or again, we might focus on the fact that a goddess, Kuan-yin, is the central (most-worshipped, most-depicted) deity in Chinese Buddhism, and we might be tempted to say, as many have tried to say about goddess-worshipping cultures in pre- and early-historical societies, that 'actually' China is a sort of matriarchy. In short, we must be absolutely clear about *what* we are trying to explain, before explaining it.

We may isolate three levels of the problem.

1 The universal fact of culturally attributed second-class status to woman in every society. Two questions are important here. First, what do we mean by this, what is our evidence that this is a universal fact? And second, how are we to explain the fact having established it?
2 Specific ideologies, symbolizations, and social structural arrangements pertaining to women which vary widely from culture to culture. The problem at this level is to account for any particular cultural complex in terms of factors specific to that culture – the standard level of anthropological analysis.
3 Observable on-the-ground details of women's activities, contributions, powers, etc., often at variance with cultural ideology, and always constrained within the assumption that women may never be officially pre-eminent in the total system. This is the level of direct observation, often adopted now by feminist-oriented anthropologists.

This paper is primarily concerned with the first level of the problem: the universal devaluation of women. It thus depends not upon specific cultural data but rather upon an analysis of 'culture' taken generically as a special sort of process in the world. A discussion of the second level, the problem of cross-cultural variation in conceptions and relative valuations of women, must be postponed for another paper, since it will entail a great deal of cross-cultural research. As for the third level, it will be obvious from my approach that I would consider it a misguided endeavor to focus only upon women's actual, though culturally unrecognized and unvalued, powers in any given society, without first understanding the overarching ideology and deeper assumptions of the culture that renders such powers trivial.

What do I mean when I say that everywhere, in every known culture, woman is considered in some degree inferior to man? First of all I must stress that I am talking about *cultural* evaluations; I am saying that each culture, in its own way and in its own terms, makes this evaluation. What would constitute evidence, when we look at any particular society, that it considers women inferior?

Three types of data would be evidence:

1 Elements of cultural ideology and informants' statements that *explicitly* devalue women, according them, their roles, their tasks, their products, and their social milieu less prestige than men and the male correlates.

2 Symbolic devices, such as the attribution of defilement, which may be interpreted as making a statement of inferior valuation.
3 Social rules that prohibit women from participating in or having contact with some realm in which the highest powers of the society are felt to reside.

These three types of data may all of course be interrelated in any particular system, but not necessarily. Further, any one of them will usually be sufficient to make the point of female inferiority in any given culture. Certainly female exclusion from the most sacred rite or the highest political council is sufficient evidence. Certainly explicit cultural ideology devaluing women (and their tasks, roles, products, etc.) is sufficient evidence. Symbolic indicators such as defilement are usually sufficient, although in a few cases in which men and women are equally polluting to one another, a further indicator is required – and is, as far as my researches have ascertained, always available.

On any or all of these counts, we find women subordinated to men in every known society. The search for a genuinely egalitarian, let alone matriarchal, culture, has proven fruitless, and it is important for the woman's movement at large to face up to this fact. An example from one society that has traditionally been on the good side of the ledger *vis-à-vis* the status of their women will suffice. Among the matrilineal Crow, Lowie points out that 'Women . . . had highly honorific offices in the Sun Dance; they could become directors of the Tobacco ceremony and played, if anything, a more conspicuous part in it than the men; they sometimes played the hostess in the Cooked Meat Festival; they were not debarred from sweating or doctoring nor from seeking a vision.' Nonetheless, 'Women [during menstruation] formerly rode inferior horses and evidently this loomed as a source of contamination, for they were not allowed to approach either a wounded man or men starting on a war party. A taboo still lingers against their coming near sacred objects at these times.' Further, Lowie mentions, just before enumerating women's rights of participation in the various rituals noted above, that there was one particular Sun Dance Doll bundle that was not supposed to be unwrapped by a woman. Pursuing this trail we find: 'According to all Lodge Grass informants and most others, the doll owned by Wrinkled-face took precedence not only of other dolls but of all other Crow medicines whatsoever . . . This particular doll was not supposed to be handled by a woman . . .'[2]

In sum, the Crow probably provide a fairly typical case. Yes, women have certain powers and rights, in this case some that place them in comparatively high positions. Yet ultimately the line is drawn; menstruation is a threat to warfare, one of the most valued institutions of the tribe – one central to their self definition – and the most sacred object of the tribe is tabooed to the direct sight and touch of women.

Similar examples could be multiplied ad infinitum, but I think it is time to turn the tables. The onus is no longer upon us to demonstrate that female subordination is a cultural universal; it is up to those who would argue against the point to bring forth counter-examples. I shall take the universal secondary status of women as a given, and proceed from there.

If the devaluation of women relative to men is a cultural universal, how are we to explain this fact? We could of course rest the case on biological determinism: there is something genetically inherent in the males of the species that makes them the

naturally dominant sex; that 'something' is lacking in females, and, as a result, women are not only naturally subordinate but, in general, quite satisfied with their position, since it affords them protection and the opportunity to maximize the maternal pleasures that to them are the most satisfying experiences of life. Without going into a detailed refutation of this position, it is fair to say that it has failed to convince very few in academic anthropology. This is not to say that biological facts are irrelevant, nor that men and women are not different; but it is to say that these facts and differences only take on significance of superior/inferior within the framework of culturally defined value systems.

If we are not willing to rest the case on genetic determinism, it seems to me that we have only one other way to proceed. We must attempt to interpret female subordination in light of other universals of the human condition, factors built into the structure of the most generalized situation that all human beings, in whatever culture, find themselves in. For example, every human being has a physical body and a sense of non-physical mind, is part of a society of other individuals and an inheritor of a cultural tradition, and must engage in some relationship, however mediated, with 'nature' or the non-human realm, in order to survive. Every human being is born (to a mother) and ultimately dies; all are assumed to have an interest in personal survival; and society/culture has its own interest in (or at least momentum toward) continuity and survival that transcends the lives and deaths of particular individuals. And so forth. It is in the realm of such universals of the human condition that we must seek an explanation for the universal fact of female devaluation.

I translate the problem, in other words, into the following simple question: what could there be in the generalized structure and conditions of existence, common to every culture, that would lead every culture to devalue women? Specifically, my thesis is that woman is being identified with, or, if you will, seems to be a symbol of, something that every culture devalues, something that every culture defines as being at a lower order of existence than itself. Now it seems that there is only one thing that would fit that category, and that is 'nature' in the most generalized sense. Every culture, or, generically, 'culture,' is engaged in the process of generating and sustaining systems of meaningful forms (symbols, artifacts, etc.) by means of which humanity transcends the givens of natural existence, bends them to its purposes, controls them in its interest. We may thus equate culture broadly with the notion of human consciousness, or with the products of human consciousness (i.e. systems of thought and technology), by means of which humanity attempts to rise above and assert control, however minimally, over nature.

Now the categories of 'nature' and 'culture' are of course categories of human thought – there is no place out in the real world where one could find some actual boundary between the two states or realms of being. And there is no question that some cultures articulate a much stronger opposition between the two categories than others – it has even been argued that primitive peoples (some or all) do not see or intuit any distinction between the human cultural state and the state of nature at all. Yet I would maintain that the universality of ritual betokens an assertion in all human cultures of the specifically human ability to act upon and regulate, rather than passively move with and be moved by, the givens of natural existence. In ritual, the purposive manipulation of given forms toward regulating and sustaining order, every culture makes the state-

ment that proper relations between human existence and natural forces depend upon culture's contributing its special powers toward regulating the overall process of the world.

These points are often articulated in notions of purity and pollution. Virtually every culture has some such notions, and they seem in large part (though not, of course, entirely) to be about the relationship between culture and nature.[3] A well-known aspect of purity/pollution beliefs cross-culturally is that of natural 'contagion' of pollution – pollution (for these purposes grossly equated with the unregulated operation on natural energies) left to its own devices spreads and overpowers all it comes in contact with. Thus the old puzzle – if pollution is so strong, how can anything be purified? When the purifying agent is introduced, why does it purify rather than become polluted itself? The answer, in line with the present argument, is that purification is effected in a ritual context – that purification ritual, as a purposive activity that pits self-conscious (symbolic) action against natural energies, is more powerful than those energies.

In any case, my point is simply that every culture implicitly recognizes and asserts the distinction between the operation of nature as such and the operation of culture (human consciousness and its products), and further, that the distinctiveness of culture rests precisely on the fact that it can under most circumstances transcend natural givens and turn them to its purposes. Thus culture (i.e. every culture) at some level of awareness asserts itself to be not only distinct from, but superior in power to, nature, and that sense of distinctiveness and superiority rests precisely on the ability to transform – to 'socialize' and 'culturalize' – nature.

Returning now to the issue of women, in my initial thinking on the subject, I formulated the argument as follows: the pan-cultural devaluation of woman could be accounted for, quite simply, by postulating that woman is being identified with, or symbolically associated with, nature, as opposed to man, who is identified with culture. Since it is always culture's project to subsume and transcend nature, if woman is a part of nature, then culture would find it 'natural' to subordinate, not to say oppress, her. While this argument could be shown to have considerable force, it also seems to over-simplify the case. The formulation I would like to defend and elaborate on, then, is that women are seen 'merely' as being *closer* to nature than men. That is, culture (still equated more or less unambiguously with men) recognizes that woman is an active participant in its special processes, but sees her as being, at the same time, more rooted in, or having more direct connection with, nature.

The revision seems minor and even trivial, but I think it is a more accurate rendering of cultural assumptions concerning women. Further, the argument cast in these terms has several analytic advantages over the simpler formulation; I will discuss these later. It might simply be stressed here that the revised argument would still account for the pan-cultural devaluation of women, for, even if woman is not equated with nature, she is still seen as representing a lower order of being, less transcendental of nature than men. The next question is why she might be viewed that way.

It all begins of course with the body, and the natural procreative functions specific to women alone. We can sort out for discussion three levels at which this absolute physiological fact has significance.

1 Her *body and its functions*, more involved more of the time with 'species life,' seem
 to place her closer to nature, as opposed to men, whose physiology frees them more
 completely to the projects of culture.
2 Her body and its functions put her in *social roles* that are in turn considered to be
 at a lower order of culture, in opposition to the higher orders of the cultural process.
3 Her traditional social roles, imposed because of her body and its functions, in turn
 give her a different *psychic structure* – and again, this psychic structure, like her
 physiological nature and her social roles, is seen as being more 'like nature.'

My argument that woman's physiology is seen as 'closer to nature' has been antici-
pated, with great subtlety and cogency, and a lot of hard data, by de Beauvoir. De
Beauvoir reviews the physiological structure, development, and functions of the human
female and concludes that 'the female, to a greater extent than the male, is the prey of
the species.' She points out that many major areas and processes of the woman's body
serve no apparent function for the health and stability of the individual woman; on the
contrary, as they perform their specific organic functions, they are often sources of dis-
comfort, pain and danger. The breasts are irrelevant to personal health; they may be
excised at any time of a woman's life. 'Many of the ovarian secretions function for the
benefit of the egg, promoting its maturation and adapting the uterus to its require-
ments; in respect to the organism as a whole, they make for disequilibrium rather than
for regulation – the woman is adapted to the needs of the egg rather than to her own
requirements.' Menstruation is often uncomfortable, sometimes painful; it frequently
has negative emotional correlates and in any case involves bothersome tasks of cleans-
ing and waste-disposal; and – a point that de Beauvoir does not mention – in many
cultures it interrupts a woman's routine, putting her in a stigmatized state involving
various restrictions on her activities and social contacts. In pregnancy, many of the
woman's vitamin and mineral resources are channelled into nourishing the fetus,
depleting her own strength and energies, and finally, childbirth itself is painful and
dangerous. In sum, de Beauvoir concludes that the female 'is more enslaved to the
species than the male, her animality is more manifest.'[4]

De Beauvoir's survey is meant to be, and seems in all fairness to be, purely descrip-
tive. It is simply a fact that proportionately more of woman's body space, for a greater
percentage of her life-time, and at a certain – sometimes great – cost to her personal
health, strength, and general stability, is taken up with the natural processes surround-
ing the reproduction of the species. Further, in physiological structure, the woman is
weaker than the man, 'her grasp on the world is thus more restricted; she has less firm-
ness and less steadiness available for projects that in general she is less capable of
carrying out.'[5]

De Beauvoir goes on to discuss the negative implications of woman's 'enslavement
to the species' and general physical weakness in relation to the projects in which humans
engage, projects through which culture is generated and defined. She arrives thus at
the crux of her argument:

Here we have the key to the whole mystery. On the biological level a species is main-
tained only by creating itself anew; but this creation results only in repeating the same
Life in more individuals. But man assures the repetition of Life while transcending
Life through Existence [i.e. goal-oriented, meaningful action]; by this transcendence

he creates values that deprive pure repetition of all value. In the animal, the freedom and variety of male activities are vain because no project is involved. Except for his services to the species, what he does is immaterial. Whereas in serving the species, the human male also remodels the face of the earth, he creates new instruments, he invents, he shapes the future.[6]

In other words, woman's body seems to doom her to mere reproduction of life; the male, on the other hand, lacking natural creative functions, must (or has the opportunity to) assert his creativity externally, 'artificially,' through the medium of technology and symbols. In so doing, he creates relatively lasting, eternal, transcendent objects, while the woman creates only perishables – human beings.

This formulation opens up a number of important insights. It explains, for example, the great puzzle of why male activities involving the destruction of life (hunting and warfare) have more charisma, as it were, than the female's ability to give birth, to create life.[7] Yet within de Beauvoir's framework, we realize that it is not the killing that is the relevant and valued aspect of hunting and warfare; rather it is the transcendental (social, cultural) nature of these activities, as opposed to the naturalness of the process of birth: 'For it is not in giving life but in risking life that man is raised above the animal; that is why superiority has been accorded in humanity not to the sex that brings forth but to that which kills.'[8]

Thus, if male is everywhere (unconsciously) associated with culture, and female seems closer to nature, the rationale for these associations is easy to grasp, merely from considering the implications of the physiological contrast between male and female. At the same time, however, woman cannot be consigned fully to the category of nature, for it is perfectly obvious that she is a fully fledged human being, endowed with human consciousness just as man is; she is half of the human race, without whose cooperation the whole enterprise would collapse. She may seem more in the possession of nature than man, but, having consciousness, she thinks and speaks; she generates, communicates, and manipulates symbols, categories, and values. She participates in human dialogues not only with other women, but also with men. As Lévi-Strauss says, 'woman could never become just a sign and nothing more, since even in a man's world she is still a person, and since insofar as she is defined as a sign she must [still] be recognized as a generator of signs.'[9]

Indeed the fact of woman's full human consciousness, her full involvement in and commitment to culture's project of transcendence over nature, may, ironically enough, explain another of the great puzzles of 'the woman problem' – woman's nearly universal unquestioning acceptance of her own devaluation. For it would seem that as a conscious human and a member of culture she has followed out the logic of culture's arguments, and reached culture's conclusions along with the men. As de Beauvoir puts it:

For she, too, is an existent, she feels the urge to surpass, and her project is not mere repetition but transcendence towards a different future – in her heart of hearts she finds confirmation of the masculine pretensions. She joins the men in the festivals that celebrate the successes and victories of the males. Her misfortune is to have been biologically destined for the repetition of Life, when even in her own view Life does not carry within itself its reasons for being, reasons that are more important than life itself.[10]

In other words, woman's consciousness – her membership, as it were, in culture – is evidenced in part by the fact that she accepts her own devaluation and takes culture's point of view. Because of woman's greater bodily involvement with the natural functions surrounding reproduction, she is seen as more a part of nature than men. Yet, in part because of her consciousness and participation in human social dialogue, she is recognized as a participant in culture. Thus she appears as something intermediate between culture and nature, lower on the scale of transcendence than men.

Woman's physiological functions may thus tend in themselves to motivate (in the semantic sense) a view of woman as closer to nature, a view that she herself, as an observer of herself and the world, would tend to accept. Woman creates naturally from within her own being, while men are free to, or forced to, create artificially, that is, through cultural means, and in such a way as to sustain culture. In addition, woman's physiological functions have tended universally to limit her social movement, and to confine her universally to certain social contexts which *in turn* are seen as closer to nature. That is, not only her bodily processes, but the social situation in which her bodily processes locate her, may have that significance. And insofar as she is permanently associated (in the eyes of the culture) with these social loci, they add weight (perhaps the decisive part of the load) to the view of woman as closer to nature. I refer here of course to woman's confinement to the domestic family context as a 'natural' extension of her lactation processes.

Woman's body, like that of all female mammals, generates milk during and after pregnancy for the feeding of the new-born baby. The baby cannot survive without breast milk or some highly similar formula at this stage of life. Since it is in direct relation to a particular pregnancy with a particular child that the mother's body goes through its lactation processes, the nursing relationship between mother and child is seen as a 'natural' bond and all other feeding arrangements as unnatural and makeshift. Mothers and their children, culture seems to feel, belong together. Further, since children as they get beyond infancy are not yet strong enough to engage in major work, yet are mobile and unruly and not yet capable of understanding various dangers, they require supervision and constant care. Mother is the 'obvious' person for this task, as an extension of her 'natural' nursing bond with the children, or because she has a new infant and is involved with child-oriented activities anyway. Her own activities are thus circumscribed by the limitations and low levels of her children's strengths and skills; she is confined to the domestic family group; 'woman's place is in the home.'

Woman's association with the domestic circle contributes to her being seen as closer to nature in several ways. In the first place, infants and children might easily be considered part of nature. Infants are barely human and utterly unsocialized; like animals they do not walk upright, they excrete without control, they do not speak. Even slightly older children are clearly not yet fully under the sway of culture; they do not yet understand social duties, responsibilities, and morals, their vocabulary and their range of learned skills is small. One can find implicit recognition of an association between children and nature in many cultural practices. For example, the majority of cultures have initiation rites for adolescents (primarily for boys, of course – I will return to this point below), the point of which is to move the child ritually from a less-than-fully-human state into fully fledged society and culture; and many cultures do not hold funeral rites for children who die at early ages, on the explicit notion that they are not yet full social

beings. It is ironic that the rationale for boys' initiation rites in many cultures is that the boys must be purged of the defilement accrued from being around mother and other women so much of the time, when in fact it might be the case that some of the women's defilement derives from being around children so much of the time.

The second major problematic implication of women's close association with the domestic ambience derives from certain structural conflicts between the family and the society at large in any social system. The implications of the 'domestic/social opposition' in relation to the position of women have been cogently developed by Rosaldo[11] and I merely wish to show its relevance to the present argument. The notion that the domestic unit – the biological family charged with reproducing and socializing new members of the society – is opposed to the social entity – the superimposed network of alliances and relationships which *is* the society, is also the basis of Lévi-Strauss's argument in *The Elementary Structures of Kinship*. Lévi-Strauss argues not only that this opposition is present in every social system, but further that it has the significance of the opposition between nature and culture. The universal incest prohibition and its ally, the rule of exogamy, ensure that 'the risk of seeing a biological family become established as a closed system is definitely eliminated; the biological group can no longer stand apart, and the bond of alliance with another family ensures the dominance of the social over the biological, and of the cultural over the natural.'[12] And while not all cultures articulate a radical opposition between the domestic and the social as such, nonetheless it is hardly contestable that the domestic is always subsumed by the social; domestic units are allied with one another through the enactment of rules which are logically at a higher level than the units themselves, and which create an emergent unit – society – which is logically at a higher level than the procreative units of which it is composed.

Now, since women are associated with and indeed more or less confined to the domestic milieu, they are identified with this lower order of social/cultural organization. What are the implications of this for the way they are viewed? First, if the specifically biological (reproductive) function of the family is stressed, as in Lévi-Strauss's formulation, then the family, and hence woman, is identified with nature pure and simple, as opposed to culture. But this is obviously too pat; the point seems more adequately formulated as follows: the family (and hence woman) represents lower-level, socially fragmenting, particularistic sorts of concerns, as opposed to interfamilial relations, which represent higher-level, integrative, universalistic sorts of concerns. Since men lack a natural basis (nursing, generalized to child care) for a familial orientation, their sphere of activity is defined at the level of interfamilial relations. And hence, so the cultural reasoning seems to go, men are the 'natural' proprietors of religion, ritual, politics, and other realms of cultural thought and action in which universalistic statements of spiritual and social synthesis are made. Thus men are identified not only with culture, in the sense of all human creativity, as opposed to nature; they are identified in particular with Culture in the old-fashioned sense of the finer and higher aspects of human thought – art, religion, law, etc.

Once again, the logic of cultural reasoning here, aligning woman with infra-culture and man with culture, is clear, and, on the surface, quite compelling. At the same time, woman cannot be fully consigned to nature, for there are aspects of her situation, even within the domestic context, which undeniably demonstrate her participation in the

cultural process. It goes without saying, of course, that except for nursing newborn infants (and even here artificial nursing devices can cut the biological tie), there is no reason why it has to be mother as opposed to father or anyone else who remains iden-tified with child care. But even assuming that other practical and emotional reasons con-spire to keep woman in that sphere, it is possible to show that her activities there could as logically put her squarely in the category of culture, thus demonstrating the relative arbitrariness of defining her as less cultural than men. For example, woman not only feeds and cleans up after children in a simple caretaker operation – she is in fact the primary agent of their socialization. It is she who transforms the newborn infant from a mere organism into a cultured human, teaching it manners and the proper ways to behave in order to be a bona fide member of the culture. On the basis of her socializ-ing functions alone, she is as purely a candidate to be a representative of culture as anyone might be. Yet in virtually every society there is a point at which the socializa-tion of boys is transferred to the hands of men. The boys are considered, in one set of terms or another, not to have been 'really' socialized yet; their entrée to the realm of fully human (social, cultural) status can be accomplished only by men. We can still see this in our own schools, where there is a gradual inversion of proportion of female to male teachers as one progresses up through the grades; most kindergarten teachers are female, most university professors are male.[13]

Or again, we might look at cooking. In the overwhelming majority of societies cooking is the woman's work. No doubt this stems from practical considerations – since she has to stay at home with the baby, it is convenient that she perform the chores that are centered in the home. But if it is true, as Lévi-Strauss has argued,[14] that trans-forming the raw into the cooked may represent, in many systems of thought, the tran-sition from nature to culture, then here we have woman aligned with this important culturalizing process, which could easily place her in the category of culture, triumph-ing over nature. Yet when a culture (e.g. France or China) develops a tradition of *haute cuisine* – 'real' cooking as opposed to trivial ordinary domestic cooking – the high chefs are almost always men. Thus the pattern replicates that in the area of socialization – women perform lower-level conversions from nature to culture, but when the culture distinguishes a higher level of the same functions, the higher level is restricted to men.

In short, we can see once again the source of woman's appearing more intermediate than men with respect to the nature/culture dichotomy. A member of culture, yet appearing to have stronger and more direct connections with nature, she is seen as something in between the two categories.

The notion that women have not only a different body and a different social locus from men, but also a different psychic structure, is most controversial. I would like to argue that she probably does have a different psychic structure, but I will draw heavily on a paper by Chodorow which argues convincingly that that psychic structure is not innate, but rather is generated by the facts of the probably universal female socializa-tion experience. Nonetheless, my point is that, if we grant such a thing as the (non-innate) feminine psyche, that psyche has certain characteristics that would tend to reinforce the cultural view of woman as closer to nature.

It is important that we specify that aspect of the feminine psyche which is really the dominant and universal aspect. If we say emotionality or irrationality, we come up against those traditions in various parts of the world in which women functionally are,

and are seen as, more practical, pragmatic, and this-worldly than the men. The relevant, non-ethnocentric dimension seems to be that of relative concreteness versus relative abstractness: the (non-innate) feminine personality tends to get involved with concrete feelings, things, and people, rather than with abstract entities; it tends toward personalism and particularism.

Chodorow accepts a view of the feminine personality along these lines; she states that 'female ego qualities . . . include more flexible ego boundaries (i.e. less insistent self–other distinctions), present orientation rather than future orientation, and relatively greater subjectivity and less detached objectivity.' She cites various studies which have tended to confirm that this is indeed a relatively accurate picture of the female personality; these studies are primarily taken from Western society, although Chodorow suggests that in a broad way the difference between male and female personality – roughly, men as more objective or category-oriented, women as more subjective or person-oriented – are 'nearly universal.'[15]

The thrust of Chodorow's very elegantly argued paper is that these differences are not innate or genetically programmed, but arise from 'nearly universal features of family structure, [namely] that women are largely or entirely responsible for early child care and for (at least) later female socialization, [and that this is] a crucial asymmetry in male and female development.' She introduces the object-relations theorists' distinction between 'personal' and 'positional' identification as psychological processes, 'personal identification' being 'diffuse identification with the general personality, behavioral traits, values, and attitudes of someone one loves or admires,' 'positional identification' being 'identification with specific aspects of another's role,' rather than with the whole person.[16] Chodorow argues that, because the mother is the early socializer of both boys and girls, both develop personal identification with her. The boy however must ultimately shift to a masculine role identity, which involves building an identification with the father. Since father is almost always more remote than mother (he is rarely involved in child care, and perhaps works away from the home much of the day), building an identification with father involves a positional male role as a collection of abstract elements, rather than a personal one with father as a real individual. Further, as the boy enters the larger social world, he finds a world in fact organized around more abstract and universalistic criteria,[17] as indicated in the previous section; thus his earlier socialization prepares him for, and is reinforced by, the type of social experience he will have.

For girls, on the other hand, the personal identification with mother created in early infancy can persist into the process of learning female role identity. Because mother is immediate and present to the daughter during the learning of role identity, 'learning to be a woman . . . involves the continuity and development of a girl's relationship to her mother, and is based on generalized personal identification with her rather than on an attempt to learn externally defined roles categories.'[18] This pattern of course prepares the girl for, and is fully reinforced by, her central role in later life – motherhood; she will become involved in the world of women, characterized by few formal role differentiations,[19] and specifically in relationships with her children involving again 'personal identification,' and so the cycle begins anew.

Chodorow demonstrates, to my satisfaction at least, that the source of the feminine personality lies in social structural arrangements rather than innate differences. But,

for my purposes, the significant point is that, insofar as a 'feminine personality,' characterized by personalism and particularism, has been a nearly universal fact, albeit an unconscious by-product of social arrangements, then having such a psyche may have contributed to the universal view of women as somehow less cultural than men. That is, woman's dominant psychic modes of relating would incline her to enter into relationships with the world that culture might see as being more 'like nature,' immanent and embedded in things as given, rather than, like culture, transcending and transforming things through the superimposition of abstract categories and transpersonal values. Woman's relationships to her objects tend to be, like nature, relatively unmediated, more direct, whereas men not only tend to relate in a more mediated way, but in fact, ultimately, often relate more consistently and strongly to the mediating categories and forms than to the persons or objects themselves.

If women indeed have this sort of psyche (albeit as a product of social arrangements), it is not difficult to see how it would lend weight to a view of them as being 'closer to nature.' Yet at the same time, this sort of psychic mode undeniably plays a powerful and important role in the cultural process. For though unmediated relatedness is in some sense at the lowest end of the spectrum of human spiritual functions, embedded and particularizing rather than transcending and synthesizing, that quality of relatedness also stands at the upper end of that spectrum. That is, mothers tend to be committed to their children as individuals, regardless of sex, age, beauty, clan affiliation, or other sorts of categories in which the child might participate. Now, any relationship which has this quality – not just mother and child of course, but any sort of highly personal, relatively unmediated commitment – may be seen as a challenge to culture and society 'from below,' insofar as it represents the fragmentary potential of individual loyalties over the solidarity of the group. But it may also be seen as embodying the cement or synthesizing agent for culture and society 'from above,' in that it represents generalized human values above and beyond particular social category loyalties. Every society must have social categories that transcend personal loyalties, but every society must also generate a sense of ultimate moral unity for all members above and beyond those social categories. Thus that psychic mode which seems to be typical of women, which tends to disregard categories and to seek 'communion'[20] directly and personally with others, while appearing infra-cultural from one point of view, is at the same time associated with the highest levels of the cultural process. And thus, too, once again, we see a source of woman's apparent greater ambiguity with respect to culture and nature.

My primary purpose here has been to attempt to explain the universal secondary status of women. Intellectually and personally, I felt strongly challenged by this problem; I felt it had to be dealt with before an analysis of woman's position in any particular society could be undertaken. Local variables of economy, ecology, history, political and social structure, values and worldview – these could explain variations within that universal, but they could not explain the universal itself. And if we were not to accept the ideology of biological determinism, then explanation, it seemed to me, could only proceed by reference to other universals of the human cultural situation. Thus the general outlines of the approach – although not of course the particular solution offered – were determined by the problem itself, and not by any predilection on my part for global abstract structural analysis.

I argued that the universal devaluation of women could be explained by postulating that woman is seen as 'closer to nature' than men, men being seen as more unequivocally occupying the high ground of 'culture.' The culture–nature scale is itself a product of culture, culture being seen as a special process the minimum definition of which is the transcendence, by means of systems of thought and technology, of the natural givens of existence. This, of course, is an analytic definition, but I argued that at some level every culture incorporates this notion in one form or another, if only through the performance of ritual as an assertion of the human ability to manipulate those givens. In any case, the core of the paper has been concerned with showing why woman might tend to be assumed, over and over, in the most diverse sorts of worldviews, and in cultures of every degree of complexity, to be closer to nature than men. Woman's physiology, more involved more of the time with 'species life;' woman's association with the structurally subordinate domestic context, charged with the crucial function of transforming animal-like infants into cultured beings; 'woman's psyche,' appropriately molded to mothering functions by her own socialization, and tending toward greater personalism and less mediated modes of relating – all these factors make woman appear to be rooted more directly and deeply in nature. At the same time, however, her 'membership' and fully necessary participation in culture is recognized by culture and can never be denied. Thus she is seen as something in between culture and nature, occupying an intermediate position.

This intermediacy, further, has several implications for analysis, depending upon how it is read. First, of course, it answers my primary question of why woman is everywhere seen as lower than men, for even if she is not seen as nature pure and simple, she is still seen as achieving less transcendence of nature than men. Here intermediate simply means 'middle status' on a hierarchy of being from culture to nature.

Second, 'intermediate' may have the significance of 'mediating,' i.e. performing some sort of synthesizing or converting function between nature and culture, here seen (by culture) not as two ends of a continuum, but as two radically different sorts of processes in the world. The domestic unit and hence woman who in virtually every case appears as its primary representative, is one of culture's crucial agencies for the conversion of nature into culture, especially with reference to the socialization of children. Any culture's continued viability depends upon properly socialized individuals who will see the world in that culture's terms and adhere more or less unquestioningly to its moral precepts. The functions of the domestic unit must be closely controlled in order to ensure this outcome as far as possible; its stability as an institution must be placed as far as possible beyond question. We see this protection of the integrity and stability of the domestic group in the powerful taboos against incest, matricide, patricide, fratricide,[21] and so forth. These sorts of injunctions are clearly so vital for society that they are made to appear rooted in the fundamental order of existence; to violate them is to act 'unnaturally,' and the sanctions are often automatic and supernatural rather than merely social and dependent on the vagaries of human moral will. In any case, insofar as woman is virtually universally the primary agent of socialization, and is seen as virtually the embodiment of the functions of the domestic group, she will tend to come under the heavier restrictions and circumscriptions which surround that unit. Her (culturally defined) intermediate position between culture and nature, here having the significance of her *mediation* (i.e. performing conversion functions) between

culture and nature, would thus account not only for her lower status, but for the greater restrictions placed upon her activities. In virtually every culture, her permissible sexual activities are more closely circumscribed than man's, she is offered a much smaller range of role choices, and she is afforded direct access to a far more limited range of the social institutions. Further, she is almost universally socialized to have (and the contexts she lives in as an adult reinforce her having) a narrower and generally more conservative set of attitudes and views than men; this, of course, is another mode of restriction, and would clearly be related to her vital function for society of producing well-socialized members of the group.

Finally, woman's intermediate position may have the implication of greater symbolic *ambiguity*.[22] The point here is not so much her location between culture and nature, as the fact of marginality *per se* in relation to the 'centers' of culture, and the ambiguity of meaning which is inherent in a marginal position. If we think of the 'margins' of culture as a continuous periphery, rather than as upper and lower boundaries, we can understand the notion that extremes, as we say, meet – that they are easily transformed into one another in symbolic thought, and hence seem unstable and ambiguous.

These points are quite relevant to an understanding of cultural symbolism and imagery concerning women. As we know, female imagery in cultural constructs of various kinds is astonishingly variable in meaning; frequently within a single cultural tradition it embodies radically divergent and even polarized ideas. In the discussion of the 'female psyche,' I said that the psychic mode associated with women seems to stand both at the bottom and the top of the scale of human modes of relating. That mode tends to cause involvement more directly with others in themselves than as representatives of social categories of one kind or another; this mode can be seen either as 'ignoring' (and thus subverting) or 'transcending' (and thus achieving a higher synthesis of) those social categories, depending upon how culture cares to look at it for any given purpose. Thus we can account easily for both the subversive female symbols – witches, evil eye, menstrual pollution, castrating mothers – and the feminine symbols of transcendence – mother goddesses, merciful savioresses, female symbols of justice, and the strong presence of feminine symbolism (but not actual women) in the realms of art, religion, ritual, and law. Further we can understand the penchant of polarized feminine symbols, like all marginal symbols, to transform into one another in rather magical ways: the whore, it seems, can be redeemed to sainthood more easily than the faithful housewife.

If woman's (culturally viewed) intermediacy between culture and nature has this implication of generalized ambiguity of meaning characteristic of marginal phenomena, then we are in a better position to account for those cultural and historical 'inversions' in which women are in some way or another symbolically aligned with culture and men with nature. A number of cases come to mind: the Sirionó of Brazil, among whom, according to Ingham, 'nature, the raw, and maleness' are opposed to 'culture, the cooked, and femaleness;'[23] Nazi Germany, in which women were said to be the guardians of culture and morals; European courtly love, in which man was said to be the beast and woman the pristine exalted object – a pattern of thinking that persists, for example, among modern Spanish peasants;[24] and there are undoubtedly other cases of this sort. These instances (in fact, of course, *all* cultural symbolic constructs) still require detailed analysis of cultural data, but the point of woman's generalized

marginality with respect to culture, and particularly the polarized ambiguity, from the point of view of culture, of the feminine mode of interpersonal relations, may at least lay the groundwork for such analyses.

In short, the postulate that woman is viewed as closer to nature than man has several implications for further analysis, and can be read in several different ways. If female-ness is read simply as a *middle* position on the scale of culture to nature, then it is still seen as lower than culture and thus accounts for the pan-cultural assumption that women are lower than men in the order of things. If it is read as a *mediating* element in the culture–nature relationship, then it may account in part for the cultural ten-dency not merely to devalue women but to circumscribe and restrict their functions, since culture must maintain control over its (pragmatic and symbolic) mechanisms for the conversion of nature into culture. And if it is read as an *ambiguous* status between culture and nature, the ambiguity may help to account for the fact that, in specific cul-tural ideologies and symbolizations, woman can occasionally be categorized as 'culture,' and can in any event be assigned widely divergent and even polarized meanings in symbolic systems. Middle status, mediating functions, ambiguous meaning – all are different readings, for different contextual purposes, of woman's assigned intermediate status between nature and culture.

Ultimately, of course, it must be stressed that the whole scheme is a construct of culture rather than a given of nature. Woman is not 'in reality' any closer to (nor farther from) nature than man – both have consciousness, both are mortal. But there are certainly reasons why she appears to be that way. The result is a vicious circle: various aspects of woman's situation (physical, social, psychological) lead to her being seen as 'closer to nature,' while the view of her as closer to nature is embodied in institutional forms that regenerate her situation. The implications for social change are similarly circular: a different cultural view can grow only out of a different social actuality, a different social actuality can grow only out of a different cultural view.

Women cannot change their bodies. But it seems unlikely that the physiological difference between men and women would be adequate to motivate the devalued view of women were that view not lent further weight by the social and psychological variables discussed above. While I am not prepared to put forth a detailed program of social and cultural renovation, it seems clear that the way out of the circle involves society's allowing women to participate in, and women actively appropriating, the fullest range of social roles and activities available within the culture. Men and women can, and must, be equally involved in projects of creativity and transcendence. Only then will women easily be seen as aligned with culture, in culture's ongoing dialectic with nature.

Acknowledgements

The first version of this paper was presented in October 1972 as a lecture in the course 'Women: Myth and Reality' at Sarah Lawrence College. I received helpful comments from the students and from my co-teachers in the course: Joan Gadol, Eva Kollisch, and Gerda Lerner. A short version of the lecture was delivered at the American Anthro-pological Association meetings in Toronto, November 1972. In the interim, I received excellent critical comments from Karen Blu, Robert Paul, Michelle Rosaldo, and

Terence Turner, and the present version of the paper, in which the thrust of the argument has been rather significantly changed, was written in response to those comments. I of course retain responsibility for its final form [which appeared] in *Woman, Culture and Society*, ed. Michelle Rosaldo and Louise Lamphere (Stanford, CA: Stanford University Press) [1974, pp. 67–87]. The paper is dedicated to Simone de Beauvoir; *The Second Sex*, published in [French in] 1949, remains in my opinion the best single, comprehensive statement of 'the woman problem.'

Notes

1 R. G. H. Siu, *The Man of Many Qualities* (Cambridge, MA: MIT Press, 1968), p. 2.

2 Robert Lowie, *The Crow Indians* (New York: Rinehart and Co., 1956), pp. 61, 44, 60, 229. While we are on the subject of oppression of various kinds, we might note that Lowie secretly bought this doll, the most sacred object in the tribal repertoire, from its custodian, the widow of Wrinkled-face. She asked $400 for it, but this price was 'far beyond [Lowie's] means,' so he ultimately got it for $80 (p. 300).

3 Sherry B. Ortner, 'Sherpa purity', *American Anthropologist*, 75 (1973): 49–63; and Sherry B. Ortner, 'Purification rites and customs', *New Encyclopaedia Britannica: micropaedia*, 15th edn (Chicago, IL: Encyclopaedia Britannica).

4 Simone de Beauvoir, *The Second Sex* (New York: Bantam Books, 1961), pp. 60, 24, 24–7 and passim, 239.

5 Ibid., p. 31.

6 Ibid., pp. 58–9.

7 Indeed, it is one of the more egregious injustices of cultural thought that, in most cultural symbolic concordances, woman is associated with death rather than with life.

8 de Beauvoir, *Second Sex*, p. 59.

9 Claude Lévi-Strauss, *The Elementary Structures of* Kinship, trans. J. H. Bell and J. R. von Sturmer; ed. R. Needham (Boston: Beacon Press, 1969), p. 496.

10 de Beauvoir, *Second Sex*, p. 59.

11 Michelle Z. Rosaldo, 'Women, culture and society: a theoretical overview', in *Woman, Culture and Society*, ed. M. Z. Rosaldo and L. Lamphere (Stanford, CA: Stanford University Press, 1974), pp. 17–42.

12 Lévi-Strauss, *Elementary Structures*, p. 479.

13 I remember having my first male teacher in fifth grade, and I remember being excited about that – it was somehow more grown-up.

14 Claude Lévi-Strauss, *The Raw and the Cooked*, trans. J. and D. Weightman (New York: Harper and Row, 1969).

15 Nancy Chodorow, 'Family structure and feminine personality', in *Woman, Culture and Society*, ed. Rosaldo and Lamphere, pp. 43, 56.

16 Ibid., pp. 43, 51.

17 Chodorow, 'Family structure', pp. 49, 58; Rosaldo, 'Women, culture and society', pp. 28–9.

18 Chodorow, 'Family structure', p. 51.

19 Rosaldo, 'Women, culture and society', p. 29.

20 Chodorow, 'Family structure', p. 55, following David Bakan, *The Duality of Human Existence* (Boston, MA: Beacon Press, 1966).

21 Nobody seems to care much about sororicide.

22 See Rosaldo, 'Women, culture and society'.

23 John M. Ingham, 'Are the Sirionó raw or cooked?', *American Anthropologist*, 73 (1971): 1092–9. Ingham's discussion is rather ambiguous itself, since women are also associated with animals: 'the con-

trasts man/animal and man/woman are evidently similar . . . hunting is the means of acquiring women as well as animals' (p. 1095). A careful reading of his data suggests that both women and animals are mediators between nature and culture in this tradition.

24 See Julian Pitt-Rivers, *People of the Sierra* (Chicago, IL: University of Chicago Press, 1961); and Rosaldo, 'Women, culture and society'.

Carolee Schneemann, 'From Tape no. 2 for "Kitch's Last Meal"' (1973)

Text used in super-8 film 'Kitch's Last Meal' (1973–5) and 'Interior Scroll' (1975, 1977), reproduced in *More than Meat Joy: Performance Works and Selected Writings* (2nd edn, New Paltz, NY: Documentext, 1997).

I met a happy man
a structuralist filmmaker
– but don't call me that it's something else I do –
he said we are fond of you
you are charming
but don't ask us to look at your films
we cannot
there are certain films we cannot look at:
the personal clutter
the persistence of feelings
the hand-touch sensibility
the diaristic indulgence
the painterly mess
the dense gestalt
the primitive techniques

(I don't take the advice of men
they only talk to themselves)

PAY ATTENTION TO CRITICAL AND PRACTICAL FILM LANGUAGE
IT EXISTS FOR AND IN ONLY ONE GENDER

even if you are older than me you are a monster
I spawned you have slithered out of the excesses and
vitality of the '60s

he said you can do as I do
take one clear process
follow its strictest implications
intellectually establish a system of permutations
establish their visual set

I said my film is concerned with
DIET AND DIGESTION

very well he said then why the train?

the train is DEATH as there is die in diet
and di in digestion

then you are back to metaphors and meanings
my work has no meaning beyond the logic of its systems
I have done away with emotion intuition inspiration –
those aggrandized habits which set artists apart from
ordinary people – those unclear tendencies which are
inflicted upon viewers . . .

it's true I said when I watch your films
my mind wanders freely during the half hour
of pulseing dots I compose letters
dream of my lover
write a grocery list
rummage in the trunk for a missing sweater
plan the drainage pipes for the root cellar
– it is pleasant not to be manipulated

he protested
you are unable to understand and appreciate
the system the grid the numerical and rational procedures
the Pythagorean cues –

I saw my failings were worthy of dismissal
I'd be buried alive
my works lost . . .

he said we can be friends equally
tho' we are not artists equally

I said we cannot be friends equally
and we cannot be artists equally

he told me he had lived with a 'sculptress'
I asked does that make me a 'film-makeress'?

Oh no he said we think of you as a dancer.

Faith Wilding, 'Waiting' (1977)

From *Through the Flower: My Struggle as a Woman Artist*, by Judy Chicago
(New York: Anchor Books, 1977), pp. 213–17.

(A female voice speaks in passive, plaintive tone, childlike at first, becoming almost
desperate at adolescence, tender at motherhood, and then very slow and cracked in age)

Waiting . . . waiting . . . waiting . . .
Waiting for someone to come in
Waiting for someone to pick me up
Waiting for someone to hold me
Waiting for someone to feed me
Waiting for someone to change my diaper. Waiting . . .
Waiting to crawl, to walk, waiting to talk
Waiting to be cuddled
Waiting for someone to take me outside
Waiting for someone to play with me
Waiting for someone to put me on the toilet
Waiting for someone to read to me, dress me, tie my shoes
Waiting for Mommy to brush my hair
Waiting for her to curl my hair
Waiting to wear my frilly dress
Waiting to be a pretty girl
Waiting to sit on Daddy's lap. Waiting . . .
Waiting for my new school clothes
Waiting for someone to take me to school
Waiting to stay up until seven o'clock
Waiting to be a big girl
Waiting to grow up. Waiting . . .

Waiting for my breasts to develop
Waiting to wear a bra
Waiting to menstruate
Waiting to read forbidden books
Waiting to stop being clumsy
Waiting to have a good figure
Waiting for my first date
Waiting to have a boyfriend
Waiting to go to a party, to be asked to dance, to dance close
Waiting to be beautiful
Waiting for the secret
Waiting for life to begin. Waiting . . .
Waiting to be somebody
Waiting to wear makeup
Waiting for my pimples to go away
Waiting to wear lipstick, to wear high heels and stockings
Waiting to get dressed up, to shave my legs
Waiting to be pretty. Waiting . . .
Waiting for him to notice me, to call me
Waiting for him to ask me out
Waiting for him to pay attention to me
Waiting for him to fall in love with me
Waiting for him to kiss me, touch me, touch my breasts
Waiting for him to pass my house
Waiting for him to tell me I'm beautiful

Waiting for him to ask me to go steady
Waiting to neck, to make out, waiting to go all the way
Waiting to smoke, to drink, to stay out late
Waiting to be a woman. Waiting . . .
Waiting for my great love
Waiting for the perfect man
Waiting for Mr Right. Waiting . . .

Waiting to get married
Waiting for my wedding day
Waiting for my wedding night
Waiting for sex
Waiting for him to make the first move
Waiting for him to excite me
Waiting for him to give me pleasure
Waiting for him to give me an orgasm. Waiting . . .
Waiting for him to come home, to fill my time. Waiting . . .
Waiting for my baby to come
Waiting for my belly to swell
Waiting for my breasts to fill with milk
Waiting to feel my baby move
Waiting for my legs to stop swelling
Waiting for the first contractions
Waiting for the contractions to end
Waiting for the head to emerge
Waiting for the first scream, the afterbirth
Waiting to hold my baby
Waiting for my baby to suck my milk
Waiting for my baby to stop crying
Waiting for my baby to sleep through the night
Waiting for my breasts to dry up
Waiting to get my figure back, for the stretch marks to go away
Waiting for some time to myself
Waiting to be beautiful again
Waiting for my child to go to school
Waiting for life to begin. Waiting . . .

Waiting for my children to come home from school
Waiting for them to grow up, to leave home
Waiting to be myself
Waiting for excitement
Waiting for him to tell me something interesting, to ask me how I feel
Waiting for him to stop being crabby, reach for my hand, kiss me good morning
Waiting for fulfillment
Waiting for the children to marry
Waiting for something to happen. Waiting . . .
Waiting to lose weight
Waiting for the first gray hair
Waiting for menopause

Waiting to grow wise
Waiting . . .

Waiting for my body to break down, to get ugly
Waiting for my flesh to sag
Waiting for my breasts to shrivel up
Waiting for a visit from my children, for letters
Waiting for my friends to die.
Waiting for my husband to die. Waiting . . .
Waiting to get sick
Waiting for things to get better
Waiting for winter to end
Waiting for the mirror to tell me I'm old
Waiting for a good bowel movement
Waiting for the pain to go away
Waiting for the struggle to end
Waiting for release
Waiting for morning
Waiting for the end of day
Waiting for sleep. Waiting . . .

Monique Wittig, 'The Straight Mind' (1980)

From *Feminist Issues*, 1(1) (1980), pp. 106–11.

[. . .] If the discourse of modern theoretical systems and social science exerts a power upon us, it is because it works with concepts which closely touch us. In spite of the historic advent of the lesbian, feminist, and gay liberation movements, whose proceedings have already upset the philosophical and political categories of the discourses of the social sciences, their categories (thus brutally put into question) are nevertheless utilized without examination by contemporary science. They function like primitive concepts in a conglomerate of all kinds of disciplines, theories, and current ideas that I will call the straight mind (see *The Savage Mind* by Claude Lévi-Strauss). They concern 'woman,' 'man,' 'sex,' 'difference,' and all of the series of concepts which bear this mark, including such concepts as 'history,' 'culture,' and the 'real.' And although it has been accepted in recent years that there is no such thing as nature, that everything is culture, there remains within that culture a core of nature which resists examination, a relationship excluded from the social in the analysis – a relationship whose characteristic is ineluctability in culture, as well as in nature, and which is the heterosexual relationship. I will call it the obligatory social relationship between 'man' and 'woman.' (Here I refer to Ti-Grace Atkinson and her analysis of sexual intercourse as an institution.)[1] With its ineluctability as knowledge, as an obvious principle, as a given prior to any science, the straight mind develops a totalizing interpretation of history, social

reality, culture, language, and all the subjective phenomena at the same time. I can only underline the oppressive character that the straight mind is clothed in in its tendency to immediately universalize its production of concepts into general laws which claim to hold true for all societies, all epochs, all individuals. Thus one speaks of *the* exchange of women, *the* difference between the sexes, *the* symbolic order, *the* Unconscious, desire, *jouissance*, culture, history, giving an absolute meaning to these concepts when they are only categories founded upon heterosexuality or thought which produces the difference between the sexes as a political and philosophical dogma.

The consequence of this tendency toward universality is that the straight mind cannot conceive of a culture, a society where heterosexuality would not order not only all human relationships but also its very production of concepts and all the processes which escape consciousness, as well. Additionally, these unconscious processes are historically more and more imperative in what they teach us about ourselves through the instrumentality of specialists. The rhetoric which expresses them (and whose seduction I do not underestimate) envelops itself in myths, resorts to enigma, proceeds by accumulating metaphors, and its function is to poeticize the obligatory character of the 'you-will-be-straight-or-you-will-not-be.'

In this thought, to reject the obligation of coitus and the institutions that this obligation has produced as necessary for the constitution of a society, is simply an impossibility, since to do this would mean to reject the possibility of the constitution of the other and to reject the 'symbolic order,' to make the constitution of meaning impossible, without which no one can maintain an internal coherence. Thus lesbianism, homosexuality, and the societies that we form cannot be thought of or spoken of, even though they have always existed. Thus, the straight mind continues to affirm that incest, and not homosexuality, represents its major interdiction. Thus, when thought by the straight mind, homosexuality is nothing but heterosexuality.

Yes, straight society is based on the necessity of the different/other at every level. It cannot work economically, symbolically, linguistically, or politically without this concept. This necessity of the different/other is an ontological one for the whole conglomerate of sciences and disciplines that I call the straight mind. But what is the different/other if not the dominated? For heterosexual society is the society which not only oppresses lesbians and gay men, it oppresses many different/others, it oppresses all women and many categories of men, all those who are in the position of the dominated. To constitute a difference and to control it is an 'act of power, since it is essentially a normative act. Everybody tries to show the other as different. But not everybody succeeds in doing so. One has to be socially dominant to succeed in it.'[2]

For example, the concept of difference between the sexes ontologically constitutes women into different/others. Men are not different, whites are not different, nor are the masters. But the blacks, as well as the slaves, are. This ontological characteristic of the difference between the sexes affects all the concepts which are part of the same conglomerate. But for us there is no such thing as being-woman or being-man. 'Man' and 'woman' are political concepts of opposition, and the copula which dialectically unites them is, at the same time, the one which abolishes them.[3] It is the class struggle between women and men which will abolish men and women.[4] The concept of difference has

nothing ontological about it. It is only the way that the masters interpret a historical situation of domination. The function of difference is to mask at every level the conflicts of interest, including ideological ones.

In other words, for us, this means there cannot any longer be women and men, and that as classes and as categories of thought or language they have to disappear, politically, economically, ideologically. If we, as lesbians and gay men, continue to speak of ourselves and to conceive of ourselves as women and as men, we are instrumental in maintaining heterosexuality. I am sure that an economic and political transformation will not dedramatize these categories of language. Can we redeem *slave*? Can we redeem *nigger*, *negress*? How is *woman* different? Will we continue to write *white*, *master*, *man*? The transformation of economic relationships will not suffice. We must produce a political transformation of the key concepts, that is of the concepts which are strategic for us. For there is another order of materiality, that of language, and language is worked upon from within by these strategic concepts. It is at the same time tightly connected to the political field where everything that concerns language, science and thought refers to the person as subjectivity and to her/his relationship to society.[5] And we cannot leave this within the power of the straight mind or the thought of domination.

If among all the productions of the straight mind I especially challenge structuralism and the structural unconscious, it is because: at the moment in history when the domination of social groups can no longer appear as a logical necessity to the dominated, because they revolt, because they question the differences, Lévi-Strauss, Lacan and their epigones call upon necessities which escape the control of consciousness and therefore the responsibility of individuals.

They call upon unconscious processes, for example, which require the exchange of women as a necessary condition for every society. According to them, that is what the unconscious tells us with authority, and the symbolic order, without which there is no meaning, no language, no society, depends on it. But what does women being exchanged mean if not that they are dominated? No wonder then that there is only one unconscious, and that it is heterosexual. It is an unconscious which looks too consciously after the interests of the masters[6] in whom it lives for them to be dispossessed of their concepts so easily. Besides, domination is denied; there is no slavery of women, there is difference. To which I will answer with this statement made by a Rumanian peasant at a public meeting in 1848: 'Why do the gentlemen say it was not slavery, for we know it to have been slavery, this sorrow that we have sorrowed.' Yes, we know it, and this science of oppression cannot be taken away from us.

It is from this science that we must track down the 'what goes-without-saying' heterosexual, and (I paraphrase the early Roland Barthes) we must not bear 'seeing Nature and History confused at every turn.'[7] We must make it brutally apparent that structuralism, psychoanalysis, and particularly Lacan have rigidly turned their concepts into myths – Difference, Desire, the Name-of-the-father, etc. They have even 'over-mythified' the myths, an operation that was necessary for them in order to systematically heterosexualize that personal dimension which suddenly emerged through the dominated individuals into the historical field, particularly through women, who started their struggle almost two centuries ago. And it has been done

systematically, in a concert of interdisciplinarity, never more harmonious than since the heterosexual myths started to circulate with ease from one formal system to another, like sure values that can be invested, in anthropology as well as in psychoanalysis and in all the social sciences.

This ensemble of heterosexual myths is a system of signs which uses figures of speech, and thus it can be politically studied from within the science of our oppression: 'for-we-know-it-to-have-been-slavery' is the dynamic which introduces the diachronism of history into the fixed discourse of eternal essences. This undertaking should somehow be a political semiology, although with 'this sorrow that we have sorrowed' we work also at the level of language/manifesto, of language/action, that which transforms, that which makes history.

In the meantime in the systems that seemed so eternal and universal that laws could be extracted from them, laws that could be stuffed into computers, and in any case for the moment stuffed into the unconscious machinery, in these systems, thanks to our action and our language, shifts are happening. Such a model, as for example, the exchange of women, re-engulfs history in so violent and brutal a way that the whole system, which was believed to be formal, topples over into another dimension of knowledge. This dimension belongs to us, since somehow we have been designated, and since, as Lévi-Strauss said, we talk, let us say that we break off the heterosexual contract.

So, this is what lesbians say everywhere in this country and in some others, if not with theories at least through their social practice, whose repercussions upon straight culture and society are still unenvisionable. An anthropologist might say that we have to wait for fifty years. Yes, if one wants to universalize the functioning of these societies and make their invariants appear. Meanwhile the straight concepts are undermined. What is woman? Panic, general alarm for an active defense. Frankly, it is a problem that the lesbians do not have because of a change of perspective, and it would be incorrect to say that lesbians associate, make love, live with women, for 'woman' has meaning only in heterosexual systems of thought and heterosexual economic systems. Lesbians are not women.[8]

Acknowledgement

This text was first read in New York at the Modern Language Association Convention in 1978 and dedicated to American lesbians.

Notes

1 Ti-Grace Atkinson, *Amazon Odyssey* (New York: Links Books, 1974), pp. 13–23.
2 Claude Faugeron and Philippe Robert, *La Justice et son public et les représentations sociales du système pénal* (Paris: Masson, 1978).
3 See, for her definition of 'social sex', Nicole-Claude Mathieu, 'Notes pour une définition sociologique des categories de sexe', *Epistemologie Sociologique*, 11 (1971); trans. in Nicole-Claude

Mathieu, *Ignored by Some, Denied by Others: The Social Sex Category in Sociology* (pamphlet), Explorations in Feminism 2 (London: Women's Research and Resources Centre Publications, 1977), pp. 16–37.

4 In the same way as for every other class struggle where the categories of opposition are 'reconciled' by the struggle whose goal is to make them disappear.

5 See Christine Delphy, 'Pour un féminisme matérialiste', l'Arc 61, *Simone de Beauvoir et la lutte des femmes*.

6 Are the millions of dollars a year made by the psychoanalysts symbolic?

7 Roland Barthes, *Mythologies* (New York: Hill and Wang, 1972), p. 11.

8 No more is any woman who is not in a relation of personal dependency with a man.

Isabelle Bernier, 'In the Shadow of Contemporary Art' (1986)

From *Feministe toi-même, feministe quand même*, ed. Nicole Jolicoeur and Isabelle Bernier, trans. S. D. Hassan (Quebec: La Chambre Blanche, 1986), pp. 52–8.

Comments Concerning the Social Connotations of Art Forms

The social connotations (in relation to gender, culture and class, etc.) of art forms are a complex phenomenon, the study of which concerns history, sociology, semiology, psychology, etc. The aim of this article is not to explain in detail these connotations but rather to illustrate their existence and their crucial importance in the construction of the art hierarchy and, subsequently, to the maintenance of the Cultural Order. Consequently, I'll limit myself to several remarks and examples.

[. . .] in the modern Western ideology, an association with women, the working class or non-Western cultures is almost invariably accompanied by a fall in the status of the art form. These connotations can stem from the public and/or the artists with which the form is associated. For instance, jewelry's feminine connotations do not originate in the gender of the jeweler but in that of the client/public. On the other hand, the feminine connotations of quilts are based upon the gender of the maker.

Incidentally, many lesser arts do not have feminine connotations: most forms of carpentry, furniture making, iron foundry, smithery, etc. conjure extremely virile connotations.

It is clear that social connotations are neither fixed nor universal, as is demonstrated in Pollock and Parker's example of the 'connotative' evolution of embroidery, which saw its status decline as its feminine connotations increased. They illustrate the same process in their analysis of flower painting.

Taking up earlier examples, let's compare some of oil painting's connotations with those suggested by ceramics. Although Michelangelo – who was known for his frescoes – considered oil painting 'good for women and the lazy',[1] it now benefits from its association with the works by the Great Masters (men) in art history (Western). Like oil painting, ceramics have often been practiced by men (one need only refer to the

production of Sèvres and Meissen, or the works of Josiah Wedgwood). However, its common connotations are much less glorious than those suggested by oil painting. Older than oil painting, ceramics evoke non-industrialised – therefore supposedly 'primitive' – cultures and/or Oriental cultures. One encounters ceramics in museums of ethnology more often than in galleries of contemporary art. Ceramics convey the preparation of food and are by extension associated with the domestic activities of women: like jewelry, dishes have predominantly feminine connotations.

As many authors have observed, whenever an art form is practiced by both men and women, its supposedly superior mode is usually reserved for men while its 'banal' mode falls to women. Such is the case of the culinary arts, sewing and tapestry. All of them have feminine connotations because they have often been practiced by women, yet on the most 'sophisticated' level they have been controlled by men, and therefore, in their *artistic* mode, conjure masculine associations.

This is demonstrated in the *Petit Robert* (1983) which gives the following definition for *tapisserie* (tapestry):

1 Upholstery, generally made of tapestry (2 or 3); . . .
2 A work of art using textiles, executed on a loom, in which the design is the result of the weave itself. . . . *Tapestries of Flanders. Tapestries of the Gobelins, of Beauvais, of Aubusson.* . . . The art of these works; . . .
3 A work done by women with a needle in which the canvas is entirely covered with woolen or silken threads. *To make a tapestry. 'Slippers made of tapestry' (Gautier). Armchairs covered with tapestry.* The art of producing these works. *Tapestry points.* . . .

The word *tapisserie*, thus, refers to two kinds of work: a work of *art* and a work done by *women*. The opposition between art and women is well illustrated by the examples furnished by the *Petit Robert*; it is needless to say that the well-known French and Flemish factories owe their most famous designs (*cartons*) to men (Jan Van Eyck, Rogier Van der Weyden, Poussin, De Troy, Boucher, etc.).

The same comments can be made about weaving, for the *great* Western designers of fabrics are by definition men. Nonetheless, especially in its most 'rudimentary' mode, this art has a strong feminine connotation. In a ludicrous passage, Sigmund Freud attributes the invention of weaving to *penis envy*:

Shame . . . has as its purpose, we believe, concealment of (female) genital deficiency . . . It seems that women have made few contributions to the discoveries and inventions in the history of civilization; there is, however, one technique which they may have invented – that of plaiting and weaving. If that is so, we should be tempted to guess the unconscious motive for the achievement. Nature herself would seem to have given the model which this achievement imitates by causing the growth at maturity of the pubic hair that conceals the genitals. The step that remained to be taken lay in making the threads adhere to one another, while on the body they stick into the skin and are only matted together.[2]

As for *couture* (sewing), *couturier* (fashion designer, masc.) and *couturière* (dressmaker, fem.), the *Petit Robert* (again in the 1983 edition) defines them in a rather revealing manner:

Couture: 1 The action or the art of sewing. . . . 2 . . . The profession of those who make clothing for women . . . The *couturier's* profession . . .

Couturier: A person who directs a sewing shop, creates original patterns, presents them with the aid of models, and has them made in his studios upon the request of his clients . . .

Couturière: A woman who sews and makes clothing for women at her own expense . . .

Couture clearly has feminine connotations, not only because of its public/clientele but also because it has been practiced by many women in the home or professionally. However, as one might have guessed, *haute couture* is associated with men: the *couturier* directs and creates, whereas the *couturière* sews and makes.

It is interesting to note that although the representation of the human form was situated at the pinnacle of the hierarchy of 'subjects', the arts which come into contact with the body – whether they be useful or not – have a significantly lower status; and as chance would have it, the greater part of them have feminine connotations (weaving, lacework, embroidery, sewing, jewelry, etc.). Several art forms associated with the body, having feminine and/or non-'Western' connotations, barely merit the title of art: for example knitting and make up (in the broad sense of the term). Since the body, a natural element, is frequently perceived in the Western world in opposition to the intellect and to culture, it is not surprising that contact with the body is often linked with a devaluation of an art form. Moreover, the modern bourgeois ideology has attempted to limit the majority of women to a supposedly 'corporal' or 'biological' role in society (sexuality and procreation, care of the children, daily preparation of food, etc.). Similarly, it has tried to dehumanize non-Western cultures by pushing them into the sphere of nature through the application of specific stereotypes.[3]

I hope these few remarks provide a better understanding of the subliminal yet paramount presence of the social connotations attached to each of the art forms. [. . .]

Notes

1 Quoted by Jean-Paul Bonnes in *La passionnante histoire de la peinture racontée à tous* (Lausanne: Editions de l'Oeil, 1957), p. 73 (translated by SDH).
2 Sigmund Freud, 'Femininity', *New Introductory Lectures on Psychoanalysis*, trans. and ed. James Strachey (New York: W. W. Norton, 1965), p. 132.
3 In 1983 I did an installation at La Chambre Blanche entitled *Suzanna and the Elders I*, which included two columns of words written directly on the wall. Here is an extract from the columns:

decorative	significant	manual	intellectual
feeling	thought	group	individual
body	mind	anonymous	renown
nature	culture	repetitive	creative
woman	man	functional	art for art's sake
domestic	public	decorative arts	fine arts
craft	art	low	high
primitive	civilized		

Luce Irigaray, 'Writing as a Woman' (1987)

Luce Irigaray (*LI*) interviewed by Alice Jardine (*AJ*) and Anne Menke in *Je tu nous: Towards a Culture of Difference*, trans. A. Martin (London: Routledge, 1993), pp. 52–8 (first published in France, 1987).

AJ: Writing as a woman: is this valid and does it enter into your practice as a writer?

LI: I am a woman. I write with who I am. Why wouldn't that be valid, unless out of contempt for the value of women or from a denial of a culture in which the sexual is a significant subjective and objective dimension? But how could I on the one hand be a woman, and on the other, a writer? Only those who are still in a state of verbal automatism or who mimic already existing meaning can maintain such a scission or split between she who is a woman and she who writes. The whole of my body is sexuate. My sexuality isn't restricted to my sex and to the sexual act (in the narrow sense). I think the effects of repression and especially the lack of sexual culture – civil and religious – are still so powerful that they enable such strange statements to be upheld as 'I am a woman' and 'I do not write as a woman.' In these protestations there's also a secret allegiance to the between-men cultures. Indeed, alphabetical writing is linked historically to the civil and religious codification of patriarchal powers. Not to contribute to making language and its writings sexed is to perpetuate the pseudo-neutrality of those laws and traditions that privilege masculine genealogies and their codes of logic.

AJ: Many women writing today find themselves for the first time historically within institutions, such as universities or psychoanalysis. In your view, will this new place for women help get them into the twentieth-century canon, and will that be at the very heart of this corpus or will they (still) be kept to the footnotes?

LI: At the present time, there aren't that many women working in institutions. Those that do are often restricted in how far they can go in their career. Very few women reach the highest posts and they pay very dearly for it, in one way or another. That this is true is shown by the debates concerning names for occupations.

However, in order to write things that will be inscribed into and remain in the memory of the twentieth century, just being in an institution isn't enough. It sometimes enables thought to be spread rapidly, but that gives no indication of what its historical impact will be. It's quite possible that many of the women who are allowed into institutions talk about a culture that has already passed and not about what will remain as a trace of the elaboration of the present and the future.

Where will this civilization, which is in the course of construction, be expressed? Not just in writing, that's for sure! However, taking the written corpus alone, the footnotes are often the least accessible place for women. Because in these a name has to be

cited, as well as the title of the book or article, and precise references to a text have to be given; at least that's what I understand. Some women's work has already entered into the body of books, but it's often been assimilated without a precise indication of who produced it. Culture has taught us to consume the mother's body – natural and spiritual – without being indebted and, as far as the world of men is concerned, to mark this appropriation with their name. Your question seems to suggest that this cannot change. Women's words are to remain in the main body or in the notes of a text they have neither written nor signed by their name. Unless the way your question has been put or translated is incorrect?

What's most difficult to understand in History are the different contributions men and women make to civilization. A sign of the reality and recognition of this would be the publication of books signed by women that contribute to the elaboration of culture in a manner irreplaceably theirs, not that of men. Another indication of a transformation in the order of symbolic exchanges would be a proliferation of texts showing a real dialogue between women and men.

AJ: Nowadays we are witnessing the production of literary, philosophical, and psychoanalytical theory by women that is recognized as being significant, and at the same time, a new fluidity between the boundaries of disciplines and between styles of writing. Will these two parallel movements lead to women merely being welcomed alongside men or to the definitive blurring of the distinctions between categories?

LI: There is not a great amount of fluidity between disciplines and styles of writing these days. The many fields of knowledge and techniques have made the boundaries between forms of knowledge more watertight now than they were in the past. In previous centuries, there was a dialogue between philosophers and scientists. Nowadays, they are often complete strangers to each other because their languages don't enable them to communicate with one another.

Are there new areas of exchange between disciplines such as philosophy, psychoanalysis, and literature? This is a complex question. There are attempts to pass from one field to another but they are not always successful because they lack the necessary scope. What we are witnessing is a modification in the use of language by certain philosophers who are returning to their cultural origins. Thus, Nietzsche, Heidegger, and Hegel before them question their Greek foundations, their religious foundations, Derrida his relationship to the books of the Old Testament. For them this move goes along with using a style which is close to that of tragedy, poetry, the Platonic dialogues, mythical expression, religious acts and parables. This return is a return to the moment when male identity was constituted as patriarchal and phallocratic. Is it women's emergence from the home and silence that has forced men to ask themselves a few questions? All the latter philosophers – except Heidegger – are explicitly interested in female identity, sometimes in their own identity as feminine or women. Will this lead to the blurring of the distinctions between categories? Which ones? In the name of what? Or whom? Why? I think what you call categories are areas of knowledge and not the logical categories of discourse and of truth. The establishment of new logical forms or rules has to be accompanied by a new subjective identity, new rules for determining signification. Which is also a prerequisite for women to be able to situate

themselves in cultural production alongside and with men. In turning back toward the moment when they seized sociocultural power(s), are men looking for a way to divest themselves of those powers? I hope so. This would imply that they are inviting women to share in the definition and exercise of truth with them. Writing differently has not, as yet, done much to change the sex of political leaders nor their civil and religious discourses.

Is it just a matter of patience? Should we be patient faced with decisions made on our behalf and in our name? Of course, as far as I'm concerned, there's no question of us turning to violence, but we should investigate ways of giving an identity to the sciences, to religions, and to political policies and of situating ourselves in relation to them as subjects in our own right. Literature is fine. But how can we bring the world of men to govern peoples poetically when what they are interested in above all is money, competition for power, and so on? And how can we govern the world as women if we have not defined our identity, the rules concerning our genealogical relationships, our social, linguistic, and cultural order? Psychoanalysis can be a great help to us in this task if we know how to use it in a way suited to our spiritual and corporeal needs and desires. It can help us to draw away from patriarchal culture, provided we don't allow ourselves to be defined by nor attracted to the male genealogical world's theories and problems.

AJ: Given the problematic and the politics of the categories of the canon, and given the issues we've touched on here, will your work find a place in the twentieth-century canon, and how will it be presented within it? In your view, what might the contents of this canon be?

LI: [. . .] You seem to ignore the fact that there are several languages and that they evolve. Take the question of gender, for example, which not all languages treat the same way. With your hypothesis we come back to the problem of knowing which language will win out over the others. In that there is very much a cataclysmic horizon to which I couldn't subscribe, no more than I could adhere to the belief that there are universals programming meaning, eternally and globally, for all men and for all women. That being said, I could give the following response to your question: will the future emphasize the subject or the object? Communication and exchanges of meaning or the possession of material goods? To these alternatives, which in part correspond to the different expression of gender in particular Romance and Germanic languages, my response is that I wouldn't wish ancient cultural traditions to be abolished by civilizations that are less developed in terms of subjectivity. I would like the culture of the subject to which I belong, notably owing to my language, to progress toward a culture of the sexed subject and not towards a thoughtless destruction of subjectivity. Looked at in these terms, I very much hope to figure in the cultural memory of the twentieth century and to contribute to the transformations in the forms and contents of discourse. For me this wish goes hand in hand with a hope for a future that is *more* rather than *less* cultured than the past or present, a future in which symbolic exchanges will be more free, more just, and more developed than at present, including in the religious dimension which the word 'canon' evokes. [. . .]

Andrea Blum et al. (eds), 'Art' (1992)

From *WAC Stats: The Facts about Women* (New York: Women's Action Coalition, 1992), pp. 8–9.

51.2% of all artists in the US are women.[1]
30.7% of all photographers are women.[1]
90% of all artist's models are women.[2]
67% of bachelor degrees in fine arts go to women.[3]
46% of bachelor degrees in photography go to women.[3]
65% of bachelor degrees in painting go to women.[3]
60% of MFAs in fine arts go to women.[3]
55% of MFAs in painting go to women.[3]
47% of MFAs in photography go to women.[3]
59% of PhDs in fine arts go to women.[3]
66.5% of PhDs in art history go to women.[4]
59% of trained artists and art historians are women.[4]
33% of art faculty are women.[4]
5% of works in museums are by women.[5]
17% of works in galleries are by women.[6,4]
26% of artists reviewed in art periodicals are women.[2]
Women artists' income is 30% that of male artists.[2]
30% of Guggenheim grants go to women.[7]
42% of $5,000 NEA grants go to women.[7]
33% of $10,000 NEA grants go to women.[7]
29% of $15,000 NEA grants go to women.[7]
25% of $25,000 NEA grants go to women.[7]
Of the art commissioned by the Department of Cultural Affairs Percent for Art Program in New York City, 70% have been artists of color, 41% women, 39% of the 41% women of color.[8]
Of the 1992 New York Foundation for the Arts awards given, women received 53.4%, men received 46.6%.[9]
Of the world's top 200 collectors approximately 128 are male, 52 are male–female couples, 20 are female.[10]
7 out of 36 one-person museum exhibitions in the 1991–2 New York season were by women.[11]

Notes

1 1990 Statistical Abstract of the United States.
2 Devorah L. Knoff (unpublished manuscript).
3 US Department of Education, National Center for Education Statistics, 1989–90.

4 Eleanor Dickenson, 'Gender discrimination in the art world', prepared for the College Art Association, Coalition of Women, 15 February 1990 in New York City.

5 Guerrilla Girls Poster, New York, 1991.

6 National Endowment for the Arts.

7 Women's Caucus for Art, Moore College of Art Fact Sheet, citing Randy Rosen and Catherine C. Brawer (eds), *Making their Mark: Women Artists Move into the Mainstream 1970–1985* (New York: Abbeville Press, 1989).

8 Department of Cultural Affairs, Percent for Art, 1992.

9 New York Foundation for the Arts, 1992.

10 *Artnews*, cover article, January 1992, pp. 79–91.

11 *Art in America* 1991–92.

2

Activism and Institutions

INTRODUCTION

The relationship between activism and theory has always been a vital one for feminism. Without the space for reflection, analysis and development of strategy, activism would be random and counter-productive; without active intervention in patriarchal social and cultural structures, feminist thought would remain an academic, apolitical endeavour. This chapter documents exhortion to activism, reflection upon activist intervention, and analysis of institutional structures in need of feminist intervention. It is divided into five sections which address: approaches to patriarchal structures, the creation of feminist structures and spaces for women, the interrelation between art practices and activist practices, education and pedagogy, and issues of censorship.

The analysis of patriarchal structures and thinking is the bedrock of feminist activism. The first text in the section 'Challenging Patriarchal Structures' is a hand-out distributed at demonstrations against gender imbalance in the 1970 annual survey of contemporary American art at the Whitney Museum, New York. It is presented here as a sample of this form of activism and the spirit that informed the early movement. That year the percentage of women artists selected had gone up to 21 per cent from the previous year's 5 per cent, following earlier protests. The argument offered – 'an interesting possibility is emerging. Perhaps there are more' – indicates the arbitrary evaluation of quality when it is informed by prejudice, and the demand is for equity – 50 per cent.[1]

Artist and philosopher Adrian Piper argues in 'The Triple Negation of Colored Women Artists' that racism and sexism usually go hand in hand. She identifies the Euroethnic art world's negation of the contribution of those she terms 'colored women artists' because of their colour and their sex. While 'encouraged' by the reparation made in some quarters, Piper warns about the possible long-term significance of concentrating upon difference and otherness 'in which the main subject of investigation is the person, not the artifact . . . This means substituting social relations for works of art as an object of investigation.' The liberal end of the Euroethnic art establishment deflects attention in a manner which maintains old structures in a new guise. Individuals may defend this for their own 'maximal professional success'. While Piper is writing about the US experience, and the historical and contemporary formulations of racism differ

elsewhere, there is little to suggest that this model might not also be appropriate in other contexts.

The maintaining of old structures in a new guise is also investigated by Val Walsh in her accounts of two conferences, one in England and one in Scotland. In one she noted 'a female equivalent of *academic machismo*', and states that white women academics run the risk 'of being compromised by the dominant ethos of profession-alism unless we explicitly problematize it'. The other conference, informed by feminism, was 'open, loose and interactive', but 'many women ended up feeling disempowered by a looseness of structure which dissipated our energies and diluted our mutual visibility.'[2] Walsh argues that in order to avoid complicity with institution-alized masculinity, the communication, organization and purpose of such events must be subject to theorization.

Jody Berland approaches the problem of work and institutions from a different direction in an essay which is a haunting one for any woman trying to work in any professional strand of the art world. Noting that individual women often work in multiple professional capacities simultaneously – as artists, curators, critics, educators and so forth – she sets a scene where such professional fluidity may lead to slippages in subjectivity and self-knowledge which have political, bodily and pedagogical repercussions.

One strategy of the women's movement is the creation of spaces for women or environments which, if mixed, are woman-friendly, and to develop feminist theories and methods of structuring. This is in part in reaction to the problems explored in the first section of the chapter, but also to allow women to pool resources and strength, to gather information, and to develop strategy. Betsy Damon's short, untitled account of a ritual performance encapsulates the ethos of individual and collective identification and resolve that still accompanies women gathering together as women for political reasons. The consciousness-raising (CR) rules, and suggested topics for women artists, drawn up by WEB, shed light on a central early feminist activity. The rules suggested sound simple enough, but trying to maintain them in a situation that relinquished leadership required great collective sense of purpose. Needless to say, the group dynamic was all important: CR groups sometimes lasted for years and led to life-long friendship, and sometimes fizzled out or led to acrimony. They were, however, extra-ordinarily politically productive, sometimes as a result of a very particular focus. While one generation of feminism outgrew the need for such groups, a case might surely be made today for a version of CR for those new to feminism or for focusing issues raised by and for older women.

In Britain, the presence of a major (and sometimes governing) political party of the left, with formal links to the union movement, led some groups resulting from the up-risings of the late 1960s to make interventions in establishment political structures. This included the forming of the Artist's Union (AU), which was affiliated to the Trades Union Congress. The self-published document recounting the early history and aims of the Women's Workshop of the AU shows feminist adaptation of a similar strategy in relation to the AU itself. It also demonstrates its effectiveness, with one member, Mary Kelly, being elected as chair of the AU and two others to the secretariat. In the US, feminists were more likely to organize in non-affiliated groups. Either way, the processes of organizing as feminists, and the difficulties of constructing working

methods and relationships which were feminist in deed as well as in name, was diffi-
cult, time-consuming and rewarding. The results of CR can be discerned in the excerpts
reprinted here from the minutes of a meeting of the *Heresies* collective held before the
first edition of that magazine was published.

One of the myths of the history of the women's movement is that it fell to pieces in
the 1980s when issues of difference between women were raised. Researching the
history of the movement, however, proves that this is indeed a myth, and a white,
heterosexual myth at that. Women were organizing around their particular interests,
identities and differences for as long as they were organizing around anything: it can
take those with authority (particularly if they self-identify as radical) a long time to
recognize the power they use – by which time the cracks may be so wide they can-
not be bridged. Terry Wolverton's 'Lesbian Art Project' is an account, not only of the
dynamics of a feminist group, but of how a group of women attempted to negotiate the
identity lesbian/feminist/artist, and the close interweaving of the personal and the
political intrinsic to the movement. In negotiating its republication here, Wolverton
informed us that 'as originally written, this essay contained more explanation of the
theoretical bases of the Lesbian Art Project' but when it was originally published it was
edited without permission, leaving, in the author's view, 'little more than gossip'. The
author wishes readers to understand 'that the point of all the personal revelation in the
essay is that the Lesbian Art Project was attempting to construct a theory of lesbian
sensibility by studying the lived experience and relationship dynamics of lesbians,
examining our patterns of interaction and the ways in which internalized oppression
interfered.' Martha Rosler's short, succinct statement takes the well-known early tenet
of the women's movement, that 'the personal is political', and subjects it to scrutiny.
This is the case only if one applies political analysis to personal cause and effect, and
uses this process as part of a collective movement to work for political change. Rosler's
statement was a key moment in a 1980 conference in London which in turn was a pivotal
moment in US/UK relations, with the US artists appearing to have more theoretically
advanced notions of activism, while the UK supplied a more developed art theory and
historiography.[3] Anne Marsh's 'A Theoretical and Political Context' is an extract from
her book which uses the histories of particular groups in Adelaide to analyse how pol-
itical differences between feminists can lead to radically different strategies and art prac-
tices. Here, the theoretical differences – over the very political and conceptual nature
of difference – were to a large extent determined by class difference, but were also
determined by the perceived 'threat' of lesbianism.

The third section of this chapter explores how activism has affected art practices,
how art has been used in activism, and how art practice has affected activist politics. 'In
Mourning and in Rage . . .' was a large-scale collaborative, ritualistic and theatrical per-
formance. Leslie Labowitz-Starus and Suzanne Lacy describe their reaction to a series
of related rape–murders in Los Angeles, and the performance they formulated with
local women's groups. A crucial part of the action was the pragmatic self-defence work-
shop following the event and the demands presented to the city government for spe-
cific action to be taken; just as important was the garnering of media coverage, not for
the art as art *per se*, but for the art as political demonstration.[4] Mierle Laderman Ukeles's
'Touch Sanitation', conversely, comprised a very personal day-to-day interchange and
the seemingly small gesture of shaking hands with all of New York's sanitation men

(binmen). Her work on the domestic maintenance of housekeeping and cleaning led her to explore this activity on a wider social scale, forging links between feminist politics and the politics of class.

Lucy Lippard is one of the most prolific of feminist critics. Her work has always aspired to a broad radical remit, and while her general focus has moved over the past three decades from radical conceptualism, to feminism, to multiculturalism, and, more recently, to cultural tourism, it is possible to see her relate traces of all of these through all her output. 'Hot Potatoes' takes on the whole problem of the relation between art, political engagement and artists' lives in a manner that is deceptively engaging, but does in fact challenge complacency at every turn. Situating her analysis in a recent histori-cal context, she asks for understanding of the difficult position artists are in, but asks artists to be constantly vigilant about co-option or capitulation.

The passage from Marina Warner's excellent book, *Monuments and Maidens*,[5] is an account of how women who did not publicly call themselves 'artists', nor what they did 'art', none the less manifested their activism in a way that recalls the happenings, per-formance and installations of the 1960s and 1970s. The women who demonstrated at Greenham Common nuclear base in the 1980s (one of over 100 US airbases in Britain at the time) re-entered the feminine roles of nurturing and caring, and exceeded them to the nth degree, to disconcert and disrupt the masculine authorities. Warner juxtaposes this with the 'Iron Lady' image cultivated by Margaret Thatcher.[6]

In 1989, a young man went into an engineering classroom at the Polytechnique in Montreal with a gun, asked all the men to leave (which they did) and shouting 'You're all a bunch of feminists' he proceeded to massacre fourteen women. The art journal *Parallélogramme* asked a number of artists and institutions to comment on artists' responses to the massacre. The text reprinted here is from Montreal's La Centrale, the longest-lived women's art organization in Canada. The text questions the responses of women artists from elsewhere, identifying many as 'commemorat[ing] death instead of denouncing the real problems underlying such an event'. La Centrale prefers political reflection and silence rather than such gestures. The statement underlines the neces-sity for activist art to be engaged with the community rather than reducing politics to spectacle – an issue running through the whole of this chapter.

One way in which women have engaged with a community is through teaching. On the one hand, this can be a productive means of providing financial support for an artist and her practice, working in an environment where the focus is the making of work. On the other, and more altruistically, teaching is a means of engaging with emerging artists and helping provide them with a woman-friendly environment, constructive criticism, and enough information about work by other women so that they can place their own practice in a tradition and avoid reinventing the wheel.

Perhaps the best-known educational enterprises are the Feminist Art Programs (FAPs) of Fresno and CalArts in California. Judy Chicago developed the FAP at Fresno in 1971, but left after that session, when it was continued and further developed by Rita Yokoi through 1973 and beyond.[7] Chicago moved to CalArts, Los Angeles, at the invi-tation of Miriam Schapiro. The FAP there, developed by Chicago, Schapiro and Paula Harper, also lasted for just one year, but has a reputation far exceeding its duration.[8] This is for four reasons: the pedagogical processes developed; the main publicly ex-hibited product of the course, the famous 'Womanhouse'; the calibre of the graduates,

many of whom have continued working as artists, curators, critics and theorists;[9] and, finally, the tireless work of the tutors – Chicago in particular – to document and analyse the history of the programme. The first text on education is a short extract from Schapiro, outlining the teaching methods used on the programme, which are clearly developed from feminist practice and theory. Next is an extract from an essay by Paula Harper looking back at the FAP. In this section she evaluates the long-term benefits provided and problems caused by the FAP.[10]

With the different educational structures of different countries, it is doubtful whether an equivalent of the FAP could have occurred anywhere other than the USA. Certainly it could not have happened in the UK system, where the inclusive three-year BA art courses do not allow for individual staff to develop such initiatives.[11] Griselda Pollock's essay (here edited) examines the ideology underlying art educational institutions in the UK at a pivotal moment. This was the height of Thatcherism, when terminology of the 'cultural industries' was being developed, higher education was being devalued, and the polytechnic system was shortly to be abolished, bringing most studio art courses into the university sector. Pollock critiques the concept of 'the artist' – and the reality of the artist/teacher – found in the UK system. She posits that this provides little in the way of actual education for students in general, and a total lack of understanding for those who are developing a feminist engagement with practice and critical theory. Unless there is a radical shift, art schools, as a result of their failure to address the ideology of the production and consumption of art, will be easy targets for Conservative government policy.

Moira Roth gives a personal account of what feminist research, knowledge and theory have meant for her own teaching of modern art history. As someone who completed her own education in the 1960s, the increasing volume of art and art criticism, history and theory from a feminist position (to which Roth herself has contributed enormously) has at different times led her to re-evaluate both the content and style of her teaching. What emerges from this essay, as from Pollock's also, is the huge amount of work a feminist teacher has to do, not only to update the overt content of her teaching, but also to ensure that she is practising feminism in her teaching.

The final section of this chapter concerns censorship. This issue is one that has produced strongly diverging positions in the women's movement, from the anti-pornography movement to those who wish to literally make visible – and explore visually – aspects of women's sexuality. Generally, artists have been against censorship in so far as it has impacted upon the art world. The so-called 'culture wars' of the 1980s and 1990s in the USA saw broad coalitions of artists uniting against right-wing moves to censor artworks.[12] This is touched upon in the interview with Carolee Schneemann, who also contrasts the US experience with her experience in (the then) Soviet Union: 'In an economy in which soap, tampons, condoms, toilet paper, diapers are usually *unavailable*; in a demanding daily struggle which exhausts everyone – how can an examination of erotic intimacy not seem like a luxury? a risk?'

Censorship does not always come into play over overt sexual content, nor is it attempted always by government or institutions. Sarah Milroy's account of 'The Flesh Dress' by Jana Sterbak places that artwork in traditions that can be legitimated by art history, but it also transgresses 'primarily in the arena of gender' by linking femaleness with meat. Thus, as 'an act of female disobedience', it was punishable. Milroy demonstrates

how press coverage emphasized the sex of the curator and encouraged readers to send offensive material to the gallery. She links this to the sexual politics of domestic economy and of meat. Anna Douglas further complicates the issue of the censorship of art in her analysis of the events surrounding the removal of a drawing from an exhibition. The gallery concerned was known for its support of radical art, including art by feminists and black artists, and art concerning political events in Ireland. The drawing was called 'The Judgement against Rushdie': while the image, with its abstract qualities, might have not been read politically, the title gave it a very particular pro-Salman Rushdie meaning two years after the publication of the *Satanic Verses* and the *fatwa* pronounced against him. The drawing was shown unproblematically in a private gallery in London. In a publicly funded gallery in Rochdale, which has a large Muslim community, the context is different, argues Douglas. 'Might it not be reasonable to expect socially aware artists in particular to be prepared sometimes to sacrifice their artistic values in favour of social ones? . . . Their art *might* at times unintentionally reinforce or provoke a group's sense of isolation.' This reflects back to some of the difficulties for artists outlined in earlier texts in this chapter such as that by Lucy Lippard.

Notes

1 See Whitney Chadwick, *Women, Art and Society* (London: Thames and Hudson, 1990), p. 347 for even more damning statistics of the representation of women in international exhibitions in the 1980s.

2 An issue raised early for the movement and named by Jo Freeman, *The Tyranny of Structurelessness* (USA: Women's Liberation Movement, 1970); reprinted 'The tyranny of structurelessness', *The Second Wave*, 2 (1) (1972); *The Tyranny of Structurelessness* (London: Dark Star Press, 1998).

3 This was a complex moment, in part informed by the nature of the three exhibitions at the ICA in London which the conference accompanied: the activist, socially engaged work of 'Issue' curated by Lucy Lippard with mainly US artists; 'Women's Images of Men' (figurative, mainly painting, sculpture and photography, and not all explicitly feminist) and 'About Time', of performance and video work; these last two mainly of UK artists. See the three catalogues, *Issue, Women's Images of Men* and *About Time* (all London: ICA, 1980). See also Sarah Kent and Jackie Morreau (eds), *Women's Images of Men* (London: Writers and Readers, 1984) and Caryn Faure Walker, *Ecstacy, Ecstacy, Ecstacy, She Said: Women's Art in Britain – A Partial View* (Manchester: Corner House, 1994); these two alone provide accounts of the exhibitions and the conference which disprove the view of the late 1980s that feminist art theory is marked by a 'first generation', 1970s' essentialist politics from the US, and a 'second generation', 1980s' Marxist and post-structuralist theoretical politics from the UK.

4 For further writing by Labowitz and Lacy about this work and related strategy, see also Suzanne Lacy, 'In mourning and in rage (with analysis aforethought)', in *Femicide: The Politics of Woman Killing*, ed. Jill Radford and Diana E. H. Russell (New York: Twayne, 1992), pp. 317–24; Leslie Labowitz and Suzanne Lacy, 'Mass media, popular culture, and fine art: images of violence against women', in *Social Works*, ed. Nancy Buchanan (Los Angeles: Los Angeles Institute of Contemporary Art, 1979), pp. 26–31; Leslie Labowitz, 'Developing a feminist media strategy', *Heresies*, 9 (1980): 28–31; Leslie Labowitz and Suzanne Lacy, 'Feminist artists: developing a media strategy for the movement', in *Fight Back! Feminist Resistance to Male Violence*, ed. Frédérique Delacoste and Felice Newman (Minneapolis, MN: Cleis Press, 1981), pp. 266–72.

5 Marina Warner, *Monuments and Maidens: The Allegory of the Female Form* (London: Weidenfeld and Nicolson, 1985).

6 In the chapter from which the reading is taken, Warner has previously analysed the representation of Thatcher as Britannia and as Boadicea (Boudicca).

7 Rita Yokoi, 'Feminist art: California State University, Fresno, Fall 1971, Spring 1972, Fall 1972, Spring 1973', *Women's Studies in Art and Art History: Descriptions of Current Courses with Other Related Information*, 2nd edn (New York: Women's Caucus for Art, 1975), pp. 3–6.

8 CalArts also had a feminist design programme run by Sheila De Bretteville.

9 Including, for example, Suzanne Lacy, Mira Schor and Faith Wilding.

10 Among the many other accounts of this programme are: Judy Chicago, *Through the Flower: My Struggle as a Woman Artist* (London: The Women's Press, 1982); Judy Chicago and Miriam Schapiro (eds), *Womanhouse* (Los Angeles: California Institute of the Arts, n.d. (?1972); Miriam Schapiro, 'Recalling Womanhouse', *Women's Studies Quarterly*, special issue: Teaching about Women and the Visual Arts, 15 (1–2) (1987): 25–30; Miriam Schapiro (ed.), *Art: A Woman's Sensibility* (Valencia: Feminist Art Program, California Institute of the Arts, 1975); Faith Wilding, *By our own Hands: The Women Artist's Movement* (Santa Monica: Double X, 1977); Faith Wilding, 'The feminist art programs at Fresno and CalArts, 1970–75', in *The Power of Feminist Art: The American Movement of the 1970s, History and Impact*, ed. Norma Broude and Mary D. Garrard (New York: Harry N. Abrams, 1994) pp. 140–57.

11 Hilary Robinson, 'The women's movement in art education', *Circa*, 89 (1999) (supplement on art education): 6–7.

12 See Carol Vance, 'The war on culture', *Art in America* (September 1989): 38–9.

Essential reading

Burnham, Linda Frye and Durland, Steven (eds), *The Citizen Artist: 20 Years of Art in the Public Arena – An Anthology from High Performance Magazine* (Gardiner, NY: Critical Press, 1998).

Chicago, Judy, *Through the Flower: My Struggle as a Woman Artist* (London: The Women's Press, 1982).

Dubin, Steven C., *Arresting Images: Impolitic Art and Uncivil Actions* (London: Routledge, 1992).

Dworkin, Andrea, *Pornography: Men Possessing Women* (London: The Women's Press, 1981).

Felshin, Nina (ed.), *But is it Art? The Spirit of Art as Activism* (Seattle: Bay Press, 1995).

Gablik, Suzi, *The Re-enchantment of Art* (London: Thames and Hudson, 1991).

Lacy, Suzanne (ed.), *Mapping the Terrain: New Genre Public Art* (Seattle: Bay Press, 1995).

Lippard, Lucy R., *Get the Message? A Decade of Art for Social Change* (New York: E. P. Dutton, 1984).

Raven, Arlene, *Crossing Over: Feminism and Art of Social Concern* (Ann Arbor: UMI Research Press, 1988).

2.1 Challenging Patriarchal Structures

Women's Ad Hoc Committee/Women Artists in
Revolution/WSABAL, 'To the Viewing Public
for the 1970 Whitney Annual Exhibition' (1970)

Self-published hand-out distributed at demonstrations against gender imbalance
in the 1970 annual exhibition at the Whitney Museum, New York.

Don't despair!

If this exhibition leaves you cold, if you find that it doesn't
have much life, or meaning, or excitement for you, don't jump to
the conclusion that you're 'just not with it'! There's another
possibility: ─────┐
 └───▶▶▶ THE *WHITNEY* ISN'T WITH IT!!!!!

They say they are giving us a survey of what's going on in American
sculpture right now, but all they've given us is *their usual survey
of their own prejudices.*

THE WHITNEY STAFF SUFFERS! GRAVELY!
FROM ACUTE MYOPIA! This show is more about the artists they *couldn't*
see than about the ones they have included. They're just not looking
beyond their own prejudices, and WOW! Have they got prejudices!

(All kinds.)

But at the top of their list of prejudices, outnumbering all others
by far ------------- THE WINNER!! ------------ are America's
women artists, all colors. YOU DON'T BELIEVE US? THINK WE'RE
JUST A BUNCH OF SOUR GRAPES? ──┐
 ▼ Would you like to know how many
of last year's one hundred and forty-three (143) exhibitors in the painting Annual were
women? The answer is eight (8). (That was not a misprint.) And it didn't happen because
there aren't many good women painters or because they didn't submit their work.

HERE ARE	1968 (sculpture) ------10	women	out	of	137	exhibitors
SOME MORE	1967 (painting) -------16	"	"	"	165	"
DAMNING	1966 (sculpture) ------12	"	"	"	146	"
FACTS: →»	1965 (painting) -------14	"	"	"	138	"

Well now, for some strange reason, after some groups of women artists (The Women's Ad Hoc Committee, Women Artists in Revolution, and WSABAL) began to complain loudly (better late than never) about this gross bigotry, the Whitney staff did a lot of hasty and unaccustomed scrambling around to see the work of women artists, and lo! Suddenly there are a whole lot of women artists who never existed before. From nowhere! To the rescue!! Came these women artists!!!

 This year's Annual has twenty-one (21) women out of one hundred and three (103) exhibitors. That makes it about 21% of the exhibition to last year's 5%. ⌐

 An interesting possibility is emerging.

 Perhaps there are more. ◄────────┘

WE'RE NOT SATISFIED! WE WANT MORE! WE HAVE BEEN DEMANDING FIFTY PER CENT, AND WE'RE GOING TO KEEP RIGHT ON UNTIL WE GET IT.
The reason is this: there is no reason to believe that twenty-one per cent is a fair representation of the number of women artists doing good work in this country, any more than five per cent was.
EVEN WE don't know the potential of women artists in this country, because we've never had a chance to find out. ON TO FIFTY PER CENT!!!
♀ * # $ @ + & # % ! ¼ $\frac{1}{2} = \frac{1}{2} = \frac{1}{2} = \frac{1}{2} = \frac{1}{2} =$ ♀

Adrian Piper, 'The Triple Negation of Colored Women Artists' (1990)

From *Next Generation: Southern Black Aesthetic*, ed. Devinis Szakacs and Vicki Kopf (Winston-Salem, NC: South-Eastern Center for Contemporary Art, 1990), pp. 15–22.

These are interesting times in which to be a colored woman artist (henceforth a CWA).[1] Forces of censorship and repression in this country are gathering steam and conviction as those same forces in other countries are being overturned or undermined. No one should be surprised at these inverse parallel developments. Sociologists know that groups tend to increase the internal pressures toward conformity and homogeneity in order to maintain their identities against external pressures forcing dissolution into a larger whole. And just as American society is now imposing a Euroethnic, Christian,

heterosexual male ethos on all of us in order to maintain a uniquely American identity against the incursion of other, emerging democracies in Russia and Central Europe, similarly the art world is reasserting a Euroethnic, heterosexual male aesthetic on all of us in order to resist the incursion of gays, coloreds, and practitioners of outlaw sexuality into its inner sanctum.[2] In particular, I will argue that the ideology of post-modernism functions to repress and exclude CWAs from the art-historical canon of the Euroethnic mainstream. Correctly perceiving the artifacts produced by CWAs as competitors for truth and a threat to the cultural homogeneity of the Euroethnic tradition, it denies those artifacts their rightful status as innovations relative to that tradition through *ad hoc* disclaimers of the validity of concepts such as 'truth' and 'innovation.'

Item, 1982: NEA funding for the Washington Women's Art Center ceases after congressional protest over their *Erotic Art Show*. Item, 1983: Rosalind Krauss explains to her fellow symposiasts at the NEA Art Criticism Symposium that she doubts that there is any unrecognized African–American art of quality because if it doesn't bring itself to her attention, it probably doesn't exist. Item, as of this writing: No CWA is invited to show in any Whitney Biennial, ever. Item, 1987: Donald Kuspit publishes in his vanity journal a seven-page essay devoted to the thesis that my writing is a symptom of mental illness and my work is not worth discussing.[3] Item, 1988: an unusually strong group show of the work of colored women artists opens at the INTAR Gallery in Manhattan and receives no attention from the local Euroethnic press, with the exception of Arlene Raven's intelligent review in *The Village Voice*.[4] Item, 1989: Christina Orr-Cahall cancels a retrospective of the photography of Robert Mapplethorpe at The Corcoran Gallery. Item, 1989: Jesse Helms protests public funding of Andres Serrano's work by the Southeastern Center for Contemporary Art's Awards in the Visual Arts. Item, 1989: Roberta Smith explains to film interviewer Terry McCoy that the real problem with the art of African-Americans is that it just isn't any good, that it would be in mainstream galleries if it were, that she's been up to The Studio Museum in Harlem a couple of times and hasn't seen anything worthwhile, that it's all too derivative, etc.[5] Item, 1990: The National Endowment for the Arts withdraws funding from an exhibition catalogue about AIDS at Artists' Space. Item, 1990: Hilton Kramer devotes two essays in the *New York Observer* to protesting the current interest in issues of race and gender that, he claims, leave quality by the wayside.[6]

In a more intellectually sophisticated environment, these howlers would be accorded exactly the weight they deserve, i.e. none. In this decade's art world – as we can see, a world not exactly overpopulated by mental giants[7] – they are dangerously repressive in effect. Instead of being recognized and ridiculed for what they are, namely obscene theatrical gestures without redeeming social content, they legitimate and encourage further such obscenities among those who are naturally inclined to them, and intimidate the naturally docile into self-censorship. We can expect these repressive measures to increase in number, severity, and ugliness as those relegated to the margins succeed in greater numbers in gaining access to unjustly withheld social and economic advantages within the mainstream Euroethnic art world.[8]

At the same time, on the other hand, a few CWAs recently have begun to receive some modest measure of attention from the Euroethnic art world. We have been invited to show in previously all-Euroethnic group exhibitions, galleries, or museums; and we

have received some critical attention for work that for decades was largely passed over in silence, as though it did not exist. No protest against the *de facto* censorship of CWAs has ever been mounted of the sort that has rightly greeted the recent attempted censorship of the work of male artists Robert Mapplethorpe, Andres Serrano, or David Wojnarowicz. Until very recently, CWAs were ignored as a matter of course.[9] In the last few years, CWAs have begun to exist in the consciousness of the more progressive, intellectually oriented circles of the Euroethnic art world.

Certain factors can be cited to explain the recent visibility of CWAs. In 1987, without fanfare and at considerable professional risk to himself, Michael Brenson began to review the work of African-American artists in *The New York Times* on a regular basis. The appearance of these reviews, backed by Brenson's authority and that of *The New York Times*, effected a profound change in the conventions of Euroethnic art writing. By approaching African-American art with the same attention, respect, and critical standards he applied to Euroethnic art, Brenson singlehandedly exposed the tacit racism of ignoring African-American art that had prevailed among virtually all other Euroethnic art critics.[10] The same year, Howardena Pindell compiled and published 'Art world racism: a documentation,' which was excerpted for broader art world consumption in the *New Art Examiner* in 1989.[11] This work documented the hard statistics of African-American exclusion from Euroethnic galleries, museums, and publications for all to see. The statistics were so incriminating and inexcusable that they effectively foreclosed further disingenuity or rationalization of practices now clearly identifiable as racist. Both of these efforts have sparked energetic and conscientious attempts at reparation in many quarters.[12] Because racism and sexism often go together, amelioration of both together can be achieved by showcasing the work of CWAs.

I am encouraged by this recent development, but I am also suspicious of its long-term significance. It coincides too neatly with an interest in difference and otherness in other fields such as comparative literature, history, and anthropology, *in which the main subject of investigation is the person, not the artifact*. Euroethnic preoccupation with these issues in the art world forces a level of social and political self-criticism and scrutiny of entrenched conventions of aesthetic evaluation that is altogether salutary, and needed. But the object of preoccupation defined by these issues is not the artifact but rather its producer as 'other.' Not the work of art, but rather the artist often provides the content and themes of interviews, photo images, conferences, and critical essays. This means substituting social relations for works of art as an object of investigation. And in an arena as ill-equipped to investigate social relations as the art world, this means imposing only slightly more sophisticated racial and gender stereotypes rather than looking at art.

For example, a CWA who expresses political anger or who protests political injustice in her work may be depicted as hostile or aggressive; or a CWA who deals with gender and sexuality in her work may be represented as seductive or manipulative. Or a CWA who chooses to do her work rather than cultivate political connections within the art world may be seen as exotic or enigmatic. These are all familiar ways of stereotyping the African-American 'other.' When the art itself stymies the imposition of such stereotypes, the Euroethnic viewer is confronted with a choice: either to explore the singular significance of the art itself – which naturally requires a concerted effort of discernment and will for most Euroethnics; or to impose those tired stereotypes

on the artist instead. For two-cylinder intellects, the latter alternative is the most popular.[13]

Of course this tendency to focus on the artist at the expense of the work may be explained differently, as a reflexive by-product of a self-protective, general reaction to most mainstream contemporary Euroethnic art, which compels its viewers to focus on the artist out of sheer desperation, because the art itself is so boring. But for CWAs, the focus on the person rather than the art is particularly troublesome, first, because it turns the artist into little more than a cryptic, exotic object that provides the occasion for Euroethnic self-analysis. I am, after all, not an 'other' to *myself*; that is a category imposed on me by Euroethnics who purport to refer to me but in fact denote their own psychosociological constructs. If I choose to explore those constructs in my work, I am investigating Euroethnic psychosociology, not myself; which merely compounds the blunder of withdrawing the focus from the work and turning it instead onto me. This is the blunder of a bad conscience that seeks to deflect self-scrutiny, by redirecting it onto the artist, at the expense of full attention to the sociocultural meaning of *that artist's chosen form of self-expression*, namely art. This tack, of changing the subject, is just another way to silence those for whom artistic censorship has been a way of life. Euroethnics who have a genuine interest in the forms of self-expression of artists from a different culture do not dwell intellectually on the otherness of the artists for long. They get to work doing the necessary research into that culture, and achieving the necessary familiarity with it, that will yield the insights into those alien forms of cultural expression they purport to seek.[14]

Second, focusing on the otherness of the artist rather than the meaning of the art falsely presupposes a background of Euroethnic homogeneity against which the person can be identified as an 'other.' This perpetuates the ideological myth of minority status on which racists rely to exercise their strategies of disempowerment. Politically concerned Euroethnics would do better to reflect on their collusion in those strategies – for example, isolating a few token coloreds to exhibit in predominantly Euroethnic group shows, or to write about in predominantly Euroethnic art publications – against the reality of their constituting 4% of the world's population while consuming or stockpiling 40% of its resources.

Third, CWAs in particular suffer from this focus because they have to battle gender and race stereotypes simultaneously. Well-meaning critics and curators who think it is possible to make meaningful generalizations about the art of all women, all African-Americans, all Central Europeans, Italians, or gay men are depriving themselves and their audiences of the paradigm experience art is supposed to provide: to heighten one's appreciation of the singular and original qualities of an individual artifact in cultural relation to its producer, its viewer, and its social environment.[15] Whenever someone deflects attention from my work to my identity as a CWA, I start to get nervous about whether they are actually seeing my work at all.

For these reasons, the remainder of this discussion is going to be devoted to a systematic analysis of the Euroethnic art world's negation of CWAs along three dimensions: as coloreds, as women, and as artists. I want to offer a systematic analysis that can explain why, for example, no one feels the need even to defend or justify Betye Saar's exclusion from the *Magiciens de la Terre* exhibit; why the exhibition, *Autobiography: In her own Image* went virtually unremarked by the Euroethnic press; why

the repression and artistic censorship of PWAs[16] is seen as so much more urgent and threatening than that of CWAs; and why, in general, I am not yet convinced that the repression and artistic censorship of CWAs is a thing of the past.

Artistic success in the contemporary Euroethnic art world is perceived by all as the payoff of a zero-sum game, in which one player's win is another player's loss.[17] For example, not everyone can show their work at MOMA. So, it is reasoned, if you show yours there, you decrease my chances of showing mine there. So in order for me to increase my chances of showing mine there, I must, first of all, work actively to decrease yours – through professional back-stabbing, bad-mouthing, covert manipulation, dishonesty, false and loudly trumpeted I-was-there-first self-aggrandizement, etc. Second, I must work actively to increase my chances: by tailoring my work according to trends established by those already exhibited at MOMA,[18] courting the powerful, offering bribes in a variety of currencies, and censoring my impulse to protest when witnessing injustice, so as not to antagonize *anyone* who might eventually help me to get my work shown at MOMA. I must deploy similar strategies for obtaining gallery representation, selling work, or getting critical attention for work. This means that individual artists and allies see one another as professional competitors, and the assets of others as threats to the ability of each to achieve maximal professional success.

'Maximal professional success,' in turn, is defined by admission into a circumscribed set of art institutions – museums, galleries, collections, and art publications – that constitute the Euroethnic mainstream. The ideological content of that mainstream changes with fluctuations of intellectual fashion in other fields (such as Enlightenment aesthetics, analytic philosophy, or continental poststructuralism). But the underlying ideological commitment of the Euroethnic mainstream is to its own perpetuation, in whatever guise. In the Renaissance, this commitment was manifested as a belief in the ability of men creatively to transform the sensuous and material in the service of the intellectual and spiritual, i.e. to transcend the natural physical realm associated with the secular female. In modernism, this same commitment was manifested as a belief in the progression of art made by men from the concretely representational to the intellectual and abstract. In postmodernism, it is manifested in a dissolution of faith in intellectual progress, and a corresponding attitude of mourning for the past glories and achievements of all previous stages of Euroethnic art history, which are memorialized and given iconic status through appropriation into contemporary art world artifacts.

In virtually every field to which women have gained in significant numbers, the status of that field and its perception as providing significant social opportunity has diminished: if a woman can do it, the reasoning goes, then what is there to feel superior about? Therefore the first line of defense is to protest roundly that a woman can't do it. The second, when that doesn't work, is to conclude that it's not worth doing. Thus, it is no accident that the advent of postmodernism coincides with the acceptance of Euroethnic women artists into the inner sanctum of that tradition. Their success forces a choice of inference: either women are just as capable of intellectual transcendence as men, and just what is needed to bring that progression to its next stage; or else their presence undermines the very possibility of further progression altogether. It is quite clear which inference has been chosen. Not coincidentally, Euroethnic postmodernism expresses a newly pessimistic, nihilistic, and self-defeated view of the social and

intellectual status of art at just the moment that women have begun to join its major ranks in significant numbers.

Euroethnic postmodernism's attitude of mourning assumes our arrival at the end of the art-historical progression, and therefore the impossibility of further innovation indigenous to it. This means, in particular, that innovations that occur outside of that progression, or by those who are not accepted into it, cannot be acknowledged to exist as innovations at all. Accordingly, the normative category of originality against which art within the Euroethnic tradition was judged is replaced by the purportedly descriptive categories of anomaly, marginality, and otherness. These aesthetically non-commital categories can be deployed to acknowledge the existence of such innovations without having to credit them normatively as innovations at all.

Relative to the commitment of the Euroethnic mainstream to its own self-perpetuation and its rejection of any further innovation indigenous to it, the very different concerns that may find expression in the art of CWAs – identity, autobiography, selfhood, racism, ethnic tradition, gender issues, spirituality, etc. – constitute a triple-barrelled threat. First, this work has no halcyon past to mourn. Instead, it offers an alternative art-historical progression that narrates a history of prejudice, repression, and exclusion, and looks, not backward, but forward to a more optimistic future. It thereby competes with Euroethnic art history as a candidate for truth. Second, it refutes the disingenuous Euroethnic postmodern claim that there *is* no objective truth of the matter about anything, by presenting objective testimony of the truth of prejudice, repression, and exclusion.[19] Third, it belies the Euroethnic postmodern stance that claims the impossibility of innovation, by presenting artifacts that are, in fact, innovative relative to the Euroethnic tradition – innovative not only in the range and use of media they deploy, but also in the sociocultural and aesthetic content they introduce. In all of these ways, the art of CWAs are innovative threats to the systemic intellectual integrity and homogeneity of the Euroethnic art tradition. And so, because artistic success is defined within that tradition as a zero-sum game, these threats must be eliminated as quickly and completely as possible. Thus are CWAs negated as artists by the Euroethnic art world.

The Euroethnic postmodernist stance of mourning, in combination with its negation of CWAs as artists, provides the surest proof (in case we needed it) that the Euroethnic art world is fueled primarily by a spirit of entrepreneurship, not one of intellectual curiosity; and that its definition of professional success is skewed accordingly. Only a field that defined professional success in economic rather than intellectual terms could seriously maintain that the art of CWAs had nothing new to teach it. Whereas history, literature, anthropology, sociology, psychology, etc., have been scrambling for almost two decades to adjust or modify their canons so as to accommodate the new insights and information to be culled from the life experience of those previously excluded from them, only the Euroethnic art world is still having trouble acknowledging that those insights and information actually exist. In this field, if they don't exist at auctions or in major collections, they don't exist at all. Critics and curators who collaborate in this ideology sacrifice their intellectual integrity for the perquisites of market power. This is the payoff that the zero-sum game of Euroethnic artistic success ultimately offers all of its players.

The Euroethnic contemporary art world is administered primarily by Euroethnic men. As in all walks of life, there are good men and there are bad men. In this arena, the bad ones are blessedly easy to detect. Their behavior and their pronouncements indicate that they evaluate works of art according to their market value rather than according to their aesthetic value. For example, they may refuse even to acknowledge the aesthetic value of work that is not for sale in a major gallery, or they may select artifacts to exhibit or write about solely from those sources. Or they may defend the aesthetic value of very expensive artifacts at great length but on visibly shaky conceptual grounds. Or they may be more visibly impressed by the aesthetic value of a work as its market value increases. Indeed, lacking any broader historical or sociocultural perspective, they may even believe that aesthetic value is nothing but market value. And, believing that only artifacts produced by other Euroethnic men can safeguard the intellectual integrity and homogeneity of the Euroethnic tradition, they distribute payoffs, in proportion to the exercise of the winning zero-sum game strategies earlier described, primarily to other Euroethnic men.

Some women and coloreds collude in the perpetuation of this game, by playing according to its prescribed rules. Euroethnic women who compete with one another and with colored women for its payoffs divide themselves from CWAs and ally themselves with the Euroethnic men who distribute those payoffs and who are their primary recipients. They thereby ally themselves with the underlying ideological agenda of perpetuating the tradition of Euroethnic art as an intellectually homogeneous, systemic whole. This is to concur and collaborate with the Renaissance, modernist, and postmodernist agenda of implicitly denying the legitimacy – indeed, the very possibility – of intellectually and spiritually transcendent artifacts produced by women.

Put another way: by accepting payoffs for playing the zero-sum game of artistic success according to its prescribed rules, some Euroethnic women collaborate in the repression of the alternative art history to which the art of women in general, as well as that of CWAs, often gives expression. Thus CWAs are negated as women, not only through the more brutal, overt attempts at eradication by some Euroethnic male art world administrators; but *whenever* a Euroethnic woman abnegates her connections as a woman to CWAs, in order to receive the payoffs available for repressing them. It is painfully humiliating to witness a Euroethnic woman simultaneously prostituting herself and betraying us in this way.

Similarly for colored men and their connection with CWAs. All colored artists bear the burden of reflexive eradication from the Euroethnic mainstream, and of the reflexive devaluation of their work as a result.[20] Much has been written about this recently, and I will not rehearse those arguments here.[21] My point, here as above, is the same. To the extent that colored artists compete for positioning, attention, and the payoffs of winning the zero-sum game of Euroethnic artistic success, they abide by the rules of that game. In so doing, they compound their reflexive repression by the Euroethnic mainstream, by dividing themselves from another, and negating themselves and their historical tradition for the sake of the payoffs that game promises.

This has nothing to do with what kind of artifact – abstract or representational, in traditional media or new genres – any such artist produces. An unusually dimwitted defense of the repression of colored artists has it that African-Americans are naturally

most adept at expressing themselves creatively in music rather than in the visual arts; and that therefore their attempts in the latter media are invariably derivative, superficial, or disappointing. No one who has studied the artifactual strategies of survival and flourishing of colonialized peoples under hegemonic rule anywhere could take such an argument seriously. But then of course no one who would offer such an argument would be capable of the minimal intellectual effort of research necessary to disprove it. The fact of the matter is that, like other colonialized peoples, African–Americans must master two cultures, not just one, in order to survive as whole individuals, and master them they do. They contribute fresh styles and idioms to the visual arts just as abundantly as they do – and have always done – to music, literature, and film.

The Euroethnic tradition has always needed these extrinsic creative resources in order to flourish, and in the past has simply expropriated and used them without permission or acknowledgment.[22] Had that tradition long since invited their producers into the Euroethnic mainstream, it might have been better armed, with creative strategies of cohesion and survival, for withstanding the censorship attacks that continue to issue from within its own fundamentalist ranks. It is not surprising that blind reviewing is virtually inconceivable in contemporary Euroethnic art, whereas it is the norm in other areas of higher education. As an intellectually integral and homogeneous system, the Euroethnic art tradition could not possibly survive a convention of evaluation that ignored the racist, sexist, and aesthetically irrelevant social and political connections that hold it together. That is why it rewards all of us so richly for following the rules of the zero–sum game.

It is very difficult for any of us not to play this game, as it often seems to be the only game in town. But in fact that is not true. It is not true that Euroethnic payoffs of the zero–sum game are the only measures of artistic success, nor the most important over the long term, nor even the most satisfying ones. There is great satisfaction in affecting or transforming the audience to one's work, and in making those personal connections that enable the work to function as a medium of communication. There is great satisfaction in learning to see whatever resources are freely available in one's environment as grist for the mill of artistic imagination; and indeed, in seeing one's environment in general in that way. There is satisfaction in giving work away, and in avoiding or refusing the corrupting influences of those payoffs, and in reaping the rewards of authentic interpersonal relationships as a consequence. And there is a very great satisfaction in not caring enough for those payoffs to be willing to follow the rules in order to receive them: in not caring enough to tailor one's work accordingly, or offer bribes, or curry favor, or protect one's position by remaining silent in the face of injustice, or by undercutting others.

In fact the very conception of artistic success as the payoff of a zero–sum game is faulty, since the price of playing by those rules is the *de facto* deterioration, over the long term, of the aesthetic integrity of the artifacts produced in accordance with them.[23] Those who play that game according to the rules and win the perquisites of market power may, indeed, achieve artistic success in the Euroethnic art world. But the price they pay is alienation from their own creative impulses and from their own work as a vehicle of self-expression; addiction to the shallow, transitory material and political reassurances of worth that are recruited to take their place; sycophancy and betrayal

from those they temporarily view as allies; and mistrust and rejection from those who might otherwise have been friends. It hardly seems worth it.

Because commitment to that game is so self-defeating and divisive for all who try to play it, I do not believe the triple negation of colored women artists will come to an end until that game itself is over. It will come to an end, that is, when the Euroethnic art world stops trying to negate them as players, and when women and coloreds and Euroethnics stop trying to negate themselves and one another in order to gain entry to it.

I have suggested that Euroethnic postmodernism is finally an attempt to change a few of the rules, hastily, in order to preserve intact the stature of the winners and their payoffs. I neglected to add that the attempt is clearly failing. While larger and larger quantities of money, power and inflated prose are being invested in more and more desiccated and impotent caricatures of Euroethnic art, those who have been excluded from that system have been inventing and nurturing their own idioms, visions, and styles of expression out of that greatest of all mothers, namely Necessity. That is our strength and our solace. That is why the Euroethnic art world needs our resources and our strategies – as it always has – in order to progress to the next stage of development. But we are no longer so preoccupied with other matters as to overlook backdoor expropriation of those resources, nor to take comfort in being the invisible powers behind the throne. As we come to feel the strength of our numbers and the significance of our creative potentialities, we approach a readiness to drop out of the zero-sum game, and claim our roles as players in a very different kind of game, in which the payoffs are not competitive, but rather cooperative. In this kind of game, no one has to lose in order for someone else to win, because the payoffs – self-expression, personal and creative integrity, freedom, resourcefulness, friendship, trust, mutual appreciation, connectedness – are not scarce resources over which any player must be attacked, negated, or sacrificed. Nor are the rules of this game – mutual support, honesty, dialogue, sharing of resources, receptivity, self-reflectiveness, acceptance – of such a kind as to butcher the self and cheapen one's central commitments. It does seem, in so many respects, to be a more appealing game to play. The only question is whether we are all wise enough to be willing to play it.

Notes

1 Let's begin with a word about terminology. I do not like the currently fashionable phrase, 'people of color,' for referring to Americans of African, Asian, Native American, or Hispanic descent. It is syntactically cumbersome. It also has an excessively genteel and euphemistic ring to it, as though there were some ugly social fact about a person we needed to simultaneously denote and avoid, by performing elaborate grammatical circumlocutions. Moreover, discarding previous phrases as unfashionable or derogatory, such as 'Negro,' 'black,' 'colored,' or 'Afro-American,' implies that there is some neutral, politically correct phrase that can succeed in denoting the relevant group without taking on the derogatory and insulting connotations a racist society itself attaches to such groups. There is no such phrase. As long as African-Americans are devalued, the inherently neutral words coined to denote them will themselves eventually become terms of devaluation. Finally, the phrase is too inclusive for my purposes in this essay. I want to talk specifically about women artists of African descent, in such a way as to include those Hispanic-Americans, Asian-Americans, and Native Americans who publicly

acknowledge and identify with their African–American ancestry, and exclude those who do not. The term 'colored' seems both aetiologically and metaphorically apt.

2 Needless to say, this explanation is compatible with self-interested attempts of congressmen and senators such as Alphonse D'Amato and Jesse Helms to find some local scapegoat to substitute for foreign communism, in order to divert attention away from their ineffectuality in simply representing their constituencies.

3 Donald Kuspit, 'Adrian Piper: self-healing through meta-art', *Art Criticism*, 3 (3) (September 1987): 9–16.

4 Arlene Raven, 'Colored,' *The Village Voice* (31 May 1988): 92. The title of the exhibition was 'Autobiography: In her own Image', curated by Howardena Pindell.

5 Telephone conversation between the author and Terry McCoy (Fall 1989).

6 Attempts were made to obtain copies of Kramer's articles from the *New York Observer* as well as from Kramer himself. An *Observer* staff person explained that they were not equipped to handle such requests, while Kramer, in a telephone conversation, acknowledged that the articles existed and agreed to send copies. After many weeks and several unreturned messages, the Kramer articles have yet to arrive (Devinis Szakacs, SECCA).

7 I am not an intellectual elitist, but I do believe that racism, sexism, homophobia, and intolerance generally involve cognitive deficits and elementary errors in reasoning and judgment. See my 'Higher-order discrimination,' in *Identity, Character and Morality*, ed. Owen Flanagan and Amelie O. Rorty (Cambridge, MA: MIT Press, 1990) for a fuller treatment.

8 It's so amusing how arguments that there are no more margins always seem to come from those in the center. Just as it's amusing how arguments that there is no more *avant-garde* always seem to come from those who have gotten the greatest economic mileage from being a part of it. In general, it's immensely entertaining to watch the keepers of the brass ring start to deny that it exists just when they notice that the disenfranchised are about to grab it. No doubt this is pure coincidence.

9 My personal experience is of having been included in 'definitive' major museum shows of conceptual art in the late 1960s, until the art world contacts I made then met me face to face, found out I was a woman, and disappeared from my life; and in 'definitive' major museum shows of body art and women's art in the early 1970s, until the contacts I made then found out I was colored, and similarly disappeared from my life. Although I have had virtually no contact with major museums since those years, I fully expect the situation to improve as all those individuals die off and are replaced by smarter ones.

10 An attempt to sully Brenson's achievement by portraying him as moved by professional self-interest recently appeared in *Spy* magazine (J. J. Hunsecker, 'Naked city: *The Times*', *Spy* (April 1990): 48). This uncommonly ugly and snide article backfires, by revealing the author's own inherent racism. That the very choice to treat Brenson's decision to write about African-American artists as cause for ridiculing him itself demeans those artists doesn't seem to have occurred to Hunsecker. Whatever Brenson's actual motives were, they do not undermine the cultural and historical importance of his actions and their consequences. But as described in *Spy*, they at least provide a refreshing contrast to those sterling motives, so frequently professed by the politically correct, that nevertheless fail to spark any effective political action at all.

11 Howardena Pindell, 'Art world racism: a documentation', *New Art Examiner*, 16 (7) (March 1989): 32–6.

12 And brazenly arrogant bullet-biting in others, as some of the above items suggest.

13 And make no mistake about it: for the two-cylinder intellect, these are *mutually exclusive* alternatives. An identifying feature of such cognitive malfunctions is the absence of any sustained attention to the work itself. Thus Elizabeth Hess, ('Ways of seeing Adrian Piper', *The Village Voice* (26 May 1987): 100, alternates between journalistically compelling 'inside reports' (without ever having met me) on my hostile, aggressive, enigmatic motives in doing the work, and creative fictional accounts of virtually every characteristic of the work itself she mentions. Robert Morgan, 'Adrian Piper', *ARTS*

Magazine, 63 (10) (Summer 1989): 99, does not bother describing the content of the work at all. Instead he generously concentrates on offering free career advice as to how, by doing a different work that 'told us more about Adrian Piper and how she as a person had personally suffered from racial prejudice and abuse (if this is indeed the case),' I could have avoided hurting the feelings of '[a]nyone who has worked in ghettos and has read what black activist writers have written, and has tried to put into practice some positive methods for ending bigotry on a day-to-day basis.' To all of you out there who satisfy this description, I want to take this opportunity to apologize to you for hurting your feelings; for failing to devote my work to 'autobiographical ideas and constructs' that confirm how much I 'personally [have] suffered from racial prejudice and abuse'; and for failing more generally to just plain mind my own business. *Tant pis!*

14 Christopher Isherwood's lifelong involvement with the translation, exposition, and practice of Vedanta philosophy would provide a paradigmatic example of this, as would Robert Farris Thompson's involvement with African and African-American culture.

15 'All-black' shows are in this respect unlike, for example, all-Russian or all-Italian shows. Whereas all-Russian shows function unproblematically to showcase the singularity of artifacts for an interested and enthusiastic public, all-African-American shows often function controversially to demonstrate, to a resistant and defensive public, that original and singular artifacts produced by African-American artists actually exist. I am proud to have shown in the company chosen for the all-African-American shows in which I have participated. But clearly, the necessity of these shows has been more didactic than aesthetic, regardless of the valuable aesthetic qualities that inhere in the artifacts shown, or even the motives and interests of their curators. That the charge of 'ghettoization' is thus asymmetrically applied only to all-African-American shows signals the inability of the accuser to perceive and appreciate this work on its own terms. (To see this, one need only consider the likely reaction to a *mostly* African-American show, mounted in a major Euroethnic museum, including just a small sample of Euroethnic artists. The very concept boggles the mind.)

16 i.e. People with AIDS. This phrase was coined in the gay community a few years ago so as to avoid the dehumanizing and victimizing connotations of phrases such as 'HIV-positives' and 'AIDS victims.'

17 The classic text in game theory still seems to me to be the best. See R. Duncan Luce and Howard Raiffa, *Games and Decisions* (New York: John Wiley, 1957), esp. ch. 4.

18 I discuss this phenomenon at greater length in 'Power relations within existing art institutions' (unpublished essay, 1983; forthcoming in *The Collected Writings of Adrian Piper: Meta-art and Art Criticism, 1968–1990*). There I treat it as a matter of institutional suasion. But anyone with a talent for market analysis and a few months of careful study of major New York gallery exhibitions can figure out what kind of work to produce in order to elicit market demand, if that is one's motive for producing the work.

19 Colored proponents of poststructuralist discourse often seem not to grasp the self-negating implications of advocating the view that objective truth doesn't exist and that all discourses are suspect, nor the self-defeating implications of adopting what amounts to an unintelligible private language discourse in order to defend these views. But I believe that most Euroethnic poststructuralists grasp these implications quite clearly. That's why they welcome their colored cohorts into the academy so enthusiastically.

20 See n. 9, above.

21 Patricia Failing, 'Black artists today: a case of exclusion?' *ARTnews* (March 1989): 124–31; Michael Brenson, 'Black artists: a place in the sun,' *The New York Times* (12 March 1989): C1; Lowery Sims, 'The mirror, the other', *Artforum*, 28 (7) (March 1990): 111–15.

22 A recent example of this depredation is the treatment of graffiti art by the Euroethnic mainstream. Unlike other media of expression in hip-hop culture, such as rap music, which has received sustained attention and encouragement by the music establishment, graffiti art was off the streets, on the walls of major galleries, in the work of various young up-and-coming Euroethnic painters, and

out the art world door within two seasons. Now that its idioms have been furtively incorporated into the Euroethnic canon, it is once again safe to minimize its originality and significance as an independent movement.

23 Piper, 'Power relations within existing art institutions'; also see my 'A paradox of conscience', *New Art Examiner*, 16 (8) (April 1989): 27–31.

Val Walsh, 'Art Conferences: Passification or Politics?' (1991)

Article in *And: Journal of Art and Art Education*, 25 (1991), pp. 40–42.

Last September I spent five days in Glasgow at a conference organized by Women in Profile and Women 2000, both Glasgow-based women's groups concerned with women in the arts. The conference theme was 'Women Setting Agendas for Change in the Arts'. Three days later I spent two days at 'The Body in Representation Conference', organized jointly by the Association of Art Historians and Birkbeck College, and held at the Union Building, University of London. The two conferences were contrasting in organization and ethos. I will argue here that, taken together, they raise issues for and about women in the arts: in particular, our relation to malestream academic discourses and practices; the relationship between feminism and professionalism; and the relationship between feminists and the women's movement. The repercussions for male artists and art scholars will be implied, in a way which I hope is helpful.

In examining how we are positioned in relation to art practice, as women and as men, we face the complexities of our lived relations with each other. We confront difference and division between and amongst women and men. How we confront and work with these differences, with what degree of sensitivity and creativity, is a matter of practical and political concern (i.e. it makes a difference to outcomes). For feminists, the rigour of our efforts (our research, our theory, our political practice, our living) depends on a commitment grounded simultaneously in self-scrutiny and collective awareness. I am suggesting that intellectual rigour (conventionally associated with notions of the academic and the scientific, and with considerable implications for the concept and practice of theory within these domains) should be seen as intimately connected to relevance. Relevance is here presented not as something to be found in, for example, a separate social or political domain of human activity, or as emanating from the academic or professional domain in question. It is rather the vital apprehension/interaction/integration of what have hitherto been seen separately as actions and contexts: a human/humane connectedness.

Our language itself fails us as we try to speak of a field of activity and concern which is not composed of polarized, opposed, clearly demarcated territories, such as, for example, *art* and *society*. This methodology (with its binary mechanisms), *this way of constructing knowledge*, has been handed down to us with its own gender and sexuality (a specific masculinity) coded as neutral scholarship, the universal paradigm of excellence. When women occupy and participate in the public domain and in particular

in the cultural construction of knowledge (as in the visual arts and media, art history and criticism), what are the risks (personal, professional, political)? And what are the opportunities?

In Glasgow, conference sessions ranged from slide talks in a lecture theatre, slide shows and video viewings in informal settings (with or without organized seating), workshops, seminars, and exhibitions. The sessions and events were spread across a number of venues, including the University of Glasgow, one of its halls of residence, Glasgow School of Art, the Women in Profile Resource Centre, and various exhibition spaces. The programmed themes were commendably wide.[1] In addition, on the Sunday after-noon, after three and a half days of action, there was a plenary session held in the Council Chambers of Strathclyde Regional Council, at Strathclyde House. A welcom-ing address was given by councillor Neelam Bakshi on behalf of the Strathclyde Regional Council's Women's Advisory Committee, which was hosting this session. The plenary thus connected the conference events and themes, the women participating, the specific Glasgow context, and the wider world of women and malestream politics. It was an important act of affiliation on the part of the organizers, and of solidarity on the part of the Strathclyde Women's Advisory Committee: a reminder of the impor-tance of active bonds and networking between women working in different spheres. Councillor Bakshi herself made those arguments. I see this connecting across and in defiance of established boundaries as an important feature of feminist/womanist[2] action and theory: crucial to a creative politics.

Finally, on the Monday after the plenary, the International Association of Women Artists (IAWA) held a day's conference, at which representatives from Europe reported the development, activities and various strategies of their groups, and moved towards the establishment of a constitution and administrative body of IAWA, with the possi-bility of funding.[3] The Glasgow conference therefore had both a strong local (Scottish), and international dimension (participants from all over England, Wales and Ireland, as well as Canada and Europe).

In London, 'The Body in Representation Conference' consisted of twenty-seven academic papers delivered over two days, in one venue, in batches of three, four, or five at a time, grouped together under the banner of specific themes.[4] Dual slide projection accompanied the papers, but with little finesse. Slides were projected at an angle, fre-quently overlapping on the single screen available, and the lighting was difficult to adjust suitably to ensure good quality images. Within this format there was no time allowed for discussion. Questions were invited from the floor at the end of each group of papers. Many speakers failed to communicate their material effectively: some *read* their papers in a manner which made you wish you were reading them yourself in the privacy of your own room. Words were swallowed or mumbled into the podium; sentences were spoken too quickly, and without pause or expression. The lack of intonation at times impeded both meaning and interest, making it difficult to sustain attention. Reading written papers to an audience rendered passive by the conference format adds to the sense of avoidance of interaction and participation between platform speakers and audi-ence. I suspect this was a disappointment for many of those attending the conference. Live attendance should involve more than simply taking your seat and listening. And academic papers which are personally and physically presented at a conference involve

different communicative acts and skills from published papers. On this occasion some speakers gave the impression that the audience were marginal to their purposes. The written paper awaited its 'life' elsewhere: the conference presentation was merely a formality prior to publication.

At the Art Historians' conference there were thus strict demarcations between audience and speakers. We all knew our place. And as on previous occasions (the Dégas conference at the Liverpool Tate in 1989, for example) some women art historians showed themselves to be highly competitive and aggressive in style, in particular in dealing with speakers from the floor (including young women on both occasions), who went beyond asking easy-to-handle questions to offering statements or comments. It was implied from the Chair that the motives of these speakers were not as 'scholarly' as those of the organizers/platform speakers: at the very least, that their contributions were not relevant.

As David Morgan has observed in introducing the notion of *academic machismo*, 'The arenas of the practice of academic rationality – the seminars, the conferences, the exchanges in scholarly journals – are also arenas for the competitive display of masculine skills . . .'.[5]

Were we here faced with a female equivalent of *academic machismo*? And how should we name it? *Passing as a man* is too feeble a phrase to describe its features and its effects, in particular on other women, and especially women outside of or lower down the hierarchy of academia (non-academics, students, part-time or temporary tutors, and those not domestically attached to white male academics, for example). Morgan continues: 'The symbolic leaders or academic folk heroes are sharp, quick on the draw, masters of the deadly put-down . . .'.[6] If such practices are unacceptable from men, I am certainly not going to accept them from women. Our reflexes should be different, our voices authoritative without being authoritarian.

So what is all this powerplay about? Why so much need to control the rest of us? It was so obvious that no risks were to be taken with the academic decorum of the conference, and the Chairpersons too often took known speakers from the floor (including those who were already platform speakers) before waiting for other, lesser known, speakers to indicate their participation. As a tutor working mainly in the context of communication studies and women's studies, I was acutely aware of all these breaches of professional good practice.

Working with small or large groups, the function of the convener should be to facilitate open and easy communication and participation on as equal a basis as possible. This must include an awareness of structural features in a group (who has power vested in them via role, reputation, experience, etc.); an awareness of one's own power in that situation; and a commitment not to abuse that power by means of one's own communication style (for example, by talking too much, not listening, interrupting, or controlling the participation of others, verbally or non-verbally).

To see women unselfconsciously enacting a professional authoritarianism, and thereby oppressing other women, is deeply problematic: an example of powerplay mistaken for rigour and professionalism. What is feminist or professional about communication strategies which intimidate, control, or exclude? One young woman's contribution from the floor at the end of Saturday was openly disdained. She did not reappear on the Sunday. I wondered whether this incident had also affected the possible participation of others, in particular young women. In all we do as women, and in

particular as feminists/womanists (if these are to be anything more than professional labels), and as professionals in privileged positions, we must act in ways which open up spaces for other women. If we do not consciously try to do this, we are no different *in effect* from most professional men. Or maybe it is worse because we thereby fail both ourselves and each other.

I suspect that behind this failure to identify generally with other women, lies the fact that most women art historians have spent all or most of their professional lives (and perhaps most of their personal and domestic lives) with men, that is in working and social situations which are not just numerically male-dominated, but which supply a frame of reference saturated with the assumptions and values of white male hetero-sexuality. In these situations, 'You've got to pretend to be a man.'[7] But, 'women who imitate the masculine professional stereotype in male-dominated environments make their colleagues uneasy.'[8] So *imitation* may be extravagantly coded, in particular visually, via dress and interpersonal presentational styles which act to contain both the anxiety of male colleagues (and some female colleagues also), and the *professional femininity* of female scholars and academics. It is a cruel irony that, in the contexts of work in the visual arts and media, our reflexivity as women and as scholars should be consumed via such visual codes, thus rendering us continuous with the field of study, instead of taking forms which serve to disrupt the continuity of Western aesthetics.

White women academics, especially those working in the art world,[9] run the risk of being compromised by the dominant ethos of professionalism, unless we explicitly problematize it, make it visible, and actively work to dismantle it through our research and teaching. This process simultaneously makes visible and confronts this profession-alism as institutionalized masculinity, which necessarily positions women sexually in terms of its own heterosexual assumptions and expectations. To do this work our pro-fessional identity must be informed by our identity and experience as women outside the area in question (this being part of the heresy of feminism!)

Andrea Spurling, examining the situation of women in higher education, highlights the problem of women who have succeeded in masculine environments when she describes 'the professional personality popularly known as the Queen Bee.'[10]

> She is deemed to have determination and single-mindedness and, above all, she is hard . . . Her central philosophy is simple: the only way to succeed is through super-human effort and self-control. She, therefore, has no brief to help other women strug-gling to follow in her footsteps . . . She is just as likely as a male manager to discriminate against them.[11]

While we can understand the determining forces which create this stereotype, as women we also have to actively work against this model as the only possibility.

By contrast to the London conference, in Glasgow the conference experience was likely to be open, loose, and interactive, providing you could find your chosen session! Participants necessarily spent a lot of time moving around the city in search of what at times must have seemed an elusive conference. We had been invited or had signed up, and demarcations were minimal. A hierarchy of responsibility was studiously avoided, at least by one group of organizers, but what also slipped away in the fluidity was that intensity of involvement and focus so many of us sought, and which many of us ended up finding together over coffee or meals. Whereas the Art Historians appeared

unperturbed by thoughts of elitism, fearing only untidy insurrection from the floor, in Glasgow the fear of women oppressing other women because of differences of role, reputation, experience, etc. was palpable in some quarters, and had informed the structure of the conference. As a result, however, many women ended up feeling disempowered by a looseness of structure which dissipated our energies and diluted our mutual visibility. The connectedness and effectiveness we sought was frustrated.

I understand the nervousness about conventional, hierarchic structures, but in the 1990s we should have more confidence. We must not underestimate ourselves and each other. I cannot accept that to have specified speakers, panel members, and other participants automatically results in an oppressive format. In fact, to suggest that as women we have to fall into those traps is offensive. There are many women who have developed teaching styles or organization and management styles which do not mimic men's practices, and I know they were present at the Glasgow conference.

So what can we learn from these two events? Can the experience of these two conferences help us set agendas for change in the visual arts and media, in art education, in women's studies, and in gender studies? Or do they demonstrate the futility of a conference format, loose or rigid, for the tasks at hand? I suggest that the issues fall into three main categories (not mutually exclusive): communication, organization, and purpose.

First, as suggested above, communication effectiveness matters. Without it we fail to connect or combine. Communication is not an extra (although it appears to be an additional skill) on top of content, meaning, and purpose; nor is it simply a technical matter (better slide projections, fewer venues). The quality of our communication can be seen as a function of our purposes: why we are doing what we do, and with what degree of commitment to goals which extend further than the boundaries of any single academic discipline. In practice, therefore, communication realizes and makes manifest the connections between ethics, aesthetics, and politics. Public speaking as communication, rather than indicator of status in role, plus practice and encouragement of active listening and dialogue, would greatly enhance the value of conferences for everyone involved.[12] 'Conventions of teaching and learning which reward competitive and aggressive behaviour'[13] likewise have no place in the conference setting. We have a right to expect that in the 1990s such events will help in 'redefining the very criteria that govern existing stereotypes of "professionalism".[14] Nothing less will do.

In relation to organization, what is the responsibility of conference organizers? Both the Glasgow and the London conferences held out great promise in their themes and organization. In the event, their organization revealed a lack of confidence in the rest of us. Behind the looseness of Glasgow and the rigidity of London lay an uncertainty, a fear even. After attending the Art Historians' conference, those of us who had also attended the conference in Glasgow were perhaps in a better position to understand the reservations, even hostility, of the Glasgow organizers towards academic women who already have some visibility, and who, if given prominence at conference, might marginalize or intimidate less-established women. The pity is that the strategies adopted at both conferences left the divisions and differences intact, and wasted the opportunities for finding ways of working together. The creative political energies of those involved were thus not harnessed. Power relations remained as before, because we were too timid. Even our discontent, if articulated, could have acted as a base for future initiatives. And perhaps that is why I am writing now.

An open call for papers, such as was presumably the basis of the Art Historians' conference, may reveal serious omissions and exclusions: but only if the organizers are able to see those absences (for example, the experience and scholarship of black and Asian women, lesbians, gay men). It then requires a code of practice with regard to what is not there as a result of the initial call for papers. Otherwise we can end up with something which looks respectable, even promising on paper, but which experientially, intellectually and politically fails us in terms of developing an academic agenda adequate to our needs, and methodologies relevant to our purposes. This challenge to malestream professionalism in the visual arts is a necessary part of the process of re-vision[15] with regard to aesthetics and art history as epistemologies.

This sense of the politics of art and aesthetics was evident in the Glasgow programme, but was undermined on the day by very practical matters, such as who was doing what where, and the cost to women of having to travel by taxi to most sessions. Ironically, the London conference, at £12 and £6, was on the day more physically and economically accessible. And physical accessibility is also a major consideration when organizing for women: our time and energy are precious because they are much in demand by others. Every minute counts, and spending it in a taxi may not count as sufficiently rewarding an activity, despite the good company at all times. We come back to the question of relevance.

I found myself confronting this question after a day of 'The Body in Representation'. The following morning was to start with 'Men's bodies', I braced myself. The break came for me with Alex Potts' paper, 'The violence of the ideal male nude'. I cheered: at last someone taking risks and in this case positioning himself not just as a scholar, but as a man. I was grateful. My complaint of the conference thus far had been that, whilst undeniably much interesting material had been presented to us in the papers, mostly the mode was a documentary one. Material was too often not contextualized or theorized. The danger in this is that we simply add to the stockpile of art historical material, and maybe provide the basis for someone else to do the contextualizing or theorizing. I suggested that we should ask: How can we use this material? Where can it take us? In particular, the men[16] mostly failed to position themselves reflexively as men in relation to their material. This does require an extra effort, a personal/political/professional commitment:

> Men . . . have to work against the grain – their grain – in order to free their work from sexism, to take gender into account. The male researcher needs, as it were, a small voice at his shoulder reminding him at each point that he is a man.[17]

David Morgan is here suggesting that reflexivity, which is so important for living, [should be carried] over as a necessary prerequisite for rigour and quality (i.e. relevance) in academic and scholarly work. It is, it should be noted, a gendered reflexivity, not simply academic or professional. In relation to men, Morgan has suggested that:

> There may be something to be gained in men getting together to discuss these issues, not simply in order to combat some of the more overt modes of sexism but also as the beginning of ways of understanding.[18]

What is our responsibility as professionals and as scholars? Is it different and separate from our responsibility as people, as citizens of the world? I would argue that to deny the relevance of our human and sexual identities in the pursuit of art, aesthetics or art history is a denial of our professional responsibility. If we do not actively theorize these discourses and their practices, we become complicit with their terms of reference and their continuing agenda. For feminists/womanists, the concept of professionalism must be determined by our lived connections to the women's movement and our responsibility towards the lives of other women not just our own. We must ask: what work needs doing urgently? What are the criteria of relevance for research? Is our research likely to leave existing power relations intact? We are running out of time: academics and scholars must now make an effort to contribute to knowledges which will save lives.[19] In the context of a competitive and finite environment, when there's too much to do, too little time to do it, and diminishing resources to do it with, we are told to prioritize. Let's do it.

Notes

1 'Women and Space', 'Women and Publishing', 'Women and Philosophy', 'Women and Performance', 'Women and Music', 'Women Writers', including sessions focusing on the experience and work of lesbians, and of black and Asian women. 'Women and the Visual Arts' and 'Women and Visual Arts Education' were major themes, including 'Women's History in the Visual Arts: Contemporary Art Practice', for example, 'Women and Community-based Arts', 'Women in the Arts in Latin America', the work of East German and West German women artists, and the experience of women students and tutors in art education today. Media and broadcasting, and women's popular culture in Scotland, also featured, as did sessions concerned with the relevance of theory, for example 'Feminism, Art, Class, and Psychoanalysis'. Funding and publishing as major facilitating strategies also had meetings devoted to them, as well as being themes which understandably recurred in other sessions.

2 Alice Walker offers comprehensive definitions of 'womanist' at the start of *In Search of our Mothers' Gardens: Womanist Prose*. For example: (a) A black feminist or feminist of color . . . Wanting to know more and in greater depth than is considered 'good' for one . . . Being grown up . . . Responsible. (b) A woman who loves other women, sexually and/or non-sexually. Appreciates and prefers women's culture . . . Sometimes loves individual men, sexually and/or non-sexually. (c) Womanist is to feminist as purple to lavender' (London: The Women's Press, 1984), pp. xi–xii.

3 The funding and organization which made possible the participation of these women artists (from Austria, Switzerland, East/West Germany, Britain, Ireland) was the contribution of a third women's organization working for women in the arts, the Women Artists' Slide Library, based in London.

4 'Social Control' was the opening theme, followed by 'The Age of Reason', 'Surrealism', 'Medicine', 'Men's Bodies', 'Portrait and Gesture', 'The Modern', and finishing with 'Photography' on the Sunday afternoon.

5 David Morgan, 'Men, masculinity and the process of sociological enquiry', in *Doing Feminist Research*, ed. Helen Roberts (London: Routledge and Kegan Paul, 1981), p. 101.

6 Ibid.

7 Private communication, cited by Andrea Spurling, 'Women in Higher Education Research Project', King's College Research Centre, King's College, Cambridge, 1990, p. 13.

8 Ibid.

9 Val Walsh, 'Walking on the ice: women, art education and art', *Journal of Art and Design Education*, 9 (2) (1990): 147–61. Also 'Femininity, fine art and art education: sexuality and social control', *Women's History Review* (June 1992).

10 Spurling, 'Research Project', p. 38.

11 Breakwell (1985), cited in ibid.

12 Spurling notes the importance of listening skills. She quotes a woman Fellow: 'Until they can listen to our silences . . . they're going to misunderstand.' She observes: 'One problem is that the skills of active listening are much more difficult to recognise and teach than the skills of public speaking' (p. 58). Dinah Dossar discusses this problem in relation to art education in 'Gender issues in tertiary art education', *Journal of Art and Design Education*, 9(2)(1990): 163–9.

13 Spurling, 'Research Project', p. 96.

14 Ibid., p. 5.

15 'Re-vision – the act of looking back, of seeing with fresh eyes, of entering an old text from a new critical direction – is for women more than a chapter in cultural history; it is an act of survival'; Adrienne Rich, 'When we dead awaken: writing as re-vision', in *On Lies, Secrets, and Silence: Selected Prose 1966–1978* (London: Virago, 1979), p. 35.

16 Apart from Alex Potts, already mentioned, David Lomas, in his paper, 'Medical imagery in the art of Frida Kahlo', and Michael Hatt, in his paper 'Muscles, manners, morals: the meanings of the male body in Eakins' boxing pictures'.

17 Morgan, 'Men, masculinity', p. 95.

18 Ibid., pp. 108–9.

19 'It is, in the end, the saving of lives that we writers are about': Alice Walker (1976), 'Saving the life that is your own: the importance of models in the artist's life', in Alice Walker, *The Temple of my Familiar* (Thorndike, Me: Thorndike Press, 1990), p. 14.

Jody Berland, 'Bodies of Theory, Bodies of Pain: Some Silences' (1993)

From *Harbour*, 6 (1993), pp. 14–21. A later version appeared in *Theory Rules: Art as Theory, Theory and Art*, ed. Jody Berland, Will Straw and David Tomas (Toronto: YYZ Books, 1996), pp. 133–155.

Speaking of the Self

Arlyn Diamond (1985: 205) describes the intellectual dilemma that she encountered, with others, in trying to conceive interdisciplinary work on women: if, as Lucien Goldmann suggests, 'the progress of knowledge proceeds from the abstract to the concrete through a continual oscillation between the whole and its part,' then 'how does one grasp a *continual oscillation*, when one is part of the flux and cannot be sure which is a whole and which a part?' 'Again,' wrote Virginia Woolf in *A Room of One's Own*, 'if one is a woman one is often surprised by a sudden splitting of consciousness, say in walking down Whitehall, when from being the natural inheritor of that civilization, she becomes, on the contrary, outside of it, alien and critical.' This offers us, Gill Frith (1991: 74) writes, 'an understanding of feminine subjectivity as *slipping continually* between the apparently "transcendent" and the specifically "female".'

Most women who have had to work within institutional contexts know this sense of oscillation – this occasional, very private, sometimes empowering and sometimes extremely destabilizing movement between different senses of one's place there. Does our knowledge of these institutional spaces reveal any certain place for our own precarious subjectivities and too specific bodies? Does our knowledge of our own subjectivities and bodies offer any certain place for this legitimated, privileged, empowered and empowering self we at least momentarily inhabit? How can we inhabit both of these spaces at once? Doesn't our awareness of these slippages in spatial terms measure the kinds of distance between them, distance which indeed defines the awareness itself?

Arising as a response to this oscillation/slipping, this fluid movement between the aspiration to transcendent or abstract knowledge, and very different kinds of personal knowledge and feeling – one of the more visible contributions of feminist art, writing, criticism and theory – is the increasingly valorized practice of autobiography. The requirement that authors locate themselves in terms that make explicit their own invest-ments and conditions, and how these might bear on their subject matter and mode of inquiry, is now well ensconced in theory and to some limited extent in academic and critical practice. The emergence and legitimation of the first person singular for pres-entation or representation of self and idea, and more specifically, of autobiography as a valorizing narrative trope within critical writing, can be understood both as a positive influence of feminist politics within criticism and the academy, and as an expression of the crisis of authenticity within theory as a mode of intellectual production. Unlike visual production, the 'authenticity' of criticism is not (so much) threatened by copies or reproductions, and unlike popular music, is not (so much) 'corrupted' by sampling, pirating, imitation, and audio holography, but nonetheless theory, and thus criticism, has shown its own evidence of immanent crisis.

In philosophical terms this crisis of authenticity has to do with the disintegration of truth and value as assumed normative attributes of humanist discourse. It is obvious that this crisis has its origins in social contestation – challenges from women, from intel-lectuals or artists of different races and ethnicities, from gays and lesbians, even from Canadians reacting to the universalizing flourishes of American populist rhetoric – which are also articulated in/with theoretical discourses. But further examining the context of contemporary social relations shows that the rise of autobiography as privileged tactical response to this philosophical and narrative crisis can also be dis-cussed, just as appropriately, in terms of the foregrounding of signature, whose impor-tance is directly tied to the requirements of genealogy and market exchange (who wrote Shakespeare, is that artist or author white or black, straight or gay, who is, needs to be, must be cited, did Spivak or Heath first propose a 'strategic use of essentialism'?).[1] If we retain our knowledge of/outside the academy as well as our demonstrable expertise within its constituent theoretical and critical discourses, we can recognize the degree to which the contemporary academy can now accept and perhaps, in those areas where 'signature' has been the subject of theoretical analysis – art criticism, literary theory, philosophy, feminist theory, cultural journalism and 'Theory,' generally – may even privilege the autobiographical gesture as a procedure for coping with contemporary methodological scepticism. For the autobiographical gesture can function as an expres-sion of political or cultural pluralism and epistemological liberalism, as well as a vehicle

for oppositional critique, and its current practice can be seen as consequently ambiguous in both intellectual and social/economic terms. Understanding its dual functioning in contemporary cultural production is key to explaining its proliferation, contradictoriness, and generative effects.

No doubt there are now as many styles of autobiography as there are of ambiguity, though I would not attempt to catalogue them here. However it is framed, the autobiographical moment productively addresses both terrains: it can ascertain more clearly the limits and implications of the writer's own truth claims, and it can facilitate the entry of writing into a market with specific needs and conditions. In narrative terms, autobiography offers an accessible mediation between the story-teller/critic and that elusive 'whole,' that demonstrable truth about the world which postmodernism has dismissed as 'master narrative.' It marks at one and the same time the return of the story and the renovation of the subject: it was through the birth of fiction as a genre, after all, that the subject 'I' was first introduced and legitimated in narrative writing. Secretly, none of us prefers to live without narrative (probably three out of four feminists have a mystery by the bed) and at a time when theoretical imperatives are felt quite strongly, its pleasures are briefly restored (sometimes without otherwise alleviating or explicating theoretical opacity) by the autobiographical moment. The autobiographical strategy offers a way to place whatever experience we are willing and sanctioned to reveal in the context of larger historical and political systems – at least potentially, assuming that the storyteller is willing to take that crucial next step, which in some cases, like the proverbial other shoe, one may await forever. This placement of the personal within the frame of public debate is, at its most effective, a courageous gift that reveals and illuminates the important feminist adage that 'the personal is political.' At the same time, the autobiographical trope has come to offer a viable space for making recognizable/repeatable gestures of self-presentation which function as a post-expressionist, post-humanist, and (in some cases) post-visual mode of 'signature,' enabling critical and theoretical work, i.e. writing, to enter into and circulate within market processes that have defined the visual arts since the rise of modernism.

This discursive space contributes to – and relies upon – a thriving market in cultural theory dependent upon growing collaboration between the art world, the academy, and the publishing industry. The narrative practices produced by and within this conjuncture of intellectual, political, and economic determinants – among which I include not only theoretical canons, but also autobiographical gesture and 'signatures' of difference – reveal specific imperatives and absences that have shaped autobiography as an emergent institutionally mediated narrative tactic. I turn now to consider several enlarged details of the picture I have presented. In looking at women, writing, and the body, we see that the institutional and conceptual mediation of this burgeoning field of inquiry has produced its own eloquent silences.

Writing over the Body

Women work, as I have already pointed out, in the context of a broad interwoven apparatus of educational, curatorial, and critical institutions, and we tend to be situated in complicated ways between them, as teachers, graduate students, curators, researchers,

artists, editors, and critics, drawing on a multiplicity of experiences, resources, and sources of income. The rise of autobiography has occurred within these contexts and is marked by them: by the need for feminists to constantly challenge and debate universalizing discourses and practices; by the tendency for women to move (whether through greater professional fluidity or greater necessity, or more probably, both) among different contexts and discourses; by the need to create a viable intellectual and economic space for feminist work, often (but not always) at the edge of institutions and centres of power; by the conditions and constraints of contemporary theory; by the contradictory politics and aspirations produced in these spaces. In what follows I will discuss the significant silences that have arisen in this context.

The first has to do with a more balanced understanding of power and privilege arising from being in the academy, that is to say, in the complex of cultural institutions as I have broadly defined this term. Being located within this complex of institutions means being enfranchised to speak: to produce works, to theorize in and about works, and thereby (sometimes) to earn a living. This means being able to articulate or posit, in material terms, a unique subjectivity whose 'signature' claims, and may even be rewarded with, the privilege of display and/or circulation in commodity form. Aside from feminist humour, current writing all too rarely affirms (or challenges) this privilege. As Kari Delhi observes in a recent anthology of essays on feminist struggles in the university (1991: 50):

> There seems also to be another process at work here, even as academic feminists embrace autobiography and personal narratives. While it is important for all kinds of women to tell stories of relations with men and experiences in male-dominated institutions, it still seems difficult for us to talk about our locations inside several sets of social relations and practices where we are dominant rather than dominated.

As women we are subject to an endless parade of petty and other horrors – those we are personally subject to, those we observe, and can we clearly delineate the difference? – but we are also, mainly, middle-class, white, variously privileged in terms of cultural and symbolic capital, and variously able to exercise our privilege in relation to the professional world. We pursue careers in institutional communities whose structure, shape, and division of labour are so far little altered by our presence. And we are able to transform our experience into pleasurable text-making activities, publications, grants, exhibitions, personal myths and reputations, and even tenure, regardless of whether our critical output succeeds in affecting the lives of students or secretaries, or those whose lives we document or discuss in our work.

The second area has to do with the physical and psychic suffering that we experience and tolerate working in male-dominated institutions, especially academia, where women who wish to pursue artistic and critical careers are increasingly located (though why, in that case, is the proportion of women teaching in colleges and universities rising so very slowly?). As Kate McKenna (1991: 125) writes in the publication to which I have already referred:

> What seems to have changed with women's entry into academia is not the actual work or organization of that work but that more women – mainly white women, usually

from privileged backgrounds – have gained entry into the abstracted mode. For the most part, the mental/manual division of academic labour, the erasures of bodies, the denial of location and the institutional hierarchies of authority and subordination have still not been problematized.

The silences measured here concern the dark side of our work within those institutional contexts, of which we so rarely speak in our work: erasure, denial, dislocatedness, subordination, infantalization, and their effects: illness, anger, and despair.[2]

Now these appear, on the surface, to be contradictory assertions: first, that what remains (largely) silenced is our own privilege, creativity, powers of myth-making and practices of empowerment; second, that what remains (largely) silenced is our own subordination and suffering within the institutions. They are, of course, connected. It is valid, but too easy, to say that such vulgarly material issues tend to disappear in what McKenna calls the 'abstracted mode,' wherein discourses usually associated with women – everyday life, gender, community, the body – have now been introduced, but mainly as analytic abstractions subject to epistemological and theoretical debates wherein autobiography functions as illustrative gesture. In her discussion of feminism and interdisciplinarity, Arlyn Diamond describes a dualistic silence much like this one which she attributes to a disciplinary distinction: in her experience, humanists have felt apologetic about their lack of power, while social scientists have felt defensive about the abuse of power (1985: 200). For those of us working across the disciplinary divide, this is an interesting but not an adequate explanation. McKenna seeks a more intimate connection between these two silences: 'I am beginning to suspect that these silences and erasures of "the private," of "the personal," are practices that enable middle class women to deny our positionality – constructing it as obvious, neutral and universal' (McKenna, 1991: 126–7). Like McKenna, I envisage the articulation of these absent 'personal' truths not merely as confessional, revelatory or illustrative 'self-indexing' gestures but rather in some reflexive, critical, and pragmatic relation to the processes of institutionalization that empower and contain these selves, these truths, these silences. For it is not only positionality that is denied, but also alternative and more complex feminist definitions of our needs. This means, as Nancy Fraser (1989) argues in *Unruly Practices*, that women must seek to permit previously 'private' questions of legitimate needs to enter into our institutional and discursive spaces, while being prepared simultaneously to challenge the institutional and administrative interpretation of women's needs in patriarchal discourses. As Fraser argues, the articulation of needs may follow a therapeutic or resistant path (1989: 171–83), but such contestation cannot occur in silence.

These silences have consequences and costs. Among the consequences: that women, like men, are compelled (internally, externally) to ascribe to the hyper-theorization, competitiveness and hyperbolic production quotas of contemporary professional self-marketing and institutional survival/advancement, without acknowledging *either* the social arrangements that make this level of production possible (if only for some), *or* the costs that make achieving it painful and problematic. These costs are important because they contribute to continuing hidden inequities between women on the basis of different conditions – for instance, health, wealth, partnership, child support, age, and singularity of commitment. We cannot, in other words, separate the consequences

from the costs of these silences. Three categories help to identify these costs: the political, the physical, the pedagogical.

Much of the current theorizing about identity, representation, gender, and the body – aside from AIDS research – has occurred in an analytic sphere that pays little regard to public and institutional contexts and needs. This abstraction can be advantageous within the contemporary critical/academic apparatus, which privileges performative theory. And it no doubt seems safer to excel in institutionally sanctioned intellectual performance than to criticize the institutions or expose their lived consequences. But such abstraction has an obvious political cost. As Kari Delhi observes (1991: 49–50),

> Learning particular forms of argument – debating within new or established acade-
> mic discourses – is an important part of academic training . . . The pressures to write,
> research or teach within specific forms, for example, by showing 'mastery' of 'the lit-
> erature', are embedded in the ways university education is put together and practiced.
> Learning how to use difficult concepts, reciting the arguments of 'great' theorists, or
> publishing in scholarly journals is a hard and time-consuming business. It is this kind
> of work rather than political activism and personal history which counts as properly
> academic. The more feminists adjust their work to these parameters, the more we risk
> being split from transformative politics within and beyond the universities.

Second, and related to the first, there are *physical* costs, with which I have long been on intimate terms. But I am not alone: if female illness was once interpreted as metaphor for hidden passion, it is now emerging as an otherwise suppressed sign of hidden overwork and personal implosion. Chronic or acute illness, divorce and familial dis-integration, hyper-stress, drugs, physical collapse: many women have become variously disabled *vis-à-vis* their work and/or personal life as a consequence of the intense demands of their work. The frequency of women's illness amongst intellectuals and teachers is appalling and remains largely unacknowledged outside of conservative medical contexts and discourses (whose linking of women and disease we know all too well). Most women continue to try to meet all their obligations, their opportunities, afraid to refuse even one despite their accumulating costs. Given the recession, the rising cost of living, the reduction of public spending, the precariousness of grants, the remarkable speed-up of work in academic and cultural institutions, the continuing insti-tutional marginality of women, the continuing inequities of housework and child care, and the competitiveness of the communities in which we work, being professionally active means working schedules our mothers (not to mention fathers) would have never dreamed of. We find ourselves in the midst of a subtle undeclared war against the phys-ical and spiritual capabilities of our bodies, our relationships, our families and com-munities. The work patterns and social practices required by these institutions were not designed for women, even before such demands were exacerbated by contemporaneous speed-up, cutbacks and hyper-productivity. They were designed for men whose wives managed the materialities of their everyday lives. It is now a commonplace to observe how much harder women work, often without the structures of caring and comfort or the benefits of public approval taken for granted by male colleagues. What I see in many women and have experienced in my own life is a resistance to institutional exploitation and alienation that is expressed through the body because it is not able to be expressed elsewhere. Thus the growing frequency of collapsed immune systems, intolerable aller-gies, migraines, neurological diseases, particularly MS, alcoholism, drug abuse, ectopic

pregnancies, miscarriages, infertility, mental breakdowns, suicide, and above all cancer, as well as a plethora of unidentified ailments. Illness has come to function as a silent private narrative by women about the failures of public life whose only translations into public discourse take place in expert languages of medicine and (related) gender-biased victimhood. There are many poignant reasons for this silence. There are also consequences: the number of women who live on the border of physical or emotional collapse still outnumbers those who succumb to it, but by how much, and for how long? When our women colleagues and friends collapse, what changes? What is permitted, and what is spoken?

Despite the present hegemony of bodily thematics in feminist theory, the body continues to be 'written' as a subject of textual analysis focusing on gender identity and the theory and critique of representation, rather than as a site of knowledge whose articulation can variously empower/disempower women and would certainly seek to challenge present institutional arrangements. Contemporary discourse on the body, now a dominant currency in art work and critical theory, threatens (aside from work on AIDS and reproductive technologies) to become indistinguishable from a new type of formalist semiotics in postmodern guise: the body and its disposition(s) offers itself up as a sign system for complex and convincing but overly transcendent textual analysis. This texted body has a gender (or not) and a deliciously worked vocabulary, but it does not have an everyday life, it does not have to decide whether to get up and go to work, it does not speak about the suffering or danger of sitting for hours in front of the computer, or register the traumas of overwork and indifferent administrators, it is never injured by its own being-thought, it does not register the effects of its own labours. It is a body that produces meanings, in other words, but not commodities. Its silences are therefore akin to those I have discussed in current autobiographical narratives. This textual body eliminates not only the production of commodities, however, but also that of/in space: the space of the computer, the office, the rushing about, the aching body taking up thought where words should be, without finding its way to words. The space of this body is reduced to that of two measurable but problematic tropes, sexuality and observability, conflated through the critique of representation. These bodies remain in an abstracted space, a philosophical space, rendered as a space of surfaces, which is to say, no space at all.

This semiotic inflation provides us with a set of critical 'readings' or textual analyses 'informed by an ideological-critical perspective, and hence necessarily sensitive to social and political factors. But they are rarely readings which attempt to discuss representation as the complex product of processes and institutions,' as Janet Wolff writes (1990: 109). These readings speak of the body, but not about the (disembodying) conditions of producing such readings, never about the effects of contemporary modes of intellectual or artistic production on the body, especially – as I look about me – the woman's body. These bodies are subject to and index of a historic foregrounding of the body as carrier of meaning marked resolutely by irresolute fragility, that is to say, by an inadequately fuelled 'velleity of regrasping the world'. These unspoken 'processes and institutions' meanwhile retain their (internal/external) power by converting our experience into complicit textuality, working to ensure continuing productivity and the unacknowledged perpetuation of systemic and inequitable suffering and pain.

The third consequence of this silence is pedagogical. It concerns the models we are able to set for viewers, readers and students, which oscillate between the subjectivity of

victimhood and the shadow of intimidation – being a successful woman within the pro-
fessional cultural/theoretical terrain means having to write two books and eighteen arti-
cles a year, attend many conferences, sit on ten juries or committees, and often (though
this is not pursued in public), abandon family life, especially motherhood. So many
women now seem to be writing or making art as daughters, as though our mothers
are the last generation of women who can identify us. (This explosion of mother/
daughter films is closely linked to current debates in feminist psychoanalytic theory, but
in what context is this an adequate explanation?) Joining the new academy comes to
resemble a new type of voluntary commitment, as in a religious order – at Concordia,
a colleague warned incoming graduate students that they should be prepared to
sacrifice jobs, relationships, and family life during the duration of their studies.

There are now an unprecedented number of feminist graduate students working in
the domain of culture and theory. Is this the product of the post-1970s seduction of
theory as it disseminates itself across institutions, disciplines, and practices? Or rather
does it derive from the increasingly brutal fiscal crisis of the state, which greedily
rationalizes the spaces for intellectual and artistic work? There is much to be said
about the relationship between these developments. While students have marginally
more women faculty than I did with whom to work, I have never heard so much
ambivalence and anxiety about life in the 'academy.' It is not surprising: they observe
a seemingly merciless standard of intellectual productivity – the dark side of institu-
tional survival which relies on health, privilege, a growing inability or disinclination to
respond to the demands of teaching and/or local community (neither of which is
rewarded with publishing contracts or tenure), and a new level of structurally enforced
competitiveness that undermines everything that women can and must bring to critical
knowledge.
 These issues have tended to be set aside in feminist theoretical and critical discourse,
whose sophistication in debates around psychoanalytic theory, representation, textual
analysis, and subjectivity, has emerged with ambiguous success in the context I have
described. Such sophistication makes it possible to demonstrate one's familiarity with
the masters, and to position one's work in relation to theory in its most recent formu-
lation. But it is also possible, given the intellectual, symbolic and social resources that
feminists have struggled to create, to pursue strategies for feminist intervention
which would counteract the silences I have described. We can learn something from
homeopathy, which reinvents the 'reading' of the body's messages by searching for
meaning in terms of systemic interactions between social experience and personal
wellbeing. Rather than shunning the well-entrenched metaphorization of illness
or further pursuing the well-examined labelling of women as hysterics, we need to
confront, appropriate, and transform these 'metaphoric' discourses for our own needs.
Such work will re-situate the critical thematics and practices of feminist theory,
drawing on the resources of autobiography; the structural analysis of institutions
and markets active in the production of knowledge, ideas, and images; critical analysis
of patriarchal institutional discourses; the medical politics of AIDS activism; and
the suppressed knowledges and narratives of the body. With such work we can continue
to challenge and rebuild the contexts in which art, knowledge, and women's lives are
produced.

With this in mind, I append my statement to the Art and Theory Conference on International AIDS Day (December 1, 1991). Its purpose was to affirm what we have learned in the past decade from the work of gay and feminist activists, artists, and intellectuals engaged in the struggle with AIDS. This is in addition to their embattled engagement with medical professionals and medical knowledge, whose relationship with the concerns in this paper would require another one to explore.

1 The critique of representation – of images, signs, symbols, social narratives – is connected in profound and distinctive ways with the domains of politics, identity, power, solidarity, life, and death, with each of these separately, and together.
2 We know that rigorous and subtle work can be produced in the context of collective work, a collective spirit, and a collective (if often contentious) agenda.
3 We are continuously reminded of the urgency and intensity of challenges facing artists and critics today: to know the fragility of the human body, the neediness of the social body, the state of the body politic (yesterday diagnosed with rigor mortis) and the health of the earth itself, outside and beyond any of our bodies. We turn our backs on these at our peril.

Notes

1 Spivak raises this question – and returns to it – in the interview 'Practical politics of the open end' (1990). Her interviewer, Sarah Harasym, introduces a discussion of 'the critique of the ideological subject constitution within state formation and systems of the "political economy"' by referring to the dual concept of representation employed by Spivak. Spivak raises the question of essentialism in connection with the process of representing. What is so interesting about this discussion, and the challenge Spivak herself mentions – 'Well, you know people talked about you and it was stressed that Stephen Heath had actually said this before you . . .' – is that she returns to authorship/genealogy several times but does not ever address or explicate it as such. It seems odd to see this anxiety present but unexamined in the context of discussing 'the ideological subject constitution within state formation and systems of the "political economy"'! But it's one of many instances.
2 Perhaps this is why the increasingly popular genre of mystery fiction by women now proliferates with murderous horrors on university campuses, mainly enacted upon and detected by valorous women otherwise committed to more traditional scholarly pursuits.

References

Baudrillard, Jean (1981) 'Gesture and signature: the semiurgy of contemporary art', in For a Critique of the Political Economy of the Sign, trans. Charles Levin (St Louis, MO: Telos Press).
Delhi, Kari (1991) 'Leaving the comfort of home: working through feminisms', in Unsettling Relations: The University as a Site of Feminist Struggles, ed. Himani Bannerji, Linda Carty, Kari Delhi, Susan Heald and Kate McKenna (Toronto: The Women's Press).
Diamond, Arlyn (1985) 'Interdisciplinary studies and a feminist community', in For Alma Mater: Theory and Practice in Feminist Scholarship, ed. Paula Treichler, Cheris Kramarae and Beth Stafford (Urbana, IL: University of Illinois Press).
Fraser, Nancy (1989) Unruly Practices: Power, Discourse and Gender in Contemporary Social Theory (Minneapolis, MN: University of Minnesota Press).

Frith, Gill (1991) 'Transforming features: double vision and the female reader', *New Formations*, 15 (Winter 1991): 67–81.

McKenna, Kate (1991) 'Subjects of discourse: learning the language that counts', in *Unsettling Relations: The University as a Site of Feminist Struggles*, ed. Himani Bannerji, Linda Carty, Kari Delhi, Susan Heald and Kate McKenna (Toronto: The Women's Press).

Wolff, Janet (1990) *Feminine Sentences: Essays on Women and Culture* (Cambridge: Polity Press).

2.2 Building Feminist Structures

Betsy Damon, 'Untitled Statement' (1972)

From *Shrine for Everywomen* (Artist's Book: Betsy Damon, n.d. [c. 1985]), statement dated 1972.

In 1972 I was standing in a circle of woman and I gave my hand to the woman next to me and said

'I am a woman I give you my hand'

Each woman repeated those words until we were all connected and then I said

'We are woman our hands form a circle'

and each woman repeated those words and next we said

'We are woman the circle is powerful'

WEB (West–East Coast Bag), 'Consciousness-raising Rules' (1972)

From WEB: *West–East Coast Bag* (June 1972), p. 1.

1 Select a topic.
2 Go around the room, each woman speaking in turn. Don't interrupt, let each woman speak up to 15 minutes and then ask questions only for clarification.
3 Don't give advice, don't chastise, don't be critical.

4 Draw generalizations after everyone has spoken or, before that, go around the room and talk again.
5 Draw political conclusions – if you can.
6 Keep the group below 10 women.
7 In order to develop trust and confidence, don't repeat what has been said in the meeting or talk about members outside of the group.
8 This is not a therapy, encounter, or sensitivity group situation.

Topics

How do you feel about other women? Why did you become an artist? How do you feel about yourself as a woman artist? How do you feel about being a mother? How do you feel about your own mother? father? about passivity? about your body? about growing older? about dividing the housework, if you live with a man? How do you feel about friendship? therapy? your difficulties in working? What, if anything, do you need from a man? What can we do about men in power? Do you think of yourself as a woman artist or an artist who happens to be a woman? Do you think the woman artist has any degree of responsibility to commit her art to fight against women's oppression? If so, in what way? If not, why not? Does the feminist artist have something to offer that no other artist has? To what degree and what manner can a successful woman artist use her success as a weapon or resource to improve the status of the woman artist in society? How have you been encouraged to be an artist/creative? discouraged? by whom? Do you feel you have a responsibility to your audience? Are you a male-oriented woman or a female-oriented woman? What does this mean? What did you used to be? What kinds of life styles are available to women? How was your education affected by your sex? What kind of work do you do? How do you feel about it? Define female identity and speculate as to how it evolved, socially and personally. Are you competitive with other women? With men? Why are women's masturbation fantasies often masochistic? Do you feel that masochism or 'being the victim' has been a large part of your life? Why is this? How does male supremacy poison communication between men and men? Women and men? Women and women? Children and adults? What are the problems between married women and single women which make close relationships difficult? Between younger women and older women? Between working women and housewives? Between women of different social classes? Between women of different races? Is there a connection between violence and heterosexual sex? Do you feel that this is true from your own life experience? How much is fear, intimidation, or terrorism used to keep women in their place? How much is 'a sense of incompetency' used to keep women in their place? What are you doing to reduce this in your own life? Why do men rely so heavily on vision for erotic stimulation and how does this enslave women? What is the difference between male and female ego? Why is it so easy to 'put a man down'? Why are we so afraid of doing it? Feminist historians are revealing evidence of early civilizations which were matriarchal and/or woman dominated (The First Sex – Davis). Speculate as to how the shift from a feminist to a masculist society took place and why.

Women's Workshop, 'A Brief History of the Women's Workshop of the Artist's Union, 1972–1973' (c. 1973)

Hand-out produced by the Women's Workshop of the Artist's Union, London, n.d., c.1973.

A group of women artists first met in London, in January 1972, at a studio in Southwark where two of the founding members worked, to discuss the possibility of joining the newly formed Artist's Union. We wanted to do this as an organized group, rather than individuals, in order to ensure that women's demands became an effective part of the Union's aims and programme of action.

The main activity of the Artist's Union is located within the workshops which are set up, by majority vote at regional meetings, to deal with the special areas affecting artists; for example, education, art patronage and exhibitions. Our women's group succeeded in establishing a special workshop on women and have been working actively in the Union on that basis ever since.

The Artist's Union formed with the aim of seeking affiliation to the Trades-Union Congress, and with this in mind, the members ratified a constitution and elected officers in May 1972. The Women's Workshop made nominations for all positions and as a result Mary Kelly was elected as Chairman, and Margaret Harrison and Carol Kenna to the Secretariat. We also demanded that the Union seek to establish parity on the Regional Council, which consists of all Union officers and workshop convenors, and in the entire Union membership as well.

With women actively engaged in running the Union, women's issues were brought to the foreground: 'To take action to end sexual and racial discrimination in the arts' was established by a majority vote as one of the Union's major aims, membership cards were altered to include 'Do you need crèche facilities at Branch meetings?', and resolutions were passed in support of the women workers occupation at Fakenham and the night cleaners campaign.

One of the aims of the Women's Workshop is to set up links with women's sections in other unions. In a regional report we stated: 'The Women's Workshop maintains that women in whatever sector they are employed are largely unorganized and consequently receive the lowest pay and work in the worst conditions; it is our intention to support our sisters in their struggle for unionization and also in the action they take as organized workers.'

As women artists working within a male-dominated culture we face the following contradiction: the notable absence of women in history as practising artists and their overwhelming presence as subject matter, portrayed in a way which often idealizes but nevertheless confirms their second-class social status. In order to make a start at changing our situation we proposed these actions:

- To pressure local councils to provide studio space for women with children.
- To ensure that public galleries and national museums include women artists in both retrospectives and contemporary surveys.

- To demand that art colleges hire female staff in proportion to the number of female students (could be enforced through the anti-discrimination bill).
- To examine the entrance requirements for art schools (especially proposed A-levels) in relation to discrimination against women.

Heresies Collective, 'Minutes: Heresies Collective' (1976)

From minutes of Heresies Collective meeting, 7 October 1976.

The following are *excerpts* from the discussion on collective process and self-criticism. They include topics for future discussion, decisions the Collective must make as to procedure, perspectives on our collective process:

- We must discuss our division of labor . . . is it according to skills, responsibility, willingness to work, time to work, etc?
- There is a difference between fine arts and design, and an uneasiness among the visual artists about expressing their desires to be involved in the visual concerns of the publication.
- I would like to see the greatest possible variety in terms of design and format, as well as working combinations . . . individual work, collective work, committee work, etc.
- The larger problem is one of assuming responsibility. Plus, we don't say what we feel when we feel it, as a Collective, we need to do this.
- Important question: *what does it mean 'to function collectively?'*
- Hierarchies of skills must be acknowledged at different times – different skills, different committees, different work loads are needed.
- We suffer from placing more value on some tasks than others, i.e. it is more important to design something than to run an errand. Editing and production are *not* exciting; they are simply hard work for those who do that every day.
- We might be making an incorrect association between those who have assumed responsibility and those the Collective has termed as 'professionals'. We also seriously lack any validation or visible appreciation of others' hard work.
- Most of the Collective seems to have had an ego involvement with the issues of 'professionalism', 'power', and 'expertise'.
- We cannot resolve the issue of project responsibility by delegating projects to one or two individuals to complete autonomously. The Collective deserves, and indeed must have, approval responsibility.
- *We need to clarify what we as a Collective endorse as processes.* How are we going to go about our business of putting out a publication *and* working as a Collective?
- I would like to see Heresies, the Collective, compartmentalize functions and develop links of communication between compartments.

- In terms of the meeting two weeks ago and the criticizing of members when they were not here; it was the *process* that we regret, not the actual decisions that were made in terms of the flyer.
- The Collective tends to be swayed by a certain kind of personality because of experience and skills. We all have to be responsible for asking ourselves whether we are being persuaded by the expertise of the proposer or the idea proposed.
- Before we move on in the discussion to structure, let's decide exactly what we are going to do with *this* discussion. Are we going to table it? till when? drop it? *Let's establish a process from which we move from one item on the agenda, one discussion, to another.*

Vote: to move on to a discussion of structure, without any clear decision as to when we will pick up the discussion on collective process and self-criticism again. Perhaps the retreat???

- We have to learn, as a collective, to talk about our individual behavior . . . in order to work together and relate as a collective.

Terry Wolverton, 'Lesbian Art Project' (1979)

From *Heresies*, 2 (3) (1979), pp. 14–18.

In February of 1977 I attended a one-day workshop presented by Arlene Raven at the Woman's Building in Los Angeles.[1] This workshop, called 'Lesbian Art Worksharing,' was attended by about 20 women who were identified with, or at least intrigued by, the notion of 'lesbian art.'[2] Arlene asked each of us to discuss our connections to art and lesbianism. I remember saying that lesbian art is characterized by the breaking of taboos about women's bodies and spirits, 'speaking the unspeakable.'

As we then shared our own work – paintings, fabric sculpture, drawings, graphics, ceramics, poetry and 'coming out' letters – we saw the diversity of form, as well as some remarkable similarities in issues addressed, and in our process of artmaking. We began to name these similarities 'lesbian' and to explore their connectedness.

In April, during a second worksharing at the home Arlene shared with art historian Ruth Iskin, Arlene announced a research project she would begin on the history and meaning of lesbian. The effect on me was profound – for the past five years I had been involved in a number of feminist and lesbian groups, some artistic, some political, some educational, but I had always felt apart from them. I knew immediately that I wanted to work on this project.

A number of women were interested and we decided to create a project group and met to discuss the kinds of agreements needed. We decided that the group would be non-hierarchical, based on peership and collectivity, and would utilize consciousness raising, mutual support and mutual responsible criticism. Our relations were complicated by the fact that Arlene had been a faculty member at the Feminist Studio

Workshop while the rest of us had been students there. Few of us had achieved the professional credentials or status Arlene had. Moreover, Arlene wanted to require all participants in our group to be involved in FSW. Her own work on lesbian art had grown from her work there and she wanted to bring a powerful lesbian presence to the school. We discussed these difficulties. Each woman asserted her desire for equality in our working relationships.

We decided that the project group should meet regularly, once a week, and that this time would be a priority commitment for everyone. Arlene requested that we all commit ourselves to working in the project for one full year. This was especially hard for me; the idea that I would be restrained from being able to take off at any moment (a hippie leftover from the 60s) was terrifying. I had previously been unwilling to make such a commitment to friends, lovers or institutions.

By May of 1977, six women were committed to work on the project: Kathleen Burg, an artist and gallery director at the Woman's Building; Nancy Fried, an artist and dough sculptor; Sharon Immergluck, a writer and feminist therapist; Maya Sterling, a writer and witch; Arlene, and me. Nancy and Maya were lovers. Kathleen, Sharon, and Maya were longtime friends and CR-group members from FSW. Nancy was helping me print my book, *Blue Moon*. Arlene had once been involved with my lover, Cheryl.

We named our work the Lesbian Art Project and our group the Natalie Barney Collective.[3] Among our goals: educating the public; conducting research and creating theory; making art; establishing support groups of lesbian artists; connecting with other lesbian creators, nationally and internationally; attaining national media coverage. We wanted to sponsor community events, conduct lesbian CR groups, develop a slide library and archives and be elegant and outrageous lesbian creators. We agreed to meet at one another's houses rather than at the Woman's Building, to create a more comfortable and intimate environment.

Almost immediately, a number of events occurred that provoked sudden and deep transformations among all members of the group. Arlene and Ruth decided to end their lovers' relationship at the same time that Cheryl and I decided to end ours. Arlene and Cheryl resumed their relationship. It was a time of intense personal pain for all of us, and although we recognized it as transformative and ultimately positive, it was impossible to avoid feelings of hurt, anger and mistrust. It is a common situation in a lesbian community, but one which I have never been able or willing to deal with. My first impulse was to move out of town. It was our commitment to the Lesbian Art Project that allowed Arlene and me to view our pain in a context of our vision, which motivated us to work out our difficulties.

These personal changes coincided with the national uproar over gay rights and the anti-homosexual campaign headed by Anita Bryant. With the repeal of the gay rights ordinance in Dade County, Florida, gay and lesbian groups all over the country began mobilizing for protest, action, legislation. The connections between homophobia and misogyny were revealed to us in the utter mystification and/or complete erasure of lesbians in the 'gay right' issue.

As a result of this national crisis, we decided to become more 'public' with our lesbianism – individually, with our art work, and as the Natalie Barney Collective. Women in the group implemented this immediately by 'coming out' to parents, to co-workers, to strangers on the street. Those of us already 'out' as lesbians confronted our families,

friends and associates, demanding their active support for gay rights. The response was often disappointing, or, in the case of Maya, one of outright family rejection. We had not previously realized how affirmed we were in the feminist community at the Woman's Building.

Throughout this period of personal and national turmoil (June–July of 1977), we were engaged first in creating and then in administering the Lesbian Art Project – advertising, seeking funding, developing a mailing list. A lot of work – and no salaries. We all had other full-time jobs for our survival.

Fall 1977, we began the project as a program within the Feminist Studio Workshop. FSW provided us with an established structure, space for our activities and students, and the status of a nonprofit organization. We also offered events available to non-FSW women, since many lesbians could not afford or did not choose to enroll in FSW.

The Natalie Barney Collective became a powerful presence in FSW. We were a strongly identified group; we had a deep and common purpose; we were producing a lot of art, theory, information, energy. I think we provided a model for other women. As a staff member, Arlene incorporated her lesbian sensibility into all of the classes she taught: identifying the lesbian content in students' work, articulating the lesbian perspective when a feminist issue was discussed.

The project sponsored a lesbian/feminist dialogue for students and faculty, attended by about 40 women. This was the first time in the five years of the FSW that lesbian-ism as a consciousness (rather than a sexual preference) had been discussed among the community. I began sponsoring monthly worksharing sessions. These were free and open to women in the community, as well as FSW. Many attended, bringing writing, music, visual art of all descriptions. At first, the sessions were exciting and nourishing, but I did not know how to channel the energy generated.

At the same time, Arlene sponsored a Lesbian Creators Salon at the Woman's Build-ing, where she presented her research on lesbian art and artists. She invited Alice Bloch, a lesbian writer and educator, and Joanne Parrent, at that time an editor for *Chrysalis: a Magazine of Women's Culture*, to discuss their work. Arlene discussed the place of lesbian artists in their communities, their relations and their portrayal of each other in their work. Alice talked about lesbian writers in Paris in the early 1900s (particularly Gertrude Stein), and Joanne talked about witchcraft, lesbians as witches, the impor-tance of being 'out' as a witch, women's spirituality and the growing awareness among lesbians of the spirit of the Goddess.

In the fall of 1977, another series of personal transformations occurred: Bia Lowe and I became friends, and soon, lovers. Nancy and Maya were ending their lovers' rela-tionship; it was hard for them to relate within the collective. In November, Sharon and Nancy had a serious argument while working together on a Lesbian Art Project event; this produced a deep rift in their friendship. As winter neared, almost everyone was feeling bad about herself – depressed, physically ill and overworked.[4]

In the Natalie Barney Collective, we held a criticism/self-criticism session and re-alized that we were unable to share our deepest feelings. Maya left in the middle of the meeting, announcing her intention to quit the group. All of us felt wounded. We did not understand what had happened. We were angry, doubtful, afraid, but lacked ability to understand what had happened. The fragility of our commitments and our trust, the tenuous nature of women's bonding in patriarchy, were all too clear.

Only four of us attended our first meeting in January: Sharon, Kathleen, Arlene and I. Nancy decided to participate only as an artist, not an organizer; Maya was unwilling to participate at all. It was clear that the Natalie Barney Collective as an administrative group had dissolved.

Finally, Arlene and I formed a partnership to co-direct the Lesbian Art Project. It was important for us to build on the experiences of the Natalie Barney Collective, to analyze the issues that had emerged, and invent some strategies for dealing with them.

• The issue of homophobia, self-hatred and alienation shows how much pain we have as lesbians and how embarrassed we are by it, how we deny it, how we are isolated in it. We have seen how hard it is to commit to lesbian consciousness, because the 'reward' is so often a confrontation of deep pain of lesbian oppression within the self.[5] We know that this issue will rear its head again and again. Taking control of the situation involves *naming* it. To combat lesbian oppression we must be willing to take more risks, become more vulnerable to one another.

• How do we create peership? Arlene is ten years older than I, has been married, has a PhD, has taught, lectured, published, co-founded FSW and the Woman's Building, is well known and well respected in her profession. I am younger, less experienced, absent (by choice and by design) from the professional sphere; my achievements and activities have all occurred within lesbian culture, and I have ultimately refused (*and* have been denied the opportunity) to direct my creative energies to the patriarchy. Arlene is clearly a mentor to me: she offers me her knowledge of art, education, politics, psychology. She shares her organizational and leadership skills with me. Most importantly, in naming lesbian art and lesbian sensibility, she has illuminated my own vision, brought me to an awareness of its possibilities. In a patriarchal context, a mentoring relationship stops here: the older, more experienced woman gives to the younger, untrained one. In this model, there is no room for peership or mutual growth.

In taking an active step towards peership with me, Arlene not only had to transform her vision of herself, to be 'student' as well as 'teacher,' but also face ridicule and devaluation from her professional colleagues. In return, I needed to assume equal responsibility, commitment and participation, to give up acting like the 'student' or a lesser participant.

• Although we did not want to retreat from our desire to publicly manifest lesbian sensibility, we were also aware of the unsatisfying nature of 'serving the Public.' We knew that in the Natalie Barney Collective women had been expected to do administrative work that was personally unfulfilling, and got burned out doing organizational/maintenance/'shitwork.'

Arlene and I decided to implement 'making administration fun'; that is, we created the work of the project so that it was satisfying. In realizing a lesbian separatist vision, we decided against writing grants; we could not stake our survival upon patriarchal funding institutions. Instead, we planned a membership campaign and solicited donations from other lesbians.

Through this process we began to uncover many aspects of our vision of a lesbian sensibility. One way of manifesting this was the decision to use Arlene's house as a gathering center for lesbian artists, emulating the salons of La Belle Epoque. Cheryl and

Arlene had transformed their space with plush fabrics, lush colors, and beautiful objects. There was an air of Victorian elegance. Lesbian art adorned the walls, and the images evoked the presence of the spirit of the Goddess – the rooms took on lives of their own. One entered here into a new environment, sensuous, pleasurable – a lesbian space.

In this atmosphere, we discovered the identities that characterize our lesbian relationship: The Mentor/Peer, the Mother/Daughter, the Lovers, and the Triple Goddess: Nymph/Maiden/Crone. In each case, we were first confronted by the patriarchal deformation and debasement of these identities, the distortion or disguising of their true and mythic meanings.[6] We experienced our own deep rage and despair at the loss; we saw how we (women) had been turned against one another. By supporting each other, we were able to see possible transformation of these roles, which suggested a new vision of their meaning for lesbians.

The Mentor/Peer. In patriarchy, the hierarchical structure of Teacher/Student and the fixity of those roles dictate a separation and a polarization between women who are teaching and learning from one another. The 'Mentor' is all-powerful; the 'student' must overcome or rebel against her teacher in order to become powerful. In our relationship, Arlene and I actively develop consciousness of what we are learning from each other and make an effort to acknowledge these things both publicly and to each other.

The Mother/Daughter. When Arlene first suggested that there was an element of the mother and daughter in our relationship, I was fearful. This seemed like a dark connection, taboo. Under patriarchy, the Mother and the Daughter are forced to separate, betray each other, compete for survival.[7] In studying the patriarchal myth of Demeter/Persephone[8] we read of how the daughter is taken from the mother, how the daughter is raped, how the mother is forced to comply with the will of the gods, how the daughter must pretend to like it. It is no wonder we experience alienation, rage, resentment and betrayal in this most primary connection.

The Lovers. When Arlene and I acknowledged sexual energy between us, we both responded with immediate and instinctive fear. We discussed the sources of the fear: that our working relationship would be threatened, that it would be too emotionally intense, that our lovers would be alienated, that the pain we share would devour us.

Yet we acknowledged that we have a lovers' relationship: inspired by mutual love and respect, by connection, by the sparking of creative energy. After agreeing not to engage in a sexual relationship, we both felt safer to explore this area.

The Triple Goddess: Nymph/Maiden/Crone. Working in the Lesbian Art Project had deepened our belief and understanding of the power of the Goddess (by which I mean the power of women's/lesbian energy).[9] We had learned that magic is common to women: in our ability to create life in our bodies and our imaginations (the power of the Nymph); in our ability to maintain and preserve life, our ability to heal (the power of the Maiden); and in our ability to change and transform our lives, to enact alchemy (the power of the Crone).

A major manifestation of the Lesbian Art Project was the development of the Sapphic Model of Education. This is a conceptual model which draws inspiration from the community and school of Sappho on the island of Myteline (Lesbos) in Greece, nearly 2,400 years ago. Women who went to live and study there created some of the finest art, verse and music of their times. Their education included living within a community of women, having love affairs, worshipping the Goddess, developing creativity and self-awareness, and celebrating the seasons.

My vision is of a lesbian/learning community, dedicated to the holistic development of each woman in the community, expansion of the interconnections between each woman, and the survival of the group. I posit six roles which derive from Arlene's and my exploration of our relationship and now seem necessary to fulfill this vision. The functions of the roles are interchangeable, and they are:

The Visionary. She who looks to the future, anticipates what cannot be known, imagines what does not yet exist – the Dreamer, the Prophetess.

The Organizer. She who creates and maintains structure, is responsible for continuance, and actualizes plans in the material world.

The Artist. Translator of metaphor, shaper of communication; she who creates cultural language and mythology, conducts ritual, transfers energy from spiritual to material to spiritual form.

The Lover. She who generates pleasure, beauty, joy, celebration and dancing; includes, but also goes beyond, the concept of a sexual lover; the energy of bonding between women.

The Mother. The Life Giver, the nurturer, the caretaker, the healer, the comforter; the blood ties between women.

The Mentor. The Teacher, she who provides a lesson or example, and she who is also committed to learning from those around her.

Another component of the Sapphic Model is a seasonal structure.[10] Fall is the time for gathering, community-building and self-discovery. Winter brings the energy of focusing, delving into research or concentrating on a work project. Spring is the season for bursting forth, with events and celebrations to share publicly. Summer is migration time, devoted to traveling and exploration, making connections with other communities.

At this time, the model is theoretical; I have neither a clear intention nor a clear strategy for putting it into practice. Still, it articulates a vision of a lesbian community. Arlene and I planned an educational program, based on the Sapphic model, which we began teaching in October, 1978. The topics were:

Lesbian Creators' Herstory
Feminist/Lesbian Dialogue
Lesbian Art Worksharing
Sapphic Education
Lesbian Relationships
Lesbian Writing
I Dream in Female: Lesbianism as Nonordinary Reality[11]
The Lesbian Body

Our current plans for the third and final year of the Lesbian Art Project (1979–1980) revolve around the creation and publication of a large volume presenting the story of the project; the theories of lesbian sensibility we have discovered; the artwork, writing and theater that have emerged from the project; our work processes; and our visions of the future.

The work of the Lesbian Art Project is valuable to women interested in creating a vision and then implementing it; to women who wish to seek an alternative to patriarchal reality; to women who have a commitment to work, to art, to lesbianism; to women interested in exploring their unique identity as lesbians; to women interested in establishing community; to women who research; to all women who are committed to undertaking a journey in consciousness.

Notes

1 The Woman's Building is 'a public center for women's culture,' founded in Los Angeles in 1973. It houses community galleries; Women's Video Center, Women's Graphic Center, Women against Violence against Women, the Lesbian Art Project, Ariadne: A Social Art Network, and a host of other women's cultural projects. The educational component includes the Feminist Studio Workshop, the Extension Program and the Summer Art Program.

2 For more information about the feminist art movement in southern California, see Faith Wilding, *By our own Hands* (Santa Monica: Double X, 1977).

3 For more information about this outrageous lesbian writer, see George Wickes, *The Amazon of Letters: The Life and Loves of Natalie Barney* (New York: G. P. Putnam, 1976).

4 In the process of feminist education at the FSW, it has been observed that this time of year is especially hard on women. It is expected that women will have difficulties with issues of work and community at this time.

5 Mary Daly eloquently discusses the pain involved in committing to the journey into consciousness in *Gyn/ecology: The Meta-ethics of Radical Feminism* (Boston, MA: Beacon Press, 1978).

6 I use the word 'mythic' here and throughout the article to mean larger than life, supranatural, or having a significance beyond its tangible or apparent existence.

7 The issue of betrayal between mothers and daughters is insightfully articulated by Barbara Love, Elizabeth Shanklin and Jesse Slote in 'Matriarchy: the end of woman-hating', *The Matriarchist*, 1 (4).

8 See Charlene Spretnak, *Lost Goddesses of Early Greece: A Collection of Pre-Hellenic Mythology* (Moon Books, 1978); also Nor Hall, *Mothers and Daughters* (Rusoff Books, 1976).

9 The Los Angeles women's community has been involved with spirituality and Goddess consciousness since 1970, when Z. Budapest founded the Susan B. Anthony Coven #1. See Zsuzsanna Budapest, *The Feminist Book of Lights and Shadows* (Luna Publications, 1976).

10 The concept of seasonal education was first developed by Jere Van Syoc and Linda Smith, lesbian artists, philosophers and educators who work with ARADIA, a women's learning community in Grand Rapids, Michigan.

11 This course includes information about lesbian consciousness and magic. Slides are shown of art made by women relating to ritual, transformation, alchemy. Then women share their experiences of nonordinary reality: dreams, visions, telepathy, past lives, astral projection, imagination.

Martha Rosler, 'Well, *is* the Personal Political?' (1980)

Statement for the Conference 'Questions on Women's Art', ICA, London, 15–16 November 1980.

Yes, if it is understood to be so, and if one brings the consciousness of a larger, collective struggle to bear on questions of personal life, in the sense of regarding the two spheres as both dialectically opposed and unitary.

No, if attention is narrowed down to the privatized tinkering with one's solely private life, divorced from any collective effort or public act, and simply goes on to name this personal concentration as political. For art, this can mean doing work that looks like art has always looked, challenging little, but about which one claims that it is political just because it was done by a woman. (There is, in fact, a lot of these claims being made.)

Yes, if one exposes to view the socially constrained elements within the supposed realm of freedom of action – namely, 'the personal.'

No, if one simply insists on protecting one's right to autonomy and regards the triumph of personal politics as a publicly emancipatory act.

Yes, if one is sensitive to the different situations of people within society with respect to taking control of their private lives, but no, if one simply urges everyone to 'free themselves' or 'change their lives'.

Yes, if we understand how to make these demands for the right to control our lives within the context of a struggle for control over the direction of society as a whole.

Anne Marsh, 'A Theoretical and Political Context' (1985)

From *Difference: A Radical Approach to Women and Art* (Adelaide: Women's Art Movement, 1985), pp. 1–6.

A Women's Art Group (WAG) was formed in August 1976; during this time, and up to 'The Women's Show' in 1977, the group met at artworld associations[1] and the homes of group members. The main focus of the group was to establish a women's art slide registry in Adelaide. Later, the organisation and production of 'The Women's Show' opened the group up and allowed a more diverse group of women to become involved.

Evidence of a liberal, a-political, trend manifested itself early as feminists debated the title of the group. Women's Art Movement, the name preferred by the politicized women, was considered too radical by the bourgeois sentiment. A similar discourse arose over the title of the Artworkers Union in Australia. Some resisted the name 'union' fearing it would align them with a left-wing concept! Eventually the name of the art group was changed: Women's Art Movement (WAM) first appeared on the February 1977 newsletter.

The second, most public, ideological argument to be debated was over the issue of selection for 'The Women's Show'. Would the exhibition be around a particular theme? Would contribution be open and then selected by a panel (of experts)?

In the meantime word had reached the Adelaide Women's Liberation Movement and the wider women's community that a women's *art* organisation had formed and was planning a large show. In the beginning the new group was seen as quite separate: only representing a small minority of women-in-the-arts, some saw it as elitist and

bourgeois, a reflection of the patriarchy and his culture, albeit presented by women. Gradually politicized women within the Women's Art Movement began to beckon women in from the women's movement.

The organisational mechanism of 'The Women's Show' grew, allowing other women to get involved politically. This was done in a semi-organised way. There were several meetings at the Bloor Court art studio, Studio 4,[2] where women discussed various strategies to counteract the bourgeois values being perpetuated by the Women's Art Movement.

As news of the struggle within the Women's Art Movement, over the issue of selection, broke, more radical women started to attend the meetings. Their presence and ideological weight helped the struggling voice within WAM, giving volume to a feminist ideal: to include *all* women regardless of age, class, race, sexual preference, and in this specific case: degrees of pre-judged, patriarchal 'standards of excellence'. The idea of selection of any kind was dropped and the Women's Art Movement guaranteed to hang *all* works received.

The enormity of 'The Women's Show' meant that a wide cross-section of the women's community made contact with the Women's Art Movement. The exhibition itself has been well documented in the publication *The Women's Show 1977*.[3] The process leading up to the exhibition, the ensuing organisational tasks, and the huge range of activity pursued by women proved that a purely artworld identified group could not hope to represent the diversity and ingenuity of women's culture.

Bringing-in the Women's Movement: Opening-up the Feminist Debate

The Women's Art Movement was pioneered by women in the artworld, women who already considered themselves women-in-the-arts. The production of the first major, non-selected show opened up a plethora of women's culture. The values and assumptions of the artworld identity were soon questioned by a politicized feminist identity which sought to de-construct the given order.

There was a degree of tension between the radical and the liberal as politicized women started to find a voice within the Women's Art Movement. As the group developed, various, and sometimes conflicting, arguments arose over issues of selection, collectivity, aims and objectives. Most of these conflicts can be attributed in some way to the continuing debate over *difference*. 'Patriarchal ideology pulsates like an octopus: if the feminist would avoid the corrupt embrace of the tentacle of difference with its image of woman-as-other, the tentacle of same still promises to draw her to its heart.'[4]

During the early seventies the dissolving of difference was part of a developing feminist critique. In the grass roots movement consciousness-raising sought to reduce the differences between women. It was thought that emphasizing difference would lead to competition, the development of hierarchies and ultimately separation and loss of unity. Sisterhood could not be powerful if it continued to be separated by race, class, sexual preference, marital status etc. Sisterhood needed to be united to conquer the familiar divide-and-rule paradigm of the prevailing hegemony. 'Ultimately, it was thought, the condition and experience of being female would prove to be more important in defining women than the specifics of our differences from one another.'[5]

The women-are-the-same-as-one-another policy, developed by the movement on a practical level, was paralleled by the theoretical concerns of feminism at the time.

Feminist writers following on from Simone de Beauvoir's assertion that 'woman is not born, but becomes female' argued that gender is acquired, subject to social conditioning, and evident in 'sex-role' behaviour.[6] Feminists sought to dispel the patriarchal argument that *women are different*, and that this difference confines women to the reproductive and domestic sphere. Feminist theorists set out to demonstrate that sex-role stereotypes could be separated from biological sex.

The patriarchal notion of difference was seen as a major obstacle for women. It was argued that the differences between men and women had been exaggerated to keep women powerless, and that these differences should be reduced to allow women full participation in all aspects of life. 'Feminist analysis had revealed that the traditional celebration of women's "difference" from men concealed a conviction of women's inferiority and an intention to keep women relatively powerless.'[7] The Women's Art Movement developed, in its founding years, amidst a conceptual shift in feminism. Indeed, it could be said that this shift gave way for a Women's *Art* Movement to emerge. The advent of women's studies made way for a shift in the arguments developing around the theme of *difference*. Feminist scholars started to assert that the universality of women's experience justified the use of 'women' as a field of study. It was argued that defining 'women' as a legitimate category for academic research would enable certain imbalances to be redressed. Women had been excluded from history and patriarchal knowledge, feminists would redress the situation by focusing on women, their lives and experiences. 'Purportedly comprehensive accounts of human experience were rejected on the grounds that they did not include female experience, and were therefore both inaccurate and distorted.'[8]

The shift in argument should now be apparent. Whereas initially, feminists sought to dissolve culturally produced difference between men and women, and between women themselves, now the focus of 'women' as a field of study was built around the assumption that *women are different*, and that this difference required our attention. 'Originally seen as a source of oppression, these [differences] were now beginning to appear, on the contrary, as a source of enrichment.'[9]

The theoretical complexities apparent in the development of a *Women's Art* Movement, in the context of the debate over difference, cannot hope to be unravelled completely at this time. The shift outlined here is only the beginning of what has now developed into one of the most profound discourses within feminism in our time.

Debates on Feminism Developed at WAM

Collectivizing a movement

One of the longest debates to gain attention at WAM was the issue of collectivism. 'The Women's Show' had been organised on a collective basis yet after the exhibition, partly due to the diminished energy of the group, a decision was made to employ a co-ordinator. In effect this set up a hierarchy where once there was none. The co-ordinator structure survived for 2 years until it was successfully contested by the left.

The movement to dissolve the hierarchy was brought about due to the structure's obvious limitations. Struggling for a policy of non-selection and collectively organising, 'The Women's Show' had opened the group up; the decision to implement a hierarchical structure closed the group, once again tying it to an artworld identity.

The trouble with the artworld identity was the strong bourgeois philosophy pursued and perpetuated by the artworld generally. This led to the belief that art is not concerned with politics, but is essentially a-political in nature. In turn, this led to the underlying belief that life itself is not political, and therefore feminist analysis is neither essential or necessary. In fact it was posited, by some lines of argument, that: women organising together can be *wrong*, perpetuate dualisms, make *man* the enemy and so on. Here we see how the critique of difference was used to perpetuate a bourgeois philosophy.

The artworld identity tended to contradict itself within the context of a Women's Art Movement. As I have already suggested, the concept of an *art* movement specifically for women was justified by an assumption that women were different, and this difference needed illumination. An artworld identity tended to support the women-are-the-same-as-men argument, which manifested itself in lobbying for equal representation in major/mainstream exhibitions; what has been termed the piece-of-the-pie strategy: women seeking to claim a bigger slice of the male-dominated sphere by reducing the differences between men and women. The reduction of difference between the sexes ironically led to an increase in the differences among women. It separated women from one another since the patriarchy was not about to let *all* women have a piece-of-the-pie. Often, women had to demonstrate their difference from other women in order to make-it in a 'man's world'.

As we have already discussed, activist feminists schooled in the early seventies were also pursuing a strategy to minimize difference, but their concern was woman-to-woman. Radical feminists, who continued to be activists throughout the seventies, learned through the development of theory and practice that the acknowledgement of *difference* was as much a political as an academic necessity. To this extent they tended to be more aware of the conceptual shift in feminism, and did not see the recognition of *difference* as a retrograde step. The critics of difference would argue that such acknowledgement reaffirmed woman's identity with the *inferior* realm of *nature*; thus playing into the 'ideal-typical complementary of "male" and "female"'.[10] 'Not only does this routine feminist objection to what is called "nature" rest on a gross oversimplification of the issues involved in that determination, it overlooks the possibility of some very radical implications – epistemological, political, personal – which might be had in the *practice of difference*.'[11]

In the process of collectivizing the Women's Art Movement a variety of defensive postures were taken over the notion of difference. The liberal and the marxist positioned themselves within a strong critique of difference, arguing that the notion was retrograde. The radical feminist, not seeing difference as implying an intrinsically *natural state*, realised the political necessity of acknowledging difference. Furthermore the radical saw, in the critique of difference, the old dualism nature *v.* culture as representative of an obsessive and repressive code. 'To deny specificity to the female unconsciousness means nothing else than to deny her any right to speak up. It means denying that she can hold her own discourse.'[12]

Collectivism on one level supported the women-are-the-same argument. On a practical level it reflected the initial strategy of the women's movement: to diminish the differences between women. On another level it supported the notion of *difference*, since the women actively involved in lobbying to change the structure were committed to the idea of 'women's culture'. This meant the development of a separate women's art movement, as a support structure for women's art and as a resistance to the dominant patriarchal, cultural mechanism. As we have already noticed the parameters set for a women's *art* movement supported this notion in its very foundation. Within this context the critique of difference was, to a certain extent, a non-issue. Since the argument could be put that: if women were not prepared to acknowledge difference in culture, then why were they members of a group which in its very concept made an assumption about such difference?

The liberal contradiction

The liberals, being unfamiliar with the grass roots women's movement and the politics of feminism generally, absorbed the status quo image of the movement portrayed by the media: women's liberation was seen as a *threat to the differences* between men and women. The patriarchal notion of difference was reiterated: reducing the differences between men and women would reduce sexual excitement thus destroying heterosexual bonding, the family and eventually the whole of society.[13] The liberals at WAM tended to agree with this prognosis, which they saw as manifesting itself in 'separatism'. For the liberal, lesbianism was the epitome of separatism.

There is a contradiction evident in this rationale. The very same contradiction that allowed the liberal to join the marxist in the 'critique of difference'. The media, of course, was saying that women were *not* the same as men, they were projecting a woman-as-other argument. The media portrayed feminists as masculine women: within the liberal this produced a fear of 'separatism' and its extension, as they saw it, in lesbianism. Lesbians *were* 'masculine women'. The contradiction became explicit when the liberal tried to argue that making woman the same supported a woman-as-other philosophy. It was argued that lesbians by celebrating woman-ness or a separate woman's culture perpetuated woman's difference. The point was that lesbians were not celebrating a traditional (patriarchal) definition of woman's difference, their concept and practice of difference was much more radical. The liberal was initially reacting to lesbianism because it made woman-the-same-as-man. To travel full-circle in the argument and start asserting that lesbian difference perpetuated a patriarchal notion of woman-as-other was somewhat incongruous.

The liberal is good at changing colours, like the chameleon reflecting the dominant environment. Within the women's movement, and specifically over the issue of difference, the liberal changed platform several times. When it suited she joined with the marxist in an historical analysis of femininity-as-social-construct and opted to dissolve difference. The liberal usually used the social construct rationale to lever for a bigger piece-of-the-pie, being content to attain bourgeois status. The trouble with the wavering liberal is that she can often project the most reactionary view due to her lack of political analysis. This caused her violent reaction to lesbianism in the first instance as she saw it as a threat to her own heterosexual relations, and so chorused the status quo which saw homosexuality as a threat to 'natural' bonding and the family.

The criticisms of collectivism

The debate over difference influenced the debate over collectivism. The artworld, or liberal, stance opted for a woman-as-same theory, albeit with implicit contradiction in their opposition to lesbianism-as-separatism. *Interventionism* became the rallying platform of the liberal in an effort to promote a stronger artworld identity for *women artists*.

The argument presented at WAM developed briefly as follows. Femininity and masculinity are social constructs. To admit to the uniqueness of being a woman, to celebrate feminine concepts/cultures, is to support woman-as-other and to manifest her separateness from the *whole* of society. Feminists committed to providing services for *women only*, or artists concerned with representing woman-ness, are merely condoning the system which supports the polarity man–woman in the first place.

The solution to the separation of women from the *whole* of society was seen to be via interventionism. This in-itself entailed positing women within an artworld identity. The left resisted such a move because of the bourgeois nature of the artworld, and the bourgeois/patriarchal notion of art supported by it. *Collectivism* became the rallying platform of the left, who sought to undermine the artworld identity by dislodging the hierarchy and positioning collectivism as left praxis. In creating a structure of rotating collectives, feminists hoped to introduce a continuous flow of *difference* which would in-process question and undermine the bourgeois identity. In this way it was hoped that a different (other-than-bourgeois) process, practice and eventually concept of art would develop, or at least have a fighting chance.

Notes

1 The Experimental Art Foundation, the Media Resource Centre, and the Wattle Park Teachers College.

2 Studio 4 was a feminist art studio adjoining the Women's Liberation Centre, Bloor Court, Adelaide, 1975–6.

3 *The Women's Show 1977* (Adelaide: WAM, 1978).

4 Kay Salleh, 'Contribution to the critique of political epistemology', *Thesis Eleven*, 8 (1984): 31.

5 H. Eisenstein and A. Jardine (eds), *The Future of Difference* (Boston, MA: Barnard College Women's Centre, 1980), p. xvii.

6 Ibid., p. xvi.

7 Ibid., p. xvii.

8 Ibid., p. xviii.

9 Ibid.

10 Salleh, 'Critique of epistemology', p. 24.

11 Ibid., p. 25.

12 J. Feral, 'The powers of difference', in *The Future of Difference*, ed. Eisenstein and Jardine, p. 90.

13 *The Future of Difference*, ed. Eisenstein and Jardine, p. xv.

2.3 Activism in Practice, Practices of Activism

**Leslie Labowitz-Starus and Suzanne Lacy,
'In Mourning and in Rage . . .' (1978)**

From *Frontiers: A Journal of Women*, 3 (1) (1978), pp. 52–55.

'In Mourning and in Rage . . .' was conceived as a response to Leslie and Suzanne's very personal grief and rage over the incidents of rape-murder in Los Angeles which are labeled the 'Hillside Strangler Case.' After reading about the tenth victim, they decided to design a media event which would include the collaborative partici- pation of women's organizations, city government, and members of the women's community.

Seventy women dressed in black gathered at the Woman's Building in Los Angeles. The women received instructions for the event which began when ten actresses dressed in black mourning emerged from the Building and entered a hearse. The hearse and two motorcycle escorts departed from the Building, followed by twenty-two cars filled with women in black. Each car had its lights on and displayed two stickers: 'Funeral' and 'Stop Violence against Women.' The motorcade circled City Hall twice and stopped in front of the assembled members of the news media.

One at a time, nine seven-foot-tall veiled women mourners emerged from the hearse and stood in a line on the sidewalk. The final figure emerged, an active woman clothed in scarlet. The ten women faced the street as the hearse departed while women from the motorcade procession drove slowly past in silent homage to the mourners. Forming a procession three abreast, the mourners walked toward the steps in front of City Hall.

Women from the motorcade positioned themselves on either side of the steps forming a black-clothed chorus from a modern tragedy. They unfurled a banner which read 'In Memory of our Sisters, Women Fight Back.'

As soon as the media had positioned itself to record this second part of the event, the first mourner walked toward the microphone and in a loud, clear voice said 'I am here for the ten women who have been raped and strangled between October 18 and November 29!' The chorus echoed her with 'In memory of our sisters,

we fight back!' as she was wrapped with a brilliant red scarf by the woman clothed in red. She took her place on the steps, followed by the second mourner. Each of the nine women made her statement which connected this seemingly random incident of violence in Los Angeles with the greater picture of nationwide violence toward women; each received her red cloak; and each was greeted by the chorus, 'We fight back.' Finally the woman in red approached the microphone. Unveiled, speaking directly and powerfully, she declared 'I am here for the *rage* of all women. I am here for women fighting back!'

The ten women on the steps, the chorus and their banner, served as a background of unified woman-strength against which the remainder of the piece unfolded. A short statement, directed at the press, was read explaining the artists' rationale for the piece. A member of the Los Angeles Commission on Assaults against Women read a prepared list of three demands for women's self-defense. These were presented to three members of City Council: Pat Russell, Joy Picus, and Dave Cunningham, and the Deputy Mayor, Grace Davis. The final image consisted of a song, written especially for the event, sung by Holly Near. The audience joined in this and a spontaneous circle dance as the artists and political organizers met with and answered questions from the press.

Script:

Actress 1: I am here for the ten women who have been raped and strangled between October 18 and November 29.
Chorus: In memory of our sisters, we fight back!
Actress 2: I am here for the 388 women who were raped between October 18 and November 29.
Chorus: In memory of our sisters, we fight back!
Actress 3: I am here for the 4,033 women who were raped last year in Los Angeles.
Chorus: In memory of our sisters, we fight back!
Actress 4: I am here for the half-million women who are being beaten in their own homes.
Chorus: In memory of our sisters, we fight back!
Actress 5: I am here for the one out of four of us who is sexually abused before the age of eighteen.
Chorus: In memory of our sisters, we fight back!
Actress 6: I am here for the hundreds of women who are portrayed as victims of assault in films, television, and magazines.
Chorus: In memory of our sisters, we fight back!
Actress 7: I am here to speak for the thousands of women who are raped and beaten and have not yet found their voices.
Chorus: In memory of our sisters, we fight back!
Actress 8: I am here for the women whose lives are limited daily by the threat of violence.
Chorus: In memory of our sisters, we fight back!
Actress 9: I am here to mourn the reality of violence against women.
Chorus: In memory of our sisters, we fight back!
Actress 10: I am here for the rage of all women. I am here for women fighting back.
Chorus: In memory of our sisters, we fight back!

Statement Read During the Performance

For all of the women here now, for all the women who will see this: we are here today in memory of the ten women who were recently slain in Los Angeles, *and* we are here in memory of all women who have been, and are being, battered, raped, and killed throughout this country, a result of the pervasive and ongoing attitude of violence toward women.

We are here because we want you to know that we know that these ten women are not isolated cases of random, unexplainable violence. That this violence wreaked upon them is not different, except perhaps in degree and detail, from all of the daily real-life reports which reach the news media, from those fictionalized mutilations shown by our entertainment industries, and from the countless unreported cases of brutalization of our relatives, friends, and loved ones who are women.

Today we are here to share our grief and our understanding and our rage in a public manner. That concern, which before was only expressed as isolated fear by each individual woman, we now express together, through our combined voices, and we are mourning each other loudly, mourning in rage, as we recognize our own collective strength through action. We are fighting back.

Our Purpose

It was apparent that the news reports about the 'Hillside Strangler' and the histories of his victims, quotations from frightened neighbors, speculations about the personality and motives of the murderer, and detailed photographic accounts of the victims in life and in death were serving only to terrorize the female population of Los Angeles. Far from raising women's consciousness as to the necessity of self-protection as a way of life, and as to the reality of violence toward women in our society, the media coverage of these ten incidents provided an unreal focus for women's unspoken fear of assault. Women were living in more fear, feeling more isolated and helpless because of their awareness of these particular acts of terrorism. They had no context in which to understand them. Ironically, the images of victimization used to describe these acts of violence have reinforced those feelings and have helped cultivate the image of 'woman as victim.'

As image-makers, as artists professionally concerned with the changing images and conditions of women in our culture, we were distressed with the particular images of women as represented by the media in this case. We recognized the linkage of these images with the thousands of images in advertising, news, and entertainment media which depict woman as victim or potential victim. We knew that the highly sensationalized reporting of these particular acts of violence avoided the recognition that these current acts of brutality were part of the ongoing condition of violence toward women, a condition which is reflected in American homes and streets, with wife and child battering, rape, and homicide.

Our purpose was to provide a public space for women to come together to share their grief and rage through a ritual. The imagery of the ritual would transform the isola-

tion of each woman's attempt to deal with the reality of these violent assaults into a collective statement of unity and aggressive action. The motorcade allowed for the participation of sixty women who came to mourn the ten women and the tens of thousands of women who have died, been maimed, or terrorized by physical violence. The chorus provided participants with a structure for the active denial of collective victimization. The nine figures in black, each seven feet tall, stood as symbols of the power of women who have historically banded together as mourners, and as givers of life and death in their culture. This image of mourning was not a weak one, but showed women united in their pain and their rage. Rage provides the courage and the energy to demand social change. Each woman in black represented a specific aspect of physical violence against women, and spoke in memory of the women who have suffered or died from it. Rather than focus on the ten victims of this specific incident of violence, we wanted to show the connection of this case with the total picture of violence toward women. The woman in red represented our rage: any of us could have been the woman who was killed, the victim of impersonal violence directed toward all members of the female sex.

Our second concern with the piece was to provide a framework for the participation of women's organizations and governmental representatives who would like to share in the collective statement against this violence. By incorporating elected representatives in city government, we increased our power base, and provided officials with a means of participating in radical feminist thinking and politics. To this end, we began our construction of the piece by calling a meeting with women from Los Angeles Commission on Assaults against Women, Women against Violence against Women, Los Angeles County Commission on the Status of Women, and Women against Sexual Abuse. We outlined our performance ideas, and offered the event as a framework for the publication of their on-going activities in the prevention of violence. A list of three demands for city government was created: mandatory self-defense in the grammar schools, telephone emergency listing of rape hotline numbers, and funding for neighborhood protection programs. A self-defense workshop open to the public was planned for the Saturday following the event. We solicited the appearance in support of these demands by several members of the City Council, who were pleased to pledge their support of the issues.

The final and perhaps most important aspect of the piece, in terms of its mass audience effect, was our careful creation of a public image of our work to be seen through television, radio, and periodical coverage. We created a network of media representatives who would cover the event. During the formation of the motorcade at the Woman's Building one of the collaborative artists was on the site of the performance at City Hall, preparing press arrivals for the event which would take place. Throughout the event the press were directed to obtain the footage which would best represent the piece's conceptions. The ideal coverage was one which would convey to the women in the media audience the feminist ideas being presented. Subsequent television footage from news reports and talk shows was collected. It will be edited, along with our own video coverage, into a distributable tape.

This piece was structured by the artists to serve as a media vehicle for their political ideas, and to serve as a focus of action for the women who participated in its creation and exhibition. The artists have been consciously working on models of collective

action which combine the collaborative activities of artists and nonartists alike. We see the political artist in present-day society as a model maker as well as an image maker. The artist uses her understanding of the power of images to communicate information, emotion, and ideology; to critique currently existing images; and to create models for the interaction of people with her images in the service of her philosophy. The models we are currently creating involve the entire city of Los Angeles: government, community organizations, and the media. It is obvious that each of these groups will perceive the work of the artist in a somewhat different fashion – as political demonstration, as a 'skit,' as protest. From our viewpoint, however, the overall structure of the piece comes as much from political as emotional and aesthetic decisions. All three aspects equally contribute to the formation of successful media events which affect varied levels of the human psyche.

Mierle Laderman Ukeles, 'Touch Sanitation' (1980)

From *Issue*, ed. Lucy Lippard (London: ICA, 1980), unpaginated.

On July 24, 1979, I started shaking hands with the first of all New York City's 8,500 sanitationmen and officers, 'sanmen', the housekeepers of the whole City, workers in the largest of maintenance systems. I called the performance 'Touch Sanitation', a maintenance ritual act, celebrating daily survival. To each man I said, 'Thank you for keeping New York City alive.'

As an artist, I tried to burn an image into the public eye, by shaking shaking shaking hands, that this is a human system that keeps New York City alive, that when you throw something out, there's no 'out'. Rather there's a human being who has to lift it, haul it, get injured because of it (highest injury rate of any US occupation), dispose of it, 20,000 tons every day. Our garbage, not theirs.

As woman artist injecting myself into a 'man's world', I represented the possibility of a healing vision: not a pretend sanman, not an official investigator, not a media voyeur, not a social scientist; rather a 'sharer' in an ecological vision of the operating wholeness of urban society.

Over the next 11 months, through all 4 seasons, I followed in their footsteps, modelling my performance art-time on the sanman's 8 hour work shifts, starting at 6a.m., or 4p.m., or midnight. To reach all 59 sanitation districts in every part of New York City, I divided the performance into 10 'sweeps', 10 circles of the City, creating a citywide spiral tracking-form, hand to hand.

I did a round-robin, where you get called back to work with no choice after only 8 hours off, for several days running, until your eyeballs turn inside out and you don't know what time it is. I ate with sanmen, often on curbsides when restaurants wouldn't serve them. I talked with them on audiotape and shot video throughout. Mostly I stayed behind the hopper, as they do – where you can't escape the scare of the wind, sheets of

rain, beating sun, stumbling in the snow, when you get soaked from sweat inside your rain-gear and drenched outside anyhow, facing the stink and ultimate jungle of juxta-positions that is garbage.

A world unfolded, work performed right in the public eye, where sanmen feel so isolated they could be working on the moon, a world most people have no idea about. I saw the hypocrisy of our society that demands complete 8 hour everyday 'produc-tivity' (which sounds reasonable especially when New York City is in extremely dire fiscal straits), yet which, at the same time, presents that sanitation worker with utterly degrading work conditions and facilities, often 1 toilet for 120 men, no showers!, frozen pipes, Byzantine work shifts, improperly packaged garbage – overflowing, frozen to the ground, smeared curb to curb – the excessive glut of waste from our egregious consumerism. I developed a reflexive flinch from the common public attitude that merges the worker with the waste product that we, not they, make but which nevertheless stigmatizes them. They spoke of being thought of as part of the garbage, the lowest of the low.

'I hope you washed your hand,' people said to me all year, as if sanmen didn't wear gloves or remove them when they weren't handling the garbage, forgodssakes. Do they say that after you meet a surgeon?

I got depressed, I got enormously angry. Many sanmen, thousands, said, 'You're the only person in the world who gives a damn about us.' Is that ridiculous? Is that any way to run a society?

I got enlightened about the expertise of balance, 20 to 30 year spans of strength, about camaraderie and life–death teamwork under such stress your hair could stand up on end, mostly about spirit even where there's zero morale and supreme endurance, dedication, keeping going no matter what comes at you.

I finished on June 26, 1980. But they didn't. Does the noise of the hopper's grinding away aggravate you? It means we've made it to another day.

Lucy Lippard, 'Hot Potatoes: Art and Politics in 1980' (1981)

From *Block*, 4 (1981), pp. 2–9.

Every summer I sit down and try again to write about 'art and politics'. Every summer, the more the possibilities have expanded and the changes been frustrated, the harder it gets. Despite years of 'art activism' the two still crouch in separate corners of my life, teasing, sometimes sparring, coming to grips rarely, uneasily and without con-clusion or issue. Even now, when many more visual artists are informed about radical politics, when 'political' or 'socially concerned' art has even enjoyed a doubtful chic, artists still tend to think they're above it all and the Left still tends to think art's below it all. Within the feminist art movement as well, polarities reign, although because of its fundamental credo – 'the personal is political' – they have different roots, and different blossoms.

I wrote the paragraph above in the summer of 1977, two years before the cusp of 1980 where I stand now. Things haven't changed much. Contrary to the popular image of the wildeyed radical, artists are usually slow to sense and slower to respond to social currents. Yet perhaps in response to the anti-60's economic backlash that has only recently reached the artworld in the guise of punk and/or 'retrochic', it does seem that an increasing number of young artists are becoming concerned with social issues – though often in peculiar and ambivalent ways. I tend to be over-optimistic, and at the moment am obsessed with the need to integrate ivory tower and grass roots, particularly within the 'cultural' and 'socialist' branches of feminism. So I could be wrong, as I was when I hoped for too much from the conceptual third stream around 1970. But first, a little history.

A Little History

Art and politics as currently defined can't get together in America because they come from opposite sides of the tracks. Art values are seen by the Left as precisely bourgeois, even ruling-class values, while even the most elitist artists often identify vaguely – very vaguely – with an idealized working class. Or perhaps painter Rudolf Baranik's way of putting it is fairer: 'Art both serves and subverts the dominant class of every society. Even the most passive or subservient art is not the precise carrier of ruling class ideas, though in every way the ruling class makes an effort to make it so.'[1] Art may feel trapped in the ivory tower, now and then complaining bitterly, now and then slumming for a while, but it lets its hair down selectively so only a chosen few can climb to its chamber. Politics has other things to think about, and aside from occasional attempts to knock down the tower, is little concerned with what goes on inside it. At financial crises, politics may solicit money and propaganda from art's liberal conscience, which also provides cocktails and imaginative bursts of energy until 'too much time is taken away from the studio'. Caught in the middle of all this is the socially conscious and sometimes even socially concerned artist.

The American art world where most of these forays take place, is a curious barnacle on capitalist society that imagines itself an esthetic free agent. The art world has been wary of politics since the late 40s, when artists were in danger of being called before the House Unamerican Activities Committee if their work was too comprehensibly 'humanist.' In 1948 a soon-to-be-famous painter and a critic jointly declared that 'political commitment in our time means no art, no literature.'[2] Variations on this position dominated the next twenty years, only a few hold-outs insisting that 'painting cannot be the only activity of the mature artist' (though continuing to support the separation between art and politics).[3]

American art subsequently became a world power precisely by severing itself from politics (read Left politics, since the center and right are just presumed to be 'society' or 'life'). By the late 50s, the New American Art – abstract, and therefore, paradoxically, far more socially manipulable than representation – sidled forth from the tower to issue internationally impressive 'breakthroughs'. Those who had initially objected to its red range began to like warm colours when these could be paraded as testimony to the glories of esthetic freedom in a democracy. No one seemed to notice until the later

60s that artists had lost control of their art once it left the studio – perhaps because the whole experience was a new one. Some American artists were enjoying for the first time a general prestige. In the process of acknowledging that content in art was inseparable from form, many also fell for the next step (offered by critics who had been 'political' themselves in the 40s) – that form alone was the only possible content for 'important' or 'quality' art. This recipe was swallowed whole in the period between Korea and Vietnam. How, after all, could pure form be political? How indeed. The problem seemed solved as the international 'Triumph of American Painting' paralleled the triumph of American multi-nationals. Again, in all fairness, it should be noted that the artists themselves were rarely if ever aware of these implications, and when they were, their extraordinary esthetic achievements could be identified, as Irving Sandler has said, as 'a holding action on the threshold of resistance.'[4]

All this time there was a good deal of banter about the superior 'morality' of American art as compared to European art; yet political morality – ideas affecting culture from the depths rather than on the famous surface and at the famous edges – was all but invisible in the art world. For a while the yacht was too comfortable to rock, even though it was still too small to accommodate the majority of the artist population, not to mention the audience. By the mid-60s, the small number of highly visible artists who had 'made it' offered a false image of the future to all those art students rushing to New York to make their own marks, and to have nervous breakdowns if they didn't get a one-man show within the year (I say one-man advisedly, since the boys suffered more than the girls, who had been led to expect nothing and had to cultivate personal survival powers).

Throughout the 60s a good healthy capitalist dog-eat-dog competition flourished with the free-enterprise esthetic. More or less abruptly, at the end of the decade, reaction set in, taking the form of rebellion against the commodity the art object had involuntarily become. Conceptual art was conceived as a democratic means of making art ideas cheap and accessible by replacing the conventional 'precious object' with 'worthless' and/or ephemeral mediums such as typed sheets, xeroxes, snapshots, booklets, streetworks. This coincided for obvious reasons with the conscientious downward mobility of the counterculture and the rhetorical focus of the often academic New Left. It was crowded in the streets in 1970, what with the blacks, the students, the antiwar movement, the feminists, the gays. Art felt like one of the gang again, rubbing elbows with the masses, fighting a common enemy. After all, despite the elitist fate of their art, artists can easily identify with oppressed minorities whose civil rights are minimal.

But wait. The enemy looks familiar. It is the hand that feeds us. We were picketing the people we drank with and lived off of. We were making art in a buyer's market but not a consumer's market. We were full of 'mixed feelings', because we wanted to be considered workers like everyone else and at the same time we weren't happy when we saw our products being treated like everyone else's, because deep down we know as artists we *are* special. What we (artworkers) wanted, and still want, as much as control over our labour power and over the destiny of our products, was *feedback*. Because art is communication, and without contact with its audience it becomes the counterpart of a doorhandle made on a Detroit assembly line. (I have this vision of a 1990's artist seeing a film of a Soho gallery in the 70s and finding herself unable to recognize her own work – just as the factory worker would not be able to distinguish her doorhandle.)

A little dissent goes a long way in the art world. By 1971 the ranks were dissolving back into the white-walled rooms. Pluralism reigned and there was more room at the top. For the most part this pluralism was healthy, though attacked from the right as a fall from grace, too democratically open to mediocrity; and from the left as a bribe, too tolerant of anything marketable, a confusion of the issues. Dissent was patronized, patted on its ass and put in its place. Those who were too persistent were ghettoized or, more subtly, discredited on levels they were never concerned with. After a brief flurry of Women's Art and Black Art shows, the institutions subsided to prepare for a backlash campaign. Yet one thing that the art activism of the late 60s and the increased (if intermittently applied) theoretical awareness of the 70s did accomplish was a fairly thorough purge of the 'my art is my politics' copout, which encouraged Business as Usual and blocked all avenues (or alleys) to change. We were all aware by then that every move we made was political in the broad sense, and that our actions and our art were determined by who we were in the society we lived in. (This is not to say that most of us cared to think about these insights.) We were also beginning to realize that concep-tual art (the so-called movement, not the third-stream medium) had, like the dress and life styles of the period, made superficial rather than fundamental changes, in form rather than in content. When we trooped back into the galleries, back to a Soho already cluttered with boutiques and restaurants its residents couldn't afford (a far cry from the Artists Community envisioned around 1968) we bore this new burden of awareness. We could no longer seriously contend that because art tends to be only indirectly effective, artists should be exempt from all political responsibility and go bumbling on concerned only with their own needs. (Yet again, this is not to say that most of us cared to act on these insights.)

If my Art Isn't my Politics, What is?

One point at which art and politics meet is in their capacity to move people. Even though communication with non-buying or non-writing viewers is an unpopular or uncon-sidered goal in the high art world, art that has no one to communicate with has no place to go. Contemporary criticism has offered no solid analyses of the artist's exile status, nor any sophisticated notion of art's audience – either present or future/ideal. We might get further faster by asking ourselves as artists and artworkers: who are we working for? The accepted avant-garde answer has long been 'for myself', and 'for other artists.' These responses reflect the rugged individualist stance demanded of American (male) artists and the fundamental insecurity of an artist's existence in a society that tolerates but does not respect cultural activities and practically denies the existence of cultural *workers*. Reaching a broader public, aside from its populist correctness *and* aside from the dangers of esthetic imperialism, might revitalize contemporary art by forcing artists to see and think less narrowly and to accept ideological responsibility for their products. By necessity, the feminist art community has made important moves toward a different conception of audience. Perhaps this is what Jack Burnham meant when he saw feminism as offering a potentially 'vernacular' art to replace the 'historical' art that has dominated modernism.[5] (My dictionary's first definition of vernacular gave me pause: 'belonging to homeborn slaves.') Although it was still possible in 1977 for *Studio International*'s special issue on 'Art and Social Purpose' to ignore feminism, this has

been a central concern of the most original feminist artists and writers for some time. Feminist artists are luckier than most in that we have a constant dialogue between a network of intimate art support groups and the rest of the women's movement, which is dealing with non-art issues in the real world. (An example is the current campaign in New York of Women against Pornography.)

Yet the 'high' or commercial art world's lack of respect for a less than classy audience whose tastes differ from its own continues to be conveyed through its patronizing (and, alas, matronizing) accusations that any popular work is 'rabble-rousing' and 'crowd-pleasing'. The institutional reception, or lack thereof, given Judy Chicago's monumental and collaboratively executed sculpture *The Dinner Party*, and the overwhelming enthusiasm it has sparked in non-art-world audiences, is a significant case in point, which I've treated at length elsewhere. Suffice it to say that the notion that elitism is necessary to the survival of quality is tendered by the same liberals who deny all evidence of repression in America and continue to defend the superiority of a capitalist democracy.

For all the Global Village internationalism supposedly characterizing the 70s, in 1980 most artists are still working for exactly the same economically provincial audience, 'It's a free country'. We are supposed to recognize that personal tastes differ. In the high art world, however, 'quality' *is* the status quo. It is imagined to be permanently defined by those controlling the institutions. While stylistic pluralism has been encouraged in the 70s, deeper divergences from the mainstream are still not tolerated. Given the reigning criteria by which lousy art cast in the proper mould or accompanied by the proper prose is consistently hung, bought, approved by the most knowledgeable professionals, the issue of quality seems irrelevant. Since quality comes from art, and not vice versa, the question is, how do we arrive at an art that makes sense and is available to more, and more varied people, while maintaining esthetic integrity and regaining the power that art must have to provoke, please, and mean something?

For better or for worse, most people go through life without even wanting to reach the inner sanctums where art coyly lurks. What the ruling class considers 'low art' or 'bad art' plays a role in the lives of many more people than 'high art' does, and it is this need that new art is trying to tap. Right now, only the lucky few get 'good art' or are educated to recognize it, or decide what it is. (Recently feminists, Marxists and third-world artists have been trying to re-educate ourselves in order to avoid seeing with the conditioned eyes of the white capitalist patriarchy.) But are we really so lucky? How much of the avant garde high art we see gives us profound sensuous or intellectual pleasure? How often do we lie to ourselves about our involvement in the art we have convinced ourselves we should like? How many sensible middle-class people devoted to the survival of 'good taste', as intoned by the powers that be, secretly pine for the gaudy flimsiness, the raucous gaiety of 'lower class' culture? Judging from the popularity of such art from other, more 'primitive' or ancient cultures, of Pop Art, 'camp' and the whole punk or New Wave phenomenon – quite a few.

Is There Art Post Life?

In the 70s it became critically fashionable to call art 'post' anything that peaked in the 60s: 'post studio', 'post conceptual', 'post modernist', 'post minimalist', even 'post

modern'. (Where does that leave us?) Maybe in the 80s we'll just find out that 'beyond' was nothing but a vacuum. Or a void – as in a *tabula rasa*, which is not a bad thing, especially when things need cleaning up as badly as they do, now. For some of us who lived through the 60s and have spent the last ten years waiting for the 70s to stand up and identify itself, the 70s has been the vacuum. It was only in its past three years or so that it got it together to pinpoint an esthetic of its own, and this it did with a lot of help from its friends in the rock music scene, not to mention S & M fashion photography, TV and movie culture, and a lot of 60s' art ideas conveniently forgotten, so now eligible for parole. As we verge on the 80s, 'retrochic'[6] – a subtle current of content filtering through various forms – has caught up with life and focuses increasingly on sexist, heterosexist, classist and racist violence, mirroring, perhaps unwittingly, the national economic backlash.

(Some parenthetical examples of retrochic in case it hasn't spread as far as I'm afraid it has: an exhibition of abstract drawings by a first-name-only white artist gratuitously titled 'The Nigger Drawings' for reasons so 'personal' he is as reluctant to murmur them as he is to wear black-face in public; this was studiously defended as 'revolutionary' by a young Jewish critic who has adopted a pen-name associated with Prussian nobility. Or a male Canadian rock group called 'Battered Wives', who could be speaking for all such 'artists' when they explain 'the name is symbolic. It doesn't mean anything;' the group sings a song called 'Housewife' – 'she's a housewife/Don't know what to do/So damn stupid/She should be in a zoo.' Or a beautifully executed and minutely detailed 'photorealist' painting called The Sewing Room dedicated to some poor soul named Barbara, which depicts a pretty middle-class sitting room in which a workclothed man gorily stabs the lady of the house in the neck).

Some of its adherents seem to see the retrochic trend as a kind of acatatic but dangerous drug not everybody has the guts to try. It has been called a 'DC current that some people pick up on and others don't', that combats '60s' tokenism' and is 'too hot to handle.'[7] Some retrograde punk artists share with the Right Wing an enthusiasm for the 50s, which are seen as The Good Old Days. They are either too young, too insensitive or too ill-informed to know that the 50s were in fact Very Bad Old Days for blacks, unions, women (viz. the crippling and deforming fashions like stiletto heels, long, tight skirts and vampire makeup) and for anyone McCarthy cast his bleary eye on. The earth-shaking emergence of Rock 'n' Roll notwithstanding, it was also a time of censorship in the arts, of fear and dirty secrets that paved the way for the assassinations, open scandals and quasi-revolution of the 60s.

Punk artists – retro and radical – also trace their bloodline back to Pop Art and Warhol (though the latter epitomized the scorned 60s) and to Dada (though it's not fair to blame a socialist movement for its reactionary offspring). The real source of retrochic is probably futurism, which made no bones about its fundamental fascism and disdain for the masses. Violence and bigotry in art are simply violence and bigotry, just as they are in real life. They are socially dangerous, not toys, not neutralized formal devices comparable to the stripe and the cube. So I worry when a young artist whose heart and mind I respect tells me he's beginning to like the reactionary aspects of punk art because he sees them as a kind of catharsis to clear the decks and pave the way for change in the art world. At this point, as in the idealization of the 50s, I become painfully aware

of a generation gap. The anticipated catharsis sounds like the one I was hoping for in 1969 from conceptual art and in the 70s from feminist art.

And if retro-punk is too hot to handle, where are all those burned fingers? Most of the hot potatoes seem to have been cooled to an acceptable temperature and made into a nice salad. If Warhol is king of the punk party, the real retrochic heroine should be Valerie Solanas – the uninvited guest, whose 'Scum Manifesto' was too hot for *anyone* to handle.

I hope retrochic is not the banner of the 80s, but merely the 70s going out on an appropriately ambiguous note, the new wave rolling on and leaving behind an ooze primed for new emergences. I have nightmares about a dystopian decade dominated by retrograde fascist art which, while claiming on one hand to be 'space age social realism'[8] manages on the other hand to be just Right for up-and-coming extremists, for those people who simultaneously jerk off to and morally condemn violence and bigotry. The living rooms of the powerful, however, will not be hung with blurry photos of gum-chewing sock-hopping terrorists torturing each other. The establishment's taste in politics and art do not coincide any more than does that of the artists themselves. With a nod to upward mobility, one can probably expect to find hanging over these mantles the same good solid bluechip formalism associated with the 50s and 60s, which continued to be successfully promoted and sold throughout the 70s. Inflation encourages such acquisitions, and the SoHo boutique mentality will maintain its strongholds. Or perhaps the art of the 80s will be a hybrid of the 70s progeny: impressive acres of coloured canvas and tons of wood and steel functioning as covers for safes full of money and dirty pictures, with give-away titles like *Snuff*, *Blowupjob*, *Monument to a Rapist*, *Faggot Series*, *Kike I*, *Kike II*, *Kike III* and so forth – a charming and all too familiar blend of the verbally sensational and the visually safe.

There is, I'm glad to report, another, more hopeful side to all of this, which is subtly entwined with the above. The pivot is an ambiguous notion of 'distancing'. We critics have been talking about 'distancing' or 'detachment' or good old 'objectivity' with admiration since the early 60s, applying it in turn to Pop Art, Minimalism, Conceptual Art, and now to performance, video, photography and film. Irony is usually an ingredient, and if we're seeking a *tabula rasa*, irony is a good abrasive. But irony alone, irony without underlying passion, becomes another empty formal device. Today 'distancing' is used two ways, which might be called passive and active. Distinguishing them is perhaps the most puzzling aspect of today's esthetic and moral dilemma.

The passive artists tend toward the retrochic extreme. They are sufficiently 'distanced' (or spaced out) to see offensive racist or sexist words and images as a neutralized and harmless outlet for any perverse whim; after all, it's only Art. (They are not usually so far gone, however, as to use such epithets outside of the art context – in the subway, for instance.) These artists would subscribe to the formalist maxim 'If you want to send a message, call Western Union', and they tend to have great disdain for old-fashioned radicals (like me) who take such things seriously.

The active artists also use distancing as an esthetic strategy, but to channel social and personal rage, to think about values, to inject art with precisely that belittled didacticism. Instead of calling Western Union, these artists hope that they will be able to put their message across by themselves. They often use understated satire or deadpan black humor to reverse offensive material and give it a new slant. The younger they are, the

rougher they get, and sometimes the cycle reverses itself and it's difficult to distinguish earnestness from insanity.

Passive or active, the crux of the matter is how do we know what's intended? We're offended or titillated or outraged; now we have to figure out whether it's satire, protest or bigotry, then whether the intended content has been co-opted by its subject matter. These are questions that must be asked about much of the ambiguous new art. These are questions particularly important for feminists working against, say, pornography and the violent objectification of women, and for blacks working against racists in liberal clothing.

For example, when a woman artist satirizes pornography but uses the same grim image, is it still pornography? Is the split beaver just as prurient in a satirical context as it is in its original guise? What about an Aunt Jemima image, or a white artist imitating a black's violent slurs against honkies?

Answers, though not solutions, have just been proffered by two leading and very different practitioners of social irony. Yvonne Rainer, who works from a Brechtian viewpoint, treated sex and female nudity with humour and 'distance' in her films until she realized from audience responses that the strategy wasn't working. At that point she became convinced, according to Ruby Rich, 'that no matter what techniques surrounded such a depiction, no matter what contradictions were embedded in the presentation, nothing could ever recoup the image of a woman's body or sexuality bared.'[9] Similarly, black standup comedian and pop hero Richard Prior has just vowed publicly to give up a staple of his routines – the word nigger. 'There was a time', he says, 'when black people used it as a term of endearment because the more we said it, the less white people liked it, but now it seems the momentum has changed . . . There's no way you can call a white person a nigger and make him feel like a black man.' Asked why whites are getting so fond of the word, he replied, 'I don't think enough of them have gotten punched in the mouth.'[10]

Distancing, it seems to me, is effective only if it is one half of a dialectic – the other half being intimacy, or approaching, or optimism. You move away to get a good look but then you move back toward the center where the energy is. This seems to be the position of a number of younger artists whose often para-punk work bears some superficial (and perhaps insidious) resemblance to retrochic. An increasing number are disillusioned with what they have found in art and the art world (including the alternate spaces and the current dissenters): 'Embrace fearlessness. Welcome change, the chance for new creation . . . There is no space for reverence in this post-earthrise age. We are all on the merit system. The responsibility for validity is the individual artist's. The art critic is dead. Long live art.'[11] To which I would holler Hallelujah, but not Amen.

Some young artists are working collectively, making art for specific installations, public places, or for their own breezy, often harsh little shows in flaky impermanent spaces (the model for which may have been Stefan Eins' idealistic if not always fascinating 3 Mercer Street Store, and now his more fully developed Fashion Moda in the South Bronx). One of the most talked-about exhibitions last season in New York was 'The Manifesto Show', collaboratively organized and open to friends, invitees, and off-the-street participation, through which it organically almost doubled in size. There was no single, recognizable political line, but a 'social and philosophical cacaphony'[12] of

specific statements, rhetoric straight and rhetoric satirized, complaints, fantasies, threats – some more and some less geared to current art attitudes. Distancing techniques were used against themselves in self-referential hooks into content from art, as in Barbara Kruger's contribution, which began: 'We are reading this and deciding whether it is irony or passion/We think it is irony/We think it is exercising a distancing mechanism/ . . . We are lucky this isn't passion because passion never forgets.' There were also the unselfconscious atypically straightforward works that said what they meant and meant what they said. And there were Jenny Holzer's dangerously conventional collages of propaganda with lethal reminders built in for anyone who swallows them whole ('REJOICE! OUR TIMES ARE INTOLERABLE TAKE COURAGE FOR THE WORST IS A HARBINGER OF THE BEST . . . DO NOT SUPPORT PALLIATIVE GESTURES: THEY CONFUSE THE PEOPLE AND DELAY THE INEVITABLE CONFRONTATION . . . THE RECKONING WILL BE HASTENED BY THE STAGING OF SEED DISTURBANCES. THE APOCALYPSE WILL BLOSSOM.') The message seems to be *think for yourself*.

This up Against That

Those invested in a perpetual formal evolution in art protected from the germs of real life won't like my suspicion that the most meaningful work in the 1980s may depend heavily on that still pumping heart of 20th century art alienation – the collage esthetic, or what Gene Swenson called 'The Other Tradition'. Perhaps it will be only the alienated and socially conscious minority that will pursue this, and perhaps (this demands insane heights of optimism) the need for collage will be transcended. Obviously I mean collage in the broadest sense, not pasted papers or any particular technique but the 'juxtaposition of unlike realities to create a new reality.' Collage as dialectic. Collage as revolution. 'Collage of Indignation.'[13] Collage as words and images exposing the cultural structure of a society in which art has been turned against itself and against the public. Martha Rosler, for instance, sees her sarcastic narratives (book, video, performance artworks) as 'decoys' that 'mimic some well-known cultural form' so as to 'strip it of its mask of innocence'. And the media strategies for public performance used by west-coast feminists Suzanne Lacy and Leslie Labowitz (with the 'social network' Ariadne) juxtapose two kinds of image within the context of street, shopping mall or press conference. The first is an image of social reality as we all know it through TV and newspapers. The second is that image seen through a feminist consciousness of a different reality – for instance looking at the media coverage of the Hillside Stranglers murders in Los Angeles, analysing its sensationalism and demeaning accounts of the victims' lives, then offering an alternative in the form of a striking visual event ('In Mourning and in Rage') and controlling the subsequent media interpretations. The public thus receives, through art, information contrary to that which it sees as 'the truth' and receives it in a manner that is striking and sufficiently provocative to encourage reconsideration of 'the truth'. Ariadne's media strategies obviously have limited means at their disposal, but their performances have played to audiences of thousands and have an impact only professional artists can bring to bear.[14]

The attraction of a collage esthetic is obvious when we realize that most of us, on the most basic level, exist in a downright Surrealist situation.

Consider the position of an artist in a society that perceives art as decoration or status symbol, investment or entertainment.

Consider the position of a visionary artist in a society devoted solely to material well being.

Consider the position of a person making impermanent objects of no fixed value in a time of inflation and hoarding.

Consider the position of an artist labouring under the delusion that individuality is respected in an age of bland, identical egos.

Perhaps most Surrealist of all, consider the position of a feminist/socialist/populist artist in a patriarchal capitalist marketplace.

Now What?

After the pluralism of the 70s, the 80s are going to have to make art that stands out in sharp relief against our society's expectations for art. Artists are just beginning to understand the flood of new media available, after a decade of enchantment with their novelty. Comprehension of 'the nature of the medium' may sound like an echo of formalist dogma, but if the medium is one whose nature is communication – the video, the street performance, posters, comic strips, graffiti, the ecologically functional earth-work, even photography, film and that old but new-for-the-visual-artist medium, the book – then such comprehension may have more impact on audience and on art. We are supposed to have grown up absurd already. Yet through the 70s I've asked myself why the hell these new mediums were the vehicle for so little socially concerned art. If there is all this rebelliousness and unease among young artists about how the art world treats art (and there is) why are such appropriately outreaching mediums so little explored and exploited? Why is there such a dearth of meaningful/provocative and/or effective public art? Has distancing gone too far? Have we gotten carried away? Spaceage objectivity over our heads? Over and out?

I hope we're not just doomed to follow the bouncing ball through endless cycles of romanticism/classicism, subjective/objective, feeling/intellect, etc. If the 60s proved that commitment didn't work, the 70s proved that lack of commitment didn't work either. The 80s decade is coming into a legacy of anxiety, of barely articulated challenge to boringly predictable mainstream art. It is going to have to restore the collective responsibility of the artist and create a new kind of community within, not apart from the rest of the world. The danger on all esthetic fronts is the kind of factionalism that already divides the politicized minority within the art world. Too many of us spend our time attacking everyone else's attempts at relevance while para-noically guarding our own surburban territories. There is an appalling tendency to insist on the need for theoretical understanding of the artist's position in a capitalist society and simultaneously to destroy by 'logic' every solution offered. It is all too easy for any intelligent observer to be devastatingly cynical about Marxists making abstractions, artists made vulnerable by working at the same time in communities and in museums, feminists riding the women's movement to commercial success and getting off there. The denial of support to an artist or group who is trying to work out of this dilemma we all share, the questioning about presentation, form, and motivation when it appears

that communication *is* nevertheless taking place, all this merely recapitulates the competition that maintains the quality-based 'high art' world.

Merely opportunist as some of it may be, art with overtly social content or effect still poses a threat to the status quo. And, ironically, no group is so dependent on the status quo as the avant garde, which must have an establishment to attack, reverse, and return to for validation. It is true that most politically aware artists and artworkers would sooner give up politics than give up art. Embedded in the whole question of why more visual artists aren't more committed to combining form and content in more interesting ways is the tabu against 'literary' art. Artists emphasizing words and ideas over formal success have been seen since the 60s as traitors to the sacred modernist cause; just as the Dadas and Surrealists are not considered serious contributors to modernism even when their *contributions* are considered serious. This sort of prejudice has been blurred by the mists of pluralism, but it remains as subtle conditioning. Because visual art is about making things (even if those things have no 'pictures'). And this is what visual artists justifiably don't want to give up. In the late 60s we got sidetracked by the object/non-object controversy. Sheets of paper and videotapes, though cheaper than paintings and sculptures, are still objects. Conceptualism, we know now, is no more generically radical than any other *ism*, but it's no less art.

Another major question we have to ask ourselves as we enter the 80s is: *why is it that culture today is only truly alive for those who make it, or make something?* Because making Art, or whatever the product is called, is the most satisfying aspect of culture? Its subsequent use or delectation is effective only to the extent that it shares some of that intimacy with its audience? Even as a critic, I find that my own greatest pleasure comes from empathetic or almost kinesthetic insights into how and why a work was made, its *provocative* elements. So the necessary changes must broaden, not merely the audience, but the makers of art (again a fact the feminist art movement has been confronting for some time over the issue of 'high', 'low', craft and hobby arts). Maybe the ultimate collage is simply the juxtaposition of art and society, artist and audience. Maybe that's what a humanist art is – it comes in all styles and sizes, but it demands response and even imitation. It is alive.

For the vast majority of the audience now, however, culture is something dead. In the 50s the upwardly mobile bourgeois art audience (mostly female) was called the 'culture vultures'. They didn't kill art but they eagerly devoured it when they came upon its corpse. As Carl Andre has observed, art is what we do and culture is what is done to us. That fragile lifeline of vitality, the communication to the viewer of the ecstasy of the making process, the motive behind it and reasons for such a commitment can all too easily be snapped by the circumstances under which most people see art – the stultifying classist atmosphere of most museums and galleries and, in the art world, the personal intimidation resulting from overinflated individual reputations.

What, then, can conscious artists and artworkers do in the coming decade to integrate our goals, to make our political opinions and our destinies fuse with our art? Any new kind of art practice is going to have to take place at least partially outside of the art world. And hard as it is to establish oneself in the art world, less circumscribed territories are all the more fraught with peril.

Out there, most artists are neither welcome nor effective, but in here is a potentially suffocating cocoon in which artists are deluded into feeling important for doing only

what is expected of them. We continue to talk about 'new forms' because the new has been the fertilizing fetish of the avant garde since it detached itself from the infantry. But it may be that these new forms are only to be found buried in social energies not yet recognized as art.

Notes

1 In conversation with the author. In this and other conversations and writings over the years, Baranik has been a rational radical voice in my art-and-politics education.

2 Robert Motherwell and Harold Rosenberg in *Possibilities*, 1 (1948).

3 Ad Reinhardt, *Arts and Architecture* (January 1947). Many of the ideas in this article have their source in Reinhardt's ideas and personal integrity.

4 Irving Sandler, *The Triumph of American Painting* (New York: Praeger, 1970). Max Kozloff, William Hauptman and Eva Cockcroft have illuminated the ways in which Abstract Expressionism was manipulated during the cold war in *Artforum*, May 1973, October 1973 and June 1974.

5 Jack Burnham, 'Patriarchal tendencies in the feminist art movement', *The New Art Examiner* (Summer 1977).

6 I don't know who coined the term 'retrochic', but it was used frequently during the controversy over the 'Nigger Drawings' show at Artists' Space, NYC, 1979. A classic practitioner is Norman Mailer, who in his 1957 *The White Negro* praised two hoods who had murdered a store owner for 'daring the unknown' in an 'existential' act, and who later said he 'felt better' after stabbing his own wife.

7 Douglas Hessler, letter to the editor of *The SoHo News* (21 June 1979) in response to a piece by Shelley Rice (7 June 1979) which bemoaned the prevalence of 'apolitical sophistication'.

8 J. Hoberman, 'No wavelength: the para-punk underground', *The Village Voice* (21 May 1979).

9 Ruby Rich, in *The New Art Examiner*'s special issue on 'Sexuality' (Summer 1979).

10 Richard Prior, quoted by Richard Goldstein in *The Village Voice* (23 July 1979).

11 Lauren Edmund, review (in the spirit of) 'The Manifesto Show', *East Village Eye* (15 June 1979).

12 Peter Frank, 'Guerilla gallerizing,' *The Village Voice* (7 May 1979): 95.

13 'Collage of Indignation' I and II were the titles of two separate exhibitions of art for social protest, the first a painted-on-the-spot collage in 'Angry Arts Week', 1967; the second a show of commissioned political posters at the New York Cultural Center and other locations in New York, 1970–71, organized by myself and Ron Wolin.

14 For more on Ariadne, see *Heresies*, 6 (1978) and *Heresies*, 9 (1980).

Marina Warner, 'The Front Page (London)' (1985)

From *Monuments and Maidens: The Allegory of the Female Form* (London: Weidenfeld and Nicolson, 1985), pp. 55–60.

Margaret Thatcher affirms the master fictions interwoven in British memory;[1] but not everyone consents to them. At Greenham Common, since 1981, protesters against the

nuclear defence policy of Great Britain and Cruise missiles in particular have attacked those fictions and sought to empty them of influence and meaning. The constantly changing members of the group camping outside the base took the label 'Iron Lady' at face value and flung it back in the face of the Prime Minister as an insult, as they evolved a long, complex, richly inventive allegory about good and evil, in which they were the champions of life, and their adversaries the soldiers of death. This group also knew that, by placing themselves near an active centre of power, and by confronting its force, they excited media attention on an international scale, and thereby increased remarkably in charisma. It is notable that a band of women, pitched in Berkshire in tents called 'benders', after the gypsies' most primitive shelters – plastic sheeting slung over a branch – with no official organization, no leaders, could have alerted so much anxiety about the deployment and control of nuclear weapons on British soil.[2]

Like a mediaeval morality play about the dangers and perils of Everyman (Everywoman), the continuing demonstration at the former USAF base, now officially under the British RAF, has unfolded a dramatic cycle of scenes about a visionary peace and a nightmare war. In real life, the protesters have undergone a series of ordeals, constructed as *tableaux vivants*, about their terrors, their hopes and the character of women and the female order. The media have given them unstinted attention, often hostile, often scornful, sometimes sympathetic, not because they were interested in the arguments or the ethics on the whole, but because 'Greenham Women', as the members of the peace camp have come to be typed, have wrought a theatrical *coup*: the battle of the sexes, something embedded in the deepest strata of common culture, a drama performed in the pubs, on the buses, in television sit-coms, in the gossip columns, as well as in Shakespeare's comedies, had been annexed to name the sides in a political struggle.

The women invert the perceived male order in a series of dramatic gestures: they throw back in the faces of the soldiers working in the base the image of men as the saviours and defenders of the world; pinning them down inside the wire, like prisoners in surroundings they have themselves made, the demonstrators literally hold up mirrors in which the men see themselves reflected, and make them willy-nilly represent and stand for the work they are doing. The protests are intended to brand them, to forbid them claims to individually mitigating circumstances, to make the forces accept they have given their allegiance to violence, impersonality and extinction. And the lines between the people inside the wire and people outside are drawn in the name of sexual difference. 'Greenham Woman' is a compound sign, personifying peace and love and the future, in an apocalyptic allegory of human struggle for survival in which 'Greenham Man' is the angel of death. A banner made by T. D. and C. I. Campbell and J. Higgs for the blockade of the Common in July 1983, just two months after Mrs Thatcher's resounding success at the polls, vividly expressed the polarity. On the left-hand – pink – side, milk, fruit, flowers and doves encircled the floating green earth proffered by hands, black and white; on the right – blue – side, bombs, hooded like phalli, a battleship, a tank, rockets and the two-headed eagle of imperialism surrounded a world shadowed and blasted by war. 'It's Them or Us', read the caption.

To look across from one of the beleaguered women's camps at the gates of the base, itself established in anticipation of beleaguerment on a worldwide scale by another, far more distant adversary, immediately introduces any visitor to Greenham to the two

symbolic worlds created by the protest. Concrete, wire, uniforms, grey, dark blue, machines, cleanliness, order, regulations characterize the space of the nuclear deterrent; its heart conceals the bombs. The focus of the women's camp is fire, too, the campfire, the kitchen, the ancient symbolic hearth where the flames of nourishment and trans-formation of a different kind were to be kept ever burning, the protesters hoped (though the series of evictions which took place throughout 1983 and 1984 made their ambition impossible). The space of anti-nuclear protest is improvised, makeshift, disorderly; the benders are put up here and there, razed by eviction squads, erected again. Coloured ribbons used to hang festively from the bushes, plaited wool in bright dyes decorated the women, their quarters, their few scant possessions: flowers, struggling through the rubble tipped on to the camp site by the Berkshire authorities to discourage the demon-strators, grew by the wire; the toys of childhood, puppets made like corn dolls, paint-ings of the mother goddesses and moon deities marked out the women's sphere. In one painting, a freedom fighter lifted a fist and proclaimed again in the language of liberty, 'I am a woman, and if I live, I fight, and if I fight, I contribute to the liberation of all women and so victory is born even in the darkest hour.' Another painting showed a woman crucified, her breasts and womb marked to indicate the body as the vessel of reproduction, for beside her a blackboard read, 'I am Woman/Inflicted with the burden of bearing mankind.'[3]

In the early days of the camp, one of the women began weaving webs of coloured wool, and thereafter the web spread as the symbol of the women's peace movement itself. An organic structure, found in nature rather than man-made, fragile in its parts and strong in its whole, adept at capturing and defeating large predators, woven in the manner women have worked for centuries, and also evoking memories of Gandhi's paci-fism, the web became an image of the message radiating from the peace camp and the bush telegraph which could gather hundreds, even thousands of women together for a mass protest.[4] It was used with telling, mythopoeic effect on 12 December 1983, when the fence of the base was encircled by demonstrating women who wove into the wire mementoes, toys belonging to their offspring or others, flowers, ribbons, snapshots of loved ones, of children, grandchildren, and all manner of peace offerings, to represent the private sphere of affection, stability and fertility which the protest desires so des-perately to maintain in the face of possible annihilation. Powerful at a symbolic level, the web even proved practical: the intricate tangle of symbols had to be laboriously unpicked by the authorities, proving far more arduous to clear than the rubbish of placards left by a more usual march. During the lie-in of October that year women enmeshed themselves on the ground under a tangle of wool and lay quiet; to pick them up and carry them off, the police had to cut loose the strands, an operation which forced them down to the women's level, to personal contact of a more delicate kind than the regular violent hauling and dragging and struggle of an arrest. On both occasions, the forces of the law found themselves undertaking a fiddly task of the kind women are traditionally required to do. In the film *Carry Greenham Home* (1984), made by two members of the peace camp, Biban Kidron and Amanda Richardson, one of the scenes shows the guards at the base attempting to unlock a bicycle chain placed on the main gate by the women. Unable to hack, saw or pick it, the police, ever increasing in strength, rushed the entrance in a posse. The lock did not give; the gate came away instead at its

hinges. The women laughed, as well they might, at the grim sight of force failing to prevail against humble craft.

Greenham Woman dances, keens, picnics in fancy dress, wears witches' costumes; constantly, she has recourse to archaic female customs and tasks, as mother, mourner, midwife and wisewoman. The imagery used derives from stock definitions of what is feminine, and does not hesitate to assume many descriptions of women's 'nature' which feminism has rejected. The female order presented by Greenham is nurturing, peaceable, kind, fostering, forbearing; women soothe, they comfort, their nature is sacrificial.

The protesters are indeed living out a life of extreme hardship: enduring their fourth winter at the time of writing, and under continual harassment, from bailiffs, police, soldiers, and from local youths, who have attacked them with pig's blood and excrement. The soldiers behave obscenely; their children make V-signs and have been taught to swear at the women. They endure it on others' behalf, to bring about a revolution in consciousness, to bear witness to the horror contemplated by the defence policy-makers. But in almost all other respects Woman, as dramatized by their gestures and protests, bears no resemblance to the people they have to be in order to act her; the text they perform does not speak directly of the anger, strength, celibacy, courage, unhomeliness, determination and militancy of the protesters, though of course their actions confirm all these qualities. The surface text says one thing, about love and peace, joy and the maternal character of women, but the way the message is conveyed upsets all assumptions any soldier in the base might have entertained about accompanying docility or desire to give pleasure, to accommodate, to obey. By confusing their enemies' impulse to chivalry on behalf of women and children, by robbing them of this rationale of war and soldiery, Greenham Woman has taken a master fiction and turned it inside out. She invokes a stereotype in order to shatter it, and in so doing she has earned her popular character as a deviant.[5]

Like the revolutionary sects of the seventeenth century, and like earlier millennial movements which also anticipated the end of all things, Greenham Woman wants to turn the world upside down and substitute her radical vision for the prevailing order of salvation. And the dream she performs sets the symbol of woman at its centre; the Greenham drama belongs to the long tradition of expressing virtue in the female form. The demonstrators embody the concepts they strive to put before us as an alternative. They have made fundamental sexual difference the premise of their vision, and they ground that difference in the body, from which their mental and emotional attitudes follow. They have hung rags dipped in red paint on the wire to symbolize menstruation, investing the blood from which babies could be born with apotropaic power to face out death. A child was born in the camp, out of a shared need to show that women on their own can deliver life as well as give birth, and do not need obstetricians and hospitals, identified with the impersonal, mechanistic male world. During the deeply ugly struggles when bailiffs violently seized the campers' possessions and turned them off the land in 1984, the women, trying to protect one another from manhandling, pleaded the privilege of their sex. 'She's a women, she's precious,' said one, trying to prevent a bailiff from pulling her friend into a van.[6] When some women returned, in the summer of 1984, eight of them commemorated the fortieth anniversary of the

bombing of Nagasaki by stripping themselves naked and smearing their bodies in ash and blood-red paint, thus crystallizing three years' sacramental imagery of the human body and the female body in particular.[7]

The courage and determination of women at Greenham pose a dilemma for a believer in nuclear disarmament and in sexual equality. The dominant voices among them hark back to the fantasy of the archaic, all-encompassing mother of creation, and this may be ultimately the most dangerous and intractable patriarchal myth of all, responsible for the long history of inequity argued from biology. The camp at Greenham acts out the predicament of women's marginal status and scapegoat condition. The protesters have harnessed the powers that the anomalous outsider within any society possesses, to inspire loyalty, sympathy and rage, to infuriate and alarm, to move and to prophesy. But some of the Greenham women do not see this as conferred by their adversary role, but claim such powers are intrinsically, essentially and uniquely female, the result of women's deeper intimacy with the life forces. Greenham women have been remarkably effective as propagandists, at raising the alarm, at uncovering the evasions of government, but the drama of the sex war they perform may have surprisingly traditional roots.

On returning from her holidays in 1984, Margaret Thatcher announced publicly and immediately that the returned demonstrators at Greenham would be again removed. Both the representative of due order, who has so judiciously avoided identification with the female interest, and the subversives who have risen up against the values she represents have been shown through newspapers and television all over the world as signifying something other than their own persons. The Prime Minister was elevated through an allegorical use of her figure at the time of the Falklands War, and she has played the part as well as she can, once it was thrust upon her. The peace campaigners at Greenham Common, and the sympathizers who have imitated them in other nuclear bases in Great Britain, in Italy, in the United States, by establishing women-only protests, have shown the inspiration and the zeal of religious radicals, the spirit of the Ranters and the Levellers and the Diggers, and the Quakers who are still active in the peace movement, when they enact, in the life they have chosen, or in small protests like the memorial for Nagasaki, or in mass demonstrations, the living allegorical drama of Everywoman, violated by her offspring who are blind to her gifts of life.[8]

Notes

1 See Clifford Geertz, 'Centers, kings and charisma: reflections on the symbolics of power', in J. Ben-David and T. N. Clark (eds), *Culture and its Creators: Essays in Honor of E. Shils* (Chicago and London, 1977), p. 171.

2 For Greenham, see Caroline Blackwood, *On the Perimeter* (London, 1984); Barbara Harford and Sarah Hopkins (eds), *Greenham Common: Women at the Wire* (London, 1984); Alice Cook and Gwyn Kirk, *Greenham Women Everywhere* (London, 1983); and Lynne Jones, 'On common ground: the women's peace camp at Greenham Common', in Lynne Jones (ed.), *Keeping the Peace* (London, 1985).

3 Author's visit, March 1983; see also 'Women for peace', special issue of *Feminist Art News*, 2 (1).

4 See Mary Daly, *Gyn/ecology: The Metaethics of Radical Feminism* (Boston, MA: Beacon Press, 1978), pp. 400–403, for development of weaving and spinning metaphors as fundamental to an essentialist feminism; and Mary Daly, *Pure Lust: Elemental Feminist Philosophy* (London: The Women's Press, 1984), passim, for her revival of 'webster' as a counterpart to 'spinster' as a positive name for a woman.

5 Cf. Geertz, 'Centers, kings and charisma', p. 168.

6 Scene in *Carry Greenham Home* (1984).

7 *The Times*, 13 August 1984.

8 Compare the dread expressed in women's testimonies in Cook and Kirk, *Greenham Women Everywhere*, e.g. Wendy's statement, pp. 20–1, with the 1649 confession of Abiezer Coppe, a Ranter, quoted in Norman Cohn, *Europe's Inner Demons* (London, 1975), p. 320. See also Christopher Hill, *The World Turned Upside Down: Radical Ideas during the English Revolution* (New York, 1972).

La Centrale, Montréal, 'Silence as a Vigil' (1991)

From *Parallélogramme*, 16 (4) (1991), p. 31.

We received a request. La Centrale (feminist group?) was invited to express an opinion on the Polytechnique massacre.

La Centrale cannot have an opinion or adopt a specific position as it is composed of numerous individuals who have different opinions. There is not just one feminism. No one woman can speak for all other women. La Centrale cannot speak for all of its members or for the community as a whole. This trend towards generalizations is another media trap. Each member of La Centrale is affected by the massacre, as are all women. None of them wants to turn it into a media event espousing *one single* position.

The media coverage of the event and the *spectacle* of the funeral services for the fourteen women were replete with all the codes and all the symbols of a society dominated by men. These attempts to *reassure*, to minimize the horror, have necessarily provoked a profound reticence, a denial of our emotions. Right up to the present day, women and women's groups in Montréal have been less *demonstrative* of their reactions than women outside Montréal.

In January 1990, several American women artists erected a monument commemorating the massacre. Such immediate reactions are purely spectacular and obstruct serious analysis of the events. La Centrale has received many artists' proposals dealing with the massacre from as far away as California. The fact that these women artists decided to submit their proposals to La Centrale led to a discussion within the Programming Committee on the possibility of defining its stance. The choices made by committee in an artist-run centre cannot be solely based on emotion or the desire to commemorate something. Rather, consideration is given to encouraging serious political reflection, and to formal and æsthetic values.

What about all the (other) women who are killed in one way or another in their (own?) kitchens? Many artists' proposals seemed to commemorate death itself instead of

denouncing the real problems underlying such an event. However, the current recession has aggravated women's poverty and the plight of the destitute in our society. The problems of violence, harassment and abuse of women are increasingly urgent. Therefore, we have often preferred silence to gestures made in vain. Silence as vigil.

Gail Bourgeois, Carole Brouillette, Barbara McGill Balfour, Suzanne Paquet, Programming Committee members, 1990–91

2.4 Education

Miriam Schapiro, 'The Education of Women as Artists:
Project Womanhouse' (1972)

From *Art Journal*, 31 (3) (1972), pp. 268–270.

The Feminist Art Program at the California Institute of the Arts has just completed its first quarter of the school year. Three months of joyous and exhausting work. Judy Chicago and I, embarking on this team-teaching experiment, are finding our collaboration in such an intensive teaching situation inspiring and liberating. Ideas and energy spark off from one teacher to another; and the feeling that one does not have to carry the entire responsibility for the Program frees us.

Methods of Teaching: Group Operation

Twenty-one young women artists elected to join this exclusively female class. We do not teach by fixed authoritarian rules. Traditionally, the flow of power has moved from teacher to student unilaterally. Our ways are more circular, more womb-like; our primary concern lies with providing a nourishing environment for growth.

Classes begin by sitting in a circle; a topic for discussion is selected. We move around the room, each person assuming responsibility for addressing herself to the topic on her highest level of self-perception. In the classical women's liberation technique, the personal becomes the political. Privately held feelings imagined to be personally held 'hang-ups' turn out to be everyone's feelings, and it becomes possible to act together in their solution, if there is a solution. Our use of this technique serves a different purpose. We are artists. We search for subject matter. It is often wearying to struggle alone for the courage to bring material to the surface which would be fit for artistic form. In our group we make laws based on mutual aesthetic consent to encourage and support the most profound artistic needs of the group.

Sometimes the struggle for subject matter assumes a different cast. We are able to find material to make art from, but we sense that the material is inappropriate. There

are some interesting unwritten laws about what is considered appropriate subject matter for art making. The content of our first class project *Womanhouse* reversed these laws. What formerly was considered trivial was heightened to the level of serious art-making: dolls, pillows, cosmetics, sanitary napkins, silk stockings, underwear, children's toys, washbasins, toasters, frying pans, refrigerator door handles, shower caps, quilts, and satin bedspreads. [. . .]

Paula Harper, 'The First Feminist Art Program: A View from the 1980s' (1985)

From *Signs*, 10 (4) (1985), pp. 777–781.

[. . .] In discussing the advantages and disadvantages of the [Feminist Art Program] FAP with a number of its former students, I found general agreement on the nature of the advantages. The program provided a psychological environment that gave them the confidence to trust their own instincts and judgment, even if their judgment was to leave or rebel against the FAP. It released their creativity. It was stimulating, demanding. It created a strong feeling of community and a conviction that the group was engaged in an experiment that was making history. Mira Shor described it as the 'boot camp of feminism,' implying an affectionate nostalgia for the hardships of its members' initiation. That feeling is one that bonds former students, no matter how severe their criticisms. Most of them acknowledge that for better or for worse the FAP changed their lives.

When they assessed the program's disadvantages, the former students showed more variety in their viewpoints. Some criticisms recurred, particularly that both Schapiro and Chicago had, in carrying out their ideas, been psychologically manipulative; that Chicago's psychodrama exercises created more emotional disturbance than her training could manage and therefore were potentially dangerous; that the students were encouraged to express anger toward men that not all may have felt; and that Chicago, especially, projected her own goals on the students and tried to dictate the content of their art. On the last point, Robin Mitchell noted, 'The students were not supposed to make abstract art. Making images like mainstream art was a terrible no–no. Judy was so doctrinaire about what art was: it had a hole in the middle. That was okay for her but not for me.'[1] These pressures to conform to the ideology of the community were resisted in varying degrees by many of the students, but Chicago felt them to be necessary: 'Since women have so much trouble bonding, it was very important in the early seventies to build an artificial environment which supported bonding.'[2] A former student's response was, 'It couldn't last too long. It was a forced situation, too artificial. At one time I thought I would throw up if I saw another drawing of a split pear.'[3]

The most troublesome aspect of the FAP, the one that generated the most serious and searching criticism from those involved, was its separatism. The students acknowledged that the sense of community was strongest when as a totally female group they

were working on Womanhouse in close, daily association away from the Cal Arts build-ing. When the separatism was most complete, the program was most successful. But a number of the former students are now bitter over what they see as the program's hos-tility to men. Students who were in relationships with men were often criticized; some were encouraged to repudiate their boyfriends or husbands. The emphasis was on the building of careers and the development of a professional life. They now question the sacrifices that were made for the goals of the feminist community and accept the goals themselves only as they can be modified as part of a larger social framework that includes men.

Was the separatism of the FAP worth the difficulties it caused? Wilding's response is, 'That's a hard question . . . I guess I'd have to say it was worth it, but it cost a lot. I'm only now beginning to realize how much it cost. But we wouldn't have made the gains without that drastic, radical dislocation of the status quo. Once you've done that you can't go back. You can go somewhere else but you can't go back.'[4]

Chicago's assessment of this issue is that failure to solve the problem of interaction between the community and the dominant male culture weakened the program.

> Since most of the women, including me, lived with men, when we left our group it was very easy to move back into our identification with men. One of the things that destroyed the FAP is that the students used to have to leave the safety of the program and reenter their bonds with men, and they were continually, every day, every hour, confronting where their loyalty and primary identification lay. There was continual pressure on them.[5]

A few lesbian members of the FAP did not experience this problem of conflicting loyalties, but their solution could not work for the majority of the women because of their own sexual preferences and social conditioning. Schapiro's statement on why she ultimately had to forsake a separatist women's community reflects these concerns.

> I am married to a painter, I have raised a son, I have parents who are part of my family. I could not adhere to a woman's community and keep one foot in a traditional nuclear family, so I was bound to go the way I did. One of the disadvantages with such a program is that you fall so in love with the community that you don't realize that in order to survive in the real world you have to play a different kind of role where you hop on one foot and then the other foot and that your manipulative resources have to be strengthened.[6]

The FAP, although short-lived, demonstrated that a community of women could deliberately effect change in their own creativity and direct it toward specific goals. The art that resulted from the interaction of the group was of a different kind from that concurrently being made by any individual male or group of males working tradition-ally or as part of a conscious vanguard. (It had, however, some precedents in the work of California artists Edward Kienholz and Bruce Connor.) This achievement stimulated the debate, already begun by Chicago and Schapiro, on the question of whether a specifically female art exists and, if so, what its nature had been in the past and could be in the future.

The debate itself, with the attendant, critical writing, probably encouraged the creation of the kind of art defined as 'female.' In the 1970s, the quantity of art by women that dealt overtly with female experience increased – or at least more of it was seen in national magazines and in exhibitions. When representational, this art dealt with sexual, domestic, and social experiences and situations. When abstract, it tended to use materials associated with women's experience and with the tradition of women's crafts as well as forms with a biological connotation. By the early 1980s, however, some women artists perceived that their creations of the 1970s had been adapted – sometimes expropriated – by male artists to different purposes. Schapiro, for example, began making collages in the early 1970s that incorporated pieces of pattern-printed and embroidered fabrics – tablecloths, curtains, and aprons. She called these 'femmages' to make their source in women's tradition clear. Schapiro took a leading role in the subsequent development of 'pattern and decoration.' This movement includes both men and women and provides an example of the way the experimentation carried on by women in the early 1970s has been accepted by men and absorbed into mainstream art. A difference remains in the way men and women use pattern and decoration, but it is not one readily apparent. A pattern painting by an artist like Robert Zakanitch, for example, deals with color, form, and modes of stylization – it is about the formal aspects of decoration. A similar painting by Schapiro is about the tradition of women's involvement in the decorative arts. Although the two kinds of work may appear very similar, there is a crucial difference in their intention. This difference, however, is often of little interest to the dealer or critic, and so women's special contribution to the movement can easily be overlooked. Schapiro feels that 'the real substance of the feminist contribution to the art of the seventies has never been acknowledged.'[7]

Feminist art – embodied for a short time in the FAP – has had a strong influence on broader developments in the 1970s. By the end of the decade the cool abstractions, deadpan Pop images, and conceptual art of the 1960s had to a great extent been replaced by an interest in pattern and decoration, in the figure, in images that express emotional states, in the autobiographical statement, in new syntheses of arts and crafts, and in the use of nontraditional materials. The women's art of the early 1970s opened up the possibility of a wider range of subject matter for artists in general and, after decades of formalist abstraction, seems to have stimulated an interest in content. But since the kind of imagery and attitudes that were engendered, recognized, and described in the early 1970s have been, to some extent, subsumed into the mainstream, women's art seems less visible now than it did ten years ago.

In the climate of feminist thought in 1985, a separatist experiment such as the FAP would probably not have much appeal. Now the challenge, as articulated by several former students, is to return with feminist goals to a social dialogue that includes men. Yet the problematic nature of the relationship between a community of women and the prevailing male culture remains. Some students felt that the FAP had failed to prepare them for the shock of the world of men in which they would have to compete; others said the experience of being in a women's community 'strengthened' them. Clear answers have not yet emerged on the most effective ways to strengthen women's consciousness of their own constellation of interests, activities, and powers; effectively communicate this to the general culture; and achieve and maintain public recognition of the equal value of women's contribution. Recent events suggest that some degree of

separatism is desirable, even if only to maintain a position from which a visibly female contribution can be made.

The differing directions taken by Chicago and Schapiro serve as illustration of the dilemma. While Chicago feels that an experiment such as the FAP could not be carried out now in a period of reaction and retrenchment, with institutions alert to potential disruption, she is still devoted to the idea of women's community – although not one tied to a specific place. The women whose needlework completes her designs for her *Birth Project* live all over the country. They consult with her by mail and telephone; she visits them in their homes, and they assemble periodically at her studio in Benicia, California. A regular newsletter documents progress. The sense of community necessary to women artists, she feels, comes from working together toward a shared goal, not from being together in the same place.

> The *Birth Project* is a decentralized community. It's about building a sense of community in people who are separated geographically . . . It's still very frustrating for me to watch women refuse to accept the evidence of history – which is that women do not achieve in isolation. They achieve in a context of support, and it's what's required and it's what's usually not there and that's why women go mad. The old communities of women huddled together for a sense of identification and survival. At some stage in their development women need to go through this. But huddling together is hardly a strategy for the future. The strategy for the future is to move into a new sense of the planet and a world community. This is where I feel I'm working.[8]

Schapiro has returned to the world she successfully inhabited before the FAP. Her combinations of collage and painting are formally excellent and can be situated in an aesthetic continuity with other twentieth-century developments. But to gain acceptance, she has had to compromise her feminist challenge to some extent. She is working within the system, and her art has necessarily been assimilated to it. Since she believes that 'all feminist revolutions are doomed in a patriarchy,' it would be foolish for her to take a revolutionary stance. From her current position she can make gains and offer younger women a solid model of a successful woman artist whose work has been nurtured by feminist ideas.

Women in the academic community face a similar situation. We exist within institutions that are dominated by male interests, preferences, and traditions. We are accustomed to working within the system, making the necessary compromises, 'hopping on one foot and then the other,' as Schapiro put it. This is a practical path, one resigned to small gains. While requiring tenacity and endurance over the long haul, it lacks the purity, drama, and possibility of creative leaps that a women's community can provide.

Notes

1 Robin Mitchell, interview with author, Los Angeles, California, July 1982.
2 Interview with Judy Chicago.
3 Mira Shor, telephone conversation with author, June 1982.

4 Interview with Faith Wilding.
5 Interview with Judy Chicago.
6 Interview with Miriam Schapiro.
7 Ibid.
8 Interview with Judy Chicago.

Griselda Pollock, 'Art, Art School, Culture: Individualism after the Death of the Artist' (1985)

From *Block*, 11 (1985), pp. 8–18.

The terms of the debate, Art, Art School and Culture, seem at first sight to link easily into a consecutive movement.[1] Art is taught at art schools and both institution and practice are part of Culture. On further reflection about the contemporary state of any one of these terms, let alone that to which they might refer, a profound disjuncture begins to fissure the neat simplicity of apparent inter-dependence.

Let me start with a mundane example from everyday experience. I regularly visit art schools either to give a lecture or as an external examiner and in recent years there has been a recurrent crisis over the assessment of a certain kind of art practice. It is usually photo-text, scripto-visual or some such form; it is often sustained by reference to a body of cultural theories; it generally handles questions of gender, representation, sexuality. The students offering such work are often well thought of intellectually and produce theoretically developed work in complementary studies and art history. Most of the resident staff don't like this work and can't assess it. (They still try to do so nonetheless.) To an art historian involved with a decade and a half of conceptual art as well as the diverse and substantial feminist practices of that period, such work if often not brilliant is both recognisable in terms of what it is addressing, what frames of reference are suggested, what work it is trying to do. It is by any criteria certainly assessable.

This conflict can be explained sociologically. There is in art schools a generation or two of teachers and artists whose sense of art and culture[2] was formed at a different moment from that of their current students. Confrontation with deconstructive practices is found hard to accommodate to their paradigm of art and its appropriate terms of assessment (such as does it move me?). Added to this cultural generation gap there is the fact that the majority of teaching staff in art schools are men and the majority of the students engaged in this tradition of work are women. Thus is produced a quite vicious antagonism. It is one thing to say that many art school teachers hold outdated notions of art having themselves been socialised within one form of modernism or another and that these folk find it hard to adjust to radical post- or anti-modernist art. Such an account falls within the legendary narratives of bourgeois histories of art with their radicals against academics. What makes the current crisis so acute and significant is that art schools have become a particular terrain of feminist struggle and masculinist resistance at a period of intense social conflict.

I am considering this issue from a feminist perspective. That much must by now be obvious. Such a viewpoint does not entail that I only address women and their (often ignored and repressed) participation in cultural production. It is a necessary part of feminist cultural intervention to analyse the nature of the discursive exclusion of women from the records which we call art history, the effect of which is to celebrate the great and creative as exclusively masculine attributes.[3] Man is an artist *tout court*. Thus a feminist is of necessity an analyst of mainstream ideologies of art and art education. These are not, however, mere historical relics. [. . .]

[. . .] Bourgeois concepts of art celebrate individualism by means of the idea of the self-motivating and self-creating artist who makes things which embody that peculiarly heightened and highly valued subjectivity. It is fundamentally a romantic idea of the artist as the feeling being whose works express both a personal sensibility and a universal condition.[4] What art schools today actively propose or promote any other concept of the artist, for instance, as producer, worker, practitioner?[5]

Consider the organising principles of many schools. The basic pedagogical plan is that the privileged independent spirits selected for the course at interview are given the opportunity to sink or swim. Space is provided, materials, a few technical resources. The student is expected to develop a programme of work, 'my work', that precious phrase, a project about which, from time to time a conversation is held in unequal, ill-defined and educationally lamentable conditions. Assessments, when recorded, tend towards personal comment and register from the staff point of view the kind of contact (was the student aggressive, resistant to advice, willing to take up suggestions etc. . . .). Undoubtedly many students thrive in this hostile and unsupportive environment, especially where their own sense of identity is implicitly reinforced by the hidden agenda of macho self-reliance and aggression, the son's battle with the father [. . .] The hidden agenda is institutional sexism. Let there be no flippant underestimation of what this intimidating and bizarre parody of an education means to women. Some have literally died of the experience.

One response to such a critique would come from educationalists. Many professional teachers not involved with Fine Art traditions find the typical art school scenario quite horrifying in the licence it potentially gives to those in full-time paid employment at an educational institution. Better teaching methods, more pastoral care cannot however be the answer, though they might be an improvement in the worst cases. What is overlooked in such a response is the structural contradiction which is at the root – the collision of two professions – artist and teacher; the collision of two ideologies – individualism and socialisation.

Education has been named as one of the major ideological state apparatuses – that is not just a place of learning, but an institution where, like the family, we are taught our places within a hierarchical system of class, gender and race relations.[6] The recent conflicts in the education sector between teachers, colleges and universities and the state have brought to the surface what is usually hidden, that education is a vital site of social management. Professionals of course deny their implication in state strategies by proclaiming the high ideals of critical education. Art schools are a particularly contradictory site. They are a location for the perpetual production of key ideologies. But, in practice, art schools deliver very little education. Indeed art students are put at a scandalous disadvantage (and ironically glory in it) *vis-à-vis* other students in higher and

further education. The absence, however, of systematic induction into an (ortho)doxy leaves open unexpected possibilities for counter courses, women's workshops etc. The rationale of the art schools is to train rather than educate artists, to become professionals who must compete with each other and other professionals in a difficult market for jobs and sales. Yet their training leaves them totally unequipped to grasp their place in the competitive world of business, professionalism or, no longer so inevitable, education. The school sustains a powerful sense of the being of an artist in total mystification of what working as one entails.

Art schools and especially the one in which this debate is taking place[7] are not immune from the social strategies of the present government and the political culture which supports it. All sectors of education are being asked to be more *productive*, i.e. to produce something quantifiable, both in terms of marketable goods and saleable personnel. Against this radicalism, traditional ideologies of art schools offer the weakest of defences, the ideals of High Culture:

> We certainly need to remain open to public needs and opportunities in the field of public art, but we must remain firmly established in the traditional role that art has held in society in the past. Art schools should be there to preserve and keep alive the higher values of art. As educationalists teaching in art schools we have a role to play in society. We need to remain firmly entrenched in values that society in its quest for economic survival tends to ignore. The values that artists hold inevitably have their source in a spiritual, rather than a mental or material one.[8]

Art is thus the realm apart from the utilitarian demands of economic survival, which as in the early nineteenth century must be protected for fear the higher values it alone secures will wither. Few ever dare to question what these values are, whom they serve or how justified is this division of the spiritual versus the utilitarian. History doesn't bear out the defence of higher values or the spirit in art.

[...]

[...] The insistence on artistic practices as products of a socially produced discursive category sustained by a community of specialist users – makers, consumers, managers and related professionals – is often coupled with more elaborated theories about the social production of the individual. Indeed in several influential trends in twentieth-century theories the individual is completely dissolved as an ideological category into the notion of a split, fragmented and mobile subject, held only in the place of illusory unity by the structures of language and society of which being a subject is but an effect. The most extreme statement of this position is associated with the structuralist Marxist theories of ideology and the interpellated subject associated with Althuserrian writings.[9] Related but distinct is the psychoanalytical intervention, also based on a structuralist premise about the split subject – conscious/unconscious produced as an effect of entering into the social/symbolic system of language.[10] Feminist theory has explored the implications of both these resources and articulated specific theories about the production of the gendered subject; that is, our sexuality is not natural, pregiven, innate, but the product of multiple determinations at the psychic and social levels.[11] Many of these have been deployed in the specific area of cultural analysis to argue for the so-called 'death of the author'.[12] A great deal of literary and

artistic criticism concerns itself with discovering in the works analysed the presence of the originating subject. The meaning thus found is often no more than what is claimed as the artist's intention.

In art history in particular supporting evidence is often directly biographical [. . .] In contrast it can be argued that the reader is in fact the author of the meanings of the work read or viewed. Yet to be able to make a reading of a work the reader/viewer must possess a modicum of social knowledge about the practice (what is a novel, a painting, a photograph?), what kinds of behaviour are appropriate, what kinds of readings will be recognised as art consumption and so forth. The reader/viewer therefore herself becomes a site for social exchanges which displace meanings from being a something put there or taken out to being a process of productive activity predicated again upon a social community. The death of the author, or the artist, as privileged individual speaking herself through the medium of work to a sensitised receiver is displaced by an awareness of the calculations and ventures of producers working within, for, or against the community of knowledges and expectations which constitute the social practice of which she is but one active participant. Where this knowledge is mobilised by feminist producers the challenge to the orthodoxies of art, art school and culture begins to appear in its true proportions.

Feminist practices in art schools therefore do more than irritate the established staff at the level of personal affronts to their masculine privilege as the Fathers and Sons of Culture. They threaten the dominant modernist paradigms of art and artist. Modernism is traditionally posed as radical, anti-establishment. This is of course a myth, for Modernism became by the third decade of this century the official art of the capitalist West and has been institutionalised as such since the 1929 foundation of the Museum of Modern Art in New York. Feminism and its cultural politics are inevitably posed against that Modernism. Indeed Lucy Lippard has defined feminist art as anti-modernist in her statement that the major contribution of feminism to the future vitality of art is its *lack of contribution to modernism*.[13] This is far too simplistic for it tends to equate modernism with only one recent phenomenal form, formalism, identify that with men and oppose to it women's art with its political or autobiographical purposes. Since the late 1960s western culture has been rapidly diversifying but it has been re-assimilated to the modernist concept of Post-Modernism (cf. Impressionism and Post-Impressionism coined by Fry and McCarthy in 1910 and sealed in modernist orthodoxy by Rewald in 1956).[14] Feminist concerns with figurative work, overt subject matter and personalised testimony can be accommodated in this renewed trend towards figuration and expressionism but subsumed as a second category of women's expressionism within the major trope of extreme claims to individualistic creativity in the Grand (Men's) Tradition.

More convincing is Mary Kelly's dialectical analysis of Modernism's contradictory field in the late 1950s and 60s, torn between objective purposes and transcendental subjects (Greenberg's pure opticality in painting and Rosenberg's action pioneers) which led to a serious threat to the economy of desire in Modernism's market.[15] The market she argues could not literally afford to sustain the loss of the author, the loss of that commodification of the name splattered across the canvas or sculpture or whatever. In the move towards abstraction what had been lost at the level of content – what the artist expressed through recognisable narratives or obsessional concerns – had been retrieved

by fetishising the trace of the artist at work, the gesture which comes to stand for the creative subject. The market has relished the revival of gestural expressionism, an added bonus for the associated producers of art literature who once again have biographical subjects to interrogate. This form of practice moreover satisfies the constant pressure for novelty within the diversified field of contemporary art. The predominant strategies of art school education – develop yourself, find your own project, define your own speciality – all these collate within that economic and ideological structure.

Faced with the conservatism of much that is heralded as post modernist art, some critics have attempted to distinguish between a conservative and radical trend. The progressive practices according, for instance, to Hal Foster produce a culture of exposé, shock, discoordination and disidentification.[16] One leading feature is to disown the notions of creative authorship by means of appropriation of publically authored media imagery or in order to force us to recognise the collective identities which seduce us from the billboards, cinema and video screens, magazines and t.v. programmes as well as the places of High Culture.

Feminist activity in this field addresses the deconstruction of the collective noun WOMAN in order to expose the social construction of femininity. Characteristic of this kind of feminist work is a rejection of the autobiographical personalised I as a point of identification for the audience with the artist as somehow embodied in the work. The loss of the author and the associated individualism upon which it rests cannot be seriously mourned by women because they have never truly enjoyed the privilege. As artists they have always been condemned to a collectivity of otherness, the category – women artists. As has been suggested the very notion of the individual as it emerged and was socially experienced rendered it a facet of the masculine. The Individual is a man in the public field of self-determination and it hardly needs to be rehearsed here how since the foundation of bourgeois civil society the feminine has been sedulously constructed as selfless, ever losing itself in the man it loves, the children it bears and nurtures, the parents it cares for, the tremulous emotionality with which it melts.

In cultural activity the expression of a point of view by a woman has traditionally been consumed as an expression not of an individual but of some facet of WOMAN. The struggle of women now is complexly caught between a resistance to the ideological collectivity of WOMAN and the construction of a politically conscious collectivity, the Women's Movement which requires to defend the specificity of women's experiences while refuting the meanings given them as features of woman's natural and inevitable condition. The struggle is therefore a collective one composed of distinct persons with particular and heterogeneous personal ends and means but neither of these is oriented towards the celebration of individualism.

The form which this exigency takes in feminist practices involves, on the one hand, creating for women the conversational communities of which they have been deprived. After fifteen years there is a feminist tradition with various strands, offering points of recognition, identification and indeed competition through which women can both locate themselves and develop related practices. There have also been, on the other hand, the production of what Rozsika Parker and I have called strategic practices to complement these practical strategies.[17] This work focused particularly around the issues of representations and sexuality, the title in fact of a recent exhibition *Difference: On Representation and Sexuality* which was first shown at the New Museum in New

York December 1984 and then at the Institute of Contemporary Art in London in September 1985.[18] The exhibited work demonstrated several of the tactics outlined above, the critique of authorship in the work of Sherrie Levine, the analysis of popular images by Silvia Kolbowski, the use of advertising methods to confront and discomfort a viewer who can no longer escape the sense of being got at in the work of Barbara Kruger. In the work of Marie Yates, Mary Kelly and Yve Lomax as it was shown in New York Paul Smith noted the strenuous refusal to locate the she or person speaking in the pieces with a specifically documentable woman. The effect is to make the viewer conscious of how much she desires to find within a work of art a secure locus of meaning either in a woman about whom a story is being told or in one telling the story. We scan the work for that identity around which our fantasies can be permitted to develop. Marie Yates exhibited a work called *The Missing Woman* (1983–4) which utilised all the rhetorics with which we are familiar from novels, magazines, serials and films. Narrative, biographical excerpts from diaries, photographs, mementoes, scenarios of intimate spaces, recorded conversations, all these typically promise us the plenitude of woman but their deployment and recalcitrance in this piece forces the viewer to recognise the fact of representational strategies, a fact which is overlooked in our normal consumption of their constructs as truths revealed.

Equally it is possible to use a first person noun within a text to allow for the fact that the producer of the work is to some extent referring to and drawing on particular and personal experience. But that experience is not displayed for a voyeuristic consumption of someone else's life, suffering or anxiety. It is subject to the rigorous revisions of being remade within a practice, it is thus changed to perform a job for the viewer, to provide active places for the viewer so that what is referred to in the work can be mobilised for the viewer to produce knowledge, not of the private circumstances of the work's producer, but of the social conditions within which that aspect of a woman's life intersects with aspects and concerns of other women's lives. This is particularly apparent in two works, one by Marie Yates called *The Only Woman* (1985) which handles a daughter's mourning of a mother, a search for a relationship through a social history which hints at a network of personal and familial histories and public collective histories which can conjoin private grief and the struggle of the miners.

Mary Kelly's new project *Interim* addresses the public and private faces of women as they confront getting older. The project (4 parts with several sections each) activates public discourse about women using as its sign the framework of J. M. Charcot's publication of photographs of women patients at his clinic in what he defined as five passionate attitudes of hysteria (Threatened, Supplication, Eroticism, Appeal and Ecstasy). But whereas in the three volumes of images *Iconographie Photographique de Salpetrière (1877–80)* a woman's body is exposed to the scrutinising gaze, Mary Kelly has displaced that woman as object by a trace, i.e. an object belonging to a woman which thus functions as both a sign of a person and at the same time a reminder of the public discourse of fetishism in which parts of women's bodies and their attributes are reworked in fantasy to stand for the object whose lack in woman threatens the masculine viewer.

In the first section of the first part (there are four major parts of the project – The Body, History, Money and Power) a black leather jacket is used as the object of clothing and it is presented in a number of different poses each of which is suggestive of

one of the ways in which a woman's sexual identity is constructed: fashion and beauty, medicine, romantic fiction. Thus there are several layers of reference available to be activated, some general knowledge, others more specialist, and focusing their resonances is a piece of written narrative, in part a scene, in part conversations, in part analysis, giving access to the procedures – of consciousness raising, personal testimony, historical and theoretical analysis – by which women have been learning to make sense of and produce knowledge of the social world which endlessly plays over their minds and bodies producing them but never entirely captivating them within its contradictory and discontinuous patterns.

What gives such work specificity is not any simplistic opposition to modernism but the complex strategies evolved by such practitioners to produce a certain kind of image and discourse which is both recognisable as art – it means to be nothing else – but which constantly erodes the ideological limitations to which historically the dominant definitions and procedures have constrained the making of art. This artistic practice intends to reinsert art in the social and in history – and that means it addresses and works upon the ideologies and social relations of class, gender and race.

What this article has been concerned to articulate are the complex relations between feminism and modernism in current art, art schools and culture. Women have trouble in art schools because they are the bastion of reactionary ideas about art, teaching, self-expression and above all individualism. The positions sustained by these ideas are difficult if not impossible for women to adopt without some severe distortion or negation of aspects of their particularity as persons – they can become one of the boys, or accept being graceful and decorative. The problem exceeds the simple but harrowing daily experiences of sexist behaviour – from ribald jokes to intimidating or patronising encounters with teachers. These could and do happen anywhere. What makes the institutional sexism of the art school more violent is the interface between a sexist hierarchy of staff usually all male (full-time) and students (many of whom are women) with the structural ideologies of the practice, the production of saleable individualism masked as the pursuit of personal truth, the truth of an artist. A feminist consciousness in art schools is often an existential response to daily tribulations. Feminist artistic practices, however, develop a sustained critique of both the economic exchange and the ideological formation of which current art and art schools form the discursive and institutional base.

The women who produce work which belongs to this tradition of feminist strategic practices are experienced as threatening; their novelty is barely accommodated even within the most pluralist establishment for their particularity as members of a conversational community is simply not recognised. They defile the category existing for self-conscious women artists, namely women's art, while defying the authority of Art, and Artist in their masculine privilege. Over and over again I have heard and been told of the ways in which women thus involved are dismissively categorised as 'that bunch', that lot, the feminists. In one instance several students were actually assessed as a group because of the commonness of purpose and despite the difference of strategies. Would anyone ever imagine assessing all the gestural painters as a group as that lot of modernists, or neo–expressionists, or whatever? As I have argued elsewhere femininity was once the blanket term through which women's art was marginalised, now feminism performs the function of disqualifying the work from being seen as art.[19]

There are numerous substitute definitions – it's all theory, it's all politics, it's all too personal – they vary but at heart they say the same thing. What is different, however, is the feminist critique exposes the skeleton in the cupboard by insisting upon the relations that art and art schools sustain to the social world, to the culture of class, of a sexist and racist society. And furthermore the argument is that art and art schools are actively involved in its reproduction – and not a protected realm apart for the cultivation of higher, spiritual values. It is therefore urgent not to confront the Higher Education policies of the present administration with retrenchment behind the lines of Individualism, Creativity and High Culture, or with a born-again messianic avant-garde. In April 1984 Martha Rosler and John Tagg debated this issue on Channel 4's *Voices*. John Tagg pointed to the survival of the idea of the special mission of the special person, the artist in Martha Rosler's otherwise exemplary statement about the necessity for resistance to incorporation and the mounting of critical interventions from what she called the margins.

> Only those artists who raised their voices on the outer bounds of the high art world were able to speak with the urgent impetus of a challenge which goes beyond style . . . The art world, like the mass media, has learned to fill the void at its centre by sucking into it these figures at the margins. Black, Third World, gay and lesbian, political and street culture artists supply the necessary transfusion of energy and style, and social conflict magically appears solved by this symbolic acceptance of the socially dispossessed. The art system has recently entered a period of strongly renewed control by dealers who mean to regulate production and reputation . . . It is only marginal figures who still represent the oppositional trend yet in a hungry market they too are candidates for celebration virtually as soon as they emerge. It is only through guerilla strategy which resists deadly universalisation of meaning by retaining a position of marginality that the production of critical meanings still remains possible. It is only on the margins that one can still call attention to what the universal system leaves out.[20]

In contrast John Tagg argued for a more centrally focused and calculated programme of interventions based on a full understanding of the numerous participants in the production of culture and thus abandoning the residual avant-gardism which still privileges the artist as the voice outside the city gates, able to make these critical meanings alone in the studio garret on the margins.

> The specialness of the artist, point of honour of the avant-garde and held fast even by practitioners like Martha Rosler, can no longer serve as a mobilising myth. Cultural institutions require a whole range of functionaries and technicians who contribute their skills or service cultural production in a whole range of ways. A painting is as much a collective work as a film and only takes on the currency of social meaning through the application of multiple levels of expertise. It follows, then, that any adequate cultural intervention must be collective – as collective as advertising, television or architecture – as collective as the accumulated skills, the layers of habit, practices and codes, production values, rituals of procedure, technical rules of thumb, professionalised knowledges, distinctions or rank and so on, which makes up the institutional base.[21]

It is evident from this kind of statement that a great deal of theory is being mobilised, theory about production, society, history, the subject, and so forth. Very little of it is so called art theory. I teach, as John Tagg used to, the course at Leeds University on the Social History of Art. It attracts a lot of applicants from Fine Art courses who are aware of a serious absence in their education, a lack not just of art history but of the means of understanding art and its history past and current. The course spends a great deal of time reading texts on historiography, theories of society as a complex totality, theories about language, subjectivity, ideology. What is being offered is some means to map a place as cultural producer in the social synthesis of which cultural production is a part. This should be one of the jobs of art education, to produce for its students a usable knowledge of the social and of culture's complex relations to the structures of economic, social and political power and to the production of meaning. These tasks become more urgent precisely because the world we now confront threatens to lose us in the gloss and glitter of its spectacle while demanding the art students to become its ever more explicit functionaries.

I have posed the struggle throughout this article in terms of a conflict of gender power. I cannot leave the subject without further reference to the question of race. There is a massive absence in British art schools of students from the growing sections of the multicultural communities. This absence speaks of an even vaster gap between the Eurocentric Western ideal of competitive Individualism and the cultural and social experiences of Afro-Caribbean and Asian peoples. The changes needed now can only come about with both the recognition of the specificity of these peoples' struggles against racism both inside and outside other politically progressive moments and by some form of alliance between the displaced and marginalised, the dominated. Art schools may never be high on the general political agenda, but culture in its broadest sense is now the scene of massive investment and attempted regulation. Art schools will remain the privileged site for the reproduction of white male supremacy, and as such an easy target for and all too willing ally in the doomed Thatcherite reconstruction of imperial Britain unless the double challenge of feminist and anti-racist struggles is confronted now.

Notes

1 This article is a corrected version of a lecture given at the Royal College of Art on 14 June 1985, in a series of seminars organised by Guillem Ramos-Poqui and the Students' Union. The other speaker in this debate was Professor Philip King.

2 The reference to the title of the collected essays by Clement Greenberg published in 1961 is intended.

3 Rozsika Parker and Griselda Pollock, *Old Mistresses: Women, Art and Ideology* (London: Routledge and Kegan Paul, 1981).

4 H. Abrams, *The Mirror and the Lamp: Romantic Theory and the Critical Condition* (London: Oxford University Press, 1953); M. Shroder, *Icarus: The Image of the Artist in French Romanticism* (Cambridge, MA: Harvard University Press, 1961).

5 W. Benjamin, 'The author as producer', in *Understanding Brecht* (London: NLB, 1973).

6 L. Althusser, 'Ideology and ideological state apparatuses: notes towards an investigation', in *Lenin and Philosophy and Other Essays*, trans. B. Brewster (London: NLB, 1971); K. Jones and K. Williamson, 'The birth of the schoolroom', *Ideology and Consciousness*, 6 (1979).

7 The Royal College of Art; see note 1.

8 Philip King – statement made for the debate 14 June 1985.

9 See note 6.

10 For a useful discussion of Lacan's notion of the subject, see Rosalind Coward and J. Ellis, *Language and Materialism* (London: Routledge and Kegan Paul, 1977), ch. 6, 'On the Subject of Lacan'.

11 Rosalind Coward, Sue Lipshitz and Elizabeth Cowie, 'Psychoanalysis and patriarchal structures', and Cora Kaplan, 'Language and gender', in *Papers on Patriarchy* (Women's Publishing Collective, 1976). See also J. Mitchell and J. Rose, *Feminine Sexuality* (London: Macmillan, 1982).

12 R. Barthes, 'The death of the author', in *Image–Music–Text*, trans. and ed. S. Heath (London: Fontana, 1977).

13 Lucy Lippard, 'Sweeping exchanges: the contribution of feminism to the art of the 1970s', *Art Journal*, 41 (1–2) (1980): 362–5.

14 F. Orton and Griselda Pollock, 'Les données Bretonnantes . . .' (review of 1979–80 exhibition on Post-Impressionism), *Art History*, 3 (3) (1980).

15 Mary Kelly, 'Reviewing modernist criticism', *Screen*, 22 (1981); reprinted in B. Wallis (ed.), *Art after Modernism: Rethinking Representation* (New York: New Museum of Contemporary Art, 1984).

16 H. Foster, *Post Modern Culture* (London: Pluto Books, 1985).

17 Rozsika Parker and Griselda Pollock, *Framing Feminism: Art and the Women's Movement 1970–85* (London: Pandora Press, 1987).

18 This is not a full discussion of the exhibition for it omits reference to the three men who also participated whose work also addresses the issues of sexuality and representation, Ray Barrie, Victor Burgin and, to a lesser extent, Hans Haacke.

19 Griselda Pollock, 'Feminism, femininity and the Hayward Annual 1978', *Feminist Review*, 2 (1979); reprinted in Parker and Pollock, *Framing Feminism*.

20 Martha Rosler, statement made to Brook Productions, 1984.

21 J. Tagg, 'Post-modernism and the born again avant-garde', paper given at Newcastle Polytechnic, 1984.

Moira Roth, 'Teaching Modern Art History from a Feminist Perspective: Challenging Conventions, my Own and Others' (1987)

From *Women's Studies Quarterly*, special issue, 'Teaching about Women and the Visual Arts', 15 (1–2) (1987), pp. 21–24.

If the art of Frida Kahlo and Tina Modotti has appeared to be detached from the mainstream this by no means entails any loss of value. In many ways, their work may be more relevant than the central traditions of modernism, at a time when, in the light of feminism, the history of art is being revalued and remade.

Laura Mulvey and Peter Wollen[1]

Kollwitz is best known for many lithographs portraying the conditions of the working class before the rise of National Socialism. No one has excelled her portrayal, with a few broad and fluent lines, of the agonies caused by war, inflation, disease, and economic chaos, but her work, however estimable for its humanitarian purpose, lay slightly outside the formal developments of strictly modern art.

George Heard Hamilton[2]

Who defines the developments of 'strictly modern art' and why? And how do such definitions as Hamilton's affect a feminist teaching of modern art? With nonchalant conviction, George Heard Hamilton reiterates the standard litany about the values and developments of modern art in his widely used 1970 textbook, *Nineteenth and Twentieth Century Art*. Hamilton grants only one paragraph to Käthe Kollwitz, despite her acknowledged achievements, because she lies 'slightly outside the formal developments of *strictly modern art*' (my italics). This litany, with its singular concern for formal innovations and its consequent roster of approved artists, is very familiar to me. I was brought up on it in college. But over the past fifteen years, this approach has become less and less tenable for me as it has for many feminist and/or socially and politically sensitive art historians.

This essay will address two questions: what is wrong with this litany? And what are alternative ways to teach modern art history? Before turning to these questions, however, I want to describe the slow process by which I came to them. Dealing with these questions has been a twofold process. First, I had to re-educate myself. Second, I have tried to restructure my courses so that they would not only include more women artists but, even more importantly, be taught from a feminist perspective. Given the abundance of published material, it has been relatively easy to become more knowledgeable about women artists of the last two centuries. Far more difficult has been the task of developing a gender-based understanding of art history. In the latter part of this article I will discuss some of the ways in which I am trying to accomplish this in my current teaching, including revisions of existing survey courses, which I have taught frequently over the past fifteen years or so, and a new series of specialized courses on women and modern art.

Let me begin with my own re-education which started after having jumped the hurdles and run the course earning me a PhD (with a dissertation on Marcel Duchamp) at the University of California at Berkeley in the 1960s. The first step was to teach myself to examine, and ultimately to reject, the underlying male assumptions about art history that had been presented as the objective voice of scholarship during my graduate training. Berkeley was politically radical at the time but my radical art history consciousness raising began in the 1970s. In the 1980s it has continued, even more compellingly so.

In the 1970s, the core feminist texts that circulated and recirculated within the California feminist art community included Linda Nochlin's article, 'Why Have There Been no Great Women Artists?' (1971), the early issues of the *Feminist Art Journal* (1972), and, a little later, *Heresies* and *Chrysalis* (both started in 1977), and several historical surveys of women artists. These readings opened up new worlds and visions for us, as did Judy Chicago's autobiography, *Through the Flower: My Struggle as a Woman Artist* (1975) and Lucy Lippard's writings on contemporary women artists, *From the*

Center: Feminist Essays on Women's Art (1976). Finally, in 1976, under pressure from the feminist art community, the Los Angeles County Museum of Art sponsored a comprehensive survey of women painters from the Renaissance to the present: 'Women Artists: 1550–1950,' curated by Ann Sutherland Harris and Linda Nochlin. Suddenly, we could *see* firsthand our own history.

During the 1970s, I lived mainly in southern California. While teaching at the University of California at Irvine in the early part of the decade, I joined a consciousness-raising group as well as a large action-oriented group of Los Angeles women artists, critics, and historians. I formed many close friendships with women artists and critics and began to write on the contemporary women's art movement. In 1974, I joined the faculty of the University of California at San Diego, an ambitious avant-garde department, which includes both artists and historians. Because of my own interests and the department's emphasis on contemporary art practices, many of my courses were devoted to art and criticism of the 1960s and 1970s. These courses led me to question and challenge standard art history litany as it influenced the reading of contemporary art. In these courses I emphasized women artists and their work, and the processes, media, and movements in which women led the way. My feminist values also profoundly shaped my selection and assessment of contemporary male artists.

Earlier art history, however, was much more problematic to teach from a feminist perspective. For a number of years I continued to teach nineteenth- and early twentieth-century art history along the conventional lines of the evolution of individual careers and art movements, and to accept unquestioningly the dominating role of the avant-garde. Only with difficulty (and, as I now read it, with damage) did I fit our new heroines into these patterns.

A good example is the case of my nineteenth-century art survey. I would begin admiringly with Jacques-Louis David moving inexorably toward his 1789 revolutionary role in France, and mention in passing Elizabeth Vigée-Lebrun, the court painter of Marie Antoinette. I was embarrassed by her politics and, therefore, neglected her artistically. In lectures on the Romantic and Realist movements, I gave Eugène Delacroix and Gustave Courbet prime time while Rosa Bonheur made a brief appearance at the end. When speaking on Impressionism, I focused on the 'dominating' innovations of Edgar Degas and Claude Monet and placed Mary Cassatt and Berthe Morisot in the role of 'also rans.'

Women artists in the early twentieth century did not fare much better in my courses. Like Hamilton, I too gave Kollwitz short shrift – much as I was moved by her work – because I never quite knew what to do with her (or Paula Modersohn-Becker) in lectures on German Expressionism, a movement (or rather movements) led by Ernst Ludwig Kirchner and Wassily Kandinsky, whom I accordingly starred. In my discussion of the international drive toward abstraction in the early twentieth century, I focused on the art and theoretical writings of Kandinsky, Piet Mondrian, and Kasimir Malevich. But what was I to do about the abstraction of Sophie Taeuber-Arp? As with Kollwitz, I could not accommodate Taeuber-Arp into the litany. Dazzling and brilliant as her paintings were, they came too late chronologically; in addition, she theorized insufficiently about their meaning. I was still too obedient to these visual and verbal authoritative male texts, to the idea of chronological 'firsts,' and to leadership roles in avant-garde art movements to do anything but mention Taeuber-Arp in passing.

In the past few years, it has become apparent to me (and many others) that this additive approach does not function well. I needed to re-educate myself further. Accordingly I went back somewhat feverishly to my bookcases and the library stacks to reread the sources from which I had received my training in modern art history. And, far more constructively, I began to reread contemporary feminist criticism of the litany of that history – to reread articles and books that earlier I had presented in courses when (and only when) I was talking specifically about feminist art history and criticism.

Over and over again in writings of feminist and feminist-Marxist critics,[3] the litany was criticized for:

1 Structuring art history as a history of individual careers – with the emphasis on the individual genius and freedom of the artist – and of dominant art movements.
2 Ignoring gender as well as class and race when considering art and the circumstances of its inspiration, iconography, commission (if commissioned), exhibition, and critical reception.
3 Focusing on 'high' art and ignoring popular and 'low' art. Furthermore, within the category of high art, paying scant attention to certain media (notably photography) and genres (portraiture, etc.), and the art production of certain regions (e.g. seventeenth-century Dutch art, nineteenth-century American art, and the whole arena of non-Western art).
4 Neglecting work that does not fit into the concept of the avant-garde and its development and concerns over the last hundred years or so.

Obviously the basic issue here was the need to rethink art history itself rather than merely to insist upon the inclusion of women artists into an unrevised history. The next issue in light of all this was how was *I* to revise my teaching?

I teach a recurrent series of survey courses that begin with the late eighteenth century. In attempting to revise them I return over and over again to the following questions:

1 What are the current issues to stress in teaching the wealth of new material that has been published on women's art over the past fifteen years?
2 Should I leave out 'old' material if I am to include so much new material?
3 How do I integrate the new and old material?

The first question was the easiest. At the beginning of the current research on the history of women artists, there was an understandable inclination to present too abundantly the new biographical data (often seductively anecdotal) and to neglect slightly the art itself. We also amplified at length on the limitations and difficulties that beset the psyches and careers of almost all women artists. Generally, in order to cope with the welter of new material, and to impose some sort of initial pattern on it, we tended to stress common denominators, be they biographical or formal.

In the mid-1980s, however, it is high time to develop a more subtle understanding of the relationship of the artist's biography and her art. It is high time to study more meticulously and theoretically the art itself, and to take on the sticky issue of critical criteria. It is high time to discuss what women artists do well – for example, the par-

ticipation in the development of genre in the nineteenth century, and portraiture in the twentieth century – instead of primarily focusing on their often troubled and tangential relationships to avant-garde artistic movements. Finally, it is high time to savor and analyze the differences between women artists who work within a specific time or geographic frame, genre, ideology, class, or race.

Take, for example, the topic of women and photography in nineteenth-century England. When I first began to lecture on the incisive portraits and dreamy pre-Raphaelite narratives of Julia Margaret Cameron, I would compare her to Nadar, the French photographer. Now, in discussions of Cameron's work, I find it more significant to compare her images and concerns with those of male Victorian photographers, and even more significantly, with the haunting and elusively intimate scenes of Lady Clementina Hawarden, a lesser-known but highly original English aristocratic amateur photographer. I also show examples of Hannah Cullwick's working-class, idiosyncratic photographic fictitious 'self-portraits' – as a hardworking maid, a slave, a chimney sweep, a Shropshire peasant, and in male attire.[4] The comparison of Cameron, Hawarden, and Cullwick facilitates discussion of the differences in class as well as the commonality of gender between women. It also broadens the general discourse on nineteenth-century photography.

Class differences certainly cause profound variances among women artists as to their intent, imagery, and audience. Equally, profoundly different life experiences can differentiate dramatically the art of women who otherwise have much in common. As a classic case study of the impact of individual life experiences on art, I have students in my twentieth-century survey read biographies of Frida Kahlo, the Mexican painter, and Tina Modotti, the American photographer. Ideologically and socially, they possess much in common. In the aftermath of the Mexican Revolution, both of them lived and worked in Mexico City in the 1920s and their mutual circle was that of left-wing artists, writers, and revolutionaries. Their art, however, appears remarkably different. Kahlo's preoccupation with self-portraits is diametrically opposite to Modotti's photographs of working women with children, demonstration meetings, and still lives composed of bandoliers, guitars, sickles, and corn-cobs. I have students read a brilliant 1982 comparative study of the two artists by Laura Mulvey and Peter Wollen. In a section on the 'Discourse of the Body,' Mulvey and Wollen argue convincingly that Kahlo and Modotti were deeply affected, politically as well as psychologically, by their contrasting experiences of the body: 'The art of both Kahlo and Modotti had a basis in their bodies: through injury, pain and disability in Frida Kahlo, through an accident of beauty in Tina Modotti's.'[5] [Kahlo underwent innumerable operations and Modotti had once been an actress and model.]

Mulvey and Wollen conclude their essay by questioning the values of the modernist litany that detaches the art of Kahlo and Modotti from the mainstream (see the quotation at the beginning of this article). In the mid-1980s, we should be evolving a new way of seeing and teaching modern art history in which artists such as Kollwitz, Taeuber-Arp, Kahlo, and Modotti hold central rather than peripheral positions.

The answer to the second question (should I leave out 'old' material?) is emphatically yes. To revise art history we must ditch some baggage from our litany-trained past. It is essential to give ourselves permission to leave out art works previously judged to be necessary for the responsible teaching of a survey. Do we, therefore, include every

woman artist and give up teaching the Van Goghs and Picassos? Of course not. But we can resist temptation to trace the chronological developments of all such artists. That 'tracing' has always taken up a considerable amount of lecture time in traditional surveys. Not only is it time-consuming but, even more importantly, such tracings of early work to mature/great work often lead one down the primrose path of the Great Geniuses approach to art history.

The third question (how to integrate new and old material?) is also easily answered in theory but difficult to execute in practice. As mentioned earlier, I had found the piecemeal approach of addition (be it adding women artists or photography, American art, folk art, caricature, etc.) did not work. Rather a wholesale revision of *all* material was necessary. Key in all this is the examination of how gender together with class and race affect *all* artists, for to discuss the effect of gender only in the case of women artists places us yet again in the role of the 'other' (a once-useful term/analytic structure that is now not only outworn but also pernicious). Thus, I am now radically changing the structure of both individual lectures and of entire courses. Below are specific examples of such rethinking drawn from a nineteenth-century survey I taught last year.

The first lecture of this survey introduced a range of alternatives and possibilities in art training and in the commission/patronage/gallery criticism structure for a group of European and American artists – notably Angelica Kauffmann, Jacques-Louis David, Giovanni Piranesi, Harriet Hosmer, Edmonia Lewis, and the Peale family (especially Charles Wilson and Sarah Peale). I stressed the impact of artistic genre and medium as well as gender, class, and race, and of the dictates of place and time as well as the artist's psychology and ideology. The intent in this first lecture was to challenge the belief of the students that art history is the story of individual geniuses and acts of artistic freedom.

The topics of the next two lectures were 'Rome: Past and Present' and 'American Artists in the New and Old Worlds.' In the lecture on Rome, I presented the city as a palimpsest in which Antique, Renaissance Catholic, and nineteenth-century contemporary Rome acted as lodestars for different artists: Piranesi, Kauffmann, David, the German Nazarenes, Theodore Gericault, and finally the 'White Marmorean Flock,' those astonishing American women sculptors (among them Hosmer and Lewis) who came to study and live in Rome in the middle of the century. In juxtaposition to Rome, we then studied the art activities in America of the Revolution and the new Republic. Finally the class looked at the France of Vigeé-Lebrun and David and the England of Joshua Reynolds and James Gillray in the later eighteenth century.

Thus, by the end of the fourth lecture, we had explored the period's possibilities in artists' training, professional opportunities, and genre in their historical and geographical frames. Gender became a distinctive perspective through which to study both male and female artists, not just a way to include notable women artists. These early lectures also set the tone for my desire to disrupt the litany's single-minded focus on grand French art and on the tracing of the onward-and-upward emergence of the European avant-garde in the middle of the nineteenth century.

In addition to revising my existing courses, I am also constructing a series of ongoing seminars in the history of modern women artists, women's culture and history, and

feminist critical theory. For example, I am now considering such topics for future seminars as 'Victorian Women in Art and Life,' 'Women Artists and the Women's Movement in Germany and Russia, 1900–1920s,' and 'Gender, Race, and Class in American Art of the 1930s.'

My first attempt with this new format was in 1986 with a seminar entitled 'The New Woman in America, 1893–1920s.' This began with the arts and politics of the 1893 Chicago Woman's Building (for which Mary Cassatt painted her fifty-foot-long *Modern Woman* mural) and continued through to the 1920s, the decade in which American women won suffrage. We tracked the emergence of the 'New Woman' as she appeared in life, literature, and the arts. We looked at the dance of Loie Fuller, Isadora Duncan, and Josephine Baker, turn-of-the-century etiquette books, the buildings of Julia Morgan, the music of Amy Beach, the history of women's education, the pottery of Maria Nichols and Maria Martinez, the family portraits of Florine Stettheimer, the biographies of Elizabeth Cady Stanton and Emma Goldman, the sculpture of Meta Vaux Warrick Fuller, and the photographs of Gertrude Kasebier, Frances Benjamin Johnston, Tina Modotti, and Alice Austin. Out of our research on these and other subjects, we produced a 'book' on a laser printer of student essays, biographies, chronologies, and annotated bibliographies – and I plan to make a sequel to this book when I teach the material the next time around.

I feel that such specialized courses – if the constraints of one's teaching load permit – are better responses now to the current state of research than the galloping style of our earlier women artist surveys. Such specialized courses are not only innately necessary and interesting but they are also necessary politically these days on most campuses. They are loud and clear reminders to one's colleagues, students, department, and administration of the existence of a highly sophisticated body of feminist theory and concerns. At the same time we do not want to ghettoize women artists into the exclusive context of 'women studies.' Obviously, women artists and gender analysis should be part of *all* art history courses.

The litany of modern art history has to be discarded. The integrity of our discipline demands that the insights and information provided by feminist scholars be used not to include the occasional woman artist into the saga of male geniuses but to redefine the perspectives and values of modern art as a whole.

Notes

1 Laura Mulvey and Peter Wollen, 'Frida Kahlo and Tina Modotti', in *Frida Kahlo and Tina Modotti* (London: Whitechapel Art Gallery, 1982), p. 27.
2 George Heard Hamilton, *Nineteenth and Twentieth Century Art: Painting, Sculpture, Architecture* (Englewood Cliffs, NJ: Prentice-Hall and Harry N. Abrams, 1970), pp. 192 and 194.
3 I am particularly indebted to the writings of Carol Duncan, Lucy Lippard, Linda Nochlin, and Griselda Pollock.
4 See Liz Stanley (ed.), *The Diaries of Hannah Cullwick: Victorian Maidservant* (London: Virago, 1984), and also an intriguing essay by Heather Dawkins, 'Politics of visibility, domestic labour, and representation: the diaries and photographs (1853–74) of Hannah Cullwick', *Parallélogramme*,

10 (4) (1985): Symposium on Feminism and Art. (I am deeply indebted to Heather Dawkins for introducing me to the study of Cullwick.) Over the years, Cullwick commissioned a sizable number of images of herself from local photographers and these together with her diary constitute Cullwick's ambitious analysis of herself and her experiences as a servant in Victorian London.

5 Mulvey and Wollen, 'Kahlo and Modotti', p. 25.

2.5 Censorship

Aviva Rahmani, 'A Conversation on Censorship with
Carolee Schneemann' (1989)

From *M/E/A/N/I/N/G*, 6 (1989), pp. 3–7.

The following conversations with Carolee Schneemann took place beginning on January 28, 1988. The last discussion was on August 24, 1989, shortly after she had returned from Russia, where her film *Fuses* was to be shown at the Moscow Film Festival. The program for the American Soviet Joint Venture (ASK) was organized by the San Francisco International Film Festival. The program included: Philip Kaufman's *Unbearable Lightness of Being* (as a feature); and a side bar of 'Sexuality in American Films' including *Trash* by Paul Morrissey, *Working Girls* by Lizzie Borden, *She's Gotta Have It* by Spike Lee, Russ Meyers' *Beyond the Valley of the Dolls*, *Desert Hearts* by Donna Deitch, *Sex, Lies, and Videotape* by Soderbergh, Mark Huestis' program on AIDS, Obie Benz's *Heavy Petting*, and three shorts by James Broughton. Only *Fuses*, after an opening night unscheduled screening, was canceled from subsequent planned screenings, and was finally screened unannounced after pressure from the USA organizers. *Fuses*, made from 1965 to 1967, is the first film shot by a woman in which she's also the participant in her own love-making. There is no third person – on camera. It's painterly, densely collaged, and all the sequences are in complex rhythms which disappoint pornographic expectations. This was not Schneemann's first encounter with censorship, and it was being mirrored in Washington, DC with Jesse Helm's crusade against the Mapplethorpe exhibit and the NEA. (*Aviva Rahmani*)

Aviva Rahmani: You've dealt with aggression in your audiences in your career from both men and women. In your recent trip to Moscow you traveled all the way there, they put you up and gave you a translator only to divert your work! That's a tremendous blow to your adrenalin, isn't it?

Carolee Schneemann: How about, tremendous spark? Censorship breaks your integrity, it's sinister because the work is endangered and engaged in a falsification of motive. In

Moscow I was struggling against invisible powers and was always the fool because I didn't know where my enemy was. The Russian organizers were cordial, gracious and every day they had increasingly unbelievable stories as to why the showing of *Fuses* was postponed or canceled. I was fortunate to have a translator who became a defender, champion, fighter – very aggressive on behalf of the film. Every time *Fuses* was diverted he would arrange for TV and journalists to be present; we would have interviews about whether or not the film was to be shown.

One TV interview was under the direction of a small round woman in her sixties who arrived at my hotel room with a full crew. She was the head of 'Sexual Education in the Soviet Union.' She would introduce the interview, then Vladimir, my translator, would translate her questions, he would then translate my response. She was smiling approvingly, looking into my eyes as she spoke into the microphone. 'What's she saying?' I asked Vladimir . . . he paused . . . 'She's saying you are a pornographer and a dangerous woman.'

AR: Of course, you *are* dangerous. Jesse Helms speaks for a lot of people who intend to resist having their traditional convictions threatened by 'dangerous people.' But sometimes it comes from unexpected sources.

CS: In Cannes, in 1968, *Fuses* was shown as part of a special jury selection. This sophisticated French audience went beserk. I was standing in the back with Susan Sontag, expecting a pleasurable audience response. Instead, a great commotion erupted in front of the screen. French men were ripping up the seats with razor blades and screaming because it was *not* truly pornographic. It wasn't satisfying the predictable erotic, phallocentric sequence they wanted. It was a source of frustration and anger.

AR: Carolee, I feel a great deal of rage and bitterness over this censorship issue that has come up, but not for the reasons I hear everyone else ranting about. I'm furious because this is the art world's equivalent of the one white male heterosexual who gets AIDS and all of a sudden everyone takes notice. It's tremendously hypocritical and self-righteous. The fact that Mapplethorpe was gay and Serrano is black is incidental, in the art world, to their fashionable status. The reason I accuse the art world of hypocrisy on this is that no one stood up to defend or protect twenty years of feminist artists and feminist work that got trashed. And anyone who doesn't think that has economic and self-censoring effects has their head in the sand. In 1968 the backlash against all of us who challenged the established norms of sex and power began.

It seems ironic to me that after twenty-five years, America and Russia have reached parity over censoring your work. *Glasnost* and American conservatism equals out. If the art world had cared to acknowledge what was happening all along and resisted years ago, the right wouldn't have such a podium today. The art world has failed itself by failing those of us who knew all along that we were at war. But at best they were either cowards or indifferent.

CS: So, hey, Judy Chicago puts a sacred vulva – which celebrates an historic woman of unique creative authority – on a dinner plate! And she wants people to sit down, say grace and eat! . . . Hey! We're not going to get approval and funding from the Bridal Registry . . . not even Duchamp's.

We're examining deflected censorship and violent censorship (consider abortion rights); individual and communal censorship (consider AIDS research and care). My experiences with censorship cover a wide range: from the man who attempted to strangle me during the Paris performance of 'Meat Joy' (1964); to USA government intervention preventing my anti-Vietnam war performance 'Illinois Central' (Chicago 1968); to the manager of a world famous rock group spiking the sangria which was passed out from the dressing room of the Round House to 2,000 participants in the 'Celebration of the Chicago 8' (London, 1969); to the local police arresting the projectionist and the projector with *Fuses* still on it (El Paso, Texas, 1985) . . .

My work within erotic and political taboos has been fueled by the constraints of sexism; but my work has offended both men and women, and been defended by both women and men; my work has offended granting agencies and institutions, and been supported by granting agencies and institutions. I like the margins to slip on . . . the uncertainty. From the margins I've been free to attack, to sniff out the leaking repressions and denial of subordination. Head-on is too much – it's macro, you'll get knocked out of the rink . . . your body is chopped up, head cut off, your children disappear. In male power structures you purchase incivilities for their own self-justification . . . better to run free out here. It's a relatively recent social process in which the good guys *don't* get blown away . . . that they can play with the girls and find meaning, value – a complementariness of action, insight, and force; a repositioning of the old heroic mold . . . We still build on the underlying pattern that good guys get blown away – that identification with the female, interiority, the unconscious, puts them in jeopardy . . . The male psyche unearths lost attributes, missing attributes when the female no longer represents the victim-self. Well really it's a privilege to produce work that provokes censorship! Although I don't believe that is my intention, nor that of Judy Chicago, Mapplethorpe, Serrano – even the contentious actions of Karen Finley do not 'invite' censorship – rather, controversy, confrontation . . . an unraveling of submerged, denied, latent content. Volatile erotic, sexual denial underlies the self-righteousness of our reactionary censors. Each of our transgressive visions rises from a particular brew, a churning of contradictory values and our insistence to cut through cultural delusion and psychosis. Our lived insights merge with our imagining and materials.

So the real dilemma of the censor is to corral the imagination and the passage of visceral insights into aesthetic and political contexts. Denying a few photographs an exhibit, canceling screenings of *Fuses* only heightens our necessary bite and gnaw – to cut into layers of taboo, denial and projection.

AR: Tell me something about your experience with other artists, writers or journalists in Moscow.

CS: Our conversations were curtailed – not by overt censorship – but by a disparity of analytic precedents. The erotic and political thrust of my work has particular cultural referents which we take for granted: the writings of Artaud, De Beauvoir, Wilhelm Reich were early influences; Freud, Jung, feminist investigations in art history, psychology, linguistics and concepts of the sacred erotic, of an ecological economy; even the gender constructions of Russian Marxism not implicit in Soviet discussions. Issues of sexuality pivot on authoritarian constructs. Our feminist issues which have

assertively dismantled male definitions of female value have not reached into the newly shifting Soviet morality. The intellectual sophistication of my Russian friends – their sharp, ironic perceptions – and the depth of Western influence merges with Russian metaphysical traditions, fueling profound longings – to be released from paranoia, punishing consequences; to express convictions, passions which were punishable by incarceration, exile, repudiation, for the past forty years. It is *impossible* for us to realize Stalinist terror and suppression left not one person, place, or thing unscathed. How do they now contemplate a life of economic scarcity and hardship with the new creative frankness? In an economy in which soap, tampons, condoms, toilet paper, diapers are usually *unavailable*; in a demanding daily struggle which exhausts everyone – how can an examination of erotic intimacy not seem like a luxury? a risk?

Among all the sexuality in USA films, *Fuses* hit a taboo button in *Perestroika*. But the great achievement was for so many Soviet films which had disappeared to be 'off the shelf' – to be shown publicly for the first time since they had been 'purged.' The issues of women in the Soviet Union were addressed in a remarkable program of documentary films.

Patriarchal gender constructions systematize transference and mythification lurking within the idealization of the arts. We are looking at different forms of denial/ censorship: one form instigates public outrage, outcry; the other acts as a slow smothering, a constraint. In the former instance you might have to fight for the immediate fate of your work; in the latter you have to wait it out, persist, live in the basement . . .

It's interesting that this year, twenty-four years after *Fuses* was made, it could be both censored and uncensored at the Moscow Film Festival and receive its most intensive structuralist analysis in David James's *Allegories of Cinema* – an analysis in which my deepest motives and methods are clarified.

So, I understand your rage and fury at the dissimilar suppression of works by feminist artists and by Mapplethorpe and Serrano. The only way I ever learn how transgressive my works are – I have this naive, messianic streak and an instinct for the cultural distortions which surround me – the only way I experience the resistance in my culture is by the denigration, denial, and attempt to obliterate or trivialize my work and its direction. But in the Soviet Union there would have been no chance to ever produce such work! I recognize the measure of society's psychosis when I realize there are only two roles offered me to fulfill: either as a 'pornographer' or as an emissary of Aphrodite!

Given our contemporary morality, woman artists and gay artists have to fight like guerillas . . . from the edge of the aesthetic encampments . . . from under and over the banquet tables. I think gay men can assume a particular posture – it's often super-phallic or meta-phallic, to challenge and flush out the underlying grandiosity of male erotic fantasy and its concomitant castration fears. Conservative straights hate to face the paradoxical magnification of their own suppressed desire. Female sexuality incites another sort of proscriptive idealization to ward off detestation, envy, and fear.

AR: In the process of working with sexuality can you describe an evolution in the material?

CS: My exhibit in March 1989 at Emily Harvey Gallery, NYC raised all the same difficult issues about the perception of the body and the body as a source of structuring form. 'Infinity Kisses' is a composition of over 160 color photographs displayed in a 9 foot by 7 foot arc. Over a six year period I shot in available light closeups of my cat Cluny's morning ritual mouth to mouth kisses. Because in many of the photographs you can see tongues touching, many people found the sequence obscene.

AR: But by using a cat, you're going even further and making it 'non-pornography,' taking the erotic issue out of the context of heterosexual mating into eroticism for its own sake. Eroticism becomes a language of communication not necessarily attached to specific organs, actions, people, but simply part of being alive.

CS: I feel I've worked into a big blind spot in the art world. I've been enraged by the sexually negative reactions to so much of my work. I always felt I was doing the obvious next step. In *Fuses*, the necessity was to investigate the absence in my culture of a visual heterosexual intimacy that corresponded to my own experience. If there was no example, could I possible produce evidence? *Fuses* does. It became a classic work despite resistance; some people used to think of it as this narcissistic jerk-off. The invisibility of 'self' that I experience is that I really don't see *myself* there. I'm an available conscious form that's permeable, that I'm able to use. The culture obfuscates lived experience, the female erotic and the sacredness of sexuality. There's a similar motive in my performance piece 'Interior Scroll.' I didn't *want* to pull a scroll out of my vagina and read it in public, but it was because the abstraction of eroticism was pressuring me in a way, that this image occurred, which said, you must demonstrate this actual level . . .

AR: It sounds like you are saying that sexuality as it presents itself in our culture became a form, a metaphysical structure on which to hang the whole issue of human intimacy and the deeper experience of intimacy itself. It's a double-edged sword, of course, because of the baggage our society brings to sexuality and nudity.

CS: I'm using myself in a culture that surrounds me with artifice, lies, obfuscations, grandiosity. Every time a film is made you are cast to act, constrained to 'represent' someone and something that you're not, or in semiotic structure you are abstracted into a set of propositions to demonstrate something you may or may not believe. In using the actual lived life – that's the only chance for me to see: is there a sensory and conceptual correspondence between what I live and what can be viewed and seen? It's not normal to be phallicized or de-phallicized! The world is a great vulva that mirrors and imprints the phallic shape, not the reverse! So you see, for me to get clear, I have to make it all inside out and backwards. But there's a way I protect myself from thinking this is 'myself.'

AR: That sounds like it has a painful aspect.

CS: This is the work and I'm an element in it, the best available material for investigative work. With the cat imagery, I have that same surprise and bewilderment when people say this is 'bestiality, obscenity.' Their negative response seems a measure of erotic dislocation and cultural deception. Tenderness, sensitivity, yielding, wetness, permeability are all taboo aspects, isolated as 'female.' The cat is an invocation, a sacred being, profoundly devoted to communicating love and physical devotion.

AR: Quoting from the *Allegories of Cinema* by David James: 'in *Fuses* the only stable persona implied is a black (actually grey) cat; its manifest sexuality is a purring correlative to the action.' I would say that the cat was more than the correlative, its content was the symbol of a general harmony with nature.

CS: My next film is on the burner – that is – percolating and it's inspired because *Fuses* continues to raise questions of the essential erotic. As you say, it is 'warfare' and the battleground of greatest intensity has been and remains the body – the female body. The taboos are still in place. The transgressive works you mention focus outrage accorded to male sensibility, constructs of male culture. Female creative assaults – with their deep spiritual implications, their attention to gender declivities are surfacing in male consciousness . . . we are still streaming in from the Moon . . . from our planet.

Sarah Milroy, 'The Flesh Dress: A Defence' (1991)

From *Canadian Art*, 8 (2) (1991), pp. 71–72.

Jana Sterbak's meat dress (actually called *Vanitas: Flesh Dress for an Albino Anorectic*) is one of my favorite works of contemporary Canadian art. It was thus with great interest that I watched it stand trial at the National Gallery this spring. What exactly was it guilty of?

The work can be defended on many grounds. First, its situation within the art-historical tradition of the Vanitas – a still life mode in which the cycle of fecundity, plenitude and then decay is suggested, our mortality made visible to us through the visual imagery of ripening/rotting fruit, vegetables, overblown flowers, even aging meat (often a human skull was thrown in for good measure). Sterbak's work is thus legitimated by being situated within this art-historical trajectory. Fair enough. Another argument could stress the importance of non-traditional materials in 20th-century art (Meret Oppenheim's fur teacup, Robert Rauschenberg's stuffed goat, Joseph Beuys' felt and fat spring to mind). As well, the work stands in the Surrealist tradition of the uncanny, of the *informe*, disturbing the distinctions, by which we categorize experience (animate/inanimate, dry/wet, animal/human and so on).

Valid as these approaches to the work are, it nonetheless seems to me that the strength of the work lies not in its adherence to cultural norms but in its deviation from them. A better defence of the work lies in naming the ways in which Sterbak's flesh dress transgresses. And I would argue that its transgressions are enacted primarily in the arena of gender.

The flesh dress is female, and it is made of meat. In cojoining these two signs, Sterbak commits a major gender infraction, naming the equation between meat and women – both objects for male consumption – that patriarchal society would prefer to leave unspoken (and therefore more pervasive). As Carol Adams writes in her recently pub-

lished book *The Sexual Politics of Meat*, 'Sexual violence and meat-eating, which appear to be discrete forms of violence, find a point of intersection in the absent referent. Cultural images of sexual violence, and actual sexual violence, often rely on our knowledge of how animals are butchered and eaten.' Thus, as Adams points out, whorehouses are described as *maisons d'abattage*, literally 'slaughterhouses', and the accoutrements of bondage suggest the domination of animals – bullwhips, prods, chains and ropes. To me, it's fascinating that the flesh dress controversy erupted just at the moment that *Silence of the Lambs* was dominating the box office, a movie in which a serial killer butchers women for their skins. Clearly, Sterbak is on to something.

The flesh dress thus constitutes an act of female disobedience: it speaks the unspeakable and is therefore punishable. Shortly after the gallery began exhibiting the work, the *Toronto Sun* and *Ottawa Sun* ran a cartoon presenting the flesh dress refashioned as a curvy, spaghetti-strapped slip (emphasizing its female gender) and encouraging the public to cut the image out, smear it with disgusting foodstuffs and mail it to Diana Nemiroff, the curator responsible for the show at the National Gallery. The cartoonist included the address. He urged respondents to use the most repulsive materials possible because 'Diana will like that' (by calling the curator 'Diana' instead of 'Nemiroff,' he emphasized her gender and in his phrasing – 'Diana will like that' – subtly intimated her sexual appetite).

More than 200 people mailed in the cartoon. Some of them smeared the paper with shit; gallery mailroom staff had to open the mail with rubber gloves for weeks. Meanwhile the gallery's communications officer, also a woman, whose name had been in the news defending the work, received a sexually threatening letter. Had the artist, the curator and the communications officer at the National Gallery all been men, the controversy would without a doubt have had an entirely different inflection. (For starters, the work would probably have been deemed sexist.) The stridency of the work resides in the gender of the sender; Sterbak's flesh dress functions as much as a work of performance art – as an action – as it does as sculpture.

Meat is traditionally for men. As Adams writes,

> People with power have always eaten meat. The aristocracy of Europe consumed large courses filled with every kind of meat while the laborer consumed the complex carbohydrates. Dietary habits proclaim class distinctions, but they proclaim patriarchal distinctions as well. Women, second-class citizens, are more likely to eat what are considered to be second-class foods in a patriarchal culture: vegetables, fruits, and grains rather than meat. The sexism in meat-eating recapitulates the class distinctions with an added twist: a mythology permeates all classes that meat is a masculine food and meat-eating a male activity . . . Women . . . engage in deliberate self-deprivation, offering men the *best* foods at the expense of their own nutritional needs.

In the home, the woman is traditionally responsible for maintaining this domestic economy, for harboring the family's resources, for saving. Significantly, most of the negative response to Sterbak's work – both from the public and from Parliament – centred on the issue of waste; how can the gallery show a work of art made out of 50 pounds of meat when people are starving? But, as Sterbak has pointed out, there is no meat shortage in Canada; there is a money shortage. If waste alone were truly the issue,

similar arguments would surely have been raised regarding Richard Serra's extravagant use of building materials – Corten steel, for example – in his monumental sculptures. These materials, after all, could have been put to better practical use building housing for the homeless. Somehow, to my knowledge, the issue just never came up. (Neither, for that matter, has it come up in relation to the work of Austrian performance artist Hermann Nitsch, who slaughters animals as part of his work. Here dissenting criticism has centred on the issues of cruelty and sensationalism, not waste.) But for a woman artist (and curator) to 'waste' 50 pounds of meat constitutes a transgression of her traditional role as woman, a creature who requires no meat, who is herself meat, who saves herself and her resources for male consumption. What is posited by Sterbak's critics as an issue of class in fact screens an issue of gender.

If she can find it in herself to do so, Sterbak should revel in the notoriety of the flesh dress. The intensity as well as the nature of the public's response are a testimonial to the work's commendable defiance, and to its effectiveness as a social intervention.

Anna Douglas, 'Where Do We Draw the Line? An Investigation into the Censorship of Art' (1995)

From *New Feminist Art Criticism: Critical Strategies,* ed. Katy Deepwell (Manchester: Manchester University Press, 1995), pp. 102–110.

Does art have the right to 'offend' its public? Is it legitimate for art and artists to be exempt from legislation governing 'ordinary citizens'? What kind of responsibility should artists have in producing and disseminating their art? Where do we draw the line? Despite talk of democracy, defenders of artist's rights under the free speech principle have failed to recognise a glaringly obvious issue: that dearly held beliefs about art are not unquestionable truths, self-evident principles unequivocally for the best. That these are ideological constructs enshrined in artistic practice goes almost unacknowledged. This is characteristic of a problem not only with the moral absolutist terms of the 'freedom of speech' criteria, but a failure of the art community to face up to some of the more contentious sides of the art world: its cultural and social isolation, its own elitism, inequalities, differences and use of regulatory practices.

Censorship: New Models for Investigation

Since Britain is not experiencing a 'war against art',[1] is the issue of censorship at all relevant to us? I will argue that it is, further proposing that our apathy is due to the limiting ways in which the social function of both censorship and art are conceptualised. It is true that we do not live in a totalitarian regime where political expression is restricted and state bodies vet all material shown publicly. In Britain art does not play a clandestine, subversive role as in the former Eastern Bloc countries or present-day

Indonesia, where artists have been banned or imprisoned. But while art is generally not restricted by overt censorship to ensure its consonance with government values, we do nevertheless live in a country where regulatory practices define our 'civic milieu',[2] and that includes art. The art community has grown accustomed to what it perceives is an unregulated and therefore privileged existence. There are no institutions devoted to the regulation of visual art practice in this country, as for example with the British Board of Film Classification, nor is there legislation aimed solely at art. When visual art is censored it is usually through existing legislation such as the Obscene Publications Act (1967).[3]

Annette Kuhn's study of film censorship, however, argues against this misconception, claiming that traditional definitions of censorship limit our understanding of the processes involved in social regulation and control:

> Historical and sociological studies of film censorship have invariably emphasised its institutional and prohibitive aspects, constructing it as an activity on the part of specific organisations – organisations whose avowed objective is to impose controls on films, usually by excluding from them themes, topics and images deemed for one reason or another unacceptable.[4]

However, despite the absence of such prohibitive organisations in art, various 'incidents' (see below) would suggest that art is regulated, but in other ways. For even when censorship does operate through identifiable institutions, not necessarily with the sole function of censorship, e.g. local authorities or galleries (even curators themselves), there is always more to censorship than merely the effect of 'cuts, bans and censor boards'.[5]

Kuhn proposes an alternative investigative strategy for comprehending censorship, which in moving beyond the 'prohibition/institutions' model releases censorship from its limited negative function within organisations, concomitantly liberating the censored artwork from its previous inertia. The art text, no longer a passive object and 'subordinate to the structure and organisation of censor boards and other institutions'[6] is accorded a productive role in a process of regulation.[7] Borrowing from Foucault's theories of power, Kuhn redefines censorship not as a one-way traffic of repression, but as a far more fluid and potentially productive process which emerges through and participates in 'an apparatus or set of practices whose interrelations are imbued . . . with the "play" of power'.[8] This approach permits censorship to be understood not as an agent of (state) repression, but as a process of regulation which is uneven, contradictory, possibly productive,[9] open to conflict as well as resistance and ever changing.

Employing this new approach transforms our understanding of censorship. The question is no longer *what* is this thing called art censorship, so much as *how*, *when* and *with what consequences* does it emerge? Censorship in Kuhn's 'causational model' is not 'reducible to a circumscribed and predefined set of institutions and institutional activities',[10] knowable through marked instances such as exhibition closures or the excision of pictures from exhibitions, becoming instead something which emerges through 'an array of constantly shifting discourses, practices and apparatuses. It cannot therefore be regarded as either fixed or monolithic';[11] nor is it necessarily immediately observable.

The value of this expanded approach is that it permits censorship to be understood as part of the contradictory practices that contribute to the management of our social order. It opens up the possibility of seeing regulation functioning in 'everyday' ways, both positively and negatively: as self-censorship, in what we allow ourselves to do or even imagine, as a means to circumvent confrontation or the 'principled' exclusion of representation deemed unfit for public consumption;[12] as economic censorship via the provision or withholding of funding, and importantly as something we are all necessarily involved in through processes of selection. Considered in this way censorship cannot be all 'bad', for essentially it is a process we are all subjectively engaged in. If censorship is 'all around us', how can we ever come to recognise and analyse its operations? It is a point of fact that censorship often goes unrecognised, for its operations are only made knowable through the investigation of social practices. But history does reveal patterns of regulation which appear to emanate from a social or political context. How then do we respond to these 'compounded' or overt incidents of regulation?

Annette Kuhn suggests that these occurrences are recontextualised in a broader investigative framework: 'censorship becomes an activity embedded within an ensemble of power relations, whose operation can be unpicked through attention to particular events and instances.'[13] While the event itself is observable, its extended context only becomes knowable through investigation. In this causational model, the historical, 'real' event or set of practices acts as a 'trigger' for a process of analysis which aims to uncover and 'scrutinise' the operation of social forces through which the event came about.

Britain has not experienced a mounted attack on art, but over the course of the past five years we have witnessed more 'incidents' restricting the viewing of art in the public sphere: e.g. the removal of two nude self-portraits from Pendle Photography Gallery; the prosecution of the Young Unknowns Gallery for conspiracy to corrupt public morals; the cancellation of exhibitions such as 'Ecstatic Antibodies' in Manchester, or Southwark Council's last minute refusal to fund an Irish arts festival; sponsors reversing commitments to fund exhibitions such as 'Egon Schiele' at the Royal Academy; and the continued involvement of the police in exhibitions which involve images depicting naked bodies. Varied as these instances are, they must all be understood as expressions of an anxiety concerning art's cultural role. They raise questions concerning what is appropriate subject-matter, where it should be shown and what its audience should be. And more critically, given recent struggles over definitions of the public sector, what can be shown in publicly funded places, what can public monies support, and who has the right to decide these things.

To move towards a precise understanding of the way in which art censorship is currently functioning, we must recognise that neither art nor 'cases' of regulation can be treated uniformly. There has been a tendency to view the above incidents, amongst many others,[14] as arbitrary indications of artistic philistinism, legal 'contradictions/absurdities/archaisms'[15] or, even more inaccurately, as the crude reawakening of outmoded moral principles. It is essential that we develop a more sophisticated and accurate analysis of why certain and particular artworks are caught up in a grid of regulation, sometimes legal, usually less formal, often 'top down', but just as capable of being 'bottom up'. Failure to do so is to misunderstand the nature of society with its complex and conflicting value systems. The art community gets nowhere by burying

its head in the sand or refusing to accept the 'values' of others (even others in its own community) while defending its own rights. How is it possible for the same art text to be 'censored' at one historic moment and not another; for one photograph to be removed from an exhibition in one town, but be 'unproblematical' elsewhere? What allows sexually 'explicit' advertisements national circulation while the showing of sexually explicit art may be restricted? In short, what may variously cause 'readings' (and feelings) of 'offence'? It is tempting to look for the answer in the art itself. But the very fact that the same work can be viewed as either offensive or not, no matter how justifiable such judgements may be, suggests that the 'problem' *ipso facto* cannot lie wholly in the artwork. This signals much greater uncertainties within our social and political fabric.

Deanna Petherbridge/Rochdale Art Gallery: Liberalism, Cultural Difference and the Public Sector

It is actually easy to grasp the main thrust of the free speech arguments. What is difficult is to be sure that we understand the dispute to which we bring those arguments.[16]

In 1990 Rochdale Art Gallery rehung 'Themata', an exhibition of drawings by Deanna Petherbridge first shown in London at Fischer Fine Art, a private commercial gallery. Collectively the curators, without consulting the artist, decided not to hang one of the drawings, *The Judgement against Rushdie* (1989), despite its unproblematic showing in London. That the drawing was considered 'problematic' in one gallery and not in the other, even in a show which addressed a wide range of controversial and political subjects, can only be understood through a broad investigation into the specific social and political forces that affected its interpretation. The differences between the public and the private gallery with their particular audiences and systems of accountability frame our investigation.

Rochdale Art Gallery is publicly funded through the (Labour) local authority of a provincial Lancashire town. As a municipal gallery, Rochdale Art Gallery is expected to 'reflect' the interests (variously interpreted) of the 'public' (which includes a large Muslim constituency) as represented in the form of the elected council. The gallery's cultural role and artistic policy is negotiated between local authority officials (curators and relevant department officers), elected councillors and funding bodies, such as the Arts Council of Great Britain. Over the years Rochdale has built up a reputation for programming radical and politically committed work from feminists, black artists and Irish artists. With the management of, and provision for, cultural difference becoming a pressing reality in multi-ethnic towns such as Rochdale, the role of public amenities such as galleries can be crucial in the practical implementation of the council's commitment to multi-culturalism. By contrast private galleries, like Fischer Fine Art, cannot operate outside the law, but its mechanism for accountability rests with the financial and cultural interests of its directors. By identifying an exclusive art market and appealing to a particular audience, culturally and economically elite, mainly European in origin, Fischer's exhibition policy is framed by economic, not 'public', interests.

Indeed one might argue that curatorial decisions simply boil down to the question, will the work sell?

In *Art Monthly* (September 1990) Deanna Petherbridge voiced her concern over the 'censorship' incident: 'If one cannot even name the name Rushdie, irrespective of context and width of debate, then cultural freedoms have already been jeopardised in Rochdale. Rushdie is right: freedom of speech is not divisible.'

In suggesting that the context in which the overdetermined signifier 'Rushdie' circulated was irrelevant, Deanna Petherbridge overlooked the particular political circumstances in which Rochdale Art Gallery was operating. Britain was experiencing a violent debate following the publishing in 1988 of Salman Rushdie's *Satanic Verses*, and community relations in multi-ethnic towns such as Rochdale were extremely volatile. The book had been interpreted by many Muslims as blasphemous and it became a symbol of the injustices perceived by some British Muslims. The polarised interpretation of the 'Rushdie Affair' between liberal and fundamentalist Muslim communities, coupled with the increased regulation of the public sector and the complex relationship between representation, audience and meaning had determined how her work could be read in Rochdale and triggered the pre-emptive action of the curators. The Rochdale incident has been regarded as an infringement of an artist's rights at the hands of censors. But to discuss this incident through the discourse of artistic freedom (as Petherbridge herself does in her *Art Monthly* article) obscures why and how regulation came about.

Space restricts a comprehensive analysis of the social factors which made various readings of the (censored) text possible: as a drawing of great skill and form (by a feminist artist); as having something valuable to say about artistic isolation and power; as either a potentially culturally offensive or a politically problematic work. But this brief introduction has highlighted certain key elements. At the height of the 'Rushdie Affair' the private gallery context, socially and geographically isolated, publicly unaccountable and with its elite audience, minimised the possibilities of Petherbridge's drawing being read as pro-Rushdie/racially provocative and politically problematic for its curators. Yet the complex racial politics and issues of accountability in Rochdale at the time made these readings probable, heightening the anxiety felt by and acted upon by the Rochdale curators. Although it might seem that Deanna Petherbridge's drawing was totally subordinate to the political situation in Rochdale, the art object is never totally passive in the regulatory process. In writing about 'Themata' Katy Deepwell states that Petherbridge's art resisted 'being contained by a single reading', presenting 'a range of positions from which a specific political issue can be viewed' ('Themata' catalogue, 1990). In considering why this drawing was not exhibited in Rochdale, its textual openness must be 'accorded a productive role'.

The curators' interpretation of the drawing was entirely dependent upon the signification of its title, *Judgement against Rushdie* – indeed the imagery of the drawing was not directly at issue. Without the title, the formal content of the work could variously connote human alienation, isolation, imprisonment and so on. The work itself contained nothing that anyone might find ideologically 'offensive'. Once the picture was read with its title this openness to meaning was constrained. But the title that Petherbridge selected, while referring to Rushdie, thus framing the audiences' interpretation of the content (the figure in the drawing 'becoming' Rushdie), was nevertheless still

suitably ambiguous. Do the title and the picture refer to a Muslim judgement against the writer Salman Rushdie or the artist's own judgement that the author's actions were questionable? Even if the drawing was intended to question artistic responsibility – as provoked by the Salman Rushdie incident – this symbolic reading was still wide open to the ideological 'stance of the viewer'.

Petherbridge's comments in *Art Monthly* are indicative of an absolutist position that assumes that freedom of speech/artistic activity is a self-evident principle unequivocally for the 'best'. Her espousal of freedom rests on the understanding that free speech fundamentally protects the rights of the 'weak' against the 'strong'; censorship restrains the 'powerless' from 'speaking'. Her commentary implies that given open 'debate', 'reason' and 'truth' will triumph over social difference of values. But her statement does not acknowledge that our society's unequal distribution of power limits access to freedom. This is a reality which most ethnic groups in Britain are daily reminded of. Nor does she seem aware that the line drawn between 'oppressor' and 'oppressed' is not fixed or clear cut, and indeed an artist's personal freedom may limit that of another individual. The absolutist criterion of free speech tends to ignore the fact that we willingly accept many regulations of our freedom and do not call these 'censorship'. There is little sense that freedom is not an overriding neutral principle, but is a value inextricably linked with other values, and cannot exist by itself. What is missing from the moral absolutist appeals to freedom of speech is the recognition that what is at stake should not be an abstract principle, but the issue of values. Without further clarification Petherbridge's abstract appeal to freedom ironically protected the rights of the curators to impose a ban as much as her right to show her work.

If we are not explicit about the values we wish to uphold, it may well be that liberal principles like freedom of speech help to maintain social inequalities we would otherwise seek to eradicate. Ultimately, society comes to terms with social and cultural difference and conflict by 'preferring' and regulating certain values over others. This is not an activity undertaken exclusively by state regulatory bodies, but, as Annette Kuhn makes clear, it is a process we all participate in. The Rochdale incident reveals the difficulty of resolving, evaluating and giving preference to competing values, particularly when the conflict arises between liberals. The action of the curators was not a blanket ban on references to 'Rushdie', but a questioning of the appropriateness of an ambiguous text, given the political context in which it was selected to be shown. Characteristic of a particular postmodern conception of art, as anti-polemical and open to meaning, is the artist's expectation that audiences' plural interpretations will mirror her own cultural liberalism. It seems ironic that Deanna Petherbridge (a 'politicised' artist) should produce an artwork circumscribed by multi-cultural debate but which ultimately is reliant upon a narrow liberal intellectual reading. In effect the exhibition context at Fischer Fine Art closed down the multi-cultural pluralism of the work. The drawing was not 'culturally provocative' *per se*; its exhibition in London and a feature in *Eastern Art Report*, an Asian arts magazine, had been interpreted very differently, as a contribution to the debate; rather it was the particular social context of Rochdale which was 'problematic'. Undoubtedly a public forum (which the artist offered to lead) or publicity material could have closed down the meaning of the text, but could this realistically have succeeded, given the 'explosive' social circumstances of the time? For at the height of the 'Rushdie Affair' it was impossible for the signifier 'Rushdie' –

however it was used and in whatever circumstances – not to provoke an intensified response. The curators recognised that the conditions of reception and the ambiguity of the text made for too unstable a meaning. 'In good faith' they judged that the 'value', that the provocation of the text posed, was not 'worth' the price of damaging community relations in Rochdale, which would have repercussions for the council's own political standing. The curators recognised that though Petherbridge's drawing was in no way intentionally anti-Muslim, in this context it had the capacity to be read as culturally offensive.

It would be wrong to ask Deanna Petherbridge to shoulder the whole responsibility for the regulation of her work, for the chain of causality that the drawing was caught up in was far beyond her immediate control, and the curators should in any case have been mindful of the potential problems when selecting the show. Neither am I suggesting that Deanna Petherbridge or other artists should stop producing culturally provocative work. But it seems vital that artists (and curators) accept that in a fundamentally unequal society, with different cultural values and access to power, artistic values could well conflict with those of social groups. To rally behind a defence of artistic freedom *misses* an opportunity for artists *and* curators to challenge this system of inequality. Might it not be reasonable to expect socially aware artists in particular to be prepared sometimes to sacrifice their artistic values in favour of social ones? The thought that Deanna Petherbridge and many other artists seem unable to acknowledge is that their art *might* at times unintentionally reinforce or provoke a group's sense of alienation.

I have been arguing for an expanded interpretation of censorship. This is not to undermine its significance, but to understand what lies behind systems of regulation, in order that we might pre-empt, confront or change those relations of power; significantly this process restores art to its social context. In defending the principle of artistic freedom, artists defend their own right of exclusion and elitism, protecting art as a privileged domain. To be truly effective in bringing about social change, artists must understand that art is not isolated from other struggles in society and that these are not necessarily antithetical to artistic interests. The art community needs to come out from behind its aesthetic barricades and make connections between the symbolic and the real. Failure to do so ensures the survival of artistic privilege but at the price of foregoing the cultural relevance of art.

Notes

1 For an introduction to the Congressional attacks on art in the USA, see C. Vance, 'The war on culture', *Art in America* (September 1989): 38–9. It has been widely noted that this censorship crisis served to 'politicise' an otherwise politically apathetic community.
2 B. Brown, 'Troubled vision', *New Formations Journal*, 19 (1993): 29.
3 Ibid., p. 30.
4 A. Kuhn, *Cinema, Censorship and Sexuality, 1909–25* (London: Routledge, 1988), p. 3.
5 Ibid., p. 127.
6 Ibid., p. 4.
7 Ibid., p. 5.
8 Ibid., p. 7.

9 A number of artists from former communist countries have lamented that without official state censorship art seems to have lost its purpose and direction.

10 Kuhn, *Cinema, Censorship*, p. 127.

11 Ibid.

12 Even amongst liberals there is profound disagreement regarding the relationship between representation and 'reality'. This debate is tirelessly reworked, particularly in regard to images of sex and race – do images effect attitudes to sex and race? Even if this causational model is not endorsed by liberals, the fundamental question still remains. How should we regulate images?

13 Kuhn, *Cinema, Censorship*, p. 9.

14 Brown, 'Troubled vision', p. 44.

15 Ibid.

16 S. Lee, *The Cost of Free Speech* (London: Faber, 1990), p. 69.

3

Historical and Critical Practices

INTRODUCTION

The discourses around artworks – the critical writings, the theoretical construct used to validate readings of them, the venues in which they are seen, the market value ascribed to them, the other artists selected alongside them, and so forth – all of these help form the social meanings ascribed to them. On an individual level, we reach understandings of artworks through the mediation of words. Although artworks may provoke in us a visceral reaction, and one's bodily relation to them is crucial, we reach understanding of how and why this might be so, and what its implications are, through thinking, discussing and writing. As Michael Baxandall says succinctly in the opening sentence of his book *Patterns of Intention*, 'We do not explain pictures: we explain remarks about pictures – or rather, we explain pictures only in so far as we have considered them under some verbal description or specification.'[1] Such verbal description can be both partial, supplying a single exclusive reading, and totalizing, ascribing this reading with the whole truth. It is easy to think of examples of this: why was Jenny Saville's painting related almost exclusively to that of Lucien Freud? Why is Tracy Emin's work not related to feminist work of the 1970s? Why do the words used to describe particular paintings change when they are re-attributed from a male artist to a female?[2] Why are words associated with femininity often words of disapproval in art criticism (soft, pretty, pastel, passive, etc.) and words associated with masculinity approving (strong, vigorous, assertive, challenging, etc.)? Feminist work in the art world has had to engage with, disrupt and reform the partial and totalizing discourses surrounding art by women. While this is a factor throughout this book, this chapter focuses upon the discourses of art criticism and art history.

The first section of the chapter attends to the very *words* of criticism and history. Valerie Jaudon and Joyce Kozloff went to work in the library and selected passages from critical, theoretical and historical texts. As they say, 'We needed to take these words away from the art context to examine and decode them. They have colored our own history, our art training.' By entering into these texts and extracting short quotes, they expose the ideology of racism, sexism and associated prejudice against qualities deemed to connote the feminine and the non-Euroethnic. While it may be argued that some of these quotes are dated, it should be remembered that their *influence* upon today's art

writing is every bit as discernible as the influence of contemporaneous artworks upon today's art. The two are linked.

Susanne Kappeler's 'No Matter How Unreasonable' is a critique of the language used by Norman Bryson in his essay 'Two Narratives of Rape in the Visual Arts: Lucretia and the Sabine Women'. Noting the 'asymmetry of women's silence and men's public voice', Kappeler relates this to academic discourses of rape. She exposes the assumed universality and impartiality of Bryson's voice, which is demonstrated as only credible when understood as a pro-male voice on this issue. This is present in the words he uses and in the structure of his argument: his deflection of the rape of the Sabine women as a social crime, enacted against the state, rather than a crime enacted through the violation of women's bodies; and his reading of the story of Lucretia as one of consent rather than one where she has no choice. Janet Wolff's 'On the Road Again: Metaphors of Travel in Cultural Criticism' also exposes the androcentrism of supposedly neutral – or neuter – discourses. This is an elegant critique of the geographical metaphors that (to prove a point) ground the territories of exploration in the field of cultural studies. Access to the road is not equitable, and Wolff builds her case in layers to warn that 'We therefore have to think carefully about employing a vocabulary which, liberatory in many ways, also encourages the irresponsibility of flight and misleadingly implies a notion of universal and equal mobility.'

The need to build new structures of criticism forms the focus of the second section of the chapter. The first text is the statement printed inside the front cover of the first issue of *Heresies*. The magazine's Collective presents the ethos informing both their structures of working and the approach to criticism: 'We will not advertise a new set of genius-products just because they are made by women.' It is clear that for *Heresies* the politics of making art and the politics of writing about it were inextricably linked. This issue is taken up by Corinne Robins in her analysis of the US feminist art journals of the 1970s. Using scrupulous statistical analysis, she demonstrates the strategies employed by different journals and how these were the products of contrasting political positions. In this text it is possible to discern the contribution of individual writers to the collective responsibility of building feminist modes of criticism.

One of the writers most vigilant about the relationship between the politics readable in artworks and that of the discourses around art is Griselda Pollock. Tireless in teasing out the nuances involved, she has made a unique contribution to the disciplines of writing about art. The text published here is her response to the reception granted a book she co-edited with Rozsika Parker, *Framing Feminism*, in particular an associated debate at the Institute of Contemporary Art in London which was then continued in the pages of the *Women Artists' Slide Library Journal* (*WASL Journal*). Much of what Pollock discusses touches upon the responsibility that a feminist political position requires of the individual who takes up such a position – responsibility for omission, responsibility for commission and vigilance, and responsibility to the women's movement as completely as is possible. She states: 'I know why I write as I do: it is a political act of contesting the power invested in institutions of knowledge and demanding a space for women to redefine the world.' Meaghan Morris also refers to the 'political, rather than ethical, responsibilities of criticism'. In the case to which she refers, these responsibilities are sociable, community-building and vital: 'it kept something alive.' Situating her own practice of criticism in a particular cultural and political environ-

ment, she notes how politics and criticism may overlap but are not the same thing; each requires particular commitments.

For Freida High (Wasikhongo Tesfagiorgis) the political responsibility of her criticism is plain: 'For Black women artists the contradiction between their material culture and their configurated negation, complementarity and/or marginality in discourses on art constitutes the crisis they consistently resist: one that must be vehemently confronted in the 1990s and beyond if history's given course is to be altered. A discourse that would prioritize the lives and concerns of Black women artists is urgently needed.' Her paper (edited here) demonstrates, however, that such a task, if it is to be done properly, is not straightforward. Analysis of the present situation is required alongside investigation of the theoretical structures and methodological models currently available. Black feminist theory, while encompassing a multiplicity of positions, has not yet given much attention to art. Freida High (Wasikhongo Tesfagiorgis) provides a summary of various positions expounded by black theorists and white, evaluating each for its potential use for a black feminist discourse. She provides case studies of Harriet Powers and Edmonia Lewis, and finally outlines the questions that a black feminist critique should prioritize.

The final reading in this section is Stephanie Cash's 'The Art Criticism and Politics of Lucy Lippard'. This provides a useful overview and analysis of more than two decades of Lippard's work – something which is itself double-edged: as Cash says of the 1970s, 'to criticize Lippard's writings from this time is to criticize the feminist art movement' in the USA. However, it is worth remembering the words of Gayatri Chakravorty Spivak. In a different context, Spivak clarified her use of the term 'critique', which 'should not be seen as being critical in the colloquial, Anglo–American sense of being adversely inclined, but as a critique in the very strong European philosophical sense, that is to say, as an acknowledgement of its usefulness'.[3] This is an important distinction and deployment for feminism, which I think lies at the heart of Cash's essay. Cash is alert to the inconsistencies in Lippard's work, but outlines its strength in a manner that interacts interestingly with Meaghan Morris's position, suggesting that Lippard's critical methodology is idiosyncratic, and that her first responsibility is to her political involvement: 'it is her deep emotional involvement with both the art and the causes that sets her apart from most critics. While this can impede rational evaluation . . . it can also lead to a new and different understanding of art and its function in society.'

The final section of this chapter turns attention to feminist interventions in the discipline of 'Art History'. This section focuses not on art historical work as such, but rather on the interventions that have been made concerning the very structure of the discipline. None of the articles selected is content to let Art History as an academic subject remain in its present form with the addition of women and artists of colour – indeed, it is demonstrable that Art History has always been able to allow a few women and artists of colour in as tokens, as 'magnificent exceptions' or as oddities. Instead, these texts work at the undoing of the structures and ideology of a discipline which, particularly in the twentieth century, has been content to exclude women from its definitions of greatness, has maintained through its discourses structures of attaining greatness which exclude women, and (as has been demonstrated in previous texts) has had prejudice and exclusion embedded in its language. In this respect, these writers are

'art historians' rather than Art Historians, masquerading in the discipline while working to undo it. As Griselda Pollock wrote recently: 'while I would answer in the affirmative to the question "Are you a feminist?", I could not do the same if asked "Are you an art historian?" I am always tempted to ask, as I did at the Women's Caucus in 1990, "Can art history survive the impact of feminism?".'[4]

The first article in this section is by Linda Nochlin, who is generally credited with starting the interrogation of structures and terminology of art history from a feminist position with her germinal essay, 'Why Have There Been no Great Women Artists?'.[5] Her text 'Courbet's *L'origine du monde*: The Origin without an Original' begins with an account of some of the slog of art historical work: trying to trace the present where-abouts of a particular painting. Much of Nochlin's work concerns images of women produced by male artists: this painting is Courbet's infamous image of a woman's genitals. Nochlin weaves a web of correspondences between her search for the original painting and Courbet's search for 'The Origin of the World' in the woman's vulva, referencing both Freudian psychoanalytic theory and the visual links between this painting and both contemporary pornography and landscape paintings by Courbet. Pivotal to this is a discussion of Courbet's *The Studio*, where he depicted unformed matter – paint – at the centre. Nochlin shows that Courbet's representation of the artist at work in *The Studio* and his concept of the origin of meaning fulfil similarly gendered functions.

Lisa Tickner's text 'Modernist Art History: The Challenge of Feminism' (a section from a much longer essay) is a wonderfully clear elaboration of why feminism cannot leave Art History intact: to do so would be a defeat of political purpose. Modernist Art History has a 'sense of itself as objective and disinterested, [a] pursuit of universal values at once transcendent (of mundane social realities) and intrinsic (to the autonomous work of art, severed from the social circumstances of its production and circulation)'. From a feminist stance, a total reworking of the terms of discussion – including 'art' and 'history' – is imperative. Following this, the autonomy of the art object must be interrogated: 'The object is the focal point of connoisseurship, which is a discourse of value: it is the object *as text* – a more porous entity – which is the concern of all approaches centered on the social production of meaning.' Tickner argues for feminist work where 'The image comes to be understood as a site – a very particular kind of site – for the production of meanings constantly circulated and exchanged among other texts and between other sites in the social formation.'

Joan Borsa holds up to scrutiny what might be on offer from certain strands of post-modernist theory. In particular she questions the implication of the theoretical death of the author and the proposition that meaning is produced only by the reader at the moment of consumption.[6] This, in conjunction with interest in the marginal and the decentred, can lead to the conclusion that it is no longer significant who speaks and from where. This, argues Borsa, is highly problematic for groups that have tradition-ally been marginalized and that are now asserting that they have voices which signify. Having laid out this theoretical problem, Borsa focuses on 'the function of female sub-jectivity and the significance of other personal and political margins associated with author and reader positions'. Her case study is Frida Kahlo whose life and work has traditionally been beyond the art historical canon. She is concerned to demonstrate, on the one hand, how Kahlo structured her own subjectivity through her work and, on the

other, to critique how Kahlo has been produced as an exotic exception through other discourses (both art historical and populist) and her work reduced to illustration or novelty. This is a complex and layered article in which Kahlo is produced in relation to a politics of location, and to her own articulation of her political subjectivity through her work.

A good portion of Judith Wilson's 'Getting Down to Get Over: Romare Bearden's Use of Pornography and the Problem of the Black Female Body in Afro-US Art' is concerned with establishing or clarifying terminology. She notes the 'volatile conjunction of gender and race [and] the inflammatory myths of black sexuality that the black nude also inscribes'. In order to begin to account for and critique work by Bearden, the critical disciplines have to be wrested from their traditional place, as suggested in texts such as those by High (Tesfagiorgis), Tickner and Borsa. Wilson, in providing such a title and laying out her intentions behind each phrase, shows the present inadequacies of Art History – a fact further demonstrated by her commentary on the ongoing 'archeological' work uncovering 'lost' black artists. Only then can close readings of the work begin to indicate Bearden as an African-American artist and to produce meaning for today's viewers – and to present challenges for the discourses presently surrounding work by African-American artists – in particular, the representation of African-American women and sexual desire.

Pamela Allara's 'The Creation (of a) Myth' is the first chapter of her book on the work of Alice Neel.[7] In it she sets out the difficulty of writing on Neel's work when criticism of the work has been obscured by anecdote, by autobiography (Neel produced different narratives at different times in her life) and biographical detail (as with Kahlo, the work is often reduced to an adjunct of a life deemed more interesting). The autobiographies are presented here as Neel's clear (and successful) strategy for making her work visible: 'Her artistic reputation thus became inextricably bound up with her talks, and unfortunately the journalistic press, sensing the broad popular appeal of a juicy life story, enthusiastically bought into it.' The problem for the art historian is then to read against the grain not only of the discipline of Art History, but also against the narratives supplied by the artist herself: 'the traumatic events thus transcribed can help elucidate her art only when lodged in the social and intellectual milieu of which she was a part.' The narratives created by the artist and by the art historian may conflict.

Notes

1 Michael Baxandall, *Patterns of Intention: On the Historical Explanation of Pictures* (New Haven, CT: Yale University Press, 1985), p. 1.
2 See Rozsika Parker and Griselda Pollock, *Old Mistresses: Women, Art and Ideology* (London: Routledge and Kegan Paul, 1981), particularly the first chapter for examples of this, and other partialities in art history.
3 Gayatri Chakravorty Spivak with Ellen Rooney, 'In a word (interview)', in *The Essential Difference*, ed. by Naomi Schor and Elizabeth Weed (Bloomington, IN: Indiana University Press, 1994), pp. 151–84 (p. 157).
4 Griselda Pollock, 'The politics of theory: generations and geographies in feminist theory and the histories of art', in *Generations and Geographies in the Visual Arts: Feminist Readings*, ed. Griselda Pollock (London: Routledge, 1996), p. 18.

5 Linda Nochlin, 'Why have there been no great women artists?', *Artnews* (January 1971): 20–39, 67–71; reprinted in *Women, Art, and Power and Other Essays* (London: Thames and Hudson, 1991) pp. 145–77; *Writings about Art*, ed. Carole Gold Calo (Englewoood Cliffs, NJ: Prentice-Hall, 1994).
6 Propounded initially by Roland Barthes, 'The death of the author', in *Image–Music–Text*, ed. Stephen Heath (London: Fontana, 1978), pp. 142–8; and Michel Foucault, 'What is an author?', *Screen*, 20 (1) (1979): 13–33; reprinted in *The Foucault Reader*, ed. Paul Rabinow (Harmondsworth: Penguin, 1986), pp. 101–20.
7 Pamela Allara, *Pictures of People: Alice Neel's American Portrait Gallery* (Hanover, NH: Brandeis University Press/University Press of New England, 1998).

Essential reading

Broude, Norma and Garrard, Mary D. (eds), *The Expanding Discourse: Feminism and Art History* (New York: Icon Editions, 1992).

Broude, Norma and Garrard, Mary D. (eds), *Feminism and Art History: Questioning the Litany* (New York: Harper and Row, 1982).

Chadwick, Whitney, *Women, Art and Society* (London, Thames and Hudson, 1989; 2nd edn, 1996).

Deepwell, Katy (ed.), *New Feminist Art Criticism: Critical Strategies* (Manchester: Manchester University Press, 1995).

Lippard, Lucy, *The Pink Glass Swan: Selected Feminist Essays on Art* (New York: The New Press, 1995).

Nochlin, Linda, 'Why have there been no great women artists?', *Artnews* (January, 1971): 20–39, 67–71; reprinted in *Women, Art, and Power and Other Essays* (London: Thames and Hudson, 1991) pp. 145–77; *Writings about Art*, ed. Carole Gold Calo (Englewood Cliffs, NJ: Prentice-Hall, 1994).

Parker, Rozsika and Pollock, Griselda, *Old Mistresses: Women, Art and Ideology* (London: Routledge and Kegan Paul, 1981).

Pollock, Griselda, *Differencing the Canon: Feminist Desire and the Writing of Art's Histories* (London: Routledge, 1999).

Pollock, Griselda, 'Women, art and ideology: questions for feminist art historians', *Women's Art Journal*, 4 (1) (1983): 39–47; reprinted in *Visibly Female: Feminism and Art Today – An Anthology*, ed. Hilary Robinson (London: Camden Press, 1987; New York: Universe, 1988), pp. 203–21.

Raven, Arlene, Langer, Cassandra and Frueh, Joanna (eds), *Feminist Art Criticism: An – Anthology* (London: UMI Research Press; New York: Icon Editions, 1988).

Rees, A. L. and Borzello, Frances (eds), *The New Art History* (London: Camden Press, 1986).

3.1 The Uses of Language

Valerie Jaudon and Joyce Kozloff, 'Art Hysterical Notions of Progress and Culture' (1978)

From *Heresies*, 4 (1978), pp. 38–42 © Valerie Jaudon and Joyce Kozloff/Licensed by VAGA, New York, NY.

As feminists and artists exploring the decorative in our own paintings, we were curious about the pejorative use of the word 'decorative' in the contemporary art world. In rereading the basic texts of Modern Art, we came to realize that the prejudice against the decorative has a long history and is based on hierarchies: fine art above decorative art, Western art above non-Western art, men's art above women's art. By focusing on these hierarchies we discovered a disturbing belief system based on the moral superiority of the art of Western civilization.

We decided to write a piece about how *language* has been used to communicate this moral superiority. Certain words have been handed down unexamined from one generation to the next. We needed to take these words away from the art context to examine and decode them. They have colored our own history, our art training. We have had to rethink the underlying assumptions of our education.

Within the discipline of art history, the following words are continuously used to characterize what has been called 'high art': man, mankind, the individual man, individuality, humans, humanity, the human figure, humanism, civilization, culture, the Greeks, the Romans, the English, Christianity, spirituality, transcendence, religion, nature, true form, science, logic, purity, evolution, revolution, progress, truth, freedom, creativity, action, war, virility, violence, brutality, dynamism, power and greatness.

In the same texts other words are used repeatedly in connection with so-called 'low art': Africans, Orientals, Persians, Slovaks, peasants, the lower classes, women, children, savages, pagans, sensuality, pleasure, decadence, chaos, anarchy, impotence, exotica, eroticism, artifice, tattoos, cosmetics, ornament, decoration, carpets, weaving, patterns, domesticity, wallpaper, fabrics and furniture.

All of these words appear in the quotations found throughout this piece. The quotations are from the writings and statements of artists, art critics and art historians. We do not pretend to neutrality and do not supply the historical context for the quotations. These can be found in the existing histories of Modern Art. Our analysis is based on a personal, contemporary perspective.

War and Virility

Manifestos of Modern Art often exhort artists to make violent, brutal work, and it is no accident that men such as Hirsh, Rivera, and Picasso like to think of their art as a metaphorical weapon. One of the longstanding targets of this weapon has been the decorative. The scorn for decoration epitomizes the machismo expressed by Le Corbusier, Gabo/Pevsner and Marinetti/Sant'Elia. Their belligerence may take the form of an appeal to the machine aesthetic: the machine is idolized as a tool and symbol of progress, and technological progress is equated with reductivist, streamlined art. The instinct to purify exalts an order which is never described and condemns a chaos which is never explained.

Joseph Hirsh, from 'Common Cause,' D. W. Larkin, 1949:
'The great artist has wielded his art as a magnificent weapon truly mightier than the sword . . .'

Diego Rivera, 'The Revolutionary Spirit in Modern Art,' 1932:
'I want to use my art as a weapon.'

Pablo Picasso, 'Statement about the Artist as a Political Being,' 1945:
'No, painting is not done to decorate apartments. It is an instrument of war for attack and defense against the enemy.'

Le Corbusier, 'Guiding Principles of Town Planning,' 1925:
'Decorative art is dead . . . An immense, devastating brutal evolution has burned the bridges that link us with the past.'

Naum Gabo and Antoine Pevsner, 'Basic Principles of Constructivism,' 1920:
'We reject the decorative line. We demand of every line in the work of art that it shall serve solely to define the inner directions of force in the body to be portrayed.'

Filippo Tommaso Marinetti and Antonio Sant'Elia, 'Futurist Architecture,' 1914:
'The decorative must be abolished! . . . Let us throw away monuments, sidewalks, arcades, steps; let us sink squares into the ground, raise the level of the city.'

El Lissitsky, 'Ideological Superstructure,' 1929:
'Destruction of the traditional . . . War has been declared on the aesthetic of chaos. An order that has entered fully into consciousness is called for.'

'Manifesto of the Futurist Painters,' 1910:
'The dead shall be buried in the earth's deepest bowels! The threshold of the future will be free of mummies! Make room for youth, for violence, for daring!'

Purity

In the polemics of Modern Art 'purity' represents the highest good. The more the elements of the work of art are pared down, reduced, the more visible the 'purity.' Here Greenberg equates reductivism with rationality and function. But it is never explained why or for whom art has to be functional, nor why reductivism is rational. Among artists as diverse as Sullivan, Ozenfant and de Kooning, we found the sexual metaphor of 'stripping down' art and architecture to make them 'nude' or 'pure.' The assumption is that the artist is male, and the work of art (object) female.

> Clement Greenberg, 'Detached Observations,' 1976:
> 'The ultimate use of art is construed as being to provide the experience of aesthetic value, therefore art is to be stripped down towards this end. Hence, modernist "functionalism," "essentialism" it could be called, the urge to "purify" the medium, any medium. "Purity" being construed as the most efficacious, efficient, economical employment of the medium for purposes of aesthetic value.'

> Louis Sullivan, 'Ornament in Architecture,' 1892:
> 'it would be greatly for our aesthetic good, if we should refrain from the use of ornament for a period of years, in order that our thought might concentrate acutely upon the production of buildings well formed and comely in the nude.'

> Amédée Ozenfant, *Foundations of Modern Art*, 1931:
> 'Decoration can be revolting, but a naked body moves us by the harmony of its form.'

> Willem de Kooning, 'What Abstract Art Means to Me,' 1951:
> 'One of the most striking of abstract art's appearance is her nakedness, an art stripped bare.'

Purity in Art as a Holy Cause

Purity can also be sanctified as an aesthetic principle. Modern artists and their espousers sometimes sound like the new crusaders, declaring eternal or religious values. A favorite theme is that of cleansing art. The ecclesiastical metaphor of transcendence through purification (baptism) is used to uphold the 'Greek' tradition (as in the van de Velde quotation) or the 'Christian' tradition (as in the Loos quotation). Cleansing and purification are sometimes paired with an exalted view of the artist as a god, as in Apollinaire's desire to 'deify personality.'

> Henry van de Velde, 'Programme,' 1903:
> 'As soon as the work of cleansing and sweeping out has been finished, as soon as the true form of things comes to light again, then strive with all the patience, all the spirit and the logic of the Greeks for the perfection of this form.'

> Adolf Loos, 'Ornament and Crime,' 1908:
> 'We have outgrown ornament; we have fought our way through to freedom from ornament. See, the time is nigh, fulfilment awaits us. Soon the streets of the city will

glisten like white walls, like Zion, the holy city, the capital of heaven. Then fulfilment will be come.'

Guillaume Apollinaire, *The Cubist Painters*, 1913:
'To insist on purity is to baptize instinct, to humanize art, and to deify personality.'

The Superiority of Western Art

Throughout the literature of Western art there are racist assumptions that devalue the arts of other cultures. The ancient Greeks are upheld as the model, an Aryan ideal of order. Art in the Greco-Roman tradition is believed to represent superior values. Malraux uses the word 'barbarian' and Fry the word 'savages' to describe art and artists outside our tradition. The non–Western ideals of pleasure, meditation and loss of self are clearly not understood by the exponents of ego assertion, transcendence and dynamism.

David Hume, 'Of National Characters' (on Africans), 1748:
'There scarcely ever was a civilized nation of that complexion nor even any individual, eminent either in action or speculation. No ingenious manufactures amongst them, no arts, no sciences.'

Roger Fry, 'The Art of the Bushmen,' 1910:
'it is to be noted that all the peoples whose drawing shows this peculiar power of visualization (sensual not conceptual) belong to what we call the lowest of savages, they are certainly the least civilizable, and the South African Bushmen are regarded by other native races in much the same way that we look upon negroes.'

André Malraux, *The Voices of Silence*, 1953:
'Now a barbarian art can keep alive only in the environment of the barbarism it expresses . . . the Byzantine style, as the West saw it, was not the expression of a supreme value but merely a form of decoration.'

Roger Fry, 'The Munich Exhibition of Mohammedan Art,' 1910:
'It cannot be denied that in course of time it [Islamic art] pandered to the besetting sin of the oriental craftsman, his intolerable patience and thoughtless industry.'

Gustave von Grunebaum, *Medieval Islam*, 1945:
'Islam can hardly be called creative in the sense that the Greeks were creative in the fifth and fourth centuries B.C. or the Western world since the Renaissance, but its flavor is unmistakable . . .'

Sir Richard Westmacott, Professor of Sculpture, Royal Academy (quoted in *Rediscoveries in Art: Some Aspects of Taste, Fashion and Collecting in England and France*, Francis Haskell, 1977):
'I think it impossible that any artist can look at the Nineveh marbles as works for study, for such they certainly are not: they are works of prescriptive art, like works of Egyptian art. No man would ever think of studying Egyptian art.'

Adolf Loos, 'Ornament and Crime,' 1908:
'No ornament can any longer be made today by anyone who lives on our cultural level.'

'It is different with the individuals and peoples who have not yet reached this level.'
'I can tolerate the ornaments of the Kaffir, the Persian, the Slovak peasant woman,
my shoemaker's ornaments, for they all have no other way of attaining the high points
of their existence. We have art, which has taken the place of ornament. After the toils
and troubles of the day we go to Beethoven or to Tristan.'

Fear of Racial Contamination, Impotence and Decadence

Racism is the other side of the coin of Exotica. Often underlying a fascination with
the Orient, Indians, Africans and primitives is an urgent unspoken fear of infiltration,
decadence and domination by the 'mongrels' gathering impatiently at the gates of
civilization. Ornamental objects from other cultures which appeared in Europe in the
nineteenth century were clearly superior to Western machine-made products. How
could the West maintain its notion of racial supremacy in the face of these objects?
Loos's answer: by declaring that ornament itself was savage. Artists and aesthetes who
would succumb to decorative impulses were considered impotent and/or decadent.

Adolf Loos, 'Ornament and Crime,' 1908:
'I have made the following discovery and I pass it on to the world: The evolution of
culture is synonymous with the removal of ornament from utilitarian objects. I
believed that with this discovery I was bringing joy to the world; it has not thanked
me. People were sad and hung their heads. What depressed them was the realization
that they could produce no new ornaments. Are we alone, the people of the nine-
teenth century, supposed to be unable to do what any Negro, all the races and periods
before us have been able to do? What mankind created without ornament in earlier
millenia was thrown away without a thought and abandoned to destruction. We
possess no joiner's benches from the Carolingian era, but every trifle that displays the
least ornament has been collected and cleaned and palatial buildings have been erected
to house it. Then people walked sadly about between the glass cases and felt ashamed
of their impotence.'

Amédée Ozenfant, *Foundations of Modern Art*, 1931:
'Let us beware lest the earnest effort of younger peoples relegates us to the
necropolis of the effete nations, as mighty Rome did to the dilettantes of the Greek
decadence, or the Gauls to worn-out Rome.'
'Given many lions and few fleas, the lions are in no danger; but when the fleas
multiply, how pitiful is the lions' lot!'

Albert Gleizes and Jean Metzinger, *Cubism*, 1912:
'As all preoccupation in art arises from the material employed, we ought to regard the
decorative preoccupation, if we find it in a painter, as an anachronistic artifice, useful
only to conceal impotence.'

Maurice Barrés (on the Italian pre-Renaissance painters), 1897 (quoted in André
Malraux, *The Voices of Silence*):
'And I can also see why aesthetes, enamored of the archaic, who have deliberately
emasculated their virile emotions in quest of a more fragile grace, relish the poverty
and pettiness of these minor artists.'

Racism and Sexism

Racist and sexist attitudes characterize the same mentality. They sometimes appear in the same passage and are unconsciously paired, as when Read equates tattoos and cosmetics. The tattoo refers to strange, threatening customs of far-off places and mysterious people. Cosmetics, a form of self-ornamentation, is equated with self-objectification and inferiority (Schapiro). Racism and sexism ward off the potential power and vitality of the 'other.' Whereas nudity earlier alluded to woman as the object of male desire, here Malevich associates the nude female with savagery.

Herbert Read, *Art and Industry*, 1953:
'All ornament should be treated as suspect. I feel that a really civilized person would as soon tattoo his body as cover the form of a good work of art with meaningless ornament. Legitimate ornament I conceive as something like mascara and lipstick – something applied with discretion to make more precise the outlines of an already existing beauty.'

Adolf Loos, 'Ornament and Crime,' 1908:
'The child is amoral. To our eyes, the Papuan is too. The Papuan kills his enemies and eats them. He is not a criminal. But when modern man kills someone and eats him he is either a criminal or a degenerate. The Papuan tattoos his skin, his boat, his paddles, in short everything he can lay hands on. He is not a criminal. The modern man who tattoos himself is either a criminal or a degenerate. There are prisons in which eighty per cent of the inmates show tattoos. The tattooed who are not in prison are latent criminals or degenerate aristocrats. If someone who is tattooed dies at liberty, it means he has died a few years before committing a murder.'

Meyer Schapiro, 'The Social Bases of Art,' 1936:
'A woman of this class [upper] is essentially an artist, like the painters whom she might patronize. Her daily life is filled with aesthetic choices; she buys clothes, ornaments, furniture, house decorations; she is constantly re-arranging herself as an aesthetic object.'

Kasimir Malevich, 'Suprematist manifesto Unovis,' 1924:
'we don't want to be like those Negroes upon whom English culture bestowed the umbrella and top hat, and we don't want our wives to run around naked like savages in the garb of Venus!'

Iwan Bloch, *The Sexual Life of our Time*, 1908:
'[woman] possesses a greater interest in her immediate environment, in the finished product, in the decorative, the individual, and the concrete; man, on the other hand, exhibits a preference for the more remote, for that which is in process of construction or growth, for the useful, the general, and the abstract.'

Leo Tolstoy, 'What is Art?' 1898:
'Real art, like the wife of an affectionate husband, needs no ornaments. But counterfeit art, like a prostitute, must always be decked out.'

Hierarchy of High–Low Art

Since the art experts consider the 'high arts' of Western men superior to all other forms of art, those arts done by non-Western people, low-class people and women are categorized as 'minor arts,' 'primitive arts,' 'low arts,' etc. A newer more subtle way for artists to elevate themselves to an elite position is to identify their work with 'pure science,' 'pure mathematics,' linguistics and philosophy. The myth that high art is for a select few perpetuates the hierarchy in the arts, and among people as well.

Clement Greenberg, 'Avant-garde and Kitsch,' 1939:
'It will be objected that such art for the masses as folk art was developed under rudimentary conditions of production – and that a good deal of folk art is on a high level. Yes, it is – but folk art is not Athene, and it's Athene whom we want: formal culture with its infinity of aspects, its luxuriance, its large comprehension.'

H. W. Janson, *History of Art*, 1962:
'for the applied arts are more deeply enmeshed in our everyday lives and thus cater to a far wider public than do painting and sculpture, their purpose, as the name suggests, is to beautify the useful, an important and honourable one, no doubt, but of a lesser order than art pure and simple.'

Amédée Ozenfant, *Foundations of Modern Art*, 1931:
'If we go on allowing the minor arts to think themselves the equal of Great Art, we shall soon be hail fellow to all sorts of domestic furniture. Each to his place! The decorators to the big shops, the artists on the next floor up, several floors up, as high as possible, on the pinnacles, higher even. For the time being, however, they sometimes do meet on the landings, the decorators having mounted at their heels, and numerous artists having come down on their hunkers.'

Le Corbusier (Pierre Jeanneret) and Amédée Ozenfant, 'On Cubism,' 1918: (quoted in Ozenfant, *Foundations of Modern Art*):
'There is a hierarchy in the arts: decorative art at the bottom, and the human form at the top.'
'Because we are men.'

André Malraux, *The Voices of Silence*, 1953:
'The design of the carpet is wholly abstract; not so its color. Perhaps we shall soon discover that the sole reason why we call this art "decorative" is that for us it has no history, no hierarchy, no meaning. Color reproduction may well lead us to review our ideas on this subject and rescue the masterwork from the North African bazaar as Negro sculpture has been rescued from the curio-shop; in other words, liberate Islam from the odium of "backwardness" and assign its due place (a minor one, not because the carpet never portrays Man, but because it does not express him) to this last manifestation of the undying East.'

Barnett Newman, 'The Ideographic Picture,' 1947 (on the Kwakiutl artist):
'The abstract shape he used, his entire plastic language, was directed by a ritualistic will towards metaphysical understanding. The everyday realities he left to the toymakers; the pleasant play of nonobjective pattern to the women basket weavers.'

Ursula Meyer, *Conceptual Art*, 1972:
'In the same sense that science is for scientists and philosophy is for philosophers, art is for artists.'

Joseph Kosuth, 'Introductory Note by the American Editor,' 1970:
'In a sense, then, art has become as "serious as science or philosophy" which doesn't have audiences either.'

That Old Chestnut, 'Humanism'

Humanism was once a radical doctrine opposing the authority of the church, but in our secular society it has come to defend the traditional idea of 'mankind' and status quo attitudes. The 'human values' such authorities demand of art depend on the use of particular subject matter or particular ideas of 'human' expression. Without humanist content, ornament, pattern and ritual or decorative elaborations of production are condemned as inhuman, alien and empty. 'The limits of the decorative,' says Malraux, 'can be precisely defined only in an age of humanistic art.' We could rather say that the generalities of 'humanist' sentiment characterize only a small part of world art, most of which is non-Western and decorative. But why should anyone prefer the false divisions of these writers, based on ethnic stereotypes, to a historical awareness of the interdependence of all 'human' cultures?

Camille Mauclair, 'La Réforme de l'art décoratif en France' (on the Impressionists), 1896:
'Decorative art has as its aesthetic and for its effect not to make one think of man, but of an order of things arranged by him: it is a descriptive and deforming art, a grouping of spectacles the essence of which is to be seen.'

Rudolf Arnheim, *Art and Visual Perception*, 1954:
'Paintings or sculpture are self-contained statements about the nature of human existence in all its essential aspects. An ornament presented as a work of art becomes a fool's paradise, in which tragedy and discord are ignored and an easy peace reigns.'

Hilton Kramer, 'The Splendors and Chill of Islamic Art,' 1975:
'for those of us who seek in art something besides a bath of pleasurable sensation, so much of what it [the Metropolitan Museum's Islamic wing] houses is, frankly so alien to the expectations of Western sensibility.'
'Perhaps with the passage of time, Islamic art will come to look less alien to us than it does today. I frankly doubt it – there are too many fundamental differences of spirit to be overcome.'
'there is small place indeed given to what looms so large in the Western imagination: the individualization of experience.'

Sir Thomas Arnold, *Painting in Islam*, 1928:
'the painter was apparently willing to spend hours of work upon the delicate veining of the leaves of a tree . . . but it does not seem to have occurred to him to devote the same pains and effort on the countenances of his human figures . . . he appears to have been satisfied with the beautiful decorative effect he achieved.'

André Malraux, *The Voices of Silence*, 1953:
'The limits of the decorative can be precisely defined only in an age of humanistic art.'
'It was the individualization of destiny, this involuntary or unwitting imprint of his private drama on every man's face, that prevented Western art from becoming like Byzantine mosaics always transcendent, or like Buddhist sculpture obsessed with unity.'
'How could an Egyptian, an Assyrian or a Buddhist have shown his god nailed to a cross, without ruining his style?'

Decoration and Domesticity

The antithesis of the violence and destruction idolized by Modern Art is the visual enhancement of the domestic environment. (If humanism is equated with dynamism, the decorative is seen to be synonymous with the static.) One method 'modernism' has used to discredit its opponents has been to associate their work with carpets and wallpaper. Lacking engagement with 'human form' or the 'real world,' the work of art must be stigmatized as decorative (Sedlmayr and Barnes/de Mazia). So decorative art is a code term signifying failed humanism. Artists such as Gleizes and Kandinsky, anxious to escape the tag of the decorative, connect their work to older, humanist aspirations.

Aldous Huxley on Pollock's *Cathedral*, 1947:
'It seems like a panel for a wallpaper which is repeated indefinitely around the wall.'

Wyndham Lewis, 'Picasso' (on *Minotauromachy*), 1940:
'this confused, feeble, profusely decorated, romantic carpet.'

The Times of London critic on Whistler, 1878:
'that these pictures only come one step nearer [to fine art] than a delicately tinted wallpaper.'

Hans Sedlmayr, *Art in Crisis: The Lost Center*, 1948:
'With Matisse, the human form was to have no more significance than a pattern on a wallpaper . . .'

Dr Albert C. Barnes and Violette de Mazia, *The Art of Cézanne*, 1939:
'Pattern, in Cézanne an instrument strictly subordinated to the expression of values inherent in the real world, becomes in cubism the entire aesthetic content, and this degradation of form leaves cubistic painting with no claim to any status higher than decoration.'

Albert Gleizes, 'Opinion' (on Cubism), 1913:
'There is a certain imitative coefficient by which we may verify the legitimacy of our discoveries, avoid reducing the picture merely to the ornamental value of an arabesque or an Oriental carpet, and obtain an infinite variety which would otherwise be impossible.'

Wassily Kandinsky, *Über das Geistige in der Kunst*, 1912:
'If we begin at once to break the bonds that bind us to nature and to devote ourselves purely to combinations of pure color and independent form, we shall produce works which are mere geometric decoration, resembling something like a necktie or a carpet.'

Autocracy

Certain modern artists express the desire for unlimited personal power. The aesthetics of 'modernism' – its ego-mania, violence, purity-fixation and denial of all other routes to the truth – is highly authoritarian. The reductivist ideology suggests an inevitable, evolutionary survival of the (aesthetic) fittest. Reinhardt declares throughout his writings that all the world's art must culminate in his 'pure' paintings. Ozenfant equates purism with a 'super-state.' Mendelsohn believes the advocates of the new art have a 'right to exercise control.'

Ad Reinhardt, 'There is Just One Painting,' 1966:
'There is just one art history, one art evolution, one art progress. There is just one aesthetics, just one art idea, one art meaning, just one principle, one force. There is just one truth in art, one form, one change, one secrecy.'

Amédée Ozenfant, *Foundations of Modern Art*, 1931:
'Purism is not an aesthetic, but a sort of super-aesthetic in the same way that the League of Nations is a superstate.'

Erich Mendelsohn, 'The Problem of a New Architecture,' 1919:
'The simultaneous process of revolutionary political decisions and radical changes in human relationships in economy and science and religion and art give belief in the new form, an *a priori* right to exercise control, and provide a justifiable basis for a rebirth amidst the misery produced by world-historical disaster.'

Adolf Hitler, speech inaugurating the 'Great Exhibition of German Art,' 1937:
'I have come to the final inalterable decision to clean house, just as I have done in the domain of political confusion . . .'
'National-Socialist Germany, however, wants again a "German Art," and this art shall and will be of eternal value, as are all truly creative values of a people. . . .'

Frank Lloyd Wright, 'Work Song,' 1896:
'I'LL THINK
AS I'LL ACT
AS I AM!
NO DEED IN FASHION FOR SHAM
NOR FOR FAME E'ER MAN MADE
SHEATH THE NAKED WHITE BLADE
MY ACT AS BECOMETH A MAN
MY ACT
ACTS THAT BECOMETH THE MAN'

We started by examining a specific attitude – the prejudice against the decorative in art – and found ourselves in a labyrinth of myth and mystification. By taking these quotes

out of context we are not trying to hold these artists and writers up to ridicule. However, to continue reading them in an unquestioning spirit perpetuates their biases. The language of their statements is often dated – indeed, some of them are over a century old – but the sentiments they express still guide contemporary theory in art.

Modernism, the theory of Modern Art, claimed to break with Renaissance humanism. Yet both doctrines glorify the individual genius as the bearer of creativity. It seems worth noting that such heroic genius has always appeared in the form of a white Western male. We, as artists, cannot solve these problems, but by speaking plainly we hope to reveal the inconsistencies in assumptions that too often have been accepted as 'truth.'

Acknowledgements

We relied heavily on Joseph Masheck, 'The carpet paradigm: critical prolegomena to a theory of flatness,' *Arts Magazine* (September 1976), for the quotes about carpets and wallpaper.

To Amy Goldin whose ideas and encouragement made this piece possible.

Susanne Kappeler, 'No Matter How Unreasonable' (1988)

Review of *Rape*, ed. Sylvana Tomaselli and Roy Porter (Oxford: Blackwell, 1986), from *Art History*, 11 (1) (1988) pp. 118–123.

Among the many inequalities between the genders, feminists have long drawn attention to the asymmetry of women's silence and men's public voice. Silence has significantly surrounded women's experience of male violence throughout history, while men have produced their own discourse on sexual aggression, violence and domination for public consumption, that is to say, for themselves.[1] Feminists call this discourse pornography, although mainstream, or malestream, parlance reserves the term for the mass production of 'low culture'.[2] It is a particularly poignant irony that the recent feminist struggle to break female silence on rape and sexual abuse by means of an extensive research literature should be seen by men – including academics – as providing a widened opportunity for man-to-man talk of sexual fantasy. In the sphere of academic discourse, I would call this phenomenon 'academic pornography'.

To women, it comes as no surprise that men are keen to 'talk rape' – we have long argued the connection between pornography ('fantasy', discourse) and sexual violence. A recent researcher of convicted rapists in prison reports that offenders 'queued up' when 'invited to talk about their crimes', while the publication of his book occasioned 'more calls than he can cope with from men who want to talk'.[3] This stands in sharp contrast to the fact that women find it exceedingly difficult to talk about their experiences of sexual violation, even to women.[4] So we should not be all that surprised to find

that academic men, too, are queuing up to talk about rape, pornography and sexual violence, revelling, as one author puts it, 'in a daze of scholarly sexuality, in a world eroticized in a peculiarly Platonic way: mocked simultaneously by genital stirrings and philosophical amazement, stimulated by ubiquitous beauty [sic] into urges analytically perverse and perversely analytic'.[5] Nor should we be too surprised to find academic publishers queuing up behind the feminist presses to publish books on rape, pornography and sexual violence.[6]

What better pretext, then, for indulging the pleasure of talking rape than a renewed look at the classic depictions of rape enshrined in the art historical canon? Norman Bryson contributes an article, 'Two Narratives of Rape in the Visual Arts: Lucretia and the Sabine Women' to a recent example of academic pornography, a book simply called *Rape*.[7] A close look at his argument reveals the classic motivation behind most of men's rape talk, namely the production of pleasure through violence in discourse, and the self-persuasion (man-to-man talk) that rape, far from being violence perpetrated by men, is 'pleasure' courted by women. This is no different from the 'defence' argued by every charged rapist in court, and usually reiterated by defence lawyers, prosecution and judges: 'I honestly believed the lady consented' pleaded by the rapist,[8] and powerfully endorsed by the notorious ruling of Judge Morgan in 1975: 'a man should be ac-quitted of rape if he *honestly believed* that the woman consented, *no matter how unrea-sonable*'.[9] How a belief, no matter how unreasonable, may come to seem reasonable enough for the protection of the law and the advocacy of academics is precisely what Bryson demonstrates to us. The issue is not whether or not a crime of rape has taken place, but whether the criminal offender thought his victim appreciated victimisation, in a context where not only criminal offenders, but officers of the law encourage unrea-sonable beliefs, and academics construct sophisticated discourses to vindicate them.

Bryson starts with a surprising claim regarding the status of rape (p. 153):

> Ours is, remarkably, a culture where rape can no longer be thought of as unitary, as singular, as an event with appropriate spokesmen [sic] . . . Rape exists for us . . . in a highly refracted form . . . Rape is splintered, broken up, diffracted . . . Whence the impossibility of our portraying rape, of rape existing for us as an image . . . the impos-sibility of reclaiming rape for the single representation, of making rape exist as an image . . . rape belongs here to the sphere of discourses, not events . . . The space where rape had once been something that could receive actual portrayal, where it could be *visualized*, no longer exists: the mind is too refractive to have its eye. [his emphasis]

What is remarkable about this lament of the lost object is the allusion to a golden age where rape still existed as an unitary event, for the mind to visualise and the artist to claim for representation. I am also struck by the use of the pronoun 'us' for whom rape is said to exist in a highly refracted form that belongs to the sphere of discourses, *not of events*. It must refer to those 'spokesmen' among us who neither lament rape, nor would celebrate its decline, but who worry about producing an image of it, who 'embrace rape as their object of knowledge', 'who discuss it and embrace it as theirs' (p. 153), in a language positively amorous. Most of all, however, I am struck by a lan-guage which makes 'rape' the victim of a discursive attack by a 'wide variety of accents'

and a 'babel of voices' (p. 153) which leaves it 'splintered, broken up, diffracted'. It is a curious display of sympathy for a violated 'object of knowledge', on the part of an author who also tells us that with regard to 'the women themselves', 'compassion cannot be the only, or the final, response' (p. 162). Compassion is due, it seems, exclusively to a mode of discourse – visual representation – which fails to 'embrace' rape and make it its own as an image.

There is no evidence, of course, of any such historical chronology of decline, since rape never was an object. Its lack of representability as an image is due to its being an action or event, of one person violating another, and which requires a narrative dimension for representation. But Bryson's concern is to move away from any mundane reality of action, offender and victim to reach the spheres of discourse and 'transmissible iconographies' (p. 173), where he quickly loses track of his 'object' and hence its appropriate representation, scrambling between image and narrative. Thus he finds it 'understandable' that your first reaction in the face of the 'dehumanizing formalism' of Poussin's paintings of the rape of the Sabine women might be 'depression' and even 'indignation' (pp. 154–5). 'But' he argues, 'the situation is in fact more complicated': 'we need to know *exactly* what the story of the Sabine women involves' (p. 155). And through an impressive scholarly expedition into mythology, literature and Roman law we discover what exactly the story of the rape of the Sabine women involves: it is, according to Bryson, 'about law, not seizure' (p. 159), and 'is not to be understood as a specifically sexual crime, nor is it a crime against individual women in any direct sense' (p. 156). This is because 'daughters fall under the sway of the eldest male ascendant in their family, the *pater familias*' (p. 156). Since all these fathers and guardians make a truce in the end with the Roman rapists of their daughters and recognise their abduction as legitimate marriages, all is well, Rome has been constituted, and 'Rome has legitimate wives and children' (p. 158). Rome, one takes it, is male and endowed with a penis.

The legitimate form of Roman marriage, Bryson explains, is one involving *manus*, where 'the *pater familias* emancipates the daughter or ward to the power of the husband' (p. 157). This may remind us of the connection with the related concept of the manumission of slaves, the release of slaves from the hands of their owner, only that in this case, the daughter or ward is released from the hands of the father into the hands of another, to be a slave to her husband. Whilst Bryson thinks that 'the English word "rape" is an obviously misleading term in this context' of forcible abduction and sexual appropriation, he seems to find 'emancipation' a fit word for the transfer of women 'to the power of the husband'. It is neither emancipation in the modern sense of gaining autonomy and personhood, nor in its original classical or Roman sense where it applies to the release of a son into independence.[10] Rather, it relates to a third sense of 'emancipate' under Roman law, namely 'to deliver into subjection; to enslave (because emancipation in Rom. Law was effected by fictitious sale)' (*OED*). All is well and lawful, we have 'a fable of law, not of violence, or rather it is a fable of the ways in which law had emerged from violence' (p. 158). Or perhaps, of how the very law embodies and sanctions violence. No crime of rape has been committed 'against individual women in any direct sense', since we are dealing with a form of lawful slavery which, in the art historian's eyes, has nothing to do with violence in any direct sense.

Poussin is rescued from being depressing by a further archaeological excursion, this time into the Christian era and its views on rape. Under Christian perspective, rape becomes a public crime which incurs the death penalty for the man, while the woman is also punished, 'according to the degree of sexual guilt': death by burning 'if she had been willing', or a lighter sentence if unwilling (p. 161). The notion is that if she had been unwilling enough, her screams could have been heard by neighbours who would have come to her rescue. This would presumably render a victim of murder guilty and willing in the same way, for not having screamed loud enough. What is remarkable about Christian thinking is that the victim is found guilty – regardless, or rather by virtue, of being a victim. What is even more remarkable is the semantic feat of constructing a willingness to be victimised, a willingness to be forced against one's will, a willingness to be unwilling.

No matter how unreasonable, having got the stories right, having consulted his Livy and his Plutarch, Roman and Church law, Bryson saunters on to explore his next narrative of rape, with never a thought of analysing the complexities of his patriarchal sources. His Christian spectacles never fail him, for he is now firmly focused on Lucretia's 'consent' to be taken without her consent. Having managed twice to write 'if she had been willing' and 'if she consented' to be raped in expostulating Church law without so much as a stumbling of the pen, he now moves Lucretia's 'consent' to the centre of concern. Her 'consent' takes the following form, in the written accounts: Tarquinius enters Lucretia's bedroom armed with a sword. When he declares that if she will not let him have his way he will kill her and her male slave and tell the world that he found them in adulterous embrace, 'Lucretia yields' (p. 163). No blood has been spilt (for the mind to visualise), no physical struggle taken place, and of course, no cries could be heard by neighbours; hence, we are to believe, no violence has taken place and Lucretia 'consented' to be violated. Only two forms of violence have taken place: intimidation by exhibition of force and threat, and rape upon the woman.

The next form of violence comes at the hands of the Church fathers (*patres ecclesiae*), who not only read her 'consent' in the fact that she was raped (i.e. robbed of the possibility of giving or withholding consent), but who add a 'secondary consent' of the mind for good measure. Imagining rape to be an act 'which perhaps could not have taken place without some physical pleasure', they forget about 'perhaps' and conclude that it therefore 'was accompanied by a consent of the mind' (p. 167). While Bryson is not without perception of the extraordinary sophistry (violence in sense l.b. of the *OED*), and what he calls the 'very disagreeable final twist of Augustine's argument' (p. 167), this does not prevent him from accepting Augustine's penultimate twist (no matter how disagreeable) of Lucretia's 'actual consent': he takes it as established that 'Lucretia gave it' (p. 167). And from that it is not so very disagreeable to set out to convince us that she is about to give it also in the second sense (final twist), through his analysis of Titian's *Tarquin and Lucretia* of the Fitzwilliam Museum in Cambridge.

Titian, he tells us, 'on the whole, lacks sensitivity to the political aspect of the case': 'What is shown in the Titian version is exactly what forms the centre of Augustine's discussion: Lucretia's consent' (p. 167). And 'Titian's painting represents either the consent itself, or the consent about to be given' (small difference, from fact to unreasonable belief); 'in so far as it is a painting of Tarquin and Lucretia, it represents . . .

the giving of consent' (p. 168). QED. The nudity of Lucretia, we are also told, enhances the sexual nature of the painting (not, for instance, her vulnerability). This brings it that much closer, in Bryson's as in Augustine's mind, to the woman's pleasure and her consent of the mind. As with most male interpreters of rape, rape is here conflated with a sexual act and hence divested of its aspect of violation and of violence, the coercion against the woman's will. The naked body of a woman is evidence enough of pleasure (for the mind to visualise), a body presupposed to be made for sex, a body presupposed to produce pleasure through sex – regardless. Rape is equated with sex, the woman equated with her body and an automatic physiological response called 'her pleasure', while the will of the person has disappeared – except that she or her body is said to be willing and to consent.

Tarquin's act, in Bryson's analysis of Titian's painting, becomes one 'simply, of debauchery or sexual excess' (p. 169). 'Tarquin's act', we are told, 'is intelligible in the terms which the painting itself offers, terms which the image is able to supply from its own internal resources directly' (p. 169). In other words, it does not require a detour into the sources of reinterpretations of the narrative, it can be read off the canvas, out of its visual resources. Let us see how Lucretia's consent to be violated can be read off from the painted image.

Lucretia, half-sitting, half-lying on her bed, is naked bar a veil across her thigh and the jewellery around her neck and wrists. Tarquin, fully dressed, looms over her, his right knee thrust between her legs, his left arm holding off Lucretia's arm, while his right arm holds a dagger about a yard from her face and chest, extended to strike with full swing. Lucretia's face is focused with an expression of fear on her attacker. Threat and intimidation are compounded and visually supplied out of the image's internal resources, its means of visualising the differential in power: the woman is faced by a man; she is naked while he is dressed, unarmed while he is armed; she is half-lying on her back, having lost her balance, while he is towering over her, knee firmly lodged on the edge of the bed; her one arm is made defenceless by his grip, her other cannot reach the arm that holds a knife over her, ready to strike. It is an unambiguous exhibition of force and defencelessness, of intimidation and fear, of violation of the woman's privacy, integrity, selfhood and will. We are told we are seeing her consent.

Despite the art historian's assertion that he reads the painting's internal resources, he does in fact require a detour via a mid-seventeenth-century Florentine painting in order to read the figure of Lucretia in the Titian, which he says 'is actually rather harder to read than Tarquin's' (p. 170). It is indeed harder to read if you are determined to read her consent, and her secondary consent of pleasure, from her defenceless figure and her face of fear. However, the Florentine painter obliges with a representation of Lucretia as already supine – a sign the male critic without fail finds enhancing the sexual meaning of the painting. Here, her body is said 'to belong amid the linen and the pillows', and the pose to be 'much more clearly one of seduction' (p. 170). The expression on her face, foreshortened by the perspective and her pose, is actually difficult to read, yet the intrepid critic assures us that 'it is not fanciful to see on her lips something of a smile, if not of pleasure in the act (which would push the painting fully into the abyss of kitsch), then of pleasure despite the act, of pleasure, as Augustine describes it, in the second form of consent, the consent that the body gives even though the spirit resolutely holds out; the pleasure which man can never conceal, being as he is, but which

woman is able to conceal from all but her conscience, and from God' (p. 170). And from the art historian, it would seem. Notice the rhythmic thrust of his prose, bearing down again and again on her pleasure, her pleasure visible to him despite its invisibility, despite its concealment from all but her conscience and God. He looks with her con- science and with God, which in any case he has constructed himself, with the help of Augustine and a discourse manhandled into sophistry with its very disagreeable twists. Twists like consent under the threat of a knife, twists like a woman's body *belonging* amid linen and pillows, twists like a woman on her back signifying the sexual and hence perforce seduction, twists like claiming to be able to read 'despite' from the visual resources of an image. What would it look like if it were 'pleasure in the act' rather than 'pleasure despite the act'? We know it would plunge a work of art into the abyss of kitsch, but what would be the visual difference?

But Bryson cannot stop to trifle with such details, he is heading off to the climax of the consummation of his pleasure: 'If Lucretia smiles, the fact or possibility of radical (physiological, moral) difference in the constitution of the sexes can be consolingly overcome: Lucretia's smile quickly becomes what we see it is in Cagnacci's representa- tion: a sexual sign, like the dagger, the pillows, the nudity' (p. 170). If she smiles, sexual difference is 'resolved, and despite every appearance to the contrary she is like him, like *us*' (p. 170). 'Us/we' are obviously male, like Tarquin, like the art critic, who looks and sees with his penis, whose gaze penetrates the invisible, who looks past appearance to something which is contrary to appearance: to a smile which is not visible and does not appear on the face of Lucretia. For whom the dagger is a sexual sign: a harbinger of (his) pleasure, not a threat of (her) death. Like Tarquin, he holds dagger, penis and pen over the naked woman supine on the bed and terrorises a smile on to her face, reading her consent: her consent to rape and violation, her consent to the violation by his inter- pretation. His eye, as he said in the beginning, is too diffracted, his mind is too refrac- tive to see a rape; he sees instead a smile and the victim's consent. But it is not so much the other discourses which had diffracted rape into invisibility: it is his own discourse which attempts to render rape invisible against all appearances, and it is his discourse which attempts to defract the image in front of our eyes, to make us believe – no matter how unreasonably – that rape no longer exists for 'us', not in representation, and not as an event.

Notes

1 C. Froula, 'The daughter's seduction: sexual violence and literary history', *Signs*, 11 (4) (Summer 1986): 621–44.
2 S. Kappeler, *The Pornography of Representation* (Cambridge: Polity Press, 1986).
3 R. Wyre, *Women, Men and Rape* (Oxford: Penny Publications, 1987); M. Ingram, 'Rape – the man to man talk', *Guardian* (7 January 1987).
4 Writing our own History Interview: London Rape Crisis', *Trouble and Strife*, 10 (Spring 1987): 50.
5 A. Soble, *Pornography: Marxism, Feminism, and the Future of Sexuality* (New Haven, CT: Yale University Press, 1986), p. iv.
6 E.g. Blackwell and the book *Rape* reviewed here; Yale University Press and *Pornography* (see n. 5); Polity Press, Cambridge, and K. Theweleit, *Male Fantasies*, 1987.

7 N. Bryson, 'Two narratives of rape in the visual arts: Lucretia and the Sabine women', in *Rape*, ed. Tomaselli and Porter, pp. 152–73.

8 B. Toner, *The Facts of Rape* (London: Arrow Books and Hutchinson, 1977; rev. edn, Arrow, 1982), p. 19.

9 The London Rape Crisis Centre, *Sexual Violence: The Reality for Women* (London: The Women's Press), p. 32.

10 See Lewis and Short's *Latin Dictionary* (Oxford, 1962).

Janet Wolff, 'On the Road Again: Metaphors of Travel in Cultural Criticism' (1993)

From *Cultural Studies*, 7 (2) (1993), pp. 224–239; reprinted in Janet Wolff, *Resident Alien: Feminist Cultural Criticism* (Cambridge: Polity Press, 1995).

> Theory is a product of displacement, comparison, a certain distance. To theorize, one leaves home. (Clifford, 1989: 177)

> A model of political culture appropriate to our own situation will necessarily have to raise spatial issues as its fundamental organizing concern. I will therefore provisionally define the aesthetic of such new (and hypothetical) cultural form as an aesthetic of *cognitive mapping*. (Jameson, 1984: 89)

> While it is important to recognize the specific power of intellectual practices, they cannot be separated from our existence as nomadic subjects in everyday life . . . Cultural critics are co-travelers. (Grossberg, 1988: 388–9)

Vocabularies of travel seem to have been proliferating in cultural criticism recently: nomadic criticism, traveling theory, critic-as-tourist (and vice versa), maps, billboards, hotels and motels. There are good reasons why these particular metaphors are in play in current critical thought, and I'll review some of these in a moment. Mainly, I want to suggest that these metaphors are *gendered*, in a way which is for the most part not acknowledged. That is, they come to critical discourse encumbered with a range of gender connotations which, I will argue, have implications for what we do with them *in* cultural studies. My argument is that just as the practices and ideologies of *actual* travel operate to exclude or pathologize women, so the use of that vocabulary as metaphor necessarily produces androcentric tendencies in theory. I think it therefore follows that it will not do to modify this vocabulary in the attempt to take account of women, as some critics have suggested we might do. Some discourses are too heavily compromised by the history of their usage, and it may be that the discourse of travel (or at least certain discourses of travel) should be understood in this way.

Gender is not, of course, the only dimension involved in travel. Disparities of wealth and cultural capital, and class difference generally, have always ensured real disparities in access to and modes of travel. In addition, it is clear that the *ways* in which people travel are very diverse, ranging from tourism, exploring and other voluntary activity to

the forced mobility of immigrant workers and 'guest workers' in many countries, and to the extremes of political and economic exile. In examining here a single notion of travel, which for the most part rests on a Western, middle-class idea of the chosen and leisured journey, I am merely taking as my subject that metaphor which is in play in these particular discourses. (The fact that it *is* this idea of travel which is operating here is another important question which deserves examination, though it is not my focus here.)

Theory and Travel

Quite apart from the increasing use of travel metaphors in critical theory, it is worth noting that a number of cultural analysts have been writing about travel itself.[1] Dean MacCannell's book, *The Tourist*, first published in 1976, was reissued in 1989 with a new introduction in which the author responds to more recent work on theory and travel.[2] Other studies of travel include John Urry's *The Tourist Gaze* (1990), and essays on the semiotics of travel by Jonathan Culler (1988)[3] and John Frow (1991). In addition, the work of travel writers is more prominent, with (at least on an impressionistic rather than statistical count) more review space in newspapers and journals.[4] In some cases, the work of travel writers is cited by theorists of travel (and theorists of travel-theory), as for example in James Clifford's reference to Bruce Chatwin (Clifford, 1989: 183). Clearly this is a restless moment in cultural history.

In MacCannell's account of the nature of tourism, we are first presented with the idea that the tourist is typical of the modern person and, in particular, of the social theorist. In all three cases, it is a question of reacting to the increased differentiation of the contemporary world, and the consequent loss of sense or meaning. 'Sightseeing is a kind of collective striving for a transcendence of the modern totality, a way of attempting to overcome the discontinuity of modernity, of incorporating its fragments into unified experience' (1989: 13). Social and cultural theory are then reconceptualized as a kind of tourism, or sightseeing, founded on the search for authenticity and the attempt to make sense of the social. (In the introduction to the second edition of the book, however, MacCannell firmly distances himself from postmodern theories which take the more radical view that there *is* no social, or that there is no fundamental ['real'] structure below the play of signifiers. In this his notion of sightseeing is something like Jameson's concept of 'mapping', which is also based on the need to negotiate the lost [but still existing] totality.)

A different link between travel and theory is made in Edward Said's influential essay, 'Traveling Theory' (1983). Somewhat strangely, the use made of this notion hasn't always had much to do with Said's argument in that piece, in which he is interested in the question of what happens to theory when it does travel – for example, the transformations of a theory in passing from Lukács to Goldmann to Raymond Williams, and its location/interpretation in very different historical and political moments. (Said also refers to this as 'borrowed' theory: p. 241.) This is not the same thing as arguing that there is something mobile in the *nature* of theory, which is the way the notion of 'traveling theory' has been interpreted. In other words, the fact that theories sometimes travel (and therefore mutate) does not mean that theory (transported or not) is

essentially itinerant. Actually, both senses of 'traveling theory' are in currency in cultural criticism.

Postcolonial Criticism and Travel

The quotation with which I began, from James Clifford, has to be seen in the context of important developments in postcolonial criticism. Here, the metaphors of mobility operate to destabilize the fixed, and ethnocentric, categories of traditional anthropology. Clifford is one of a number of cultural theorists who have recently revolutionized the methodologies and conceptual frameworks of cross-cultural study, at the same time demonstrating and deconstructing the entrenched ideologies of self and other on which such study has been based. For Clifford, the metaphor of 'travel' assists in the project of de-essentializing both researcher and subject of research, and of beginning to transform the unacknowledged relationship of power and control which characterized postcolonial encounters. Here, the notion of 'travel' operates in two ways. It is both *literal* – the ethnographer *does* leave home to do research – and *epistemological* – it describes knowledge in a different way, as contingent and partial. Related 'travel' vocabulary in this particular discourse includes Clifford's invocation of the hotel as 'a site of travel encounters', rather than either a fixed residence or a tent in a village (1992: 101). It is a notion (or, as he puts it, following Bakhtin, a 'chronotope') which registers both location and its provisional nature.

Postmodern Theory and the Need for Maps

The quotation from Fredric Jameson is from his important essay on postmodernism as 'the cultural logic of late capitalism' (1984). The motivation behind a travel vocabulary here (and in the next case I shall take) has something in common with its location in postcolonial criticism: namely the response to, and attempt to negotiate, a crisis in both the social and the representational in the late twentieth century. Nevertheless, we should not equate postcoloniality, postmodern theory and poststructuralism, though it is important to keep in mind that there are intellectual and political links between them.

Jameson's notion of 'cognitive mapping' (spelled out in more detail in a subsequent essay: 1988) is offered as a metaphor which captures the nature of theory in the postmodern age. As is well known, Jameson's argument here is that in the era of late capitalism, it is no longer possible to perceive the social totality. At the level of the economy, multinational capitalism is not 'visible' in the way that entrepreneurial capitalism, and even monopoly capitalism, were. At the level of technology, steam and electric power (characterizing respectively the two earlier stages of capitalism) have given way to the hidden processes of nuclear power and electronic knowledge. The social subject (and *a fortiori* the sociologist and cultural critic) must therefore resort to new strategies of orientation and analysis. Already immersed in the chaotic and disorganized flow of late capitalist society, the only strategy is to 'map' the social from within. As I said earlier, like MacCannell (and unlike other theorists of the postmodern) Jameson has not given

up on totality himself. His argument is that we need new ways of grasping and understanding the fundamental social structures and processes in which we live.[5]

Poststructuralism and Nomadic Subjects

The third theoretical origin of travel vocabularies, and the last I shall discuss here, is the poststructuralist theory of the subject. The product of radical semiotics, Lacanian psychoanalytic theory, and deconstruction, this critique demonstrates the fluid and provisional nature of the subject, who must now be seen as decentred. In the context of media studies and reception theory, Deleuze's notion of the 'nomadic subject' has been found to be a useful way of acknowledging the television viewer's (or the reader's) complex ability to engage with a text both from a position of identity and in an encounter which also (potentially) *changes* that identity. Lawrence Grossberg puts it like this: 'The nomadic subject is amoeba-like, struggling to win some space for itself in its local context. While its shape is always determined by its nomadic articulations, it always has a shape which is itself effective' (1987: 39; see also Grossberg, 1982 and 1988). Similarly, Janice Radway (1988) has employed the notion of the nomadic subject to provide the necessary conception of readers/viewers as active producers of meaning in their engagement with texts (see also Meaghan Morris, 1988).[6]

Related metaphors of travel here are the idea of the 'billboard' (Grossberg, 1987; Morris, 1988) as signposts which 'do not tell us where we are going but merely announce . . . the town we are passing through' (Grossberg, 1987: 31); and the concept of the 'commuter', also suggested by Grossberg (1988: 384).[7]

Off the Road: Women and Travel

So far, I have located the emergence of vocabularies of travel in three related major theoretical developments: postcolonial criticism, postmodern theory and poststructuralist theories of the subject. There is no doubt that in each case the metaphors I have identified have proved useful and suggestive, as well as promising specific solutions to the ideological effects of dominant terminologies. In all three cases, it is easy to see why notions of mobility, fluidity, provisionality and process have been preferable to alternative notions of stasis and fixity. In cultural criticism in the late twentieth century we have had to realize that only ideologies and vested interests 'fix' meaning, and it is the job of cultural critics to destabilize those meanings.

Of course, this work has already been criticized on a number of counts. The radical relativism of some of these texts has proved unacceptable for those who are not prepared to abandon certain meta-narratives. In addition, there is a tension between what we might think of as the more and less radical versions of semiotics: in short on the question of what (if anything) lies behind the play of signifiers in our culture. From the point of view of engaged politics, and here specifically in relation to feminism, a certain postmodern stance is incompatible with the fundamental commitment to a critique which is premised on the existence of systematically structured, actual, inequalities (of gender). In a recent critique of some tendencies in cultural studies in the

United States, the point is made in this way: 'Unless it is reflexive and critical, nomadic subjectivity is unlikely to organize meaningful political thought or activity, especially against elites whose thinking is more organized and purposeful. People who are nomads cannot settle down' (Budd et al., 1990: 176). I don't want to rehearse the various critiques of 'post' theories here, but instead to focus on the narrower case of a possible feminist critique of travel metaphors.

I should start by explaining the *untheoretical*, and coincidental, origin of my unease with this vocabulary, which was twofold. Like many other people, I had read Bruce Chatwin's *The Songlines* (1987) a few years ago, when it first came out. Also like many of its readers, I found it a compelling journal of the author's travels in Australia. At the same time, I felt, in a somewhat unarticulated way, alienated from it as a 'masculine' text. In particular, in a long section of the book which consists entirely of quotations about travel (including from Chatwin's own diaries from other travels), I had the sense that women did not travel like this.[8] The fact that Clifford and others cite this particular text mobilized that reaction again.

Secondly, I had been doing some work on the 1950s – specifically on the fantasy of 'America' in Britain in that decade. In this connection, I was reading newly published accounts of the period by the women of the Beat Generation: Joyce Johnson, Carolyn Cassady, Hettie Jones. This was the other side of the stories we already knew, which was until now unrecorded – as the title of Carolyn Cassady's book puts it, what it was like 'off the road'. Reading Johnson (one of Kerouac's women) and Cassady together was illuminating – one woman on each coast, both waiting for Jack or Neal (in Cassady's case, sometimes for both) to get back. Johnson once wondered if she could join Kerouac *on* the road:

> In 1957, Jack was still traveling on the basis of pure, naive faith that always seemed to renew itself for his next embarkation despite any previous disappointments. He would leave me very soon and go to Tangier . . . I'd listen to him with delight and pain, seeing all the pictures he painted so well for me, wanting to go with him. Could he ever include a woman in his journeys? I didn't altogether see why not. Whenever I tried to raise the question, he'd stop me by saying that what I really wanted were babies. That was what all women wanted and what I wanted too, even though I said I didn't . . . I said of course I wanted babies someday, but not for a long time, not now. Wisely, sadly, Jack shook his head. (Johnson, 1983: 126)[9]

Reading these texts, I was already sensitized to certain questions of gender and travel, and perhaps suspicious of the appearance of travel metaphors in cultural theory. But this, of course, only raises the question of whether such metaphors are gendered – it doesn't decide the issue.[10]

Histories of travel make it clear that women have never had the same access to the road as men:

> In many societies being feminine has been defined as sticking close to home. Masculinity, by contrast, has been the passport for travel. Feminist geographers and ethnographers have been amassing evidence revealing that a principal difference between women and men in countless societies has been the licence to travel away from a place thought of as 'home'. (Enloe, 1989: 21)

In a major study of travel over centuries ('From Gilgamesh to Global Tourism' as his subtitle says), Eric Leed makes similar generalizations about gender imbalances:

> The erotics of arrival are predicated on certain realities in the history of travel: the sessility of women; the mobility of men . . . In the conditions of settlement and civility, travel is 'genderized' and becomes a 'gendering' activity. Historically, men have traveled and women have not, or have traveled only under the aegis of men, an arrangement that has defined the sexual relations in arrivals as the absorption of the stranger – often young, often male – within a nativizing female ground. (Leed, 1991: 113)

Of course, women do have a place in travel, as also in tourism. Often that place is marginal and degraded. John Urry (1990) and Cynthia Enloe (1989) both discover women in the tourist industry in the role of hotel maids, or active in sex-tourism. I will come back to the question of women who do travel. For the moment, I am simply recording the limited access and problematic relationship women have generally had to varieties of travel. (Another example, from Judith Adler's history of tramping [1985], also confirms the tendency for such undirected mobility to be the preserve of men.)

I have yet to move from the recognition of travel as predominantly what men do to, first, an argument that there is something *intrinsically* masculine about travel, and, secondly, that therefore there are serious implications in employing travel *metaphors*. At this point, though, I should note that at least two of the cultural critics I have been discussing recognize that there is a problem. James Clifford acknowledges that travel, and therefore travel metaphors, are not gender-neutral: 'The marking of "travel" by gender, class, race, and culture is all too clear . . . "Good travel" (heroic, educational, scientific, adventurous, ennobling) is something men (should) do. Women are impeded from serious travel' (1992: 105). Meaghan Morris, who, as I have said, has also employed travel metaphors in her recent work, makes the same point:

> But, of course, there is a very powerful cultural link – one particularly dear to a masculinist tradition inscribing 'home' as the site both of frustrating containment (home as dull) and of truth to be rediscovered (home as real). The stifling home is the place from which the voyage begins and to which, in the end, it returns . . . The tourist leaving and returning to the blank space of the *domus* is, and will remain, a sexually in-different 'him'. (1988: 12)

Her suggestion is that the metaphor of the 'motel' may prove more appropriate for a non-androcentric cultural theory: 'With its peculiar function as a place of escape yet as a home-away-from-home, the motel can be rewritten as a transit-place for women able to use it . . . Motels have had liberating effects in the history of women's mobility' (1988: 2). The question is: what is the link between women's exclusion from travel, and uses of notions of travel in cultural theory and analysis? (And then: will modified metaphors of travel avoid the risk of androcentrism in theory?)

Masculinity and Travel

If it is only a *contingent* fact that, as Eric Leed says, 'historically, men have traveled and women have not', there might be no reason to argue that the vocabulary of travel is irrevocably compromised and, hence, unacceptable to cultural criticism. Here, I want to explore the possibility that the connection isn't just contingent, but that there is an *intrinsic* relationship between masculinity and travel. (By 'intrinsic', though, I do *not* mean 'essential'; rather my interest is in the centrality of travel/mobility to *constructed* masculine identity.) Leed himself has a fairly straightforward view of what he calls the 'spermatic journey'. He argues that it is likely that 'much travel is stimulated by a male reproductive motive, a search for temporal extensions of self in children, only achievable through the agency of women' (1991: 114). On this view, women's identification with place is the result of reproductive necessities that require stability and protection by men.[11] Such an account, however, does not really get us very far in explaining the persistence of these arrangements in totally transformed circumstances.

Mary Gordon has recently argued that men's journeys should be construed as a flight *from* women. In an essay on American fiction, she notes the centrality of the image of motion connected with the American hero (authors she discusses include Faulkner, Dreiser and Updike). At work here is 'a habit of association that connects females with stasis and death; males with movement and life' (1991: 17). Indeed, she notes how frequently in such fiction the females have to be killed to ensure the man's escape. According to Gordon, 'the woman is the centripetal force pulling [the hero] not only from natural happiness but from heroism as well' (1991: 6). I think it would be possible to pursue this suggestion in psychoanalytic terms (though I don't propose to do this here): for example, feminists have used the (very different) work of Nancy Chodorow and Julia Kristeva to explore the male investment in strong ego boundaries, and the consequent and continuing fear of engulfment (in the female) and loss of self.

In MacCannell's account of tourism, the search for 'authenticity' is foregrounded. By this he means the attempt to overcome the sense of fragmentation and to achieve a 'unified experience', which is less to do with the 'authentic' *self* than a quest for an authentic *social* meaning. But tourism and sightseeing can be seen just as much to operate as productive for the 'postmodern self' so frequently diagnosed by sociologists, and to that extent I think the gender implications are equally clear. (If, that is, we do take the view that in our culture men have a different and exaggerated investment in a concept *of* a 'self'.) Some years ago, two British sociologists wrote a book entitled *Escape Attempts*, whose subtitle is 'The Theory and Practice of Resistance to Everyday Life' (Cohen and Taylor, 1976).[12] I had always wondered why one would need to 'resist' everyday life (by which the authors mainly mean routine, meaninglessness, the domestic, repetitiveness). Certainly the particular account they give, both *of* that everyday life, and of the types and strategies of resistance discussed (including fantasy, hobbies, role-distance, holidays), are, to say the least, extraordinarily *male*. Could such a text be written from the point of view of women, or in a gender-neutral way? My sense is that it probably couldn't.

My suggestion that a connection of masculinity/travel/self can be made is not unproblematic. First, I could argue the opposite case, based on the same theories. For

example, since (according to Chodorow and others) women are produced as gendered subjects at the expense of any clear sense of self (of definite ego boundaries) – the result of inadequate separation from the mother – one might think that women have *more* of an investment in discovering a 'self' and that, if travel is a mode of discovery, then this would have a strong attraction to women. (Indeed, Dea Birkett, in her study of Victorian lady travellers, has suggested that it operated this way for some women, whose fragile sense of identity collapsed on the death of parents in relation to whom such women defined themselves; Birkett, 1991: 71). Here I think the important distinction is between the defence of a precarious but already constructed self (the masculine identity) and an unformed, and less crucial (*to* identity) sense of self. The investment in travel in relation to the former seems to me to be potentially far greater.

Secondly, the notion of feminine identity as relational, fluid, without clear boundaries seems more congruent with the perpetual mobility of travel than is the presumed solidity and objectivity of masculine identity. And thirdly, and related to this, it might be argued that women have an interest in destabilizing what is fixed in a patriarchal culture (as those who propose an alliance between feminism and postmodernism have suggested), and hence that methods and tactics of movement, including travel, seem appropriate.[13] I want to return to these last two points later, when I will suggest that such destabilizing has to be from *a location*, and that simple metaphors of unrestrained mobility are both risky and inappropriate.

I haven't set myself the task of analysing in depth the gendered nature of travel and escape, and all I have done in this section is to indicate some of the ways in which this might be pursued. My interest in this paper is to explore how metaphors of travel work. So far, I hope to have shown that they are (in fact and perhaps in essence) androcentric. For although I do think it is interesting to pursue the possible connection between masculinity and travel, my real interest is in the discursive construction involved – in other words, in the ways in which narratives of travel, which are in play in the metaphoric use of the vocabulary, are gendered. As Georges van den Abbeele has recently argued (1992: xxv–xxvi), although there is nothing inherently or essentially masculine about travel, in the sense that women have certainly travelled, nevertheless 'Western ideas about travel and the concomitant corpus of voyage literature have generally – if not characteristically – transmitted, inculcated, and reinforced patriarchal values and ideology.' The discourse of travel, he argues, typically functions as a 'technology of gender'.

Women who Travel

The major objection to my argument so far is that, in fact, women *do* travel.[14] The case of the 'Victorian lady travellers' is the prime example.[15] Isabella Bird, Isabelle Eberhardt, Mary Kingsley, Freya Stark, Marianne North, Edith Durham and many other redoubtable women at the end of the nineteenth and beginning of the twentieth century left homes that were often extremely constraining to travel the world in the most difficult and challenging circumstances. Their lives and their journeys have been well documented, both by themselves and by subsequent historians (Middleton, 1965; Eberhardt, 1987; Russell, 1988; Birkett, 1991). If indeed travel is gendered as male, and

women's travel restricted, here is a case when at a moment of exaggerated gender ideologies of women's domestic mission the most dramatic exceptions occur. It is interesting, here, to consider how this travel was construed and constructed, both by the travellers themselves and by the cultures they left and returned to.

Dea Birkett has suggested that in an important way these women inhabited the position of men. In fact, they rarely dressed as men (Hester Stanhope and Isabelle Eberhardt were among the few who did) though they did, like Isabella Bird, sometimes modify their dress in a practical way. Nor did they define themselves as anything other than 'feminine' (and in many cases, also anti-feminist). But the relationship of authority they unquestioningly entered with the natives of places they visited and traversed (they were often addressed as 'Sir'; Birkett, 1991: 117) overrode considerations of gender: 'As women travellers frequently pointed to the continuities and similarities with earlier European male travellers, the supremacy of distinctions of race above those of sex allowed them to take little account of their one obvious difference from these forebears – the fact they were female' (1991: 125). In addition, Birkett suggests that many women travellers had a strong identification with their fathers from an early age, and through that identification learned to value the prospect of escape and freedom, since several (Ella Christie and Mary Kingsley, for example) had fathers who travelled widely: 'Their mothers', and sometimes sisters', domestic spheres were associated with cloistered, cramped ambition and human suffering. In response, they created their own sense of stability and belonging in exploring their paternal ancestors, thereby reinforcing their identity with their father and his lineage' (1991: 18). Isabella Bird resolved some of the problems of gender-identification which 'masculine' travel could have produced by externalizing the feminine in her sister, Henrietta – to the extent that on Henrietta's death in 1880, she 'lost her ability to revel with impunity in her travels' (1991: 95), and in fact married (at age fifty) and settled (for a while) back in Scotland. Sisters played a similar role, as conscience, home-self, and recipient of journal-letters, in the travels of Ella Christie, Mary Slessor and Agnes Smith Lewis. This suggestion of the coexistence of two identifications is attested to by Isabella Bird's remarkably dual life. She started travelling in her forties, having so far lived the life of the frail, and sometimes invalid, daughter of a Victorian clergyman. She travelled to Hawaii, Australia, across the Rockies on horseback, to India, Persia, Korea, China and (at the age of seventy) Morocco. Between travels, back in England and Scotland, she invariably became ill again and spent much of the time on her day bed.

When women do travel, then, their *mode* of negotiating the road is crucial. The responses to the lady travellers by those back home are also illuminating in their own contradictory negotiation of a threatening anomaly. Dea Birkett discusses the reactions of the press, other travellers and members of the Royal Geographical Society, which included minimizing the travels (in relation to those undertaken by male explorers), stressing the 'femininity' of these women (despite such masculine pursuits), and hinting that their conduct overseas might well have been improper. In other words, we do not need to discover that women travellers were in any straightforward sense 'masculine' to conclude that their activities positioned them in important ways as at least problematic with regard to gender identification.[16]

The gendering of travel is not premised on any simple notion of public and private spheres – a categorization which feminist historians have shown was in any case more

an ideology of place than the reality of the social world. What is in operation here, I think, *is* that ideology. The ideological construction of 'woman's place' works to render invisible, problematic, and in some cases impossible, women 'out of place'. Lesley Harman, in her study of homeless women in Toronto, shows how the myth of home constructs homeless women in a very different way from homeless men. As she puts it, 'the very notion of "homelessness" among women cannot be invoked without noting the ideological climate in which this condition is framed as problematic, in which the deviant categories of "homeless woman" and "bag lady" are culturally produced' (1989: 10). It seems to me not entirely frivolous to consider the hysterical and violent responses to the film *Thelma and Louise* in the same way. As Janet Maslin has pointed out (1991), the activities of this travelling duo are as nothing compared with the destruction wrought in many male road movies. She writes in response to an unprecedented barrage of hostile reviews, of which one in *People Weekly* (10.6.91) is an example:

> Any movie that went as far out of its way to trash women as this female chauvinist sow of a film does to trash men would be universally, and justifiably, condemned . . . The movie portrays Sarandon and Davis as sympathetic . . . The music and the banter suggest a couple of good ole gals on a lark; the content suggests two self-absorbed, irresponsible, worthless people.

My argument is that the ideological gendering of travel (as male) both impedes female travel and renders problematic the self-definition of (and response to) women who *do* travel. As I have said, I don't claim to have offered an analysis of this gendering (though I have suggested that, for example, a psychoanalytic account would be worth pursuing). Nor, once again, am I arguing that women *don't* travel. I have been primarily interested in seeing how *metaphors and ideologies of travel* operate. In the final section, I will consider the implications of this for a cultural theory which relies on such metaphors.

Feminism, Travel and Place

By now, many feminists have made the point about poststructuralist theory that just as women are discovering their subjectivity and identity, theory tells us that we have to deconstruct and decentre the subject. Susan Bordo has identified the somewhat suspicious timing by which 'gender' evaporates into 'genders' at the moment in which women gain some power in critical discourse and academic institutions (Bordo, 1990). In the same way, I'd like to suggest that just as women accede to theory, (male) theorists take to the road. Without claiming any conspiracy or even intention, we can see what are, in my view, exclusionary moves in the academy. The already-gendered language of mobility marginalizes women who want to participate in cultural criticism. For that reason, I believe there is no point in tinkering with the vocabulary of travel (motels instead of hotels) to accommodate women. Crucially, this is still *the wrong language*.

How is it that metaphors of movement and mobility, often invoked in the context of radical projects of destabilizing discourses of power, can have conservative effects? As

I said earlier, one would think that feminism, like postcolonial criticism, could only benefit from participating in a critique of stasis. Here I think we confront the same paradox as in the proposed alliance between feminism and postmodernism. The appeal of postmodernism lies in its demolition of grand narratives (narratives which have silenced women and minorities). The problem with an overenthusiastic embrace of the postmodern is that that same critique undermines the very basis of feminism, itself necessarily a particular narrative. Feminists have only reached provisional conclusions here based on either a *relative* rejection of grand narratives, or a pragmatic retention of (less grand) theory.

In the same way, I think that destabilizing has to be *situated*, if the critic is not to self-destruct in the process. The problem with terms like 'nomad', 'maps' and 'travel' is that they are not usually located, and hence (and purposely) they suggest ungrounded and unbounded movement – since the whole point is to resist fixed selves/viewers/subjects. But the consequent suggestion of free and equal mobility is itself a deception, since we don't all have the same access to the road. Women's critique of the static, the dominant, has to acknowledge two important things: first, that what is to be criticized is (to retain the geographic metaphor) the *dominant centre*; and secondly, that the criticism, the destabilizing tactics, originate too from a place – the margins, the edges, the less visible spaces. There are other metaphors of space which I find very suggestive, and which may be less problematic, at least in this respect: 'borderlands', 'exile', 'margins' – all of which are premissed on the fact of dislocation from a given, and excluding, place. Elspeth Probyn (1990) recommends we start from the body – what Adrienne Rich has called 'the politics of location' (1986) – to insist on the situated nature of experience and political critique. Caren Kaplan's (1987) use of the notion of 'de-territorialization' similarly assumes a territory from which one is displaced, and which one negotiates, dismantles, perhaps returns to.

For all these metaphors, there *is* a centre. In a patriarchal culture we are not all, as cultural critics any more than social beings, 'on the road' together. We therefore have to think carefully about employing a vocabulary which, liberatory in many ways, also encourages the irresponsibility of flight and misleadingly implies a notion of universal and equal mobility. This involves challenging the exclusions of a metaphoric discourse of travel.

Metaphors, though, are not static.[17] My critique of the specific metaphors of travel in relation to gender should not, therefore, be read as either a ban on metaphors (which are inevitable in thought and writing, and which always import certain limits and ideologies), or as a definitive condemnation of travel metaphors, but rather as a provisional and situated analysis of the current working of discourse. In the end, too, a different critical strategy might be the *reappropriation*, not the avoidance, of such metaphors – a good postmodern practice which both exposes the implicit meanings in play, and produces the possibility of subverting those meanings by thinking against the grain.

Acknowledgements

This paper is based on a lecture first given at Dalhousie Art Gallery in November 1991. I'd like to thank the Gallery for inviting me, and those who attended and participated

for their comments. Thanks, too, to seminars at the Nova Scotia College of Art and Design; the Susan B. Anthony Center, University of Rochester; Nazareth College, Rochester; the Cultural Studies Work Group at Northwestern University; Ontario Institute for Studies in Education; and the Center for the Humanities, Wesleyan University.

Notes

1 The real proof of this is that in David Lodge's latest novel, *Paradise News* (Viking, 1992), there is a character who is a professor investigating the sightseeing tour as secular pilgrimage.

2 An early example of the current interest in travel and theory, however, was Georges van den Abbeele's (1980) review of MacCannell's book, four years after its publication.

3 In fact, first published in 1981 but, as far as I can see, provoking more of a response in the last few years.

4 For example, the full-length, front-page symposium in *The New York Times Book Review*, 18 August 1991, entitled 'Itchy feet and pencils', in which Jan Morris, Russell Banks, Robert Stone and William Styron discuss travel writing.

5 In a different use of the metaphor of a 'map', Iain Chambers, describing the intellectual as a 'humble detective', explicitly abandons the idea of social totality (1987).

6 My knowledge of Deleuze's work is mostly secondary, but it is worth pointing out that in his essay 'Nomad Thought', Deleuze means something rather different: the nomad as someone who opposes centralized power (1977: 148–9). This doesn't seem to have anything to do with decentred subjects, but more with the idea of displaced (groups of) people, able to contest authority from the outside.

7 This metaphor does not work so well, I think. Grossberg says this: 'Nomadic subjects are like "commuters" moving between different sites of daily life ... Like commuters, they are constantly shaped by their travels, by the roads they traverse ... And like commuters, they take many different kinds of trips, beginning from different starting-points, punctuated by different interruptions and detours, and arriving at different stopping-points' (1988: 384). But I would have thought that the central characteristic of commuting is that you always start from the *same* starting-point and end at the *same* stopping-point: primarily, of course, home/work.

8 In going back to read that section, some forty pages of text, quotation and aphorism, I couldn't find very much to support my sense of it as 'masculine'. It even included a reference to nomadic cultures in which it is the women who initiate the move. One entry was clearly 'male' – even misogynistic: 'To the Arabian bedouin, Hell is a sunlit sky and the sun a strong, bony female – mean, old and jealous of life – who shrivels the pastures and the skin of humans. The moon, by contrast, is a lithe and energetic young man, who guards the nomad while he sleeps, guides him on night journeys, brings rain and distils the dew on plants. He has the misfortune to be married to the sun. He grows thin and wasted after a single night with her. It takes him a month to recover' (Chatwin, 1987: 201). Nevertheless, I retained the feeling that I was 'reading as a man' here – a feeling which partly motivated the initial attempt in this essay to analyse that feeling.

9 This is also cited by Alix Kates Shulman in her review of *Minor Characters* (1989).

10 For one thing, it may be that the fifties, and more particularly the so-called Beat Generation, constituted a very specific phenomenon, in which case any generalization would be totally misconceived. It's part of my project here to examine *how* general the gendering of travel might be. But here I might also mention a recent piece of journalism, which replays Kerouac/Cassady, if in ironic form. Nicolas Cage, the movie actor, wrote a piece for the magazine *Details* (July 1991) entitled 'On the Road Again: Retracing Kerouac's Footsteps in the Wild Heart of the Country', documenting his drive from LA to New Orleans and his experiences and reflections en route. To me, both the events and the recollections seem very much in the Kerouac mode, despite a certain self-awareness and irony (for

example, in relating the fact that the first car he took broke down when he and his friend were 'still comfortably within the 213 area code').

11 This is an argument that was used, a few years ago, by feminist anthropologists concerned to explain the historical and apparently universal oppression and domestication of women. Here, as in its other manifestations, it is an argument that raises as many problems as it solves.

12 This is soon to be reissued, by Routledge, in a second edition.

13 Here Deleuze's sense of 'nomad criticism' (see n. 6) is more appropriate than the usage I have taken up in this paper.

14 Often, the fact of women's travels has been obscured by historians and other narrators, Gordon DesBrisay has pointed out to me that recent historical research has shown that in early modern Scotland women were more mobile than has generally been thought (Whyte, 1988).

15 I could, of course, have taken other examples – contemporary women explorers, round-the-world yachtswomen, female truckers, for instance. Many of the suggestions I make here about the Victorians would then be likely to be seen as specific to their case.

16 Box Car Bertha, who spent her life on the road, took advantage of similar ambiguities in gender identification, in this case in her unusual upbringing. 'My childhood was completely free and always mixed up with the men and women on the road. There weren't many dolls or toys in my life but plenty of excitement . . . We took for playthings all the grand miscellany to be found in a railroad yard. We built houses of railroad ties so big that it took four of us to lift one of them in place. We invented games that made us walk the tracks . . . We played with the men's shovels and picks and learned to use them . . . We girls dressed just like the boys, mostly in hand-me-down overalls. No one paid much attention to us.' (in St Aubin de Teran, 1990: 48–9).

17 Indeed, van den Abbeele points out that the word 'metaphor' comes from the Greek word which means to transfer or transport (1992: xxii).

References

Abbeele, Georges van den (1980) 'Sightseers: the tourist as theorist', *Diacritics* (December).

Abbeele, Georges van den (1992) *Travel as Metaphor: From Montaigne to Rousseau* (Minneapolis, MN: University of Minnesota Press).

Adler, Judith (1985) 'Youth on the road: reflections on the history of tramping', *Annals of Tourism Research*, 12.

Birkett, Dea (1991) *Spinsters Abroad: Victorian Lady Explorers* (London: Victor Gollancz).

Bordo, Susan (1990) 'Feminism, postmodernism, and gender-scepticism', in *Feminism/Postmodernism*, ed. Linda J. Nicholson (London: Routledge).

Budd, Mike, Entman, Robert M. and Steinman, Clay (1990) 'The affirmative character of US cultural studies', *Critical Studies in Mass Communication*, 7.

Cage, Nicolas (1991) 'On the road again', *Details* (July).

Cassady, Carolyn (1990) *Off the Road: My Years with Cassady, Kerouac, and Ginsberg* (New York: Wm Morrow).

Chambers, Iain (1987) 'Maps for the metropolis: a possible guide to the present', *Cultural Studies*, 1 (1) (January).

Chatwin, Bruce (1987) *The Songlines* (Harmondsworth: Penguin).

Clifford, James (1989) 'Notes on travel and theory', *Inscriptions*, 5.

Clifford, James (1992) 'Travelling cultures', in *Cultural Studies*, ed. Lawrence Grossberg, Nelson Cary and Paula Treichler (London: Routledge).

Cohen, Stanley and Taylor, Laurie (1976) *Escape Attempts: The Theory and Practice of Resistance to Everyday Life* (London: Allen Lane).

Culler, Jonathan (1988) 'The semiotics of tourism', in *Framing the Sign: Criticism and its Institutions* (Oklahoma: University of Oklahoma Press).

Deleuze, Gilles (1977) 'Nomad thought', in *The New Nietzsche*, ed. David Allison (New York: Delta).

Eberhardt, Isabelle (1987) *The Passionate Nomad: The Diary of Isabelle Eberhardt* (London: Virago).

Enloe, Cynthia (1989) *Bananas, Beaches and Bases: Making Feminist Sense of International Politics* (London: Pandora Press).

Frow, John (1991) 'Tourism and the semiotics of nostalgia', *October*, 57 (Summer).

Gordon, Mary (1991) 'Good boys and dead girls', in *Good Boys and Dead Girls and Other Essays* (New York: Viking).

Grossberg, Lawrence (1982) 'Experience, signification, and reality: the boundaries of cultural semiotics', *Semiotica*, 41 (1–4).

Grossberg, Lawrence (1987) 'The in-difference of television', *Screen*, 28.

Grossberg, Lawrence (1988) 'Wandering audiences, nomadic critics', *Cultural Studies*, 2 (3) (October).

Harman, Lesley D. (1989) *When a Hostel Becomes a Home: Experiences of Women* (Toronto: Garamond Press).

Jameson, Fredric (1984) 'Postmodernism, or the cultural logic of late capitalism', *New Left Review*, 146.

Jameson, Fredric (1988) 'Cognitive mapping', in *Marxism and the Interpretation of Culture*, ed. Cary Nelson and Lawrence Grossberg (London: Routledge).

Johnson, Joyce (1983) *Minor Characters* (London: Picador).

Kaplan, Caren (1987) 'Deterritorializations: the rewriting of home and exile in western feminist discourse', *Cultural Critique*, 6.

Leed, Eric J. (1991) *The Mind of the Traveller: From Gilgamesh to Global Tourism* (New York: Basic Books).

MacCannell, Dean (1989) *The Tourist: A New Theory of the Leisure Class* (New York: Schocken Books, orig. pub. 1976).

Maslin, Janet (1991) 'Lay off "Thelma and Louise"', *The New York Times*, 16 June.

Middleton, Dorothy (1965) *Victorian Lady Travellers* (Chicago: Academy Chicago Books).

Morris, Meaghan (1988) 'At Henry Parkes Motel', *Cultural Studies*, 2 (1) (January): 1–47.

Probyn, Elspeth (1990) 'Travels in the postmodern: making sense of the local', in *Feminism/Postmodernism*, ed. Linda J. Nicholson (London: Routledge).

Radway, Janice (1988) 'Reception study: ethnography and the problems of dispersed audiences and nomadic subjects', *Cultural Studies*, 2 (3) (October).

Rich, Adrienne (1986) 'Notes towards a politics of location (1984)', in *Blood, Bread and Poetry: Selected Prose 1979–1985* (New York: W. W. Norton).

Russell, Mary (1988) *The Blessings of a Good Thick Skirt: Women Travellers and their World* (London: Collins).

Said, Edward W. (1983) 'Traveling theory', in *The World, the Text, and the Critic* (Harvard, MA: Harvard University Press).

Shulman, Alix Kates (1989) 'The beat queens: boho chicks stand by their men', *Voice Literary Supplement* (June).

St Aubin de Teran, Lisa (ed.) (1990) *Indiscreet Journeys: Stories of Women on the Road* (London: Faber and Faber).

Urry, John (1990) *The Tourist Gaze: Leisure and Travel in Contemporary Societies* (London: Sage).

Whyte, Ian D. (1988) 'The geographical mobility of women in early modern Scotland', in *Perspectives in Social History: Essays in Honour of Rosalind Mitchison*, ed. Leah Leneman (Aberdeen: Aberdeen University Press).

3.2 Rebuilding Practices of Criticism

Heresies Collective, 'Statement' (1977)

From inside front cover of the first issue of *Heresies* (1977).

Heresies is an idea-oriented journal devoted to the examination of art and politics from a feminist perspective. We believe that what is commonly called art can have a political impact, and that in the making of art and of all cultural artifacts our identities as women play a distinct role. We hope that *Heresies* will stimulate dialogue around radical political and esthetic theory, encourage the writing of the history of *femina sapiens*, and generate new creative energies among women. It will be a place where diversity can be articulated. We are committed to the broadening of the definition and function of art.

Heresies is structured as a collective of feminists, some of whom are also socialists, Marxists, lesbian feminists or anarchists; our fields include painting, sculpture, writing, anthropology, literature, performance, art history, architecture and filmmaking. While the themes of the individual issues will be determined by the collective, each issue will have a different editorial staff made up of contributors as well as members of the collective. Each issue will take a different visual form, chosen by the group responsible. *Heresies* will try to be accountable to and in touch with the international feminist community. An open evaluation meeting will be held after the appearance of each issue. Themes will be announced well in advance in order to collect material from many sources. (See inside of back cover for list of projected issues.) Possibly satellite pamphlets and broadsides will be produced continuing the discussion of each central theme.

As women, we are aware that historically the connections between our lives, our arts and our ideas have been suppressed. Once these connections are clarified they can function as a means to dissolve the alienation between artist and audience, and to understand the relationship between art and politics, work and workers. As a step toward a demystification of art, we reject the standard relationship of criticism to art within the present system, which has often become the relationship of advertiser to product. We will not advertise a new set of genius-products just because they are made by women. We are not committed to any particular style or esthetic, nor to the competitive mentality that pervades the art world. Our view of feminism is one of process and change,

and we feel that in the process of this dialogue we can foster a change in the meaning of art.

Corinne Robins, 'The Women's Art Magazines' (1979)

From *Art Criticism*, 1 (2) (1979), pp. 84–95.

In 1976, two women's art magazines, the *Feminist Art Journal* and *Womanart* appeared quarterly to discuss and describe the problems and successes of women artists and the women artists movement. A monthly, six to twelve page *Women Artists Newsletter* was issued regularly and the *Heresies* Collective (which included a number of women artists) announced it was about to publish the first issue of a quarterly magazine devoted to exploring broader women's issues. The next year, in 1977, the *Feminist Art Journal* announced it was 'suspending publication after five and one half years of successful operation'[1] and *Womanart*'s third issue headlined the question, 'What ever happened to the Women Artist's Movement?' in heavy black type on its winter/spring cover. Inside, the issue offered an assessment of the women artists' movement in the form of interview/statements with eight activist women artists, a woman critic and a woman art historian. The upshot of these statements was that things indeed had changed for the better, all the women were proud of their past activities but, as Michelle Stuart observed, the problem was: 'You have to keep going with it. You can't drop it. Even if one personally can't, you have to find someone who is going to take your place to keep going with it.'[2] And Nancy Spero, in the same issue stated, that now for her, 'Just being in the co-op gallery is idealistically and practically a political enough statement which has even politicized members who weren't.'[3] Thus, it was obvious that these women's activism had taken a different turn. And, in the light of their statements, it was not altogether surprising that *Womanart* itself folded the next year after publishing its seventh issue because, according to its editor Ellen Lubell, 'We couldn't afford to stay small and the 1977–78 inflation and recession had sent our costs way up.'[4] Pat Mainardi, one of the first editors of the *Feminist Art Journal*, suggests that both magazines were killed by their own success. 'When we began,' Mainardi explains,

> there was no way to get articles in print that raised the issues those articles did. It was difficult to reproduce the work of women in magazines, and the other journals wouldn't even see or accept art history articles about women. One of the things that the *Feminist Art Journal* and *Womanart* did was to force major magazines to recognize women artists' existence. Thus, in a certain sense, by 1977 we had been co-opted by success.[5]

In any case, the seven years from 1971 to 1978 were certainly the most active and exciting in the women's movement, and the two issues of *Women and Art* and the magazine's subsequent incarnation as the *Feminist Art Journal* (for five and a half years) together with *Womanart* magazine reflect and refract this period.

Women and Art, which appeared in the winter of 1971 and published a second issue in the summer/fall of 1972, was a highly political feminist magazine, its first issue being a series of protest articles concerning the treatment of women artists by male critics, curators, and art historians. One of the lead stories on page one of this first issue was an article on Rosa Bonheur documenting the treatment the artist had received from 1855 to the present, showing that as a woman artist, Bonheur was considered something of a freak who, it behooved all art writers to portray 'underneath her smock as a very feminine woman.'[6] (Such stereotyping of women artists by male critics subsequently became the subject of an article by Cindy Nemser in the first issue of the *Feminist Art Journal*.) Thus, *Women and Art*, which was not only the predecessor but the model for both the *Feminist Art Journal* and *Womanart*, began by publishing a minimum of one feminist art historical piece per issue. The Rosa Bonheur article was the only such article in the first issue, while *Women and Art*, no. 2, contained accounts of the lives of both Paula Moderson-Becker and Romaine Brooks. As opposed to the documentary approach adopted by Christine Smith in the Bonheur article, which examines Bonheur's work in terms of critical response, the Modersohn-Becker and Brooks articles put an unequal emphasis on their subject's lives at the expense of their artistic productions. (Thus, it was the woman artist's life rather than her work that became the central subject. This trend was to become even more accelerated in later issues of the *Feminist Art Journal*. The irony here is that this is exactly the type of treatment of women artists that Christine Smith was objecting to in her Rosa Bonheur article in *Women and Art*'s first issue.)

There were a total of 21 articles in the 20 pages that comprised the first issue of *Women and Art*. Its second, a double issue with a supplement, 'On Art and Society,' offered 16 articles, 3 poems and 7 brief 'News' pieces for a total of 32 pages. The second issue devoted pages 17–22 (or approximately 20% of its space) to an open forum on 'What is Feminist Art?' and/or 'Is There a Feminist Sensibility?' In this section, it published definitions and slightly longer statements by a total of 25 women. Of all of them, Joyce Kozloff's succinct description of feminism as 'a sensibility under duress' would seem to come closest to summing up the then prevailing mood of women artists in the movement. This second issue also featured Carol Duncan's 'Teaching the Rich' as the lead article for its *Art and Society* section. In this essay, Duncan examines the 'economic givens' behind the teaching of art history in the United States in the late fifties and early sixties. The article, mildly Marxist in tone, itself reflected the New Left perspective at the end of the sixties. But the Duncan piece aside, the second issue of *Women and Art* confined itself to focusing on the injustices done to women artists, and the rampant sexism inherent in the male power bastions of the American art world. And it was this split in emphasis that subsequently divided the editorial board of *Women and Art* and was responsible for the magazine's demise. According to Pat Mainardi, the disagreement, whether to emphasize the Marxist struggle or the fight against male chauvinism came to a head over the question of publishing Mainardi's own article, 'Artists Rights in the New Left' (a piece that was subsequently published in the first issue of the *Feminist Art Journal*). This article describes how artists were being taken advantage of in terms of their works being auctioned off at less than cost at benefits and their writings altered and copyrights ignored by new left organizations and publications. The way Mainardi tells it is that while none of the members of *Women and Art*'s editorial

board protested the article's accuracy, several felt the article itself was 'divisive and amounted to washing our dirty linen in public.' As a result of this disagreement, Pat Mainardi, Irene Moss and Cindy Nemser resigned from *Women and Art* (the other members of the board retaining the magazine's name but never publishing any further issues), and became in their turn, the editorial staff for the newly formed *Feminist Art Journal*, vol. 1, no. 1 of which appeared in April 1972.

From 1972 to 1977, the *Feminist Art Journal* published 19 issues containing a total of 225 articles, plus brief art and music reviews. *Womanart*, in its seven issues from 1976 to 1978, published over 53 articles, together with a minimum of 20 short exhibition reviews per issue. From 1972 to 1976 though, the *Feminist Art Journal* was the only full length publication entirely devoted to women's activities in the visual arts. Because of this, it becomes doubly unfortunate in historical terms that some of the important events *not* covered by the *Feminist Art Journal* in these years included the major 'Women Choose Women' exhibition of 109 women artists that took place at the New York Cultural Center in 1973 (which was organized by *Women in the Arts*), the opening of the first women's co-operative in New York, the A. I. R. Gallery in 1972, and the activities of Judy Chicago and Miriam Shapiro's California-based Womanhouse exhibition center, which the *Feminist Art Journal* almost totally ignored. (I will discuss and document the FAJ's aesthetic omissions later in this article.) Meanwhile, the *Feminist Art Journal* did headline the 'In her own Image' Philadelphia exhibition in the spring 1974 issue of the magazine. This was an exhibition organized by Editor Cindy Nemser 'which presented 45 images of women executed in a diversity of media.'[7] In the absence of a catalogue, Nemser printed her own essay on the exhibition, which turned out to be one of the few extensive pieces of art criticism, political or otherwise, to be published in the *Feminist Art Journal* between the years 1972 and 1978.[8] (All broadly based art critical articles after 1974 are written solely by Nemser herself. And, in point of fact, in the FAJ's spring 1975 issue, vol. 4, no. 1, 'wherein the *Feminist Art Journal* evolves from a newspaper to a magazine format,' Pat Mainardi and Irene Moss's names disappear from the editorial page and Cindy Nemser and Chuck Nemser are listed as editors-in-chief.)

The Phoenix, a Brooklyn weekly newspaper, wrote up both the *Feminist Art Journal* and *Womanart* in its March 17, 1977 issue under the heading 'Filling the Void: Two Women's Art Journals Where There Once Were None.' The article describes the magazines as 'two Brooklyn-based publications, both of whose editors agreed that their magazines exist, most importantly to fill a gap, a void left by the established press, which has a long and predictable history of ignoring women artists.'[9] Cindy Nemser as *Feminist Art Journal* editor speaking for the magazine, explained: 'We have no formula, no prescription of what feminism means.' And Ellen Lubell, *Womanart*'s editor concurred, saying she 'had no strict feminist ideology,' adding, furthermore, 'I don't foist a feminist framework on anything.' If the word 'feminist' was thus indefinable by 1977, from its very beginnings in 1972, the *Feminist Art Journal* emphasized a negative rather than a positive feminist critical ideology. Nemser writes against 'Feminine Stereotypes,' attacks 'phallic criticism' and complains about the fuzzy and chauvinist ways men describe art made by women.[10] Also, the ways women artists were discriminated against are documented over and over again in the magazine. On the positive side, the *Feminist Art Journal* published the documents of the first Women's Caucus at the College Art

Association and records its subsequent meetings and panels along with some solidly researched articles on women artists whose achievements had been underplayed or gone unreported by male art historians. For the first time, it became possible to read material on artists such as Natalia Goncharova, Gabrielle Munter and Sonia Delaunay, who because of their association with well-known men artists had been assigned a brief listing or footnote appearance in standard art history books. Of the 225 articles ultimately published in the *Feminist Art Journal*, 42 or a little more than 20% were concerned with these hitherto little known historical women artists. In *Womanart* magazine, the ratio of such historical pieces was even higher: 19 articles of one-third of the magazine's 53 articles concerned women artists of the past. Thus, both magazines were dedicated to providing women artists with their own heroines and a sense of their own history. One article published in the *Feminist Art Journal* went beyond this, uncovering for women and men as well a hitherto neglected art. Pat Mainardi's 'Quilts: The Great American Art'[11] combined historical research and critical analysis in an exemplary fashion. Mainardi's informed descriptions of the styles as well as the historic content involved in early American quilts made one slightly concerned for the contemporary women artists interviewed in the magazine's pages, none of whose work received such careful attention. Indeed, in the majority of the 22 interviews and write-ups of contemporary women artists, the emphasis is anywhere except on the aesthetic content of the work. Instead, it is the life of the artist, her difficulties as a woman in both making her work and getting it shown, with perhaps a little discussion of the artist's choice of subject matter that make up the bulk of these articles. Individual paintings and sculptures are never analyzed and rarely described. Most often it is the artist herself who makes references to her working process or to individual pieces in passing so that finally the subject's sense of dedication at least is allowed to come through. Women artists such as Louise Nevelson, Deborah Remington and the late Barbara Hepworth and Eva Hesse are called to account for their lives. In the case of Hesse, the reader is also given an account of editor Nemser's difficulty in accepting Hesse's sculptures as valid, and her final gut decision that Hesse's work will continue to be important, and she therefore must be counted as an artist heroine.[12]

There are, happily, a few exceptions among the 22 interview/profiles on artists published by the *Feminist Art Journal*. There is Nemser's own piece on Audrey Flack, which discusses the artist's photo-realist approach in terms of both style and content,[13] Sally Webster's considered discussion of the changes in content that have taken place in Joan Snyder's work,[14] and Fay Lansner's interview with Arthur Cohen, in which she cross-examines him about the stylistic evolution of Sonia Delaunay's work.[15] (I cannot judge my own output, but believe my article 'Nancy Spero: Political Artist of Poetry and the Nightmare'[16] belongs in the category of pieces that attempt a critical assessment of an artist's output.)

In the light of the aesthetic wars of the seventies in which women artists played important roles in many different camps, it seems relevant to list the 22 women written up in the *Feminist Art Journal* between the years 1972 and 1977 in terms of the broadest stylistic divisions, into abstract and representational categories, as follows:

Abstract

Louise Nevelson	Fall '72
Eva Hesse	Winter '73
Barbara Hepworth	Spring '73
Deborah Remington	Spring '74
Joan Mitchell	Spring '74
Lila Katzen	Summer '74
Lee Krasner	Spring '75
Joan Snyder	Summer '76
Sonia Delaunay	Winter '76–7

Representational

Marisol	Fall '73
Frida Kahlo	Fall '73
May Stevens	Winter '74–5
Nancy Spero	Spring '75
Audrey Flack	Fall '75
Betye Saar	Winter '75–6
Isabel Bishop	Spring '76
Janet Fish	Fall '76
Chicago Women	Fall '76
Diane Burko	Spring '77
Kate Millet	Spring '77
Sakiko Ide	Spring '77
Irene Moss	Summer '77

That 13 of these artists are representational as opposed to nine abstract, and that more than a third of the abstract artists belong to the class of grand old lady or the deceased artist category (only Mitchell, Katzen and Remington can be counted as contemporary artists) would seem to shed some light on the *Feminist Art Journal*'s aesthetic bias. What is even more enlightening to this reader is the fact that none of the process artists (such as Jackie Ferrar or Jackie Winsor), none of the decorative artists or pattern painters (such as Joyce Kozloff, Mary Grigoriadis and Cynthia Carlson), none of the younger abstract women painters who came to prominence in the seventies (Elizabeth Murray and Frances Barth), and none of the women landscape sculptors (such as Mary Miss, Michelle Stuart, Alice Adams and Alice Aycock) are discussed. The result is that one comes away from reading back issues of the *Feminist Art Journal* with no grasp of the aesthetic movements save for photo-realism that prevailed during the seventies and no knowledge of some of the women artists who were major leading figures. Feminism itself is not offered as an aesthetic, so, finally, what one is faced with is Nemser's own Famous Artist School. This becomes somewhat ironic when one compares Nemser's own words in the fall 1972 issue, specifically the fictional piece she wrote entitled 'Interview with a Successful Woman Artist' with her last editorial written in the final, summer 1977 issue. In the 1972 interview piece, Nemser has her fictional Successful Woman Artist announce: 'No matter what they (men) say, I'm still up there with the best of

them – even if I've had to suck up to any man who could advance my career and shit on any woman who got in my way.'[17] (It is probably no coincidence that in Nemser's subsequent non-fictional interviews with women artists, she pressures them one way or another to comment on both how abused and how great and glorious they are.) Thus, it seems both fitting and ironic that the final issue of the *Feminist Art Journal* was devoted to the theme: 'Women: In Pursuit of Success' and that Nemser's editorial preface read in part, 'As we shall see as we move through this issue of the *Feminist Art Journal* . . . women move out of the traditional roles of wives and mothers to pursue, battle for, redefine and attain that ever allusive chimera we have tried to pin down with the word *success*.'[18]

By this last issue, the magazine's concern with the visual artist had considerably lessened. In contrast with the occasional piece on a woman writer or composer that appeared in the first year's issues, of the total of 13 articles in that final 1977 summer issue, five of them, or almost half, focused on women *not* involved with the arts of painting and sculpture. Considering that two years earlier, in the summer of 1975 Nemser published an article entitled 'Blowing the Whistle on the Art World,' in which Nemser herself seconds and applauds Tom Wolfe's book *The Painted Word*, and long-windedly describes her own growing disgust with art criticism, the art world and its contemporary aesthetics as well as non-representational art beginning with abstract expressionism, the magazine's shift in emphasis was not altogether unexpected. Indeed, the direction away from contemporary visual art taken by the *Feminist Art Journal* in 1975 ultimately paved the way for *Womanart* magazine, which began a year later, in the summer of 1976.

The women profiled in the seven issues of *Womanart* included: Pat Adams, Dotty Attie, Eva Hesse, Joan Semmel, Sylvia Sleigh, Nancy Spero and Michelle Stuart. In every case, each of these articles focuses on the artist's work rather than her life. There are also round-up aesthetic pieces such as Katherine Hoffman's 'Toward a New Humanism' in which the author interviews a cross-section of women artists ranging from Audrey Flack to Cecile Abish.[19] While, as has been noted, 35% of *Womanart*'s seven issues were devoted to art history, at least 28% of the magazine's issues concentrated on contemporary works. The remaining 37% were concerned with news of feminist political activities. The radically different percentage figures for the *Feminist Art Journal*, besides indicating a different editorial emphasis, also suggest the shift in political activism from the years 1972 to 1977. Certainly the early issues of both *Women and Art* and the *Feminist Art Journal* were 90 to 95% political in content (vol. 1, no. 1 of the *Feminist Art Journal*, included for example, 30 pieces of writing, 25 of which were political in content). The change of emphasis begins to make itself felt with the 1974 spring issue, in which only four of the 13 articles that comprise the issue are concerned with political matters. In the next issue, only one of the issue's five articles touch on politics and from then on, an average of 20% political coverage per issue prevails. Indeed, tracing the decreasing amount of coverage of feminist actions in the *Feminist Art Journal* leaves one face to face with *Womanart*'s 1977 theme question, 'What ever happened to the Women Artists Movement' and, in this sense, at least, the *Feminist Art Journal* remains a good barometer of the political climate of the time.

A brief analysis of the contents of the summer 1977 issue of the *Feminist Art Journal* and the spring/summer 1977 issue of *Womanart* should tell us more about these

magazines' very different approaches. The *Feminist Art Journal*, vol. 6, no. 2, summer 1977, contained a total of 13 articles (as noted on page 7's break-down), of which two were outright historical pieces, and five concerned with women in other media (two being on women filmmakers; one on women composers; one on a book on arts and crafts and one a music review). The back of the issue offered a heavy art review section, which included 14 small reproductions, of which three were in color. The spring/summer issue of *Womanart*, vol. 1, no. 4, contained only five articles plus a reviews and reports section. *Womenart*'s somewhat larger exhibition review section included 20 reproductions of artists' work, but none of them was in color. Two of *Womanart*'s five articles could be considered in the 'historic' category, the other three being pieces of contemporary criticism (two of which, in turn, had a more than slightly political emphasis).

The art history articles in the *Feminist Art Journal*'s summer issue included a piece on Marie de Medici, subtitled 'Self-promotion through Art,' in which Marie de Medici has Peter Paul Rubens paint her life cycle (and that's the way she got herself into art history), and an interview/profile of Adelyn Breeskin, a woman who became acting director of the Baltimore Museum in 1942. The Breeskin story was planned to appear in two parts, and the section in the summer 1977 issue gives an extremely detailed, even cliff-hanging account of Breeskin's early life, marriage, divorce and first twelve years at the Museum. Under the category of articles on contemporary art, the summer *Feminist Art Journal* issue leads off with painter Irene Moss's autobiographical piece titled 'In Pursuit of Success,' being another life story, but in this case told by the artist herself and centered about her need and feeling for success and recognition. There is no discussion of her work's evolution of aesthetic content. We are left to draw our own conclusions from the cover and two inside reproductions of the work. The best feature in the issue is a piece of investigative reporting by Brenda Price entitled, 'Who's got What? A Survey of Collectors and their Relationships to Women Artists.' The article comes complete with a break-down chart detailing the answers of ten major collectors to the following queries: 'Collector's occupation/No. of works in the collection/Price range paid/Types of works collected/Aesthetic emphasis/How were works acquired/Accepts direct contacts from artists/Commissions works/Per cent of women in collection/Per cent of work bought before artist was shown in major museum, etc. – all potentially valuable information for a women artist readership. The writing that precedes and amplifies this data, Price's account of how she went about collecting this information, is refreshingly direct and free of gush. (Indeed, for this reader, this single article justified issue vol. 6, no. 2.) The other political piece in the issue is of somewhat less general interest. Entitled, 'Why is *Art Talk* Threatening to New York Museums,' it is Cindy Nemser's own story of her efforts to get her book *Art Talk* stocked by museum bookstores. This, too, is a well researched story, but, even after reading it, I doubt if its political urgency is self-evident to anyone save its bemused author.

The political/critical articles in the summer 1977 issue of *Womanart* exhibit very different concerns. One piece is a 'Report From the Women's Caucus for Art' by J. Brodsky, its president, and details the Caucus' past achievements as well as current goals. The other is almost a border-line historical piece titled, 'Why Have There Been no Great Women Architects' which combines a discussion of women in American

architecture *vis-à-vis* a show put on by the Brooklyn Museum with a survey of exist-
ing anti-feminist feeling in the field. Lawrence Alloway's discussion of Georgia
O'Keeffe's flower imagery suggests there are alternate interpretations other than the
sexual one usually assigned to this artist's motifs. And despite its historic subject matter
seems to belong in the category of contemporary criticism together with Robert Hobbs'
article on Michelle Stuart's paper, rock and book pieces (in which Hobbs offers his own
rather provocative views of this artist's work *vis-à-vis* Zen on the one hand and Robert
Smithson on the other). Also under this heading could be classed Peter Frank's extra
California Review section. The only straight art history article in the issue is on Paula
Modersohn-Becker and discusses Modersohn-Becker's thoughts on her role as woman
and artist in terms of her own, now historic, journal jottings. Thus, the final count on
this issue of *Womanart* is two articles of contemporary criticism, two political pieces
and one art history piece – that is, without totaling up the additional reviews and reports
sections. From this, it seems clear that the emphasis at *Womanart* was much heavier on
critical interpretation than that at the *Feminist Art Journal*. In fact, going no further
than the issues' two contents pages demonstrates that these magazines at the time were
addressing somewhat different audiences.

As I write this article, on my desk is a letter asking support for a new project, a
semi-annual publication to be called the *Woman's Art Journal*, which it has been
proposed will be a magazine to take the place of both the *Feminist Art Journal* and
Womanart. In July 1977, when the *Feminist Art Journal* folded, it had, according to its
editors, a circulation of 8,000 and, furthermore, its editors felt 'had accomplished
all its goals, that museums and galleries who in the past ignored women artists totally
are now making a conscious effort to include women on a more than token basis'.[20]
Well, the 1979 Whitney Annual has come and gone with one-third or thirty-three
and a third percent of the artists represented being women, so perhaps life for women
artists is not as rosy as the Nemsers choose to believe. The *Feminist Art Journal*, which
just about paid for itself through sales during its first two newspaper format years
became a 'not-for-profit' quarterly supported in part by the Nemsers and in part by
grants from the Coordinating Council of Literary Magazines. As far as I have been able
to find out, it never, even in its later years when it managed to acquire a good bit
of advertising, became financially independent. *Womanart*'s middle issues, via gallery
advertising, did break even, but finally, due to rising costs, the magazine became too
much of a financial burden to its editor. There is a question as to whether any such
art magazine could survive on a non-subsidized basis. The fact that the need and
audience for such publications remain seems indisputable. Also, in terms of its
documentation of political acts and, in particular, the early records of the College Art
Association caucuses, and women's panels and affirmative action groups, the *Feminist
Art Journal* remains an invaluable source for future feminist historians. On aesthetic
grounds, especially in terms of contemporary as opposed to historic material, *Woman-
art* simply wasn't around long enough and the *Feminist Art Journal*, now in retrospect,
seems plain unconcerned. Thus, if one wants to know about the directions and
achievements of contemporary women artists during the seventies, both *Womanart* and
the *Feminist Art Journal* remain only as adjunct publications to the other art magazines
of the period.

Notes

1 Press release dated July 1977, issued by the *Feminist Art Journal* and signed by Cindy Nemser and Chuck Nemser, announced that the magazine was suspending publication.
2 *Womanart*, 1 (3) (Winter/Spring 1977): 29.
3 Ibid., p. 31.
4 From a conversation with Ellen Lubell, September 1979.
5 From a conversation with Pat Mainardi, September 1979.
6 *Woman and Art* (Winter 1971): 5.
7 *Feminist Art Journal*, 3 (1) (1974): 10.
8 Ibid., essay runs from pp. 11 to 18. In her Introduction, Nemser explains: 'One must keep in mind that these art works could be given other interpretations which would not cancel out sexual significance but which would amplify their essential universality. However, in this essay, I shall limit myself to gender-linked readings of these works.'
9 *The Phoenix*, 5 (41) (17 March 1977): 11.
10 *Feminist Art Journal*, 1 (1) (April 1972): 22.
11 Ibid., 2 (1) (Winter 1973): 1.
12 Ibid., pp. 12–13.
13 Ibid., 4 (3) (Fall 1975): 5.
14 Ibid., 5 (2) (Summer 1976): 5.
15 Ibid., 5 (4) (Winter 1976–7): 5.
16 Ibid., 4 (1) (Spring 1975): 19.
17 Ibid., 1 (2) (Fall 1972): 6.
18 Ibid., 6 (2) (Summer 1977): 4.
19 *Womanart*, 2 (2) (Winter 1978): 23–5.
20 *Feminist Art Journal* press release of July 1977 forwarded to me by Cindy Nemser, who declined to be interviewed or discuss on the telephone her publication.

Griselda Pollock, 'Framing Feminism' (1988)

From *Women Artists' Slide Library Journal*, 26 (1988), pp. 22–23.

The pages of the WASL [Women Artists' Slide Library] Journal have carried a continuing debate over the last few issues (nos. 22,23,24) which was initiated by Clare Rendell's review of the Framing Feminism event at the ICA in January 1988. Even before the Journal invited me to comment on the article and following letters I had decided to write some kind of response. I felt that the issues raised by the debate were crucial for contemporary feminist cultural politics.

I felt that Clare Rendell misrepresented the book. Rozsika Parker and I wrote *Framing Feminism* because we felt the urgent need to keep a record of what had happened in the 1970s, to provide a history for younger women and those coming into the movement who might no longer have access to the often ephemeral documents which were the remaining traces of that history. The book is more than an anthology. Two

major essays charted a history of the women's art movement and its place in its historical moment on the hinge of late and post modernism. We mapped a gradual shift from a primary focus on 'practical strategies' for women to exhibit their work together and gain recognition to 'strategic practices', the question of what kinds of art practice constituted a feminist intervention.

Retrospectively we may now see the 1970s history as exclusive – a history of small, mostly metropolitan groups of white women gaining a modicum of visibility. Writing a history of those groups without the sense of the struggle of women who did not even enjoy that small degree of recognition for their cultural activity can rightly be indicted for its unconscious racism. It is a point that Lubaina Himid and other black women from the audience made at the ICA. The forum for debate at the ICA was therefore essential in making us recover many histories, but this does not invalidate the importance of struggling to recover histories or writing those to which Rozsika and I had access.

Framing Feminism included a lengthy essay on 'Feminism and Modernism'. This was my attempt to balance the necessary narrative of women's activities featured in the first chapter by looking at the larger issues governing cultural production in the visual arts in the same period. This is where my reference to Mary Kelly's sense of the place of women *in history* was offered. The essay addressed both the internal field of feminist art politics and the broader field of cultural politics in which feminism is rapidly being assimilated to the umbrella term 'post-modernism' without fully grasping the critical part played by feminism in Britain in making a radical challenge to modernism and, now, to the reactionary forms of post-modernism. Feminist art practices have a place in the cultural history of our time. It is an injustice to women to treat them in a separate category; that replicates the 19th-century strategy for isolating women from the seemingly universal category art. Feminism has obviously validated women's sense of their specificity and much art work is based on that politicisation of *Difference*. But in representing feminism in art it is important not to discuss it only from a feminist context.

What I said about Mary Kelly's knowing interventions into the field of late and post-modernist art practice has been misunderstood. I suspect that the reasons for this were twofold. Feminist debate remains caught up with the margins versus mainstream question. The autonomous women's movement has been a major strength for feminism. Separatism has its basis in women's real needs and orientations. The mainstream is identified with men – rather than with institutions in which men and whites are privileged. But as feminist art history has argued, white women have never been totally excluded from the narratives of western art. Their continual presence in cultural production has merely been *represented* as marginal, or supplementary, or amateur or 'feminine'.

What I have just written involves a lot of theory – about institutions, representation, discourse, sexual difference etc. This is the second reason. Those who advocate intervention in the mainstream operate from a different set of theories about art and society from those who worry about the mainstream. Writing *Old Mistresses* and this chapter on 'Feminism and Modernism' in *Framing Feminism* was part of an attempt to make the theoretical and political assumptions underpinning this kind of cultural analysis accessible to readers.

I stressed in my essay for *Framing Feminism* what makes the work of feminist artists feminist is never exclusively what they do at the level of the text. It involves a sense of acting in a social world – or that part of it concerned with the production of meanings and identities. Their work is a political practice, bound in with the vitality of a political movement, a critique of economic and ideological power shaping and oppressing people's lives in many ways, gender being merely one of them. Women's Liberation as we called it in the 1970s was redolent of that Utopian conviction of the possibility of political change through people's participation. Thatcherism has made such ideals seem simply outmoded. But that is why it is important to me to locate the emergence of feminist art practice on that specific historical moment which offered a critique of modernism but was based in the political hopes for a women's liberation movement. I do not think we can understand what is happening to us unless we retrieve these specific histories, unless we think historically in general and see what we do as women as part of the vast canvas of historical processes and not a tiny, marginal even dislocated island composed exclusively of women.

Clare Rendell puzzled about the dialogue between Lubaina Himid and myself in terms of the conflicts between 'the ordering impulse of a white art historian' and the position of a practising black artist. This statement worried me because she seemed to question the validity and indeed possibility of thinking historically. It seems to set up the absolute primacy of the artist upon whom art historians 'impose meaning'. Of course what people write is shaped by their interests and competences; we are all constrained by our culture.

But why do we continue to fantasise about artists as other than the rest of us? Why do feminists keep the old romantic myths going? In *Framing Feminism* we tried to explain the kind of cultural theory in which the artist is not privileged as the 'creator' but as a social producer working with inherited conventions, socially shaped possibilities, and deploying socially acquired competences in pursuit of particular but historically locateable interests. The real excitement of feminist theory and the cultural analyses it currently draws upon is the debunking of mystifying ideas about creativity, the artist, art. Instead we work (artists and historians alike) with a recognition of skills, insights, sensibilities and competences but with a shared sense that what we produce – visual art or critical texts – are produced in a public language. The meanings of any piece are effectively what the consumers produce in looking and reading, and this is mediated by the prevailing languages of criticism, institutional sites for the consumption of culture, as well as several other histories. Feminists intervene therefore not only by what they produce, in the knowledge that they must control (as much as possible for never entirely) the probable readings of their work but they also develop new critical languages, new ways of understanding art and culture as a political site. It is in the dialogue between producer and critical consumer that women artists get both genuine critical, engaged response, and also a social image of what they are doing.

I realised after the ICA event that there was a growing gap between the kind of cultural politics, which Rozsika and I were documenting and analysing in *Framing Feminism*, the kind of cultural politics in which we were formed in the 1970s and the current mood of the women's art movement. The critical review of the Framing Feminism event is symptomatic for me of a depressing political divide, signified by the lack of communication, the lack of a common language, the lack of common theoretical assumptions.

Can this be bridged? Can we set up debates in which anxieties can be acknowledged and allayed, anxieties which sophisticated theorising and new languages, new concepts, all implying a challenge to the safe and comfortable mythologies which sustain artists, men and women, black and white, in capitalist systems, inevitably incite?

Clare Rendell's text had an unfortunate effect in the way it repeatedly referred to me. 'Pollock's determination to create a rigid ideological context for women's art practice'. 'The motivation behind Pollock's determination to create an inclusive ideological framework'. There are political worries about writers being accused of having too much or too rigid an ideology. It smacks of the Cold War. It also indicates a failure to be able to deal with a forcefully argued position. I know why I write as I do: it is a political act of contesting the power invested in institutions of knowledge and demanding a space for women to redefine the world.

But how does this work when the readers are women? Some styles for women writing are more easily accepted in the women's community than others. Women intellectuals and theorists are always suspect. There is anger if the maternal voice of unconditional love and support gives way to a claim for paternal authority – the ability to speak and name the world, to give meaning, to make knowledge power.

But there are also sociological reasons for artists who are women having problems with the way feminist theorists of culture write nowadays. In British art education we are not used to theoretical or critical or academic training such as artists get in the States where Greenberg, Craig Owens, Martha Rosler, and so forth teach in art colleges and universities, where art students get something that passes for a decent general education instead of the apology for an education with which they are palmed off here. Women's education in general in Britain schools women to be silent, if not silent, quiet in direct contrast to the North American model where artists are frequently articulate speakers and educated writers.

The debate about theory versus practice, words versus art, is part of an outmoded and debased romantic tradition which cannot be allowed to prevent women having access to the vital cultural theories which feminists in education sites are developing. We cannot afford to caricature those who offer their work in history and cultural theory to the women's community as rigid ideologues imposing frameworks on feminist art.

There is another side to it. Clare Rendell admitted that those who do not share my analysis do not feel able to advance their position coherently. Education privilege plays a part. But at the risk of falling back into the framework Clare accuses me of pushing too hard, I must at least suggest the possibility that there isn't much alternative.

By that I don't mean I think my view is the only one – rather that we cannot go back on history. We have to go forward from understanding what happened in the 1970s in feminist art. Understanding and taking on board our history does not result in outlawing certain practices or positions. Our history as we struggled to make sense of it provides a field of possibilities on which, as Kate Bush pointed out, everything must be calculated and theorised.

Nowhere does this matter more than in the current, widespread nostalgia for painting. What I said at the ICA was inspired by the issue of *Feminist Art News*, vol. 2, no. 4 'Women Painting Today'. In her article, 'In Defence of the Indefensible: Feminism, Painting and Post-Modernism' Katy Deepwell criticised the advocacy by me and others

of 'scripto-visual' art as the only way forward for feminist art practice. Katy Deepwell then outlined the possibilities for feminists interested in painting.

'Painting' defines an activity; in modernist theory and practice, however, it signals a very particular view of art. I sympathise with women who want to paint, who enjoy this medium, who feel compelled to express themselves through its possibilities. But when I hear someone differentiate between art practices in terms of medium, scripto-visual versus painting, I know I am still in the orbit of modernist theory which primarily defines art forms through their media, saying that what each art form must do is pursue the logic or potential of the medium. Feminist art has been posed, by the American critic Lucy Lippard for instance, as anti-modernist precisely because it refused to see games with flatness and colour as the be-all and end-all of art. Feminists reclaimed art for narrative, autobiography, collage, decoration. It reclaimed other media and skills outlawed by modernism's hierarchies.

Feminist art also brought back a public – not just buyers and connoisseurs, but audiences about whom and for whom art was being actively made. The result was the complete overthrow of medium as a critical category. Explorations of diverse resources for art works motivated not by formal concerns but the necessity of communication and representation led to the use of video, performance, tape-slide, collage, patchwork, installations, montage, film, postcards, mixed media events, thematic exhibitions, multipieced art forms, posters, photography, paint, you name it, it was utilised and validated under the conditions which we now call post-modernism, which ruptured the formalist domination of art by modernism.

Furthermore feminist cultural theory and practice critiqued other tenets of modernism – the primacy of the visual, the heroic celebrating of the artistic subject as source of meaning and reference for all art. We exposed the institutions, the critical writings, the role of magazines, exhibitions and art history in producing and sustaining a discriminatory system in which only selected white men achieved recognition as artists while only their work was hailed as Art. We indexed the art world to the social world of politics and power. Thirdly we established a continuum between images and ideals in art and other kinds of imagery – advertising, pornography, cinema. All these moves radically changed what art was thought to be, breaking the modernist myth that art was a separate realm, apart from society and immune to politics and power.

After what was said and done in the 1970s no one should be arguing the relative claims of painting or scripto-visual art. To do so shows a complete failure to grasp hold of what feminist cultural practice has been all about. No one is compelled to make art that looks like Mary Kelly's or Susan Hiller's or Lubaina Himid's or Sutapa Biswas's, but I think we owe it to the women of the 1970s and early 1980s to come to appreciate and understand what they have done to the very possibilities of art as part of women's political struggle.

If we consider that feminism has radically revolutionised our theories of art and culture, provided ways of understanding it as part of a complex network of representations, ideologies and institutions, then we can begin to approach the pressures and interests surfacing at the present. Can painting as a practice tell us about women, their position, the world? While I want to make it quite clear that I think the present terms of discussion about painting versus scripto-visual art or deconstruction to be quite pointless, there is none the less an important issue here: how do we react to women who

want to paint as feminists now and feel inhibited because of the imagined force of a feminist orthodoxy? Firstly we must think historically to comprehend the revolution in cultural theory. Secondly we think about feminism and painting in radically new terms: we need a feminist theory of painting. But it will come from a historical analysis of women who have painted – especially in the modernist era in which this medium became an issue in art practice separate from its utility in representation. Secondly we could look to a range of feminist theories within semiotics and psychoanalysis to draw upon new models to understand ways of inscribing meanings from a feminine use of colours, shapes, gestures, etc. i.e. semiotic systems. There is much to be worked out. But I fear that the climate as represented by Clare Rendell's response to *Framing Feminism* suggests a battle between the generations of feminists when what we most need is to open the channels of communication and dialogue between all the communities involved across the factors of race, class, sexual orientation, age and educational background in the movement of women.

Meaghan Morris, 'Critical Reflections' (1992)

From *Artforum*, 30 (8) (1992), pp. 78–79.

I dislike the messianic view allowing critics to speak with confidence (or these days, sell endorsements) on every issue in social life, and I do not think that those who refuse are acting irresponsibly or evading a public role. In a much more complicated way, I am also uneasy with the puritan variant that requires us to rehearse, in exemplary fashion and no matter what the occasion, our difficulties and crises of confidence in having access to public speech. My first ethical principle – which, as a self-employed writer, I cannot always carry out – is to respond as a critic only to what engages me so deeply and directly that I cannot *not* work for as long as it takes to articulate my engagement.

Objects and practices framed as art rarely have that effect on me, and my own sense of critical responsibility is rarely engaged by the problematic of art. This is partly just a matter of temperament, and I think that critics too willingly confuse the limits of our own capacities with grueling conflicts of principle. On an average day, I love stories, talk, movement, the flow of language and images on television, and my ordinary mode of 'esthetic' response is one of burbling enthusiasm. At the same time, I have a horror of the stillness of those mute, inscrutable norms that a part of me thinks of (despite the criticism I read and the living art practices I see) as 'dead things in galleries.' I find esthetics proper – the critique of judgment – an emotionally baffling discourse. I don't know why those problems matter, and so I am perhaps less irritated than I could be, as a feminist, with Jean-François Lyotard's distinction between works as 'cultural objects' and works construed as 'art.'[1] When Lyotard invokes an 'art and beauty' that 'do and will take place . . . because their place is not a place in the world,' I can say that my critical passion is unequivocally for cultural objects – and for practices of art that construe themselves as *making* a place in the world.

Of course, this temperamental response is also a product of history. I grew up in rural and then industrial parts of Australia where the white people told good stories and jokes but had no time or respect for 'art' (and no concept at all of aboriginal art), where silence could be played like a musical instrument, lowered like a barrier, or wielded as a weapon, and where the radio and later the television would act as a life-line that peopled differently the spaces of social existence. In bringing other voices and alternative values into our everyday lives, the media slowly helped to transform the terms on which we could struggle to change our social relations of race, gender, sexuality, and, more obliquely, class.[2] This history inclines me at times to romanticize the popular media in Australia, and to react with an easy contempt to derivative forms of art-world commodity fetishism. So my second ethical principle is to keep both tendencies in check in all of my critical work.

For just as I know that TV is by no means generally a benign political force, so I know that in exactly those places of the world that have formed my sense of history – the parched wastelands, not of Australia, but of industry, modernity, and colonialism – the forces of impoverishment have sometimes shaped the work of great creative esthetes. So if I have no interest in esthetics *per se*, I have no critical mission to denounce or oppose 'estheticism.' In the noisy, image-saturated places that I mostly inhabit now, the anti-intellectualism and repressive *in*tolerance of cultural elites right across the political spectrum seem to pose a much more alarming problem. While 'estheticism' can cover a multitude of sins, the invention of what I take to be fictions of other-worldliness and transcendence is sometimes not an evasion or an illusion but a way of affirming both survival and the real possibility of liberation.

It all depends. This is the more equivocal premise of a criticism that does not work with the dichotomy between art and cultural objects, but that engages with cultural *practices*. Such a criticism is then immediately faced with a problem of defining its objects. We can certainly say that cultural criticism is itself a 'practice' among others. But while this is the case (and while it is well worth putting this case to those who think that 'criticism' and 'theory' are activities not of this world), it is trivially the case if we ignore the institutional and social power relations that differentiate between practices (art, criticism, theory) – and that discriminate between practitioners. My view is that the role of cultural criticism cannot usefully be stated (except for polemical purposes) in general terms. It is a question that has to be asked and answered each time a critic undertakes a project, and each time a reader makes use of a work of criticism. This is not to adopt, as some critics have claimed, an extreme form of relativism that condemns us to a chaotic, unintelligible universe of infinitely dividing particles and proliferating specificities. It is simply to say that some questions may not be as sensible as they seem.[3]

In my own practice, for example, critical *discipline* is not a matter of addressing a coherent range of objects or their associated scholarly traditions (I work primarily with films, media events, poems, buildings in social landscapes, philosophy books, my own and other people's memories), and it is not grounded by the protocols of any one academic field, political culture, or professional 'world.' That is to say, my critical discipline does not generate my critical questions. It is, on the contrary, a way of answering questions that arise for me insistently in the course of my everyday life. Most of these I can only formulate at first as rudimentary, even infantile, personal 'why?'

problems – why could I watch *Crocodile Dundee* six times before I stopped laughing? Why do I feel so safe in this motel, and so sad in that shopping mall? Why does that awful politician make me feel like a kid with a crush on a pop star?[4] These questions have to bother me enough to break down my burbling enthusiasm, and to drag me into the disciplined procedures of research, thinking, argument, and (worst of all) writing – ways of shaping a form of discourse that will, when I have finished, have freed me from the question.

There are many more sociable ways, I know, for a feminist to talk about criticism. I could, and usually do, derive the principles of my practice from the broad political struggles that have shaped my life and labors for over 20 years. I also can, and some-times do, participate in political struggles in excess of my work as a critic. The fact is that in order to write criticism (rather than some other kind of socially useful text), I need to begin with a pressing, wordless feeling that I must work to render sociable – by writing out of it a cultural history that may *serve* a political struggle.

This fact is important to me in the context of the current cycle of debate about the politics of cultural criticism. In my view, politics and criticism may overlap and affect each other (and I accept that all criticism has, for the worlds in which it circulates, political consequences), but they can never be made identical. I think that while both must be more – but not *other* – than 'personal' in import to have any social effect, the work of politics requires commitment to formal organizations. I also think that when we forget this, or reject the social goals it entails, our critical debates about the massive global conflicts of our time – conflicts of race, gender, class, morality, religion, nation-ality, and environmental responsibility – may end up having less to do with politics than with a ritualized theater of cruelty.

Again, it all depends. I am not sure what my views would be if I lived in the United States. Australian intellectuals often moan about their marginal social status, but we have relatively easy access to national media on the one hand and institutional power on the other. In a small nation constituted thinly across vast space – and still, in many ways, in the early stages of becoming a nation state – it is also difficult for dense pro-fessional milieus, insulated from each other as well as from the rest of society, to form. To say this, however, is to say that I take it as a general principle that the politics of cultural criticism are always produced relationally as well as provisionally. Cultural criti-cism has to take material as well as conceptual account of the heterogeneity of social forces and human aspirations that are now shaping the future of mixed societies. Para-doxically, I think that in practice this means paying scrupulous attention as critics to the specificity of our objects as well as to our audiences and communities. Only by doing this can I ever hope to make political sense of those questions emerging from a layer of my experience that I still call 'ideology.'

Cultural critics work primarily as mediators – we are writers, readers, image pro-ducers, teachers – in a socially as well as theoretically obscure zone of values, opinion, belief, ideology, and emotion. This is slow work, and whatever political effectivity we might claim for it can only be registered, most of the time, by gradual shifts in what people take to be thinkable and doable, desirable and liveable, acceptable and unbear-able, in their particular historical circumstances. In more peaceful or settled times, this can be cast by its enthusiasts as an intrinsically splendid endeavor. In fearful or

turbulent times, it is easily denounced as trivial. In between, I agree with Margaret Morse when she says that

> changes in shared fictions, values, and beliefs occur over the long term, slowly and incrementally, not merely because once shared values are discredited or may be no longer viable, but because alternative values and their constituencies have labored to mark themselves in discourse. I believe the criticism of television can serve cultural change when it keeps such long-term goals in mind.[5]

To undertake such labor is necessarily to make a commitment to creating some sense of solidarity and continuity with others who are laboring in the present, and who have labored in the past. It is exactly at this point that I can begin to engage with the problematic of art, and to learn from artists and critics who are redefining by their practice the role of art criticism today.

Some time in the early 1970s, I told my friend Virginia Coventry – a feminist artist and teacher – that I had no idea what people were supposed to do with those inscrutable things in galleries. She took me on a tour of a National Gallery, and talked to me not about the photographs and mixed-media installations that I could understand and enjoy, but about my greatest horror – painting. I told her that the quiet and immobility of paintings reminded me of those parched and wasted places where the silence could be lowered like a barrier or wielded as a weapon. We stood in front of what I saw as a pointless picture of some flowers in a vase, and she played it like a musical instrument. Although I was by that time fluent in the Stalinist esthetic vocabulary of political criticism (and so an opponent of estheticism, relativism, pluralism, theoreticism, elitism, populism, and defeatism), I had never heard anything like the stories she told about the labor in the painting (by, I think, Margaret Preston). In ten minutes, I learned to see difference instead of monotony, gaiety instead of dullness, and the movement in a still life.

Virginia's pedagogy had three interdependent elements that I still value – if often in a more abstract way – in the work of feminist art critics and art historians today. First, it was what I call 'sociable'; it was not a self-referring display of erudition, but an act of creative understanding that made an experience available for someone else to develop. Second, it was community building; scrupulous about its audience as well as its object, it made possible a form of social exchange about *comparable* (if not 'common') prob- lems that had not existed before. Third, it kept something alive – not only a moment of one woman's labor in making a painting, but a sense of that labor's value and why remembering her work could matter. For me, these elements can properly count as political, rather than ethical, responsibilities of criticism.

Notes

1 Jean-François Lyotard, 'Critical reflections', *Artforum*, 29 (8) (April 1991): 93.
2 I talk about some aspects of this history and the problems it raises in 'Panorama: the live, the dead and the living', in *Island in the Stream: Myths of Place in Australian Culture*, ed. Paul Foss (Leichhardt, NSW: Pluto Press, 1988), pp. 160–87.

3 See Paul Hirst, 'An answer to relativism', *New Formations*, 10 (Spring 1990): 13–23; and Paul Patton, 'Marxism and beyond: strategies of reterritorialization', in *Marxism and the Interpretation of Culture*, ed. Cary Nelson and Lawrence Grossberg (Urbana and Chicago: University of Illinois Press, 1988), pp. 123–36.
4 These questions underlie my essays 'Tooth and claw: tales of survival and *Crocodile Dundee*', in my book *The Pirate's Fiancée: Feminism, Reading, Postmodernism* (London: Verso, 1988), pp. 241–69; 'At Henry Parkes Motel', *Cultural Studies*, 2 (1) (January 1988): 1–47; 'Things to do with shopping centres', in *Grafts: Feminist Cultural Criticism*, ed. Susan Sheridan (London: Verso, 1988), pp. 193–225; and 'Ecstasy and economics: a portrait of Paul Keating', *Discourse* (1992).
5 Margaret Morse, 'An ontology of everyday distraction: the freeway, the mall and television', in *Logics of Television: Essays in Cultural Criticism*, ed. Patricia Mellencamp (Bloomington, IN: Indiana University Press, 1990), p. 215.

Freida High (Wasikhongo Tesfagiorgis), 'In Search of a Discourse and Critique(s) that Center the Art of Black Women Artists' (1993)

From *Theorizing Black Feminisms: The Visionary Pragmatism of Black Women,* ed. Stanlie M. James and Abena P. A. Busia (London: Routledge, 1993), pp. 228–266.

A Critical Call: An Introduction

Black women artists in the USA confront the attitude and practice of negation and marginalization in conventional art history and criticism,[1] the cornerstone discourses of the dominant art world Euro-patriarchy.[2] However, beyond the hegemonic utterances of artwriting[3] and art world practice,[4] their largely dismissed voices and unexhibited works evince a pervasive presence that intimates the longevity and complexity of their lives, works and interventions within their diverse contexts.[5] The art history and criticism of African-Americanists prioritize the lives and works of African-American men while inscribing women as complements, those of Euro-American feminists center the work and issues of Euro-American women while marginalizing American women of color. Black women artists, in the last decade of the twentieth century, remain semi-muffled, semi-invisible and relatively obscure.[6]

For Black women artists the contradiction between their material culture and their configurated negation, complementarity and/or marginality in discourses on art constitutes the crisis they consistently resist: one that must be vehemently confronted in the 1990s and beyond if history's given course is to be altered. A discourse that would prioritize the lives and concerns of Black women artists is urgently needed.

Without a discourse of their own, Black women artists remain fixed in the trajectory of displacement, hardly moving beyond the defensive posture of merely responding to their objectification and misrepresentation by others, the severity of this predicament

is clearly evident in the agency of protest consistently registered in their voices, a sign of the need not only for a drastic change but also for a specific discourse wherein that change can be seriously initiated. [. . .]

Claimin' Discourse

The act of claiming a particular discourse, in and of itself, asserts a claim for visibility and registers a theoretical position.

Discourse, literary critic Terry Eagleton informs us, constitutes 'language grasped as utterance, as involving speaking and writing subjects and therefore also, at least potentially, readers or listeners' (Eagleton, 1989: 115). As intersubjective communication, discourse is language that encodes cultural conventions (Fowler, 1990: 90), a crucial point for as poet and literary critic Abena Busia explains, 'Language is not "innocent": It is ideologically and culturally bound, and it both expresses and conceals our realities . . . Language can also shape our realities, and either enslave, by concealing what it might truly express, or liberate, by exposing what might otherwise remain concealed' (Busia, 1988: 6–7). The exclusion of Black women artists from dominant artwriting, except in voyeuristic discourses that forcibly manipulate them into passive positions of 'othering' reveals just how potent and rupturing Euro-patriarchical language and power can be to their lives. For the language of art truly controls the system of art, and that very language has concealed the art and ideas of Black women artists for hundreds of years.

With a self-initiated and sustained discourse of our own, we Black women artists could begin collectively to recover our lives, which might prove to be even more nurturing than our individual self-recovery or than our exclusive bonding in other groups which maintain different priorities.[7] By speaking a shared language derived from shared knowledge/s and cultural and social experiences, Black women artists could collectively discover each other, and our collective history. The proposed discourse would process the exchange of our particular subjectivities and become the source of our self-knowing. Such a source could subvert the current proscriptions of our erasure, marginalization, fragmentation, 'Other-ness' and isolation with the inscription of our self-defined divergent qualities of presence, centralization, wholeness, Self-ness, and empowerment with some measure of continuity.

Currently we are talking across the boundaries of geography and professional and personal commitments. But with a sustained discourse of our own, we could circumvent the continuous closures and exclusions and could also collectively decide the proper tone and focus for investigating what is truly important to us as artists and artists/scholars (art historians, curators, etc.) in our efforts to be properly seen, heard, effective, and actively engaged in our contexts according to our own definitions.

Literary critic Barbara Johnson reminds us that to assume the position of speaking subject 'means to activate the network of discourse from where one stands' (Johnson, 1989: 43). Speech, cultural theorist bell hooks elaborates, is a 'revolutionary gesture' that makes one primary in 'talk, discourse, writing and action' (hooks, 1989: 12). As subjects actively engage speech, they acquire a performative power to take nourishment from multiple sources and subsequently to construct a new synthesis of knowledge

(Johnson, 1989: 43). Such a synthesis for Black women artists could contribute to our empowerment at both intellectual and practical levels, and thus potentially lead to the development of an irreversible collective critical art history and activism that would not only make us visible and effective in the various institutions of the dominant art establishment, but also increase our effectiveness in our multiple communities.

How would the proposed discourse differ from the circulating knowledge in ongoing discourses? The answer to this question might be implicit in the current fragmented articulations of Black women artists/scholars, the most vocal thus far, who would initialize the discourse with their affective ambience of shared, though diverse, social and cultural values. As both the primary speaking subjects and the primary subjects of investigation, they would connect the knowledge that now exists in fragmented states, prioritizing, meditating and circulating it according to their judgements. Since no other identities have given priority to either Black women artists or their works, it appears natural that Black women artists/scholars would collectively initiate and lead a discourse that would continue to challenge their own adverse circumstances and even more importantly contribute to the recovery and analysis of their own production, and would welcome others to participate in its construction and expansion; I would identify such a development as a Black feminist art-historical discourse.

In her elucidation of the transformative value of speech/discourse, hooks underscores the implications of a Black feminist art-historical discourse particularly for many heretofore silenced and disconnected Black women artists. She observes:

> Moving from silence into speech is for the oppressed, the colonized, the exploited, and those who stand and struggle side by side a gesture of defiance that heals, that makes new life and new growth possible. It is that act of speech, of 'talking back,' that is no mere gesture of empty words, that is the expression of our movement from object to subject – the liberated voice. (hooks, 1989: 9)

Speech/discourse, in this regard, is both a theoretical and social practice (Eagleton, 1990: 24). As such, observes historian E. Frances White, it intertwines ideological and material conditions that 'help to organize our social existence and social reproduction through the production of signs and practices that give meaning to our lives' (White, 1990: 77). The proposed discourse for Black women artists, therefore, would not merely remove them from object to subject and from margin to center, but serve as an apparatus wherein qualified artists and scholars would interpret and evaluate the ideological and material signs relevant to their existence and their diverse forms of production and interests.

The empowering function of discourse, particularly within the hierarchy of power and knowledge, is insightfully explained by French theorist Michel Foucault who observes that those in power control 'domains of knowledge,' thus subjugating, disguising or disqualifying knowledges that in their judgement are 'located low down on the hierarchy, beneath the required level of cognition or scientificity' (Foucault, 1980: 84). According to this theory, those who have historically controlled the domains of knowledge and power in the art world have historically circulated and legitimated their knowledge and the material objects derived from that knowledge which they identify as truth and quality. Foucault exposes how the 'normalization' of Euro-patriarchist

knowledge has functioned simultaneously to validate Eurocentric judgements of various kinds including aesthetic while disqualifying those of others, and reminds us of the subjugation of knowledge pertaining to Black artists in general, and also of the counteraction of cultural nationalists (in particular) to that subjugation. The problematic of power and knowledge is clearly apparent in the juxtaposition of the language, ideologies and production of the ruling order of the art world and those of cultural nationalist ateliers, Afri-COBRA of Chicago and Weusi of New York (Gaither, 1989: 17–34), which avow the aesthetic values of African-American traditions. Most importantly the polemical relationship between Eurocentric dominance and African-American resistance signifies the empowering function of speech/discourse in both established Eurocentric 'regimes of thought' and in rupture, or what Foucault would call the 'insurrection of subjugated knowledge' (Foucault, 1980: 81) of oppressed peoples, better known to us as our traditions which are by no means fixed.

In general, Foucault's analyses are especially insightful in elucidating what Black artists and cultural theorists have long articulated: that Eurocentric self-validating histories, theories, critiques, exhibitions and among other factors patronage function to (self) enthrone Eurocentric perspectives, aesthetic values and objects of European civilization that are historically derived from 'the ancients'; meaning Greeks not Africans, Asians, or diverse people of color. They also help to explain how such judgements place art works by people of color low-down, or even below the 'scale' of the self-validating Eurocentric hierarchy. What becomes particularly clear in the power-knowledge construct is the critical interplay of knowledge, identity, speech and power that decides the visibility and invisibility of subjects. But above all in relation to Black women artists, it underscores the need for a specific site wherein the insurrection of subjugated knowledge pertaining to Black women artists could occur and deploy qualitative interpretations of its subjects.[8]

The proposed discourse must assert language to refashion dominance in its various forms without losing sight of the critical art-historical component wherein the recovery of empirical data, the exchange of the knowledge derived from them and the construction and inscription of texts based on them must occur. Essentially, the challenge of opposition cannot overshadow the challenge of construction. Literary critic Henry Gates urges us 'to address the political black signified, that is, the cultural vision and critical language that underpin the search through literature and art for a profound reordering and humanizing of everyday existence' (Gates, 1992: 82). Given such challenges, a Black feminist art-historical discourse must intervene in existing knowledge/s with new subjects, canons and methods that will provide new facts about and analyses of the lives, production and interventions of Black women artists. Ultimately it would contribute to the revision of art history and criticism, art education, museum practices and other oppressive institutionalized operatives that are fast becoming outdated with changing demographics.

As an apparatus for change, the proposed discourse would be directed by the ideological proclivities of the speaking subjects. Any attempt to centralize it in existing discourses (at this stage) would be antithetical to the goal of circulating, synthesizing and debating the knowledge of artists/scholars and others who are seriously interested in the art, lives and interventions of Black women artists since existing discourses maintain other priorities;[9] our marginality in those discourses is totally unacceptable. As the

major site wherein the knowledge/s of Black women artists, artists/scholars and art historians, and others would be exchanged, the discourse would adhere to its immanent objective to circulate knowledge, language, power for its Black women subjects, thus ultimately contributing to the 'new growth' of a more comprehensive art history and larger art world practice.

Theorizing Black Feminism/s: An Artist/Scholar Speaks

My search for a discourse and critique appropriate to understanding the thoughts, cultural production and interventions of Black women artists has led me to the domain of knowledge of Black feminist theory, criticism, history and practice, wherein I found that the historical gaps and silences of Black women were displaced by Black women's visibility in intelligible analyses and acts informed by a distinctive critical gaze/s that simultaneously consider/s race, class, gender and sexuality.[10] Black feminist theory, unlike any other, prioritizes the knowledge and interests of Black women as it makes available critical thought about their oppression, self-definition, self-determination and intervention by presenting a wide range of analyses that engage social, historical, cultural, economic, literary and psychoanalytical theory and empirical facts. Critical thought about our art engages our material conditions and cultural attitudes among other factors which are commonplace considerations in discourses on Black feminist theory, therefore sharing much common intellectual ground with the knowledge in this interdisciplinary area.

In spite of the commonalities among Black women that are grounded in shared historical conditions, the multiplicity of positions articulated in debates within Black feminist theory reveals divergent critical stances that are healthy for scholarly growth. Particularly irreconcilable at this point (perhaps for ever) are arguments pointing out problems of heterosexism and unacknowledged imperialism based in theoretical differences among constructionists, essentialists, cultural nationalists, lesbian critiques, complementarists and so on.

The constructionist stance which rejects any notion of essentialism or innatism is clearly presented by sociologists King and Collins who emphasize the importance of socially constructed material conditions (especially African-American) as a framework for investigation. White assumes a Black feminist historical materialist perspective in her specific critique of the oppositional debates on African-American history and culture and in her anti-essentialist stance observes, 'Black feminists do not have an essential, biologically-based claim on understanding black women's experience since we are divided by class, region, and sexual orientation. Even we have multiple identities that create tensions and contradictions among us. We need not all agree nor need we all speak with one voice' (White, 1990: 82). Concurring, literary theorist Hazel Carby stresses the importance of recognizing both diversity and specificity in Black feminist thought: 'We must be historically specific and aware of the differently oriented social interests within one and the same sign community. In these terms, black and feminist cannot be absolute, transhistorical forms (or form) of identity' (Carby, 1987: 17). Specificity means recognizing the particular historical and social constructs that contribute

to the production of the material conditions, objects and ephemeral forms of Black women and others.

Essentialism, the binary opposition of constructionism, 'is most commonly understood as a belief in the real, true essence of things, the invariable and fixed properties which define the "whatness" of a given entity' (Fuss, 1989: xi). In her germinal essay 'Toward a Black Feminist Criticism' in 1977,[11] literary critic, publisher and activist Barbara Smith presented the need for a Black feminist critique that would take into account race, gender, class and sexuality, create a 'climate in which Black lesbian writers [could] survive' and develop analyses appropriate to the eye of a 'woman-identified-women' (Smith, 1982: 173). Smith's call asserted the importance of identity and experience as essential to the proposed critique which necessitated an interlocking political movement (Smith, 1982: 159). Her perspective was somewhat similar to the cultural/political critiques of Euro-cultural feminists who articulated an essential female experience during that period and also recalls arguments of cultural nationalists of the late 1960s (and beyond) who defined and debated its relationship to 'Black art' and 'Black culture.' But most importantly, Smith's discussion broke the silence on heterosexism in dominant and oppositional discourses.

Though path-breaking, Smith's 'blueprint' is criticized by Black feminists for various reasons. Literary critic Deborah McDowell questions whether a 'lesbian aesthetic' approach might not be too reductive and whether the question of identity might impose a 'separatist' problematic along with other issues (McDowell, 1980: 153–9). Hazel Carby posits critiques that overlay those of McDowell, though she also criticizes McDowell's 'mystifying' methodology. In assessing both Smith's and Black feminist criticism in general, she rejects the 'reliance on common, or shared, experience,' and the assumption of a Black female language and African-American canonicity (Carby, 1987: 16). Alternatively, Carby's constructionist stance stresses the need for a 'material account of the cultural production' of Black women in 'societies that are structured in dominance by race, class and gender,' and in addition, for specificity in the investigation of sexuality ideologies and other questions in Black feminist theory and criticism (Carby, 1987: 18). This cursory consideration of various viewpoints within Black feminist theory, particularly the dominant constructionist and essentialist issues, reveals overlapping and divergent positions that are critical to an understanding of the complexities of Black feminist thoughts, conditions and productions and also of the importance of working across the boundaries of disciplines in that quest. The common factors in the debates among literary theorists and sociologists are interactive with the debates among artists, art historians, curators and others who consider questions of identity, creative production, canonicity and the African-continuum among other issues. Given the groundwork that has been laid in those areas, their debate can critically inform developments in the arts.

My own position in this debate is that essentialism, constructionism and other stances warrant more careful investigation. It seems that closure on essentialism is premature at this juncture particularly since serious debates within Black feminist theory have hardly begun. As we explore issues of race, gender, class and sexuality, we must recognize that both natural and socially constructed factors are inextricably bound, and are of such complexity that the various issues within and beyond the debate of that

binary opposition require greater scrutiny than time has allowed. Will constructionism remain the prevailing tenet in Black feminist theory? An increasing number of voices are emerging to contribute to this discussion.

In addition to the given dynamics in Black feminist theorizing, the problem of heterosexism and imperialism needs to be interrogated. Feminist discourse could learn much by consistently engaging lesbian critiques which are, in fact, feminist critiques. Clearly as we oppose the domination of Euro-patriarchists, Afri-patriarchists and Euro-feminists, we ironically assert domination of a different order in our hetero-sexist assumptions and language about which we must be more critical.

Theorist/poet Audre Lorde's adamant claim of speech and the distinctive subjects of her speech exemplifies the centrality of lesbian critiques to Black feminist theory. For example, her powerful yet simple, very personal statement made in 1977 at the Modern Language Association effectively drew attention to the alarming reality of one's mortality, and to the tragedy of the unspoken word of the living body: 'My silences had not protected me. Your silence will not protect you' (Lorde, 1984: 41). Lorde's piercing words were/are especially empowering to disempowered women who were/are afraid to speak, and especially to Black women artists who are prominent among disempowered women. She continued:

> What do you need to say? What are the tyrannies you swallow day by day and attempt to make your own, until you will sicken and die of them, still in silence? Perhaps for some of you here today, I am the face of one of your fears. Because I am woman, because I am Black, because I am lesbian, because I am myself – a Black woman warrior poet doing my work – come to ask you, are you doing yours? (Lorde, 1984: 42)

Lorde's words are especially pertinent to Black women artists for they underscore the severity of our silence. In addition to interrogating the Euro-patriarchy and others about our buried histories, we must also question our own silence and fears which contribute to our own absence in artwriting and negation in this world.

Black feminist theory seeks to explain how both positive and negative factors have influenced and been influenced by the interventions of Black women in their social structures, as it challenges the hierarchies of powers within those structures. It stimulates debate about Black women's heroic acts of self-determination: abolitionism, suffrage, temperance, racial uplift, painting, teaching, among other roles that evince their existence, achievement and outright rebellion. It also stimulates thought about the longevity of our oppression through various periods of history: forced migration–enslavement, forced labor, breeding rape, self-gratifying rape, mythologized imagery, beatings, lynching and death among other types of domination, along with our resistance to them. By enlarging such issues, Black feminist theory coalesces with Black feminist history, criticism and social practice to clarify relevant ideological and political formations that are essential to the survival, challenges and future developments in Black women's lives and interventions in society.

Theories function to explain and challenge 'patterns of cultural power' (Ferguson, 1990: 5). Eagleton explains that theory 'on a dramatic scale happens when it is both possible and necessary for it to do so – when the traditional rationales which have

silently underpinned our daily practices stand in danger of being discredited, and need either to be revised or discarded' (Eagleton, 1990: 26). Black feminist theorizing occurs because we Black women are very aware of our historical oppressive conditions, and given that awareness we find it not only both possible and necessary to be self-reflexive about them, but also both possible and necessary to change them. In articulating that awareness, in Busia's words, we recognize that we 'are speaking from a state of Siege' (Busia, 1988: 2). Black feminist theorizing illuminates the diverse circumstances of that siege as it conjoins the social praxis to confront problems inherent in our material conditions and culture, and subsequently to project emancipatory thought and action on our own behalf.

Though the perspective of Black feminist theory requires knowledge of Black women's social history, its utilization as a tool of investigation does not imply acceptance of the base–superstructure model of historical determinism that is found in the social history of art. Such a model constructs art as sign or expression of determinants that occur in the economic base of society; i.e. as the 'epiphenomenon of base action' (Bryson et al., 1991: 67). My interest in Black women's material conditions is derived from the understanding of art as an integral component of the social structure wherein those conditions are produced. Historian/art historian Jan Vansina observes that art cannot be viewed as an object situated in a cultural milieu (Vansina, 1984: 121); rather, it has to be seen as an integral part of its social structure. Nor can I see art situated above that social structure, emerging from the dictates of economic imperatives, a view more related to Marxist analyses. In any case, the primacy of economics in such an approach is much too limited since a Black feminist stance necessarily takes into account the simultaneity/multiplicative factor of race, gender, class and sexuality. The main point here is that Black feminist theory presupposes an historical knowledge of Black women's material conditions and culture. Given that art is material culture that is interactive with those conditions, a systematic investigation of the interrelationship between the art, artists, larger historical conditions and Black women's particular circumstances among other factors must be significantly considered in the construction of a critical art history that centers Black women artists. Art is neither a mere reflection of historical events, nor a mere instrument of ideology, though it cannot be divorced from either; most importantly, it actively contributes to the social structure wherein it is situated.

Given that the work of Black women artists (and of others as well) is interactive with the multiple factors of their existence, and therefore cannot be substantively studied in isolation from the sociological, psychological and other aspects of Black women's material realities, Black feminist theory becomes a critical tool for exploring contextual questions pertaining to their identity and production. Its critiques of patriarchy, race, gender, class, sexuality and imperialism are especially important in this regard. Overall, the conceptual focus, fact-finding and analytical methods derived from Black feminist theorizing and praxis underscore the relevance of both to formulating a critical art history of Black women's artistic production.

Given that the act of theory targets history, then joins it in the process of altering it (Eagleton, 1990: 27), theorizing for Black women inscribes its distinctive critical subjectivities. Its inscription constructs a position from which to negotiate the circulation of knowledge and actions of, by and about Black women and other subjects of interest.

But it must be clear that the 'joining' of the history after the 'targeting' in the discipline of art history and the dominant art world would in itself remain polemical for the theorizing of Black feminism/s has never and can never simply assimilate into bodies of knowledge, nor can it at any point become fixed; it historically changes according to need. It would assert its critical difference by inserting contrasting viewpoints, re-iterating the abnormalcy of the European 'normalcy' in art world and other discourses. The juxtaposition of our interpretations with those of Euro-patriarchists (and others) exposes a critical difference in aesthetic values that is inextricably bound to differences in specific histories and cultures. Black feminist theorizing, in this regard, emphatically declares that historical and cultural knowledge are essential to the understanding and appreciation of the art object and other phenomena pertaining to art. It therefore stimulates thought about cultural difference/conflict as it questions the legitimacy of critical judgement that emerges from one position within cultural conflict to judge the 'Other' that it has veiled, and therefore has yet to understand.

Black feminist theorizing to date has given minimal attention to art and where it has, the focus is on popular art and culture; i.e. film, video and music.[12] Michele Wallace and bell hooks are the most prominent scholars, particularly in film criticism. Their theories intersect with the artwriting of historians, curators, artists and others who have given particular attention to visual and/or performing art by Black women.[13]

Given the precedent that Black feminist theorizing has established in subjectivizing the thought and challenges of Black women, and given its analytical approach, it is evident that a discourse and critique that center the art of Black women artists would benefit tremendously from its perspective/s.

A Working Black Feminist Critique of the Visual Arts

The critique within the proposed Black feminist art-historical discourse would constitute a significant component of a critical art history. Because of the differences between art history and criticism, the former concerned with the reconstruction of the history of the art objects and the latter with an evaluative response to the art objects that are recovered by art history, the two disciplines are recognized as separate yet interrelated (Ackerman, 1963: 162). However, art historians necessarily make critical evaluation that goes beyond basic art-historical methods, and critics significantly contribute to the development of art history; hence the boundary is sometimes problematic. Within the proposed discourse, criticism must be developed along with Black women's art history (African-American, British, Nigerian, etc.) since the latter is hardly known. Pre-eminent is the archeological recovery of buried art objects and lives, and the description and systematization of relevant empirical data both diachronically and synchronically. This project includes the discovery, description and attribution of art works to artists and their particular historical periods among other problems. The fundamental task is to locate and organize a vast body of data for study, interpretation and evaluation. Essentially, the significance of this beginning phase for Black women artists would mean the systematic recovery and historicizing of their work, little of which has been done to date. Most of what has been written lies within the history of African-American art, is secondary to male production, and for the most part is without

critiques of class, gender and sexuality, though racial and aesthetic difference are traditionally considered in discussions of style, historical periods, and cultural and political movements.

Inextricably bound to the task of historicism is the formulation of analytical methods that would contribute to an understanding of the polyvalent production of Black women artists and to other scholarly/social interests of the Black feminist imagination/s. As art historian Michael Podro expounds, the archeological question requires us to 'provide answers on diverse matters of fact, on sources, patronage, purposes, techniques, contemporaneous responses and ideals'; while the critical history itself requires us to examine questions of sustained purposes and interests that are 'both [irreducible] to the conditions of their emergence as well as [inextricable] from them' (Podro, 1989: xviii). Hence a careful balance of formal and extra-formal investigations must constitute a significant element in the proposed critique. Analyses of form, iconography and iconology, engaged in that critique, should consider integrally the simultaneity-multiplicative construct of race, class, gender and sexuality, a consideration beyond conventional criticism which is largely formalist in its focus on the intrinsic qualities of the art object, though new art history and criticism both include and move beyond formalism (Flemming, 1991: 8).

Art educator Paulette Flemming criticizes the conventional art critics who 'in vernacular and academic settings arbitrate meaning, significance, and value of art forms, stabilizing meaning or offering new insight into those forms with which they are familiar and explaining and evaluating those with which they are unfamiliar' (Flemming, 1991: 9). She calls attention to the inadequate perspectives in existing art criticism, attributing them to the lack of research and theory development in its fundamental teaching. Her critique of enthroned models of criticism in the educational system such as E. Feldman's 'critical performance' (description, analysis, interpretation and evaluation) and H. S. Broudy's 'aesthetic scanning' (discussions of sensory, formal, expressive, and technical qualities) and others (Flemming, 1991: 9) reveals the limitations of those approaches, as does her interrogation of criticism's claim of universality based on the belief that 'the aesthetic experience, formal qualities of the art object, and pansocial human activities' are universally accessible (Flemming, 1991: 9). Flemming's rejection of the cultural elitism and legitimacy given to 'certain artworlds' overlays that of Black feminist theory in general as does her reiteration of the need to recognize cultural difference and the subjective response to aesthetic experience; qualities in which art criticism must engage if it is to be pluralistically valid.

Functionalist and contextualist theories are important to the proposed Black feminist critique, though at present apt to show limitations with greater focus on extrinsic factors sometimes to the detriment of intrinsic and historical considerations. Africanists, for example, utilize functionalism and contextualism to concentrate on art and cultural phenomena, often focusing on a specific ethnic area wherein they give primary attention to ritual, audience and symbolism, and their collective significance. Historian/art historian Jan Vansina criticizes the limitation of this conventional anthropological ahistorical approach and calls for the inscription of an historical (diachronic) approach to the study of African art (Vansina, 1984).

Marxist archeological and critical scholarship, which overlaps the Africanist, is also useful to a Black feminist critique though its emphasis on the economic base of

social history and its insistence on the instrumental value of art to society are somewhat problematic. The Marxist and functionalist/contextualist critiques of African art are especially relevant to those of cultural nationalists, particularly in regard to the latter's concern with the social value of Black aesthetics and the functions of art and artists in society; as the work and philosophy of the Afri-COBRA group demonstrate (Thorson, 1990: 26–31). An examination of selected social issues along with the examination of art objects contributes to understanding the dynamics of events and attitudes of historical periods in relation to the themes and styles of art objects, and the ideologies of artists. This means that investigations of art must include intrinsic and extrinsic analyses.

Feminist analyses in general are assumed to be fundamental to a Black feminist critique in that they raise questions of gender in formal, contextual, psychoanalytical or other critical approaches. Their interrogation of patriarchy, elitism and classism is especially useful; however, the assumed Europeanisms of British Marxist scholars that suppress or dismiss critical awareness of the art of people of African descent reveal their limitations (see Pollock, 1988; Wolff, 1990). Some American feminist critiques also fail on the issue of race,[14] others do ascribe to minimal inclusion with discussions of art by African-American women in the USA and/or the inclusion of essays by Black women art historians, critics, etc. (Raven et al., 1988; Chadwick, 1990; Broude and Garrard, 1992).

What is especially important about the various voices of contextualism and functionalism is a fundamental rejection of the formalist paradigm of modernist criticism that Roger Fry, Clive Bell, Clement Greenberg and other critics dogmatically utilized, convinced that appreciation of the art object must rest on its intrinsic values, i.e. its 'significant form' alone (Greenberg, 1965; Chipp, 1975). Such rejection coalesces with the conventions of such African-Americanist scholars as philosopher Alain Locke and art historians/artists James Porter, David Driskell, Samella Lewis and Richard Powell, whose critical approaches synthesize formalism and contextualism from diverse perspectives to document and integrally interpret form, content, social and cultural meanings, audiences and reception among other factors.[15] African-Americanist approaches in the area of art history and criticism are most relevant to the proposed critique since their investigations engage material culture and social history that include the issue of race and more recently gender in the archeological recovery of the lives and works of Black women and men.

Contextualism and functionalism, as Africanist anthropologist Warren d'Azevedo explains, alert us to the importance of understanding both the art object's aesthetic qualities and the context in which it originates: 'The significance of any object – its "form" – can be ascertained only with reference to the esthetic values of the members of a given sociocultural system for whom it functions esthetically' (d'Azevedo, 1958: 702–14).

Black feminist art criticism must both utilize aspects of existing paradigms and introduce new ways of thinking about art as it inserts its distinctiveness in subjects and perspectives, to: (1) assert the visibility and production of Black women artists in the USA and in other areas of the African diaspora and Africa, uncovering and documenting their lives, works and interventions in society; (2) reject any question of universal truth or beauty since its basic assumption is that art is interactive with the specific cultural

values of the context in which it originates and to which it contributes; (3) recognize the importance of both the African continuum and the European continuum in the development of African-American art which, in fact, is American art; (4) reject the established hierarchy of materials extant in conventional art history, and alternatively recognize the diversity in the artistic production (fine art, crafts and popular) by academic and nonacademic artists and assume that each has to be evaluated in terms of its particular form, function and value to its audience/s; (5) examine representation, particularly in regard to the history and politics of race, gender, class and sexuality; (6) speak across the boundaries of race, class, gender, sexuality, age and discipline, to be enriched by and to enrich existing knowledge; (7) remain open to utilizing aspects of conventional methods (style–iconography–iconology) and revised approaches (influenced by literary criticism, anthropology, sociology, psychology and interrelated political movements) while exploring new ways to inscribe and critique a yet to be written critical history of art of Black women artists.

Given its anticipated performative function, a Black feminist critique would resist the basic assumptions in the canons of art history that identify artists as 'great'/inspired 'geniuses' and their art as 'masterpieces', an idea highly influenced by Florentine culture and derived from the ideals of ancient Greek models (Vasari, 1987: vii). Its interrogation of the canon would recognize that the current exclusionary art world practices are based on judgements derived from Eurocentric art-historical knowledge, particularly that developed during the Italian Renaissance with artist/art historian Giorgio Vasari's publication, *Le Vite de 'più eccellenti Pittori, Scultori e Architettori Italiani* [Lives of the Most Excellent Painters, Sculptors and Architects]; dated 1550 and expanded 1568. Because of its official standardization of the discipline of art history, Vasari's *Lives* has been identified as 'perhaps the most important book on the history of art ever written' (Osborne, 1987: 1177). Art historian Hans Belting observes that Renaissance art historiography 'erected a canon of values, and in particular a standard of ideal or classic beauty,' a norm of historical progress toward 'a universal classicism, against which all other epochs are to be measured' (Belting, 1987: 8). In her resistant reading art historian Nannette Solomon surmises, 'Vasari introduced a structure or discursive form that, in its incessant repetition, produced and perpetuated the dominance of a particular gender, class, and race as the purveyors of an art and culture' (Solomon, 1992: 223). A Black feminist critique would reject the preeminence and persistence of that influence and its adverse impact on art history texts, university curricula and museums throughout the world, and especially in art world practices that enthrone art/artifacts of European cultures while devaluing those of people of color (see Lewis, 1982: 42).

Art historian John Tagg reminds us that any adequate critique of art history must critique not only its paradigm of art, but also its 'repertoire of legitimate objects with which art histories have engaged,' since art history 'operates with and defends a given definition of its object of knowledge, while limiting the permissible methods for constructing and establishing such knowledge' (Tagg, 1992: 42–3). African-Americanists and Euro-feminists have already legitimated their own forms in their publications, museums, galleries, exhibitions and other networks, but Black women artists have minimally benefited from these developments. Ultimately, the concept 'canon' has to be challenged with the question 'Whose canon?' By recognizing canonicity within

constructs of its particular culture, whether Italian Renaissance or Yoruba antiquities, the critical art historian must reject universalizing tendencies, and work toward constructing analyses based on informed judgements that are validated by cultural grounding.

Material cultural theory would be particularly useful here for it raises many questions beyond conventional approaches that would allow the incorporation of vernacular forms into art history. Jules D. Prown informs us that material culture refers to manmade artifacts as well as to the study of beliefs through artifacts of 'values, ideas, attitudes, and assumptions – of a particular community or society at a given time' (Prown, 1982: 1–18). The inclusion of vernacular forms by pioneer African-American James Porter set the precedent for considering crafts with fine arts. An understanding of vernacular forms is highly significant to the development of a critical art history of African-American art for pottery, basketry, quiltmaking and others provide primary evidence of historical, material and aesthetic links to the history of African-American fine arts in the USA, and links to the past/African heritage; i.e. African art, aesthetics and cultural elements that entered the country with enslaved Africans during forced migration and slavery. Material culture as discussed by John Vlach, Robert Thompson and others offers some direction for the proposed critique; however, they fall short of gender analyses though women's material production is included. We must go beyond mere inclusion.

Given the precedent in African-American art history surveys to include both 'fine art' and 'folk art' and the interrelated qualities of the two, the proposed critical art history must carefully inscribe both and show how they contribute to the overall picture, but with greater depth. It would resist the problematic assumption of a hierarchy in materials, recognizing that the life and work of nineteenth-century Harriet Powers (1837–1911), an enslaved and later 'freed' quilter of Athens, Georgia, are as important for investigation as those of Edmonia Lewis (c.1845–c.1911), a 'free' woman of color who produced marble sculpture in the neo-classical tradition during the same period. Both artists significantly participated in the shaping of the history of African-American art and both interacted within their various contexts to make an imprint that merits attention. Powers is often excluded and Lewis often included in Euro-feminist and African-American art-historical scholarship, though brief discussion of quilting and other craft traditions occurs; but Powers is included and Lewis excluded in the work of material culturalists. A Black feminist critique must carefully review the data of both, and of those who produce on either side of the 'fine art'/'craft' boundary, in order to reconstruct the proposed critical art history.

The craft tradition is significant material evidence of woman's personal expression, aesthetic taste, productive labor, and intervention in her given social structure. Crafted forms constitute a functional body of work that was and remains interactive with fine arts in the larger scheme of development in African-American women's art history and often signify a Black woman's difference in artistic production, raising the debate of essentialism and constructionism. Regardless of the stance there taken, a distinct expressiveness in quiltmaking forms by Black women has become well known through the scholarship of Maude Wahlman, John Vlach, Reginia Perry, Eli Leon and others. Specific identifiable qualities in quiltmaking traditions[16] and other African-American

folk art forms are derived from conventional aesthetic values within the communities wherein those works are produced and whose aesthetic and moral tastes they, in turn, influence. Vernacular values are diffused with the migration of African-Americans (including fine artists), for Black women took their traditional skills with them and generally passed them on to their daughters.[17]

But simply inscribing folk, fine art and popular art by Black women artists is not enough to justify the uniqueness of a Black feminist critique. Here the multiplicative-simultaneity factor of race, gender, class and sexuality requires specific attention, in regard to Black women's work, the works of others and many critical issues.

A brief contextual consideration of nineteenth-century artists Harriet Powers and Edmonia Lewis will exemplify the potential instrumental value of a Black feminist critique in the production of a critical art history.

Lewis was northern, 'free' (not enslaved), college-educated, 'privileged' (access to limited economic and patriarchal power) and single (free of man and child); Powers was enslaved and later emancipated, 'uneducated,' without privilege (money and power), married and with children. Lewis was born possibly in New York, possibly in Green-high, Ohio; attended Oberlin College and later made her mark in art history, after expatriating to Rome in 1865; she is believed to have died there c.1911. Powers, on the other hand, lived and died in Georgia. Little is known about her life or travel, except that she and her husband were landowners and that she was able to care for herself after his departure, perhaps through her farm animals and sewing abilities (Fry, 1990: 84–91). The works of both artists are preserved in major museum collections, though only two of Powers's are known; but Powers's works were powerful enough to launch her into posterity. Powers's quilts are, in fact, canonical works: they link African-American quilting traditions to African textile traditions (West and Central), though often compared specifically with the Fon appliqué of the Republic of Benin. [Powers's 'Bible' quilt] consists of fifteen rectangular and square motifs arranged in strip design, each framing human, animal, or astronomical silhouettes in high-contrast colors. The pictorial character that combines imagery from biblical, local history and social commentary is linked to the Fon appliqué in its structure, technique and narrative function. Its formal rhythmical style, combining both structured organization and improvisational qualities, reveals a dynamically controlled horizontal composition with limited color scheme, dominated by warm tonalities, though dramatically activated by its high-contrast design. Art historian Gladys-Marie Fry notes that Powers's 'fascination with biblical animals and characters probably stemmed from hearing vivid sermons in church on Sundays' and that the core of Powers's religious imagery invoked biblical figures who 'struggled successfully against overwhelming odds' (Fry, 1990: 84–5). Could this work perhaps be seen as a composition that expressed the artist's personal view of life, a view related to her desire to intervene in her contexts to present aesthetic beauty that articulated her particular sociopolitical stance? Is it possible to interpret the selection of particular empowered imagery, consonant with prevailing African-American religious-political metaphors of her period, as a practice expressive of her own individuality and shared 'cultural memory' and material conditions? Representation of religious genre and historical events suggests this possibility. The Bible quilt is of special interest in this regard. How might such imagery be interpreted in light of

Powers's low economic status, strong religious beliefs, and her victimization by slavery, racism and patriarchy? Such thoughts would be invoked and investigated in a Black feminist critique.

The question of subject-matter in Lewis's work is also important in addition to form and context. Hagar, for example, though different in materials and style from Powers's biblical imagery, faced tremendous odds as the Egyptian maidservant of Hebrew Sarah, wife of Abraham. Renita Weems calls attention to Hagar's symbolism; slave woman, powerless, reproductive/exploited/manipulated body, unprotected, cast out into the desert with her son/Abraham's son; a story of victimization. Yet Lewis, daughter of a Chippewa mother (who remained in her environment and maintained her life-style) and an African-American butler father, rendered Hagar in an ennobled dramatic gesture, subverting the oppressive imagery of Hagar and in a sense of oppressed people of color as did other African-American women such as educator Anna Julia Cooper (1858–1964), who 'authored the first black feminist analysis of the condition of blacks and women' (Guy-Sheftall, 1990: 25). Lewis's works intervened in public spaces in exhibitions to assert the dignified representation of Black, Native American and biblical figures, displaying a resonance that radically expanded conventions of her neo-classical style beyond Greek influence. Her sculpted marble forms, characteristically ennobling Black and Native American subjects in gesture and overall effect with a characteristic dramatic grandeur, were oppositional to prevailing degrading representations of Black people in the popular Euro-patriarchist media that proliferated during her period (Lemons, 1977: 102–16). They also differed from the hierarchically encoded and delimited representations of Black subjects by fine artists of European descent (see Fredrickson, 1971; Boime, 1990; McElroy et al., 1990). In referring to Hagar (1875), Lewis noted that the subject-matter was inspired by her 'strong sympathy for all women who have struggled and suffered' (Hartigan, 1985: 94). The empowered presentment of the form immediately calls to mind the strong female biblical characters of African-American orators and educators who synthesized religious beliefs and political resistance. Though her work adheres to the European canon, some of her subject-matter and its iconography emerge from specific lived experience, social conditions and interpretations interactive with those experiences and conditions.

The form and meaning in the works of Powers and Lewis reveal that the artists intervened in their contexts with their own particular Black feminist or womanist voice and drew upon shared cultural and social attitudes not unrelated to their shared racial identities. Their materials are related to the class and opportunities available to each, while their aesthetic effect is related to the qualities that most appealed to their individual sensitivities. Meaning and associative values in the two works substantiate the point that 'low' craft and 'high' fine art traditions in the history of African-American art interpenetrate each other and are both essential to the critical art history of Black women's art.

Unlike Powers, who apparently 'stayed put' as wife and mother, and unlike Black women of the intelligentsia, Cooper and Stewart, who grounded themselves in the ideals of the 'Cult of True Womanhood' of the nineteenth century as they fought for the rights of Black women and men, Lewis chose to bypass such ideals and, independent of children, men and the 'Cult', became a member of the 'White, Marmorean Flock' of American women sculptors in Rome (Thorp, 1959), where she reportedly

exhibited her 'strong-mindedness' (Hartigan, 1985: 94) though tenuously regarded as an 'exotic' other.

By reviewing the imprint of these important nineteenth-century figures, one can resist the canonical debate of high v. low art and begin to think with greater depth about the importance of fine art and craft to African-American life and history and to the construction of a critical art history that centers the lives and production of Black women artists.

The question that art historian Linda Nochlin asked in 1971, 'Why Have There Been no Great Women Artists?'[18] assumes that greatness is defined by the ideology of the speaker and his/her constituency, and therefore remains problematic. A Black feminist critique would instead ask who were/are Black women artists; what styles, subject-matter and meanings did they produce in their various forms; how did their specific circumstances contribute to or restrict their production; how did those works intervene in the society of which they were a part; what was their particular reception; where, by whom and why? Questions pertaining to Black women's simultaneous production (art)/reproduction (children) roles and those addressing woman-identified-women must be integrally explored. Simultaneously it must debunk historical racialist theories that promoted 'Negro' inferiority with articulations that declared the 'Negro's in-ability to produce art though having a "natural talent for music"' (Fredrickson, 1971: 105), theories fundamental to the current exclusionism extant in the art world today for they reinforce the stereotyped idea that while African-Americans might appear to appreciate the visual art, they were/are 'manifestly unable to produce it' (Hartigan, 1985: 73). Such myths cannot be ignored though they cannot be the focus of discussion in a Black feminist critique.

As Black women artists speak and work throughout the country today, they reveal cultural and political commonalities that are coextensive with their shared histories and material conditions, though their differences are apparent in the individuality of their personalities and vision. Their different styles, media, themes, reputations and professional roles display a heterogeneous body of work that ranges from abstract formalized structures meant to invoke mere aesthetic contemplation, to evocative performance pieces which synthesize aesthetic and extra-aesthetic qualities that are intended to activate immediate political responses from the spectator. No monolithic quality defines their style, though there is often some reference to their identities, and beyond the work itself, a commonality in the race and gender of those identities; also class and sexuality though perhaps more variable. It is their identity, in fact, that situates them outside of dominant art history and at the periphery of the art establishment. Those locations and the artists' response to them are coextensive with their collective history, culture and ideologies that link them to each other and to other African-American women in the USA, past and present. To engage these various aspects of Black women artists' lives and works is the challenge of a Black feminist critique and the larger art-historical discourse. Until that particular discourse is constructed, Black women artists and their production will remain behind the veils of art history. But as we collectively activate our knowledge and power, we can inscribe new discourses on art wherein we can locate our histories and construct critiques that will appropriately inscribe our lives, production and interventions in this world.

Notes

1 Art history is a discipline that regulates the scholarly investigation of selected works of art and the historical evidence pertaining to them. The discipline systematically focuses on the fine art and lives of men of European descent. It chronicles developments of works of art (primarily painting, sculpture and architecture) by styles and periods, giving attention to form (structure), iconography (meaning), iconology (subject-matter, meaning and cultural attitudes), biography and historical contexts among other concerns. Its conventional purpose is to provide knowledge about developments of 'major works,' 'masterpieces' by 'major figures,' 'geniuses' and ultimately to influence appreciation of them. Despite much debate over the past twenty years about its racial and gender biases, little has been done to alter the exclusion of people of color in the basic texts, professional journals, museum practices, etc. The art of African-Americans and various people of color (excepting forms of Africa often designated as 'primitive') remain virtually excluded. The past decade, however, has seen an increasing number of exhibitions of the art of people of color, an influence perhaps of the rhetoric of multiculturalism, but group exhibitions are disproportionately male and the solo exhibition is invariably a 'one man show'. Criticism is integrally related to art history, though it produces evaluative responses to art objects. Such responses are grounded in the art-historical knowledge and cultural values/biases/subjectivities of the critics who are, by and large, Eurocentric in their orientation.

2 The patriarchy of men of European descent that regulates the art world operates a hierarchical system that asserts Euro-male superiority and domination over everyone else and the value of Euro-male production over that of others. In referring to the networking powers of Euro-male dominance, Elizabeth Grosz identifies three terms in particular that she says are not mutually exclusive: (1) sexism – an empirical phenomenon wherein women are treated as unequal to men; (2) patriarchy – a structure that 'systematically evalutes masculinity in positive and femininity in negative terms'; (3) phallocentricism – two types, the first being modes of representation that reduce differences to a common denominator of masculinity, and the second a process of hierarchization wherein one sex is judged as better than its counterpart (Grosz, 1990: 152). See Royland and Klein (1990: 277). The noted terms and definitions identify the character and operation of the dominant art world.

3 Artwriting is the term used by David Carrier (1991: introduction) to refer to texts by art historians and art critics.

4 The term 'art world' generally refers to 'universes of regularized responses' that 'coalesce around the production, creation, distribution, and evaluation of various' art works. See Vlach and Bronner (1986: 1–10). The dominant art world (Euro-partriarchy) places emphasis on fine art, setting and regulating standards according to the particular interests of its controllers. Vlach and Bronner call attention to the networks of folk art and utilize the term 'folk art worlds' to designate different aspects of the larger network that is yet another component of the overall multilayered system of art. The term 'art worlds' is appropriate since there are others beside the dominant one; i.e. African-American, Euro-feminist, Africanist, Chicano/a, etc. Each of the structures, developed because of specific interest, reclaims and promotes the art of specific heritage/s as they interpenetrate the dominant art world, while resisting devaluation and exclusion from museum and gallery spaces. I will use 'art world' or 'dominant art establishment' to refer to the ruling fine art world of the Euro-patriarchy.

5 See Driskell (1976); Bontemps and Bontemps (1980); Jones (1990); Lewis (1990a, b); Sims (1990); Vlach (1990).

6 Many Black women artists have articulated the problems that they encounter in the 'art world', concurring that those problems are often related to race, gender and difference in aesthetic taste (see Piper, 1990: 15–20).

7 Bonding in various groups is a must for Black women artists, especially with Africans, Native Americans, Chicano/as, Asian-Americans, Euro-feminists and 'radicals.' What especially unites these

various groups is their resistance to the overt and covert racism in the art world. While intellectual exchange across the cultures (through group discussions, exhibitions and political strategies, etc.) is very important, it is also necessary that individuals discuss shared problems which are particular to specific group identities. Of course we Black women artists are greatly enriched by our culture; but that would also be discussed in the proposed sustained discourse. Essentially as we need to interact with various groups, we also need to interact among ourselves in order to address our own specific shared conditions.

8 Busia discusses language as a tool of domination, particularly in relation to its function in the European colonization of African countries. She notes that language 'can be and has been used as one of the central instruments of Empire, as those who have been colonized know.' Her assessment of language is applicable to the dynamics of domination and resistance in the art world (see Busia, 1988: 6).

9 I have participated for many years in various professional sites where discourses are varied. Though diverse perspectives and lively debates ensued in each site, certain ideologies prevailed that were regulated by the dominant speaking subjects: College Arts Association (dominated by Euro-patriarchists); National Conference of Artists (cultural nationalists/male and female); Women's Caucus for the Arts (Euro-American feminists); Feminist Art History Conference (Euro-American feminists); National Council of Black Studies (African-Americanists of cultural nationalist proclivities); African Studies Association (Euro-Africanists); Arts Council of African Studies Association (Euro-Africanists with few African and African-American Africanists). In the sites of each professional organization an exciting body of knowledge circulates and I have learned from each. But there is that glaring absence of Black women. When art historian Ann Sutherland Harris enthusiastically proclaimed to the participants at the Feminist Art History Conference in 1990 at Barnard College that 'we had taken over art history,' it was clear that the few people of color who were in that room in 1990 were as invisible to her then as they were/are in her exhibition and catalogue text (with Linda Nochlin), *Women Artists: 1550–1950* produced in 1976. While I did remind her and others that the 'we' was a misnomer, the shock of that statement remains with me. Although Black women artists do, in fact, operate in various discourses, it is high time that we convened at a national level to talk academics and politics with each other.

10 See Davis (1981, 1989); hooks (1981, 1984, 1990); Steady (1981); Hull et al. (1982); Smith (1983); White (1985); Davies and Graves (1986); Carby (1987); Terborg-Penn et al. (1989); Wall (1989); Braxton and McLaughlin (1990); Guy-Sheftall (1990); Wallace (1990).

11 This essay was first presented July 1977 (Smith, 1982).

12 Michele Wallace's work is particularly insightful in this regard, especially her film criticism. Wallace makes it clear, for example, that as Black male film-makers join the workforce of Hollywood, their production also joins the existing practice of exploiting the images of Black women. The shift of authority from White to Black male producer/speaker extends the tradition of locking Black women into negative imagery that reduces them to passive, sexualized objects of various types (see Wallace, 1990).

13 Like Wallace, bell hooks is a significant cultural critic (see 1981, 1984 and especially 1990). See art historians/curators/artists: Lewis (1984, 1990a, b); Wilson (1988); Jones (1990); Sims (1990); Tesfagiorgis (1990, 1993). Wallace and hooks are foremost among Black feminist theorists to discuss the visual arts. Their focus tends, however, to be on popular and folk art, though Wallace does include fine art. Black women art historians, curators and artists are significantly contributing to the recovery and reinscribing of the lives, works and interventions of Black women artists. Our task, however, has hardly begun.

14 Ann Sutherland Harris and Linda Nochlin (1976) definitely fail.

15 See Locke (1925); Porter (1943); Driskell (1976); Campbell (1985); Leon (1987); Powell (1989, 1991); Wright and Reynolds (1989); Lewis (1990a, b); Robinson and Greenhouse (1991). Other catalogue texts: Studio Museum in Harlem, *Harlem Renaissance: Art of Black America* (New York: Harry N. Abrams, 1987); The Abby Aldrich Rockefeller Folk Art Center, *Joshua Johnson: Freeman and Early*

American Portrait Painter (Williamsburg, MD: The Abby Aldrich Rockefeller Folk Art Center and Maryland Historical Society, 1987); Philadelphia Museum of Art, *Henry Ossawa Tanner* (New York: Rizzoli, 1991); Studio Museum in Harlem, *Memory and Metaphor: The Art of Romare Bearden, 1940–1987* (New York: Oxford University Press, 1991). Fortunately, there is an increasing interest in African-American art; the focus on male subjects and marginalization of women, however, need to be corrected.

16 Vernacular principles and such elements as color scheme (generally warm and high contrast), polyrhythms, strip design, and others have been defined and linked to specific qualities in various locations of Africa (see Ferris, 1983; Thompson, 1983; University Art Museum, 1987; Wardlaw et al., 1989; Vlach, 1990; Tesfagiorgis, 1992: 28–37, 39).

17 The texts in n. 16 reveal this pattern (see also Kunene-Pointer, 1985).

18 This is a vital essay in feminist art history which was first published in 1971 and has been reprinted in Nochlin (1988).

References

Ackerman, J. (1963) 'Western art history', in *Art and Archeology* (Englewood Cliffs, NJ: Prentice-Hall).

Belting, H. (1987) *End of Art History* (Chicago: University of Chicago Press).

Boime, A. (1990) *The Art of Exclusion: Representing Black in the Nineteenth Century* (Washington, DC: Smithsonian Institution Press).

Bontemps, A. and Bontemps, J. (1980) *Forever Free: Art by African-American Women 1962–1980* (exhibition catalogue) (Alexandria, VA: Stephenson).

Braxton, J. M. and McLaughlin, A. N. (eds) (1990) *Wild Women in the Whirlwind: Afro-American Culture and the Contemporary Literary Renaissance* (New Brunswick, NJ: Rutgers University Press).

Broude, N. and Garrard, M. D. (1992) *The Expanding Discourse: Feminism and Art History* (New York: Icon Editions).

Bryson, N., Holly, M. A. and Moxey, K. (eds) (1991) 'Semiology and visual interpretation', in *Visual Theory: Painting and Interpretation* (New York: HarperCollins).

Busia, A. P. A. (1988) 'Words whispered over voids: a context for black women's rebellious voices in the novel of the African diaspora', *Studies in Black American Literature*, Vol. III: *Black Feminist Criticism and Critical Theory*, ed. Joe Weixlman and Houston A. Baker, Jr (Greenwood, Fla: Penkevill).

Campbell, M. S. (1985) *Tradition and Conflict* (New York: Studio Museum in Harlem).

Carby, H. (1987) *Reconstructing Womanhood: The Emergence of the Afro-American Woman Novelist* (Oxford: Oxford University Press).

Carrier, D. (1991) *Principles of Art History Writing* (University Park, PA: Pennsylvania State University Press).

Chadwick, W. (1990) *Women, Art, and Society* (London: Thames and Hudson).

Chipp, H. (1975) *Theories of Modern Art: A Source Book by Artists and Critics* (Berkeley, CA: University of California Press).

Davies, C. B. and Graves, A. A. (eds) (1986) *Ngambika: Studies of Women in African Literature* (Trenton, NJ: Africa World Press).

Davis, A. (1981) *Women, Race and Class* (New York: Random House).

Davis, A. (1989) *Women, Culture and Politics* (New York: Random House).

d'Azevedo, W. L. (1958) 'A structural approach to aesthetics: toward a definition of art in anthropology', *American Anthropologist*, 5: 702–14.

Driskell, D. (1976) *Two Centuries of Black American Art* (exhibition catalogue) (Los Angeles, CA: Los Angeles County Museum).

Eagleton, T. (1989) *Literary Theory: An Introduction* (Minneapolis, MN: University of Minnesota Press).

Eagleton, T. (1990) *The Significance of Theory* (Oxford: Blackwell).

Ferguson, R. (1990) 'A box of tools: theory and practice', in *Discourses: Conversations in Postmodern Art and Culture*, ed. Russell Ferguson, William Olander, Marcia Tucker and Karen Fiss (Cambridge, MA: Massachusetts Institute of Technology).

Ferris, R. (ed.) (1983) *Afro-American Folk Art and Crafts* (Jackson, MS: University Press of Mississippi).

Flemming, P. (1991) 'Pluralistic approaches to art criticism', in *Pluralistic Approaches to Art Criticism*, ed. Doug Blandy and Kristin G. Congdon (Bowling Green, OH: Bowling Green State University Press), pp. 60–5.

Foucault, M. (1980) *Knowledge/Power: Selected Interviews and Other Writings 1972–1977*, ed. Colin Gordon (New York: Pantheon Books).

Fowler, R. (1990) 'Feminist knowledge: critique and construct', in *Feminist Knowledge: Critique and Construct*, ed. Sneja Gunew (London: Routledge), pp. 13–35.

Fredrickson, G. M. (1971) *The Black Image in the White Mind: The Debate on Afro-American Destiny, 1817–1914* (New York: Harper and Row).

Fry, G-M. (1990) 'Harriet Powers: Portrait of an African-American Quilter', in *Stitched from the Soul: Slave Quilts from the Ante-Bellum South* (exhibition catalogue) (New York: Dutton Studio Books in association with Museum of American Folk Art), pp. 84–91.

Fuss, D. (1989) *Essentially Speaking: Feminism, Nature and Difference* (London: Routledge).

Gaither, E. (1989) 'Heritage reclaimed: an historical perspective and chronology', in *Black Art: Ancestral Legacy: The African Impulse in African-American Art* (exhibition catalogue) (Dallas, Tex.: Dallas Museum of Art), pp. 11–54.

Gates, H. L., Jr (1992) *Loose Canons: Notes on the Culture Wars* (New York: Oxford University Press).

Greenberg, C. (1965) *Art and Culture: Critical Essays* (Boston, MA: Beacon Press).

Grosz, E. (1990) 'Philosophy', in *Feminist Knowledge: Critique and Construct*, ed. Sneja Gunew (London: Routledge), pp. 59–120.

Guy-Sheftall, B. (1990) *Daughters of Sorrow: Attitudes Toward Black Women, 1880–1920* (Brooklyn: Carlson).

Harris, A. S. and Nochlin, L. (1976) *Women Artists: 1550–1950* (Los Angeles, CA: County Museum of Art; distrib. New York: Random House).

Hartigan, L. R. (1985) *Sharing Traditions: Five Black Artists in Nineteenth-century America* (exhibition catalogue) (Washington, DC: Smithsonian Institution Press).

hooks, b. (1981) *Ain't I a Woman?: Black Women and Feminism* (Boston, MA: South End Press).

hooks, b. (1984) *Feminist Theory: From Margin to Center* (Boston, MA: South End Press).

hooks, b. (1989) *Talking Back: Thinking Feminist, Thinking Black* (Boston, MA: South End Press).

hooks, b. (1990) *Yearning: Race, Gender, and Cultural Politics* (Boston, MA: South End Press).

Hull, G. T., Bell-Scott, P. and Smith, B. (eds) (1982) *All the Women are White, All the Blacks are Men, But Some of Us are Brave* (Old Westbury, NY: Feminist Press).

Johnson, B. E. (1989) *Afro-American Literary Study in the 1990s* (Chicago: University of Chicago Press).

Jones, K. (1990) 'In their own Image', *Artforum*, 29 (November): 132–8.

Kunene-Pointer, L. (1985) 'Continuities of African-American quilting traditions in Wisconsin', unpublished MA thesis, Department of Afro-American Studies, University of Wisconsin-Madison.

Lemons, S. (1977) 'Black stereotypes as reflected in popular culture, 1880–1920', *American Quarterly*, 29: 102–16.

Leon, E. (1987) *Who'd a Thought It: Improvisation in African-American Quiltmaking* (San Francisco: San Francisco Craft and Folk Art Museum).

Lewis, S. (1982) 'Beyond traditional boundaries: collecting for black art museums', *Museum News*, (3) (January/February).

Lewis, S. (1984) *Elizabeth Catlett* (Claremont, CA: Handcraft Studios).

Lewis, S. (ed.) (1990a) *International Review of African-American Art (African-American Women Artists: Another Generation)* (2) (October).

Lewis, S. (1990b) *Art: African-American*, reprint edn (Los Angeles, CA: Handcraft Studios).

Locke, A. (1925) 'Ancestral legacy', *The New Negro* (New York: Maxwell Macmillan), pp. 254–67.

Lorde, A. (1984) *Sister Outsider: Essays and Speeches* (Freedom, CA: Crossing Press).

McDowell, D. (1980) 'New directions in black feminist criticism', *Black Feminist Literary Forum*, 14 (4) (Winter): 153–8.

McElroy, G. C. et al. (1990) *Facing History: The Black Image in American Art 1710–1940* (Washington, DC: Bedford Arts).

Nochlin, L. (1988 [1971]) 'Why have there been no great women artists?', in *Women, Art, and Power and Other Essays* (New York: Harper and Row), pp. 145–78.

Osborne, H. (1987) *The Oxford Companion to Art* (Oxford: Clarendon Press).

Piper, A. (1990) 'The triple negation of colored women artists', in *Next Generation: Southern Black Aesthetics*, ed. Devinis Szakacs and Vicki Kopf (Winston-Salem, NC: Southeastern Center for Contemporary Art).

Podro, M. (1989) *The Critical Historians of Art* (New Haven, CT: Yale University Press).

Pollock, G. (1988) *Vision and Difference: Feminity, Feminism and the Histories of Art* (New York: Routledge).

Porter, J. (1943) *Modern Negro Art* (New York: Dryden Press).

Powell, R. J. (1989) *The Blues Aesthetic: Black Culture and Modernism* (exhibition catalogue) (Washington, DC: Washington Project for the Arts).

Powell, R. J. (1991) Homecoming: *The Art and Life of William H. Johnson* (Washington, DC: The National Museum of American Art, Smithsonian Institution).

Prown, J. D. (1982) 'Mind in matter: an introduction to material culture, theory and method', *Winterthur Portfolio*, 17 (Spring): 1–18.

Raven, A., Langer, C. L. and Frueh, J. (eds) (1988) *Feminist Art Criticism: An Anthology* (Ann Arbor: UMI Research Press).

Robinson, J. T. and Greenhouse, W. (1991) *The Art of Archibald J. Motley, Jr* (Chicago: Chicago Historical Society).

Royland, R. and Klein, R. D. (1990) 'Radical feminism: critique and construct', in *Feminist Knowledge: Critique and Construct*, ed. Sneja Gunew (London: Routledge), pp. 271–300.

Sims, L. (1990) 'The mirror: the other', *Artforum*, 28 (March): 111–15.

Smith, B. (1982) 'Toward a black feminist criticism', in *All the Women are White, All the Blacks are Men, But Some of Us are Brave*, ed. G. T. Hull, P. Bell-Scott and B. Smith (Old Westbury, NY: Feminist Press), pp. 157–75.

Smith, B. (ed.) (1983) *Home Girls: A Black Feminist Anthology* (New York: Kitchen Table/Women of Color Press).

Solomon, N. (1992) 'The art historical canon: sins of omission', in *(En)Gendering Knowledge: Feminists in Academe*, ed. Joan E. Hartman and Ellen Messer-Davidow (Knoxville, Tenn.: University of Tennessee Press).

Steady, F. C. (ed.) (1981) *The Black Woman Cross-culturally* (Cambridge, MA: Schenkman).

Tagg, J. (1992) *Grounds of Dispute: Art History, Cultural Politics and the Discursive Field* (Minneapolis, MN: University of Minnesota Press).

Terborg-Penn, R., Harley, S. and Rushing, A. B. (eds) (1989) *Women in Africa and the African Diaspora* (Washington, DC: Howard University Press).

Tesfagiorgis, F. H. W. (1990) 'African artists' and 'African-American artists', *Women's Studies Encyclopedia Project: Literature, Arts and Learning*, II (Fall).

Tesfagiorgis, F. H. W. (1992) *Black Art: Ancestral Legacy, African Arts* (catalogue review), 25 (2) (April).

Tesfagiorgis, F. H. W. (1993) 'Elizabeth Catlett', in *Black Women in the United States: An Historical Encyclopedia* (Boston, MA: South End Press).

Thompson, R. (1983) *Flash of the Spirit: African and Afro-American Art and Philosophy* (New York: Random House).

Thorp, M. F. (1959) 'The white, Marmorean flock', *New England Quarterly*, 32 (2) (June).

Thorson, A. (1990) 'AfriCobra – then and now: an interview with Jeff Donaldson', *New Art Examiner*, 17 (March): 26–31.

University Art Museum (1987) *Baking in the Sun: Visionary Images from the South* (Lafayette, LA: University of Southwestern Louisiana).

Vansina, J. (1984) *African Art and History* (New York: Longman).

Vasari, G. (1987) *Lives of the Artists*, trans. G. Bull, Vol. II (New York: Penguin).

Vlach, J. (1990) *The Afro-American Tradition in the Decorative Arts* (Athens, Ga: University of Georgia Press).

Vlach, J. and Bronner, S. J. (eds) (1986) *Folk Art and Art Worlds* (Ann Arbor: UMI Research Press).

Wall, C. (ed.) (1989) *Changing our own Words: Essays on Criticism, Theory and Writing by Black Women* (New Brunswick, NJ: Rutgers University Press).

Wallace, M. (1990) *Invisibility Blues: From Pop to Theory* (London: Verso).

Wardlaw, A. et al. (1989) *Black Art: Ancestral Legacy: The African Impulse in African-American Art* (Dallas, Tex.: Dallas Museum of Art).

White, D. G. (1985) *Ar'n't I a Woman? Female Slaves in the Plantation South* (New York: W. W. Norton).

White, E. F. (1990) 'Africa on my mind: gender, contemporary discourse and African-American nationalism', *Journal of Women's History*, 2 (1) (spring).

Wilson, J. (1988) 'Art', in *Black Arts Annual 1987/88*, ed. Donald Bogle (New York: Garland).

Wolff, Janet (1990) *Feminine Sentences: Essays on Women and Culture* (Berkeley, CA: University of California Press).

Wright, B. J. and Reynolds, G. A. (1989) *Against the Odds: African-American Artists and the Harmon Foundation* (Newark, NJ: Newark Museum).

Stephanie Cash, 'The Art Criticism and Politics of Lucy Lippard' (1994)

From *Art Criticism*, 9 (1) (1994), pp. 32–40.

The 1970s were a time of war, protests, political movements, peace and love. Minority groups began to demand equality and recognition. Women fought against socially ingrained forms of repression such as sex discrimination, harassment, and violence, and loudly asserted their right to equal pay and equal opportunity. The women's movement reached a feverish and controversial, if not rhetorical, pitch. It manifested itself in almost every aspect of life, even becoming part of the academic establishment. Because visual representation, i.e. movies, magazines, advertisements, was noted as one of the most problematic issues in their promotion of women as dependent, inferior, and superficial, it is only natural that 'high' art would not escape feminist scrutiny. It is in this fertile environment that Lucy Lippard 'found' herself.

Lippard's career as an art critic began in the 1960s. After graduating from prestigious Smith College she spent time in a Mexican village with the American Friends Service Committee, an organization providing assistance, not unlike the Peace Corps, to underdeveloped countries. This is indicative of her early interest in non-white and repressed cultures, one that has resurfaced almost thirty years later in her most recent book *Mixed Blessings*.[1] How this experience affected her at the time is unclear, however, since she returned to New York and immersed herself in the white male establishment of the art world. Lippard took a position as page, indexer, and researcher at the Museum of Modern Art's library where she met three fellow employee artists who, as she later states, would have a profound ideological impact on her career: Dan Flavin, Sol LeWitt, and Robert Ryman, who would later become her husband. In the early 1960s they became part of a group known as the Bowery Boys that also consisted of Robert and Sylvia Mangold, Frank Lincoln Viner, Tom Doyle, Ray Donarski, and Eva Hesse. At the same time she was also working on her Master's degree at the elite Institute of Fine Arts at New York University.

In 1964 Lippard was asked by Max Kozloff to write the New York reviews for *Artforum*, which she described as a crummy little magazine at the time. Through a strange course of events, the position of senior critic at *Art International* feel into her pregnant lap. She describes her writing at this time as 'new criticism' which was art historically grounded and formally analytical. She has since toyed with different ways of presenting art, from straightforward description to compiling data with little or no commentary or critical intervention.[2] While the topics and artists she chooses to cover change sporadically throughout her career, an underlying, sometimes even blatant, tone of disenchantment with her position in the art world as a critic recurs:

> I've never had much faith in art criticism as a primary form because you are leaning on somebody else's work. It's not that it can't be a positive parasitic process, not that you can't bring new insights to the work, or get out the artist's intentions better than the artist himself or herself might be able to do, but I can't think of any criticism that has ever stood up in the long run as a real parallel to the art. It's self-indulgence when you come right down to it, you like something and you enjoy plunging into it with words. I don't finally know what the hell criticism does for anybody except the artist and the writer.[3]

This seemingly self-effacing statement, which in reality is an attack on all critics and art criticism, is very telling of Lippard's on-going struggle to justify her involvement with art. It is the self-indulgent and incestuous nature of the art world that plagues her conscience throughout her career as a member of the upper class, a guilt assuaged by her coverage of systematically excluded marginals. Hence, this is an issue she continues to address. In another book, *Six Years: The Dematerialization of the Art Object*,[4] she removes her written voice and attempts to make an original contribution in the presentation of different artists, thus making herself something of an artist and alleviating her shame and/or fear of being a mere parasite, again raising the age-old question of the role of a critic. She makes an interesting point for a type of criticism that is art imitative; art leads, criticism follows.[5] This almost necessarily implies involvement with the work on an emotional level instead of forcing the work into a rigid Greenbergian

paradigm. She repeatedly criticizes the whole system for placing monetary value over all else, yet it is a system that she supports, reluctantly or not, through her participation; hence her need to constantly justify her continuing presence. Paradoxically, her coverage of 'unknown' artists, e.g. women in the 70s and artists of color in the 80s, lends them instant credibility and monetary value. Her establishment status automatically inducts any artists she covers into the system, making Lippard a reluctant avant-garde critic.

It is interesting to compare Lippard's early critical work with her writings done after the 70s and the feminist movement. *Changing* is an early collection of essays, like several other of her books, but is unique from her others in that it includes only white male artists. It is in the prefatory notes that Lippard claims not to have a critical system because of 'the distortions that occur when a critic has a system and must cram all the art he likes into those close quarters.'[6] This is a statement she relies on and reiterates throughout her career because it allows her the prerogative of changing her mind. However, this can lead the reader to wonder whether, blinded by her own ideologies, she thoroughly thinks through her arguments. Here she also touts the benefits of the formalist criticism of the 60s because it 'omitted extraneous speculation and emotionalism and purged criticism of the permissive lyricism and literary generalization of the 50s.'[7] It is interesting to note that these very qualities will color her criticism within five years, something she will later proudly admit. Lippard grapples with the critic's right to set *him*self (italics mine) up as a judge because it is the artist who decides what is art.[8] Thus, the role of the critic should be to describe the work and not make a prescription for what the art should be or do. It is precisely because of the rapidity with which the definition of art changes, or more specifically taste as dictated by the establishment, that Lippard feels criticism should not be consistent 'for consistency has to do with logical systems, whereas criticism is or should be dialectical and thrive on contradiction and change.'[9] Again, it is statements such as these whereby Lippard affords herself 'critical flexibility.' Unfortunately, this also lends a certain quality of indecisiveness to her collected writings.[10]

While she finds the possibility for significant change in new or trendy movements, Lippard wryly comments that only journalists are interested in the new for the sake of sensationalism.[11] Yet, in almost the same breath she acknowledges that she could be perceived as an opportunist or public relations person in advocating change and novelty in critical writing. Nonetheless, this awareness of her paradoxical, even hypocritical position does not induce her to be more focused in her opinions or critical writings. This idea of change is more fully developed when she discusses novelty for artists. Lippard claims that artists are usually the best judges of innovation; therefore, if an idea is copied by other artists it most likely signifies an important change and not merely a trend.[12] This implies that artists are not subject to sensationalism or trends (inherent genius?), when indeed many artists will copy the work of successful colleagues in order to absorb a little of the limelight. At this time, Lippard still sees the production of art in modern terms, i.e. art for art's sake: 'The artist does not set out to change the visible world or reform taste; his expansion of how people see or his comments on the world are by-products of the initial impulse to make art.'[13] In closing she states, without much trace of remorse, that a committed and professional audience is finally the serious critic's only audience. Comparatively, her involvement in the feminist movement

inspired Lippard to redirect her writing to a conceivably non-art audience. This is obviously problematic in that the average woman, and later people of color, do not read art criticism. The paradox of activist art and criticism is that the message usually only reaches an audience who already has an opinion on the issue, and frequently the same opinion.

It can be argued that most of Lippard's statements in the above essay are valid and even essential to good criticism. Yet she refutes almost every one of them when she becomes a feminist art critic. The women's movement changed not only the private lives of many women, but permeated and altered methods of inquiry in many disciplines as well. Lippard has been categorized as a first generation feminist art historian.[14] Feminist artists and historians at this time were analyzing the structure of the art world, both past and present, to determine how and why women were excluded. Questions of identifying female sensibility and imagery in art were also being addressed. Much writing at the time was peppered with rhetoric as is to be expected at the birth of any political movement. Yet, underneath this poetic protesting are very pertinent observations. What is perhaps disturbing is the way arguments were taken to such an extreme that they alienated not only society but women as well, something of which Lippard is guilty. Her embrace of the feminist movement occurred after her personal realization of the shame she felt in being a woman. She partially attributes this to her living and working closely with so many male artists as well as her guilt at the realization of her own exclusion and ignorance of female artists.[15] In order to rectify this situation Lippard stridently sought to establish her position as a feminist critic.

The product of her feminist phase is a collection of essays entitled *From the Center* and published in 1976. In the opening essay, 'Changing since *Changing*,' she refutes most of her previous opinions in her new-found freedom of expression she attributes to the women's movement. Lippard readily admits that she makes use of the emotionalism and lyricism she had found inappropriate just five years before. Where Lippard previously thought the use of extraneous information was a distraction, 'other experience,' including biographical information and emotions, becomes imperative in feminist art and criticism. Her former idea of social commentary in art as a by-product had to be reworked at this point. She increasingly begins to support artists who feel compelled toward social commentary; art becomes the incidental didactic vehicle.[16] While several of her views on the art scene could be considered critical of the establishment, she feels the need to highlight her dissent:

> I recognize now the seed of feminism in my revolt against Clement Greenberg's patronization of artists, against the imposition of the taste of one class on everybody, against the notion that if you don't like so-and-so's work for the 'right' reasons, you can't like it at all.[17]

She implies that her opposition to Greenberg was indicative of her true underlying feminist tendencies. It is obvious, however, that criticism can be aimed at Greenberg without relying on a feminist argument. While there is nothing wrong with a change of opinion, something we are all entitled to, Lippard subtly tries to deny that she could have been any other way, as if to say: 'See, I was with it all along.' Of course, she must

address and redress comments that are blatantly in opposition to her newly 'enlight-ened' position. But then she extricates the subtleties, often even the tone, to exemplify, and often exaggerate, her 'correctness.'

To criticize Lippard's writings from this time is to criticize the feminist art move-ment. Understandably, there are points which can be quibbled with, but the movement, both in and out of the art world, provided a forum for dialogue and an important impetus for social change. Feminist art historians and artists sought to restructure the existing art system. But because the discourse was always art-related, what was being treated was the symptom and not the cause. The larger social mentality which under-lies all human interaction has to first be deconstructed before thorough change can be felt in other spheres of life. Is this a task too large for art to accomplish? Probably. Nonetheless, artists and critics tirelessly fought the prejudices and did make some headway. In issues such as representation of women in galleries and museums, change was relatively easy, although still not equal. It is in the less tangible areas of social con-ditioning and gender construction that progress was, and is, slow. These problems manifested themselves in feminist art discourse in the debate over a separate feminist esthetic and women's imagery.

Lippard, like many feminists, resists comparing women's art to that of men. She prefers to encourage a dialogue with the work itself. In doing so, Lippard hopes to help forge a separate female esthetic. Further, because women are historically deprived of interaction and dialogue with the male-dominated art world, such a comparison would be incompatible.[18] Yet, as she notes, absorption into the prevailing system is problem-atic because women would begin to create art for the establishment and not for them-selves. This implies a repression of their female sensibility. If women remain outside the system, however, they remain free from the pressures of a biased commodity market as well as ideological and stylistic influences.[19] Accordingly, Lippard supports the notion of a separate system for women until the current system has been changed, realizing that 'the danger of separatism . . . is that it can become not a training ground, but a protective womb.'[20] Indeed, if women's art is never allowed into the system, how can it compete? Thus, integration should be the immediate goal. Waiting for a separate esthetic to be established, much less accepted, entails waiting for society to undo that system which has developed over hundreds of years. It is not likely that most women, no matter how idealistic, are willing to wait any significant length of time, be it ten years or a hundred, to stake their claim to fame.

Therefore, the argument of most feminists is to deconstruct the system. They feel it is dominated by a male esthetic, i.e. men have traditionally set the standards by which to judge 'great' art and have had control over the means of art instruction and educa-tion.[21] This is an understandable problem. However, would the politics and, more simply, imagery change if women were at the helm? Tempting as it may be, it is very idealistic to think that women *en masse* would be more fair or sensitive to issues that men are accused of ignoring.

Perhaps a more puzzling and problematic issue is that of female imagery. In the early 1970s, Lippard became involved with Judy Chicago and Miriam Schapiro who were actively developing this concept in their work. While a long list of 'female' character-istics was cited by Lippard (obsessive detail, circular forms, central focus, inner space, layers, windows, autobiographical content, animals, flowers, binding, sexual imagery,

grids, etc.),[22] Chicago and Schapiro claimed central core imagery to be the most predominant.[23] Clearly, this list set forth by Lippard can in no way be said to be exclusive or privy to women or even feminine in nature.[24] It is important to keep in mind that any conception we have of a form being male or female is due to social imposition of these values onto an otherwise gender-neutral form. Admittedly, many women were drawn to 'traditional' female art forms, e.g. pattern and decoration, but only to assert their identity as women artists. As such, these choices of imagery and technique can be said to be a movement like any other in the art world.

Lippard feels that because women have different social and biological experiences than men, their art should differ as well. Thus, she claims that if such elements do not appear in the work of a woman, then that woman is repressing her sex.[25] Here Lippard seems to ignore the possibility of a woman, or even man, expressing a *human* experience, i.e. going beyond their immediate perceptual reality. This is not to say that experiences are not different, indeed they are an amalgam of intricate experiential nuances as well as the obvious sex, race, and class. Yet, she insists that the sexual identity of the artist be evident in the work. This demand can only serve to restrict the artistic freedom of women.

Lippard is convinced that there are aspects of women's art that are inaccessible to men (attributable to different life experiences), thereby claiming that there is an art unique to women. However, anyone can appropriate forms or manners of representation. Lippard even addresses this in her evaluation of the Pop art movement. She sarcastically accuses men of pillaging household imagery, saying that it would have been impossible for a woman to produce this art and be taken seriously.[26] So it is evident that men can use, or abuse according to Lippard, images that are traditionally associated with women. Perhaps what is more relevant is the inaccessibility of female experience to men. For Lippard to lump women, or any minority group, into a category and say that they have the same experience is ill-conceived. Obviously, the life experience of a privileged woman will not be the same as a lower class woman. Thus, the notion of group-identity art not only denies unique experience, which is often the motivating force in creating art, but more importantly segregates it from the larger art discourse, inhibiting interaction and exchange.

While her approach to women's art at this time seems to be more concerned with style and representation, her continuing exploration eventually leads her to a more political approach:

> if our only contribution is to be the incorporation on a broader scale of women's traditions of crafts, autobiography, narrative, overall collage, or any other technical or stylistic innovation – then we shall have failed.
>
> Feminism is an ideology, a value system, a revolutionary strategy, a way of life. (And for me it is inseparable from socialism.)[27]

Lippard's politics have recently led her to support other causes as well. It is curious that she seems almost to have abandoned her involvement, on an academic level at least, with feminist art, especially now when the field is ripe for a new insurgence of interpretation. Lippard must feel that she has done her part for women artists and instead now supports artists of color, the new underdogs in the art world. It appears that she is

biased toward anti-establishment art with a political slant, that is art favoring didactic content over visual representation, thus calling into question her purported standard of aesthetic quality.

Although Lippard seems to be confused or non-committal, she is praised by many for her 'astounding lucidity and her capacity for self-analysis,' which 'allowed her to understand fully the position of her own discourse at its every stage.'[28] It is her deep emotional involvement with both the art and the causes that sets her apart from most critics. While this can impede rational evaluation (something Lippard herself would question as even necessary) it can also lead to a new and different understanding of art and its function in society.

Notes

1 Lucy Lippard, *Mixed Blessings: New Art in a Multicultural America* (New York: Pantheon Books, 1990).

2 Lippard in an interview with the editors of *Art-Rite*, 'Freelancing the dragon,' *From the Center: Feminist Essays on Woman's Art* (New York: E. P. Dutton, 1976), p. 17.

3 Lippard, 'Freelancing,' p. 20.

4 Lucy Lippard, *Six Years: The Dematerialization of the Art Object from 1966 to 1972* (New York: Praeger, 1973).

5 Lippard, 'Freelancing,' p. 22.

6 Lippard in the prefatory notes, *Changing: Essays in Art Criticism* (New York: E. P. Dutton, 1971), p. 12.

7 Lippard, 'Change and criticism: consistency and small minds,' in *Changing*, p. 32.

8 In the preface to her book, *From the Center*, Lippard corrects herself on using the pronoun 'he' as a term that incorporated not only female artists, but herself as a critic.

9 Lippard, 'Change and criticism,' p. 25.

10 This creates something of a catch-22: is it possible to remain consistent without being too rigid? Perhaps Lippard could have avoided her, or her readers', critical confusion by developing her ideas from her previous statements instead of merely changing sides. Granted, it may be difficult to reconcile such opposing methods. Instead of providing readers with her personal reasons for such a change, it may have been more conducive to the understanding and acceptance of her argument to develop this transforming dialogue within her writings, thereby lending more lucidity and credibility to her opinions.

11 Lippard, 'Change and criticism,' p. 28.

12 Ibid., pp. 28–9.

13 Ibid., p. 34.

14 Thalia Gouma-Peterson and Patricia Mathews, 'The feminist critique of art history,' *Art Bulletin*, 69 (September 1987): 326–57.

15 Lippard, 'Changing since *Changing*,' *From the Center*, p. 4.

16 Lippard states in her review of the Times Square Show (1980) that activist artists are not concerned with esthetics and that much political art is esthetically ineffective. Politics seems to become her system of artistic evaluation.

17 Lippard, 'Changing,' p. 3.

18 Ibid., p. 5.

19 Ibid., p. 9.

20 Ibid., p. 11.

21 For a thorough investigation of this problem, see Rozsika Parker and Griselda Pollock, *Old Mistresses: Women, Art, and Ideology* (London: Routledge and Kegan Paul, 1981).

22 Lippard, 'Prefaces to catalogues of women's exhibitions (three parts),' p. 49, and 'Fragments,' p. 69, *From the Center: Feminist Essays on Women's Art*.
23 Lippard, 'Prefaces,' p. 49.
24 Lippard's example of grids as an inherent component of female imagery is undermined in the exhibition she curated, *Grids* (Institute of Contemporary Art, University of Pennsylvania, Philadelphia, 1972) in which a good number of men were included, e.g. Jasper Johns, Ad Reinhardt, Ellsworth Kelly, Sol LeWitt, Larry Poons. While she admits that there is not a form used exclusively by women ('Fragments,' p. 69), the fact that it is so prevalent in men's work as well would seem to throw the idea of female imagery into question.
25 Lippard, 'Fragments,' pp. 71, 73.
26 Lippard, 'Household images in art,' *From the Center*, p. 56.
27 Lippard, 'Sweeping exchanges,' *Get the Message? A Decade of Art for Social Change* (New York: E. P. Dutton, 1984), pp. 149–50.
28 Nicole Dubreuil-Blondin as quoted in 'The feminist critique,' p. 343.

3.3 Interventions in the Discipline of Art History

Linda Nochlin, 'Courbet's *L'origine du monde*: The Origin without an Original' (1985)

From *October*, 37 (1985), pp. 77–86.

Nothing could be more Freudian than the scenario I am about to rehearse in this narrative, for it concerns the endlessly repetitive quest for a lost original, an original which is itself, in both the literal and the figurative senses of the word, an origin. I am referring to Courbet's painting, *The Origin of the World*, a work which is known to us only as a series of repeated descriptions or reproductions – an *Origin*, then, without an original. But I shall also be discussing notions of origination and originality as they inform the discipline of art history itself: the founding notion that through the logic of research – i.e. the repetitive act of searching over and over again – one can finally penetrate to *the* ultimate meaning of a work of art. In the case of Courbet's *Origin*, this ultimate-meaning-to-be-penetrated might be considered the 'reality' of woman herself, the truth of the ultimate Other. The subject represented in *The Origin* is the female sex organ – the cunt – forbidden site of specularity and ultimate object of male desire; repressed or displaced in the classical scene of castration anxiety, it has also been constructed as the very source of artistic creation itself.

The first part of my scenario has to do with a failure: the failure to locate the original of Courbet's *Origin of the World* for a forthcoming exhibition of the artist's work. I had gone about my art-historical business in the usual way: tracing the work back to its origin in the Courbet literature, and then, working forward, attempting to discover its present location – to no avail. Not only was the original *Origin* impossible to find, but the clues to its location seemed to be perversely, almost deliberately misleading, fraught with errors in fact. Nor did the errors seem to me to be entirely fortuitous. Rumors that *The Origin*, now veiled behind a canvas by André Masson, was actually in the collection of Sylvie Bataille Lacan – former wife of both Georges Bataille and Jacques Lacan – seemed almost too good to be true, even when they were confirmed by a French expert who claimed to have seen the *Origin* in Mme Lacan's apartment. This hot lead, sending my colleague and myself to a sure address in the sixth arrondisse-

ment, left us standing frustrated in the lobby. On a subsequent trip another French expert, the head of the Societé des amis de Gustave Courbet, assured us that the work was not in France at all, but in the United States, in a collection on the West Coast the name of which he had forgotten – perhaps the Norton Simon Collection, perhaps not. My heart leaped when I discovered a photograph of the work accompanying Neil Hertz's provocative article, 'Medusa's Head: Male Hysteria under Political Pressure,'[1] credited to the Boston Museum of Fine Arts – certainly the most unlikely possible location, one would imagine, for a work that might be thought of as prototypically 'banned in Boston'! A call to the curator of the Boston Museum confirmed my doubts. After helpfully going through all the files of the museum, including those of visiting exhibitions, he assured me that there was no record of *The Origin* in Boston. A call to Neil Hertz revealed that the attribution to the Boston Museum had been a printer's error – an error more recently repeated by Denis Hollier in *his* provocative article, 'How to Not Take Pleasure in Talking about Sex':[2] perhaps Boston is the literary critic's preferred mislocation of *The Origin*? Hertz told me that he had really meant to credit the *Budapest* – not the *Boston* – Museum of Fine Arts. Yet the hope that *The Origin* might be in Budapest was dashed by further research. Peter Webb, in his discussion of Courbet's work in his 1975 publication, *The Erotic Arts*, states that this painting which had been reproduced in hand-tinted full color in Gerald Zwang's *Le sexe de la femme*[3] – a limited edition, luxe, pseudoscientific, soft-porn production – with the provenance 'Museum of Fine Arts, Budapest, formerly collection of Professor Hatvany,' was not in fact in the Budapest Museum any more than it had been in the Boston one. Says Webb, 'In a communication to the author dated 4 February, 1972, the Director of the Museum of Fine Arts at Budapest (Dr Klara Garas) wrote, "Courbet's painting has never been in our museum; it was in a private collection in Budapest and disappeared during the war."' Webb continues, 'During a visit to Budapest in October 1972, the author learned that the painting had been stolen by the Germans during the war and had then been appropriated by the Russians. Professor Hatvany had bought it back and later taken it to Switzerland. Wayland Young, in *Eros Denied*,[4] reports a rumor that the painting was sold in America in 1958.' At this point, Webb simply throws up his hands in despair: 'This painting has rarely been seen or even heard of, and judgment of its quality is difficult from the blurred photograph that remains.' He concludes rather lamely, 'This painting was last heard of in Budapest in 1945'[5] – which leaves us more or less where we began, although, to be sure, Robert Fernier, in his catalogue raisonné of Courbet's work, asserts, without further substantiation, that *The Origin* returned to Paris after the war, where it was sold to an unspecified 'amateur' in 1955.[6]

More secure, in terms of the art-historical quest for the original *Origin*, is the reference to the Hatvany Collection. In his 1948 publication, *Courbet et son temps*, Charles Léger, one of the major Courbet scholars of the earlier twentieth century, states that the work was bought in about 1910 by the Baron Francis Hatvany of Budapest.[7] Baron Hatvany had seen the painting at the Bernheim-Jeune Gallery in a double-locked frame, hidden by a panel representing, Léger asserts, not a 'church in the snow' as Edmond de Goncourt had described it in his diary in 1889, but rather a 'castle in the snow.' Even the supplementary details relating to *The Origin*, it must be re-emphasized, tend to be fraught with error. One might almost say that no statement can be made about it – including my own – that does not contain some deviation from empirical factuality,

much less from 'truth' in the larger sense. Léger continues, 'M. de Hatvany, with whom I was formerly in correspondence, for he owned *The Wrestlers* of Courbet [a work now in the Budapest Museum], naturally spoke to me about this *Origin of the World*, acquired at Bernheim-Jeune, with the frame, while the little panel hiding the canvas, the *Castle in the Snow*, became the property of Baron Herzog, of Budapest.'[8]

Working ever backward in our search for the original *Origin*, we come upon a sighting in June 1889, recorded in the pages of Edmond de Goncourt's *Journal*. Goncourt writes that a picture dealer had shown him a painting of a woman's *bas-ventre* which made him want to make 'honorable amends to Courbet.' That belly, declared Goncourt, 'was as beautiful as the flesh of a Correggio.'[9] Also dating from the 1880s, May 27, 1881, to be precise, is Ludovic Halévy's account of Gambetta's spirited recollection of the work, which the latter had encountered, many years earlier, in the company of Courbet, at the home of its owner, the notorious art collector and Turkish ambassador to St Petersburg, Khalil Bey.[10] Here is Gambetta's rather scrappy reminiscence as recorded by Halévy in his memoirs: '*L'origine du monde*. A nude woman, without feet and without a head. After dinner, there we were, looking . . . admiring . . . We finally ran out of enthusiastic comments . . . This lasted for ten minutes. Courbet never had enough of it.'[11] Still earlier, we have the notorious 'hysterical' description of the work by Maxime du Camp in his four-volume denunciation of the Paris Commune, *Les convulsions de Paris*, written ten years after the fact:

> To please a Moslem who paid for his whims in gold, and who, for a time, enjoyed a certain notoriety in Paris because of his prodigalities, Courbet . . . painted a portrait of a woman which is difficult to describe. In the dressing room of this foreign personage one sees a small picture hidden under a green veil. When one draws aside the veil one remains stupefied to perceive a woman, life-size, seen from the front, moved and convulsed, remarkably executed, reproduced *con amore*, as the Italians say, providing the last word in realism. But, by some inconceivable forgetfulness, the artist, who copied his model from nature, had neglected to represent the feet, the legs, the thighs, the stomach, the hips, the chest, the hands, the arms, the shoulders, the neck, and the head.[12]

The search, then, ends, fruitlessly, in the dressing room of an Oriental *bon vivant*, or rather in a textual allusion to Khalil Bey, who commissioned the work from Courbet in 1866. Ultimately we find the origin of *The Origin* in the desire of its possessor, the exotic collector of erotica, Khalil Bey, but it is still an origin without an original: we have come no further in our search for the lost painting itself. In this almost parodic – because failed – rehearsal of a familiar art-historical scenario, which has turned into a kind of allegory of the scholar's enterprise itself, I wish to emphasize the repetitiveness at stake here, within the context of a discussion focused on originality and repetition. Each new find simply repeats, as though original, a new set of false clues. Each so-called discovery simply mimes the 'truth' it supplants without bringing the quest any nearer to completion. One might go further and say that art-historical practice is itself premised on the notion of originality as repetition, an endless rehearsal of the facts which never gets us any closer to the supposed 'truth' of the object in question.

Yet the presumed origin of *The Origin* in masculine desire leads to still another scenario of origination, that of the origin of art itself. In an article entitled 'The Origins of

Art,' Desmond Collins and John Onians attempted to 'trace back' historically the origin of art to the engraving of crude but recognizable vulvas on the walls of caves in Southern France during the Aurignacian Period, about 33,000 to 28,000 BC.[13] According to this scenario, masculine desire literally led lusting but frustrated Aurignacian males to represent in stone the desired, absent object – the female sex organ – and thereby to create the very first artwork. In the light of this assumption, all other artworks ought to be considered simulacra of this originating male act, and representation must itself be considered a mere simulacrum of that desired original. What a perfect example such art-historical scholarship offers of the assumption that 'everything has to begin somewhere,' referred to by Rosalind Krauss in her introduction to this discussion! What a perfect disregard of the 'always already' is demonstrated by such an enterprise!

It is equally clear that Courbet shared in this myth of the origination force of the artist's desire. To construct still another scenario implicated in the quest for the *Origin* without an original, one must turn to *The Artist's Studio*, a work in which Courbet clearly and literally turns his back on the social and political contextualization which had marked his earlier achievements – *The Stonebreakers* or *The Burial at Ornans*. The central portion of *The Studio* constitutes Courbet's most complex and profound meditation on art as an originating act and the position of the artist in relation to that act of origination.

In *The Studio* Courbet positions himself at the very heart of what must be read as the oedipal triangle, classic site of origins, a configuration constituted by the female model – the mother – the little boy spectator – the son – and the dominating figure of the painter – the father. In a single, powerfully determined image, Courbet has locked into place patriarchal authority and pictorial originality as the inseparable foundations of Western art: great or ambitious art, needless to say.[14] Turning away from the nude model and her forbidden sexuality, the patriarch-painter is absorbed in his act of pro-generation, the supremely originating thrust of brush to canvas. And what he is represented as creating in the painting-within-a-painting is not an image of the nude model, who functions unthreateningly as a kind of motherly muse behind his back, but rather a landscape. The reading of landscape as a manifestation of the psychoanalytic process of displacement in Courbet's oeuvre becomes even clearer if we consider a work like *The Source of the Loue* – itself the representation of an origin, or source – whose morphological relationship to *The Origin of the World* has often been asserted in the Courbet literature. Nor is it any accident, to continue this Freudian scenario, that, at the crucial heart of a crucial painting, Courbet-as-patriarch is represented as inscribing sheer matter – the actual pigment on the palette – as the origin of his creation. Not only is the pigment emphasized by its denseness, thickness, and brightness; not only is it unequivocally centralized; but also, by calling attention to the shape of the canvas-within-the-canvas, as well as the shape of the *actual* support of the painting, the rectangular palette which supports that pigment focuses our attention on the manipulation of matter, the application of paint to canvas, as the originating act of the artist. It is this that makes his work authoritatively original. Here, the strict Freudian, or the reductivist one, might say that the patriarch/originator becomes identical with the child who plays with his feces.

Which leads us to the final scenario: that of the quest for originality in Courbet's *Origin*. In the absence of the painted materiality of the original, that incontrovertible

evidence of the father-generator's presence constituted by Courbet's unique mode of applying his *matière* to the canvas; in the absence, in short, of all the identifying signs of the artist's imperious originality in the available images of the work, there is really no satisfactory way of differentiating Courbet's painting from a thousand ordinary beaver shots available at your local news-stand. In its blurry, reproduced repetitions, most of which seem to have been printed on bread, *The Origin* is literally indistinguishable from standard, mass-produced pornography – indeed, it is identical with it.

Critics have, understandably, attempted to read the signs of originality back into these inadequate reproductions of Courbet's *Origin of the World*: it is a practice in which almost all of us who work with reproductions must inevitably engage. Here is Neil Hertz, in an otherwise exemplary article, having a try at establishing the authoritative originality of the *Origin*:

> The darkness of the paint combines with the pull of erotic fascination to draw the eye of that central patch, but this centripetal movement is impeded, if not entirely checked, by the substantiality of the figure's thighs and torso, by details like the almost-uncovered breast . . . and by what I take to be (judging from black-and-white reproductions) Courbet's characteristic care in representing the surfaces of his model's body – the care, at once painterly and mimetic, that can be observed in his rendering of the rocks surrounding the cave of the Loue. *The Origin of the World* . . . explores a powerfully invested set of differences – the difference between paint and flesh, between a male artist and his female model, between sexual desire and the will to representation.[15]

Surely, the last two sets of differences fail to distinguish Courbet's *Origin* from any other representation of the female nude, in whole or in part; and in the absence of the original, the first set of differences is unsubstantiated by the visual evidence. This passage simply indicates the degree to which eyes have been strained and discourse put under pressure in the vain attempt to find traces of the patriarchal caca, the spore of genius, in an unprepossessing black and white, infinitely repeatable, reproduction.

But it is this infinite repeatability, ironically enough, which characterizes the very *subject* of Courbet's *Origin*: a metonymy, which, in Lacanian terms, poses the question of lack and desire. Desire itself, according to Lacan, is a metonymy, for metonymy expresses itself as 'eternally stretching forth towards desire for something else.'[16] Courbet's *Origin of the World*, then, finally re-enacts the infinite repetitiveness of desire, the impossible quest for the lost original. Or, to return to our original Freudian scenario, one might say that in the case of Courbet's *Origin of the World*, as in that of the founding myth of Oedipus, the search for lost origins leads ultimately to blindness.

Notes

1 Neil Hertz, 'Medusa's head: male hysteria under political pressure", *Representations*, 4 (Fall 1983): 27–54; with responses by Catherine Gallagher and Joel Fineman and a reply by Hertz, pp. 55–72.
2 Denis Hollier, 'How to not take pleasure in talking about sex', *Enclitic*, 8 (1–2) (Spring–Fall 1984): 84–93.
3 Gerald Zwang, *Le sexe de la femme* (Paris: La jeune Parque, 1967).

4 Wayland Young, *Eros Denied* (London: Corgi, 1968), p. 96.

5 Peter Webb, *The Erotic Arts* (London: Secker and Warburg, 1975), pp. 166, 451–2, n. 67.

6 Robert Fernier, *La vie et l'oeuvre de Gustave Courbet* (Paris and Lausanne, 1977–8), vol. II, p. 6, no. 530.

7 Léger does not reproduce the work; I have not been able to find any reproductions of the *Origin* dating before the 1960s.

8 Charles Léger, *Courbet et son temps* (Paris, 1948), p. 116.

9 Edmond and Jules de Goncourt, *Journal: mémoires de la vie littéraire* (Paris: Fasquelle, Flammarion, 1956), vol. III, p. 996.

10 For information about Khalil Bey, see Francis Haskell, 'A Turk and his pictures in nineteenth-century Paris', *Oxford Art Journal*, 5 (1) (1982): 40–7.

11 Ludovic Halévy, *Trois dîners avec Gambetta*, ed. Daniel Halévy (Paris: Grasset, 1929), pp. 86–7.

12 Maxime du Camp, *Les convulsions de Paris* (Paris: Hachette, 7th edn, 1889), vol. II, pp. 189–90.

13 Desmond Collins and John Onians, 'The origins of art', *Art History*, 1 (1) (March 1978): 1–25.

14 This is not the first, nor the last, time that a major artist will resort to such a gesture, needless to say; both Michelangelo in his *Creation* and David in *The Oath of the Horatii* offer memorable analogues.

15 Hertz, 'Medusa's head', p. 69.

16 Jacques Lacan, 'The insistence of the letter in the unconscious', in *The Structuralists: From Marx to Lévi-Strauss*, ed. F. and R. DeGeorge (Garden City, NY: Doubleday, 1972), p. 313; see also Holly Wallace Boucher, 'Metonymy in typology and allegory, with a consideration of Dante's *Comedy*,' in *Allegory, Myth and Symbol*, ed. M. M. Bloomfield, Harvard English Studies, no. 9 (Cambridge, MA: Harvard University Press, 1981), p. 141.

Lisa Tickner, 'Modernist Art History: The Challenge of Feminism' (1988)

From 'Feminism, Art History and Sexual Difference', *Genders*, 3 (1988), pp. 92–128.

The history of art history begins with Pliny in classical antiquity, with Vasari in the Italian Renaissance, with Winckelmann in the eighteenth century ('first of the great German art historians'),[1] or with Thoré in nineteenth-century France (founder of art history 'as a positive or scientific enterprise'),[2] according to criteria which stress the descriptive, biographical, antiquarian, or positivist study of art. Other strands are gathered unevenly into the fabric of art history as a modern academic discipline: the sociohistorical, the archival, the philosophical, the aesthetic, the iconographic, the psychological, the evaluative and attributive aspects of connoisseurship.

Each approach, or group of approaches, provides a frame of reference for the understanding of art; or, to be more precise, 'art' is variously produced by the discourses that lay claim to it. This is not to suggest that all approaches are equally valid (intellectually) or equally valued (institutionally). Some definitions of art, some narratives,

concepts, and methods, are dominant in the *generalized* profile of art history, not only as it is taught and practiced in the academy – which is of course how academics think of it – but also as it informs a range of related activities in schools, museums, auction houses, general publishing, and the mass media.

The principal components of this paradigm derive from an empirical Anglo–Saxon tradition, based on description, biography, attribution, and connoisseurship (as opposed to the more rigorous Germanic tradition rooted in philosophy, aesthetics, and icono-graphic analysis).[3] This 'bourgeois' or (now) 'modernist' art history with its emphasis on style, attribution, dating, authenticity, rarity, reconstruction, and the rediscovery of forgotten artists has always been challenged from the left.[4] (Frederick Antal, Max Raphael, Francis Klingender, Arnold Hauser, Meyer Shapiro, O. K. Werckmeister, and more recently T. J. Clark are names that come to mind.) In the 1970s the 'social history of art' was developed and transformed by marxists, feminists, philosophically inclined art historians, and theoretically self-conscious strays from adjacent disciplines.

It is nevertheless possible to argue that these developments were both limited and marginal (by comparison with the transformation of cultural studies and literary theory in a similar period), and that Nicos Hadjinicolaou's claim that art history is 'one of the last outposts of reactionary thought . . . still stagnating in the first stage of its develop-ment' retains its resonance.[5] In its retention of the figure of the artist as the principal point of reference for the work – and in the face of the intellectual revolutions effected by Marx, Freud, and Saussure – it might as well still be a nineteenth-century disci-pline.[6] And this is crucial for feminism, since feminism will always be disabled by the principal terms of modernist art history: its formalism and ahistoricism, its reverence for the avant-garde and the individual artist-hero, its concept of art as individual expres-sion or social reflection, its sense of itself as objective and disinterested, its pursuit of universal values at once transcendent (of mundane social realities) and intrinsic (to the autonomous work of art, severed from the social circumstances of its production and circulation).

An academic discipline that draws on terms of analysis shared by a cultivated and professional group is unlikely to run counter to widely held social values and beliefs. Feminism is compelled to contest the established protocols of art history (and cautiously and critically to form alliances with other approaches which seek to undermine the certainties of its discourse). A feminism which does not do so will be tamed and disabled by the terms it leaves unquestioned: there will be no new knowledge but only a poignant parody of the old. The category of 'art,' the boundaries, concepts, and language of historical inquiry, the privileging of the artist, and the invisibility of the viewer must be reworked, not in some abstract theoretical space, but as part of the understanding of objects and relations that are locally and historically specific.[7]

We have to account for the traffic in signs between different sites of representation (not for the preciosity of the discrete object, arranged in a narrative sequence that guarantees its authorial, stylistic, or national identity). We need a history of the 'battle-field of representations,' which is something other than a history of style and *facture* (or handling) on the one hand and events and institutions on the other.[8] We need an understanding of the visual articulation and production of ideological components (works of art are neither ideologically saturated nor ideologically pure). We need a

theory of subjectivity that can cope with the unconscious and with the splintering identifications of gender, class, and race as momentarily they collide or overlap.

Feminist art history thus cannot stay art history: first, because the conventional premises of the discipline destroy its potential for radical readings; second, because feminism has to be interdisciplinary (since it questions the structure and interdeterminations of existing fields of knowledge it cannot remain simply a new perspective within any of them); and third, because feminism (like marxism) is politically motivated – it examines new tools for their use value and not for their novelty. At the same time feminism cannot *leave* art history. There is too much to be done in it. We are engaged, as Griselda Pollock puts it, 'in a contest for the occupation of an ideologically strategic terrain.'[9] This contest begins with the definition of 'art' and 'history.'

To speak of 'art' is to speak with a certain intensity of a specially valued but arbitrarily constructed category of human production. Not until the nineteenth century did 'art' and 'artist' acquire their modern significance, in the context of massive shifts in the organization of industrial labor.[10] As opportunities for skilled and inventive workmanship declined, artistic activity came to be seen as the antithesis of alienated industrial labor. Irrespective of the actual and varied circumstances in which artists made and sold their work, a particular representation of art took hold: one that articulated the cultural values and legitimated the hegemony of the bourgeoisie, that naturalized alienation and reserved the possibility of self-determining creativity to a group that did what it had to do 'not to make a living, but in obedience to some mysterious necessity.'[11]

The aesthetic theories of Roger Fry and Clive Bell, devoted to the precipitation of 'significant form' from works of widely different contexts, helped to confirm a category of art purged of historical significance. Bloomsbury formalism offered a corrective to sentimental or moralizing interpretation, but at a price. The 'art' in art became narrowly identified with those formal values that were held to have survived the contingent circumstances of a work's original production and reception.[12] In fighting for the acceptance of the French avant-garde (specifically for what Fry was the first to term 'Postimpressionism'), Bloomsbury aesthetics stressed stylistic innovation at the expense of historical analysis and strengthened the hold of connoisseurship over modernist art history. The formalist position was most extensively consolidated and developed in the work of Clement Greenberg. For Greenberg the most important art was (abstract) art, which embodied the specificity of a particular process ('painterly' painting as opposed to illusionistic or narrative or socially tendentious painting) and demonstrated the impetus of modern art forms to rid themselves of impure or extraneous elements.[13]

Modernist art history and criticism insist on the autonomy of art and on the formalist procedures of the critical text. Objects are removed from the conflict of history, from their specific conditions of existence in social relations and institutions, and inserted into a narrative of stylistic innovation premised on the authority of individual artist-heroes. Conflict, discontinuity, and overdetermination are smoothed into the comforting narratives of harmonious evolution, of the emergence of new styles from outworn convention. It is not that the details are not historical (the names, dates, and pedigrees), rather that in its conventional formulations art history fails to provide a mode of inquiry into the social production of cultural meanings, meanings articulated

in distinctively visual configurations. The irony is, as Edmund Burke Feldman puts it, that the discipline should so frequently employ historical evidence and historical methods to separate art objects from the processes of history. 'Lifting art out of the context of productive human relationships denudes it of all but its metaphysical value at one extreme and its pecuniary value at the other.'[14] Cumulatively, modernism is the shaping tradition 'of and for twentieth-century culture in the west,' as Griselda Pollock puts it; an influential *representation* of art practices 'which selects some as significant (advancing, avant-garde), while marginalising others as residual, reactionary or histori-cally irrelevant.'[15] The Whig interpretation of history lives on in art history.

Feminists have to reject this conception of art and this mode of historical writing. The category of art is not given but produced: 'art' is whatever is professionally dis-cussed, displayed, and marketed as art. Works of art are objects designated 'aesthetic,' in intention or in the eye of the beholder, at the moment of their production or retro-spectively through the networks of intellectual and economic exchange that give them value. Feminists looking for a history of women's creative production recognized that there was every reason to celebrate and revalue the work of women artists in the post-Renaissance Western tradition and to ponder the circumstances of its (relatively recent) neglect. But it was also crucial to examine the effect of a whole history of divisions that had marked off the aesthetic field and patrolled its boundaries, attributing or with-holding value from work made in different circumstances for different ends. It was the development of modern distinctions between art and craft, men's capacities and women's, fine art and domestic or ethnographic curiosities – beginning in the Renais-sance but accelerating with the impact of industrialization – which rendered the forms of work that women were in a position to produce nonaesthetic or only trivially and marginally aesthetic.

The point is not to sanctify an artisanal tradition by calling it art: that leaves the term *art* in place as a special kind of aesthetic grace occasionally bestowed on humble objects. It leads to several kinds of difficulties, including the temptation to celebrate a homo-geneous and essentially female culture as a complement to a masculine 'history of art.' Women are to patchwork as men are to oil painting. At a stroke we are unable to account for the historical and technical specificity of particular practices, the place of men and women in their production, and of sexual difference in their representations. We need to identify the particular history of artistic practice in the West as one specially privi-leged instance of cultural activity. Once the field is expanded in this way we have a chance of examining the particular affordances for women in different and hierarchi-cally ordered forms of cultural production. We can analyze the critical discourses which preserve the status and autonomy of art as it threatens to approach the decorative, the domestic, or the ethnographic.[16] And we can trace the ideological import of a special-ized category of art as something like (in Ruskin's phrase) 'the expression of the spirits of great men'.[17]

This leads to a second point. It is not just the autonomy of the field that needs to be questioned but the autonomy of the *object*. The object is the focal point of connois-seurship, which is a discourse of value: it is the object *as text* – a more porous entity – which is the concern of all approaches centered on the social production of meaning whether they are iconographic, psychoanalytic, semiotic, or sociohistorical in charac-ter.[18] Different approaches are ordered by different assumptions (explicit or implicit)

which structure the field in particular ways. Bourgeois (mainstream, modernist) art history assumes the transcendence of art and the individuality of artists and viewers as outside of economic and sexual relations. Marxism assumes that art has an ideological function (or ideological components) related to the economic division of labor and the maintenance of class relations. Feminism assumes a social order based on divisions of gender as well as class and race and examines from that perspective the productive roles of women and the circulation of women as signs. Psychoanalysis presumes a subject (artist or viewer) split between conscious rationality and unconscious desires: a desiring, as well as an economic subject. Semiotics concerns itself with the circulation of signs and their organization into signifying systems that cross conventional boundaries between 'high' and 'low' culture, language and art. Deconstruction is addressed, among other things, to the unsettling of traditional concepts and categories that have sedimented into routine habits of thought.

Women can only stay marginal in an object-centered art history. Producing a few more names and flirting with the possibility of a 'feminine' input into existing categories of genre and style embellish the margins while leaving them . . . marginal. On the other hand, feminism finds natural allies among those poststructuralist and psychoanalytic approaches whose object of study is the field of signification and that offer accounts of the individual subject along linguistic lines as both subject *of* meaning (an active 'I') and subject *to* meaning (an object of reference). Taking the internal operations of the work and its moment of reception together, it becomes possible to understand the interaction between painting and viewer (text and recipient) as the point at which meaning is secured. An image ceases to mean on its own and in accordance with the intentions of its author; it means according to the context of its reception and the interpretative predilections and competences of its viewers. These are themselves socially constituted and subject to various forms of pressure and negotiation (viewers do not automatically perceive what it might be in their best interests to perceive). Nevertheless, this opens the way for symptomatic readings, readings 'against the grain,' which effectively remake the work for a particular audience. The principal components for a feminist art history are provided by a revisionist history of production and by theories of representation and the subject. The first maps the social positions from which women have worked as artists and the codes, conventions, and institutional opportunities available to them at particular moments. The second enables us to see how representations of femininity contribute to the production of feminine subjects while having no *necessary* relation to the referent 'woman' or the daily experience of women's lives ('that grim and comic conjunction of self 'in' and 'out' of society that representation inscribes').[19]

The concept of art-as-text assumes not that an image is translatable into words without residue or loss, but rather that 'the boundaries which enclose the "work" are dissolved; the text opens continually into other texts, the space of *intertextuality*.'[20] The image comes to be understood as a site – a very particular kind of site – for the production of meanings constantly circulated and exchanged among other texts and between other sites in the social formation. Several things follow from this for the writing of history. A scrupulous, analytical, and largely synchronic form of historical inquiry has to resist the pull of linear, evolutionary narratives. The historian has to be alert to conflicts and discontinuities, picking at the seamless whole of the work without

assuming any simple division *or* any easy continuity between internal or 'formal' relations and external or 'social' determinants. And art history ceases to be an autonomous discipline devoted to a privileged class of object and becomes an emphasis within a general history and theory of representation. (If it begins with the paradigmatic work of art it is rapidly swept into the traffic in signs.)

This is not to claim that documentary evidence on the production and history of a work and close scrutiny of its condition and *facture* are irrelevant; rather (to take an example), that there are two ways of looking at a work like Holman Hunt's *Awakening Conscience*. One is to place it chronologically and stylistically within Hunt's *oeuvre* in particular and Pre-Raphaelitism as a stylistic category in general; the other is to see it as belonging to a whole class of Victorian paintings concerned with the troubling sexuality of women. This involves keeping hold of what is specific to this particular painting and to the practices of high culture as opposed to those of medicine, psychology, philanthropy, and law (all of which concerned themselves with the question of sexuality); and at the same time recognizing the place of such images in a central nineteenth-century concern – the definition and regulation of ideal and deviant femininities.[21]

The continuities of history are made by a series of investments in the present. (History is part of what has to be struggled over). As the neutral and transparent record of past events, history is an effect of the disembodied, omniscient narrative in which it is conventionally clothed (most histories share with the nineteenth-century novel the structure of the 'classic realist text').[22] If feminism challenges the realism of orthodox histories, it is, as Claire Pajaczkowska puts it, 'to replace the notion of an omniscient, disinterested "histoire" with the more dialectical reality of writing as a site of conflict,'[23] including the conflict of different histories vying for hegemonic status. Historical narrative organizes objects and events into meaningful discourse, and probably feminism cannot do without it. But it can question the adequacy and tidiness of particular narrative forms, opening them up to the struggle and chaos they work to suppress; it can write narratives of its own. As Peter Wollen puts it: 'Endings rewrite beginnings. Every new turning-point in the history of art brings with it a retrospective process of reappraisal and redramatization, with new protagonists, new sequences, new portents. We discover possible pasts at the same time as we feel the opening-up of possible futures.'[24] [. . .]

Notes

1 Peter and Linda Murray, *A Dictionary of Art and Artists* (London: Penguin, 1959), p. 349; Kenneth Clark also argued that the modern concept of art history originated in the work of Winckelmann. Norma Broude and Mary D. Garrard, *Feminism and Art History: Questioning the Litany* (New York: Harper and Row, 1982) list the chief sources on the evolution of art history as a discipline (p. 16, n. 1).

2 Linda Nochlin, *Realism* (London: Penguin, 1971), p. 42.

3 T. J. Clark noted in 1974 that at the turn of the century art history was one of the central practices of a history addressed to the analysis of social and cultural systems; T. J. Clark, 'The conditions of artistic creation,' *Times Literary Supplement* (24 May 1974): 562. On the Germanic tradition, see Michael Podro, *The Critical Historians of Art* (New Haven, CT: Yale University Press, 1982); and on

the impoverishment of the Anglo-Saxon tradition, see John Tagg, 'Marxism and art history,' *Marxism Today* (June 1977).

4 See Michael Baldwin, Charles Harrison, and Mel Ramsden, 'Art history, art criticism and explanation,' *Art History*, 4 (4) (December 1981): 444–5. [. . .] On 'modernist' art history, see Griselda Pollock, 'Feminism and modernism,' in *Framing Feminism: Art and the Women's Movement 1970–1985*, ed. Rozsika Parker and Griselda Pollock (London: Pandora Press, 1987); Fred Orton and Griselda Pollock, '*Avant-gardes* and partisans reviewed,' *Art History*, 3 (3) (1981); and Charles Harrison and Fred Orton, 'Introduction: modernism, explanation and knowledge,' in *Modernism, Criticism, Realism* (New York: Harper and Row, 1984).

5 Nicos Hadjinicolaou, *Art History and Class Struggle* (1973) (London: Pluto, 1978), p. 3.

6 Frederick Antal had predicted in 1949 that 'the last redoubt which will be held as long as possible is of course the most deeply rooted 19th century belief, inherited from Romanticism, of the incalculable nature of genius in art'; 'Remarks on the method of art history,' in *Classicism and Romanticism* (London: Routledge and Kegan Paul, 1966), p. 189.

7 I have to confess that I have not dealt with the 'locally and historically specific' here, but rather with general issues which I believe more particular studies are obliged to address, albeit on the territory of their own material and to some extent in the terms provided by it.

8 The phrase is T. J. Clark's, from *The Painting of Modern Life* (London: Thames and Hudson, 1985), p. 6: 'Society is a battlefield of representations on which the limits and coherence of any given set are constantly being fought for and regularly spoilt.'

9 Griselda Pollock, 'Vision, voice and power,' *Block*, 6 (1982): 5.

10 Raymond Williams provides a useful summary in *Keywords* (London: Fontana, 1976), pp. 32–5. See also his *Culture and Society* (London: Chatto and Windus, 1958).

11 'They do not produce to live – they live to produce': Clive Bell quoted by M. Baldwin, C. Harrison, and M. Ramsden, 'Art history, art criticism and explanation,' *Art History*, 4 (4) (December 1981): 445. The authors describe this 'ideal projection of art' as one in which 'the intellectual abilities, the needs, desires, pleasures, aspirations and self-images of the literate hereditary bourgeoisie achieved their perfect realisation.'

12 Nicos Hadjinicolaou remarks that it is 'typical of bourgeois art ideology to consider the Ravenna mosaics, the Altamira paintings or Cézanne's watercolours as *aesthetic objects*' (*Art History and Class Struggle*, p. 180).

13 The classic account is in Greenberg's 'Towards a newer Laocoon', *Partisan Review*, 7 (4) (July–August 1940).

14 Edmund Burke Feldman, 'Art history and the socialist critique of culture', *Papers Delivered in the Marxism and Art History Session of the College Art Association Meeting* (Los Angeles, 1977), p. 10.

15 Griselda Pollock, from 'Feminism and modernism', in *Framing Feminism*, ed. Parker and Pollock, p. 103. Cf. Herbert Butterfield, *The Whig Interpretation of History* (London: Bell, 1931), which describes the tendency of historians to write the past as a narrative of conflict between elements subsequently labeled progressive and reactionary (progressive victories then bring about the modern world).

16 See Rozsika Parker's excellent study, *The Subversive Stitch: Embroidery and the Making of the Feminine* (London: The Women's Press, 1984), which examines the complex, historically developing and mutually determining relations between ideologies of femininity and the practice of embroidery. And on 'abstraction versus decoration,' see Valerie Jaudon and Joyce Kozloff, 'Art hysterical notions of progress and culture', *Heresies*, 4 (Winter 1978): 38–42; Norma Broude, 'Femmage: reflections on the conflict between decoration and abstraction in twentieth-century art', reprinted in Broude and Garrard, *Feminism and Art History*; and Peter Wollen, Fashion/orientalism/the body,' *New Formations*, 1 (Spring 1987). Wollen points out that 'modernism wrote its own art history and its own art theory, identifying its mythic point of origin with cubism and Picasso rather than fauvism and Matisse.' Adolf Loos's linking of 'Ornament and crime' (1908) is echoed by Greenberg's insistence on preserving the 'pictorial' from the 'decorative.'

17 'Great art is precisely that which never was, nor will be taught, it is pre-eminently and finally the expression of the spirits of great men': *Modern Painters* (London: Smith Elder, 1843–60), vol. 3, 4.3.28 (women were tacitly excluded from this formulation.)
18 See Roland Barthes, 'From work to text', in *Image–Music–Text*, ed. Stephen Heath (London: Fontana, 1977), esp. pp. 160–1.
19 Cora Kaplan in *Ideas from France*, ed. Lisa Appignanesi (London: Institute of Contemporary Arts, 1985), p. 13. (I have changed 'the literary' to 'representation' to make sense in this context.)
20 Victor Burgin, *The End of Art Theory: Criticism and Postmodernity* (London: Macmillan, 1986), p. 73. (I am indebted to Burgin here).
21 The example is Lynda Nead's, 'The Magdalen in modern times', *Oxford Art Journal*, 7 (1) (1984), reprinted in *Looking On: Images of Femininity in the Visual Arts and Media*, ed. Rosemary Betterton (London: Routledge and Kegan Paul, 1987), p. 91. See also Lynda Nead, *Myths of Sexuality: Representations of Women in Victorian Britain* (Oxford: Blackwell, 1988).
22 On the 'classic realist text', see Colin McCabe, 'Realism in the cinema: notes on some Brechtian theses', *Screen*, 15 (2) (Summer 1974).
23 Claire Pajaczkowska, from an unpublished essay on questions of historical evidence in relation to women and the Second World War. (I am very grateful for its loan.) If we were to borrow Benveniste's distinction between *Histoire* and *Discours* we might assume that a feminist history would be closer to the discursive text (which inscribes a subject, a point of view, and some sense of who is being addressed) than to the more conventional historical text (which offers an 'objective' narrative and represses the point of view of the speaker along with the authorial 'I').
24 Wollen, 'Fashion/orientalism/the body', p. 5.

Joan Borsa, 'Frida Kahlo: Marginalization and the Critical Female Subject' (1990)

From *Third Text*, 12 (1990), pp. 21–40.

Authorship: Authors as Readers/Readers as Authors

In the recent debates around authorship that have gained currency in intellectual circles in Europe and the United States, the *author* being considered appears all too frequently to be some homogeneous, universal entity, as if representative of authors everywhere, under all conditions and at all times. The authorship debates have generated crucial questions about how we receive and consume information, why specific Authors and texts have gained significance, and exposed the complicated constructions behind the concept of the author as some gifted genius who originates or gives birth to particular works or texts. But it seems vital to remember that the discussions that certain circles hold in common have been fuelled by an active literary and intellectual tradition in a particular country, France, and that the debates themselves have been framed by key players, key texts, and Authored in particularly Eurocentric terms. Where I insert my Canadian history, references and experience, for example, is not easily reconciled. Too much reliance on Roland Barthes' article 'The Death of the Author'[1] or Michel

Foucault's article 'What is an Author?'[2] makes for a somewhat disembodied experience and does not get me close enough to my own problematics within this larger dilemma we now call 'authorship'.

While I learn from their (Barthes and Foucault) articulation on specific forms of authorship, while I know that their interrogations have helped to reposition our understanding of who and what an author may be, there are many questions which remain outside the boundaries they have taken on. I do not dismiss their specific interrogations, but if I am to go beyond the very dilemma they address, that is, the very real danger of falling under the spell of Authoritative texts, and taking the Author's words as truisms, I cannot forget the different social location I occupy, and my relationship as reader and critical consumer of those texts. What for example am I to make of Barthes' insistence in 'The Death of the Author' that 'the birth of the reader must be at the death of the Author' where I am first led to believe that the destination of texts or their meaning is focused on the reader, whereby the multiplicity of readers should become crucial. And then only to be told within the same article that 'this destination (the reader) can no longer be personal: the reader is a man without history, without biography, without psychology; *he* is only that *someone* who holds collected into one and the same field all of the traces from which writing is constituted.'[3] How then does this de-personalized and de-politicized account of the reader, as if *he* is some receptacle, a neutral space acted upon, allow for the significance of the different social locations a reader may occupy?

On this point I have found Nancy Miller's article 'Changing the Subject: Authorship, Writing and the Reader' particularly helpful. Miller suggests that Barthes' dead Author is a very particular type of author – a 'canonized, anthologized and institutionalized' Author who within structuralist and post-structuralist debates can no longer justify the 'natural authority' of his Speech.[4] In shifting the 'critical emphasis from author to reader, from the text's origin to its destination'[5] the power and domination of the canon is de-emphasized as if to claim it no longer matters *who writes*.

Barthes' argument suggests that *writing* is both practice and process, one component within a larger discursive field. The author simply 'performs' through language, bringing together textual interplays and associations that he may structure and facilitate but not necessarily originate – thus the Author's disappearance. In this way the author's diminished status or death is a necessary displacement which allows for the emergence and significance of the reader, that presence and site where it is suggested meaning is no longer deposited but now more democratically negotiated.

But the innocence and neutrality that seems to surround this newer version of the author presents a particularly complex situation for the noncanonical author, the one who never made it into the anthologies, or the institutional and mainstream environments where the critical obituaries can afford to circulate. For example, Nancy Miller's reading of the authorship debates asks whether those lesser-known and formerly excluded works by authors outside the boundaries of the canon can logistically come under the same critical scrutiny . . . never having occupied positions within the established framework of authority, genius and power that the debates attempt to revise. Instead of opening up the potential for a 'multiplicity' of authors and readers Miller believes the subjective identity of both positions, that is, authors and readers, has been

sacrificed, reduced to some neutral ground where a more abstract and depersonalized framework comes into play.

Because, writes Miller, certain subjects have always been 'disoriginated, decentered and deinstitutionalized', their relation to the text, to authority and to speech remains 'structurally different'. Her central concern with the 'postmodernist decision that the Author is dead' is that 'subjective agency' dies 'along with him'. For 'women' who 'have not had the same historical relation of identity to origin, institution and production that men have had' the hypothesis that the Author is dead 'prematurely forecloses the question of identity for them.'[6]

More importantly, through the *hypothetical* and *theoretical* death of the Author we now are offered a revised and preferred script; the illusion that the canon and the hierarchies that have secured its presence have been decentered, that their privilege and meaning have been destabilized to the extent that we now have a more *heterogeneous* and open space where there is room for difference, dissent and multiplicity.

But where does this leave those authors and readers who have always occupied a decentered location, whose production as authors and presence as readers has only known what is now being presented as a new position – can they afford to give up their specific marginal identity and join the ranks that suggest we now *all* occupy the peripheries, as if a new non-hierarchical space has been created where we are all on equal footing? Are we not still caught up in a notion of universality, simply exchanging an older version of universal meaning which carried with it 'naturalized' forms of authority and exclusion for a newer version of 'sameness' that proposes it no longer matters *who writes*, what and from where, because only in the *consumption* of the text (which is common to all authors) does meaning materialize?

What is still missing is a more radical and complex account of social and historic location that does not only destabilize the lines of 'natural authority' that have existed, but insists on a recognition of how that authority has already been resisted. In other words, attempts to decentralize and destabilize the power dynamics that have positioned us in very specific relations to speech, writing and the production and consumption of texts are not new phenomena, and have not 'originated' with Barthes, Foucault or more recent postmodern debates around authorship. In the concrete realities that have developed Authors and readers, Centres and margins, Privileged and other status, a great deal of resistance, debate, and struggle has already occurred by the very group Barthes would call readers; those sites where the text reaches its destination, where supposedly *critical* consumption has the ability to check and control the effect, impact or meaning of what is produced. Has this been the case when various critical consumers throughout history have pointed to exclusion, misrepresentation or exploitation in the dominant texts of their day? Has the point of resistance (the reader, the *critical consumer*) been heard, had any real impact? Has their production, their articulation been recognized, gained currency, come into wider circulation or been seriously comprehended as a result of their function as *critical* consumers of existing texts? And what is it in the theoretical parameters that Barthes and/or the authorship debates bring forth that may at this point in time de-marginalize the *concrete conditions* that many people live?

We do not need to find a new homogenizing mechanism but to address the difference between us, the specific social and political conditions that surround a particular author

or reader where we move beyond the shift from Author to reader, from Authority to performance, to acknowledge the significance of subjectivity, identity and difference.

If the debates on authorship continually generate references to the significance of the non-universal, to the destabilizing of master narratives, then it seems crucial that issues of authorship specific to peripheral locations are on the agenda. Much of what the specialized postmodernist debates address point to a theorization of the *politics of location*, something that the subjects living and producing *within* 'peripheries' have attempted to articulate for a very long time. If the theoretical parameters around author-ship are going to extend far enough to consider the power relations that have distin-guished between the pedigree of Authors (producers) and readers (consumers) and explore the construction of Centres and margins then spaces for other ways of con-sidering the topics will have to be made. It is not simply a re-formulating of the questions, a re-emphasis on where meaning resides that will challenge the authority of a history that has kept certain stories, certain authors and certain reading positions away from the centralized debates. Clearly more attention needs to be paid to production *within contexts marked by their own heterogeneous and discontinuous frameworks*; activity that generates a valuable critical and historical understanding of authorship.

The acknowledgement by literary and cultural theorists that the reader occupies a critical function in authorship will not alter the power dynamics now in place. Only a willingness to shift the directional flow between Authors (producers) and readers (con-sumers) where an exchange between positions and a negotiation of who occupies what function can begin to dismantle the fixed postures now in place. The questions that loom over and above the death of the Author 'complex' focus on how a decentered, disoriginated reader (consumer or subject) may become a productive author whose readers are not limited to other decentered subjects. Can the rigid boundaries that have surrounded Author/reader positions shift to the extent that subjects do not have to leave their locations in order to listen or speak, read or produce? Can their marginal or central identity continue to function but in a different way – where neither the centre nor the margin is seen as authority or deprived but occupying a specific position, a critical loca-tion which allows sufficient grounding for identity, representation and articulation to occur?

This is the area that Barthes' essay points to but, stating the questions as he does, does not take us into that messy zone where certain Authors (no matter how theoreti-cally astute or guarded) interrogate how their own production is implicated in the sta-bilization of authority, whether in the new (postmodernist) or old (modernist) form. As practitioners (producers, authors) and as consumers (readers) *with* 'history, biography, psychology', we occupy structurally 'different' locations. Unless we are to become hopelessly disembodied, distanced and destabilized within our own identities (which we do carry with us) our locations need to be accounted for, not willed away, disguised, denied or melted down into some big pot of sameness.

Female Subjectivity: Opening up Personal and Political Margins

Continuing with Nancy Miller's focus on the non-canonical or marginal identity, I wish to consider both the function of female subjectivity and the significance of other

personal and political margins associated with author and reader positions. My specific focus is one author, the artist Frida Kahlo, and the readings her work has received. My selection of this particular artist has as much to do with passion as reason. Something about what I know of her personal and cultural history as evident in her work, and what we can piece together from various texts that detail her production, suggest that a more critical exploration may bring me closer to understanding my own social location and the location of many others like me. Referring again to Nancy Miller's article on author-ship, the *writing* (speaking, reading) subject persists in its need 'to find a subject to love': 'to find someone somehow *like her*, in her desire for a place, in the discourse of art and identity, from which to imagine and image a writing self "absorbed, drudging, puzzled"; at a desk, not before a mirror'.[7]

In considering the work produced by the artist Frida Kahlo I take on an author who, I believe, lived and worked outside of the canonical, institutional and hegemonic struc-tures that I imagine Barthes' Authors to occupy. In this paper I will attempt to estab-lish why I believe Kahlo's production falls outside of Barthes' Eurocentric theoretical boundaries and to explore the margins her production occupies. The conditions of Kahlo's production, the discourses that surround her and her work, her position as a woman artist and her Mexican context must be accounted for if we are to understand how she has been authored and how she has attempted to author herself. I am not inter-ested in demonstrating that Kahlo has not had her fair share, that she has been 'pro-fessionally neglected', that her art is the result of a life filled with physical and emotional pain or that her work somehow speaks of a truly female space. These approaches which now surround Kahlo's work further reinforce the myth of the artist as tortured genius and present the woman artist as victim – as if irreconcilably outside and other. In these sources Kahlo's production is explained as therapy, substitutes for what she really wanted, lacked and could not have.

Instead I wish to consider how within the complicated conditions surrounding Kahlo, she constructed her own history, how she resisted the spaces designated female and artist as laid out by patriarchal and hegemonic systems – how Kahlo's work articulates the 'structural difference' of her location within gender, art and discourse hierarchies, and what she did about the marginality that she was presented with.

So who is this person, the artist Frida Kahlo? How do we know what we do about her life, her art and how she has been represented? Kahlo lived in the first half of this century (1907–1954). She died at the age of 47 in her native Mexico. Her mother was Mexican, her father was German-Jewish and moved to Mexico as a young man. Kahlo began painting in her early twenties and was completely self-taught; it is apparent that she admired and incorporated popular Mexican art traditions. By mid-life she had met and become friendly with a number of influential artists and other members of the gallery and art system in Europe, the United States and Mexico. Her entire production approximates 200 paintings and drawings most of which are intimate in scale and personal in nature. It is this latter quality of Kahlo's work that has engaged the most discussion.

Kahlo produced a large number of self-portraits as well as works that address issues and situations close to her own life. The critical reception of her exploration of subjectivity and personal history has all too frequently denied or de-emphasized the politics involved in examining one's own location, inheritances and social conditions.

And despite the now well-worn phrase generated by feminist activity in the '60s and '70s, *the personal is political*, critical responses continue to gloss over Kahlo's complex reworking of the personal, ignoring or minimizing her interrogation of sexuality, sexual difference, marginality, cultural identity, female subjectivity, politics and power.

The one English language text which has provided us with the most information on Kahlo to date is the American art historian Hayden Herrera's biography on the artist entitled *Frida*, published in 1983.[8] Although the book, the first comprehensive overview of Kahlo's life and work available in English, provides valuable and extensive information, it offers a rather cause and effect, chronological narrative, focusing primarily on Kahlo's complicated medical and marital history. Through an incredibly heterosexual lens, Frida Kahlo's production is explained in relation to her volatile love affairs, her tormented long-term marriage to Mexican muralist Diego Rivera, her subjection to intense and continuous physical trauma (for the latter half of her life) and her deep grief over her inability to have children. Clearly we learn as much about Diego Rivera, his sexual infidelities, his mural commissions and his artistic career as we do about Kahlo. By the end of the book it has been established that Frida Kahlo's life revolved around love, marriage and pain; in short a rather traditional feminine sphere has been presented. It is not that Kahlo did not experience love, marriage and pain or that frequently Kahlo is reduced to these spaces where her subject matter is regarded as a fixed text as if confirming the traditional spaces assigned woman, woman's body, the private sphere and the status of the woman artist.

What is missing is a more *critical* reading of the *gaps* between the author and the text, constructions of the author and Kahlo's specific social location. For example, while her encounters with male lovers are fully developed (the number of pages devoted are in proportion to the lover's public status) Herrera for whatever reason alludes to but de-emphasizes the number and significance of Kahlo's same-sex relationships. And so we learn a great deal about her involvement with the exiled Trotsky who was hosted in Mexico City by Kahlo and Rivera, and her connection with American sculptor Isamu Noguchi, and almost nothing about her love affairs with women that particularly in the latter stages of Kahlo's life become increasingly more prominent.[9] By minimizing the full range of Kahlo's exploration of her sexuality we are left with an exaggerated account of her heterosexuality – a situation that de-emphasizes Kahlo's resistances to prescribed behaviour and the significance of her struggles with the formation of sexual difference and the sexually coded spaces of her time. Herrera's tendency to detail Frida Kahlo's sexual explorations but to offer a rather censored version of their form, leaves us with the impression that Kahlo was sexually quite casual and lascivious. It seems more likely that Kahlo's exploration of her lived sexuality paralleled the reworking of assigned feminine spaces evident in her art. From the documentation available to us it appears that the politics and resistances within her imaging of self, female subjectivity and female sexuality were not saved for the language of art alone.

As I already mentioned, Hayden Herrera's biography is clearly the most comprehensive and accessible English version of the artist Frida Kahlo's life and work. As the handbook to Frida, it is the major resource book available to anyone looking for accurate documentation of the artist's production. How Herrera has framed Frida Kahlo becomes absolutely crucial as we are unable to cross-reference against other well-researched and perhaps contradictory texts. With only 200 works in existence, many of

which are in private collections, it is difficult for most people to have an opportunity to see the actual works. So in considering Kahlo's production we learn a great deal about the complications of the authority of certain texts and authors and the significance of the position of the reader that Barthes pointed to.

Within a theoretical framework cultural theorist Gayatri Chakravorty Spivak and feminist art historian Griselda Pollock offer valuable examples of struggling with and locating a specific person's archive. For different reasons, each one points to the need to approach the search for appropriate representations of a specific person's life/production as a process of unravelling or decoding a complicated and extended text. A process that cannot be simply reduced to formal description or interpretation but must be considered *across* the intersecting and contradictory discourses and representations that surround the specific topic or person being addressed. In her article 'Artists, Mythologies and Media: Genius, Madness and Art History',[10] Pollock's problematic within an art historical context is to decode the myths, ideologies and traditions functioning within art history itself in order to see more clearly how the accounts or authoring of the artist Vincent Van Gogh may have more to do with a discipline (art history), its effects, practice and process than the life and work of Van Gogh himself.

Similarly Gayatri Chakravorty Spivak in her article 'The Rani of Sirmur'[11] attempts to locate the appearance and the disappearance of a specific Indian woman across discourses of indigenous patriarchy, the imperialist presence of the British East Indian Co. and her husband the King of Sirmur's overpowering presence. In the final analysis Spivak suggests the real Rani cannot be located and retrieved – that we can only know her through the cultural, colonial and patriarchal inscriptions that surrounded her. Although we can never arrive at a conclusive or truly 'authentic' account of Kahlo's life and work, what these two examples offer me in my exploration of someone called Frida Kahlo, is the importance of reading the accounts she herself authored – the 200 works produced, which despite all the other texts and discourses about her life and production may bring us closest to the location Kahlo actually occupied.

This seems particularly important in light of the variety of the material that now describes and interprets Kahlo's production, especially the proliferation over the past year that indicates 'Frida' and her art are increasingly being promoted as cultural fetishes, exotic symbols appropriated by fashion magazines, major art exhibitions, book covers, etc. to signify Latin American (Mexican) culture and otherness. The full range of Kahlo's recent commodification is intriguing. Her image, a self-portrait in Mexican wedding dress with a third eye containing an image of Rivera (the painting is called *Self-Portrait as a Tehuana* or *The Bride Frightened at Seeing Life Opened Up*), could be seen all over London during the summer of 1989, forming the key component of the Hayward Gallery exhibition poster for their *Art in Latin America* show.[12] It has obviously been featured on the poster as one of the 'Latin' images most likely to seduce or attract the audience. Whether it is Kahlo's physical beauty, the integrity and power of her gaze or her look of otherness that the exhibition co-ordinators hoped would impact, the isolated image has been commodified and asked to package much more than it contains.

Similarly a book published in 1989 called *You Can't Drown the Fire: Latin American Women Writing in Exile*,[13] features a self-portrait by Kahlo on its cover even though there is no mention of Kahlo within the book itself. British writer Angela Carter's recent

'Frida' marketing scheme is a poster/postcard box of Frida Kahlo images containing a brief descriptive essay by Carter (again reminiscent of Herrera's biography) with about twenty postcards and two badly reproduced posters folded to fit a $5 \times 4''$ *Frida* box. The most amazing feature of *Frida* by Carter from Redstone Press is the price – £9.95 which in North America pays for the 500 page Herrera biography with full color reproductions. And then there is the May 1989 issue of the British fashion magazine *Elle* which features 16 pages on the life, art and fashion of Frida Kahlo. Most of the article appears to have been taken directly from Hayden Herrera's biography *Frida*, although it is presented as if it is an original article by *Elle* staff. For every page of text with images telling the 'Frida story', a corresponding page features a brash, pouty, young model stylishly costumed in contemporary gear mimicking, fetishizing and eroticizing the Frida look of pain, the Kahlo look of integrity and the Frida Kahlo look of Mexican peasant. Full descriptions provide the details on each designer item – where and for how much it can be purchased. The article presents Kahlo as a strident earth mother from sun-drenched Mexico; who despite (or perhaps because of) a tormented life of medical and marital complications, remained exotic, beautiful and above all sexually desirable.

Countering the overly personal, not so political monographic format of Herrera's biography *Frida* (as stated earlier I am referring to what is available in English only), which seems to surface as the major reference for many of the more sensationalist versions of the artist's life and work, are several critical articles in specialized art and culture magazines like *Art in America* and *Block*[14] and a 1989 book by Oriana Baddeley and Valerie Fraser called *Drawing the Line: Art and Cultural Identity in Contemporary Latin America*[15] which contains an insightful discussion of Kahlo's work. But perhaps the most significant and remaining as the most thoughtful and critical assessment of Kahlo's work are the essays written by British film makers and film theorists Laura Mulvey and Peter Wollen in 1982, published within an exhibition catalogue on the occasion of the *Frida Kahlo and Tina Modotti* travelling exhibition organized by the Whitechapel Art Gallery, London. It is impossible to do justice to any one of these sources in an essay of this length, therefore I will concentrate on the Mulvey/Wollen essays and make brief reference to the *Drawing the Line* text.

The *Frida Kahlo and Tina Modotti* exhibition and subsequent essays by L. Mulvey and P. Wollen are significant for several reasons: (1) a political framework is established for the artists' work; (2) a dialogue is generated between the two Mexican artists' production which allows a fuller understanding of the complexities of their Mexican context and their negotiations as critical female subjects; (3) the myth-making, career-building and cultural 'othering' that can all too easily occur when one artist's work is isolated, gives way to a much more provocative consideration of marginality; and (4) finally, the essays themselves do not shy away from the complicated terrain of talking about class, gender, race and politics as central to the production and reception of art.

In the case of Frida Kahlo, Mulvey and Wollen are quick to point to the political negotiations within her representations of a private world and to suggest that the intersection of art and politics within Kahlo's work is not so dissimilar from production by much more recent artists. Perhaps of greatest significance is the attention paid to Kahlo's social location: (1) to her status as a Mexican self-trained artist working outside the centres and high art traditions of Europe and the United States, and (2) to her status

as a woman artist who refused the male-dominated language of high art and worked in what Mulvey and Wollen call a 'dialect' that embraced the peripheries of low art practice popular in Mexico at the time.

Of crucial importance is their analysis regarding the political location the images occupy – their discussion of 'woman's body and its problematic place in representation', and Kahlo's imaging of her own body and her own immediate experience through which it is suggested she arrives at an 'analysis of the female condition rather than a celebration of it'.[16]

In considering Kahlo's work within the contexts of its own *heterogeneous* and *marginal* framework, Mulvey and Wollen highlight the politics of location that her production explores, focusing specifically on Kahlo's position as a self-trained artist working within a Mexican context; her identification with popular or low art practices; her status as a woman artist and the status of representations of woman and woman's body which Kahlo's work pushes against.

Chilean art critic, Nellie Richard, refers to the significance of contemporary work that calls into question both *local* or *marginal contexts* and *representations* of the *body* and *sexuality*, suggesting that to investigate areas that have been controlled within hierarchical and representational systems, introduces a sense of the political which ultimately leads to a consideration of power. In contemporary work by Chilean artists, Richard sees the emphasis on the body and sexuality as a significant political act which refuses dominant cultural codes and explores instead the notion of peripheries and their relationship to power and authority. Richard believes 'the body must be seen as a frontier between biography and the social'; she emphasizes that images of the body liberate a level of speech that has been censored in that 'the body is a support structure for the forms of obedience and discipline already in place.'[17] In considering Richard's remarks against Kahlo's production, we see how Kahlo's images of a private world, where woman's body and her own direct experiences come into focus, call direct attention to the repression, inscriptions and discipline surrounding the roles and margins her particular body was submitted to. In Kahlo's work the body and assigned feminine spaces are taken on *not to celebrate or glorify them but to parody and invert the ways they are represented*. Mulvey and Wollen call this a 'stripping away of the reassurance of the feminine sphere'. The feminine sphere they refer to is really the ideology of the feminine as it has been broadly represented and lived within private worlds of oppression.

> Kahlo continually gives the impression of consciously highlighting the interface of women's art and domestic space, as though in her life (and in her dress) she was drawing attention to the impossibility of separating the two. However, her art also acts as an ironic bitter comment on women's experience. *The feminine sphere is stripped of reassurance* [my emphasis]. The haven of male fantasy is replaced by the experience of pain, including the pain associated with her physical inability to live out a feminine role in motherhood . . . she takes the 'interior' offered as the feminine sphere, the male retreat from public life and reveals the other 'interior' behind it, that of female suffering, vulnerability and self-doubt. Frida Kahlo provides an extremely rare voice for this sphere, which almost by definition lacks an adequate means of expression or a language.[18]

What is suggested in this specific passage is that Kahlo's work plays with the spaces she occupies. She acknowledges and manages to image both the 'structure that contains her', that codifies her existence and asks her to 'perform' in particular ways and simultaneously suggests her awareness and discomfort in carrying this codification. The 'interior' behind the image not only suggests an analysis of sexual differentiation, its formation and impact, but reveals a reworking of the conditions and margins she has inherited. Kahlo's self-portraits for example play with the outward appearance of self; the projection and image that is presented for public consumption versus the screened, masked and complex inner workings of the subject behind the representation. The complex psychological and social realm that is alluded to carries a highly developed language of signs and signification which within a contemporary theoretical framework takes us into the realm of semiotics, psychoanalysis and particularly the female masquerade.

While Kahlo's images lend themselves to these discourses it is crucial to remember the time, circumstances and *specific* location which surrounded her production. If the work carries a similar analysis to these established theoretical frameworks then Kahlo's work which was produced outside of a consciously feminist or theoretical practice poses a significant challenge to these debates. However to impose specialized and centralized discourses on Kahlo's margins seems like another exercise in colonization, an act that would tell us more about the authority of the canon and avant-garde practice than about Kahlo's work.

Shifting: Social Locations

Kahlo's reworking of signs, symbols and meaning, her ability to speak from several places at once, her 'stripping away of the reassurance of the feminine sphere' both brings forward and pushes away the familiar, the known, as if there is a layer of disguised speech within the straightforward realism she employed. What is not said (Mulvey/Wollen's interior behind the interior) takes on a *critical presence* as if an investigation or exploration is in process. Referring again to Nellie Richard's theorizing of peripheral locations, artists (subjects, authors) are frequently in a position where dominant systems introduce some form of censorship making the producer acutely aware of the parameters of acceptable speech . . . boundaries beyond which one begins to feel threatened, anxious or in conflict. In these contexts Richard believes 'the speaker or visual communicator is hypersensitive to the manoeuvring of signs' and may become extremely adept at masking the full potency of their articulation or resistance. It is also possible that the artist (author) is aware of a tension or conflict but does not fully comprehend its implications. In the practice and process of articulation and representation the 'unsaid assumes the form of an investigation sorting through all the hidden signs of its meaning'.[19]

The sense of a coded or hidden meaning points to several readings all at once. There is the feminine sphere where signs and symbols are being reworked, and there is the sense of an investigation of subjectivity and identity where the artist herself is located in the process of discovery. But there is also a sense of a larger cultural and symbolic field whose inner workings inform the images – this is Kahlo's *specific* 'dialect', a lan-

guage that she places us outside of because of our inability to read the signs. This is a complex reworking of the notions of centres and margins, inside and outside, normative and other as Kahlo's references to her *specific peripheries* cannot be decoded unless we demonstrate a willingness to consider the time and conditions of a specific location. In this way Kahlo not only strips the reassurance of the feminine sphere but she dismantles the security of author and reader positions. Through her *marginal* 'dialect' (a highly symbolic, coded language) the parameters of critical understanding and the limitations of 'universal' art language are revealed. Her margins become central – we become marginalized.

As viewer (reader, consumer of her texts) it is difficult to ignore Kahlo's alliance with Mexican art and culture and her resistance to dominant cultural codes. Clearly these works are marked by a specific location. To rely on formal description, semiotics or psychoanalysis for example, or to attempt to classify them within established art contexts, would reduce the art to a mere illustration of those theories and would repeat the Andre Breton and Hayward Gallery's *Art in Latin America* exhibition approach to Kahlo's work. In both instances Kahlo is pronounced a Surrealist and offered as an exotic example of how other cultures spoke a unique version of the dominant language. Kahlo herself has frequently been quoted as saying 'I didn't know I was a Surrealist until Andre Breton came to Mexico and told me I was. . . .'[20] She has also been quoted as describing Surrealism as a decadent bourgeois art movement, emphasizing the distance between Surrealism and her work, Europe and Mexico, established art practices (modernist and avant-garde) and her own more localized production.

Paying particular attention to the different approaches pursued by Pollock and Spivak in attempting to unravel the cultural inscriptions surrounding a particular person's archives and their emphasis on decoding and accounting for those discourses that frame subjectivity and history, I believe it is crucial to examine (with much closer scrutiny) Kahlo's Mexican margins and reconsider the 'cultural parameters' existing readings of her work may have set in place. That is, in both cases (Pollock and Spivak) the *limitations* of description and interpretation are presented through an unravelling or mapping of the complex inscriptions that have authored a particular life and a particular person's production.

Gayatri Spivak has devoted much attention to this process and practice of othering, classification and categorization where the effects and strategies of historical constructions are dismantled in order to see the complex relations surrounding a particular person's history and location. In looking for what is a 'missing' or 'silenced' archive, and underneath the mediations, representations and discourse that have layered themselves upon Spivak's 'Rani of Sirmur', we find not the Rani herself but the space where she resided. Given the Rani's complicated historical location and the ways she was coded within larger cultural and representational systems, Spivak believes there is no real Rani to be found and that it would be to no one's advantage to invent or substitute a preferred Rani. Instead we must be satisfied with understanding how the Rani was a site of complex power relations and cultural inscriptions, a fragmented historical presence who lived during the constitution of India as a British colony.

Spivak's work on locating the 'Rani of Sirmur' provides a significant example of the need to explore ways we have been grounded and positioned – the productiveness of examining the conflicts and contradictions that surround our particular locations and

suggest ways that we can begin to unravel the ordering and structuring of dominant cultural codes so that we may better utilize the locations we occupy as sites of resistance – spaces where critical positioning, or a process of identification, articulation and representation can occur.

In the case of Frida Kahlo, a similar situation presents itself. It is difficult at this time in history, some forty years after Kahlo's death, to know which historical accounts come close to the space Kahlo actually occupied – but this is not the purpose of this paper – I am more interested in arriving at some understanding of the *gaps* within the various ways Kahlo has been authored and to reconsider how her work, standing as a body of texts, may *eclipse* some of those readings. Three areas that have received a great deal of attention, that have been used to explain and justify the 'meaning' of Kahlo's work and that therefore offer themselves for reassessment are: (1) the accounts of Kahlo's deep grief over her inability to have children; (2) her repeated imaging of her own physical pain; and (3) her attention to adornment and the costuming of her body.

In each instance interpretations suggest a rather obsessive preoccupation with self and the possibility of reading Kahlo's work as narcissistic, excessively focused on the female form, femininity and traditional accounts of the feminine sphere. Her *childlessness* and the accounts of the extreme anguish it caused her is explained in reference to her *womanliness* and to a woman's disappointment in fulfilling a *natural, biological female role*. Cultural attitudes towards children within Mexico where ritual and a highly symbolic religious life revolve around family is not considered. Kahlo's longing for children may have less to do with a generic 'woman's' desire than larger cultural textures and rhythms where people, history and symbolism are complexly interconnected.

Kahlo's references to physical pain by her use both of her own body as a site of physical violations and images of violence and pain inflicted upon others, alter when considered within a Mexican context. In Mexico it is common to find papier-mâché skeletons hanging in doorways and over beds and to make and exchange sugar skulls and special breads to commemorate the dead. This is less an obsession than a symbolic and often humorous acknowledgment of the reality of death and pain in life. As Mexican writer Octavio Paz wrote in *Labyrinth of Solitude*: 'The word death is not pronounced in New York, in Paris, in London, because it burns the lips. The Mexican in contrast, is familiar with death, jokes about it, caresses it, sleeps with it, celebrates it; it is one of his favourite toys and his most steadfast loves.'[21]

While the second half of Kahlo's life was tormented by physical pain (the result of a bus accident where she was severely injured) it is simplistic to read this event as the primary cause of Kahlo's references to woman's body, her own body and physical violations of the body. For example, in *A Few Small Nips* (1935), a man and a woman's body are isolated in a stark domestic environment. The man stands next to a bed, knife in hand where a nude female body lies lifeless. The body carries multiple wounds and patches of blood cover the bed sheets, the man's shirt and the room. This particular painting is apparently 'based on a newspaper account of a drunken man who threw his girlfriend on a cot and stabbed her twenty times; brought before the law, he innocently protested, "But I only gave her a few small nips!"'[22]

In another painting *Suicide of Dorothy Hale* (1939), a woman wearing only a dress and a corsage lies lifeless in a pool of blood on the ground. A dream-like serialized image of a woman (the same woman) tumbling through clouds from a skyscraper confirms the cause of death. Again the painting is based on a real event where an unemployed fashion model committed suicide within a few years of her husband's death. Explanations of the woman's death suggest that her inability to cope without her husband complicated by a rejection from a new lover, pushed her over the edge. Kahlo knew Dorothy Hale and offered to paint (as a commissioned piece) a *recuerdo*[23] commemorating Hale's death. The painting (within the acknowledged style of *recuerdo* and *retablo*) deals directly with the pain and tragedy of Hale's death – a kind of exorcism and acknowledgement of her experience, her life. However the responses to the painting which Hayden Herrera chooses to emphasize, all stress how gory, gruesome and offensive it was. Herrera's comments:

> Perhaps Dorothy Hale was a victim of a set of values that Frida Kahlo did not share, but Frida's compassion for her fall – literal and figurative – and her identification with her dead friend's plight gives *Suicide of Dorothy Hale* a peculiar intensity. *Abandoned by Diego, Frida could easily understand why the jilted woman* [my emphasis] might give a farewell party, and then, clad in her most beautiful dress, plunge to her death. In the months of separation from Diego, Frida often thought, as she had after her accident, that it might be preferable if la pelona would take her away.[24]

Herrera's framing of the discussions of both *A Few Small Nips* and *Suicide of Dorothy Hale* exaggerates Kahlo's identification with the victimized position. Although earlier in her book Herrera stresses Kahlo's stylistic association with Mexican *retablos* and *recuerdos*, she does not develop this enough. Instead both paintings are read within a 'universal' art historical, descriptive, Euro-American narrative framework, where subject matter, composition, colour, etc. are categorized as common elements of art language. The complex cultural symbolism functioning within Kahlo's particular social location is glossed over. In that Kahlo's images refer to concrete experiences and events that surrounded her, the work is more likely to carry an analysis and investigation of place, identity and subjectivity than indulge in a morbid or narcissistic vision.

And finally in considering Kahlo's sense of adornment and costume there is every indication that the 'decorated' Kahlo appearing in most of her self-portraits carries a great deal of 'cultural' *signification*. From Kahlo's diaries and photographic and written accounts of her life, it appears that from her early twenties onward (immediately after her marriage to Diego Rivera) Kahlo adopted a traditional Mexican peasant costume, the *Tehuana*, which was worn by the Tehuantepec women, one of the oldest matriarchal groups in Mexico. In her visual identification with the Mexican peasant and Mexico's past, Kahlo's long peasant skirts, hand-woven shawls, embroidered blouses, elaborate ceramic and silver jewellery, and braided and sculpted hairstyles combined with her overall striking physical features did create a rather 'spectacular' visual presence. On one level Kahlo's use of costume does call attention to appearance and self in a way that approximates spectacle and masquerade, but body adornment does not only

or necessarily mean fashion or exotica – a desire to make yourself the object of the gaze. Once again, Kahlo's *conscious* 'appropriation' of a *specific* costume, her incorporation of cultural signs and symbols, appears to contain a much deeper subversive element . . . a much more critical and political position.

Like her images of woman's body or references to death and pain, Kahlo's use of costume does not allow for a comfortable single reading. This isn't simply a historical or traditional costume; neither is it purely Mexican or female, and clearly it isn't only functional clothing worn without regard for effect, symbolism or aesthetics. There is something unsettling about Kahlo's layering of woman's beauty adornment against the historical, against the cultural, against the political. In this way, Kahlo does not allow fixed meanings and manages *to remove* both herself as producer and us as consumer of the images from the parameters that commodify and fetishize other cultures and/or aesthetic objects. In Kahlo's appropriation of costume we are not able to perform an easy classification – the woman we see is beautiful but is much more; we are allowed into the image but not able to completely comprehend its meaning; the costume is consistent from image to image and has a particular Mexican and political identity yet something is slightly out of context, elusive and unknowable.

Kahlo's awareness and reworking of otherness can be seen in her consistent atten- tion to marginality, where contradictions and classification are always in view. From her own social location as artist, woman and Mexican working more closely with the popular art traditions in Mexico than with the high art and male-dominated 'universal' prac- tices of her time, she offers us a great deal of information about the intersection of art and politics, strategies of resistance, the significance of colonial discourse and the prac- tice and process of negotiating *critical subjectivity* in an attempt to 'deconstruct' and 'reconstruct' our own histories.

In her painting *My Nurse and I* of 1937, the complexity of Kahlo's analytical visual language, her position as a *critical* female subject and her attempts at a *politics* of loca- tion are clearly articulated. The painting, like much of Kahlo's work, is in the style of the popular Mexican *ex-voto* painting: religious offerings painted on tin, done on the occasion of births, deaths and significant events. In the painting Kahlo presents us with two female figures, one obviously being nurtured by the other, reminiscent of the many religious representations of the 'Madonna and Child'. The large dark Madonna figure (the wet nurse) dominates the space and is presented as if in two parts: a large fertile nurturing body contrasted with a much darker carved mask-like face. In the Nurse's arms a female adult-child is being suckled; clearly this infant is the artist Frida Kahlo. A similar bodily disjuncture occurs with the contrast between the child-like frail body and the adult-artist's face and head. As with the nurse, the child's face is expression- less, mask-like and similar to most of Kahlo's self-portraits, suggesting once again a layering of complex, unknown or in-process signification. Like the two figures, the nurse's breasts are contrasted; one represents the 'exterior' appearance of fertility and motherhood while the other contains a complex and intricate 'interior' webbing, dupli- cating the delicate lace edge on the child's dress which reappears in the patterning in the large leaf in the background. In the disjuncture between the bodies and faces several associations or layers of past and present come into play. The nurse's mask-like face is reminiscent of an Olmec stone mask. The Olmecs, Oriana Baddeley and Valerie Fraser tell us in their discussion of Kahlo's work,[25] were among the earliest civilizations of

ancient Mexico. Kahlo's detailing of the Indian female body and a pre-Hispanic past, suggests a complicated interplay between nature, culture and history . . . Mexico's colonial past, the history of the land and the continuation of Mexican culture despite the massive interventions and historical disjunctures.

In the painting the child-Kahlo is visually linked to the female nurse both by the black coarse hair and the converging eyebrows, but clearly the two female figures are not of the same race and class. The usual negative representation of gender and race as 'oppressed' or *lacking* and the frequent allusion to racial and class (or caste) difference as *oppositional* is transformed in Kahlo's work. Instead the Indian/pre-Hispanic figure represents the power of life and the contingency of history. The traditional gendered image of colonization – the female land as overpowered and plundered is symbolically reworked, suggesting instead a regenerative and powerful presence. The visible 'difference', the *boundaries* between the two female figures (clearly from different times, histories and social locations) appear interconnected within a larger framework of gender, colonial history and human frailty.

The referencing of Mexico's past and peasantry as her own life-line is not isolated to this particular work. Both in her everyday dress and in various cultural codes Kahlo's identification with Mexico and popular Mexican culture is obvious. The Mexican muralists of her time also worked with Mexican idioms, particularly the conditions of workers and peasant life, but in their dedication to art as career, commissioned works for major corporations and institutions, and their involvement with the established art systems of their time, the Mexican muralists do not reach the same level of resistance and *personal* political commitment that Kahlo manages.

The Kahlo that we begin to get a sense of through works like *My Nurse and I* is a much more complicated, politically engaged and *analytically subversive subject* than many of the existing texts would have us believe . . . what Nancy Miller hopes women are in the process of becoming *critical female subjects*. Kahlo's resistances are not accidental, there is a great deal of contradiction, calculation and struggle evident in her images. It appears that the language (dialect) and situations that Kahlo understood best, those sites where she staged her struggles and in the end were the closest to home, allowed her to interrogate and speak with the greatest clarity. The structural difference her particular location as woman, Mexican and self-taught artist introduced was never a place Kahlo accepted. Her production leaves us with a sense of urgency in her desire to announce and understand difference and above all to remain suspect of any practice or process that attempts to speak on your behalf.

In this way Kahlo approximately fifty years ago was actively pursuing the boundaries of authorship as framed in more recent intellectual circles. Returning to Barthes' question what matters *who writes*, Kahlo's work leaves us with the same utterances that Nancy Miller's article points to: if you are disciplined into the peripheries and slotted into spaces someone else has made, you may not easily 'perform' the currency and rhetoric of your time. This does not mean that the dominant language is no longer with you but that there may be many indications of resistance and struggle. Frida Kahlo's relationship to art parallels much contemporary cultural production: a political articulation in a discourse capable of re-symbolizing the fractures of desire – a form of communication that holds the potential for larger personal and political intervention.

To arrive at a larger critical understanding of our own historical location hopefully allows for a larger critical understanding of other historical locations. In this way we move beyond the current limitations suggested by postmodernist debates on authorship by arriving at a historical moment where positions are marked by difference but not 'fixed' into designations of authors and readers – a framework that is still obsessed with categorization and oppositional politics. To speak about and search for a 'politics of location',[26] is not to desire a final resting place, and essence that we can comfortably attach ourselves to, but a 'position' that works against disembodiment, immobilization and silence . . . a location from which to productively articulate and represent our concrete and structural difference.

Acknowledgements

This article formed part of my postgraduate thesis for the Social History of Art programme at the University of Leeds (completed September 1989). Several people contributed friendship and critical readings of my text: Olga Borsa, Mina Kaylan, Vayu Naidu, Griselda Pollock, Russell Keziere, Lynne Bell, Julien Harriss, Louise Parsons and Fred Orton.

Notes

1 Roland Barthes, 'The death of the author' (1977), in *Image–Music–Text*, ed. Stephen Heath (London: Fontana, 1978), pp. 142–8.

2 Michel Foucault, 'What is an author?', *Screen*, 20 (1) (1979): 13–33; also in J. Caughie, *Theories of Authorship* (London, 1981).

3 Barthes, 'The death of the author', p. 148.

4 Nancy Miller, 'Changing the subject: authorship, writing and the reader', in *Feminist Studies: Critical Studies*, ed. Teresa de Laurentis (Bloomington, IN: Indiana University Press, 1986), p. 104.

5 Ibid.

6 Ibid., p. 106.

7 Ibid., p. 109.

8 Hayden Herrera's book *Frida: A Biography of Frida Kahlo* was first published in North America (Harper and Row) in 1983 and then in London (Bloomsbury Publishing) in 1989.

9 In several films, various articles and H. Harrera's book, there is continuous reference to the significance of Kahlo's same-sex relationships. Whether these were sexual, sensual, platonic, etc. (and to what degree) is not of importance. But accounting for the prominence women played in Kahlo's life would help to alleviate the sensationalized versions of her reliance on her husband Diego Rivera, her many love (heterosocial sexual?) affairs and would instead establish the function of 'passion' and 'intensity' in her art, loves, friendship, politics and life in general. The danger in much of Herrera's emphasis on Kahlo's sexual relationships with men is that we are left with the impression that romantic heterosexual activity was more significant than many of the other passions Kahlo seemed equally engaged in.

10 Griselda Pollock, 'Artists, mythologies and media: genius, madness and art history', *Screen*, 21 (3), (1980): 57–96.

11 Gayatri Chakravorty Spivak, 'The Rani of Sirmur: an essay in reading the archives,' *History and Theory*, 24 (1985).

12 *Art in Latin America* presented six pieces of Kahlo's work in an overly ambitious pot-pourri of Latin-ness, which presented hundreds of artists from all over Latin America, covering approximately a 100 year span within a formulated European art historical structure.

13 Alicia Partnoy, *You Can't Drown the Fire: Latin American Women Writing in Exile* (London: Virago, 1988).

14 In addition to the Mulvey and Wollen essays which I refer to there are few articles that have addressed the more critical and theoretical side of Kahlo's margins. Some articles that I found useful in thinking through Kahlo's relationship to high art, dominant cultural codes, Surrealism and her own 'dialect' are: Terry Smith, 'From the margins: modernity and the case of Frida Kahlo', *Block*, 8 (1983), and 'Further thoughts on Frida Kahlo', *Block*, 9 (1983); Michael Newman, 'The ribbon around the bomb', *Art in America*, (April 1983); Whitney Chadwick, 'The muse as artist: women in the Surrealist movement', *Art in America* (July 1985). By far the most useful essays were those from within feminist and cultural studies' contexts. In addition to those listed within these notes I would draw attention to: Nellie Richard, 'Postmodernism and periphery', *Third Text*, 2 (1987–8); bell hooks, *Feminist Theory: From Margin to Center* (Boston, MA: South End Press, 1984); Laura Mulvey, 'Changes: thoughts on myth, narrative and historical experience', *History Workshop*, 23 (Spring 1987); Homi K Bhabha, 'The other question . . .', *Screen*, 24 (6) (1983). As well I am grateful to the Quatemalan author (writer/producer) Rigoberta Menchu for her book *I Rigoberta Menchu: An Indian Woman in Quatemala* (London: Verso, 1983), which points to issues of authorship in terms that finally made sense. Since completing this article (September 1989) a new publication, Jean Franco, *Plotting Women: Gender and Representation in Mexico* (London: Verso, 1989), has appeared. Had I had access to it earlier my research would have been much easier.

15 The text referred to offers a much needed critical (contemporary) assessment of Latin American art and culture from a perspective that considers the historical fragmentation, politics and social conditions *specific* to Latin American cultural production (London: Verso, 1989).

16 Laura Mulvey and Peter Wollen, *Frida Kahlo and Tina Modotti*, exhibition catalogue (London: Whitechapel Art Gallery, 1982), pp. 9, 13.

17 Nellie Richard. These comments were made in the context of a presentation 'Art in Chile since 1973,' made at the Department of Fine Art, University of Leeds, June, 1989.

18 Mulvey and Wollen, *Frida Kahlo*, pp. 15–16.

19 Nellie Richard, 'Margins and institutions: *Art in Chile* since 1973,' *Art and Text*, 21, special issue (Melbourne), pp. 30–1.

20 Frida Kahlo, cited in Herrera, *Frida*, p. 254.

21 Octavio Paz, *The Labyrinth of Solitude: Life and Thought in Mexico*, trans. Lysander Kemp (New York: Grove Press, 1961), p. 57.

22 Herrera, *Frida*, p. 180.

23 *Recuerdos* are a remembrance, an object of some sort (often visual) made and offered as a keepsake, a memory or memento of a person.

24 Herrera, *Frida*, p. 294.

25 My discussion of Kahlo's work, particularly *My Nurse and I*, has benefited from Baddeley's and Fraser's analysis of contemporary Latin-American art, especially their exploration of Kahlo's relationship to cultural margins.

26 This term formed the basis of discussion at a symposium in Birmingham, England, October, 1988. A publication with papers presented at the symposium has been instrumental in helping me rethink the notion of margins. For further information see: 'Third scenario: theory and the politics of location', *Framework*, 36 (London: Sankofa Film and Video, 1989), particularly the papers by bell hooks, Coco Fusco and Stuart Hall.

Judith Wilson, 'Getting Down to Get Over: Romare Bearden's Use of Pornography and the Problem of the Black Female Body in Afro-US Art' (1992)

From *Black Popular Culture: A Project by Michelle Wallace,* ed. Gina Dent (New York: Dia Center for the Arts, 1992), pp. 112–122.

I want to address the topic of sexuality and black images in popular culture by linking it to what I know best: the record of US black artists' efforts to assert themselves in the language of Western high culture. In seeking to bridge these two quite disparate discourses, that of black high art and that of the black image in popular culture, I have begun to see a central problem in the history of African-American art, the problem of the black nude, in different terms than I had previously.[1] The following remarks are therefore exploratory. They reflect a process of rereading I have just begun.

Now, let me lay out the intended contents of my title.

'Getting down' alludes to cultural hierarchy. It either speaks pejoratively of a descent from some more elevated plane into the 'abyss' of popular culture, or it approvingly describes the act of dismounting one's high horse to commune with the masses. In US black vernacular, 'getting down' has long been associated with funk, that is to say, with manifestations of an aesthetic that celebrates and requires sweat as evidence of putatively honest feeling. Given this tendency to equate the aromatic pungency of body odors with what is emotionally compelling in cultural products, it is not surprising that 'getting down' has also been associated with a particularly pleasurable form of sweat-inducing physical exertion, namely, you guessed it, sexual intercourse.

To 'get over' has a different set of meanings, different but related. Transcendence – as described by the black spiritual 'How I Got Over,' for example – is one of them. On a more mundane level, to 'get over' an illness or some other setback denotes recovery. And in yet another black contribution to contemporary English, to 'get over' refers to the achievement of success through some form of duplicity. (That the latter use of this term also frequently implies sexual conquest is not irrelevant here.)

In my subtitle, 'Romare Bearden's Use of Pornography and the Problem of the Black Female Body in Afro-US Art,' I have purposely inserted several troubling terms. By 'pornography,' I mean the entire spectrum of representations that fetishize the body and objectify desire for public consumption. I have employed the slightly awkward, unfamiliar label 'Afro-US' to clearly localize my frame of reference.[2]

What I am trying to suggest with this title is that by 'getting low,' culling images from pornography,[3] the least reputable of pop cultural sources, and dealing with black sexuality in an unusually explicit manner – Romare Bearden managed to transcend the widespread stigmatization of black sexuality.[4] He was able to recuperate the nude black female body, wresting it from the clutches of white purveyors of erotic fantasies about exotic Others,[5] and reposition it in relation to black vernacular culture. By juxtaposing the black female body with such resonant figures as the train[6] (see *Work Train*, 1966) and the patchwork quilt[7] (see *Patchwork Quilt*, 1970), Bearden visualized the historic

conjunctions of black female beauty and eroticism with jazz, blues, African–American folklore and religion, as well as African-derived visual practices.[8]

As both image and idea, the black body has long been a contested site. In antiquity, Herodotus retailed rumors that certain parts of the African continent were inhabited by a race of monstrous-looking humans.[9] A millennium or so later, southern Europe was brought face to face with dark-skinned peoples as Spain fell to the Moors.[10] At first, thanks to the combination of Christian symbolism – with its stark equations of good and evil with light and dark – and the tendency of conquered peoples to demonize their foes, medieval European art often represented blacks as grotesque figures whose defining features were impossibly thick lips, bulbous noses, and receding chins, along with prominent cheekbones and curly hair.[11]

By the eighteenth century, according to David Dabydeen, the author of a study of William Hogarth's images of blacks, some European artists and intellectuals had begun to recognize the subjectivity of their own beauty standards *and* to observe that Africans showed a corresponding preference for their own physical traits.[12] For the most part, however, we must speak of the black body as 'haunting' the artistic production of both white and black artists in modern times – either in the form of what George Nelson Preston has dubbed 'the peripheral Negro' (in reference to the legions of black servants who loom in the shadows of European and Euro-American aristocratic portraiture and to those blacks perpetually cast in supporting roles in allegorical works like William Blake's 1793 print *Europe Supported by Africa and America*) or, as a set of compulsively repeated stereotypes (such as nineteenth-century American painting's genial watermelon eaters and banjo pluckers, or the twentieth-century electronic media's favorite emblems of poverty, physical prowess, and emotional abandon).

The ghosts I have just listed are, of course, white inventions. Nonetheless, they also haunt black visual artists, for whom these apparitions have provoked a different, often antithetical, set of responses. For much of the two-hundred-year history of fine art production by North American blacks, the chief reaction was avoidance of one of high art's favorite categories – the nude.

I must acknowledge my debt to the African-American art historian Sylvia Ardyn Boone. The paucity of black nudes in US black artistic production prior to 1960 has intrigued me ever since Dr Boone first called my attention to it as an unexamined problem in the history of African-American art. To my knowledge, nineteenth-century black artists produced no counterparts to works like Giacomo Ginotti's monument to black emancipation.[13] I do not mean that nineteenth-century blacks produced no emancipation monuments. They did, but not with quite this tone! Apparently, the black nude only becomes a permissible subject for black artists in the twentieth century.

I say 'apparently' because we currently know far too little about nineteenth-century black artistic production to enumerate its repertories with certainty. Who knew that nineteenth-century New England had possessed a black specialist in fruit and flower still lifes until the Connecticut Gallery mounted a survey of Charles Ethan Porter's career a few years ago?[14] Who knew that a black marine painter had operated in nineteenth-century Chicago until Derrick Beard unearthed James Bolivar Needham a couple of years ago?[15] And surely we can expect the work of a new generation of black scholars, like Juanita Holland, to further expand our conceptions of nineteenth-century black artistic production.[16]

By 1931, with the Harlem Renaissance well under way, we find images like Archibald Motley's *Brown Girl After the Bath*, in which Motley borrows a theme from seventeenth-century Dutch art – the harlot performing her toilet.[17] Motley strips the Dutch image of its occupational specificity, but does so without entirely erasing its voyeuristic prurience. By the late 1930s, William H. Johnson and Francisco Lord were painting and sculpting nudes, respectively. At some point, Lord's teacher, Augusta Savage, would also produce her own nudes. Throughout the 1940s, Eldzier Cortor would mine his memories of a stay in the Georgia Sea Islands for statuesque images of dark black women like the ones in his *Southern Gate* and *Room No. 6*. Yet, none of these works openly confront the various legends surrounding the black female body – except for the charge of its aesthetic unworthiness. Merely by making it their subject, all of these artists proclaim the beauty of the black nude. But none of them focus on the volatile conjunction of gender and race or the inflammatory myths of black sexuality that the black nude also inscribes.

Bearden had begun grappling with the nude early in his career and, subsequently, reported his initial frustrations with working from the live model.[18] His 1981 collage *Artist with Painting and Model* seems to reflect this struggle. It shows an early work, *The Annunciation* (1942),[19] mounted on an easel and flanked by the artist and a black model, whose figure is clad only with a bit of drapery. The 1942 painting exemplifies the artist's attempt to 'universalize' black subject matter, that is, to shift from the sort of social realist imagery seen in his 1941–2 *Folk Musicians* to a Christian story told in blackface. Both *The Annunciation* and *Folk Musicians* demonstrate Bearden's early assimilation of geometric stylization derived from cubism and traditional African sculpture.[20] The artist's subsequent exploration of cubist fragmentation and a jazz-inspired visual syncopation would, ultimately, lead to his shift to collage in the early 1960s. And his unique contribution to this fundamentally modernist medium, of course, was the conflation of high-art references with pop cultural images, in the form of mass media photography, in order to represent black history and culture.

Obviously, Bearden's use of images derived from pornography, as well as his use of the conventions of the high-art nude, is not unproblematic. There are issues here that I do not have time to unpack. But, in conclusion, I would like to at least enumerate some of them.

First, his reproduction of pornographic strategies, such as the voyeuristic gaze. For example, by representing, in *Dream Images* (1976), both the Peeping Tom and the mirrored image of the sexually aroused male, at whom the supine nude directs her gaze but who is positioned outside our view, does the image 'expose itself' or merely multiply the viewer/voyeur's trespass, locking us into an obscene triangle of vision?[21]

Second, his representation of prostitution. *Mamie Cole's Living Room* (1978) is one of a number of works based on Bearden's childhood memories, which included contact with a boy who was the son of a prostitute. Does the artist romanticize the condition of sex workers, their commodification, or the various forms of alienation involved in their provision of sexual services?

Third, what I call his domestication of the nude. By placing the female nude in an interior and juxtaposing her form with that of an older, clothed black woman engaged in some routine domestic activity, does Bearden level distinctions between the sexualized female (*femme fatale*) and the 'angel of the hearth,' that wife/mother/guardian of

the domestic sphere? Do these images offer a simultaneous view of opposite faces of Eve? Or do they simply reinforce a psychosocially restrictive dichotomy?

And finally, his reiteration of the standard gender trope equating Woman with Nature, and the female body with the landscape (see *Memories*, 1970). In what ways does this naturalization of female nudity render 'the feminine' a passive site, presumably awaiting creative exploitation by men?

That is just a sample of the kinds of questions I think need to be explored with respect to the gender politics of Bearden's nudes. We have seen that, by undoing the erasure, marginalization, and fetishistic exoticizing of the black female nude, he participated in an important recuperative project of twentieth-century African-American art. We have seen, too, that his specific contribution to this project was the reinscription of black beauty and eroticism *in the context of African-American vernacular culture*. Yet, we have also seen how, insofar as Bearden's nudes replicate some of pornography's standard tropes – its voyeurism, romanticizing of sex work, reliance upon dualistic stereotypes, and naturalization of female nudity, for example – these images suggest the insufficiency of efforts to revise a high-art category by importing into it elements of either popular or vernacular culture, while leaving unexamined the politics of formations at both ends of the spectrum.

It might be argued that the sort of feminist interrogation to which I have subjected these images is inappropriate because their author's views are the products of a prefeminist generation. But I am as troubled by the fact that *we do not know* his views on this subject as I am by anything else. The general silence about this disturbing aspect of Bearden's oeuvre is symptomatic of the state of criticism on African-American visual artists – the almost exclusively celebratory discourse produced by blacks and the intellectually ghettoizing discourse produced by whites. Here, too, we need to think about 'getting down to get over' – 'getting down,' in this instance, in the sense of shedding inhibitions and risking descent to uncharted depths in order to transcend (or 'get over') existing cultural barriers.

Notes

1 The resulting adjustments include a heightened awareness of the necessity of specifying gender with respect to 'the' black nude. Within both the pop-cultural and fine-art realms, black male nudity and black female nudity have generally functioned incommensurately. Thus, it would be instructive to consider, for example, the implications of Edmonia Lewis's decision to pair a seminude African-American male with a tunic-clad African-American female figure in her 1867 emancipation group *Forever Free*, or to compare Richmond Barthé's treatment of black female nudity in his 1933 *Wetta* with his treatment of black male nudity in his 1935 *Feral Benga*. Such analyses, however, are beyond the scope of the present discussion, which is limited to representations of the black *female* nude.

2 I am preceded in this usage by black cultural critic Albert Murray. See Murray, *Stomping the Blues* (1976; New York: Da Capo Press, 1989), p. 65.

3 Tom Wesselman's *Great American Nudes* series, begun in 1961, can be seen as a precedent for Bearden's use of images from porno magazines. But, whereas Wesselman's schematic, painted renditions of the nude employed the grammar of contemporary pornography – its languid poses, bikini marks, and lipsticked open mouths – Bearden used fragments of porno magazine photos, as well as other materials, to construct his female figures' anatomies – as if they were

quilts pieced together from scraps of various discarded fabrics. For a discussion of Wesselman's early nudes, see Irving Sandler, *American Art of the 1960s* (New York: Harper Icon, 1988), pp. 180–2. For a description of Bearden's use of photographic material, see Sharon F. Patton, 'Memory and metaphor: the art of Romare Bearden, 1940–1987', in *Memory and Metaphor: The Art of Romare Bearden, 1940–1987*, ed. Kinshasha Conwill, Mary Schmidt Campbell, and Sharon F. Patton (New York: Oxford University Press in association with Studio Museum in Harlem, 1991), pp. 44–5.

4 See, for example, the discussion of English and American views of black sexuality during the colonial and antebellum eras in Winthrop D. Jordan, *White Over Black: American Attitudes Toward the Negro, 1550–1812* (New York: W. W. Norton, 1977), pp. 32–43, 150–63.

5 For a rare examination of this eroticization of the black body in the visual arts, see the third chapter, 'The Seductions of Slavery', in *The Image of the Black in Western Art*, Vol. IV: *From the American Revolution to World War 1*, Part 2: *Black Models and White Myths*, ed. Hugh Honour (Cambridge, MA: Harvard University Press, 1989), pp. 145–86.

6 Elton Fax quotes the artist as stating: 'I use the train as a symbol of the other civilization – the *white* civilization and its encroachment upon the lives of the blacks. The train was always something that could take you away and could also bring you to where you were. And in the little towns it's the black people who live near the trains'; Bearden quoted in Fax, *17 Black Artists* (New York: Dodd, Mead & Co., 1970), p. 143. For the frequent occurrence of the train motif in African-American folklore, see Albert Murray's brief references to the mythic, functional, and historic dimensions of 'railroad imagery in blues titles, not to mention blues lyrics'; Harold Courlander's remarks on the train as a 'widespread image' in black sacred music; and Lawrence W. Levine's discussion of the railroad as 'a persistent image of change, transcendence, and the possibilities of beginning again'; Murray, *Stomping the Blues*, pp. 118, 124; Courlander, *A Treasury of Afro-American Folklore* (New York: Crown, 1976), pp. 305–8; Levine, *Black Culture and Black Consciousness: Afro-American Folk Thought from Slavery to Freedom* (New York: Oxford University Press, 1978), pp. 262–7.

7 For an overview of African-American quilt traditions in the antebellum South, see Gladys-Marie Fry, *Stitched from the Soul: Slave Quilts from the Antebellum South* (New York: Dutton Studio Books, 1990).

8 Bearden's *Storyville* (1974), a collage from his *Of the Blues* series, pays homage to the birthplace of jazz – New Orleans's fabled pre-1917 red-light district – by showing a piano player at work in a brothel, the inhabitants of which include several white and at least one possibly mixed-race nude female. In *Conjur Woman as an Angel* (1964) from his *Prevalence of Ritual* series, Bearden includes a seated nude in an image that makes reference to African-American folk spiritual beliefs. And, of course, the stuttering, staggering rhythms of the bits of striped cloth in *Patchwork Quilt* (1970) are typical of a peculiarly African design preference for 'interruption' in pattern sequences, as discussed by Marie-Jeanne Adams in regard to Kuba textiles in Central Africa and by Roy Sieber and Robert Farris Thompson with respect to textiles from various parts of West Africa. *Storyville* appears in Myron Schwartzman, *Romare Bearden: His Life and Art* (New York: Harry N. Abrams, 1990), p. 229. *Conjur Woman as an Angel* is reproduced in Conwill, Campbell, and Patton, *Memory and Metaphor*, p. 41. Marie-Jeanne Adams, 'Kuba embroidered cloth', *African Arts*, 12 (1) (November 1978): 24–39, 106–7; Roy Sieber, *African Textiles and Decorative Arts* (New York: Museum of Modern Art, 1972), p. 190; Robert Farris Thompson, *African Art in Motion* (Berkeley: University of California Press, 1974), pp. 10–13.

9 Herodotus, *The Histories*, trans. Aubrey de Sélincourt (Baltimore, MD: Penguin, 1971), p. 306.

10 According to Peter Mark, this took place during the eleventh century AD, when the Iberian peninsula was occupied by Almoravid forces that included black Africans; Mark, *Africans in European Eyes: The Portrayal of Black Africans in Fourteenth and Fifteenth Century Europe*, Monograph XVI: *Foreign and Comparative Studies/Eastern Africa* (Syracuse, NY: Maxwell School of Citizenship and Public Affairs, Syracuse University, 1974), p. 14.

11 For a discussion of the relationship between medieval Christian color symbolism and European attitudes toward Africans, see Jean Devisse, *The Image of the Black in Western Art*, Vol. II: *From the Early Christian Era to the 'Age of Discovery,'* Part 1: *From the Demonic Threat to the Incarnation of Sainthood* (New York: William Morrow, 1979), pp. 39–80.

12 David Dabydeen, *Hogarth's Blacks: Images of Blacks in Eighteenth Century English Art* (Athens, Ga.: University of Georgia Press, 1987), pp. 41–6.

13 This is *not* to say that African-American artists failed to produce an emancipation monument during the nineteenth century. But the one extant work in this category, Edmonia Lewis's 1867 marble group *Forever Free*, pairs a bare-chested male with a fully robed female figure. To my knowledge the only nineteenth-century *nudes* by a black artist are statues of non-black children – Lewis's 1876 *Poor Cupid*, her 1871 *Asleep*, and one of the two children in her 1872 *Awake*.

14 Organized by the Connecticut Gallery, the exhibition took place at the Old State House in Hartford from October 9–November 8, 1987. The show featured sixty-eight canvases by Porter, who was born around 1847, in or near Hartford, Connecticut, and died there in 1923. The exhibition was accompanied by a 113-page catalogue with numerous black-and-white and color reproductions documenting the artist's career.

15 Beard, a young dealer who currently operates a gallery in San Francisco, was director of Chicago's Galerie Americana in 1988 when Needham's work first came to his attention. For more information on the painter, who was born in Canada in 1850 and died in Chicago in 1931, see Judith Wilson, 'Art', *Black Arts Annual 1988/89*, ed. Donald Bogle (New York: Garland, 1990), pp. 20–1.

16 A doctoral candidate in art history at Columbia University, Ms Holland is conducting research on the lives of several African-American artists who were active in Boston during the nineteenth century in an attempt to determine what effects their location had upon their careers. She has also curated a major survey of the work of the great nineteenth-century Afro-New England landscape painter, Edward Mitchell Bannister, which opened in New York in May 1992 at the Kenkeleba Gallery.

17 The similarity of Motley's composition to a 1663 painting by Jan Steen currently located at Buckingham Palace was pointed out to me by a student in the undergraduate survey of African-American art that I taught at Syracuse University in spring 1990. I am indebted to Dr Wayne Franits for supplying information about the date and location of Steen's image of a prostitute at her toilet. Dr Jontyle Robinson has noted Motley's admiration of various seventeenth-century Dutch painters; Jontyle Theresa Robinson, 'Archibald John Motley, Jr: a notable anniversary for a pioneer', in *Three Masters: Eldzier Cortor, Hughie Lee-Smith, Archibald John Motley, Jr*, exhibition catalogue (New York: Kenkeleba Gallery, May 22–July 17, 1988), p. 45.

18 Sharon Patton mentions that 'four drawings of nudes were shown at his "306" exhibition in 1940.' This show, which took place at 306 W. 141st St, the Harlem studio/atelier *cum* salon of painter Charles Alston, sculptor Henry 'Mike' Bannarn, and dancer Ad Bates, was Bearden's first. The exhibition brochure lists twenty-four examples of the artist's work – seven oils, six gouaches, five watercolors, and six drawings – dating from 1937 to 1940. The same year as the '306' exhibition, Bearden leased his first studio, a floor above Jacob Lawrence's at 33 W. 125th St. It was there, in 1940, that a reproach from a failed prostitute-turned-model spurred the young artist to overcome a creative block. Bearden's account of this crucial experience is reported with slight variations by several authors, including Calvin Tomkins, Avis Berman, and Myron Schwartzman. According to Schwartzman, this encounter initiated the artist's subsequent preoccupation with 'the black female form'; Conwill, Campbell, and Patton, *Memory and Metaphor*, p. 67; '306' exhibition brochure, Romare Bearden papers, Archives of American Art, New York (Roll N68–87); Calvin Tomkins, 'Putting something over something else,' *The New Yorker* (November 28, 1977): 56, 58; Avis Berman, 'Romare Bearden: "I Paint Out of the Tradition of the Blues"', *Artnews* (December 1980): 64–5; Schwartzman, *Romare Bearden: His Life and Art*, pp. 114–16.

19 *The Annunciation* is the title that accompanies a reproduction of this work in a 1972 monograph on Bearden. Clearly, the composition is *not* an Annunciation scene, but represents the Virgin Mary's

visit to her cousin Elizabeth instead. Thus, it has become *The Visitation* in Schwartzman; M. Bunch Washington, *The Art of Romare Bearden: The Prevalence of Ritual* (New York: Harry N. Abrams, 1972), pp. 34–5; Schwartzman, *Romare Bearden: His Life and Art*, pp. 114–17.

20 See Romare Bearden, 'Rectangular structure in my montage paintings', *Leonardo*, 2 (1969), pp. 11–15.

21 Other pornographic strategies that appear in his work include a kind of eroticized synoptic vision – the optical equivalent of the 'grope.' In *Conjur Woman as an Angel* (1964) from his *Prevalence of Ritual* series, for example, Bearden includes a seated nude whose anatomy consists of fragments of various photographs pieced together so that the resulting figure seems simultaneously visible from a variety of perspectives. That is, much like some of Picasso's nudes or one of Hans Bellmer's dolls, the image totalizes viewer access to the depicted female body, which therefore becomes a cipher of sexual availability. In *Work Train* (1966), a length of chain looped around one of the nude female's wrists conveys a hint of sadomasochistic bondage. And in *Susannah at the Bath* (1969), the contrast of silhouetted areas of the central figure's face and body with her photographed breasts and one bare thigh operates like some Fredrick's of Hollywood costume – heightening the thrill of exposed flesh by juxtaposing it with partial concealments.

Pamela Allara, 'The Creation (of a) Myth' (1998)

From *Pictures of People: Alice Neel's American Portrait Gallery* (Hanover, NH: Brandeis University Press, 1998), pp. 3–11.

> I lived in the little town of Colwyn, Pennsylvania, where everything happened, but there was no artist and no writer. We lived on a street that had been a pear orchard. And it was utterly beautiful in the spring, but there was no artist to paint it. And once a man exposed himself at a window, but there was no writer to write it. The grocer's wife committed suicide after the grocer died, but there was no writer to write that. There was no culture there. I hated that little town. I just despised it. And in the summer I used to sit on the porch and try to keep my blood from circulating. That's why my own kids had a much better life than I had. Because boredom was what killed me.

Thus opens 'Alice by Alice,' Alice Neel's autobiography, published the year before she died.[1] Neel was a painter: her strong visual sense pervades her speech. In her old age, the images from her childhood, indelibly painted in her mind, carried with them all of the emotional weight of their initial impression. Colwyn, Pennsylvania was a sight, but there was no one there to record its beauty or its perversity. Neel's words suggest that as a child she knew that she had to become an artist in order to record that life in all its aspects. But of course, these are the words of an adult at the end of a long and productive artistic career. In the manner of any good storyteller, Neel has created a parable to explain her choice of an artistic vocation and to justify the direction it would take.

Like many American women artists, Alice Neel (1900–1984) painted in relative obscurity for many years before achieving artistic prominence in the 1970s. During that time, she began to compensate for the years of artistic neglect by crisscrossing the United States to deliver slide lectures on her work. A witty and intelligent woman, Neel developed an enthusiastic following, each lecture spawning new invitations. The cumulative effect of these popular lectures was that her art was and continues to be accepted as she presented it: as an illustration of her life, as extended autobiography.

The art historian, however, is bound to ask what place Neel's art occupies in American art and culture. I will argue that Neel's work presents a paradigm of the course of socially concerned art in the twentieth century. We must examine the anecdotal version of Neel for what it is: a particular instance of the complex relationship between art and biography that troubles any monographic study of an artist's work. My objection to a biographical approach to her work, which she instigated as a means of bringing her art to the widest possible audience, is not that the account of her life is untrue – it is not any more or less 'true' than any biography – but that it has obscured her work.

Trained at the Philadelphia School of Design for Women from 1920 to 1925, Neel aligned herself with the Ashcan School artists of the previous generation and with the legacy of the unsparing depiction of urban life established in Philadelphia by its founders, Robert Henri and John Sloan. Neel took the Ashcan School's premises literally. Her nascent interest in a socially concerned art was reinforced by the year she spent in Havana (1925–6) with the early members of the Cuban avant-garde.

During the 1930s, while living in Greenwich Village, Neel participated in the WPA's programs, joined the Communist Party, and was strongly influenced by the communist call for a proletarian art. However, as a portrait painter, she only occasionally peopled her art-for-the-millions with the masses. Instead, she insisted on depicting each representative of a given class as an individual and, in doing so, created an alternative version of social realism. A basic assumption of the work is that the quotidian reality of twentieth-century Americans of all classes was centered in family life. There, Neel identified such physical and psychological consequences of poverty as disease and child abuse, recording them long before they were thought to be germane to an activist art.

After World War II, when she had settled with her two sons in Spanish Harlem, Neel retained her realist style, resisting the centrist political forces that were branding it as anachronistic. Not only did her portraits from these years redefine the notion of family, but they also reconfigured urban space in terms of the experiences of those in poverty. By the early 1960s, having moved to 107th Street on the Upper West Side, the two worlds that had intersected in her art, the creative and intellectual on the one hand and the marginalized and impoverished on the other, began to diverge. She subsequently concentrated almost exclusively on her own family and on members of the New York artworld. Nonetheless the core of her artistic philosophy – her belief that an individual's body posture and physiognomy not only revealed personal idiosyncrasies, but embodied the character of an era – remained unchanged.

Neel's career and the critical reception of her work – painting in her home without institutional recognition – are representative of the situation of many women artists

and part of a cultural pattern of devaluating women's work. When broken, this pattern has often resulted in the overcompensation of adulation. Yet the critical extremes of the darkness of obscurity and the glare of publicity can hardly be expected to shed an even light on an artist's work, as Neel's career attests. Between 1926 and 1962, she was given six one-person gallery exhibitions; between 1962 and her death in 1984, she had sixty. Published reviews and articles also increased exponentially, but remained biographically based.

Just as the career trajectory of women artists in the twentieth century has been a belated and dizzying climb from the valleys of obscurity to the peaks of fame, so too the critical reception of their work has been based on the anachronistic assumption that art by men explains the world, whereas art by women explains their life. Neel's lectures served to reinforce that familiar cliché. For example, in her 1989 essay 'Tough Choices: Becoming a Woman Artist, 1900–1970,' art historian Ellen Landau found the careers of the first generation of women modernist artists to be marked by emotional conflict. Enumerating their psychological problems – their suicide attempts, alcoholism, and depressions – Landau implies that their personal difficulties were due to the conflicts the women experienced between their desire to be mothers and to be artists; their careers thus present a 'pattern whose implications should not be ignored . . . Work was not always enough to satisfy these women, and it often took a high psychic toll.'[2] Without question the conflicts of motherhood and career exacted a high toll from many artists, including Neel, but it does not follow that art making was unrewarding without the compensating fulfillment of family life. Perhaps the lack of support they received in trying to balance career and motherhood was a cause of stress, or, again, a lifetime of personally rewarding labor that remained unrecognized.

In 1958, Neel recognized that, if her art were to enter history, she would not only have to create it but participate in developing its audience. During the fifties, close friends who were also frustrated by the critical neglect of her work encouraged her to develop a slide presentation. One of her first venues was the Westchester Community Center in White Plains, where she spoke to an art class at the invitation of another friend, the socially concerned painter Rudolf Baranik. Beyond their ready wit and broad range of knowledge, Neel's lectures consistently beguiled their audience with the contrast between her grandmotherly appearance and her provocative language. With the arrival of the Women's Movement in the late 1960s, Neel was constantly in demand.

Driven by the desire to bring her art to the public, Neel appeared at almost every one of the openings of her solo exhibitions, no matter how remote their location, and invariably her lecture would be part of the opening night festivities. Her artistic reputation thus became inextricably bound up with her talks, and unfortunately the journalistic press, sensing the broad popular appeal of a juicy life story, enthusiastically bought into it, adding their own decorative flourishes.

The format of the newspaper and magazine articles on Neel forms an unvarying litany into which passing reference to her work is made to fit. The first few paragraphs invariably contain a sexist description of Neel's grandmotherly appearance and its conflict with her 'unladylike' personality:

> Alice Neel is like an old pagan priestess somehow overlooked in the triumph of a new religion. Indeed, with her shrewdly cherubic face, her witty and wizard eyes, she has

the mischievous look of a maternal witch whose only harm lies in her compulsion to tell the truth. (Jack Kroll, *Newsweek*, 1966)

Seated in front of a [canvas] in her blue smock, her bright little green eyes squinting and blinking behind her glasses, her plump legs spread forcefully apart and her space-shoed feet planted solidly on the floor, she picked up her brush gingerly and wailed, 'I'm just scared to death . . .' While she formed our torsos . . . she chattered on incessantly . . . but when she came to our faces, she became transformed; her face became ecstatic, her mouth hung open, her eyes were glazed and she never uttered a word. (Cindy Nemser, catalog essay, Georgia Museum of Art, 1975)

Such patronizing descriptions are the content of a newspaper's 'Living' pages, to which the reviews of Neel's work were frequently relegated. Although such extended attention to physical appearance is unlikely to be found in the critical discussion of art by men, the cliché of the creative artist who is seized with 'ecstasy' while painting is as old as art history itself. Its relentless repetition in the literature on Neel revives that stereotype for the purpose of establishing a myth of origins for the women's movement. Such a myth, of course, requires a narrative of triumph against all odds. The highlights of Neel's genuinely difficult life story inevitably followed the journalist's establishment of the persona: the hypersensitive child in a parochial Philadelphia suburb; marriage to an 'exotic' Cuban artist, Carlos Enríquez de Gomez (1925); the death of their first child, Santillana (1927); the break-up of their marriage and loss of custody of their second child, Isabetta, followed shortly therafter by a nervous breakdown (1930); the post-recovery move to the bohemian world of Greenwich village (1931); the destruction of over 300 of her paintings and watercolors by her jealous lover, Kenneth Doolittle (1934); the move, with José, to Spanish Harlem, where her two sons, Richard (1939) and Hartley (1941), were born; years of poverty in Spanish Harlem (1939–1962); the beginnings of her own professional success as her sons entered their careers; and finally, fame, and financial and critical success (1974–1984).

This narrative, repeated in all of the newspaper reviews of her exhibitions, culminated in Patricia Hills' judiciously edited autobiography from 1983. *Alice Neel* is Neel's life as she wanted it told, the grand summation of her lectures and interviews. Indeed, it reads like a psychological novel of the 1930s such as her friend Millen Brand would have written. Lively and engaging, the book is a testimony to Neel's prodigious and vivid memory for people and events, and to her exceptional story-telling abilities. Her life's traumas are not at all irrelevant to her artwork, but it is important to recognize that Neel was fashioning the recounting of her life as if it were a piece of fiction. In a true stroke of 'genius,' she did not write her own autobiography, even though she was a fine writer; she let others use the material she supplied in interviews to write it for her, so that the recounting conveyed a sense of objectivity.

Yet, the traumatic events thus transcribed can help elucidate her art only when lodged in the social and intellectual milieu of which she was a part, as Lawrence Alloway noted in his review of Hills's book in *Art Journal*:

In Patricia Hills' *Alice Neel* . . . the hand of the artist seems a bit heavy to me. The bulk of the book, 'Alice By Alice' . . . is the artist's oral history of herself, and Hills is present only as the author of an eight-page, unillustrated Afterword. This disparity would matter less if a solid core of critical discussion on Neel had already existed, or if her monologue were more interesting. Anyone who has heard the artist's garrulous lectures will recognize many of the anecdotes printed here . . . [T]he artist should have realized that if she is to move off the lecture circuit and enter art history, the cooperation of people like Hills should not be abused.[3]

The anecdotes and observations so familiar from Neel's lectures are best understood in their art historical context, where they provide clues to the sources of her intellectual development. Although isolated in terms of her exclusion from exhibitions, she was highly visually and critically literate. Although she professed disinterest in other artists and used her lectures as a vehicle for reinforcing the notion that her art stemmed directly from her personal life rather than from any outside influence, her extensive knowledge of art and literature permitted her to forge her art from a very broad base.

The role Neel's lectures and interviews played in the creation of a myth of her life story is hardly exceptional. Art in general, and the artistic personality in particular, have always been bound up with mythmaking. If Neel understood that a successful career would have to involve the 'marketing' of a public personality, from which sources did she create her artistic persona? In this area, Neel, like other women artists, would have lacked role models. Women artists have endured strong social pressure to construct their identity as 'female,' to emphasize their womanliness *despite* their artistic talent. Yet without an image, an artist lacks substance. Without a myth, no fame validates one's art. Women artists have long understood that these strictures against unconventional behavior have served as a means of assuring that women would never fully be accepted as artists. Because the breaking of rules of social behavior has been considered since the Renaissance to be a means of freeing oneself from outmoded artistic conventions, then women's acceptance of conventional roles would perforce constrain the creative impulse. Virginia Woolf's need to kill 'The Angel in the House' – the domestic self that is required to be sympathetic, charming, self-sacrificing – in order to become an effective writer has by now become a feminist truism. During the 1920s, when Neel came of age, the American poet Louise Bogan described the repercussion of women's socialization as docile dependents: 'Women have no wildness in them,/They are provident instead,/Content in the tight hot cell of their hearts,/To eat dusty bread.' Neel's writing during this decade reveals that she had adopted this feminist view: 'Oh, the men, the men, they put all their troubles into beautiful verses. But the women, poor fools, they grumbled and complained and watched their breasts grow flatter and more wrinkled. Grey hair over a grey dishcloth . . .'[4] In her lecture at Bloomsburg State College in 1972, Neel put it even more directly. 'In the beginning, I much preferred men to women. For one thing I felt that women represented a dreary way of life always helping a man and never performing themselves, whereas I wanted to be the artist myself!'[5]

Although one can hardly hope to assess the effect of Neel's nervous breakdown at age twenty-nine on the subsequent course of her art and career, biographical accounts

by Marcelo Pogolotti, the Belchers, and others suggest a change from a rather naive if rebellious young woman to a confirmed bohemian.[6] After her total collapse, Neel adopted a stance of resolute opposition to virtually everything that smacked of middle-class propriety or politics. She could have returned to her parents' home to complete her recovery but chose instead to summer in New Jersey with her friend Nadya Olyanova, through whom she had met Kenneth Doolittle. When, at the end of the summer, she moved to Greenwich Village to live with the drug-addicted seaman who, as a member of the IWW, was also left-wing, Neel claimed citizenship in a 'country' that John Sloan and Marcel Duchamp had once mockingly declared had seceded from the United States. Although the Greenwich Village of the early 1930s had lost the revolutionary fervor of the prewar years, it remained the locus of alternative life-styles as well as of much important creative activity. The utopian visions of a socialist activist like Polly Holliday may have been replaced by the barbed commentary of the essayist Dorothy Parker; nonetheless the Bohemia of Greenwich Village could still be counted on to remain a thorn in the side of polite society.

The artistic and literary example of New York's bohemia in these years provided rather flimsy material on which to construct an identity, however. Neel came to maturity during the great age of film, and as Robert Sklar has observed, many men and women learned about social relations, and male–female relationships in particular, from what they saw on the screen. A prototype enjoying wide popularity in media culture – the bawdy comedic type personified by Mae West – may have provided the most compelling *topos* for the construction of Neel's persona.

Although the stereotypical virgin–whore opposition that dominated fin-de-siècle art was perpetuated in the roles played by early film stars such as Lillian Gish and Theda Bara, a figure such as Mae West could irreverently mock the entire system with her outrageous screen behavior. Aggressive and loud-mouthed, but with her hair dyed platinum and her hourglass figure swathed in sequined gowns, West was part temptress, part truck driver. Like the transvestite she appeared to be, she could at once play and parody female sex roles. Perhaps for males, her homeliness and sexual ambiguity allowed them to laugh at her jokes without feeling threatened by her professed voracious sexual appetite, but for women, her lack of concern for male opinions or approbation must have provoked a different kind of awe. Here was a woman whose dedication to her own sensual pleasure was so strong that she would refuse to confine herself by giving her hand in marriage to even the most cinematically desirable screen bachelor. For young women, including Neel, who watched her as they reached the age of consent, West offered the possibility of saying 'no' to society's expectations by insisting on putting her own needs first.

According to June Sochen, bawdy comediennes such as Mae West and vaudevillian Eva Tanguay used bathroom humor and sexual jokes to take

the Eve image and turn it around; no longer was woman's sexuality viewed as evil . . . They also displayed, as all iconoclasts do, a marked irreverence for sacred subjects. Nothing was out of bounds. No gesture, no thought, no action had to be self-censored or controlled . . . The female rebel performer would not ever become a comfortable part of popular culture because she was too avant-garde, too outrageous in her words and actions.[7]

Because such sexual freedom has long been the purview of the male avant-garde artist, Neel could easily have linked the two realms – high art and popular culture – in terms of image making. Both aimed to *épater les bourgeois*, the middle-class consumer, providing the common ground for West's irreverent wit and that of the artistic avant-garde. Neel's outrageous stories, then, were geared to adding lustre to her role as the quintessential bohemian. *Neel* wanted to perform – *Neel* wanted to be the artist, and so at the end of her life she performed her life and art.[8]

By using bawdy humor to reduce the powerful and the famous to the basest common denominator, Neel's naughtiness demystified the artworld's elites, thereby also pointedly rebuking those who for so long ignored her work. The edge to Neel's humor, like West's, stemmed ultimately from anger – her mocking laughter and outrageous language perhaps the only effective means for expressing genuine outrage and exposing the artificiality, if not the devastating psychological consequences, of the conventional constructs of woman and of artist.

Her lecture at Harvard University's 'Learning from Performers' series at the Carpenter Center on March 21, 1979, exemplifies her fine-tuned presentations, and although her humor is considerably dulled in my summary, her violation of every rule of feminine decorum should be evident. Her chronological survey began with her early training at the Philadelphia School of Design for Women. She went on to express her disdain for many of the influential realist painters of her generation, for example the Art Students League's Eugene Speicher and his 'cow-like women.' Having summarily dismissed the artistic context in which she worked, she began a chronological sequence of slides of her work. When she came to her *Ethel Ashton* of 1930, herself a bovine woman profoundly ashamed of her naked body, she asked the audience to 'look at all that furniture she is carrying around.' With reference to *Nadya and the Wolf* (1931), Neel claimed that her friend, the handwriting expert, could not have children because 'she used drugs for douches,' while her portrait of *Nadya Nude* could not be photographed because in 1933 'you could not make a slide of pubic hair.' *Symbols* (*Doll and Apple*), one of the artist's most wrenching works, is described as 'sexy,' and the outrageous triple genitals in the 1933 portrait of *Joe Gould* 'look like St Basil's domes upside down.'[9] Near the end of the Harvard lecture, when she showed her double portrait of the artists Red Grooms and Mimi Gross, and described Grooms as 'ready to jump up and perform,' she openly acknowledged her belief that contemporary artists had of necessity become 'performers.'[10]

Neel was far from the only female artist-rebel of her generation, but she was one of only a few who rebelled through both an unconventional life-style and a biting wit, actions and words that indicated an absence of self-censorship, a determination to disrupt polite society. Neel joins the ranks of those writers and painters – among them Gertrude Stein, Mabel Dodge Luhan, and Romaine Brooks – who ignored their physical appearance and/or permitted themselves the comfort and convenience of male garb. It was not until the 1970s that Neel's unfashionable persona was adopted by younger feminist performance artists. Annie Sprinkle, whom Neel painted in 1982, pushed the Mae West image even further toward outrageous camp, which Neel captured perfectly in Sprinkle's blowsy expression, tacky feathered hat, overblown breasts, and pussy ring. Flaunting sexuality was the means for all three women to gain creative as well as economic autonomy. By refusing sexual subservience, they became sufficiently threatening

to be let alone, and perhaps to gain a grudging respect. In a culture that restricted women's options, the strategy worked.

Much as Neel's autobiography has obscured her art, it is essential to it and inextricable from it. Were it not for her efforts to narrate her life, her work might have remained unknown. She realized this when she was in her fifties, and spent the rest of her life insuring that her work would not be lost to history. 'When Sleeping Beauty wakes up/she is almost fifty years old,'[11] wrote poet Maxine Kumin, brilliantly pinpointing the moment when many women realize that a passive life is a lost life. To conserve her transgressive art, created at great emotional cost, she had to translate it into another medium, whose form would make clear how flagrantly she had violated the unspoken rules of the appropriate in realist art and in real life. According to the feminist psychologist Nancy K. Miller, 'To justify an unorthodox life by writing about it is to reinscribe the original violation, to reviolate masculine turf.'[12]

Neel's lectures were part of her battle to secure a well-earned piece of art historical turf. Having recognized the futility of waiting passively for recognition, Neel admitted to Hills in 1983 that she had had 'a block, I still have it, against publicity . . . I reached the conclusion that if I painted a good picture, it was enough to paint a good picture . . . I didn't know how to go-get, so I just put it on the shelf.'[13] In her fifties, after her children were in college, Neel took charge. Although hardly a wallflower previously, she was now officially off the shelf. In *Writing a Woman's Life*, Carolyn Heilbrun has identified this 'awakening' as the key moment in a woman's artistic career: '[A] woman's selfhood, the right to her own story, depends upon her "ability to act in the public domain." '[14]

To take one's life into the public domain, one must write it as narrative. Neel chose the genre of satire, the female equivalent of modernist irony. Yet it is important to remember that Neel 'wrote' her long life well after she had begun to paint it. She created her autobiography twice, with the later version directed toward popular consumption, and the creation of a marked and a public space for efforts long confined to her studio/home. Her talents as a raconteur put her work into the public domain. The art historian's task is to situate it within the matrix of American culture.

Notes

1 In Patricia Hills, *Alice Neel* (New York: Harry N. Abrams, 1983, 1995), p. 12.

2 Ellen Landau, 'Tough choices: becoming a woman artist, 1900–70', in *Making their Mark: Women Artists Enter the Mainstream*, ed. Randy Rosen and Catherine C. Brawer (New York: Abbeville Press, 1988), p. 33.

3 Lawrence Alloway, 'Patricia Hills, *Alice Neel*' (review), *Art Journal*, 44(2) (Summer 1984): 191–2.

4 Hills, *Alice Neel*, p. 28.

5 Transcript of Bloomsburg State College Lecture, March 21, 1972. Alice Neel papers, Archives of American Art, Smithsonian Institution, Washington, DC.

6 Marcelo Pogolotti, *Del Barro y las Voces* (Mexico City, c.1955), pp. 191–223. In his account of the early Cuban avant-garde, Pogolotti describes Neel as naive but exceptionally talented. See also Gerald L. Belcher and Margaret L. Belcher, *Collecting Souls, Gathering Dust: The Struggles of Two American Artists, Alice Neel and Rhoda Medary* (New York: Paragon House, 1991), ch. 1. In

describing Neel at the Philadelphia School of Design for Women, the Belchers write: 'At twenty-one years of age, Alice still approached life tentatively. She had little experience with creative people . . .' (p. 12).

7 June Sochen, *Enduring Values: Women in Popular Culture* (New York: Praeger, 1987), pp. 61–2.

8 So compelling was the image she forged that four biographical films were made about her. In addition, she conducted numerous TV and radio interviews, including two appearances on the Johnny Carson Show in 1982 and 1983 where, even in her final illness, she was far more lively than Carson's other guests. As she remarked to the critic Harry Gaugh in 1978, 'In a culture like ours, anything is better than anonymity'; Harry Gaugh, 'Alice Neel', *Arts* (May 1978): 9.

9 Alice Neel lecture, Harvard University, March 1979. Oral History Collection, Archives of American Art, Smithsonian Institution, Washington, DC.

10 If asked to vary her routine, Neel became evasive or even rude. When the artist Karl Fortess taped an interview with her at Boston University in September 1975, he declared in frustration: 'I want to press you on your work. Please cut out your fascinating personal life.' Neel responded with another anecdote. Questioned about her artistic sources, she claimed disingenuously that she 'never looks at other artists.' Thus Neel the performance artist carefully concealed the tracks of Neel the painter, transforming a sophisticated and visually educated artist into an 'original' and deflecting attention from the deeper issues her art raised. To be fair, she may have wanted not simply to distract the listener but also to mask her own pain. When Fortess asked her which of her teachers was most supportive of her work, Neel started to cry, and for a moment the long-suppressed emotional strain of forging an artistic career on her own surfaced. Her nonstop patter perhaps kept both critics and her own feelings at bay. Karl Fortess's taped interviews with artists, Oral History Collection, Archives of American Art, Smithsonian Institution, Washington, DC.

11 This and most of the quotes in this paragraph are from Carolyn Heilbrun's study of the genre of women's autobiography, *Writing a Woman's Life* (New York: W. W. Norton, 1988).

12 Quoted in 'Introduction' to Heilbrun's *Writing a Woman's Life*, p. 11.

13 Hills, *Alice Neel*, p. 103.

14 Heilbrun, *Writing a Woman's Life*, pp. 17–18.

4

The Aesthetic

INTRODUCTION

Discussion of the aesthetic aspects of art by feminists began as soon as artists declared they were feminists. It was clear from the broader women's movement that notions of beauty and, by extension, aesthetic pleasure were not neutral. While this was readily expanded in discussing images of women in art by men, the implications of this disruption of beauty for art made by women were more contentious. This was further complicated in discussions of what constituted the feminist aspects of an artwork. What does art which is feminist look like? What does it do? What visual pleasure does it give? These issues are still much in contention. The very term 'feminist art' can be problematic in that it implies a style of work (like Impressionist art, Cubist art etc.) rather than an approach to art-making which is politically informed. Realizing that art made by feminists does not conform to a particular style produces a more complex question: how does a political stance interact with what art looks like and with notions of the aesthetic, beauty and visual pleasure?

Four early articles reproduced here lay out clear positions that can be understood as main strands of thinking about the issue. Marjorie Kramer denies that there is any such thing as a feminine aesthetic, but that instead there are tasks for artists who are feminists. Prime among them is that of being 'socially legible, that is, recognizable. Figurative.' Abstract work is not legible enough: feminists should make both realist and idealist work. Judy Chicago, however, puts forward the idea that women can either make work that relates to their experience or choose 'those areas of subject matter that most closely approximate the experiences of the male'. For Chicago, a woman's 'experience' means 'her feelings as a female' and 'the nature of a female and the societal definitions of her'. This is found primarily in the body. Due to abstraction being the prime contemporary visual art language, women can represent the cunt image or central core imagery in their work – but also have this misunderstood and invalidated as it does not correspond to male experience.

Pat Mainardi argues strongly against this position in a reference to 'the right wing of the women artists' movement'. She states that this move towards a female or feminine aesthetic is 'opportunist' in the style of work it supports, and 'reactionary because it is going backward into some form of biological determinism'. In contrast to a search for 'feminine sensibility', she supports 'feminist art'; that is, 'political

propaganda art which like all political art, should owe its first allegiance to the political movement whose ideology it shares, and not to the museum and gallery artworld system'. Indeed, feminist men could produce such art. Judith Stein, in an article for the student magazine at CalArts (where Chicago and Miriam Schapiro ran the Feminist Art Program from which Stein clearly differed) raises the point that 'never (it seems) is the idea of a feminist art without a "feminist imagery" conceived of. The terms are used interchangeably.' Grounding her argument in a difference between the feminist and the 'liberated woman' she points out that some 'feminists' appear to emulate men, their behaviour and their systems, particularly those which are ego-focused, when they should be concerning themselves with building feminist systems. Defining feminist art 'is obviously missing the point'.

The text of Silvia Bovenschen's 'Is There a Feminine Aesthetic?' (here edited) is more speculative than the others. Bovenschen outlines the dire position in which women find themselves in the art world and some strategies taken to remedy this. She declares that 'We ought to rid ourselves of the notion of a historically ever-present female counter-culture. And yet, on the other hand, the very different way in which women experience things, their very different experiences themselves, enable us to anticipate different imaginations and means of expression.' Throughout the essay she makes reference to particular artworks and tests them out against a web of ideas. Thus, in a complex relation, the possibility of identifying a woman's aesthetic processes, the social impacts upon women's creativity and the impossibility of defining women's art – and feminist art – are suggested.

Michèle Barrett, in the sections of her essay 'Feminism and the Definition of Cultural Politics' reprinted here, goes back to the question of what we mean by 'art', and what we can mean by 'art' when evaluating both aesthetic value and political value. Outlining three different feminist positions, she suggests that each is insufficient: each ignores the aesthetic impact upon the audience and the notion of the skill of artists in producing the effects they do. In these apparently conservative issues can be found democratizing elements if they are reconsidered radically.

Luce Irigaray's essay 'How Can We Create our Beauty?' suggests that it is necessary to have a complete re-evaluation of what is 'beautiful' for women. Enclosed 'in an order of forms inappropriate to us', we (women) have become desolate, removed from our sense of a female divine, from our languages, from our subjectivity, from our mothers. Unless we 'break out of these forms' we cannot exist – cannot achieve full subjecthood. Until we can restore appropriate forms of communication, in line with our subjectivity, we cannot create beauty; attaining our subjectivity through its articulation in appropriate forms will itself be creative of beauty for women.

Hilde Hein's essay (here edited) explores structural correspondences between the traditional academic field of aesthetics and feminist theory. In this sense, aesthetics is understood as the philosophy of beauty and of art, and aestheticians work in philosophy, not art history, departments in universities. Their discourses, terminology and frames of reference are thus distinct from those found in art history. Hein suggests that aesthetics now addresses central cultural concerns with a structure which is also found in feminist theory: not one which 'is motivated to discriminate and make diversity intelligible without reducing or destroying it. The success of feminist theory, like that of

aesthetic theory, depends on its ability not simply to *tolerate* or reconcile differences – an aim that liberal democratic theories profess to embrace – but to welcome the novel and the unexpected and to rejoice in their multiplicity.' Hein works through the feminist critique of traditional aesthetics, and through their structures of judgement and discrimination. Feminism argues, she says, that 'the personal is and has always been political. Only the overt acknowledgment is new.' Laying out how multiplicity is found in aesthetic theory – through its rejection of a misreading of art history as a progressive movement towards truth – Hein demonstrates that feminist theory can expand interpretative possibilities and thus aid the sometimes peripheral role granted aesthetics.

Belinda Edmondson's substantial essay pushes this proposition further by contrasting feminist thinking on the interrelation of art, aesthetics and politics with African-American thinking on the same issue, in light of the 'advocacy by black feminist authors and scholars for a black feminist aesthetic'. Her aims are to 'disentangle [the] overlapping definitions of aesthetic criteria', identifying differences and the philosophical problems facing both the women's movement and the black movement in their engagement in such work. Edmondson traces the history of black aesthetic discourse and its political implications, and contrasts this with the various positions within feminism, including a critique of Rita Felski[1] and of essentialism. Summarizing Henry Louis Gates's critique of post-structuralist theory, and the usefulness of Fredric Jameson's Marxist critique, she concludes that, while there are interlocking struggles, 'what gives meaning to black and feminist discourse is an autonomous sense of self, of essence, which is what they are struggling not simply to articulate and validate but *preserve*.' Ultimately, she finds that 'a culture-based discourse stands on surer ground than a gender-based discourse.' This is a conclusion which reflects retrospectively over all the texts in this chapter: to what extent do they argue from a culture-based position – with a cultural definition of gender, even? To what extent can a cultural position be more 'universal' than a 'gender-based' discourse (or one based on sex)?

Note

1 Rita Felski, *Beyond Feminist Aesthetics: Feminist Literature and Social Change* (London: Hutchinson Radius, 1989).

Eessential reading

Brand, Peggy Zeglin and Korsmeyer, Carolyn (eds), *Feminism and Tradition in Aesthetics* (University Park, PA: Pennsylvania State University Press, 1995).

Ecker, Gisela (ed.), *Feminist Aesthetics* (London: The Women's Press, 1985).

Felski, Rita, *Beyond Feminist Aesthetics: Feminist Literature and Social Change* (London: Hutchinson Radius, 1989).

Hein, Hilde and Korsmeyer, Carolyn (eds), *Aesthetics in Feminist Perspective* (Bloomington, IN: Indiana University Press, 1993).

Marjorie Kramer, 'Some Thoughts on Feminist Art' (1971)

From *Women and Art*, 1 (1971), p. 3.

For a year or so now, I have had a couple of conversations a week on Feminist Art. Should this mean any strong painting by a woman, say a nonobjective work or a landscape? Should it mean work that unconsciously expresses a feminist point of view? Or should it mean work that consciously is a political statement in subject matter and content? During this time, I have come to a few conclusions with the help of other members of Red-Stocking Artists. I ruled out first of all the 'Anatomy is Destiny' theory that we women have some inherited feminine quality that pervades all our work and constitutes a 'feminine aesthetic' such as innerspace (vaginas) or delicacy because I've never seen such an 'aesthetic'. Henry Moore does holes as much as Georgia O'Keeffe and Bonnard's work has a 'feminine' quality. To say that women paint cunts doesn't ring any bells in my head. Men have been painting cunts (and war) almost exclusively for hundreds of years. I prefer to assume that there is no 'feminine aesthetic' and if there really is one, we'll find out what it is after we change the world so men don't oppress women, because then women won't live in a different environment from men. Up to now, feminine sensibility has been slave sensibility.

My position is that not all a woman artist's paintings are or should be feminist. I certainly don't mean to give women fewer choices of what to paint than we used to have. There are and have been women artists of excellence in landscape and other subjects where men's and women's views are the same. There is always a need for good art; this is not a reactionary thing to do. Seeing such a painting could encourage another woman, but I don't think it should be called a feminist painting. I think there are two main kinds of feminist painting: unconscious and conscious; both elucidate women's point of view. They are sympathetic to women and they are socially legible: that is they communicate something that the artist put there rather than just being totally subjective or self-expression. Works which unconsciously express a feminist point of view could be male nudes, self-portraits, portraits, images of our cage, i.e. views of the kitchen, Dormeyer Mixers; our view of anything in a way that a man couldn't have done it. If our art comes out of our experience, then our experience as a woman is bound to be in some of our paintings. Those are feminist paintings. Alice Neel asked me if I thought any of her work was feminist. I was sure her consciousness was feminist and that this would show through in her work just as lechery can show through in a man artist's images. Alice did an unromantic nude of a pregnant woman holding her arms away from her body because she was too hot and sweaty to lean on herself. Alice said it showed pregnancy as a burden. Feminist Art comes out of feminist consciousness.

Feminist paintings are sympathetic to women in the sense that they don't degrade or exploit us. They do not point out our weaknesses either. Men, i.e. DeKooning, have already done this quite eloquently. Some work portraying the otherness of women, women as objects, or monsters, has been said to be bitterly portraying

what oppressed, brutalized women have been made into. Works by people like Wesselman, or Pop Art are supposed to be sarcasm or satire in some campy way. Bullshit. These works are part of the exploitation of women. Feminist painting does not exploit women.

Another phenomenon that is part of the exploitation of women is the tendency of men artists to project their idea of reality onto the bodies of young women. The result is tortured twisted slashed up nudes, disfigurement and hostility towards women masquerading as some angst-ridden hip new philosophy. These works exploit women as the symbol of his latest idea. That's as degrading as to be up in the clouds naked or in the studio naked and him with his clothes on and called humanism.

Feminist art is not art for art's sake – art in a closed system of rich collectors, trustees, and a few superstar artists whose audience is the former. This art only speaks to the privileged few, usually a few friends of the artist who have learned some obscure art language, sometimes called the Avant-Garde. Feminist art reaches out to people, especially women, with a communicated truth.

The most controversial conclusion I came to seems to be whether a feminist painting can be abstract or not. I feel that abstract can communicate, but only abstract ideas such as power, violence, a sense of flux (Gorky), or a moving sense of order (some oriental carpets). Feminism is not a quality like that. I think the images in a feminist painting have to be socially legible, that is, recognizable. Figurative.

Feminist art has to be as well drawn, as structured as solid formally as any other art. Good content should bring out the best in us aesthetically, but it is no excuse for poor or sloppy form.

I would like to say a word about the difference between subject matter and content or meaning in painting. Last spring, the Figurative Artists' Group at the Educational Alliance had a meeting on the subject 'How female artists relate to the male tradition of the nude'. Only women were invited to bring work to be on view during the panel discussion. Even though there had been previous meetings with themes such as still life and no portrait painter had felt compelled to bring in a portrait, a few men brought in outsized canvases of themselves with clothes on, and one man brought in a mother and child. Many women present felt that this was a way of showing us as we were supposed to be. With the babies. The content of that work was to put us in our place. At the same meeting was a painting of a nude mother and child. The child was holding out a globe to the viewer. She had painted her self-portrait with her third child on her hip. My reaction to this beautiful painting was 'oh my god, how does she do it'. The bodies were painted in a warm and familiar way but with no idealization or romanticization. It was a feminist painting by Janet Sawyer.

Some of the things a consciously done feminist painting could be about are women running the world, women doing work, women making revolution, women as people who do things . . . we are. A feminist painting could be about the shit and suffering women have to go through, or it could be about the progress women have made, or it could reveal some truth about women's point of view. This subject may produce a lot of art in the next decade because the women's movement is one of the healthy sources of energy around that is not involved in decadence, but in changing the world for the better.

Judy Chicago, 'Woman as Artist' (1972)

From *Everywoman*, 2 (7) (1972), pp. 24–25.

[. . .] Let me go back to Georgia O'Keeffe and say that I believe her to be the first great female artist because she bases her work on the experience of a female. What that brings us to is, first of all, the nature of 'cunt' as an image. Men say, 'Oh, look at those paintings, they look like cunts.' Well, of course they look like cunts because the first struggle every female artist has is to define the nature of a female because it is not accepted that a female is an active, aggressive, creative person.

Every female artist has to evaluate for herself the nature of a female and the societal definitions of her and build on that self-struggle. So you see cunts in Bonticou, and cunts in Barbara Hepworth, and cunts in Georgia O'Keeffe, and cunts in Miriam Schapiro's paintings and cunts in my work. What happens then when that work is looked at? Cunt is a symbol of contempt, i.e. 'she is a dumb cunt.' A male looks at an image of a cunt and reacts with his socially conditioned feelings about women. And if the painting is good, it is good despite the fact that it reveals the female experience; it is good for formal reasons, it is good for reasons that correspond to what the male establishment has said is important. The tools of criticism and evaluation of art which are based on male experience are inadequate to deal with the work of a woman, who is intent on arriving at an art that grows out of her experience. A woman's work cannot be perceived accurately and will never be perceived accurately until women are perceived accurately, with the exception of work by women who are attempting to paint or make art like a man, and who have accepted the framework of art-making as dictated by men and by what serves men.

If you look at art today, you can see a reflection of the entire value structure of the society; and by looking at who makes the art and what kind of art is valued, you see what kind of society we live in. First, most of the art is made by white men. Second, the kind of art that is valued is one that is based, not on human struggle, but on what might be called visual specifics. This is primarily because the exposure of direct feeling in the society is taboo for men. They are brought up not to cry, not to express emotion and therefore they remain emotionally infantile. In art-making, men often are very intellectual, involved with systems, concepts, and ideas, and they see these as an appropriate basis for art. Women, however, are brought up with a different orientation, toward feeling and away from abstract thought. Therefore women often approach art-making more directly and see it as a vehicle of feeling. But art language as it exists today excludes a direct content or feeling orientation. Therefore, women's work is often totally misperceived, and the more a woman's work is oriented towards emotional content, the more it is misperceived. The mechanism of misperception is based upon the perception of art according to values introduced and imposed by the male in a society that does not value female feelings. So if a woman's work is deeply involved with her feelings as a female it is likely that a man will: (a) approach it in the same way as he does the work of a man; (b) expect ideas which he can apprehend intellectually; (c)

disregard as unreal or invalid ideas that do not conform to his conception of reality; and/or (d) be unwilling to experience reality as if he were a woman. With his mind set this way, he will be totally unprepared to experience or evaluate the work before him. Moreover if the work deals with feelings of softness, vulnerability, gentleness, delicacy or other feelings associated with the feminine, he will probably experience a kind of terror because he has been trained to deny the feminine within him.

In an attempt to compensate for the often uncomprehending responses, the woman artist tries to prove that she's as good as a man. She gains attention by creating work that is extreme in scale, ambition or scope. She tries to impress with her drive, determination, her toughness, or her integrity. She demands ever greater acrobatics of herself, or she becomes a 'lady artist' content with a minor position in the art world. In one way or another, she is not dealing only with art-making, she is dealing with her social status as well. She either struggles against, or compromises with, the confines she feels as a woman.

She chooses those areas of subject matter that most closely approximate the experiences of the male, and she avoids those images that would reveal her to be a woman. She resists being identified with woman because to be female is to be an object of contempt. And the brutal fact is that in the process of fighting for her life, she loses her self. For instead of deriving strength, power, and creative energy from her femaleness, she flees it and in fleeing it, profoundly diminishes herself. She must turn and claim what is uniquely hers, her female identity. But to do that is the most difficult of tasks; it is to embrace the untouchable and to love what is despised.

Pat Mainardi, 'A Feminine Sensibility?' (1972)

From *Feminist Art Journal*, 1 (1) (1972), pp. 4, 25.

I think the question of gender in art is asked as a red herring to conceal the real question which is not is there any gender in our art, but is any art being made – by anyone, male or female? The answer to that is very little, if any. But America is preoccupied with sex – it was no accident that the (male) youth culture came up with a sexual revolution before it recognized the need for a political and economic one.

So now the artworld is asking itself if there is a feminine sensibility in art. No one ever asks if there is a masculine sensibility in art for a very simple reason – men have appropriated all of art to themselves. They have the freedom to be sensitive and delicate or strong and bold. Men have made art out of their loves and hates, their politics and religion, their ideas about colour and light and form and space, and even their anatomy. They have made every kind of art that is known, in fact most of the art that is known. For us, the only artistic freedom worth fighting for is the freedom to do the same. But we women have only been permitted to make art influenced by our anatomy or by our wish to have male anatomy – (male interpretations, designed to cover the entire field of female possibilities).

Am I surprised that the right wing of the women artists' movement is codifying a so-called 'female aesthetic' which interprets art by women as having validity (being 'truly female') only insofar as it can be analyzed in terms of female anatomy? No.

Am I surprised that most of it just so happens to look like minimal art, the style fashionable when the theorizing began? No.

I wouldn't even be surprised if now that minimal is moving out of the artmarket-place and sharp focus realism – paint by numbers for the upperclasses – is moving in, if suddenly we were treated to a new theory as to how female aesthetic is best expressed in terms of New Realism. If the women hadn't thought it up themselves, Ivan Karp would have done it for them. Because:

1 Women have got to have something to sell.
2 It had to be something you couldn't buy from a man but could only get from a woman.
3 It shouldn't challenge too many of the market's standards at once but should be similar to what men are doing and collectors want.
4 Female aesthetic should be based on form, not on content, just like everything else in the artworld.

To put it bluntly, I think the whole thing is opportunist. It is reactionary because it is going backward into some form of biological determinism at a time when the most progressive women and men are fighting their way out of repressive ideas that one's humanity should be defined and limited by the location of one's genitals or the colour of one's skin.

I don't think there is anything for good or bad that men are capable of that women could not do also, although if we are wise, we wouldn't want to repeat a lot of their mistakes. Similarly, I don't think there is anything women are capable of doing that men couldn't do also, if they would only try a little harder.

Feminist Art is different from feminine sensibility. Feminist Art is political propaganda art which like all political art, should owe its first allegiance to the political movement whose ideology it shares, and not to the museum and gallery artworld system. Since feminism is a political position (the economic, political and social equality of women and men) and feminist art reflects those politics, it could even be made by men, although it is unlikely that at this point men's politics will be up to it. But the artworld in its neverending search for new thrills has already begun to pick up on its own version of political art (that is, the politics of the right and center) for its next one-night stand. We must be aware that this phenomenon, for example the recent 'Collage of Indignation' Show in which all the white male superstars, and some female ones, were asked to do a little number on peace – to the exclusion of peace movement artists – and the article 'Posters of Protest' in the February '72 *Artnews* which might have been more aptly titled 'Posters of Commerce', has little to do with either progressive politics or art, both of which are increasingly happening away from the decaying artworld. In fact, talking about any form of political art within artworld limitations and audiences is absurd. Doing political art for Rockefeller's MOMA [Museum of Modern Art]! Good grief!

Judith Stein, 'For a Truly Feminist Art' (1972)

From *The Big News*, 1 (9) (1972), p. 3.

[. . .] The question of whether there is or could be a feminist art is one that is being raised more and more frequently these days. Many people are aware of some of the definitions of female or feminist imagery. The realists tell us about cunt paintings, and depictions of rape and childbirth. The non-figurative painters have their ideas about central imagery, a central form being compressed by (under pressure from) two or more outer forms, mirrors, etc. These ideas are (I suppose) interesting. But ultimately they are (even to a painter who uses such subject matter or forms in her work) incredibly limiting. Never (it seems) is the idea of a feminist art without a 'feminist imagery' conceived of. The terms are used interchangeably. It seems to me that in striving towards a feminist art *we would not want to limit women artists in any way*. We would want to make women as free as possible to discover those means of expression and authentic art making of which we have so long been deprived. To achieve this we would not want to define (and hence limit) the art projects themselves. Rather, we should concern ourselves with those areas that we so often ignore . . . the art-making process, and the system in which the art exists.

I think it would be appropriate here to stop and give a definition, or rather, make a distinction. There is a profound difference between (what I will refer to as) a 'liberated women' and a feminist. The liberated woman doesn't really see past herself. She wants (competes for, and often wins) equal pay for equal work, more respect and prestige in the society, more orgasms, higher status – in short, she wants to 'make it in a man's world.' Insofar as she appears to dominate the women's movement the accusations of 'middle-class!' are justified. The feminist, however, sees herself as part of a broad movement. She understands the implications of sisterhood and marxism. She does not strive for a bigger piece of the male-defined pie, but rather towards a society where not only *all* women, but all people are able to define their own existences.

Clearly this distinction can be applied to women artists. There are many women today who call themselves feminist artists. However, what they are really doing is vying for power and status in the male-defined art system. Their aim is fame and (if possible) fortune . . . to be able to show in more museums and more prestigious galleries. This may sound like an overstatement, but in actuality I don't consider it to be one. Because basically, although these women recognize that the art system as it exists today does not serve women (and consequently them, as individuals) they seldom question that system. If they did they would not (and this is just for starters) emulate the egocentric, artist-on-the-hill, elitist role of the male artist in our society. It seems clear to me that a feminist art would not be based on masterpieces or 'dialogues with oneself about oneself'. Perhaps the only things a truly feminist artist would concern herself with are the feminist movement *and building a feminist art system* inside a feminist society. To try and construct a definition of what the feminist art itself would be is

obviously missing the point. To tell a young woman that she would never be able to show her work in a so-called 'feminist' gallery because it was not feminist (i.e. it was non-objective and did not conform to the 'laws' of 'feminist imagery') is an outrage. Because if an artist is truly a feminist (in actions, not just in rhetoric), and if she is given complete freedom with her art, that feminism will come to be reflected and expressed in that art. Maybe not in the obvious and trite form of cunts (a male-defined view and objectification of women, in my opinion) and central imagery . . . but in an authentically feminist way which is yet to be discovered. [. . .]

Silvia Bovenschen, 'Is There a Feminine Aesthetic?' (1976)

From *Feminist Aesthetics*, ed. Gisela Ecker, trans. Beth Weckmueller (London: The Women's Press, 1985), pp. 23–50 (originally published in Germany in 1976).

[. . .] Art has been primarily produced by men. Men have neatly separated and dominated the public sector that controls it, and men have defined the normative standards for evaluation. Moreover, in so far as they came into contact with this sector at all, women have for the most part acquiesced to its value-system. These realisations led Shulamith Firestone to the conclusion that 'It would take a denial of all cultural tradition for women to produce even a true "female" art.'[1] Such a statement is easily made. Indeed, aesthetic norms and cultural standards have meaning only in their sublation. But those standards and those norms were not even our own. What is the ground that we are working? From where does a 'feminine' art get its identity? Or does it not need to do that? Is art, then, still art in the traditional sense, no matter how far it has gone to the dogs? Is 'feminine' a criterion of substance, an ontological entity?

Let us then radically negate all the masculine cultural achievements and begin anew at the point where we once left off, tilling the soil as our female ancestors did before the great male *putsch*. That is not very funny, even as a powderroom joke. Perhaps we would enjoy that – linking ourselves directly to bygone power – but we should be wary of construing a direct connection where none exists. Making such a connection can raise false hopes of finding help.

Call as often as we might to the old mother goddesses – Aphrodite, Demeter, Diana and all the rest of those Amazons of long lost female empires – their power cannot reach this far, for their empires have been extinguished. Only the important consciousness that things were once different eases our burden a bit. To be sure, it is very important that we reappropriate moments of female potential from past cultures which have been silenced in organised fashion by male history. And the work to be done in this area is immense. (I emphasise this to avoid any misunderstanding.) But any attempt to link them directly to our experiences in the twentieth century will be unsuccessful. And if we none the less force a direct connection, the results will be downright pitiful. We shall be left with parsley as a method of inducing abortion, and here and there a herbal home remedy.

The desire to tailor a positive (female) counterpart to the world that was constructed and interpreted by men is not satisfied in this manner. And are we even concerned with chronology? Let us rather quote the women of the past as we wish, without being pressured into retroactively fabricating continuity. On the other hand though, a historical archaeology in search of women past and forgotten, their obscured activities, living conditions and forms of resistance, is not just nostalgia. The hidden story of women, which reveals itself to us as primarily one of suffering and subjugation (now *here* is continuity!) is the dark side of cultural history – or better, the dark side of its idealised version. Illuminating this side initially implies no more than reiterating the aforementioned state of affairs; namely, that women put their souls, their bodies and last but not least their heads on the block for men, thus enabling them to take off on their cultural aerobatics and to sink to their barbaric lows. Women artists waft through history as mere shadows, separated from each other. Since their deeds remained for the most part without effect and their creations were, with rare exception, absorbed into the masculine tradition, it is not possible retrospectively to construct an independent counter-tradition. Only the female martyrs are not in short supply. All of this would certainly seem to be grounds enough for avoiding even the most trifling involvement with the problems of art and cultural history.

But the great refusal is not the solution either. To believe that feminine spontaneity need be creative in every case is to fail to recognise the powerful effect that cultural and historical deformation also had on the subjectivity of women, as mentioned by Firestone. Can women just 'be women', reduced to some elemental Being? We are in a terrible bind. How do we speak? In what categories do we think? Is even logic a bit of virile trickery? Or to put it even more heretically, how do we feel? Are our desires and notions of happiness so far removed from cultural traditions and models? Feminism cannot ultimately imply that we are to stop thinking, feeling, longing. No one ever claimed that. On the contrary, we are consciously just beginning to do these things. No doubt we have always done these things differently from men (we are dealing with a sort of double exposure here). But the means of expression most readily available to us for communicating our perceptions, our thought processes – language, forms, images – are for the most part not originally our own, not of our own choosing. Here we are still at the beginning. Sensitivity to the patriarchal structures common to language usage, such as we find in Verena Stefan's book *Häutungen* (*Shedding*), is certainly a step in this direction.

> What seems to be most important in this whole matter is that we focus our eyes and our feelings upon the flashes of insight which our feminine sensitivity affords us.[2]

> Language, the medium of my work, is for me already so generalised and mute that I cannot strive for even further generalities. Instead, I direct all my energies towards making the wall of generalities so thin that something will be able to break through the barrier, something can come from within my body and enter the over-articulated linguistic sphere. I want to show the generative base of language before it atrophies in communicable form.[3]

We ought to rid ourselves of the notion of a historically ever-present female counter-culture. And yet, on the other hand, the very different way in which women experience

things, their very different experiences themselves, enable us to anticipate different imaginations and means of expression.

No matter which tack I take, I am left with the frustrations and difficulties inherent in positive definitions.

A Digression on Feminine Nature

[. . .] Even when debating the prevalent theories, as I notice now in writing this, certain linguistic structures prove difficult to avoid and continue to manifest themselves. I am disturbed by the formal problems that show up while I am writing, when I am, so to speak, in dialogue with myself. What about academic language? We have to wade through it, it seems. We can expect many accusations, most of which we can ignore, but the charge of ignorance is not one to which we should expose ourselves. The rejection of every theory and every academic legacy expresses abstract hostility and puritanical celibacy; it is nothing more than irrationality and politically question-able anti-intellectualism. But we must keep a close eye on ourselves at all times, we must be careful at all times. There is only a very fine line between committed criticism and academic conformism. The battle must be waged on every front. The analysis of linguistic structures, imagery, the forms and symbols of behaviour and communication, is tough work which has hardly begun. If women are to succeed in freeing themselves from old patterns, in conquering new terrain and – finally to return to the subject at hand – in developing different aesthetic forms, they can do this only on the basis of their autonomy. Women's specific and unique experiences (so that knowledge can be experienced, not learned), rooted in their collective endeavours, are the preconditions for their success in any practical sense.

Schematically apportioning or redistributing 'qualities' by merely inverting or redefining them does not seem to provide a particularly fruitful answer to the question of women's creative potential. Nonetheless, I felt that discussion of theoretical pro-posals such as these would be useful, for two reasons. First, as it occurred to me while reading the Marcuse article,[4] we are dealing with examples of how language and abstrac-tion serve to widen *the gap between the concept and the object* in a manner which engulfs every instance of experience. The object rebels against this. This relates to the ques-tion, *How can the specifically feminine modes of perception be communicated?* The answer here may actually be in the examples of female creativity which already exist (i.e. in women's manner of looking at things, whereby I do not mean merely the aspect of visual perception suggested by the term), rather than in a premature programme of 'feminist aesthetics'.

And the second reason: in attempting to conceptualise female creativity, the old dual-istic notion of the 'natural' and the 'artificial' is often evoked. If these concepts are taken in their trivial sense, then the principle of femininity is represented solely by the first. I have already alluded to the supposed naturalness of women. So here only a word in clarification. There is more behind the cosmetic industry than simply the idea of 'natural beauty'.

Such formulations suggest evasiveness on our part, suggest renunciation of all that is artistic, refusal of any attempt to use the media for our own purposes, denial of any

aesthetic transformation. The verbal debate about this topic suffers greatly from linguistic inadequacy, with the result that in fighting with words one often loses sight of the tangible referent. However, perhaps precisely because of these obvious difficulties, it would be an act of sheer ignorance for women to neglect the aesthetic activities constituting an interesting aspect of our reality.

Difficulties arise when the notion of beauty is attached to an empirical woman. Marilyn Monroe was at one and the same time artistic product, myth of femininity and victim of an inhuman culture industry. We cannot posthumously dissect her into one natural and one artificial woman, leaving one part of her to Norman Mailer and turning the other part, clothed in jeans, into the figurehead of women's lib. The entire woman belongs to our side.

Digression II: On Feminine Beauty

Amazingly, it seems that even those images of femininity constructed by men or by the male art industry are turning against their creators in ever-increasing numbers. Having become mere commonplace myths, they are stepping out of their moulds, out of their literary or film contexts. I believe that their metamorphosis is not only the result of the new interpretation and effect they now have, due to the influence of the women's movement, it is much more dependent upon the fact that an element of female resistance, if only a passive one, has always contributed to artistic production. Mario Praz, for one, set out to learn about the uncanny from the *Belles Dames sans Merci*.[5] Olympia, Lulu, Nana, the Salome and Judith figures of the *fin de siècle*, Marlene Dietrich . . . One need not engage in interpretational acrobatics to recognize the subversive disturbances instigated by these dangerous, wild women of history. In his lecture on 'Femininity', Sigmund Freud said to his audience, 'People have always pondered the riddle of femininity . . . [There follows here an insignificant passage from a Heine poem, S.B.] Those of you who are men will not have been spared this pondering either. It is not expected of the women among you, for you yourselves are the riddle.'[6] The possibility that women might experience and perceive femininity differently from men was often seen as a way of questioning, of posing an indirect threat to masculine art. Men's failure to comprehend this riddle was not, however, seen as their shortcoming. Instead, it was projected back onto women, seen as the eternal feminine mystique. But Oedipus did not solve the riddle of the Sphinx (that is only men's wishful thinking), though any woman could have. If women had been the ones to stand and stare in like amazement at the riddles of art – especially the one in which the feminine image is supposed to convey the idea of beauty, the one in which the riddle has been shoved off onto women – they could only have marvelled at the extent to which they had become a secret about which they themselves knew nothing. Treatises like those by Walter Pater and d'Annuncio on the smile of the Mona Lisa yield information about the riddle, abysses and revelations which they find crystallised in the image of woman. Of course, this pursuit was not concerned with empirical women but rather, for the most part, with images of women as created by male artists. It is possible that the more sensitive artists, those who passed the riddle along to their contemporaries and followers, were already operating on the assumption that they would never be able to comprehend fully the truth about femi-

ninity. Instead, they limited themselves to dealing with only *that* part of 'universal' woman that was accessible to their individual dispositions, their sex and their sensory faculties. Through the centuries, culturally diverse standards of beauty have repeatedly re-established the status of the female body as object. On the other hand, adoration of masculine beauty, or of beauty as manifested in the male body, as we see with Michelangelo, was more rare and often clouded by the aura of homosexual desire. And an aesthetic theory measured in terms of the masculine model, such as Winckelmann's, only purports to glorify an ideal purged of such longings, even if generations of educators tried to make us believe otherwise.

> She looked at Amabel through his eyes. And saw everything in her escape them. Her poses and mannerisms, that were second nature, he would amusedly accept as so many biological contrivances. And if he thought her 'pretty' – sacrilege, even in thought, to apply to Amabel this belittling expression that at this moment I see as part of his deliberate refusal to take any kind of womanhood seriously and is not condoned by his protesting that neither does he take himself seriously – would play up to her as he does, as I have seen him do, with women who 'exploit' themselves; subtly conveying at the same time, to the simple female he saw behind the manoeuvres, that he knew what she was about and that she was doing it rather well. But perhaps he would not even think her pretty.[7]

Women's identification with the aesthetic objectification of femininity has traditionally been misplaced. Only when the artistic figures embodying the principle of femininity broke away from the traditional patterns of representation and managed to avoid the usual clichés, could there be any real identification. Barring this, identification on the part of women could take place only via a complicated process of transference. The woman could either betray her sex and identify with the masculine point of view, or, in a state of accepted passivity, she could be masochistic/narcissistic and identify with the object of the masculine representation.

Causing women to conform mindlessly to the masculine image of them is not, however, the only way in which men have helped determine women's image of themselves. This is because aspects of true femininity, instances of female resistance and uniqueness – though often in disguised form – have always been contained in the artistic product. These instances then appeared as indicators of the mysterious and puzzling nature of women. [. . .]

The Aesthetic and the Feminist Public Spheres

'The women who wished to be taken for men in what they wrote were certainly common enough; and if they have given place to the women who wish to be taken for women the change is hardly for the better . . .'[8] Virginia Woolf wrote this rather malevolent sentence in 1918, a time at which people in England were conducting heated arguments about the demands being made by the women's movement. The author did not entirely evade these feminist issues, even if her comments on this subject are pleasantly unorthodox. The quote contains an attack on the ignorance of formal problems in aesthetics – mistaking pamphleteering for literature – and raises the question of competence.

Virginia Woolf's own works exemplify care and precision in dealing with linguistic material. She was an author who did not think that by simply recalling her female sex, her experience or nature or whatever else would dictate instant art onto the page. Of course women possess the potential and the right to do anything. It is indeed idiotic that we must emphasise even these old concepts of natural rights with regard to women. But a stick figure is a far cry from a Sarah Schumann painting. The combination of artistic ability with 'feminine' innovativeness is still a rare stroke of luck. Only the progress of feminism can make this happen more often and seem less exceptional, in all areas.

A feminine approach to art must include both aspects mentioned above. It cannot ignore the problems of what is aesthetically possible, the difficulties involved in working with artistic material, the matter of technique and of the intrinsic dynamics of various media, but neither can it ignore the question of the relationship between art and feminism.

Once before, it seemed as though a new age were dawning:

> But here, too, women are coming to be more independent of opinion. They are begin-
> ning to respect their own sense of values. And for this reason the subject matter of
> their novels begins to show certain changes. They are less interested, it would seem,
> in themselves; on the other hand, they are more interested in other women . . . Women
> are beginning to explore their own sex, to write of women as women have never been
> written of before; for, of course, until very lately, women in literature were the
> creation of men.[9]

And once before, these literary expectations were dashed, bound up as they were with the development of a new feminine self-consciousness and the hopes engendered by the women's movement. Once before, female artists were thrown back upon them-selves and forced to rely upon a male-dominated public in order to get their works published or shown, in order to obtain even the slightest degree of recognition.

Thus far, I have found tangible instances of what might be termed female sensi-tivity towards writing (or towards painting, etc.) only in certain moments of female sub-version, female imagination or formal constructs within various works. And I find these only when the specifics of feminine experience and perception determine the form that the work takes, not when some 'feminine concern' has merely been tacked on to a tra-ditional form. The question directed at a painter of why she did not portray women's demonstrations or activities in her paintings is an objectively cynical and insulting one. Such a question reduces her work to the level of photo-journalism in weekly news magazines, something any man could do. The feminine quality of a work ought not be determined solely by its subject-matter.

The bridge linking the demands of the movement on the one hand with artistic activity and its concrete work with materials and media on the other is still very narrow. Thus, those women who are committed to both sets of demands face a terribly diffi-cult situation. They are risking their fate to demonstrate that the gap *can* be bridged. Overcoming this opposition between feminist demands and artistic production is, even today, the special task faced by those women who dared to venture into artistic work and yet managed to avoid betraying their sex in the process, despite all the obstacles and resistance they met with. For them, the alternative of either 'real artist' or 'recorder

of the movement's activities' can only seem a bad joke. It is risky to rely solely upon a public that is still in the formative stages of development – namely women – and that has not always proven itself capable of making aesthetic judgements. Yet one can expect perhaps even less from the established art public, for they demand even greater willingness to compromise. For a long time the reigning men in this sphere, the big shots, critics and producers, willingly believed that art was an exclusively male province. (In fact, they still believe that today – they simply no longer advertise the fact!) Recently though, out of sheer necessity, they have conceded that art is androgynous in nature. (But even this in no way means that they consider women's works to be on a par with men's; their concession to androgyny is only a smokescreen.) But they will declare war on any feminist art that sees itself as something other than merely one odd variation among others cropping up on the currently bleak artistic scene. If women view their art as something produced by women for women men will fight it, if for no other reason than because their aesthetic yardstick is unable to measure a phenomenon such as this. Patriarchal blinkers cannot be taken off at whim.

The Pre-aesthetic Realms

Even in the past, I contend, the exclusion of women from the artistic realm could not extinguish all their aesthetic needs. These creative impulses, however, were shunted off into the 'pre-aesthetic realms', where they evaporated under the strain of women's daily routine. Women furnished the living quarters, set the tables, arranged, decorated and adorned their clothing, and above all themselves. That was allowed, as long as it was being done to please the man. These activities quickly corrupted women. They set the table for the man, they dressed and adorned themselves for the man – not for themselves or for each other, but rather in competition with each other. They busied themselves weaving and knitting, but such functional artworks, handicrafts and decorations have always been considered inferior, commonplace. This verdict is of course not entirely unfair, especially in those cases where even these most timid efforts were channelled into subservient obsequiousness and excessive affection-seeking.

> Once when I visited Buddy I found Mrs Willard braiding a rug out of strips of wool from Mr Willard's old suits. She'd spent a week on that rug, and I had admired the tweedy browns and greens and blues patterning the braid, but after Mrs Willard was through, instead of hanging the rug on the wall the way I would have done, she put it down in place of her kitchen mat, and in a few days it was soiled and dull and indistinguishable from any mat you could buy for under a dollar in the Five and Ten.[10]

Here the ambivalence once again – on the one hand we see aesthetic activity deformed, atrophied, but on the other we find, even within this restricted scope, socially creative impulses which, however, have no outlet for aesthetic development, no opportunities for growth. These impulses could not be concretely realised, nor could they lead to an artificial desire to experiment.

It is true that these activities never had to become static, unchanging artistic norms. They never became obsolete products, they remained bound to every-day life,

feeble attempts to make this sphere more aesthetically pleasing. But the price for this was narrowmindedness. The object could never leave the realm in which it came into being, it remained tied to the household, it could never break loose and initiate communication . . .

But what would happen if someday we cleared out this realm and opened it only to ourselves and other women? What if we alternated painting our faces with painting on canvas? What if we turned recipes into poetry? What if all these activities were to shed their utilitarian rationale of male approval?

[. . .]

[. . .] Attempting to knit the gap between the artistic realm and social reality is problematic in that this gap is not simply the result of foolish blunder but is rather the result of particular preconditions.

However, it can be proved that women succeeded in entering the artistic realm when they gained access to it via the adjoining 'pre-aesthetic' realms. In the eighteenth century women were able to enter the realm of literature by means of letters (the epistolary novel), since this was an age in which letters and novels were gaining dignity and the dissolution of rigid formal rules allowed greater flexibility. Experience could be gained in writing private letters. Since letters and diaries have no clearly defined literary niche, it was all right for women to practise on them. Only the Romantics considered conversation – another feminine domain in literature – to be aesthetic activity. The letters of Caroline Schlegel are true masterpieces of mixed aesthetic form: wardrobe descriptions alternate with philosophical discourses, gossip with literary quotations, allusions and criticism. Men were amazed by the new tenor, the new tone, the irreverence and more sensual descriptions unique to women's letters, and on occasion they even showed open admiration. It did not take long for this medium to be included in the literary canon.

However, it is difficult simply to go back, optimistically to take up again those 'feminine' media – letters, weaving. It is, in fact, almost more difficult to do this than to work with the 'unfeminine' technical media such as film, since these need not contend with being traditionally relegated to the domain of the housewife. We should not foster the false assumption that our sewing teachers indeed pointed us in the right direction. There is no direct path from the decorative potholder to the tapestries of Abakanovicz. Besides, I am still horrified by the whole ruffles-and-sewing-basket business we were subjected to as young girls.

I believe that feminine artistic production takes place by means of a complicated process involving conquering and reclaiming, appropriating and formulating, as well as forgetting and subverting. In the works of those female artists who are concerned with the women's movement, one finds artistic tradition as well as the break with it. It is good – in two respects – that no formal criteria for 'feminist art' can be definitively laid down. It enables us to reject categorically the notion of artistic norms, and it prevents renewal of the calcified aesthetics debate, this time under the guise of the feminist 'approach'.

If, however, women have different assumptions with regard to their sensory approach, their relationship to matter and material, their perception, their experience, their means of processing tactile, visual and acoustic stimuli, their spatial orientation and temporal rhythm – and all these things are what aesthetics meant at one time,

according to its original definition as a theory of sensory perception – then one could logically expect to find these things expressed in special forms of mimetic trans-formation. Put emphatically, this would mean that within the framework of a female cosmology there would be a changed relationship between the subjective artistic appropriation of reality on the one hand, and formal suggestiveness and receptive per-ception on the other. But it will be nearly impossible to find categorical evidence for this changed relationship: reality is not that logical, and there is no female cosmology either.

> And yet, there can be no doubt that the realm of female experience is sociologically and biologically different from that of the male . . . Is feminine sensitivity best expressed by a particular fragmented form or through strict unity? In circles, oval blocks or through a striped, filagreed pattern? Through sensual surfaces or through a subtle sense of colour? The images, the choice of theme, even the intentions behind the application of these forms or similar ones in video, film, dance – all these are merely superficial indicators of a more fundamental difference. I count myself among those who are convinced that this differentiation exists, and yet for every case that I can specify there are innumerable others that defy such specifications.[11]

There is no proof of a different (female) relationship to detail and generality, to motion-lessness and movement, to rhythm and demeanour. At present, this is all still conjec-ture. I find the only sensible approach to be the search for evidence within individual, concrete texts (pictures, films, etc.) as Virginia Woolf once attempted with Dorothy Richardson's writing:

> She has invented, or, if she has not invented, developed and applied to her own uses, a sentence which we might call the psychological sentence of the feminine gender. It is of a more elastic fibre than the old, capable of stretching to the extreme, of suspending the frailest particles, of enveloping the vaguest shapes. Other writers of the opposite sex have used sentences of this description and stretched them to the extreme. But there is a difference. Miss Richardson has fashioned her sentence con-sciously, in order that it may descend to the depths and investigate the crannies of Miriam Henderson's consciousness. It is a woman's sentence, but only in the sense that it is used to describe a woman's mind by a writer who is neither proud nor afraid of anything that she may discover in the psychology of her sex.[12]

Dorothy Richardson on the masculine manner of writing:

> The self-satisfied, complacent, know-all condescendingness of their handling of their material . . . The torment of *all* novels is what is left out. The moment you are aware of it there is torment in them. Bang, bang, bang, on they go, these men's books, like an L.L.C. tram, yet unable to make you forget them, the authors, for a moment.[13]

The exclusion of women from vast areas of production and the public sphere has directed women's imagination along other lines, not to speak of women's responsibil-ity for the biological and social reproduction of the species, as well as the economic, if they are working. Moreover, the much touted ahistoricity of women kept the polarity

between intellectual labour and manual labour from becoming too traumatic. The disparate development of the sexes, though origin of so much of women's suffering, fortunately has not yet allowed women's behaviour and needs to become reified to the degree found in advanced capitalism. But generations of women paid for this with their banishment into the marital ghetto.

Is there a feminine aesthetic? Certainly there is, if one is talking about *aesthetic awareness* and *modes of sensory perception*. Certainly not, if one is talking about an unusual variant of artistic production or about a painstakingly constructed theory of art. Women's break with the formal, intrinsic laws of a given medium, the release of their imagination – these are unpredictable for an art with feminist intentions. There is, thank heavens, no premeditated strategy which can predict what happens when female sensuality is freed. Because it is a process and historically tentative, we cannot verbally anticipate this freeing of feminine sensuality either at its traditional erotic centre (even though there's a lot going on there every month) or in the context of individual choice. We can do it only on the basis of a movement by women for women. Art should become feminised, and women's participation (limited by men to their sensuality alone) would do it a lot of good. Perhaps, then, our male colleagues would not need to proclaim the death of art one year and recant the next. But that is only peripheral here.

It is also premature to revel in women's spontaneous activities, such as their parties, as if they represented a new, 'vital' aesthetic, totally different from the aesthetic of objectified art products. (This would be analogous to the slogan of the student movement that art would henceforth take place in the streets.) Women will know how to resist the imprisonment of their imagination in the artistic ghetto, not because this fits into their 'aesthetic programme', but rather because, whereas terminology may fail, this imagination constitutes the movement itself.

The predisposition to feminine/sensual cognition and perception becomes most apparent in women's collective actions which in their appearance rise above the ordinary. Let us be wary of methods, however. These actions would be quickly coopted as manifestations of living or body art, or body language. Feminist art is not a stylistic trend. Women's actions or demonstrations are not artistic events. The relationship between political actions and art – as well as the reflecting upon this relationship – cannot operate on the level of traditional leftist animosity to art. Nor can it exist on the level of apolitical esoteric views of the type which allowed a demonstration for legalised abortion to be interpreted as a rebirth of the 'happening' scene. The point here is neither to rescue the notion of the 'beautiful illusion' nor to over-extend the concept of aesthetics, a term which by definition already encompasses all activity and hence has become totally meaningless. The important thing is that women artists will not let themselves be kept back anymore. They work on canvas, they make films and videotapes, they write and sculpt, they work with metal and with fabric, they are on stage . . . So let us take a look at what they are doing.

Notes

1 Shulamith Firestone, *The Dialectic of Sex* (New York: The Women's Press, 1970), p. 159.
2 Lucy Lippard, 'Warum separiette Frauenkunst? [Why a separate women's art?]', *Feminismus: Kunst & Kreativität*, ed. Valie Export (Vienna, 1975).

3 Frieda Grafe, 'Ein anderer Eindruck vom Begriff meines Körpers', *Filmkritik* (March 1976).

4 Herbert Marcuse, 'Marxismus und Feminismus', *Zeitmessungen* (Frankfurt am Main, 1975), p. 13.

5 Mario Praz, *Liebe, Tod und Teufel: Die schwarze Romantik* (3 vols, Munich, 1970).

6 Sigmund Freud, 'Die Weiblichkeit', in *Vorlesungen zur Einfuhrung in die Psychoanalyse*, Studienausgabe, vol. 1, p. 545.

7 Dorothy Richardson, *Dawn's Left Hand* (London, 1931), p. 204f.

8 Virgina Woolf, 'Women novelists', in *Contemporary Writers* (London, 1965), p. 26.

9 Virginia Woolf, 'Women and fiction', in *Collected Essays*, vol. II (New York, 1967), p. 146.

10 Sylvia Plath, *The Bell Jar* (London, 1963), p. 88.

11 Lippard, 'Warum separiette Frauenkunst?'

12 Woolf, 'Romance and the heart', in *Contemporary Writers*, p. 124f.

13 Richardson, *Dawn's Left Hand*, p. 202f.

Michèle Barrett, 'Feminism and the Definition of Cultural Politics' (1982)

From *Feminism, Culture and Politics*, ed. R. Brunt and C. Rowan (London: Lawrence and Wishart, 1982), pp. 37–58.

Cultural politics are crucially important to feminism because they involve struggles over *meaning*. The contemporary Women's Liberation Movement has, by and large, rejected the possibility that our oppression is caused by either naturally given sex differences or economic factors alone. We have asserted the importance of consciousness, ideology, imagery and symbolism for our battles. Definitions of femininity and masculinity, as well as the social meaning of family life and the sexual division of labour, are constructed on this ground. Feminism has politicized everyday life – culture in the anthropological sense of the lived practices of a society – to an unparalleled degree. Feminism has also politicized the various forms of artistic and imaginative expression that are more popularly known as culture, reassessing and transforming film, literature, art, the theatre and so on.

Immediately we begin to think about this it becomes difficult to say exactly what is meant by cultural politics. If I spray-paint a sexist advertisement this is quite clearly cultural politics. But if I do it so imaginatively that a feminist photographer captures it for the walls of an alternative art gallery, has my illegal graffiti then become feminist art? The distinction between art and culture is a vexed one, but there are political (as well as academic) reasons for thinking it through further.

Raymond Williams, who recently published a book entitled *Culture* (Williams, 1981), sensibly refuses to give a snap definition of the term. Instead he outlines the historical meanings of the concept and discusses more recent influences on his own use of it. To the anthropological and popular uses that I have already mentioned he adds the current interest in 'signification' – systems of signs, cutting across the conventional division between art and popular culture, through which meaning is constructed, represented, consumed and reproduced.[1] But if culture is difficult to define, art is certainly impos-

sible. In the absence of any convincing account of what is intrinsically 'aesthetic', art can only be that which is defined as art in a particular society at a particular time. Indeed the category of 'art' is not a universal one.

I raise these problems at the outset since the purpose of this paper is to question what we mean by art and culture in the context of current feminist practice. Is a work of art a battleground for ideological struggle in the same way as a sexist poster? Or are there qualities to art that render a directly political approach less relevant? To engage in cultural politics is to take a stance on these questions [. . .].

When is Culture 'Art'?

The third issue I want to take up is the rather thorny one of what we mean by 'art'. This is very difficult to approach in a direct way, since our ideas about art are profoundly influenced by, and entangled with, a particular historical conception of art which affects feminist as well as other types of thinking.

Elaine Showalter (1979) has pointed out that feminist criticism has tended to take two clearly identifiable paths. She calls the first 'feminist critique'. This is the study of woman as reader, and it concentrates on woman as a reader of male literature, emphasizing the sexist assumptions of that body of art. The second she calls 'gynocritics', the study of woman as writer in which we can explore the development of a female literary tradition. If this is an accurate account, which it probably is, then it reflects rather badly on feminist criticism. For it represents a way of looking at literature which completely separates the activity of reading (consumption) from that of writing (production). It assumes that art is produced by specialized individuals ('artists') and passively consumed by everyone else. This assumption is deeply engrained in our culture. Our entire education system is based on the assumption (to simplify a little) that small children enjoy splashing about with paint, banging drums and writing stories, but that by the time we reach the end of secondary school we will have naturally separated into the uncreative majority and the few who go on to study or practise 'art'. For most adults the world of art is one which other people make for us – for our edification, enjoyment or entertainment. It comes as a shock to us to realize that in other cultures, and in our own in the past, art was not thought to be the province of particular individuals but was distributed more evenly across all social activity.

Without going into the question of how and why this specific social role of 'the artist' came about, it is clear that we have inherited a conception of art as something removed from other forms of social activity. Art is seen as the antithesis of work. It is mythologized as an oasis of creativity in the desert of alienated mass-production capitalism. It is idealized as the inspired product of a few gifted and privileged people, constructed on we know not what principles and existing in a kind of other-worldly limbo. It is credited with the ability to transcend the 'real world', lifting us into an arena of higher experience. Confronted with a 'masterpiece' we are to wonder, dumbly, at the unimaginable talent that went into making it. The viewer takes a humble distance from the artist.

To challenge these myths is to raise some interesting questions. If we reject the view that art is necessarily different from work we find ourselves considering afresh the ways in which artistic production may be akin to other forms of social production.

Janet Wolff, in *The Social Production of Art* (1981), argues that the work involved in producing an artistic or imaginative work is not essentially different from other forms of work. Marx's well-known remark on the difference between the worst of architects and the best of bees (that the former raises the structure in the imagination before starting to build) stresses the fact that human labour is based on the creative act of planning. It is only the degradation of work under capitalist relations of production, including the degree to which workers have been stripped of mental control over their labour, that makes us perceive such a huge gulf between work and what we call 'creative' work.

Marxists working in the field of aesthetics have tried to develop an analysis of artistic production and, to a lesser extent, of distribution and consumption of art. One central question, however, tends to remain evaded or unsatisfactorily dealt with. This is the question of aesthetic value. I want to raise it again here because it has not yet been resolved in feminist thinking about art and we tend to operate with varying sets of assumptions on this question.

The problem posed by 'aesthetic value' is a very simple one: are some works of art 'better' than others and, if it is possible to say that they are, then how do we justify our judgements? Literary and art critics have been renowned for the ease, if not arrogance, with which they have presumed definitively to rank works of art or individual artists in levels of greatness. In a more everyday sense people will often confidently say that something is 'good', not necessarily linking this to whether they 'liked' the work in question or not. A high level of confidence in such judgements seems to have been common until well into this century, when this exercise came to be challenged seriously. The challengers have tended to criticize the assumption that 'aesthetic value' exists as a universal category, manifested as an intrinsic property of certain works of art, and have pointed to the political character of such judgements – they are biased towards the artistic production of dominant social groups. To recognize this is inevitably to cast suspicion on the objectivity and universality of the criteria used to rank art.

A number of possible arguments flow from this recognition.

(1) The first would be to say that because judgements of aesthetic value have always been not merely culturally bound but the expression of dominant groups within particular cultures we can therefore have no confidence in them at all. In a radical rejection of the claim that aesthetic value can be assessed objectively we can then arrive at the view that any art is as good as any other. The poem you scribble on the back of an envelope is every bit as good as the sonnet by D. H. Lawrence that F. R. Leavis admires.

(2) A second response would be to argue that aesthetic value does exist as an objective category, and that our task is to remove political prejudice from its measurement. Our role is to insist on the value of the work usually ignored or rejected by the critical establishment. Where they tend to value the work of the white, male bourgeoisie we must insist on the value of working class culture, or women's art, or black art. According to this view our task would be to struggle with the arbiters of aesthetic value and force them to assent to a high value being placed on excellent instances of minority culture. When the league-table of great artists is drawn up we want our candidates up there at the top.

(3) A third possibility is to resolve the apparent conflict between aesthetic value and political value by attempting to construct an explicit relationship between the two – in essence, to argue that far from being divorced from political significance, aesthetic value should in fact be attributed on the basis of political progressiveness. Using this view rather loosely we could argue that feminism at present can and should regard art that is firmly located in women's experience and that points to a less oppressive future as of great value – as 'good' in a particular historical and political context.

None of these views is ultimately satisfactory though, and I think this is because they all evade the problem of how we can specify what really constitutes aesthetic value. The first view tends towards complete relativism – aesthetic value is merely judged according to political prejudice and is not a meaningful category – and leaves us with total inability to distinguish between a random scrawl and a finely wrought painting that has moved generations of people. The second view is somewhat uncritical of existing criteria used for judging aesthetic value and in practice tends to lead towards unconvincing conclusions. Is it really only because of male dominance in art history that we think Rembrandt a 'better' painter than Angelica Kauffman, or because of patriarchal criticism that we find Stendhal a 'better' novelist than Marie Corelli? The third view evades the problem altogether, simply abandoning any notion of value which is independent of the political significance of the work at the time it was produced.

It might be possible to side-step some of these difficulties by asking a rather provocative question. Is it feasible to rehabilitate a category of objectively judged aesthetic value? The answer to this question could in fact be yes, and in exploring this we might be able to consider afresh two problems raised by contemporary 'radical' approaches to art. These two problems are *imagination* and *skill*. Neglect of both of these, in feminist as in Marxist aesthetics, has led to some of the difficulties and confusions I have already touched on. So I want to put forward the proposition that skill and imagination have played a larger part in the construction of art than many radical critics have chosen to think.

We can think about the question of skill by referring back to the idea that artistic production is not essentially unlike other forms of social production. Now, although we know that social definitions of skill are the product of struggle (in that particular groups of workers have succeeded in achieving definition of their work as skilled while other groups doing similar work have lacked the bargaining power to do this), it cannot be denied that there is an objective element to skill. We can all recognize that a television engineer, a typesetter, a midwife, have skills that have been learnt. Similarly we grant that acting, stage design, pottery or tapestry are skilled crafts. The distinctions between 'work', 'craft' and 'art' are difficult to maintain when we consider the question of skill. We have little hesitation in attributing and estimating skill in work such as decorating, and the concept of craft is popularly identified with training and skill. Yet a curious indulgence sets in when we come to consider art – we are reluctant to see it in terms of the skills by which it was produced, partly no doubt because we are so badly educated in art that often we cannot even assess the skills involved. We cannot see how a particular effect was achieved. Yet skill plays a central role in artistic production, and the most brilliantly imaginative idea will be frustrated if we lack the skill to execute and express it. There are many problems attached to assessing artistic skill, but we gain

nothing by avoiding them and pretending that skill is not a crucial element in the production of art.

On the face of it there seems to be no need to point to imagination as a defining characteristic of art, since the popular view of art is to perceive it exclusively in these terms. Radical criticism has, however, tended to reject this view to the point of virtually denying the imaginative character of art. The everyday meaning of fiction (the antithesis to fact) is forgotten by a radical aesthetics that has seen fiction as a descriptive category, like painting or sculpture. All too often fiction is treated solely in terms of the social reading we can make of it, the points where we can pin it down by its social or psychic determinants. This approach to fiction rests on a more or less crude application of sociological content analysis. In its more vulgar form it looks for the reflection in fiction of social fact, historical reality; in its more sophisticated form it sees fiction as a site in which various possible extra-textual elements can be located and dissected out. Yet in all this we often forget that fiction has a very oblique relation to the social reality to which we are trying to link it. This is precisely because fiction is an imaginative construction and is hence not a reliable indicator of social reality. We can never know exactly what relation a particular fictional work bears to the historical context of its production. Obviously to some extent, as Terry Eagleton points out, every work 'encodes within itself its own ideology of how, by whom and for whom it was produced' (Eagleton, 1976: 48); but this should not lead us to believe that the only way in which we can relate to the work is by trying to decode it. Such decoding exercises may be very useful, but cannot ultimately provide all that we need to know about the work.

There is, then, something to be gained from rehabilitating what is currently thought of as a rather reactionary view of art. Within specific aesthetic forms and conventions we may be able to identify different levels of skill as well as the expression of particular fictional, or imaginative, constructions of reality. To point to this is not to slide into the individualistic romanticism of traditional bourgeois theories of art; it is merely to indicate the extent to which radical criticism has abandoned this dimension of art altogether.

To assert the possibility of critical and imaginative consciousness brings certain advantages to our thinking about art. It may, for instance, enable us not to separate so rigidly and disastrously the aspects of artistic production and consumption. For if we can identify levels of aesthetic skill in the construction of works of art, and the expression of critical and fictional representation of the world, it becomes clear that the reading of the work will inevitably depend upon the corresponding consciousness and knowledge of the audience. The more we understand about the principles, and skills required, for the construction of particular works the more completely we shall be able to receive them. The more we share, or identify with, a particular consciousness of the world the more we shall enter into a fictional rendering of that consciousness. Hence the rehabilitation of a specifically aesthetic level of meaning may enable us to see why works of art cannot be understood either as *intrinsically* feminist (or anything else), or as *necessarily* carrying a meaning determined by the authors' intentions. The meaning they have is constructed in our consumption of them and it becomes impossible to separate the production of the work from its consumption.

What are the implications of this for feminist cultural politics? First, a priority would be to try and break down the idealization of the 'artist', which occurs as frequently in

feminist culture as elsewhere. We need to reject the notion that women's liberation needs feminist artists to inspire us for more mundane struggles and move towards a greater acknowledgement of the reciprocal character of art in the social construction of political meaning. We need to work towards the creation of a cultural milieu in which feminist vision is creatively consumed as well as imaginatively produced. In this context an emphasis on aesthetic skills is in fact *democratizing* rather than elitist – for skills may be acquired – whereas the notion of an artistic 'genius' forbids the aspirations of anyone outside the small and specialized group. Differences in individual aptitude do not affect this generalization. Secondly, it suggests that we need to rethink our attitude towards the type of interventions currently being made in cultural politics. [. . .]

Note

1 Williams summarizes the present co-ordinates of the term 'culture' as follows: 'Thus there is some practical convergence between (i) the anthropological and sociological senses of culture as a distinct "whole way of life", within which, now, a distinctive "signifying system" is seen not only as essential but as essentially involved in *all* forms of social activity, and (ii) the more specialized if also more common sense of culture as "artistic and intellectual activities", though these, because of the emphasis on a general signifying system, are now much more broadly defined, to include not only the traditional arts and forms of intellectual production but also all the "signifying practices" – from language through the arts and philosophy to journalism, fashion and advertising – which now constitute this complex and necessarily extended field.'

References

Eagleton, Terry (1976) *Marxism and Literary Criticism* (London: Methuen).
Showalter, Elaine (1979) 'Towards a feminist poetics', in *Women Writing and Writing about Women*, ed. Mary Jacobus (London: Croom Helm).
Williams, Raymond (1981) *Culture* (London: Fontana).
Wolff, Janet (1981) *The Social Production of Art* (London: Macmillan).

Luce Irigaray, 'How Can We Create our Beauty?' (1990)

From *Je, tu, nous: Towards a Culture of Difference*, trans. A. Martin (London: Routledge, 1993), pp. 107–111 (originally published in France in 1990).

Very often, when looking at women's works of art, I have been saddened by the sense of anguish they express, an anguish so strong it approaches horror. Having wanted to contemplate beauty created by women, I would find myself faced instead with distress, suffering, irritation, sometimes ugliness. The experience of art, which I expected to

offer a moment of happiness and repose, of compensation for the fragmentary nature of daily life, of unity and communication or communion, would become yet another source of pain, a burden.

I wondered why women exhibit such pain and agony, women I believe to be more than capable of creating beauty. I thought over some of the reasons why. I'd like to express what I think so as to help women exteriorize in their works of art the beauty, and the forms of beauty, of which they are capable.

(1) I am one of these women. And although I do avoid writing about and pointing to things that are wretched, ugly, I often have occasion to deal with painful realities. As far as I'm able, I discuss them in a literary style, which I hope cushions the sense of dereliction these disclosures can lead to. I also strive to discover or define something positive at the same time I'm stating the negative. I am, moreover, criticized for this, by women among others, who have a tendency to identify only with what they lack, their shortcomings.

Personally, I rather regret having to show the negative, but the point of doing it, from a female perspective, is positive and necessary given that it reveals what was meant to remain hidden.

The portrayal of suffering is, then, for women an act of truthfulness. It's also akin to an individual and collective catharsis. As women they've been obliged to keep quiet about what they go through, and have often converted it into physical symptoms, mutism, paralysis, etc. Daring to manifest publicly individual and collective pain has a therapeutic effect, bringing relief to the body and enabling them to accede to another time. This doesn't come as a matter of course, but it may be the case for some women, for the female people. The anguish shown in women's works might be related to those masked characters of Greek tragedy who were subject to the force of fate. Some would be overdressed, particularly as women, others completely stripped, denuded. No longer would they have even their skin intact to keep them together physically, no longer even the love of their mother to protect their identity as girls, as virgins.

(2) As women, we engender children. Can one create anything more extraordinary, bodily or spiritually, than a living being? This creation, which is our preserve, is so wonderful that all other works can seem secondary, even raising the children themselves. But this marvelous women's work has been turned into an obligation to procreate, especially boys. The greatest creators of the universe, women, have thus become servants devoted to the reproduction of the male social order. Of all the glory of their greatest work, often all they keep is the pain of the 'labor' of childbirth and the trials of mothering. On top of this, the patriarchal cultural order has reduced them to what's labeled procreation by forbidding them to be creative or making it impossible for them to do so. As far as childbirth goes, there would seem to be confusion nowadays between the beauty of the work and its definition within a between–men civilization in which women no longer have a recognized right to engender spiritual values.

(3) As women, we have thus been enclosed in an order of forms inappropriate to us. In order to exist, we must break out of these forms. That act of liberation from imposed norms could have various results:

(a) It may be that, in wanting to throw off the physical and spiritual clothing of oppression, we destroy ourselves, too. Instead of being reborn, we annihilate ourselves.

(b) Or, in breaking out of our formal prisons, our shackles, we may discover what flesh we have left. I think color is what's left of life beyond forms, beyond truth or beliefs, beyond accepted joys and sorrows. Color also expresses our sexuate nature, that irreducible dimension of our incarnation (cf. 'Les Couleurs de la chair' in *Sexes et parentés*). When all meaning is taken away from us, there remains color, colors, in particular those corresponding to our sex. Not the dullness of the neuter, the non-living or problematically living (stones, for example) but the colors that are ours owing to the fact that we are women. Colors are also present in nature – particularly plant life – and there they express life, its becoming and its development according to days, seasons, years. In the world around us, they also express what is sexuate in life.

(c) Or, finally, it may be that in destroying already coded forms, women rediscover their nature, their identity, and are able to find their forms, to blossom out in accordance with what they are. Furthermore, these female forms are always incomplete, in perpetual growth, because a women grows, blossoms, and fertilizes (herself) within her own body. But she cannot be reduced to a single flower, as in the male image of virginity. In line with her own virginity, she is never completed in a single form. She is ceaselessly becoming, she 'flowers' again and again, if she stays close to herself and the living world.

(4) The between-men cultures have deprived us of the expression of meaning through images, which for the most part constitutes our female and maternal genius. The child a woman engenders is visible in a multitude of moving and developing images. It is not an abstract nor arbitrary sign. For us women, meaning remains concrete, close, related to what is natural, to perceptible forms. It also develops like our bodies, those of our children, of our sexual partners, of those that belong to the living world. At that time in History – conventionally termed Prehistory – when women participated in civil and religious life, written signs were still partially figurative, non-abstract, arbitrary, fiduciary. In those days women were represented as goddesses: not only as mother-goddesses – the only ones subsequent eras accepted – but also as women-goddesses. This is particularly evident in the fact that women-goddesses are beautiful, slim, and their sex marked by a triangle (as for mother-goddesses) in which the lips are drawn; all this was to be wiped out by what followed. Their divinity doesn't depend upon the fact they can be mothers but upon their female identity, of which the half-open lips are an affirmative expression.

The loss of divine representation has brought women to a state of dereliction, which is felt all the more because sensible representation is our primary method of figuration and communication. It has left us without a means of designating ourselves, of expressing ourselves, between ourselves. It has also separated mothers from daughters, depriving them of mutually respectful mediums of exchange. It has subjected them to a reproductive order – natural and spiritual – that is governed symbolically by men.

In my view we can and must rediscover the originality of our works. They are particularly important for sensible representations of ourselves, of our world, of vertical and horizontal relations between ourselves. Of course, this creativity correlates to what our current world – gray, abstract and destitute – needs. Even if it is reluctant to recognize our work as being necessary, we can and must accomplish it as a woman's and

a mother's contribution to not only the natural but also the spiritual life of the world. With this intention, the beauty of our works is a medium that enables us to pass from nature to the spirit, while all the while remaining natural. Isn't that where our genius lies?

Hilde Hein, 'Where is the Woman in Feminist Theory? The Case of Aesthetics' (1990)

From *Philosophic Exchange*, 21–22 (1990), pp. 21–36.

Most people believe that feminism, and by association, feminist theory, is about the status and welfare of women. It certainly is true that feminists aim to achieve the equality of women and the end of patriarchal domination. However I shall argue that feminism *as a theory* is a pattern of thinking that is not fundamentally *about* women, although it begins with a gendered perspective. It is, rather, an alternative way of theorizing about a host of topics that include, but are not limited to women. Feminists believe that the adoption of this way of thinking would advance the well-being of women among such other beneficent results as bringing about peace, respect for the environment, and the end of racial intolerance. Most feminists do have global goals such as these, and that alone should justify taking feminism seriously. In addition, there are intellectual features of feminism that speak directly to the interests of philosophers and scholars, and I will concentrate my remarks on these.

I will discuss the logic by which feminism redefines the very notion of theory, revealing it to be less a unifying device than a bedrock for difference; not as transcendent of experience, but as inextricably lodged within it. Feminist theory, according to this position, arises out of the plurality of practice and must be multiple because women and the realities of their experience are irreducible to any singular unit such as class, caste, nation or race. At the same time, women cannot be regarded purely as individuals, since their identity is denoted by each and all of the identifying categories that other theoretical systems have adopted as social, political and economic units of classification. Feminists believe there are excellent reasons in favor of redefining theory rather than repudiating plurality. They do not take the fact of plurality as grounds for nihilism or despair over the death of theoretical reason. On the contrary, openness to diversity appears to revitalize, not to hinder, theoretical discourse.

A model for the 'thickened' view of theory that feminists advocate can be found in the realm of the aesthetic.[1] Having survived a period of banishment as the stepchild of philosophy, where aesthetics was relegated to the non-essential and trivial, aesthetics seems now to have come into its own as addressing our central and most important cultural concerns. I will argue that there is a lesson for feminist theory in the development of aesthetic theory, which, like feminism, is motivated to discriminate and make diversity intelligible without reducing or destroying it. The success of feminist theory, like that of aesthetic theory, depends on its ability not simply to *tolerate* or reconcile dif-

ferences – an aim that liberal democratic theories profess to embrace – but to welcome the novel and the unexpected and to rejoice in their multiplicity. In my view the pluralism and relativism that are distinctive of both feminism and aesthetics are not cynically adopted 'postmodern' surrogates for certainty, but represent genuine alternatives to a totalizing theory which advances knowledge only at the cost of diminishing what is knowable.

[. . .]

The Place of Aesthetics in Feminist Theory and of Theory in Feminist Aesthetics

Traditional philosophical aesthetics has never successfully transcended the paradox that it strives toward uniformity and universality while rooted in the particular earthbound plurality of the senses. For all the idealism of its aspiration, aesthetic experience cannot be deduced from first principles. Aesthetic theory and criticism remain embedded in the manifold of phenomena.[2] The honest aesthetician must always return to the sights and sounds and feelings from which not even a hidebound Platonist can be long distracted. Moreover aesthetic theory, if it is not moribund, must remain open to new technologies, new movements, new materials, new ways of experiencing and new ideas in the arts. In addition to the feuding partisans of successive theories and their opposing definitions of art, there are phalanxes of metatheoreticians who dispute the very possibility of defining art on the ground that it is inherently 'open-textured' and any purported definition is therefore to be suspected as a covert proposal for new critical canons.[3]

Feminist theoreticians, like these aestheticians, deny that genuine feminist theory can arise *de novo* or out of abstract definition. It cannot have the axiomatic purity to which much of classical theorizing aspires. Since feminism presupposes the acknowledgment of gender as socially constituted, the theory that it articulates is inherently contextualized even as it struggles to overcome the situation that produces it. Encountered in a social context, feminism is often challenged, on the one hand, because it is ideological (or polemical) and, on the other, as anti-theoretical. Aesthetic theory, likewise, balances between the vitality of new-made art which defies it and the authority of canonic judgment which trivializes it. New art risks non-comprehension or violence, while the reliably familiar reaffirms the reliably certain and same.

There are other possibilities. Feminists have learned to circumvent the exclusivity of theory as a by-product of masculine self-confinement, leaving women free to write, sing or paint themselves out of the world that men have constructed and into one of their own design. Men are not absent from that limbo-world, but they appear differently proportioned from the stature that they normally assign to themselves. Time and space are also altered, as are other categories of thought that have been reified, definitively it seemed, by the legions of male authors and artists who have dominated all modalities of representation and pre-empted our vision and thought. The reclamation of theory by feminists is inseparable from our painstaking, but also raucous and jubilant reappropriation of experience.[4]

This reappropriation turns out to be a revisioning and a renewal. A breakaway from the canonic 'things as they are,' it is an act of discovery. Especially as expressed by feminist artists, such discovery has provoked the criticism (from traditionalists) that feminist art is political and polemical, and therefore violates the prescriptive ideal that art be non-political and impersonal. Feminist artists, however, like all artists, draw the inspiration for their work from those features of the world that touch them most profoundly. Their art, therefore, does frequently depict aspects of male oppression as well as some of the banalities of femininity that elude men's consciousness (the fear and the reality of sexual assault, menstruation, childbirth, housework, unsentimentalized childcare, etc.). Feminist artists are uniquely affected by the clash between the canonic rituals that define the male-dominated artworld in which they are educated as artists and the world that they know as women who are routinely exploited by that artworld. It would indeed be remarkable if such incongruity did *not* manifest itself in their work, just as the cataclysmic personal and political confrontations of the Reformation and Counter-Reformation are evident in the art of the Baroque period.[5]

In order to give voice to the unheard sound of this experience feminists sometimes produce works that are innovative in form and in their use of materials. Feminist exhibitions as a whole tend to be organized according to different structural priorities than traditional gallery shows (e.g. 'Portrait of the Artist as Housewife,' London, ICA, 1977; 'The Dinner Party,' Judy Chicago; 'Post-partum Document,' Mary Kelly). They are meant to produce in the gallery-visitor an experience that is unlike and disruptive of the normal, spectator-to-object relation. To the degree that these qualitative differences depart *by design* from critical standards, feminist art subverts traditional values. Feminists mean to call those values into question, and in so doing feminist art blurs the distinctions between art and criticism, art and politics, and theory and practice. The message to be imparted is that the apparent neutrality of the artworld – its apoliticism and transcendence of partisan interests – is as much an obfuscation as is the corresponding pretense to the existence of a neutral, ungendered archetype of 'man.' The 'masculinist' perspective turns out to be the 'default model' of artistic expression, assumed automatically by practitioners as well as appreciators except where an oppositional stance is deliberately taken.

Feminist art and art criticism therefore do not pretend to neutrality, but declare themselves gendered and political. They affirm the watchword of feminist theory that the personal is and has always been political. Only the overt acknowledgment is new. Feminist aesthetic theory states its intention to intervene in a socially produced gender system. Art, art criticism, and aesthetic theory combine interactively, first to articulate that system and render it intelligible, second to expose it in qualitative detail, and thirdly to dismantle it. By means of artistic expression and/or representation feminist art achieves aesthetically the realization that other feminist theorists strive to explain indirectly and abstractly. 'Art does not just make ideology explicit but can be used, at a particular historic juncture, to rework it.'[6]

Like most modern art, feminist art feeds upon the history of art, borrowing from, modifying, transforming and reversing traditional forms. But feminists are not merely competing to be innovative. They are struggling to say something that has not yet been said and whose expression requires the formulation of a radically new language. In forging the symbols of that language, they are creating a new theory, scraped together

with the help of the outworn tools of the culture that they aim to supersede. The theory is not independent of the expression, and the expression relies for its meaning upon the simultaneous emergence of theory. Traditionally these operations have been profoundly separate, successive and sometimes mutually antagonistic. Among feminists they have become simultaneous and mutually supportive.

I am arguing that feminists can take reinforcement even from conventional masculinist aesthetic theory in so far as it legitimizes the openness and interpretability of experience and promotes the peaceful coexistence of alternative reifications. Aesthetic theory does not forbid hanging a work by Picasso alongside one by Rembrandt and revering them both as great art rather than as competitive visions. The history of art is sometimes misrepresented as a progressive approximation to the truth. This is a pathological misjudgment derived from a view of science and social history that is only slightly less misplaced. By and large, however, aestheticians are not committed to the salvationist premise that ties success to the defeat of the dissimilar. ('We will bury you.') In the realm of the aesthetic we are not undone by multiple, equally viable interpretations of a single state of affairs or works of art. We are not compelled to make definitive or exclusive choices, and yet we are able to state reasons for preferring one choice above another and sometimes for rejecting alternatives that appear unworthy.[7] In short, we are able to live civilly with a level of freedom and plurality in the aesthetic domain that appears to be unacceptable in civil society or in the market of ideas. Feminists question why this is the case, pointing also to such balmful synergism as arises from the multiple and various voices of a chamber orchestra. Far from producing conflict and disorder, their diversity produces a collective experience that is rich and vital for individual listeners and that enhances collegiality. In this respect too, therefore, feminists can look to the aesthetic for a positive model.

I am not proposing that aesthetic experience or the development of aesthetic theory (conventional or feminist) is sufficient as a basis of feminist theory, but I do maintain that the first is necessary to and the second a valuable resource for its construction.[8] I would like now to illustrate with some concrete examples how aesthetic and theoretical reflection do fertilize one another mutually, yielding understanding even of matters that are not overtly or exclusively related to women, feminism or aesthetics.

What Lessons for Theory Can be Drawn from Feminist Theory

Evelyn Fox Keller discusses an instance of theoretical reflection which infuses a feminist consciousness into a biological dispute that is not inherently or directly linked to issues relating to women.[9] Keller describes the unique self-organizing behavior of the cellular slime mold, *Dictyostelium discoideum*. This organism, while in a single cell stage, reacts to starvation by a process of aggregation and differentiation. The prevalent explanation of its behavior was that a special founder or pacemaker cell predetermines and triggers the differentiation. Keller, with Lee Segal, suggested a locally initiated spontaneous organization that did not presuppose the governing pacemaker. Their idea was given little credence in the biological community, leading Keller to ponder upon the similar disinclination on the part of that community to take seriously the non-hierarchical account of cellular process defended by Barbara McClintock. Keller went

on to write an intellectual biography of McClintock in which that biologist's unorthodox manner of communing with organisms is discussed, along with her now famous, but then unusual conclusions.[10] Keller suggests that the predisposition among male scientists to favor single central governance explanations over non-hierarchical ones affects not only their choice of explanatory models, but also the analytic tools (mathematics) that they use to justify these. The non-linear mathematical techniques that have been refined subsequently for modelling steady-state and complex reaction-diffusion systems seem to bear out that suggestion. Keller looks hopefully toward a science that will be receptive to models of discourse sufficient unto the complexity of their task and therefore both non-gendered and non-hegemonic.

Keller observes that it will not be easy to dislodge analyses that use the military 'command and control' imagery because that model has been so indelibly etched into our conception of the universe – with its commander God. All science seems to demand similar large- or small-scale impositions of authority. The idea that a 'simple accumulation of cells and the consequent local exhaustion of food' would be the stimulus for a compensatory mechanism seems downright anarchic and conventionally implausible. The metaphor is inappropriate in a world dominated by male values, but it is not unlike women to come together in little gossipy centers without visible leadership and get things done by a kind of diffusion. Feminist science would support such feminine models, probably with no more conscious awareness of their gendered perspective than is now professed by (masculinist) science when it stands behind the 'command and control' metaphor.

The slime mold example illustrates how feminist consciousness, the assumption of a gendered-feminine point of view, extends the range of plausible interpretations of phenomena, and also reveals how the covertly gendered-masculine point of view restricts the range of interpretations. Feminist perspectives promise greater sophistication, more in keeping than simplifying formulas with the complexity of the world we know.

Feminism is nothing if not complex. Myra Jehlen speaks of the 'fruitful complication' of feminist theory and welcomes contradiction not for its irrationality, but in order to 'tap its energy.'[11] Sandra Harding recommends that we abandon the faith that coherent theory is desirable and instead declare our fidelity to 'parameters of dissonance within and between assumptions of patriarchal discourses,' a route that will free the consciousness that is alienated, bifurcated and oppositional and whose psychic, intellectual and political discomfort we should cherish.[12] These authors convey a certain enthusiasm and delight in the profusion of feminist theory. We must understand that this is not due to a perverse pleasure in the obscure, but to an aesthetic rapport with a situation that does not demand containment, but invites understanding. Gratification arises too with release from theories meant more to subdue and confine than to liberate intellectual inquiry.

A second example of theoretical reflection that uses a feminine metaphor also shows how an overtly acknowledged gendered-feminine perspective enlarges our understanding of a subject that, notwithstanding its inherently female reference, is typically associated with men. Susan Stanford Friedman examines the appropriation of the metaphor of childbirth to artistic creativity.[13] As Friedman points out, the meaning of the metaphor is inevitably overdetermined by resonances of motherhood and the cultural

significance of that institution. In western patriarchal society it evokes the sexual division of labor and the correlative duality of mind and body. Women in that tradition are reduced to the material process of maternity which excludes them from the spiritual act of creative productivity. The use of the childbirth metaphor with reference to artistic creation therefore evokes a paradox. Implicitly, it contradicts the comparison that it calls to mind. Drawing upon reader response theory, Friedman shows how the reader's gender, but also that of the authors, as well as the reader's expectation of the author's gender, affect the construction of the metaphor's significance.

Applied to a female artist, the metaphor takes on the meaning of slow and painful delivery, continuous involvement with the offspring, loving oversight, and protective concern. The woman's double-birthing capacity as woman and as artist is evoked, sometimes as a conflict, but often as mutually intensifying. Directed at the male artist, the metaphor highlights the tension of overcoming natural impossibility. Childbirth here is a heroic act, sometimes involving the expulsion of a resistant object into the light of day.

The pervasive use of the childbirth metaphor (and such correlated images as conception, incubation, gestation, and parturition) to express male activity – even in blatantly anti-maternal contexts such as the production of the atomic bomb – raises questions as to the intention of the users. Friedman contends that for both biological and historical reasons, men and women bring different meanings to the metaphor. Men's use of it begins in distance from the Other and expresses ambivalence toward it – desire and rejection, reverence and fear, envy and hatred. Having given birth to the object, one has demonstrated power over it and has it, so to speak, under control. Men's image of childbirth is god-like and detached, though the appearance of the child is often associated with the mortality of its author and therefore engenders mixed emotion. Women are likely to employ the metaphor in a more intimately personal fashion. Some suggest the conflict of the woman who is an artist in contravention of social prescription. Others reflect upon the fragility of the offspring and the constancy of its need for care and nurturance. Still others express relief at the lifting of a burden carried alone, and anxiously assume a new burden of shared responsibility. Friedman anticipates that, with changing mores and the spread of feminist ideas, the profusion of meanings of the birth metaphor will increase, especially as women seize upon that image to celebrate their own self-creation. Women giving birth to themselves was a popular image of the 1970s.[14]

Friedman notes that some women internalize male ambivalence toward childbirth, expressing fear that genuine maternity will undermine their creativity. At the same time, other women wear their (pro)creativity proudly and defiantly, exulting in their animal vigor. Men do not face this duality, and their conception (*sic*) of the creative experience is essentially intellectual. Through her analysis of a variety of gendered differences in uses of the birth metaphor, Friedman reveals the male focus on exclusion and separation in contrast to women's emphasis on collusion and union. Women's exclusion from the creative process has effectively extended to denying them access to the metaphor of (pro)creativity as well. Apart from the irony of this prohibition, the silencing of women's voices deprives not only women but the world, of rich insight into the complex process of creation. By contrast to the feminine deconstructions of the birth metaphor, those offered by men are formulaic, disingenuous and dull.

In this example, a gendered analysis of an apparently non-gendered phenomenon de-conceals the difference that gender makes. Retailed concrete experience in place of wholesale abstractions discloses aspects of mothering, fathering and parenthood that are normally suppressed by metaphors that replace and discount experience that is surely relevant. Gendered-feminine imagery awakens attention to phenomenal complexity and revives the stagnant intellect so that it may once again question the obvious and take note of the anomolous. We have been immunized against contradiction by the male-appropriated metaphor of childbirth. So deeply etched upon our consciousness is the myth that neutral creativity can bring forth monsters as word becomes deed, will becomes act, and the maker leaves his mark upon dumbly resistant matter that we forget the origin of this revolting parody. Friedman does not discuss the practical urgency of bringing feminist theory to bear on this state of affairs, and I cannot do more at this point than call it to the reader's attention in the hope that the need will be clear. In that hope, I conclude instead with some remarks about the pleasures of theorizing.

The Aesthetics of Theory

Not everyone loves theory. Some of its opponents find it dry and dull, and others are offended by its cold calculation. Some feminists denounce theory as impractical and removed from reality while others object to its arrogant authoritarianism. Some accuse feminist theorists of capitulating to male ideology, of 'selling out,' and suspect them of seeking male power. However, theory-making need not be assaultive or a rape. It can be festive and voluptuous, an act of love that heals and strengthens and is a source of pleasure. Feminist theory, unlike some feminist practice, is not destined to make itself superfluous. As a musing upon its own edges, it envisions a process of self-explication and understanding that is likely to remain with us.[15]

Theory production is not usually described as aesthetic activity, but there are hints among contemporary apologists for theory who are sensitive to its aspect as self-contained entertainment. Pierre Bourdieu, for example, applauds Jacques Derrida's examination of Kant's *Critique of Judgment*, describing it as a 'skewered' reading in which the treatise is treated as a work of art to be approached disinterestedly, for pure pleasure that is irreducible to pursuit of the profit of distinction. By dramatizing or making a spectacle of the 'act' of stating the philosophy the critique draws attention to itself as philosophical gesture. However, Bourdieu goes on to note the serpent in Paradise: 'Even in its purest form, when it seems most free of "worldly" interest, this game is always a "society" game based . . . on a "freemasonry of customs and a heritage of traditions".' In other words, there are rules that delimit the sacred space and the players of the game, and they are meant to be exclusive.[16] Women 'might as well have beards' – they do not belong here.

Excluded by the rules, feminists have not given up on the pleasures of theorizing however limited are the options available within the mainstream. Women can join in the game as junior partners with patronizing approval from the elect, or accept a designated position as outsiders. Feminists have rejected both options. Instead, they are construing a theoretical discourse that draws upon an alternative aesthetic. It does not resemble the heritage claimed by conventional aestheticians, a yoking of Greek theory

of Beauty and Poesis with eighteenth century theory of taste. Instead it builds directly upon an aesthetic experience that is not transcendent and does not exalt duality. It therefore disregards many of the problems and puzzles of classical aesthetics. Feminists are not much occupied, for example, with the relation of the autonomous artist (the subject author) to the object that he wills into being. Genius is a male concept that feminists find of little interest. They do not question the subject/creator's rationality or freedom, or the merits of (objective) representation over (subjective) expression. Feminists do not endorse the dualisms of mind over matter, determinism vs. freedom, intellect vs. feeling, subject vs. object, art vs. recreation, work or other forms of doing. They take very seriously the domination of one invented pole by another, and explore in art and its theory the multifarious phenomenology of that relation. There is also among feminists a fascination with the transformation of media, be it the woman herself, the language she employs, or the pliant matter that she works. Feminists are not unconscious of the traditional interests of aestheticians in defining art, its life and death, its judgment and (proper) appreciation. Beauty and ugliness, form, expression and representation, are topics that feminists address, but they are not feminist issues and rarely arise as Problems within a feminist framework. No one pretends that the conventional problems have been solved, but they have been superseded by others of greater interest.

So far, feminist theory has been concerned chiefly with the deconstruction and critique of phallocratic theory and practice. Feminist theory is invoked in a piecemeal fashion, and only when the context of experience or discourse seems to require it, often as a corrective to conventional exclusivity or generalization. Feminist theory is still in its infancy, and feminist aesthetic theory has barely seen the light. I am suggesting that aesthetic theorizing can provide a key to the development of feminist theory for several reasons. (1) Because it necessarily adheres to the minutiae of the immediate and the experiential, aesthetic theory is genuinely pluralistic. It is bound to seek intelligibility among the anecdotal iterations. It must be undaunted by complexity and undevastated by uncertainty. Indeed it must greet these with joy. (2) Aesthetic theory must be open to innovation, since art is inherently expansive, ever appropriative of new materials, technologies, techniques and concepts. The multiplicity at its heart is not a mere contingency, but is its very meaning. As the source of life and the perpetuation of the species, women, likewise, have a commitment to innovation and to a future that is open-ended. Submission to a fixed definition is not only violence to the spirit; it is its death. (3) Aesthetic theory has long played a peripheral part in the global schematism. Parasitic upon art, itself a commentator, aesthetic theory has been consigned to the sidelines of conventional theory, where it recapitulates the problems and paradoxes of metaphysics and epistemology. Feminist theory reverses that practice and gives the aesthetic pride of place. Renouncing universality and attending closely to the particular, feminist theory accentuates those events and circumstances that are divulged in aesthetic experience and works of art. Feminist theory reclaims that which traditional philosophy pronounces inessential, contingent and superfluous. This is the domain of the aesthetic, and feminist theory, by embracing it, can retain a perspective on value that is neither undermined by marginality nor in demand of sanctification. Feminist theory affirms pluralism without celebrating relativism and without despair.

Notes

1 John Hospers in *Meaning and Truth in the Arts* (Chapel Hill, NC: University of North Carolina Press, 1946) distinguished between a 'thin' formalist sense of the aesthetic and a 'thick' contextualized sense. At that time the former was prevalent both in the arts and in philosophy of art. At the present time the fashion has turned toward the thick in both areas.

2 This paradox is at the root of the Kantian analytic and of twentieth-century analytic philosophy. It is uniquely treated by Arnold Isenberg in *Aesthetics and the Theory of Criticism*, especially in the essay 'Critical communication', ed. Callaghan, Cauman, Hempel, Morganbesser, Mothersill, Nagel and Norman (Chicago: University of Chicago Press, 1973).

3 Morris Weitz, 'The role of theory in aesthetics', *Journal of Aesthetics and Art Criticism*, 15 (1956); William Kennick, 'Does traditional aesthetics rest on a mistake?', *Mind*, 67 (1958); Paul Ziff, 'The task of defining a work of art', *Philosophical Review*, 62 (1953), and others observe that traditional theories of art such as the imitation, expression, formalist theories and their variants, though applicable in principle to the same works of art, were actually advanced by their promoters in order to justify new art forms. They concluded with the bankruptcy of all definitions of the general idea of art and turned unapologetically to the differences between artforms and among art objects.

4 Erik Erikson gave pride of place to space, absence and negativity in women's experience because of an imagined analogy they bear to women's anatomy; 'The inner and the outer space: reflections on womanhood', *Daedalus*, 93 (2) (1964). A more plausible resonance for feminists is in the figurative hollow of woman as potentiator. As mothers, but also in many other private and professional capacities, women create the time, the space, and the limits in which men, other women and children grow, move, experiment and think; see Ruth Perry and Martine Watson Brownley (eds), *Mothering the Mind* (New York: Homes and Meier, 1984). In the struggle for equality women often focus upon space as one of our greatest needs, viz. V. Woolf, *A Room of one's Own* (New York: Harcourt, Brace and World, 1929). See also 'Womanhouse' by Miriam Schapiro and Judy Chicago (California Institute of the Arts, 1973). Space and time of our own are critical factors in all the centers for battered women, rape and incest victims, abortion referral, child care, health care and reading centers. Artists, novelists and poets celebrate their newly reclaimed sense of time and space, and these have even begun to make inroads among geographers, archaeologists, linguists and others.

5 Radical transformations in style mark artistic movements throughout history. Profoundly philosophical at their center, such developments in art as the rise of abstractionism, cubism, impressionism and varieties of analysis speak as much to epistemological change as to social crisis. Without insisting upon autobiographical detail, one may assume that sensitive and aware artists would be affected by the major perturbations in the *Zeitgeist*. That women and feminist artists should resonate with those social movements that affect them most closely should surprise us no more than that Goya was affected by the Spirit of the Enlightenment or that Giotto reflected controversial tendencies within Christianity.

6 Lisa Tickner, 'The body politic: female sexuality and women artists since 1970', in *Framing Feminism: Art and the Women's Movement 1970–1985*, ed. Rozsika Parker and Griselda Pollock (London: Pandora Press, 1987).

7 Analytic aesthetics, even during the period of its greatest estrangement from professional philosophy, was preoccupied with the justification and the logic of critical judgment. However puzzling the possibility of standards might be, it was never seriously in doubt that some art is better than other art, that some interpretations are more plausible than others, that, in short, taste is disputable and for legitimate reasons. What was clear was that these reasons did not hold as dictatorial a sway over action and opinion as the injunctions of law and ethics or the rationalizations of the system of truth.

8 It goes without saying that not all the preoccupations of conventional aesthetics are of equal worth to feminists. Many remain within the standard hierarchical lexicon of philosophical rationalization of the masculinist worldview. Feminists have not been greatly concerned, for example, with

distinguishing the 'beautiful' from the 'sublime' or with driving a wedge between 'high' and 'low' art or identifying art that is 'popular,' 'decorative' or 'secondary' in order to contrast it with 'fine' art. Feminists have also avoided discussing aesthetic theories that defend the aesthetic experience as one that assumes 'distance' or 'disinterest'. This is not because these problems have been solved, but because they do not merit solution.

9 Evelyn Fox Keller, 'The force of the pacemaker concept in theories of aggregation in cellular slime mold', in *Reflections on Gender and Science* (New Haven, CT: Yale University Press, 1985). Reference is made to a collaborative study with Lee A. Segal in *Journal of Theoretical Biology*, 26 (1970): 399–415.

10 *A Feeling for the Organism: The Life and Work of Barbara McClintock* (San Francisco: Freeman, 1983). McClintock was subsequently proven right and acclaimed by the community that had ostracized her. She won first the prestigious MacArthur 'genius' grant, and then a Nobel Prize for her work in genetics.

11 Myra Jehlen, 'Archimedes and the paradox of feminist criticism', in *Feminist Theory: A Critique of Ideology* (Chicago: University of Chicago Press, 1981).

12 Sandra Harding, 'The instability of the analytical categories of feminist theory', *Signs* (spring, 1988).

13 Susan Stanford Friedman, 'Creativity and the childbirth metaphor: gender difference in literary discourse', *Feminist Studies*, 13 (1) (Spring 1987).

14 It is possible that she is wrong about this. Perhaps the increased technologizing of the birth process and the compromises that women are making in order to achieve equality will lead to the masculinization of childbirth. This question is poignantly explored in novels such as *Woman on the Edge of Time* by Marge Piercy and *The Handmaid's Tale* by Margaret Atwood.

15 Unlike those followers of Wittgenstein who expected philosophy to put itself out of business once its therapeutic job was done, feminist theorists fully anticipate that reality will keep gushing along, presenting new and unresolved questions for the pleasure of our understanding.

16 Pierre Bourdieu, *Distinction: A Social Critique of the Judgement of Taste*, trans. R. Nice (Cambridge: Cambridge University Press, 1984).

Belinda Edmondson, 'Black Aesthetics, Feminist Aesthetics, and the Problems of Oppositional Discourse' (1992)

From *Cultural Critique*, 22 (1992), pp. 75–98.

In recent years American and, more particularly, European feminists have sought to identify a 'feminist aesthetics' or a purely 'feminine' writing in order to distinguish the 'true' female experience from its representation within canonical, patriarchal discourse. In the haste to identify and develop a discourse empowering to women, no particular distinction is made between 'feminine' and 'feminist,' since the former is understood to embody the latter. And while the formulations of a feminist aesthetic vary greatly among its advocates – the American school presupposes a specifically female consciousness in its reading of canonical and noncanonical female-authored works while the French school privileges formal and linguistic experimentation – the premises upon which the formulations are based are the same: namely, that an essentially female/feminist discourse exists or can be created.

The polemics and political thrust of this line of feminist criticism strongly resembles arguments made by the Negritudinists of the 1930s for a pan-African aesthetic and, more particularly, arguments of the (male) black literary theorists of the 1960s and 1970s, who similarly sought to define that ephemeral thing – the 'black novel' – through the concept of a diasporically all-inclusive 'black aesthetics.'

However, while many American feminists have linked the political agendas of blacks and (white Western) women, and (in an argument which brings uncomfortably to mind Freud's depiction of [white] woman as the Dark Continent) feminist scientist Sandra Harding (1986) has gone so far as to suggest that blacks and (white Western) women share a common 'worldview,' no one would suggest that a feminist aesthetics and a black aesthetics are the same thing. (Indeed, a culture-based aesthetics stands on surer ground, I would think, than a gender-based aesthetics, though even to claim that black aesthetics is grounded in culture and not politics is to stand on shaky ground indeed.) Yet, as we have seen, traits commonly identified as belonging to an intrinsically 'feminine' discourse – that is, the fragmented, circular, or otherwise antilinear (some would call it 'anti-phallocentric') narrative – are also the bywords for the 'black novel.' The mutability of this narrative category suggests that it might owe more to an oppositional tradition in literature than to a specifically culture-based or gender-based aesthetic, and certainly some of the most revered canonical works in the Western tradition arose out of a tradition of 'negative aesthetics.'

The disconcerting similarity between these two 'camps' is further complicated by the recent advocacy by black feminist authors and scholars for a black feminist aesthetic, epitomized by Barbara Smith's (1985) seminal essay 'Toward a Black Feminist Criticism.' My intent, then, will be, first, to define and disentangle these overlapping definitions of aesthetic criteria; my second, to identify any critical differences in black and feminist formulations; third, to connect the philosophical problems in formulating black and feminist aesthetics to the effort in recent Marxist scholarship to reconcile utopian political goals with the 'realities' of class and group consciousness; and finally, to elucidate whether in fact such categories are useful to authors and scholars interested in social transformation. I shall discuss the various versions of the black aesthetics movement which have circulated within the diaspora and their correlative debates in recent feminist criticism; from there I shall look at theoretical attempts by Rita Felski and Henry Louis Gates, Jr – with a quick comparison to Fredric Jameson's efforts on behalf of Marxist scholarship – to remedy the problems of what Anthony Appiah (1986) calls 'the classic dialectic' of marginalized discourses.[1]

Locating Blackness: Negritude, Pan-Africanism, and the Black Aesthetics Movement

Before proceeding to compare black and feminist aesthetics, I need to clarify precisely what I mean by black aesthetics, which connotes different things in different contexts. The debate over what constitutes the black aesthetic has dominated discussions of Afro-American, African, and Caribbean literature; the problem with the term is self-evident: it suggests a cohesiveness of culture and context that simply does not exist, at least to the extent that an orthodox application of the term would demand. Yet despite this, the

term persists, and the debate continues because of the relative sameness of position that *all* black peoples find themselves in with regard to white culture in the Western world, an ironic but pivotal factor in the formulation of the black aesthetic. As such, oppositional racial politics is an intrinsic part of black discourse.

Like the French feminists, the Negritudinists – interestingly enough, all French colonials of Africa and the Caribbean – also emphasized an essential blackness grounded in biology, which, they argued, was reflected in black art and literature. Ironically, Léopold Senghor – Senegalese poet, president, and a key figure in the Negritude movement – cites the racial theories of the racist French intellectual Gobineau and others when he insists that emotion is the domain of black people (Senghor, 1964: 136, 141).[2] And the poet Aimé Césaire, one of the founders of Negritude, writes, '[T]here flows in our veins a blood which demands of us an original attitude toward life . . . [W]e must respond, the poet more than any other, to the special dynamic of our complex biological reality' (Taylor, 1989: 173).[3] As such, while the black aestheticians of the later period stressed a shared history of suffering and resistance to white hegemony over any shared biological heritage, the result was the same: the claim to a literature which possessed essentially black discursive properties.

The cognizance of the political dimensions of African-American art is commonly held to have begun with the Black Arts Movement heralded by Amiri Baraka, Addison Gayle, and Larry Neal in the 1960s, but recently some African-American scholars have been arguing very persuasively that the very *genesis* of African-American arts was itself political. According to bell hooks, whatever African-Americans created in music, dance, poetry, painting, and so forth, challenged racist beliefs that blacks were uncivilized and that they were collectively incapable of creating 'great' art. Furthermore, she states, African slaves brought with them an aesthetic emphasizing kinship ties that helped to ensure the survival of the community; as such, these ideas formed the basis of African-American aesthetics since cultural production and artistic expressiveness were also ways for displaced African people to maintain connections with the past (hooks, 1990: 105).

However, recently it has been argued that the earlier efforts of W. E. B. Du Bois and the later Harlem Renaissance writers to formulate an African-American aesthetic was in effect a move *not only* to counter white claims that blacks had no art and therefore no culture but also to erect an African-American aesthetic as *the* American aesthetic. This is similar to how white America itself labored under a sense of its own lack of culture when compared to Europe and therefore searched for a peculiarly *American* aesthetic (see Warren, 1989: 178–80). As such, one might infer that though at one level the aim of these African-American progenitors of the black aesthetics movement was to seek an African connection, at another, their aim was to become an established influence in American society as a whole. There are echoes of this in J. Saunders Redding's observation in the mid-70s that 'even while [African-American students] sloganize "Back to Africa" and form study groups and forums as the means by which they will reclaim their African heritage, they are saying in the words of . . . Langston Hughes, "I, too, am America"' (Redding, 1976: 46).

The impetus for a Caribbean aesthetic has similar political motives that strive to uncover an 'authentic' and liberating African-based culture from the stifling confines of European mores and structures. Yet discussions of an authentic Caribbean aesthetic most often fall into a sort of orthodoxy of blackness. A case in point: the Barbadian

poet and scholar Edward Brathwaite, in his definitive essay on Caribbean aesthetics (Brathwaite, 1976), approvingly cites Jamaican scholar and author Sylvia Wynters's call for the West Indian writer to focus on the 'anonymous mass of our people' who have 'absolutely no documented history at all,' even as he notes that she herself has not yet been able to capture that authentically Caribbean 'form' in which to do so. However, he adds, she is working her way toward it, moving as she has from 'Marxist overtones and citations' to 'African culture' (1976: 27). Elsewhere, in *Contradictory Omens* (1978), he denies white Dominican writer Jean Rhys admittance to the West Indian canon on the basis that her writing does not adhere to an Afrocentric worldview, arguing that her novels are more English than they are Caribbean. Brathwaite's remarks embody the basic tenets of the Caribbean aesthetics as they have been thus far defined: black, working-class culture is the 'authentic' culture of the Caribbean, and 'authentic' Caribbean writing must utilize the creole languages and exhibit principles of orality among other things (this is particularly ironic, since most Caribbean writers come from the logocentric middle class and are familiar, mostly from a distance, with working-class oral black culture).

This codification of black reality is not confined to the Caribbean alone. Both Caribbean and African-American aesthetics are based on the presumption of an African aesthetic, to be uncovered whole under the layers of hegemonic European culture. Yet, African scholars and writers have been wrangling for decades over precisely this notion, inasmuch as an African aesthetic may be no more than a Yoruban aesthetic – something which Wole Soyinka advocates even as he does not particularly 'buy into' the notion of an African or a black aesthetic – or a Gikuyu aesthetic or a Wolof aesthetic, and so on.

A number of texts on the subject attempt the sort of codification Brathwaite displays in order to pin down what a 'black' text really is, and the most common traits cited are, as I noted above, the so-called 'circular' narrative which makes use of a 'myth-based' 'non-Western' time found in agrarian societies of Africa,[4] 'orality' (the discursive representation of oral narrative forms – a hard concept to pin down in a written document), realist writing that is accessible to the uneducated reader and which does not utilize any of the 'elitist' stylistic innovations of the modernist and postmodernist schools, and, finally, the 'authentic' language of black people, whether African-American dialect, Caribbean creole, or indigenous African languages.

Yet while these narrative traits are more or less observable in several African texts the same cannot be said for 'black novels' from North America or the Caribbean, where the debates over the 'black' aesthetic were markedly different from their African counterparts in that the debates tried to establish what a 'black novel' *should* do rather than determine to what extent the novels actually *did* so. The Black Arts Movement in the United States during the 1960s and the early 1970s attempted to lay down criteria for black literature. What emerged was a body of literature and drama of a didactic and historically specific nature, and not often referred to in present debates on black discourse. And yet art products *are* historical items, and any discussion of an all-encompassing black aesthetic must take into account the historicity of the black text rather than only ground it in an essence of 'blackness.' Interestingly, the best examples of a black aesthetic as it has been defined in these debates are to be found in the more recent fiction of African-American women, such as Toni Morrison's *Song of Solomon*. Much of this literature, ironically, is often perceived as politically moderate or even

conservative because of its indifference to analyzing or depicting white racism, focusing instead on the day-to-day lives of its black characters.

Feminist Aesthetics and the Question of Essence

Turning to the feminist sphere, one finds a similarly complex and factionalized debate over the constitution of a feminist aesthetic. These advocates of feminist aesthetics believe that current aesthetic criteria are chosen solely because they endorse dominant ideology; as Gayle Greene and Coppelia Kahn (1985: 22) put it:

> The criteria that have created the literary canon have, like the traditional conception of history, excluded the accomplishments not only of women but of people of races, ethnic backgrounds and classes different from the politically dominant one, which is Western and white. Feminist criticism questions the values implicit in the Great Works, investigating the tradition that canonized them and the interests it serves . . .

As such, recognizing that art is produced and given meaning through various ideological and social formations, one might infer that the primary thrust of feminist aesthetics advocates is to replace one set of political underpinnings with another.

Yet much of this scholarship argues, paradoxically, for an ahistorical female essence, grounded in a biological imperative, giving rise to an essentially female way of thinking (so the premise goes) that in turn dictates a specifically female language, which consequently manifests itself in a female way of writing: Luce Irigaray's *parler femme* and Hélène Cixous's *l'écriture féminine*.[5] To confuse matters, *feminine* and *feminist* writing/language is conflated under this prescription, and because every woman must write as a female and because female language is intrinsically oppositional, it would follow that every female-authored document is inherently feminist. Furthermore, as more than one outraged critic has pointed out, these theories depend on an essentialist construction of woman to make sense, and as everyone knows, essentialism is bad, bad, bad.[6] Lost in the acrimony is the most enduring point: any articulation of a female consciousness *necessarily* involves an essentialist construction of the subject.

Black Aesthetics, Feminist Aesthetics: Are They the Same Thing?

Are the persistent similarities in feminist and black aesthetics the result of similar worldviews or similar desires for difference and sameness? By way of answering, let me point out a precursor of this connection between the interests of white women and blacks in the transient yet significant coalition of the women's movement and the antislavery movement during the nineteenth century. As Angela Davis (1981) points out, white women invoked the analogy of slavery to express the oppressive nature of marriage.[7] One might argue that the invocation of black people was strictly a political tactic to highlight their own condition, but certainly it highlighted a mutual source of oppression. Of the current debates, it is conspicuously apparent that whereas

white feminists continuously link feminist oppositional practices to black oppositional practices, the reverse is definitely not the case. Indeed, black scholars have traditionally remained ominously silent on this score; the connecting factor is, of course, the recent criticism by black feminists, but as we shall see, this does not necessarily explain the situation.

The progenitors of black aesthetics have left their mark on today's black theorists, who, while negotiating issues of gender and class, nevertheless adhere to a principle of blackness similar to that of their predecessors. Yet each criterion they raise as formulating part of an intrinsically black discourse is paralleled by similar moves in the feminist sphere. Just as black scholars have emphasized the personal narrative and the autobiography as particularly suited to black authors, so have feminist scholars claimed the same for (white) women. For instance, Selwyn Cudjoe (1984: 6) claims that 'the Afro-American autobiographical statement is the most Afro-American of all Afro-American literary pursuits': this is because it is 'bereft of any *excessive subjectivism* and *mindless* egotism,' and represents the autobiographical subject emerging as an almost random member of the group, selected to tell his/her tale (1984: 9). As such, black autobiographical literature emphasizes the commonality of black experience and its position as an alternative history. Similarly, Rita Felski (1989: 94) observes that, in its effort to document a distinct women's history, 'feminist confession . . . is less concerned with unique individuality or notions of essential humanity than with delineating the specific problems and experiences which bind women together. It thus tends to emphasize the ordinary events of a protagonist's life, their typicality in relation to a notion of communal identity.'

Furthermore, just as black scholars, echoing W. E. B. Du Bois's famous declaration that the black American possesses a 'double consciousness,' argue for the innate double-voicedness of black speech, so do (white) feminists argue the same for female language. Henry Louis Gates, Jr, formulates this hypothesis in *The Signifying Monkey* (1988) and used it to defend the rap group Two Live Crew on charges of obscenity by arguing that black speech is inherently double-voiced – that is, what sounds like obscenities to the nonblack ear are in reality an ironic commentary (Gates, 1991: 3). (Gates's intellectual virtuosity notwithstanding, this black listener could discern no finely veiled irony in 'make the pussy splat.')

Similarly, Elaine Showalter (1985: 263) states that 'in the reality to which we must address ourselves as critics, women's writing is a "double-voiced discourse" that always embodies the social, literary, and cultural heritages of both the muted and the dominant.' Rachel Blau Du Plessis (in a self-conscious essay which attempts to simulate a 'feminine' aesthetic through a fragmented narrative style) claims even more unequivocally that this double-voicedness is inherently female:

> Insider–outsider social status will also help to dissolve an either–or dualism. For the woman finds she is irreconcilable things: an outsider by her gender position, by her relation to power; maybe an insider by her social position, her class. She can be both. Her ontological, her psychic, her class position all cause doubleness. Doubled consciousness. Doubled understandings. How then could she neglect to invent a form which produces this incessant, critical, splitting motion. To invent this form. To invent the theory for this form.

Following, the 'female aesthetic' will produce artworks that incorporate con-
tradiction and nonlinear movement into the heart of the text. (Du Plessis, 1985: 278)

However, Du Plessis does acknowledge that other writing – nineteenth-century Russian
fiction, 'high' modernism, and most particularly, the Negritude literature – exhibits the
'nonhegemonic' tenets ('pointless' or 'plotless' narratives, etc.) that she has assigned to
the feminine aesthetic, but she does not make this observation in order to derail her
argument, for she separates what she perceives to be oppositional convergences from
aesthetic practices. This is most difficult to do when making comparisons to black
writers; nevertheless, she asserts, though blacks will also 'affirm a connection to rhythms
of earth, sensuality, intuition, subjectivity,' they will only '*sound* precisely as some woman
writers do' (1985: 286, my emphasis). The similarity, in other words, is a surface one.

Replacing Female Essence: The Feminist Public Sphere

Feminist scholar Rita Felski critiques the entire notion of feminist aesthetics and instead
advocates what she terms a feminist public sphere as a better model from which to
develop a counterdiscursive space for feminism. In *Beyond Feminist Aesthetics*, Felski
(1989) argues that it is impossible to define a feminist aesthetic, correctly pointing out
that 'women-centered' writings are not necessarily, ideologically speaking, feminist
and that even texts with an explicitly feminist agenda usually owe more to various
oppositional literary genres (for example, postmodernist, avant-garde writing) than to
a specifically feminist way of writing; indeed, as Felski notes, the common equation of
the feminine with the oppositional collapses crucial distinctions in ideology, culture,
and class through an appeal to a common negativity (describing oneself through what
one is not), which in turn is equated with the feminine – hardly the way, it would seem,
to articulate a useful theory of feminist aesthetics. Since the Western ontological
concept of Man has traditionally depended on such attributes as rationality and
linearity, attempting to empower the category of Woman by merely revaluing the
antithesis of these would not only preserve but ironically reinforce this formulation of
Man. Furthermore, this binary relation would then subsume everything that is not Man
under the category of Woman; this logic has indeed permeated oppositional discourse
to the point where Caribbean feminist Carol Boyce Davies (1990) feels compelled to
reassure Caribbean men that 'women's issues, and development, need not mean the
further erosion of their manhood' (1990: xvi).

In concluding her critique of aesthetics, Felski notes that stylistic innovations, or any
particular literary technique, for that matter, can be used to generate conservative or
radical meanings depending on the agenda at hand, and concludes that '[i]t is thus
increasingly implausible to claim that aesthetic radicalism equals political radicalism and
to ground a feminist politics of the text in an assumption of the inherently subversive
effects of stylistic innovation' (Felski, 1989: 161). However, I am not sure that this is
what feminist aesthetics – as a broad category – tries to do (the French school being an
obvious exception). As is the case with black aesthetics, it seems that the focus is rather
to *retrieve* radical meanings from extant texts and to construct an aesthetics out of a
literary tradition spanning different eras and stylistic genres.

Furthermore, having disposed of the premise for a feminist aesthetics, she then argues *against* the dissolution of aesthetic categories, stating that 'this repoliticization of the aesthetic sphere does not imply, in my view, that aesthetic categories are to be interpreted as a direct reflection of the interests of a political ideology, or that literary meaning is limited to its current political use-value for the women's movement' (Felski, 1989: 175). She goes on to assert that the correct relationship between aesthetics and ideology is 'a continuum in which the aesthetic function may be more or less dominant but always intermeshes with the ideological conditions governing the text's own historical location' (1989: 177).

However, I should point out that it would be an injustice to Felski and a misreading of her very thorough argument to lump her in with the orthodox poststructuralists who believe that any conception of the subject is founded on an inevitable phallocentrism because it must necessarily involve the repression of other groups or ideas. And unlike those poststructuralists who critique the very premise of race- and gender-based discourses, Felski sees the need for a conception of subjectivity in feminist discourse even as she warns against its becoming dissociated from its origins as a political construct erected to address particular strategic concerns:

> [T]o expose critically the inadequacies of the rationalistic and self-sufficient individualism of liberal political theory is not thereby to argue that subjectivity should be abandoned as a category of oppositional political thought, nor does the decentering of the subject in contemporary theory mean that discourses which appeal to an experience of self are therefore anachronistic. Subjectivity remains an ineradicable element of modern social experience . . . (Felski, 1989: 68)

And furthermore: '*[E]ven the most subjective feminist writing . . . appeals to a notion of communal identity which differs significantly from the literature of bourgeois individualism*' (1989: 78, my emphasis). Yet elsewhere she argues that there is no archetypal female subject and warns that '[t]he ambiguous status of subjectivity in contemporary women's writing will become apparent . . . [in] the possibility that the very pursuit of authenticity can become a self-defeating process' (1989: 75). This last clause is crucial to understanding Felski's notion of subjectivity, and is the basis of what I see as a fundamental contradiction in her position, which is symptomatic of a larger tension in feminist and black discourse in general (a problem I shall address later in this paper).

Felski does, however, put forward some useful ideas for the rehabilitation of the notion of subjectivity in her analysis of the so-called death of the subject in postmodern society. She argues that reconstitution of the subject does not have to entail the mere replacement of the white heterosexual Western bourgeois male subject with the black/non-Western/lesbian/female subject – the problem here is in our very *notion* of what constitutes subjectivity. As a solution, she advocates the creation of a feminist counter-public sphere, modeled on the Habermasian definition of the public sphere of bourgeois white Western men of the eighteenth century, where all men were equalized by their participation in rationalism and enlightenment. In this countersphere, the various factions of the feminist movement would be united by their common gender and oppressive status to men:

Like the original bourgeois public sphere, the feminist public sphere constitutes a dis-
cursive space which defines itself in terms of a common identity; *here it is the shared
experience of gender-based oppression which provides the mediating factor intended to unite
all participants beyond their specific differences . . . [T]he 'we' of feminist discourse is
intended to represent all women as callective cosubjects.* As a consequence, the women's
movement can accommodate disparate and often conflicting ideological positions,
because membership is conditional . . . on a more general sense of commonality in
the experience of oppression. (Felski, 1989: 166–7, my emphasis)

While I find Felski's notion of feminist public sphere useful in theory, and certainly
desirable in practice, it has universalizing overtones which gloss over difference: that is,
is common female status enough to generate a conversation, especially when the very
conception of womanhood is at issue? I am thinking particularly of black women's
relationship to feminism and of the history of womanhood in the Western world, where
black women – and men, for that matter – were in a sense degenderized altogether. As
Hazel Carby (1987: 39) notes, the cult of true womanhood in nineteenth-century
America, which drew ideological boundaries to exclude black women from 'woman'
(woman being that which is virtuous, chaste, etc.), is reflected in twentieth-century
notions on the subject. We might infer the same of manhood, which could never be
achieved by black men because as slaves they could not protect and make inviolable
the body of the black woman, a necessary prerequisite of manhood (Carby, 1987: 35).
Correspondingly, there was very little division of labor on the slave plantation, and
certainly throughout most of the twentieth century Western black men and women have
been in the work force in comparatively equal numbers.[8] As such, current calls for the
dissolution of gender roles will not have the same effect in communities where such
roles still have the aura of luxury. There is also a certain irony in her choice of model,
in that membership to the public sphere of the eighteenth century required rational
thought, of which women and, more particularly, nonwhites were deemed to have none.

Moreover, debate within a public sphere is not so much contingent upon possessing
common social status as it is on speaking the same language, and I am not altogether
convinced that this should be taken as a given in feminist discourse. One might argue
that the very language of feminism is fiercely contested. For instance, although Felski
acknowledges that the 'ideal of a communal gendered identity generated by the femin-
ist public sphere . . . can be viewed negatively as ideology insofar as it fails to come to
grips with the material reality of class – and race – divided society' (1989: 169), she
then argues that radical critiques of white feminists, such as bell hooks's, presuppose
and are only made possible through a preexisting ideal of a feminist public sphere which
claims to represent all women (1989: 168). And while I agree with this to a certain
extent, it does not take into account the discourses generated *within* particular groups
that do not engage 'mainstream' feminism; consider, for instance, Toni Morrison, an
African-American author much cited in feminist and black literary criticism, who rejects
unequivocally feminism as the prerogative of white women as well as the notion of an
all-inclusive black aesthetic, arguing that '[b]lack men don't write very differently from
white men' but that there is an 'enormous difference' in the narratives of black and
white women.[9] Morrison is in the curious position of disavowing a feminist aesthetic
and a black aesthetic yet affirming a black feminist – or rather, *female* – aesthetic. At

what point does – or can – a position such as hers enter the feminist public sphere? Can Morrison inhabit a position within the feminist public sphere when for all practical purposes she does not believe it to exist? This dilemma would also seem to highlight the problem of reading as a critical component of the feminist aesthetic, but it is one I will not be addressing here.

As a parallel issue in black aesthetics, we must also ask ourselves how, in fact, can black women's writing be 'blacker' than that of the men? Since, according to Morrison, black men's writing is structurally indistinguishable from white men's, does this mean that black women's writing embodies the 'authentic' black experience? Morrison's logic seems grounded in the sort of essentialism which views women as 'natural' bearers of culture, and therefore black women writers as possessing cultural intuitiveness that 'transcends' the adversarial (as I think she would see it) phallocentric writings of black men, even though the latter are engaged with racial politics.

Nor does Felski's formulation address the fact that, as it is, the parameters of the debate within feminist discourse are themselves defined by power relations among its participants. This is so much the case that black feminist criticism, for example, is marginalized within the discourse by being categorized either as merely 'celebratory' because of its emphasis on the personal experiences of black women, or as solely 'political,' a symbol or signifier for white feminist theory but not theoretical in and of itself.[10]

These reservations notwithstanding, I find Felski's theory of a feminist public sphere convincing enough to apply its logic to the black aesthetics debate. If Felski's arguments against the essential properties of art or discursive formations hold true for feminism and its constituents, should this not also hold true for black aesthetics and *its* constituents? This is an issue which logically leads to my overarching concern of whether *all* oppositional social movements are not in some key sense overturned by a dismantling of a discourse which is vitally bound together by an essential – and yes, essentializing – concept of its own subjectivity, on which aesthetic theories are inevitably based.

Reading Blackly: Black Aesthetics and the Post-structuralist Debate

At this point it might be useful to outline current debates among black literary theorists on how to explicate the black text, since the issues raised here about the terms of admission to the public sphere parallel those concerns of theorists of black discourse. Felski's observations on the problem of defining a feminist aesthetic bear an important resemblance to the questions being asked among black studies scholars (indeed, some of the issues noted are identical) as to whether there is indeed such a thing as a 'black novel' or a black aesthetic; at stake in this debate is the idea that if one relinquishes the concept of a black aesthetic, such a declaration would have far-reaching negative political implications for the black diaspora. I would like to discuss the idea of a feminist aesthetic in terms of this debate to see if it can provide any solutions short of dispensing with the category altogether, a move which Felski favors.

Insofar as theories are text-specific, for many of these scholars, the study of black texts requires a fundamentally black literary theory. Perhaps the most famous of these theorists is Henry Louis Gates, Jr, who, after spending a good deal of time defending

deconstruction and post-structuralist theory generally to skeptical black critics,[11] recently has written that theory 'is not much good at exploring the relations between social identity and political agency' (Gates, 1989: 12) and defends the creation of the black subject in black literature against the 'universalizing antiuniversalism' hegemony of these theoretical enterprises:

> The constitution of the Western male subject, after all, has enjoyed quite a different history from that of its racial or sexual others. Consider the irony: precisely when those 'others' gain the complex wherewithal to define a countervailing subjectivity in the republic of Western culture, our theoretic colleagues declare the subject to be mere mystification. It is hard not to see this as the critical version of the grandfather clause, the double privileging of categories that happen to be, as it were, preconstituted, a position that seems to leave *us* nowhere, invisible and voiceless. The universalism that undergirds poststructural antiuniversalism is finally seen in its inability to comprehend the *ethnos* as anything other than mystification, magic or mirage – or what once would have been called false consciousness. (Gates, 1989: 13)

There are echoes in Gates's complaint of the dictum that to be a black intellectual is to be *de facto* marginalized from the black community; this reflects the dilemma of many black academics who feel that in order to be admitted to the public sphere of intellectual debate, they must subscribe to a particular way of thinking, engage a particular set of analytical tools, use a particular language – a way of thinking, a language which, by its very nature, cuts them off from the very thing that they are seeking to bring into the academic sphere: the black experience. If we consider the issue of language then we see a parallel dilemma inherent in Felski's conception of the feminist public sphere.

In *The Signifying Monkey* Gates (1988) advocates an updated version of black aesthetics, declaring that black texts must be analyzed with a 'vernacular ideology,' which black critics must construct from the peculiarly 'black' ideology embedded within the black text. This is necessary, he says, because insofar as *all* theories of literature are text-specific, 'black' literature needs a specifically 'black' theory of literature for its explication, an idea with the disquieting implication that a text is understood only with the analytical tools that are the product of its own cultural mode – that is, a modernist text can only be understood within the context of New Criticism, and so forth. Gates's ideas on the subject of indigenously black principles of criticism could be said to contain a certain racial determinism – for instance, that black people think blackly[12] – which is of course the thing which theorists (not least of all Gates himself) struggle against. There is here, on the one hand, the desire to transcend that difference which has kept blacks out of the academy so long: blackness as an essential essence, tied to intellectual inferiority, or capable only of understanding itself – that is, parochial. On the other hand, there is a desire to hold on to that essence, to view it as that which gave the black critic the wherewithal to see and deconstruct the hierarchies of race and culture in the first place: that is, one can critique the modes of hegemonic ideology by the very experience of being black.

Again, there are obvious parallels to the tensions produced in Felski's argument against feminist aesthetics and her concomitant argument in favor of what can only be described as an ideologically *aware* subjectivity, or a subjectivity that understands that

it is a product of social and ideological formations and as such not a fixed and absolute entity. One must seriously question whether it is possible for such a thing to ever exist except theoretically.

Why, then, to come back to Gates's apparent contradiction in position, is there a suspicion of post-structuralism, why the belief that it can actually sever the connection between social identity – subjectivity – and political agency in its dismantling of the notion of the subject? In a parallel argument, Felski points out that post-structuralism has been a boon to feminism because its iconoclastic notions of life/literature have made it possible to remove the power of those hegemonic institutions and have identified the text as a site of resistance to ideology, only to make it more difficult to harness theory to the necessarily more determinate interests of oppositional politics.

Gates's contradictions of position stem from a wider tension indicative of those who have traditionally worked outside of the institution trying to get into it. Consequently, there is a suspicion that a theory created by the dominant group, which dismantles *all* claims to power through difference (difference which derives meaning and force in part *through* its very exclusion from the dominant culture/ideology), is simply another strategy to hold on to power. Thus Gates's much-quoted claim that black people have been deconstructing before Derrida does not make much difference, particularly when the deconstructionists have the power to transform their theory into a form of hegemony. (I am generalizing trends here: this is by no means meant to reflect on Derrida's intentions at all!) Gates's apparent ambivalence on the question of the subject points to an appreciation, on one hand, of the revolutionary potential for black people and their relation to power in the death of the subject; on the other, he is aware that the subject was not killed for this purpose and perhaps suspects, since post-structuralist theory appears to have covered all bases by the 'grandfather' clause in its universalizing antiuniversalism, that it might even have been tailored to *prevent* it.

Subjectivity and the Marxist Dilemma

If we consider Gates's contortions from the wider sphere of oppositional politics, we see that the same problem resurfaces in slightly altered forms. Fredric Jameson in *The Political Unconscious* wrestles to rescue the notion of Utopia from the post-structuralist fragmentation of the subject and eternal difference. His project is an obvious one: as a Marxist critic, he has a vested interest in believing in the collective, in collective action, in collective will, for without these there can be no social revolution and, consequently, no utopian moment.

As a result, he offers up a most curious assessment of Utopia when he claims that the ideological is also necessarily utopian; taken to its logical conclusion, fascism becomes, even though dystopian, an expression of *collective* will representative of a repressed utopian ideal (Jameson, 1981: 289–90). Jameson defends this somewhat bewildering position by arguing that whereas the universalism of the liberal worldview is predicated on a separation of the political/ideological and private/individual spheres, the brand of universalism he advocates realizes a fusion of ideological (collective) and individual (subject) consciousness. Class consciousness in whatever form consequently becomes utopian because it represents this fusion of the individual and the collective

belief systems. In a related argument, he posits that there is no distinction between the ideological and the thematic substance of the text (which interestingly echoes Houston Baker, a proponent of the Black Aesthetics movement of the 1960s and 1970s who states that in black literature, meaning and expression are one, a position in contradistinction to that of post-structuralists, who generally deduce ideology in the form of the narrative alone.

Through strategic position-taking, Jameson hopes to rescue the radical post-structuralist notion of an ideology of narrative structure in textual analysis and its correlative assessment of the ideological and constructed nature of cultural icons and hegemonic institutions, and to do so without forfeiting a political determinism, the loss of which, as he sees it, would negate any possibility of change. As such, Jameson's conception of revolutionary subjectivity is embedded within a unifying essence of class, nation, and/or culture, the realization which ironically contradicts the aims of orthodox Marxism, which typically would find the very epitome of false consciousness in aristocratic collectivity or in bourgeois ideology embedded in a nationalism not based on Marxist principles of revolution. Like Gates, Jameson juggles several contradictory lines of analysis: on the one hand, he recognizes the necessity of retaining a form of Marxist determinism to effect political agency; on the other, he holds to the post-structuralist critique of (bourgeois, humanist) subjectivity, useful as it is for dismantling a hegemonic worldview from within society. And between the two, he argues the presence of the utopian impulse within various opposing social factions, which, if harnessed properly, can effect the utopian (I take it to be Marxist) vision. The notion of subjectivity is important here because it is the element that can do the harnessing; as Jameson reflects, the collectivity needs incentives for ideological adherence.

As such, one can only deduce, from such a bewildering variety of positions and contradictions within each of their discourses, that Gates and Felski want to have their cake and eat it too, since the notion of subjectivity they perceive as necessary for harnessing political agency is also one they would like to eliminate at another level. While Gates clearly contradicts himself, Felski attempts to use her model to negotiate a fine line by advocating a form of identity politics while acknowledging the constructedness of that identity; either way, the problem is the same – they both desire the benefits of essentialism without being essentialist.

Diana Fuss, in her excellent book on the 'problem' of essentialism in oppositional discourses, makes a crucial intervention when, attempting to debunk the essentialist/antiessentialist categorization of feminist theorists, she characterizes most feminist theorists as *both* essentialists and constructionists (Fuss, 1989: 121). All sides of the debate make the same mistake of treating 'essentialism' as if it has 'essence' in and of itself, when the only real essence of feminism is politics (Fuss, 1989: 21, 37). Fuss points out that many post-structuralists have resolved the problem by revaluing essentialism as a temporary strategy or recontextualizing it as a 'discourse of resistance,' and while she expresses 'serious reservations' ('At what point does this move cease to be provisional and become permanent?'), ultimately she approves of this strategy because

the determining factor . . . is dependent upon who practices it: in the hands of a hegemonic group, essentialism can be employed as a powerful tool of ideological domination; in the hands of the subaltern, the use of humanism to mime (in the Irigarian

sense of to undo by overdoing) humanism can represent a powerful displacing rep-
etition. *The question of permissibility, if you will, of engaging in essentialism is therefore
framed and determined by the subject-position from which one speaks.* (Fuss, 1989: 32, my
emphasis)

However, while I will agree that highlighting positionality as a way of determining
the use-value of 'essentialist' categories is helpful in some respects, it is perhaps more
dangerous than others: the question then becomes, just who gets to use essentialism?
Who inhabits that moral high ground where one can employ essentialist concepts
without being infected, as it were, with essentialist *beliefs*? Can we separate *beliefs* from
practices? And does this not return us to the privileging of 'biological insiderism'? The
significance of essences is their status *as* belief systems: their use as political strategies
comes *after* that fact, not with it and particularly not before it.

I find myself in an awkward position here. While theoretically I agree enthusiasti-
cally with Felski's analysis (but with the significant reservations noted earlier), I find
myself by default trying to make a case for what are in some ways essentialist views on
aesthetics, if only to highlight the practical problems of Felski's model (and indeed of
all extant models). Just *how* does one use the continuum to which she refers in any
meaningful application? Is it possible to manipulate subjectivity in the strategic manner
which she advocates without losing it? And would this not then reduce subjectivity to
a generalized oppositional consciousness, a proposition which sounds particularly bland
and impotent? For, while there *are* indeed significant correlations in the assessments of
Felski and Gates, they are not after the same things, even though their struggles may
interlock at points. And it is, ironically, that *difference* which, in its implications, Felski's
analysis is in danger of erasing. While strategically I find it important – even crucial –
for them to be linked politically, in the final analysis what gives meaning to black and
feminist discourse is an autonomous sense of self, of essence, which is what they are
struggling not simply to articulate and validate but to *preserve*.

Yet even that self is a site of contestation. Does this mean, then, that aesthetic
categories are always to be interpreted as a direct reflection of the interests of an explicit
political ideology, which, once the historical moment is gone, become obsolete and in-
applicable? And that, apart from their political confluence, texts of the black diaspora
or texts by women have nothing to say to each other? As I stated at the beginning of
this article, I think, for obvious reasons, that a culture-based discourse stands on surer
ground than a gender-based discourse; yet without an acknowledgment of the differ-
ences inherent in the formulation of a black aesthetic, such discourse is doomed to the
sort of unrealistic revolutionary orthodoxy in which Marxist and other oppositional
discourses have become mired.

Notes

1 In 'The uncompleted argument,' Appiah (1986) contends that Du Bois is held in thrall by two
equally intractable principles of the Other's discourse: 'The thesis in this dialectic – which Du Bois
reports as the American Negro's attempt to 'minimize race distinctions' – is the denial of difference.
Du Bois' antithesis is the acceptance of difference, along with a claim that each group has its part to

play; that the white race and its racial Other are related not as superior but as complementaries; that the Negro message is, with the white one, part of the message of humankind. I call this pattern the classic dialectic for a simple reason: we find it in feminism also – on the one hand, a simple claim to equality, a denial of substantial difference; on the other, a claim to a special message, revaluing the feminine Other not as the helpmeet of sexism, but as the New Woman' (1986: 25).

2 This point is summarized in Taylor (1989: 172).

3 However, there is some dissent about Senghor's and Césaire's beliefs in a biological blackness; in *The Collected Poetry of Aimé Césaire*, translators Eshleman and Smith write: 'Senghor was understood – perhaps wrongly – to consider black culture as the product of a black nature . . . Césaire seems to have shared Senghor's view in the early part of his career . . . In an interview with Jacqueline Leiner in 1978, however, he maintained that for him black culture had never had anything to do with biology and everything to do with a combination of geography and history: identity in suffering, not in genetic material, determined the bond among black people of different origins' (Césaire, 1983: 6).

4 These tenets are delineated explicitly by Barthold (1981) in parts one and two of *Black Time*.

5 See Hélène Cixous's contributions in *The Newly Born Woman* (1986) and Luce Irigaray's *This Sex which is Not One* (1985: 34). Both positions are summarized in chapter 1 of Fuss (1989), 'The "risk" of essence' (pp. 1–21), and in chapter 4, 'Luce Irigaray's language of essence' (pp. 55–72).

6 See Toril Moi's *Sexual/Textual Politics* (1985: 139 and 147–8), and Monique Plaza's ' "Phallomorphic power" and the psychology of "woman" ' (1981) for some of the more well-known criticisms leveled at Irigaray in particular. These charges are summarized by Fuss (1989: 56–7).

7 See Davis (1981a: ch. 2), 'Anti-slavery movement and the birth of women's rights', p. 33. For more on the relationship, see also ch. 4; 'Racism in the woman suffrage movement' (Davis, 1981b).

8 For an analysis of the role of gender in the division of plantation labor, see ch. 1, ' "My mother was much of a woman": slavery', in *Labor of Love, Labor of Sorrow*, by Jacqueline Jones (1986).

9 See *Black Women Writers at Work*, ed. Claudia Tate (Morrison, 1983: 122–3). For a discussion of Morrison's position on feminism see pp. 299–324, 'The women's movement and black discontent', in *When and Where I Enter: The Impact of Black Women on Race and Sex in America* by Paula Giddings (1985).

10 I am reminded of an incident that took place at the opening ceremonies of a feminist graduate students' conference I attended, where the white opening speaker set the tone for the conference by describing in reverential detail Maya Angelou's appearance on stage the day before. 'Picture, if you can,' she said, 'a SIX-FOOT, BIG, EBONY BLACK WOMAN, wearing a red, yellow, and green caftan and a headdress.' She paused in emphatic silence. 'It was an *empowering* experience.' Empowering indeed, but for whom? That was the last word I heard on black feminism for the next three days.

11 See the debate between Gates and Baker, on the one hand, and Joyce Joyce, on the other, in the Winter 1987 issue of *New Literary History*. Joyce advocates a return to the black scholarship of the 1960s and 1970s, which 'saw a direct relationship between Black lives – Black realities – and Black literature' (Joyce, 1987: 338), and scolds those whom she sees as 'sell-outs,' such as Gates and Baker, who have cast in their lot with the post-structuralists who seek to dismantle that relationship (as she sees it). They, on the other hand, dismiss her position as one of 'minstrel simplicity' and feel that by opening up black literature and experience to the rigors of post-structural theoretical critique, it is possible to bring it into the realm of theoretical debate on an equal footing.

12 Gates actually *has* been accused of a form of racial determinism: see Todorov (1986: 376).

References

Appiah, Anthony (1986) 'The uncompleted argument: Du Bois and the illusion of race', in *'Race', Writing, and Difference*, ed. Henry Louis Gates, Jr (Chicago: University of Chicago Press), pp. 21–37.

Baker, Houston A., Jr (1987) 'In dubious battle', *New Literary History*, 18 (2) (Winter): 363–9.

Barthold, Bonnie J. (1981) *Black Time: Fiction of Africa, the Caribbean and the United States* (New Haven, CT: Yale University Press).

Brathwaite, Edward Kamau (1976) 'The love axe (1): developing a Caribbean aesthetic, 1962–1974', in *Reading Black: Essays in the Criticism of African, Caribbean, and Black American Literature*, ed. Houston A. Baker, Jr (Ithaca, NY: Cornell University Press), pp. 23–37.

Brathwaite, Edward Kamau (1978) *Contradictory Omens: Cultural Diversity and Integration in the Caribbean* (Mona, Jamaica: Savacou).

Carby, Hazel (1989) *Reconstructing Womanhood: The Emergence of the Afro-American Woman Novelist* (Oxford: Oxford University Press).

Césaire, Aimé (1983) *The Collected Poetry of Aimé Césaire*, trans. Clayton Eshleman and Annette Smith (Berkeley, CA: University of California Press).

Cixous, Hélène (1986) *The Newly Born Woman*, trans. Betsy Wing (Minneapolis, MN: University of Minnesota Press).

Cudjoe, Selwyn R. (1984) 'Maya Angelou and the autobiographical statement', in *Black Women Writers (1950–1980): A Critical Evaluation*, ed. Mari Evans (New York: Anchor/Doubleday), pp. 6–24.

Davies, Carole Boyce (1990) 'Talking it over: women, writing and feminism', in *Out of the Kumbla: Caribbean Women and Literature*, ed. Carole Boyce Davies and Elaine Savory Fido (Trenton, NJ: Africa World Press), pp. ix–xix.

Davis, Angela Y. (1981a) 'The anti-slavery movement and the birth of women's rights', in *Women, Race and Class* (New York: Random House), pp. 30–45.

Davis, Angela Y. (1981b) 'Racism in the woman suffrage movement', in *Women, Race and Class* (New York: Random House), pp. 70–86.

Du Plessis, Rachel (1985) 'For the Etruscans', in *The New Feminist Criticism: Essays on Women, Literature and Theory*, ed. Elaine Showalter (New York: Pantheon Books), pp. 271–91.

Felski, Rita (1989) *Beyond Feminist Aesthetics: Feminist Literature and Social Change* (Cambridge, MA: Harvard University Press).

Fuss, Diana (1989) *Essentially Speaking: Feminism, Nature, and Difference* (London: Routledge).

Gates, Henry Louis, Jr (1987) ' "What's love got to do with it?": Critical theory, integrity, and the black idiom', *New Literary History*, 18 (2) (Winter): 345–62.

Gates, Henry Louis, Jr (1988) *The Signifying Monkey: A Theory of Afro-American Literary Criticism* (Oxford: Oxford University Press).

Gates, Henry Louis, Jr (1989) 'Racism in the profession', *African Literature Association Bulletin*, 15 (1): 11–21.

Gates, Henry Louis, Jr (1991) 'State of Florida vs. Luther Campbell', reprinted in *Passages: A Chronicle of the Humanities*, 1: 3.

Giddings, Paula (1985) 'The women's movement and black discontent', in *When and Where I Enter: The Impact of Black Women on Race and Sex in America* (New York: Bantam), pp. 299–324.

Greene, Gayle and Coppelia, Kahn (eds) (1985) *Making a Difference: Feminist Literary Criticism* (London: Methuen).

Harding, Sandra G. (1986) 'Other "others" and fractured identities: issues for epistemologists', in *The Science Question in Feminism* (Ithaca, NY: Cornell University Press), pp. 163–96.

hooks, bell (1990) *Yearning: Race, Gender and Cultural Politics* (Boston, MA: South End Press).

Irigaray, Luce (1985) *This Sex which is Not One*, trans. Catherine Porter, with Carolyn Burke (Ithaca, NY: Cornell University Press).

Jameson, Fredric, 'The dialectic of utopia and ideology', in *The Political Unconscious: Narrative as a Socially Symbolic Act* (Ithaca, NY: Cornell University Press), pp. 270–95.

Jones, Jacqueline (1986) ' "My mother was much of a woman": slavery', in *Labor of Love, Labor of Sorrow* (New York: Vintage), pp. 11–43.

Joyce, Joyce Ann (1987) 'The black canon: reconstructing black American literary criticism', *New Literary History*, 18 (2) (Winter): 335–44.

Moi, Toril (1985) *Sexual/Textual Politics: Feminist Literary Theory* (New York: Methuen).

Morrison, Toni (1983) 'Interview', in *Black Women Writers at Work*, ed. Claudia Tate (New York: Continuum), pp. 117–31.

Plaza, Monique (1981) ' "Phallomorphic power" and the psychology of "woman" ', *Ideology and Consciousness*, 4 (Autumn): 57–76.

Redding, J. Saunders (1976) 'Afro-American culture and the black aesthetic: notes toward a reevaluation', in *Reading Black: Essays in the Criticism of African, Caribbean, and Black American Literature*, ed. Houston A. Baker, Jr (Ithaca, NY: Cornell University Press), pp. 41–7.

Senghor, Léopold (1964) *Négritude et humanisme* (Paris: Seuil), vol. 1 of *Liberté* (1964–).

Showalter, Elaine (1985) 'Feminist criticism in the wilderness', in *The New Feminist Criticism: Essays on Women, Literature and Theory*, ed. Elaine Showalter (New York: Pantheon Books), pp. 243–70.

Smith, Barbara (1985) 'Toward a black feminist criticism', in *The New Feminist Criticism: Essays on Women, Literature and Theory*, ed. Elaine Showalter (New York: Pantheon Books), pp. 158–85.

Taylor, Patrick (1989) *The Narrative of Liberation: Perspectives on Caribbean Literature and Politics* (Ithaca, NY: Cornell University Press).

Todorov, Tzvetan (1986) ' "Race", writing and culture', in ' *"Race", Writing, and Difference*, ed. Henry Louis Gates, Jr (Chicago: University of Chicago Press), pp. 370–80.

Warren, Kenneth W. (1989) 'Delimiting America: the legacy of Du Bois', *American Literary History*, 1 (1) (Spring): 172–89.

5

Politics in Practice: Material Strategies

INTRODUCTION

All but two of the contributors to this chapter are practising artists. The focus here is on the struggle involved when the personal is understood as political and when that political consciousness engages with the actual making of artworks; and the choices artists make to reconcile their personal choices with their political thinking and both of these with their artwork, while retaining the integrity of all three. It is a struggle that is frequently manifested at the level of the use of materials and technical aspects of the work, and much of the discussion in this chapter concerns the choice, use and signifi-cance of media and materials. The ways in which artworks produce their meanings is not only through the explicit images they carry and their attendant representational sig-nifications: a substantial part of their meaning rests upon the use of materials being not only skilful but augmenting the representations and significations suggested by other aspects of the work, such as the image, the composition, the scale and so forth.

We can take a particular example to illustrate these issues. A feminist painter might be concerned with the issue of child sexual abuse and make a work concerning this, which she considers to convey the horror of such abuse. However, if she employs a particular handling of paint – say, an expressionist style which might be validated by reference to, possibly, Willem de Kooning's paintings of women – then, rather than disgust for the abuse, what might be represented is disgust for the child. Again, through her compositional practice she may wish to show the effect such abuse has on the child by constructing a frontal image, but this composition might instead produce space for the viewer to fantasize that he or she is in the position of the perpetrator – a classic compositional device found in pornography and film in particular. Thus, a work intended to evoke a particular response could instead reinforce the victim-status of children and enhance the power of perpetrators. The answer is not to avoid such a subject, but rather to engage with the problem of how material and technological practices signify.

The opening text in this chapter, Lauren Rabinovitz's comparison of Judy Chicago and Joyce Wieland, makes no reference to the lives of the two artists other than their similar age and career profile when they each made major works informed by their feminism. Throughout, the article highlights the close similarities between the artists' approaches to making *The Dinner Party* and *True Patriot Love* respectively, in order to

throw into sharper contrast the results of their differences. Concentrating upon the artists' working methods, their uses of collaboration, of materials, of accompanying documentation, and of imagery, Rabinovitz argues that, although it predates *The Dinner Party*, *True Patriot Love* is the more radical work from a feminist perspective as a result of telling choices made by Wieland in each of these areas.

Jo Spence develops elements of both these discussions (her article is shortened a little here). Stating that 'we urgently need to know how it was that we came to (mis) recognize ourselves as being present in the representations offered to us', she charts her political analysis of how individuals are socialized through layers of representation, and how they then represent themselves. As a photographer she acknowledges the role of photography in everyday life, producing images for us to live up to and providing templates for our own family photo albums. She explores the gaps between her family representations and moments in her autobiography and describes her photographic quest to re-represent her subjectivity as a feminist and socialist. This pivots not only on the notion of the self-portrait, but indeed on the notion of the 'self' and its social construction through representation.

Linda Montano's text is a selection of pages from her 1981 documentation of her work. Rather than exploring her history, she shows her engagement with the present. A brief factual description of an artwork (mostly performance) is juxtaposed with a few lines about concurrent events and realizations in her life which informed or were caused by the artwork. The reader is left to speculate upon the process of moving between the two, and the artwork as a mediation of present life. In a contrasting autobiographical account by the painter May Stevens, three struggles come to the fore: that between her desire to identify as an American, and her critique of American racism; her hatred for her father's racism and sexism, which destroyed her mother's life; and her struggle to paint what was both a strong political and emotional reaction to her family background, and its political implications.

The interview with Susan Hiller questions the whole category 'art' from a number of angles. Hiller states that in working from a marginal position – as women artists do – she is involved in a struggle to redefine what art might be. While particular media can be defined, 'art' is a much more problematic term, involving socialization, subjectivity, language and representation. These are the areas with which her work engages in order to produce new social significance. However, while her feminism is crucial for her and therefore is inextricable from her practices as an artist, she refuses the term 'feminist artist' as it is a restrictive definition. Having stated that there is no female language with which she can speak, she does not wish to be sidelined by terms not of her making.

The extract from the discussion between Mary Kelly and Griselda Pollock reproduced here starts from a similar point when Kelly refuses the definition 'feminist art' in favour of discussing feminist interventions in art practice. The two women then explore what such interventions might be, how they differ from other political interventions, strategic responses to different contexts, and indeed how their own strategies as artist and academic differ from each other. Kelly's most productive engagement is with the artists and theorists, mainly in North America, who have developed an oppositional postmodernism, while Pollock's starting-point is to develop discourses disaffirming patriarchy, including that found within the Marxist engagement with

modernism. The pivotal differences are highlighted in their discussion of practices of painting. Kelly disentangles her attitude when teaching from her own practices as an artist. Describing this as 'cultural warfare', she decries an emotional choice of medium in favour of a rigorously theoretical and strategic choice. This brings her to a position where she is closer to artists such as Hans Haacke or Victor Burgin than to most women who paint. As Pollock's practice is to establish historical and theoretical discourses rather than make art she feels a broader responsibility to explore such questions as 'what are the arguments available which might propose some kind of radical practices for women who paint?' This means that she has to acknowledge and move beyond work by such critics as John Roberts (whom Kelly dismisses) in order to recoup the potential of certain media for a radical feminist practice. Both Kelly and Pollock agree that the prime issue at stake is not choice of media (and therefore whether or not to paint) *per se*, but rather the critique of broader discourses around the medium of paint and the practices of painting.

Nell Tenhaaf demonstrates the philosophical justification for masculine discourses of machines and technology before identifying feminist possibilities in the structures and discourses of electronic – and specifically video – technology. Starting with discourses of the will to power developed by Friedrich Nietzsche and Martin Heidegger, she moves on to one of its manifestations in twentieth-century modernism. The bachelor machine is found paradigmatically in the work of Marcel Duchamp, and contains the feminine as an 'implicit and unspoken function in the machine'. Drawing upon the work of Luce Irigaray, Tenhaaf posits the auto-eroticism of the female body as a desiring engine which is not essentialist but rather understood through a complexity of signifying practices, including the mystical. She constructs an argument for the significance of the sexed body in pre-modern Western mythology, where women have had powerful roles as keepers of light and knowledge. This then relates to the morphology of video technology, its production of image through light, the electrons hitting the concave surface of the screen. The lack of fixity in the physics of electricity and its dependency upon interaction with an observer is described as 'a confirmation of spectator subjecthood . . . Unfixed subjectivity is the embracing condition of our late-twentieth-century technologized world.' Tenhaaf concludes with a brief analysis of body-based video works by some Canadian women as case studies.

The following two articles contribute to, and begin to update, the debates around practices of painting. A divisive subject through the 1980s, there has been a struggle through the 1990s (as flagged by the Pollock/Kelly discussion above) to establish feminist discourses of painting in a manner which transcends the defensive and the accusatory.[1] Katy Deepwell augments points similar to some made by Griselda Pollock. Acknowledging the presence of women in the modernist movement, despite modernism's philosophical and actual marginalizing of women, Deepwell states that feminists have developed diverse critiques of modernism, including postmodernist debates. While radical postmodernist positions are associated with practices in photography and mixed media, neo-conservative postmodernism has retrenched in narrative and figurative painting practices, leaving a paucity of discourses through which to construct radical painting practices. Deepwell outlines three problematic contemporary positions: the romantic/idealist, expressive, late modernist fantasy, often promoted in art schools; an interest in the writings of Irigaray and Kristeva, sometimes used with a superficial

understanding of those theorists, or as justification for some practices which might otherwise be validated through modernist discourses; and the return to figuration in a diversity of styles.

The text by Alison Rowley (a section from a much longer essay) is an exercise in looking and questioning. One painting only is under consideration: Jenny Saville's *Plan* (1993). Rowley discusses its size, the scale of the woman depicted in relation to the canvas, and her supposed size. Starting from compositional clues, she explores the viewing relation of both the artist and the gallery visitor to the woman depicted, and includes an account of the relation between images and brush marks, seeing the brush marks when standing close to the painting but only seeing the image when standing back. This is precisely the meticulous examination of the use of materials and the technologies of their deployment which appears to have been evacuated from feminist debate but which is necessary for any theoretical and technical developments in feminist practices.

The final text in the chapter, by Faith Wilding, turns to cyber and computer technology, and was written after the first Cyberfeminist International (at Documenta X in Kassel, Germany, 1997). The text does not discuss artworks which have been made on the Net, but rather explores the possible definitions and resistances to definition of the term 'cyberfeminism', and the potential for 'an informed practice of cyberfeminist politics'. Wilding identifies three strands of ambivalence to past feminism manifested on the web: a repudiation of 1970s feminism, often the result of a loss of historical knowledge; cybergrrl-ism, which tends to be anti-theory and often repeats unthinkingly sexist modes of representation; and utopianism, where it is expected that the new technology will be value-free and not gender-specific in its structures, and therefore will offer a *tabula rasa* upon which a feminist culture can be written. Wilding argues against each of these misconceptions, and offers strategies for countering the problems each position will create. She proposes forms of self-definition and solidarity which can be established as a means of providing for political action, with a stress upon the technology as a tool for communication rather than that which is to be communicated.

Note

1 Further contributions to this during the 1980s and 1990s include: Rosemary Betterton, '(Dis)parities', in *(Dis)parities* (Sheffield: Mappin Gallery, 1993), unpaginated; Rosemary Betterton, 'Brushes with a feminist aesthetic', *Women's Art Magazine*, 66 (1995): 6–11; Rosemary Betterton, *An Intimate Distance: Women, Artists and the Body* (London: Routledge, 1996); Sheila Butler, 'More thoughts on painting', *C Magazine*, 21 (1991): 11–13; Katy Deepwell, 'In defence of the indefensible: feminism, painting and postmodernism', *Feminist Art News*, 2, (1987): 9–12; Rebecca Fortnum and Gill Houghton, 'Women and contemporary painting: representing non-representation', *Women Artists' Slide Library Journal*, 28 (1989): 4–5; Shirley Kaneda, 'Painting and its others', *Arts Magazine*, 65 (10) (1991): 58–64; Joan Key, 'Models of painting practice: too much body?', in *New Feminist Art Criticism: Critical Strategies*, ed. Katy Deepwell (Manchester: Manchester University Press, 1995), pp. 153–61; Carol Laing, 'How can we speak to painting?', *C Magazine*, 25 (1990): 19–24; Rosa Lee, 'Resisting amnesia: feminism, painting and postmodernism', *Feminist Review*, 26 (1987); Griselda Pollock, 'Painting, feminism, history', in *Destabilising Theory: Contemporary Feminist Debates*, ed. Michèle Barrett and Anne Phillips (Cambridge: Polity Press, 1992), pp. 138–76;

46 Politics in Practice

John Roberts, 'Fetishism, conceptualism, painting', *Art Monthly*, 82 (1984): 17–19; John Roberts, 'Painting and sexual difference', *Parachute*, 55 (1989): 25–31; Hilary Robinson, 'The morphology of the mucous: Irigarayan possibilities in the material practice of art', in *Differential Aesthetics: Art Practices and Philosophies – Towards New Feminist Understandings*, ed. Penny Florence and Nicola Foster (London: Ashgate Press, 2000); Mira Schor, 'Painting as manual', *M/E/A/N/I/N/G*, 18 (1995): 31–41.

Essential reading

Barry, Judith and Flitterman-Lewis, Sandy, 'Textual strategies: the politics of art-making', *Lip: Feminist Arts Journal* (1981); *Screen*, 21 (2) 35–48; reprinted in *Visibly Female: Feminism and Art Today – An Anthology*, ed. Hilary Robinson (London: Camden Press, 1987; New York: Universe, 1988), pp. 106–17; in *Feminist Art Criticism: An Anthology*, ed. Arlene Raven, Cassandra Langer and Joanna Frueh (New York: Icon Editions, 1988), pp. 87–98; and in *Framing Feminism: Art and the Women's Movement 1970–1985*, ed. Rozsika Parker and Griselda Pollock (London: Pandora Press, 1987), pp. 313–21.
Frueh, Joanna, Langer, Cassandra, and Raven, Arlene (eds), *New Feminist Criticism: Art, Identity, Action* (New York: Icon Editions, 1994).
Kelly, Mary, 'Sexual politics', in *Art and Politics: Proceedings of a Conference on Art and Politics Held on 15th and 16th April 1977*, ed. Brandon Taylor (Winchester: Winchester School of Art Press, 1980), pp. 66–75; reprinted in *Framing Feminism: Art and the Women's Movement 1970–1985*, ed. Rozsika Parker and Griselda Pollock (London: Pandora Press, 1987), pp. 303–12; Mary Kelly, *Imaging Desire* (Cambridge, MA: MIT Press, 1996), pp. 2–10.
Parker, Rozsika and Pollock, Griselda (eds), *Framing Feminism: Art and the Women's Movement 1970–1985* (London: Pandora Press, 1987).
Robinson, Hilary (ed.), *Visibly Female: Feminism and Art Today – An Anthology* (London: Camden Press, 1987; New York: Universe, 1988).
Roth, Moira, 'Visions and re-visions', *Artforum*, 19 (3) (1980): 36–45; reprinted in *Feminist Art Criticism: An Anthology*, ed. Arlene Raven, Cassandra Langer and Joanna Frueh (London: UMI Research Press; New York: Icon Editions, 1988), pp. 99–110.

Lauren Rabinovitz, 'Issues of Feminist Aesthetics: Judy Chicago and Joyce Wieland' (1980)

From *Woman's Art Journal*, 1 (2) (1980), pp. 38–41.

In 1971, Joyce Wieland, Canada's leading feminist artist, exhibited *True Patriot Love/Veritable Amour Patriotique*, at the National Gallery in Canada. That same summer Judy Chicago discovered the craft of china painting, which would lead her eventually to what has been proclaimed 'the first feminist epic artwork,'[1] *The Dinner Party* (1979). Wieland's opening received as much publicity in Canada as Chicago's did in the United States eight years later.[2] Largely comprised of nationalist pieces utilizing women's traditional crafts, and billed as a retrospective exhibition, *True Patriot Love* began shortly after Wieland's fortieth birthday. Similarly, *The Dinner Party*'s initial San

Francisco showing occurred when Chicago was 40 years old. In the decades before their fortieth birthdays, Wieland and Chicago had each become disaffected with American art world politics. Wieland, who moved to New York in 1963, turned her back on Manhattan avant-garde art when she began making 'home totems' and quilted wall hangings in the mid-1960s. By 1971 she spent most of her time in Canada, and soon after *True Patriot Love* returned permanently to Toronto.

Chicago discusses her separation from the contemporary professional art world in her autobiography, *Through the Flower* (1975).[3] At similar chronological and career stages, Wieland and Chicago each created a large scale feminist exhibition that synthesized her professional training and female experience, while relying upon systems traditionally used to maintain male domination. However, whereas Wieland's show exposed how advertising symbols function to preserve power, *The Dinner Party*'s feminist rhetoric masks its conservative, religious underpinnings.

Wieland and Chicago began by making different demands on themselves and their projects; Wieland worked with a particular museum space and date while Chicago elaborated a specific idea without space or time commitments. Wieland had to keep her designs flexible enough to adapt to spatial, financial, and time schedules and their changes. Chicago, working for herself, could adhere to her original plans more closely. But Chicago's seemingly greater artistic freedom did not encourage the refinement and crystallization of her ideas, whereas Wieland's need to meet outside changes necessitated greater ongoing intellectual discipline, and the two shows reflect the difference.

However dissimilar, both shows unify thematic presentations involving women's crafts. By writing books to accompany their exhibits, both artists showed how their political beliefs and work processes with other artists helped them arrive at their formats. Chicago's book, *The Dinner Party*, emphasizes her own creative process, psychological crises, and continuing role in *The Dinner Party* exhibit. It focuses on the artist rather than the artwork. Excerpts from the diary Chicago kept during the exhibit's creation openly reveal her view of herself as a role model, a self-image Chicago discusses more fully in *Through the Flower*. Chicago assumes that by creating *The Dinner Party* she becomes as exemplary as the women on whom the piece centers. Once she sets herself up as a role model, her artistic process redeems itself politically and becomes a central part of the project.

Wieland's book, also titled after her show, offers a more challenging resolution than Chicago's literal retelling of the work in progress.[4] It is a pastiche of photographs, words, and drawings overlaid on a mock governmental bulletin of Canadian flora and fauna. Incorporating reproductions of show pieces, photographs of works being prepared, and photographs of and by the artist, the resulting collages echo the show's nationalist theme while the scrapbook appearance and method re-establishes another domestic art ('scrapbooking') as a viable artistic method. As in *The Dinner Party* book, Wieland's work progress is part of her book's content; but in Wieland's case, it is a fragmented act taken out of its original context because the reader thumbing the pages in any variety of combinations completes the artistic action by creating a final set of photo/word/picture juxtapositions. Thus Wieland, who calls herself a 'cultural activist,' makes her point by facilitating active artistic participation in a game where she has provided the playing rules. The two books document how the artists' assumptions

about themselves and their social roles directed and differentiated their feminist works.

Differing views of themselves and their social roles led Wieland and Chicago to involve other women in their projects in contrasting ways. Both, however, share the belief that making artistic creation a cooperative activity uniting women is politically important. In the *atelier* tradition, Chicago engaged numerous apprentices or assistants. In exchange for the opportunity to assist Chicago, to learn technical skills and to be part of a women's artistic community, apprentices provided the labor Chicago required to complete her designs. Critics since have debated whether or not Chicago exploited her unpaid helpers and devalued their sense of worth and professionalism. Many feel that *The Dinner Party* would possibly not have been finished if the workers had been paid, and that it is too significant an art work to make arguing this issue worthwhile. Such unquestioning acceptance of Chicago's methods fits the way a self-appointed role model might want her audience to think. Nevertheless, by emphasizing her role as an authority figure and encouraging 'volunteerism,' Chicago emulated the societal and art school practices that many feminists have fought.

Wieland, too faced an economic dilemma in trying to unite women to assist in the project. She searched country fairs for talented craftswomen and used personal grant monies to commission specific show pieces. Valerie McMillin, a champion knitter, completed four worsted flags of various proportions (*Flag Arrangement*, 1970–71); Joan McGregor embroidered photographic reproductions of British and French Canadian military commanders' letters (*Wolfe's Last Letter*, *Montcalm's Last Letter*, both 1971), and a series of mouths drawn by Wieland which shaped, syllable by syllable, the Canadian national anthem (*O Canada Animation*, 1970–71); Nova Scotia women hooked rugs, incorporating Eskimo and English versions of an Eskimo poem (*The Great Sea*, 1970–71); and Wieland's sister, Joan Stewart, and Joyce Martin helped complete the quilted hanging commissions (*Arctic Day*, *109 Views*, *The Water Quilt*, *Spring Tree*, all 1970–71).[5]

Wieland abandoned her initial plan of many women working together so that she might financially and psychologically acknowledge the professional status of each woman with whom she worked. Her respect and recognition of her associates seems, at first, a more appropriate feminist expression than Chicago's neglect of her assistants' financial and artistic recognition. Both, however, uphold the romantic concept of the artist as an individual, creative force that has traditionally undermined the bulk of women's artistic output – Wieland by celebrating the uniqueness of her invited artists, and Chicago, despite the attempt at communal process, by announcing herself as role model.

The extent to which traditional professional artistic standards affected Chicago's and Wieland's choices and designs may be seen most pointedly in the ways they reflected on and incorporated women's crafts into their shows. In 1971, when Wieland treated regional craftswomen as professional artists by including their work in her retrospective, she publicized women's crafts as artistic expressions at a time when North American art centers ignored such work. Wieland appeared to be claiming a common heritage, but she still titled and arranged *True Patriot Love* as a personal retrospective. Such an arrangement, however, may have been due to existing limitations: perhaps if Wieland, at that time, had not prepared the show as her own, the museum would

have been reluctant to finance and sponsor an exhibit composed of women's crafts. As it was, several critics attacked the show's focus on domestic arts since they considered women's crafts unsuitable art museum materials. By including and claiming domestic crafts as valid artistic activity in 1971, Wieland began raising her audience's consciousness as she showed them what Canadian women were and had been doing for years.

Because the following eight years brought heightened awareness of women's crafts, one might have expected Chicago to set forth a bolder statement about domestic arts than Wieland could in 1971. While *The Dinner Party* encompasses and explores a more varied heritage in a more integrated fashion than *True Patriot Love*, it does not go any further than initial consciousness raising through recapturing obscured history. The need to cloak such lessons behind recognized artists' names may not have changed in eight years, but what Wieland did as a politically radical lesson in 1971 had become publicly acceptable by 1979–80.

More disturbing than Chicago's inability to provide a more advanced feminist statement regarding women's crafts are her contradictory public remarks about domestic arts. Her words suggest that she has been unable to reconcile her feminism with her artistic training regarding women's crafts. As one critic said:

> On the one hand, Chicago is delighted that American women have kept the china-painting tradition alive; on the other, she is horrified that women have 'wasted their talents putting roses on plates.' Chicago the feminist wants to give the china painters their historic due. Chicago the artist is offended by the aesthetic of what they have done.[6]

Chicago further expresses ambivalence toward craft methods in her diary: 'Stuffed and dimensional fabric work is always so tacky, and I'm not sure we can make it work.'[7] Her words echo the perjorative bias that some critics showed toward Wieland in 1971. It is ironic that Chicago shares her gravest doubts about the very craft – 'stuffed and dimensional fabric work' – that Wieland most completely and successfully embraced and celebrated. It seems that while Wieland initiated efforts to break down and erase the line between fine arts and crafts, Chicago calls attention to the gap and expresses a further reluctance toward artistic redefinition, a political necessity for the development of feminist art.

Weiland and Chicago accepted women's crafts in differing degrees, but both used them to create brightly colored, boldly composed, decoratively styled signs. By employing open, circular forms, they made vaginal images that would reclaim and celebrate women's bodies. Wieland's *O Canada* and *O Canada Animation* serialize reddened mouths on two-dimensional surfaces producing abstract overall patterns that dilute the sensation of vaginal confrontation. *O Canada*'s pink lipstick mouthprints and the embroidered mouths of *O Canada Animation* provide environmental and textural familiarity that further tempers any literal effect. In the same way, her quilts' domestic, nurturant connotations subdue underlying political statements.

Wieland literally cushions her message with the materials and further softens a tough political statement through humor. Typical of her ironic, whimsical style, *O Canada*'s and *O Canada Animation*'s lips shaping syllables of the national anthem provoke mirror

reactions that lead to a heightened oral awareness, and they suggest by further sexual analogy the absurdity of cosmetically packaged 'singing' labias. Through 'cosmeticizing' the genital images, Wieland consciously satirizes how advertising uses women's bodies for commercial purposes: she then satirizes the satire by allowing the same package to reclaim women's artistic heritage.

Whereas Wieland played with and satirized mouths and their sexual analogies, Chicago literalizes the genital image. Chicago's presentation does not soften or camouflage genitalia with color, materials, or humor. Her dinner plates, based on what she calls 'butterfly images,' more closely resemble brilliant vaginas. They become increasingly three-dimensional and organically shaped so that the final forms appear as magnified sculptural genitalia. The hard, glazed plates lose their form and identity as familiar environmental objects as the plates themselves become only vaginal shapes and designs. The plates' dramatic placements and individualized styling dominate the place settings and exact one-to-one confrontations with each magnified vagina. Although each place setting includes designs and themes from the life of the person it commemorates, each plate unmistakably depicts a vaginal image.

Consistent with Chicago's desire to invite reverential attitudes, the exhibit's subdued lighting and cavernous spaces create a chapel-like atmosphere. The three-sided table and 39 place settings invoke Christian Trinity symbolism, and *The Dinner Party* itself alludes to the Last Supper, a sophomoric bit that Chicago proudly points out in interviews and in *The Dinner Party* book. She further strengthens the holy altar effect by making the central space physically inaccessible. By casting historic heroines and goddesses in an environment diffused with patriarchal religious symbols, Chicago has attempted to create a heritage, if not for religious purposes, then for mythological ones. But *The Dinner Party* does not transcend the banality of its articulation enough to create a new feminist mythology.

Like Chicago, Wieland arranged the environment to appear as more than an art exhibit. Her 'political slogan' quilts, quilts and embroideries depicting Canadian wildlife (while warning of its impending destruction), assemblages, inked nationalist cartoons, live duck pond, Arctic Passion cake, and bottles of Sweet Beaver perfume studiously evoke a bazaar or county fair atmosphere. While Wieland's and Chicago's 'packaged' exhibits were smart political publicity strategies, they also resulted in internal contradictions because the packagings, whether advertising or religious, have historically been considered major contributors to the oppression of women.

Chicago's religious shrine assumes that by using old packaging for new materials one presents an entirely new appearance, which in effect, ignores the problem. Wieland did not ignore the inherent contradiction; she set it up as an ironic statement, best exemplified by Sweet Beaver perfume. A batch of scented cologne that Wieland cooked up, bottled, and displayed for sale at *True Patriot Love*, Sweet Beaver expresses the artist's nostalgic longing for a Canadian wilderness past, while it calls up pornographic connotations of women as sensual but passive vaginal objects. Wieland views such an image of women as analogous to Canada's reputation: Canada's history as land raped and colonized by England and then by the United States parallels women's history of oppression. Wieland's analogy of Canada's and women's positions reinforces her celebration of women's domestic arts, traditionally regarded as a culture's most provincial art. By

making Sweet Beaver a commercial item, Wieland played on how the advertising indus-try participates as a patriarchal tool in selling images of women and of a culture. A Pop art ploy, her use of the way the advertising industry packages its products articulates a satirical protest.

The superficial charm and naïveté of Wieland's show mask a rigorous intellectual-ism. *True Patriot Love* introduced feminist concerns upon which later North Ameri-can artists have elaborated: the incorporation and celebration of women's craft heritage, the redefinition of what 'artistic creation' means, the reclamation of women's sexual self-identities, and most importantly, the utilization of a method which allows active audience participation.[8] Chicago's *The Dinner Party* has brought more public attention to the above issues than any other feminist art work, and its didactic role is its most dis-tinguished feature. But the fact that it passively involves the audience, depends upon patriarchal religious symbols, and employs simplistic themes to achieve its measures provides some disturbing and disappointing resolutions to challenges that Wieland adroitly articulated nine years before. *True Patriot Love* is about its own contradictions; *The Dinner Party* lacks awareness of the contradictions it employs.

Notes

1 Kay Larson, 'Under the table: duplicity, alienation', *The Village Voice* (11 June 1979): 49–51.

2 Publicity attending *True Patriot Love* began as early as six months before the show's July 1971 opening, and the exhibition itself received reviews (mostly descriptive) in prominent Canadian and American newspapers and magazines, as well as international art periodical coverage.

3 Because of this book, Judy Chicago's life history is available to her supporters. Joyce Wieland studied at Toronto's Central Technical and Vocational High School and at local commercial art and design companies. In 1955 she went to work for Graphic Films, a Toronto animation company com-posed of former National Film Board of Canada film-makers, where she learned animation techniques from George Dunning (who later directed *Yellow Submarine*, 1968) and made her first films. The only woman to achieve prominence when Toronto developed into a leading art center in the late 1950s and early 1960s, Wieland exhibited frequently between 1959 and 1963. Her early paintings reflected the influence of Abstract Expressionism, but by 1963, when she and her artist–film-maker–musician husband Michael Snow moved to New York, her sexual and humorous paintings and constructions employed Pop art advertising techniques. During her eight years in New York, Wieland received recog-nition in Canada for her satirical comic strip paintings and quilts. In 1967, Canadian critic Harry Mal-colmson (Toronto *Telegram*, 25 March 1967, p. 16) could write 'Canada in art, I then discovered, comes in two parts: Joyce Wieland in one section and the rest in the other.' By 1972, Wieland was considered the most important living Canadian female artist (William Withrow, *Contemporary Cana-dian Painting* [Toronto: McClelland and Stewart, 1972], pp. 121–8). Although she did not exhibit her paintings in New York, Wieland often showed her experimental films. P. Adams Sitney (*Visionary Film* [New York: Oxford University Press, 1979], p. 369) recognized her as one of a group of important film-makers working in New York in the mid and late 1960s. Since returning to Toronto, Wieland has participated actively in an artists' political coalition, Canadian Artists Representation (CAR), and in various ecological actions. She has made two documentary films, and her commercial feature, *The Far Shore*, was released in Canada in 1976 and in the United States, 1977. Although she no longer makes quilts, she has continued drawing and painting and is working currently on a series of paintings and drawings involving female mythological figures.

4 Joyce Wieland, *True Patriot Love/Veritable Amour Patriotique* (Ottawa: The National Gallery of Canada, 1971).

5 Wieland and Stewart had collaborated for several years on the large quilted hangings. Wieland began the arrangement because her sister, an expert quiltmaker, needed a job. Stewart completed Wieland's designs on the following pieces that appeared in *True Patriot Love: For Father Lavalle*, 1967; *La Raison avant la Passion*, 1968; *Reason over Passion*, 1968; *I Love Canada/J'Aime le Canada*, 1969; and *O Canada*, 1970.

6 Diana Ketcham, 'On the table: joyous celebration', *The Village Voice* (11 June, 1979): 47–9.

7 Judy Chicago, *The Dinner Party* (New York: Anchor, 1979), p. 45.

8 Throughout the past decade, Canadian art critics have called Wieland a role model and inspiration for a younger generation of feminist artists.

Jo Spence, 'Beyond the Family Album' (1980)

From *Ten-8*, 4 (Spring 1980), pp. 8–10.

Ideology

To those people who are not feminists or socialists – for it is on their work that I want to concentrate here – nor even in sympathy with what is being done by us (and others) on representation, it must seem that we are obsessed with ourselves. Certainly some of the national newspapers and art journal critics at the *Three Perspectives* seemed at a loss to understand what much of our work was about, trivializing and categorizing it (as we had expected) in their reviews.[1]

> Much of the work had no place on the walls of an art gallery . . . it is difficult to imagine where the efforts of Jo Spence might be shown to their best advantage . . . let us not deny her doubts and confusion, but may we ask that she convey them to us in a way that raises them above the level of therapy.[2]

This type of criticism raises further interesting (and political) questions around the notion of 'therapy'. Certainly if feminists are involved in forms of therapy, many of us are not interested in adapting ourselves to the environment, nor in 'personal growth' (the two most popular definitions of therapy), but rather in undergoing a process of political analysis so that we are better equipped for struggle and *change*.

Such crucial issues of definition are hardly likely to be taken up by bourgeois art critics who are disappointed to see gallery wall space being 'wasted' with such 'amateur' efforts which have no exchange value. To those who don't understand (or don't want to) I can only say that the work we are doing is of an ideological nature. Through this work-in-progress we are interested to better understand how, through visual and other forms of representation, our psychological or subjective view of selves, and others, are constructed and held across the institutions of media, and within the hierarchical relationships in which we are constantly encountering the various facets of capital and the state.

In other words we don't just want to leave it to the professional, mediating, groups (whether they be in health, education, the media, or whatever) to *represent* the world to us, or to speak for us, however well intentioned – or not.

We urgently need to know how it was that we came to (mis)recognize ourselves as being present in the representations offered to us. This has meant starting from scratch with everything from children's reading, history and text books, to moving across a wider range of media, including the unsolicited imagery of the high street, together with newspapers, advertising, cinema and television. Only then have we been able to begin the work of comprehending *how* our socialization takes place, how meaning is generated for us, particularly inside the family, within schooling, and at the work place. Only then does it become possible to take a more actively critical stance towards those mediating organs which construct reality for us (often in the security of our own homes, or in the cinema), whilst placing us in a position of passive readership. However, we cannot possibly tackle this alone, as individuals, so this raises for me the question of organization and alliances, and the even greater question of class consciousness, to which I will return later.

Perhaps it is partly our initial incoherence and anger about the enormity of these all-pervasive representations which forces us to be so drastic in the work which we do on ourselves. Certainly in retrospect I feel that I have exploited *myself* in the work I did on 'image', especially in the ways in which I have permitted it to be used because I just did not understand the recuperative powers of the mass press.

Perhaps too (for those of us who are photographers) it is a growing concern at the ideologically oppressive nature of our own images of *others* which we produce to earn a living, over which we have little or no control once we have released them into agencies and libraries, that forces us to look beyond the production of yet more stereotypes of oppression with which to service the left-wing presses. Thus invitations to participate in critical work on idology are one way of activating others of similar mind for the intense period of political struggle which lies in the immediate future, in which the power of the state will undoubtedly become more and more central, naked, and intrusive.

The feeling of total inadequacy at denying the dominant forms of imagery, or in replacing them in any systematic way with anything 'better' was possibly what drove me, as a woman photographer, to give up an established career in portraiture, turning the camera instead onto myself, and looking at my own visual history whilst working as a secretary. In this process of 'symbolic reclamation', I transformed my rag-bag of private photographs (culled from family, albums, drawers, wallets, files, friends and relatives) into a more coherent shape which ranged from me at six weeks in a laundry basket, to me at 40 years. This proved to be the starting point for future work on looking at *photography* itself (and my own practice within it) for my 'history' seemed to con-verge on many of the commonest types of snapshots, portraits and conventions of the period it spanned from 1934 to 1974, and was totally unexceptional in its content. I think it was only my own direct experience as a photographer which enabled me to quickly grasp the fact that the photographs were an interface between ways in which various forms of 'construction' had taken place. First, they showed how I had literally constructed myself for the camera – the way I held my head, face muscles, use of make-up, hairstyle, clothes, backgrounds, etc. Secondly, they showed, through my

knowledge of the ways in which photographers (like me) had, with their manipulation of light, focus, their choice of techniques and use of photographic codes, constructed me on paper. Third, it showed how I had built up a view of myself through all this.

Clearly these sets of relationships do not exist in a vacuum away from everything else, but I want to focus on them for the purposes of this article. It was only later when I had looked at an extended range of images from popular publications that I began to understand the ideological work of these mutually complex operations. Then, as I began to identify with work in the feminist and labour movements, and hear from women's consciousness raising groups that spontaneous discoveries were often made about their collective (but previously experienced as individual) 'problems', or 'lacks', so my photographs became the embodiment of all the fears which I had displaced of not being 'beautiful' enough, not being very 'intelligent', of not being very 'well off', or being thought 'tarty'.

Until this revelation, the photographs had always served rather to confirm for me my record of 'achievements' as a woman. Without any comprehension of how or why, I had turned myself into a spectacle across the years, stripping myself of any other function than to be looked at, within my photographs – for such is the nature of the medium as used. This relationship with myself, through photographs, with its atten-dant repertoire of memories or reminiscences, has been confirmed countless times with people who understood what I was saying before I had finished my sentences. (Most of them were women – just as most of the clients who 'disliked' their own faces when I was a portrait photographer were also women, regardless of their social class.) I became aware that I had lived my life full of shame.

Montage and Deconstruction

These initial phases of looking prompted me to begin the work of categorizing many of these pictures which create 'woman as image'. I then began to try to analyse them from a feminist perspective, both for what they spoke, and for their silences. I then started this same work of deconstruction on photographs of myself and family, adding to them by playing out for the camera some of the dominant sex roles and images of glamour – montaging and juxtaposing them with media images. I began, too, to play out some stereotypes of 'working class' women but found them to be so limited and denigrating, so little to do with my own life, that I was forced to abandon it.

I feel that this parodying and montaging process has been the most fruitful part of the whole project for me. Instead of being ashamed and repressing my sexuality, I took on board the surface appearance of some of the representations offered to me as woman. At first tentatively, then seriously, then to the point of parody. This final work – of fantasy – was at first terrifying, then exhilarating. Later, when I saw the photographs of it, it was funny. When added to my visual history, plus new 'non-idealized' pictures taken of me (without my knowledge) by somebody I fully trusted, only then did it become feasible to understand that I could not be (as I had been taught, as I had striven to be), a unified self, but was a fragmented, divided and contradictory one. It was only later when I began to symbolically reconstruct (and stand even more outside) myself that the 'whole' became larger than the parts which I had taken to pieces.

I then began to see myself as the *site* of contradiction, and to grapple with the concept of a dialectical self, a self which is in a constant process of change, of working and reworking the past in the light of new knowledge, shifting, adjusting, changing, to different conscious energy levels. Finally, it became clearer by putting myself under scrutiny within the arena of my family, that not only I, but my whole family (as individuals and as an organized unit), were sites of contradiction. Here I began to look further than what had been included in our history. I began to conceive of what had been transformed or displaced (or repressed) – and had therefore not been recorded – through the intense sexual and class struggles *within* the family, which itself was intersected (through my parents as part of the labour force) with *wider* social and economic forces which constituted those same struggles.

This final dawning (so long repressed by me in my anxiety to 'blame' *them* for my 'failures' and theirs) caused a drastic shift away from how I perceived my parents for what they lacked, for not understanding me, for what they had done to me. Most essentially I became aware of how I had always needed to be different from them, locked as they were into their oppressive sex roles and their 'inferior' class position. I became aware of the guilt attached to this shame, with its endless circle of supressed anger. This awakening of my own class awareness, pushed away from childhood and adolescence was, and still is, painful and extreme. If this has become too abstract, it may perhaps be clearer if I give a concrete example in photographic terms of what I am hinting at.

The Illusions of the Past?

Let us now take one single picture – we don't even need to see it. Here I am, aged 30, smiling, on Hampstead Heath. I am wearing a small fur hat from which stray curls escape to frame my face. My head is tilted back so that the tiredness showing under my eyes becomes less noticeable. My *double* chin is held in check; my *crooked* nose is held straight on to the camera; my *large* mouth is shut (in spite of the smile), hiding my *tombstone* teeth. My body is completely covered up. The resolution of the lens is not good which means that the picture lacks *fine detail*, thus disguising my *ageing* skin. How do I know all this? Because I have lived it so many times before, because I wanted to minimize these *flaws*. So I project onto my face great areas of sexual repression which I have internalized, but which I am permitted to show (which I permit myself to show). My boyfriend has taken the picture. I am in love with him, I want to please him, to look as beautiful (as sexually desirable?) as possible for him, so that he will enjoy looking at me in the photograph. Simultaneously, I know that I also feel like death, because I am ill (I have just had an operation for the removal of an ovarian tumour), I am worried about my 'incompleteness' as a woman. But I smile, wistfully. This picture now stands in my exhibition as a record of me, on this occasion. However, my memory reminds me that I had nothing to smile about (but then nobody knows what is in my memory, which is anyway able to re-invent the past with great facility). All this is taking place at the surface level of the photograph – and here I take little account of the photographic conventions at work, although they are a determining factor in all this.

Now, back in the present, I remind myself that it *could* have been a different photo-graph. I could have had a different expression on my face. It could have shown what was dominating my life (I could have been photographed in hospital, with my numer-ous medicines, with the nurses who cared for me). I could perhaps have attempted to show what was invisible (for instance the reason for my illness) – the continual stress of my life (perhaps my parents' desire for me to settle down and be like them?), the use of under-tested steroid drugs with their crippling side-effects?

Perhaps it would have been possible to show my class or gender relationship to the welfare state, of my having no say in my own bodily health – my body which has been constantly pulled and dieted into shape, tested and timed, drugged and cut open, had the fruits of its labour taken away from it, had its sexuality made respectable, had its inquisitive spark shorted-out.

Perhaps it could have shown the profit motive of the international drug companies whose products I consume on the health service (as perhaps socialists or feminists might wish to show)? I could have considered showing people (others and myself) taking part in political struggle to change all this. I could go further with this scenario . . . but of course none of this even remotely crossed my mind when the photograph was being taken, nor the mind of the photographer, who was my friend. And how much more complex this hypothesizing if I had been able to engage a 'professional' photographer (like myself), or asked an artist to conceptualize any of these events for me.

The question arises here of why we should expect *photographs* to do all this. The reply is that, as enshrined in the current dominant practices of the medium, we are led to believe that they already do attempt all this, and more. (Sometimes our perception of a complex war hinges around a handful of photographs which are supposed to elaborate on what national newspaper texts tell us.) As picture-readers we are dis-couraged from ever becoming aware of the ways in which photography's conventions compress and transform everything into universal cyphers which we are taught to call 'snapshots', 'news photographs', 'portraits', 'documentary' pictures etc. – which displace the complex political, ideological and economic determinants central to any event.

For us as women, we are constructed as universalized, idealized, but always fetishized, units of normality – transcendent of class and outside of history. Addition-ally, we are put into a position where we are forced to evaluate ourselves, other people, events, with such scant information that we are lucky if we can move beyond its 'good' or 'bad', 'right' or 'wrong', 'them' or 'us' qualities. And we are constantly grouped and re-grouped into such categories as adults, children, girlfriends, teenagers, housewives, mothers, or into the larger groupings of the family, the community, the nation, the British and now Europeans – or if we don't belong to those categories we are repre-sented as deviants, hooligans, rioters, terrorists, etc. But always these groupings sup-press the idea of any notion of class solidarity *across* them, and mask the growing power of the state and its agents. The *types* of photographs and the ways in which they are used, with or without text, are integral to this agenda-setting process. Of course, much work is going on which opposes all this (as for instance in *Spare Rib*) with re-captioning, recontextualization, re-working and juxtaposing of this found imagery, but the dominant forms persist, and even recuperate and celebrate our efforts.

Aesthetic Strategies

I have related as much as I understand of the *process* of working on this self material, but let me now describe the *form* which it eventually took. For ease of transport and quick hanging I chose to work with 30 single panels 20″ × 30″, cheaply laminated. These could be hung in linear or block fashion, butted up against each other, as necessary. Throughout I used original photographs, reducing coloured media images by 50 per cent into black and white xerox. I used the formal device of three parallel narratives: an autobiographical written text, in accessible language, shifting from humour to self-criticism, anecdotes, half-remembrances, analysis, non-comprehension – I was not trying to construct myself as 'romantic or suffering heroine'; my private photographs; and a commentary on the photographic processes and the photographers involved.

The risk with such a presentation is that the narrative structure with 'me' as the central point of visual identification, speaking with various 'voices' across the photo-graphs and text, might force the reader to identify *with me*. This mode of presenta-tion had been chosen in order *not* to bring about either an identification or a catharsis, presenting the viewers with my transformation and resolution through the narrative (in which case they could all go home and forget about it), but rather to encourage them to do some work – drawing them in with my 'confessional' style of writing – and then leaving them to get through the fragmented and less accessible aspects. Just as the unity of the pictorial elements of my first 40 years of pictures is then disrupted with later contradictory elements which never resolve, so the two written texts continuously jump across and upset the flow of the pictorial elements.

Hopefully, the reader is ultimately forced to abandon trying to resolve the narratives, and to consider the dynamic social reality to which it refers outside of the work. The representation of this initial unity of 'me' (moving to fragmentation and then to a more dialectical self, more in control, but always in transition and change) was set more objec-tively against whole sets of social formations which I can still barely perceive. Here it should be difficult to close off meanings, rather to open up possibilities. Possibilities which come not from some 'neutral' unknown voice, but from the representations of 'me', spoken through the everyday language and practice of a feminist with a growing socialist or class consciousness.

The problem is, therefore, according to a constant Brechtian emphasis, not to con-tinue to supply the production apparatus of photography as it is, but to change it; without a radical restructuration, the attempt to join photography – or film – and rev-olutionary commitment is a contradiction in terms, and this transformation is what Brecht refers to as 'literarisation': . . . here, the breaking down of the barrier between image and writing, depiction and meaning: 'Literarising entails punctuating "repre-sentation" with "formulation"; it being this that could give to photography its revo-lutionary value' . . . following Brecht, Benjamin talks of montage in this connection as a form of such punctuation, as 'the agitational use of photography'.

It is significant . . . that it is to the principle of montage that Brecht continually refers to suggest the realisation of this active (readership) . . . (a reference which . . . distinguishes him sharply from Lukács for whom montage is a potential destruction of essential forms.)[3]

Cultural Commodities?

Moving on, what is it then that happens when we enter the arts arena with our work; work which we never dared to call art? It soon becomes clear, as it is categorized, personalized, reproduced, criticized, validated, valued . . . until it is eventually filed away again. (If funding is involved this in itself can even create the notion of what the funded object should be.) Once inside this cultural factory we again lose control. At the Hayward we, as exhibitors, had little or no say in the events which surrounded the show, nor in the publicity attached to it.[4] Seeing my work hanging in the premier British gallery gave me no pleasure – rather I felt alienated and ashamed that I had been chosen. Because I had hoped my work would have a use within political struggles (and because I had been convinced that to put it in this *particular* context would be equally useful) it had not occurred to me until I saw totally *random*, unknown, people looking at the exhibition, that I would be prevented (ideologically) from approaching them, or making any kind of critical contact with them. I was upset when people praised the work, saying 'how brave I was', and how much it would 'help my career'. This indicated to me that I had simply not thought through this final resting place; the point at which it would be totally removed from my control (where the process had been so valuable), reified onto a gallery wall. It is probably in the nature of this 'self portraiture' that I should feel this way; not because it is not useful for others to see the process and engage with the contradictory struggle of the representations of themselves, but because the material itself had now become 'other'. It may be ironic that the nature of any work of reclamation (and of learning to 'speak') should remain in the hands of those who do the reclaiming. I feel now that I have made my work available to a whole ideological state apparatus, with all the attendant status-validation which I don't want, where prints of it can now remain locked in the filing cabinets of the Arts Council, on piles of regional arts pamphlets, in the press cuttings book of the show. This is not why the work was made, and it is difficult to deal with this ultimate contradiction of having given up photography because of a lack of control over my work, only to end up five years later having converted my voluntary work into a 'cultural artifact' which now has a life of its own outside of me. I wonder, on reflection, if I have moved very far? It is this power of reproducability which also transforms because we cannot ever know the *context* in which anything ends up. Somehow we have not evolved (or perhaps gone back to) vastly different modes of distribution and exhibition, ones in which we had an interface, a possibility of feedback, of knowing if we were useful, of reworking materials. This is what was irresolvable at the Hayward Gallery . . . the structures won in the end, we remained out of control, in the exhibitionist/voyeur situation we have always been in. On the more positive side, I have had useful responses from many people already working in the field of representation.

For those who, like me, are coming from a variety of non-academic or non-artistic backgrounds, it is so easy for us to be pleased to have our naïve, non-theoretically grounded, work taken up as part of a liberal arts policy within major institutions. For us to be elevated into personalities, as a way of displacing the wider, non-personalized educational and political aspects of the work in which we are engaged. We can so easily become the radical salt and pepper within the institutions of mediation (where, as in

this instance, we are paid a nominal hanging fee of £150, to cover material outlay), rather than remain as rank and file members of the groups to which we belong and with which we identify. Perhaps the continuing work of institutional intervention is better coming from those *already* working within the gallery system, who are better equipped to know best how to deploy their efforts.

Practice and Theory?

My work has drawn very heavily on my own experience of many years within commercial photography, across a range of activities from local newspaper, advertising, high street portrait, and documentary photographer. By my writing about this, I don't wish to imply that I have gone through some sort of mechanistic stages and progressions, reaching some ultimate goal. Rather I have tried, in this instance, to use my own self portraits as the visible referant of an actual person, to understand the complexities of how representations mediate from the institutions of our social formation (outside of us) to a psychological subjectivity (inside of us), and then out again. And what all this has to do with my day-to-day life, and with feminist and socialist struggle. By demystifying myself as a 'professional' photographer coming to an awareness of class conflict, looking at the role that people like myself play in mediation, and yet showing how I too had been 'visually constructed', and by my method of producing the exhibition (even to including the bills of what it had cost), I had hoped it might make a useful contribution to ongoing debates.

These debates around representation usually ignore the crucial world of the 'private' photograph – as if it were somehow apart and untouched by other forms of mediation – or as if it were not also a site for cultural struggle. It is here in the realm of this so-called private photograph that I think some future strategies for political struggle lie. It is here that we can continue to develop ways of representing ourselves (also with video, film, poetry, music, prose, sport) and the groups to which we belong, rather than leaving it to other – professional – mediators to do it on our behalf, so we can be sold back to ourselves at a huge profit. In fact most mediating is not done on our behalf at all, but is done *on behalf of the owning classes*, in order to maintain the status quo for as long as possible.

If we are to pick up the tools of 'private' photography, though, we also need to be totally critical of how they have already helped to shape and construct us. In order to proceed we need a materialist theory of ideology, linked to a coherent theory of political struggle and *class* consciousness. Such theoretical reading, if it exists, will probably be difficult and abstract. Such work – in order to be relevant – must be dragged out of its compacted, elitist and perhaps deliberately alienating language, into the world of lived experience, so that we can understand the connection between the two. If not, we may be forever in danger of chasing theoretical moonbeams, of tearing out our 'empiricist' roots, in the vague hope that somehow we may be better socialists or feminists. We need a joint language which not only has its specialist discourses in the journals of the various Marxisms, feminisms and structuralisms, but which is penetrable enough for us to know if it is worth the hard work of taking up their conceptual tools, and what their application could be for a revolutionary practice in

photography. Perhaps we could look in the direction of the Writers and Readers Publishing Cooperative who, with their excellent 'Beginners' series have made accessible to us such great male 'thinkers' as Freud, Marx, Lenin, Einstein – but not the *application* of their philosophies. And perhaps we could encourage them to see the need for synthesizing work to produce 'Beginners' on representation, on psycho-analysis, on historical materialism, on dialectics, on ideology, on methodology . . . They are urgently needed.

It seems relevant now to question the notion of *self* portrait. We have to understand what is meant by the term *self*, and how the ways in which we are socially, economically and ideologically formed are crucial to any idea of this self, otherwise we may be in danger of the idealism of trying to peel back layers of representation until we think we can show a true self somewhere underneath it all. Also the idea of the portrait, enshrined as it is in the history of bourgeois art, as a set of aesthetic conventions revolving around the idea of the individual becomes a problem if we think of ourselves as members of a group, or a class, with an identity and history outside of our individualized lives. [. . .]

Notes

1 Some other typical reviews include: 'Worst of all are a series of panels by the (all female) Hackney Flashers Collective – a name which in itself indicates a certain lack of humour. Their work is the sort of thing an earnest schoolmistress might pin on the notice-board of a church hall' (Edward Lucie Smith in *Evening Standard*, 7 June 1979). 'And then, agony on agony, less than a projector's throw away, is the Alexis Hunter section, rich in tinsel, power and veal sausage fingers . . . But what will people think when they climb the stairs and come face to face with all this gibberish? Sarah McCarthy tells a tale in 88 photographs about the exploitation of women in nineteenth century society; called The Milliner and the Student. It combines features of Julia Margaret Cameron's home theatricals, the Fosdyke Saga and the Mill on the Floss produced as a BBC children's programme . . .' (Ian Jeffrey in *Artscribe*, 18). Contrast this with: 'the London Nursery Campaign were demonstrating (outside the Hayward Gallery) against inadequate provisions for young children in the widest sense . . . There are large contingents from several nurseries . . . One of the Hackney Flashers, who took some of the photos in the exhibition, looks cheerful despite the problem of how to take photos while holding a toddler at the same time. I had already seen the exhibition on nurseries in a local community bookshop, Centerprise. There are collages about the politics of childcare, photos of demonstrations. They look a bit entombed in the Hayward, their immediacy distanced by the atmosphere of a large gallery. But the pictures of the children and the nursery workers in a Hackney Community nursery are still direct. They are moving because they are not only protesting the injustice and disregard of capitalism, but asserting the intensity of people's ability to love and communicate, even despite these' (article by Sheila Rowbotham in *The Leveller*, July 1979).
2 Richard Ehrlich in *Art and Artists* (August 1979).
3 From Stephen Heath, 'Lessons from Brecht', *Screen*, 15 (2). I am grateful to Pam Cook for drawing my attention to this text which has made much clearer to me the problems which I have not resolved within my own work.
4 Just as the artists were removed from their context and their work personalized, so too were the political efforts of John Tagg and Angela Kelly, the socialist and feminist selectors. This point is critically expounded upon most usefully by Griselda Pollock in *Screen Education*, 31.

Linda Montano, 'Art in Everyday Life' (1981)

From Linda Montano, *Art in Everyday Life* (Los Angeles: Astro Artz, 1981), unpaginated.

Crucifix (Saugerties, New York, 1964)

Art: I made a found object, junk sculpture crucifix in my parents' backyard.

Life: By 1964 I had spent two years in a convent and fourteen years in Catholic schools. As a result I could relate to the crucifix.
In 1964 I related to the crucifixion as a real event which signalled the death of Christ.
By the 70s I laid in a cruciform position in a chicken bed and later walked in a cross pattern during a 'trance dance' that I did in the Chicago Art Institute cafeteria. I was internalizing the crucifix form and beginning to see it as something related to me and not the historical event.
Now I see the crucifix as an abstract symbol which structures my work. For example in Mitchell's Death, events happened on the vertical and horizontal axis. The evolution from the crucifix as a real time occurrence to using the sign as an abstract organizing device has been gradual and in retrospect, correct.

Lying: Dead Chicken, Live Angel (Berkeley Museum, Berkeley, California, 1972)

Art: For three days, from twelve noon to three, I laid in a chicken bed which had a twelve foot wing span.
I wore a blue prom dress, tap shoes and feather head band.
Polyethelene curtains surrounded the bed.
Fig leaves covered the floor.
A bird tape played during the event.

Life: This is the San Francisco version of the lying down piece . . . except I had moved from the east to the west coast and as a result, everything was more fairy tale like . . . more whimsical. I was curious about female imagery and tried making art that looked as if it were made by a woman but felt that feather covered female, donut shaped sculptures didn't satisfy me.
Wings did.
I provided sound this time and yet was still talked to/with and even kissed on the lips by a self-designated prince.
It was the time of silence.

Home Endurance March 26, 1973 – April 2, 1973 (1300 Rhode Island
Street, San Francisco, 1973)

Art: For a week I stayed at home and sent invitations to friends to visit me. I
announced my availability.
While at home I documented all thoughts, activities, foods eaten, phone calls. I
photographed all visitors.

Life: I was scattered, nervous, running . . . and the only way to counteract the ten-
dency was to stay in one place and call it art. That way I felt as if I were really
doing something, in this case being peaceful, and making art.
Maybe I could learn to be harmonious by practicing stillness in my work . . . was
the reasoning.
It was also a way of being home on my own terms.
I didn't want to be a housewife.

Handcuff: Linda Montano and Tom Marioni (Museum of Conceptual
Art, 75 Third Street, San Francisco, 1973)

Art: For three days Tom Marioni and I were handcuffed together. For ten minutes
each day we made a video document of the event. The time together became a
study in movement and mutual signaling.

Life: Somehow this event, more than any other one, raised questions about
public/private, and I felt a tension between my ability to be permissive in my
work and yet not in my life.
I needed to redefine marriage and tried to do so with art. Despite the conflict,
it was a magical piece and I discovered that Tom and I had probably been related
a long time ago.

Garage Talk (1300 Rhode Island Street, San Francisco, 1974)

Art: For three days I talked to everyone who went by my garage.
I was there from nine am to five pm.

Life: Art has often felt like a luxury to me. It seemed as if I could do whatever I wanted
but always in my own time. But I often questioned the politics . . . Was I really
working like everyone else? Earning my keep in the world? Was I a valuable
professional person?
I constructed this event which somewhat silenced the questions . . . keeping
9 – 5 hours as an artist for just three days, transformed me into a worker.
People responded to my presence . . . neighbors told me problems, a birthday
was celebrated . . .
I was available like my grandmother.

*Lying in a Crib for Three Hours Listening to my Mother Talk about Me as an
Infant* (63 Bluxome Street, San Francisco, 2 November 1974)

Art: For three hours I laid in a baby crib and listened to tapes of my mother talking
about me as an infant.
It was All Souls Day and our dog Chicken died as I was performing.

Life: I kept feeling, if only my mother would tell me what happened to me as an infant
then I could discover why life seemed imperfect. My mother kept saying how
normal I was.

Three Day Blindfold/How to Become a Guru (Woman's Building,
Los Angeles, 22 March 1975)

Art: For three days I lived blindfolded in a gallery at the Woman's Building. Pauline
Oliveros became my guide and didn't speak during the event.

Life: I loved camping out probably because I always wanted to go to summer camp as
a child and couldn't. So I often camped in galleries, sometimes living there for
some time.
In this event I blindfolded myself because I didn't want to react visually or
socially and thought that I could alter my perceptions and therefore drop
habituation and judgement. It was exhilarating and I was fearless . . . beyond
society, acting intuitively.
Pauline Oliveros became my guide for that time and we moved without guilt for
those three days. I keep repeating similar experiments in other ways in order to
become familiar with expanded body feelings.
This piece was a vacation.
It changed my life.

Rose Mountain Walking Club (San Francisco, 1975)

Art: I formed a walking club, sent out announcements and gave tours of San
Francisco.

Life: I was walking out of my current life at the time and so this piece was meta-
phorical of the change. It was a good idea but I did only three tours and only a
few people came.
My marriage was over.

Erasing the Past (Woman's Building, Los Angeles, 1977)

Art: I laid for three hours in an empty room, my torso exposed, seven acupuncture
needles in my conception vessel.
I intended to forget the past.

Life: I had just been on the David Ross show at the L. A. art convention. I was bold,
talkative, funny . . . Dr Jane Gooding.
The next day, Suzanne Lacy asked me to do something at the Woman's
Building. I think that they were having a circus. It was upstairs, and festive.
I was downstairs – isolated, silent, faceless and feeling somewhat foolish . . . I
couldn't always be Dr Jane Gooding.

May Stevens, 'Looking Backward in Order to Look Forward: Memories of a Racist Girlhood' (1982)

From *Heresies*, 15 (1982), pp. 22–23.

[. . .] R. and I married and went to Paris to study painting. Paris in 1948 was in
post-war turmoil. Art was dominated by Picasso, Léger, and Fougeron, around whom
political and cultural controversies swirled. Picasso did a peace dove, Léger construction
workers full of optimism, and Fougeron miners with broken bodies and missing limbs.
Anti-Americanism ran high. A painter I met told me I was too sympathetic and humane
to be an American.

It was the era of SHAEF [Supreme Headquarters Allied Expeditionary Forces]
and the Marshall Plan abroad and McCarthyism at home. Graffiti on pavements
under our feet said AMERICANS GO HOME. We were actually afraid to return
to our country. Abroad I felt patriotism for the first time. A sense of place. The
desire to be with people I had grown up among, to hear my own language in the
street, to have a fullness in my speech that comes only from stored-up images and
remembered relationships. Paris was not beautiful to me until I had met someone
on that street corner, had lunch in that cafe, and it developed a human history I could
touch.

After three years we returned to newspaper photographs and television films of buses
burning in Alabama and Civil Rights workers being hosed and beaten in southern towns
and cities. The nonviolent nature of the struggle spoke to my New England upbring-
ing. I lived out that drama daily and turned the media documentation into a series of
paintings and collages I called *Freedom Riders*. The Rev. Dr Martin Luther King, Jr,
wrote an introduction to the catalog (a sign of white-skin privilege since I had access
to him through largely white artists' groups). I wanted to donate a percentage of sales
to CORE [Congress of Racial Equality] but the gallery said no. Nothing sold until
later when the AFL-CIO circulated the exhibition to its New York and Washington,
DC headquarters. Then someone bought a little painting on which I had written
edge-to-edge:

WESHALLOVERCOMEWESHALLOVE
RCOMEWESHALLOVERCOMEWESHA
LOVERCOMEWESHALLOVERCOMEW

People who saw these works over my Anglo–Saxon name thought I must be black. John Canaday of *The New York Times* thought they were not violent enough. Others thought paintings and politics shouldn't be mixed. I almost despaired of being understood.

If I had been able to leave my five-day-a-week teaching job and my small son and go south, I would have painted different paintings. (Or perhaps not painted at all. How many paintings came out of that struggle, painted by people who were there?) Northern white that I was I romanticized distant battles. But I painted with a feeling of great excitement, risking my art in an attempt to move others as I had been moved. I would move out of the guilty past into a fighting present.

These collages, drawings, and paintings approached the social issue I cared most deeply about. The personal aspect was my father's racism and the racism I had breathed in growing up where and when I did. Since my father's ethnocentrism had many faces, I saw them as part of the same pattern in spite of their differences and the extremity and singularity of black history in America.

In my private emotional journal through this swamp, I

turned to a Jew and a radical and married him
turned against my Yankee racist father
publicly painted him as a bigot
turned toward my Catholic mother
celebrated her in poems and painted her as companion to Rosa Luxemburg
turned to Rosa Luxemburg, Jew, radical, as spiritual mother
bore a half-Jewish son in Europe when the smoke from the ovens was still in the air
painted the Freedom Riders of the Civil Rights Movement
painted myself in the place of Courbet/male artist/leader/master surrounded by art
 world friends and supporters
painted contemporary women artists as they enter a new role in the history of art

I think I've come to a place where it's necessary to say: No single oppression justifies the practice of, or indifference to, or ignorance of, any other. No doubt there is need for different emphases at different moments and we each fight best our own particular victimization. But surely nobody believes any more we can take them in some sort of sequence, assigning values – whose pain hurts more, whose sense of rejection is more profound.

Strangely, my racist father taught me to hate racism just as his oppression of my silent, sick, lapsed Catholic mother taught that oppressions come in clusters. Somehow I must look at what he did and what he became in doing it, without throwing up on the wall of the cave another phantom that caricatures the world.

Susan Hiller, 'Anthropology into Art' (1985)

Interview by Sarah Kent and Jacqueline Morreau in *Women's Images of Men*, ed. Sarah Kent and Jacqueline Morreau (London: Writers and Readers, 1985), pp. 148–153.

Jacqueline Morreau: Can we talk about working as an artist in the 1980s? What, for instance, is your response to Germaine Greer's conclusion at the end of her book *The Obstacle Race* – she writes that 'Feminism cannot supply the answer for an artist, for truth cannot be political. She cannot abandon the rhetoric of one group for the rhetoric of another, or substitute acceptability to one group for acceptability to another. It is for feminist critics to puzzle their brains about whether there is a female imagery or not, to examine in depth the relations between male and female artists, to decide whether the characteristics of masculine art are characteristics of all good art, and the like. The painter cannot expend her precious energy in polemic, and in fact very few women artists of importance do.'

Susan Hiller: She collapses a number of terms in that paragraph and mixes up the meaning of words like 'rhetoric' and 'polemic'. Still, it's thought-provoking. I do think it's an important point to discuss – whether art and politics are different discourses. Greer says that very few good artists concern themselves with political ideas, but what she really means is that they don't concern themselves with political subject matter. Actually, there's no reason not to adopt as a hypothesis, that everything one does and believes informs one's art. As a woman and artist, I am inevitably redefining what the category 'art' includes, and that's a cultural struggle.

It's all so much more subtle than Greer implies. All representation is political, and art carries meaning into the future. Whether or not these meanings coincide with the stated intent of the artist is another question.

Sarah Kent: You mean that you're not necessarily in control of the ideas that your work conveys?

SH: Yes, that's part of what I'm saying. One of the more interesting fallacies in art is that of intentionality – that intention and interpretation ought to be, or even can be, the same. One definition of art, for instance, might be of something open ended and productive of meaning. As far as politics goes, there's a whole range of possibilities – you can be an artist who is active in politics; you can declare a political intention in work designed for the gallery world; you can work within a community doing what might be thought of as agit-prop, and so on. Personally, I tend to reject any claim that there's a direct relationship between any artist's work and its political effect. It's more as though politics and art reflect and formulate the same terms – there's a kind of parallelism.

Each group and subgroup in society produces artists appropriate to its particular formation. Some artists have an archaic notion of themselves as geniuses, speaking from some unexamined notion of authority, while others assume that their radical political sympathies give them a transcendent overview. In either case, the resulting arrogance is much the same and the different forms that the justification takes may simply be a matter of temperament.

Personally I believe the function of art is to show us what we don't know that we know – and this is definitely a social function with political implications . . . But I'm not interested in using art to present journalistic or sociological ideas – since I think art is of the same order of importance as other disciplines.

SK: There's a crucial distinction to be made, though, between those who work in a form that is easily understood, in an attempt to radicalise people through content, and

those who want to radicalise their audience by introducing them to a new way of looking at and considering art by opening up the boundaries of art in unexpected ways.

SH: The whole issue of modes of representation is so complex. There are people nowadays who can relate more easily to a videotape than a painting. But the notion of radicalness or street worthiness of new media *per se* and their innate credibility – I'm not sure. It's true that the slender history of film, and particularly of video and performance art, means that the artist can start off fresh, without the weight of a long tradition, and this has certainly released a lot of creative energy amongst people excluded from the tradition of, let's say, painting – particularly women. On the other hand, the 'left' in art practice and the 'left' in politics hardly match up. We have 'left-wing' critics, for instance, equating art solely with traditional media and trying to exclude all the new stuff – just like the conservative critics.

JM: How does gender come in here and/or marginality?

SH: Well, since women are excluded from the tradition, when a woman makes art that speaks as clearly and adroitly as she is able, can the issue of gender not be present? I would say not. And to the extent that the artist speaks about herself as sexed, specific and particular, the work is located oppositionally. Of course, she can try to avoid issues of gender, thus betraying herself. Marginality means that you internalize two conflicting but sometimes overlapping sets of ideas about everything. I'm a marginalized person because as a woman in this culture I do not have a female language. I am excluded from culture and from cultural traditions unless I speak as a man – have one-man shows, for instance! The work I find most interesting is a very sophisticated play on accepted and recognized systems of representation, format and so on, with a desire to subvert, modify, change and, through this interplay, create a space, gap, hiatus or absence in which something new can come into being.

JM: I see in your work a relationship between what is sayable and seeable with what is unutterable, invisible, yet present. I see your work as dealing with archetypes, yet as an individual you are informed by politics, feminism, anthropology and so forth.

SH: You seem to be suggesting that there is conflict, or you feel these elements are contradictory. That's because you are making 'politics, feminism,' etc sound like abstraction. All my work is about *enunciation* – articulating the suppressed, the overlooked, the previously unsaid, unsayable and so on. Usually I begin with cultural artifacts that seem to me to embody the unconscious side of our collective social production – such as the *Rough Sea* postcards, for instance. And sometimes I start with my own personal productions – drawings, photographs, etc. but always there's an assumption of shared subjectivity. My work is located where my personal awareness intersects with the social – as is all art. So there's no contradiction. [. . .] Let me sidetrack a bit – I've been throwing the word 'art' around very freely, but I'm not actually sure what 'art' is. I know what painting is; I know what performance is; I know what video is; but whether or not any work qualifies as art is an assessment that is made retrospectively. We don't know which work will be judged positively in the future and this allows for some optimism.

In fact, we are helping to enable a particular future to come about – at least that is what I believe. You've talked about the disadvantage of being a woman in the arts, but for those of us who have a feminist perspective, there's a sense that what we are doing

matters. As far as my own work goes – even if it's rejected or misunderstood, and always falls short of my ambitions – I still know that I am speaking on behalf of vast numbers of other women whose versions of reality have been misrepresented. This gives me a sense of rootedness, of community and is a source of strength.

SK: There are many different ways of mattering, though – that's the conflict.

SH: Well different audiences bring different judgements to bear. But it's not a conflict for me! I think of art as a first-order practice – as important as sociology, psychology, physics, politics or whatever. Artists take shared internalizations and find a form for them, and certain social values are upheld while others are contradicted or modified. Art is a way of carrying ideas forward, of giving them a shape and making previously incoherent or unconscious feelings and attitudes articulate and available.

[. . .]

JM: So how does one make the work accessible without losing its complexity of meaning?

SH: Well, in my own work, I try to allow various levels or means of entrance. But for artists with a more overtly political aim, trying to achieve political clarity may mean losing everything that makes art, art. My position on this is changing. I would suggest that art practice with no overt political content may, nevertheless, be able to sensitize us politically. This is just a hypothesis, based on my observations and work on these issues over the past ten years. Conversely, and this is very important, political experience can sensitize artists and put them in touch with what their work is actually about, could be about, or ought to be about . . . But certainly there's no simple relationship between the political content of an artwork and its effectiveness. 'Isms' within the art world, whether socialism, feminism or any other 'ism' are used to define territory. Then once a territory has been established there are people inside it and those who are excluded. Claiming a territory has a lot to do with hustling for a place in the art world and excluding as a threat all those who don't immediately follow as acolytes.

SK: You've said many times that you're a feminist but not a feminist artist. I've never completely understood what you meant by that distinction.

SH: I refuse to be relegated to the sidelines or to collude in qualifying or limiting the nature of what I'm doing! I happen to believe that being a feminist is good for my work because it's crucial for me as a person. It enables me to understand some of the things I'm dealing with. Feminism is a profoundly significant perspective, which does not imply speaking exclusively about so-called 'women's issues'. In art the implication is that there's a quest for a language to express perceptions shared by more than fifty percent of the population – this matters, it indicates that art means something, is real and, thank goodness, I know I'm not just playing end-of-the-world type games . . . A few years ago I talked about 'truth-telling' in art practice, and for me, since gender, language and desire seem crucial to what I'm about, feminism has been of primary significance – though of course many other things feed in, too. [. . .]

Mary Kelly and Griselda Pollock, 'In Conversation at the Vancouver Art Gallery' (1989)

From *In Conversation at the Vancouver Art Gallery* (Vancouver: Vancouver Art Gallery, 1989), pp. 22–40.

Disaffirmative and Strategic Practices

Griselda Pollock: One of the things I was trying to explore for myself last night was the position or set of arguments that are put forward around the legacy of modernism as it's being re-examined by social historians of art, particularly the Clark debates with Greenberg;[1] all of that which leads to a sense of modernism as a process of taking on existing versions of art, accepted protocols and procedures, and systematically disrupting, destroying them, which leads to this thesis about 'botching'.[2]

On the other hand, there are a series of practices which that group of people represent as having abandoned the whole legacy of modernism. They have instead taken as their focus of attention the dominant forms of capitalist culture in terms of photography, the cinematic, the media. Critics localize certain main tendencies of post-modernism in this strategy, dumping feminism into it. That's what the John Roberts paper[3] says is the 'anti-painting argument' which basically explains feminist interest in photography as the result of its being democratic, or popular culture. It, therefore, repeats a basic division which derives from Greenberg's 1939 paper, 'Avant-garde and Kitsch'. Modernism still retains, as its central point, that awkward relationship between high art and popular culture.

Now what interests me is: how do we think about feminism's place in these debates about strategies because I don't accept that all kinds of feminist practices, even critical feminist practices, can be classified in that way, but I am interested that one could look at it in those terms and raise those questions about it.

And obviously, feminist art work is always perceived as trying to be 'disaffirmative' – disrupting, playing against the grain. And yet it does so by means of studied, formal, appropriateness which is easily misrecognized as a kind of fetishized formalism. What we've been talking about so far is that, you arrive at certain formal solutions in notions of 'appropriateness' in terms of quite a complex set of strategic calculations, recognitions and the acknowledgement of desire and pleasure.

Mary Kelly: This is one thing that I do have a problem with that I want to talk to you about. It sounds like there are all these so-called feminist practices – and there are many, many women working in the same way. I don't think that's the case. I think that there's a particular kind of working process that, probably, is appropriate for each person and one of the things that I'd be very adamant about in my case is the project nature of the work and that this is a strategy, across the board, as a *corrective* to the one-liners of the so-called 'new criticality', and that one is making an intervention. I take your own saying which was 'Let's not talk about feminist history; let's talk about

feminist interventions in art history.' And I think you have to talk about feminist inter-ventions in art practice and not 'feminist art'. I would go on record as saying that now.

I know that you suggest this in your book[4] but then you always slip into feminist art practice again. That essentially was the thing I wanted to take up. You then have to look at the way feminism is imported into the art world because you're really talking about that kind of intervention in art and not feminist practice. The most common and visible form of this is what I'm going to call 'opportunistic references to sexuality and to the category of woman'. In *The Forest of Signs*[5] you have examples such as Cindy Sherman and Barbara Kruger. The critical discourse around the work, not the artists necessarily, opportunistically imports those references, but is very careful never to mention the term 'feminism'. It's the political dimension that remains totally unac-ceptable in the art world. I'd say we have not gotten anywhere with that. What's happened is that they've been able to use work around the idea of 'woman' or of 'sexuality', as particular themes that certain artists are working with. On the other hand, there are artists, an example would be Nancy Spero or others, where the pos-itions are very much carried over into the practice almost as direct quotations.

I would say that both of those kinds of strategies are still very different from the practice that I was trying to describe. It's not just that you're importing the positions or quoting the theory. You're actually making an intervention which shows that you're thinking through the art work, coming up with a visual debate that's contributing in some way to the ongoing debate in the women's movement as well as in the art world. There are other artists who try to do this, like Marie Yates perhaps, but I think it would be more a matter of (to use your terms) the 'specificity' of all of these practices rather than any generalization that you could make about feminism, and I think that this is also a very important point because, after all, what the boys always do is deny, adamantly, any kind of covering term or tendency for *their* unique production.

Judith Mastai: Seeing that you've brought up the John Roberts article a few times, I'd like to raise a couple of questions. First of all, I'm not quite sure that I understand the point you were making about the article in terms of resurrecting a Greenbergian dichotomy between kitsch and the avant-garde, or popular culture. What, in simple terms, do you think that the scriptovisual represents?

Another question has to do with the business of 'disaffirmative practices'. With these, the list has been constructed, it appeared somewhere[6] therefore the procedures and the methods of disruption are now known, and so, what the process becomes is, not exactly formulaic, but a lot of 'knowns' being worked out in contemporary situations, as opposed to the modes, the practices, the materials, as well as the disaffirmations, the disruptions, the feminist interventions in our practice – all those are *unknowns* when you're trying to do that kind of practice.

I appreciate very much the term 'disaffirmative practices', the concept behind 'botching' something on purpose, but I think it's about apples and oranges. One is a total enterprise, starting from almost ground zero and the other has a social, political, historical context that's been ongoing all this time.

GP: This has clarified something important here. If you say, 'What is it that feminism, in its specific disaffirmative practices, is disaffirming?' one might say, and I apologize for this but for the sheer sake of short hand, we're disaffirming patriarchy. We're dealing here with whatever term we have for the kind of complex social, economic, ideological

and psychic processes which we identify as constituting 'the problem' in all its varied forms. Whereas, what John Roberts and those people are disaffirming, is culture, good art. They're disaffirming culture as some kind of comfort by trying to show that the forms of culture and the majority of what the bourgeoisie purchase and consume is the product of and the realization of the culture that condones the murder of six million people, the holocaust, or condoned the dropping of the first atom bomb on Hiroshima and Nagasaki and introduced us to the world in which we now have the potential for one group of people, seriously or accidentally, to wipe us off the face of the earth.

There is a connection there, and Greenham Common is an instance of the feminist movement's attempt to try and bring those two processes into some kind of vivid connection for us. But it seems to me, that putting the two together shows that those people who were arguing for disaffirmative practices have a sense of it only disaffirming culture. Whereas, what we have been trying to explore is that, in the process of disaffirming patriarchy and the constitution of sexual difference, we may well find ourselves operating strategically and calculatedly in certain domains called culture, even deploying very sophisticated aesthetic processes or techniques, lures and pleasures, for which this notion of 'botching' your feminist work doesn't make a lot of sense in some crucial way. That's what I was really interested in. If one explores the logic of that kind of Marxist modernist/postmodernist debate, it enables us to see more distinctly what feminism is. And, I think, what Mary is saying, in terms of this intervention, also confirms that particular point. What John Roberts represents, to go with the first point of your question, why I brought up the avant-garde/kitsch – is that they're caught in a cleft stick between fundamentally being passionate about modernist culture, just loving what it can do, and yet being politically in a position where they have to say they don't like it because it is the culture that produced Auschwitz and Hiroshima. So, Terry Atkinson then comes out with this notion of simply going on, you just keep doing it. You know that there will be poetry after Auschwitz, there shouldn't be poetry after Hiroshima, but somewhere along the line you have to do it. And some of that must be important to feminism because of the overlay of the world we live in. The question of where you locate the structures of violence is somewhere slightly different, and therefore that question – 'what is it that feminist interventions disaffirm?' – isn't modernist culture, but something more structural. And therefore, bringing those kinds of artwork, the processes and practices which, as Mary says, co-opt notions of sexuality, references to sexuality or voyeurism, the gaze or fetishism, or any of the elements of psychoanalytic theory, without that overall sense of what one's doing it for, how it articulates, appear to the John Robertses of this world as simply failing to disaffirm culture.

MK: Before you go too much further with John Roberts, I would like to say that he is a critic of absolutely no consequence and I don't think we should be wasting our time talking about it, because the way this debate has shaped up just recently in Europe is not even as interesting as Greenberg and it rehashes the very same kind of dilemma between high art and low art. And that is so completely out of sync with the more interesting things that have gone on in North America as far as the postmodernist debate in art is concerned. Here, at least there's been some idea that the whole field of postmodernism can't be captured by one tendency. There's writing by Hal Foster and Craig Owens about oppositional postmodernism and some acknowledgement, if

minimal, of the way that feminism is based with a wider context of theoretical work in that field. You were referring to Jacqueline Rose's earlier article which points out just how permeated the current discourse is with the radical, mostly French, feminist theories and how people like Jameson use this without really acknowledging where it comes from and you could say, 'How did they come to that position?' It was coming very much from the debates that went on at that time in France, that is from feminism – other examples are found in Lyotard or in Ken Frampton's writing on critical regionalism. Its been very far-reaching. We're not claiming a little territory, as it were, a little intervention by feminists in some kind of reserve of popular cultural kitsch. There's a centre or 'totality' of modernism that's been shattered by the things that feminism, feminist theory, I should say, raised. So, why not drop John Roberts, and think about other kinds of critics, and other debates, that actually do have some space to situate a discussion of women artists and feminism, in particular.

GP: I'm very *un*interested in the fact that it's so easy to stay, automatically, within the field in which everybody is talking your own language; and I'm very *in*terested in establishing dialogues with those critical positions which seem so far removed and incompatible that you wouldn't have any conversation. Now then, there are those people who are happily within the frameworks of Lyotard and Baudrillard, but there are whole groups of feminists who are working in areas of art practice in which that is not what they're based on, and what I am interested in is making sure that there is a feminist discourse large enough not to have left the territories of painting. Women who are involved in painting feel that the only place that feminist debate takes place is with those who use a certain kind of discourse, a certain kind. . . .

MK: That is a terrible problem, because what you're doing is trying to accommodate *all* women and accommodate *all* feminisms and that's taking the politics right out of the art practice. I am not sympathetic at all to the woman who stood up last night and said, 'Well, I'm so happy you talked about gesture and about paint because I just love to paint and I want to paint.' You don't need to accommodate that. It's like somebody saying 'Well, I'd like to have socialism but don't take away my summer home or my BMW.'

JM: Now you are coming to a very crucial issue though because, let us argue for the moment, for the sake of argument, that you can write off John Roberts because he's not an important critic. The fact is that he does mention the work of four women artists who are using paint. By writing him off we're writing off the four women artists he's talking about, under the same rubric. So where does that leave us in terms of paint?

MK: I have to finish just one more thing because now I'm getting worked up if this attempt to accommodate women leads you to accept forms of painting that aren't very radical. Let's acknowledge that teaching is one thing, and the world of art institutions, which I would define as entertainment, is very different. I think here we have to acknowledge that we are involved in a kind of cultural warfare where not everything goes. When you're teaching you don't set up hierarchical relations to a particular medium. What you're interested in is the development of the student. In that sense, you're not prescribing the students' politics. But in terms of your own practice, that is where you absolutely lay down the line. There is an argument. If

representations have meaning, and we have responsibilities for making them, those positions really matter. And the difference is that, within the academic institutions, we have to believe that art is a teachable craft, so all the Greenbergian formulations about appropriateness of medium, etc. might apply, but in the entertainment sector, which is what's on right now at the Vancouver Art Gallery or wherever, there is a very different set of criteria also central to modernism which is about establishing artistic authorship, originality, genius, and what is most compatible with those kind of demands is a traditional form of practice like painting. So we're not saying that there is no hope for painting; we're saying it is historically very specific, very strategic, what you take up in your practice and not 'anything goes' and not every woman needs to be supported.

GP: I don't accept that by listening to what is actually being said in a range of practices that one is necessarily saying 'anything goes'. What are the arguments available which might propose some kind of radical practices for women in painting? What are the historical legacies of either modernism or feminism or any of the others as they converge across the territory of feminism? There is some set of strategic difficulties. That's one fact which is more available for you to take up because that is where you make your choices. What would you do? In a sense, what surface and what kind of positions would you advance? On the other hand, I think it is really important, without any sense of just either falling into 'anything women do is okay' and 'anything anybody wants to do is okay', to take what people are saying, either at a level of expressing a desire to paint or, institutionally, the pressure to paint, and somewhere along the line, you have to investigate what the implications are in that territory. Otherwise you end up in a situation which I see constantly being re-enacted where the nature of the feminist interventions is being massively displaced and marginalized by being described in terms of a choice about media.

On Alliances

MK: We're not talking about a hobby here. We're talking about a very different kind of practice and what you *fear* about marginalization you might be *reinforcing* by looking for these threads of feminism that cross all these diverse practices because the alliance, as I see it, is that I would be much more interested in the work of Hans Haacke or Victor Burgin or even Jeff Wall than I would be in any of the women mentioned in John Roberts's article. I think that the debate lines up more along those lines.

GP: That is a position which anybody could observe in terms of the strategies that you've outlined. You don't make women's shows. You make group shows in which the issues that feminism has put on the agenda are explored by those who practice, and that may include men as much as women . . . I don't think that you can cancel out what I'm doing as lending legitimacy or not lending legitimacy. I'm not a critic. My perspective is historical. I'm not in a position of lending currency or political legitimacy to any particular position. I'm interested in what you call 'the cultural warfare'. That kind of cultural intervention has to be engaged in. This may be because of the British situation out of which I have come. There hasn't been a show since *Difference*[7] in 1984

that has seriously taken these questions on board and, even when *Difference* came out, all of two people wrote about it in a major way; John Roberts and me.

There is a kind of silencing, which is interesting because, historically, that is why it has been imperative that you relocate. Some places aren't really interested in certain kinds of discussions. For instance, this kind of debate – could I imagine this happening in Leeds or Cardiff? That may be where I get my sense of 'I have to take the battle now to where those who seem to be in control of critical discourse are'.

I see in the feminist journals a certain kind of discontent. It is the revolt of the daughters against their mothers. And it seems to me that British daughters are far more rebellious than in any other country. Particularly, there is much less generosity to the first generation of feminists than there is in any other country.

The other thing is that there is a very strong formulation of who my potential allies might be, in terms of left critics, which would be those people who are very heavily influenced by Clark and that tradition must have some currency in Vancouver.

My strategy at the moment is, if the consistency of a feminist attack on a certain kind of feminist work is being mounted, and if that argument gains currency without being contested, and without an equally probing and intelligent response to the basis of this attack, that field of critical feminist possibilities, as a possibility for critical practices, is lost because the assault is from the feminists; the assault is from the left and we know that, as far as the establishment is concerned, it's not working. Within the American art system (I don't know what the Canadian territories are) where you're located at the moment, I would be very anxious, precisely by what you're saying, because the show *The Forest of Signs* provided a situation where there was currency for a certain kind of work. But even in *Beyond the Purloined Image*[8] you were safe, satisfied to mark out the difference between the Brechtian-inspired critical practices that seemed to be characteristic of British artists, and the Baudrillardian tendencies that seem to me to lead into very murky ideological territory.

MK: I can see what you're doing. Obviously, in fairness, you're engaging with Roberts because this is being politically responsible. That shapes the debate in England at the moment. But going back to *Beyond the Purloined Image*, which was 1983, every 'good Marxist' believes in the specificity of a particular political, social, geographic location, but somehow that has managed to fall apart, partly because capitalism – everything – is international, or multinational. And in a sense when Thatcher got in, and now she's been in for ten years, the things that began to change in the art scene in England were so dramatic. First of all, the so-called alternative spaces – many of them were closed. And it virtually wiped out all forms of performance, installation and video art because these were the kinds of centres that showed them. The ICA and Riverside Studios remained. But also the Arts Council, given that there was now a Conservative government, didn't have to abide by any of those things that we had accomplished in the Artists' Union early on. They stopped giving grants, much less getting them distributed equally among women and ethnic minorities. So all of that was scrapped. Now, because (and this is terribly superficial) there is no real ground for modernism in England, or modern art, or collecting of modern art, the private sector is quite small. This I attribute to the fact historically that they never had a proper bourgeois revolution, so they didn't need the cultural products of the middle class to consolidate it. But when you get such a long period of conservatism, then you can see that the space

for this oppositional practice is disappearing, becoming almost impossible, unless you make an alliance with other kinds of oppositional practices that were going on, as in North America. Or outside of Britain. And that was my reason for curating *Beyond the Purloined Image*. It was an attempt to shape that tendency, to prepare for the *Difference* show, which would then bring together the two kinds of tendencies. Because even though there have been conservative or Republican governments in the United States, it didn't sufficiently damage the industry, so that it would close up around traditional practices. It remains, for economic and other reasons, possible to sustain that kind of art, so you find that this new criticality eventually peaked. And I think that was simply one of the reasons that leads me to emphasize that it shouldn't be just national in its focus, and that perhaps the emphasis, again, on feminisms, shouldn't be national either; if one really wants to get round the whole problem of ghettoization, and see these issues sustained and historicized.

Of course, as you said, you're not primarily a critic, and I'm making a plea for a more radical criticism, but because there are so few women that have your purchase on all of these ideas and can really enter into those debates, you have to perform the function of critic, historian – the whole thing. Who is there who can cover that in the way that you can?

Rewriting the History of the Twentieth Century
from a Feminist Perspective

GP: The project I've set myself is to say: 'Can I write a feminist theory of painting?' I doubt it. But I try to sort out all the terms in which that word operates. Painting is not just a particular medium, but there is a certain amount of desire invested in it, and I'm not going to dismiss that desire until I've worked out what it is. In some sense, it can be examined in the light of this set of practices or set of priorities that feminism might pose for me. It is also something that is incredibly heavily invested in terms of the legacy of cultural languages and dominant paradigms that we inherit.

Where painting stands to modernism is almost synonymous with a certain set of practices clearly authorized and validated through the major museums. What we're seeing, through the market place, is a whole range of those elements that you've mentioned in terms of authority and authorship and authenticity and expression. There is a massive number of historical and ideological investments which are signified by the term 'painting' which go far beyond that simple thing you know – hogshair brushes or pieces of linen with mud on them. And there's a confusion there between the technical and the institutional.

There's another domain (which is what I was trying to bring out in the lecture last night). There are two different cases being made. There's the case for a kind of painting that is the site of figurative explorations which are affirmative in the sense of saying 'these are *about* my relationship to landscape, to woman, to my babies, to whatever, etc.' And there are also those who pursue painting as a site of some kind of feminine inscription. So there is an enormous amount of confusion if anybody says, 'you should paint; you shouldn't paint'. All I'm saying is I'm one of those boring people who wants to know what it is that you are saying by using that word? And this launched me into an enormous conundrum of different communities using the term, different

traditions, etc., and what I was trying to do is to throw some of them into a context with each other, so that we might profitably come to some conclusions.

Now, I suspect it is over-determined that painting is difficult in so far as all the available practices and justifications that I've come up with, in terms of women's use of it, have a certain problem because women tend to be using painting in order to affirm some sense of women's meanings of some sort, whereas those in the account (for instance, go back to Terry Atkinson) use painting, not as a *means* of exploring certain ideas, but as the site against which he throws the British involvement in Ireland, for instance, the whole question of nuclear war and militarism. He's gone through using figuration and drawing and narrative and history painting and collage and photography and prints; now he's into taking on non-representational art – abstract art – as a site. Now that's a very different set of practices, which is to say painting is that legacy which I am going to trample over in my hobnail boots with my father's mining helmet on my head, which is to some extent what's going on – a certain enforced exploration of the culture of the bourgeoisie from a perspective of someone who wants to be involved in cultural production but has other investments of a very political kind. Now, is that an interesting model to look at?

Or is it an interesting model to look at, for instance, the Latin American situation that Nelly Richard describes, which seems to raise some of the possibilities in her history of art in Chile in the past 20 years? It's really fascinating because it mirrors exactly what's happened in feminism. You have the quilts and patchworks in the early periods of 1973 when there was propagandist, affirming, populist, political art; then came a generation which has forgotten that history, comes back to the European art schools with their paint boxes and paint brushes and has got 'expression'. This is just as interesting because it's the same trajectory. Now, if I put those together, am I not going to get a purchase for the feminist community, in its diversity, which enables us possibly to arrive at some strategic possibilities for feminist intervention, in that institution, in the art world, which is centralized under American hegemony.

But there are all these peripheries with which we can form interesting alliances which may have some serious effect in both the entertainment sector and the art education sector because we're providing our students with text (what you're suggesting about being in a dilemma because what you've got comes through the magazines or your art instructors) and if we don't write feminist histories of the whole lot . . . that's my sense, rewriting this whole history of the twentieth century contemporary situation from a feminist perspective because you need that knowledge to make those decisions. You may say that's kind of redundant because we're going to end up with the same conclusion that you've already come to – you don't paint – its just not on.

MK: No. I just said that it was historically very specific, and I think the example you give of Chile is very important because you can see that it's not the medium, it's the context. What I was arguing for was a visual debate; not a dogmatic art practice. I wasn't dismissing the academic institutions; I was just saying, in general, that there are many discourses and institutions, and they aren't always in sync. The perfect example: we're here, meeting – under Judith's education program, feminism is consolidated, right? But in the collection or in the shows, it's not. These are not necessarily overlapping sites. There's certainly room there to make more demands, but exactly what happened

in terms of art education could happen in the other sectors; that is, you make a demand for more women, and they bring in women who aren't necessarily feminist or interested in the kinds of issues that you say you want to discuss, and you encourage the women to paint and do their own thing, and not to be engaged with the politics or polemics outside the institution, and lo and behold, then you give institutions the perfect opportunity to dismiss feminism because here they have women doing something that fits in with the tradition. I'm only asking to consider the dialectic of this, but not to be prescriptive in any final sense at all. [. . .]

Notes

1 These debates have been chronicled in two books: first, Francis Franscina (ed.), *Pollock and After: The Critical Debate* (London: Harper and Row, 1985) and, second, Benjamin H. D. Buchloch, Serge Guilbaut and David Solkin (eds), *Modernism and Modernity*, The Vancouver Conference Papers (Halifax: Press of Nova Scotia College of Art and Design, 1983).
2 This term 'botching' and the definition used here by Pollock of 'disaffirmative practices' are discussed in an essay by British artist, Terry Atkinson, in a catalogue of his work *Mute I* (Copenhagen: Galleri Prag, 1988).
3 John Roberts, 'Painting and sexual difference', *Parachute*, 55 (1989): 25-31.
4 Pollock's book here referred to is *Vision and Difference: Femininity, Feminism and the Histories of Art* (London: Routledge, 1988).
5 *Forest of Signs* (Los Angeles: Museum of Contemporary Art, 1988).
6 Terry Atkinson, a colleague of Pollock's at Leeds University, has defined 'disaffirmative practices' in a catalogue essay entitled 'Disaffirmation and negation', *Mute I* (Copenhagen: Galleri Prag, 1988), pp. 8–9. He based his definition on an author's note (1984) by T. J. Clark in 'Clement Greenberg's theory of art' in *Pollock and After*, ed. Franscina, p. 55. [. . .]
7 *Difference: On Representation and Sexuality* (New York: New Museum of Contemporary Art, 1984).
8 *Beyond the Purloined Image* (London: Riverside Studio, 1983).

Nell Tenhaaf, 'Of Monitors and Men and Other Unsolved Feminist Mysteries: Video Technology and the Feminine' (1992)

From *Parallélogramme*, 18 (3) (1992), pp. 24–34.

Contemporary women artists who work in technological media are faced with a contradiction. The domain in which they are operating has been historically considered masculine, yet women's current access to electronic production tools seems to belie any gender barrier. Indeed, women have benefited by these tools in the last two decades to the extent that they have offered some freedom from the sexist art historical and critical practices attached to more established media. The philosophy of technology, however, has been articulated entirely from a masculinist perspective in terms that

metaphorize and marginalize the feminine.[1] In real social discourse, this claiming of technology has been reinforced by, and has probably encouraged, a male monopoly on technical expertise, diminishing or excluding the historical contributions of women to technological developments.[2]

From a feminist point of view, female invisibility in the discourses of technology calls for nothing less than a radical reconstitution of technology, its development and its uses. While this massive agenda is clearly beyond the purview of feminist cultural practitioners, it is well within our scope to develop images and tropes that are body-based in a way that opens up an affirmative space for the feminine in electronic media practices. My hypothesis is that autobiographical, metaphorical, even mythical feminine enunciations in this domain contribute to an unwriting of the masculine bias in technology.

Willing Machines/Bachelor Machines

The modernist philosophical framework for technology is the discourse of the will, specifically the will to power postulated by Friedrich Nietzsche in the late nineteenth century. Expanded upon by subsequent philosophers, in particular Martin Heidegger, this discourse sustains a view of technology as the manifestation of an essential masculine will that is the driving force of the whole modern era. In its language and imagery, the will to power is interwoven with a deeply entrenched and mythic concept of duality that describes commanding (and the power of the machine) as a masculine attribute, while submission (and the rule of feeling) is described as a feminine one.

For Nietzsche, will commands the body toward ineffable and always predetermined desires. Will, as being, is a kind of machine, necessarily engendering the will to power which is defined as always wanting more power. And will has replaced reason as the highest mental faculty, so that the modern thinking ego is characterized by the I-will and, subsequently, the I-can.[3] This characterization has generated a metaphor central to modernity, that of machine-like man, in whom the body as the domain of affect and source of any sense of authentic desire is disconnected from and subjugated to the mind, configured as pure will.

Will doesn't stop at commanding the interior life of the male social subject and fueling a cyclical and vicious internal battle in which, according to Nietzsche, pleasure is defined by the conquest of displeasure. The philosophy of the will also constitutes the (male) body as subject to an externalized ruling drive to power, a technological power that is unidirectional and obsessed with the future. Nietzsche writes: 'perhaps the entire evolution of the spirit is a question of the body; it is the history of the development of a higher body that emerges into our sensibility . . . In the long run, it is not a question of man at all: he is to be overcome.'[4] And in the mid-twentieth century, Heidegger in *The Question Concerning Technology* reads this forward-looking drive as a progression in which technology, whose very nature is the will to will, would annihilate everything arising from it, an essential and inevitable destructiveness.

The fundamental duality of will, its stakes of masculine dominance and feminine submission, may be played out psychologically within any one person, any one body.

Or in contemporary sexual politics, it might shed all gender specificity and be played as a game between consenting adults. But because of its central place in the philosophical legacy of modernism, this duality marks the real technologized world as a battleground characterized by rigid gender differences and a will to power actualized in the form of male-controlled progress through technological growth. This Nietzschean drive, fueled by nineteenth-century man's inner battles, has resulted indeed in a certain amount of destructiveness, through the development of a multitude of technologies that project out into the modern social body in the form of invasive and colonizing tools.

The bachelor machine is an update on Nietzsche's willing machine that is driven by will and desire. An alluring and obscure figure of the twentieth-century avant garde, the bachelor machine is constructed around a desire that is equally turned in on itself. This desire is frustrated, and also regenerated, by a nihilistic preponderance of denials focused on celibacy, autoeroticism and death. The bachelor machine is a literary and theoretical construct taking as its paradigm Marcel Duchamp's *Le Grand Verre: La Mariée mise à nue par ses célibataires, même* (1912–23). Both as representation and as philosophical proposal, it connects a masculine bachelor to a feminine bride in an impossible, eternally suspended, internal coupling of opposites. Depicted by Duchamp as a drawing of simple mechanical elements and recordings of chance events, all caught or 'delayed' on a large piece of glass, the bachelor machine has come to mean a self-perpetuating masculine psychic machine. Freud too was very fond of the psychic-machine metaphor, and declared it to be quintessentially masculine: 'It is highly probable that all complicated machinery and apparatus occurring in dreams stand for the genitals – and as a rule the male ones.'[5]

The bachelor machine exposes desire, that is *male* desire, as entirely subject to instrumentality. Two terms mediate the bachelor's desire: the machine or technology, present in *Le Grand Verre* as 'working parts' that simulate the absent body; and 'the feminine,' represented as an ethereal cloud or skeleton in the upper half of the work. This bride functions as a conduit for information from another (fourth or *n*th) dimension and as the desiring impetus that the bachelor below needs for his solitary pursuits. For Duchamp, the bride herself knows a certain limited machine desire, as a 'motor with very feeble cylinders: Desire magneto (sparks of constant life).'[6]

Through a multitude of writings which embrace everything from origin myths to alchemy, and which do not overlook psychoanalysis, the bachelor machine has become the signifier for a multiple and layered interpretive strategy that stretches across time like an Einsteinian clock caught in the effects of relativity. In *Le Macchine Celibi*, an exhibition catalogue produced in 1975 containing several texts on the bachelor machine, Michel de Certeau calls it a 'way of writing' or 'writing machine.' This machine supplants an older, maternal 'way of speaking,' that of the seventeenth-century mystical tradition. In this displacement, the loss of the mother leads to 'the solitude of speech with itself.'[7]

In another of the catalogue texts, Michel Serres situates the bachelor machine within a representational history of the machine, from the static model (statues) through a system of the fixed reference point (perspective) into the workings of engines and thermodynamics with God as the motor of meaning. Now, he writes, 'the transformational

engine of our fathers' days has simply moved on into the informational state.'[8] Serres' reading is echoed in Jean-François Lyotard's observation that 'the growth of power, and its self-legitimation, are now taking the route of data storage and accessibility, and the operativity of information.'[9] The bachelor machine thus outlines a mythical techno-logical framework within which the male nihilistically identifies himself as a point of origin, circumscribing the female, and within representation, playing both masculine and feminine parts: 'The bride stripped bare, de-realized, is a pretext for producing without her.'[10] She is necessary, but she is other than and separate from that dynamo that sustains itself *ad infinitum*.

The bachelor machine is not the same thing as the willing machine; some of its features are quite different. In particular, the feminine is more present in the bachelor machine, and complicates its mechanism. Also, the bachelor machine, as Duchamp posited it, is an ironic, self-conscious, even whimsical construct. But each of these ap-paratuses proposes representation as male self-representation, and this self-rationaliz-ing strategy is couched in autoerotic fantasy. Nietzsche's willing machine has power over nature, is self-reproducing. The bachelor creates *ex nihilo*, he needs neither mother nor father because, as an androgyne incorporating the anima and as a celibate priest incarnating God, he himself plays the role of archetypal creator. (He halts evolution, though, and directs it toward self-destruction and the end of the world.) However, in a fundamental way, these psychic machines are not autonomous. Their origin fantasies rely implicitly on a mythical conception of nature as a unified matrix, an assumed but necessarily inarticulated feminine that works as an instrument with which the male, the bachelor, touches and arouses himself.

To become desiring machines that are productive, in the sense employed by Deleuze and Guattari,[11] is to go beyond this desperate dream of original totality toward 'pure multiplicity,' an affirmation that is not reducible to any sort of unified state. Whatever the desiring machine (literary machine, social machine, celibate machine, etc.) produces, whether it be representation, the body, libido or madness, this product exists only alongside the separate parts that make it up; it is itself a part. This is how Deleuze and Guattari articulate polyvocality and flux as points of resistance to a unitary history of repressed and repressive desires.

But how to deliver the feminine from its implicit and unspoken function in the machine? The male author is able to speak of his parts, his body parts in relation to a whole body or libido, from a positive masculine position in the symbolic order, a pos-ition of presence as a subject. It is still not as possible for a woman to speak in this way. For a woman, particularly in this era of biotechnologies and their 'mechanical repro-duction,' the body as 'object of scopic consumption . . . [is] hyperrealistically over-represented . . . [it] remains profoundly absent,' Rosi Braidotti says. And in relation to this absence, the feminine is both overinvested within discourse and feared as an essentializing term, so that, as Braidotti clarifies: 'it signifies a set of interrelated issues but it is not one notion *per se*. Not one corpus.'[12]

To speak from this fragmentary and fluid feminine place is to see that the strange conjuncture of technological mastery, autoerotic pleasure and nihilism of the mascu-line machines might be thought of differently. It might be thought of as a mythical territory to be reclaimed by the desiring bride.

Turn-on

'If machines, even machines of theory, can be aroused all by themselves, may women not do likewise?'[13] So asks Luce Irigaray in a 1974 essay with the enticing title 'Volume-fluidity.'

How do women turn themselves on in the technological order? Irigaray has proposed a kind of feminine autoerotic engine in her theorization of female body parts, specifically the 'self-caressing' of the labial lips, indicating a sexuality that is always plural and a psychic economy of 'never being simply one.'[14] Autoeroticism is a site of empowerment for women, in Irigaray's terms. How is this possible, when the autoerotic in the bachelor machine, corresponding as it does to the loss of the divine commandment of love and procreation written on the woman's body, signifies self-destruction? The bachelor's eroticism is reduced to a mechanism without a soul, while a woman reclaims her soul when she touches herself as, Irigaray says, she always and immediately can. Her autoeroticism can never by reduced – a utopian thought perhaps, but one that at least indicates a sexuality not shattered by the disappearance of laws for procreation and sacred heterosexual union.

Irigaray's emphasis on women's bodies elicits for many of her readers a fear of biological determinism or reductivism, of women's sexuality turned back on itself as defining the essence of being female. This argument against theorizing from the body is valid only if we accept the idea that any aspect of the body is simple or innocent, free of complex and controlling signifying practices. To foreground the body is to confront a set of social meanings already assigned to every one of the body's attributes, including biological sex difference. And it is in fact the persistent, if often invisible, masculinist essentialism in western philosophy and epistemology that has kept these socially constructed limitations in place. Thus a woman 'thinking through the body'[15] and arousing herself is both multiple and complicated, not a reductivist proposition, overturning rather than reinforcing the legacy of dualistic thought.

Irigaray's focus on female autoeroticism is intensely bound up with the pain of living out the textual and sexual instrumentality that the willing/bachelor machine represents. The effects of this instrumentality are lived not just in the psyche by women but as well in the body, and are traditionally called mystery, enigma or hysteria. Irigaray writes about a possible renewed meaning of mysticism for women.[16] She delineates the historical mystic's path of contact with divinity, which is equally a process of reclaiming her 'soul,' her identity, from its ethereal state. The blissful and tortuous visit to the mystic of the divine essence, of 'God,' is registered forever afterward not just on her inner self but also on her body as a wound. The sought-after experience is a searing flame or lightning flash that lights up understanding, and this entails pain: 'the wound must come before the flame.'[17] But this newly discovered self who has had God as a lover and has fully debased herself (mimetically) to the nothingness that He knows her to be, by this process also reclaims her (auto)eroticism. The mystic's autoeroticism, once it is alight, signifies her coming into herself.

Light my Fire

Mythology is both pre- and post-modern, pre- and post-scientific, in its power to metaphorize primal forces. Different accounts of human introduction to fire are also stories of the acquisition of knowledge, as are the various accounts of mysticism, including Irigaray's reworked version.

Mythology shapes our reception of light, and delineates both its masculine and feminine attributes. Light in the form of raw energy, fire, lightning, the sun, combustion; this light is mythically phallic. But keeping the hearth, harnessing and sustaining pure energy for light and heat, corresponds to matriarchal goddess lore.

Classical Greek mythology operates on a gender duality parallel to the one that structures the philosophy of technology. Theft of fire from the heavens was the birth of technology, and took the form of a man's rebellion against the gods. Prometheus stole energy in the form of fire from the gods and gave it to humans for light, heat and the ability to transform raw matter, a primal moment of technological enabling. As punishment for his hubris, he was chained to a rock and his liver was consumed each day by a carnivorous bird. Further, in Hesiod's telling of the tale, the gods punished humankind by first having Hephaestus, their artisan, fashion the beautiful Pandora, then sending her to earth with a grain jar full of evil.

In parallel biblical lore, Lucifer offered knowledge (light) to Eve and Adam in the garden. Pandora and Eve, anti-heroines of the earliest writing cultures, became figures of the gods' punishment for acquisition and transmission of the light of knowledge.

In pre-patriarchal lore the figure of fire-guardian or guardian of the hearth is the original keeper of light and heat, and she is embodied in Hestia/Vesta. She was conceived as both the centre of the household and the omphaloid centre of the earth (the *beth-el* in Hebrew), within a geocentric universe. Her legacy was carried over from the polytheistic into the early Christian era, so that her priestesses in ancient Rome were the Vestal Virgins, entrusted with keeping alight the perpetual fire at the mystic heart of the empire. As the rise of Christianity wiped out pagan supernatural practices, even as it offered magical revival from death and assumption into heaven for its adherents, and science came to acknowledge heliocentrism as the ordering physical principle of the universe, Vesta was displaced by androcentric figures of power.[18]

These stories break open the philosophical stranglehold of the self-rationalizing will to power by reformulating its strict gender duality, and by restoring the sexed body as active agent in the scene of the unconscious. Further, the multiplicity of mythological lore undermines the primacy of the Oedipal story in the modern western imagination, with its constitution of subjectivity structured on a masculine model.[19]

Threshold

Now turn on the TV. The monitor screen is the threshold of passage from dark into light/life, the cervical opening from a womb that permits a spark of consciousness to come into being. The effect of the monitor screen is a sustained emission of contained light. This is emblematic of birth itself – coming into light, harnessing of energy,

materialization from a crossing of electronic codes – from two sources, the feminine mystic flame and masculine raw energy. A pattern of light built on replication and combination of coded information, a passage between states.

The monitor is a new technological paradigm within the schema of the apparatus. As in cinema, the screen is an interface between a viewing subject and a complex representational apparatus, the camera. But it can also be read alternately, as other than a bachelor machine, because it isn't a mechanical model but an electronic one. Rather than a set of moving parts that go round and round perpetually, it is an instantaneous and ephemeral event, a burst of electrons like a Promethean lightning bolt from within the monitor. The double-sided mirror of the monitor screen focuses light on one side and on the other emits light as it reflects an image. Superseding the mirror effect (the constitution of the spectator as a desiring subject, or the cinematic experience), and the look (the male gaze situating the subject within the dominance of the phallic), even before representation itself (establishing the symbolic order of the phallus), the monitor produces an effect of pure light. The bias of technological progress persuades us to think of video display as post-cinematic, but it might also be seen to correspond to a much more primary, generative event: coming into light out of darkness.

Contemporary physics tells us that both the wave-like and particle-like behaviours of light are products of our interaction with it, the result of our observations. In this respect, looking at light in display patterns is a confirmation of spectator subjecthood, whatever the apparatus used. But, in one of the paradoxes of quantum mechanics, it is a subjecthood confirmed by computation from probability waves that describe only a tendency to a pattern.[20] Unfixed subjectivity is the embracing condition of our late-twentieth-century technologized world.

The representational fragmentation proliferating in media technologies reiterates this dispersed condition of subjectivity. Digital imaging techniques are particularly prone to hallucinatory visions that scatter the subject's viewing space and identification process – image fragmentation, simulation, virtual realities. Computer-generated imaging proposes thoroughly artificial scenarios and shattered points of view, often in speeded-up motion that would be impossible in the physical world. As Paul Virilio says, 'That's how we program our definitive absence.'[21] Indeed, the male subject may be experiencing an evacuated subjectivity that is new to him, in this dispersal that we could think of as an electronic overthrow of the will to power. But for the female subject, an assertion of corporeality in electronic space is also a struggle against historical absence.

Inside the monitor, in the darkness, is the matrix of electronic matter that generates display. In a cathode ray tube (CRT), the familiar TV or video monitor, electron beams hit a hemispherically curved concave surface coated with phosphor. The phosphor glows and produces light. The negatively charged electron beam starts in an electron gun at the back of the tube and is accelerated down a long neck toward the tube face by a large positive voltage. On the outside, the convex side of the screen, the continuous stream of images poses the to-be-looked-at. Irigaray:

> But which 'subject' up till now has investigated the fact that a *concave mirror* concentrates the light and, specifically, that this is not wholly irrelevant to woman's sexuality? Any more than is a man's sexuality to the convex mirror? . . . Not one

subject has done so, on pain of tumbling from his ex-sistence. And here again, here too, one will rightly suspect any perspective, however surreptitious, that centers the subject, any autonomous circuit of subjectivity, any systematicity hooked back onto itself, any closure that claims for whatever reason to be metaphysical – or familial, social, economic even – to have rightfully taken over, fixed, and framed that concave mirror's incandescent hearth.[22]

A refusal of fixed, framed systematicity is a refusal of the rule of the male machine-body.

Body Parts

I propose that the early history of video art provides an instance of such a refusal. In the seventies, certain women producers inserted the feminine into video technology, in a spontaneous and provisional way, risking essentialist identification with a female machine-body so as to open a space there for the articulation of female desire.

Kate Craig's *Delicate Issue* (1979, colour, 12 min.) is a powerful tape about relations between the body, technology and power. A woman's body, the artist's own, is framed by a shaky hand-held camera which scans at such proximity that the body part being looked at is often unidentifiable. As the body goes out of and comes back into focus, its image alternately breaks down into patterns of light or reads as acute detail: creases, hairs, moles, eye, nipple come under the same scrutiny. A voiceover by the artist situates the viewer *vis-à-vis* issues of closeness and distance, private and public and how 'real' we want the subject to be. The sound of someone breathing accompanies the voiceover, and as the camera travels up the crease of the legs toward the vagina the breathing accelerates. It's never clear whether the breathing is the artist's or the camera person's. The credits will tell us later that a man is behind the camera and clearly he is complicit with both Craig's ironic voyeurism and her exposure of her own sexuality. The cameraman shifts between standing in for the imagined viewer, as a trope for Craig's arousal through fantasy, and simply enabling her to fill the visual and auditory space. He is, plainly, her device. The camera's gaze lingers on the area around the clitoris, which appears as glistening, pink, vulnerable surfaces folded in on themselves. This is as close as we get, Craig's voice tells us.

The implied autoerotic pleasure mediated by the camera (and the cameraman) in Craig's tape contrasts with the expression of rage as a perverse autoerotic pleasure in *Trop(e)isme* (1980, colour, 14 min), a videotape by marshalore. The artist is again the subject, her face in profile appearing in the foreground of the screen for much of the tape, contorted in a succession of silent screams. Enacting a metaphor for accessing her inner rage, this subject puts her fingers into her vagina, framed very close, then takes them out covered in menstrual blood and smears the blood across her face. In this intense and cathartic moment that Deleuze and Guattari would characterize as a (schizophrenic) hiatus in the production of the real, excess finds an opening, surfacing as a wounding knowledge akin to the enlightening wound of the mystic. After this disturbing, taboo-breaking gesture, the artist takes a long drag on a cigarette, exhaling slowly with sensual satisfaction.

Women's early appropriation of the space of the video monitor can now be seen as a particularly necessary position-taking in the face of the scattered, absent subjectivity that characterizes postmodernism. This issue has been a focal point of women's recent agenda in the domain of technology and its media, where women have been doing much of the important work in both theory and practice. Much of it has been psychoanalytically based deconstructive work, particularly in the domain of cinema, but this work also parallels contemporary feminist projects in language in its proposal of a female subject-in-process.[23]

There are complications in proposing a language of technological media as a language of the body, in particular the female body. In the all-encompassing embrace of the technological apparatus, any declaration of the body is suspect. On the one hand, assertions of bodily integrity are swept up into an ideology of the (always unattainable) idealized body, to be striven for as a commodity like so many others. On the other, the body fragmentation of the de-centred subject feeds the metal-flesh interpolation that is postulated as irreversible in the technological dynamo (the automaton, the bionic body, half metal–half flesh). These processes reflect the ideological underpinnings of a society that has come to be controlled by its technological media: a de-natured 'natural,' one that is artificially constructed, plays a critical re-affirming role, and technology itself is naturalized. This ideological premise seems to reconfigure a reductivist reading of the body: what was previously determined by 'life cycle,' the biological, will now be circumscribed in the biotechnological, the body enhanced through designer body parts.

The problem thereby posed is, how can women speak from an interior knowing to arrive at a transformative language that opens up possibilities for operating within the technological? The heated debates around essentialist practices in the past decade imposed constraints on naïve representations of the feminine, but didn't adequately address women's deeply felt need to assert difference, and not only deconstruct it. This lacuna was necessarily reformulated as women of colour called attention to specifics of difference, breaking down the monolithic construction of gender difference held by white western feminism. It remains pertinent to the many feminisms now being formulated to develop theories and strategies for female self-representation that both assert identity and challenge any form of fixed labelling. Especially in convergence with technological or electronic media, self-representation is key to affirmation, visibility and strategies for changing consciousness that can take into account the whole range of technological intervention in identity formation.

I've looked at certain body-based video works by Canadian women producers that are representations of self made prior to these debates. Although they were formulated outside of any feminist theoretical construction and address difference from only a gender standpoint, they can be seen as not just refusing the longstanding representational codes of male control over women's bodies, but also transgressing the theoretical limits of the philosophical discourse on technology. I've looked at these works because they articulate in electronic technology a metonymical correspondence between the body, implicitly problematized by the probing eye of the camera, and the video viewing apparatus itself: body parts become the very substance of the monitor, become its shifting incandescent feminine insides. These works are historical moments, and are emblematic of women's practices in relation to the philosophical and historical framework that I've delineated.

These are not the only instances of genital imaging in women's video history (a quiet closeup in *Facing South*, Lisa Steele, 1975; and later, a digital drawing overlay of vaginal forms in *Hot Chicks on TV*, Liz Vander Zaag, 1986). Such images are an immediate challenge to the persistent figure of the feminine in philosophy, of idea, truth, morality, nature, etc. More to the point, now, at a time when there is no possible 'imagined organic body'[24] resistant to the effects of technology, women are turned into techno-tropes anyway, without our complicity, let alone our control. In popular cultural imagery, women are represented as powerful yet docile sex-robots or androids (as in the film *Blade Runner*). Our bodies are taken over, hybridized. The developers of technology seek out metaphors, such that DNA replication produces 'daughter' strands from the mother, a voice-recognition cellular phone is named 'Sally,' etc. These trendy tropes reiterate the familiar figure of woman as nature, biology, matter or extension of man.

The video screen is a threshold of possibilities, the place at which a stimulus is of sufficient intensity to begin to produce an effect. The screen is a site of agency, of an event brought about through intention and action. Through strategic self-representation, certain video works by women producers have documented the feminist project of freeing the female body from its status as a reflection to be looked upon. The video screen is a two-way reflection, and is thus a threshold of something from nothing. Its implications of the body through elusive, mutating images, parallel to our own complex interior knowing through our bodies, constitutes a site of the feminine in technology.

Acknowledgements

This article forms part of the inter-magazine publishing project entitled *The Video Issue / Propos Vidéo*, edited by Renee Baert and sponsored by Satellite Video Exchange Society, Vancouver, 1992–93. It has been revised and edited for publication in *Parallélogramme*. This text had its origins in a course called 'Panic Science' given by Arthur Kroker at Concordia University in 1988. Thanks also to Michael Dorland and Johanne Lamoureux, and Kim Sawchuk and Robert Prénovault concerning the title.

Notes

1 My terminology includes the whole gamut of gender difference identifiers: woman and man, female and male, feminine and masculine, feminist and masculinist. These are not used interchangeably, but certainly they overlap. My intention is to emphasize that even the biological terms, male and female, have to be seen as socially constructed. I use the term 'the feminine' in the sense that it has been proposed by the French feminists, especially Luce Irigaray.

2 See, for example, Joan Rothschild (ed.), *Machina Ex Dea: Feminist Perspectives on Technology* (New York: Pergamon Press, 1983) and Maureen McNeil (ed.), *Gender and Expertise* (London: Free Association Books, 1987).

3 Hannah Arendt, *The Life of the Mind: Willing* (New York and London: Harcourt Brace Jovanovich, 1978), p. 20.

4 Friedrich Nietzsche, *The Will to Power*, trans. Walter Kaufmann and R. J. Hollingdale (New York: Vintage Books, 1968), p. 358.

5 Cited in Constance Penley, 'Feminism, film theory and the bachelor machines,' in *mlf*, 10 (1985): 49.

6 Paul Matisse, *Marcel Duchamp: Notes* (Boston: G. K. Hall, 1983). This is from note 155.

7 Michel de Certeau, 'Arts of dying / Anti-mystical writing', in *Le Macchine Celibi / The Bachlor Machine*, ed. Jean Clair and Harald Szeemann (Venice: Alfieri, edizioni d'arte, 1975), p. 88.

8 Michel Serres, 'It was before the (world-) exhibition', in *Le Macchine Celibi / The Bachelor Machine*, ed. Clair and Szeemann, p. 68.

9 Jean-François Lyotard, *The Postmodern Condition: A Report on Knowledge*, trans. Geoff Bennington and Brian Massumi (Minneapolis, MN: University of Minnesota Press, 1984), p. 47.

10 De Certeau, 'Arts of dying', p. 92. Constance Penley calls attention to another apparatus that links the individual psyche, technology and the social body, 'one that can offer impeccable credentials with respect to the bachelor machine's strict requirements for perpetual motion, the reversibility of time, mechanicalness, electrification, animation and voyeurism: the cinema'; Penley, 'Feminism', pp. 39–40.

11 Gilles Deleuze and Felix Guattari, *Anti-Oedipus* (Minneapolis, MN: University of Minnesota Press, 1983), pp. 33–43. Deleuze and Guattari describe the desiring machine as producing repression, its own antiproduction, which is then integrated into the desire-production process, in the way that interruptions or breakdowns in the functioning of the technical machine are integral to its operations. Likewise, schizophrenia is a break in the flow of the real, in its production, which permits that flow to continue outside of the constraints of (Oedipal) social production. The interest of Deleuze and Guattari's machines is precisely their productivity, in contrast to bachelor nihilism.

12 Rosi Braidotti, 'Organs without bodies', in *Differences*, 1 (1988): 52. See also Donna Haraway, 'A manifesto for cyborgs', *Socialist Review*, 80 (1985).

13 Luce Irigaray, *Speculum of the Other Woman*, trans. Gillian C. Gill (Ithaca, NY: Cornell University Press, 1985), p. 232.

14 Luce Irigaray, *This Sex which is Not One*, trans. Catherine Porter (Ithaca, NY: Cornell University Press, 1985), p. 31.

15 See Jane Gallop, *Thinking Through the Body* (New York: Columbia University Press, 1989).

16 Irigaray, 'La mysterique,' in *Speculum of the Other Woman*, p. 191.

17 Ibid, p. 193.

18 Ginette Paris, *Pagan Meditations*, trans. Gwendolyn Moore (Dallas, Tex.: Spring Publications, 1986), p. 176.

19 See Jessica Benjamin, *The Bonds of Love: Psychoanalysis, Feminism, and the Problem of Domination* (New York: Pantheon Books, 1988), pp. 133–81, and Deleuze and Guattari, *Anti-Oedipus*.

20 Gary Zukav, *The Dancing Wu Li Masters* (Toronto, NY: Bantam Books, 1980), pp. 65–6.

21 Chris Dercon, 'An interview with Paul Virilio,' *Impulse*, 12 (4) (Summer 1986): 36.

22 Irigaray, *Speculum of the Other Woman*, p. 144.

23 This is a central concern of the writers identified with French feminism, writers who engage in a specifically feminine practice of writing or 'écriture feminine': Luce Irigaray, Julia Kristeva, Hélène Cixous, Michele Montrelay. Another important issue is that in video practices it is especially women's narrative video that has characteristically refused narrative closure and sought to subvert rather than confirm a potentially unified subject and spectator. See Dot Tuer, 'Video in drag: trans-sexing the feminine', *Parallélogramme*, 12 (3) (February/March 1988): 26–8.

24 See Haraway, 'A manifesto for cyborgs.'

Katy Deepwell, 'Paint Stripping' (1994)

From *Women's Art Magazine*, 58 (1994), pp. 14–16.

The assertion that to be a woman and just paint could constitute of itself a feminist statement has been rightly criticised since the 1970s as different theories of what constitutes feminist art practice and feminist cultural politics have developed and as the work of women artists of the past have been recovered. Painting, because it is popularly understood, taught and discussed as a vehicle for personal expression, when linked to a common understanding of feminism as women 'speaking out', 'giving voice to perspectives which are in opposition to men's' or 'different', suggests a feminist potential. As feminist critiques of the novel have shown, however, there are feminist novels and women's novels. A woman writing however, cannot automatically be regarded as producing feminist work or offering a feminist perspective on the world.

Contrary to popular belief, painting is not a transparent medium of communication: like language, it is heavily coded and conventionalised. Its methods of production, distribution and consumption and the (re)production of its traditions are not neutral or objective means which affirm only the great and the good of past and present. Its selective canons, its advocacy of particular role models are the result of choices, selections determined by and regularly reinvested in, albeit with shifting configurations of social, political and economic values. In spite of the diversity of claims made for and against painting; for its ability to represent either a 'window on the world' or a spiritual autonomous realm; for its political significance as an embodiment of shared cultural value (its role as propaganda) or for the specificities of a visual/private language, painting has not been divorced from politics. The internal strategies of the practices of painting merge with the politics of exhibition, criticism, and the work of dealers, markets, curators and collectors. Modernism claims its founding moment in the break from the Academy in a critique of the institution of art. Yet modernism itself became an establishment as the next new break from its traditions was declared. Despite the fact that the death of painting in the twentieth century has frequently been declared by avant-garde artists, the endless renegotiations of painting as a practice and its mediations by the art market, auction houses and museums continue. What, then, is at stake in this continuous reinvestment?

[. . .]

The problematic status of painting, after the institutionalisation of modernism, is an important question, particularly for women artists. Women painters may have been marginalised by modernism as an institutionalised discourse within the culture industry but they have been far from absent from modernist practice, e.g. Gabriele Münter, Eileen Agar, Leonora Carrington, Georgia O'Keeffe, Joan Mitchell, Nikki de Saint-Phalle's shot paintings, Bridget Riley, Agnes Martin, Gillian Ayres, to name just a few. Feminists have questioned, critiqued and established practices in opposition to, or contesting, modernism, while recognising and working to counteract the exclusions of women artists from institutions. Such approaches have included Lucy Lippard's

conviction in the 1970s that feminism's greatest contribution to the vitality of contemporary art has been precisely its lack of contribution to modernism,[1] to Mary Kelly's arguments that feminism contests the materiality, sociality, and sexuality of modernism,[2] to the many critiques of the institutional exclusions which modernism has perpetrated to maintain culture as dominated by DWEMs (dead white Euro-American males).

Women artists did not stop painting in the early 1970s and some constituencies amongst the plurality of painting practices have made claims for feminist possibilities in painting, even as the majority of feminist art practice(s) were identified with work in mixed media, film, video, performance and scripto-visual works and now in post-modernism with strategies of resistance. Denunciations of painting as a corrupt bourgeois commodity and an outmoded negatively loaded media for women were particularly resonant in the 1970s when the art object was 'de-materialised' and sites and values involved in its production, distribution and consumption repeatedly brought into question. However, work on theories of representation and interest in re-writing myths from a feminist perspective moved discussion about painting away from the notion of 'personal' expression and towards theories of communication, analyses of the signifying field and a critique of the politics of representation.

Postmodern debates have identified feminist practice in photography, performance and mixed media as central to Hal Foster's anti-aesthetic, a neo- or post-conceptualist wing of postmodernism in the visual arts and it is here that strategies of resistance are positioned. Susan Rubin Suleiman has argued that postmodernism is the first avant-garde movement in which the work of women, specifically feminists, has been central, providing a political guarantee for postmodernist claims to critique logocentric and Eurocentric thought.[3] Suleiman's point echoes Craig Owens's often-quoted arguments of a relationship between the feminist critique of patriarchy and the postmodernist critique of representation and language in the work of Mary Kelly, Laurie Anderson, Martha Rosler, Sherrie Levine and Barbara Kruger.[4] Painting practices, specifically the 'Neo-Geo' or any 'return to narrative/figurative painting and sculpture' is positioned as the opposite tendency – neo-conservative and as reinforcing the machinations of the art market as cultural industry through the cosy acceptance by the art market of an empty unchallenging pseudo avant-garde philosophy. As John Roberts has suggested, painting practice is frequently either fetishised as a release from the cognitive and political (Searle) or dematerialised as being outside the possibilities for any form of cultural intervention.[5] So where does this leave the question of possibilities for feminist painting post modernism or are we still negotiating our way out of modernism? Doesn't this depend on how the legacy of late modernist painting is understood and what position feminists adopt in relation to it?

Griselda Pollock has recently sought to map the relationships of (modernist) painting, feminism and history in their problematic relationship with three orders of space: the social space of art's production; the symbolic space of the art object and its statement; and, finally, the space of representation in which social and sexual hierarchies are figured.[6] Women painters, she argues, must necessarily operate in the strategic field delineated by these three orders: specifically 'the painter's body', the feminine body and the contestation of both through feminist discourse and the practice of 'the women's body'. Her account foregrounds a politics of representation in her discussion of

Lubaina Himid's work and a critique of 'presence' in modernist painting through a consideration of Jackson Pollock and Helen Frankenthaler and the continuation of their project in the work of Gillian Ayres. She is insistent, however, that feminism is not about women's claims to the body of the painter nor is it an art-world feminism where women adopt the isolation of studio practice.

Pollock is also rightly critical of the ways in which the question for feminism about aesthetic practices has appeared to be reduced to a simple set of oppositional choices for or against painting as opposed to scripto-visual work. As she suggests: 'Feminism . . . provides a theory of interventions within a field of signification, rather than an alibi for female expressivity . . . [or] women's equal right to the "body of the painter"'. However, if what is at stake in feminist interventions in the field of significations is not to be reduced to choice of medium it is equally the case that transformative work on the codes and conventions does not exclude transformative work in or using painting as one of a number of potential visual resources.

In the mid-1980s John Roberts identified three feminist approaches to painting and sexual difference: firstly, the anti-painting argument where painting in its late modernist and social realist variants is regarded as a double obstacle to the specificities of the representation of gender; secondly, the anti-functionalist argument, painting as a radical resource for women, linking up bodily experience with a distinct female aesthetic or 'visual economy' and, thirdly, the female centred approach, defending the descriptive powers of the figurative tradition as the basis for a feminist narrative or mythological painting.[7] Feminist debates about painting still largely fall into these three categories.

The modernist and romantic/idealist (psychic) fantasy of total self-expression, of the freedom of acting out across the surface of the canvas – and the signification of the gesture as a mark of the painter's presence/psychic expression – upon which many anti-painting arguments have been constructed, remains a powerful fantasy because of its reproduction in the art school where modernism remains a dominant practice as well as an object of study and feminist theory is marginalised. Griselda Pollock has recently criticised this, from a Lacanian perspective, because of the ways in which it serves a regressive fantasy – 'the moment when the proto-subject first imagines itself unified'. This powerful fantasy of a unified subjectivity which can freely express itself, she argues, while shared by both men and women, is one which is shattered by the entry into the Symbolic which inevitably organises trajectories in the social-political-symbolic order for men and women.

The overwhelming interest in Kristeva and Irigaray from contemporary women painters, who wish to re-read the phallic symbolic, to re-negotiate and even parody the legacy of modernism (like Fiona Rae, or Laura Godfrey-Isaacs' 'Alien Blobs'), make it clear that women are not prepared to accept the psychic-social closure offered by Lacan's formulation of the Symbolic. Nor is it clear that this regressive fantasy is the one which has served women's activities as modernist painters, e.g. the shifting investments of Lee Krasner as painter/woman in both practice and person, as Mrs Jackson Pollock and as LK, as 'good pupil of Hans Hoffman' and reclaimed as a feminist painter and survivor in the 1970s might indicate.[8]

The desire of women painters to explore the 'Imaginary' as a pre-symbolic space is, on occasion, justified as a disruption, a chora, to the phallic symbolic order. Similarly

women painters working in abstract modes have put forward readings of their work as explorations of the woman's body, as valuing touch/textuality, bodily wastes, excess and fluidity – a reading of feminine difference (écriture féminine) potentially constructed against the Symbolic order. Women painting in abstract modes and employing French feminist theory (as diverse in their projects as Avis Newman, Therese Oulton or the artists who participated in the Mappin Gallery's (Dis)parities show in 1992) rarely interrogate or critique the principles which they claim to espouse. Irigaray's own writing of a feminine imaginary rooted outside the role of vision/the look as determining in sexuality or Kristeva's theory of the 'abject' or the powers of the chora as 'disruptive' is frequently invoked as an alibi to old modernist practices, without regard to these women's own writing on feminist politics or painters or the status of optics in psychoanalysis. All too often psychoanalytic theory appears dragged in at the last minute, a theoretical adjunct to 'reading' practice which continues in modernist modes as explorations of the body of 'universal' woman/and radical women painter. Kristeva and Irigaray have been used as a new means to argue a 'feminist' case for value in the feminine, in women's already over-determined position as 'Other' and as an attempt to radicalise any mark of feminine difference. The re-investments made in abstraction by women painters which are ambiguously reclaimed as feminine/feminist instances mistakenly associate a recovery of texture/tactility/facture as a textual strategy for writing of the feminine body from the position of the woman's body as painter. My criticism of this strategy is that it repeats the formula invested in the symbolic order without effecting any disruption of the binary oppositions which structure this status quo. As Andreas Huyssen has argued, post-structuralist thought frequently presents itself as a different means to re-engage with modernist works, to think about it differently, but it has not provided a basis for discussion of postmodernism in the visual arts.[9] This criticism can easily be applied when considering the claims for the feminist radicalism of such work when it is so thoroughly invested within the modernist tradition. The attachment of these theories to certain forms of practice often fails to acknowledge – and perhaps seemingly reproduce – the ambiguities of the political positions of the same theorists towards feminism. The same cannot be said for Bracha Ettinger whose painting practice contributes to and renegotiates her own theoretical work on a 'matrixial space' which emerges out of a refusal to limit the 'only' symbolic order to Lacan's Phallic Symbolic.

Figurative women painters have been included in major feminist exhibitions – Women's Images of Men, Painting is the Issue, Along the Lines of Resistance – and their work has been read as communicating feminist ideas, and as engaging with feminist critiques of representation e.g. Margaret Harrison's 'Rape' (1978); Monica Sjöö's 'God Giving Birth'; Sutapa Biswas's 'Housewives with Steak-knives'; or Deanna Petherbridge's series, 'Themata'; Sherrie Levine's works reproducing Ludwig Kirchner's paintings; Sue Williams' 'It's a New Age' or Ida Applebroog's 'Marginalia'. While all of these works use the medium of painting not one of these works is about the rehabilitation of presence or the pure 'unmediated' expression of the artist, in fact most are critiques of these notions. The forms, codes and methods of signification employed, the contexts in which they were seen, shown or discussed similarly cannot be homogenised back into a unified category maintained by modernist painting nor can

they be seen as a desire to reproduce 'painting' as the uncritical expressive product of a humanist, unified subject 'giving voice'. Each would lay claim to represent a feminist position though much could be said about the character or politics of their representations with regard to feminist politics, narratives and myths. It is also clear that these disparate works are not about re-investing in 'painting' as a nihilistic play of empty referents.

Although there are marked shifts suggested by the work of some practitioners to rearrange the 'visual economy' set by a modernist agenda and which might alter the overview Roberts constructed in the mid-1980s, the critical debate has so far not maintained its necessary engagement with current practice and interrogated the claims put forward. The challenge to late modernist painting and its mythologies from feminism remains. How to produce an effective set of feminist possibilities in painting without re-instating the purity of painting or re-investing again in its overblown status remains the issue.

Notes

1 Lucy Lippard, 'Sweeping exchanges: the contribution of feminism to the art of the 1970s', *Art Journal*, 41 (1–2) (1980): 362–5.
2 Mary Kelly, 'Reviewing modernist criticism', *Screen*, 22 (3) (1981); reprinted in *Rethinking Representation: Art after Modernism*, ed. B. Wallis (New York: New Museum of Contemporary Art/Godine, 1984).
3 Susan Suleiman, 'Feminism and postmodernism: a question of politics', in *The Postmodern Reader*, ed. C. Jencks (New York: St Martin's Press, 1992).
4 C. Owens, 'The discourse of others', in *The Anti-aesthetic: Essays on Postmodern Culture*, ed. Hal Foster (Port Townsend: Bay Press, 1983).
5 John Roberts, 'Fetishism, conceptualism, painting', *Art Monthly*, 82 (1984–5): 17–19.
6 Griselda Pollock, 'Painting, feminism, history', in *Destabilising Theory: Contemporary Feminist Debates*, ed. Michèle Barrett and Anne Phillips (Cambridge: Polity Press, 1992), pp. 138–76.
7 John Roberts, *Postmodernism and Cultural Politics* (Manchester: Manchester University Press, 1990); see also Katy Deepwell, 'In defence of the indefensible: feminism, painting and postmodernism', *Feminist Art News*, 2 (1987): 9–12; and Rosa Lee, 'Resisting amnesia: feminism, painting and postmodernism', *Feminist Review*, 26 (1987).
8 A. Wagner, 'Lee Krasner as LK', in *The Expanding Discourse: Feminism and Art History*, ed. Norma Broude and Mary D. Garrard (New York: Icon Editions, 1992).
9 A. Huyssen, 'Mapping the postmodern', in *Feminism/Postmodernism*, ed. Linda Nicholson (London: Routledge, 1990).

Alison Rowley, 'Plan: Large Woman or Large Canvas? A Confusion of Size with Scale' (1996)

From 'On Viewing Three Paintings by Jenny Saville: Rethinking a Feminist Practice of Painting' in *Generations and Geographies in the Visual Arts: Feminist Readings*, ed. Griselda Pollock (London: Routledge, 1996), pp. 93–96.

Her canvases are very large, conventionally so, but that she should then impose upon them out-size images of the figure that are often too big for them, is rather less expected. That these images should then be positively outrageous – fat, bloated, distorted female nudes, scratched and scrawled with slogans and graffiti, gleefully flouting all canons of taste and decency – only compounds the visual shock.

<div align="right">William Packer, The Financial Times, 28 January 1994</div>

There tends to be, in the rhetoric, itself overblown, surrounding Jenny Saville's work, a conflation of very large woman and very large canvas. In this respect also the Hunter Davies interview photograph can be read as symptomatic. The 'small' figure of Jenny Saville posed in front of *Plan* does indeed produce the effect of the hugeness of the depicted woman. The canvas is obviously much larger than the figure of Saville herself, yet to reiterate her own words about *Plan*, 'The head is mine, in fact the painting is really based on me.' This might prompt us to ask the question: *is* this a huge woman, or is it a canvas a good deal larger than the size of a human being, on which a composition is constructed so that the frame is nearly all filled with the head, torso and hips of a female figure? The canvas in fact measures $9' \times 7'$. Why Saville might choose a canvas $9' \times 7'$, how she manages to fill it with almost all body, and why she should want to do so must now be considered if we are to unravel wherein lies the hugeness of *Plan*.

The figure is, to begin with, hugely foreshortened. This allows Saville, first of all, to fill well over the bottom two-thirds of her canvas from edge to edge with painted flesh and hair: the thighs and pubis of her female figure. But is the figure lying down or standing up? The bottom edge of the canvas stops it at the thighs. The surface around where the torso begins, from the hips, to recede towards the head is painted a neutral grey, tonally modulated enough to allow it to read as space but with nothing to indicate whether it might be floor or wall. Does the depicted female figure look down at us to where we might imagine ourselves positioned in the space of the picture in relation to her at roughly knee height? Does she look along her own body at us from where she is lying to where we might imagine ourselves sitting or crouching somewhere by her knees? Are we really allowed a viewing position within the represented space of the picture at all? Can we imagine how we would place ourselves as the painter in the space of the studio in order to paint this view of the model? The picture is spatially ambiguous, the figure seems neither to stand nor to lie but to be tilted at a 45-degree angle between the two. The effect is as if the canvas is a large mirror which has been placed on the floor to catch the woman's reflection and then tilted upwards slightly from the back. The narrative of the depicted space is not one in which we can easily imagine ourselves as part of the story as a character (except perhaps, and perhaps revealingly, as a child hanging onto or sitting on her knees). Neither, in the imagined narrative of painter and model in the studio, is it easy to determine what would be their spatial relationship. If the painter is indeed her own model, the narrative is one of self-examination to which we as viewers are witnesses.

Griselda Pollock has argued that the fraught relationship between painting and feminism can be 'rhetorically tracked in the contradictory placements and significations of two bodies: the "body of the painter" and the "feminine body"'.[1] In Matisse's painting *The Painter and his Model* of 1917 Pollock identifies as represented 'three orders of space which define modern western art-making':

It is a social space shaped in the concrete social and economic relations in one par-
ticular studio in Paris in 1917 in which a white bourgeois man paid a probably
working-class woman to work for him. Then it is a representation of the symbolic
space of art, the studio, and it makes a statement about the basic components of art-
making – the artist, the model and the site of their one way transaction, the canvas.
Finally it presents to us the space of representation, that canvas, upon which is painted
a fictive body which has been invented by the combination of the painter's look and
gesture. A social and sexual hierarchy are pictured: the artist is canonically male (sig-
nalling the fusion of Culture with masculinity); his material is female (the assimila-
tion of nature, matter and femininity). By its formal disposition of man/artist:
woman/model, the painting articulates the symbolic value and symbolic gender in
western modernism's discourse of the 'body of the painter'.[2]

With *Plan*, Saville collapses all three of these spaces. Working mainly from her own
middle-class white body she renegotiates the social and economic relation between
painter and model. The studio, then, is no longer the space of a one-way transaction;
this is *self*-examination. From the third space, the space of representation, the painting
Plan, we can consequently read a rearticulation of western modernism's discourse of
the 'body of the painter'. The represented body is no longer 'the supine female object
body' but the active *female* creative body examined in the practice of the 'woman's
body'.[3]

But why, it might still be asked, does Jenny Saville use a canvas as large as 9′ × 7′ for
her image, why not paint life-size? To begin to answer this question I want to continue
with the idea of self-examination and turn to Saville's own words. Talking to David
Sylvester about the contour lines incised into the paint of the figure in *Plan*, Saville
says: 'The lines on her body are the marks they make before you have liposuction
done to you.' Speaking about the image of the marked-up woman in the Hunter Davies
interview she says:

> I'm not painting disgusting, big women. I'm painting women who've been made to
> think they're big and disgusting, who imagine their thighs go on forever . . . I haven't
> had liposuction myself but I did fall for that body wrap thing where they promise
> four inches off or your money back.

Does Saville, then, worry about her own size? In the company of thinner women,
looking at photographs of the models in *Cosmo*'s exercise regimes, does she feel that
her body occupies a vast amount of space by comparison? Informed by the work of
Freud and Foucault, it would be possible to read as signified by the size of the canvas
for *Plan* Saville's figuration of the psychic dimensions of her own body, as it is con-
structed at the intersection of her physical body with all those discourses, of the fashion
and cosmetics, the diet, health products and plastic surgery industry, that operate to
produce the sign 'desirable feminine body' for this culture as something other than her
size and shape. The composition of the figure within the frame strengthens this sig-
nification: not only does it need a canvas 9′ × 7′ to accommodate it but even then it's a
squash to get it in. In her work on Degas, Heather Dawkins has referred to the body
as a 'memorable space'.[4] On one level it is perhaps the memory of the mismatch, as it
is lived from day to day, between a female body of a particular appearance and the

culture's sign for the desirable, feminine body that is caught in the dimensions and represented space of *Plan*.

I would now like to evoke another memorable space, that between my own body and *Plan* in the Saatchi Gallery. At my height of 5'7" if I stand at painting distance from the canvas (by the size of the marks this is closer than arm's length as these are manipulations of the brush by fingers and wrist, not swings from the shoulder), I have in my focused vision a group of oblongish marks of flesh tones modulated to simulate the play of light over a smooth but slightly uneven surface. Into this surface break some small brownish black curved marks of raised paint which I can imagine as having been made by gently laying a fine, long-haired brush loaded with colour onto the surface of the canvas and quickly lifting it off again. The memory from my own experience of manipulating paint, of the controlled combination of amount of paint, weight of hand, movement of fingers needed to execute marks like these is very pleasurable. At this distance from the canvas I'm lost in the memory of the tactile pleasures of paint application. And literally lost in the space of the canvas with nothing to locate myself, I cannot see any whole shapes or the edges of the canvas. How does this area of painted marks relate to those on the rest of the canvas, and to construct what? To find out, I have to pull a good way back from touching distance before I have the whole canvas within my field of vision and can see that what the marks make is where pubic hair peters out into the smooth skin of the stomach. But at this distance my memories are of another order, in another register: they are memories of other images of women without clothes, from other paintings and photographs with which I begin to compare *Plan*. By moving back to hold the whole canvas within my view so that I can see how the marks coalesce into the bounded shape I look for as standing for the human figure in the conventions of western painting, I have to forfeit the tactile pleasure of an imaginary application of marks to the surface of *Plan*, the memory of my own body in contact with a canvas. But I can move in and back again at will. I want to suggest here that at the level of the lived space of the viewer moving back and forth in the Saatchi Gallery, it is the attempt to accommodate these two modes of looking, of both proximity and of distance within the space of the same canvas, that we can account for the large, 9' × 7' dimensions of *Plan*.

As it turns out, the viewer experiences in *Plan* traces of the working space Jenny Saville sets up in her studio. In interviews she has referred to her need to paint large areas of flesh at close range, and to the fact that she 'gets nothing' from the model in the life room. But she also remarked that she finds the presence of the model intimidating.[5] She takes close-up photographs of parts of her own body, those of her friends, and sometimes a model from which to work alone in the studio. The room she works in on canvases as large as *Plan* (9' × 7') is small. There is no space to stand back to see the whole of the composition as she works so she sets up a series of mirrors into which she glances, over her shoulder, to see how her marks at close range are hanging together to make the figure as a whole.[6] I want to suggest that in her studio practice these procedures are set up, consciously or not, to allow Jenny Saville a fantasy of tactile contact with a body as she constructs it. To Clare Henry, in the *Herald Review*, Saville says: 'I didn't want an illusion of flesh, but the feel of it; the body of flesh.' At the same time, they also provide for her recognition that a certain distance is necessary to allow for the production of meaning in the register of sight. [. . .]

Notes

1 Griselda Pollock, 'Painting, feminism, history', in *Destabilising Theory: Contemporary Feminist Debates*, ed. Michèle Barrett and Anne Phillips (Cambridge: Polity Press, 1992), p. 140.
2 Ibid., pp. 138–40.
3 Ibid., p. 141.
4 Heather Dawkins, 'Frogs, monkeys and women: a history of identifications across a phantastic body', in *Dealing with Degas: Representations of Women and the Politics of Vision*, ed. Richard Kendall and Griselda Pollock (New York: Universe, 1992), p. 206.
5 'I find working from life really intimidating. I couldn't draw or paint on a size like that [indicating a medium-sized sketch-book]. I find it so hard to do unless I do a detail of an enlargement or something. There is no point in me doing a study like that. It's just more natural for me to use larger areas of flesh. I don't like working in a life class. There's no recognition from the model; he or she's sort of indifferent. I don't get anything from it' (Jenny Saville talking to David Sylvester, 'Areas of Flesh', *The Independent on Sunday Review*, 30 January 1994).
6 Ibid.

Faith Wilding, 'Where is the Feminism in Cyberfeminism?' (1998)

From *n.paradoxa*, 2 (1998), pp. 6–12.

Against Definition

The question of how to define cyberfeminism is at the heart of the often contradictory contemporary positions of women working with new technologies and feminist politics. Sadie Plant's position on cyberfeminism, for example, has been identified as an absolutely post-human insurrection – the revolt of an emergent system which includes women and computers, against the world view and material reality of a patriarchy which still seeks to subdue them.

This is an alliance of the goods against their masters, an alliance of women and machines.[1] This utopian vision of revolt and merger between woman and machine is also evident in VNS Matrix's Cyberfeminist Manifesto for the 21st Century: 'we are the virus of the new world disorder/rupturing the symbolic from within/saboteurs of big daddy mainframe/the clitoris is a direct line to the matrix.'[2] Another position in this debate is offered by Rosi Braidotti: 'cyberfeminism needs to cultivate a culture of joy and affirmation . . . Nowadays, women have to undertake the dance through cyberspace, if only to make sure that the joy-sticks of cyberspace cowboys will not reproduce univocal phallicity under the mask of multiplicity.'[3]

The press release issued at the cyberfeminist discussions in Kassel[4] declared that: 'The First CYBERFEMINIST INTERNATIONAL slips through the traps of definition with different attitudes towards art, culture, theory, politics, communication and technology – the terrain of the Internet.' What strangely emerged from these discussions was the attempt to define cyberfeminism by refusal, evident not only in the inten-

sity of the arguments, but also in the 100 antitheses devised there – for example: 'cyber-feminism is not a fashion statement/sajbrfeminizm nije usamljen/cyberfeminism is not ideology, but browser/cyberfeminismus ist keine theorie/cyber feminismo no es una frontera.'[5] Yet the reasons given by those who refused to define cyberfeminism – even though they called themselves cyberfeminists – indicate a profound ambivalence in many wired women's relationship to what they perceive to be a monumental past feminist history, theory, and practice. Three main manifestations of this ambivalence and their relevance to contemporary conditions facing women immersed in technology bear closer examination.

Repudiation of 'Old-style' (1970s) Feminism

According to this argument, 'old-style' (1970s) feminism is characterized as monu-mental, often constricting (politically correct), guilt inducing, essentialist, anti-technology, anti-sex, and not relevant to women's circumstances in the new technologies (judging from the Kassel discussions, this conception is common in the US and Western Europe). Ironically, in actual practice cyberfeminism has already adopted many of the strategies of avantgarde feminist movements, including strategic separatism (women only lists, self-help groups, chat groups, networks, and woman to woman technological training), feminist cultural, social, and language theory and analysis, creation of new images of women on the Net to counter rampant sexist stereotyping (feminist avatars, cyborgs, genderfusion), feminist net critique, strategic essentialism, and the like. The repudiation of historical feminism is problematic because it throws out the baby with the bathwater and aligns itself uneasily with popular fears, stereotypes, and mis-conceptions about feminism.

Why is it that so many younger women (and men) in the US (and Europe) know so little about even very recent histories of women, not to speak of past feminist move-ments and philosophies? It is tempting to point the finger at educational systems and institutions that still treat the histories of women, and of racial ethnic, and marginal-ized populations, as ancillary to 'regular' history, relegating them to specialized courses or departments.

But the problems lie deeper than this. The political work of building a movement is expertise that must be relearned by every generation, and needs the help of experienced practitioners. The struggle to keep practices and histories of resistance alive today is harder in the face of a commodity culture which thrives on novelty, speed, obsoles-cence, evanescence, virtuality, simulation, and utopian promises of technology. Com-modity culture is forever young and makes even the recent past appear remote and mythic. While young women are just entering the technological economy, many older feminists are unsure how to connect to the issues of women working with new tech-nology, and how to go about adapting feminist strategies to the conditions of the new information culture. The problem for cyberfeminism, then, is how to incorporate the lessons of history into an activist feminist politics which is adequate for addressing women's issues in technological culture.

To be sure, the problem of losing historical knowledge and active connection to radical movements of the past is not limited to feminism – it is endemic to leftist move-ments in general. By arguing for the importance of knowing history I am not paying

nostalgic homage to moments of past glory. If cyberfeminists wish to avoid making the mistakes of past feminists, they must understand the history of feminist struggle. And if they are to expand their influence on the Net and negotiate issues of difference across generational, economic, educational, racial, national, and experiential boundaries, they must seek out coalitions and alliances with diverse groups of women involved in the integrated circuit of global technologies. At the same time, close familiarity with post-colonial studies, and with the histories of imperialist and colonialist domination – and resistance to them – are equally important for an informed practice of cyberfeminist politics.

Cybergrrl-ism

Judging by a quick Net browse, one of the most popular feminist rebellions currently practiced by women on the Net is *cybergrrl-ism* in all of its permutations: *webgrrls, riot grrls, guerrilla girls, bad grrls,* etc.

As Rosi Braidotti[6] and others have pointed out, the often ironic, parodic, humorous, passionate, angry, or aggressive work of many of these recent grrl groups is an important manifestation of new subjective and cultural feminine representations in cyberspace. Currently there is quite a wide variety of articulations of feminist and protofeminist practices in these various groups which range from: anyone female can join chatty mailing lists, to sci-fi, cyberpunk, and femporn zines; antidiscrimination projects; sexual exhibitionism; transgender experimentation; lesbian separatism; medical self-help; artistic self-promotion; job and dating services; and just plain mouthing off. Cybergrrl-ism generally seems to subscribe to a certain amount of Net utopianism – an 'anything you wanna be and do in cyberspace is cool' attitude. Despite the gripings against men in general, which pervade some of the discussions and sites, most cybergrrls don't seem interested in engaging in a political critique of women's position on the Net – instead they adopt the somewhat anti-theory attitude which seems to prevail currently; they'd rather forge ahead to express their ideas directly in their art and interactive practices.

While cybergrrls sometimes draw (whether consciously or unconsciously) on feminist analyses of mass media representations of women – and on the strategies and work of many feminist artists – they also often unthinkingly appropriate and recircu-late sexist and stereotyped images of women from popular media – the buxom gun moll, the supersexed cyborg femme, and the 50s tupperware cartoon women are favorites – without any analysis of critical recontextualization. Creating more positive and complex images of women that break the gendered codes prevailing on the Net (and in the popular media) takes many smart heads, and there is richly suggestive feminist research available, ranging from Haraway's monstrous cyborgs, Judith Butler's fluid gender per-formativity, to Octavia Butler's recombinant genders. All manner of hybrid beings can unsettle the old masculine/feminine binaries. Cybergrrlish lines of flight are important as vectors of investigation, research, invention, and affirmation. But these can't replace the hard work that is needed to identify and change the gendered structures, content, and effects of the new technologies on women worldwide. If it is true, as Sadie Plant argues, that 'women have not merely had a minor part to play in the emergence of the

digital machines . . . [that] women have been the simulators, assemblers, and program-
mers of the digital machines'[7] then why are there so few women in visible positions of
leadership in the electronic world? Why are women a tiny percentage of computer pro-
grammers, software designers, systems analysts, and hackers, while they are the major-
ity of teletypers, chip-assemblers and installers, and lowskilled tele-operators that keep
the global data and infobanks operating? Why is the popular perception still that women
are technophobic? Sadly, the lesson of Ada Lovelace is that even though women have
made major contributions to the invention of computers and computer programming,
this hasn't changed the perception – or reality – of women's condition in the new tech-
nologies. Being bad grrls on the Internet is not by itself going to challenge the status
quo, though it may provide refreshing moments of iconoclastic delirium. But if grrrl
energy and invention were to be coupled with engaged political theory and practice
. . . Imagine!

Imagine cyberfeminist theorists teaming up with brash and cunning grrl Net artists
to visualize new female representations of bodies, languages, and subjectivities in cyber-
space! Currently (in the US) there is little collaboration between academic feminist
theorists, feminist artists, and popular women's culture on the Net. What would happen
if these groups worked together to visualize and interpret new theory, and circulate it
in accessible popular forms? Imagine using existing electronic networks to link diverse
groups of women computer users (including teleworkers and keystrokers) in an
exchange of information about their day-to-day working conditions and lives on the
Net; imagine using this information network as an action base to address issues of
women digital workers in the global restructuring of work. Such projects could weave
together both the utopian and political aspirations of cyberfeminism.

Net Utopianism

As noted in a previous essay on the political condition of cyberfeminism, there is much
to be said for considering cyberfeminism a promising new wave of feminist practice
that can contest technologically complex territories and chart new ground for women.[8]
There is a tendency though among many cyberfeminists to indulge techno-utopian
expectations that the new e-media will offer women a fresh start to create new lan-
guages, programs, platforms, images, fluid identities and multi-subject definitions in
cyberspace; that in fact women can recode, redesign, and reprogram information tech-
nology to help change the feminine condition. This Net utopianism declares cyberspace
to be a free space where gender does not matter – you can be anything you want to be
regardless of your *real* age, sex, race, or economic position – and refuses a fixed subject
position. In other words, cyberspace is regarded as an arena inherently free of the same
old gender relations and struggles. However, it is of utmost importance to recognize
that the new media exist within a social framework that is already established in its prac-
tices and embedded in economic, political, and cultural environments that are still
deeply sexist and racist. Contrary to the dreams of many Net utopians, the Net does
not automatically obliterate hierarchies through free exchanges of information across
boundaries. Also, the Net is not a utopia of nongender; it is already socially inscribed
with regard to bodies, sex, age, economics, social class, and race. Despite the indis-

putable groundbreaking contributions by women to the invention and development of computing technology, today's Internet is a contested zone that historically originated as a system to serve war technologies, and is currently part of masculinist institutions. Any new possibilities imagined within the Net must first acknowledge and fully take into account the implications of its founding formations and present political conditions. To be sure, it is a radical act to insert the word feminism into cyberspace, and to attempt to interrupt the flow of masculine codes by boldly declaring the intention to mongrelize, hybridize, provoke, and disrupt the male order of things in the Net environment. Historically, feminism has always implied dangerous disruptions, covert and overt actions, and war on patriarchal beliefs, traditions, social structures – and it has offered utopian visions of a world without gender roles. A politically smart and affirmative cyberfeminism, using wisdom learned from past struggles, can model a brash disruptive politics aimed at deconstructing the patriarchal conditions that currently produce the codes, languages, images, and structures of the Net.

Definition as a Political Strategy

Linking the terms *cyber* and *feminism* creates a crucial new formation in the history of feminism(s) and of the e-media. Each part of the term necessarily modifies the meaning of the other. *Feminism* (or more properly, *feminisms*) has been understood as a historical – and contemporary – transnational movement for justice and freedom for women, which depends on women's activist participation in networked local, national, and international groups.[9] It focuses on the material, political, emotional, sexual, and psychic conditions arising from women's differentialized social construction and gender roles. Link this with *cyber*, which means to steer, govern, control, and we conjure up the staggering possibility of feminism at the electronic helm. Cyberfeminism could imagine ways of linking the historical and philosophical practices of feminism to contemporary feminist projects and networks both on and off the Net, and to the material lives and experiences of women in the integrated circuit, taking full account of age, race, class, and economic differences.

If feminism is to be adequate to its cyberpotential then it must mutate to keep up with the shifting complexities of social realities and life conditions as they are changed by the profound impact communications technologies and technoscience have on all our lives.

While refusing definition seems like an attractive, non-hierarchical, anti-identity tactic, it in fact plays into the hands of those who would prefer a Net quietism: 'Give a few lucky women computers to play with and they'll shut up and stop complaining.' This attitude is one toward which cyberfeminists should be extremely wary and critical. Access to the Internet is still a privilege, and by no means to be regarded as a universal right (nor is it necessarily useful or desirable for everyone). While brilliant consumer marketing has succeeded in making ownership of a PC seem as imperative as having a telephone, computers are in fact powerful tools that can provide the possessor with a political advantage (the personal computer is the political computer). If the Internet is increasingly the channel through which many people (in the over-

developed nations) get the bulk of their information, then it matters greatly how women participate in the programming, policy setting, and content formations of the Net, for information coming across the Net needs to be contextualized both by the receiver and by the sender. On the Internet, feminism has a new transnational audience which needs to be educated in its history and its contemporary conditions as they prevail in different countries. For many, cyberfeminism could be their entry point into feminist discourse and activism. While there is a great deal of information about feminism available on the Net – and new sites are opening up all the time – it must be remembered that the more this information can be contextualized politically, and linked to practices, activism, and conditions of everyday life, the more it is likely to be effective in helping to connect and mobilize people.[10] A potent example is in the Zamir Network (Zamir 'for peace') of BBS and e-mail that was created after the eruption of civil war in Yugoslavia in 1991 to link peace activists in Croatia, Serbia, Slovenia, and Bosnia across borders via host computers in Germany. The point is that computers are more than playful tools, consumer toys, or personal pleasure machines – they are the master's tools, and they have very different meanings and uses for different populations. It will take crafty pilots to navigate these channels.

While cyberfeminists want to avoid the damaging mistakes of exclusion, lesbophobia, political correctness, and racism, which sometimes were part of past feminist thinking, the knowledge, experience, and feminist analysis and strategies accumulated thus far are crucial for carrying their work forward now. If the goal is to create a feminist politics on the Net and to empower women, then cyberfeminists must reinterpret and transpose feminist analysis, critique, strategies, and experience to encounter and contest new conditions, new technologies, and new formations. (Self)definition can be an emergent property that arises out of practice and changes with the movements of desire and action. Definition can be fluid and affirmative – a declaration of strategies, actions, and goals. It can create crucial solidarity in the house of difference – solidarity rather than unity or consensus – solidarity that is a basis for effective political action.

Cyberfeminists have too much at stake to be frightened away from tough political strategizing and action by the fear of squabbles, deologizing and political differences. If I'd rather be a cyberfeminist than a goddess, I'd damned well better know why, and be willing to say so.

A Cyberfeminist Cell

How might cyberfeminists organize to work for a feminist political and cultural environment on the Net? What are various areas of feminist research and Net activity that are already beginning to emerge as cyberfeminist practice? The First Cyberfeminist International (CI) in Kassel serves as an example of feminist Net organiz(m)ation.

Responsibility for organizing the CI workdays was taken on by Old Boys Network (OBN) – an *ad hoc* group of about six women – in on-line consultation with all participants. Because of the on-line communications between the OBN leadership and participants, collaborative working relationships and the content of the meetings were already established by the time the participants met together face to face in

Kassel. A shifting and diverse group of more than thirty women (self-selected by open invitation to members of the FACES listserv [with a core of about ten]) participated in the CI.

From the first day this collaborative process – a recombinant form of feminist group processes, anarchic self-organization, and rotating leadership – continued to develop among women from more than eight countries and from different economic, ethnic, professional, and political backgrounds. Each day began with participants meeting in the Hybrid Workspace to work on various taskforces (text, press, technical, final party, etc.) and to organize the public program for the day. This was followed by three hours of public lectures and presentations for *Documenta* audiences. Afterward the closed group met again for dinner and to discuss issues such as the definition of cyber-feminism, group goals, and future actions and plans. Work was divided according to inclination and expertise; there was no duty list and no expectation that everyone would work the same amount of hours. Flexible schedules permitted conviviality, impulsive actions, brainstorming, and private time. Constant connection of participants to the FACES listserv was maintained electronically.

Practically all group activities were video and audiotaped and photographed. Participants' personal computer equipment was set up in the open work/meeting space and most of the lectures were accompanied by projected images from the lecturers' web-sites. One participant taught the group how to set up CU_SeeMe_ connections and continued to participate virtually after she had to leave, and two young Russians trying to join the CI in Kassel, faxed a diary of their illegal journey as they jumped from country to country to evade visa problems. Thus there was an interesting inter-play between virtuality and flesh presence. The face-to-face interactions were experienced as much more intense and energizing than the virtual communications, and forged different degrees of affinity between various individuals and subgroups, while at the same time they made all kinds of differences more palpable. Brainstorming and spontaneous actions seemed to spring more readily from face-to-face meetings. The opportunity for immediate question and answer sessions and extended discussion after the lectures also enabled more intimate and searching interchanges than are usually possible through on-line communications. Most important, all presentations, hands-on training, and discussions took place in a context of intense debate about feminism, which produced a constant awareness of the lived relationship of women and technology.

The wide variety of content presented in the lectures, web projects, and workshops touched on many of the hottest topics of concern to cyberfeminism: theories of the visibility of sexual difference on the Net; digital self-representations of on-line women as avatars and databodies; analyses of gender representations, sex-sites, cybersex, and femporn; strategies of genderfusion and hybridity to combat stereotyping, essentialism, and sexist representations of women; 'feminism as a browser'; the dangers of the fetishistic desire for information and the paranoia created by the new technologies; dissemination of knowledge about women in history; studies of differences between women and men programmers and hackers; an examination of feminist electronic art strategies; feminist models of technological education; health issues of wired women and discussion of how to organize and support feminist networking projects in different countries.[11]

The chief gains from the CI discussions were trust, friendship, a deeper under-standing and tolerance of differences; the ability to sustain discussions about contro-versial and divisive issues without group rupture; and mutual education about issues of women immersed in technology, as well as a clearer understanding of the terrain for cyberfeminist intervention.

While the CI did not result in a formal list of goals, actions, and concrete plans, we reached general agreement on areas in need of further work and research. An ongoing concern is how to make cyberfeminism more visible and effective in reaching diverse populations of women using technology. Options discussed included creating a cyber-feminist search engine that could link strategic feminist websites; country-by-country reports of Net activity and cyberorganization for women; forming coalitions with female technologists, programmers, scientists and hackers, to link feminist Net theory, content and practice with technological research and invention; education projects (for both men and women) in technology, programming, and software and hardware design, that would address traditional gender constructions and biases built into technology; and more research on how the ongoing global restructuring of women's work results from the pervasive changes introduced by information technology.

(Cyber)feminism is a Browser through which to see Life[12]

If cyberfeminists have the desire to research, theorize, work practically, and make visible how women (and others) worldwide are affected by new communications technologies, technoscience, and the capitalist dominations of the global communications networks, they must begin by clearly formulating cyberfeminisms' political goals and positions. Cyberfeminists have the chance to create new formulations of feminist theory and prac-tice that address the complex new social, cultural, and economic conditions created by global technologies. Strategic and politically savvy uses of these technologies can facilitate the work of a transnational movement that aims to infiltrate and assault the networks of power and communication through activist-feminist projects of solidarity, education, freedom, vision, and resistance. To be effective in creating a politicized feminist environment on the Net that challenges its present gender, race, age, and class structures, cyberfeminists need to draw on the researches and strategies of avant garde feminist history and its critique of institutionalized patriarchy. While affirming new possibilities for women in cyberspace, cyberfeminists must critique utopic and mythic constructions of the Net, and strive to work with other resistant netgroups in activist coalitions. Cyberfeminists need to declare solidarity with transnational feminist and postcolonial initiatives, and work to use their access to communications technologies and electronic networks to support such initiatives.

Notes

1 Caroline Bassett, 'With a little help from our (new) friends?', *Mute*, (August 1997): 46–9.

2 VNS Matrix webpage [sysx.apana.org.au/artists/vns].

3 Rosi Braidotti, 'Cyberfeminism with a difference' [www.let.ruu.nl/womens_studies/rosi/cyberfem.htm].

4 The First Cyberfeminist International took place in Kassel, Germany, 20–28 September 1987, as part of the Hybrid Workspace at Documenta X.

5 The complete 100 antitheses can be found at Old Boys Network [http://www.obn/org].

6 Braidotti, 'Cyberfeminism'.

7 Sadie Plant, *Zeros and Ones: Digital Women and the New Technocultures* (Garden City, NY: Doubleday, 1997), p. 37.

8 Faith Wilding and Critical Art Ensemble, 'Notes on the political condition of cyberfeminism' [http://mailer.fsu.edu/~sbarnes].

9 Using the term 'feminist' is very different from using the term 'women', although perhaps one should consider using the term 'cyberwomanism,' which acknowledges the critique of racist white feminism so justly made by Audrey Lorde, Alice Walker, bell hooks, and others.

10 See, for example, the listings of 1,000 feminist or women-related sites in Shana Penn, *The Women's Guide to The Wired World* (New York: Feminist Press, 1997).

11 For more information on the First Cyberfeminist International and papers see [http://www.obn.org].

12 Alla Mitrofanova, presentation at the First Cyberfeminist International in Kassel, September 1997.

6

Claiming Identity, Negotiating Genealogy

INTRODUCTION

For as long as women have been organizing as women under the umbrella of the women's movement, they have been organizing also as women with particular interests, identifications and affiliations. Finding consensus or solidarity across difference has not always been possible due to the difficulty of recognizing power relations beyond those of gender and relinquishing that power, and due to the liberal ideal of erasing difference in favour of the unified voice. This certainly was one spur towards organizing around focused identities. It was not, however, primarily a defensive move: organizing, pooling resources and information, and developing thinking as women with particular identifications of race, nation, religion, class and sexual identity was and is a strategic necessity.

Texts addressing issues of, say, art history, or the sexual body, which intersect with particular analyses of racial, national, class or sexual identification and representation, have been placed as appropriate through this book in order to affirm that such analyses are intrinsic to those debates.[1] The texts in this chapter can be read in conjunction with those in other chapters to provide a sharper focus on the ways in which national and racial identities have been claimed, not as an essentialist move, but as a continuing identificatory process socialized through culture and language. They also highlight the negotiations women have to make of the related genealogies which have been provided for them in a sexist, racist and colonialist culture. As Ella Shohat has written 'multicultural feminism is thus less concerned with identities and something one has than in identification as something one does.'[2] The aim of this chapter is not to provide a definitive text for each identity – an impossible task – nor to present each writer as a spokeswoman for a particular group. As with the rest of the book, the texts have been selected to provide a juxtaposition which is productive of more than the individual texts considered separately. Cultural diversity means different things in different places – how history and its discourses play out in Belfast, Montreal, Sydney or San Francisco will be productive of differing subtleties of language, representation and strategy – and so too will the understanding of what it means for a society or a political movement to be multicultural and how that might be achieved. What this chapter aims to achieve, then, is an awareness of the significance of difference and that strategies developed in one place may not be appropriate elsewhere.[3]

The first text in the chapter applies this latter assertion. Kass Banning (in the section of her essay reprinted here) provides an analysis of the essays in the catalogue for Canadian feminist Joyce Wieland's 1987 retrospective at the Art Gallery of Ontario. Two were written by American women, one by a Canadian. The paradox outlined by Banning is that this artist, whose work frequently addressed the intersection of Canadian national identity with sexed identity, is ill served by each essay. The two US critics (Lucy Lippard and Lauren Rabinovitz) 'could not read Wieland in a multiplicity of contexts, particularly those contexts that could lead to considerations of [national] specificity'. Instead, Wieland's work is reduced by them to issues of gender specificity. A further issue is that US feminism is marginalized in US art discourse; and Canadian art is marginalized in favour of American. Thus feminist issues of authorship and agency differ in the two countries and the strand of valorizing US feminism presented in the essay by Lippard, while it might be appropriate in a US context, does not address the issues as they face Canadian artists. However, in the absence of a developed and advanced Canadian feminist criticism, the Canadian writer (Marie Fleming) grafts this model of feminism on to her knowledge of Canadian culture, also with inappropriate results. Colonialist and masculine patterns of structuring 'the artist' are thus unwittingly repeated through the catalogue.

Ailbhe Smyth's text is a meditation upon, and dissection of, the ways of naming women that occur in Ireland. Written in the wake of the installation in Dublin of a sculptural fountain representing James Joyce's creation Anna Livia Plurabelle, it opens with the nicknames Dubliners were quick to provide, such as 'the floozie in the jacuzzi' and 'Bidet Mulligan'. Starting with comments on the sculpture and on Joyce's creation, Smyth exposes the construct of both as she reflects them back through a collage of quotation, ironic comment, and word association. The second section of the text is in note form, juxtaposing thoughts upon identity, Irishness and womanliness, and moves towards the analyses and reconstructions offered by Irish women poets. The romantic essentialism that often masks racism, is imposed upon Irish women, and constructs the image of Irish femininity at home and elsewhere, is exposed for what it is.

In contrast, Hung Liu is an artist from mainland China who now lives in California. Her text starts with five terms used to define her, exposing the totalizing and partial effects of naming. The bulk of the text consists of two letters: one to the chair of a search committee, withdrawing her job application following an interview, and the other an open letter to students of a university in a gallery of which she was exhibiting. Liu highlights the necessity of writing histories which record positions, whether of recent events or of the more distant past.

It is the relation between choices of dress and assumed and perceived identities that forms the focus of the text by Coco Fusco. Noting that anti-Muslim racism in Europe often manifested itself through discussion of gender-specific dress – the chador or veil worn by Muslim women and girls – while European women were themselves adopting dress and activity from traditions whose politics they decried, Fusco discusses 'examples of transfers of appearance between privileged and subaltern women'. Signs of oppression are borrowed by privileged Western women and transformed in their new usage 'into symbols of transgression' which are usually depoliticized. Fusco states that the negotiations for survival undertaken by women of colour are turned into mere style statements. This is historically specific and a recent phenomenon. Fusco demonstrates

this through autobiographical anecdote, and relates her new understanding of the dress and behavioural choices made by her foremothers.

Fiona Foley is an Aboriginal Australian artist and curator. Diana Losche discusses in her text how Foley 'reconfigures museological representation and representational practices'. The institutions of art and representation are mimeticized and reflected by Foley in such a way that their shortcomings and blind spots become apparent as they are transcended. One example is where Foley quotes the words of a black British curator to expose his own racism and sexism. Foley's main work under discussion here concerns the ethno-pornographic tradition of photographs of Aboriginal people by the white colonists. Stripped of their names and given generic titles such as 'Native Woman', these photographs erase histories and genealogies. Foley was working with some such photographs of her ancestral people, the Badtjalas, in order to represent a well-known historical event. As Foley worked with these photographs she recognized one woman as her own kin because of the similar shape of that woman's breasts to her own. Losche discusses the need for dispossessed women to establish maternal kinship and nurturing, and Foley's apt symbolizing of this through the representation of her own bare breasts. She argues that Foley re-invents the nude through mimeticizing and subverting the forms of discredited ethnographic photography in order to assert a female Aboriginal genealogy.

Notes

1 Among the texts which attend to racial and national identification and representation in other chapters are those by Buseje Bailey, Joan Borsa, Michelle Cliff, Anna Douglas, Belinda Edmondson, Amelia Jones (chapter 8), Adrian Piper, Faith Ringgold, Freida High (Wasikhongo Tesfagiorgis) and Judith Wilson.
2 Ella Shohat, 'Introduction', in *Talking Visions: Multicultural Feminism in a Transnational Age*, ed. Ella Shohat (New York: New Museum of Contemporary Art; Cambridge, MA: MIT Press, 1998), p. 9.
3 One element which is clearly missing here is the anger that informs political reaction to actual and cultural genocide. It is a matter of regret that discussions towards gaining permission to reproduce a piece which addresses this issue broke down at a time too late to find an appropriate replacement. I would like to draw attention to Native American artist Jimmie Durham's excellent essay 'The Search for Virginity' in the book edited by Susan Hiller, listed in the Essential Reading for this chapter.

Essential reading

Bloom, Lisa, *With Other Eyes: Looking at Race and Gender in Visual Culture* (Minneapolis, MN: University of Minnesota Press, 1999).

Hassan, Salah M. (ed.), *Gendered Visions: The Art of Contemporary Africana Women Artists* (Trenton, NJ: Africa World Press, 1997).

Hiller, Susan (ed.), *The Myth of Primitivism: Perspectives on Art* (London: Routledge, 1991).

hooks, bell, *Art on my Mind: Visual Politics* (New York: The New Press, 1995).

Lippard, Lucy, *Mixed Blessings: New Art in a Multicultural America* (New York: Pantheon Books, 1990).

McIntosh, Peggy, 'White privilege and male privilege: a personal account of coming to see correspondences through work in women's studies' (1988), in *Race, Class, and Gender: An Anthology*, ed. Margaret L. Andersen and Patricia Hill Collins (Belmont: Wadsworth, 1995), pp. 76–87.

Shohat, Ella (ed.), *Talking Visions: Multicultural Feminism in a Transnational Age* (New York: New Museum of Contemporary Art; Cambridge, MA: MIT Press, 1998).

Walker, Alice, 'In search of our mothers' gardens' (1974), in *In Search of our Mothers' Gardens: Womanist Prose* (San Diego: Harcourt Brace, 1983), pp. 231–43.

Kass Banning, 'The Ties that Bind: Here We Go Again' (1987)

From 'The Mummification of Mommy: Joyce Wieland as the AGO's First Living Other', *C Magazine*, 13 (1987); reprinted in *Sightlines: Reading Contemporary Canadian Art*, ed. Jessica Bradley and Lesley Johnstone (Montreal: Artexte Information Centre, 1994), pp. 161–167.

Even before reading the AGO [Art Gallery of Ontario] catalogue, one's response may approach stupefaction when it is learned that two of the three essays were written by Americans. This choice presents the penultimate irony, given not only [Joyce] Wieland's former allegiance to place, the insistence on the local, but also her once-pervasive anti-American sentiments. (Wieland is still the artist who drew the cartoon *First Bombing in English Canada* (1972), where characters abduct pro-Americans to a 'Canadian Content Camp.') Our colonization by Americans is a consummate concern in many of her works.

The choice of critics provides the last word on colonization: a conspiracy now engineered by ourselves (in this case, presumably with Wieland's consent). This reaction is not informed by a single-party imperative, of the nationalist navel-gazing variety. Nor does it endorse the homogeneity of stagnant, local advocacy. It stems from a desire to fight off the claims of the past and witness the latent possibilities that were imminent in a reconsideration of Wieland, possibilities that needed the (seemingly oxymoronic) maintenance of borders to guarantee heterogeneity.

The nationality of two of the critics could make one wary as to their ability to contextualize locale, as ignorance of the place of enunciation could narrow the scope of inquiry. Because of this, the writers could not read Wieland in a multiplicity of contexts, particularly those contexts that could lead to considerations of specificity. Such specificity and contextualization would exempt Wieland from the normative consolidation – feared from this direction – emanating from south of the border.

Confirmation of this anticipatory scepticism about the catalogue occurred early for this author. As a 'Wielandphile' I enquired of the AGO as to who had written the catalogue essays. While I was put on hold, I could hear, 'who is that famous woman from New York, the art critic?' 'Famous' and 'New York' say it all; she is Lucy Lippard. I do not wish to diminish Lippard's achievements; she is a competent critic and has written numerous books, including *From The Center*[1] – the paradigmatic American feminist art text that paved the way for a generation of women artists. Nevertheless,

the American involvement does bring to the fore one of the contradictory strains evident in the Wieland paradigm. The essay on Wieland's films was written by the American academic, Lauren Rabinovitz, who wrote a doctoral dissertation on Wieland and other women filmmakers. Marie Fleming, formerly of the AGO, writes the art historical perspective on Wieland.

In the face of the reservations mentioned above, a central paradox emerges. How does this form of validation, a marginalized discourse itself – American feminism – speak to Wieland's local context? On the other hand, we have no indigenous discourse to replace it. If one considers Wieland's claim that she is Canadian, in addition to her twice-delegated 'first Other' status, this places Wieland in the position of absolute signification. She represents all of the Others. How do we avoid conflation?

There are inherent dangers in appraising an individual artist. The lure of placing an individual's work solely within the matrix of the biographical beckons insistently. This easily leads to an overvaluation that places the artist on the side of the original and unique, often explaining production through personality. This trap is especially appealing when it comes to Wieland. It is difficult not to scramble for personality, to opt for the obvious methodological choice when there is no critical discourse laid out. And we cannot deny that Wieland is original and unique. Barthes and Foucault, among others, have signalled the decline in the status of authorship, of textual authority. The author whose 'death' they announce, is, of course one long revered in Western culture (and still fetishized in many quarters – not the least of which the art field). That is, the author as master, as phallic will-to-power over the text. The suggestion of the possibility of another author emerging, one conditioned by the principle that is decidedly not phallic and not bound by conflation, was but one of the critical challenges these critics failed to meet in the catalogue. Of course, within the Canadian context this is impossible – there is no history to de-authorize, just as there are no authors to speak of. In this light Wieland is a first.

New critical currents, those arising out of recent considerations of the text, could have provided a way of addressing the troubling paradox arising when sympathetic individuals approach the individual female artist. The writer's desire to redress the past, to inscribe a place in linear history, is set against the knowledge that this is no longer the task of criticism. Affirmation can easily tip over into the realm of positivism.

Unfortunately no one rose to the challenge. The catalogue realizes every fear for it: it bites the lure of biography, falling into the same trap as its predecessors, the popular press. Through the persistent pursuit of questions of intention and biographical context, Fleming and Lippard attempt to pin down their subject by naming her as eccentric and determined.

Fleming takes up this interpretive model, based on the analogy between the work and its maker, with a vengeance. She makes her claims for this practice early; she announces that biographical references enrich the readings of the works.[2] Perhaps this is so, but her wholesale utilization of this method steers into the absurd. Fleming traces the life with the works, neck and neck. A pattern emerges. She draws from Wieland's personal history, extracting a prevalent mood or feeling from a particular time, and she illustrates this through examples in the art works. Next she turns to Wieland for substantiation. Such disclaimers as 'Wieland has denied this intent' (p. 22) or 'while Wieland did not consciously intend such a reading, she concedes that it could never-

theless have been unconsciously incorporated' (p. 31) are pervasive. Fleming, however, is extremely thorough; she consolidates the general line of Wieland rather elegantly. She takes stabs at outlining the artistic movements that influenced Wieland, and some of these connections, such as those with Miró and de Kooning, are informative. Nevertheless, statements that narrowly prescribe how Wieland should be interpreted severely mar the essay. Her claim that Wieland's work 'is not directed at theoretical aesthetics or ontological problems' (p. 45) holds no credence within the current critical climate. Fleming echoes the popular press in her reliance on personality and does not provide a way out of the biographical conundrum. The words 'intuitive,' 'personal,' and 'originality' appear consistently. Similarly, the naming of 'feminine sensitivity (delicacy, paleness, lyricism)' as 'that irritant to feminism' (p. 44) demonstrates precisely how she does not grasp that feminism is a generic term of semantic complexity.

When exhibited in the public domain, a work's meaning cannot be commanded by the artist but is at large, in circulation. The artist is one viewer among others. Her reading may be better than most, but it is not definitive. The intrusion of otherness into one's discourse, produced by exhibiting, manufactures meanings that are unbeknownst to her. Seen in this way, Wieland's original self becomes an illusion, an imaginative function constructed to augur the anxiety that is engendered by excess.

The desire to emphasize and construct a self additionally derives from the restorative imperative of feminist revisionism. Such efforts at validation are understandable, indeed commendable, given the past exclusions – there were very few selves to speak of. The cry of 'the personal is political' informs this approach, a strategy that was obviously seen to redress past exclusions, absences, and inadequate contextualizations. What must be remembered is that this cry for equality and the validation of difference, without considering its effects, arose out of the particular contingencies of an era. 'Me-too-ism,' fetishistic counterpower, must be reconsidered, given that equalization has not produced its desired effect – social equality – in spite of orders to the contrary.

These observations do not endorse the dreaded disease of postfeminism, a disease that some find lurking within the 'excesses' of theory. They are informed by a knowledge of the dangers in appraising an artist solely through gender. And Wieland's 'femaleness' is often the sole criterion by which she is defined in these essays. The authors 'flip' the 'personal is political' imperative in order to personalize Wieland's art objects. Such categorization provides an aberrant form of legitimization – it ghettoizes.

Lippard's essay is guilty of this practice. Her valorizing pen delightfully places Wieland as an eccentric, building up a case for greatness. This particular brand of American feminism, with its affirmative rhetoric, is not problematic in and of itself. It becomes something else once transposed to a Canadian context and displaced onto Wieland. Inadvertently, this approach becomes an agent of colonization, by conflating the differences between women artists in different countries.

Rabinovitz's essay also suffers from its place of enunciation. The repeated use of the phrase 'in Canada' reminds the reader that she is speaking at us from afar. Feeble attempts are made to include specific Canadian references, but this is thwarted by data that is simply not true. For example, her claim, in an effort to differentiate *Reason Over Passion*, that Canadian television in the 1960s and 1970s provided no in-depth analysis of nationalist concerns, is simply unfounded. Rabinovitz places Wieland within a

feminine aesthetic context, then describes the films within the tradition-bound experimental film category, walking through the structuralist preoccupation with form. She points out that Wieland has feminine sensibility and that her works are political, but without examining the effects of these engagements. Rabinovitz ends with an adequate description of *The Far Shore* (1976). But *The Far Shore* is by no means Wieland's last film, and this oversight is certainly telling – the essay's 'staleness' becomes magnified. Missing is a discussion of Wieland's most recent films: *A and B in Ontario*, *Birds at Sunrise* (1985), and *Peggy's Blue Skylight* (1985).

By not acknowledging the difficulties inherent to an analysis of a female Canadian artist, and Wieland in particular, the authors repeat the ways in which the feminine has been made a fetish by male writers. This is compounded by the manner in which they echo the cultural context of America's dispossession of Canadian production. They provide a fetishistic reification of the feminine in and of itself and thus repeat the cycle of the Eternal Feminine – as if a colonized culture could afford to go 'cosmic.' And in this way they unwittingly repeat what they have set out against. They recreate the fantasy of the phallic, all powerful mother through which women reconnect with the very Law they had set out to fight.[3]

Instead of challenging historicism's link to the paternal function, these essays invent their own brand of historicism by attempting to construct a new canon. In an effort to provide a formal consistence that would match her brother artists, or her American sisters, they bind and conflate Wieland into sameness. Joan Copjec's warnings against simply inverting the terms of the traditional canonical economy of literary writing are apposite here:

> What must be questioned is not the incompleteness of a list which can then simply be added to, nor, alternatively, the covering up of a separate and autonomous tradition of women writers (a feminine canon) which can then be simply uncovered. Instead one must analyse the way male-transference histories take their form (and not just their 'facts') from their exclusions of women. The whole radical effect of feminism would not be the admitting of women, finally, into existing disciplines but the breaking up of the concordant epistemological fantasies which are their support and limit. The plain observation that a text takes up a sexist position is much less instructive (and much less effective) than the analysis of how this position is enabled from within the theory in which it arises.[4]

The catalogue ricochets between a historicism on the one hand and a transhistorical Feminine on the other. This double desire bespeaks an 'I want it all' attitude – a mutation: the right to remain both inside and outside. And in this way, this retrospective encounters Wieland, but at the same time, it paradoxically exiles her. The relativizing agency of America has donned the unlikely masquerade of the Eternal Feminine, and thus mythologized that which Wieland demythologizes: representation and identity. Naming, a practice that Wieland threw into relief, ironically became the agent that cloaked the contradictions. Grafting, not interrogation, and affirmation, not analysis, become the order of the day.

American feminism has paradoxically occluded specificity here: gender is privileged over other, local differences. Unfortunately, Kristeva's hope 'that having started off with

the idea of difference, feminism will be able to break free of its belief in Woman'[5] was not realized. Same-sex choice, in this case, has paradoxically conflated, and thus limited, the number of considerations we could bring to bear on a reading of Wieland's work. This same-sex contextualization has enabled history to repeat itself. The girls are still playing with the girls, and the Americans are still on top.

It is the Canadian fate to live with the grim reality (after Thucydides) of 'having consciousness of much but the ability to do nothing about it'; then it is also the Canadian circumstance to be in a privileged position to take full measure of European scepticism and American hyper-pragmatism without surrendering to either fatalism or ecstasy.[6]

It takes Arthur Kroker to name the Canadian dilemma. However, it is up to the analytic dissidence typical of feminism – a feminism that is in process – and a concentration on the local to deal with the paradox engendered by the authorization of our women artists. Examining the layers of this paradox points out some of the differences that are being smothered by this retrospective's conflation of Joyce Wieland. Perhaps with this knowledge, we can begin to articulate the specificity she deserves.

Notes

1 Lucy Lippard, *From the Center: Feminist Essays on Women's Art* (New York: E. P. Dutton, 1976).
2 Marie Fleming, 'Joyce Wieland: a perspective,' in *Joyce Wieland: Art Gallery of Ontario, Musée des beaux-arts de l'Ontario* (Toronto: Key Porter Books, 1987), p. 11. Further references to this volume appear in parentheses in the text.
3 Julia Kristeva, 'Women's time,' *Signs*, 7 (1) (Autumn, 1981): 33.
4 Joan Copjec, 'Transference: letters and the unknown woman,' *October*, 28 (Spring 1984): 76.
5 Kristeva, 'Women's time,' p. 33.
6 Arthur Kroker, 'Mediascape,' *Canadian Journal of Political and Social Theory*, 10 (1–2) (1986): 63.

Ailbhe Smyth, 'The Floozie in the Jacuzzi: The Problematics of Culture and Identity for an Irish Woman . . .' (1989)

From *Circa*, 48 (1989), pp. 32–38 (first published in *The Irish Review*, spring 1989).

The title is not one, but many. Not definitive but open. Sign of difficulty and fragmentation but also of possibility.

THE FLOOZIE IN THE JACUZZI/ *The problematics of culture and identity for an Irish woman*

or

THE WHORE IN THE SEWER/ *Intersextextual inserts and excerpts*

or

BIDET MULLIGAN/ *Averse versions of the immersion of women
in Irish culture*

or

THE SKIVVY IN THE SINK/ *'Dreams go by Contraries'*

or

ANOREXIA/ *Denying denial of identity*

or

ANNA LIVIA PLURABILITY/ *The singular diversities and diverse
singularities of Irish women*

O

tell me all about
Anna Livia! I want to hear all
about Anna Livia, Well, you know Anna Livia?

Anna Livia Plurabelle, transmuted from Joyce 1939 into stone monument in the centre
of Dublin City 1987. Erected by the Smurfit Corporation in agreement with Dublin
City Corporation. From disembodied embodiment to embodied disembodiment,
'Riverrun' itinerary of Women:

Why I'm all these years within
years in soffran all beleaved.

A L P supine, reclining in a pool of water. Long tresses (is she marcellwaved or is it
weirdly a wig she wears?) chastely covering barely tumescent breasts, hands prudently
redundant, knees neatly aligned tightly together. Entirely de-eroticised for all her
nudity. All revealing nothing. Blank sightless eyes closed speechless mouth destined
eternally to rigid frigidity (frigor mortis). Impenetrable, not an orifice in sight. Invio-
lably inviolate body unassailably confined within a wall of stone ('leda, lada, aflutter
afraida, so does your girdle grow.'). Relentlessly lapped and licked, caressed and
purified by the unceasing flow of clearly polluted city water ('oiled of kolooney'
toilet water) unsoftening a body hammer-hardened against seduction. Her fleshy
womanness excised unfleshed in stone, anorexically attenuated denial. Impossible
body, sign of the impossibility of Woman. River-woman, projection of male fantasy
and desire, 'daughterwife', doubled, split, shifting, merging 'woman formed mobile?'
Immobilised.

Head, back and heart aches of
waxed up womanage

A L P spectacular obstacle: physically impassable, spatially irreducible, symbolically
incontrovertible. Insurmountable impermeable block of stone, moulded and cast,
beaten into shape, hammered into place.

A L P Monumental assertion of the power of the patriarchy; massive appropriation of Woman, sign and symbol; pompous denial of women's right to self-definition; emphatic affirmation of the negation of women excluded from the generation of meaning.

A L P The name in ironic counterpoint to its own forever-fixed materiality; 'Woman' symbol of plurability, cruel insane mocking contradiction of the circumscribed realities of Irish women's lives. Mater-reality; peremptory pre-emption of interrogation and exploration (*who am I? what can I do?*).

A L P Parthenogenetic reversal, virgin birth, begat by Joyce, born of the incestuous transaction between the Fathers of the Capital and the genitors of Capital. Non-negotiable gender-bender.

A L P Progeny of the miscegenation of Culture and City, without legitimate autonomous existence within their walls. Produced by the brokers of male power, imaginative, economic and political, she exists to reproduce their ideas, their economy, their values, their desires. Her function is 'purely' iconic. Pure, unpolluted, uncontaminated by the actuality of actual women. Having no historical veracity/validity, she cannot represent her own plurability any more than she can represent the historically and materially rooted diversity of all/Irish/Dublin women. Her very unreality (conventional stylised allegorical figure) functioning to erase the untidy realities of fleshy women.

A L P Symbolises the plural omnipotence of someone/something else. She functions 'successfully' as symbol of civic power, *not* because she stands for 'Woman' but precisely because 'Woman' always stands for something else. 'Woman' is an empty signifier or, to put it another way, can be construed to mean whatever 'we' want it to mean. Transparent, transmutable, not generatrix of meaning but receiver carrier site of passage:

> Meanings of all kinds flow
> through the figures of women,
> and they often do not
> include who she herself
> is
>
> Marina Warner, *Monuments and Maidens*

Anna Livia River Liffey River Woman, flowing through the City of Dublin

> ducking under bridges
> bellhopping the weirs,
> dodging by a bit of bog
> rapid shooting of the bends.

A L P exists not in and for herself but in and for something *other* than herself. Essentially vacuous, receptacle without individual identity, mute spectacle, silent cipher, the

symbolic female figure is capable of *conferring* meaning. Massive, monumental, grandiose, but powerless to ascribe any meanings other than those prescribed by culture, where the (only) point of view (acting or seeing) is assumed to be and designated as male. Always seen, never seer.

The space between producer and consumer of the symbol is negotiated unproblematically by the male, because the point of view (viewing) is the same, homogenous. It is fraught with ambiguity and danger for a woman because not only not-same but *also* not *acknowledged* as different. Virtually impossible to traverse that space without erasing woman-self. We can only buy into the image and its symbolic/value system by suppressing our individuality as women. Overwhelmed by its sheer bigness, we are lured into a belief in the *significance* of the representation. But the message carried is paradoxically (?) one of our in/non-significance. Woman-as-image and woman-as-spectator participate in the reproduction of our own *meaninglessness* in culture.

A L P is not an image *of* women *for* women. Monuments *to* not representation *of*. It uses 'Woman' as a sign in a discourse from which women, imaginatively, economically, politically disempowered, are in effect and effectively excluded.

<div align="center">(What is my name?)</div>

In post-colonial patriarchal culture, naming strategies have an overdetermined role, invested with an irresistible double force and double meaning. The long-denied power to name, to confer meaning, and thus (illusion?) to control material reality, is all the more powerfully experienced and pleasurably exercised when finally acquired. It is a treacherous ambivalent power if the paradigm for its exercise remains unchanged. The liberation of the state implies male role-shift from that of Slave or Master, Margin to Centre, Other to Self. Women, powerless under patriarchy, are maintained as Other of the ex-Other, colonised of the post-colonised.

A L P is hewn into silence,

> the stench of her fizzle and
> the glib of her glab

appropriated by

> the drunken drabbletail Dublin
> drab

Dubliners have appropriated the monument in their midst through a multiple, re-naming game, manifestly pleasurable, which reverberates with a *plurality* of significations, of ten contradictory (but 'dreams go by contraries') infinitely translating travesty.

Iconoclastic and irreverent, the renamings are an ironic recognition of the power of icons in a culture still significantly shaped by religion. Disparaging and reductive, each re-name is a paradoxically clear statement of the *desire* to appropriate and of the *inability* to do so. The joke around which each re-name revolves is an overt assertion of

dominance masking actual (but unacknowledged) powerlessness. Substitute for the 'real' power to move, remove, form, transform. Most of the re-names are in jokes, depending for their effect on a set of communally shared meanings, incomprehensible (ostensibly) beyond the confines of the City. At once appeal to a shared, closed system of meaning and mechanism for the reproduction and reinforcement of sharing and closure.

Playing on a deliberate and overdetermined contrast between the *inflatedly* 'High Art/High Culture' connotations of the monument and the 'ordinary' mythology of Dubliners, each joke is a consciously *deflationary* tactic. The 'Man in the Street' incisively sanctions pomposity, cuts it down to size, re-names it, so that it fits in to his world. Recuperation by the everyday.

And ironically, the foreign words incorporated in the jokes, debasement of the 'Master' language of the Colonisers, betray our island isolated vulnerability. Persistent fear, residue of our colonial past, of permeability by outside influence, invasion by the alien force – cultural, technological, economic. The litany of re-names enabling exorcism of the foreign devils.

Deflation and exorcism *pass through* 'Woman', absolute patriarchal Other. Demystification of the monument (and all it symbolises) *passes through* a reconfirmation of the mythology of 'Woman' (and all she has been made to signify).

> (And when 'Woman' signifies
> anything, everything and nothing,
> how can women signify?)

A L P 'Riverrun' Woman through whom meanings flow. Site of passage, carrying (away) fantasies, dreams, desires, uncertain insecurities; contradictions, paradoxes; dangers, fears, terrors.

Anna Livia/Anorexia Ultimate denial of unrepresentable woman-self; de-sexed, demystified; pared away to bone/stone.

Bidet Mulligan Biddie Mulligan, the pride of the Coombe, brought to her knees, abased. Bidet: 'Vessel which can be bestridden' (OED), Ould Biddie Ridden bestridden 'rightjungbangshot into the goal of her gullet'. Ould Biddie, ould hag, ould bag. Receptacle, dump for the shaming/shameful detritus of desire.

Whore in the Sewer/Skivvy in the Sink Equivalent in a pruriently puritanical culture of the Madwoman in the Attic. *Confined/contained* within base materiality/sexuality. *Confining and containing* animal urges. Woman-as-pollutant, source of sin, synonymous with dirt and obscenity.

Floozie in the Jacuzzi Glamourised whore, condemned to float precariously between two cultures, the indigenous and the foreign; carrier of ambiguously contrary desires; temptress redemptress; sexual slave, talisman and sacrificial victim.

Floozie, Skivvy, Whore Patriarchal generic. Interchangeable. Infinitely transmutable, always the same. All women are prostitutes. Commodity/commodious object.

Floozie, Skivvy, Whore is my name, marker and symbol of my identity.

> Which brings me in passing to the
> question of Irish women's place
> within but without culture and
> identity
>
> Transparent floating capacious signifier,
> from what place can I speak?
> Confined 'by the waters of Babalong'
> in sink, sewer, bidet, jacuzzi, in a
> flowing babel of other-determined
> myths, symbols, images, can I speak
> myself at all?
>
> Ciúnas! Quiet!
> I can't hear myself think.

said my mother and my grandmother before her and I to my daughter. Can't hear myself
talk, can't see myself look, can't feel myself move, can't let myself be, can't be my self.

> I can't hear
> I can't see
> I've done the job too well
> I never thought, I never thought
> I could come to this.
> I shake in my vacancy.
> Eavan Boland, 'The Woman as Mummy's Head',
> *Nightfeed*

The vacant space where nothing is identically the same. Where everything is virtually
possible. Where nothing is no more and everything becomes.

 In the end, I couldn't get a fix on identity. But identity is not an end. Only a becoming.

> (What, after all, do you do when
> you find it?)

In the end, I couldn't speak for Irish women. Can barely speak of myself. Can barely
speak.

> (Suppose there is no I?)
>
> Where is my savour
> watered with freshets away?
> Where is my seasoning
> locked from the weather's
> sweat?
> Long have I languished
> with inland tribes,

> silent, choking, sick, by
> racks and managers
> troughs and racks.
>
> <div align="right">Catherine Byron, 'Inland', Settlements</div>

Outlandish inlander/Inlanded outlander. Described, prescribed by the scribes of inland tribes.

Story Two years ago, I spent a brief summer in France, struggling relentlessly with identity, Irishness, womanness. This summer, ritual reenactment in Greece. In the end, I wrote these 'bits and scraps' not continuously, not smoothly. In excerpted moments extracted from the ragbag spectrum of my life. Inserting other excerpts.

> 'fragmented, with sources from
> everywhere' she said 'digging
> up the fragments, not written
> in their books' she echoed her

Why summer? France? Greece? Why never Ireland?

 Only in time out of time, place outside place, vacant space, that it becomes possible, bearable, to face the sense of absence (if it has a sense). Only fitting elsewhere, otherwise.

> Only lately can I say it; only through
> felt life has it come:
> Ritual can lead to the real.
> Reared to ritual, none
> of my received messages regarding it
> were proof against rebellion.
> For a long time I put it all
> away; it seemed parade, seemed pseudo.
>
> <div align="right">Eithne Strong, 'Ritual', My Darling Neighbour</div>

In the end, no continuity, coherence, unity.

> For there is, and at last I
> recognise it, no unity whatsoever
> in this culture of ours. And even
> more important, I recognise that
> there is no need whatsoever
> for such unity. If we search
> for it we will, at a critical
> moment by mutilating with
> fantasy once again the very
> force we should be liberating
> with reality.
>
> <div align="right">Eavan Boland, 'The Weasel's Tooth',
Irish Times 7/6/74</div>

Beginning middle without end. In the end is where potentially this begins.
 The original point of revolution. Liberating.

> Identity is a form of oppression,
> but also an imperative of Revolution?
>
> Gerardine Meaney

Interrogative mode. Incomplete. Unfinished. No one solution to the problem. No one answer to the question

> (Who am I, Irish Woman?)

But not either negation of each. Multiplication of both and. Much of a muchness. Other of anotherness. And again. Problem. Question. Woman. Irish.
 Undeniably woman – genetic fortune. Undeniably Irish – trick of birth and history. But long/denying/denied both.

Story I choose the oblique because I am not of the centre. Edgy, laterally moving. Tangential.
 Always side by side, uncertain of connection. so long eclipsed, fear of eclipsing. Reluctant to impose, so long imposed upon. So maintaining the politeness of ellipsis. Unused to I, speaking subject, so eliding into other I's.

> (The voices in my ear, images
> in my eyes, symbols of my self –
> not mine, theirs)

Unused to inhabit space from which evacuated long ago. Fadó Fadó.
 Space now for self with others (but still uncertain of connection). Listening, looking, hearing, seeing, speaking, writing with self and others. Slow unaccustomed halting process. Merging to emerge.

> 'I am emerged in a book' my
> daughter said

Emergency.
 Patterns of silence not easily broken.

> Sometimes I'd have to kneel
> an hour before her by the fire
> A skein around my outstretched hands
> While she rolled wool into balls.
> If I swam like a kite too high
> Amongst the shadows on the ceiling,
> Or flew like a fish in the pools
> of pulsing light, she'd reel me firmly
> Home, she'd land me at her knees.

> Tongues of flame in her dark eyes
> she'd say, 'one of these days I must
> teach you to follow a pattern'
>> Paula Meehan, 'The Pattern' *Reading, The Sky*

Constructions

Irishism (*Roget*) paradox sophism equivocation nonsense untruth error lapse lapsus
 linguae
Woman (Aristotle/Aquinas/Freud/Lacan) defect, lack, absence, lapse, lapsus linguae
Identity tautology id-entity, non-entity in-sense non-sense absense sense absconded

> 'Words! The Irish are great with
> words!' he exclaimed 'But they
> don't *mean* anything,' he roared.
> 'They obfuscate. They play about
> with. They lie and deny . . .
> I don't want words. I want you'.
> 'The word made flesh'.
>> Julia O'Faolain, *No Country for Young Men*

And flesh made word.
No country for Irish women
Unconstruction Detach each one of the terms. Shifting. Unstable. Jerry-built.
Demolish. Reveal the site of sight. The source.
Myth

> There was once a *well* into whose
> depths it was forbidden to look.
> A woman nevertheless looked into it.
> The water *surged up* from the
> well; it pursued the woman and
> *drowned* her, at the same
> time giving birth to a stream
> that fructified the country.
>> Clémence Ramnoux, 'The Finn Cycle: the symbols of
>> a Celtic Legend', *Crane Bag*, 2(1975)

Look nevertheless. Immersion for emergence.

> I am a woman of Ireland
> Is bean Eireannach mé.
> (Genitive/Generated by, not Generative.
> In apposition. Contiguous. Tangential)

'Ireland is a country of the mind'
(whose mind? Not mine.
Whose country? Not mine
Myth and mind bind/unbind remyth remind)

Contorted into contours other than our own.
Imaged by the image.
Constructed by the construct.
Invaded, occupied, inhabited, squatted.

> We are speaking your language
> We are wearing your names
> fathers, husbands
> We are living your laws
> We are your subjects?
> Just listen
> Anne le Marguard Hartigan, 'Occupied Country'

Can they? The ex-colonised oppressors colonise. (Habit of centuries) They don't listen.
Theirs is the Republic, the Power and the Discourse.
Definition 'a linguistic unity or group of statements which constitutes and delimits a
particular area of concern, governed by its own rules of formation with its own modes
of distinguishing truth from reality'. I am for me a particular area of concern consti-
tuted delimited governed by their rules of deformation and proclamation 'Irishmen and
Irishwomen: In the name of God/the Father Son and Holy Ghost'.

> Inhabited by their myths and mind (The Irish Mind)
> their triple double bind (Father Faith and
> Motherland)

> Just listen

> The past twenty years have seen
> a proliferation of debates about
> Irish nationalism and cultural
> identity.
> Eamonn O'Flaherty, *The Irish Review*, 2(1987)

> . . . the infernal navel-gazing
> about 'Irishness' and 'Identity'
> Gerald Dawe, *Krino*, 5(1988)

> (Whose navel?)

No lack of identity. Historical identity. Cultural identity. National identity. Irish iden-
tity. In crisis and transition. But theirs. Not mine.

> *Theirs* subject: thinking, speaking, defining
> and identifying
> (Transitive active)

> *Mine* subject: subject, subjugated
> by: thought/spoken/
> identified object
> (Intransitive passive)

Between oppressor and oppressed, coloniser and colonised, the Cause/Code is not shared, but imposed. Enforced, unfittingly assumed. The tense misfit between the two maintained by the powerful group.

Myths and legends, histories and fictions. The narratives of Irishness express the pain of failure, sacrifice and loss, dispossession, dislocation, diminishment (the plaint of the maimed claiming their right to name).

> Why then misfit? Surely these are
> my themes too?

The words sound the same, but resonate with different realities.

> You would not accept me when I came
> a queen, like a tree be-garlanded.
> My womanness overwhelmed you
> as you admitted after to a friend
> over a mutual drink.
> Fear, certainly, of castration
> fear of false teeth in my cunt
> fear my jaws would grind you
> like oats in a mill
> me having a good comb to tease you
> you ball-less little bollocks
> I was never bad for you . . .
>> Nuala Ní Dhomhnaill, 'The Great Queen Berates
>> the Badbh to Cù Chulainn', *Selected Poems*
>> (trans. M. Hartnett)

Transference. Fear. Terror. Dread. Afraid of the dark. The Unknown. Defense against themselves. I am their ransom against past and future; death and annihilation. Advance guard. Front line. Negative affirming their existence.

> I am their wall against all danger.
> Their door against the wind and snow.
>> Katherine Tynan, 'Any Woman'

Myth

> . . . the woman, who is present
> at the birth of the king or hero and
> also becomes his consort in the guise
> of the goddess of sovereignty, finally
> becomes the arbiter of death.
>> Muireann Ní Brolcháin, *Crane Bag*, 4(1) (1980)

We are damned, my sisters,
we who accepted the priests' challenge
our kindred's challenge: who ate from
destiny's dish . . .

> Nuala Ní Dhomhnaill, 'We are damned my sisters',
> *Selected Poems* (trans. M. Hartnett)

(So I am conceived, inscribed.
Ireland/woman. The slash of elision.
Sacrificial offering, the priests
ordaining my immolation. For their
Cause, in accordance with their
coded rules.)

Listen. This is the noise of myth. It makes
the same sound as shadow. Can you hear it?

> Eavan Boland, 'Listen. This is the Noise of Myth',
> *The Journey and other Poems*

Consider again the ethic and rhetoric of sacrifice and martyrdom for the Irish male. Inflationary. Heroic self-enhancement, self-fulfilment. To die for. Transitive.

For Irish women, sacrifice signifies nothing. Annihilation. To die. Intransitive.

Fuel on the fire of macho heroism. Metaphor in their discourse. Symbol. Icon. Even still.

Woman Ireland Banba Foladh Eiriú Red Rose Róisín Dubh. Caitlín Ní Houlihán. Mother Mother of God Holy Mother Mother Machree Mother Ireland Ochón is Mavróne

Some people know what it is like
to be called a cunt in front of their children
to be short for the rent
to be short for the light . . .
to be second hand
to be second class
to be no class
to be looked down on
to be walked on
to be pissed on
to be shat on

and other people don't

> Rita Ann Higgins, 'Some People Know what it is Like',
> *The Salmon*, 7(1988)

The words resonate with different realities.
Penetrating body heart and head. Inside my head. Always image. Never imagining. How to imagine?

Snake Mother at the psyche's core

Roz Cowman, 'Medea Ireland'

Voracious legends and myths of Mother Ireland, bulimiac contrary of her virgin self, devouring her offspring.

Maiden and mother, oh nurse, oh atom bomb,
you will spurt on us the black liquid milk,
volcano dust will burst from your throat
from your heart the burnt smell be stripped.

Nuala Ní Dhomhnaill, 'Great Mother', *Selected Poems*
(trans. M. Hartnett)

How to emigrate from the myths of the Motherland?

You puffed up, arrogant bloodsucker,
If I survive no thanks to you
I'll show each soul I meet
My shrunken twisted heart
And give you credit for your economic artistry

Kathleen O'Driscoll, 'Motherland', *Pillars of the House*

Mother/land: Bonded with the one, rooted in the other, we are yet outside the economy of culture. Out of place, without place,

Now Bridie keep your legs crossed
and the rosary between your toes
Give me your fat

Leland Bardwell, 'Poem for Geraldine O'Reilly'

Dear M/other. M/other tongue.

Land of our Fathers
Our tongues have been tied cleft
to our palate, have been cut out.
Listen.

Anne le Marguard Hartigan, 'Occupied Country'

Definitions
'Nationalism and feminism both privilege the desire to name, to classify, to distinguish themselves from the Other'.
Colonisation 'The act of colonising, the fact of being colonised'. Theirs the act, mine the fact. The act of naming, the fact of being named.

> The following day during lunch
> father told the family he had an
> announcement to make . . .
> He told them he had changed his
> name. Nan could not remember what
> his name was. She never heard him
> called anything except father . . .
> She saw it then, the power in those
> haughty hands. He had taken away
> their name. It was as if their
> lives were empty frames of his
> making within which he had chalked
> their features. He had taken a duster
> and wiped them clean . . .
>
> *Clare Boylan, Holy Pictures*

(What is my name/In the name of the Father?)

Identity for Irish women is a dual complex, defined by two political and cultural realities: 'Irishness' and 'Womanness'. Overdetermined, both, as subordinating negative signs.

> ('We operate', she said 'out of a
> kind of nagativity')

Double caught in the double bind/mind.

Story

> It took so long to recognise how
> inextricably the one was implicated in
> the other. Denying, Repudiating (apostate)
> my Irishness. Borrowing speech,
> lifestyle, ideas, politics, even lovers.
> A hot potato in my anglicised
> mouth. Metaphorical emigrée. Smooth
> undifferentiated veneer of international
> statelessness.
> Hating my assigned woman-state,
> internalising patriarchal contempt.
> Denial, refusal (anorexic)
> of my flesh, a metaphor of
> my cultural excision.
> Metaphors can kill.
> No neat theory this.

'Irish culture is rooted in a devaluation of the feminine' he said – or was it I in passing? – 'through its identification with the place of victim, with instinct, emotion, celtic

romanticism, soft-focus nationalism. Its opposition to reason, strength, power, superiority.'

Dual struggle with the imprint of colonially induced dependence and patriarchally imposed otherness struggling to extricate ourselves from the altogether simultaneous web that binds us into the pattern of dual non-entity.

> Back and forth
> warp and woof
> wing of angel
> devil's hoof
>
> May Morton, 'Spindle and Shuttle',
> *Pillars of the House*

Reiterated double need for confirmation of our existence, worth and value.

> (We send our saints to Rome for
> canonisation, our scholars to
> Harvard for approbation, our
> writers and artists for
> international publication, acclamation
> even our business for foreign
> flotation)

I *need* the legitimating male imprimatur, which nonetheless modulates my discourse, shapes my tongue, turns my eye. Appropriating, validating what they can use. Negating, illegitimating the rest as non-existent, worthless, 'not quite the ticket'.

I *need* the ticket so that I can pass, for in passing lies my survival. But it is a trap. Penetration is their only way. To the point of saturation. Colonisation of the subconscious. How can I speak if that 'I' has been passed off, and on, as Other?

Dear M/other

'Irish Woman' enables definition of 'Irish man'. I am the edge, defining the centre. Border country. Margin, Perimeter. Outside.

> How to combat the myths within,
> and the myths without?

The problem is *not* how to negotiate entry *inside*, into a tradition, culture, discourse which designates the Other as necessary alien, necessarily *outside*.

(They will not, in any case, permit disruption of the space between, the poles of their existence; will not permit their own annihilation.)

Nor even how the discourse can be so altered as to accommodate alien expression. Both strategies of assimilation, recuperation. Insertion.

> *Reality 1*
> The Irish are the dispossessed.
> Chained to an endless churning and rechurning.

Revisionist revising Revisionism.
A surfeit of history the stultifying sign of loss.
Ceaselessly remembering loss.

Reality 2
Irish women are twice dispossessed.
Disremembered. Unremembered.
No body, so to speak.
No past to speak of.
Unremembering our history
of absence, sign of our existence.

(Never possessed of our history
Never possessed of ourselves.)

'As everyone knows every negation is a definition'
<div align="right">Julia Kristeva</div>

Is double negation double definition? Double negation producing affirmation?
In truth, we cannot be dispossessed of what we never had.
In truth, we are the unpossessed, the unpossessable.

Tabula Rasa, Free space
Uninscribed place of the future. This is what we must remember.

> ... wildish things these
> little newbreed Irish girls, scarce
> parented, not to be grooved into
> rectangular requisite
> <div align="right">Eithne Strong, 'Identity', *My Darling Neighbour*</div>

Ab(ovo)
Issue from 'the silences in which are our beginnings'. So listen, first, to the absence –
Not their 'noise of myth and history'.

> (What is my story?
> Imagine from the beginning.
> Gestate myself. Invest.)
>
> Putting back the flesh
> sewing bones to bones
> The dead begin to dance
> They are shaking the earth
> <div align="right">Anne le Marquard Hartigan, 'Occupied Country'</div>
>
> (Changing reality as much through
> our imaginings as through our
> material acts) Both and.
> Not easy. Nervous, Edgy.

> The first angels must have been
> like this, intolerant, haughty,
> slightly clumsy, their wings
> more beautiful than themselves
>
> and not respectful to the godhead
> but watching, chins lifted
> hearing false notes with
> spiritual ears
>> Roz Cowman, 'The Goose Herd', *The Salmon*, 7 (1988)

This is not what it was set out to be: insert in the obsessive discourse on Irishness and identity. I sought cool, dispassionate, definitive objectivity. Evacuated 'I', anonymous. Same. One of them. Implicated. Self-centered. Not exile on the edge, emigrant/exile in the place of my birth.

A last-ditch effort at the identity fix. Then *finis*. Unease resolved, question answered. 'I am who I am . . .'

> Wrong question.
> Prefixed, suffixed; out of my mind.
> Must unfix, Move from where
> I am, whatever, wherever.
> Not seek to integrate insert.
> Move from eccentricity, extricate,
> extrapolate, explore excess, excursion.
> Away from image id (non) entity.
> Imagining existing exhilarating.
> Excerpt from a journey towards
> my self:
> from the space between what
> I say and what I want to say
> from the space between what
> I am and am becoming
> 'When the shackles come off,
> there's scar tissue, bone damage,
> and that sudden unbalanced feeling
> of a lopped-off limb'
>> Roz Cowman, 'Dancing the Sega'

Uncertain, risky, feeling inappropriate because, place of passage, of becoming, beyond (mis)appropriation. Evolving, open, spacious, unfixed.

> A floozie, forsaking their jacuzzi
> must always feel like this.
>
> 'I won't go back to it'
>> Eavan Boland, 'Mise Eire', *The Journey*

Ciúnas! Quiet! Listen!

Hung Liu, 'Five Terms, Two Letters' (1990)

From *M/E/A/N/I/N/G*, 7 (1990): 17–18.

> My legal term: *Resident Alien*
> My professional term: *Artist*
> My academic term: *Assistant Professor*
> My racial term: *Asian (Chinese)*
> My art world term: *Woman of Color (Yellow)*

The following two letters were written in 1989. I believe they pertain to the relationship between artists (and especially women) of color and the academic art world. The first letter was to the Chairman of a Search Committee for a western university; the second letter was posted in a university art gallery along with my floor installation, 'Where is Mao?,' which was the object of some confusion by both American and Chinese students.

Letter to the Chairman of a Search Committee
Dear Professor:

With this letter, I would like to withdraw my application for the drawing/painting position in your department. I have based this decision on the interview I had with you at the College Art Association meeting in San Francisco.

To begin with, you didn't have my slides at the interview, and were apparently not familiar with my work. In fact, your comments suggested that you thought I was a traditional Chinese artist with little or no sense of contemporary art. Consequently, the interview was more about my racial and cultural background than my abilities as an artist or an educator, even though I'm sure you believe the reverse to be true.

From my perspective, your questions were arrogant, patronizing, condescending, and full of false assumptions. For example, you continually noted your 'concern' about my nationality, as if being Chinese automatically meant that I was unqualified to practice as a contemporary artist in America, or to teach American students. I wonder, was I the only candidate to be asked such questions? Or was I just your token 'woman of color?'

While you allowed me a 'profound knowledge' of Chinese art and culture, you questioned my ability to 'help students survive' in this one. Being a professor in a university, however, does not necessarily involve teaching students to survive. Such a notion has never occurred to me, either here or in China. Rather, I believe, my responsibilities to students involve preparing them to take themselves seriously as artists, as well as to expose them to as many different aesthetic and cultural viewpoints as I can. In fact, diversity is precisely what I can offer American art students, and what is more 'American' than pluralism?

But what disturbed me most about our interview was the underlying assumption in your questions that American art and culture is somehow monolithic and uniform, more like 'us' than 'them.' At best, your assumption is merely academic; at worst, it is racist.

Finally, I am left with several 'concerns' of my own about art education in your depart-
ment, and since you seem to have yours as well, I don't wish to add to them by being Chinese
at_____University.
Thank you,
Hung Liu

Letter to University Students

Seventy-five years after the famous battle had been fought, the former soldiers, from both
the North and the South, gathered together at Gettysburg for a spectacular banquet instead
of a battle. Their average age was ninety-three. One of them said: 'I am enjoying it more
now than I did 75 years ago.'

In order to understand the past – we call it History – we need to have a distance, a gap
between Now and Then.

When I was in China during the Cultural Revolution, I was sent by the government to
work in the fields, as were thousands of Chinese students, intellectuals, and artists. At that
time – in 1968 – I didn't understand what was happening to me and to the whole nation.
'We the people' lost families, jobs, health, and sometimes our lives. Bending over in the sun,
laboring like a cog in the proletariat machine, I experienced both physical and spiritual oppres-
sion. Time seemed endless, but after four years I was able to return to Beijing, my family,
and my education.

In 1989, I find myself once again bending, but this time over a gallery floor as I place
fortune cookies (which are American–Chinese inventions) on the face of Mao Tse Tung. It
reminds me of the rice fields, but from both an ironic and a historical distance. If you under-
stand the difference between a rice field in China and a gallery floor in America, then you
may understand the satirical nature of my 'memorial' to Mao. After all, I am here, but where
is he? And like the Gettysburg veteran, I am enjoying it more now than I did twenty years
ago.
Hung Liu

Speaking on behalf of the academic art world, Moira Roth once said: 'We should
work *with* artists of color, not *on* them.' Perhaps there is hope for cultural and aesthetic
pluralism in the 90s. As a classically trained Chinese artist in the United States,
my responsibility is *not* to assimilate, but to express my Chineseness as clearly as
I can.

Coco Fusco, 'We Wear the Mask' (1998)

From *Talking Visions: Multicultural Feminism in a Transnational Age*, ed.
Ella Shohat (New York: New Museum of Contemporary Art; Cambridge, MA:
MIT Press, 1998), pp. 113–118.

During a trip to Europe in 1993, I could not avoid taking note of resurgent hatred
directed at foreigners in general, and Muslims in particular. It seemed as if Europeans

reserved a special kind of malevolence for the last non-Christian people to have succeeded in conquering parts of their continent. In this climate of animosity, derisive comments about what was perceived as stubborn insistence on maintaining traditional connections between identity and appearance were common. More than a few Europeans reminded me of the legal battle involving the young Muslim girls and their chadors (veils), which the French state had sought to remove while they were in school. In many more conversations, I noted how even progressive Europeans equated 'traditional' appearance with 'oppressive' culture and minorities resistant to assimilation.

The European feminists I encountered were no exception. I heard too many horror stories about Muslim treatment of women that often began with comments about chadors, and led to assertions that 'traditional' men didn't allow their women to be feminists (European style). But in Germany I was also told that the latest craze for middle-class European women trying to 'get in touch with their bodies' was belly-dancing classes, which are even more popular than salsa workshops that have sprung up like weeds all over northern Europe. No one spoke of the simultaneous embrace of a culture and rejection of the people who originate it as a contradiction; in fact, some Germans even argued that their interest in Black culture, for example, was simply a by-product of an imperialist American culture industry. Exotic dance classes, herbal medicine and hair care, nose piercing, and world beat clothing, all acts of cross-cultural appropriation and identity displacement, were all among the latest defining markers of the transgressive northern European woman. As I have argued elsewhere in relation to my recent experiences masquerading as a 'primitive' in a cage, Western culture continues to rely on stereotypical notions of otherness and non-Western identity to define itself; and Western feminism, together with other attempts to redefine, transform and broaden contemporary developed societies, also depend on those same reified notions of difference to delimit their transgressiveness.

The history of the Americas is rife with examples of transfers of appearance between privileged and subaltern women. One of my favorite cases is that of the *tapadas* of the sixteenth-century viceroyalty of Peru (and much of South America during the colonial period): libertine *criollas* used their shawls as chador-like veils, covering all but one eye to hide themselves and thus to be freer and less easy to identify in public places. This practice had originated in Spain where, after the expulsion of the Moors in 1492, Islamic veils were banned and Morisca slaves turned to shawls to cover their heads and faces. Catholic women quickly perceived in the use of this body covering the advantage of its allowing them more social mobility (downward) and privacy. They took on the practice with such gusto and success that the Spanish crown outlawed it soon thereafter. In South America in the 1580s, the Council on the Indies saw in *tapadas* potential damage to the empire, noting that their sexual behavior could not be controlled and that even men were using the shawls to engage in 'sin and sacrilege.' Despite frequent attempts to outlaw it, the practice continued into the eighteenth century, when Enlightenment ideas redirected privileged women's desire for more liberty to cerebral rather than sensual pursuits.

In my imagination, I envision *tapadas* as precursors to both commercialized and avant-garde 'bad girls' such as Madonna and the thousands of non-Latin Frida look-alikes who roam the Southwest. They borrow from subaltern female and sex-trade

stereotypes (and take belly-dancing and salsa classes), and in doing so miraculously transform signs of oppression into symbols of transgression. In the context of the current celebration of transferable identities, such acts of appropriation are posited as emblematic of the postmodern severing of traditional or natural unions of identity and appearance. Unfortunately, however, this celebratory position tends to depoliticize and equate all forms of identity twisting, reaching the point at times of assuming that women are what they wear. It collapses the historical, political and social influences in the construction of identity and appearance into a superficial reading of identity as appearance, complementing the impulses of a society that uses consumption as its model of cultural assimilation. Thus, the history among women of color of manipulating self-image to negotiate sexist and racist realities (sometimes known as passing) becomes, at this moment, a kind of beacon for white feminists in the post-modern age in search of a positive relation to style. I take as an indicator of this phenomenon the current feminist film theory fad of teaching and writing about *Imitation of Life* more than just about any other films with African-Americans in them.

It is important to remember, however, that this was not always the mainstream feminist line on style, the body, and appearance. Much feminist art in the 1970s stressed the biological functions of the female body and ancient (or at least pre-capitalist) matriarchal mythologies. In the early 1970s, when white feminism established itself in the academy and within certain sectors of popular culture, 'style' and other forms of attention to appearance were often written off, somewhat ethnocentrically, as capitulation to patriarchy. Implicit in this position was a puritanical rejection of adornment as a form of dissimulation. During this period, I recall being looked upon with skepticism by the director of the women's center at my college (always clad, by the way, in grays, brown, and tans), who could not understand how I could be a budding feminist theorist in fishnets, pink mini-skirts, and purple hair. My success strategy at that time, at a very WASPy Ivy League university, was to deliver a paper at a conference at the women's center my senior year, dressed as a man, on Lit Crit goddess Virginia Woolf's only funny book, *Orlando*. I ended up winning the prize for the best women's studies thesis on the same subject a few weeks later. (And some people think I just started performing . . .) Two years later, I decided to drop the cultural drag, leave the academy and commit myself to less recherché pursuits.

It wasn't until I left school and tried to enter the work force that I grasped just how much of that past was still present, making the very idea I could escape an identity by altering my appearance patently absurd. While I had spent years nourishing my brain, identities I found reductive, unacceptable, and racist continued to be thrown my way. The best I could hope for in most cases was acknowledgment that my identity might be something different or more complicated than the expectations generated by my appearance. The cultural debates and resurgent racial tensions of recent years have only served to make those expectations more apparent, not to make them disappear. In the midst of this, I felt myself beginning to lose sense of the pleasure I might have found in delving into other cultures without sensing a connection to mine. There is nothing radical for people like me about trying to be somebody else – our problem is how to get others to see who we are. At some instinctual, or perhaps unconsciously political, level of my psyche, I felt that the struggle to transform

limiting notions of the self had to come from *within*, from inside the cultures that had socialized me, and began to excavate the language I had first learned to understand myself.

Was I sensitive to the relationship between identity and appearance because I was a feminist? I cannot answer that question without first asking what kind of feminist I am speaking of. Feminism as it was defined by institutions at the time I began to think of myself as an adult woman sent me very mixed signals about both my identity and appearance, and I negotiated those looks by parodying them. That strategy, however, was one I had learned from women who had never participated in a feminist movement, let alone called themselves feminists. They were my mother, my aunts, my maternal grandmother, and family friends, all masterful manipulators of appearance, as their being women of color in the highly stratified societies of the Caribbean had necessitated. Before I reached adolescence, my power to manipulate my appearance had been forcefully communicated to me. I had been taught how to lighten my skin, get rid of my freckles, narrow my nose, straighten my hair, walk like a Parisian, sit like a virgin, speak like a lady, and dress like someone wealthier than I was. I watched them all go in and out of that posing as the situation called for it, saving their feistier selves for private moments. To follow their example meant to look one way and be another – tough, self-reliant, and prepared to face off against a system that would block my success at every turn. When I was younger, I thought they were hypocritical, even silly. I resented their screams when I decided to wear an Afro in the seventies. I now see them as survivors, women who tried to shield me from the suffering that lives in their memories. In their suggestions that I feign weakness to avoid physical labor, I hear the weariness of women who never had the luxury to fight for the right to work, and who have never experienced the claustrophobia of being supported by a man because no man available to them could offer such security. Through their admonishments and masquerades, a past that binds me to them speaks to me.

Diane Losche, 'Reinventing the Nude: Fiona Foley's Museology' (1999)

From *Past Present: The National Women's Art Anthology,* ed. Joan Kerr and Jo Holder (Sydney: Craftsman House, 1999), pp. 98–102.

Dangerous Ground

Perhaps the most important task of all would be to undertake studies in contemporary alternatives to Orientalism, to ask how one can study other cultures and peoples from a libertarian, or a nonrepressive and nonmanipulative, perspective. But then one would have to rethink the whole complex problem of knowledge and power.[1]

Each time an Aboriginal artist such as Fiona Foley enters a museum or gallery space, we are confronted with Edward Said's lightly dropped suggestion about the need to rethink knowledge and power in the context of representation. From this point of view, the art of Foley (and other Aboriginal artists) is not simply the presentation of an Aboriginal position, another side of the story. It is not simply the articulation of an Aboriginal presence in the art institutions of the day, even though this is a worth-while project in itself. The artwork is also a necessary reconfiguration of museological representation and representational practices. This can be a difficult territory in the light of the continuing necessity to circulate around issues of mimesis, appropriation and hybridity.

Dangerous ground here. Mimesis has a fraught history in the visual arts. As art historian Arthur Danto has pointed out, sometimes the visual arts are damned for being mimetic yet at other times this is the pinnacle of artistic achievement.[2] One way or the other, art always seems to be on the horns of this dilemma. For artists such as Foley, the question becomes: how does one remake an institution using the very tools that have been used to build that institution, an institution that is clearly not representing one's own views or interests?

There are any number of solutions. Some artists believe that it is necessary to turn away from traditional art practices because these are so blighted by their institutional pasts. Others, like Foley, travel a thinner, more dangerous line, using the techniques and territory of institutional practices while reinventing them by some shift within the genre, thereby reflecting the practice mimetically back onto itself. In this way, Foley's work travels a path of mimetic hybridity which is in fact a path of transformation and assertion over a particular territory of representation. It is on the twin edges of mimesis and transformation that Foley's museological and representational practices/interventions often move.

Foley has been involved in a number of such interventions, often playing different roles. In 1991 she was involved in a joint installation, 'The Concept of Country', with two Maningrida artists, Terry Ganadilla and Dale Yowingbala, at the Ivan Dougherty Gallery, Sydney. This show crossed the already institutionalised barriers set up between so-called urban and traditional Aboriginal artists and expanded established ideas of form and genre. In 1992, with Djon Mundine, she curated 'Tywerabowarryaou, I Shall Never Become a White Man' at Sydney's Museum of Contemporary Art, plus a second version of this large group show which travelled to the Fifth Havana Biennial in 1994. Once again, she was intervening in the various classifications of contemporary Aboriginal art to produce a body of work that showed that, across urban and rural, art-school trained and traditional, young and old, female and male distinctions, there are consistent, overarching concerns in Aboriginal art today – concerns related to survival (at many different levels) and to identity (in many different ways).

Perhaps for those very reasons, Foley's constant attempt to illuminate differences within particular categories – to point out blind spots in particular forms of cultural and racial classification or to reflect museological practices back on themselves – has sometimes got her into trouble. In 1993 she mounted an installation, first at the Australian Centre for Contemporary Art in Melbourne and then at Roslyn Oxley9 Gallery in Sydney, entitled 'Lick my Black Art'. It comprised a series of separate installations, including one called *Every Girl Needs her Golliwog*. Tacked up on the wall,

almost like Martin Luther's theses, were a series of phrases. Troublesome, naughty and funny, these ironic and critical reflections on simplistic statements made to Foley by a visiting black British curator – a fact mentioned in the catalogue – traversed complex intersections of race, gender, nationalism and imperialism:

> I HAVE NEVER LIVED WITH A WOMAN
> I AM BLACK, BRITISH, CURATOR
> I DON'T GO TO OPENINGS
> I DON'T LIKE SPIKE LEE FILMS
> I'VE NEVER BEEN IN LOVE
> LOVE COMES FROM HOLLYWOOD
> I NEVER TOLD MY FATHER WHAT I DO
> WHAT ARE YOU IF YOU DON'T HAVE AN OPINION
> ALL IRISH ARE ALCOHOLICS
> ALL AUSTRALIANS WALK AROUND WITH COMPLEXES
> SOME BLACK MEN ARE INTO WHITE WOMEN
> SOME WHITE WOMEN ARE INTO BLACK COCK
> I HAVE NEVER SHAVED
> I AM THIRTY-TWO
> I OWN MY OWN HOUSE
> I DON'T DRINK ALCOHOL
> IF I HAVE A GIRL I AM GOING TO CALL HER HYACINTH[3]

One very upset member of the art world responded to the installation by writing to *Art Monthly Australia* condemning Foley for the 'racism' (however unintentional) resulting from drawing attention to these statements by a visiting black British curator.[4] The letter writer's perception was that Foley's installation had created an image of the black man as a stereotypical bastard. This reaction was interesting in highlighting the fragile boundaries we live by, and our tendency to construct art institutions as places with sterile, depoliticised and clean white walls. The argument seemed to be that since Foley was 'black' like the curator, she should make common cause with him in public, that is, on art gallery walls, ignoring her own reaction to any sexism, racism or imperialism she perceived in him – the implication being that, for 'political' reasons, Foley should suppress her reactions and engage in self-censorship. Such a view implies that art ought to maintain its role as a shopfront where complicated political issues of gender and race are tidied up before display.

'Lick my Black Art' had a particular method in its madness, which marks much of Foley's reworking of museological practice. Her technique is one of critical mimesis in which the representation of the museum space is reflected back on itself, but the context or medium is changed. Hence words from a private conversation are translated into edict-like texts in a public space. Subsequent works employed a comparable method. From the historical past, a genre of racist and sexist representation was reborn in a series of works about heritage, genealogy and pornography – with a difference. This mimetic reflection works by the postulation or, one should really say, the *creation* of difference within some particular space or practice. I want to look at one

example of this, a series of installations that led Foley to a necessary reinvention of the nude.

Fiona Foley Reinvents the Nude

Museum of Contemporary Art, Sydney, 1994. Three black-and-white photographs of a woman. You look. You look again. It is a young bare-breasted woman in three different poses. The title of the work is *Badtjala Woman*. In front of them is a sand sculpture.

Somehow the entire installation raises a series of interlinked questions. All are obvious queries. Yet at the same time, in this show, 'Localities of Desire: Contemporary Art in an International World', in this year, 1994, a shadow haunts them. Who is this woman? The installation's creator is Fiona Foley. The subject of each photograph is Fiona Foley. The photographer is Greg Weight. The photos look new so why is the subject, Foley herself, bare breasted? Doesn't the woman know that bare-breasted women of colour are somewhat risqué images in art these days? What is the connection between the photos and the sand sculpture?

In the answer to these questions lies a haunting tale about the necessary reinvention of pictorial imagery and the museum space by an Aboriginal artist, the author and subject of this work. One hundred years ago portraits of native women were a secure genre of photographic practice; they mediated the ethnographic and the pornographic and had distinct characteristics. The subject was seldom named, the breasts were always bare, sometimes the genital region as well. While such imagery was not genocidal in the same way as the outright killing of people, these forms of representation had a comparable effect of liquidating culture and genealogy. Through the erasure of name (usually by translating it into a generic term such as 'Native Woman') memory was extinguished.

What if one of these women was one's own great-great-grandmother? Would there be any way of knowing this fact, given the erasure of name, place and memory? Foley's answer is a most imaginative affirmative solution to this mystery, while at the same time addressing issues about remaking representation within museum structures.

If colonisation in Australia reduced people to living in dreadful conditions, it is often necessary to remind oneself that those same people were still able to maintain lively and active interior lives that were carried on from one generation to the next. 'Degradation' is the coloniser's word. It does not represent the interiority of a person since it is precisely that interiority that the coloniser, of course, can never know. Colonisation is a story of appearances, not of interiorities. Despite the appearances of degradation of one people by another, colonisation is also a story of survival: of gifts from the past smuggled into the present and a recognition of the kinship and reciprocation that made this possible.

> Five fathom five thy father lies;
> Of his bones are coral made;
> Those are pearls that were his eyes . . .[5]

The search for genealogy and heritage is often associated in patriarchy with a search for the lost father, as Shakespeare's lines suggest. But in Foley's installations we find a search for and discovery of kinship with the lost maternal line, a reconnection to the maternal breast. The story of how *Badtjala Woman* came to be on the walls of the Museum of Contemporary Art is a story of retrieving the thread of kinship from an apparently vanished past fabric. It is also a story of the mimetic transformation of museological practices of representation.

Photographs from the days of colonisation of Fraser Island, the home of Foley's people the Badtjala, have recurred in a number of this artist's installations since 1988 like strands of memory and continuity. In her 1988 show 'Survival', Foley combined a photographic portrait of an unnamed Aboriginal man from Fraser Island with a simple black-and-white landscape photograph of the island beach. The paired images evoked both loss and survival. In a 1991 installation, *Lost Badtjalas, Severed Hair*, which I saw at the National Gallery in Canberra, five black-and-white photographs of (once again) unnamed Aborigines from Fraser Island were framed by a free-standing wooden apparatus from which a box of Foley's own hair was suspended. This seemed like a memorial, both a lament and an homage to her dead ancestors.

In her 1992 *Givid Woman and Mrs Fraser* an ethno-portrait of a bare-breasted woman was repeated four times in xerox form, each positioned above a rat-trap inscribed with a portrait of Mrs Fraser. In this installation Foley was circling, with increased focus, the issue of the search for maternal ancestry and genealogy, literally hunting for kinship with a maternal breast with which to replace the white body of the legendary Mrs Fraser in Australian colonial history.

The story of Eliza Fraser's 52 days with Foley's Badtjala ancestors is iconic of the Australian colonising cultural process and the erasure of Aboriginal histories and genealogies. Patrick White based his novel *A Fringe of Leaves* (1976) on the story; Sidney Nolan painted the subject many times; Tim Burstall made a movie and Barbara Blackman drafted a libretto from it. As Martin Thomas states, maternal nurturing is a significant issue in some versions of the story of Mrs Fraser's sojourn on the island:

> It is claimed that Eliza gave birth immediately after the shipwreck but that the infant died as they approached the island. The mother was, of course, still lactating and the Badtjalas insisted that she wet-nurse an Aboriginal child whose mother had been lost.[6]

The irony of Thoorgine becoming Fraser Island and of one maternal ancestry replacing another is not lost on Thomas:

> The memory of a white woman unwillingly providing sustenance to a black child acquires a certain poignancy in the light of the troubled inter-racial relations that have characterised Australia's colonial history.[7]

In her brilliant re-fashionings of the concept of the nude, Foley sought to give that long-lost mother a name. As in most ethno-portraits, the name of the woman in the four xeroxes of *The Givid Woman and Mrs Fraser* has long been lost. Her namelessness

evokes a series of questions and problems about memory and genealogy, for the work of remembering and rediscovery is not simple. Where do we find our memories? How do we find a history, a maternity, which has escaped or been excluded from the archive? In a situation of colonial erasure the artist works at a double task: refinding a lost past, and recreating the artistic and museological landscape of the present.

Fiona Foley told me that when she was looking at and handling the 'Givid Woman' xerox she suddenly realised that this woman was her ancestress, not because of a common name (which of course had been lost) but because of a similarity in the shape of their breasts. Out of this recognition grew Foley's own photographic installations, *Badtjala Woman*, *Native Blood* and *Native Hybrid*, in which she names her unnamed ancestress and recognises their kinship in a very particular way. Each comprises a set of three black-and-white photographs of a bare-breasted Foley on one wall and a variety of elements on an adjacent wall. In them, Foley does not recognise or memorialise kinship by name or language but by repetition of shape and form. What Foley's ancestress bequeathed to her was her portrait, an image not only of a face but also a breast. Hidden in the degradation and objectification of the coloniser's gaze is a gift, a hidden story, a story which says: 'I am here and you have come from me.' That was the information concealed in this early ethno-pornograph, lying like detritus on the edge of the shore, yet available for re-reading.

Foley's installation is also a story of mimesis and of reclaiming the territory of mimetic reflection. In a risky venture, the artist literally mimics the pornographic genre of the 'Native Woman' portrait. Yet by imitating it with a difference she claims this territory as her own. In 1992 the Native Woman is again named. Forms of artistic practice are reflected back via 'the spectre of Truganini' (to use Bernard Smith's well-known phrase), yet aspects of conventional museological representational art and cultural practice are foiled. The artist puts herself in the picture, the artist disrobes. In this important moment in the history of representation, the artist reinvents the nude.

Foley's 1994 black-and-white photographs coupled with a sand sculpture of a female symbol seem quite romantic, but in 1995 she once again had herself photographed, this time by Sandy Edwards. If the Museum of Contemporary Art installation was poetic and beautiful, her 1995 'Perspecta' installation at the AGNSW – which once again used a series of three black-and-white, bare-breasted photos of the artist – was ironic and funny, with a touch of kitsch. In these *Native Blood* sepia photos we have Foley, the 'Native Woman', wearing outrageous red, black and yellow platform shoes (the colours of the Aboriginal flag). Instead of accompanying her images with a sand sculpture, in *Native Hybrid* an adjacent wall was decorated with kangaroo-paw flowers, emu eggs painted with 'Aboriginal' designs and miniature painted boomerangs, thus placing the nude within another long-established tradition, that of the tourist culture where sexuality – and, yes indeed, even a breast – is packaged as convenient take-away.

What her ancestress gave Foley was her breast. The issue then becomes a question of returning that gift by naming the maternal donor. How does Foley establish this kinship and history? Not by word or genealogy but by shape and form – by the shape of the breast. So it is by shape, smell, texture that we make our way through the darker corridors of history. This is a question of knowing in a state of absence, of a silence speaking its own form. It is in this way that Foley reinvents the nude, moving it from

the realm of patriarchal domination and colonisation to the zone of the maternal breast, recovering in herself, in her own body, her lost ancestress.[8]

Notes

1 Edward Said, *Orientalism* (Harmondsworth: Peregrine Books, 1985, first pub. 1978), p. 24.

2 Arthur Danto, *The Philosophical Disenfranchisement of Art* (New York: Columbia University Press, 1986), pp. 5–9.

3 Fiona Foley, *Lick my Black Art* (Melbourne: Australian Centre for Contemporary Art, 26 November–19 December 1993), exhibition catalogue, cover illustration.

4 Deborah Ely, 'The black bastard as a cultural icon', *Art Monthly Australia*, 73 (September 1994): 12–13.

5 William Shakespeare, *The Tempest*, act I, scene 2, lines 396–8.

6 Martin Thomas, 'Fiona Foley', in *Identities: Art from Australia: Contemporary Australian Art to Taiwan*, ed. Deborah Hart (Taipei: Taipei Fine Arts Museum, 1993), p. 69. For the Eliza Fraser legend from the 1830s to the present, including Foley's representations, see Kay Schaffer, *In the Wake of First Contact: The Eliza Fraser Stories* (Cambridge: Cambridge University Press, 1995), particularly the final chapter.

7 Thomas, 'Fiona Foley', p. 69.

8 For the artist's own comments on the Badtjala story, see Fiona Foley, 'A blast from the past', *The Olive Pink Society Bulletin*, 7 (1–2) (1995): 4–8.

7

Theorizing Representation

INTRODUCTION

This chapter and the next are in many ways linked. Between them they indicate the matrix of debates around the construction of representation, images of women, the body and sexuality. This also intersects with the critique of modernism, the uses of postmodernist theory and the debate around essentialism.

This chapter begins with a section exploring how images produce representations and how they function, then moves on to the debates around modernity and postmodernism, and, finally, essentialism. The relation between an image and a representation is often implicit in discussions of art, and the two words are often used interchangeably. They have, however, two related but distinct attributes and functions, and the political significance of images can often only be fully discerned through teasing the two out and considering both in relation to each other. A description of the difference can be simply provided.[1] One of the dominant genres of Western painting is the nude. Imagine one such painting: a woman lies naked in a landscape, her body arranged so the viewer can admire a line describing her breast, waist, hips and leg, and also gaze at the full length of her body. Her eyes are closed, one arm raised behind her on which her head rests. Trees and other plants surround her; the landscape is fertile, and the only signs of human habitation are in the distance. This describes the *image*. What it *represents* may be more intangible: it may evoke particular understandings of femininity, luxury, passivity and beauty. How it achieves this may be better understood as a result of questioning the image which seems at first sight unexceptional. Why is she naked in such a place? Why does she have no body hair other than on her head? Why does the shape of her shoulders, hips, and legs seem at first perfect but in fact turn out to be anatomically implausible? Why is this genre known as 'the nude', and why is the expectation of a naked woman rather than a naked man? As both John Berger and Linda Nochlin demonstrated in 1972, substituting a man for the woman in many images of women both exposes and does great violence to what that image represents.[2]

Sally Potter's text initially discusses the naming of 'art', 'artist' and 'performance art' in order to suggest a context where representation is fluid in its format, and not attached solely to images. In her raising of the issues concerning the woman performer, she gets to the heart of the relation between image or object (or woman) and its (her) representation. Suggesting that it is common for women to experience 'themselves in

everyday life as a kind of living continuous performance', she teases out the represen-
tation context in which the woman performer works and the representational choices
with which she is faced. The political potential of the situation is indicated.

Judith Williamson lucidly raises not only the relation between image and represen-
tation in Cindy Sherman's work, but parallels this with the relation between actual
women and the concept of 'woman', and between women and femininity. Sherman's
work cumulatively disproves any link between an individual woman and the concepts
of 'woman' or of femininity she represents. Through her reading of Sherman's work,
Williamson exposes these concepts, which viewers of images recognize with ease, as
representations constructed through visual clues and not qualities which are predeter-
mined. The theoretical structures which inform such readings are complex and layered.
In her catalogue essay for the exhibition *Difference*, Lisa Tickner outlines the theoret-
ical positions that produce the working definitions of terms like 'ideology', 'represen-
tation' and 'sexuality' as derived from writers such as Louis Althusser, Sigmund Freud,
Jacques Lacan and Roland Barthes, mediated into a visual art context by artists and
theorists like Victor Burgin, Stephen Heath and Laura Mulvey.

The intersection between theories of art, feminism and psychoanalytic theory has
been extremely important, with effects that echo across most of the sections in this
book. Jacqueline Rose provides an account of this relation that is historically grounded.
Much of Freud's work rests upon a relationship of the visual with the development of
sexuality and subjectivity. One example is castration theory, dependent upon the boy
seeing that the woman does not have a penis.[3] However, 'the sexuality lies less in the
content of what is seen than in the subjectivity of the viewer.' As Freud's work devel-
oped, he demonstrated increasingly that psychoanalytic 'truth' does not lie 'behind the
chain of associations' made by the patient, but *within* the chain: meaning is thus made
through interrelation, juxtaposition and deferral, and objects or events in themselves
cannot contain the whole 'truth'. Rose follows this forward along two strands: the
importance of this for postmodern theory, which denies any final referent for 'truth';
and the instability of meaning attached to seemingly fixed images. Thus the stage is set
for a politicized artistic practice which stresses the instability of meaning and the lack
of fixity in sexuality and identity.

Jo Anna Isaak's text complements Rose's in that it also provides an historical account
of the development of psychoanalytic theory. She provides particular focus on the
classification and representation of hysteria as found in the work of Freud's teacher
Jean-Martin Charcot, who was also an artist and art historian. Charcot attempted
to rationalize hysteria through visual representation, aided by his understanding of
other forms of visual rationalizing – perspective and map-making. Isaak provides
case studies showing how two artists – Nicole Jolicoeur and Mary Kelly – have utilized
psychoanalytic theory and history in their own disruption and representation of female
subjectivity.

The last text in this section draws upon, and develops, earlier feminist work by
writers such as Williamson and Rose. Jan Zita Grover raises the issue of 'positive
imaging', often dismissed in the wake of psychoanalytic and postmodern theory as
fixing idealized images of women which are equally as problematic as those produced
from a patriarchal nexus. Developing her argument from photographic practices within
lesbian communities, Grover posits that representations gain their meaning not only

from what they 'remember' but from what they 'forget' – and that what positive images 'remember' is how they wish their communities to be seen: 'The lovingly crafted portraits made by so many lesbian photographers in the 1970s and 1980s attested to the growing wish for legitimation, the longing for recognition, of individuals and couples in our communities.' The problem is one of scarcity of images: an abundance of images would produce a plurality of representations, and a lack of fixity of meaning. Her thesis is tellingly confirmed through her analysis of the exhibition 'Drawing the Line'.

The second section of this chapter plots out some of the debates concerning the relation of women to modernism, modernity and postmodernism. While modernism has been subject to much feminist criticism for its marginalizing of women,[4] what constitutes modernity and the position of women – and 'woman' – in postmodern thought is still very much in the processes of unfolding. Nicole Dubreuil-Blondin, in the section of her text reprinted here, focuses on the gender-specificity of formalist and Greenbergian, modernist discourse, and how the 'woman paradigm' ruptured it to form new discourses.

The phenomenon of 'post-feminism' has variously been seen as a product of postmodernist thought, as a result of decreasing interest in activism, or as connected to the rise of gender studies (as distinct from women's studies) in academia and publishing. Whatever the cause, the main symptom of post-feminism is widely regarded as the depoliticizing of women's lives and issues. In Toril Moi's important essay of 1988, 'Feminism, Postmodernism and Style: Recent Feminist Criticism in the United States' (which was unfortunately not available for inclusion in this collection),[5] it is stated that post-feminism 'avoids taking sides'. Writing two years later, Amelia Jones's concern is the appearance of post-feminism in art criticism: a phenomenon she reads as 'part of a larger discursive project . . . to appropriate feminism into the larger (masculine) projects of "universal" humanism or critical postmodernism'. Thus the end of feminism, signalled by the prefix 'post', is not because feminism has achieved its goals, but a negating of feminist politics 'often articulated by male critics who congratulate themselves for their attention to art by women'.[6] In this essay, Jones performs a feminist exegesis on discourses of post-feminism constructed by Arthur C. Danto, Craig Owens, Andreas Huyssen, Dan Cameron and Donald Kuspit. She demonstrates how each depoliticizes feminism by reducing it to a subsection of (masculinist discourses of) humanism or postmodernism.[7]

As the title of her essay implies, Susan Rubin Suleiman offers a lucid argument for the need for academic theory to question its premises and ethics in the light of wider political events. Following a summary of theoretical positions in relation to postmodernism, Suleiman questions her own earlier formulation of the 'plural self' as a 'happy cosmopolitan': 'the idea of a postmodernist paradise in which one can try on identities like costumes in a shopping mall . . . appears to me now as not only naïve, but intolerably thoughtless in a world where – once again – whole populations are murdered in the name of (ethnic) identity.' Arguing against a modernist universalism in favour of the contingency of human thought – and therefore of ethical thought – Suleiman explores French and central European theories of irony and doubt, jamming her accounts up against headlines from newspapers and other moments from the

Bosnian War. This presentation of 'the old, vexed question of the relation between action and theory' centres on the relation between 'intellectuals' and 'butchers' – some of whom are intellectuals themselves. The significance of this article is its refusal to separate categories and activities, and its exposition of how each complicates the others.

The final text in this section is one written by Faith Ringgold on one of her 'story quilts'. In these artworks, the images and texts interact to produce narratives which expose the marginalization of black women. This one, written as if a letter from a niece who is an artist to her aunt, concerns the position accorded black women by French modernism in the early twentieth century. When she presents her 'Colored Woman's Manifesto of Art and Politics' the assembled artists and writers (who, from a modernist framework, wish to investigate 'woman' and 'the primitive' for their own ends) hear her words, but cannot hear what she is saying to them. Amongst their advice to her about woman's domestic place is praise for her beauty, her indebtedness to particular modernist movements and her naturalness, and she is asked to model. Her negotiation between her French friends and her African heritage is difficult. Her words can be heard and understood differently through Ringgold's non-modernist practice of quilting.

The final section of this chapter concerns essentialism. Part of the feminist critique of modernist thought has been of the belief that there is an essence to each of us which is in large part determined by our biology and which determines our capabilities and our communication – our 'selfhood'. The notions that the self is unified, predetermined by sex, and that art-making is a form of unmediated expression of the self, have been used to justify women's comparative lack of 'success' in the field of art. As Whitney Chadwick states, 'visual representations construct certain images of women and ideas of femininity, which are then "naturalized" through ideology.' The feminist counter is that the self is a construct in process, the result of history; that social constraints produce sex-specific roles, and that all forms of expression are socially legitimated and understood in specific circumstances. Abstract expressionist painting, for example, far from being universally understood as valid self-expression, is incomprehensible in many cultures and social classes.

There is a paradox here though, as suggested in the texts by Chadwick and by Diana Fuss. If patriarchy – and modernism – marginalizes women, *as women*, then one of the starting-points for countering this has to be *as women*, while at the same time working to undo that particular category. This is a complex position to adopt, both intellectually and emotionally. One of the main debates in feminist theory has concerned how this can be achieved, how feminism can identify the category 'woman', work to undo it, maintain difference from men, and inhabit a female body all at once, without re-validating notions that women will behave a certain way, make particular art, because it is biologically inevitable. Vigilance over historical and social specificity is tiring, confusing, but (most feminists would agree) necessary.

Whitney Chadwick's text maps how this debate played out among US artists and critics in the 1970s and 1980s. The following reading comprises two sections from Diana Fuss's important book, *Essentially Speaking*. She explores at greater length what is at stake in assuming a clear-cut divide between an essentialist position and a constructivist position, and complicates the debate. Looking at its philosophical history, Fuss argues that essence is a slippery and elusive concept. Essentialism and constructivism are

interdependent, she proposes: essence itself can be seen as constructed; and the constructivists, in their efforts to identify different factors, in fact build webs of essences. The final text in this section, my own 'Reframing Women', is a reflection upon strategies of 'strategic essentialism' (Gayatri Chakravorty Spivak's phrase) which can be found in recent work by some women. These thoughts were provoked in response to an exhibition of Sheela-na-gig figures (romanesque carvings of female figures displaying their genitals, mainly found in Ireland), and much of the work considered uses the image or symbol of female genitals. My conclusion is that, while not all of the work considered attacks patriarchal constructions of womanliness, none the less strategic essentialism can be demonstrated to be a risk worth taking.

Notes

1 For fuller introductions, see texts by Catherine King, Margaret Marshment and Griselda Pollock in the Essential Reading list for this chapter.
2 John Berger, *Ways of Seeing* (London: Penguin, 1972), pp. 45–64; Linda Nochlin, 'Eroticism and female imagery in nineteenth century art' (1972), in *Women, Art, and Power and Other Essays* (London: Thames and Hudson, 1991), pp. 136–44.
3 For an exposure of this as a specifically patriarchal way of seeing – the boy (and Freud) cannot see that the woman has something else – see Luce Irigaray, 'This sex which is not one', in *This Sex which is Not One*, trans. Catherine Porter (Ithaca, NY: Cornell University Press), pp. 23–33.
4 See Lisa Tickner, 'Modernist art history: the challenge of feminism' in chapter 3 of this volume. Other books and essays on this are numerous. They include (beyond those in the Essential Reading list for this chapter): Katy Deepwell (ed.), *Women Artists and Modernism* (Manchester: Manchester University Press, 1998); Nicole Dubreuil-Blondin, 'Feminism and modernism: paradoxes', in *Modernism and Modernity: The Vancouver Conference Papers*, ed. Benjamin Buchloh, Serge Guilbaut and David Solkin (Halifax: The Press of the Nova Scotia School of Art and Design, 1983), pp. 195–211; Carol Duncan, 'The esthetics of power in modern erotic art', *Heresies*, 1 (1977): 46–50; reprinted in Arlene Raven, Cassandra Langer and Joanna Frueh (eds), *Feminist Art Criticism: An Anthology* (London: UMI Research Press; New York: Icon Editions, 1998), pp. 59–70; Alice Jardine, *Gynesis: Configurations of Woman and Modernity* (Ithaca, NY: Cornell University Press, 1985); Marsha Meskimmon, *We Weren't Modern Enough: Women Artists and the Limits of German Modernism* (Berkeley, CA: University of California Press, 1999); Michele Wallace, 'Modernism, postmodernism, and the problem of the visual in Afro-American culture', in *Out There*, ed. Russell Fergusson et al. (New York: New Museum of Contemporary Art; Cambridge, MA: MIT Press, 1990); reprinted in *Aesthetics in Feminist Perspective*, ed. Hilde Hein and Carolyn Korsmeyer (Bloomington, IN: Indiana University Press, 1993), pp. 205–17; Gabriele Griffin (ed.), *Difference in View: Women and Modernism* (London: Taylor and Francis, 1994).
5 Toril Moi, 'Feminism, postmodernism and style: recent feminist criticism in the United States', *Cultural Critique*, 1 (1988): 3–22.
6 This reminds me of stickers I have seen in the homes and offices of American academic friends: 'I'll be a post-feminist when we've achieved feminism' and 'We'll have post-feminism when we have post-patriarchy.'
7 This essay has been expanded as 'Feminism, incorporated: reading "postfeminism" in an anti-feminist age', *Afterimage*, 20 (5) (December, 1992); and 'Feminist pleasures and embodied theories of art', in *New Feminist Criticism: Art, Identity, Action*, ed. Cassandra Langer, Joanna Frueh and Arlene Raven (New York: Harper Collins, 1994).

Essential reading

Berger, John, *Ways of Seeing* (London: Penguin, 1972), pp. 45–64.

Cowie, Elizabeth, 'Woman as sign', *m/f*, 1 (1978): 49–63.

Heath, Stephen, *Representation and Sexual Difference* (Oxford: Blackwell, 1989).

Jones, Amelia, *Body Art: Performing the Subject* (Minneapolis, MN: University of Minnesota Press, 1998).

Kelly, Mary, 'Reviewing modernist criticism', *Screen*, 22 (3) (1981): 41–62; reprinted in *Imaging Desire* (Cambridge, MA: MIT Press, 1996), pp. 80–106.

King, Catherine, 'The politics of representation: a democracy of the gaze', in *Imagining Women: Cultural Representations and Gender*, ed. Francis Bonner et al. (Cambridge: Polity Press, 1992), pp. 131–9.

Marshment, Margaret, 'The picture is political: representation of women in contemporary popular culture', in *Introducing Women's Studies*, ed. D. Richardson and V. Robinson (London: Macmillan, 1993), pp. 123–50.

Moi, Toril, *Sexual/Textual Politics: Feminist Literary Theory* (London, Methuen, 1985).

Mulvey, Laura, 'Visual pleasure and narrative cinema', *Screen* 16 (3) (1975): 6–18; reprinted in *Visual and Other Pleasures* (Basingstoke: Macmillan, 1989), pp. 14–28.

Nicholson, Linda, *Feminism/Postmodernism* (London, Routledge, 1990).

Owens, Craig, 'The discourse of others: feminists and postmodernism', in *The Anti-Aesthetic*, ed. Hal Foster (Seattle: Bay Press, 1983), pp. 57–82; also published as *Postmodern Culture* (London: Pluto Press, 1985).

Pollock, Griselda, 'Modernity and the spaces of femininity', in *Vision and Difference: Femininity, Feminism and the Histories of Art* (London: Routledge, 1988).

Pollock, Griselda, 'What's wrong with images of women?', *Screen Education*, 24 (1977): pp. 25–33; reprinted in *Framing Feminism: Art and the Women's Movement 1970–1985*, ed. Rozsika Parker and Griselda Pollock (London: Pandora Press, 1987), pp. 132–8.

Riviere, Joan, 'Womanliness as a masquerade', in *Formations of Fantasy*, ed. Victor Burgin et al. (London: Methuen, 1986), pp. 35–44.

Ussher, Jane M., 'The masculine gaze: framing "woman" in art and film', in *Fantasies of Femininity: Reframing the Boundaries of Sex* (London: Penguin, 1997), pp. 104–77.

7.1 Between Image and Representation

Sally Potter, 'On Shows' (1980)

From *About Time: Video, Performance and Installation by 21 Women Artists,* ed. Catherine Elwes, Rose Garrard and Sandy Nairne (London: ICA, 1980), unpaginated.

My intention is to raise questions that need to be asked by and about women working in performance. What follows of course arises out of my experiences working variously as a dancer, choreographer, musician and filmmaker. At times I have also worked, somewhat reluctantly, under the label 'performance artist'. Why this reluctance on my part? Why the anxiety experienced by so many working in these fields about what they 'really' do, and what terms describe their work best? I have found it helpful to examine the history behind the terms and so that is where I am choosing to begin.

Naming Yourself

In the nineteenth century during the consolidation of class difference to serve the new industrial capitalism, the word artist became distinct from both artisan (craftworker) and artiste (performer) – the difference implying not only one of form but also one of class position. Artisan implied a skilled manual worker without intellectual, imaginative or creative purposes (qualities that the bourgeoisie were busy naming as their own) and artiste implied entertainer; for women this usually meant a connection with prostitution, for the display of the female body in performance was considered a form of sale. The word artist was reserved for painters, sculptors and eventually also for writers and composers – part of a culture defined, funded by and mostly serving the middle and ruling classes. So to name yourself artist embodies a history of class meanings. How do people choosing this kind of work tackle this history and what does it mean to them?

For some, the work becomes criticising art itself and the prescribed role of the artist: a continuous form of self-referential protest (followed by criticism of how the protest

is transformed into saleable artifact). For others the priority is to destroy the definition as it is understood; to show that the manual worker also thinks, that the housewife creates, that art practice is a life practice and not the property of an elite. But for some people, using the name artist implies seizing the right to something which has been systematically denied them: the right to work with ideas on a large scale within a form of production over which they have complete control.

And what does it mean to call yourself a performance artist? At its most simple level it means to be an artist who performs. How is this different from other kinds of performance and entertainment? Does it imply that it has somehow been 'elevated' to the status of an art form? For the Dadaists, Futurists and Surrealists to perform was in itself to dissolve and revolutionise the function of art – to disinvest it of the deadening aura of 'high culture'. The actions and events often borrowed from other forms of performance (e.g. cabaret) and from the polemics of political practice (manifestos etc.) but the contempt for bourgeois values was often more redolent of the aristocratic prankster exercising a privileged form of protest than of the struggles of the revolutionary; and, most importantly, their work was always designed to be seen in the context of the history of art.

What reasons lie behind contemporary performance artists' choice of self-definition and anxiety to distinguish and separate their work from anything to do with theatricality? Any implication that the entertainer deals with less important issues and in compromised ways would seem to arise from the class stereotyping founded in the artist/artiste split described above. But not all performance artists think along these lines. The emphasis placed on difference arises out of a criticism of the functions of pleasure in the theatre (plays, opera, dance, music etc.). Performance art becomes a framework for this criticism through a combination of formal and structural strategies.

Performing versus Acting

Some performance artists might describe their work as a kind of anti-skill, to differentiate their way of performing from the acting skills of characterisation. Performance is seen as 'doing' – an activity which is being watched rather than a part being played. Characterisation is seen as a technique founded on a literary tradition heavily reliant on the written and spoken word and intimately connected with the aesthetics of illusionism which transport the spectator by a series of identificatory processes to another place and time. Theatre is caricatured as a place of catharsis where you vicariously emote and rarely think. You may 'lose yourself' in the displays of virtuosity of another, or via the structuring mode of the story, of realism, of narrative continuity.

Some see this process of engagement as itself the site of reactionary formation. Theatrical timing, developed to its ultimate finesse by comedians with a split-second appropriateness of word and gesture that delicately juggles the desires of an audience and orchestrates their response (often on the borderlines of repression and expectation) is rejected in favour of 'real time'. The time it takes to execute a certain task, read a certain text, and so on. The audience may be free to come and go during a piece; its duration is not necessarily determined by the conventions of the 'show'.

The performance artist is often concerned to alert the audience to the shifting constructions of the performance, to be both inside and outside it, commenting on it. Similar reasons motivate the painter who moves out of the rectangle onto the wall, drawing attention to the act of framing; the filmmaker who works with the surface and plastic qualities of film and draws attention to the structuring device of the splice. The theoretical context is that of post-linguistic structuralism in which emphasis is thrown on how meanings are formed (the 'language' of the medium) rather than on what is being said. The intention is to destroy the 'innocence' of representation, to expose its mechanics. However this strategy can be counterproductive when the enemy is wrongly named as the story, identification and pleasure. Many comedians and others working in theatre tread an extraordinary line that engages an audience on many levels at once; not in a soporific way that prevents thinking but in a way that allows precisely the opposite to happen. The audience can laugh or cry *and* think. The function of the joke (when it's not at the expense of an oppressed group) can be to open out and stir up those places in people where thinking has stopped. 'I cracked up' describes the experience of a good laugh.

In any case live action, be it in a theatre, gallery or wherever, inevitably also produces its own kind of distanciation. It can never achieve the perfection that explains the power of cinema for there is never a perfect blackout (indeed some shows happen in broad daylight) and there is never a truly empty space. The performer is at the mercy of possible mechanical failure if using lights or tapes and is constantly exposed to the hazards of accidental sound. This erosion of the perfect statement and of precise artistic control is often used as the basis for questioning both the myth of the absolute correlation between intention and realisation and as an acknowledgement of present time.

The Female Performer

For women the implied difference with theatricality has also more complex meanings because of women's relationship to entertainment, stereotype and spectacle. Once outside of the fine art context women have joined the tradition of the female performer: women as actresses, singers, dancers, strippers, music hall artistes. One could argue that even within a gallery or other self-defined art venue this history is implied. Woman as entertainer is a history of varying manifestations of female oppression, disguised, romanticised (but savingly, contradictory, of which more later). The glittering phantom ballerina wilting in her lover's arms; the burlesque queen playing with and overtly conceding to her male audience's fantasies; the singer crooning about unhappy love and her victim relationship to her lover. These are the conditions under which the female performer has been visible; positioned always in relation to the male construction of femininity and in relation to male desire. Women performance artists, who use their own bodies as the instrument of their work, constantly hover on the knife edge of the possibility of joining this spectacle of woman. The female body, nude or clothed, is arguably so overdetermined that it cannot be used without being, by implication, abused. But of course it is unthinkable that the only constructive strategy for women performers would be their absence. So steps are taken to build a new presence. How is this done?

It becomes necessary to examine what the presence of the female body means, what it means to be looked at. As a female performer you embody both the representation of a woman and you are a woman. The distinction is important, even if it seems academic, for it can illuminate why most women experience themselves in everyday life as a kind of living continuous performance, distanced by the constraints of femininity from themselves (let alone choosing to perform in the accepted sense of the word). It is like a split, being both inside your body, unable to transcend gender identity, fixed as the 'other' to man's central position in patriarchy, and yet also outside of your body in the very act of thinking, of using language. (The terms used to explain this phenomenon in psychoanalysis are very dense and need lengthy definition. In the context of this piece of writing that would be inappropriate so a form of extreme precis will have to suffice; that woman as performer represents for men a fetishistic replacement of the phallus as a way of dealing with the women's symbolic 'lack' and the implied threat of male castration.)

How can the female performer begin to dismantle this construction?

Strategies

For some it means using a feminist conception of subjectivity as the basis for the work as part of an overall strategy to reclaim on new terms what has been negatively caricatured as the realm of the feminine. An obsession with personal experience and relationships, an unwillingness to generalise, prioritising emotional over intellectual life: look differently at these characteristics and you find that what has been designated trivia has in fact profound political significance.

The women's movement has demonstrated that ideology is not merely reflected but produced in the context of the family and in personal relationships – that political structures are not just 'out there' but are manifest in the most seemingly insignificant actions, words and conditions. We have also shown how a society with power relations based on sexual, racial and class differences fixes these differences in early childhood in such a way that they are experienced as being almost outside of rational explanation – so that they seem 'natural'. Any form of objectivity based unthinkingly on the position of the white middle class male is therefore bound to be partisan and irrational, acting as a form of disguise of its author's real and subjectively experienced sex, race and class interests. In an art practice dominated by men this has led to an emphasis on formalism, 'purity', art for art's sake, the de-signified image. The raising of female subjectivity to the status of objective significance is then for some women artists a priority. So how is this subjectivity approached and worked with?

For some it means building an imagery based on the female body – on menstruation, reproduction and female sexuality; on tackling what has been endlessly portrayed as female mystery from the other side – the inside. This might be on the level of documentation of the unmentionable or its traces, or on the level of myth, taboo and a cult of the mother in opposition to the patriarchy. For others it might mean reversing the gaze, breaking the silence of centuries and getting the female nude and muse to speak.

For some women a useful step is to look at female stereotypes and how they function; in some cases to turn them against themselves. For others the key is to find and use modes that contradict the stereotypes – ways out of the representation of women as passive and incompetent. Here the contradictory aspect of the female performance tradition can be used to good effect, for women have found positive and ingenious ways in which to sidestep or criticise their impossibly prescribed roles. The ballerina's physical strength and energy which is communicated despite the scenario; the burlesque queen whose apposite and witty interjections transform the meaning of what she is doing and reveal it for the 'act' it is; the singer who communicates through the very timbre of her voice a life of struggle that transforms the banality of her lyrics into an expression of contradiction. All these can work against the pessimism of female 'absence', and also suggest a new way of looking at skill and its subversive potential.

Skill

'Femininity' demands the appearance of lack of skill and emphasises nurturance and appreciation of the skills of men. Women have therefore often been denied access to the skills they want and have also had their own skills undervalued or denigrated. In reaction to this some have seen virtuosity as the extreme example of skill that 'oppresses' by virtue of its display of superior difference. The performer becomes a symbol of privilege, of work that is valued while other kinds of labour are denigrated. Both the specialness ascribed to individual performers and the performer/audience divide itself are seen as unhealthy symptoms of a class divided society, the performer taking an honorary or symbolic position of power. The strategy then becomes to break down the divide and emphasise audience participation as a way of saying 'anyone can do it'. However, enforced participation can become a rather self-conscious and counterproductive event if it is not handled, paradoxically, with some skill.

It is this sort of realisation that leads many of us to differentiate skill defined as appropriateness of ability to meet a need, from the solidification of skill into a rigid system of technical excellence with its own insulated and self-fulfilling ways of measuring and rewarding success. This 'success' for women often means gaining the precarious position of token achiever in a male dominated profession. This position is circumscribed in such a way that as more women achieve in a given area they are forced to compete with each other for the same space rather than the space itself expanding. In the women's movement there has been an emphasis on skill sharing, on teaching other as a way of breaking down the mystiques of professionalism and working towards the realisation of each person's 'genius'.

Working Process

What of the mystiques attached to the 'creative' working process? How, in practical terms, does a performance artist set about working? This can be quite idiosyncratic, but

usually reflects the starting points learnt in some form of training or practice. The sculptor turned performance artist might start with making or finding an object and working outwards from there; in some sense activating it in time, or giving it a space, a room or set, which suggests a scenario. The painter turned performance artist might take an existing painting or a painterly principle (such as Renaissance space), and use its formal and ideological components as the basis for a 'script'. Others might use their own dreams as the starting point for assembling images, or some other kind of writing such as notebooks, diaries etc. A dancer might use a sequence of movements, a tableau or a memory of the hidden aspects of the dancer's training as a basis. Apart from improvisation, which is a discipline in itself, even very minimal performances usually have some kind of script. Sometimes the physical form of the script – the sheet of instructions, the diagram, the trace that the performance will leave, is considered more important than the performance and the event is designed as a forethought to the act of documentation. For others the performance is itself the antithesis of documentation. It is intended to strip itself of every vestige of artifact, to be purely temporal, to be the activation of an idea that then destroys itself. This is considered part of the struggle against capitalist recuperation.

Working processes of course become more systematised when people work together with the desire that each person's ideas will transform the others. Some performance artists work together side by side but continue to identify what they do individually as their own work. The fact of performing in the same space or in a series together may imply a connection, or suggest an argument. For others, such as myself, collaboration became part of a politics that questioned notions of individual ownership of ideas and of the pursuit of originality. Working with others made it possible to discuss the implications of the work, of its politics and realisation at all stages; it forced one to be conscious of what one was doing. It was also a way of combining areas of relative expertise and the lessons brought from them; and on a practical level was a way of sharing tasks. One could try out ideas physically on each other, having the opportunity to step outside the piece and look at it. Exercises would be borrowed from various sources, theatrical and otherwise, designed to focus on performance itself. To find not a right way or a wrong way of doing something, but a conscious way. It provided a way to strip vestiges of self-consciousness, to experiment with different kinds of voice, movement etc. and above all to discard, to work through the first stages of an idea towards its full realisation and, hopefully, towards a new imagery.

Imagery

Images cannot be spoken of as if they float free of formal embodiment. A painted image obviously works quite differently from a photographic one. How do you begin to define what an image is in performance? A starting point would be to consider it as a compositional unit. In this way a movement or sequence of movements can be seen as an image, as can a tableau or a combination of layers such as light, action and object; the unit functions as an entity of visual meaning. However, this meaning cannot be seen as absolute or fixed. The varying approaches to the production of images determine at least in part how they can be understood.

Some would define the image maker's task as one of selection from a store of images received in that person's lifetime via artifacts, the media and in everyday life. The problem is seen as one of appropriateness and accuracy in the illustration of an idea – to make something 'in the image of' – a pursuit of 'truth' through likeness. The image in and of itself is seen as relatively unproblematic, having a kind of transparency and essential neutrality that will be transformed into meaning by the purpose of its user. But for the feminist performer, the impossibility of neutrality arises at every turn. How, for example, do you choose what to wear in a performance? It becomes clear as you sift through the options that there is no neutral costume, that every garment for women is imbued with feminine and class specificity. That the boiler suit, so often chosen as a suitably functional basic garment by performance artists during the last decade, could be seen in much the same way as Marie Antoinette and her shepherdess scenarios – the appropriation of images of labour for the purposes of bourgeois leisure.

The experience of actually producing images also raises other questions. The sensation can be that of an ordering or letting through of a subrational area. The images seem to pop into one's head; when the 'right' one is there it appears to have arrived without conscious design. This process is conventionally defined as the use of the imagination, of intuition. Where do these images come from and how do they work? Archetypal images, myth and symbolism sometimes suggest the existence of a residual or collective unconscious, and that the image maker learns how to organise and produce from this place outside of verbal constructs in much the same way as a person can learn to produce dreams to order. The Surrealists and Dadaists considered the liberation of the imagination from sense to be a political act. The apparent randomness of the unconscious was emphasized, chance operations and arbitrariness became fetishised. The destruction of the order of the rational by giving in to 'chaos' seemed to them to be the clue to unlocking repression. But a more useful approach now seems to be to understand the order behind the apparent disorder. To unlock the power of imagery, to decode its mystery, to make the impossibly evocative also a moment of dissection and comprehension.

As a part of this project it becomes important to look at the principle of juxtaposition to see how the proximity of one image to another transforms its meaning. This is similar to the principle of montage in the cinema, but in performance, certain kinds of juxtaposition are uniquely possible. Juxtaposition through time, in space; visual and aural – the performer can simultaneously mobilise all the senses of the spectator. For a feminist, the fact of being able to work at the level of organisation of the unconscious (images and music) and in juxtaposition to rational speech offers the possibility of entering and re-entering consciousness in order to change it.

In a wider sense this dialectical principle can also focus on how performance as a whole is transformed by the environment it is shown in – by its physical characteristics, the associations it triggers, the politics it embodies and by the audience it generates. Understanding the role of the audience in *producing* the meaning of the performance, rather than just absorbing a given one, demands responsibility to them and respect for their needs (which may, within any one audience, be quite contradictory). It means finally abandoning all vestiges of alienated posturing (the 'nobody understands me now but will in posterity' syndrome) and instead finding or inventing ways of working that are effective here and now. The question is not so much one of

making difficult ideas accessible, which somehow implies diluting or transforming in a patronising way for the benefit of a supposedly less able audience, as one of appropriateness of strategy. It means discovering what specific functions this work can have as part of a wider collective strategy to transform the structures and conditions under which we live.

Judith Williamson, 'Images of "Woman": The Photography of Cindy Sherman' (1983)

From *Screen*, 24(8) (1983): 102–106; reprinted in *Consuming Passions: The Dynamics of Popular Culture* (London: Marion Boyars, 1986).

When I rummage through my wardrobe in the morning I am not merely faced with a choice of what to wear. I am faced with a choice of images: the difference between a smart suit and a pair of overalls, a leather skirt and a cotton frock, is not just one of fabric and style, but one of identity. You know perfectly well that you will be seen differently for the whole day, depending on what you put on; you will appear as a particular kind of woman with one particular identity *which excludes others*. The black leather skirt rather rules out girlish innocence, oily overalls tend to exclude sophistication, ditto smart suit and radical feminism. Often I have wished I could put them all on together, or appear simultaneously in every possible outfit, just to say, Fuck you, for thinking any one of these is *me*. But also, See, I can be all of them.

This seems to me exactly what Cindy Sherman achieves in her series of 'Film Stills' and later 'Untitled' photographs. To present all those surfaces at once is such a superb way of flashing the images of 'Woman' back where they belong, in the recognition of the beholder. Sherman's pictures force upon the viewer that elision of image and identity which women experience all the time: as if the sexy black dress made you *be* a femme fatale, whereas 'femme fatale' is, precisely, an image; it needs a viewer to function at all. It's also just one splinter of the mirror, broken off from, for example, 'nice girl' or 'mother'. Cindy Sherman stretches this phenomenon in two directions at once – which makes the tension and sharpness of her work. *Within* each image, far from deconstructing the elision of image and identity, she very smartly leads the viewer to *construct* it; but by presenting a whole lexicon of feminine identities, all of them played by 'her', she undermines your little constructions as fast as you can build them up.

'Image' has a double sense, both as the kind of woman fantasised (is your 'image' aggressive, cute, femme fatale, dumb blonde etc.), and as the actual representation, the photograph. What Sherman does is to make you see the type of 'woman', of femininity, as inseparable from the literal presentation of the image – lighting, contrast, composition, photographic style. The 'Film Stills' are the most obvious example of this. The grainy print and ominous shadows in *Untitled Film Still No. 4* are part of what makes up our idea of the woman shown leaning against the door. The low angle, crisp focus and sharp contrasts of *Untitled Film Still No. 16* are part of the woman's

sophisticated yet fragile image, just as the slightly soft focus and low contrast of *No. 40* are part of *her* more pastoral, Renoiresque femininity. The composition of the recognisably 'New Wave Art Movie' still *No. 63*, the smallness of the figure in the harshly geometric architecture, is part of the little-girl-lostness that we feel as coming from the woman. In the 'Untitled Film Stills' we are constantly forced to recognise a visual style (often you could name the director) simultaneously with a type of femininity. The two cannot be pulled apart. The image suggests that there is a particular kind of femininity in the *woman* we see, whereas in fact the femininity is in the image itself, it *is* the image – 'a surface which suggests nothing but itself, and yet in so far as it suggests there is something behind it, prevents us from considering it as a surface'.[1]

Apart from the interest of this for anyone analysing how film and photographic representations work, it is, as I have tried to suggest, particularly important for women. I find the recognition of this process, that the 'woman' is constructed in the image, very liberating; I want to say yah boo sucks to any man standing next to me looking at the photos in the exhibition. Because the viewer is forced into complicity with the way these 'women' are constructed: you recognise the styles, the 'films', the 'stars', and at that moment when you recognise the picture, your reading *is* the picture. In a way, 'it' is innocent: *you* are guilty, you supply the femininity simply through social and cultural knowledge. As one reviewer says, 'she shows us that, in a sense, we've bought the goods.'[2] The stereotypes and assumptions necessary to 'get' each picture are found in our own heads. Yet, at the risk of being attacked as 'essentialist', I really do think the complicity of viewing is different for women and men. For women, I feel it shows us that we needn't buy the goods, or at least, we needn't buy them as being our 'true selves'. But in a discussion at the first Cindy Sherman retrospective in this country, at Bristol's Watershed Gallery in May, I remember a man getting incredibly worked up about how sexist the images were, and furious at Cindy Sherman. He kept saying there were enough images of women as sexual objects, passive, doll-like, all tarted up. Although his rhetoric sounded Right On, I was certain his anger must have come from a sense of his own involvement, the way those images speak not only *to* him but *from* him – and he kept blaming Sherman herself for it, deflecting his sexism onto her, as if she really were a bit of a whore. This idea of what she 'really is' I'll return to later. But the way we are forced to supply the femininity 'behind' the photos through *recognition* is part of their power in showing how an ideology works – not by undoing it, but by *doing* it. The moment we recognise a 'character', it is as if she must already exist.

For what we construct from the surface of each picture is an interior, a mixture of emotions. Each setting, pose and facial expression seems literally to express an almost immeasurable interior which is at once mysteriously deep, and totally impenetrable: a feminine identity. Obviously this is what acting is about, but these still images are like frozen moments of performance and so the sense of personality seems more trapped in the image itself. It is both so flat, and so full (it seems) of feeling. But what links the emotions portrayed in the pictures is that they are all emotional *responses*. The woman's expression is like an imprint of a situation, there is some action and her face registers a *reaction*. Certain photos make this very explicit: *Untitled No. 96*, where a girl holds a scrap of newspaper in her hand, shows precisely the way that we read into her fundamentally 'unreadable' face some emotional response which is both very definite, and

entirely ambiguous. She looks thoughtful, but whether she is happy or unhappy, worried or perfectly all right, we have no clue. She looks, exactly, uncertain. Yet between the newspaper cutting and her face there is an endless production of significance which seems inevitable (it's always already started) and almost clear in its vagueness. Another photo from the same group, *Untitled No. 90*, shows a teenager lying, equally ambiguous in her expression, by a telephone. Is she happily dreaming, or anxiously awaiting a call? (It's just like the ads for home pregnancy testing kits which manage to get the model looking both as if she's hopefully waiting for the good news of having a baby, *and* as if she can't wait to be put out of her fear that she might be pregnant.) Either way, her expression is an index of something or someone else, something we don't know about but which everything in the frame points to. (In semiotic terms it literally is an index, as a footprint is to a foot – a relevant metaphor since so many Sherman women look as if they were trodden on by men, fate, or a B-movie plot.) With the cutting, the telephone, or the letter in *Untitled Film Still No. 5* (where there seems to be a response to two things – the letter, and someone else off screen left) something is put in the image as a snippet to represent the unknown narrative; but these images simply make explicit what happens in all of them, which is that meaning is thrown endlessly back and forth between a 'woman' and a story. The cutting gives expression to the face, the face gives a story to the cutting.

This is exactly what happens in films, news-photos, adverts and media generally. An image of a woman's face in tears will be used by a paper or magazine to show by *impression* the tragedy of a war, or the intensity of, say, a wedding. From the face we are supposed to read the emotion of the event. But conversely, it is the event that gives the emotion to the face; we have to know whether it is a war or a wedding to interpret correctly its well of meaning. Similarly in films the use of close-ups – woman screaming, woman weeping, woman watching, woman terrified, woman impressed(!) – function as an imprint of the action, like a thermometer constantly held to the narrative. And no matter what the nature or content of the imprint, it is this imprintedness itself which seems to constitute femininity.

In Sherman's 'Film Stills' the very reference to film invites this interpretation. Film stills are by definition a moment in a narrative. In every still, the woman suggests something other than herself, she is never complete: a narrative has to be invoked. Who, or what, is the dark-haired woman in *No. 16* responding to? What is troubling the Hitchcockian heroine in *No. 21*? What is that young girl in *No. 40* looking sideways at? But in the later works simply called 'Untitled', the questions are perhaps more interesting and subtle, precisely because they aren't presented as 'film stills'. *Something* is worrying, not to say frightening, the women in photos like *Untitled No. 80* – at least 90 minutes worth of something. In this group, back-projection is used to create the setting, the backdrop scenario which interacts with the woman's face to produce the story, and the visual effect stays quite close to film. The next series, from which *Untitled No. 90* and *No. 96* were selected, comes closer in to the woman's body than many of the earlier works, but still adds a prop, a clue to the story. However, the most recent work uses no props and a less 'filmy' style, so we seem to be nearer an actual woman, presented more 'neutrally'. These photos are closer to adverts than films; they still rely on clothes, lighting and a facial expression which is evocative of something outside the frame. Here we don't get *any* of the story, only the response.

But the point is, the story *is her*. As we piece together, or guess, or assume, some meaning in the narrative, we find that the meaning is the woman. She appears to express the meaning of events. How like every narrative and photographic medium this is, and also how like actual life, the 'they've got it, she wears it' of personal relations. In tapping the relation between women and meaningfulness Sherman's work resonates through many other areas. Certainly it also illuminates the process of reading all still images, especially adverts, in the way objects, details, arrangements and settings construct a story and an identity simultaneously. Women are not always necessarily a part of this visual and ideological process. But in Sherman's work, what comes out of the imagined narratives is, specifically, femininity. It is not just a range of feminine expressions that are shown but the *process* of the 'feminine' as an effect, something acted upon.

However this femininity is not all form and no content. The emotions that bounce between the narrative and the woman in each picture, though unclear, are nearly all suggestive of fear, suspicion, vulnerability, anxiety, or at best, uncertainty. And Sherman brilliantly shows how this vulnerability is linked with eroticism, not always through explicitly 'sexual' poses – as in *Untitled No. 103* and some of the earlier 'Film Stills' [. . .] – but through performing femininity at their intersection. In the earlier work, particularly, there always seems to be a sense of menace, the woman is under threat. And her vulnerability is always erotic, rather in the way that many horror movies which involve no explicit sex at all give an erotic spin-off just through having a terrified woman constantly in vulnerable positions. So strongly is femininity evoked in these situations that they have to be *sexual* – is there any definition of femininity that isn't? That's why, in so many of Sherman's images, simply the distress or passivity of the women figures feels faintly pornographic – I say that to be descriptive rather than pejorative. I feel Sherman simply brings to the surface very clearly that same whiff of the pornographic that I personally feel about so many of Hitchcock's heroines, frightened, blonde and vulnerable, or Godard's use of Anna Karina and other women stars as fathomless icons of femininity, passive repositories of desire. Sherman's women with their parted lips and their stories in their eyes (very Bob Dylan) are something to get off on in their very uncertainty. And in linking the erotic and the vulnerable she has hit a raw nerve of 'femininity'. I don't by this mean women (though we do experience it) but the *image* of women, an imaginary, fragmentary identity found not only in photos and films but the social fabric of our thoughts and feelings.

It is so important to stress the difference not because 'femininity' is just a bad, false, two-dimensional construct that is forced upon us (even if it feels that way) but precisely because, ultimately, it isn't any one thing at all. It can only exist in opposition to something else, like one half of a see-saw. In Sherman's pictures, the way the woman is *affected by* something makes her like an *effect*, her face stamped by events, and I have tried to argue that this produces the feminine sexual identity which comes across. But what is crucial to the reading of Sherman's work is also the opposition between the images. 'Essentially feminine' as they all are, they are all different. This not only rules out the idea that any one of them *is* the 'essentially feminine', but also shows, since each *seems* to be it, that there can be no such thing. Yet so tenacious is the wish for this set of psychic garments to turn out to be actual skin, that almost every time Sherman's

work is written about the issue of Cindy Sherman 'herself' comes into it. She has often been thought of as *indulging* in self-images, wishing secretly to be like Marilyn Monroe, posing as a sexy heroine. From the notion that her work springs from a desire to be more glamorous follows the idea that she is not 'really' as attractive as her heroines, the glamour is not allowed to be hers.

The best example of such an approach is Waldemar Januszczak reviewing her retrospective at Bristol in the *Guardian*: 'You see her as she sees herself, a small, scrawny girl from Buffalo, a mousey blond who dreams of becoming a peroxide starlet. Her wigs don't always fit and her bra has to be padded.' What a combination of put-down and turn-on! 'Behind the Marilyn Monroe character you finally find Cindy Sherman.' How? Does he know her? 'She is at her best looking intense, staring into the distance as intently as if it were her own past – which of course it is . . .' and finally, 'Several times she appears to be recoiling from the harsh stare of her own camera, like a scared animal trapped in a car's headlights. This too, you sense, is the real Cindy Sherman.'[3] This all reads like a patently sexual fantasy, as if she were at somebody's mercy (his). If Sherman were a man he would not even continue using her first name as well as surname beyond the first paragraph; and this detail of language might make him have to treat her as an artist, in control of her work. As it was, even the image selected to illustrate the article was one of the most sexually provocative. I have quoted this review in detail first to show that it is a possible response to the work (basically for men) but secondly because I think that this false search for the 'real' her is exactly what the work is about, and it leads people like Waldemar Januszczak right up the garden path. The attempt to find the 'real' Cindy Sherman is unfulfillable, just as it is for anyone, but what's so interesting is the obsessive *drive* to find that identity.

This comes out particularly in comments on the later photos. Almost every critic has felt the recent work is in some way moving closer to Sherman 'herself'. The catalogue introduction calls it 'free of references to archetypes' and says that 'dressed in today's clothes . . . the(se) portraits seem more refined, natural and closer to Cindy Sherman herself.'[4] But in the more recent photos there seem to me to be sets of contrasts that function in the same way as the earlier 'Film Stills', only even more pointedly. For some reason most critics have seen *Untitled No. 103* but somehow gone blind to *Untitled No. 104*, which immediately follows it and would stand beside it in a gallery. There, right next to the sexy Monroe-type image is a different one – not necessarily unsexy or unsexual but very boyish, much more alert, wearing an old teeshirt – and, most important, they are both her. The fact that it *is* Cindy Sherman performing each time is precisely what undermines the idea that any one image is 'her'. It reminds me of the Cachet ad.: 'It won't be the same on any two women . . . the perfume as individual as *you* are.' This promise is followed by a bunch of images of different 'femininities', each of which is meant to be a different *woman* (using Cachet); whereas what Sherman shows is that anyone can 'be' all of them, and none.

In the recent photos the issue seems to be pushed still farther, beyond different femininities and across the border of femininity/masculinity. This is particularly powerful because the later images do appear more 'realistic', though of course they are nothing of the sort. *Untitled No. 116* and *No. 112* both seem very straightforward, 'natural' poses compared with the earlier set-ups. Both are 'dressed in today's clothes', yet it is the subtlety in the difference between the clothes that makes one image very feminine,

the other masculine. In *No. 116* the lighting, pose, expression, gaze, hair, skin, all spell femininity, subtly, but as clearly as in *Film Still No. 40*. But *No. 112* is sharper: the pointed collar, the shorts, the 'harder' gaze, less unfixed than the other, all produce a 'masculine' reading. The way the later images move towards, not simply sexual ambiguity (as if that were an identity) but a juxtaposing of 'feminine' and 'masculine' identities, seems to demolish once and for all the idea that either of these is something that can be fully inhabited (and also the wet-dream of Sherman as frightened animal or girl in padded bra).

For the identities elusively suggested, and so obsessively sought, are trapped, not in a car's headlights (for goodness sake) but, literally, in the light of the photographic print: the lighting which makes the image possible on that surface which is ultimately nothing more than a flattened reaction to light. In *Untitled No. 110* no face is even visible in the darkness, all that the lighting lets us see is an arm, a sleeve, some soft fabric, glowing as golden as an advert. There is only just enough photographic information for us to recognise what the image is of at all, and here again we are forced to realise how these effects on their own (as in so many ads) conjure up a feminine presence. The viewer is pushed as far as possible, to search in shadows for what isn't there on the page, but which the few shapes of light suggest *is* there. Femininity is trapped in the image – but the viewer is snared too. A similar and very witty rebuffing of our 'reading in' is found in *Untitled Film Still No. 46*, where all that's visible of the woman is a diving mask looking up from the sea. We can't even see the face, and barely the eyes, yet the joke is, it *still* seems full of meaning.

In images like this one, in the whole range of work, in the juxtapositions made, there seems to me an enormous amount of wit. The conflation of Cindy Sherman as the imagined character in her performance, and Sherman as the artist, always ends up with some idea of 'her' as her heroines, frightened, vulnerable, threatened and uncertain. But clearly as an artist Sherman is sharp, controlled, intelligent, witty. Couldn't these qualities of the work itself, rather than being swamped by that femininity she exposes, reflect back on it as a biting comment? Obviously the dialectic between Sherman as performer and photographer is important, after all, she *does* choose to present *herself* (in disguise) in her pictures. The identities she acts out may be passive and fearful. But look what she *does* with them, what she *makes*: she is in control. In its very last line, the catalogue blurb turns on some of Sherman's critics: 'the women she represents, they say, are too artificial to be experienced as real people' and ends by asking poignantly, 'Is vulnerability as unreal as all that?'[5] Well no, obviously not. But both the critics referred to, and the writer of the commentary, are opposing 'artificial' and 'real' in a way that has no meaning where femininity is concerned, which is why I started this piece with the wardrobe syndrome. Femininity is multiple, fractured, and yet each of its infinite surfaces gives the illusion of depth and wholeness. Realising this means that we as women don't have to get trapped trying to 'be' the depth behind a *surface*, and men just might bang their heads up against it and stop believing in that reflected space. Sherman's work is more than either a witty parody of media images of women, or a series of self-portraits in a search for identity. The two are completely mixed up, as are the imagery and experience of femininity for all of us. Others might try to break open that web of mirrors, but Sherman's way of revealing it is just to keep on skilfully turning the kaleidoscope where a few fragments of fantasy go a long way.

Notes

1 Jean-Louis Baudry, 'The mask', *Afterimage* (UK), 5 (Spring 1974): 27.
2 Michael Starenko, 'What's an artist to do?', *Afterimage* (US) (January 1983).
3 Waldemar Januszczak, 'Here's looking at you, kid', *Guardian* (19 May 1983).
4 Els Barents, 'Introduction', in *Cindy Sherman* (Munich: Schirmer/Mosel, 1982), p. 10.
5 Ibid., p. 14.

Lisa Tickner, 'Sexuality and/in Representation: Five British Artists' (1985)

From *Difference*, ed. Kate Linker (London: ICA, 1985), pp. 19–30.

This exhibition draws together work from both sides of the Atlantic, with shared concerns but different aesthetic, theoretical, and political trajectories. It includes work by women and men on sexual difference that is devoted neither to 'image-scavenging' alone (as the theft and deployment of representational codes), nor to 'sexuality' (as a pre-given entity), but to the theoretical questions of their interrelation: sexuality and/in representation.

These questions have been rehearsed by American critics, largely under the diverse influences of Walter Benjamin, Jean Baudrillard, Guy Debord, and the Frankfurt School. A comparable body of writing in England has drawn more pointedly on the work of Bertolt Brecht, Louis Althusser, Roland Barthes, and tendencies in European Marxism, poststructuralism, feminism, and psychoanalysis.

The crucial European component in the debate has been the theorization of the gendered subject in ideology – a development made possible, first, by Althusser's reworking of base/superstructure definitions of ideology in favor of the ideological as a complex of practices and representations and, second, by the decisive influence of psychoanalysis (chiefly Lacan's rereading of Freud).

It was psychoanalysis that permitted an understanding of the psycho-social construction of sexual difference in the conscious/unconscious subject. The result was a shift in emphasis from equal rights struggles in the sexual division of labor and a cultural feminism founded on the revaluation of an existing biological or social femininity to a recognition of the processes of sexual *differentiation*, the instability of gender positions, and the hopelessness of excavating a free or original femininity beneath the layers of patriarchal oppression. 'Pure masculinity and femininity,' as Freud remarked, 'remain theoretical constructions of uncertain content.'[1]

My concern here is with the work of the British-based artists and the priming influence of material produced over the past ten years. This work has its own history, but that history is bound up with the development of associated debates on the left and within feminism: debates on the nature of subjectivity, ideology, representation, sexuality, pleasure, and the contribution made by psychoanalysis to the unraveling of

these mutually implicated concerns. What I want to turn to is a consideration of this relationship – that is, the relationship between these arguments and this work – rather than to a biographical account which treats each artist's authorship as the point of entry into what they make. It is appropriate here to stress the importance of theory – which is always transformed and exceeded in the production of 'art' – as part of the very texture and project of the work itself.

Representation: Ideology, Subjectivity[2]

The house is now filled with all sorts of replicas and copies: genuine imitations, original copies, prints of paintings, prints of prints, copies of copies . . . Do we feel that all is now becoming completely *framed* by representation and that there is no limit to this framing? Can just about everything today become an image? Are we caught within an endless process of duplication, an incessant flow whereby an image is infinitely repeatable and the real world merely a spectre, a ghost whose presence barely haunts the frame?[3]

We have no unmediated access to the real. It is through representations that we know the world. At the same time we cannot say, in a simple sense, that a representation or an image 'reflects' a reality, 'distorts' a reality, 'stands in the place' of an absent reality, or bears no relation to any reality whatsoever.[4] Relations and events do not 'speak themselves' but are *enabled to mean* through systems of signs organized into discourses on the world. Reality is a matter of representation, as Stephen Heath puts it, and representation is, in turn, a matter of discourse.[5]

There is another reason why we cannot measure representations against a 'real' to which they might be held to refer, and that is because 'this real is itself *constituted* through the agency of representations.'[6] What the world 'is' for us depends on how it is described. In an example Victor Burgin gives, we cannot evaluate a particular representation of femininity against some true or essential feminine nature because the femininity we adapt to and embody is itself the product of representation.[7] Since representations enter into our collective social understandings, constituting our sense of ourselves, the positions we take up in the world, and the possibilities we see for action in it must be understood as having their own level of effect and as comprising a necessary site of contention.

Ideology is a production of representations – although it does not present itself as such, but rather as a complex of common-sense propositions about the world, which are assumed to be self-evident. As an arrangement of social practices and systems of representations, ideology is materially operative through specific institutions. Such 'ideological state apparatuses,' as Althusser calls them, include education, the family, religion, law, culture, and communications.[8] Material circumstances may provide the raw materials on which ideological discourses operate, but these discourses, through the largely unconscious and naturalized assumptions of which they are comprised, effect certain closures and structure certain positions *on* that raw material.

At the same time, ideology has the further and necessary function of producing ('interpellating') subjects for its representations. We imagine ourselves as outside of,

even as originating, the ideological representations into which we are inserted and in which we 'misrecognize' ourselves.

These Althusserian notions of interpellation and misrecognition have been productive, but they have also been contested. They do not adequately account for the unconscious, for the constitution of the subject in language, or for the relations between ideology and language or discourse. Nor do they easily allow for the possibility of refusal and struggle in the ideological arena or for the range of interpellations to which individuals, by virtue of class, race, or sex, may *be* subject.[9]

The question of meaning relates not only to the social but also to the psychic formation of the author or reader,[10] 'formations existentially simultaneous and coextensive but theorized in separate discourses,'[11] as Burgin has written. We need to account for the deep hold of ideology, for the level on which social structures become an integral part of an identity which is in fact precarious – not fully conscious, rational, or coherent.

The subject, continually in process, is neither a fixed entity nor an autonomous being outside of history and representations. The (gendered) subject is inscribed in the symbolic order through a series of psycho-social processes as 'the product of a channelling of predominantly sexual basic drives within a shifting complex of heterogeneous cultural systems (work, the family, etc.).'[12] The formal devices of representation are effective here too, particularly the perspective and framing systems of Western painting and the camera, which produce both an object and a point of view (i.e. a coherent viewing subject) for that object. This setting-into-place of the subject is simultaneously secured through the harnessing of the sexual drives and their forms of gratification (fetishism, voyeurism, identificatory processes, pleasure in recognition and repetition). The breaking of these circuits, these processes of coherence that help secure the subject to and in ideology, becomes a central task for artists working, in Burgin's distinction, not on the representation of politics, but on the politics of representation.[13]

Art is a practice of representation, and hence of ideology (it is productive of meanings and of subject positions for those meanings). The five artists under discussion here work *in*, but also *on*, ideology: their representations attempt, in differing ways and through particular strategies (such as montage and the manipulation of image with text), to dis-articulate the dominant and naturalized discourses on sexuality, class, subjectivity, and representation itself.

The course and impact of these debates can be understood by looking at the trajectory of Victor Burgin's work since the mid-1970s. This work has put into play different concepts of ideology and representation:[14] first a classical or economistic Marxism, then its Althusserian inflection, and subsequently feminism and psychoanalysis, as interrelated in theories of the construction of the subject. 'St Laurent demands a whole new lifestyle,' from *UK 76*, is concerned with economic relations and a concept of ideology as 'false consciousness.' In setting the language of *haute couture* (and consumption) against the image of an immigrant female textile worker (and production), it renders visible the invisible social relations that commodity fetishism disavows. Similarly, it attempts to bring the outside world into the gallery through both the content of the image and its reference to advertising.

Burgin later concluded, however, that the meanings and political/aesthetic effects of this work were too quickly exhausted: 'they could be simply *consumed* as the speech of

any author, there was very little space left for the productivity of the reader.'[15] He began to alter his practice in *US 77*, which is informed by the Althusserian notion of ideological apparatuses and their relation to the construction of subjectivity. In a panel such as *Framed*, image and text offset each other in a more elliptical way than in the head-on confrontation of *UK 76*. We are drawn by their interplay into the world of frames (poster, photograph, mirror, the work itself) and of framing (the process of [mis]representation and [mis]recognition in which we find our sexed identity).[16]

Most recently, *Tales from Freud* draws on psychoanalysis not only for its concepts but also for its form, asking us to think about memory, desire, sexuality, masculinity and femininity, drawing us into and across the relations of image and text through the devices of representation, condensation, and displacement that characterize what Freud called the dream-work. This is a very different process – more enveloping and associative, more pleasurable and less conscious – from that of reading off the ironic distance of image from text in the 'St Laurent' panel of *UK 76*. It is produced within the purview of psychoanalysis, rather than at the intersection of psychoanalytic and Marxist theories of ideology; it is centered on a notion of sexual identity as an everyday process of structuring and positioning; and it is concerned now with what might be called the 'deep springs' of ideology in the constitution of subjectivity itself. (Burgin: 'There's going to be no major shift in extant social forms without a shift in the construction of masculinity.')[17]

Sexuality

[T]here is no such thing as sexuality; what we have experienced . . . is the fabrication of a 'sexuality,' the construction of something called 'sexuality' through a set of representations – images, discourses, ways of picturing and describing – that propose and confirm, that make up this sexuality to which we are then referred and held in our lives . . .[18]

What we experience as 'sexuality' has both an endogenous and an exogenous history. It is regulated and understood at the 'social' level – the level of investigation of writers such as Michel Foucault, Heath, and Jeffrey Weeks, who are concerned with the history of discourses and cultural practices.[19] But it is also organized in the history of each (sexed) subject. This is the 'psychic' level, to which psychoanalysis addresses itself, positing a sexual energy or libido that is established as 'sexuality' during the course of early life, changing in both its mechanisms and its aims.

The term 'sexuality' is a nineteenth-century one, emerging at a particular conjuncture and within the specific context of medicine, where it was understood in relation to reproduction, abnormality, and disease.[20] As Heath remarks, not until Freud's *Three Essays on the Theory of Sexuality* (1905) do we enter 'a new conception, no longer organs, the sexual act, normal penis, genital finality: sexuality now as complex history and structure and patterning of desire.'[21] Two things follow from this. First, that in psychoanalysis sexuality is not reducible to reproduction and the genital act. It 'arises from various sources, seeks satisfaction in various ways, makes use of diverse objects,'[22] and includes a range of phenomena that are not manifestly sexual but are held to be derived

from, or traversed by, the infant and adult sexual drives. Second, that the subject is understood as precipitated by and through sexuality (specifically, around the moment of the Oedipal and castration complexes). Thus in psychoanalysis 'the development of the human subject, its unconscious and its sexuality go hand-in-hand, they are causatively intertwined . . . a person is formed *through* their sexuality, it could not be added to him or her.'[23]

Both the history of the social ordering of sexuality and its psychic organization oblige us to rethink the relations between sexuality and representation. That is, to remove them from any conception as two distinct domains (representation *and* sexuality), or as a given, homogeneous, and anterior sexuality (the representation *of* sexuality), in favor of the recognition of how each is bound up in the processes of the other. On one hand, we cannot speak of a body organized sexually outside of the processes of representation.[24] On the other, we have to recognize the organization of the sexual drive *in* representation and in the viewing subject. 'The structure of representation is a structure of fetishism,' as Heath puts it, following Barthes – and visual pleasure is bound up with gratifications in looking that are sexually impelled.[25]

Questions of 'sexuality' and 'representation,' then, are complicated beyond a certain point by their mutual entanglement. They are simply not discrete, as mechanisms or as structures. Nevertheless, we can unravel some strands within that relation that are particularly relevant to the work of the artists here.

First, there is the concept of the psychic construction of gender identity through the organization of the bisexuality of the drives (Freud), reworked as an understanding of the formation of subjectivity within language (Lacan). Since these processes are neither final nor secure, there is a struggle at all levels for the definition and redefinition of negotiated categories: 'sexual difference is not an immediately given fact of "male" and "female" identity but a whole process of differentiation,' as Heath notes.[26]

Second, this differentiation is produced and reproduced in the representations of a range of discourses (medicine, law, education, art, the mass media). This moves us beyond the question of stereotypes to an understanding of how representations operate discursively, and in relation to subjectivity. It is within this complex of discourses on sexuality that a sexual politics attempts to intervene, to contest the strategies of representations, as well as those of the legal, political, and economic institutions through which they are guaranteed.

Third, there is the implication of sexual difference in the structuring of pleasure. The ordering of libidinal investments in looking is not symmetrical. For the young child, looking and being-looked-at are equally possible and pleasurable activities; in the social world of the adult, there is a division of labor between the two. In Laura Mulvey's account: 'The determining male gaze projects its phantasy on to the female figure which is styled accordingly. In their traditional exhibitionist role women are simultaneously looked at and displayed, with their appearance coded for strong visual and erotic impact so that they can be said to connote *to-be-looked-at-ness*.'[27]

Finally, the point for these artists of taking up such issues is to interrogate and reorder them as part of a political project. Their work points to the contradictory relations among discourses. It involves a refusal of the fixing of the feminine and

femininity (and, increasingly, of the masculine and masculinity). It argues for a form of female fetishism and for a place for the mother's desire. It interrogates the Lacanian identification of women and 'lack.' And it attempts forms of representation that can engage with the primary processes of visual and verbal condensation and displacement to construct new pathways of meaning and pleasure.

Mary Kelly's *Post-partum Document*, for example, draws on psychoanalysis (and particularly Lacan) in its insistence that 'the development of the human subject, its un-conscious and its sexuality go hand-in-hand.' It uses psychoanalysis for its 'secondary revision,' its way of working through difficult experiences; at the same time it attempts a deconstruction of the psychoanalytic discourse on femininity. The *Document* stresses the continuous production of difference through systems of representation (there is no essential femininity outside of representational practices); and in Kelly's terms, it argues 'against the self-sufficiency of lived experience and *for* a theoretical elaboration of the social relations in which "femininity" is formed.'[28]

Conceived as 'an ongoing process of analysis and visualization of the mother–child relationship,'[29] the *Document* was produced in six sections of 135 frames between 1973 and 1979. Through its strategic deployment of found objects, diagrams, diary frag-ments, and commentaries, the idea of motherhood as a simple biological and emotional category is displaced in favor of the recognition of motherhood as a complex psycho-logical and social process – a double movement of setting-in-place that is masked by the ideology of an instinctive and natural 'mothering.'

The physical and psychic interdependence and the pleasurable 'completeness' of the first post-natal period must gradually give way as the infant takes his/her place in the world through a series of separations or 'weanings.'[30] The six stages of the *Post-partum Document* trace this process to the point where the child signs his own name, confirmed in language and culture as a sexed individual. But at the same time these stages give a voice to the mother's fantasies, 'her desire, her stake in that project called motherhood.'[31] The structure of recognition-and-denial that characterizes fetishism can be found in the woman's castration fears which center on the loss of her loved objects, especially her children.[32] The fetishizing of the child through his gifts and memorabilia is the mother's disavowal – a fetishization that Mary Kelly *as artist* has tried to displace onto the work, at the same time drawing attention to the fetishistic nature of representation itself.

With hindsight, as she indicates, another story unfolds across the *Document* – 'a kind of chronicle of feminist debate within the women's movement in Great Britain during the 1970s.'[33] And, through the empirical data and their reworking in artistic practice, a series of conceptual shifts was also taking place: the *Document* moves from a primary emphasis on sexual division in 1973 to the question of sexual difference in 1976, to a point at which notions of a 'negative entry into the symbolic of patriarchy' were replaced by the development of theories of representation – that is, representation in both the psychoanalytic sense (the 'feminine' as position in language) and the ideologi-cal sense (the reproduction of difference within specific discourses and social prac-tices). *Documentation VI* attempts to bring these analyses of sexual division and sexual difference together – it is together that they work and find their effectiveness in describ-ing 'the construction of the agency of the mother/housewife within the institution of the school.'[34]

Masculinity, of course, is implicated here as well. Sexuality is not just women's problem (or symptoms, or politics), but the consequences *for men* of psychoanalytic and feminist theories of subjectivity are usually ignored.[35] The question 'can men make feminist work?' becomes 'can men make work on masculinity from a feminist position?' Both Ray Barrie and Burgin are concerned with mapping 'the constantly shifting landscape of fantasy and reminiscence that shapes male sexual identity.'[36]

Barrie's '*Master/Pieces*' and *Screen Memories* are conceived from the position of a male author questioning masculinity (men do not speak as men, men speak as *authority*), and the authorship of the work is raised as an issue and a problem in terms of its sexuality. Both pieces deal with the repressed in the sense of phantasy and desire, but also as that which is lost to collective representation. (How often do we see images of a *domestic* masculinity?) They also deal with masculinity in the naturalizing processes of signification – the phallic investment of the natural and manufactured worlds in the shark and the car ('the hottest shape on the road') – and with the exchange of meanings from and for a masculine position that is common to both the public world of advertising and the private space of toilet graffiti. Advertisements offer meaning and pleasure in the process of consuming the representation as well as the product. This kind of graffiti, which is based on a reduced iconography of the sex of women, of sex with women, also offers pleasure in consumption. It reconstructs an active, possessive, phallic sexuality for the male, and through the symbolization of women it enables an exchange of meanings around that sexuality among men.

The title and format of *Screen Memories* connect in two directions: first, to the counterpoint of visual and verbal elements in film (the first-person narrative, taken from John Dos Passos, suggests the difficulty and cost of a masculine position); and second, to psychoanalysis and Freud's concept of the 'screen memory'[37] that effects a compromise between what must be simultaneously remembered and repressed. The apparent insignificance of a sharply recalled childhood memory is an alibi, its survival a trace of that which stands behind it. Like the backdrop to *Screen Memories* – spectral images, formed in dust, of picture frames in a derelict house – it is the seemingly trivial clue to an absent history.

Burgin's work has been concerned with male sexuality primarily through an exploration of the structures of voyeurism and fetishism in phantasy. Although at first sight the picturing of the naked woman in the surveillance panel of *Zoo*, or of Olympia and her stand-in in *Tales from Freud*, seems to enforce dominant relations of specularity, these images are placed within a network of references that begins to open up and challenge this very issue. The alternative and 'positive' image of the woman immigrant worker in *UK 76* gives way to a different project, that of the 'interrogation of the "male voice" as it is constructed across the specific discourses of photography.'[38] Or, we might say, a *series* of 'male' voices as they are alluded to in *Olympia*, or a series of positions on female sexuality – each a kind of consumption, each with its nexus of knowledge, pleasure, and power.

There are narrative fragments but there is no linear coherence. We are encouraged to read vertically, through association, across the relations of text to image, along the terms of the primary processes of condensation and displacement. No longer consumers at the margin of a finished work, we are drawn onto the site and into the process

of meaning itself. In this process our sexed subjectivity and its pleasures in representation are also implicated, and indeed become the subject matter of the work.

Narrative

A characteristic of the kind of society in which we live is the mass production of fictions: stories, romances, novels, photo-novels, radio serials, films, television plays and series – fictions everywhere, all-pervasive, with consumption obligatory by virtue of their omnipresence, a veritable requirement of our social existence . . . This mass-production of fiction is the culture of what might be called the 'novelistic,' the constant narration of the social relations of individuals, the ordering of meanings for the individual in society.[39]

The work of these artists employs and relates to narrative, but it does so in order to deconstruct the 'fictions of coherence' that Stephen Heath describes. It uses fragments of narrative – or the ingredients for a narrative or particular narrative devices – in opposition to a modernist elimination of content in the image. At the same time, it draws on the disruption of anticipated sequence and closure in modernist writing, and on more recent analyses of narrativity in structuralist literary criticism. It refuses the authority of the 'master narrative,' the gratification of an enigma posed and solved, and the resulting coherence and fullness of subject position ('A narrative is a *sequence* of something *for* somebody').[40]

Behind Heath's 'mass production of fictions' lies the classic realist text[41] in which one discourse – that of narration – is privileged over all others. From a position of dominance it presumes to tell us what really happens. It is both ubiquitous and persuasive, and we have every reason to take pleasure in its devices, its resolutions and its promise of authority and truth because they answer our own needs for coherence and control.[42] Just as the classic realist text conceals the fact that its master discourse is another articulation – one story amongst others – so it also conceals the position of the subject as inside this articulation, offering us instead an imaginary and coherent place external to it from which we may view things 'as they are.'

In contrast, the production of work in which there is narration but no privileged narrative aims at engaging our storytelling tendencies while refusing us a fixed position of knowledge. Robert Scholes says that the postmodernist anti-narratives:

bring the codes to the foreground of our critical attention, requiring us to see them *as* codes rather than as aspects of human nature or the world. The function of anti-narrative is to problematize the entire process of narration and interpretation for us.[43]

We should therefore distinguish between 'narrative' as a conventional means for representing and structuring the world, and the employment of certain narrative devices in an art that seeks to interrogate the processes of representation. Such work stresses the contradictions in the 'real,' the incoherence of the ego, and unexpected transfor-

mations of meaning across image and text. This disruption of the codes of the classic realist text, this relocation and imbrication of image and script, this interplay of multiple discourses without offer of a fixed position – all this is part of the productivity of the work and common to such otherwise disparate projects as the *Post-partum Document*, *Tales from Freud*, *The Missing Woman*, *Metaphorical Journey*, and *Screen Memories*.

In Marie Yates's *The Missing Woman* we are teased by a narrative process which is first offered and then withdrawn. Images are paired with fragmentary texts – letters, diaries, newspaper cuttings, official reports – that we designate as documentary, but which we might well subsume under Heath's 'mass production of fictions.' Marie Yates describes her project as: 'a play on that [i.e. Lacan's] process of identification exploring our persistence as subjects in language in our belief that somewhere there is a point of certainty, of knowledge and truth.'[44]

Through visual and verbal signs, by means of characters and occurrences, we are invited to construct the identity of a woman, 'A,' and encouraged to believe that by following the sequence we will be rewarded at this point of 'certainty, knowledge and truth.' The relations between text and image appear at times straightforward and at others elliptical. We do our best, as we do with novels, to construct the image of a whole character from the evidence we are given: to find 'A's' story, identity, and relationship to the child, for instance, in a still life of domestic paraphernalia.

In pursuing the enigma of 'A' we are tracing the production of sexual difference in fragments of discourse – feminine identities in social relationships, the family, property rights, and legal ceremonies that are not necessarily either whole or wholesome. 'Identity' is a narrativization of life, a story that satisfies us about who we are. But the pull towards narrative is finally refused, so that character and sequence remain elusive (the panels can be hung in any order), and any sense of closure or equilibrium is undermined by an assertion (attributed to 'B') that calls us into consciousness of what we do: 'however much photography is equated with content, and painting with "thing-in-itself" or "window-on-the-world," whenever we look at an image we are its authors through the field of discourse and generally put images to use in providing narratives to our satisfaction.'[45] In seeking to make sense of images, we also work to produce a coherent position for ourselves.

But the question remains: who is *The Missing Woman*? (Lacan: 'Woman as such does not exist.') Is the feminine itself the missing (woman defined as absence or lack)? Or is there – as the discrete references to culture and class in the piece suggest – no one femininity, present or missing? Perhaps we have been distracted and the absence is not 'A's' but that of whoever has ordered these elements for our reworking. Is the artist outside or inside the work ('B,' an artist. 'Y,' a woman who resembles 'B')? Is the narrator the author, a character ('B') among others, or, effectively, ourselves (on what other point does this 'evidence' converge)? Who speaks, in narrative? (Benveniste: in narrative, no one speaks.)[46] Is the image a tableau offering the fictional promise of 'a sleek and whole identity' or, as Yates suggests in her writing, a mirror 'which can reveal its operation through mobilizing the discursive in its mode of address'?[47]

Partial narratives – or the invitations to attempt them – are present in Yve Lomax's work too. What suggests a story is not the representational tableau that Barthes likened to a hieroglyph condensing past, present, and future,[48] but something closer to a frame

cut from a *film noir*: a moment of anonymity and anomie with no 'before' or 'after' except those that we propose.

The limited identifications offered by the female figures in Lomax's *Open Rings and Partial Lines* quickly come unraveled. They are in all senses flat: the sense of a represented space, a rounded character, or a moment's emotional resonance is undercut by the insistent play between narrative and surface. (Lomax: 'Think about the question of representation falling flat, spreading out and becoming a question of the horizontal assemblage of parts.')[49] Surface marks and blocks of primary color effect this pull-back from narrative and illusion, together with a particular use of montage. Representations of femininity from fashion photography, television, B-movies and advertising, technically degraded through their reproduction, abrade each other. But between the paired segments there lies a gap which challenges the classic, Eisensteinian notion of montage as the production of a third meaning from the juxtaposition of two images. As the artist remarks:

> I would say that montage is concerned with bits as bits, not as fragments broken from some original whole . . . [and] the politics of montage concerns the way in which we negotiate heterogeneity and multiplicity . . . the way in which we take up with practices (literature, science . . . sex) as assemblages, indeed as montages, and not as monolithic wholes.[50]

Pleasure

Laura Mulvey's account of 'Visual Pleasure and Narrative Cinema' assumes that pleasure is bound up in the structuring of sexual difference. Asking how systems of representation (in this case Hollywood cinema) play on unconscious pleasures in looking, she suggests a distinction: between the voyeuristic pleasure of the male-positioned viewer presented with the fetishization of woman as spectacle; and the different pleasure that the viewer takes in identifying with the (male) character who appears to control the narrative and move the plot along.

The pleasures accorded to women (or to the female-positioned subject) in this regime are those of a complementary exhibitionism. Because we are formed by it we are not immune to a narcissistic fascination with images apparently addressed to men – with finding our own satisfactions in the spotlight of that controlling gaze. Alternatively, but with some discomfort and collusion, we may cross-identify with the bearer of the look. But in so far as such forms of gratification are oppressive to us, pleasure becomes a political issue:

> The man's relation to the whole problematic differs fundamentally from the woman's: the woman must, by discovery and invention, locate herself-for-herself in representation (where now, predominantly, she takes place only for men); the man, on the other hand, is everywhere in representation in his own interest . . .[51]

Within the psychic economy, pleasure cannot be refused. Images *will* gratify scopophilic components in the libido, *will* engage the structures of fantasy and desire, *will* invoke narcissistic identifications by various means. We cannot, in Victor Burgin's terms, 'dispense with the phantasmatic relation to representation.'[52] We can work with

it (in Burgin's case, by the direct quotation of voyeuristic imagery in the context of a critique); we might be able to subvert or reconstruct it in less oppressive forms. Or perhaps the drive is sufficiently undifferentiated that there is no one thing that pleasure is: it may follow familiar paths, but cannot ultimately be defined in isolation from the social and discursive formations in which it occurs.

There is also the question of pleasure, not just as it relates to a variety of psychic investments but in relation to knowledge. Something here connects with Barthes' distinction in *The Pleasure of the Text* between 'pleasure' and 'jouissance.' The text of pleasure is the text we know how to read (the representation that supports our identifications and offers us the satisfaction of recognition). The text of 'jouissance' (or ecstasy), on the other hand, 'imposes a state of loss . . . discomforts . . . unsettles the reader's historical, cultural, psychological assumptions, the consistency of his tastes, values, memories, brings to a crisis his relation with language.'[53]

Such disruption of the 'readerly' text is necessary if the social and psychic economy is not simply to be reproduced in its dominant mechanisms and effects. But some return is necessary for this effort: the 'thrill that comes from leaving the past behind,'[54] as Mulvey calls it, or the pleasures of play as a strategy for the work as Lomax intends: 'Play . . . in all senses of the word: to disquiet; to disturb but also to engage in an amusing and pleasurable activity . . . it is also, in a sense, its politics: to no longer separate politics from pleasure.'[55] How willing the spectator is to enter into 'play' may depend on their self-perception and situation. Disruption of this order is threatening, and not only to the security of the already known. Work that denies identity and emphasizes the subject-in-process, in a sense proposes the viewer's undoing. For men, perhaps, a pleasurable reading of this work will be difficult at best. Women, on the other hand, have an investment in the deconstruction of 'femininity' and compensatory pleasures: in answering back (Barbara Kruger: 'Your gaze hits the side of my face'), in hide-and-seek (Cindy Sherman presenting herself as object of the look while refusing, in mobility of self-constructed identities, to be discovered by it), and in evacuating woman's image in favor of a more circuitous route to 'the mother as subject of her own desire.'[56]

Context: Feminism, Modernism, and Postmodernism

The first question to pose is therefore: how can women analyze their exploitation, inscribe their claims, within an order prescribed by the masculine? Is a politics of women possible there?[57]

Since the nineteenth century at least, pro- and anti-feminist positions have been engaged in struggles over the varied propositions that culture is neutral, androgynous, or gender-specific. What these debates generally have not addressed is the problematic of culture itself, in which definitions of femininity are produced and contested and in which cultural practices cannot be derived from or mapped directly onto a biological gender.

The most important contribution of the feminism under consideration here is the recognition of the relations between representation and sexed subjectivity *in process*, and of the need to intervene productively within them. The artists considered here hold

the common aim of 'unfixing' the feminine, unmasking the relations of specularity that determine its appearance in representation, and undoing its position as a 'marked term' which ensures the category of the masculine as something central and secure.

This is a project within feminism that can be seen as distinct from, say, the work of Judy Chicago. The importance of *The Dinner Party*[58] lies in its scale and ambition, its (controversially) collaborative production, and its audience. But its deployment of the fixed *signs* of femininity produces a reverse discourse,[59] a political/aesthetic strategy founded on the same terms in which 'difference' has already been laid down. What we find in the work in this exhibition is rather an interrogation of an unfixed femininity produced in *specific systems of signification*. In Burgin's words, 'meaning is perpetually displaced from the *image* to the discursive formations which cross and contain it; there can be no question of either "progressive" contents or forms *in themselves*, nor any ideally "effective" synthesis of the two.'[60]

This work has been claimed for modernism (for a Russian, rather than a Greenbergian formalism) and for postmodernism (via poststructuralist theory rather than new expressionist practice), but we need, finally, to see it in yet another context. Not as the phototextual work of the '70s now eclipsed by the panache of the new, not as one ingredient amongst others guaranteeing the plurality of the new, not even as a 'postmodernism of resistance'[61] (despite the equivocal attractions of the term). Rather as that 'cinematic of the future'[62] Barthes called for, that concern with sexuality in process which Luce Irigaray described as 'woman as the not-yet'[63] – a continued countering of cultural hegemony in its ceaseless and otherwise unquestioned production of meanings and of subject positions for those meanings.

> She had acted out for long enough, inside those four corners: frame, home, tableaux or scene. She no longer wanted to be found, where she was expected to be found, as if each time she was found it were all the same. As if it were all a matter of one pattern from which, on and on, the same was cut out, pressed out, and indeed could be put back . . . She arose. She straightened herself out. She made ready to go. But as she turned to look at what she was leaving behind, she knocked some metaphors off the table . . .[64]

Acknowledgments

I have drawn freely from conversations with the artists and from their writing. I am grateful to them for discussing their work with me but it does not necessarily follow, of course, that they would agree with all aspects of my account.

Notes

1 Sigmund Freud, *The Standard Edition of the Complete Psychological Works of Sigmund Freud*, trans. James Strachey (London: Hogarth Press, 1953), vol. 19, *Some Psychical Consequences of the Anatomical Distinction Between the Sexes* (1925), pp. 241–58.

2 I have kept the term 'representation' although it has been contested. Paul Q. Hirst's critique 'Althusser and the theory of ideology,' *Economy and Society*, 4 (5) (November 1976): 385–412 insists on *signification* and *signifying practices* as concepts that avoid, in his view, the suggestion that representation has a fixed correspondence to a 'real.'

3 Yve Lomax, 'When roses are no longer given a meaning in terms of human future', *Camerawork*, 26 (April 1983): 10–11.

4 Cf. Jean Baudrillard, 'The precession of simulacra', in *Simulations* (New York: Semiotext(e), 1983); reprinted in *Art after Modernism: Rethinking Representation*, ed. Brian Wallis (New York: The New Museum of Contemporary Art/Boston: David R. Godine, 1984), pp. 251–81.

5 Stephen Heath, 'Narrative space,' *Screen*, 17 (3) (Autumn 1976): 73.

6 Ibid.

7 Victor Burgin (ed.), *Thinking Photography* (Basingstoke: Macmillan, 1982), pp. 8–9.

8 Louis Althusser, 'Ideology and ideological state apparatuses (notes towards an investigation)', in *Lenin and Philosophy and Other Essays*, trans. Ben Brewster (London: New Left Books, 1971), pp. 121–73. This essay gave rise to extensive and detailed discussion which is not possible to outline here, but see Burgin, *Thinking Photography*, particularly ch. 3, 'Photographic practice and art theory'; and Rosalind Coward and John Ellis, 'Marxism, language, and ideology', *Language and Materialism: Developments in Semiology and the Theory* (London: Routledge and Kegan Paul, 1977), pp. 61–92.

9 Cf. Burgin, *Thinking Photography*, p. 7.

10 For a useful outline, see Rosalind Coward, 'Sexual politics and psychoanalysis: some notes on their relations', in *Feminism, Culture and Politics*, ed. Rosalind Brunt and Caroline Rowan (London: Lawrence and Wishart, 1982), pp. 171–87.

11 Burgin, *Thinking Photography*, pp. 144–5.

12 Ibid., p. 145.

13 Tony Godfrey, 'Sex, text, politics: an interview with Victor Burgin', *Block*, 7 (1982): 2–26; also Yve Lomax, 'The politics of montage', *Camerawork*, 24 (March 1982): 8–9.

14 Burgin outlines this himself in the interview with Tony Godfrey cited above, and adds that he used three 'voices' in *US 77*: a didactic voice, a narrative voice (as in 'framed'), and a paradoxical voice.

15 Godfrey, 'Sex, text, politics', p. 16.

16 Psychoanalytic concepts were present in *US 77* (see especially *Graffitification*) but were taken further in *Zoo*; for example in the bringing together of Foucault and Freud with the image of the peep show model, proposing 'the oppressive surveillance of woman in our society as the most visible, socially sanctioned, form of the more covert surveillance of society-in-general by the agencies of the state' (Burgin in Godfrey, 'Sex, text, and politics', p. 20).

17 Burgin, in conversation with Lisa Tickner.

18 Stephen Heath, *The Sexual Fix* (New York: Macmillan, 1982), p. 3.

19 Michel Foucault, *The History of Sexuality*, vol. 1: *An Introduction*, trans. Robert Hurley (New York: Random House, 1978); Heath, *The Sexual Fix*; Jeffrey Weeks, *Sex, Politics, and Society: The Regulation of Sexuality Since 1800* (New York: Longman, 1981).

20 Heath, *The Sexual Fix*, esp. p. 7 where he notes that in relation to 'sexuality' the *Oxford English Dictionary* cites James Matthews Duncan, *Clinical Lectures on the Diseases of Women* (1889).

21 Heath, *The Sexual Fix*, p. 44.

22 Juliet Mitchell, 'Introduction-1', in *Feminine Sexuality: Jacques Lacan and the école freudienne*, ed. Juliet Mitchell and Jacqueline Rose (New York: W.W. Norton/Pantheon Books, 1983), p. 2. See also the entry on 'Sexuality' in Jean Laplanche and Jean-Baptiste Pontalis, *The Language of Psychoanalysis* (London: Hogarth Press and the Institute of Psychoanalysis, 1980), pp. 417 ff.

23 Mitchell, 'Introduction-1', p. 2.

24 Cf. Parveen Adams, 'Representation and sexuality', *m/f*, 1 (1978): 78.

25 Stephen Heath, 'Lessons from Brecht', *Screen*, 15 (2) (Summer 1974): 106. Also Laura Mulvey, 'Visual pleasure and narrative cinema', *Screen*, 16 (3) (Autumn 1975): 6–18; reprinted in *Art after Modernism*, ed. Wallis, pp. 361–73; and Burgin, *Thinking Photography*, p. 190.

26 Heath, *The Sexual Fix*, p. 144.

27 Mulvey, 'Visual pleasure', p. 11. It has to be said that this question is complicated by the bisexuality of the drives, and by possible disjunctions between the (predominantly) 'male' or 'female' sexuality of author or reader, and the gendered positioning inscribed by the text. Victor Burgin (*Block*, no. 7, p. 24) refers to an unconscious, pre-Oedipal 'tourist' of a subject 'which can take up positions more or less freely on either side of the divide of gender, or even on both sides simultaneously.' Laura Mulvey herself, in an article on *Duel in the Sun* in *Framework*, no. 15/16/17 (Summer 1981): 12–15 provides some 'afterthoughts on "Visual Pleasure and Narrative Cinema"' in which she attempts to account for the position of the *female* spectator, her pleasure and identifications, and the use of a female protagonist in Hollywood melodrama.

28 Mary Kelly, 'Notes on reading the Post-partum Document', *Control*, 10 (November 1977): 10.

29 Mary Kelly, *Post-partum Document* (London: Routledge and Kegan Paul, 1983), p. xv. Ultimately the *division* of labor in childcare is insufficient to account for the structuring of *difference* which is in part determined by the place of the child in the mother's fantasies.

30 The six sections of the *Document* are headed 'Weaning from the Breast'; 'Weaning from the Holophrase', 'Weaning from the Dyad'; 'On Femininity'; 'On the Order of Things'; and 'On the Insistence of the Letter.' Across these, as Mary Kelly puts it, 'a problem is continually posed but no resolution is reached. There is only a replay of moments of separation and loss, perhaps because desire has no end, resists normalization, ignores biology, disperses the body' (*Post-partum Document*, p. xvii).

31 Kelly, ibid., p. xvii.

32 See Mary Kelly, 'On femininity', *Control*, 11 (November 1979): 14–15.

33 Kelly, *Post-partum Document*, p. xix.

34 Kelly, 'The Post-partum Document', *m/f*, 5–6 (1981): 127.

35 Ray Barrie quoted in Mary Kelly, 'Beyond the purloined image', *Block*, 9 (1984).

36 Kelly, 'Beyond the purloined image.'

37 For Freud on 'Screen Memories' (1899), see *Standard Edition* III, pp. 307, 315–16, 321–2 and chapter 4 of *The Psychopathology of Everyday Life*. Laplanche and Pontalis provide a useful summary (pp. 410–11).

38 Godfrey, 'Sex, text, politics', p. 15.

39 Heath, *The Sexual Fix*, p. 85.

40 Robert Scholes, 'Language, narrative, and anti-narrative', *Critical Inquiry*, 7 (1) (Autumn 1980): 209.

41 I am drawing on Colin MacCabe's account in 'Realism and the cinema: notes on some Brechtian theses', *Screen*, 15 (2) (Summer 1974): 7–27.

42 See Heath, 'Lessons from Brecht', p. 121.

43 Scholes, 'Language, narrative, and anti-narrative', p. 211.

44 Marie Yates in a statement accompanying the exhibition of *The Missing Woman* in *Beyond the Purloined Image* (Riverside Studios, 1983). The *dramatis personae* are outlined for us:

A a woman known to B by sight
B the narrator, an artist
C a man who lives with A
D a child
Y a woman who resembles B

Nowhere are we offered an adequate image of the woman or the narrator: 'A' is spoken by the others and by the 'evidence' (i.e. the signs) that surround her – and hence by us.

45 'From a statement by "B" Aug. 1982' partially reinserts this within the fiction; but because 'B' has been identified as both artist and narrator, and because the statement offers itself as a meta-comment on the rest of the piece, its status as inside and outside the work remains equivocal.

46 Benveniste quoted in Roland Barthes, 'Introduction to the structural analyses of narrative', in *Image–Music–Text*, ed. and trans. Stephen Heath (New York: Hill and Wang, 1977), p. 112.

47 Marie Yates in a statement accompanying the exhibition of *The Missing Woman*. For her views on representation, narrative, and subjectivity, see also Lucy Lippard, *Issue: Social Strategies by Women Artists* (exhibition catalogue) (London: Institute of Contemporary Arts, 1980), n.p.

48 Roland Barthes, 'Diderot, Brecht, Eisenstein', *Screen*, 15 (2) (Summer 1974): 36.

49 Yve Lomax from *Sense and Sensibility in Feminist Art Practice* (exhibition catalogue) (Nottingham: Midland Group Gallery, 1982), n.p.

50 Lomax, 'The politics of montage', p. 9; Heath, 'Lessons from Brecht', p. 112; and Gilles Deleuze and Felix Guattari, *Anti-Oedipus: Capitalism and Schizophrenia* (New York: Viking Press, 1977). *A note on image and text*: The 'polysemy' of the image may be 'anchored' or 'relayed' in particular ways: by montage, by text, by context (i.e. in the space of intertextuality, and by the sense-making proclivities of the viewer, which are themselves the product of what Barthes called the *déjà vu*, the already-read, already-seen). See *S/Z* (New York: Hill and Wang, 1974, p. 10: 'This "I" which approaches the text is already itself a plurality of other texts, of codes which are infinite, or, more precisely, lost (whose origin is lost).'
 Narrative, which 'smooths reading into the forward flow of its progress' may be threaded through image and text, stringing them into a single sequence of meaning in which each is reconciled to the other. On the other hand, it may be the intention of a particular (and political) representational practice to disrupt this easy flow: by setting image *against* text (as in Burgin's *UK 76*); by opening up a gap *between* image and text (as in *The Missing Woman*, where we take what clues we can in our effort to stitch them together again); by entailing us in the process of pulling together fragments of discourses that already cut *across* image and text and whose signification emerges from this interplay (*Post-partum Document, Screen Memories*); by exploiting in the construction of the work the transferability of word and image in the primary processes of the unconscious and in 'inner speech.'

51 Godfrey, 'Sex, text, politics', p. 25.

52 Burgin, in conversation with Lisa Tickner, and see also Godfrey, 'Sex, text, politics', p. 26. The possibility for change, in Burgin's account lies 'precisely in the fact of the *shared* pre-Oedipal sexuality of men and women; the recognition of sexuality as a *construct*, subject to social and historical change; and the recognition of the body as not simply given, as essence, in nature, but as constantly reproduced, "revised" in discourse.'

53 Roland Barthes, *The Pleasure of the Text*, trans. Richard Miller (New York: Hill and Wang, 1975), p. 14.

54 Mulvey, 'Visual pleasure', p. 8.

55 Yve Lomax from her unpublished notes to *Double-edged Scenes*; see also Marie Yates' article in *Camerawork*, 26 (April 1983): 16: 'for some years my work has not been about consumption but about play.'

56 Mary Kelly, *Sense and Sensibility*, and cf. Luce Irigaray as discussed in Mary Jacobus, 'The question of language: men of maxims and *The Mill on the Floss*', *Critical Inquiry*, 8 (2) (Winter 1981): 210.

57 Irigaray, quoted by Jacobus in 'The question of language', p. 207.

58 See Judy Chicago, *The Dinner Party: A Symbol of our Heritage* (New York: Doubleday, 1979) and Judy Chicago and Susan Hill, *Embroidering our Heritage: The Dinner Party Needlework* (New York: Anchor Press/Doubleday, 1980).

59 Foucault, *The History of Sexuality*, vol. 1, p. 101.

60 Burgin, *Thinking Photography*, pp. 215–16.

61 Hal Foster (ed.), *The Anti-aesthetic: Essays on Postmodern Culture* (Port Townsend, Washington: Bay Press, 1983).
62 Barthes, *Image–Music–Text*, p. 66, and Victor Burgin in conversation with Lisa Tickner.
63 Quoted in Meaghan Morris, 'A-mazing grace: notes on Mary Daly's poetics', *Lip*, 7 (1982/3): 39.
64 Yve Lomax, from *Metaphorical Journey*, exhibited in *Light Reading*, B2 Gallery, London, March 1982.

Jacqueline Rose, 'Sexuality in the Field of Vision' (1986)

From Jacqueline Rose, *Sexuality in the Field of Vision* (London: Verso, 1986), pp. 225–233.

In an untypical moment Freud accuses Leonardo of being unable to draw.[1] A drawing done in anatomical section of the sexual act is inaccurate. What is more it is lacking in pleasure: the man's expression is one of disgust, the position is uncomfortable, the woman's breast is unbeautiful (she does not have a head). The depiction is inaccurate, uncomfortable, undesirable and without desire. It is also inverted: the man's head looks like that of a woman, and the feet are the wrong way around according to the plane of the picture – the man's foot pointing outwards where the woman's foot should be, and her foot in his place. In fact, most of Freud's monograph on Leonardo is addressed to the artist's *failure*, that is, to the restrictions and limitations which Leonardo himself apparently experienced in relation to his potential achievement. Freud takes failure very seriously, even when it refers to someone who, to the gaze of the outside world, represents the supreme form of artistic success. But in this footnote on the sexual drawing, Freud goes beyond the brief of the largely psychobiographical forms of interpretation that he brings to Leonardo's case. He relates – quite explicitly – a failure to depict the sexual act to bisexuality and to a problem of representational space. The uncertain sexual identity muddles the plane of the image so that the spectator does not know where she or he stands in relationship to the picture. A confusion at the level of sexuality brings with it a disturbance of the visual field.

An artistic practice which sets itself the dual task of disrupting visual form and questioning the sexual certainties and stereotypes of our culture can fairly return to this historical moment (historical analytically as well as artistically, since the reference to Leonardo is now overlaid with the reference to the beginnings of psychoanalysis itself). Not for authority (authority is one of the things being questioned here), but for its suggestiveness in pointing up a possible relation between sexuality and the image. We know that Freud's writing runs parallel to the emergence of 'modern' art; he himself used such art as a comparison for the blurred fields of the unconscious psychic processes which were the object of his analytic work.[2] But in this footnote on Leonardo's failure in the visual act, we can already see traced out a specific movement or logic: that there can be no work on the image, no challenge to its powers of illusion and address, which

does not simultaneously challenge the fact of sexual difference, whose self-evidence Leonardo's drawing had momentarily allowed to crumble.[3]

The rest of Freud's writing shows that sexual difference is indeed such a hesitant and imperfect construction. Men and women take up positions of symbolic and polarised opposition against the grain of a multifarious and bisexual disposition, which Freud first identified in the symptom (and genius . . .) before recognising its continuing and barely concealed presence across the range of normal adult sexual life. The lines of that division are fragile in exact proportion to the rigid insistence with which our culture lays them down; they constantly converge and threaten to coalesce. Psychoanalysis itself can therefore explain the absence of that clear and accomplished form of sexuality that Freud himself had unsuccessfully searched for in the picture.

Freud often related the question of sexuality to that of visual representation. Describing the child's difficult journey into adult sexual life, he would take as his model little scenarios, or the staging of events, which demonstrated the complexity of an essentially visual space, moments in which perception *founders* (the boy child refuses to believe the anatomical difference that he sees)[4] or in which pleasure in looking tips over into the register of *excess* (witness to a sexual act in which he reads his own destiny, the child tries to interrupt by calling attention to his presence).[5] Each time the stress falls on a problem of seeing. The sexuality lies less in the content of what is seen than in the subjectivity of the viewer, in the relationship between what is looked at and the developing sexual knowledge of the child. The relationship between viewer and scene is always one of fracture, partial identification, pleasure and distrust. As if Freud found the aptest analogy for the problem of our identity as human subjects in failures of vision or in the violence which can be done to an image as it offers itself to view. For Freud, with an emphasis that has been picked up and placed at the centre of the work of Jacques Lacan, our sexual identities as male or female, our confidence in language as true or false, and our security in the image we judge as perfect or flawed, are fantasies.[6] And these archaic moments of disturbed visual representation, these troubled scenes, which expressed and unsettled our groping knowledge in the past, can now be used as theoretical prototypes to unsettle our certainties once again. Hence one of the chief drives of an art which today addresses the presence of the sexual in representation – to expose the fixed nature of sexual identity as a fantasy and, in the same gesture, to trouble, break up, or rupture the visual field before our eyes.

The encounter between psychoanalysis and artistic practice is therefore *staged*, but only in so far as that staging has *already taken place*. It is an encounter which draws its strength from that repetition, working like a memory trace of something we have been through before. It gives back to repetition its proper meaning and status: not lack of originality or something merely derived (the commonest reproach to the work of art), nor the more recent practice of appropriating artistic and photographic images in order to undermine their previous status; but repetition as insistence, that is, as the constant pressure of something hidden but not forgotten – something that can only come into focus now by blurring the field of representation where our normal forms of self-recognition take place.

The affinity between representation and sexuality is not confined to the visual image. In fact, in relation to other areas of theoretical analysis and activity, recognition of this affinity in the domain of the artistic image could be said to manifest something of a

lag.[7] In one of his most important self-criticisms,[8] Barthes underlined the importance of psychoanalysis in pushing his earlier exposé of ideological meanings into a critique of the possibility of meaning itself. In his case studies Freud had increasingly demonstrated that the history of the patient did not consist of some truth to be deciphered behind that chain of associations which emerged in the analytic setting; it resided within that chain and in the process of emergence which the analysis brought into effect. Lacan immediately read in this the chain of language which slides from unit to unit, producing meaning out of the relationship between terms; its truth belongs to that movement and not to some prior reference existing outside its domain. The divisions of language are in themselves arbitrary and shifting: language rests on a continuum which gets locked into discrete units of which sexual difference is only the most strongly marked. The fixing of language and the fixing of sexual identity go hand in hand; they rely on each other and share the same forms of instability and risk. Lacan read Freud through language, but he also brought out, by implication, the sexuality at work in all practices of the sign. Modernist literary writing could certainly demonstrate, alongside the syntactic and narrative shifts for which it is best known, oscillations in the domain of sexuality, a type of murking of the sexual proprieties on which the politer world of nineteenth-century realist fiction had been based. Although the opposition between the two forms of writing has often been overstated, it is no coincidence that, in order to illustrate this tension between 'readerly' and 'writerly' fiction, Barthes chose a story in which the narrative enigma turns on a castrato (Balzac's *Sarrasine*).[9] The indecipherable sexuality of the character makes for the trouble and the job of the text.

It is worth pausing over the implications of this for a modernist and postmodernist artistic practice which is increasingly understood in terms of a problematic of reading and a theory of the sign. Again, the historical links are important. Freud takes modern painting as the image of the unconscious. But the modernist suspension of the referent, with its stress on the purity of the visual signifier, belongs equally with Saussure who, at the same time, was criticising the conception of language as reference and underlining the arbitrary nature of the sign (primacy to the signifier instead of language as a nomenclature of the world). Lacan's move then simply completes the circuit by linking Saussure back to Freud. The unconscious reveals that the normal divisions of language and sexuality obey the dictates of an arbitrary law undermining the very possibility of reference for the subject since the 'I' can no longer be seen to correspond to some pre-given and permanent identity of psycho-sexual life. The problem of psychic identity is therefore immanent to the problem of the sign.

The same link (of language and the unconscious) can be made to that transition to postmodernism which has been read as a return of the referent, but the referent as a problem, not as a given.[10] Piles of cultural artefacts bring back something we recognise but in a form which refuses any logic of the same. The objects before the spectator's eyes cannot be ordered: in their disjunctive relation, they produce an acuter problem of vision than the one which had resulted when reference was simply dropped from the frame. Above all – to return to the analogy with the analytic scene – these images require a reading which neither coheres them into a unity, nor struggles to get behind them into a realm of truth. The only possible reading is one which repeats their fragmentation of a cultural world they both echo and refuse.

At each point of these transitions – artistic and theoretical – something is called into question at the most fundamental level of the way we recognise and respond to our own subjectivity and to a world with which we are assumed to be familiar, a world we both do and do not know. Yet in each of these instances, it is precisely the psychoanalytic concepts of the unconscious and sexuality, specifically in their relationship to language, which seem to be lost.

Thus the modernist stress on the purity of the visual signifier easily dissolves into an almost mystic contemplation. Language can be used to rupture the smoothness of the visual image but it is language as pure mark uninformed by the psychoanalytic apprehension of the sign. Cultural artefacts are presented as images within images to rob them of the values they seem naturally to embody, but the fundamental sexual polarity of that culture is not called into account. Finally, meaning is seen to reside in these images as supplement, allegory or fragment, but with no sexual residue or trace – the concept of textuality is lifted out of psychoanalytic and literary theory but without the sexual definition that was its chief impetus and support.

Across a range of instances, language, sexuality and the unconscious *in their mutual relation* appear as a present-absence which all these moments seem to brush against, or elicit, before falling away. The elisions can be summarised schematically:

- purity of the visual signifier and the unconscious as mystique (no language);
- language as rupture of the iconicity of the visual sign (no unconscious);
- cultural artefacts as indictment of the stereotype (no sexual difference);
- reading as supplement, process or fragment (no sexual determinacy of the signifier or of visual space).

Artists engaged in sexual representation (representation *as* sexual) come in at precisely this point, calling up the sexual component of the image, drawing out an emphasis that exists *in potentia* in the various instances they inherit and of which they form a part.[11] Their move is not therefore one of (moral) corrective. They draw on the tendencies they also seek to displace, and clearly belong, for example, within the context of that postmodernism which demands that reference, in its problematised form, re-enter the frame. But the emphasis on sexuality produces specific effects. First, it adds to the concept of cultural artefact or stereotype the political imperative of feminism which holds the image accountable for the reproduction of norms. Secondly, to this feminist demand for scrutiny of the image, it adds the idea of a sexuality which goes beyond the issue of content to take in the parameters of visual form (not just what we see but how we see – visual space as more than the domain of simple recognition). The image therefore submits to the sexual reference, but only in so far as reference itself is questioned by the work of the image. And the aesthetics of pure form are implicated in the less pure pleasures of looking, but these in turn are part of an aesthetically extraneous political space. The arena is simultaneously that of aesthetics and sexuality, and art and sexual politics. The link between sexuality and the image produces a particular dialogue which cannot be covered adequately by the familiar opposition between the formal operations of the image and a politics exerted from outside.

The engagement with the image therefore belongs to a political intention. It is an intention which has also inflected the psychoanalytic and literary theories on which such

artists draw. The model is not one of applying psychoanalysis to the work of art (what application could there finally be which does not reduce one field to the other or inhibit by interpretation the potential meaning of both?). Psychoanalysis offers a specific account of sexual difference but its value (and also its difficulty) for feminism lies in the place assigned to the woman in that differentiation. In his essay on Leonardo, Freud himself says that once the boy child sees what it is to be a woman, he will 'tremble for his masculinity' henceforth.[12] If meaning oscillates when a castrato comes onto the scene, our sense must be that it is in the normal image of the man that our certainties are invested and, by implication, in that of the woman that they constantly threaten collapse.

A feminism concerned with the question of looking can therefore turn this theory around and stress the particular and limiting opposition of male and female which any image seen to be flawless is serving to hold in place. More simply, we know that women are meant to *look* perfect, presenting a seamless image to the world so that the man, in that confrontation with difference, can avoid any apprehension of lack. The position of woman as fantasy therefore depends on a particular economy of vision (the importance of 'images of women' might take on its fullest meaning from this).[13] Perhaps this is also why only a project which comes via feminism can demand so unequivocally of the image that it renounce all pretensions to a narcissistic perfection of form.

At the extreme edge of this investigation, we might argue that the fantasy of absolute sexual difference, in its present guise, could be upheld only from the point when painting restricted the human body to the eye.[14] That would be to give the history of the image in Western culture a particularly heavy weight to bear. For, even if the visual image has indeed been one of the chief vehicles through which such a restriction has been enforced, it could only operate like a law which always produces the terms of its own violation. It is often forgotten that psychoanalysis describes the psychic law to which we are subject, but only in terms of its *failing*. This is important for a feminist (or any radical) practice which has often felt it necessary to claim for itself a wholly other psychic and representational domain. Therefore, if the visual image in its aesthetically acclaimed form serves to maintain a particular and oppressive mode of sexual recognition, it does so only partially and at a cost. Our previous history is not the petrified block of a singular visual space since, looked at obliquely, it can always be seen to contain its moments of unease.[15] We can surely relinquish the monolithic view of that history, if doing so allows us a form of resistance which can be articulated *on this side of* (rather than beyond) the world against which it protests.

Among Leonardo's early sketches, Freud discovers the heads of laughing women, images of exuberance which then fall out of the great canon of his art. Like Leonardo's picture of the sexual act, these images appear to unsettle Freud as if their pleasure somehow correlated with the discomfort of the sexual drawing (the sexual drawing through its failure, the heads of laughing women for their excess). These images, not well known in Leonardo's canon, now have the status of fragments, but they indicate a truth about the tradition which excludes them, revealing the presence of something strangely insistent to which these artists return. '*Teste di femmine, che ridono*'[16] – laughter is not the emphasis here, but the urgent engagement with the question of sexuality persists now, as it did then. It can no more be seen as the beginning, than it should be the end, of the matter.

Acknowledgments

This essay was written for the catalogue of the exhibition 'Difference: On Representation and Sexuality', held at the New Museum of Contemporary Art, New York, December–February 1984–5 and at the Institute of Contemporary Arts, London, September–October 1985, pp. 31–3. The exhibition, curated by Kate Linker, included works by Ray Barrie, Victor Burgin, Hans Haacke, Mary Kelly, Silvia Kolbowski, Barbara Kruger, Sherry Levine, Yve Lomax, Jeff Wall and Marie Yates. There was also a film and video exhibition in conjunction with the art exhibition in New York, curated by Jane Weinstock.

Notes

1 Sigmund Freud, 'Leonardo da Vinci and a memory of his childhood', *The Standard Edition of the Complete Psychological Works*, ed. James Strachey (London: The Hogarth Press, 1955–74), vol. II, p. 70n, p. 159n. Only part of the drawing discussed here is now attributed to Leonardo, see 'Leonardo da Vinci', *Pelican Freud Library*, vol. II, p. 161n.

2 Sigmund Freud, 'The dissection of the psychical personality', *Standard Edition*, vol. XXII, pp. 79, 112; passage retranslated by Samuel Weber in *The Legend of Freud* (Minneapolis, MN: University of Minnesota Press, 1982), p. 1.

3 Peter Wollen makes a similar point on the relationship between perceptual and sexual contradiction in Manet's Olympia in 'Manet – modernism and avant-garde', *Screen*, 21 (2) (Summer 1980): 21.

4 Sigmund Freud, 'Some psychical consequences of the anatomical distinction between the sexes' (1925), *Standard Edition*, vol. XXIV, pp. 252, 335–6.

5 Sigmund Freud, *From the History of an Infantile Neurosis* (1918), *Standard Edition*, vol. XVII, pp. 29–47, 80–1.

6 On the centrality of the visual image in Lacan's topography of psychic life, and on enunciation and the lying subject see 'The imaginary' and 'Dora – fragment of an analysis'.

7 For discussion of these issues in relation to film, see Laura Mulvey's crucial article, 'Visual pleasure and narrative cinema', *Screen*, 16 (3) (1975): 6–18; and also Jane Weinstock's article in *Difference: On Representation and Sexuality* (New York: New Museum of Contemporary Art, 1984).

8 Roland Barthes, 'Change the object itself', *Image–Music–Text*, trans. Stephen Heath (New York: Hill and Wang, 1977).

9 Roland Barthes, *S/Z*, trans. Richard Miller (New York: Hill and Wang, 1974).

10 Leo Steinberg defined postmodernism as the transition from nature to culture; this is reinterpreted by Craig Owens, 'The allegorical impulse – towards a theory of postmodernism', *October*, 12–13 (Spring and Summer 1980), esp. pp. 79–80, and also Douglas Crimp, 'On the museum's ruins', *October*, 13 (Summer 1980). Craig Owens has recently used Freud's account of the creative impulse in a critical appraisal of the Expressionist revival, 'Honor, power and the love of women', *Art and Artists* (January 1983).

11 For a discussion of some of these issues in relation to feminist art, see Mary Kelly, 'Reviewing modernist criticism', *Screen*, 22 (3) (Autumn 1981).

12 'Leonardo da Vinci and a memory of his childhood' (1910), *Standard Edition*, vol. II, pp. 95, 186–7.

13 The status of the woman as fantasy in relation to the desire of the man was a central concern of Lacan's later writing; see *Encore*, especially 'God and the jouissance of the woman' and 'A love letter' in *Feminine Sexuality: Jacques Lacan and the école freudienne*, ed. Juliet Mitchell and Jacqueline Rose (New York: W. W. Norton, 1982), and the commentary, 'Feminine sexuality – Jacques Lacan and the école freudienne', in the *Feminine Sexuality* collection.

14 Norman Bryson describes post-Albertian perspective in terms of such a restriction in *Vision and Painting: The Logic of the Gaze* (London: Macmillan, 1983).

15 See Jacques Lacan on death in Holbein's 'The Ambassadors', in *The Four Fundamental Concepts of Psycho-Analysis*, trans. Alan Sheridan, ed. Jacques-Alain Miller (New York: Norton, 1978), pp. 85–90.

16 'Leonardo da Vinci and a memory of his childhood', *Standard Edition*, vol. II, pp. 111, 203. An exhibition entitled 'The Revolutionary Power of Women's Laughter', including works by Barbara Kruger and Mary Kelly, was held at Protetch McNeil, New York, January 1983.

Jo Anna Isaak, 'Mapping the Imaginary' (1987)

From *The Event Horizon: Essays on Hope, Sexuality, Social Space and Media(tion) in Art*, ed. Lorne Falk (Toronto: The Coach House Press and Walter Phillips, 1987), pp. 138–157.

While the psychoanalytic study of art is as old as psychoanalysis, it is only in recent years, notably through the work of Lacan, that the psychoanalytic concept of the subject has become a part of the study of representation. One of the essential correlates of consciousness is its relation to representation. The Cartesian *cogito*, in which the subject (presumed to be outside the systems of signification) apprehends himself as thought, has been afflicted by a sort of methodological doubt by the implication of representation in thought. 'I think therefore I am' becomes 'I see myself seeing representations of myself'. 'In this matter of the visible,' Lacan warns, 'everything is a trap' – interlacing, intertwining, labyrinthine; the world becomes suspect of yielding the subject only his own representations, his own misrecognitions.[1] 'We are beings who are looked at in the spectacle of the world. That which makes us consciousness institutes us, by the same token as *speculum mundi*.'[2] In the context of this bipolar reflexivity, I will explore the relationship between the invention/discovery of Renaissance modes of representation and the invention/discovery of the unconscious.

Terra Incognita

Psychoanalysis began with hysteria – a disease occasioned by a problem of representation. The two early explorers of this unmapped terrain saw the reflecting relation differently. Pierre Janet believed that paralysis occurred in the hysteric because she was unable to form the image of her limbs and thus was unable to move them; whereas Charcot believed the hysteric was unable to obliterate a pre-existing image of paralysis. For both, hysteria was a problem of representation – the incongruence of image and thought. Charcot's photographs of the hysterics of Salpêtrière are the record of an attempt to make visible this disease which cannot be known except through behaviour, or representation. Because the underlying pathology is invisible, Charcot was concerned that hysteria was in danger of not being a disease at all. Joan Copjec in her essay on

Freud's *The Psychotherapy of Hysteria*, points out that hysteria, the illness of imagination, 'menaced knowledge, confusing categories of real and unreal illness, true perception and false images, making the physician a potential victim of trickery and deception and casting doubt on his senses which were the foundation of his knowledge, the image, in brief, conflated with madness and presented as inimical to thought.'[3] It was in order to *anchor* this mobile disease that Charcot enlisted the aid of photography. Photography, then being theorized as both the product and handmaiden of positivism – objective, unmediated, actually imprinted by the light rays of the original – was the ideal representational mode to bring the disease into discursive constructions.

Although the *photo-graph* (as Lacan fragments the word) became the major mode of documentation at Salpêtrière, Charcot continued to make extensive use of other art forms. An artist himself, Charcot made many sketches and paintings. Freud described Charcot as 'not a reflective man, not a thinker – he had the nature of an artist – he was, as he himself said, a "visuel", a man who sees.'[4] This image of Charcot as seer links him with the Romantic notion of the artist – the man distinct from his fellow beings by virtue of his keener insights into nature.

The Romantic artist that Charcot is most indebted to is Theodore Géricault. Géricault studied the influence of mental states on the human face and believed that the face accurately revealed the inner character, especially in madness and at the instant of death. He did studies of inmates in hospitals and institutions for the criminally insane, where he himself spent time as a patient. His work, like Charcot's, functioned as the *institution* of the subject into the visible. As Norman Bryson points out:

> The Géricault portraits of the mad: from the first a contradiction, if the historic purpose of the portrait genre is to record the precise social position, a particular instance of rank in the hierarchy of power: the portrait of the insane is, therefore, an impossible object, a categorical scandal since the mad are exactly those who have been displaced from every level of the hierarchy, *who cannot be located on the social map*, whose portraits cannot be painted; Géricault fuses the categories together, of privilege and placelessness, society and asylum, physical presence and juridical absence.[5]

What Charcot learned from works such as Géricault's *Insane Woman (Malicious Mischief)* or *Insane Woman (Envy)* was not how malicious mischief or envy would manifest itself on the human face, but what the photographs as Salpêtrière should look like. The indefinite backgrounds, the luminosity of the lighting, the lack of distinguishing features of clothing all draw attention to the facial expression. Each picture is captioned as though the physiognomic determined the reading rather than the other way around. Thus, when looking at Géricault's *Envy*, the art historian Gardner sees:

> Géricault's *Insane Woman (Envy)* her face twisted, her eyes red-rimmed, leers with paranoid hatred in one of several 'portraits' of the insane subjects that have a peculiar hypnotic power as well as astonishing authenticity in presentation of the psychic facts. The *Insane Woman* is only another example of the increasingly realistic core of Romantic painting. The closer the Romantic involved himself with nature, sane or mad, the more he hoped to get at the truth. Increasingly, this will mean for painting, the *optical* truth, as well as truth to 'the way things are'.[6]

If this painting were called *Portrait of the Artist's Mother*, the 'optical truth' would be altered. What Charcot, an art historian as well, learned from Géricault was not 'authenticity in presentation of psychic fact', that is, Géricault as a visionary Romantic artist, seer of the truth of nature; what Charcot learned was a Renaissance notion of the artist as quantifier, instituting the visible into a rationalized system of perceptual codes. He published (with Paul Richer) two books on art, *The Demonic in Art* (1887) and *Deformities and Maladies in Art* (1889). The illustrations in the latter book are organized in categories, such as dwarfs and pygmies, cripples, epileptics, syphilitiques, and the possessed. For the most part, the selections were made from Renaissance paintings or paintings that utilized Renaissance perceptual codes: chiaroscuro, the explored view, the cutaway, linear perspective and the grid. Linear perspective achieved what Panofsky called a 'decompartmentalization' of the old medieval categories of things and recompartmentalized the natural and physical world into forms preparatory for scientific study. Art historian Samuel Edgerton notes that the grid was thought to facilitate 'mathematical, exact, impersonal, objective statements . . . producing identical meanings in all [viewers], referring to accumulative and repeatable effects.'[7]

Renaissance perspective based on projecting a grid plane to a single vanishing point has always been credited with enabling a new *realism* in picture-making, but it is more important for the way it influenced psychological perception, for the way it began to 'structure' the physical world. The cartography of Ptolemy and Toscanelli demonstrated that 'once the surface of the earth was conceptually organized into a rectilinear grid, it took on a new sense of conformity. It was no longer to be thought of as a heterogeneous assemblage of frightening unknowns.'[8] The actual geography of Ptolemy's map was extremely erroneous and seafarers continued to use the portolan sailing charts until late in the eighteenth century. These charts provided details of coastal features derived from seafarers who navigated the area, that is, they were maps of what had been seen, not an hypothetical space. Ptolemy's contribution was not to topographical knowledge, but to the science of measurement.

This device by which the world could schematically be represented was extremely useful to Europeans who needed to develop a visual language of property or territory in order to inventory their 'discoveries,' both actual and potential. This representational system was understood as the paradigm of divine order, as a device for the conquest of the physical world and as a practical tool for an imperialist venture. Tzvetan Todorov in his book *The Conquest of America* makes the connection between perspective and property in this way:

> It may seem bold to link the introduction of perspective to the discovery and conquest of America, yet the relation is there, not because Toscanelli, inspirer of Columbus, was the friend of Brunelleschi and Alberti, pioneers of perspective (or because Piero della Francesca, another founder of perspective, died on October 12, 1492), but by reason of the transformation that both facts simultaneously reveal and produce in human consciousness.[9]

The ascendance of scientific cartography only became possible when the language of property became so basic and taken-for-granted that it lost visibility. It is this '*belong to me*' aspect of representations, so reminiscent of property that Lacan reveals in his reflec-

tions on perspective – that bipolar reflexive relation by which, as soon as I perceive, my representations belong to me:

> It was Durer himself who invented the apparatus to establish perspective. Durer's *lucinda* is . . . a trellis that will be traversed by straight lines – which are not necessarily rays, but also threads – which will link each point that I have to see in the world to a point at which the canvas will, by this line, be traversed.
>
> It was to establish a correct perspective image, therefore, that the *lucinda* was introduced. If I reverse its use, I will have the pleasure of obtaining not the restoration of the world that lies at the end, but the distortion, on another surface, of the image that I would have obtained on the first, and I will dwell, as on some delicious game, on this method that makes anything appear at will in a particular stretching.[10]

Feminine Hysteria

I now return to the discussion of hysteria, the blind spot in the old dream of symmetry, by introducing the work of two contemporary artists who explore Charcot's attempt to bring something not subject to the rule of visibility into the system of 'presence' and representation. Nicole Jolicoeur and Mary Kelly examine the semantic field generated by Charcot's codification of pathological attitudes in terms of that 'delicious game.' The method that makes anything appear at will is used to explore not what appears, but the will itself, the authority that occasions the process of production, reproduction, meaning, mastery, and profitability.

Nicole Jolicoeur, an artist from Montreal, in 1981 began with a suite of pastiches from Charcot's tabulation of the stages of an hysterical fit, what he calls the '*grande attaque hystérique complete and régulière*' with typical positions and variations. These sketches of women in various contorted positions are arranged into twelve columns which are labelled alphabetically and then numerically subdivided into four phases: *période epileptoide, période de clownisme, période des attitudes passionnelles, période de delire.* Jolicoeur's gouaches entitled *Women in Hysteria (after Charcot)* rework Charcot's sketches into large-scaled and vividly coloured drawings which proceed linearily along a scroll. The image of the women's bodies become increasingly more chaotic as the scroll progresses, until the final body ends in a green scream. Jolicoeur replaces Charcot's system of classification with musical notations by Stockhausen. The horizontal axis reads: Evolution, Spiral, Adoration, Pause; the vertical axis reads: Tempi, Bet-gesten, Melodie, Dynamik, Klangfarben, Davern. The images of the women's bodies are rationalized in an equally arbitrary system, an aesthetic order of wholeness. But this superimposed choreography discloses the way in which the women were made to function at Salpêtrière as part of the performance of a mimetic theatre. 'We must not forget,' Copjec stresses, 'that the theory of hysteria was from the beginning a theory of mimesis – of the histrionics of the hysteric, their mimicry of physical diseases, and of the imitation produced by hypnosis. It is this fact which Lacan recalls in his elaboration of the mirror phase, which can only be seen as the grounding of the thetic, the positing and positioning of the ego and the object, in the Theatrics of the Imaginary.'[11]

Jolicoeur's second work on Charcot, entitled *Charcot: Two Concepts of Nature* is based on a series of seemingly accidental associations between photographs, sketches, charts and diagrams made by Charcot at Salpêtrière and those made by his son Jean-Baptiste, that documented his experience as an Antarctic explorer. The work consists of large drawings and a book. Jolicoeur appropriates the explorer's charts of J-B.'s 'natural resources' (the winds, the sea currents, and the stars) as well as his cartography of the Antarctic in which the undiscovered terrain is named after himself, or after his ship the 'Pourquoi Pas', or after his bitch 'Polaire'. These are drawn together in such a way as to suggest their similarity to J-M. Charcot's charts of women's bodies. J-B. Charcot's photographs of icebergs, ships, explorers, dog teams and so on, are photocopied, extended by colour and drawing, aligned according to their horizon lines, then provided with a unified vanishing point. (Here, Renaissance perspective is used to provide a plentitudinous picture of the terrain.) In splicing together several photographs in order to extend and complete the narrative, Jolicoeur is following J-M. Charcot, who put together several images of different women with 'incomplete' hysteria attacks in order to complete the desired cycle, to fill in the 'clinical picture'. The book which accompanies Jolicoeur's drawings continues this questioning of the putative unity of concepts, representations formalized in language which prescribe the 'order of things'. The codifications of reality made by the father and son are juxtaposed in a way that reveals the connections between the mapping of 'feminine hysteria' and 'terra incognita'.

Mary Kelly's work, *Interim*, uses Charcot's classifications of 'passionate attitudes' in a series of representations of aging, specifically, of women entering middle age. In place of Charcot's photographs of the positioned or observed woman's body, Kelly uses some emblematic article of her own clothing. The clothes are folded, opened or knotted and captioned as Charcot captioned the bodies: 'Menacé', 'Appel', 'Supplication', 'Erotisme', 'Extase'. In 'Menacé', the article of clothing is a black leather jacket. The narrative tells us that it is the orthopedic prop donned by the woman to signify 'artist'. For each attitude there are three positions which are captioned in a different typeface to illustrate the way sexual identity is constituted in a number of discourses, such as fashion and beauty, popular medicine, sexology or romantic fiction. The images (laminated positives on perspex) have a 'presence', that is, they cast a shadow on a fleshy pink background. These black images act as a mirror in which the viewer catches her own reflection. The reference, of course, is to Lacan's mirror stage:

> The *mirror stage* is a drama whose internal thrust is precipitated from insufficiency to anticipation – and which manufactures for the subject, caught up in the lure of spatial identification, the succession of phantasies that extends from a fragmented body-image to a form of its totality that I shall call orthopaedic – and, lastly, to the assumption of the armour of an alienating identity, which will rank with its rigid structure the subject's entire mental development.[12]

In *Interim* Kelly effects a displacement, that is, exhibits the neurotic symptom of hysteria. The identification with the woman observed is transferred to the article of clothing – a metonymy, not a presence. Each image is accompanied by a text, a compilation of over one hundred conversations with women – women listened to, rather than looked

at. There are various ways 'through' the texts: they can be read as 'inner speech', repeated preoccupying phrases, or unconscious thoughts. Some of the phrases have what looks like red lipstick drawn over them – elisions or emphasis. The first story is of a fortieth birthday party:

> you look great . . . well preserved . . . content . . . how old are you . . . she can't even say it . . . middle age . . . a phobia . . . what to wear . . . get it right . . . the uniform freedom . . . like a man . . . secure . . . surprised to catch a glimpse of myself as others see me.

The second story takes place in a family planning clinic as a male doctor examines an older woman who has come for an abortion:

> take off your clothes . . . don't want another child . . . won't listen . . . preoccupied with looking . . . at the facts . . . blind spot . . . being older . . . not wanting . . . to know . . . desires . . . can't wait . . . why is this woman so hysterical . . . ridiculous . . . get dressed.

In the third episode an older woman is at a dance with her students:

> want to dance . . . see myself . . . images grate . . . clothes . . . hair . . . expression . . . arms . . . hips . . . feel silly . . . everyone here so Goddamn young . . . reduced to a voyeur . . . hate them . . . turn them both into frogs and vanish.

If the mother who knows sexual pleasure, the subject of Mary Kelly's earlier work *The Post-partum Document*, is the most severely repressed 'feminine' figure in Western culture, then the middle-aged woman runs a close second. If the assumption of an image occasions desire, then middle age marks the occasion of the loss of that assumed image, of not being the object of man's desire, of being out of sync with how one looks, of alienation from one's image. It is precisely this transition in representation that links *Interim* to the *attitudes passionelles* of Charcot.

What the work of these artists discloses is that the image of the woman, the hysteric, is not a pedagogic prop, but a contested terrain. In his essay 'In Praise of Hysteria', Moustapha Safouan says: 'Wherever the hysteric goes, she brings with her a war, an ideological war . . . a war which we know has no object.'[13] All is endangered by a *nothing*, by what Irigaray calls 'a *hole* in men's signifying economy'.[14] A nothing that might cause the ultimate destruction, the break in the mirror that has always been charged with returning man's image to him. The hysteric has 'renounced being what men fight over',[15] renounced, that is, being the image of man's desire.

Notes

1 Jacques Lacan, *The Four Fundamental Concepts of Psycho-Analysis*, ed. Jacques-Alain Miller, trans. Alan Sheridan (New York: Norton, 1977), p. 75. Lacan is referring here to an observation made by Maurice Merleau-Ponty.

2 Ibid., p. 93.

3 Joan Copjec, 'Flavit et dissipati sunt', *October*, 18 (Fall 1981): 23.

4 Sigmund Freud, 'Charcot' (1893), *The Standard Edition of the Complete Psychological Works of Sigmund Freud*, ed. James Strachey (London: The Hogarth Press, 1962), vol. III, p. 12.

5 Norman Bryson, *Vision and Painting: The Logic of the Gaze* (New Haven, CT: Yale University Press, 1983), p. 143.

6 Louise Gardner, *Art through the Ages*, 7th edn (New York: Harcourt Brace Jovanovich, 1980), p. 737.

7 Samuel Edgerton, 'The Renaissance artist as quantifier', *The Perception of Pictures*, vol. I: *Alberti's Window: The Projective Model of Pictorial Information*, ed. Margaret A. Hagen (New York: Academic Press, 1980), p. 182. Edgerton is here quoting and taking issue with Harcourt Brown's thesis in his lecture 'The Renaissance and historians of science', *Studies in the Renaissance*', 7 (1960): 30. Panofsky used the term 'decompartmentalization' in a lecture delivered at (and published by) the Metropolitan Museum of Art in *The Renaissance: Symposium*, 8–10, February 1952.

8 For this section of my discussion, I am indebted to another article by Samuel Edgerton, 'Florentine interest in Ptolemaic geography as background for Renaissance painting, architecture, and the discovery of America', *Journal for the Society of Architectural Historians*, 33 (1974).

9 Tzvetan Todorov, *The Conquest of America: The Question of the Other*, trans. Richard Howard (New York: Harper and Row, 1984), pp. 121–3.

10 Lacan, *Four Fundamental Concepts*, pp. 81, 87.

11 Copjec, 'Flavit et dissipati sunt', p. 33.

12 Jacques Lacan, *Ecrits*, trans. Alan Sheridan (New York: Norton, 1977), p. 4.

13 Moustapha Safouan, 'In praise of hysteria', *Returning to Freud: Clinical Psychoanalysis in the School of Lacan*, ed. and trans. Stuart Schneiderman (New Haven, CT: Yale University Press, 1980), p. 59.

14 Luce Irigaray, *Speculum of the Other Woman*, trans. Gillian C. Gill (Ithaca, NY: Cornell University Press, 1985), p. 50.

15 Safouan, 'In praise of hysteria', p. 59.

Jan Zita Grover, 'Framing the Questions: Positive Imaging and Scarcity in Lesbian Photographs' (1991)

From *Stolen Glances: Lesbians Take Photographs*, ed. Tessa Boffin and Jean Fraser (London: Pandora Press, 1991), pp. 184–190.

Positive Images

Five years ago, I wrote an essay called 'Dykes in Context' in which I argued that lesbian images read differently for lesbian and non-lesbian audiences because, among other things, of the constraints on self-identification ('this is a portrait of me as a lesbian') and distribution that precede audience readings.[1] That argument was useful, as far as it went, because it was important to challenge dismissive views from both outside and inside lesbian communities which saw lesbian photographs as merely formally conservative, 'painterly' and idealising. But in thinking about a parallel situation surrounding

photographs made by Central Americans, I realised that the problem of subcultural positive imaging needed to be aired at greater length.

In 1985, I sat in the apartment of a friend who was helping put together an exhibition of photographs on Nicaragua. The exhibition was mounted in support of the Sandinista government; all those involved in the project had nothing but good intentions toward the state and people of that Central American nation. Yet as I watched, my friend rejected photograph after photograph made by Nicaraguans and Cubans in favour of photographs made by North Americans and Europeans.

Finally I asked why. A grimace, a gesture of impatience: 'They're *so sentimental*: laughing children, smiling peasants. They're *Family of Man*, salon photography. Definitely not cutting edge.'

That incident has stuck in my mind all these years, and now I know why. With the best of intentions, my friend was denying at least two important things: the aspirations of those Cuban and Nicaraguan photographers – their need (however compromised or impure it may have been) to see their own communities represented *as they wished them to be* – and the fluid nature of their meanings.

Photographs, we know, are not simply records of what has already taken place. In fact, outside of some snapshots, photographs usually function not as reflections of reality at all but as alternatives/enhancements to it: fulfilments of wishes, idealised models, what the late Raymond Williams might have termed 'subjective images' – photographs hurled toward the future cast ahead of us as visual guideposts to what we hope to become.

Think about the ways that photographs figure most prominently and institutionally in North American and Northern European cultures: as television programmes, magazine and newspaper illustrations; school, debut, engagement and wedding photographs, both moving and still.[2] None of these categories bears an indexical relationship to the life it purports to represent: instead, it hyperbolises, glamorises, nostalgises or sensationalises. *And always it radically simplifies.*

In the service of such motives as, for example, whetting appetites for consumption (advertisements) and reinforcing existing institutions (marriage and family photographs), photographs commonly propose the ideal as already present, as natural. In effect, they naturalise the unnatural – that realm of ideality – by giving it an illusory tangibility, a virtual presence.

It is because of this that most of us have such a stake in the terms and extent of representation; it is because of this that my friend the curator of (non)Nicaraguan photographs could fall quite easily into valorising only certain photographs as 'true', as having a useful potential. In her particular case, the 'truth' most valued was that of photographic process or mediation itself – of formal 'toughness', of television cool. The truth value of affirming the possibility of happy, laughing peasants living on their own land, of well-fed babies safe from war, seemed not as important. But both truths, I would argue, are equally subjunctive, for both tell us as much (implicitly) about *what is* as what could be. And both are equally subjective, for both tell us as much about their makers' desires as they do about the subjects within their frames.

Simon Watney, in writing about the necessity for reading photographs as more than simple records, emphasises the role of the unconscious in framing photographs:

Psychoanalysis refuses any notion of direct, unmediated vision, since it understands seeing as a constant site of unconscious activity . . . We cannot theorise the workings or nature of *remembering* without at the same time considering the systematic mechanisms of *forgetting*. Once we begin to think of both seeing and memory as primarily defensive and self-protective operations, saturated with fantasy, then the status of photographic imagery is affected rather radically.[3]

In effect, we must learn to look at representations both for what they forget and what they remember; photographic absences ('forgetting') are equally as meaningful as photographic presences ('remembering'). Thought about in this way, ordinary photographs – advertisements, say, for beauty products – are equally important for what they 'forget' (class, colour, sickness, old age, poverty) as for what they 'remember' (youth, health, wealth, Anglo-Saxon appearance and social power). 'Romantic comedies' are significant not only for what they 'remember' (the social and economic primacy of the heterosexual couple) but for what they 'forget' (the possibility of same-sex couples, social collectives, the single person).

In the same way, countercultural or subcultural positive images propose a complex 'forgetting' of present realities – a resistance to, say, the painful realities of war, powerlessness or poverty – and 'remembering' of possible alternatives: peace, security and affluence. Thus it is naïve – or very cynical – to dismiss positive images as merely sentimental or old-fashioned. To do so is to treat them as if they proposed no arguments, embodied no aspirations, reflected no ongoing struggles.

I know this is true of the first widely circulated lesbian images, which were formally conventional portraits of lesbian couples that attested to the wish for, *willed the existence of*, enduring couplehood. In the early 1980s I looked at many lesbians' photographs of their communities constructed according to these terms and I always found them affecting at this level of yearning, of desire. Conventional portraits set up their subjuncts as socially respectable individuals, as a socially respectable unit, in a custom stretching back to at least the fifteenth century in Northern Europe. The lovingly crafted portraits made by so many lesbian photographers in the 1970s and 1980s attested to the growing wish for legitimation, the longing for recognition, of individuals and couples in our communities. These images of single women and couples surrounded by their cats, dogs, plants and furniture embodied the desire to stay time, to make things as perfect as one wished they could be. These photographs frequently involved a second coming-out for their subjects, for they formalised their identity as lesbian and attested to their desire to maintain the social identity embodied in the photograph – whether as couple, homeowner, biker, what-have-you.

What these photographs did *not* very often subjunctively embody was a sense of lesbians as people for whom their sexual relationships to other women were determinants of identity both within and outside their primary communities. The entire topic of identity politics is far too complex to go into here; I'll remark only that the dominant strategy in North America[4] was to downplay the sexual component in the lesbian community and instead emphasise its spiritual or emotional basis (Adrienne Rich's 'the lesbian in all of us'). There are historic reasons for this particular emphasis – for example, the homophobia of heterosexual women within the women's movement, the wish to see women defined for once in terms *other* than sexual – that find their traces

in the almost rigorously asexual lesbian portraits of the period before 1986. But what these photographs managed to 'forget' – that sexual desire is what drives a great deal of lesbian identity – resurfaced (one is tempted to say, *with a vengeance*, as in: the return of the repressed) in the second half of the 1980s.

The form in which subjunctive discourses shifted was the sudden explosion of sexually explicit lesbian imagery. This is not to say that such images were not being made *before* the mid-1980s; among the lesbian photographers whom I interviewed while writing 'Dykes in Context' (1984–6), many mentioned that tucked away amid their negatives they had some pretty hot stuff. When I asked why they hadn't exhibited or published that work, all of them told me that they didn't think their communities 'were ready' to see it. The institutions through which their images circulated were, they thought, unable to accept sexually explicit lesbian photographs. And this has unhappily proved to be the case: with few exceptions, erotic/porn lesbian photographs have been circulated through a wholly different set of channels than earlier and more 'respectable' photographs were shown. *Objectification* – lesbian feminist for 'concentrating-on-body-parts-at-the-expense-of-the-whole-woman' – and other displacements away from desire function to police the boundaries of respectable lesbianism. Thus publications like *Off our Backs* in the USA and *Spare Rib* in Britain keep a kind of faith that is increasingly irrelevant to large numbers of lesbians, most particularly those who came of age after about 1978.

Increasingly, young lesbians are rejecting even the label *lesbian*; they are *queer*, they'll have us know, and *queer* transcends older categories of sexual and political identity. Older defectors are also donning silicon dicks, reliving the bad old days before the women's movement in masquerade – re-enacting butch/femme identities, the perils and pleasures of sexual/social pariahism. It is an invigorating time to be alive. And the photographs that explore these mutable, fantastic possibilities seem to me infinitely exciting. They are an augmentation to the existing visual arguments about what lesbians are and can be, just as Nicaraguans' photographs of laughing children and well-fed peasants are. No one has the right to censure these evocations of what is yet to be – lesbian sexuality as present, hot and inclusive.[5] These images, so frequently scorned as *pornographic* or *obscene*, are much more complicated than such dismissals suggest. They are before anything else idealising: they attempt to fix desire as iconically as formal portraits fix identity. Where scarcity existed, they propose plenitude: tattooed women, non-thin women, women of colour, physically disabled women, butch women, femme women. And this, I would argue, can only advance *everyone*'s agendas – from the delighted inventors of lesbian porn to the women who cancel subscriptions to *OUT/LOOK* and threaten in print to burn *On our Backs*.

The Problem of Scarcity

What are the usual effects of any form of scarcity? People hoard; people attribute immense value and power to whatever commodity has become or is designated as scarce. For example, diamonds are not actually scarce gemstones; it is the artificial scarcity created by the De Beers cartel that gives them their enormous metaphoric and material value.

In a similar way, subcultures that are consistently *un*-represented, *under*-represented or *mis*-represented[6] deal out of a scarcity of images that does not accurately reflect either their sense of current realities or their aspirations for future ones. I can think of no other explanation for the extraordinary passion – most of it, unfortunately, splenetic and censorious – that meets any but the blandest representations of lesbians or, for that matter, gay men, blacks and other socially marginalised peoples.

So few representations, so many expectations: how can any image possibly satisfy the yearning that it is born into? If a sexually explicit lesbian image depicts desire in the terms of a soft-focus greeting card, a significant portion of those among whom it circulates deride its sentimentality and sexual evasion: they want something to reflect *their* reality. If another photograph fixes desire through signs of otherness – for example, leather and sex roles – it will be decried by women who associate desire with romantic merging.

So few representations, so many expectations: the burdens of scarcity. Look at images of social and sexual identity for heterosexual women in, say, the movies. Does Jane X feel 'threatened' or 'oppressed' by the heroine of *Nine and a Half Weeks* if she is instead drawn to the heroine of a romantic comedy? Must the existence of Pauline Reage's *O* be obliterated because of its threat to women who prefer *Pride and Prejudice*? Does a giddy, drunken, flirtatious white woman in public leave her more sober white sisters feeling compromised, complicit, guilty? The likelihood is that she does not – there are so many available models *and examples* of public behaviour of white women that one embarrassing woman does not seem to imply shameful identity in others superficially like her.

In the case of a woefully under-, un- or mis-represented subculture, however, the unseemly behaviour of even one member – or one representation – carries a far greater significance, a much heavier burden. Here, there are few or no examples to provide counter-arguments for the centrality of this particular identity or behaviour. As a result, subcultures are more likely to actively police members' behaviour and representations than are dominant cultures. When was the last time you heard a lesbian (or a black woman) described as 'a disgrace to her community'?

When was the last time you heard a white person described as 'a credit to his/her race'?

I'd like in the light of the above comments to briefly discuss some sexually explicit lesbian images that were exhibited in San Francisco last summer. Kiss & Tell, a three-woman art collective from Vancouver, British Columbia, produced a wonderfully ingenious exhibition, 'Drawing the Line', that made the individual mechanisms of 'remembering/forgetting' and the collective consequences of subcultural scarcity stunningly clear.

'Drawing the Line' consists of a suite of sexually explicit photographs. The images depict a variety of sexual desires and practices ranging from hugging and soft kissing through whipping, bondage and voyeurism. The actors in all the photographs are two of Kiss & Tell's members, Persimmon and Lizard, while the third member, Susan, took all of them. The images ranged round the walls in an order running from the commonest expressions of affection to those that most viewers would regard as extreme. Kiss & Tell's wall labels invited viewers to consider where

they would 'draw the line' on what was erotic/permissible/pornographic. But unlike most gallery shows, which prevent viewers' reactions from becoming part of the exhibition's extended argument, 'Drawing the Line' invited spectators to write their reactions to the photographs and to the question of *drawing the line*, right on the walls. (Black pentels were supplied for this purpose.) But only women were invited to respond in this highly public manner; men were instead invited to write their comments in 'The Men's Book'.[7]

As a casebook example of the intersecting roles played by unconscious viewing mechanisms and scarcity of representation, 'Drawing the Line' makes several things a bit clearer. First of all, the comments scribbled on the walls were frequently more projective than descriptive. For example, viewers frequently overlooked the fact that *all* the photographs framed the same two models. Instead, they complained that the couple in a given photograph were less attractive, less 'hot' than the couple in a previous one. Or they objected to the 'loveless' interaction of one couple.

Such comments suggest that the site of interpretation was not so much the photographs' contents than the viewers' own mechanisms of 'forgetting' or 'remembering' catalysed by the photographs. Viewers who objected to the enacted representations of sado-masochistic sex were reacting *not* to *SM* but to a depiction of it designed to provoke response. They responded as if they were gazing through a keyhole and deriving guilty pleasure from it, reacting in rage toward other viewers' enthusiasm.

Watching lesbians cancel each other's work – including the framed photographs, which several times were scrawled across with big black pens – is not a pretty sight. Clearly it does not arise out of a wish to protect anyone else, to initiate a debate, to frame an argument. It arises out of complex individual resistances transmuted into social behaviours designed to assuage one's own dis-ease by projecting that dis-ease onto other viewers' experiences, which must then be monitored and censored. Instead of understanding these photographs as gestures toward wider possibilities, other futures, censors interpret them literally, naïvely, as if they were direct reflections of an already-existing world.

The second thing that becomes clear from looking at 'Drawing the Line' is that the stakes are terribly high because of the relative paucity of lesbian imagery, never mind lesbian sexual imagery. Although Kiss & Tell chose to limit its models for the series to the same two women in order to deflect debate from questions of the models' individual desirability (body type, age, colour, facial features, and so on), this decision was lost on many viewers – they either missed it entirely or rejected it. I believe this was a naïve hope on their part, given the burdens imposed by scarcity of representation. It was hardly likely that women of colour, non-thin women, women whose sexual valence was tall blondes or tiny Asians or muscular Latinas would be appeased by Kiss & Tell's decision to avoid addressing the part played by the specificity of desire, the paucity of their own presence, in one of the few projects to address lesbian desire and sexual practice so openly.

Were there thousands of sexually explicit lesbian images circulating unimpeded throughout our communities, such objections would not be voiced. But there are not, and this is precisely why lesbian feminists who would limit production and circulation even further are so far off-base. We need more, not fewer, sexual representations to

choose from: a greater variety of women to enact them, a wider range of practices to be enacted.[8]

But the current debates around lesbian porn, lesbian sexual and social representation may well become moot before long. A new generation of women whose primary sexual commitment is to members of their own sex is already rejecting the terms in which the debates have historically been couched. As *queers* (not *lesbians*), they claim affinity with men, transvestites, bisexuals, transsexuals – an entire panoply of self-defined sexual communities. They mean to go beyond our impoverished archives to create representations far more inclusive, far more transcendent, than my generation's. (Yes, I know, you're thinking: *they'll learn. They're young.* Thank god: *there lies possibility.*) They're making photographs. And they're only beginning.

Notes

1 J. Z. Grover, 'Dykes in context', in *The Contest of Meaning* (Cambridge, MA: MIT Press, 1990).
2 I localise because these are the only cultures I pretend to know anything about; I suspect that photographs function similarly in other places but cannot make a claim to know that.
3 Simon Watney, 'Introduction', in *The Image of the Body* (Cambridge: Cambridge Darkroom, 1988), n.p.
4 With the exception of Quebec, where French feminist theory held sway during the 1970s and early 1980s in a way that it would not in Anglophone Canada and the USA until later.
5 I don't know if this apocryphal tale is common in Britain as it is in the USA, but it is nonetheless telling: 'If you put a penny in a jar for each time a lesbian couple has sex in the first year of their relationship and then *withdraw* a penny for each time they have sex in subsequent years together, you will never get to the bottom of the pennies.' *QED*.
6 I am indebted to Douglas Crimp for this particularly pithy phrasing of the problem.
7 An all-too-short selection of Kiss & Tell's project appears in the fall 1990 issue of *OUT/LOOK*.
8 In the winter 1991 issue of *OUT/LOOK*, Julia Creet argues that it is gay male sexuality, not straight male sexuality, that provides the terms of new debates and practices within lesbian sexual communities.

7.2 Modernity and Postmodernism

Nicole Dubreuil-Blondin, 'Feminism and Modernism: Paradoxes' (1983)

From *Modernism and Modernity: The Vancouver Conference Papers*, ed. Benjamin Buchloh, Serge Guilbaut and David Solkin (Halifax: The Press of the Nova Scotia College of Art and Design, 1983), pp. 195–211.

The woman-paradigm has been ignored by all the major approaches to modernism, notably by structural linguistics which can be said to have provided contemporary critical thought with its most privileged models:

> even though early writers noted the difference in male and female linguistic usage, all linguists – or nearly all – act as if the question had never arisen: Saussure's notion of *langue*, and Chomsky's model of competence both seem to exclude the recognition of any such variance.[1]

American formalism, dominating art-criticism in the post-war decades, was equally unmoved by the rise of a feminine problematic. Defining modernism as an auto-critical enterprise leading to the definition of specificity of each art-form, formalism translated the history of art since Manet into Wölfflinian terms of formal evolutionary cycles of refinement; thus it impeded the possibility of a typically feminine contribution. In its dialectical history, in fact, formalism naturalizes the producer of art and deals only with the connections between works. One of the few women to be seriously dealt with is Helen Frankenthaler. Michael Fried analyses her work as a stage in a design problem inaugurated by Pollock's drips and completed in Morris Louis' work.[2] In an attempt to map all the significant productions of the plastic arts' constant self-renewal, formalism pursues an aesthetic of the masterpiece, linking the great masters of the present with the great masters of the past. The facts have shown clearly that for reasons other than entirely aesthetic ones woman and the category of the 'great master' have never gone together well.[3]

Yet even though formalist criticism is not too concerned with the artists, its vocabulary and its rhetoric none the less fashion 'personalities' to measure up to the works. An analysis of the terms used in Greenberg's criticism to talk about Pollock and his work shows a constant recourse to manifest male power. There the artist, full of energy, is defined by his forcefulness, his frustration, his innate violence – a rugged and brutal character reminiscent of the myth of the all-conquering American hero. The work itself is situated in the same terms: monumental, brave, intense, extravagant, and powerful.[4] So the difficulties Pollock's wife Lee Krasner had in affirming herself, and Greenberg's harsh judgement of her, should be no surprise. 'I never went for her paintings. She immolated herself to Pollock. Lee should have had more faith in herself and more independence.'[5]

The criticism itself is ultimately inscribed within a particular sexual politics. When the formalist critic does not show his blatant misogyny – as is often the case with Greenberg – he employs an objective discourse in which only his educated eye is apparent. Rosalind Krauss recalls Philip Leider's astonishment about her age.[6] The tone of formalist criticism made her seem older than she really was. And, without a signature, even the sex of the author could be mistaken. The cold authoritarianism and the judgemental imperialism, detached from the text, made the criticism seem not only 'old' but 'male'.

From the heart of the formalist fortress, then, it seems unthinkable to approach the problematic of feminine art. But recent transformations in the avant-garde are nonetheless provoking reflections on the place of the feminine dimension in art. For example, in America we have witnessed a theoretical and actual affirmation of women artists over the last fifteen years, sustained by an ever larger group of critics and art-historians. We can even see at the heart of the avant-garde a type of consecration relatively unheard of for women. Some women, like Eva Hesse, find themselves in the pantheon of the creators of contemporary art paradigms because of their specifically feminine practice, marked by the experience of a sexed body. Others, like Judy Chicago, are resolutely feminist, totally devoted (on formal, iconographic, material and socio-political levels) to the expression of 'femininitude'. Such a radical position would once have earned no more than a *succès de scandale*. But it was an almost academic reception given by the spectators who lined up in close ranks for a long wait, their heads buried in huge catalogues, to see the tables for *The Dinner Party* at the San Francisco Museum.

Women avant-garde: we can sense today the formation of a new and forceful alliance whose complexity has not yet been thoroughly examined and which at first sight seems to have found a paradoxical formulation. Must the woman-paradigm be considered as the model rupture, the total 'other', the definitive subversion that will finally reconcile aesthetics and politics? Does its forceful arrival on the contemporary art-scene mark an assault on an enemy territory that must be conquered and rebuilt on better foundations? Or is not the avant-garde itself undergoing profound changes in its postmodernist phase,[7] its new configurations corresponding exactly to the problematics of women's art? Will that art be simply another chapter – albeit a chapter particularly rich in plastic propositions – of the dominant art that is now creating history?[8]

The question of women's relations to contemporary art was implicitly allowed at a conference in Montreal in September 1979. Although the position of women had been solicited (with Lucy Lippard as its representative), it had no real official voice and was not discussed as such. Yet it made itself felt beneath each critique, each explanation of the classic notions of American formalism. Formalism was attacked for its rationalist imperialism and authoritarianism, and found itself trampled beneath appeals to the emotions and to the imaginary. Its classic formal analysis was threatened by the infiltration of new, more autobiographical substance; art was beginning to entertain more open and more ambiguous structures.

The dogma of the specificity of medium and of the flatness of surface was to be replaced by a real critical function that would attempt the insertion of art into the social (trying to avoid the traps of a party line, however). At the source of this interrogation of formalism we find the fractured condition of contemporary art-practice: fractured, in the sense that its multiple aspects by far exceed the traditional categories while none of these aspects is dominant (the formalism of the fifties and sixties related above all to painting); these are fragmented and individual propositions, appearing to escape any form of categorization or grouping. Ultimately, in the background of an artistic map peppered with islands, we find a change in the relation between artistic and political power: this marks the end of the unilateral and preponderant influence of the United States over the western world.

Within this new geography there seems to be room for the feminine problematic. [. . .]

Notes

1 Anne-Marie Houdebine, 'Les femmes et la langue,' *Tel Quel*, 74 (Winter 1977).

2 Michael Fried, *Morris Louis* (New York: Abrams, 1967), p. 11.

3 An excellent article on this question is Linda Nochlin's 'Why have there been no great women artists?', in *Art and Sexual Politics: Women's Liberation, Women Artists and Art History*, ed. T. B. Hess and E. C. Baker (New York: Macmillan, 1973), pp. 1–39.

4 Nicole Dubreuil-Blondin, 'Number one,' in *Jackson Pollock: Questions* (Montreal: Musée d'Art Contemporain, 1979), p. 64.

5 Quoted by Cindy Nemser, 'Lee Krasner's paintings, 1946–1949', *Artforum* (December 1973): 64.

6 Rosalind Krauss, 'A view of modernism,' *Artforum*, 11 (1) (September 1972): 48.

7 The term 'postmodernist' is used here in preference to 'postmodern' so as to mark its provenance in the American context which is the ground of the present article in respect to both the body of art and the theory dealt with.

8 Even if postmodernism is regarded by some theoreticians as marking the end of history, or at least of an evolutionary concept of the history of modernity in art, and even if institutions and markets are in some way confused by the complexity of contemporary artistic productions, we must still recognize that recent trends in art nonetheless are consecrated by the media and institutions (even video and performance have their exegetes just as Post Painterly Abstraction did in its time; art works will perhaps pass into the history of art without a plastic 'aura' but with a theoretical aura that has been constructed around them).

Amelia Jones, ' "Post-feminism":
A Remasculinization of Culture?' (1990)

From M/E/A/N/I/N/G, 7 (1990), pp. 29–40.

> The most important question . . . is whether . . . feminism is coopted by being har-
> nessed to other discourses which neutralise its radical potential.[1]

As developed in the last twenty-five years, feminism and its corollaries, feminist art and
art criticism, are critical perspectives that offer multiple positions and strategies as a
means to critique and disrupt patriarchal practices on political, economic, and cultural
fronts. The critical goals of feminism are thus nothing short of the dismantling of
patriarchy's strategies of ideological and institutional repression. Given these goals, it
is clear why patriarchal formations would have a large stake in repressing or diffusing
feminism's various voices.

I shouldn't have been surprised, then, by the title of a recent article on postmodern
art by critic Dan Cameron – 'Post-feminism.'[2] Perhaps too insulated by my own iden-
tification with the theoretical promise of various feminist positions, however, I *was* taken
aback – and since that time, my dismay has grown as I have encountered this term more
and more frequently in the art and popular presses. What is 'post' but the signification
of a kind of termination – a temporal designation of whatever it prefaces as ended,
done with, obsolete?

To make matters worse, this determination of an end to feminism, most often
articulated by male critics who congratulate themselves for their attention to art by
women, is revealing itself to be part of a larger discursive project (one that appears to
be spreading like a voracious fungus) to appropriate feminism into the larger (mascu-
line) projects of 'universal' humanism or critical postmodernism. This subsumption
is certainly a strategy of negating feminism's specific political power – its perceived
potential to undermine the theoretical certainties that continue to validate American
cultural discourses, including, it seems, that of 'postmodernism,' though the latter
defines itself as having left these certainties behind in its modernist wake.

Evidence abounds of this insidious reworking of feminism, which can certainly be
seen as part of a broader socio-political shift toward a newly entrenched patriarchal for-
mation in the 1980s, 'in which the new masculine affirms itself as incorporating . . . the
feminine.'[3] The texts I examine here work to reinforce and (re)produce increasingly
hegemonic patriarchal relations of domination in society at large.[4] They represent the
dominant postmodernist cultural discourse, one that continues to empower itself
through a modernist 'aesthetic terrorism'[5] that hierarchizes art on the basis of tradi-
tional categories of value and negates that which threatens its hegemony through
various means. These texts operate first to arrogate feminism into a universalist
'mainstream' or into postmodernism (as one radical strategy among many available
to disrupt modernism's purities); they then work to proclaim the end of feminism
altogether, gen(d)erously celebrating its welcomed inclusion into the humanist canon

or into a supposedly widescale, already achieved radical project of postmodernist 'cultural critique.'

While the former gesture is more easily identifiable as coming from a center or right position within art discourse, the other strategy is more difficult to recognize and negotiate, since it often comes from well-meaning critics who position themselves as 'left.' Even some well-intended arguments articulated from a feminist perspective feed into this dynamic by praising feminism as a useful tool for postmodernism; this allows for the subsequent conflation of the two into an exhausted leftist category of 'anti-authoritarianism,' with texts viewed as inherently critical if they fall into this category of 'radicality.'[6] Or feminism is lumped with civil rights and other specific protests as merely a 'jargon' taken up as a means of empowerment: thus Fredric Jameson includes feminism as an example of the 'stupendous proliferation of social codes today into professional and disciplinary jargons, but also into the badges of ethnic, race, religious, and class-refraction adhesion.'[7]

Before discussing the trajectory this move has taken specifically in art discourse, let me submit evidence, from the popular media, of this 'remasculinizing' strategy in its visual and textual structuring of gender roles.[8] Using a position offered to me by feminist cultural theories,[9] I will analyze an example of public representations of the feminine and feminism to identify points of rupture where ideological inconsistencies come through in the form of unconsciously gendered language and logical confusion.

What can the *Time* cover story of December 4, 1989,[10] then, tell us about current construals of feminism? 'Women Face the 90s,' the cover reads in bold yellow letters; it continues, less favorably, in white: 'In the 80s they tried to have it all. Now they've just plain had it. Is there a future for feminism?' Our first warning should be the very fact that this mouthpiece of reactionary journalistic 'objectivity' posing as middle-of-the-roadism chooses to spotlight (the death of) feminism.

The accompanying image is a further warning sign, but an intriguingly ambiguous one: filling the red bordered cover is a wooden block on which is drawn a very boxy (one could say 'masculine') woman's body, Caucasian of course, in a severe business suit. Appended are stubby feet, a blockish head with quite 'mannish' features, and crudely carved hands, one tensely clutching a briefcase, the other (attached to a fleshy, peasant-like arm) a child also carved of wood. We are graphically presented with the dilemma of the 90s woman (that is, the white upper-middle-class woman): the restrictive choice between having a child, and by extension a procreative life of the flesh, and the alternative, a (non) life of the coarse, brutal face and the obliterated body, hidden by masculine clothing – signifiers of what a woman must sacrifice, must *become* in order to achieve (masculine) 'success.' But this image, a kind of mysticized voodoo or votive figure, is rendered in the folksy medium of handcarved and painted wood that links the two terms: the 'feminine' and the atavistically 'primitive.'

Inside on the title page, there is a photograph of pro-choice advocates on the mall in Washington with their banners and raised fists, trapped, ironically, behind a chain link fence (the 90s equivalent of the Delacroixian barricade?). The accompanying caption reads: 'The superwomen are weary, the young are complacent. Is there a future for feminism?,' and continues in smaller type, 'some look back wistfully at the simpler times before women's liberation. But very few would really like to turn back the clock . . .' The second sentence in the smaller type indicates that perhaps the 'end' of

feminism is not as conclusive as the bulk of the textual and visual codes would suggest. The text naturalizes what is being questioned by preceding its acknowledgment of the possible continuation of feminism with the 'weary,' and 'complacent' attitude of today's women. Furthermore, the assumption that the 'pre' feminist phase was 'simpler' goes unchallenged and is doubly insidious by its casual placement. Here the masculine basis of judgment is laid bare, for it is certainly *men* who would find the monolithic dominance of pre-feminist patriarchy 'simpler.' For women, life under patriarchy has always been complicated by our ambiguous relation to our own domination.

The term 'post-feminist' is used here to describe the rejection of feminism by younger generations of women as a result of their realization that women can't (what a surprise!) have it all. To naturalize this rejection as logical, the article confirms for us that 'motherhood is back.' In this way, hoping to encourage an image of younger women's enthusiastic subscription to American narratives of the familial, the article constructs for these women the desire for a secure position of femininity (remember, it is 'simpler'). By presenting these ideas as *a priori* facts, the *Time* writers avoid the appearance of validating them as right. Yet their language manipulates the reader into accepting these terms that call so innocently for a return to a 'simpler' previous state. In the same moment that they appear to 'ask' innocently if there is 'a future for feminism,' they effectively preclude any consideration of this 'future' with their term 'post-feminist.'

Finally the article confirms the sensibleness of the supposed rejection of feminism by explaining that, after all, 'hairy legs haunt the feminist movement, as do images of being strident and lesbian. Feminine clothing is back; breasts are back . . . [and] the movement that loudly rejected female stereotypes seems hopelessly dated.' So it's all about *looks*, as usual, when women are the question.

The *Time* article is one among innumerable examples of popular culture text's construction of feminism as a unified, precisely articulated attack on the American family.[11] This in turn produces the necessity for its obliteration – in order to enable the 'return' to a previous state of 'simplicity,' once feminism's shortcomings have revealed themselves. 'Post-feminism' in this context, then, means anti-feminism – the appropriation of feminism as a theme and then its brutal repression as failed and so implicitly over.

Predictably, there are parallels to this dynamic in art writings of the 1980s, where a similarly motivated discursive appropriation and negation of feminism as 'post' has also been pervasively deployed. The decade began with Mary Kelly's article 'Re-viewing Modernist Criticism' which showed the potential of radical feminist critical theories and art practices to *dismantle* patriarchal modernist systems of exhibition and interpretation by deconstructing the centered subject from which art historical modernism drawns its authority. However, a precedent for discussing feminist art practice as one among several means of critiquing modernism had also already been established. Even Kelly writes of feminism only near the end of her article, positioning it as one possible parameter of a broad 'Crisis in Artistic Authorship.'[12] In addition, other counter-discourses maintained from earlier modernisms were already at work, operating actively to recuperate the feminist project back into a mainstream (white, Western, male) humanist or critical theory project.

A discursis on this idea of 'mainstream,' a notion complicit with the assumption of a masculine 'norm,' is in order here. A recent exhibition catalogue is entitled *Making their Mark: Women Artists Move into the Mainstream 1970–1985*.[13] Even aside from the obvious phallic connotations of 'making a mark,'[14] and the quite amusing if somewhat horrifying fact that the catalogue and exhibition were sponsored by Maidenform, we can ask: what does the term 'mainstream' imply as an ideological field? As revealed in the title of the exhibition and catalogue, the show relied on the premise that women artists desire to enter a 'mainstream.' And, while not necessarily problematic in itself, the show's bringing together of works by women artists with diverse – even contestatory – positions (from Miriam Schapiro to Sylvia Sleigh to Sherrie Levine) raises the question of the meaning and political efficacy of the category 'women' as a means of grouping art works.

Arthur Danto's review of this exhibition in *The Nation*[15] activates the assumptions embedded in the term 'mainstream,' making clear the potential problems presented by the exhibition. Danto recognizes that the show raises as many questions about the 'mainstream' as it does about the 'artistic relevance of the eighty-seven artists' all being female,' but he fails to go beyond this basic acknowledgement. The question for Danto becomes, 'whether this particular period, and hence this particular mainstream, was made to order for women, even if the work in question might not have any especially feminine – or feminist – content.' For Danto, there must have been 'something in the times, in the structure of the art world, that made this female ascendancy possible and even necessary . . .'

Danto seems to think of women artists in terms of an *a priori* patriarchal mainstream. This norm, which he calls a 'prescribed line,' consists of the American genealogy of male artistic 'tradition,' from the Abstract Expressionists through to the Minimalists and beyond. While he admits that Miriam Schapiro 'found a certain liberation from the very idea of this [prescribed line] in feminism,' the assumption of a firmly drawn, pre-existing 'line' is still intact. For Danto, Schapiro isn't different after all from the (male) artists already in the line: 'much the same moral revelation was being made all across the art world, if not through feminism then through the discovery that not only had the old dogmas died but the very idea of dogma was itself dead.'

He concludes by *eliding* feminism with any number of 'radical' critiques, stating that what *allowed* feminism its efficacy in changing the art world[16] was 'poststructuralist philosophy, with its possibilities of ultraradical critique.' He continues, '[a]nd from this perspective women did not so much enter the mainstream as redefine it, and the *men* who entered it were more deeply feminist than they could have known.'

Danto tells us that feminism required the outside impetus of poststructuralism to make it truly itself but he implies, conversely, that its goal has been *not* to critique phallically invested hierarchies of art history, but merely to fit art by women into the mainstream 'line.' And, while he allows that women have 'redefined' this mainstream, he claims that men are also 'deeply feminist.' Through this rhetorical strategy, Danto subsumes both male and female artists into a larger (masculine) 'critical' project. Feminism does not, for Danto, have a specific critical position *vis-à-vis* notions of 'mainstream' – it is simply one of many refigurings of this mainstream which is thus left more or less intact.

Since Danto's article appeared, *The Nation* has printed a letter by Kathy Constan-
tinides critiquing his piece along with a reply by Danto.[17] Constantinides mentions
several editorial slights and personal inconsistencies in Danto's account of the exhibi-
tion and she critiques Danto for his tendency 'to universalize, which is to say, replicate,
the male standard/language.'

Danto's reply testifies to his own stake in maintaining his critical authority and
dominance over feminist voices. He astutely answers her first complaints, but in
response to Constantinides' claim, phrased in extremely gentle terms, that he has unwit-
tingly reinforced gender stereotypes through his language, Danto replies that: 'it is
possible to raise consciousness to a height from which nothing said by males can be
other than invidious. This will be the case if the very language we all use is, somehow,
"male oriented." This may take an extreme form – seeing, for example, in "universa-
lization" a form of male-centered discourse.'

In claiming that language structures 'cut across the differences between the
genders and touch us in our essential humanity,' Danto promotes the reduction
and erasure of feminism as a part of a broader humanist project. His seemingly
willful misunderstanding of the gendered nature of language and of the bias of a
notion such as 'mainstream' allows him to imply that women should feel honored to
be considered a part of the humanist project, not as subjects capable of producing their
own counter-discourses to it, but as passive objects of its generous ('genderless')
embrace.

Another related means of negating feminism is the appropriation of feminist theory
as merely one 'postmodernist' strategy among many to critique modernist ideologies.
Craig Owens' often cited article 'The Discourse of Others: Feminists and Post-
modernism'[18] is an instructive example here. While Owens presents in a concise and
polemical way some of the major issues confronting feminist theory, his discussion
places it in the same field as the 'postmodernist critique of representation': the two dis-
courses have an 'apparent crossing,' and his essay is thus a 'provisional attempt to
explore the implications of [this] intersection.' He astutely calls for a recognition of
feminist art as explicitly operating to disrupt traditional configurations of sexual
difference, critiquing, as I do here, writers who 'assimilat[e feminism] to a whole string
of liberation or self-determination movements.'

And yet Owens' approach is symptomatic of what must be seen as an ultimately
anti-feminist appropriative strategy. He begins by placing feminism and postmodernism
in the same space, describing 'women's insistence on incommensurability' as 'not
only compatible with, but also an *instance of* postmodern thought' (my emphasis).
Owens then further dilutes feminism's specific agenda by appropriating Lyotard's terms
to describe its goal of critiquing 'master narratives' as commensurate with (and so
implicitly included within) the goals of postmodernism: 'this feminist position is also
a postmodern condition.' And finally, he reduces feminism to simply another of the
'voices of the conquered,' including 'Third World nations' and the 'revolt of nature,'
that challenge 'the West's desire for ever-greater domination and control.' Without
seriously questioning his role as male critic, Owens takes up the position he believes
to be offered by feminism to empower his own construction of a field of intersection
that ultimately subsumes feminism into the postmodernist critique of 'the tyranny of
the signifier.'

There is a complex background for this understanding of the potential of *the feminine* or *feminism* to disrupt 'modernist purity,' understood in most of these texts as the Greenbergian assumption of the self-sufficiency of the modernist signifier to contain within it transcendent meaning regardless of its context or enunciative situation. This understanding has been primary in American art discourse's self-conscious deconstruction of modernism and construction of postmodernism in its place as a radical, feminized alternative to the phallic closures of Abstract Expressionist modernism.[19]

Early descriptions of work that would later be labelled 'postmodern' – Susan Sontag and Calvin Tomkins, for example, on so-called 'Neo-Dada' art – are structured by gendered systems of oppositions; thus Sontag, in her well-known article on camp,[20] associates neo-Dada with what she calls the 'camp sensibility,' which she characterizes as a homosexual sensibility of decadence, artificiality, and effeminacy and opposes to the virile certainties of Abstract Expressionist ideologies. More recent theories of modernism – some explicitly feminist in their approach – have identified postmodernism with the anti-phallic merging of feminized mass culture with so-called high art, interpreting this blurring of boundaries and destruction of dichotomies as a feminist-inspired project.

Andreas Huyssen's article, 'Mass Culture as Woman, Modernism's Other' (1986),[21] for example, defines modernism as a 'reaction formation' arising out of a fear of the feminine 'other' of mass culture. For Huyssen, postmodernism is a specifically American phenomenon that began in the 1960s[22] and has the radical potential of *dissolving* these boundaries modernism sets up between itself, as 'high' culture, and what it perceives as a feminine mass culture. For Huyssen, feminism – as the heir of the 'avant-garde's attack on the autonomy aesthetic' – is one of many potential forces to produce a 'postmodernism of resistance' (those forces include the ecology movement, new social movements in Europe, and non-Western cultures) that will break apart modernism's hierarchies to allow (male) critics like Huyssen a critical foothold.[23]

While articles such as Huyssen's have been important for feminism's negotiation with modernist art history, unfortunately, these positionings of feminism as a strategy *within* a larger postmodernist project have unwittingly contributed to the incorporation of feminism into postmodernism as, in Owen's words, an 'instance of' the latter. And it is this incorporation that has facilitated the declaration of the end of feminism with 'post-feminism' rising from its ashes.

What is 'post-feminism' in art discourse, then? Dan Cameron, who tends to slide back and forth between the terms 'feminism' and 'post-feminism,' uses the latter broadly to encompass all art by women in the late 1980s that uses 'structuralism to critique social patterns in terms of social domination,' and sees it as a result, in part, of 'the increased commodification of the art world in the late 70s, and the adjustment of world capital to a global order based on information distributed through advanced technology.' Under the rubric 'post-feminism,' he discusses women artists as diverse as Barbara Kruger and Susan Rothenberg. Cameron even claims that 'there is by no means a dearth of male artists working from these identical premises,' which he defines as the acknowledgment of the contingency of art as language.

One wonders why Cameron references this art through the term 'feminism' at all, and, furthermore, why this feminism is deemed to be 'post.' It seems to prove yet

another example of the use of feminism as a term of radicalization to be subsumed into a broader field of cultural critique. Cameron's 'feminism,' or rather its reincarnation as 'post,' is increasingly confused – it appears any female can be (and, perhaps, necessarily is) 'post-feminist' just by virtue of her sex. But men seem to be able to appropriate this radicality easily too. Cameron also discounts the explicitly feminist in their work by placing these artists in a masculinist genealogy of avant-garde critique: 'following on the heels of Pop,' they then become the 'sources' for male artists Jeff Koons, Peter Halley, and Philip Taaffe, whose works, Cameron admits, are – no surprise here – 'more vociferously' collected than those of their supposed mentors (matriarchs?), the 'post-feminists.'

Andy Grundberg's article 'The Mellowing of the Post-Modernists'[24] provides another example of the reduction of feminist messages by their identification with generalized or even anti-feminist strategies. Here, with obvious signs of relief, Grundberg praises postmodern artists as having 'mellowed' such that they are 'more willing to allow their audiences some unalloyed visual pleasure' with new works that are 'more viewer friendly than those of 10 years ago.' Lucky for us viewers, then, Laurie Simmons has 'polished and refined' her 'message' (perhaps that of 'hairy-legged' feminism?) to produce 'more fully realized' art. These new, 'polished' works are her recent photographs of commonplace objects with a doll's clearly *female* legs (which Grundberg identifies only as 'humanoid and endearing').

Again, whatever feminist message Simmons is trying to make is elided: the critique of a modernist notion of the female body as commodified object on display is not new, nor is her approach particularly subtle – how could Grundberg miss it except willfully? Grundberg, who prefers to let these 'endearing' objects seduce him with their 'more fully realized' voluptuousness, refuses to acknowledge their gender specificity.[25] Furthermore, he conflates the photographs of Simmons, which draw directly on gendered codes of representation, with the overtly non-feminist – the nostalgic macho thematics of Richard Prince's slick fiberglass re-creations of car hoods, and with a work that deals with patriarchy in a more oblique way – a recent piece installed by Louise Lawler at Metro Pictures in New York.

Grundberg is cheered also by Lawler's work, a series of photographs of paper cups labelled with the names of Senators who voted to support the Helms proposal to block federal funding for AIDS information and prevention. Grundberg sees this work – which was quite austere to this viewer's mind – as evidence of Lawler's beginning 'to shed what some consider an icy conceptual reserve.' Whether or not we agree with his assessment of the Lawler installation, we can see that seduction, apparently, is 'in' – and the specific political message is erased beneath the overall pleasurable effects the objects provide.

Grundberg seems to deny the possibility of a work of art that is both *sensual* and *conceptual* or politically critical at the same time – a possibility that feminist artists have continually explored and have a high stake in maintaining, since such a work breaks down the rigid divisions required by modernist notions of criticality. As articulated by Grundberg, this emphasis on *seduction* serves to *produce* the (female) artist as sexually manipulative, as a tease who has finally shed her 'icy conceptual reserve' (her 'strident' feminist ideas?) in favor of acting from her body as a woman should. If the art is seductive, she's seducing. In reading the work this way, Grundberg refuses to acknowledge

the difficult conceptual challenges the work poses for patriarchy's formations of power – its critique of the government's hostile stance toward homosexuals as Others of the white male heterosexual establishment.

This process of transforming the woman artist into seductress as a means of opposing her to the cerebral confirms the mastery of the thinking male 'analyst'; it has an accomplice in the criticism that deflates feminist art's disruptions of systems of sexual difference by interpreting the art in other terms. For example, Barbara Kruger's pointed interrogations of patriarchy (as in her 1981 images with texts such as 'Your comfort is my silence,' or 'Your every wish is our command') are often interpreted as generalized critiques of the frame, artistic originality, and modernism's claim for the signifying wholeness of the image. And Sherrie Levine's astutely engineered deflations of overblown masculine myths of authoritative creative genius, her deftly phallic appropriations of works by modernist masters and reinscription of them as her own, are reduced to non-specific critiques of the institution of authorship. Kruger and Levine are claimed only to be using 'photography conceptually to ask questions about the source and presentation of images in our culture.'[26] And Levine's work is seen as motivated only by a desire to 'represent the idea of creativity, re-present someone else's work as her own in an attempt to sabotage a system that places value on the privileged production of individual talent.'[27]

Even Cindy Sherman's incisive critiques of the visual construction of the feminine – as em-bodied object, photographically frozen within gendered positions of vulnerability in her untitled film stills; or as, in her more recent works, monstrously overblown in the very clichéed 'darkness' of her sexual unknown, barely visible as reflected, for example, in the lenses of sunglasses, lying on dirty ground strewn with nasty signs of sex and human excretions – these are construed as 'universal' laments on the condition of humanity. In Donald Kuspit's words:

> Sherman's work has been interpreted as a feminist deconstruction of the variety of female roles – the lack of fixity of female, *or for that matter any*, identity, although instability seems to have been forced more on women than men. . . . But this interpretation is a very partial truth. *Sherman shows the disintegrative condition of the self as such, the self before it is firmly identified as male or female*. This is suggested by the indeterminate gender of many of the faces and figures that appear in these pictures, and the presence of male or would-be male figures in some of them. Female attributes – for example, the woman's clothes in one untitled work . . . – are just that, dispensable attributes, clothes that can be worn by anyone. The question is what the condition of the self is that will put them on . . . (my emphases).[28]

In this article – aptly entitled 'Inside Cindy Sherman,' and fittingly reprinted in his book *The New Subjectivism* – Kuspit proves my point with a final flourish. Not only, being 'inside' her, does he know the artist better than she does herself (for how else could he 'know' that what appear to be feminine attributes – women's clothing, a female authorial name, and even bloody panties – are really things 'that can be worn by anyone'), but also he believes to have penetrated into this interior via a massive set of pre-poststructuralist metaphysical tools: geiger counters for registering the mysterious univeral truths that encompass and negate Sherman's feminist themes. (What are 'would-be male figures' anyway? And what about Sherman's obsessive inclusions of

herself – exaggeratedly as woman – in, or rather *as*, these works?) Sherman's insistence on her otherness, as 'symptom' of masculinity's uncertainties about itself, is folded back into a narrative of universal (masculine) positivities.

Kuspit seals our confidence in his ability to manipulate brilliantly art history's time-honored methods in summing up: 'It is this artistic use – her wish to excel with *a certain aesthetic purity* as well as to represent inventively – that reveals her wish to heal a more fundamental *wound* of selfhood than that which is inflicted on her by being a woman' (my emphases). We women are encouraged to assure ourselves that this bleeding WOUND is nothing for us to worry about – everyone has it. And Sherman is to count herself lucky that, in a great irony of misreading, Kuspit employs his great (phallic) authority to validate her works as 'aesthetically pure.' Then he can congratulate himself as well for 'understanding' this art not as feminist but, even better, as moving *out of* the narrow strictures that feminism necessarily enforces, to the wide expanse of the universal. This appears to be the final effect of a construction of feminism as 'post.'

Through the preceding argument, I have examined the insidious project currently at work to dis-arm feminists, coaxing us into sympathy with the broad postmodernist project by flattery, then extinguishing our tracks behind us. While we are offered a 'new subjectivism,' this gesture obliterates our sex and anti-sexism by so generously/genderlessly including us as part of the 'universalist' subject of the art of the 1980s (a subject curiously textually determined in Kuspit's article by the pronoun 'he'). We must be wary of this gesture of inclusion, resisting the masculinist seduction that produces feminism as subsumed within a critical postmodernist or genderless universalist project. We must refuse what Jane Gallop calls 'the prick' of patriarchy, which operates to remasculinize culture by reducing all subjectivity to the 'neutral subject . . . [itself] actually a desexualized sublimated guise for the masculine sexed being.'[29]

Notes

1 'Introduction' by Lorraine Gamman and Margaret Marshment to *The Female Gaze: Women as Viewers of Popular Culture* (Seattle: The Real Comet Press, 1989), p. 3. This book contains two essays particularly salient to my topic: Janet Lee, 'Care to join me in an upwardly mobile tango: postmodernism and "the new woman"', and Shelagh Young, 'Feminism and the politics of power: whose gaze is it anyway?'

2 *Flashart*, 132 (February/March 1987): 80–3.

3 Susan Jeffords describes the 1980s in these terms in her remarkable study of the gendering operations of popular texts on Vietnam, *The Remasculinization of America: Gender and the Vietnam War* (Bloomington, IN: Indiana University Press, 1989), p. 138. She sees the past decade as a climax of the increasing 'remasculinization' of American culture from the late 1960s on.

4 I take this notion of 'hegemonic formation' from Chantal Mouffe, who describes it in these terms in 'Hegemony and new political subjects: toward a new concept of democracy,' trans. Stanley Gray, in *Marxism and the Interpretation of Culture*, ed. Cary Nelson and Lawrence Greenberg (Urbana: University of Illinois Press, 1988), pp. 89–101. See also the extended study of hegemonic formations in her collaborative book with Ernesto Laclau, *Hegemony and Socialist Strategy: Towards a Radical Democractic Politics*, trans. Winston Moore and Paul Cammack (London: Verso, 1985). Unfortunately, Mouffe weakens her call for resistance to hegemonies by conflating different positions of resistance, including feminism, into a generalized notion of 'democratic struggle.'

5 In her article 'Figure/ground', $M/E/A/N/I/N/G$, 6 (1989): 18, Mira Schor introduces this notion of 'aesthetic terrorism,' with reference to Klaus Theweleit's theorization of the texts of European leftist political parties. Theweleit discusses their dependence on *exclusion* to devalue that which threatened their authors' phallic boundaries of subjectivity. See his *Male Fantasies Volume 2, Male Bodies: Psychoanalyzing the White Terror* (Minneapolis, MN: University of Minnesota Press, 1989), p. 418.

6 This is typified by such critics as Hal Foster, who delineates two clear lines of postmodernism based on an implicit attitude of criticality: a reactionary postmodernism of pastiche (usually associated with architecture), and a radical postmodernism of deconstructive strategies. Ultimately his value system is based on circular reasoning. It relies on a notion of criticality implied to be immanent in the work itself, as intended by an absent author, but this criticality is actually determined to be structurally present by the empowered interpreter her/himself. See '(Post) Modern Polemics', *New German Critique*, 33 (Fall 1984): 67–78.

7 Fredric Jameson, 'Postmodernism or the cultural logic of late capitalism', *New Left Review*, 46 (July–August 1984): 65.

8 One way of viewing popular press constructions (or erasures) of feminism is proposed by Laura Kipnis, who argues that it is the left's abandonment of 'narratives of liberation,' and its scorning of mass cultural venues as commercial and so presumably complicit with the capitalist bureaucracy, that has enabled the right to appropriate the popular media for its own ends. Thus the right 'has successfully fought on the terrain of popular interpellation: controlling the terms of popular discourse, arrogating the terrain of nature, family, community, and the fetus; not hesitating to appropriate and rearticulate a traditionally left rhetoric of liberation and empowerment.' See Laura Kipnis, 'Feminism: the political conscience of postmodernism?', in *Universal Abandon? The Politics of Postmodernism*, ed. Andrew Ross (Minneapolis, MN: University of Minnesota Press, 1988), p. 164.

9 See, for example, Tania Modleski's discussion of popular culture's structuring of the feminine in her book *Loving with a Vengeance: Mass-produced Fantasies for Women* (Hamden, CT: The Shoe String Press, 1982).

10 *Time* 134, no. 23 (4 December 1989): 80–2, 85–6, 89.

11 The image of the woman's responsibility to the family is reinforced in the *Good Housekeeping* 'New Traditionalist' advertisements displayed at bus stops and in upscale magazines such as *The New York Times Magazine*. In these ads, bold texts – such as 'Who says you have to discard your own values to be a modern American mother?' and 'More and more women have come to realize that having a contemporary lifestyle doesn't mean that you have to abandon the things that make life worthwhile – family, home, community, the timeless, enduring values' – are accompanied by images of a mother in a domestic setting with one or two children. See also Paulette Bates Allen's strange article, 'A reluctant education', where she writes of her regret at having been encouraged not to have children by feminism's emphasis on the woman's right to 'make choices.' In blaming feminism for her desire to develop her writing career instead of bearing children, she naturalizes childbearing as 'right,' while branding feminism as an ideological imposition on this natural state; *The New York Times Magazine* (December 10, 1989): 44, 83, 85, 90–1.

12 Mary Kelly 'Re-viewing modernist criticism', *Screen*, 22 (3) (Autumn 1981); reprinted in *Art after Modernism: Rethinking Representation*, ed. Brian Wallis (New York: New Museum of Contemporary Art; Boston: David R. Godine, 1984). Other examples of this optimistic phase of believing in the potential of ideas generated by feminism to question and dismantle modernism's hierarchizations and value systems are: Norma Broude and Mary D. Garrard, *Feminism and Art History: Questioning the Litany* (New York: Harper and Row, 1978); Rozsika Parker and Griselda Pollock, *Old Mistresses: Women, Art and Ideology* (New York: Pantheon Books, 1981), ideas of which are expanded in Pollock's *Vision and Difference: Femininity, Feminism and the Histories of Art* (London: Routledge, 1988), see esp. 'Feminist interventions in the histories of art: an introduction', pp. 1–7.

13　(New York: Abbeville Press, 1989); curated by Randy Rosen and Catherine Brawer, this exhibition travelled to Cincinnati, New Orleans, Denver, and the Pennsylvania Academy of the Fine Arts.

14　See Jacques Derrida's discussion of the stylus as phallic 'spur' in *Spurs: Nietzsche's Styles*, trans. Barbara Harlow (Chicago and London: University of Chicago Press, 1978); or Sandra Gilbert and Susan Gubar's discussions of literary paternity and the penis/pen in 'The queen's looking glass: female creativity, male images of women and the metaphor of literary paternity', in their book *The Madwoman in the Attic* (New Haven, CT: Yale University Press, 1979).

15　*The Nation*, 249 (22) (25 December 1989): 794–6, 798.

16　Although, clearly, with his own continued use of notions of *a priori* mainstreams, genius, and simplistic notions of innovation he perceives a system largely unchanged from its Greenbergian modernist state.

17　*The Nation*, 250 (8) (26 February 1990): 258, 288. All citations are from p. 258.

18　In *The Anti-aesthetic: Essays on Postmodern Culture*, ed. Hal Foster (Port Townsend, Washington: Bay Press, 1983).

19　I am currently analyzing this configuration of postmodernism in relation to Marcel Duchamp, who is often claimed as its origin, in my dissertation in progress for the University of California, Los Angeles: 'The fashion(ing) of Duchamp: authorship: postmodernism, gender.'

20　'Notes on camp', (1964), in *A Susan Sontag Reader* (New York: Farrar, Straus, Giroux, 1982).

21　Published in Huyssen's *After the Great Divide: Modernism, Mass Culture, Postmodernism* (Bloomington, IN: Indiana University Press, 1986).

22　He conceptualizes postmodernism in these terms in his essay 'Mapping the postmodern', reprinted in *After the Great Divide*, and originally published in *New German Critique*, 33 (Fall 1984).

23　'Mass culture as woman', p. 61 and 'Mapping the postmodern', p. 220. Griselda Pollock has also focused on the usefulness of the feminist perspective on patriarchy in the project of breaking down notions of originality and modernist hierarchies that invariably privilege the masculine. Pollock sees feminism's project to be the use of Marxian tools to critique modernism as an ahistorical bourgeois and consummately masculinist discourse. Feminism thus becomes *the* model for postmodernism as a new avant-garde or politics of rupture. Pollock avoids the negation of feminism's specificity that Huyssen's text implies by structuring all of her inquiries in terms of questions of sexual difference; feminism prescribes the set of concerns by which she analyzes art and art discourse. See Pollock's essay 'Screening the 70s' in *Vision and Difference*.

24　*The New York Times* (17 December 1989), s. 2, p. 43.

25　Grundberg does mention gender as an issue *once*, but quickly negates it by subsuming it under a larger critical concept: 'Here, as in most of her work, gender is pushed into the foreground: one wonders not only about the master–slave relationship built into the profession but also about its repressed erotic content.' Why abstract the messages of these works by referencing 'master–slave' relations? These seem to be the only terms by which Grundberg can himself repress their 'erotic content,' as having to do not with sex but, metaphorically, with economic and/or racial relations of domination.

26　Richard B. Woodward, 'It's art, but is it photography?', *The New York Times Magazine* (9 October 1988): 31.

27　Thomas Lawson, 'Last exit: painting', in *Art after Modernism*, p. 161. Originally published in *Artforum*, 20 (2) (October, 1981).

28　Donald Kuspit, 'Inside Cindy Sherman', in *The New Subjectivism: Art in the 1980s* (Ann Arbor: UMI Research Press, 1988), p. 395. Originally published in *Artscribe* (September–October 1987).

29　Jane Gallop, *The Daughter's Seduction: Feminism and Psychoanalysis* (Ithaca, NY: Cornell University Press, 1982), pp. 36, 58.

Susan Rubin Suleiman, 'Epilogue: The Politics of Postmodernism after the Wall; or, What do We do When the "Ethnic Cleansing" Starts?' (1994)

From *Risking Who One Is: Encounters with Contemporary Art and Literature* (Cambridge, MA: Harvard University Press, 1994), pp. 225–242.

> All over the world today identity politics (that is to say, a separation in the name of undifferentiated identity of religion, nation or subnation) is big news and almost everywhere bad news.
>
> *Gayatri Chakravorty Spivak, 'Acting bits/identity talk'*

> And yet there is something going on between poetry and power, something almost paradoxical. In some way, power is afraid of poetry, of what has no strength, only the power of words.
>
> *Hélène Cixous, 'We who are free, are we free?'*

Budapest, May 1993: every day the newspapers talk about Bosnia. Will aerial bombings stop the Serbian aggression? Will sending in ground troops start another Vietnam? Will the Serbs, if attacked, turn on the Vojvodina, a region in Serbia inhabited mostly by Hungarians? But not to intervene is unconscionable, like passively witnessing another Holocaust. Should the West send arms to the Muslims? Are the Bosnian Croats, too, killing Muslims? And in the background, the common knowledge which, once put into words, flares like an accusation: 'The West has failed to protect Sarajevo, where Muslims, Croats, and Serbs lived together in peace for centuries.'[1]

I am living for a few months in my native city, at the center of the center of Europe, two hundred kilometers from the border of what was once Yugoslavia, thinking again about the politics of postmodernism. The last time I wrote about this question was in Paris, spring 1989: Khomeini had just put a price on Salman Rushdie's head for writing a novel. Since then, more radical changes have occurred in Europe – which also means in the rest of the world – than could have been foreseen by the most farsighted of political analysts. A cause for rejoicing? Yes, most say. A cause for worry? Yes, most say. (The current joke in Budapest: 'What is the worst thing about Communism?' 'What comes after it.') Some things have not changed, however; there is still a price on Rushdie's head.

In certain inner-city neighborhoods in the United States, those in which the greatest poverty and hopelessness reign, young men have killed each other for not showing respect: 'He dissed me' ('He showed me disrespect') is considered sufficient cause. Up to today, the Iranian government continues to claim that Rushdie 'dissed' the Prophet with his fiction. The price of 'dissing' is death.

When is the price of 'dissing' death? When is the self so fragile that the mere perception of a slight (not a physical threat – a slight, a symbolic act) provokes it to murder? Are these questions about the politics of postmodernism? I recently came across an essay by Hélène Cixous, just published:

In our grating and jarring present . . . a phobia of nonidentity has spread, and indi-
viduals, and nations like individuals, are infected with this neurosis, this pain, this fear
of nonrecognition, where each constructs, erects his self-identification, less out of
intimate reflection than out of a system of rejection and hatred. The Serb says: I am
not Croatian; to be Croatian is to be non-Serb. And each affirms him- or herself as
distinct, as unique and nonother, as though there were room only for one and not for
two . . .

 Who is afraid of nonidentity, of nonrecognition?[2]

I would ask, rather, who is not afraid? And how can those who are not afraid persuade
those who are to stop dreaming of murder? Can they persuade them to stop being
afraid? And what can those who are not afraid do when the dream of murder becomes
the reality of murder, when 'each side's paranoia [feeds] upon the other's'?[3]

 Yes, these are definitely questions about the politics of postmodernism.

The 'Postmodernism Debate' Seen through the Telescope

Why ask about the politics of postmodernism in 1993? To answer that question (for
those who came in in the middle of the movie), I offer a brief bedtime story:

 Once upon a time, not so long ago, there existed in the world of intellectuals a 'debate
over postmodernism.' Although it was carried out in the pages of learned books
and journals chiefly in the United States and England, some of its best-known par-
ticipants came from other countries, such as France, Germany, or India, and its
fame spread far and wide. The debate concerned the definition and evaluation of a wide
range of philosophical ideas and cultural practices, lumped under the heading 'post-
modernism.' One of the chief questions asked about these ideas and practices was:
'Does postmodernism have a politics?' Which meant, in fact: 'Does it have a positive
political "edge"?'

 In philosophy, postmodernism was identified as a self-styled mode of 'weak thought,'
prizing playfulness above logic, irony above absolutes, paradoxes above resolutions,
doubt above demonstration. Some intellectuals found this dance of ideas liberating; to
others, it appeared irresponsible, a dangerous nihilism. In the arts – literature, photog-
raphy, architecture, film, performance, painting – postmodernism was identified with a
freewheeling use of pastiche, quotation, and collage, methods that some intellectuals
saw as innovative and critical, having the potential to undo (or at least put into
question) received ideas and established ideologies. Other intellectuals voiced their
disapproval or despair: for them, the loose eclecticism of postmodernist art, mixing up
historical styles, ignoring boundaries between genres, scrambling distinctions between
'high' art and low, between original and copy, was of a piece with the laxness of post-
modernist philosophizing, a sign of the cultural exhaustion of late capitalism, or of the
decay produced by the proliferation of mass culture.

 The first group (let's call them pro-postmodernists) sought at times to distinguish
the 'postmodernism of resistance' from the postmodernism of 'anything goes,' and
invoked the experimental work of feminists, people of color, and other traditionally

silenced subjects as examples. (According to them, postmodernism did have a politics, and it was good – that is, progressive.) For the second group (let's call them pro-modernists), such a distinction was useless. In order to resist, they argued, one has to have firmly held values and principles; postmodernism, whether as an artistic practice or as a philosophy, lacked the necessary firmness, and therefore represented an unfortunate falling away from the positive, largely still unfulfilled project of modernity. Finally, there was a third group, which we may call the cultural pessimists. They, too, denied the possibility of a postmodernism of resistance; to that extent, they shared the negative analysis of the pro-modernists. However, they also refused to envisage a 'better' (modernist) alternative because in their view postmodernism was here to stay.

The attitude of the first group toward postmodernism was, on the whole, celebratory; that of the second, disapproving; that of the third ranged from the resigned to the cynical. If I were asked to name names, I would not. Let everybody recognize his or her own kin.[4] I will simply mention, for the record, that I consider Jean Baudrillard a member of group three, not group one; and that almost everyone in the first two groups has, so far as I can see, on occasion dipped one foot, or at least a couple of toes, in group three. That is what is known as the ambivalence of (and toward) postmodernism.

But enough play; let's be serious. Four years ago, in an essay concerned chiefly with the salutary conjunction of feminism (as politics) and postmodernism (as artistic practice), I spent many pages worrying about the political status of postmodernist irony and postmodernist intertextuality (the use of quotation, parody, pastiche, and other kinds of textual *mélanges*), arguing that political effects reside not in texts but in the way they are read – not in what a work 'is' but in what it 'does' for a given reader or community of readers in a particular place and time. I still hold to that idea, and would provide further evidence for it by citing the controversy over some photographs by Robert Mapplethorpe that broke out in the United States in the summer of 1989. The controversy, which concerned the definition of obscenity in art and the use of public funds to support unpopular art – and which almost led to the dismantling of the National Endowment for the Arts, the government organization that had provided some funding for the Mapplethorpe exhibit and was therefore considered too 'political' by its right-wing critics – contributed to the self-conscious politicization of many American artists and museum officials; this in turn fostered a climate of political readings for contemporary art. Another contributing factor of politicization was the ongoing problem of AIDS, which affected many members of the artistic community and produced some powerful works of criticism and protest, as well as expressions of personal anguish. The mixed-media collages of David Wojnarowicz (who has since died of AIDS) are one example – in 1990 Wojnarowicz, too, got into trouble with right-wing critics of the NEA.

The question of political reading of works of art, whether visual or verbal, continues to interest me; but the question I really struggle with today, and which I now think I treated too lightly four years ago, concerns the political status of the plural self rather than of the plural text – not postmodernist intertextuality, but postmodernist subjectivity. Conceptions of the text and conceptions of the self are, of course, not unrelated: unity, coherence, stability are all categories that apply to the one as well as

to the other. But how much higher the stakes are where the self is concerned, and how much more urgent the dilemmas it poses, are illustrated all too tragically in the current Bosnian conflict and have been dramatized elsewhere as well in the post-Wall world.

In my earlier discussion, I formulated the question primarily in terms of gender identity because at that time (and, indeed, since then) the postmodernist theory of the 'decentered' subject – as opposed to some form of feminine specificity – was vigorously debated among feminist theorists. The 'decentered' subject, evading all stable categorizations, including that of gender, was seen by some feminists (including myself) as a great point of alliance between postmodernism and feminism. Other theorists, no less 'sophisticated' and no less adept at deconstructive moves in literary criticism, were less sanguine about this alliance and cautioned against giving up what women had struggled so long to obtain: a female signature, the recognition of a female self. The feminist discussion is continuing, and over the past few years we have seen increasingly subtle defenses of both the (so-called) essentialist and the (so-called) postmodernist positions.[5] Personally, I continue to maintain that the ability to put the self 'into play' – into what D. W. Winnicott called an 'unintegrated state of the personality' – is essential to creativity, whether in women or men; nor would I recant the statement, made on the last page of *Subversive Intent*, that 'I feel much drawn to [Julia Kristeva's] evocation of the "happy cosmopolitan," foreign not only to others but to him- or herself, harboring not an essence but a "pulverized origin." '[6]

What has changed for me, after the Wall, is that I have lost my innocence about the 'happy cosmopolitan.' Things are not so simple; the idea of a postmodernist paradise in which one can try on identities like costumes in a shopping mall ('I'm a happy cosmopolitan; you can be a happy essentialist; they can be happy ironists or defenders of the one and only Faith') appears to me now as not only naïve, but intolerably thoughtless in a world where – once again – whole populations are murdered in the name of (ethnic) identity.

Does this statement make me into a 'modernist' defender of Reason and universal values? Some would argue that that is the only way to counter the irrationalism, the racism, the xenophobia that have resurfaced or grown stronger, in the East and in the West, since the fall of the Wall. Christopher Norris makes this argument, and it is interesting that he states it most impassionedly in the context of a war – but not 'my' war. His most recent attack on postmodernism – which he simply and, in my opinion, unreflectively equates with the writings solely of Jean Baudrillard – is prompted by his indignation at the Gulf War, which he considers to have been a cynical, imperialist, unjust attack on Iraqi civilians.[7] As a matter of fact, I, too, was opposed to that war and to the outbursts of 'yellow-ribbon' patriotism it provoked in the United States, and I agree that a great deal of hypocrisy was involved in the rhetoric used to justify it (covering up naked oil interests with a discourse of democratic indignation); but none of that seems to me a sufficient basis on which to launch a blitzkrieg against Baudrillard-cum-postmodernism. 'My war,' the Bosnian war (but also, I suddenly realize, my other war, the war of my early childhood, World War II) prompts an altogether different set of reflections: is it possible to theorize an *ethical* postmodernist subjectivity without recourse to universal values, but also without the innocent thoughtlessness of the 'happy cosmopolitan'? Is it possible to argue that such an ethical postmodernist subjectivity has *political* (collective, relating to the public good) import and relevance? Finally, is it pos-

sible to argue for a political postmodernist praxis? In plainer words, what do we do if words fail and the shooting starts?

Ethical Postmodernism

It appears to be a truth universally accepted, by the modernist critics of postmodernism, that postmodernist theory is incapable of furnishing either an ethics or a politics. By arguing against a unified (rational) subject and (his) universal values, this theory, according to its critics, is unable 'to take any principled oppositional stand,' be it as concerns individual action or 'local or world politics.'[8] Irremediably compromised by its own relativism (so the argument continues), postmodernist thought has no moral foundation, just as, for similar reasons, it occupies no firm epistemological ground.

I find it astonishing that this argument is still current (witness its being made, in 1992, by Norris), despite the fact that it has been answered again and again by postmodernist theorists of contingency – who argue, in brief, that values are not universal but context-bound, not discovered in some Platonic sky but fashioned by historically situated human beings, and are for that reason subject to change. Barbara Herrnstein Smith and Richard Rorty, who are among the most articulate of these theorists, have explicitly (and, to my mind, persuasively) countered the notion that a belief in the contingency of values implies moral paralysis. 'The fundamental premise of [this] book,' writes Rorty at the end of his *Contingency, Irony, and Solidarity*, 'is that a belief can still regulate action, can still be thought worth dying for, among people who are quite aware that this belief is caused by nothing deeper than contingent historical circumstances.'[9] And Smith, in a similar vein, writes:

> Someone's distaste for or inability to grasp notions such as 'absolute value' and 'objective truth' does not in itself deprive her of such other human characteristics, relevant to moral action, as memory, imagination, early training and example, conditioned loyalties, instinctive sympathies and antipathies, and so forth. Nor does it deprive her of all interest in the subtler, more diffuse, and longer-range consequences of her actions and the actions of others.[10]

The universalist (or, if you will, modernist) claim is that only by ascribing universal validity to one's ethical beliefs is one able to act ethically. A postmodernist ethics refuses to take that step, arguing that such ascriptions merely elevate one set of contingent beliefs to 'universal' status and that too many horrors have been inflicted by some human beings on others in the name of *their* universal values. As Smith's and Rorty's arguments show, however, this does not mean that there can be no such thing as a postmodernist ethics. The accusation that a refusal of universalism leads to a paralyzing, immoral relativism seems to me just that – an accusation, not a demonstration. And since we are in the realm of intellectual debate (as opposed to, say, physical conflict), the only way to counter the accusation is by replying to it as often and as forcefully, as persuasively, as one can.

But have we not strayed somewhat from the question of postmodernist subjectivity? I think not. What I am calling postmodernist subjectivity seeks, first and foremost, to undo a unitary and essentialist conception of the self that would allow for statements

of the type: 'I am only, unconditionally X' or 'He is, she is, only, unconditionally Y.' Does that mean that Serbs should not think of themselves as Serbs, and Croats not think of themselves as Croats? No, it means that Serbs should not think of themselves as 'only, unconditionally Serbs' unto the death; nor (remember, this is before the shooting starts) should they think of their Croat neighbors as 'only, unconditionally Croats.' For besides being Serbs and Croats, they are also sons or daughters, parents, students, teachers, doctors, plumbers, apartment dwellers or village neighbors, TV watchers and sports fans, and many other things as well. If you don't put all your identity eggs in one basket, the chances are less likely that you will kill anyone who looks at them (or who you think looks at them) as if he wanted to break them. If you don't put all the identity eggs of people who are different from you in one basket, the chances are less likely that you will want to break theirs (or look as if you did).

The universalist/modernist argument would be that in order not to feel 'only, unconditionally' Serb or Croat or Arab or a woman or anything else, one would need to replace such specific identifications with the general category of 'the human race.' But I am persuaded by Rorty's argument that it is not by identifying with an imaginary community of 'fellow human beings' that people engage in humane interaction with their fellow human beings; rather, they forge the bonds of community by 'smaller and more local' links, and by 'imaginative identification with the details of others' lives' (pp. 190, 191). 'You don't have to be Jewish to love Levy's Jewish Rye,' proclaimed subway advertising posters in New York City around twenty years ago. You don't have to be a universalist to love your neighbors enough not to kill them or wish them harm – even if they occasionally 'diss' you, wittingly or not.

But I may be taking things too lightly again, as indeed I think (and will shortly argue) Rorty tends to do. Is it because we are both middle-class white Americans, occupying good jobs with lifetime security, that we lack a real sense of tragedy – and, I suspect, of irony as well? I ask myself this in Budapest, my native city, where even the street names speak of tragedy and irony. (A Hungarian acquaintance tells me, a few minutes after we are introduced: 'Our Champs-Elysées, Andrássy Avenue [Andrássy was a late nineteenth-century statesman, from the period of Hungary's greatest prosperity] became Stalin Avenue in 1945, Young Guard Avenue after 1956, People's Republic Avenue under the Kádár regime, and is now once again Andrássy Avenue. Back to zero: a perfect image of our history over the past half-century!' And he laughs.) I must have left this city too early in life; I have become too light. Let me therefore call on a more tragically aware Central European to comment on the consequences of divorcing ethics from universalism. Zygmunt Bauman, a sociologist and a Polish Jewish exile living in England, writes:

> The ethical paradox of the postmodern condition is that it restores to agents the fulness of moral choice and responsibility while simultaneously depriving them of the comfort of the universal guidance that modern self-confidence once promised. Ethical tasks of individuals grow while the socially produced resources to fulfil them shrink. Moral responsibility comes together with the loneliness of moral choice.[11]

You don't have to be a universalist to make humane ethical choices, or even to die for them – but you can feel a certain loss (ironically aware of your own nostalgia) at the thought of a time when you might have been.

Political Postmodernism

'This book tries to show how things look if we drop the demand for a theory which unifies the public and the private,' writes Rorty in his introduction to *Contingency, Irony, and Solidarity* (p. xv). I, on the other hand, want to argue that it is essential to think about the continuity between the private and the public; and that without claiming anything as grand as a general unifying theory, one must consider a postmodernist conception of the self to have public relevance. In other words, that one can and should establish a continuity between postmodernist subjectivity, postmodernist ethics, and postmodernist politics.

Rorty's book is a good place to start in making this argument because it presents an unusually clear and compelling case for what I am calling postmodernist subjectivity – and then stops short and claims that this subjectivity has no relevance at all for public discourse and the public good. I would like to push his argument further, to what I think is its proper conclusion.[12]

Theorists of the postmodern subject have a penchant for allegory, or more exactly for emblematic figures: Derrida's dancer, Haraway's cyborg, Scarpetta's cosmopolitan, Kristeva's happy cosmopolitan, Cixous' Jewoman, Spivak's feminist internationalist, my laughing mother – all of these are allegorical figures (some more poetic than others), standing for a set of ideas. But they are not only allegorical or emblematic; they are also utopian, offered as idealized models or myths. Haraway calls the cyborg an 'ironic political myth,' thus insisting on the continuity between the personal and the political.[13] Rorty, in an apparently similar move, offers the ironist as his emblematic figure – but he refuses to accord this figure political status.

The ironist makes her appearance in Rorty's book (all of his descriptions of this figure *as allegory* use feminine pronouns, although the actual philosophers he discusses as ironists are all male) in a chapter entitled 'Private Irony and Liberal Hope.' Here is his capsule description:

> I shall define an 'ironist' as someone who fulfills three conditions: (1) She has radical and continuing doubt about the final vocabulary she currently uses [final vocabulary is the 'set of words people employ to justify their actions, their beliefs, and their lives'], because she has been impressed by other vocabularies, vocabularies taken as final by people or books she has encountered; (2) she realizes that argument phrased in her present vocabulary can neither underwrite nor dissolve these doubts; (3) insofar as she philosophizes about her situation, she does not think that her vocabulary is closer to reality than others, that it is in touch with a power not herself. (p. 73)

Moving from the singular to the plural, Rorty notes that ironists are 'never quite able to take themselves seriously because always aware that the terms in which they describe themselves are subject to change, always aware of the contingency and fragility of their final vocabularies and thus of their selves' (pp. 73–4). The opposite of the ironist is the metaphysician, who must found his beliefs on proof and argumentation, and on values he claims as universal (Rorty consistently describes the metaphysician as 'he').

So far, so good. (A minor disagreement: 'fragility' is not the word I would use in describing the ironist's sense of self; 'in process,' a term proposed by Julia Kristeva

some years ago, seems to me stronger, more positive, as well as less 'feminine' in the traditional sense.) As I have already noted, Rorty counters the notion – put forth by metaphysicians, in his terms – that ironists are relativists unable to make ethical choices. He even gestures, occasionally, in the direction of claiming that ironists can constitute a *collective* force ('One of my aims in this book is to suggest the possibility of a liberal utopia: one in which ironism, in the relevant sense, is universal' – p. xv). At a crucial moment, however, he abandons that line of thought and never returns to it. In his chapter on the 'liberal community,' he confronts Habermas's critique of Foucault and other philosophers – Nietzsche, Heidegger, Derrida – whom Habermas considers as having dangerously veered from the project of the Enlightenment but whom Rorty admires as great ironists. Rorty concedes: 'I agree with Habermas that as *public* philosophers they are at best useless and at worst dangerous, but I want to insist on the role they and others like them can play in accommodating the ironist's *private* sense of identity to her liberal hopes' (p. 68).

Even this attempt at an 'accommodation' between private and public (Rorty evidently considers 'accommodation' a weak link, nothing so ambitious or theoretically viable as a synthesis) is abandoned in his next chapter: 'Ironist theorists like Hegel, Nietzsche, Derrida, and Foucault seem to me invaluable in our attempt to form a private self-image, but pretty much useless when it comes to politics' (p. 83). In the end, Rorty finds himself in a strange position: he concedes everything to the Habermasian critique of Foucault and Derrida as anti-Enlightenment philosophers – everything except the notions of universality and rationality, on which the Habermasian position is founded. He is therefore left, theoretically speaking, with neither the strength of Habermas nor the strength of 'Foucault and the others.' Rorty, like Habermas, makes little attempt to distinguish among his 'ironist theorists' insofar as their political ideas are concerned – he seems to lump them all, as Habermas polemically did, into the 'antiliberal' category without asking what each one is (or can be construed to be, on the basis of his philosophical positions) 'for.' In the end, he reduces them to a status approaching the trivial: 'I tried to show how ironist theory can be privatized, and thus prevented from becoming a threat to political liberalism' (p. 190).

In what I read as a highly dramatic moment, Rorty makes the claim that 'literary criticism does for ironists what the search for universal moral principles is supposed to do for metaphysicians' – that is, allow us to 'revise our own moral identity' (p. 83). If, however, this high calling for ironist theory is merely a way of preventing it from 'becoming a threat to political liberalism,' that is – to say the least – an anticlimax.[14]

I believe that a much stronger case than Rorty is (or was, in 1989) willing to make can and should be made (and already has been made, by some) for the political relevance of postmodernist views of the self. As Anthony Appiah and Henry Louis Gates, Jr, note in their editors' introduction to a recent special issue of *Critical Inquiry* devoted to 'Identities,' 'The calls for a "post-essentialist' reconception of notions of identity have become increasingly common. The powerful resurgence of nationalisms in Eastern Europe provides just one example of the catalysts for such theorizing.'[15] Already in 1981, the French cultural critic Guy Scarpetta noted that what had been a positive outcome of May 1968, the coming to voice of suppressed minorities, threatened a decade later to degenerate into new theories of 'racial' or 'biological' purity.

Scarpetta, for that reason, proposed 'cosmopolitanism' as his political myth: 'to try the untenable position of a systematic crossing-over, of an essential exile, of an endlessly recommended diaspora, of movement, of a tearing away from everything that keeps you rooted, that fixes and freezes, to perceive that no value is fixed, no language is all – that, in the end, is cosmopolitanism.'[16] The question that confronts today's 'post-essentialist' critics is how to get away from the negative consequences of identity politics without simply returning to notions of universalism, Reason, and the unified subject.

I suggest that one way to do this is to take the step Rorty refuses to take: accord to 'ironism' (or to the same thing by a different name) a public stature. Rorty actually goes more than halfway toward that position when he claims that 'a liberal culture whose public rhetoric is nominalist and historicist [that is, recognizing contingency, not claiming universal principles as a basis for values] is both possible and desirable.' However, he concludes that he 'cannot go on to claim that there could or ought to be a culture whose public rhetoric is *ironist*.' He 'cannot imagine a culture which socialized its youth in such a way as to make them continually dubious about their own process of socialization. Irony seems inherently a private matter' (p. 87). But if a culture – or, more precisely, a community – recognizes the contingency of its values and vocabularies, as Rorty claims is possible in public rhetoric, then why is it unimaginable that its public rhetoric should go one step further and become ironist *according to his own definition*? Rorty suggests that a culture that socialized its youth in an atmosphere of doubt is not viable. Yet his figure of the individual ironist, who is characterized by 'radical and continuing doubt about the final vocabulary she uses,' is not only viable but can act as an agent of ethical choice. Why, then, can't a community aim for a similar combination of self-doubt and responsible action? Since public rhetorics of certainty, whether of the historicist or the universalist variety, don't seem to have worked all that well in preventing war, genocide, and other forms of political murder in the past two thousand years, why not try a public rhetoric of doubt?

No sooner have I written these words, than I already hear, in my own inner ear as well, the 'realist' response: 'Can you seriously claim that politicians and statesmen should engage in a rhetoric of doubt? That's really a flaky idea!' Etcetera. Yes, I know it sounds flaky – or to put it more kindly, utopian. So what? I can only repeat: the other kind of rhetoric hasn't done too well; why not envisage an alternative?

A few years ago, my colleague Barbara Johnson told the following story. After one of her lectures in a large course on deconstruction (or maybe it was another occasion of public speech, I no longer remember exactly), a young woman came up to her and asked, intrigued: 'Are you a feminist, or are you just hesitant?' The female student wanted to know whether the female professor's lack of certainty (Rorty would call it her irony) was a failure of character, or on the contrary an ideological and rhetorical choice. It suddenly occurs to me that the question about a rhetoric of doubt is really a question about the place of women in the public sphere. The emblematic ironist, as Rorty portrays her, is a woman. Could it be that by insisting that irony is 'inherently a private matter,' Rorty was reiterating (even if unwittingly) the dictum that a woman's place is in the home?

But what if *women*'s place were in the center of the public sphere? That, too, has not been tried in the last few millennia.

Postmodernist Praxis?

I said earlier that I thought Rorty, like me, lacked a sufficient sense of tragedy and even of irony (whose fiercest form is tragic, as Aristotle showed). An insufficient sense of tragedy and irony dulls one's awareness of the intractability of things. 'Rough reality,' '*la réalité rugueuse*' that Rimbaud said he wanted to embrace, has a way of eluding you – until it punches you in the face.

June 2, 1993: I'm back in the States for a few days. In *The New York Times*, Bosnia is still front-page news. 'MORTAR FIRE KILLS TWELVE AT SOCCER GAME IN BOSNIAN CAPITAL. Sarajevo, June 1: Mortar shells exploded today amid a neighborhood soccer tournament, killing at least a dozen people and wounding 80 . . . The attack came on a day of chaotic violence . . . that was shocking even by local standards.' The war is getting worse, now that it is clear the West will not rearm the Muslims, not bomb the Serbian artillery positions, not intervene. The so-called safe zones lack all safety, as well as fresh water. Three United Nations aid workers were killed yesterday in a region pounded by Bosnian Serb artillery over the past two weeks. 'However, the Bosnian Serbs' leader, Radovan Karadzic, denied today that his forces were responsible for the attack.'

The idea underlying *Contingency, Irony, and Solidarity* is that human beings are, on the whole, nice. To put it in philosophically less inane terms, Rorty believes that everyone in the world has the potential to be a liberal, borrowing Judith Shklar's definition of liberals as 'the people who think that cruelty is the worst thing we can do' (p. xv). The liberal's desire to avoid inflicting pain constitutes, for Rorty, the modest but significant basis for human solidarity. The 'liberal ironist,' who refuses to invoke universals and lives in a constant (private) condition of self-doubt, nevertheless subscribes to the idea that not inflicting pain on others is the minimal, sufficient condition for a just and moral world. We are now living, Rorty concludes, in 'the first epoch in human history in which large numbers of people have become able to separate the question "Do you believe and desire what we believe and desire?" from the question "Are you suffering?"' (p. 198). The first question, he says, is private; the second, public.

The Central European ironist laughs and reads the newspaper. The French literary critic asks herself: Has Rorty read Sade? Has he read Genet, or Bataille? Of course he must have, but his separation of private irony from public hope allows him to sweep them – along with Nietzsche and Heidegger, whom he mentions, plus Kafka, Gombrowicz, and a few others he does not – into the realm of the private. Philosophy in the boudoir, transgression in the closet, perversion in the prison cell? Sure, why not? But keep them private. They have nothing to do with politics.

No, he has not read Sade or Bataille or Genet. Or, for that matter, Duras, author of *La Douleur (War)*, a political book.

But do let's be serious, now that the end is near. I claim that, although it might be convenient, it is not possible, in a postmodernist discourse about politics, to separate considerations about private irony – or private obsessions and fears and hatreds, or private sadisms – from considerations about public action and the public good. Obviously, I don't mean by this that a postmodernist theory of politics should envisage

legislation controlling private fantasies. But neither should it try to pretend that public action can be cordoned off from private fears.

Recently, I learned that Radovan Karadzic, the leader of the Bosnian Serbs – thus, presumably, one of the architects of the policy of systematic rape and murder of Muslim women by Serb 'ethnic cleansing' squads – is a psychiatrist. This news shocked me almost as much as learning that the head of the Serb 'interrogation bureau' in Pale is a one-time professor of literature. He is reputed to be merciless.[17] Did he teach post-modernist fiction? How would he interpret Salman Rushdie's statement that 'the novel should be a celebration of impurity'?[18]

The Central European ironist would laugh at me this time, for sure. Yet I cannot help thinking that postmodernist intellectuals may have a social role other than that of torturer. Zygmunt Bauman has theorized that, succeeding to the modernist view of intellectuals as legislators ('collective owners of knowledge of direct and crucial relevance to the maintenance and perfection of the social order'), has come the post-modernist view of intellectuals as interpreters:

> With pluralism irreversible, a world-scale consensus on world-views and values unlikely, and all extant *Weltanschauungen* firmly grounded in their respective cultural traditions (more correctly: their respective autonomous institutionalizations of power), communication across traditions becomes the major problem of our time ... The problem, therefore, calls urgently for specialists in translation between cultural traditions.[19]

Bauman, Central European ironist that he is, concludes on a pseudo-comic note: 'In a nutshell, the proposed specialism [for intellectuals] boils down to the art of civilized conversation' (p. 143). But why not take seriously, just long enough to try it, the view propounded by Lonnie Kliever, quoted by Bauman, that 'relativism, far from being a problem, is ... a solution to the pluralist world's problem; moreover, its promotion is, so to speak, a moral duty of contemporary intellectuals'? In the absence of such relativism, Kliever suggests, 'old authoritarian habits would soon reassert themselves and the pluralist world would turn into one of "multiple absolutisms." '[20] The bloody clash of multiple absolutisms is no longer in the conditional: it is what we are seeing today in Bosnia, and potentially in any number of other 'border conflicts' between cultures, religions, and ethnic groups in Europe, the Middle East, and India (to name a few).

But that introduces (or brings us back to) the old, vexed question of the relation between action and theory: can the discourse of intellectuals, whether modernist or postmodernist or other, have any effect on 'rough reality'? And what, in particular, can intellectual discourse accomplish once the shooting starts? 'Today,' wrote the ex-Yugoslav writer Vladimir Pistalo in 1992, 'words have nothing in common with the atrocities committed.' He felt that the witnesses' testimonies regarding the atrocities committed in Bosnia had not been heard, that their words had been stifled. Today (June 1993), the testimonies have been heard; yet, Pistalo's next question remains timely: 'And if we got our words back ... What would we cry out? That it's not right to destroy cen-turies-old monuments? That it's not right to slit other people's throats? That it's not

right to mistreat women and children? That to destroy all values by means of oblivion, by instructions renewed each day, has no sense?'[21]

In this perspective, the 'debate over postmodernism' appears grotesque; for in this perspective, the problem is not choosing between 'modernist' or 'postmodernist' views of subjectivity and ethics – Norris wasted his time writing a whole book attacking Baudrillard. The problem is deciding what to do when it becomes obvious that conversation, dialogue, translation have failed. In the absence of any possible debate, what relation can exist between intellectuals modernist or postmodernist, and butchers or would-be butchers? This question appears all the more agonizing when one realizes that some of the butchers and would-be butchers are themselves intellectuals.[22]

Wayne Booth, worrying in a recent essay about very similar questions concerning torture, asks: 'How . . . could one ever persuade a regime and its hired torturers to listen to arguments as elusive and as non-utilitarian as those I've offered here?'[23] He then comes up with 'an argument that ought to work, if listened to, even with the most self-centered, non-altruistic of would-be torturers.' It runs like this: 'You – you loyalist torturer – are actually destroying your own self. Since selves overlap – not just metaphorically but literally – it is clear that you are destroying not just the life drama of the tortured one but of your own soul as well' (p. 97). Note that Booth's notion of 'overlapping selves' could qualify as postmodernist. Note, too (as I have, in the margin of my copy of the book in which Booth's essay appears), that the likely response of a torturer to this argument will be: 'Oh, yeah?' Or, like the torturer in J. M. Coetzee's *Waiting for the Barbarians* (which Booth quotes), he might respond with 'one more brutal blow.' It is not the elusive or non-elusive, utilitarian or non-utilitarian nature of the argument that is in doubt, but the very nature of argumentation: words versus blows.

Finally, for me, the only question about the politics of postmodernism that really matters is this – and I offer it with fully ironic awareness of its inadequacy: how can one help create a world in which butchers and would-be butchers are kept in check (or, if you have a more benign view of human possibilities, in which they are persuaded to give up their murderous fears), so that intellectuals can continue to argue about universals versus particulars and artists can go on painting and writing and making music of whatever kind they feel moved to make? How can one help create a world where dialogue is not only valued over butchery, but actually prevails?

In order to make the world safe for dialogue, will one have to resort to blows? Now there is a familiar paradox. Is it a postmodernist repetition (as in 'the war to end all wars')? Is it ironic? Perhaps. But it's not funny at all.[24]

Notes

1 Michael Ignatieff, 'The Balkan tragedy,' *New York Review of Books* (13 May 1993): 5.
2 Hélène Cixous, 'We who are free, are we free?,' *Critical Inquiry*, 19 (2) (Winter 1993): 202–3. I have substituted 'self-identification' for 'auto-identification' in the translation, for reasons of euphony.
3 Ignatieff, 'The Balkan tragedy,' p. 4.

4 Okay, okay, I will name a few. I take sole responsibility for assigning them to their respective groups, and apologize in advance for those I have overlooked. Among the members of each group, significant differences may exist. Pro-postmodernists: Hal Foster, Linda Hutcheon, Andreas Huyssen, Rosalind Krauss, Jean-François Lyotard, Craig Owens, Richard Rorty (sometimes), Gayatri Spivak. Pro-modernists: Terry Eagleton, Fredric Jameson, Jürgen Habermas, Christopher Norris. Cultural pessimists: Jean Baudrillard, Gilles Lipovetsky, and all the 'occasional' visitors from among the first two groups.

5 For a good summing up of the issues, see Linda J. Nicholson (ed.), *Feminism and Postmodernism* (New York: Routledge, 1990). Among the most recent position statements are Naomi Schor's defense of 'essentialism' in 'This essentialism which is not one: coming to grips with Irigaray,' *Differences*, 1 (2) (1989): 38–58; and Drucilla Cornell's defense of the 'postmodern subject' in *Beyond Accommodation: Ethical Feminism, Deconstruction, and the Law* (New York: Routledge, 1991).

6 Susan Rubin Suleiman, *Subversive Intent: Gender, Politics, and the Avant-garde* (Cambridge, MA: Harvard University Press, 1990), p. 205. The argument about putting the self into play is made fully in ch. 7; the quote from Winnicott, also quoted there, is from *Playing and Reality* (New York: Basic Book, 1971), p. 64.

7 Christopher Norris, *Uncritical Theory: Postmodernism, Intellectuals, and the Gulf War* (Amherst: University of Massachusetts Press, 1992); Norris's account of postmodernism in this work is surprisingly reductive for such a well-informed critic. Equally surprising is his attempt to 'divorce' Derrida from other poststructuralist philosophers such as Lyotard or Rorty, by arguing that Derrida is essentially an Enlightenment philosopher! Norris seems to want to 'save' Derrida by showing that his philosophy is (unlike postmodernism, in Norris's view) compatible with ethical and political positions. As Norris himself admits, his reading of Derrida entails a lot of omissions – and, I would add, no small degree of interpretive arm-twisting.

8 Norris, *Uncritical Theory*, p. 28.

9 Richard Rorty, *Contingency, Irony, and Solidarity* (Cambridge: Cambridge University Press, 1989), p. 189. Subsequent page references to this book will be given in parentheses in the text.

10 Barbara Herrnstein Smith, *Contingencies of Value* (Cambridge, MA.: Harvard University Press, 1988), p. 161.

11 Zygmunt Bauman, *Intimations of Postmodernity* (New York: Routledge, 1992), p. xxii.

12 A number of commentators, including some of the first reviewers of Rorty's much-discussed book, have criticized his attempt to separate the public from the private, though not exactly in the terms in which I will argue here. One of the most extended of these critiques is Nancy Fraser, 'Solidarity or singularity? Richard Rorty between romanticism and technocracy,' in *Unruly Practices: Power, Discourse, and Gender in Contemporary Social Theory* (Minneapolis, MN: University of Minnesota Press, 1989), pp. 93–112. See also David Lachterman, review essay, *Clio*, 18 (4) (1989): 390–9; and Michael S. Roth, review essay, *History and Theory*, 29 (3) (1990): 339–57.

13 Donna Haraway, 'A manifesto for cyborgs: science, technology, and socialist feminism in the 1980s,' *Socialist Review*, 50 (1984): 100.

14 Nancy Fraser makes a somewhat similar point when she notes that, in Rorty's system, radical social theory 'becomes aestheticized, narcissized, bourgeoisified'; for Rorty, in other words, ironist theory must be apolitical ('Solidarity or singularity?', p. 103).

15 'Editors' introduction: multiplying identities,' *Critical Inquiry*, 18 (4) (Summer 1992): 625. See also Hohmi K. Bhabha, 'Introduction: narrating the nation,' in *Nation and Narration*, ed. Hohmi K. Bhabha (London: Routledge, 1990); Bhabha proposes hybridity and the 'crossing' of national boundaries as positive values. The hope for a 'new transnational culture' (p. 4) may strike one today as even more utopian than it appeared in 1990.

16 Guy Scarpetta, *Eloge du cosmopolitisme* (Paris: Grasset et Fasquelle, 1981), p. 25; my translation.

17 See Mirko Kovac, 'Les Jeux olympiques de la mort,' *La Règle du jeu*, 9 (January, 1993): 237. This issue of the journal is devoted largely to writings about Sarajevo, most of them by eyewitnesses, some by people still living there.

18 Salman Rushdie, 'Le Roman est la preuve de la démocratie,' *La Règle du jeu*, 9 (January 1993): 178; my translation.

19 Zygmunt Bauman, *Legislators and Interpreters: On Modernity, Postmodernity and Intellectuals* (Cambridge: Polity Press, 1987), p. 5. Subsequent page references to this book will be given in parentheses in the text. [. . .]

20 Lonnie D. Kliever, 'Authority in a pluralist world,' in *Modernisation: The Humanist Response to its Promise and Problems*, ed. R. Rubenstein; quoted in Bauman, *Legislators and Interpreters*, p. 129.

21 Vladimir Pistalo, 'Mr Hyde dans les Balkans,' *La Règle du jeu*, 9 (January 1993): 198.

22 The theory of 'greater Serbia,' which has provided the ideological justification for the current war, is the work of intellectuals, many of them writers and university professors. Dobrice Cosic, the recently ousted Yugoslav president, was among them – he is now considered too 'moderate' by the extreme Serbian nationalists. See the articles by John Darnton in *The New York Times* (1 June, 2 June and 3 June 1993), as well as Juan Goytisolo's essay (one of four published under the general title 'Sarajevo mon amour') in *La Règle du jeu*, 9 (January 1993). Goytisolo considers 'a core of intellectuals from the Academy of Sciences in Belgrade' as the real driving force behind the current war; they are the ones who 'made themselves into the spokesmen for *the purest essences* of the nation' and 'elaborated the expansionist doctrine of greater Serbia' (p. 248).

23 Wayne Booth, 'Individualism and the mystery of the social self; or, does Amnesty have a leg to stand on?,' in *Interpretation: The Oxford Amnesty Lectures, 1992*, ed. Barbara Johnson (New York: Basic Books, 1993), p. 95. Subsequent references to this essay will be given in parentheses in the text.

24 I wish to thank Michael Suleiman, whose comments about the necessity of 'taking a stand' forced me to rework the last section of the essay; Veronika Görög, whose comments after my public lecture in Budapest helped me sharpen my argument about the rhetoric of doubt; and Richard Rorty, who pointed out to me the all too familiar status of the paradox I mention in the last paragraph. (Rorty does not consider it a paradox, but I do.)

Faith Ringgold, 'Le Café des Artistes
(The French Collection, Part II, no. 11)' (1998)

From *Dancing in the Louvre: Faith Ringgold's French Collection and Other Story Quilts*, ed. Dan Cameron (Berkeley, CA: University of California Press, 1998), pp. 141–142.

Dear Aunt Melissa,

1 Pierre left me as the owner of a Paris café, Le Café des Artistes, le rendezvous des arts et des lettres. It is located on the Boulevard de Saint Germain de Prés across from the church in the heart of the artists' quartier.

2 I am here every day now. We are a very popular café. Every Saturday nite we have le dancing le plus gai et le plus curieux de Paris. Today the tables are humming with the usual clientele of artists and writers nursing a café crême and making art history right before our eyes.

3 Pierre would be proud of my associations with the artists and writers. But still I have mixed feelings. Sometimes I feel as though I am one of them; at other times I feel like 'The Spook that Sat by the Door.' I feel that I now have words to say that simply will not wait.

4 Today I will issue the Colored Woman's Manifesto of Art and Politics. What would Pierre have to say about that? His timid wife all of 20 years old and addressing the greatest artists and writers of the century. I doubt that I would be doing this if Pierre were alive. But he is not and I am.

5 Madames and Monsieurs, I said, may I have your attention? This is a momentous time in the history of modern art and I am excited to be in Paris, the center of cultural change and exchange. 'It is a pleasure to have one so beautiful among us Madame Willia Marie. Bon chère noire.'

6 Like the symbolists, dadaists, surrealists and cubists I have a proclamation to make for which I beg your indulgence. It is the Colored Woman's Manifesto of Art and Politics. 'Women should stay home and make children not art.' 'Soulard, alcoolique.' '*You* should go home!' 'Silence! Taisez-vous!'

7 I am an international colored woman. My African ancestry dates back to the beginnings of human origins, 9 million years ago in Ethiopia. The art and culture of Africa has been stolen by western Europeans and my people have been colonized, enslaved and forgotten.

8 What is very old has become new. And what was black has become white. 'We Wear the Mask' but it has a new use as cubist art. 'But you are influenced by the French Impressionists.' 'No the German Expressionists.' Modern art is not yours, or mine. It is ours.

9 There is as much of the African masks of my ancestors as there is of the Greek statuary of yours in the art of modern times. 'No it is the Fauve that has influenced you Madame Willia Marie.' And who made the first art . . . a doll maybe for an unborn child? A woman of course.

10 'You are a primitive but very pretty.' Paris artists are shaping the culture of the world with their ideas. But modern art is much bigger than Western Europe or Paris. I am here (in Paris). I am there (in Africa) too. That is why I am issuing a Colored Woman's Manifesto of Art and Politics.

11 'You should learn French cooking. It will help you to blend your couleurs.' 'No she is a natural with couleur. Very Primitive.' I will call a congress of African American women artists to Paris to propose that two issues be discussed: What is the image of the Colored Woman in art? And what is our purpose as modern artists?

12 No important change of a modernist nature can go on without the colored woman. 'Her palette is too harsh, she needs to develop a subtle range of greys.' Today I became a woman with ideas of my own. Ideas are my freedom. And freedom is why I became an artist.

13 The important thing for the colored woman to remember is we must speak, or our ideas and ourselves will remain unheard and unknown. The café is my academie, my gallery, my home. The artists and writers are my teachers, and my friends. But Africa is my art, my classical form and inspiration.

14 'You will come to my studio Madame Willia Marie. I will show you how to make a rich palette of couleurs and teach you to paint like a master. But first you will model for me my African maiden! Earth Mama! Queen of the Nile!' C'est la vie Auntie. The price I pay for being an artist.

7.3 Essentialism

Whitney Chadwick, 'Negotiating the Feminist Divide' (1989)

From *Heresies*, 24 (1989), pp. 23–25.

> Woman, then, stands in patriarchal culture as signifier for the male other, bound by
> a symbolic order in which man can live out his fantasies and obsessions through lin-
> guistic command by imposing them on the silent image of woman still tied to her
> place as bearer of meaning, not maker of meaning.
>
> *Laura Mulvey, 'Visual pleasure and narrative cinema'*[1]

First published in 1975, Laura Mulvey's germinal essay located the image of woman
as the site of the struggle over 'meaning' in art. Who speaks? And to whom? Who
is silenced? By whom? Fourteen years later feminism in the arts has broken into
increasingly, sometimes absurdly, polarized groupings: feminism/postfeminism,
feminism/theoretical feminism, essentialism/poststructuralism, feminist practice/
poststructuralist theory, feminist analysis/gender studies. Among feminists themselves
the issue of woman – as artist and as image – increasingly occupies a contested space,
and it is by focusing on this issue that we can perhaps begin to question the political
implications of the new divide between theory and practice.

It is ironic that shortly after feminism legitimized the unique experiences of women,
experience *itself* as a way to understand the world and one's place in it has come under
attack. One can't help but see significant and ominous parallels with the history of
women and academic art in the late eighteenth and nineteenth centuries, a time when,
just as the academies finally began admitting women, male artists decamped and new,
bohemian social and artistic ideals began to dominate. As a feminist art historian now
writing a book that deals with a series of historical issues having to do with the inter-
section of production by women and representation of women,[2] I am struck both by
how far we have traveled since the early 1970s, and how conflicted many of us feel about
the current disjunction between feminist practice and poststructuralist theory, or
between modernist views of artistic innovation and postmodernist rejections of origi-
nality, or between the production of gender relations and the processes of making art.

Stepping into the divide between essentialism and poststructuralist theory is a way of raising a few of the issues that confront all of us working as feminists in the arts today. I want to emphasize that there is no inherently 'correct' feminist art and art criticism, but there are ways of using what feminism has taught us to produce art and criticism, which can take their place among the varied strategies through which we understand the production of meaning today.

Feminism in the arts grew out of the contemporary women's movement of the early 1970s; its first investigations relied heavily on sociological and political methodology. Early feminist analyses focused new attention on the work of remarkable women artists *and* on unsurpassed traditions of domestic and utilitarian production by women. These analyses uncovered a history of productive women artists long overlooked, misunderstood, and neglected by art historians. They revealed the ways that women and their productions have been presented in a negative relation to creativity and high culture. It is now a tenet of feminist analysis that the esthetic value of painting and sculpture is often defined in opposition to qualities such as 'decorative,' 'precious,' 'miniature,' 'sentimental,' etc. Those very qualities which are used to construct a social ideal of 'femininity' are also employed to denigrate its productions. Presented as outside culture and history, women and their art have provided a set of negative characteristics against which to oppose 'high' art. Economically, legally, and politically powerless through much of Western history, women have been linked to nature and the unknowable through metaphors of the body while the masculine has signified culture and mental activity.

As the inadequacies of methodologies based on the ideological and political conviction that women were more unified by the fact of being female than divided by the specifics of race, class, and historical moment were exposed, many feminists began to turn to structuralism, psychoanalysis, and semiology for theoretical models. As feminist teaching programs in the arts have closed or moved outside the university in recent years, often in response to economic and political changes in society, and as many women artists have sought support and community in the professional art world rather than in the academy, earlier alliances between feminist artists, critics, and historians appear to have broken down. The multiple discourses that make up poststructuralism today challenge the humanist notion of a unified, rational, and autonomous subject, which has dominated study in the arts and humanities since the Renaissance. Yet much art by women, many of them encouraged to speak out for the first time during the early, heady years of the women's movement, remains rooted in a search for authentic modes of expression that are centered in the experience of the body.

For many women, authenticity of artistic expression and the experience of being female were inextricably bound together. A belief in essentialism, or a true biological femaleness, most convincingly theorized by Adrienne Rich, Mary Daly, and Susan Griffin, motivated much art by American women during the 1970s. Primarily ahistorical, and outside of race or class analysis, essentialism offered fixed ideas about the 'nature' of women. These ideas were often reduced to a set of characteristics or a form language – layered, tactile, 'central core,' etc. – and used to validate empirical data rooted in women's experiences of life under patriarchy. Women artists turned to menstrual blood, vaginal images, feminine body language, pregnancy, childbirth, and maternity to offer aspects of female sexuality, which are largely repressed in the history of

male art. In the end, however, after proposing new subjects and compiling an inventory of features characteristic of art produced by women (and eliminating all those evident in the work of male artists), it was not clear that we had arrived at anything essentially feminine. More likely, we had simply established a new notion of historically defined *difference*; the genuinely feminine was defined only in relation to what was understood as male at a specific time.[3] This paradox, and the difficulty of stripping art by women from social constructions of gender, is central to Rozsika Parker and Griselda Pollock's 'deconstruction' of femininity in *Old Mistresses*.[4]

Our ways of evaluating art remain shaped by patriarchal ideologies, which prevent us from arriving at a moment of truth that would allow us to conclude that an image or a process is innately female. Because we live in a culture that has deeply internalized the codes through which we understand visual representations of the female body, it is hard to shake that body image loose from the conventions that structure its meaning in Western culture. The feminist iconography of the body often tells us less about essential experiences of being female than about how patriarchy has mapped and controlled the female body and used it as an object of exchange between men. We have seen images made by women in celebration of the female body read as pornography by some male viewers. Instances of the censorship and destruction of nude images made by women have highlighted the difficulty of producing positive images of the human form in a culture that has no tradition of erotic art and in which the nude female has traditionally served as an object of exchange. Yet refusing to represent the female body and female sexuality, as some feminist critics have advocated, eliminates the possibility of addressing important issues of women's sexual pleasure.

Essentialism has been viewed by its critics as serving to confirm the positioning of woman in patriarchal society – as unconscious force, as nature, as mystery. Since its biological orientation prevents those who adhere to it from engaging with the problems and power relations of everyday life, it has remained a discourse without the social and institutional power to effect change. Although essentialists have equated the feminine with the unconscious and the prelinguistic, the art that results from this position still has to be understood as involved in the broader cultural production of meaning. Yet, if essentialism has come to be seen as naïve by some academic feminist critics and historians, poststructuralist theory appears to many women artists to be little more than another misogynist denial of their voices. (In Alexis Hunter's 1982 painting *Considering Theory*, an enraged Eve bites the snake's tail with ferocious force.)

All forms of poststructuralism – the structural linguistics of Ferdinand de Saussure and Emile Benveniste, the Marxist analysis of Louis Althusser, the psychoanalytic theory of Jacques Lacan, the theories of discourse and power associated with Michel Foucault, and Jacques Derrida's critique of the metaphysics of presence – assume that subjectivity is produced through a whole range of discursive practices (economic, social, political) and that meaning is not determined or guaranteed by author or artist). Poststructuralist theories have worked to deny the authenticity of individual experience by decentering both the rational autonomous subject of liberal humanism and the essential female nature advocated by many radical feminists. Instead, subjectivity is seen as socially constructed within language. Language becomes the common factor in analyses of social organizations, social meanings, uses of power, and individual consciousness.[5]

Poststructuralism has deeply influenced a wide range of recent artistic practices. Originating in structural linguistics and the analysis of literary texts, poststructuralism has been applied to visual images as a means of unraveling the way that images confirm or interrupt dominant contemporary ideologies, such as gender, power, and patronage. Derived from complex, primarily European, intellectual traditions, poststructuralism remains centered in the university, answerable neither to the realities of studio practice nor to women's need to transform patriarchy through political action. Often viewed as denying the authenticity of individual experience, while reinforcing the goals of academic feminist intellectuals, poststructuralist theory has become the primary means of defining a new avant-garde in the arts. Weighting text over image, and theory over practice, it has provided developmental models against which issues of content can be measured.

At the same time, the writings of Luce Irigaray, Hélène Cixous, Julia Kristeva, and other contemporary French theorists interested in female authorship, pose the issue of woman's 'otherness' from radically different bodily perspectives. Kristeva's semiotic proposes a denial of the body *in order to speak*; Irigaray and Cixous demand that we locate the feminine in the unconscious and introduce the body into art as a way of disrupting a restrictive phallocentric control of language. Both positions have proved problematic for American women artists. For Cixous, feminine writing means 'writing the body'; yet her demand that we enter and 'explore the dark continent' has been too closely aligned with the psychoanalytic orientation of French theory to have attracted many American converts among artists. The originators of the discourse about *écriture féminine* have demonstrated a brilliant understanding of the dangers of a reductive essentialism on the one hand, and the limitations of current psychoanalytic ideologies on the other. Yet the traditions of *sentiment* and bodily sensation that originated in eighteenth-century France and that familiarize their views for European feminists have no real parallel in American culture. The stress on writing in French theory, its adherence to the principles of structural linguistics, and its rejection of the empiricism and pragmatism that underlie American feminism have limited its appeal for many American artists.[6]

As poststructuralist theory has moved from academic contexts into public consciousness, it has become one of many reflections of the forces shaping contemporary culture. I don't believe that any of us can, or should, retreat from its challenges. Nor do I believe that artists must read Derrida or, worse, struggle through Lacan's tortured prose. As feminists we need to be aware of theoretical models that can help us understand the positioning of women in Western culture, and we need to find new ways of using language to confront *and* deconstruct dominant assumptions and hierarchies. At the same time we need to be constantly alert to the political and artistic implications of discourses that circumvent or ignore the real conditions of artistic production and often fail to address issues of social context, particular interests, and changing power relations. Above all, we need to be cautious of tendencies that polarize intellect and feeling, thus reiterating the mind/body duality of Western culture with its delineation of intellectual activity as masculine and 'nurture' as feminine. Artist May Stevens has called for 'a balancing act'. 'Theory cuts off its roots, loses its connection to reality when it ignores feeling; feeling needs structuring, a means of evaluating between conflicting feelings.'[7]

One of the functions of a feminist art history has become the exploration of ways in which visual representations construct certain images of women and ideas of femininity, which are then 'naturalized' through ideology. Although most feminist art historians working today are convinced that there is no essential femininity, no linked lineage of women artists that transcends historical specificity, there is little agreement about how to proceed from that point. We now have an important tradition of writings about art that express aspects of women's experience in the world, which are not shared by men, and about works of art as examples of how class and gender are constructed and reinforced through representation. Much less has been written about the intersection between production *by* women and representation *of* women or about attempts by women artists to negotiate a new understanding of subjectivity based on feminine knowledge and desire.

The focus of much recent writing about women and art seems to have shifted from production of representation as recent theoretical developments have focused attention on textual issues. But language, whether verbal or visual, is inflected by specific historical conditions; often it is the artist, not the intellectual, who can most quickly embody ideological contradictions and force a meeting between intellect and feeling. It remains for women artists to negotiate new relationships to the noncolonized body and to find ways of speaking the *difference* of femininity, which is not bound to negation and otherness. We need a feminist art that retains its ability to affect the institutions of power by refusing to ignore issues of race, class, sex, and age; and a feminist criticism/history that can continue to respond to and theorize a feminist art, which is accessible to and pleasurable for women.

Notes

1 *Screen*, 16 (3) (autumn, 1975): 6–18.
2 Whitney Chadwick, *Women, Art and Society* (London: Thames and Hudson, 1989).
3 The issue of essentialism is the subject of Gisela Ecker's introduction to *Feminist Aesthetics*, trans. H. Anderson (London: The Women's Press, 1985), pp. 15–22.
4 Rozsika Parker and Griselda Pollock, *Old Mistresses: Women, Art and Ideology* (New York: Pantheon Books, 1981).
5 The best current introduction to these issues is Chris Weedon, *Feminist Practice and Poststructuralist Theory* (Oxford: Blackwell, 1987).
6 Toril Moi, *Sexual/Textual Politics: Feminist Literary Theory* (London: Methuen, 1985), pp. 102–67.
7 May Stevens, 'Taking art to the revolution', *Heresies*, 9 (1980).

Diana Fuss, 'The Risk of Essence' (1989)

From *Essentially Speaking: Feminism, Nature and Difference* (New York: Routledge, 1989), pp. 2–6, 18–21.

Essentialism *v.* Constructionism

Essentialism is classically defined as a belief in true essence – that which is most irreducible, unchanging, and therefore constitutive of a given person or thing. This definition represents the traditional Aristotelian understanding of essence, the definition with the greatest amount of currency in the history of Western metaphysics.[1] In feminist theory, essentialism articulates itself in a variety of ways and subtends a number of related assumptions. Most obviously, essentialism can be located in appeals to a pure or original femininity, a female essence, outside the boundaries of the social and thereby untainted (though perhaps repressed) by a patriarchal order. It can also be read in the accounts of universal female oppression, the assumption of a totalizing symbolic system which subjugates all women everywhere, throughout history and across cultures. Further, essentialism underwrites claims for the autonomy of a female voice and the potentiality of a feminine language (notions which find their most sophisticated expression in the much discussed concept of *écriture féminine*).[2] Essentialism emerges perhaps most strongly within the very discourse of feminism, a discourse which presumes upon the unity of its object of inquiry (women) *even* when it is at pains to demonstrate the differences within this admittedly generalizing and imprecise category.

Constructionism, articulated in opposition to essentialism and concerned with its philosophical refutation, insists that essence is itself a historical construction. Constructionists take the refusal of essence as the inaugural moment of their own projects and proceed to demonstrate the way previously assumed self-evident kinds (like 'man' or 'woman') are in fact the effects of complicated discursive practices. Anti-essentialists are engaged in interrogating the intricate and interlacing processes which work together to produce all seemingly 'natural' or 'given' objects. What is at stake for a constructionist are systems of representations, social and material practices, laws of discourses, and ideological effects. In short, constructionists are concerned above all with the *production* and *organization* of differences, and they therefore reject the idea that any essential or natural givens precede the processes of social determination.[3]

Essentialists and constructionists are most polarized around the issue of the relation between the social and the natural. For the essentialist, the natural provides the raw material and determinative starting point for the practices and laws of the social. For example, sexual difference (the division into 'male' and 'female') is taken as prior to social differences which are presumed to be mapped on to, *a posteriori*, the biological subject. For the constructionist, the natural is itself posited as a construction of the social. In this view, sexual difference is discursively produced, elaborated as an effect of the social rather than its *tabula rasa*, its prior object. Thus while the essentialist holds that the natural is *repressed* by the social, the constructionist maintains that the natural is *produced* by the social.[4] The difference in philosophical positions can be summed up by Ernest Jones's question: 'Is woman born or made?' For an essentialist like Jones, woman is born not made; for an anti-essentialist like Simone de Beauvoir, woman is made not born.

Each of these positions, essentialism and constructionism, has demonstrated in the range of its deployment certain analytical strengths and weaknesses. The problems with essentialism are perhaps better known. Essentialist arguments frequently make recourse

to an ontology which stands outside the sphere of cultural influence and historical change. 'Man' and 'woman,' to take one example, are assumed to be ontologically stable objects, coherent signs which derive their coherency from their unchangeability and predictability (there have *always* been men and women it is argued). No allowance is made for the historical production of these categories which would necessitate a recognition that what the classical Greeks understood by 'man' and 'woman' is radically different from what the Renaissance French understood them to signify or even what the contemporary postindustrial, postmodernist, poststructuralist theoretician is likely to understand by these terms. 'Man' and 'woman' are not stable or universal categories, nor do they have the explanatory power they are routinely invested with. Essentialist arguments are not necessarily ahistorical, but they frequently theorize history as an unbroken continuum that transports, across cultures and through time, categories such as 'man' and 'woman' without in any way (re)defining or indeed (re)constituting them. History itself is theorized as essential, and thus unchanging; its essence is to generate change but not itself to *be* changed.

Constructionists, too, though they might make recourse to historicity as a way to challenge essentialism, nonetheless often work with uncomplicated or essentializing notions of history. While a constructionist might recognize that 'man' and 'woman' are produced across a spectrum of discourses, the categories 'man' and 'woman' still remain constant. Some minimal point of commonality and continuity necessitates at least the linguistic retention of these particular terms. The same problem emerges with the sign 'history' itself, for while a constructionist might insist that we can only speak of *histories* (just as we can only speak of feminisms or deconstructionisms) the question that remains unanswered is what motivates or dictates the continued semantic use of the term 'histories'? This is just one of many instances which suggest that essentialism is more entrenched in constructionism than we previously thought. In my mind, it is difficult to see how constructionism can *be* constructionism without a fundamental dependency upon essentialism.

It is common practice in social constructionist argumentation to shift from the singular to the plural in order to privilege heterogeneity and to highlight important cultural and social differences. Thus, woman becomes women, history becomes histories, feminism becomes feminisms, and so on. While this maneuver does mark a break with unitary conceptual categories (eternal woman, totalizing history, monolithic feminism), the hasty attempts to pluralize do not operate as sufficient defenses or safeguards against essentialism. The plural category 'women,' for instance, though conceptually signaling heterogeneity nonetheless semantically marks a collectivity; constructed or not, 'women' still occupies the space of a linguistic unity. It is for this reason that a statement like 'American women are "x"' is no less essentializing than its formulation in the singular, '*The* American woman is "x."' The essentialism at stake is not countered so much as *displaced*.

If essentialism is more entrenched in constructionist logic than we previously acknowledged, if indeed there is no sure way to bracket off and to contain essentialist maneuvers in anti-essentialist arguments, then we must also simultaneously acknowledge that there is no essence to essentialism, that essence *as* irreducible has been *constructed* to be irreducible. Furthermore, if we can never securely displace essentialism, then it becomes useful for analytical purposes to distinguish between *kinds* of essen-

tialisms, as John Locke has done with his theory of 'real' versus 'nominal' essence. Real essence connotes the Aristotelian understanding of essence as that which is most irreducible and unchanging about a thing; nominal essence signifies for Locke a view of essence as merely a linguistic convenience, a classificatory fiction we need to categorize and to label. Real essences are discovered by close empirical observation; nominal essences are not 'discovered' so much as assigned or produced – produced specifically by language.[5] This specific distinction between real and nominal essence corresponds roughly to the broader oppositional categories of essentialism and constructionism: an essentialist assumes that innate or given essences sort objects naturally into species or kinds, whereas a constructionist assumes that it is language, the names arbitrarily affixed to objects, which establishes their existence in the mind. To clarify, a rose by any other name would still be a rose – for an essentialist; for a constructionist, a rose by any other name would not be a rose, it would be something altogether rather different.

Certainly, Locke's distinction between real and nominal essence is a useful one for making a political wedge into the essentialist/constructionist debate. When feminists today argue for maintaining the notion of a *class* of women, usually for political purposes, they do so I would suggest on the basis of Locke's nominal essence. It is Locke's distinction between nominal and real essence which allows us to work with the category of 'women' as a *linguistic* rather than a natural kind, and for this reason Locke's category of nominal essence is especially useful for anti-essentialist feminists who want to hold onto the notion of women as a group without submitting to the idea that it is 'nature' which categorizes them as such. And yet, however useful the 'real' versus 'nominal' classification may be for clarifying the relation between essence and language (transposing essence as an effect of language), the distinction it proposes is far from an absolute one. Real essence is itself a nominal essence – that is, a linguistic kind, a product of naming. And nominal essence is still an essence, suggesting that despite the circulation of different kinds of essences, they still all share a common classification *as essence*. I introduce the Lockean theory of essence to suggest both that it is crucial to discriminate between the ontological and linguistic orders of essentialism and that it is equally important to investigate their complicities as types of essentialisms, members of the same semantic family.

My point here, and throughout this book, is that social constructionists do not definitively escape the pull of essentialism, that indeed essentialism subtends the very idea of constructionism. Let me take another example, one often cited as the exemplary problem which separates the essentialist from the constructionist: the question of 'the body.' For the essentialist, the body occupies a pure, pre-social, pre-discursive space. The body is 'real,' accessible, and transparent; it is always *there* and directly interpretable through the senses. For the constructionist, the body is never simply there, rather it is composed of a network of effects continually subject to sociopolitical determination. The body is 'always already' culturally mapped; it never exists in a pure or uncoded state. Now the strength of the constructionist position is its rigorous insistence on the production of social categories like 'the body' and its attention to systems of representation. But this strength is not built on the grounds of essentialism's demise, rather it works its power by strategically deferring the encounter with essence, displacing it, in this case, onto the concept of sociality.

To say that the body is always already deeply embedded in the social is not by any sure means to preclude essentialism. Essentialism is embedded in the idea of the social and lodged in the problem of social determination (and even, as I will later argue, directly implicated in the deconstructionist turn of phrase 'always already'). Too often, constructionists presume that the category of the social automatically escapes essentialism, in contradistinction to the way the category of the natural is presupposed to be inevitably entrapped within it. But there is no compelling reason to assume that the natural is, in essence, essentialist and that the social is, in essence, constructionist. If we are to intervene effectively in the impasse created by the essentialist/constructionist divide, it might be necessary to begin questioning the *constructionist* assumption that nature and fixity go together (naturally) just as sociality and change go together (naturally). In other words, it may be time to ask whether essences can change and whether constructions can be normative.

[. . .]

'The Risk of Essence May Have to be Taken'

Despite the uncertainty and confusion surrounding the sign 'essence,' more than one influential theorist has advocated that perhaps we cannot do without recourse to irreducibilities. One thinks of Stephen Heath's by now famous suggestion, 'the risk of essence may have to be taken' (1978: 99). It is poststructuralist feminists who seem most intrigued by this call to risk essence. Alice Jardine, for example, finds Stephen Heath's proclamation (later echoed by Gayatri Spivak) to be 'one of the most thought-provoking statements of recent date' (Spivak, 1987: 58). But not all poststructuralist feminists are as comfortable with the prospect of re-opening theory's Pandora's box of essentialism. Peggy Kamuf warns that calls to risk essentialism may in the end be no more than veiled defenses against the unsettling operations of deconstruction:

> How is one supposed to understand essence as a *risk* to be run when it is by definition the non-accidental and therefore hardly the apt term to represent danger or risk? Only over against and in impatient reaction to the deconstruction of the subject can 'essence' be made to sound excitingly dangerous and the phrase 'the risk of essence' can seem to offer such an appealing invitation. . . . 'Go for it,' the phrase incites. 'If you fall into "essence," you can always say it was an accident.' (Kamuf, 1987: 96)

In Kamuf's mind, risking essence is really no risk at all; it is merely a clever way of preserving the metaphysical safety net should we lose our balance walking the perilous tightrope of deconstruction.

But the call to risk essence is not merely an 'impatient reaction' to deconstruction (though it might indeed be this in certain specific instances); it can also operate as a deconstructionist strategy. 'Is not strategy itself the real risk?' Derrida asks in his seminar on feminism (Derrida, 1987: 192). To the deconstructionist, strategy of any kind is a risk because its effects, its outcome, are always unpredictable and undecidable. Depending on the historical moment and the cultural context, a strategy can be 'radically revolutionary or deconstructive' or it can be 'dangerously reactive' (1987: 193).

What is risky is giving up the security – and the fantasy – of occupying a single subject-position and instead occupying two places at once. In a word, 'we have to negotiate' (1987: 202). For an example of this particular notion of 'risk' we can turn to Derrida's own attempts to dare to speak as woman. For a male subject to speak as woman can be radically de-essentializing; the transgression suggests that 'woman' is a social space which any sexed subject can fill. But because Derrida never specifies *which* woman he speaks as (a French bourgeois woman, an Anglo–American lesbian, and so on), the strategy to speak as woman is simultaneously re-essentializing. The risk lies in the difficult negotiation between these apparently contradictory effects.

It must be pointed out here that the constructionist strategy of specifying more precisely these sub-categories of 'woman' does not necessarily preclude essentialism. 'French bourgeois woman' or 'Anglo–American lesbian,' while crucially emphasizing in their very specificity that 'woman' is by no means a monolithic category, nonetheless reinscribe an essentialist logic at the very level of historicism. Historicism is not always an effective counter to essentialism if it succeeds only in fragmenting the subject into multiple identities, each with its own self-contained, self-referential essence. The constructionist impulse to specify, rather than definitively counteracting essentialism, often simply redeploys it through the very strategy of historicization, rerouting and dispersing it through a number of micropolitical units or sub-categorical classifications, each presupposing its own unique interior composition or metaphysical core.

There is an important distinction to be made, I would submit, between 'deploying' or 'activating' essentialism and 'falling into' or 'lapsing into' essentialism. 'Falling into' or 'lapsing into' implies that essentialism is inherently reactionary – inevitably and inescapably a problem or a mistake.[6] 'Deploying' or 'activating,' on the other hand, implies that essentialism may have some strategic or interventionary value. What I am suggesting is that the political investments of the sign 'essence' are predicated on the subject's complex positioning in a particular social field, and that the appraisal of this investment depends not on any interior values intrinsic to the sign itself but rather on the shifting and determinative discursive relations which produced it. As subsequent chapters [of *Essentially Speaking*] will more forcefully suggest, the radicality or conservatism of essentialism depends, to a significant degree, on *who* is utilizing it, *how* it is deployed, and *where* its effects are concentrated.

It is important not to forget that essence is a sign, and as such historically contingent and constantly subject to change and to redefinition. Historically, we have never been very confident of the definition of essence, nor have we been very certain that the definition of essence is to *be* the definitional. Even the essence/accident distinction, the inaugural moment of Western metaphysics, is by no means a stable or secure binarism. The entire history of metaphysics can be read as an interminable pursuit of the essence of essence, motivated by the anxiety that essence may well be accidental, changing and unknowable. Essentialism is not, and has rarely been, monolithically coded. Certainly it is difficult to identify a single philosopher whose work does not attempt to account for the question of essentialism in some way; the repeated attempts by these philosophers to fix or to define essence suggest that essence is a slippery and elusive category, and that the sign itself does not remain stationary or uniform.

The deconstruction of essentialism, rather than putting essence to rest, simply raises the discussion to a more sophisticated level, leaps the analysis up to another higher

register, above all, keeps the sign of essence in play, even if (indeed *because*) it is continually held under erasure. Constructionists, then, need to be wary of too quickly crying 'essentialism.' Perhaps the most dangerous problem for anti-essentialists is to see the category of essence as 'always already' knowable, as immediately apparent and naturally transparent. Similarly, we need to beware of the tendency to 'naturalize' the category of the natural, to see this category, too, as obvious and immediately perceptible *as such*. Essentialism may be at once more intractable and more irrecuperable than we thought; it may be essential to our thinking while at the same time there is nothing 'quintessential' about it. To insist that essentialism is always and everywhere reactionary is, for the constructionist, to buy into essentialism in the very act of making the charge; *it is to act as if essentialism has an essence.*

Notes

1 A comprehensive discussion of the essence/accident distinction is elaborated in Book Z of Aristotle's *Metaphysics*. For a history of the philosophical concept of essentialism, readers might wish to consult DeGrood (1976) or Rorty (1979).

2 See, for example, Hélène Cixous's contribution to *The Newly Born Woman* (Cixous and Clément, 1986).

3 I want to emphasize here that most feminist theorists are, in fact, *both* essentialists and constructionists. E. Ann Kaplan, who often takes the essentialist/anti-essentialist distinction as a primary organizational frame in her discussions of film and television criticism, has identified four 'types' of feminism: bourgeois feminism, Marxist feminism, radical feminism, and poststructuralist feminism (Kaplan, 1987: 216). The first three types – bourgeois, Marxist, and radical – Kaplan categorizes under the rubric 'essentialist'; the fourth type – poststructuralist – she labels 'anti-essentialist.' I would submit that the division here is much too simplistic to be useful: it sees *all* poststructuralist feminists as anti-essentialists and *all other* feminists as essentialists. Such a schema cannot adequately account, for example, for the work of Luce Irigaray, a poststructuralist Derridean who many consider to be an essentialist; nor can it account for a theorist like Monique Wittig who appears to fall into at least two of Kaplan's essentialist categories, Marxist feminism and radical feminism, and yet who identifies herself as a committed social constructionist. We must be extremely wary of using the constructionist/essentialist opposition as a taxonomic device for elaborating oversimplified and deceptive typologies (another powerful argument to be made in favor of working to subvert, rather than to reify, this particularly pervasive dualism).

4 I am reminded of that curious but common saying, 'second nature.' The qualifier 'second' implies orders, gradations, types of 'nature.' It further implies that some 'kinds' of nature may be closer to the ideal or prototype than others – indeed, that some may be more 'natural' than others. Essentialism here crumbles under the weight of its own self-contradiction and opens the door to viewing essence as a social construct, a production of language.

5 For example, the nominal essence of gold (Locke's favorite example) would be 'that complex idea the word gold stands for, let it be, for instance a body yellow, of a certain weight, malleable, fusible, and fixed'; its real essence would be 'the constitution of the insensible parts of that body, on which those qualities, and all the other properties of gold depend' (Locke, 1690: 13.6). Locke discusses real versus nominal essence in numerous passages of *An Essay Concerning Human Understanding*, the most important of which are 2.31; 3.3; 3.6; 3.10; 4.6; and 4.12.

6 Toril Moi's *Sexual/Textual Politics* (1985) provides a particularly good example of how this locution can be used to dismiss entire schools of feminist thought – in Moi's case, to discredit 'Anglo-American' feminism. Moi's sweeping criticism of writers as diverse as Elaine Showalter, Myra Jehlen, Annette Kolodny, Sandra Gilbert, and Susan Gubar consists mainly in mapping out in detail the points

in which their analyses 'slip into' essentialism and therefore 'reinscribe patriarchal humanism.' Such an ostensibly anti-essentialist critique can only be built on the grounds of the twin assumptions that essentialism is, in essence, 'patriarchal' and that 'patriarchal humanism' has an essence which is inherently, inevitably reactionary.

References

Cixous, Hélène and Clément, Catherine (1975) *La jeune neé* (Paris: Union Générale d'Editions); *The Newly Born Woman*, trans. Betsy Wing (Minneapolis, MN: University of Minnesota Press, 1986).

DeGrood, David H. (1976) *Philosophies of Essence: An Examination of the Category of Essence* (Amsterdam: B. R. Gruner).

Derrida, Jacques (1987) 'Women in the beehive,' in *Men in Feminism*, ed. Alice Jardine and Paul Smith (New York and London: Methuen).

Heath, Stephen (1978) 'Difference,' *Screen*, 19 (3): 50–112.

Kamuf, Peggy (1987) 'Femmeninism,' in *Men in Feminism*, ed. Alice Jardine and Paul Smith (New York and London: Methuen).

Kaplan, E. Ann (1987) 'Feminist criticism and television,' in *Channels of Discourse: Television and Contemporary Criticism*, ed. Robert C. Allen (Chapel Hill, NC: University of North Carolina Press).

Locke, John (1690) *An Essay Concerning Human Understanding* (London: Printed by Elizabeth Holt for Thomas Bassett).

Moi, Toril (1985) *Sexual/Textual Politics: Feminist Literary Theory* (New York: Methuen).

Rorty, Richard (1979) *Philosophy and the Mirror of Nature* (Princeton, NJ: Princeton University Press).

Spivak, Gayatri (1987) 'Men in feminism: odor di uomo or compagnons de route?,' in *Men in Feminism*, ed. Alice Jardine and Paul Smith (New York and London: Methuen).

Hilary Robinson, 'Reframing Women' (1995)

From *Circa*, 72 (1995), pp. 18–23.

The recent exhibition of Sheela-na-gig figures at the Irish Museum of Modern Art [IMMA] was for me both deeply moving and highly problematic. It was moving because these carvings of women displaying their genitals (carved we know not why, nor by whom) are so utterly removed from the common present display of female genitals yet able to carry profound meanings to a contemporary audience of women. Non-functional as provokers of male sexual desire, they are none the less deeply alluring to women viewers as they enact a representation of female sexuality not found elsewhere in our culture. Powerful, stark, literally unspeakable (what are the words that I can begin to use to construct this – what is it? emotion? knowledge? intelligence? – that I experience in this encounter), a wish for identification is provoked in me, a woman viewer, by the carvings. At the same time, the exhibition was problematic for a number of reasons. Some of these sprang from the immediate context in which the Sheela-na-gigs were placed – the juxtaposed exhibition, 'Picasso to Koons,' gave a confrontational pos-

itioning rather than the subtle or rich dialogue that might have been possible with other works. Some of the other problems came from my own positioning, from what I brought to the moment of encountering the Sheela-na-gigs: an English woman, no longer young, with experience of feminist art practices and theories, and some understanding (via psychoanalysis, semiotics and politics) of visual representation, its construction and reading.

Reflecting upon the Sheela-na-gigs, the thorny issue of essentialism loomed: the inherent racism and anti-feminism which would inform any romanticising of them as eternally 'Other', as a-historical, as 'primitive', and as the products of a 'primitive' culture, and which insisted that I therefore recognize the specifics of their being. Contrastingly, the womanly, bodily, sexual identifications which permeated my encounter with the Sheela-na-gigs encouraged a notion of being an 'everywoman', that I could be part of – and representative of – a womankind with whom these images might universally speak, and in turn who they might universally represent.

But maybe contradiction is productive.

It is widely understood that western (Euro-centric) culture is predicated upon a value system of binary oppositions: male–female; rational–emotional; mind–body; culture–nature; light–dark; masculine–feminine; and so on. Binary positions have been mapped onto each other, leading to ever-increasing polarity, with the male/rational/mind/culture axis claiming supremacy over that which it can then call 'Other' and relegate to subordinate and marginal positions: the female/emotional/body/nature axis. From this have grown strong and subtle roots and branches, constructing and justifying differences as 'natural', maintaining supremacies. Sanctioned within this binary opposition, perpetuated by it, we find sexist behaviour, racism, colonial impulses. The 'Other' is always clearly marked; and many definitions of 'Others' remain remarkably consistent, despite differences between these 'Others' in their cultural positionings and histories: they are frequently classified as closer to nature, emotional, instinctual, fluid, lacking in moral or intellectual discipline.

Within this construct of 'Otherness' the space for a discriminatory essentialism is clear; and the maintaining of essentialist beliefs is merely a maintenance of the status quo, a maintaining of what is described as 'common sense'. Thus, the belief that, say, women are not capable of undertaking certain responsibilities because they are emotional creatures, and that they are emotional creatures because they are somehow closer to nature, are beliefs that are used against individual women because any individual woman is believed to have within her an essence of womanliness – those particular qualities – that she has in common with all other women.

Women, across race, class and age are thus elided, joined, and named as different; and the mark of their difference is their biology. Essence and biology are then conflated: essential womanliness and femininity are an inevitable result of a biological female sex.

The reasons for the development of anti-essentialist positions in feminist (and post-colonialist) theory become clear. If the identity of a particular group or class of people is considered to be in place because of an essence that each of them individually will have and collectively will share (if they are considered to 'naturally' or intrinsically have certain attributes) then the possibilities for political change are radically disrupted and minimalized. If on the other hand the attributes of, say, 'womanliness' or (even more movable a concept) 'femininity' are theorised as culturally constructed and determined,

then change is not only possible, it is inevitable – and so strategies for progressive or revolutionary political change can be developed, implemented and tested.

Conversely, the pleasures and even political desirability of developing a workable theory of essentialism from a position of 'Otherness' can also be recognised – what post-colonial theorist Gayatri Spivak has discussed under the name of 'strategic essentialism'.[1] If you are classified as a member of a category of people which is disenfranchised, silenced, objectified and otherwise disempowered, then to think of that category as contingent or non-unified can at times be both unsettling and a sign of weakness – in fact, it can be seen as compounding your problems. It can be both enriching and powerful to categorise yourself as having a transcendent affinity with your peers, and thus the collective ability to speak with one voice. The attributes assigned to you can be revalued or re-named – for instance, the desire to nurture or mother can be seen as the most important human desire, rather than something of little social or economic value; being irrational can be re-named as pragmatism in the face of adversity, or as a different form of rationality.

In 1979 the first public exhibition of *The Dinner Party* occurred. This project had been underway since 1974, instigated, designed and co-ordinated by Judy Chicago, and made by her with some 400 assistants. Central to the imagery of the work were large dinner plates. Each carried, in abstract and stylised form, an image of a vulva. Each place setting at the table was for – and representative of – a particular woman, historical or pre-historical, who was named on the table runner. The vulva thus became symbolic of an essential womanliness, a biological fact to which the subjectivities, historic realities and personal experiences of individual women (as expressed by Chicago through each particular design) were subsumed. While there is no doubt in the mind of most people who saw it that *The Dinner Party* was a considerable undertaking, and that it could be experienced as celebratory, stirring and inspiring, the debate it engendered amongst feminists clarified the problems of suggesting an essential womanliness through visual representation. Vulva-as-symbol in Chicago's work was reductive of womankind as a category, and of the individual. Although the consistent symbolic use of the vulva implied a universality and all-embracing inclusiveness, *The Dinner Party* in fact repeated old exclusions. Of the 39 women given places at the table, the bias was towards the US first, Europe second and the rest of the world a poor third: room was granted to just one black woman from any period post the Egyptian dynasties, and to two known lesbian women. Some women, it seemed, were less essential than others.

In the early 1970s Suzanne Santoro produced a series of photo-works juxtaposing pared-down images of vulvas with other disparate but formally similar objects – shells, flowers, Greek sculptures of draped figures. The series culminated in an artist's book, *Per una espressione nuova / Towards New Expression*.[2] While the use of flowers and shells was a cliché redolent of discriminatory essentialism, the intent of the book (as made explicit in the short text it contained) was quite different from Chicago's production of the vulva-image as an inclusive symbol. Santoro wished to encourage women to explore the specificity of their individual bodies, desires and sexuality – the title indicates as much: a revolutionary intent at a time when the concept of the vaginal orgasm had only recently been exposed as a myth. It is debatable how far Santoro's images embody this, and how much they repeat patriarchal concepts of female sexuality; but the intent was

clear enough for the Arts Council of Great Britain to decide to remove it from an exhibition it had organised of artists' books. They had been advised that it could be classified as 'obscene' legally, as it was an incitement to action – whereas the book of fetishized representations of women by Allen Jones was not intended as a call to action, but as art to be contemplated, and could thus remain in the exhibition.[3]

A similar series of events occurred with work by Tee Corinne. In 1975 she produced an artist's book, *The Cunt Coloring Book*. The aim of this was also to allow women space to contemplate their own bodies and sexualities: the book consisted of line drawings, portraits of the vulvas of women Corinne knew, which the women who bought the books could colour in. The book, and reproductions from it, have been censored on a number of occasions.[4]

Work like *The Dinner Party*, *The Cunt Coloring Book* and *Towards New Expression* formed part of an exploration of imagery by women artists which had become all the more visible since the rise of the new women's movement in the late 1960s, since when it had often been produced in the name of feminism. US art historian Barbara Rose had given it the (biologically confusing) name: vaginal imagery or iconology.[5] Critic Lucy Lippard called it 'female imagery',[6] which allowed for discussion of, for instance, formal aspects and imagery found in work of non-feminist artists such as Barbara Hepworth. On this side of the Atlantic, although 'vaginal imagery' was relatively common in art schools and in feminist artists groups, there was ambivalence about making it generally public. This was reflected in the critical writing. For Lisa Tickner, the efficacy of 'vaginal imagery' was contingent upon it not being re-appropriated by the patriarchy:

> If the vagina has been anaesthetized or omitted as part of the de-sexualizing of women and the fetishization of their image, then an emphasis on genital imagery as a parallel to women's reclamation of their sexual identity is fine. The implications are fairly clear. But if vaginal imagery, however beautiful, exists in this way within a male-dominated society . . . that is another matter, and the symbol is not open to 'reclamation'.[7]

For Griselda Pollock, writing a few months earlier, the point was that the moment had passed:

> [T]hat the radical potential of this kind of feminist imagery can easily be re-appropriated can be seen if one looks beyond the petit bourgeois ideology of the art establishment to the major conveyors of bourgeois patriarchal imagery in the big selling sex magazines where a profoundly disturbing development has taken place.
>
> In the pages of a recent Penthouse (v. 12 n. 3) vaginal imagery appears in all its force and decorative glamour, liberated from the traditional coyness of such magazine's sexual invitations. . . .[8]

It is worth bearing in mind that in the UK it was only 18 years ago that 'High Street' pornography began showing representations of women's genitals. This is a demonstration not only of how fast representations of sexuality shift imagery, but also of how the mass media can with equal speed and ease 'normalize' its own imagery, making it appear that things have always been this way. The shift towards mass imagery of

women's genitals also insists upon re-considerations by feminist artists of their use of 'vaginal imagery', and of its strategic use.

Theories of culture and art over the past two to three decades have seen a significant shift in the focus of their attentions, from the artwork as the object to be contemplated which could create and carry meaning in and of itself, to an attention to the context and 'framing' (in the widest sense) of the object. An artwork can only be understood if its wider significations and the context of its production and consumption are understood – its relationship to an artist, and its relationships (no matter how problematic) with the institutions of art and culture – market, exhibiting spaces, criticism, theory, history and education systems. This shift has been encouraged in no small part by theories developed from marxist, feminist, and post-colonial thinking, as the need has been recognised for strategic approaches to, and interventions in, dominant culture. (This is in contrast to the belief that an artwork has meaning in itself – an essentialist approach to art, if you like – which would include believing in the ability of an artwork to carry or effect agendas for change, no matter what its context and languages of representation.)

Spivak has been interviewed on her stated belief in the possibilities for a 'strategic use of a positivist essentialism in a scrupulously visible political interest'. In response she insisted upon a political approach to the question – an attention to strategy, rather than a more academic definition of what was or was not essentialist:

> I think the way in which the awareness of strategy works here is through a persistent critique. The critical moment does not come only at a certain stage when one sees one's effort, in terms of an essence that has been used for political mobilization, succeeding, when one sees that one has successfully brought a political movement to a conclusion . . . It is not only in that moment of euphoria that we begin to decide that it was strategic all along . . . [T]he awareness of strategy – the strategic use of an essence as a mobilizing slogan or masterword like woman or worker or the name of any nation that you like – it seems to me that this critique has to be persistent all along the way, even when it seems that to remind oneself of it is counterproductive . . . [W]e have to look at where the group . . . is situated when we make claims for or against essentialism. A strategy suits a situation; a strategy is not a theory.
>
> . . . Now I think my emphasis would be on noting how we ourselves and others are what you call essentialist, without claiming a counter-essence disguised under the alibi of strategy . . . [V]igilance, what I call building for difference, rather than keeping ourselves clean by being whatever it is to be an anti-essentialist, that has taken of much greater emphasis for me.[9]

An example of strategic essentialism can be found in some of the work of Adrian Piper. Piper uses her ambiguous racial identity (she is a light-skinned black woman) and the history of miscegenation in the US to confront a largely white gallery-going audience with facts about its own biological make-up, which many find deeply disturbing and upsetting: their essentialist view of black people leads them to be unable to countenance any inclusion of black blood in themselves, or to see it as incompatible with their assessment of their own subjectivities.

In the last Dokumenta (1992) Zoë Leonard made strategic use of 'vaginal imagery'. At the previous (1987) Dokumenta the Guerrilla Girls had distributed cards asking

'*Why in 1987 is Documenta 95% white and 83% male?*' In 1992 the statistics were not much better. Some of the women selected were rumoured to have threatened withdrawing following tokenising and patronising behaviour from the curator. Leonard made work for the city gallery. Here, a series of elegant rooms housed 17th century and 18th century portraits. Leonard removed the portraits of men, replacing them with 10″ × 8″ black and white photographs of women's genitals, framed simply with glass and clips.

The effect was three-fold. First, the work insisted upon a highly visible, talked-about, defiant and undeniably female presence. Second, it exposed and embarrassed the normative gendered economy of the gaze by making what is usually private operative in a place of public spectacle. Third, it exposed how the women in the portraits were positioned by bourgeois ideology by removing the bourgeois aesthetic of portraiture. It resisted containment by drawing attention strategically to the framework of Dokumenta – the site, the concept, and the event.

Back in IMMA, the exhibition of Sheela-na-gig figures, through its framing, asserted a discriminatory essentialism. The juxtaposed exhibition, 'Picasso to Koons', presented work of five mainstays of masculinist modern art practice: Picasso, Duchamp, Warhol, Beuys and Koons, often featuring male representations of 'Others', which can be read from that position of otherness as essentialist and retrogressive. (I am thinking here particularly of the Picasso painting 'Maternité'; his drawings of 'Africanised' women; the Warhol portrait of Basquiat.) The dialogue set up among these works and the Sheela-na-gigs foregrounded an opposition between maleness and femaleness, between the 'cultured' and the 'primitive', along demarcation lines that were all too familiar. If one wished to exhibit the Sheela-na-gigs, as representations of female figures from Ireland about whose origins no one knows very much, in a way that did not encourage reactionary constructions of both Irishness and womanliness, then acute strategic thinking and contextualising would be necessary. As contemporary artists like Leonard and Piper demonstrate, the risk of essentialism is worth taking; the strategies are worth getting right.

Notes

1 G. Spivak, with E. Rooney, 'In a word: interview', *Differences: A Journal of Feminist Cultural Studies*, 1 (2) (Summer 1989): 124–56.

2 S. Santoro, *Per una espressione nuova/Towards New Expression* (Rome: Rivolta femminile, 1974).

3 See R. Parker, 'Censored', *Spare Rib*, 54 (1977).

4 T. Corinne, *Twenty-two Years: 1970–1992* (self-published documentation of work).

5 B. Rose, 'Vaginal iconology', *New York Magazine* (11 February 1974).

6 L. Lippard, *From the Center: Feminist Essays on Women's Art* (New York: E. P. Dutton, 1976), p. 77.

7 L. Tickner, 'The body politic: female sexuality and women artists since 1970', *Art History*, 1 (2) (June, 1978): 236–49.

8 G. Pollock, 'What's wrong with "Images of Women"?', *Screen Education*, 24 (1977): 25–33.

9 Spivak, 'In a word'.

8

Body, Sexuality, Image

INTRODUCTION

The impulse to develop feminist representations of the female body and sexuality is not hard to locate. If our culture does not provide representations, or provides images which are understood as misrepresentations or inadequate representations, then there will be a response. This will manifest itself as critiques of the present representational regime (artists like Hung Liu, Adrian Piper, Cindy Sherman); withdrawal from imaging the female body as such images are too vulnerable to being recouped by extant discourses (Mary Kelly, Barbara Kruger, Jenny Holzer); attempts to disrupt present representational codes (Helen Chadwick, Jenny Saville, Lorna Simpson, Nancy Spero); and investing in a new symbology and/or evocation of the female body and sexuality (Judy Chicago, Laura Godfrey-Isaacs, Annie Sprinkle). As can be seen from even these brief lists of artists, there is a diversity of material, political and strategic responses to consider in each category – and indeed the categories may overlap in the work of each of them. But attempts to assert the presence of differing female sexualities and a re-imaging of the female body can be found in much art by feminists, and this chapter begins to present some of the debates around such work.

The first section consists of texts which affirm the presence of lesbian sexuality and lesbian artists.[1] Lesbian women have been additionally marginalized not only by having their sexuality deemed 'aberrant' or 'abnormal', but also by having it represented in visual images as an object for male erotic investigation (see, for example, pornographic imagery and paintings such as those of female couples by Courbet). The text by artist Shonagh Adelman is a useful drawing together of texts and theories found elsewhere in this book in order to work towards theories of representation for lesbian feminist artists. In contrast, Ann Gibson uses art historical methodologies to assert the lesbian presence at the centre of that bastion of masculinist art practices, New York's Abstract Expressionist movement. Curator Betty Parsons gave artists like Jackson Pollock, Mark Rothko and Hans Hofmann their first one-man exhibitions. Gibson exposes the silences that have developed around Parsons's work, and demonstrates her support not only for homosexual male artists such as Alphonso Ossorio and Forrest Bess, but for heterosexual women like Hedda Sterne and lesbian women like Sonia Sukula. The disjuncture between the macho discourses of Abstract Expressionism, Parsons's own support of those artists but her refusal to allow that debate to determine her

curatorial practice, and her pragmatic approach to the relation between her sexuality and her public life (prioritizing her career), and matters like Barnett Newman's camp personal style, are all investigated in order to build up the complexity of Parsons's identity as lesbian and as curator.

The problem of historiography is also one which affects contemporary artists. Harmony Hammond situates herself as a lesbian making art today who was also making art – and out as a lesbian – in the 1970s. Calling it 'cultural amnesia', she outlines how younger lesbian artists today have a lack of knowledge of, or forget to acknowledge, both the history of lesbian-focused exhibitions and the work of older lesbian artists. What is at stake here is not only lesbian histories and agency, but also the relation between feminist history and the development of lesbian codes of representation. Hammond contrasts the work of one straight-identified and one lesbian-identified 'older' artist (Joan Semmel and Tee Corinne respectively) with two 'younger' lesbian artists (Patricia Cronin and Zoe Leonard) to demonstrate how remembering the history of even two to three decades can enrich the possibilities for and understandings of contemporary practices by lesbian artists.

The second section of this chapter turns to representations of the female body, the structures of the ideology informing dominant representations, and constructing oppositional readings of difference. Mary Duffy is an Irish artist who 'was born without arms due to thalidomide'. Her text presents her negotiation of her identity as an artist with a disability, and her use of her own body in her work to challenge assumptions of wholeness, beauty and the female body. Lynda Nead's important book *The Female Nude* remains the only full-length analysis of the subject from the ideology informing art history to the practices of contemporary women artists (including Mary Duffy). The opening section, reprinted here, starts with three quotes from art historian Kenneth Clark, anthropologist Mary Douglas, and philosopher Jacques Derrida. Drawing from their discussion of borders, containment and frames, Nead argues that across discourses in Western culture 'one of the principal goals of the female nude has been the containment and regulation of the female sexual body.' She demonstrates this through analysis of a sixteenth-century allegorical painting of 'Chastity' by Giovanni Battista Moroni, a photograph of body-builder Lisa Lyon by Robert Mapplethorpe, the visual elements at play in anorexia nervosa, and an etching by Albrecht Dürer. In this way she shows that similar ideologies are at work in these differing fields of representation of the female body in Western history.

In her book *Body Art*, Amelia Jones argues, amongst other things, for a discourse and practice of 'radical narcissism'. In the section reprinted here, she discusses the discourses surrounding early works by Japanese artist Yayoi Kusama in the USA. Treating the documentation of body art as performative of the public identity of the artist, Jones argues that Kusama's 'particularized' subjecthood, represented through the medium of performing her irrefutably, exaggeratedly female, Asian, body, 'enacted against the grain of the normative [artist] subject' ensures that 'the hidden logic of exclusionism underlying modernist art history and criticism is exposed'.

The final section of this chapter concerns the representation of the sexual body. Barbara Rose's 1974 article first gave the name 'vaginal iconology' to the work made by feminists in the early 1970s depicting women's genitals.[2] She places such work in the context of the radicalizing of art and of sex, and makes an analogy with the black

movement in its valorizing of difference. She points out that such feminist work is mis-labelled erotic but it 'is nothing of the sort. It is designed to arouse women, but not sexually.' It is 'an overt assault on the Freudian doctrine of penis envy, which posits that all little girls must feel that they are missing something'. This blind spot – because of course women are missing nothing, they have something different which Freud couldn't 'see' that they have – is also alluded to in the text from Suzanne Santoro's artist's book, *Towards New Expression*. This book depicts photographic images of women's genitals, pared down to the almond shape of the vulva and labia, juxtaposed with photographs of shells, flowers, and the pubic area of women as depicted by artists such as Raphael and Cranach, where pubic hair and the meeting of the two lips are ignored: 'When I saw how this subject had been treated in the past, I realized that even in diverse historical representations it had been annulled, smoothed down and, in the end, idealized.'[3] Santoro asks with her book that women explore and express their sexuality and their sexual bodies.

In the chapter reprinted here from her catalogue essay on Hannah Wilke, Joanna Frueh provides a reading of Wilke's body art and 'cunt sculptures'. Wilke's early work showed her own body in a variety of provocative and ambiguous contexts, with the aim of 'respecting the objecthood of the body'. Frueh shows how Wilke knowingly re-entered certain forms of representation in order to expose and reflect them back to the viewer. Acknowledging the feminist argument for not representing the body in such a manner, Frueh argues that the ambiguous and equivocal nature of this work is useful for feminism. She brings into the discussion Wilke's cunt sculptures – vulva-shaped loops of materials such as clay, chewing-gum and kneaded erasers. Through attaching these to her body as if they were scars, or through placing larger ones massed on the walls of galleries or in public situations, Wilke developed a symbology to counter the phallic visual order with which we presently are faced. Through their sheer number and multiplicity, Wilke avoids a simplistic substitution of a female symbol for a male, remaining in a monolithic phallic order. Frueh argues that from such visual and political risks a new mother-tongue might develop.

The final text is one of two contributions to the debates about representation of the black female body, the lesbian body, and the sexual body made by artist Buseje Bailey in the Canadian journal *Matriart*.[4] In this piece she protests against an orthodoxy of representation developing, in which lesbian content was expected to be overt and sexual: 'My work has always been about women, children, and my experience as a Black woman in this society. Every decision I make is political, even where I buy my bread . . . I had assumed that one could not separate who one is from the work one does, i.e. the per-sonal, from the political.' For Bailey, with her multiple identities – black, lesbian, female, poor – in exploring her body she is 'exploring racism, colonialism, sexism, and ulti-mately I am exploring my lesbianism.' In each of her named identities she is brought up against the marginalizing of her other identities: her work is towards self-acceptance and survival.

Notes

1 There are a number of other texts by lesbian women in this collection. Not all focus on lesbian art, artists or theories: among those that do are texts by Buseje Bailey, Jan Zita Grover, Monique Wittig

and Terry Wolverton. This section, as indicated, comprises texts which deal primarily with the issue of lesbian presence.

2 Strictly speaking, the word 'vaginal' is incorrect, as it was the vulva that was most usually evoked in such work, but the term entered the discourse. Strangely, the essay title was even more misleadingly altered to 'Venus Envy' when the article was reprinted in Rose's collected essays, *Autocritique: Essays on Art and Anti-art 1963–1987* (New York: Weidenfeld and Nicolson, 1988), pp. 27–9.

3 This book was, famously, censored by the then Arts Council of Great Britain from an exhibition of artists books because it was overtly a call for sexual activity and thus could be classified as pornographic, while a book by Allen Jones of fetishistic images of women was left in as it was deemed to be artistic rather than sexual in intent, and also did not depict the genitals. Rozsika Parker, 'Censored', *Spare Rib*, 54 (1977): 43–5; reprinted in *Looking On: Images of Femininity in the Visual Arts and Media*, ed. Rosemary Betterton (London: Pandora Press, 1987), pp. 254–8.

4 See also Buseje Bailey, 'Lesbian art and identity', *Matriart*, 1 (2) (1990): 6–7.

Essential reading

Betterton, Rosemary, *An Intimate Distance: Women, Artists and the Body* (London: Routledge, 1996).

Caughie, John et al. (eds), *The Sexual Subject: A Screen Reader in Sexuality* (London: Routledge, 1992).

Hammond, Harmony, *Lesbian Art in America: A Contemporary History* (New York: Rizzoli, 2000).

Horne, Peter and Lewis, Reina (eds), *Outlooks: Lesbian and Gay Sexualities in Visual Cultures* (London: Routledge, 1996).

Lippard, Lucy, 'The pains and pleasures of rebirth: European and American women's body art', *Art in America*, 64 (3) (1976): 72–81; reprinted in *From the Center: Feminist Essays on Women's Art* (New York: E. P. Dutton, 1976); and *The Pink Glass Swan: Selected Feminist Essays on Art* (New York: The New Press, 1995), pp. 99–113.

Meskimmon, Marsha, *The Art of Reflection: Women Artists' Self-portraiture in the Twentieth Century* (London: Scarlet Press, 1996).

Nead, Lynda, *The Female Nude: Art, Obscenity and Sexuality* (London: Routledge, 1992).

Suleiman, Susan Rubin (ed.), *The Female Body in Western Culture: Contemporary Perspectives* (Cambridge, MA: Harvard University Press, 1986).

Tickner, Lisa, 'The body politic: female sexuality and women artists since 1970', *Art History*, 1 (2) (1978): 236–49; reprinted in *Framing Feminism: Art and the Women's Movement 1970–1985*, ed. Rozsika Parker and Griselda Pollock (London: Pandora Press, 1987), pp. 263–76; *Looking On: Images of Femininity in the Visual Arts and Media*, ed. Rosemary Betterton (London: Pandora Press, 1987).

Warner, Marina, *Monuments and Maidens: The Allegory of the Female Form* (London: Weidenfeld and Nicolson, 1985).

8.1 Lesbian Presence

Shonagh Adelman, 'Desire in the Politics of Representation' (1993)

From *Matriart*, 3 (3) (1993), pp. 21–25.

If it could be said that lesbians produce a different kind of work or see things differently, what is the origin of this difference? Is there an inherent secret which always gives itself away[1] or have lesbians developed a vernacular arising out of a common experience of oppression? If definition requires the naming of essential qualities or essences, are those essences 'natural' or *a priori*, as theoretical essentialists would have us believe. Diana Fuss argues that essence can be conceived of in two ways: essence as natural, belonging to an ontological order and alternatively essence as nominal, belonging to a linguistic order,[2] that is, 'existing in name only, as distinct from real or actual'.[3]

While essentialist theories characterized late 19th and early 20th century judicio-medical models of homosexuality as deviance and inversion, psychoanalysis offered a psychosocial theory of subjectivity, later revamped by Lacan to privilege a meta-theory of linguistic construction. As Fuss notes, this paradigmatic shift did not purge essentialist thinking. Social constructivism has been equally susceptible to determinism. This essentialist/constructionist binary has created what has been characterized as an 'impasse [in feminism] predicated on the difficulty of theorizing the social in relation to the natural, or the theoretical in relation to the political'.[4] Similar, apparently incommensurable camps have emerged in the lesbian community evidenced in particular by the implicit assumptions within the porn/censorship debate. While a provisional theorizing of essence is important for the political mobilization of collective activity, the displacement of a provisional or instrumental function onto an ontological or 'natural' platform engenders regulation and exclusion. This deconstruction of the etymology of 'essence' allows for its strategic use as a concept which is changeable, multiple, sometimes contradictory, and articulated from a location of specificity.

Fuss's argument is useful in illuminating some of the problems around defining lesbian identity and strategizing lesbian representation. The recent history of theorizing about lesbian identity has been characterized by a theoretical utopianism. In 1980 Monique Wittig challenged the inherence of social determinants in language by naming the lesbian 'not woman'.[5] Situating lesbianism outside a heterosexual patriarchal matrix inevitably sets up an idealized political status not unlike that posited by Adrienne Rich in the same year. Rich's 'lesbian continuum' conceived of lesbianism as inherently revolutionary, a rejection of 'compulsory heterosexuality' and a resistance to patriarchy.[6] Despite fundamental differences, both concepts of lesbianism invoke an essence which presumes political agency. This assumption collapses lesbianism as a political/semiotic sign, and lesbianism as a desiring, sexual practice.

While a political identity founded on the importance of affirming sexual identity entails provisional generalization, to reverse the equation, to found sexuality on the ground of politics, transforms provisional generalizations into theoretical orthodoxy, and reifies the subject positions, resulting in the superimposition of a theoretical, utopic figure and the displacement of the social subject. Theorizing the representation of identity engenders this difficulty two-fold, since identity is, in itself, already a form or representation.

Lesbian representation takes on the difficulty of negotiating what psychoanalytic feminist film criticism describes as a phallocentric scopic economy and the attendant stigma of objectification. Constructing a visibility is complicated by the inheritance of an assumed 70s lesbian feminist orthodoxy, in particular, a pejorative view of objectification. How is it possible to make visible, to represent lesbian desire, to cast 'woman' as object of the gaze, without re-inscribing phallocentric codes or risking co-optation? The question of authorship and intentionality becomes an important key to shifting these codes since this information signals, through the inscribed desire and hypothetical identification of the author, a different narrative appellation, whether explicit or not.

Lesbian culture negotiates not only with straight dominant culture but also with strong influences from the gay male community and feminism. Although it is crucial not to equalize the implications of these influences, they all, to some extent, have had and continue to have the capacity to obscure lesbian desire. However, it is paramount to remember that, as de Lauretis suggests of the feminist subject, the lesbian subject and lesbian representation exist 'at the same time inside and outside the ideology of gender'[7] although, unlike the feminist subject, the lesbian subject is not necessarily 'conscious of being so'. Given possible pitfalls, the scarcity of images, and the political import of lesbian representation, it is not surprising that lesbian images are, on the one hand, a valued commodity within the community and, on the other, highly scrutinized.

It is impossible, and at this point counterproductive, to posit a queer or a specifically lesbian aesthetic. In light of the increasing proliferation of splinter groups within progressive organizations, which have developed totalitarian and exclusionary theories and strategies, it is essential to extend both production and theory to encompass queer aesthetics, of reception as well as production, that is, a plurality of culture practices which challenge regulatory imperatives, whether those imperatives are hegemonic, feminist or lesbian injunctives.

Notes

1 Michel Foucault, *The History of Sexuality, Volume I: An Introduction* (New York: Vintage Books, 1980), p. 43.

2 Diana Fuss, *Essentially Speaking: Feminism, Nature and Difference* (London: Routledge, 1989), p. 5.

3 *Shorter Oxford Dictionary.*

4 Fuss, *Essentially Speaking*, p. 1.

5 Monique Wittig, 'The straight mind', *Feminist Issues*, 1 (1) (1980): 106–11.

6 Adrienne Rich, 'Compulsory heterosexuality and lesbian existence', in *Powers of Desire*, ed. Ann Snitow, Christine Stansell and Sharon Thompson (New York: Monthly Review Press, 1983), pp. 177–205.

7 Teresa de Lauretis, *The Technologies of Gender: Essays on Theory, Film and Fiction* (Bloomsbury, IN: Indiana University Press, 1987), p. 10.

Ann Gibson, 'Lesbian Identity and the Politics of Representation in Betty Parsons's Gallery' (1994)

From *Journal of Homosexuality*, 27 (1–2) (1994), pp. 245–270.

Abstraction is rarely approached in terms of gender; in fact, it is usually considered to have escaped such constraints. And certainly it has seldom been analyzed in a lesbian perspective. It is a striking fact, however, that just before mid-century in New York, a type of art characterized as heterosexual and male – Abstract Expressionism – and recognized as the major abstraction in its time, appeared to emanate from a gallery run by a lesbian – Betty Parsons. Parsons also showed art that was not 'Abstract Expressionist,' a fact that indicated to some critics and even some of her artists that her standards of quality weren't strong or consistent enough. I would like to argue that both her advocacy of the art that became Abstract Expressionism and of art that did not issued from her belief that *difference* superseded 'quality.' Or put another way, for her, difference – stubbornly defended, even pursued past the point of practicality – was the quality she valued most highly. 'There is room in the creative world,' she exclaimed, 'for creative people. I don't give a damn *how* they're creative. Just so long as they're different.'[1]

Her artists were different from each other and many were different from those most frequently seen in other galleries in the forties. Some thought she didn't know what she wanted. Given her legendary self-assurance, however, this perception was more prob-ably due to the fact that what she wanted was frequently different from what others thought she should want. Rather, the differing facets of aesthetic belief demonstrated by the work of the artists she showed mirrored and sustained her own multiple facets, perceptively portrayed in Richard Pousette-Dart's photograph of her. Parsons refused to experience difference – either aesthetic difference or her own sexual preferences – as a damaging psychic split (so often attributed to lesbians that it amounts to a myth).

In constructing herself – and her gallery – in more than one way, she assumed an anti-essentializing freedom that permitted her to recognize qualities in art and in persons that were less obvious to those for whom 'compulsory heterosexuality' was the only game in town.[2]

Now, difference, whether it is between realism and abstraction or loving someone of the same or other sex, is not intrinsically oppositional or hierarchical. What makes difference into opposition are often acts based on a desire to make one object, mode, or person superior to another. If power is developed when one group of people direct the actions of another group, it is necessary to specify how one group differs from the other so that the group in power can define itself. In the case of sexual difference this has meant drawing distinctions that form the web of relations that have empowered some sexualities and disempowered others.[3] In the case of realism and abstraction it has taken the form of arguments about how art best represents experience.[4] To do as Parsons did – to favor what was *different* for its own sake – was to short-circuit power plays based on the preferences that calling something 'different' facilitated.

When the National Gallery opened its new East Wing in 1978, the critic John Canaday noted that 10 out of the 23 artists represented had been given their first one-man shows in Betty Parsons's gallery. In addition to Pollock and Gottlieb there were Mark Rothko, Clyfford Still, Barnett Newman, Hans Hofmann, Ad Reinhardt, Richard Pousette-Dart, Joseph Cornell, and Bradley Walker Tomlin.[5] Although in fact the credit for some of these discoveries must be ceded to Peggy Guggenheim, the point is that by the end of the third quarter of the twentieth century, it seemed as if Betty Parsons had launched Abstract Expressionism single-handedly.[6] But if Abstract Expressionism as it has been presented until recently was an all-male, all-white, heterosexual movement, it needs to be said that Parsons also gave one-person shows to a number of artists who did not fit those parameters and have yet to achieve the renown of many of those named above.[7] As noted above, some were women. Of these at least one, Sonia Sekula, was a lesbian. Parsons also showed men who, although not out in today's sense, were understood by their closer friends in the art community to be devoted to their male partners; these included Alphonso Ossorio and Leon Polk Smith. She showed Forrest Bess, too, whose visionary mysticism, including gay, scatalogical, and (eventually) transexual images and themes (I'm thinking of *The Dicks*, 1946, and *Untitled*, 1948),[8] displayed form and references in some ways more extreme than the subjective biomorphism of much Abstract Expressionism. Bess, who had his first New York show with Parsons in 1950, demonstrated an ambivalence towards his gallery-mates that was typical of a number of Parsons's painters. He wrote to Meyer Schapiro, 'I went to Willard [Marian Willard, who, like Parsons, owned an avant-garde gallery] because I do not care for Parsons's painters – and I was to exhibit there – except – Willard went through my work and picked out what she called her trend. Well, naturally, I revolted . . . so I came back to Parsons.'[9]

As noted above, Abstract Expressionism has been characterized as a notably male and ostensibly, at least, a heterosexual male affair. Rudi Blesh's description of these artists in his book, *Modern Art USA: Men, Rebellion, Conquest, 1900–1956*, reads now at the end of the twentieth century as a parody. But it was not intended that way, nor initially received as anything but high praise:

They will be long remembered as a remarkably rugged lot, with minds as well muscled as their bodies (*Time* calls Pollock 'The Champ'). They are built like athletes, and some of them, like Pollock and de Kooning, paint like athletes. If pictures could explode, theirs would, so grimly by the force of their wills have they compressed their dual muscularity onto the canvas . . . If any group can ever force our museums and collectors to accept American modernism, this is surely the bunch to do it.[10]

This is an extreme example of the kind of rhetoric that put Abstract Expressionism at the forefront of the international art scene for two decades. But it is extreme only in degree, not in kind. I cite it, along with Canaday's list of Parsons's most prominent artists, to contrast with the names of the artists she showed who represent a broader spectrum of sexual and gendered identities. The contrast suggests a disjunction between the machismo popularly attributed to Parsons's artists and the character of many of the artists Parsons showed. This disjunction is particularly important in view of Betty Parsons's position as a lesbian.

In the thirties and forties it was generally assumed that women without husbands and children were neurotic and unfulfilled, even though they themselves may have thought they were having a fine life. Such ideas were common coin in the public sphere as well as in psychiatry; as mid-century approached, films such as *The Snake Pit* (1948) equated mental health for women with domesticity.[11] The conviction that women could be psychologically healthy only if they were wives and mothers pervaded the arts as it had other fields, establishing a polarity between the focused, unified potential of the artistic male psyche and what was constructed as the necessarily fragmented female artist, split between the demands of home and professional life. In a post-war America where the identity of the painter determined, to a great extent, the meaning of the painting (as B. H. Friedman wrote of one of Parsons's artists, Jackson Pollock, 'he *is* his painting, or at least literally in it'), to project what was by definition a neurotic identity was a tremendous disadvantage.[12] Elements of this disadvantage accrued, of course, not to lesbians alone, but to single heterosexual women and even married women with and without children. Recognizing the male valence of the atmosphere of Abstract Expressionism, it seemed to Gertrude Barrer – a heterosexual woman, with children, whose abstract expressionism has yet to find its place in the history of that era – that being a gay *man* was not a disadvantage for an artist, but that being a woman, straight *or* lesbian, was. A number of closeted gays were in positions of power, she recalled, and gay men could pass as straight when necessary. Women, however, could not participate as insiders in either gay or straight networks.[13] Although some might take issue with the idea that being gay and male was no problem in the arts, perceptions of insufficiency were particularly easily activated in the case of sexually active lesbian women. Sonia Sekula, for instance, showed paintings and drawings that were both abstract and expressionist with Parsons from 1948 through 1957. Although her work was well received, she was seen as unfortunate, partly because she was psychologically unstable, but partly because of her sexuality. Painter Harry Jackson, who met Jackson Pollock through Sekula, knew her as one of a lesbian couple. Recalling her girlfriend as 'very nice but sort of a sad gal because of that whole mess,' he observed: 'too many of those people seem to become inadvertent victims, perennial victims.'[14]

In an era where properly feminine women were supposed to subject themselves to masculine needs, there was, however, also an up side to lesbian identity. If gay men were belittled as 'less than' heterosexual men and therefore comic or neurotic in a binary sexual system that constructed gay males as feminine, lesbian women were 'more than' heterosexual women – that is, more like men. Men in dresses were funny; women in pants were real artists. 'The lesbian world was much quieter then,' according to Alphonso Ossorio, 'although everyone knew it was there. It was chic to be a lesbian, Priscilla Park, the head of *Vogue*, was a dyke. The art world was riddled with rich young queens.'[15] As poet and painter Elise Asher observed of lesbians in the forties, 'compared to other women, lesbians had force and aggression when they got together – since women had to insist more, this was an advantage. Lesbians were living for themselves. They didn't need that male affection.'[16]

Most contemporary work on sexuality presents 'lesbian' and 'homosexual' or 'gay' as historical constructions. Some definitions claim as lesbian all 'women-identified-women' who reject society's 'compulsory heterosexuality.' According to these all persons, activities, and products that reject a male-centered focus and celebrate female–female experiences (mother–daughter relations, for instance) whether they are sexual in nature or not, are eligible for inclusion in a lesbian continuum. Others feel that to refuse lesbian sexuality a central place in radical feminist discourse denies lesbian sexuality its most valuable role as a political tool to dislodge male hegemony. 'Lesbian sex is nonprocreative sex,' Joyce Fernandes writes, 'sex that is threatening to a mainstream value system anxious to keep women in place as mothers and nurturers.' For Fernandes, sexualized lesbianism provides a way to move beyond 'the trap of motherhood-defined femininity.' To ignore the physical sexuality of lesbian intimacy is to dilute its most radical potential.[17]

If lesbian sexuality's most valuable political potential is its refusal to let male power determine female desire, then one of its most notable loci at mid-century was Betty Parsons's gallery. Parsons's 'giants' as she called them – Rothko, and Newman particularly – were eager to guide her in her exhibition and sales policies. As early as 1949 some of her more prominent artists (Newman, Still, Pollock, Rothko) urged her to abandon most of her other artists to concentrate *their* (the giants') version of abstraction. In 1951, led by Barnett Newman, these men gave her an ultimatum: get rid of the other artists or we will leave.[18]

'I was present at that extraordinary meeting,' recalled Alphonso Ossorio,

> where seven powerhouse artists were thinking of leaving Betty . . . They presented their ultimatum: either you cut down on the frequency of shows and give us some sort of assurance – a contract of some kind – or else we'll just have to leave you. Betty said, 'Sorry, I have to follow my own lights – no.'[19]

Lee Hall, Parsons's biographer, recounted a somewhat different version of this meeting, attended by Pollock, Rothko, Newman, and Still in early 1951. 'We will make you the most important dealer in the world,' Parsons recalled Newman's telling her. 'But that wasn't my way,' Parsons said. 'I need a larger garden.'[20] Parsons's relations with her artists were multifaceted. 'Betty promoted the men more actively than she did

the women,' reflected Jeanne Miles, an artist whose painting is best known for its con-templative geometry. 'Betty's being a lesbian didn't mean that she was pushing women's work. She thought like a man, in a way. She liked having women around. But she was not going to break her head against the wall for women artists. Men were in a position to do a lot for themselves.'[21] Stamos, who also showed with Parsons, made a similar observation: 'I had to go out and get my own clients,' he said.[22] Parsons's obvious enjoy-ment of her artists and her simultaneous refusal to permit them to determine her gallery's direction provides an example of a woman who refused to let masculine insis-tence fashion her desires or determine her program. Parsons supported her gallery not only by her artists' sales, but also through the financial assistance of a network of women friends.[23] A painter herself, Parsons resented the implication that the men's work was so important that the other artists she showed should be discarded.[24]

Some of the artists whose representation by her gallery Parsons had no intention of disturbing included Hedda Sterne, Sonia Sekula, Maud Morgan, Adaline Kent, Buffie Johnson, Jeanne Miles, Perle Fine, Anne Ryan, Sari Dienes, Day Schnabel, and Ethel Schwabacher. As the reputation of her gallery grew, Parsons was increasingly discreet about the fact that women held the central place in her affections and, indeed, provided her most valuable business connections. Worried that she would be identified as a lesbian, she told Hall, 'You see, they hate you if you are different; everyone hates you and they will destroy you. I had seen enough of that. I didn't want to be destroyed.'[25] But neither did she have any intention of caving in.

Betty Parsons's own sexuality was not exactly a secret. She had affairs and liaisons with both men and women after an early and short-lived marriage. But her most passionate and lasting relationships were with women. Although at various periods in her life, urged by friends such as Dorothy Oehlrichs, she considered marriage, she could not bring herself to sacrifice her independence and what she described in her diary as 'Strange wild wishes never quite the same. / Desires no mortal man can name. . . .'[26]

The result was that although most of Parsons's artists and her closest friends knew about the women she loved, this legendary art dealer did not permit her sexuality to become a part of her public persona, the Parsons she presented to visitors to her gallery. In effect, she 'passed' as a heterosexual.[27] What part may her sexuality, in whatever degree closeted, have played in the way she chose the artists she so successfully showed?

The idea that you must be a lesbian – or at least bisexual – to authentically address issues of lesbian identity is a belief that runs deep – and for good reasons, as Diana Fuss has demonstrated in *Essentially Speaking*.[28] But sexuality is a complex and fluid component, one that is constructed to a greater degree than society has been willing to admit. One's social identity affects what one wants to write about, for instance, and how much one knows about it. But *how* it counts is not always the same. The relation, that is, between one's identity and what one does is not one of fixed determinism. A desire to escape aspects of my straight sexual identity probably motivates me to see a similar desire in Parsons's choice of art and artists for her gallery.

For Betty Parsons's gallery had a distinct reputation. She was the champion of abstraction, a quality she identified with 'The New Spirit,' and 'the expanding world.'[29] To be shown at Parsons, recalled painter Buffie Johnson, 'you had to be abstract.'[30] Although the aspect of this abstraction that was subsequently called 'Abstract Expres-

sionism' has become most famous, its variants – like the work of Barrer, Sekula, and Parsons herself, and even the comparatively naturalistic work of Walter Murch, whom Parsons showed from 1947 through 1976 – are instructive.

One of the artists whom Parsons might have had to drop had she acceded to the 'giants'' demands was Walter Murch, whose strangely incandescent realism seemed to them regressive.[31] But Parsons refused to drop him. 'Murch wasn't abstract in the sense that Pollock or Rothko was abstract,' she said. 'Anyone could see that. But he was abstract in a real way. He was abstract in space and he created a totally new and terrific universe. Not everyone could see abstraction in that way.'[32]

Parsons championed Hedda Sterne, too, who painted in both abstract and more naturalistic modes. Sterne was 'a genius,' who could 'do anything in paint' and 'understands everything from dreams to science,' of whom Parsons observed: 'but she changed all the time, and the damn critics thought she wasn't serious. Maybe they thought that because she was a woman. And beautiful . . . Hedda was always searching, never satisfied. She had many ways; most artists have only one way to go.' It is worth noting that the stylistic variation that Parsons cultivated in her gallery appeared also within the production of some of her individual artists: not only Sterne but also Sekula, who wrote to Parsons in 1957, 'I paint each hour differently, no line to pursue no special stroke to be recognized by . . . it is still me though it contains over a 1000 different ways.'[33] In the light of Parsons's personal and business decisions, the refusal to grant one stylistic mode hierarchy over another begins to appear as something of principle. Never one to lock herself into something as fixed as a principle, however, she later said simply of her decision to reject the 'giants'' offer: 'I always liked variety.'[34]

That Barnett Newman was so determined to streamline the Parsons gallery into a machine to launch what was apparently a heterosexual, male, and anti-naturalistic version of abstraction must have been troublesome for Parsons. Newman was her guru, her touchstone, her friend. She had discussed her own painting, her gallery, and the history and future of art with him for years. They agreed, for instance, that abstract artists such as those in the Parsons gallery shared with preliterate peoples the ability to tap the sources of spiritual inspiration that resided in the cosmos. And even though he thought Parsons should trim her gallery by showing only abstraction, Newman shared Parsons's appreciation of Murch. Ten years after his death in 1970, Parsons would still exclaim that Newman 'could do anything, think anything. God, what a force he was,' she said. 'A true friend.'[35]

What was it that Parsons found so important about Newman and his ideas, even after he precipitated the departure from her gallery of some of her most noted artists? Lee Hall attributes Parsons's lasting loyalty to Newman to his willingness to share with her his intellectual acuity and his versatility, surely important attributes to Parsons. But Theodoros Stamos, one of Parsons's artists from her early days as a dealer, and one in an unusual position in those years as a colleague of the 'giants' (Newman wrote the introduction to his one-man exhibition at Parsons in 1947) and also as a social intimate with Parsons and her group of women artist friends,[36] has at various times made another observation, one that has the potential to factor in Parsons's necessarily complex relation as a lesbian to the heterosexual appeal of her 'giants.'

Newman's whole act was camp, Stamos has observed, the monocle, the suit, his grand manner.[37] Newman looked like a successful banker, while actually serving as the

strategist and publicist – as well as a major participant – of the most outrageously unconservative art movement of the day. When Barnett Newman had his first show at Parsons in 1950, according to Stamos, 'the reaction was: what a camp – you know the word was around then,' he added.[38] One of the virtues of camp – the exaggeration of what is assumed to be natural to the point that it appears artificial – is that it suggests that the 'natural,' the original, is as much a construction as is any supposed copy. In regard to gender, one of the most important examples of camp is drag. By reproducing the naturalistic effects of heterosexual genders through imitating them, drag exposes heterosexuality as a construction that depends on casting homosexuality as fiction. The function of heterosexuality's casting homosexuality as fiction, as something made up, unnecessary, is to maintain heterosexuality's status as natural, original, sex. Thus, as Judith Butler has noted, the manifestation of camp called drag 'enacts the very structure of impersonation by which *any* gender is assumed,' and thus calls into question the naturalness, the originality, of heterosexism.[39]

Generalizing on this insight, one could say that what camp does is to demonstrate that what is 'natural' is constructed, too. Newman inserted his own identity as an advocate and producer of what was seen as the most unconservative abstraction at mid-century into the business-like persona and studied reserve of the upper-class male. In doing so, for Stamos, at least, and I think for Parsons, too, he presented *as constructions*, rather than as something 'natural,' both the bohemian proletarianism of the avant-garde (which survived in Abstract Expressionism in popular presentations of identities such as Pollock's and De Kooning's) and the appearance and behavior of the upper class. While Newman was not gay, the way he structured his own persona was camp, and camp had been coded as gay for generations.

Similarly, in using not only hard-edged form (typical of Neo Plasticism) but in mixing it in the same piece with the more gestural application of media typical of Expressionism as he did in his sculpture *Here I* (1950), Newman refused to give precedence to either the intellectualism of Mondrianesque geometry or the emotional intensity signified for his generation by the apparent immediacy of the facture of, say, Rouault or Beckmann, to name two painters admired by American artists, or by Alberto Giacometti, a sculptor particularly to the point for Newman.[40] At the same time – and here is where he parted company with Parsons – Newman firmly and increasingly rejected any hint of naturalism in his art.

In the forties and throughout the fifties, artists promoting abstraction and those who favored more naturalistic representation warred in New York for ascendancy. Each group proclaimed itself as the best way to represent the truth. While Parsons was definitely on the side of the abstract – as was Newman – unlike him, she refused either to define it simply as the non-mimetic, as her comments on Murch show, or to abandon mimeticism for abstraction. To her, abstraction was not mimeticism's other; rather, it was that which insisted on its right to define itself, a difference that set it outside the binary system inside which most Abstract Expressionists chose abstraction over mimesis – a distinction that Parsons refused to make.

Ironically, the way in which Newman's construction of both his personal appearance and his painting emphasized the artifice of both parallelled Parson's program of sponsorship of a wide range of stylistic diversity among her artists, even though he pressed her to narrow that range. But whereas Newman blurred the boundaries between binary

terms – geometry/expression; bourgeois/bohemian – Parsons's refusals confounded binary structuring not only by refusing to accept the hierarchical relations it facilitated, but also by refusing to accept the binarity implied by the 'either–or' of geometry versus expressionism, or even of naturalism versus abstraction as the terms in which excellence, or 'quality,' would be defined.

In passing for straight, Parsons, like Newman, performed an identity. But it was an identity whose social and critical success enabled her to escape the fixed determinism of heterosexual object choice in her private life. She was not destroyed. Rather, she acted out the independence that she exercised in her refusal to accept the idea that only men could partner women in the powerful metaphor of her refusal to accept the idea that only non-mimetic representation could be abstract. After most of her 'giants' left her Parsons saw the definition of successful modernist abstraction in the 1950s narrow to allow only one version, Abstract Expressionism, to squeeze through. But more recent scholarship has pried that passage open again to permit other artists such as Bess, Sterne, Sekula, and others to re-emerge as ancestors of the broader and more inclusive understanding of representation that has since been cast as postmodernism.[41]

Acknowledgment

I would like to thank Jonathan Katz for including an earlier version of this paper in his 1992 College Art Association session for the Gay and Lesbian Caucus.

Notes

1 Betty Parsons, quoted in Lee Hall, *Betty Parsons* (New York: Harry N. Abrams, 1991), p. 95. Facts in this article about Betty Parsons's life, unless otherwise noted, are from this source.

2 The classic text is Adrienne Rich's 'Compulsory heterosexuality and lesbian existence', in *Powers of Desire*, ed. Ann Snitow, Christine Stansell, and Sharon Thompson (New York: Monthly Review Press, 1983), pp. 177–205.

3 This is the operation of difference in the production of power described by Michel Foucault in 'The subject and power', in *Art after Modernism*, ed. Brian Wallis (New York: The New Museum, 1984), p. 429. For difference and power in sexual identity, see Griselda Pollock, *Vision and Difference* (London: Routledge, 1988), p. 33.

4 See, for instance, Herbert Read's 'Realism and abstraction in modern art', *Eidos*, 1 (May–June, 1950): 26–39, and Robert Motherwell and Ad Reinhardt's 'Introduction to the illustrations', *Modern Artists in America*, 1 (1951): 40.

5 John Canaday, *The New York Times* (1 November 1978).

6 Peggy Guggenheim gave one-person shows to Jackson Pollock in 1943, to Hans Hofmann in 1944, to Mark Rothko in 1945, Clyfford Still in 1946, and Richard Pousette-Dart in 1947. Melvin Paul Lader, 'Peggy Guggenheim's art of this century: the Surrealist milieu and the American avant-garde, 1942–1947', unpublished PhD thesis, University of Delaware, 1981, pp. 395–441.

7 Before she had her own gallery, in 1943, Betty Parsons showed William H. Johnson's vivid and contentious neo-primitive figurative paintings at the Wakefield Gallery and Bookshop. Richard Powell, *Homecoming: The Art and Life of William H. Johnson* (Washington, DC: The National Museum of Art, 1991), p. 173.

8 These are reproduced in *Forrest Bess (1911–1977): Here is a Sign* (Cologne: Museum Ludwig, 1989), plates 8 and 16.

9 Forrest Bess to Meyer Schapiro, undated letter in Meyer Schapiro Papers owned by the Archives of American Art, Smithsonian Institution, Washington, DC, now microfilmed on reel 3458.

10 Rudi Blesh, *Modern Art USA: Men, Rebellion, Conquest, 1900–1956* (New York: Alfred A. Knopf, 1956), p. 291. Blesh's book grew out of a study of modern art for a television project commissioned by the Museum of Modern Art.

11 See Leslie Fishbein, '*The Snake Pit* (1948): the sexist nature of sanity', *American Quarterly*, 31 (5) (1979): 641–55.

12 B. H. Friedman, *Energy Made Visible* (New York: McGraw-Hill, 1972), p. 121.

13 Gertrude Barrer, interview with the author, 14 and 15 December 1988, Roxbury, Connecticut.

14 Harry Jackson, interview with Jeffrey Potter, 7 December 1982, tape on file with the Pollock–Krasner House and Study Center, East Hampton, New York. My thanks to Ellen Landau for alerting me to this source. For the art world's view of Sekula, see Nancy Foote, 'Who was Sonia Sekula?', *Art in America*, 59 (September–October, 1971): 73–80.

15 Alphonso Ossorio, conversation with the author, 5 October 1990, Wainscott, New York.

16 Elise Asher, interview with the author, 18 June 1988, New York.

17 Adrienne Rich, 'Compulsory heterosexuality'; Joyce Fernandes, 'Sex into sexuality,' *Art Journal*, 50 (Summer 1991): 38.

18 Hall, *Betty Parsons*, pp. 94–5, 101–3.

19 Alphonso Ossorio, quoted in Jeffrey Potter, *To a Violent Grave* (New York: G. P. Putnam's Sons, 1985), pp. 146–7.

20 Hall, *Betty Parsons*, pp. 101–2. For a third version of this meeting, see Steven Naifeh and Gregory Smith, *Jackson Pollock* (New York: Clarkson N. Potter, 1989), pp. 677–8.

21 Jeanne Miles, interview with the author, 6 August 1988, New York.

22 Theodoros Stamos, interview with the author, 18 December 1991, New York.

23 Hall, *Betty Parsons*, pp. 80, 91, 92, 103, 116, 138.

24 Ibid., p. 102. She was also saddened by their refusal to accept her as an artist. Lee Hall, 'Betty Parsons, artist', in pamphlet 'Betty Parsons, paintings, sculpture, works on paper', East Hampton: Pollock–Krasner House and Study Center, Southampton: Fine Arts Gallery, Southampton Campus, Long Island University, and the Benton Gallery, May–July 1992.

25 Hall, *Betty Parsons*, p. 53.

26 Betty Parsons, quoted in ibid., p. 53.

27 Parsons's stance in regard to the way she presented her own sexuality is similar to that for which Teresa de Lauretis approvingly cited Carolyn Allen's discussion of Djuna Barnes: the author of *Nightwood* refused to be identified as a lesbian, De Lauretis suggested, because to submit to the homophobic understanding of lesbianism was to refuse what de Lauretis discusses as sexual (in)difference: that is, defining feminine sexuality in terms of male needs – by attributing the characteristics of female sexuality (i.e. the possibility of separating sexuality and procreation) to the male and denying them to the female, Western European society has made all sexuality male, i.e. *in*different. 'Sexual indifference and lesbian representation,' in *Performing Feminisms*, ed. Sue Ellen Case (Baltimore, MD: The Johns Hopkins University Press, 1990), pp. 19–23.

28 See, for instance, her ch. 6, 'Lesbian and gay theory: the question of identity politics', *Essentially Speaking* (New York: Routledge, 1989).

29 Hall, *Betty Parsons*, p. 89.

30 Buffie Johnson, interview with the author, 25 November 1991, New York.

31 As recalled by John Stephan, art editor of the *Tiger's Eye* and an artist who showed at Betty Parsons, 'Walter Murch who I liked was . . . the antithesis of what the artists wanted.' Interview with the author, 15 August 1980, Newport, Rhode Island, quoted in 'Theory undeclared: avant-garde mag-

azines as a guide to abstract expressionist images and ideas', unpublished PhD thesis, University of Delaware, 1984, p. 48.

32 Betty Parsons, quoted in Hall, *Betty Parsons*, p. 86.

33 Sonia Sekula, letter to Betty Parsons 24 November 1957, the Betty Parsons Papers, Archives of American Art, Smithsonian Institution, Washington, DC. As Roger Perret noted, this was typical of Sonia's attitude earlier, too, as a quotation from an article in 1946 indicated: 'I change consciously from day to day, according to the daily new sphere that surrounds me. Its flux changes continuously.' Sekula in 'An artist speaks: Sonia Sekula', by Cicely Aikman, *The League* (the publication of the Art Students League) (Winter 1945–6): 2. Roger Perret, 'Auf Bedeutungsjagd, auf Bedeutungsflucht, Die Wort- und Farbkünstlerin Sonja Sekula', *Affenschaukel*, 16 (1992): 14–15.

34 Hall, *Betty Parsons*, pp. 86, 92, 102, 108.

35 Ibid., pp. 104, 143.

36 Stamos painted a portrait of Parsons and admired the work of some of the artists closest to her, such as Buffie Johnson, Jeanne Reynal, Hedda Sterne, and Sonia Sekula. Theodoros Stamos, interview with Irving Sandler, 6 August 1968, unfilmed transcript on file at the Archives of American Art, Smithsonian Institution, Washington, DC.

37 Theodoros Stamos, interview with the author, 18 December 1991.

38 Theodoros Stamos, interview with Irving Sandler.

39 Judith Butler, 'Decking out: performing identities', in *Inside/Out, Lesbian Theories, Gay Theories*, ed. Diana Fuss (New York: Routledge, 1991), p. 121. Butler cites Esther Newton's *Mother Camp: Female Impersonators in America* as her source for the idea that drag is not an imitation of some prior and true gender, but rather is a critique of the idea that there are 'natural' genders. See Harold Beaver, 'Homosexual signs', *Critical Inquiry*, 8 (Autumn 1981): 99–119, for a similar argument.

40 Ann Gibson, 'Barnett Newman and Alberto Giacometti', *Issue*, 3 (Spring 1985).

41 Hedda Sterne's retrospective took place at the Queens Museum in 1985. *Hedda Sterne: Forty Years* (New York: Queens Museum, 1985). See also *Forrest Bess (1911–1977)* and *Sonia Sekula, Affenschaukel 16* (Zwillikon, Switzerland, 1992).

Harmony Hammond, 'Against Cultural Amnesia' (1994)

From *Art Papers*, 18 (6) (1994), pp. 9–13.

Cultural amnesia seems to have reached epidemic proportions. Everyone, including lesbians, is acting like the '70s didn't exist. For examples of this (dis)ease, we have only to look as far as the 'Bad Girls' exhibitions in New York and Los Angeles, which chose not to acknowledge the ground-breaking generative feminist work of the '70s and to heterosexualize that lesbian work which was included,[1] or the curatorial scope and political economy of the many queer exhibitions of the Gay '90s, including the ten or so group exhibitions in New York independently organized to accompany the 25th anniversary of the Stonewall Riots of 1969.[2]

Instead of taking the opportunity to document and celebrate a historical tradition of lesbian/gay/queer visual art in New York, the curators of these exhibitions (mostly gay men) chose to participate in Unity '94's commodification of queer culture by showing

the same few artists – mostly young, newly emerged, and represented by dealers. This is not a criticism aimed at the artists, their gallery representation, or the artworks themselves, but rather a statement about lost opportunity and the privileging of the relationship of curator and dealer over artists and their work to community, thus leaving, once again, lesbian/gay/queer art dehistoricized – visual fragments floating without context.

I am tired of everyone saying that there was no lesbian art in the '70s when in fact there was. One has only to look as far as the 'Lesbian Art and Artists' issue of *Heresies* magazine (1977), 'A Lesbian Show' at the old 112 Greene Street Workshop (1979), 'The Great American Lesbian Art Show' (GALAS) at the Women's Building in Los Angeles and its fifty sister exhibits across the country (1980), or the exhibition 'Extended Sensibilities: The Homosexual Presence in Contemporary Art' at The New Museum (1982), to find work by real live lesbians – and that's not even touching upon shows and projects at numerous small 'gay galleries' or feminist and gay conferences, or work produced and circulated in dyke communities outside the art world. These were not obscure exhibitions, but rather conscious dyke interventions from the margins in the central whirlpool of the art mainstream. To not acknowledge these exhibitions is, at the very least, sloppy scholarship and irresponsible curating. It is not just that the mainstream art institutions ignore lesbian/gay/queer creative histories that is so horrifying, but the fact that we are doing it to ourselves.

True, lesbians are often caught between straight feminists and a gay male agenda, but lesbian artists are participating in their own commodification and erasure. I have to say that as a lesbian and an artist who, since the early '70s, has continued to sometimes, but not always, make art about the experience of being lesbian, who has remained through the years as one of the few *out* lesbian voices in the art world, I find it offensive and *out*rageous that not even one lesbian artist (young or old) has recommended my work for *any* lesbian or queer show in the '90s. It's like I don't exist.

What's happened to the girls' network? We used to have one. I've been around long enough to not take it personally, because I know that it has very little to do with me or my work. It's about deprivation. Poverty. Now that there seems to be a piece of the slimy hetero pie set aside for dykes in the art world, politics are out the window and competition is rampant in the girls' ranks. Interestingly, the attention I receive as an art writer is the complete opposite. No one needs another artist to compete with, but everyone wants another critic (to write about their work). The message is old and clear, and the girls are doing it too. When will lesbian artists realize that the artist you don't recommend, don't include, is yourself? Every silence is your own erasure.

Contrary to what popular, fine art, and even queer media would have you believe, lesbian art and artists did not emerge by virgin birth overnight. Many of us have been here making work, wrestling with issues of lesbian subjectivity for a long time. I've never thought of myself as one of the 'old girls,' but now, somehow as an 'older artist' (and I say this ironically as the 'other' of the younger) I feel a responsibility to set the record, well not straight, but accurate, or once again I and others will be erased and our work denied an existence.

Because I have been out and around for so long, I am finding that I am a 'historical voice.' This puts me in a dilemma, for while I believe that the collective historical voice is very important – precisely because we haven't had one – and I feel a responsibility

to tell our creative history as I know it, I do not want to invest in nostalgia, to be locked into the past. As an artist and writer, not to mention a lover of women, I am actively and pleasurably engaged in the present moment even as it is shifting. My feminism, like my work, is informed by the '70s, '80s, and '90s and continues to change. In the past, I have frequently functioned as a kind of bridge, insisting on a lesbian consciousness and presence in the primarily straight feminist art world, and bringing an art consciousness into dyke communities, some more receptive to art than others. Now, I am seeing myself as some sort of bridge between generations. Bridges, like history, like art, allow for meetings, crossings, mergings. Moving into new time, space, territories.

These days it's easy to be a queer artist. It's in to be out. Whether anyone admits it or not, the new generation of lesbian artists (those who have emerged since 1988) have inherited a lot from radical feminism and the Gay Liberation Movement. Bearing in mind the linguistic and ideologic dangers of constructing oneself in opposition to the so-called normative within binary systems of gender and sexuality (the other of man, the other of heterosexuality), or sounding like I accept the existence of an 'I,' preformed and separate from cultural and social forces (which I don't), let me just say that 'difference' is an old queer discussion but that the strategies of (re)presentation are new.

Because art both reflects and contributes to ever shifting definitions of lesbian identity, it can be seen to mirror the desexualization of lesbian feminism in the '70s and early '80s, the exploration of lesbian fantasy and desire in the late '80s, and the assertion of sexuality as central to lesbian identity in the '90s. It's not about locating or defining an essential lesbian aesthetic, but rather looking at art by self-identified lesbians, to see what forms it takes, what issues it addresses, what it tells us about individual and collective lesbian lives, and how it interfaces with larger social, political, and cultural fields. To look at and discuss art being made today, we must examine it in relationship to earlier art and our own cultural history.

If, from today's perspective, much of the work from the '70s looks raw, tentative, undeveloped, romantic, or conservative – often not even overtly lesbian – it must be remembered that to be in these early shows, to exhibit as a lesbian, took strength and courage and was a radical gesture not to be underestimated. It made one's personal life public, and artists risked aesthetic stereotyping or dismissal of their work. At least one artist was threatened by her gay male dealer: if she exhibited 'as a lesbian,' she could say goodbye to the gallery's exhibition and representation of her work. While artists were interested in discovering or defining an essential lesbian sensibility, in the end, exhibits like the one at 112 Greene Street simply presented a diverse range of work by artists willing to be public about their sexual preferences and willing to show in a lesbian context. Thus, these early exhibitions and projects were primarily successful in creating, for the first time ever, a public lesbian presence in visual art, and commencing dialogues on sexuality and art within the artworld and feminist, lesbian, and gay communities.

This is so different from today, when much 'lesbian art' is made specifically to be circulated within the art world, where whole careers based on producing lesbian art are made overnight, or where lesbian and/or queer readings of the work are encouraged or manipulated by artists and their dealers, even when the artist is not lesbian-

identified. To those of us who have been out there for a long time, to paraphrase Audre Lorde, living and loving in the trenches, this is a very bizarre phenomenon, raising issues of 'authenticity,' similar but not exactly parallel to new age claims of 'being Indian.'[3] Obviously both 'lesbian' and 'artist' remain unstable identities open to change, interpretation, and to a certain degree, self-construction. The question remains: does sexuality shape subjectification in visual art – and if so, how? This lingering question both assumes and proposes categories of difference. The answer refuses articulation. In fact, it is precisely the unruly, messy, rough edges, which don't or won't fit into clean contours of identity, which go against the grain, that create potential erotic and creative sites – spaces where I would argue the best art is made.

While '70s gender-based definitions of politically correct lesbianism depicted women through abstract landscape symbols or within domestic environments, hinting at fantasies and possible seductions without ever actually depicting sexual or sexualized activities, most of the new '90s work reasserts the right to move back and forth freely between high and low art, and assumes the right to all images including those generated in art history, popular culture, cartoons and comics, medical texts, fashion, advertising, and pornography. While much of the work is humorous, it is also intensely serious – depending of course on who is doing the looking.

At the same time, some of the iconography of work being made today seems remarkably indebted to earlier feminist and lesbian-feminist image-making. A closer look, however, often reveals subtle and interesting differences. Because the artistic, social, political, and economic climate has changed, the work is created, presented, and discussed within a different contextual framework which then, in turn, becomes part of the meaning of the pieces.

For the purpose of this article, I'd like to present two examples of visual art from the '90s that can be discussed in relationship to work by artists from the '70s.[4] This comparison is not meant to say that certain works are better or more authentic than others, but rather to utilize a feminist historical framework to enrich the discourse around lesbian art.

In the 1970s Joan Semmel, a straight-identified feminist, presented close-up views looking down at her own middle-aged, unidealized body which became a kind of sensuous landscape of folds, creases, swellings, wrinkles, and stretch marks filling the pictorial space. What she/we can see is framed by the canvas edge, as if to show us an intimate secret. Semmel was trying to paint the female body from the object's eye, object and subject becoming one.

Patricia Cronin is among a group of emerging lesbian artists who are overtly and subjectively depicting all kinds of lesbian sexual practices in their art – images we have not seen before in the history of Western art. Cronin's watercolors, of a woman with her hand or fist up another's vagina, inserting a dildo, or going down on a second woman, are, like Semmel's paintings, depicted from the subject's point of view (Cronin switches from top to bottom in different paintings), with the subject's field of vision marked by the painting edge – however, the visual indication of a second woman's presence lesbianizes the narrative. Thus, one way Cronin's work can be seen and discussed is as a lesbian extension of early feminist concerns to subjectify the female body and female sexuality, in this case lesbianizing it.

In 1974, Tee Corinne started her series of 'Non-traditional Portraits' – close-up photographic images of labia and clits of friends who posed for her. Intimate and beautiful, sometimes printed in sepia tones and framed in oval mats, these photographs were non-traditional because they imaged women's sexual bodies from a lesbian point of view. On another level though, they were about placing lesbian lives and culture within traditions of photography and family portraiture. Combining and subverting histories of lesbian erotic photography (usually done by men) and lesbian portraiture (snapshots by dykes of friends and lovers), her photos were meant for lesbian viewing pleasure, and were exhibited or published primarily in woman-only or lesbian contexts. Because the artist publicly identifies herself as lesbian, the work is aimed towards a lesbian audience, and the intended viewer (woman) is also the object of the gaze (a second woman), a viewing dynamic is created that makes the pieces 'lesbian.' It should be noted that Corinne, over the years, has tried to find ways to avoid male voyeurism and appropriation of images of lesbians, to imply a sexuality without necessarily showing it. In other works she has used solarized abstract images of body parts or sexually symbolic images such as flowers as stand-ins for women.

For the 1992 Dokumenta in Kassel, Germany, Zoe Leonard created a series of spread-leg photographs of women friends' genitalia, and casually tacked them up on walls between 18th and 19th century paintings in the town museum. While Leonard's images of cunts are not new to the '90s (there seems to be a resurgence of interest in vaginas) and continues a body of work begun by earlier feminists and lesbian-feminists such as Corinne, the context is decidedly different.

In contrast to Corinne's placement of her images in woman-only venues, Leonard inserts hers into what is traditionally male space. The fact that she inserts her 'pussy shots' into the historical museum system underscores the hypocrisy of so-called neutral art by men which depicts women as sex objects, thereby implying a male subject, allows Leonard to participate in the contemporary critique of the cultural institutions of authority, and opens a space for the 'cruising eye' of the lesbian viewer in those institutions. The piece works best as a 'taking of public female space,' and a very prestigious one at that – one Corinne and other lesbians in the '70s and '80s didn't have access to. While some people have criticized Leonard's intervention as 'queer oppor-tunism,' the work is an extension of her early concerns, and I think it is to her credit that she utilized her privileged 'inclusion' in the male-dominated Dokumenta to present this highly charged 'female work.' I say 'female,' because despite the conceptual underpinnings of the work and her intent to minimize or challenge male spectatorship and allow for possible lesbian readings of the work, Leonard's images, like Corinne's, in and of themselves are still vulnerable and open to appropriation by the male gaze.

Hopefully, these two comparisons suggest ways of looking at lesbian visual art and begin to develop a critical and theoretical discussion that links our work to earlier prac-tices and situates this dialogue firmly within feminist discourse. To date, queer theory has not brought lesbians into the visual field. Lesbian visual discourse has to build on what Laura Cottingham has stated is 'perhaps the only genuine mass art movement that has occurred in America in this century.' And she quotes the early Red Stockings as saying, 'The women's movement began because we were tired of not being taken

seriously.'[5] This is still the battle. Obviously, if we wish not to be ignored or erased, and wish to be taken seriously, we lesbians must insist on our history, and develop a generative dialogue around and informed by the work. The Drawing Center panel discussion 'Representing Lesbian Subjectivity' and subsequent issue of *Art Papers* are steps in this direction and important specifically because they are happening within the art world context.

But the steps are slippery. In the last year and a half, the heterosexual media have taken it upon themselves to present palatable images of lesbians, so depoliticized and so desexualized (except for those images acceptable to the hetero-imperative of the male gaze), who as Jodi Kelber has noted are 'too chic to fuck,'[6] lesbians who are so mainstreamed that they leave heterosexuality intact – what Deb Schwartz writing in the *Village Voice* has called 'lesbian lite' or 'radical lite.'[7] Placing us in the context of 'fashion' ignores and trivializes lesbian lives and experiences, and hides the real histories of survival, resistance, and creative expression around gender and sexual difference.

Now that lesbians have been 'discovered,' we lesbian artists who have been neglected for so long will have to step carefully to get the attention that is due our work without being co-opted in the process – and it may not be so easy. Exhibits like 'Bad Girls,' which reinscribe heterosexuality as normative, and exhibitions such as many of those surrounding the 25th anniversary of Stonewall, which tried to 'outqueer' each other, deny our creative histories and feed into the art market and a conservative xenophobic political agenda. I agree with the Fierce Pussy Collective when they say, 'Fuck 15 minutes of fame.'[8]

I see both current mainstream media attempts to appropriate, commodify, and consume the lesbian as spectacle and recent shifts in the art world that have bestowed momentary visibility on a few lesbian artists (white girls of course) as colonialist strategies to domesticate, silence, and ultimately disempower women, queers, and other minorities. Of course this naming, labeling, representing, authorizing, and commodi-fying is a violent dynamic that other groups who have been first marginalized and then rediscovered on the basis of their difference have had to negotiate. But it is new to us. Just how much real pussy power will be allowed remains to be 'seen.'

Self-representation (production and discourse) has the possibility of playing an important role in resisting cultural colonization (and thus erasure) and keeping what Jan Zita Grover has called the 'hole' lesbian[9] in all her fluid, layered, messy, and unruly mutations/manifestations intact – that is sexual, creative, political, and powerful.

Acknowledgments

Many of the ideas in this article first appeared in my paper 'Rough edges: resisting lesbian representation,' presented on the panel 'Disinheritances: Intergenerational Dialogues of the Dating Game,' at the 1994 College Art Association and my chapter 'A space of infinite and pleasurable possibilities: lesbian self-representation in visual art,' in *New Feminist Criticism: Art, Identity, Action*, ed. Joanna Frueh, Cassandra Langer and Arlene Raven (New York: Icon Editions, 1994). Thanks go to the Rocke-

feller funded Bellagio Study and Conference Center in Italy, which provided time and space to research and draft this material.

Notes

1 Laura Cottingham, *How Many 'Bad Feminists' Does it Take to Change a Lightbulb?* (New York: Sixty Percent Solution, 1994). A brilliant and passionate critique and analysis of the 'Bad Girls' exhibitions and catalogues.

2 Independent exhibitions curated to coincide with the 25th anniversary of Stonewall included well over a dozen group and solo shows, which ranged in curatorial scope. For me, the most interesting was 'Absence, Activism and the Body Politic' curated by Joseph Wolin at the Fischbach Gallery. The most questionable was 'Stonewall 25: Imaginings of the Gay Past, Celebrating the Gay Future', curated by Bill Arning at White Columns. In their press, it was never mentioned that the original White Columns was actually the old 112 Greene Street Workshop which was the site of the first lesbian art show in New York City (and possibly the United States) in 1978. Thus this exhibition of 'romantic nostalgia' by artists who were 'all children or not yet born at the time of the riots' erases its own history. No venue took on the task of a historical overview of lesbian/gay/queer art comparable to the important and moving historical, but more general, exhibit at the New York Public Library, 'Becoming Visible: The Legacy of Stonewall'. The only exhibit that included a diverse range of artists from the past or outside of the marketplace was 'Pride in our Diversity', curated by Ronny Cohen at the 24 Hours for Life Gallery, which is connected to the Lesbian and Gay Community Services Center. Also, my criticism does not apply to those official exhibitions surrounding 'Unity 94' (Gay Games and Cultural Festival), such as those organized or curated by Ann Meredith which were primarily photographic in nature. Anyone could submit work to these juried shows.

3 Because of decades of discrimination, many Indian peoples, until recently, hid the fact that they were Native American. This strikes me as very similar to the discrimination against homosexuals and the resulting secrecy around their lives. Now, with new age trends, not to mention a potential art market, everyone wants to be 'Indian' and 'queer'. Whether or not they really are doesn't seem to matter as non-Indians and heterosexuals appropriate style and content, and promote Indian and queer readings of their work. While I realize that one is born 'Indian' (of a specific tribe(s)) and it is not so clear whether one is born or becomes homosexual, both identities raise moral, legal, political, and creative issues around the right to claim identities.

4 It is important to note that many artists 'from the '70s' continue to make work today and thus are also 'artists of the '90s'. However, for the purpose of discussion in this article, I am using examples of work they created in the '70s.

5 Cottingham, *'Bad Feminists'*.

6 Jodi Kelber, 'Too chic to fuck: the fashioning of lesbianism by TV talk shows', unpublished paper presented at the 1994 Console-ing Passions: Television, Video, and Feminism Symposium, Tucson, 1994.

7 Deb Schwartz, 'The days of wine and poses: the media presents homosexual life', *Village Voice* (8 June 1993).

8 Text from page art piece by the Fierce Pussy Collective, 1994, in Cottingham, *'Bad Feminists'*.

9 Jan Zita Grover, 'Dykes in context: some problems in minority representation', *The Contest of Meaning: Critical Histories of Photography*, ed. Richard Bolton (Cambridge, MA: MIT Press, 1990).

8.2 Re-imaging Body

Mary Duffy, 'Disability, Differentness, Identity' (1987)

From *Circa*, 34 (1987), pp. 30–31.

I am a woman with a disability. I was born without arms due to thalidomide and I use my body in a way which is for me and for others physically and emotionally challenging. Being a woman with a disability and an artist means for me asking questions. I am aware how disability, differentness and identity are represented in our culture.

Through images saturated with emotion, pity, tragedy and courage I learned about other people with disabilities. I also learned to reject these images as not being part of my own experience, and to settle uneasily into the majority culture. I was successful, mainstreamed and normal.

But it didn't last for long. I was in art college doing my brief about a personal symbol. I decided to work on the idea of my body positions as being my symbol. It was a simple idea. My tutors reacted with statements that revealed feelings about their own physical vulnerability, and projected all those fears on to me. They experienced me (not my work!) as being introverted and obsessive, and entreated me to continue taking photographs of billboards and urban decay as I had been doing. It was this complete rejection of my proposal that at once confused and intrigued me. I was then 21 years old.

As a child, and later as a young woman, my identity as a person with a disability had been systematically eroded. Because I could not, or did not, identify wholly with the majority culture I felt alienated from a world whose images most people could identify with. My physical reality was invalidated through these images. Why were there no positive images of people with disabilities in the media? Why were all charity images of disability of children? One could be forgiven for thinking that children with dis-abilities don't grow up . . . we just disappear!

All women could argue here also feelings of alienation from media representation. However, there is a women's cultural identity which is strong, articulate and visual that operates in opposition to the male cultural view which expects women to be the object of the male gaze and allows our bodies to be used to sell merchandise. However, in the

area of disability there is no clear cultural identity, but in terms of visual images, and especially photography there is a strong historic association of disability with charity and need. Images of people with disabilities are images of problems or of courage. People become objects.

I wanted to create new images. Images that would celebrate, challenge and change. My body became a kind of metaphor. I worked through photography. I wanted to confront and contradict my own image of myself. I wanted to create a mirror image, creating illusion of sameness and subtly introduce the notion of difference.

Maybe we are not all the same, maybe difference could be welcomed and is worth celebrating. The question I was asking myself and other people was, can you understand and accept my pride in differentness, and really wanting to celebrate and share it? My work is an exploration of difference and all that it implies – deviance, death, deformity, distrust, dismay and also of delight, wonder, variety, inventiveness, creativity and uniqueness. It is a statement about and with my body. A body which does not have quite all the pieces to fit the human jigsaw, and is therefore not always considered whole. It is about looking and seeing new ways, new images where there has never been an image before without an able-bodied cultural prejudice. It is about finding a new identity for myself as a woman with a disability and my right to define that identity and its politics for myself. Realizing that my body was/is political came at first through the women's peace movement. When I became involved in non-violent direct action at a United States cruise missile base at Greenham Common in England, it usually meant using our bodies to barricade an exit or entrance at the base, we would be forcibly removed by police lifting or dragging women by our limbs. When police grabbed my empty sleeves and pulled, my clothes came away with them. They were then confronted with my half-naked body, with its uniqueness, its roundness and its threat. A political weapon. I did not want to use my body in this way. My political views, i.e. the effect of nuclear radiation on genetics led me to totally negate my identity as a woman with a disability. I feel that through the medium of photography I can channel that same political energy more creatively and effectively.

In my photography I mostly show slide tape pieces as part of art events; events involving women, or people with disabilities. This is always followed by an open forum for discussion. It is vitally important to me that the work is not shown in a vacuum. I feel that the work by its nature is confrontational and it is important in this context to deal with these issues. But with disability issues there exist factors that confront people with their own fears of physical vulnerability and mortality. When talking about racism or sexism there is no fear if one is white today one could end up black tomorrow, so there is room for disassociation. With disability however one could easily go to bed able-bodied and wake up with a disability. The fear is real, and it is universal.

One of the ways we successfully deal with our fear is to project them on to people with disabilities. So, if your worst fear about becoming disabled is about feeling helpless, isolated, sexless, you will experience people with disabilities as helpless, isolated, sexless, etc. One of the reasons I make the images I do is to make those stereotypes manifest and then to shatter them, by changing the values and attitudes behind these assumptions.

My communication is total. It is visual, verbal and physical. I create visual images because it is one of the languages I have learned towards total communication. My

photography is personal and political. My politics, identity and art are often in conflict with one another. This is my personal polemic.

My photographs have been described as 'sensuous and sensual', as 'having the potential to change our perception and extend our humanness'. They have also been described as pro-abortionist and pornographic. My work often contains references to foetuses and in connection with disability that is all that is needed to persuade some people that I am pro-abortionist. I have learned that my own personal beliefs on abortion have been demanded in the context of an open forum following a showing of my work and to argue it is about art and not politics is largely irrelevant.

I have been surrounded all my life by images of a culture which highly values physical beauty and wholeness, a culture which denies difference. My identity as a woman with a disability is one that is strong, sensual, sexual, fluid, flexible and political. Reclaiming and redefining my body and its politics continues to be an extraordinary learning experience. I am just beginning to define for myself, my difference, my sense of wholeness and to welcome it deeply and intensely.

Lynda Nead, 'Framing the Female Body' (1992)

From Lynda Nead, *The Female Nude: Art, Obscenity and Sexuality* (London: Routledge, 1992), pp. 5–11.

At no point is there a plane or an outline where the eye may wander undirected. The arms surround the body like a sheath, and by their movement help to emphasise its basic rhythm. The head, left arm and weight-bearing leg form a line as firm as the shaft of a temple.

Kenneth Clark, The Nude, *1956*[1]

Any structure of ideas is vulnerable at its margins. We should expect the orifices of the body to symbolise its specially vulnerable points. Matter issuing from them is marginal stuff of the most obvious kind. Spittle, blood, milk, urine, faeces or tears by simply issuing forth have traversed the boundary of the body . . . The mistake is to treat bodily margins in isolation from all other margins. There is no reason to assume any primacy for the individual's attitude to his own bodily and emotional experience, any more than for his cultural and social experience.

Mary Douglas, Purity and Danger, *1966*[2]

This permanent requirement – to distinguish between the internal or proper sense and the circumstance of the object being talked about – organizes all philosophical discourses on art, the meaning of art and meaning as such . . . This requirement presupposes a discourse on the limit between the inside and outside of the art object, here a *discourse on the frame*.

Jacques Derrida, The Truth in Painting, *1987*[3]

These three statements have been taken from works published over a period of three decades and from three distinct academic disciplines (art history, anthropology and philosophy), but here they are placed side by side because, in their diverse ways, they seem to unravel an aesthetic that has structured the representation of the female body in western art since antiquity. They speak of outlines, margins and frames – procedures and forms that regulate both the ways in which the female body is shown and the proper conduct of the prospective viewer. Kenneth Clark describes the achievement of the Capitoline Venus in terms of containment. The arms 'surround' and enfold the body, and the planes and surfaces of the marble itself seem to emphasize this act of enclosure. Clark's range of images is significant. The pose is likened to a 'sheath'; it has become a covering for the body and is as regular and structured as the column of a temple. It is almost unnecessary to point out the phallic connotations of this language. For Clark, the female body has been shorn of its formal excesses and, as Venus, has been turned into an image of the phallus. The transformation of the female body into the female nude is thus an act of regulation: of the female body and of the potentially wayward viewer whose wandering eye is disciplined by the conventions and protocols of art.

With the quotation from Mary Douglas, the move is from the particularities of the female nude, that is, a cultural commodity, highly formalized and conventionalized, to the more general issue of the body and its boundaries. Douglas examines the cultural links between dirt and disorder or formlessness and analyses the rituals of cleansing and purification that control this threat. Hygiene and dirt imply two conditions: a set of ordered relations and a transgression of that order. All transitional states therefore pose a threat; anything that resists classification or refuses to belong to one category or another emanates danger. And once again it is the margins, the very edges of categories, that are most critical in the construction of symbolic meaning.

From this position, it is not so far to Jacques Derrida's 'discourse on the frame'. In a radical dismantling of Kantian aesthetics, Derrida problematizes the philosophical concept of the disinterested aesthetic experience by focusing our attention not on the object of contemplation but on its boundary. The frame is the site of meaning, where vital distinctions between inside and outside, between proper and improper concerns, are made. If the aesthetic experience is one that transcends individual inclination and takes on a universal relevance, then without the frame there can be no unified art object and no coherent viewing subject.

In this section I will draw on the work of writers such as Douglas and Derrida in order to make sense of the female nude and its symbolic importance within the western tradition of high art. I will argue that one of the principal goals of the female nude has been the containment and regulation of the female sexual body. The forms, conventions and poses of art have worked metaphorically to shore up the female body – to seal orifices and to prevent marginal matter from transgressing the boundary dividing the inside of the body and the outside, the self from the space of the other. Clearly, the relevance of this analytical model goes far beyond the examination of art. For if, as Douglas suggests, the body's boundaries cannot be separated from the operation of other social and cultural boundaries, then bodily transgression is also an image of social deviation. The general movement, then, is from the specifics of representing the female body to more general structures of values and beliefs. To take up Derrida's point: the

definition of limits and frames determines not simply the meaning of art, but meaning as such.

'The chief forms of beauty are order and symmetry and definiteness.'[4] In statements such as this, Aristotle set out the classical ideal of unity and integrity of form which has had a lasting and powerful influence on western culture. It can be traced in the language of aesthetics and art criticism; it lies at the heart of much art education and it structures legal and ethical discourses on art and obscenity. What seems to be at stake in all these discourses, and what all these areas have in common, is the production of a rational, coherent subject. In other words, the notion of unified form is integrally bound up with the perception of self, and the construction of individual identity. Psychoanalysis proposes a number of relations between psychical structures and the perception and representation of the body. Here too, subjectivity is articulated in terms of spaces and boundaries, of a fixing of the limits of corporeality. Freud relates the structure of the child's ego to the psychical projection of the erotogenic surface of the body. In a footnote to the 1927 English translation of 'The Ego and the Id', Freud states that: 'The ego is ultimately derived from bodily sensations, chiefly those springing from the surface of the body. It may thus be regarded as a mental projection of the surface of the body, besides . . . representing the superficies of the mental apparatus.'[5] The female nude can almost be seen as a metaphor for these processes of separation and ordering, for the formation of self and the spaces of the other. If the female body is defined as lacking containment and issuing filth and pollution from its faltering outlines and broken surface, then the classical forms of art perform a kind of magical regulation of the female body, containing it and momentarily repairing the orifices and tears. This can, however, only be a fleeting success; the margins are dangerous and will need to be subjected to the discipline of art again . . . and again. The western tradition of the female nude is thus a kind of discourse on the subject, echoing structures of thinking across many areas of the human sciences.

The general points that are being made here can be specified and pinned down through a more detailed discussion of individual texts and images. Three further examples illustrate how the relationship between boundaries and the female body is given representation. In a painting of the virtue *Chastity* by the sixteenth-century Italian painter, Giovanni Battista Moroni, the allegorical figure holds a sieve on her lap, the symbol of her purity and inviolability.[6] The sieve is filled with water and yet no liquid runs out, for chastity is watertight; it is impenetrable and allows no leakage. The miraculous water-filled sieve is a metaphor for the ideal, hermetically sealed female body. The boundary of the body has been made absolutely inviolate; it has become a kind of layer of armour between the inside of the body and the outside. Of course, there is something worrying and incomplete about the impermeable sieve as a figure for the virtuous woman. If nothing is allowed in or out, then the female body remains a disturbing container for both the ideal and the polluted. Although the impermeable boundary may go some way towards answering fears concerning the female body, the problem does not go away, but is simply contained, staunched, for a while.

Woman is able to stand as an allegory of Chastity by displacing the worrying connotations of yielding and porous skin or oozing gaps and orifices on to the clear outline and metallic surface of the sieve. There are other ways in which this desire for clear boundaries and definitions can be satisfied. The female body can be re-formed, its

surfaces reinforced and hardened, by bodybuilding. Lisa Lyon won the first World Women's Bodybuilding Championship in 1979. About a year later she met the photographer Robert Mapplethorpe and posed for a series of pictures which were published as a book called *Lady: Lisa Lyon* in 1983.[7] Now, bodybuilding is a mixed blessing for feminism. On the one hand, it seems to offer a certain kind of liberation, a way for women to develop their muscularity and physical strength. It produces a different kind of female body-image which could be seen to blur the conventional definitions of gendered identity. But on the other hand, this revised femininity seems simply to exchange one stereotype for another – one body beautiful for another, possibly racier, image of woman which can easily be absorbed within the patriarchal repertoire of feminine stereotypes. What is interesting in the present context, however, is the way in which both Lyon's bodybuilding and Mapplethorpe's photographic techniques are articulated in terms of bringing the female body under control. In a foreword to the book Samuel Wagstaff describes the compatibility between the photographer and the model:

> Of course, Mapplethorpe always makes it more difficult for himself by deliberately framing everything and everybody in the same strait-jacket style – the world reinvented as logic, precision, sculpture in obvious light and shadow.
>
> I don't suppose he would ever have taken a second exposure of Lisa if her classicism and ideals of order had not been a match for his.[8]

The images of Lyon are presented in terms of 'logic', 'precision' and 'order', pointing, quite knowingly, to the act of regulation that has been undertaken in this work. In his search for a language to convey the effect of the images, Wagstaff hits upon 'strait-jacket style', that is, a style that is concerned with holding down, with control and containment – an allusion not at all unlike Kenneth Clark's reference to the body as 'sheath'.

In many ways, the visual appearance of Mapplethorpe's monumental black-and-white photographs accentuates this aesthetic control of the female body. The hard edges and stark chiaroscuro of the images transform the body into sculpture – an effect that is intensified by the use of graphite on the body which subordinates modulations and details of the body surface to matt articulations of form and volume. Both model and photographer are seen to collaborate in this ordering of the female body. Both are referred to as classical sculptors in their search for a physical and aesthetic ideal: 'his eye for a body [is] that of a classical sculptor in search of an "ideal"', and she is 'a sculptor whose raw material was her own body'.[9] The sculpture metaphor is one that emphasizes the projection of surfaces, the building and moulding of form. Together, Lyon and Mapplethorpe turn the raw material of the female body into art. And it is a double metamorphosis. Lyon describes herself as a performance artist; through bodybuilding she turns herself into a living art object and the process is then repeated as Lyon's body is captured in Mapplethorpe's photographic album.

Lisa Lyon has been 'framed'. By contouring her own body she turns its surfaces into a kind of carapace, a metaphorical suit of armour. But what may start out to be a parody of ideals of masculinity and a claim to a progressive image of femininity is easily reappropriated. Rather than transgressing sexual categories, Lyon simply re-fixes the boundaries of femininity. The surface of her body has become a 'frame', controlling

the potential waywardness of the unformalized female body and defining the limits of femininity.

The 'framing' also occurs at the level of the formal constraints of the medium. Lyon is contained in the frame of Mapplethorpe's photographs – the disposition of light and shade, the surface and edges of the images. In other words, the act of representation is itself an act of regulation. And finally, Lyon is framed in the sense of being 'set up', offered as an image of liberation and revised femininity, whilst actually reinforcing the place where femininity begins and ends. Her power is contained by convention, form and technique; she poses no threat to patriarchal systems of order.

Paradoxically, Lyon's body is seen to have been both built up and honed down, added to but also reduced to its bare essentials. In his introductory essay to the collection, Bruce Chatwin comments: 'it was obvious that her body was superlative – small, supple, svelte, without an ounce of surplus fat.'[10] Her body has apparently reached the highest or utmost degree of contained form. How strange that a body that has been built up through exercise and weight training is praised for being 'small'. Strange, that is, until we recognize that what Chatwin is admiring is the transformation of the female body into a symbol of containment. The aesthetic that is represented by Lyon's body is the now familiar one of boundaries and formal integrity.

Within this aesthetic, 'fat' is excess, surplus matter. It is a false boundary, something that is additional to the true frame of the body and needs to be stripped away. The categories 'fat' and 'thin' are not innate and do not have intrinsic meanings; rather, they are socially constituted, along with definitions of perfection and beauty.[11] Social and cultural representations are central in forming these definitions and in giving meaning to the configurations of the body. Over the last decade, for a woman to be in 'great shape' is to be firm, trim, fit and healthy. This in turn is seen as a quest for freedom, a way of realizing her true self and potential. As Michel Foucault has shown, in the modern period the body has become a highly political object, a crucial site for the exercise and regulation of power.[12] In this context, power is constituted both through the production of knowledge concerning the body and through self-regulation, through the individual exercising control over the self. The operations of power are thus not simply coercive, exercised from elsewhere over the individual, but are also self-regulatory and organized from within the subject. The complex relationship of the body and power is clearly demonstrated in the configuration of the female body produced by the workout ethic and aesthetic. Here, the female body, trimmed to its essential outline, promises new freedom and a healthy sexuality. The rigours of the workout signal both the need to conform to social ideals and the force of self-regulation, the exercise of power over oneself. 'I like to be close to the bone.'[13] Jane Fonda's declaration can come as no surprise; being 'close to the bone' means being closer to a bounded, structured form that is devoid of excess, that represents the true, integral self. This ideal of closeness to the bone also means that two dimensions of the idea of the bodily frame converge; the epidermal surface that is the body's *outside* frame tightening around the skeletal frame that forms the body's *inside*. Again, form and identity, visual representation and psychical structures overlap precisely on the issue of spaces and boundaries.

The common factor in all of these matters is the female body as representation, with woman playing out the roles of both viewed object and viewing subject, forming and

judging her image against cultural ideals and exercising a fearsome self-regulation. My third example of the primacy of boundaries in social configurations of the female body is anorexia nervosa.[14] Here again, the body is seen as image, according to a set of conventions, and woman acts both as judge and executioner. But rather than anorexia being seen as a distortion of physical needs, it can be posed instead as a confusion of psychical perceptions and, more exactly, as a confusion of form and its boundaries. For the anorectic, there is always excess matter deposited over the surface, the form of the body. The goal is to get rid of that surplus and to reveal the essential, core self – to get back to the original boundaries.

Woman looks at herself in the mirror; her identity is framed by the abundance of images that define femininity. She is framed – experiences herself as image or representation – by the edges of the mirror and then judges the boundaries of her own form and carries out any necessary self-regulation. The watertight sieve of the allegorical figure of Chastity; the sculpted body of the female bodybuilder; and the struggle over the body's boundaries conducted by the anorectic – all these cases illustrate the ways in which the female body is imaged in western society. The formless matter of the female body has to be contained within boundaries, conventions and poses.

This point is given a striking visual form in Albrecht Dürer's *Draughtsman Drawing a Nude*, 1538. Here a partially draped female model lies on a table opposite the draughtsman. They are separated by a framed screen which is divided into square sections. The artist gazes through the screen at the female body and then transposes the view on to his squared paper. Geometry and perspective impose a controlling order on the female body. The opposition between male culture and female nature is starkly drawn in this image; the two confront each other. The woman lies in a prone position; the pose is difficult to determine, but her hand is clearly poised in a masturbatory manner over the genitals. In contrast to the curves and undulating lines of the female section, the male compartment is scattered with sharp, vertical forms; the draughtsman himself sits up and is alert and absorbed. Woman offers herself to the controlling discipline of illusionistic art. With her bent legs closest to the screen, the image recalls not simply the life class but also the gynaecological examination. Art and medicine are both foregrounded here, the two discourses in which the female body is most subjected to scrutiny and assessed according to historically specific norms. Through the procedures of art, woman can become culture; seen through the screen, she is framed, she becomes image and the wanton matter of the female body and female sexuality may be regulated and contained.

The distinctions between inside and outside, between finite form and form without limit, need to be continuously drawn. This requirement applies to representations of the female body in high and mass culture. It extends to the way in which the categories of art and pornography are defined and maintained. In nearly every case, however, there is a point where the systems break down, where an object seems to defy classification and where the values themselves are exposed and questioned. If you know the terms of the debate then they can be played with, disrupted and this opens up the possibility for challenging and progressive representations of the female body.
[. . .]

Notes

1 Kenneth Clark, *The Nude: A Study of Ideal Art* (London: John Murray, 1956), p. 79.

2 Mary Douglas, *Purity and Danger: An Analysis of Concepts of Pollution and Taboo* (London: Routledge and Kegan Paul, 1966), p. 121.

3 Jacques Derrida, *The Truth in Painting*, trans. Geoff Bennington and Ian McLeod (Chicago: University of Chicago Press, 1987), p. 45.

4 Aristotle from *Metaphysics*, book XIII, in *Philosophies of Art and Beauty: Selected Readings in Aesthetics from Plato to Heidegger*, ed. Albert Hofstadter and Richard Kuhns (New York: Random House, 1964), p. 96.

5 Sigmund Freud, 'The ego and the id', in *The Standard Edition of the Complete Psychological Works*, trans. and ed. James Strachey, vol. XIX (London: Hogarth Press, 1961), p. 26.

6 This painting is also illustrated by Marina Warner in *Monuments and Maidens: The Allegory of the Female Form* (London: Weidenfeld and Nicolson, 1985), fig. 69. Her chapter 'The sieve of Tuccia' is an excellent account of the imagery of the female body as vessel or container.

7 For feminist responses to the book, see Silvia Kolbowski, 'Covering Mapplethorpe's "Lady"', *Art in America* (Summer 1983): 10–11, and Susan Butler, 'Revising femininity? Review of *Lady*: photographs of Lisa Lyon by Robert Mapplethorpe', first published in *Creative Camera* (September 1983), reprinted in *Looking On: Images of Femininity in the Visual Arts and Media*, ed. Rosemary Betterton (London: Pandora Press, 1987), pp. 120–6.

8 Samuel Wagstaff, 'Foreword', *Lady: Lisa Lyon by Robert Mapplethorpe* (New York: Viking, 1983), p. 8.

9 Bruce Chatwin, 'An eye and some body', in *Lady: Lisa Lyon*, pp. 9, 11.

10 Ibid., p. 12.

11 These issues are discussed in Nicky Diamond, 'Thin is the feminist issue', *Feminist Review*, 19 (Spring 1985): 45–64.

12 Michel Foucault, *The History of Sexuality. Volume 1: An Introduction*, trans. Robert Hurley (Harmondsworth: Penguin, 1981).

13 Jane Fonda, as quoted in Diamond, 'Thin is the feminist issue', p. 56.

14 For important discussions of anorexia nervosa, see Sheila MacLeod, *The Art of Starvation* (London: Virago, 1981); Susie Orbach, *Hunger Strike: The Anorectic's Struggle as a Metaphor for our Age* (London: Faber, 1986); Susan Bordo, 'Reading the slender body', in *Body/Politics: Women and the Discourses of Science*, ed. Mary Jacobus, Evelyn Fox Keller and Sally Shuttleworth (London: Routledge, 1990), pp. 83–112. In the following brief discussion I will not cover the question of anorexia nervosa as a form of protest or its clinical aspects but will concentrate on the issue of female body image.

Amelia Jones, 'Yayoi Kusama' (1998)

From Amelia Jones, *Body Art: Performing the Subject* (Minneapolis, MN: University of Minnesota Press, 1998), pp. 5–9.

[. . .] The particularization of the subject took an especially charged turn in the performative self-imaging of Japanese artist Yayoi Kusama. In a collage from the mid-1960s Kusama enacted herself as pinup on one of her vertiginous landscapes of phallic knobs, here a couch cradling Kusama as odalisque; this phallic/feminine image of Kusama

embedded in her own work is glued above a strip of decidedly unerotic macaroni with a labyrinthine maze of one of her *Infinity Net* paintings covering the surface behind her. Here, naked and heavily made up in the style of the 1960s, Kusama sports high heels, long black hair, and polka dots covering her bare flesh: all surfaces are activated in a screen of decoration, merging the body of the artist with her created universe of phallic, patterned hyperbole. I am especially interested in the role such images, as performative documents, play in *enacting* the artist as a public figure.[1] As Kris Kuramitsu has argued, this photograph 'is only one of many that highlight [Kusama's] naked, Asian female body. These photographs, and the persona that cultivated/was cultivated by them is what engenders the usual terse assessment [in art discourse] of Kusama as "problematic." '[2] Or, in the words of J. F. Rodenbeck, 'Priestess of Nudity, Psychotic Artist, the Polka-Dot Girl, Obsessional Artist, publicity hound: in the 1960s Yayoi Kusama was the target of a number of epithets, some of them self-inflicted, all of them a part of an exhibitionist's notoriety.'[3]

Working in New York at the time she was producing these performative images, Kusama played on what Kuramitsu calls her 'doubled otherness'[4] *vis-à-vis* American culture: she is racially *and* sexually at odds with the normative conception of the artist as Euro-American male. Rather than veil her differences (which are seemingly irrefutably confirmed by the visible evidence of her 'exotic' body), Kusama exacerbates them through self-display in a series of such flamboyant images. In this posed collage, she performs herself in a private setting for the public-making eye of the camera. But Kusama enacts her 'exoticism' on a public register as well, executing other performances (including at least seventy-five performative events between 1967 and 1970)[5] and posing in more public situations. In a portrait of artists participating in the 1965 exhibition of the Nul group at the Stedelijk Museum in Amsterdam,[6] Kusama sticks out like a sore thumb: there she stands, front and center – among a predictably bourgeois group of white, almost all male Euro-Americans (dressed in suits) – her tiny body swathed in a glowing white silk kimono.[7]

The pictures of Kusama are inextricably embedded in the discursive structure of ideas informing her work; viewers are forced to engage deeply with this particularized subject who so dramatically stages her work and/as her self. Too, in the collage images of Kusama such as the one discussed here, her body/self is literally absorbed into her work and indeed *becomes* it: 'I was always standing at the center of the obsession over the passionate accretion and repetition inside me.'[8] As Schneemann did in *Interior Scroll*, Kusama enacts her body in a reversibility of inside and out, the work of art/the environment is an enactment of Kusama and vice versa.

In her large-scale mirrored installations, such as *Kusama's Peep Show – Endless Love Show* (at Castellane Gallery in 1966), she forced the viewer into a similarly reversible relation.[9] Here, while listening to a loop of Beatles music, visitors poked their heads through openings in the wall of a closed, mirrored hexagonal room to see infinitely regressing reflections of themselves, illuminated by flashes of colored lights. A vertiginous sense of dislocation rocketed the visitor out of the complacent position of voyeurism conventionally staged and assumed *vis-à-vis* works of art. With such works, the spectator is locked into an exaggerated self-reflexivity that implies an erotic bond (an 'endless love show') – one that is both completely narcissistic and necessarily complicitous with Kusama's (here absent) body/self.

In all of these works, Kusama refuses the artificial division – that which enables a 'disinterested' criticism to take place – conventionally staged between viewer and work of art. Folding the work of art into the artist (and vice versa), Kusama also sucks the viewer into a vortex of erotically charged repulsions and attractions (identifications) that ultimately intertwine viewer, artwork, and artist (as artwork). Kusama constructs obsessional scenes both to stage her particularized body/self and to express it externally – to spread it over the surrounding environment while simultaneously incorporating the environment into her own psychically enacted body/self: everything becomes a kind of extended flesh. But these scenes never fully contain Kusama, who performs herself well beyond the controlling mechanisms of art historical and critical analysis (hence her disturbance to the critical discourse, noted by Kuramitsu).

Am I an object? Am I a subject? Kusama performed these questions from the 1960s on, enacting herself ambivalently as celebrity (object of our desires) or artist (master of intentionality). Either way, Kusama opens herself (performatively) to the projections and desires of her audience (American, Japanese, European), enacting herself *as representation* (pace Warhol, she's on to the role of documentation in securing the position of the artist as beloved object of the art world's desires).[10] Kusama's gesture, which plays specifically with the intertwined tropes of gender, sexuality, and ethnicity (as well as those of artistic subjectivity in general), comprehends the particular resonance of such performative posing for women and those outside the Western tradition, subjects whose non-normative bodies/selves would necessarily rupture embedded conceptions of artistic genius. It is Kusama's exaggeration of her otherness that seals this disturbance, building it into the effect of the work rather than veiling it to promote a formalist reading.[11]

Kusama's artistic strategies were inextricable from her identity politics and social politics; her work makes explicit the connections I trace throughout this book [*Body Art*] among social and identity politics and the deep interrogation of subjectivity characterizing this period. Kusama activated her always already marginalized body/self in a classically 1960s protest against bourgeois prudery, imperialism, racism, and sexism. Many of her public events were posed as demonstrations against the Vietnam War, and her strategic use of self-exposure was intimately linked to the openness urged by the sexual revolution: like Schneemann's body art works, Kusama's are both enactments and effects of the sexual revolution and antiwar movements as well as the women's movement.[12]

In its radical narcissism, where the distances between artist and artwork, artist and spectator are definitively collapsed, such body art practices profoundly challenge the reigning ideology of disinterested criticism. As I have already suggested, when the body in performance is female, obviously queer, nonwhite, exaggeratedly (hyper)masculine, or otherwise enacted against the grain of the normative subject (the straight, white, upper-middle-class, male subject coincident with the category 'artist' in Western culture), the hidden logic of exclusionism underlying modernist art history and criticism is exposed. The more exaggeratedly narcissistic and particularized this body is – that is, the more it surfaces and even exaggerates its non-universality in relation to its audience – the more strongly it has the potential to challenge the assumption of normativity built into modernist models of artistic evaluation, which rely on the body of the artist (embodied as male) yet veil this body to ensure the claim that the artist/genius

'transcends' his body through creative production. [. . .] [T]he narcissistic, particularized body both unveils the artist (as body/self necessarily implicated in the work of art as a situated, social act), turning her inside out, and strategically insists upon the contingency of this body/self on that of the viewer or interpreter of the work. As the artist is marked as contingent, so is the interpreter, who can no longer (without certain contradictions being put into play) claim disinterestedness in relation to this work of art (in this case, the body/self of the artist). [. . .]

Notes

1 This interest links to my initial engagement with body art through the numerous advertisements that began appearing in the late 1960s in art magazines such as *Artforum* – advertisements that include the *body of the artist*, often in facetious or ironic poses and humorous settings. In these self-performative advertisements, the body of the artist plays a central role in promoting the exhibition of the artist's work: the body of the artist is itself commodified but also dispersed across the field of meanings and values attributed to the works. These photographic performances respond to or negotiate earlier models of the artist, from Marcel Duchamp's rather coy self-construction in the public realm as Rose Sélavy and beyond, to the critical formulation of Jackson Pollock as veiled genius (with the famous photographs by Hans Namuth and others). Examples of this phenomenon from *Artforum* include an advertisement for a Robert Rauschenberg exhibition showing the artist perched casually on a ladder in front of a large-scale lithograph in a checked suit (September 1970): Judy Chicago's advertisement for an exhibition at California State University, Fullerton (December 1970); and Ed Ruscha's coy promotional picture of himself lying in bed between two naked women with the caption 'Ed Ruscha says goodbye to college joys' (January 1967). I discuss these at greater length in 'Dis/playing the phallus,' pp. 549–53 [of *Body Art*].

2 Kris Kuramitsu, 'Yayoi Kusama: exotic bodies in the avant-garde', unpublished paper submitted for Amelia Jones and Donald Preziosi's 'Essentialism and Representation' graduate seminar, University of California, Riverside/UCLA, spring 1996, p. 1. This image resonates with Kusama's performative self-display in the poster for her 'Driving Image Show' at Castellane Gallery, New York, spring 1964; reproduced in J. F. Rodenbeck, 'Yayoi Kusama: surface, stitch, skin', in *Inside the Visible: An Elliptical Traverse of 20th Century Art*, ed. M. Catherine de Zegher (Cambridge, MA: MIT Press, 1996), p. 148. See also the photograph taken by Rudolph Burckhardt of Kusama posing nude at the 'Aggregation: One Thousand Boats Show' at the Gertrude Stein Gallery, New York, 1964, reproduced in *Yayoi Kusama: A Retrospective*, ed. Bhupendra Karia (New York: Center for International Contemporary Arts, 1989). p. 24; and Calvin Tomkins's recent article on Kusama, 'On the edge: a doyenne of disturbance returns to New York', *New Yorker*, 72 (30) (October 7, 1996): 100–103. I am indebted to Kuramitsu for introducing me to this aspect of Kusama's oeuvre and for leading me to the best sources on the artist; I am thankful also to Lynne Zelevansky, curator of an upcoming retrospective of Kusama's work at the Los Angeles County Museum of Art, for discussing Kusama's work with me.

3 Rodenbeck, 'Yayoi Kusama', p. 149.

4 Kuramitsu, 'Yayoi Kusama', p. 2.

5 See Alexandra Munroe, 'Obsession, fantasy and outrage: the art of Yayoi Kusama', in *Yayoi Kusama: A Retrospective*, pp. 29–30; and Rodenbeck, 'Yayoi Kusama', p. 153.

6 Nul was the Dutch affiliate of the Zero group founded in 1957 in Dusseldorf by Otto Piene and Heinz Mack. See Otto Piene and Heinz Mack, *Zero* (1958/1961; reprinted Cambridge, MA: MIT Press, 1973).

7 The other artists in the portrait include Jiro Yoshihara, the founder of Gutai, Hans Haacke, Lucio Fontana, and Günther Uecker. See the labeled photograph in *Nul negentienhonderd vijf en zestig, deel 2 fotos* (Nul 1965, part 2, photographs) (Amsterdam: Stedelijk Museum, 1965), n.p. Kusama's mental

illness has also functioned in her discursive construction, as in Munroe's 'Obsession, fantasy and outrage', pp. 11–35; Kuramitsu compellingly critiques this type of reading, which draws on a modernist conception of the mad genius, in her essay 'Yayoi Kusama.'

8 Yayoi Kusama, entry in *Nul negentienhonderd vijf en zestig, deel 1, teksten.*

9 This piece is described in Rodenbeck, 'Yayoi Kusama', p. 152.

10 According to Munroe, Kusama deliberately competed with Warhol for press coverage ('Obsession, fantasy and outrage', p. 30).

11 Accounts of Kusama's work typically either attempt to dismiss her performative actions as puerile distractions from the minimalist thrust of the 'Infinity Net' and 'accumulation' works (the pieces with phallic knobs) or they surface these actions as exemplary of the insanity that naturally explains the obsessional quality of these repetitively patterned objects.

12 Among Kusama's many public performances from the late 1960s were the pieces she called 'Self Obliteration' or 'Body Festivals,' activist protests against the Vietnam War involving her arranging a meeting at a specific public site (such as the Museum of Modern Art sculpture garden or the New York Stock Exchange) with a number of dancers; the press would be alerted and Kusama, the 'priestess,' would organize a group strip session while painting the dancers' bodies with her signature polka dots as they danced. These are described at greater length in Munroe, 'Obsession, fantasy and outrage', pp. 29–30, and Rodenbeck, 'Yayoi Kusama', p. 153. Kusama's work, in its obsessional, opish effects, either directly or indirectly shows the effects of the drug culture as well.

8.3 Sexuality and the Sexual Body

Barbara Rose, 'Vaginal Iconology' (1974)

From *New York Magazine*, 7 (11 February 1974), p. 59; reprinted as 'Venus Envy' in Barbara Rose, *Autocritique: Essays on Art and Anti-art 1963–1987* (New York: Weidenfeld and Nicolson, 1988), pp. 27–29.

In 1972, Professor Linda Nochlin caused a scholarly sensation at a meeting of the College Art Association: she exposed the obvious fact that nineteenth-century erotic art was created by men for men, and suggested a facetious female analogy. First she showed a slide of a popular French illustration of a woman, nude except for stockings, boots, and choker, resting her breasts on a tray of apples; then she projected a photograph of a bearded young man, nude except for sweat socks and loafers, holding a tray of bananas under his penis. Instead of the invitation *'Achetez des pommes'* (Buy some apples) inscribed under the maiden, the man advertised 'Buy some bananas.'

A decade ago Professor Nochlin's comparison would have been unthinkable at an assembly of art historians. Even more unthinkable, however, would be the idea that women might begin producing their own erotic art, aimed at eliciting a response in a female audience. Today, women are among the most prolific producers of erotica, suggesting that if there was a revolution in the sixties, it was not political but sexual. Perhaps sexual issues appear to dominate the women's movement at this moment because erotic arguments do not fundamentally challenge the social structure as political disputes do.

By equating sexual liberation with radicalism, the women's movement is following a direction other initially revolutionary forces have taken to survive in our time. The most obvious example of the displacement of revolutionary political aims to more acceptable targets is the history of modern art itself. When the goal of social and political revolution seemed unobtainable, the ideology of modernism rephrased itself so as to locate 'revolution' exclusively within the boundaries of art itself. 'Radical' became the most flattering adjective one could apply to art, and aesthetic experiments were validated on the basis of how 'revolutionary' they were.

Now something similar is happening with sex, which, like art, has become a pursuit for its own sake. Within the general context of feminism, the women's art movement has been one of the most energetic exponents of an altered concept of female sexuality. Publications, university courses, and women's cooperative galleries stress the importance of women in art. In meetings, 'rap' sessions, and symposia, women examine the question of whether or not there are such things as a 'feminine sensibility' and a subject matter that can be described as 'female.' According to women artists associated with the feminist movement, there is. They cite Georgia O'Keeffe's voluptuous flowers and Louise Nevelson's sculptures of dark, mysterious interiors as early examples of female imagery; and they are searching out the names of the daughters, nieces, and students of famous painters whose works in the past often were attributed to the men they worked with.

Such a re-examination of the forgotten chapters of history is analogous to the quest among blacks for their essence in a universal *negritude*. Indeed, the parallel between women and blacks is one of the fundamental premises of the women's movement. As Gunnar Myrdal wrote in 1944, women, like blacks, had high social visibility because they were different in 'physical appearance, dress, and patterns of behavior.' Most men 'have accepted as self-evident, until recently, the doctrine that women had inferior endowments in most of those respects which carry prestige, power, and advantages in society.'

Inferior status has stimulated both groups to assertions of pride in their 'differences.' Black art frequently serves as propaganda for the important idea that 'black is beautiful,' essential in creating not only an ideology of equality, but a psychology built on the confidence that black is as good as white. To dignify female 'difference,' what should feminist art glorify?

The answer is obvious, and even if feminist art bears no slogans proclaiming 'power to the pubis,' that is what it is essentially about. For much of the feminist art that has been labeled 'erotic' because it depicts or alludes to genital images is nothing of the sort. It is designed to arouse women, but not sexually. Hannah Wilke's soft latex hanging pieces, Deborah Remington's precise abstractions, Miriam Schapiro's ring-centered *Ox*, Rosemary Mayer's cloth constructions, Judy Chicago's yoni-lifesavers are all vaginal or womb images. What is interesting about them is the manner in which they worshipfully allude to female genitalia as icons – as strong, clean, well made, and whole as the masculine totems to which we are accustomed. Although there are many categories of women's erotic art, the most novel are those that glorify vaginas. This category of women's art is profoundly radical in that it attacks the basis of male supremacy from the point of view of depth psychology. At issue is the horror of women's genitals as mysterious, hidden, unknown, and ergo threatening – as chronicled by H. R. Hayes in *The Dangerous Sex*, a fascinating compilation of age-old prejudices against women as unclean Pandoras with evil boxes, or agents of the devil sent to seduce and trap men.

By depicting female genitals, women artists attack one of the most fundamental ideas of male supremacy – that a penis, because it is visible, is superior. At issue in vaginal iconology is an overt assault on the Freudian doctrine of penis envy, which posits that all little girls must feel that they are missing something. The self-examination movement among women that strives at familiarizing women with their own sex organs, and

the images in art of nonmenacing and obviously complete vaginas, are linked in their efforts to convince women that they are not missing anything. In realizing that 'equality' depends on more than equal rights and equal salaries, women are exalting images of their own bodies. Their erotic art is, in effect, propaganda for sexual equality based on discrediting the idea of penis envy. Equality on these grounds is far more humane than the alienating prospect of women treating men as sex objects – my favorite example of this being Sylvia Sleigh's group portrait of nude male art critics. Turning the tables is not the road to equality; nor will male brothels solve anyone's problems. But a healthy self-respect may help diminish the debilitating inferiority complex the second sex finally shows signs of transcending.

Suzanne Santoro, 'Towards New Expression' (1974)

From Suzanne Santoro, *Per una espressione nuova/Towards New Expression* (artist's book) (Rome: Rivolta Femminile, 1974).

I found [a] picture drawn with chalk on a wall in Rome. What struck me was its size, about $3' \times 3'$. At first it seemed common enough, just like many of the graffiti that you see all over the world. Then I realized I was getting curious about the drawing and that it required a little more attention. In fact, the elements in it were quite clear if you were prepared to recognize them. The penis and the semen were drawn with force and the cup for the care and preservation of the semen was given great importance. On the other hand, there was the subordinate and mystified presence of the female genitals, the usual crack-hole, hole-crack. The drawing is a product of today.

When I saw how this subject had been treated in the past, I realized that even in diverse historical representations it had been annulled, smoothed down and, in the end, idealized.

The placing of the Greek figures, the flowers and the conch shell near the clitoris is a means of understanding the structure of the female genitals. It is also an invitation for the sexual self-expression that has been denied to women till now, and it does not intend to attribute specific qualities to one sex or the other.

Each need for expression in women has a particular solution. The substance of expression is unlimited and has no established form. Self expression is a necessity. It is easily accessible if authentically desired. Expression begins with self assertion and with the awareness of the differences between ourselves and others.

We can no longer see ourselves as if we live in a dream or as an imitation of something that just does not reflect the reality of our lives.

Men have too often wanted to attain immortality as the content and scope of their lives. Here they started a dangerous game which they are forced to continue by defending competition, superiority and ambition as positive and outstanding values.

Women are outsiders. We expressed our disapproval and looked for other more possible solutions, often improvising them. Since then, we have carried the weight of our decision, inferiorization.

We are now at the point in which we can openly manifest our own concept in human relationships. This may seem new for the world around us but we can now express a reality that has been ignored and despised for too long and finally live in a different dimension.

Joanna Frueh, 'Feminism' (1989)

From *Hannah Wilke: A Retrospective*, ed. Thomas H. Kocheiser (Columbia: University of Missouri Press, 1989), pp. 41–49.

'Feminism in a larger sense is intrinsically more important than art,' says Wilke.[1] As a feminist her primary contribution to the Women's Art Movement and to efforts to change the status of women is her focus on the female body.

Poet Adrienne Rich has written that the 'body has been made so problematic for women that it has often seemed easier to shrug it off and travel as a disembodied spirit.' Art, mythology, literature, and religion, their ideologies constructing popular concepts, have promoted two interdependent ideas that, as Rich says, 'have become deeply internalized in women, even in the most independent of us, those who seem to lead the freest lives.'[2] One notion is that the female body is impure and dangerous and provokes corruption. The other is that the body is sacred, nurturing, and asexual. The Mother–Whore ideology makes it difficult for women to be comfortable, let alone in love, with their bodies.

From the 1970s on, feminists have been asking, as Jane Flax puts it, 'What difference does it make in the constitution of my social experiences that I have a specifically female body?'[3] Women artists have responded variously.[4] But despite their 'answers,' and despite women's explorations in Body Art, an avant-garde inquiry fertilized by the Women's Art Movement, women's redefinitions and direct exposures of their own bodies are made, by the art system, to remain marginal, radically critical but all too ineffective. As Wilke says, 'Female nudity painted by men gets documented and when women create this ideology as their own it gets obliterated.'[5]

Wilke is one of the few artists creating a female erotic discourse, and she is the only one to consistently use both herself and sculptural forms 'that are nameable and at the same time quite abstract.'[6] Other bodies of work that have been influential in establishing a new female iconography are more singularly focused: Louise

Bourgeois's sensuous, tactile, and sometimes terrifying objects; Lynda Benglis's bronze mounds that look lumpy and oozing, her Sparkle Knots, and her gold and silver wall pieces that can suggest torsos, wings, and shield; Joan Semmel's paintings of female nudes and love-making couples, often seen from the subjects' perspective; Georgia O'Keeffe's flowers that radiate sensual energy; and Eva Hesse's sagging, tangled, visceral sculptures.[7]

Wilke states that her art is about 'respecting the objecthood of the body.'[8] Although she strips herself naked, in acts and records of psychic self-exposure, she also presents herself as the nude, a sculptural and ideal form. In the *So Help Me Hannah* photographs and performance, her high-heeled shoes serve as pedestals; in *SOS – Starification Object Series* (1974–1975) she uses her torso as a surface, sticking to it her one-fold chewing-gum signatures, sculptures that are themselves (erotic) objects. In performances and videos Wilke is the living sculptural object who moves through space and time.

In contemporary usage, the word *object* applied to a woman is considered negative. She is solely a sex object, a thing perceived without empathy or compassion. However, an object, defined as 'something that is or is capable of being seen, touched, or otherwise sensed,' exists; thus, respecting objecthood can be an assertion of existence. Wilke knows that 'women are ashamed of nudity. To be female and sexual is forbidden. If you show your body and are proud of it, it frightens people.'[9] For then a woman exists, intensely.

Wilke began performing and having herself photographed nude in 1970, after her mother's mastectomy. As Wilke's mother was losing her body, Wilke wore her mother's wounds. She also needed to affirm the presence of her own body, as alive and female, as the site of imposed cultural meanings, and as the source for new ones. Consequently, her images are ambivalent. For she plays with the male art language of the female nude, reinventing the beauty of the nude with a declaration of her own, while constructing caricatures, of femininity and sexuality, that require the viewer to read them back into the history of the female nude.

SOS parodies the poses of high-fashion models, their aloof gazes that exude mystery and a simultaneous blandness and extreme emotion. Also, the chewing-gum wounds that adhere to Wilke's chest, breasts, and abdomen indicate that the female nude, with her perfect(ed) looks, is a victim.[10]

Her strips are themselves parodies, for *Intercourse with* . . . and *So Help Me Hannah* radiate pain, and the latter is highly intellectual. Both demand a concentration that is visual and emotional; even watching the videotapes, a viewer feels the bizarreness of staring at a woman sadly removing her clothes for an audience.

The photograph from *So Help Me Hannah* labeled 'WHAT DOES THIS REPRESENT – WHAT DO YOU REPRESENT' is Wilke's most straightforward critique of the female nude.[11] Sitting on the floor in a corner with her knees up and legs apart, with toy guns and Mickey Mouses spread before her, Wilke assumes a contemplative posture, elbow on knee, hand to forehead. Her 'beaver shot' recalls the pose in Courbet's *Woman with White Stockings*, which Duchamp repeated as *Morceau Choisi d'après Courbet*. A seated nude with her cunt on display is a choice morsel; the female nude is a simple form representing simplistic – Mickey Mouse – notions. But dressed only in high heels, Wilke mocks sexiness. The guns (phallic weaponry symbolic of a male-dominant society's

varied forms of violence against women), Wilke's anything but coy expression and atti-
tude and the verbal questions are designed to provoke response. What images, both per-
sonal and artistic, do you and I choose to create? How do our prejudices contribute to
the making and destruction of cultural and social reality?

Many women believe that using a woman's body in art is 'problematic for femin-
ism.'[12] Artists may simply refetishize the already sexualized female body and reinforce
the prison of anatomy-as-destiny. (In Freudian theory, visible anatomical difference
ensures women's inferiority by virtue of psychic difference.)[13] Women who work with
the female body, as image or person, may produce 'politically ambiguous manifesta-
tions.'[14] Considering the layers of myth and symbolism accruing to the female body,
ambiguity, even for a feminist, seems reasonable, perhaps necessary. For to be ambigu-
ous is to be equivocal – equi-vocal – having two or more voices, two or more meanings
of equal importance. To be ambiguous is to risk not vagueness, but rather the lucid
apprehension that life is complex and artists ought not to dead-end the myriad routes
through it of understanding

Wilke risks dangers problematic to feminism in order to validate the female body. As
Lucy Lippard notes, 'When women use their own bodies in their art work, they are
using their *selves*; a significant psychological factor converts these bodies or faces from
object to subject.'[15] The validation comes from a woman speaking about her self, the
body that, from a female perspective, has been largely absent from Western culture's
representations of women.

Wilke's stand is extreme, for self-spoken female eroticism has not been welcome
in the discourses of Western culture or contemporary feminism. The latter has a
strong puritanical streak, which anthropologist and psychoanalyst Muriel Dimen
implicitly acknowledges in her discussion of feminism's contradictory imperatives:
women should be sexual explorers, yet they should let go of traditional eroticism.
Dimen says,

> On the one hand, since women have been traditionally seen as sex objects, feminism
> demands that society no longer focus on their erotic attributes, which, in turn,
> feminism downplays. In this way it becomes politically correct not to engage in any
> stereotypically feminine behavior, such as putting on make-up, wearing high heels,
> shaving legs and arms, or coming on to men.[16]

Dimen believes that sexuality must not, indeed cannot, be legislated and that erotic
conventions may be precisely what some women need to use in order to find sexual,
which is a form of political, freedom.

Wilke's signature cunts or vaginal icons, like her self-portrait female nudes, also
play with traditional sex language, and, again, the resulting discourse is extreme. 'My
concern is with the word translated into form,' she says, 'with creating a positive image
to wipe out the prejudices, aggression and fear associated with the negative connotations
of pussy, cunt, box.'[17] *Cunt* has been a pornographic word and image. Pornography
blatantly positions woman as cunt. According to Jane Root, in

> more extreme pornography, the magazine reader is presented with page after page of
> female genitals. The rest of the woman's body is foreshortened to a blur or cropped

out completely . . . She is Everywoman, and Everywoman is nothing but a passive receptacle for male imaginings, always open, always accessible and always waiting for *him*.[18]

Wilke uses an elemental image of 'extreme' pornography, isolates it, as does pornography, maintains its everywoman aspect, and expands that into a universal symbol. The cunt abstracted and recontextualized by Wilke sheds the pornographic dross that diminishes women.

She literally sees the cunt differently from how both women and men usually view it – as something ugly, obscene. Her cunts look beautiful. They are delicate pink and brilliant red, glowing gold and magic black, patterned like rich materials, firm and fluent in shape. Wilke's cunts can even be silly, as if their beauty underlies a confidence that these objects often project. In her series of postcard collages, gray, kneaded eraser 'cunts,' 'pretty little things,' promenade in Chicago's Garfield Park in one work and march in formation around the Lincoln Memorial in another. Perspective and geometric congruence merge them with a world of accepted but strangely surreal formal beauty.

Cunts are ugly to many because they are seen, with the eyes and mind, as offensive. Cunts are unclean, smelly, slimy, and hairy. 'Disgusting' fluids – urine, blood, and sexual secretions – stream, leak, and ooze from the female genital area and sweat within it. Cunts are the sign, the mark of woman. In *SOS* and in *Marxism and Art: Beware of Fascist Feminism* (1974–1977), a poster made from one of the original thirty-five *SOS* photographs, Wilke 'marks' her body with chewing-gum cunts, designating herself a marked woman. As a woman, she suffers from the 'marks-ism' of internal wounds. As a feminist, she warns of politics and theories, such as Marxism, that become popular in the art world (and with its feminist component), that dictate correct thinking and aesthetics, and that are also nonerotic. Wilke implies, 'Mark my word,' the word translated into form.

Part of the danger she faces is that her multitude of vaginal forms may either serve to continue the perception of women's bodies as parts or, on the other hand, that they will simplistically valorize women's genitals. Novelist and theorist Monique Wittig argues against both situations in *Les Guérrillères*, her trenchant and lyrical novel about women warriors who win the battle of the sexes.

> They do not say that the vulva is the primal form which as such describes the world in all its extent . . .
>
> They say it is not for them to exhaust their strength in symbols . . . They say they must now stop exalting the vulva. They say they must break the last bond that binds them to a dead culture. They say that any symbol that exalts the fragmented body is transient, must disappear. They, the women, the integrity of the body their first principle, advance marching into another world.
>
> The women say that they perceive their bodies in their entirety. They say that they do not favour any of its parts on the grounds that it was formerly a forbidden object. They say that they do not want to become prisoners of their own ideology.[19]

In the future time of *les guérrillères*, they themselves have altered reality so that the integrity of the female body seems absolute. However, in today's unadvanced reality,

the vulva is perceived not as a primal form, or a positively powerful symbol, or simply a forbidden object. Cunt as word, idea, and thing is still offensive to some people, separated from the rest of the body as much through fear and hatred as through sexual focus. In fact, all three – fear, hatred, sexual focus – are intertwined, and the reality of now is to release the cunt and female sexuality from that ideology.

If Wilke exalts the vulva, it is not as a symbol of the fragmented body, for she acts out of necessity: women's integrity, bodily and otherwise, will come only from developing love for what they hate about their selves. As Wittig suggests, symbols are transient, but they are necessary loci of energy and ideas. She says, 'They [the women] say that they did not garner and develop the symbols that were necessary to them at an earlier period to demonstrate their strength.'[20] However, Wilke *is* developing a symbol of strength.

This is a bold act in light of the absence of reference to female genitalia in both the language of art and a more general conceptualization of reality. As Wilke says,

> Nobody cringes when they hear the word phallic. You can say that Cleopatra's Needle outside the Metropolitan Museum of Art is a phallic symbol and nobody will have a fit. You can say a Gothic church is a phallic symbol, but if I say the nave of the church is really a big vagina, people are offended.[21]

A male-dominant culture has made the vagina unseen, invisible, unsightly. Western art has mostly denied and obscured women's genitals. In Classical sculpture, the penis and testicles on a male nude are perfectly apparent, but the female nude has no pubic hair or labia. From the Renaissance on, well into the nineteenth century, when realist trends began to see the truth – but not the symbolic power – of the vulva, it was hidden in shadow or literally veiled. Art, which has exhibited male genitals, has sought to prove that women have nothing.

To many feminists, Freud created a model of masculine sexuality that has castrated the twentieth-century woman. The penis is being, the vagina nothingness. In 'This Sex which is Not One,' psychoanalyst Luce Irigaray states that, in light of 'masculine parameters,' woman's

> lot is that of 'lack,' 'atrophy' (of the sexual organ), and 'penis envy,' the penis being the only sexual organ of recognized value . . . Her sexual organ represents *the horror of nothing to see*. A defect in this systematics of representation and desire. A 'hole' in its scoptophilic lens. It is already evident in Greek statuary that this nothing-to-see has to be excluded, rejected, from such a scene of representation. Women's genitals are simply absent, masked, sewn back up inside their 'crack.'[22]

But even the crack remains hidden, and many women cannot easily 'see,' comfortably look at, their genitals. This precludes an ease of language among women regarding their sexual organs. 'While women have very few words for their genitals,' note scholars Robin Lakoff and Raquel Scherr, in *Face Value: The Politics of Beauty*, 'as often as not referring to them by indirection and euphemism – "down there," "that thing," men lavish an abundance of names redolent of affection and tenderness on theirs.'[23] Wilke's words into forms, however, display an ease – with their profusion, their variety in repetition, the pleasure they give both in looking and in feeling through the eyes.

Despite the heterosexual flavor of Wilke's sculpture, she barely deals with intercourse between women and men (though the theme is constant in her photographic, performance, and video work). Many of her early ceramics of the 1960s are androgynous, but works of the later 1960s and 1970s are autonomous, autoerotic objects that represent female sexual selfhood. In their autonomy and sheer abundance, they are signs of excess, and thus excessive, exceeding the usual, proper, or normal. Examples are the orgasmic wavelike successions of her latex sculptures and the profusion of pink ceramic forms in the floor piece *176 One-fold Gestural Sculptures* (1974) and other serial ceramic works.

Irigaray considers woman as 'experiencing herself . . . in the little-structured margins of a dominant ideology, as waste, or excess,' and argues that women 'haven't been taught, nor allowed, to express multiplicity' in regard to erogenous zones, which, genitally, would be the clitoris, labia, vagina, mouth of the uterus, and the uterus itself.[24] *Cunt* is a generalized word that, in Wilke's clay and porcelain pieces in particular, embraces all of a woman's multiple and excess-ive erogenous zones. Cunt is the '*disruptive excess*' – Irigaray's term – that can jam the phallic machinery of univocality and build, according to many-voiced design, a more humanely functioning system.[25]

In that arrangement of sex and the sexes, 'Open thighs' – the cunt – will 'acknowledge female sexuality as a positive, assertive force – a force that is capable of making demands to achieve satisfaction.'[26] Such an open-thighed, open-voiced system would be attuned to the 'resonance of our physicality, our bond with . . . the corporeal ground of our intelligence.'[27] It would be clear that '*Mind* is immanent in the body,' that the cunt represents a new Mother Tongue, an ancient repository of meaning and language, Logo-rhythms that indicate an erotic way of knowing, a sensuous intellect manifested in Wilke's discourse rooted in the body and inserted into the perpetual sexual discourse of the modern and postmodern worlds, a discourse that is redundantly male, and in which contemporary feminism has often accepted as mutually exclusive 'the sexy and the self-respecting, the sensuous and the serious.'[28]

Notes

1 Avis Berman, 'A decade of progress, but could a female Chardin make a living today?', *Artnews* (October 1980): 77.

2 Adrienne Rich, *Of Woman Born: Motherhood as Experience and Institution* (New York: Bantam, 1977), pp. 20, 15.

3 Jane Flax, 'Postmodernism and gender relations in feminist theory', *Signs*, 12 (4) (1987).

4 The artists listed below, for instance, have offered these 'answers': Mary Beth Edelson, spiritually oriented mixed media works and performances; Joan Semmel, sensuously naturalistic yet hyper-real paintings of the female nude and of heterosexual couples making love; Mary Kelly, a psychoanalytically informed document about motherhood.

5 Judy Siegel, 'Hannah Wilke: censoring the muse?', *Woman Artists News* (Winter 1986–7): 47.

6 Hannah Wilke, conversation.

7 O'Keeffe did not want her flowers to be seen as a female statement, yet regardless of whether we perceive them as coming from a 'feminine' or a 'masculine' perspective, a woman *did* paint them, and

they are erotically charged. Lynda Benglis has produced specifically sexual work, the most explicit being her *Artforum* ad – nude with dildo. However, my interest here is in a more expansively erotic discourse, in which Benglis is involved overall.

8 Hannah Wilke, conversation.

9 Siegel, 'Censoring the muse', p. 4.

10 Lisa Tickner, 'The body politic: female sexuality and women artists since 1970', in *Looking On: Images of Femininity in the Visual Arts and Media*, ed. Rosemary Betterton (London: Pandora Press, 1987), pp. 247–8, discusses Wilke's and other women artists' use of parody.

11 The questions, asked by Ad Reinhardt, appear in Hannah Wilke, 'So help me Hannah', in *Dazzling Phrases: Six Performance Artists*, ed. Robert McCaskell (Forest City, Ont.: Forest City Gallery, 1985), pp. 12-15.

12 Mary Kelly, *Post-partum Document* (London: Routledge and Kegan Paul, 1983), p. xvii.

13 I paraphrase Chris Weedon, *Feminist Practice and Poststructuralist Theory* (Oxford: Blackwell, 1987), p. 49.

14 Lucy Lippard, 'The pains and pleasures of rebirth: European and American women's body art', in *From the Center: Feminist Essays on Women's Art* (New York: E. P. Dutton, 1976), p. 126.

15 Ibid., p. 124.

16 Muriel Dimen, 'Politically correct? Politically incorrect?' in *Pleasure and Danger: Exploring Female Sexuality* (Boston: Routledge and Kegan Paul, 1984), p. 140.

17 Hannah Wilke, 'Intercourse with . . .', text for videotape performance, London, Ontario, Ontario Art Gallery, 17 February 1977.

18 Jane Root, *Pictures of Women: Sexuality* (London: Pandora Press, 1984), p. 47.

19 Monique Wittig, *Les Guerrillères*, trans. David Le Vay (New York: Avon, 1973), pp. 61, 72, 57.

20 Ibid., p. 57.

21 Chris Huestis and Marvin Jones, 'Hannah Wilke: Hannah Wilke's art, politics, religion and feminism', *The New Common Good* (May 1985), p. 1.

22 Luce Irigaray, 'This sex which is not one', in *This Sex which is Not One*, trans. Catherine Porter (Ithaca, NY: Cornell University Press, 1985), pp. 23, 26.

23 Robin Tolmach Lakoff and Raquel L. Scherr, *Face Value: The Politics of Beauty* (Boston: Routledge and Kegan Paul, 1984), p. 215.

24 Irigaray, 'This sex which is not one', 'Psychoanalytic theory: another look', 'When our lips speak together', in *This Sex which is Not One*, pp. 30, 63–4, 210.

25 Irigaray, 'The power of discourse . . .', in *This Sex which is Not One*, p. 78.

26 Susan Brownmiller, *Femininity* (New York: Linden, 1984), p. 189.

27 Rich, *Of Woman Born*, p. 21.

28 Morris Berman, *The Reenchantment of the World* (Ithaca, NY: Cornell University Press, 1981), p. 245; and Wendy Chapkis, *Beauty Secrets: Women and the Politics of Appearance* (Boston, MA: South End Press, 1986), p. 131. See Michel Foucault, *The History of Sexuality: Voulme I, An Introduction*, trans. Robert Hurley (New York: Pantheon Books, 1978), p. 33 and passim, for an analysis of sexuality as a perpetual modern discourse.

Buseje Bailey, 'I Don't Have to Expose my Genitalia' (1993)

From *Matriart*, 3 (3) (1993), pp. 16–20.

Some time ago, I entered my work to be considered for selection in a lesbian art exhibition in Toronto. A young woman belonging to the selection committee asked, 'Where

is the lesbian content in your art? Say something about the lesbian content or what you feel reflects the aspects of lesbianism in your work.' What did she mean by questioning where the lesbian content is in my art? I reflect with annoyance on the words coming out of her mouth forming these questions.

I wondered to myself as I looked at my work.

My work has always been about women, children, and my experience as a Black woman in this society. Every decision I make is political, even where I buy my bread. Where is the lesbian content she asked!

AND FURTHERMORE, I AM.

I had assumed that one could not separate who one is from the work one does, i.e. the personal, from the political. I tried to explain this to her, but she was not impressed because she was looking for more explicit sexual images in my work. I felt uninformed about the Lesbian Art Community. I felt I had no visible support for my way of thinking. At the time, there was no Black lesbian community that I knew of. I was working in a vacuum, so I really didn't know that there was support for my thinking.

This interaction motivated me to take a harder look at my work, and to study the few images that represent lesbian art publicly. My questions are as follows: what is the difference between lesbian art, and lesbian sex? Who is represented by these images? How is the non-genital art of lesbians to be categorized?

Most of the work I see is of white lesbian artists, often with middle class aspirations for inclusion in mainstream society. And the focus is myopically on sex and sexual relationships. I am Black. Survival is central to my existence, and I'm trying to survive.

The bulk of my energy goes into minimizing the hardships in my life.

AND FURTHERMORE, I AM LESBIAN.

These questions were levelled at me in the mid-80s when the trend in the Lesbian Art Community was to take what we do out of the closet and put it in our bedrooms, metaphorically speaking. To let it be known that lesbians have sex too. And that we do enjoy our genitals too. I am familiar with the question of, 'So what do you do in bed?' I still believe that we don't all have to make cunt art for our art to be considered lesbian art; especially for labelled inclusion in a society that still doesn't accept me, and has sexual stereotypes of Black women. This is one of the many things I must remember when I create work dealing with sexuality.

I hold many differences. I am Female, Black, Lesbian and Poor. I hold these in my consciousness whenever I create work, and have never been able to separate my life into compartments. My sexual oppression is not isolated from other oppressions. Sexual oppression is connected to the larger struggles of power politics. I cannot choose my race over my sex, or my sexual preference over my life. When I am seen I am one person. I want to be seen, and constructed as a whole person, not just as what I do in bed, or with my genitalia, or the colour of my skin.

In doing this work 'Body Politics' I have exposed the nature of my 'being' and the nature of my practice in order to investigate and reconstruct myself in a tangible way – historically, racially and sexually, and to speak directly to the larger discourse about the politics of difference. In these photographs, *Body Politics*, I am aiming for a wider audience, not just White lesbians. In the Black heterosexual community, lesbians who

are public have not been accepted as vibrant, contributing members of the struggle, instead we are seen as part of the problem, of bringing down the race. Part of the questioning in my work is how do we approach and educate the Black conservative community without further alienating them or being further alienated from them? We can't show them cunt art, or two women sucking on each other's tongues.

I believe that an audience relates better when it can identify with issues relating to its own life and community. In my work, I link issues relevant to me as an individual, relevant to my communities, and to the cultural ideology of art, not as a bourgeois ideology and practice, but as a contemporary inclusive social and political practice. Some consider my work very threatening. It does not embody the mythologized African version of 'Woman'. My work is my body, my beliefs and my politics. By exploring my body I am exploring racism, colonialism, sexism, and ultimately I am exploring my lesbianism.

AND FURTHERMORE, I AM.

My work is not a plea for inclusion. I've grown beyond the need to be included in a problematic system. It is an honest attempt to get to know, and accept myself.

It is said that one can not go back home.

In December 1992, I returned to Jamaica with much anxiety, because of the way I groom my hair, the fact that I am a feminist, and a lesbian. The visible differences are that my hair is dreadlocked and that I have put on some weight. My solution was to wear scarves to hide my hair. I thought the weight wouldn't be an issue. I was dead wrong. Everyone commented on my weight. I asked why everyone was making a fuss about my weight, as I thought Jamaicans loved fat people. The response to my question was that everyone was now aware that being overweight was bad for one's health. In other words, they were now Americanized, and therefore image conscious. Fat is now ugly to them. I do not think I am overweight.

Then came the hair. Some of my relatives and friends were amused, only my mother was very disturbed – I expected that. She picked at my hair until I exploded.

What I was not expecting was the level of homophobia in the society. For the first few days I was impressed with the advertisements on AIDS. But the disease was not billed as a gay disease. These advertisements were aimed solely at heterosexuals. After about a week, I realized that the ads not only did not speak to drug users or homosexuals, but the ads omitted their existence. While there was an understanding that drug users exist in that society, there was no room for homosexuals. A very popular song, by a major entertainer who received a Grammy Award in 1992 and has a wide following on the Island, contains a phrase that goes, 'bum bye bye in a batty bouy head' and advocates the killing of gays by shooting them in the head. Lesbians were also not ignored. I taped a song from a popular radio station, that recommends the 'beating of lesbians' until they accept a man. There were a few incidents that warned me that if I were to reveal my sexual preference, I would not be safe. I looked around for support. There was none. This place embodied feelings of confinement for me. I was forced back into privacy, into silence, into death.

The images presented here are a personal attempt to explore and understand the diverse arguments and practices within the social, the sexual, the cultural and the political nature of my 'difference'. Not just to one segment of society, but to the global

community we are now living in. I live in a society of privilege, yet I am not considered as a legitimate citizen. Statistically I am excluded from its privileges. I believe that to understand one's present situation, one must also understand one's past, and that to deal only in the present is to work with only half of the information. But the present cannot be taken for granted. The present is my life and what it means to me.

Today inside the confines of my 'ambiguous' location, it is assuring to know that there is a Black lesbian community, made up of women from various classes and cultural backgrounds. This knowledge allows me in my work to identify myself as a Black, Feminist, Lesbian, artist. I feel there is a bit of safety in counting myself amongst this group. I do not stand alone. There are many of us who are naming and standing up to be counted. Though where we stand and how we stand is very precarious. We stand on the outside of the mainstream White society and on the outside margin of the Black community, without the support of either. SO WHERE IS THE LESBIAN CONTENT IN MY WORK? My work is my survival, and everything in my work is me.

AND FURTHERMORE, I AM WOMAN.

9

The Realm of the Spirit

INTRODUCTION

In a nominally Christian but predominantly secular society, the predominantly secular movement that is feminism (like the left in general) has tended to regard its spiritual wing and discussion of religion and the creative spirit as a bit of an embarrassment. The major religions of the world have been unremittingly patriarchal in their organizations; 'women's creativity' has smacked too much of bourgeois dilettantism and of the traditionally ascribed place allotted for women's accomplishments; talk of the spirit is too close to new-age, apolitical lack of rigour; and while the labour movement, in Britain at least, has had links with the dissenting Church, Marx proposed a revolutionary atheism. In short, religion has either required acceptance of patriarchal structures and a patriarch, or has been too concerned with individual transcendence and evacuating any collective political action.

There is evidently, however, a need to fill the vacuum left by religion. This chapter turns to some of the responses from within feminism. While for many, organized, ideological politics or activism has been the answer, for the writers in this chapter there is still something lacking. It is certainly the case that alongside the critiques of the organized religions, feminism has accommodated a small but important movement for whom female spirituality – the goddess (or goddesses) – is the main inspiration. Much of this has found an associated visual expression, and artists have attempted to create new forms of symbolism and iconography which might be appropriate for women's spirituality.

The difficulty has been to produce such images without simply substituting a male god with a female goddess while leaving patriarchal structures intact. Monica Sjöö was making paintings of women in the act of giving birth from the early 1960s, representing it as a powerful and spiritual act. The text reprinted here (an extract from a longer article) is an account of what happened when she exhibited her painting *God Giving Birth* in St Ives, Cornwall, in 1970 and in London in 1973, when on both occasions it was deemed blasphemous by the authorities concerned, and was attacked by members of the public as well as attracting great support from some women. The text by artist Mary Beth Edelson, an open letter to critic Thomas McEvilley, is her response to a lecture on feminist art by a critic reputed to be supportive. Edelson criticizes him on a number of grounds: for perpetuating a nature/culture split which is both erroneous

and supports a patriarchal position; for being ahistorical and lacking in rigour in his research; and for grouping many diverse artists together in order to dismiss them all. As she does this, she outlines her own ethos for producing images of the goddess as a metaphor, for providing objects of identification between women and their spirituality, and for deconstructing and destabilizing the constructs which McEvilley is, despite his stated intention, perpetuating.

The thesis of Michelle Cliff's article is 'that there is a complex, essential and energized connection between the visual art of Afro-Americans, specifically but not exclusively the art of Afro-American women, and the visual art of those African nations from which the slaves, the ancestors of these artists, were taken.' Cliff builds her argument slowly and carefully, drawing in many and wide-ranging examples to demonstrate her points. Beginning with an account of the fierceness found in Afro-American women and the power invested in African women, Cliff discusses the African cultures which were not quite destroyed by slavery, but which helped people to survive that outrage, using as an example the development of the spiritual. A discussion of Yoruba religion and spiritual structures leads to a close analysis of the Second Bible Quilt of Harriet Powers, tracing the use of materials, the imagery, and the symbols used for their Yoruba influence. Her conclusion is both poignant and fierce: 'Ironically, it was because of segregation – one manifestation of racism in America – that African culture was able to survive in some form among Black Americans . . . But because of racism, some of the truly *wonderful* aspects of African philosophy will never enter the mainstream of America. That may be . . . the American tragedy.'

How women are moved to make things – their creativity as opposed to their pro-creativity – is the subject of the second section of this chapter. The extract from a collectively written editorial in an 1970 issue of *Women: A Journal of Liberation* firmly situates the ability to create and the product of that process as socially and historically determined. It argues that 'self-expression' is social expression rather than individual expression, and denies 'the old myth of the "genius" artist who, ahead of her/his time, foresees and then suggests to the rest of us the vision of a new world'. Creativity is thus proposed as possible for all only as a result of a complex and revolutionary reorganization of social production, consumption and human needs.

Hélène Cixous's essay 'Laugh of the Medusa' (here in an edited version) is a utopian and passionate exhortation to writing. Urging that women write, speak and think through their bodies, Cixous too argues that notions of the artist and of creativity are socially produced, and that women's creativity has been warped into 'antinarcissism . . . the infamous logic of antilove'. She suggests that women need to rediscover the histories their bodies contain in order to discover their languages passed down through the generations: 'There is always within her at least a little of that good mother's milk. She writes in white ink.' At the same time that Cixous holds that 'There always remains in woman that force which produces/is produced by the other – in particular, the other woman,' she also argues that 'the feminine' is so much a social construct that it is able to be accessed by men: indeed, she names James Joyce and Jean Genet as writers of the feminine. In this we can see that while she is arguing for close and specific attention to the body, it is a body in social and historical process.

The last text, bell hooks on 'Women Artists: The Creative Process', argues the need for time, solitude and lack of stress, whether from family or employment, in order to

write. At the outset she distinguishes between the lack of pressure that is leisure and reverie time, and the lack of pressure that is productive of writing – and writing is work, not leisure. It is the provision of such space, for leisure and for work, which hooks addresses in this reading. This space is taken for granted in the biographies of the male writers, and yet most women feel the need to apologise for their working space, clear it away when the family or other perceived duties call. Women's 'passionate devotion to work' is often seen as suspect, and is compromised. Into her argument, hooks weaves personal anecdotes and observations of the lives of other artists to demonstrate its political implications, including the negotiation between time for political work (both theory and practice) and making art.

Essential reading

Baring, Anne and Cashford, Jules, *The Myth of the Goddess: Evolution of an Image* (London: Viking, 1991).

Lippard, Lucy, *Overlay: Contemporary Art and the Art of Prehistory* (New York: Pantheon Books, 1983).

Lorde, Audre, 'The erotic as power', *Chrysalis*, 9 (1979): 29–31; reprinted in *Sister Outsider: Essays and Speeches* (Freedom, CA: Crossing Press, 1984), pp. 53–9.

O'Faolain, Julia and Martines, Lauro, *Not in God's Image: Women in History* (London: Maurice Temple Smith, 1973).

Orenstein, Gloria Feman, 'The reemergence of the archetype of the Great Goddess in art by contemporary women', *Heresies*, 5 (1978): 74–84; also in *Visibly Female: Feminism and Art Today – An Anthology*, ed. Hilary Robinson (London: Camden Press, 1987; New York: Universe, 1988), pp. 158–70; *Feminist Art Criticism: An Anthology*, ed. Arlene Raven, Cassandra Langer and Joanna Frueh (London: UMI Research Press; New York, Icon Editions, 1988), pp. 71–86.

Warner, Marina, *Alone of All her Sex: The Myth and the Cult of the Virgin Mary* (London: Picador, 1976).

9.1 Religion, the Spiritual, the Divine

Monica Sjöö, 'Art is a Revolutionary Act' (1980)

From *Womanspirit* (Fall equinox 1980), pp. 55–58.

[. . .] In 1968 I had a few small exhibitions in Bristol and London. Then in 1970, the first real persecution started of my work, and in particular of my painting *God Giving Birth*. Six of my pictures were shown as part of a South-west arts festival sponsored by the Arts Council of Great Britain, in St Ives, Cornwall. Within ten minutes of the paintings being hung in the Guildhall they were taken down by police and city councillors and turned face against the wall.

Supposedly, *God Giving Birth* was 'obscene and blasphemous'. I would say that because 'God' is shown as a non-white woman of great dignity, looking straight ahead unsmiling, with a child coming out of Her womb, between Her legs, it is disturbing. If it had been painted in bright colours (not in its stark black/whiteness), if it had been lesser in size (it is 6 feet tall), if 'God' had had long blonde hair and been pleasantly smiling then that would have been okay because at least She would have been of the white race and She would have been attractive to men. Also, if I had called her 'Goddess', then She could have been passed off as one of many Goddesses and/or a fertility image, not as *the* cosmic creative power I intended to express. The painting attacks the absurd myth that the creative force is male and phallic. I wanted to make clear that when people say they do not see the 'God-being' as of a specific sex, they still clearly assume it to be male, and as having created cosmos and the world not by actual bloody birth but abstractly, by 'breath' or by 'word'.

The paintings were moved by us three times and exhibited in what we thought were less public places, but each time we were told to remove them. They could not be shown anywhere within the city. I was shattered by this, and exhausted from breast feeding a three-month-old baby.

After this experience I decided that never more would I exhibit on my own. So I wrote an open letter, which was published in *Socialist Woman*, saying what had happened and suggesting that women artists with similar experiences come together to form a group or movement, and that we spell out clearly who we were and what our aims

were. As a result of this letter some women contacted me and slowly a group formed: Beverly Skinner, Anne Berg, Roslyn Smythe, Liz Moore. In 1971 we applied to the Arts Council of Great Britain for exhibition space and economic support, but were refused both. After two years (!) we finally had our first large collective exhibition in 1973 in the Swiss Cottage Library in London; we called it 'Five Women Artists: Images on Womanpower.' We received economic support for the exhibition from the liberal Camden Council. As Beverly expressed it, it was 'the first tangible manifestation for centuries of the return of women's culture.'

Probably this important exhibition would have been totally ignored by the press, the public, and the arts world, however, if it had not been for the fact that once again, my painting *God Giving Birth* caused a public scandal. Some members of the local 'Festival of Light' brigade had been to the exhibition and had called the police. The pornography squad of Scotland Yard and the public prosecutor came along to investigate whether I should be taken to court for my painting. By now all this was headlines in the London and national press, which of course brought huge crowds of people to see our exhibition. I was, in fact, never taken to court, but for a couple of weeks I feared that my paintings would be burnt, disfigured, or taken away. We had to guard them daily, and we received threatening phone calls, etc.

The visitors' book at Swiss Cottage Library is full of page after page of the most incredible comments. Many are vicious, e.g. 'When you have finished burning your bras why not burn your paintings, too'; 'These are obviously five confirmed Lesbians and very unattractive women who cannot get any man and this is why they do these ugly and aggressive paintings.' Others are very supportive, e.g. 'This is the most important exhibition I have ever seen. At last, paintings that talk to me.' We felt particularly good when elderly women, who had painted for years but hidden their work away in shame in dark attics, came up to us to say, 'This show has given me courage. I no longer feel I have to apologize for doing women's painting; now I can go right ahead.' [. . .]

Mary Beth Edelson, 'Male Grazing: An Open Letter to Thomas McEvilley' (1989)

Extract from 'Objections of a "Goddess Artist": An Open Letter to Thomas McEvilley', *New Art Examiner*, 16 (8) (April 1989), pp. 34–38.

As I have great respect for much of your writing, I was surprised to be distressed by your lecture, 'Currents and Crosscurrents in Feminist Art,' which I attended at the Artemisia Gallery in Chicago last fall. Your initial overview of the feminist movement since the early '70s was harmless enough, and those who have never heard this history were no doubt enlightened; however, the second half of your nearly two-hour talk offered an interpretation of events that I dare say anyone who has been directly involved with the movement over the years would have found disturbing, if not manipulative.

In the course of the second half, using the construct of 'nature/culture,' you presented feminist work as a hierarchical progression from nature to culture, setting one against the other. You presented what you called 'Goddess Art' of the '70s as nature, and deconstructionist art of the '80s as culture. Holding out these two groups as the 'two great movements' in feminist art, you squeezed various artists into this construct whether they fit or not. As examples of culture, you cited feminist artists working with deconstruction (Barbara Kruger, Jenny Holzer, etc.); exemplifying nature were the women body artists of the '70s (Carolee Schneemann, Mary Beth Edelson, etc., with Ana Mendieta conspicuously omitted).

In defining the 'nature' group, you offered sweeping generalizations, claiming, for example, that virtually all body artists were 'Goddess Artists.'[1] There were, in reality, body artists who used their own bodies but did not use the image of Goddess or refer to Her (Americans Linda Benglis, Joan Jonas, Rita Myers, and Francesca Woodman; Europeans Rebecca Horn, Gina Pane, etc.). There were body artists who used the image of Goddess on occasion, as one might use any other image (Hannah Wilke). There were body artists whose sensibility was established in '60s performance art, whose primary interest in 'Goddess' was to expand perceptions about sexuality (Carolee Schneemann). There were body artists who were primarily interested in the political and spiritual implications of Goddess, ritual, and process (Edelson).

There were 'Goddess Artists' who met together and shared an evolving theory and practice, such as the people in the collective that edited the 'Great Goddess' issue of *Heresies* magazine. Also, there were small, ongoing, study and practice groups that networked with other feminists, both within and outside the art world – writers, activists, theologians, academics, etc. In addition, there were non-body artists who used the image of Goddess frequently, but were not written about as 'Goddess Artists' or considered as such by themselves or anyone else (Nancy Spero). In short, there are distinctions to be made between these artists, and lumping them together for your own convenience won't do.

I am aware that you could argue that I am the only artist who fits some of the issues I am presenting, but that is part of my point – these artists cannot and should not be placed in a polarized group; doing so does them a disservice. It is by now a cliché to view members of groups considered to be 'other' – women, blacks, Jews, gays, etc. – as emblematic of those groups, blurring their individual differences, holding them accountable for acts done by someone else as if they had control over them, and yet, in your summation you presented nature-related artists in this manner, as if they were interchangeable and accountable for each other. In lumping together nature-related artists and then making generalizations about them, you treated these women as reciprocal identities, alternatives that can be substituted one for the other rather than what they are – specific artists who can be no other.

This is the syndrome that Bram Dijkstra refers to in his book, *Idols of Perversity: Fantasies of Feminine Evil in Fin-de-siècle Culture*: 'where women are seen as undifferentiated beings . . . not sharply marked off from others' existences' and as 'virtual mirror images of each other.' I am not suggesting that you are the only person who has ever presented overly generalized statements about women in the art world, only that it is time to stop this practice.

These generalizations become especially ridiculous when, because of your unabashed assumptions of heterosexuality, you accuse body artists of presenting their work for 'the delectation of the male gaze' and 'as objects of man's affection.'

You also presented your nature and culture groupings as if they were locked in some ongoing war. I would be curious to learn where you did your research for your unfounded declaration, 'these artists really do not like each other,' which you repeated three times in your lecture. Furthermore, why is this kind of observation relevant and what purpose does it serve? It provides an unsupported negative stereotype of women fighting with each other, which puts you, as a man lecturing on feminism, in a suspect position.

This construct also advances the idea that women artists working with nature have accepted their bodies and intuition at the expense of their cognitive minds, and that deconstructionist artists have accepted their intellects at the expense of their sensual bodies.

I do not accept the argument that women should distance themselves from what has been judged to be a gender cliché because the cliché might be held against them. I would rather work toward changing consciousness by opening up the availability of these iden-tifications to all genders – in other words, to 'de-genderize' them. This parallels my belief that access to the shamanic – that is, the ability to have insights that may promote healing, spiritual ecstasy, and transformation – is not restricted to Third World, indigen-ous people, and women, but is available to all people who are willing to be receptive to these realms by putting themselves at risk of being in contact with more of their whole being.

You go on to develop your argument against women working with nature by saying, 'Precisely as in the old, male patriarchal ideology, she is associated with nature rather than culture . . . unconscious rather than conscious . . . intuition rather than reason . . . magic rather than science, which is exactly as it was in the old, patriarchal ideol-ogy, the difference is it is being presented by women with a very strong positive value system projected on it.'

Even as you presented it, that was not such a little thing in the early '70s. Here again, however, you present a polarized analysis with emphasis on dislocation and on splitting, rather than viewing the whole spectrum and the true implications of this work – let alone that our purposes were totally different from patriarchal purposes.

Aside from this, it was not the patriarchy that originally linked women with nature; that was in place in prehistoric times, long before there was a patriarchy.[2] What patriarchy did for us was to place a negative, divisive, and de-valued reading on this association. The nature/culture construct is itself problematic because it encourages polarization as well as a cunt-is-to-intellect-what-nature-is-to-culture analysis. This construct is also unstable and prone to contradiction. This model (nature/culture),

demonstrates the insidious manner in which men's control over women is built into a notion of culture's control over nature, reason over emotion, and so on. They hold in common the idea of a relationship between nature and culture that is not static, but always involves tension of a kind. There is more than the notion of nature and culture as the halves of a whole (dichotomy). It may also be imagined as a continuum – things can be 'more or less natural,' there are 'lower' and 'higher' degrees of what

is cultural (civilization). We may think of a process. Nature can become culture – a wild environment is tamed; a child is socialized; the individual as a natural entity learns rules. And we may think of hierarchy. This can take an evaluative form – as in the claim that culture is everywhere seen as superior to nature; or it can be a matter of logic – thus nature, the higher order category, includes culture, as the general includes the particular.[3]

Even though I was personally associated with Goddess more than any other single artist in the '70s, even in my work there has been a synthesis between such elements as nature, spirituality, participation, theorization, deconstruction, and cultural and political commentary. Furthermore, ironically, we who you call 'nature' were called *cultural* feminists in the late '70s.

The fact that the patriarchy profits from the nature/culture construct – because the dichotomy works to keep in place treatment of the sexes as they have been historically polarized with a reimposition of rigid notions of male and female – adds to my concern. Presenting Goddess-body art (nature–female) as the lower level in a progression to deconstruction (culture–male), mirrors patriarchal hierarchical structures of inferiority (female) and superiority (male) – this was precisely your own conclusion.

If I were a man – especially a man active in the ecology movement, for example – I would be angered that my gender was made to seem inauthentic in relation to its identity with nature. By extension, men who are inspired by nature are placed in a position of feeling surreptitious about their inspiration, which would then lead to feeling that they have a hidden and deceitful connection with nature, rather than a natural, original, or honest one. Why should men be put in this situation when in reality they have as much access to nature and their own natures as women do? With what alternative does this leave men? To deny those who are deemed to be *more* authentic, i.e. women and Third World people? To get rid of them? To appropriate from them, to gain their authenticity?

In addition to my objections to the nature/culture construct and your treatment of these artists as interchangeable and divided, I will now address the other points that disturbed me about your lecture. In doing so, I do not intend to speak for all feminists who were creating body art or 'Goddess Art' in the '70s, for we were each unique individual artists with different purposes. *I will speak only for myself.*

Regarding my own work, I object to some of the ways that you (mis)interpreted it; in particular, your reference to 'a nakedness which is aimed toward . . . the male gaze . . .'; your insistence that this work 'does not overthrow the male stereotypes, but reinforces them, but only with a more positive value projection . . .'; and your assertion that the 'Goddess-related feminist artists of the '70s had unintentionally been complicit with the male conspiracy . . .'. In addition, I hope to clear up some factual errors contained within your remarks.

In the '70s I presented a powerful, autonomous female who created and performed her own rituals, overthrowing contemporary stereotypes right and left – especially that women in Western culture cannot or do not take their spiritual destiny into their own hands. For example, the private ritual *Goddess Head*, like earlier private rituals in which I used my own body as a stand-in for a primary sacred being (Goddess), broke the stereotype in our culture that women do not have direct gender identity with the sacred.

The Catholic Church's argument, for instance, for not allowing women to be priests rests on the idea that, because Christ was a man, priests should also be men, so that people can relate to their priests as literal stand-ins for Christ.

In using my own body as a sacred being, I broke the stereotype that the male gender is the only gender that can identify in a firsthand way with the body and, by extension, the mind and spirit of a primary sacred being. Furthermore, these ritual images were connected directly to Goddess as an expanded image of woman as a *universal being* and not limited to the stereotype of woman as '*other*.'

The process I used to define spirituality in feminine terms was activated by and through creative ritual as direct access to metaphysical experience. My rituals also provided resistance to the mind/body split, by acknowledging sexuality in spirituality, thus reconciling the experience of a united spirit, body, and mind. These rituals symbolized the stories of our lives, our history, our transitions, our needs, and the healing of our wounds, in psychological, political, and cultural terms. This does not fulfill any male stereotype about women that I have ever heard of, but instead overthrows and revolutionizes powerful, heretofore unspoken, stereotypical assumptions that women do not originate their own spiritual processes, let alone create a new form for these processes, applicable to their own lives.

As I stated at a lecture at the University of Illinois at Chicago in the fall of 1988, 'Goddess was always a metaphor for me for radical change and change of consciousness – and for removing acceptable social codes from daily experience while opening other realms of experience. This spirituality invaded an area which in Western culture was previously a male territory, and, therefore, this action was, in and of itself, a profoundly political act against the patriarchy and for spiritual liberation – the ramifications of which are still unfolding.'

[. . .]

I will not argue the nature/culture construct as you presented it, in relationship to my own work, because I don't accept this dichotomous construct to begin with. I am interested in deconstructing it. It has been a destructive, manipulative dichotomy for both nature and culture, and, as Levi-Strauss suggested in his later work, the nature–culture contrast is an artificial creation of culture. Because I believe that the construct is false I can hardly begin to say how my work does not fit into it except to say that I have never held with the impossible idea of choosing between my body and my mind – I use and like them both. Like most dichotomies, nature/culture presents the situation in polarized, wooden opposition rather than seeing a continuum – a process and a relationship between. It is *your* argument that has the underlying agenda to 'unintentionally work to keep the male conspiracy in place,' for this dichotomy carries with it the baggage of privilege and subjugation and divide and conquer. It is the old grumpy patriarchal way of analysis to divide in two and then proceed to make a judgment about which of the two is superior. Postmodern thought is no longer binary thought as Lyotard observes when he writes, 'Thinking by means of oppositions does not correspond to the liveliest modes of postmodern knowledge [*le savoir postmoderne*]'.)[4] This is like asking, 'Which is better, black or white?' without consideration for the complexity of grays or that the choosing and the question itself are inappropriate.

For me, the irony of having to defend this work is that, in my own slide lecture, only two slides out of a whole tray are connected to these earlier works, and the positive metaphor of the Goddess (my use of Her was not meant to be taken literally).

My work is not freeze-framed in the '70s, as your presentation implied. Since the early '70s my work has moved on to include conceptually grounded installations, photo-based work, performances, artist's books, video, drawings and on-site wall paintings.

You did not attempt to analyze why the work by these artists has been unassimilated into mainstream nor to look at how it de-stabilizes pre-existing representations of masculine desire and privilege in relationship to the female body. Your thinking has shrunk this full and far-reaching complex work by feminist artists to a reductive set of polarizations, viewed not from the outlook of a participant, or even that of a thoughtful observer, but from an old-fashioned, patriarchal perspective.

Notes

1 You did not define what you meant by 'Goddess,' understandably; I am having difficulty with an adequate interpretation myself, for neither dogma nor reductionist analysis is fitting. I would like to offer the following groping, personal interpretation. She is, for me, an internalized, sacred metaphor for an expanded and generous understanding of wisdom, power, and the eternal universe. She is also alive and evolving in contemporary psyches as well as being an ancient, primal, creative force in both women and men that embodies the unity of mind–body–spirit, and a wholeness that includes our dark and light sides. Her essential being is one of a dynamic, non-hierarchical network of cooperative relationships that include nature and human liberation.

2 For further reading on this subject see: Erich Neumann, *The Great Mother* (Princeton, NJ: Princeton University Press, 1955); Robert Graves, *The White Goddess* (New York: Farrar, Straus and Giroux, 1948); Merlin Stone, *When God was a Woman* (New York: Dial Press, 1976); Marija Gimbutus, *The Goddesses and Gods of Old Europe* (Berkeley, CA: University of California Press, 1982); and Joseph Campbell, *The Masks of God: Primitive Mythology* (New York: Viking Press, 1959).

3 Marilyn Strathern, 'No nature, no culture: the Hagen case', in *Nature, Culture and Gender*, ed. Carol MacCormack and Marilyn Strathern (Cambridge: Cambridge University Press, 1980), p. 180.

4 As cited in Craig Owens, 'The discourse of others: feminists and postmodernism', in *The Anti-aesthetic: Essays on Postmodern Culture*, ed. Hal Foster (Port Townsend: Bay Press, 1983), p. 62.

Michelle Cliff, '"I Found God in Myself and I Loved Her / I Loved Her Fiercely": More Thoughts on the Work of Black Women Artists' (1996)

From *Journal of Feminist Studies in Religion*, 2 (1) (1996), pp. 7–39.

The title of this essay comes from Ntozake Shange's choreopoem, *for colored girls who have considered suicide/ when the rainbow is enuf*. The statement, spoken at the end of the play by the women whose stories we have just heard, is startling. In the context of white western culture and politics, it could be little else. Yet it is a statement, one of

profound discovery and belief, which rises naturally from the primary source of Afro-American culture and tradition. The statement and what the words represent are intrinsic to the body of African philosophy that Afro-American people have inherited, whether mixed with western philosophy and religion or not, whether they are conscious of their heritage or not. So much has been done in the dominant culture to erode Black people's connection to Africa and to cover over the real complexity of African culture. Afro-Americans have been encouraged to forget about Africa and to consider themselves 'Americans' alone, although this identity has never been truly acknowledged and has not been offered freely, or wholeheartedly.

Shange's statement is a very African statement, an affirmation of the divinity of Black women, of all life. That is why I have chosen it as the title of this essay. The Black ethnomusicologist Irene V. Jackson, in her essay 'Black Women and Music: A Survey from Africa to the New World,' speaks in another way to Shange's meaning, to the African connection of her words:

> To begin, it must be recognized that womanhood is power: as bringer of life, woman is highly valued for her natural bond with the life force. Whatever a woman does, what she is and what she is valued for, becomes projected into some kind of image or symbol. Homage is paid to Queen Oya among the Yoruba as the spirit of the River Niger. Oya is the faithful wife of Shango, who becomes the River Niger on Shango's death. Oya is water, a symbol of fertility. Yemaya, goddess of rivers and springs, is the sea itself; she is the orisha of fertility. In Africa, Yemaya is mother of all orisha, the Prime Mother of all things; her colors are blue and white like the waves of the sea.[1]

(Immediately I think of the Virgin Mother – whose colors are also blue and white – who is called 'star of the sea' – who in turn is linked to Aphrodite and Venus.)

Jackson connects this African concept to the experience of Afro-Americans:

> The same regard for woman's power existed even within the institution of slavery in the New World, which tended to develop a community where leaders were regarded as such because of their physical strength, wisdom, and mystical power. On a Georgia plantation, a female slave, Sinda, prophesied the end of the world, and for a while no threat or punishment could get the slaves back to work. In another instance, a Louisiana planter noted angrily that Big Lucy, a slave, was the leader who corrupted [his word] every young Black in her power.[2]

In their essay, 'Black Women and Survival: A Maroon Case,' anthropologists Kenneth Bilby and Filomena Chioma Steady recount the history of Grandy Nanny, female leader of the revolutionary group in Jamaica known as the Windward Maroons. They stress particularly the supernatural aspect of Nanny's power in leadership.

> In the various Maroon legends recounting Nanny's great deeds of the past, there is one dominant theme: the supernatural . . . Her great mystical power was derived from her close contact with and intimate knowledge of the spirit world, the realm of departed ancestors. In this role, as mediator between the living and the dead, Nanny symbolizes the continuity of Maroon society through time and space.

. . . Maroon storytellers overwhelmingly attribute the great historical victories of the Maroons to Grandy Nanny's phenomenal supernatural powers. The tales they recite underscore the importance of Nanny, and by . . . extension, the female contribution, to the survival of the Maroons.

. . . There is no doubt that an important personage named Nanny really existed. It is believed that her ethnic background was Akan and that she was born in Africa. There are references to her in the contemporary British literature as a powerful obeah-woman . . . There is no doubt that she wielded great authority, military and otherwise.

. . . Although Nanny was clearly an exceptional woman, there are indications that she was not the only woman of influence among the Maroons . . . Other powerful women are remembered in oral tradition, such as Mama Juba, like Nanny a great 'Science-woman' – as Maroons refer to those well-versed in the supernatural arts.[3]

There is an organic connection between African and Afro-American and Afro-Caribbean ideas and peoples. Lorraine Hansberry named this connection in one way when she spoke of 'the beauty of things African, the beauty of things Black.'[4] One manifestation of this connection and this beauty is evident in the work of Afro-American artists – and the shared belief that to create anything – craft or art – is a sacred act, a manifestation of the divine within and around us, evidence of what the Yoruba call *àshe*, the power-to-make-things-happen. One other thing which we can learn from Nanny's artful defense of her people's freedom, is that if art or craft is endowed with the power-to-make-things-happen then they become also political weapons.

The work of Betye Saar is drenched in memory and past – in 'the realm of departed ancestors'; it seems that she takes her strength from them, and from the parts of her which respond to them. She uses actual artifacts from the lives of her ancestors, and symbols which have an African content, and African origin. Her art is charged with this power, a result of what she has called her 'cumulative consciousness':

That's part of my accumulative memory from way back to the beginning of time. It includes all the things that have touched my existence even before my birth. Another small part has to do with the nostalgic past – that which exists in my lifetime. The nostalgic time is within my mother's lifetime and my aunt's lifetime. It has to do with personal fragments of things from the lives that are connected to my life now. The next phase of my work has to do with vision, dreams, insight. Future.[5]

We are, in American culture, so removed from any but the materialist world it may be difficult to understand an approach which takes magic, the connection of beings across generations and the mystery inherent in all creation and creative acts as a given, and something to be pursued, not denied.

Stories detail Nanny's confrontations with *bakra* [whites], once again emphasizing her supernatural cunning. It is said that Nanny kept a magic cauldron along the approach to the Maroon village. The huge vessel, whose contents boiled continuously without need of a fire underneath, attracted *bakra* and other unwelcome outsiders to the edge

for a curious look. No sooner would the unfortunate victim glance down than he would be pulled into the seething mess to disappear forever.[6]

We live amid white, western, Christian culture, in which the lives of Afro-American people – the work of Afro-American artists – are viewed through the scrim of white American racism, which has affected, touched, damaged *all* of us. Because of this, which filters our vision and dulls our sensitivity, the words, the song of Ntozake Shange's women, and its implications startle us. We should ask what it is about the statement that is most startling – or most thrilling. There are those of us dwelling at the edges of the dominant culture who are thrilled and excited by and believe in the statement, the discovery it describes, and its possibilities – coming from a place in us we may never have known existed.

When I first found Nanny, in an article by the Jamaican historian Orlando Patterson, I was doing research for my novel *Abeng*. Immediately she came alive in my mind. I could see her clearly as Patterson described her – an old Black woman wearing a necklace fashioned from the teeth of white men. More important, perhaps, was that once I re-membered Nanny the other female characters in my book began to emerge, and I could see how we were all her daughters, and were connected to her. My cumulative consciousness was triggered. I thought of customs we practiced, as though automatically; beliefs we held, knowing only that they had been passed down; the enormous respect I had been taught as a Jamaican child for certain old women – those considered empowered as my grandmother was empowered, that is, those close to God.

Is our reaction to Shange's words to be found in the idea that God exists within the being of a Black woman? Is that a new discovery? When speaking of the United States, I am not sure, since at least one image of Black women in white America is an image of long-suffering, saintlike, Christian martyrs sacrificed to a white Christian god. According to the white world view this is the role of some Black women – the Mammy, the Nanny (but not Grandy Nanny), the Auntie. The parameters of this role can support the judgment – whether conscious or unconscious – on the part of white people that racism in all its practical applications is but a way to assist Black women on their fore-ordained Christian journey. This sort of belief makes racism something over which no one has control, or should have control – it becomes the will of God. This image of sufferer/servant (and I stress that it is an image – as in imagination) is based on the enforced powerlessness of most Black women. It in fact reinforces that powerlessness – most simply, by saying that life in the hereafter will be better than life in the here-and-now. Mammy, Nanny, and Auntie are to be convinced of this; this will keep them in their places. This will remove them further from the knowledge that in Africa and in the slave communities of the New World, it was women such as they who held and wielded enormous political and social power.

While this white image undeniably has affected some Black women's lives, it has also been used to defuse the political effect and power of other Black women who followed a different model. Rosa Parks was imaged in the white mind as the first sort of Black woman, when she was in fact the second. She was seen as a soft-spoken older woman, a bespectacled seamstress, an unlikely troublemaker. That is why so many persist in their conclusion that her refusal to move from her seat on that bus in Montgomery was

a peculiar, idiosyncratic act brought on after a long day's work, rather than the calculated act, which it was, of a conscious revolutionary, which Mrs Parks was, a culmination of a life spent in opposition to oppression. General Moses, Harriet Tubman, has been treated similarly, as a fey, lonesome, ignorant woman, a Black St Joan – and like St Joan considered a freak of nature. If ever there was a Black woman who embodied the three qualities cited by Irene V. Jackson for a leader of the slave community – physical strength, wisdom, mystical power – she was Harriet Tubman.[7]

There is another important distinction that needs to be made here. While whites may view Mammy, Nanny, and Auntie as children of God, the central racist belief that Black people are, at worst, less human than white people, at best, less grown-up, goes unchallenged. Some Black people – the ones judged quiet, nontroublesome – are considered better *children* of God than others. Ntozake Shange is not talking about this sort of identification with God. Rosa Parks was seen as an essentially obedient, albeit exhausted, daughter of God the Father, when in fact she was an angry and defiant daughter of Yemaya; as was General Moses; as was Grandy Nanny.

I return again to Shange's statement: do her words startle or thrill because a Black woman recognizes herself as divine, claims God lives in her self, rather than observing the divine as something 'out there' which will grant favors or prayers or redemption according to its own will, as the result of righteous (by whose definition?) behavior or passive acceptance of one's fate? If a Black woman is able to recognize God in herself, by herself, and is able to love this God, then she can love herself also. She will love herself, believe in her worth, hold on to her dignity, no matter how many forces on the outside are causing her to consider suicide – the death of the body, but also the death of her self, her spirit, her voice. It is this thrilling discovery of worth, found through love, that transforms the person of Celie in Alice Walker's novel, *The Color Purple*.

Celie reports what Shug Avery, her lover, has told her about God:

Ain't no way to read the bible and not think God white, she say . . . When I found out I thought God was white, and a man, I lost interest.

Here's the thing, say Shug. The thing I believe. God is inside you and inside everybody else. You come into the world with God. But only them that search for it inside find it . . .

Man corrupt everything, say Shug. He on your box of grits, in your head, and all over the radio. He try to make you think he everywhere. Soon as you think he everywhere, you think he God. But he ain't. Whenever you try to pray, and man plop himself on the other end of it, tell him to git lost, say Shug. Conjure up flowers, wind, water, a big rock.[8]

It is the absence of this discovery, this belief in God – in herself – that destroys the child Pecola Breedlove in Toni Morrison's heartbreaking novel *The Bluest Eye*.

I would say that two of Shange's words thrill and startle more than the others: *her* and *fiercely*. The *her* – God as *her* – thrills and startles because we live in a culture which teaches above all that God is masculine. It follows, obviously, that to be female is to be one step removed from divinity. It has been and is as Shug Avery says. God is male. He is white. A white man. The most powerful white man. Monotheism is supposedly

a civilized concept, superior to the pantheon of gods preferred by other peoples, some of our ancestors. But monotheism has been used also to establish one type as holier than others, the type who obtains his identity from this concept of God. Now that white men in power have the ability to destroy the world, whether through a big bang or through pollution and neglect, their impersonation of their god has become all the more believable. This is their perversion: reversing the power-to-make-things-happen and turning it into the power-to-destroy-and-shatter-worlds.

If a Black woman finds God in herself, then does it follow that God can be Black, Black and female? What does Shange's *her* mean? Solely that God is reified as Black and female? A god without and not a god within? A simple revision of Michelangelo's ceiling? Or more complexly, more Africanly, as Shug tells Celie, that that which is God, which is life, which becomes self-love, exists in everyone. We can find and kindle this spark by considering ourselves part of life, part of the world, like a rock, tree, wind, water, the color purple. Each possesses a mystery. Once we realize this God-within-us we can possess the power-to-make-things-happen, the *àshe* of the Yoruba.

Now the word *fiercely*. A wonderful word. It denotes power. Power and protection. A sense of don't-mess-with-me. A word which characterizes Lorraine Hansberry's tone in this statement, made during the Civil Rights Movement: 'The whole idea of debating whether or not Negroes should defend themselves is an insult. If anybody comes and does ill in your home or community, obviously you try your best to kill him.'[9]

Because of my own conditioning, the first image which comes to my mind with the word *fiercely* is a lioness guarding her pride and killing to feed her cubs. Then I see a human mother protecting her children. These two images are instructive because in this white, western, Christian world (it is annoying to have to repeat this description, these qualifiers, but important to remind ourselves where we are) *fierceness* is not a quality allowed females, unless they are fulfilling their roles as mothers. It is not recommended that a woman be fierce on her own account, or that she make a judgment that her wrath is warranted against an enemy. Are women allowed to have enemies? Are Black women allowed to have enemies? The conditions under which a woman is allowed to be fierce are severely circumscribed. She is counseled not to fight a rapist, for example. Rather, she should attempt to make herself invisible in order to avoid a circumstance in which rape becomes possible.

The mother in this culture is the *real* woman still. And only the mother who is willing to devote herself to her cubs is the real mother. This applies to white women. Under racism, only the Black woman who is willing to feed, love, and protect white babies better than she does her own babies is worthy to be called Mammy, Nanny, Auntie. When Sofia, a character of true and wonderful *fierceness* in *The Color Purple*, refuses to take a little white baby boy into her heart, the mother of the child is stricken.

Sofia, he just a baby. Not even a year old. He only been here five or six times.

I feel like he been here forever, say Sofia. I just don't understand, say Miss Eleanor Jane. All the other colored women I know love children. The way you feel is something unnatural.

I love children, say Sofia. But all the colored women that say they love yours is lying. They don't love Reynolds Stanley any more than I do. But if you so badly raised as

to ast 'em, what you expect them to say? Some colored people so scared of whitefolks they claim to love the cotton gin . . . I got my own troubles, say Sofia, and when Reynolds Stanley grow up, he's gon be one of them.[10]

If ever one doubted the valuelessness of the lives of Black children in the mind of the dominant culture, the official response to the murders in Atlanta in 1980–81 should banish any doubt. It was not until Black mothers joined together and brought pressure on the city that any real investigation commenced. These women formed the organization STOP, and they were harassed by the United States government, accused of mishandling funds. Reading the newspapers, one got the distinct impression that these women, in their outrage, had stepped out of line and were being punished. Their fierceness on behalf of their children, and other Black children placed in jeopardy by violence and apathy, was seen as dangerous, out of place. Reading the newspapers at that time, I also found the following:

> Atlanta – A series of at least 38 unsolved killings of Atlanta-area females – most of them black and in their teens and 20s – has taken place since late 1978 and has gone almost unnoticed because of the attention focused on Atlanta's case of 28 murdered young blacks, 26 of whom were males.[11]

In the first place it is highly unlikely that these murders of young women, mostly Black, would have attracted any attention had not the mothers of STOP brought attention to the other sequence of murders; in the second place, the murders of twenty-eight Black children would not have been noticed had it not been for the Black mothers of STOP; in the last place, children, Black children, male and female, are still being murdered in America.

If Black women in the United States are not fierce on behalf of their children, no one else will be. And yet in Africa, *fierceness* is a quality celebrated as a female strength.

In his recent book *Flash of the Spirit*, art historian Robert Farris Thompson tracks the survival of African art and philosophy throughout the New World. With regard to the *fierceness* of women, the following three African deities are particularly interesting.

Nana Bukúu

Nana Bukúu is the mother of Obaluaiye, and such is her importance in Dahomey that there she has come to be considered the grand ancestress of all the Yoruba-derived . . . deities of the pantheon of the Fon . . . It is believed that none other than the kings of Asante and Dagomba sent gifts to her shrines in time of war. These kings sought her blessing because of her fabled powers to bring a city victory, to render in ruins the cities of one's enemies. She herself was a superlative warrior, utterly fearless, who razed the mythic city of Tejuade.[12]

In the slave quarters there were women who remembered Nana Bukúu – for she lived in their nostalgic past, in Betye Saar's phrase. To deny her presence or influence would be absurd.

Yemoja (Yemayá)

Yoruba riverain goddesses are represented by round fans (*abebe*), crowns (*ade*) . . . and

earthenware vessels (*awota*) filled with water . . . Those who worship these powerful, underwater women long ago devised an artistic strategy, the use of the round fan as an emblem embodying the coolness and command of these spirits of the water.

Imperially presiding in the palaces beneath the sands at the bottom of the river, the riverain goddesses are peculiarly close to Earth. In the positive breeze of their fans, the ripple of their water, there is coolness. In the darkness of their depths and in the flashing of their swords, there is witchcraft. And within the shell-strewn floor of their underwater province there is bounteous wealth. Yoruba riverain goddesses are therefore not only the arbiters of the happiness of their people but militant witches.[13]

If I allow my imagination to fly a bit, as I read about the round fans of the adherents of the riverain goddesses, I immediately picture the inside of a small Black church and see the older Black women who make up the majority of the congregations in these churches. These women carry several items with them on Sunday morning. A Bible. A purse. A starched or cotton handkerchief. And a fan. In Jamaica these fans were usually woven of raffia or straw, rounded, with a handle, made by women, sometimes by the women who carried them. Colored strands usually wound through the pale raffia or straw, making the shapes of fruit or a map of their island. In America I remember being in a church where the fans had been donated by the wealthiest woman in the congregation; they were made of heavy paper, light brown cardboard, and advertised her main business concern, a funeral parlor. The women in the congregation had stopped carrying their own fans and depended on her generosity. But these mass-produced fans were also rounded and all the women used them during the service. 'The positive breeze of their fans' – that calm stroke, accompanied by a slow nod of her head, as the preacher read the lesson.

'The arbiters of the happiness of their people but militant witches' as well. The woman who donated the fans was a civil rights activist – an older woman who sent her money South in the sixties and took herself to Washington DC. Like the women who boycotted the buses of Montgomery. Who organized STOP. Who led the Combahee River Raid. Sent money to John Brown. 'The flashing of their swords' is something too easily forgotten.

Oshun
she is sometimes seen brandishing a lethal sword, ready to burn and destroy immoral persons who incur her wrath, qualities vividly contrasting with her sweetness, love, and calm.

(What follows is an African hymn to Oshun)

> She greets the most important word within the water
> She is the orisha you see healing by means of water that is cool
> Iworo bird with brilliant plume upon her head
> Titled woman who heals the children . . .
> Witness of a person's ecstasy renewed
> She says: bad head – become good!
> Mistress of *àshe*, full of predictive power,

She greets the most important matter in the water.
Strong woman who burns a person.
She cures without fee; gives honey to children
Has lots of money, speaks sweetly to the multitude.
Nowhere is the kingly power of Oshun not renowned
Oshun has a mortar made of brass
Sweet is the touch of an infant's hand

. . .

She dances, she takes the crown . . .
The chiming bracelets of her dance.
She smites the belly of the liar with her bell.
Mother, O Mother of cool water,
You, who sired the soothing osun herb.[14]

These are Gods to love fiercely. Shange's statement conveys a Black woman loving God, a Blackwoman-loving God, a Black woman-loving God – a Black woman loving herself fiercely – fiercely on her own account, finding herself worthy and divine.

II

The thesis of this essay is that there is a complex, essential and energized connection between the visual art of Afro–Americans, specifically but not exclusively the art of Afro–American women, and the visual art of those African nations from which the slaves, the ancestors of these artists, were taken. This connection is part of a larger connection, which includes philosophy, language, music, theology. Unless the cultural relationship between African and Afro–American artists is understood, one cannot fully appreciate the tradition of Afro–American artists, nor the meaning, or levels of meaning, of particular Afro–American works of art. The relationship between the art created by Afro–American women and the art of Africa is manifest in specific aspects of the work: the images created, the symbolic meaning of these images, materials used, form, color, standards of beauty, three-dimensionality, usefulness. The relationship is also manifest in larger questions and responses: the idea of art, the purpose of art, what constitutes a work of art, why art is made, art as an expression of certain theological principles, certain philosophical principles. What precedes and follows is an exploration of this connection, touching on a few of these links.

Any examination of the culture of Afro–Americans must begin at the point of origin – with groups such as the Yoruba, the Kongo, the Fon, the Ewe, the Mande, the Ejagham. When the slave traders descended on the west coast of Africa in the sixteenth century and thereafter (the Atlantic slave trade lasted from about 1550 to 1850), they were met by inhabitants of urbanized, advanced, and sophisticated civilizations. Of all the nation/groups listed above, only the Ejagham were or could be considered a rural people, and they had organized towns as well as rural settlements. All the other nation/groups were highly and complexly urbanized, and had been urbanized since what Europeans call the Dark Ages. In his essay 'The Atlantic Slave Trade,' the Black Marxist philosopher C. L. R. James quotes the following from Claude Lévi-Strauss:

The contribution of Africa is more complex, but also more obscure, for it is only at a recent period that we have begun to suspect the importance of its role as a cultural melting pot of the ancient world: a place where all influences have merged to take new forms or to remain in reserve, but always transformed into new shapes. The Egyptian civilization, of which one knows the importance for humanity, is intelligible only as a common product of Asia and Africa and the great political systems of ancient Africa; its juridical creations, its philosophical doctrines for a long time hidden from the West, its plastic arts and its music which explored methodically all possibilities offered by each means of expression are equally indications of an extraordinarily fertile past.[15]

This was pre-European Africa, what C. L. R. James called 'a territory of peace and happy civilisation.'[16] I stress this fact about Africa because even though it is not a new discovery, the reverse racist image with which we are all familiar persists – that is, that the slaves came from a place which was wild and primitive, and that they themselves knew little better than to submit to slavery by white men. This includes the white assumption that Africans would respond only to backbreaking labor, and when they slacked off, to physical punishment of another sort – whether whipping, rape, branding, or mutilation. That image of Africa and Africans simply was a lie. But this lie was necessary to underwrite another lie; that slavery was justifiable, and that the slavery of Black Africans was not the crime against humanity that enslaving white Europeans would have been.

This false image of Black Africans as uncivilized is related to another historical lie, part of a complex network of distortion and amnesia; that is, that once in the New World, forcibly separated from their families and mixed with other linguistic and cultural groups, the Africans lost whatever civilization they had and reverted to primitivism and simplicity. There was a loss, of course, but it was by no means total – perhaps *change* or *transformation* would be better words than *loss* for what happened to the Africans. C. L. R. James has written:

> Who were the slaves? They came for the most part from West Africa, these slaves who had been stolen and taken from their homes and brought virtually nothing with them, except themselves. The slaves not only could not bring material objects with them, they could not easily bring over their older social institutions, their languages and cultures. Coming from a large area of West Africa in which dozens upon dozens of distinct peoples lived, with their own languages, social relations, cultures, and religions, these Africans were jumbled together on board the slave ships, 'seasoned' by the middle passage and then seasoned again in their first years in the New World.
> . . . The slave brought himself; he brought with him the content of his mind, his memory. He thought in the logic and the language of his people. He recognized as socially significant that which he had been taught to see and comprehend; he gestured and laughed, cried, and held his facial muscles in ways that had been taught him from childhood. He valued that which his previous life had taught him to value; he feared that which he had feared in Africa; his very motions were those of his people and he passed all of this on to his children. . . . All Africans were slaves, slaves were supposed to act in a specific way. But what was this way? There was no model to follow, only one to build.[17]

The Africans who came to the New World were from nations of advanced peoples, and their civilizations – the cultural and ethical standards they represented, the values they embraced – were not things which slid over the side during the Middle Passage, nor did the content of their minds and memories disappear in the barracoons, nor in the seasoning stations, on the auction block, in the quarters. As James points out, it was not easy to hold on to one's language, older social customs, culture. Something was lost, but aspects of other African nations were added, and individual talents and experiences were remembered.

Picture if you will, not the enchained and naked bodies of men and women locked in a forced march, a common, and true image of Africans in slavery in America, but rather try to imagine millions of individuals – both words deserve equivalent stress: millions and individuals. There *were* millions: estimates range from the conservative figure of fifteen million slaves landing in the New World to fifty million.[18] Numbers are not known for those who died en route – from illness and overcrowding, suicide, or as the casualties of the many slave-led revolts on shipboard – nor for those who were born into slavery in the New World. Imagine millions of individuals who were singers, traders, artists, agricultural workers, soldiers, diplomats, historians, inventors, cartographers, bankers, sculptors, dancers, educators, textile designers, potters, ceramicists, ironwork artists, blacksmiths, ceremonial drummers, composers, midwives, physicians, astronomers, architects. Imagine these people, the true wealth of their minds and memories, and you will have a more accurate idea of what the system of enslavement entailed. Think of the wealth these individuals brought with them, and you will have a sense of how America was constructed. Think also of the culture which existed within slavery – which the slaves built for themselves from the store of their minds and memories, contact with other Africans, and the new world in which they found themselves. Newspapers published. Music composed and performed. Works of art created. Acts of healing. Acts of bravery. Thread spun and cloth woven. Political organizations. Children educated. Stories remembered and reconstructed. History recorded. A new language – made from African languages and the language of the slavemasters – devised. A faith – extraordinary in its belief in justice and the right to freedom, taken from African religion and philosophy and the Bible – built.

This belief in the right to freedom and the possibilities of justice is most important; to quote C. L. R. James again:

> It must be said that the slave community itself was the heart of the abolitionist movement. This is a claim that must seem extraordinarily outrageous to those who think of abolitionism as a movement which required organizations, offices, officers, financiers, printing presses and newspapers, public platforms and orators, writers and petitions. Yet the centre of activity of abolitionism lay in the movement of the slaves for their own liberation.[19]

It has, of course, been said that African slaves were docile, that slavery suited them, that their spirits had been broken; they had no anger, no sense of nation or self left. This is another white lie that needs to be put to rest. It *has* been put to rest – by Frederick Douglass, Sojourner Truth, Harriet Tubman, W. E. B. DuBois, Lorraine Hansberry, and C. L. R. James, among others – but it keeps rising up, so I must place it in its grave

once again, fixing a bag of salt on top to forbid its resurrection. There was massive opposition on the part of Africans to their situation in slavery, an opposition which might not have been possible, had they not carried with them memories of the juridical creations and philosophical doctrines of Africa. Learning to read in secret, on penalty of blinding or death; organized, armed insurrection, on shipboard and on land; domestic subterfuge in the great house; freed slaves working to buy freedom for friends or relatives or friends of friends; artisan slaves – that is, those who worked at crafts on the plantations, like smithing, coopering, etc. – hiring themselves out to raise money to buy freedom, for themselves, for others; slaves somehow raising money to fund revolutionary organizations; slaves stealing from the slavemasters to supply revolutionary organizations; freepeople like Mammy Pleasants sending thousands of dollars to people like John Brown, to fund his raid on Harper's Ferry; women inducing abortion and committing infanticide to deny the slaveowner another commodity; women feigning pregnancy to deceive the slavemaster and so refuse forced breeding; women caring for the children of other women, when the mothers were sold away; a massive, synchronized movement of escape, led by, among others, the brilliant visionary and strategist Harriet Tubman – all of these things, and more, should prove that there was no acquiescence on the part of slaves with regard to their enforced servitude.

Perhaps the great American tragedy – because this is a tragic nation – is that whites were able to use the talents of slaves to construct a powerful country, without taking also, or even respecting, the systems of thought and ethics and society that lay in the minds and memories of the Africans.

III

To further understand how history has been stood on its head by white, American racism, consider the spiritual; the musical mode whites tended to regard as an expression of the slaves lulling themselves into submission, captured by the otherworld promise of Christianity. But songs like 'Go Down, Moses,' 'Steal Away,' and 'Swing Low, Sweet Chariot' were songs of insurrection and encoded communication, songs of mourning, but never of acquiescence. And they had African content – both in music and words.

In *Negro Musicians and their Music*, Maud Cuney Hare speaks of William Fisher's account of the origins of 'Swing Low, Sweet Chariot':

In Rhodesia . . . the natives [sic] sing a melody so closely resembling 'Swing Low, Sweet Chariot' that [Bishop Fisher] felt that he had found it in its original form; moreover, the subject was identical. The tribe . . . near the Victoria Falls have a custom from which the song arose. When one of their chiefs, in the old days, was about to die, he was placed in a great canoe, together with the trappings that marked his rank, and the food for his journey. The canoe was set afloat in midstream headed toward the great falls and the vast column of mist that rises from them. Meanwhile, the tribe on the shore would sing its chant of farewell. The legend is that on one occasion the king was seen to rise in his canoe at the very brink of the falls and enter a chariot that, descending from the mists, bore him aloft. The incident gave rise to the words 'Swing Low, Sweet Chariot,' and the song, brought to America by African slaves long ago, became anglicized and modified by their Christian faith.[20]

The song 'Swing Low, Sweet Chariot' existed in several versions. The Black political scientist and writer Dr Gloria I. Joseph has suggested that one version might have been 'Swing Low, Sweet Harriet,' in reference to Harriet Tubman and the Underground Railroad, just as 'Go Down, Moses' and 'Steal Away' were directly connected to Harriet Tubman, as she alerted slaves to get on board. In Africa, references to 'home' in songs like 'Swing Low, Sweet Chariot' may have meant an afterlife; in America these references were as likely to mean a return to Africa, or to freedom.

In her important article, 'Black Women and Music,' which I have quoted above, Irene V. Jackson describes the relationship to music of both women in Africa and slavewomen in the New World. In both cultures, women had charge of and responsibility for many forms of song – particularly songs to accompany rites of passage. For example, women composed and sang all mourning songs and funeral laments, to ease the journey of the dying and the dead and to provide catharsis for the mourners.

> The participation of women in matters surrounding death insures the 'rebirth' of the deceased. When a Basonga chief has been dead for three months, the oldest woman of the tribe is called upon to dance the womb dance which imitates every movement of generation and childbirth in order that the chief's soul might be delivered. In Dahomey the oldest woman of the family watches the dead body with the widow, and it is her responsibility to compose burial songs.[21]

In my research and reading for this essay I have been struck again and again by the fact that in African cultures, Afro-American slave communities, and post-emancipation Afro-American communities, the older woman has been a leader, someone given enormous respect because of her understanding of matters of life and death, her wisdom gained of insight and experience. With regard to the task of women, particularly older women, in easing pain and loss, Maud Cuney Hare tells the following story of the appearance of 'Swing Low, Sweet Chariot' in the slave South.

> In America, it is told that the song arose from an incident which happened to a woman sold from a Mississippi plantation to Tennessee. Rather than be separated from her child, she was about to drown herself and little one in the Cumberland River, when she was prevented by an old Negro woman, who exclaimed, 'Wait, let de Chariot of De Lord swing low, and let me take the Lord's scroll and read it to you.' The heartbroken woman became consoled and was reconciled to the parting. The song became known with the passing on of the story.[22]

Irene V. Jackson makes the connection between the spiritual and the blues and gospel, of which Afro-American women have been the primary practitioners. The link between African funeral songs and the blues and gospel was the spiritual – what W. E. B. DuBois called the sorrow songs. The continuum includes Harriet Tubman singing 'Steal Away' as she entered the quarters to gather slaves for the journey north, Billie Holiday singing 'Strange Fruit,' as the signature tune in her nightclub act, an insurrectionist lament performed for the most part in front of white audiences, and Nina Simone singing 'Mississippi Goddam' during the Civil Rights Movement and 'To Be Young, Gifted, and Black' after the death of Lorraine Hansberry. All three singers, it must be noted,

paid a price for their actions and their voices.[23] The knowledge that they might pay some price did not stem their song.

My heart stopped when I read the following – as James Baldwin described the end of Lorraine Hansberry's life:

> beautiful and . . . terrifying her face must have been at that moment when she told us, 'My Lord calls me. He calls me by the thunder. I ain't got long to stay here.' She put that on her tape-recorder in her own voice at the moment she realized that she was about to die.[24]

As beautiful and as terrifying as an African chief passing through the thick mists beneath Victoria Falls – the voices singing 'Swing Low, Sweet Chariot' – the chariot dipping. Let us not confuse mourning with acquiescence – in that act of song Sweet Lorraine was taking herself home. A Black revolutionary uniting herself with her past and with other Black revolutionaries like General Moses and all the slaves she led to freedom.

The voice of exile and captivity and sadness in the voice of the spiritual, and the dream of 'home' and of a return, of being called back, repeats and repeats.

> Dere's no rain to wet you,
> Dere's no sun to burn you,
> Oh, push along, believer,
> I want to go home.
> . . .
> Oh freedom!
> Oh freedom!
> Oh freedom over me!
> An' befo' I'd be a slave,
> I'll be buried in my grave,
> An' go home to my Lord an' be free.

IV

> The Yoruba assess everything aesthetically – from the taste and color of a yam to the qualities of a dye, to the dress and deportment of a woman or a man. An entry in one of the earliest dictionaries of their language . . . was *amewa*, literally 'knower of beauty,' 'connoisseur,' one who looks for the manifestation of pure artistry. Beauty is seen in the mean . . . Moreover, the Yoruba appreciate freshness and improvisation . . . in the arts.[25]

If everything is assessed aesthetically – from a yam to a riff to a poem to a dance to a greeting – then aesthetics, style, can be known to all people, because beauty can be found in all things. Art and the recognition of artistry are accessible and not reserved for an elite. They are created and understood by the milliner, the quiltmaker, the gardener, the poet, found in the audience, in the dress of a Sunday morning congregation, the movement and voice of the Amen Corner. Ntozake Shange has a poem called 'We Dress Up'; it is about the sense of style of Afro-American people and their tradition of

dressing for occasions, of treating ceremonies and gatherings with respect – for me this stands for never taking life for granted; making it, in fact, special.

Spoonbread and Strawberry Wine is a cookbook/family history by two Afro-American sisters, blood sisters, Norma Jean and Carole Darden. It is a book filled with a demand for style – and the importance of display and beauty in individual behavior and deportment, as well as in food and drink. The artistry demanded in display – of the individual, of her/his surroundings – is not hollow; with it goes the expectation of striving – hard work, education, decency, caring, belief in the excellence of one's self, one's own. Life is never taken for granted. No automatic advantage is expected. What is expected is adversity, but the struggle against adversity can be won in a beautiful way. The Darden sisters write of their grandmother:

> A woman with little time for nonsense, Dianah set serious standards for her family and herself . . .
>
> She was a seamstress by trade, and professional pride kept her particularly interested in the immaculate appearance of her many offspring. . . . She taught her three daughters dressmaking, needlepoint, and other . . . skills . . . in which she excelled and expected excellence.[26]

This struggle is not without price.

> There are still those . . . who tell us that Dianah worked herself into the grave . . . [She] died in the arms of her youngest son . . . who was then nine years old. Her last words to him were: 'When God sent me you, he must have wrapped up a little piece of himself.' And that is how she felt about them all.[27]

I have other responses to the description of the Yoruba by Robert Farris Thompson – particularly with regard to Afro-Americans. It is impossible to read of the Yoruban appreciation of 'freshness and improvisation' and not think of Blues, Jazz, Be-bop. Or not be reminded of Lévi-Strauss's statement that Africans took the influences of other parts of the ancient world and always transformed them into new shapes.

The Yoruba comprised Africa's largest population group. In addition, they had enormous influence on other African peoples, both in Africa and the New World. The society of the Yoruba was comprised of self-sufficient city-states, each one characterized by 'artistic and poetic richness.'[28] Much of this cultural richness was created to honor the Yoruba religion. The pantheon of Yoruban deities included the following:

Eshu	individuality and change
Ogún	iron
Ifá	divination
Yemoja/Yemayá	seas
Oshun	sweetwater, love, giving
Oshoosi	hunting
Obaluaiye	disease and earth
Nana Bukúu	mother of Obaluaiye, witchcraft
Shàngó	thunder
Obatálá	creativity

There are many more.

Overarching this collection of gods and goddesses is Olorun – God Almighty – ruler of the skies – neither male nor female. Olorun's gift to men and women is *àshe*, the power-to-make-things-happen, the energy of Olorun made accessible to men and women to be used by them according to their own judgment.

Àshe is found in certain animals: the python (*ere*), the gaboon viper (*oka olushere*), the earthworm (*ekolo*), the white snail (*lakoshe*), and the woodpecker (*akoko*).

> [Olorun], within these animals, bestowed upon [men and women] the power-to-make-things-happen, morally neutral power, power to give and take away, to kill and give life, according to the purpose and nature of its bearer. The messengers of *àshe* reflect this complex of powers. Some are essentially dangerous, with curved venomous fangs. Others are patient and slow-moving, teaching deliberation in their careful motion.[29]

Àshe is also present in iron, blood, and semen, and in certain trees.

In his description of how an object created by a human being may represent *àshe*, Robert Farris Thompson speaks of a ceramic bowl made to honor Shàngó, the thunder god.

> We note strong zigzag patterns in relief that suggest the coming down of *àshe* in the form of lightning. These patterns also signify the embodiment of *àshe* within the python, gaboon viper, and many other serpent messengers of the deities. Y-shaped representations bespeak the balancing of this fiery enabling power upon thunderstaffs, i.e. double meteorites upon a royal scepter. Above these Y-shaped thunderstaffs appear smooth rectangular emblems representing thunderstones themselves come from heaven. Time and again the story of the descent of God's *àshe*, in multiple forms, in multiple avatars, is suggested ideographically upon this important vessel. To the right and to the left of the central square emblem appear chiefly scepters, underscoring the essential nobility of the persons who embody and comprehend the power-to-make-things-happen. The three concentric circles suggest three stones, the kind Yoruba women use to support their cooking vessels, meaning that adherence to the moral sanctions of Earth supports us all, safeguarding the equilibrium of the country and its people.[30]

The bowl Thompson describes not only represents *àshe* but embodies it. 'A thing of a work of art that has *àshe* transcends ordinary questions about its makeup and confinements; it is divine force incarnate.'[31] Perhaps the most striking aspect of African philosophy is its emphasis on the symbolic. Every being, action, thing possesses or is given symbolic meaning. An example is the three cooking stones to which Thompson refers above. From the African perspective, these become not just plain domestic tools, but things which stand for something else as well, in this case the balance of the world brought about by moral behavior.

It is in this context that I would like to discuss the sources and power of what I consider one of the major works of American art: the Second Bible Quilt of Harriet Powers. It is a work immersed in symbolism, and in the power-to-make-things-happen. *Àshe* might be translated 'so be it,' 'let it happen.' For me, Harriet Powers' quilt is a work

which expresses a prophetic, magical vision. It is a vision that is expressed through the imagery of the Bible, but also through African symbolism. And, like the ceramic bowl made to honor Shàngó, Mrs Powers' quilt is charged by spirituality and the passion of the gods she honors with her work.

V

The Negro has not been christianized as extensively as is generally believed. The great masses are still standing before their pagan altars and calling old gods by a new name.

Zora Neale Hurston, 'The Sanctified Church'

Harriet Powers was born in 1837 in Georgia; her parents had been brought from Africa as slaves. In her article on Mrs Powers' pictorial quilts – of which two survive – Marie Jeane Adams observes that the generation of Harriet Powers' parents came to the New World at a time when slaves were taken primarily from the Kongo and Angola.[32] They would have brought the traditions of those regions with them and would have been one source of African knowledge for their daughter. It should also be noted, however, that the new slaves, once in America, mixed with populations of slaves from other places and cultures of Africa, at a time when the various African traditions and languages were being combined into Afro-American tradition and language. It is important to keep this condition of cultural mixing in mind when trying to understand how Mrs Powers learned the method by which she represents her vision, and the sources of the various elements in her vision, because it is a syncretic work, taking from a variety of cultures.

Her method of working is appliqué – a distinctly African invention – found in two particular cultures, both of which were plundered by the slave traders: the Fon of Dahomey and the Ejagham of southwestern Cameroon and southeastern Nigeria. Among the Fon, appliquéd textiles were ceremonial cloths, used as costumes, festival decorations, and wall hangings, which festooned the palaces of Dahomeyan kings, as well as other religious and secular spaces. Mrs Powers' Second Bible Quilt was also a ceremonial cloth, made to decorate a wall at Atlanta University, a Black college, on commission from a group of Black women who were wives of professors at the school.

The themes of the Dahomeyan wall hangings were historical and religious, representing symbolically scenes of events that had taken place in the kingdom. One such hanging at first glance appears nothing more than a display of animals, but the animals are in fact symbolic representations of several Dahomeyan kings. Marie Jeane Adams comments on the style of Mrs Powers and the style of the textile designers of the Fon:

The degree of similarity between this style and Mrs Powers's work is impressive. The general approach to depiction corresponds to her manner, using flat, colored, massive figures arranged at various angles to each other in non-geometric equilibrium. The images are also placed roughly in rows. Both employ human figures, animals and

objects as motifs which are repeated in simple form. Perhaps the most consistent formal similarity is the degree of curvature in shaping of the images. Both obviously aim for a comprehensive view of their subject.[33]

The Ejagham also employed the method of appliqué in their textile designs. Whereas the Fon used symbols to represent certain personages, the Ejagham are particularly noted for the existence of a complex system of ideographic writing – *nsibidi*. Among the practitioners of *nsibidi* were members of secret societies, separate societies of women and men. In fact, the tracing of *nsibidi* symbols on appliquéd cloth is a female practice.

> it was the Ejagham female who was traditionally considered the original bearer of civilizing gifts. Ejagham women also engaged in . . . artistic matters. Their 'fatting houses' (*nkim*) were centers for the arts, where women were taught, by tutors of their own sex, body-painting, coiffure, singing, dancing, ordinary and ceremonial cooking, and, especially, the art of *nsibidi* writing in several media, including . . . appliqué.[34]

One version of the origin of their ideographic system is that mermaids emerged to present the gift of *nsibidi* to the Ejagham. The system of ideographs ranges from signs for ordinary objects, signs representing qualities that exist in human relationships (love, hatred, disunity, unity), signs that represent human activities, etc. There are in addition a whole series of signs, called the 'dark signs' – colored in dark shades – that represented things of 'danger and extremity.'[35] In some cultures to which the ideographic system of the Ejagham had spread, *nsibidi* was entirely a woman's art and method of communication. 'Women had their secrets. . . . They slyly interposed some of these "heavy," awesome images in the decoration of outwardly secular objects – calabashes, stools, and trays – confident that only the deeply initiated would catch the glint of power veiled by decoration.'[36]

I am not saying that the symbols used by Harriet Powers in expressing her vision in the Second Bible Quilt are necessarily taken directly from the system of *nsibidi*, but I am saying that the idea of levels of meaning with the deeper levels known only by initiates, the decoration of a seemingly ordinary object with images of power so that the ordinary object becomes endowed with this power, are things which her quilt holds in common with the *mbufari* of Ejagham women, as well as the ceramic Yoruban bowl discussed above. Specifically, image by image, Harriet Powers' quilt contains symbols which occur in several African cultures. What follows is a diagram of the quilt according to Mrs Powers' own description, and a discussion of the quilt frame by frame.

It is my opinion that we should approach the quilts of Harriet Powers as the work of an artist both conscious of and in control of her images. The viewer needs to recognize that there is a plan to the construction of the work of art; the frames can be seen in relation to each other as well as separate scenes which convey messages.

1	2	3	4	5
Job praying for his enemies. Job's crosses. Job's coffin.	The dark day of May 19, 1780. The seven stars were seen at noon. Cattle all went to bed, chickens to roost and the trumpet was blown.	The serpent lifted up by Moses and women bringing their children to look upon it and be healed.	Adam and Eve in the garden. Eve tempted by the serpent. Adam's rib with which Eve was made. The sun and the moon. God's all-seeing eye and God's merciful hand.	John baptizing Christ, and the spirit of God descending to rest upon his shoulder like a dove.

6	7	8	9	10
Jonah cast overboard, and swallowed by a whale. Turtles.	God created two of every kind, Male and Female.	The falling of the stars on Nov. 13, 1833. The people were frightened and thought that the end of time had come. God's hand staid the stars. The varmints rushed out of their beds.	Two of every kind of animals continued, camels, elephants, 'gheraffs,' lions, etc.	The angels of wrath and the seven vials. The blood of fornications. Sevenheaded beast and 10 horns which arose out of the water.

11	12	13	14	15
Cold Thursday, 1895. A woman frozen while at prayer. A man with a sack of meal, frozen. Icicles formed from the breath of a mule. All blue birds killed. A man frozen at his jug of liquor.	The red light night of 1846. Man tolling the bell to notify the people of the wonder. Women, children, and fowls frightened but God's merciful hand caused no harm to them.	Rich people who were taught nothing of God. Bob Johnson and Kate Bell of Virginia: told parents to stop the clock at one and it would strike one and so it did. This was the signal that they entered everlasting punishment. Independent hog (Betts) ran 500 miles from Georgia to Virginia.	The creation of animals continues.	The crucifixion of Christ between the two thieves. The sun went into darkness. Mary and Martha weeping at his feet. Blood and water run from his right side.

The Second Bible Quilt of Harriet Powers

Frame one represents the first of ten biblical illustrations in the quilt. In this frame, Mrs Powers represents the story of Job. This first frame also introduces one of the themes of the quilt, the suffering of the righteous and their eventual deliverance by God. Job, as the righteous man subjected to suffering in order to test his faith in Yahweh, stands as an exemplum of this theme. As in many of the frames, there is a clear parallel here to the position of Africans in slavery, and the moral test to which enforced servitude put them.

My eye was caught by the two crosses in the upper corners of the frame. By calling them 'Job's crosses,' Mrs Powers may have been referring to the two calamities which Job had to bear: the loss of family and home, and the physical pain to which he was subjected. Again, the parallel with Africans in slavery is direct and clear. But that is only one level of the artist's meaning.

The crosses are, I think, meant by the artist to foreshadow the crosses in the last frame which represent the final redemption of the crucifixion; and, further, to point to a relationship between the passion of Job and the passion of Christ; one is a *type* for the other. The quilt, then, embodies a journey from suffering to redemption, beginning with Job and ending with Jesus. Why are there two crosses in the first frame and three in the final frame? I think the coffin in the first frame, balanced as it is by stars or suns at each of the four points, is meant to be a third cross, set off from the other two as Christ's cross is elevated in relation to the crosses of the thieves.

The form of the two crosses in the first frame is significant; they are not the elongated Latin cross but the equilateral Greek cross, and this, I think, signals another level of vision.[37] The Greek cross is a symbol central to the philosophy of the Kongo people; it is a charged image, standing for their belief in life without end.

> This Kongo 'sign of the cross' has nothing to do with the crucifixion of the Son of God, yet its meaning overlaps the Christian vision. Traditional Bakongo believed in a Supreme Deity, Nzambi Mpungu, and they had their own notions of the indestructibility of the soul. 'Bakongo believe and hold it true that man's life has no end, that it constitutes a cycle. The sun, in its rising and setting, is a sign of this cycle, and death is merely a transition in the process of change.' The Kongo *yowa* cross does not signify the crucifixion of Jesus for the salvation of mankind; it signifies the equally compelling vision of the circular motion of human souls about the circumference of its intersecting lines. The Kongo cross refers . . . to the everlasting continuity of *all* righteous men and women.[38]

That such a concept, represented by a cross, existed in Africa, tells us something about the reasons for Afro-American acceptance of Christianity.

In some representations of the Kongo cross it is a simple Greek cross; in others it is a Greek cross with a disk at each of its four points. This more elaborate version of the Kongo cross is described as follows.

> Initiates read the cosmogram . . . respecting its allusiveness. God is imagined at the top, the dead at the bottom, and water in between. The four disks at the points of the cross stand for the moments of the sun [i.e. the solstices and equinoxes], and

the circumference of the cross the certainty of reincarnation: the especially righteous Kongo person will never be destroyed but will come back in the name or body of progeny, or in the form of an everlasting pool, waterfall, stone, or mountain.[39]

The figure of Job's coffin, with its four points, star/sun disks at each point, fixed between the two Greek crosses, stands, I think, for this version of the Kongo cross. In fact, the message of the cosmogram is captured by Mrs Powers' rendering of the image. By fixing the four moments of the sun to each point of the coffin she has transformed what is commonly a symbol of the end of human life into a symbol of everlasting life, in which death, represented by the coffin, is but one stage.

You will note that the word *righteous* is used in each description of the Kongo cross and what it signifies; that is, the Kongo people believed in life everlasting, but only if the individual had earned it by living righteously. Mrs Powers was concerned with the rewards given the righteous, and the punishment earned by those who were not, as the pivotal thirteenth square shows.

Robert Farris Thompson, in *Flash of the Spirit*, makes a point of describing the strong survival of Kongo culture and tradition in the New World: 'Kongo civilization and art were not obliterated in the New World: they resurfaced in the coming together, here and there, of numerous slaves from Kongo and Angola.'[40] The parents of Harriet Powers were among these slaves. I stress this because, as Thompson points out, only relatively recently has the connection between the visual art and symbolism of Africa and Afro-America been acknowledged.

The second frame of the quilt is the first of four representations of a calamitous event of nature. In this frame, Mrs Powers depicts the dark day of May 19, 1780, a day, Marie Jeane Adams notes, that was known as Black Friday in New England, for the daytime sky turned dark from the effect of forest fires. People who witnessed the event were convinced the world was coming to an end.[41] To highlight the calamitous nature of the event, a dark sign perhaps, and the fear that the time of judgment was due, Mrs Powers has used the seven stars and an angel's trumpet, symbols of the Book of Revelation. This book of the Bible has inspired several Afro-American artists – James Hampton, Minnie Evans, Sister Gertrude Morgan, for example – in telling their visions. It is the biblical book which contains the most absolute statement of God's judgment, a statement captured through a complex variety of symbols, all balancing justice and mercy with punishment and wrath. The energy of the Book of Revelation is not unlike the *àshe* of the Yoruba, and the works of the Afro-American artists I have mentioned all move from the realm of decorative art to pieces which the artist intends to be charged with the power of God.

All the natural events to which Mrs Powers refers in the quilt have to do with changes in the heavens and atmosphere, a fact that may reflect a consciousness of Shàngó, the thunder god who rules the heavens. There can be no doubt as to her intentional choice of these events, especially given the fact that only one occurred in her adult lifetime. The others all occurred during the time of African enslavement.

Frame three of the Second Bible Quilt illustrates an event that occurred during the forty years in which the Children of Israel wandered in the desert. Moses is the central human figure. The Black anthropologist and novelist Zora Neale Hurston was fascinated by the figure of Moses. Hurston traced Moses' survival as an African figure

through several cultures of the New World. She writes of him in her chapter on the Voodoo gods in *Tell my Horse*:

> Damballah Ouedo is the supreme Mystere and his signature is the serpent . . . All over Haiti it is well established that Damballah is identified as Moses, whose symbol was the serpent. This worship of Moses recalls the hard-to-explain fact that wherever the Negro is found, there are traditional tales of Moses and his supernatural powers that are not in the Bible, nor can they be found in any written life of Moses. The rod of Moses is said to have been a . . . serpent and hence came his great powers. All over the Southern United States, the British West Indies, and Haiti there are reverent tales of Moses and his magic. It is hardly possible that all of them sprang up spontaneously in these widely separated areas on the blacks coming into contact with Christianity after coming to the Americas. It is more probable that there is a tradition of Moses as the great father of magic scattered over Africa and Asia.[42]

In the preface to her novel, *Moses, Man of the Mountain*, Hurston identifies Moses as a Dahomeyan deity specifically. His temples, whether found in Africa or the New World, are decorated with a living serpent, or the representation of a serpent.

It is most interesting, and I think, significant, that of all the events in the life of Moses, Harriet Powers chose to depict Moses using his magic serpent as an instrument of healing. Among the Fon of Dahomey, the good serpent Dā or Dan is a god, one who combines male and female aspects, whose province is the sky. His/her avatar is the rainbow serpent, a figure which also occurs under a different name in Kongo or Yoruba religions.[43] In Haiti the name for Dā or Dan is Damballah.

As with the Kongo crosses in the first frame, Mrs Powers included an African image in this frame, supplementing or combining African belief with her understanding of the Bible. Throughout the quilt, the biblical imagery both refers to the slavery of Africans in America and their eventual redemption through emancipation and uses figures and events from the Bible that complement or reinforce rather than contradict African belief systems. The Second Bible Quilt is an excellent example of how African beliefs mixed with the faith the slaves found in the New World. If we bear Hurston's discovery in mind, we realize that the slaves recognized Moses not only as the leader who took the Israelites out of bondage, but also as an African god whom they remembered for his magical powers and by the presence of his avatar, the rainbow serpent.

The identification of Harriet Tubman as Moses because she was a leader of her people is one thing; Harriet Tubman as Moses, a magician taking power from African tradition, one who was guided by visions and dreams, is something else. Of this latter Tubman there is the following, taken from the biography/oral history of Tubman's life, compiled by Sarah Bradford:

> [Harriet Tubman] laid great stress on a dream which she had just before she met Captain [John] Brown in Canada. She thought she was in 'a wilderness sort of place, all full of rocks and bushes' when she saw a serpent raise its head among the rocks, and as it did so, it became the head of an old man with a long white beard, gazing at her, 'wishful like, jes as ef he war gwine to speak to me,' and then two other heads rose up beside him, younger than he – and as she stood looking at them, and won-

dering what they could want with her, a great crowd of men rushed in and struck down the younger heads, and then the head of the old man, still looking at her so 'wishful.' This dream she had again and again, and could not interpret it; but when she met Captain Brown . . . behold, he was the very image of the head she had seen. But still she could not make out what her dream signified, till the news came to her of the tragedy of Harper's Ferry, and then she knew the other two heads were his sons.[44]

Like Tubman, John Brown has been identified in the Black imagination as a Mosaic figure in Afro-American history; an identification which is apparent in Harriet Tubman's dream. Moses in the wilderness, with his attribute/avatar, the serpent.

The fourth frame in the Second Bible Quilt is Harriet Powers' depiction of the story of Adam and Eve in the Garden of Eden. Several of the figures in the frame have African content. The serpent does of course, on one level, refer to the snake who tempted Eve. But, especially given the fact that it follows the frame depicting Moses and the rainbow serpent, it may also refer to Dā or Dan, who coiled his body around the earth to create a globe. For one thing, the snake's body is large and curved, much larger than usual depictions of the snake in Eden. Also there is no tree of knowledge in Mrs Powers' frame. Since this frame depicts part of the story of creation, to see in it the creature believed to have shaped the earth is not farfetched.

The particular focus of this frame is the creation of the male and female of the human species. That is why I think the presence of the sun and moon has special meaning. The highest deity of the Fon was Mawu-Lisa – the moon and the sun; the female and male. Mawu, the female, represents gentleness and coolness; Lisa, the male, fire and strength. Their union represents a 'Fon ideal.'[45] It is as if the figures of Adam and Eve, with their hands clasped, reflect this union of Mawu-Lisa, a possibility made more likely given the fact that the moon is visually related to the figure of Eve, whereas the sun is visually related to the figure of Adam. The eye of God in the frame is an additional African detail. According to the Yoruba: 'The gods have "inner" or "spiritual" eyes . . . with which to see the world of heaven and "outside eyes" with which to view the world of men and women.'[46] In the frame, both the world of heaven and the world of men and women are liberated and envisioned. When a human being becomes possessed of *àshe*, 'the radiance of the eyes, the magnification of the gaze, reflects *àshe*, the brightness of the spirit.'[47]

Frame five shows the familiar story of the baptism of Christ by John the Baptist, and God's spirit descending in the form of a dove. Among the Yoruba, *iwa rere*, good character, also known as *coolness*, was the goal of human beings who wished to achieve a higher level of behavior and being. *Iwa rere* is, like *àshe*, a gift of Olorun, God Almighty, who is also called Lord of Character, *Olu Iwa*. Good character is found in the mind, which is represented by a bird. The bird in the mind echoes the descent of Olorun's *àshe* to the earth, also in the form of a bird.

Yoruba kings provide the highest link between the people, the ancestors, and the gods . . . 'The king, as master of *àshe*, becomes the second of the gods.' Birds, especially those connoting the *àshe* of 'the mothers,' those most powerful elderly women with a force capable of mystically annihilating the arrogant, the selfishly rich, or other targets

deserving of punishment, are often depicted in bead embroidery . . . at the top of the special crowns worn by Yoruba kings . . . These feathered avatars . . . protect . . . the leader.[48]

The sixth frame on the quilt depicts the story of Jonah, echoing the story of Job told in the first frame.

Frame seven is Mrs Powers' first of three frames showing the creation of pairs of animals by God. These animal frames deserve close examination for what the animal types may represent. They serve also as the most positive frames in the quilt, a relief from the themes of the other frames. They are evidence of God's power-to-make-things-happen, to create, in beauty.

The eighth frame is the second which depicts a natural cataclysm, the first of two which have to do with meteor showers. Here Mrs Powers depicts a Leonid meteor storm which took place on November 13, 1833, and lasted for eight hours. This particular meteor storm is listed in the *Encyclopaedia Britannica* as one of sixteen major meteor storms between the years 902 and 1868. As on the 'dark day' of May 19, observers of the meteor storm were convinced the world was about to end.

Meteors, or shooting stars, have significance in African tradition. Among the Kongo, shooting stars were believed to indicate spirits traveling across the sky. Among the Yoruba, meteors indicate the power of Shàngó, the thunder god, who is sometimes depicted as carrying two flaming meteorites on his head. Shàngó is particularly characterized by the Yoruba as the god of vengeance: 'in the lightning bolt Shàngó met himself. He became an eternal moral presence, rumbling in the clouds, outraged by impure human acts, targeting the homes of adulterers, liars, and thieves for destruction.'[49] Like the god of the Old Testament, of Jonah and Job and Moses, Shàngó is capable of both mercy and wrath; he is a god who carries his power and his vengeance through the heavens, his force embodied in thunder, lightning, meteors. The apparent conflict in Shàngó's personality – he is a god of justice and judgment, combining fury and tenderness – is spoken of in the following Yoruban hymn:

> Father, grant us the intelligence to avoid saying stupid things.
> Against the unforeseen, let us do things together.
> Swift king, appearing like the evening moon.
> His very gaze exalts a person.
> I have an assassin as a lover.
> Beads of wealth blaze upon his frame.
> Who opens wide his eyes.
> Leopard of the flaming eyes
> Fire, friend of the hearth.
> Leopard of the copper-flashing eyes
> Fire, friend of the hearth.
> Lord with flashing, metallic eyes,
> With which he terrifies all thieves.[50]

Within this frame I cannot help but notice the male figure Mrs Powers has created. Her use of light and dark cloth makes him seem as if he were split in half: 'Shàngó splits the wall with his falling thunderbolt.'[51] It is significant that Shàngó's signature color is

red, and both this frame and frame twelve, depicting the 'red light night,' use this color to great effect.

Frame nine continues the creation of the animals by God. In this frame it is notable that all the animals are African: elephants, giraffes, lions, camels.

Frame ten follows. The message of the Book of Revelation, with its promise of deliverance for the righteous, and unremitting punishment for those who follow the *beast* has been used, as I mentioned above, by other Black artists. In her song, 'New World Coming,' Nina Simone juxtaposes a political vision, a world of 'peace, joy, and love,' with the message of the Book of Revelation. The singer quotes some of the words of Revelation directly, as if the events of the book must first occur in order to make a new world, a transformed political order, possible. I believe Mrs Powers' quilt carries a similar message.

While reading the Book of Revelation to find the exact images Mrs Powers has chosen, and perhaps discover why, I found the following:

> And the merchants of the earth weep and mourn . . . since no one buys their cargo any more, cargo of gold, silver, jewels and pearls, fine linen, purple, silk and scarlet, all kinds of scented wood, all articles of ivory, all articles of costly wood, bronze, iron and marble, cinnamon, spice, incense, myrrh, frankincense, wine, oil, fine flour and wheat, cattle and sheep, horses and chariots, and slaves, that is, human souls. (18: 11–13)

This is one of the few places in the Bible where it is implied that slavery is unjustifiable. The building in this passage of commodities from gold and silver to 'slaves . . . human souls' suggests that slavery is the extreme of materialism, and final proof of human worship of the *beast* rather than God.

This frame in the quilt contains, I think, Mrs Powers' judgment that slaveholders are servants of the seven-headed beast and that they will be punished on the final day. The seven vials hold the seven final plagues that will befall the wicked; the angels and their trumpets will initiate this visitation of God's justice. And the symbol between the three angels, connecting them, as it were, may represent a slender version of the Kongo cross, which would certainly fit with the message of the frame.

Mrs Powers, in this frame and throughout the quilt, takes it upon herself to judge, like the Yoruban 'mothers,' with a 'force capable of mystically annihilating the arrogant, the selfishly rich, or other targets of punishment.' The Bible warns its adherents to 'judge not, lest ye be judged'; it is a very powerful commandment. But in African religions, the righteous person is given the responsibility to judge, and the responsibility to mete out punishment. Mrs Powers takes this responsibility throughout her work, certain in her belief that her judgment is a just one.

In frame eleven, Mrs Powers depicts another natural occurrence, the only one in the quilt occurring in her adult lifetime, and the only one occurring after emancipation. This is interesting, especially since this is a frame in which the hand of God does not stay the forces of nature, and in which human beings die. I do not think this frame necessarily fits with the others showing natural calamities or upheavals. Perhaps its message is that punishment will come from God in any case; that jubilee, emancipation, did not free white slaveholders from accountability. The year 1895 is an important detail;

by that year the system of segregation in the American South had been codified. The promises of Reconstruction had been rescinded. Eighteen ninety-six would see the Supreme Court uphold the cynically named and economically absurd 'separate but equal' doctrine in their *Plessy* v. *Ferguson* decision. Perhaps Harriet Powers suggests that racism, the exploitation of Black people, by no means ended with emancipation; rather it was redefined, reinstitutionalized, and therefore God's wrath continues. But perhaps even God cannot alter the course of events for Afro-Americans. 'A woman frozen while at prayer' is a telling image – and a disturbing one. We are not sure, for one thing, whether the woman is meant to be white or Black. There may also be an element of autobiography in this frame in the quilt. In the years after emancipation, Mrs Powers and her husband, while poor, managed to work as farmers, eventually owning four acres of land, animals, and tools. But in 1895 her husband left, their prosperity was declining, and she ultimately lost the farm. It could be that the woman frozen at prayer is a self-portrait, and one of the male figures, a portrait of her husband.

Frame twelve depicts a recurrence of the sort of natural event pictured in frame eight. The 'red light night' of 1846, as Marie Jeane Adams states, was another meteor shower; the month of August was noted for such events that year. The frame is colored red – Shàngó's color.

Frame thirteen, Marie Jeane Adams has said, is the square in the quilt which most directly addresses the situation of Black people in slavery and the consequences for the whites who enslaved them. The frame contains the largest single figure on the quilt, the hog Betts, and is accompanied by the longest written description. It shows the figures of a son and daughter of Virginia slaveholders. In their attitudes and shapes they are mirror images of the figures of Adam and Eve in the fourth frame. Here the image of Mawu-Lisa is reversed – the moon is above the male figure; the sun is above the female figure. Their arms, like the arms of Adam and Eve, are upraised; but they are not clasped, because a clock separates them. The clock represents the source of their sin – their arrogance in wanting to stop time – which has condemned them to 'everlasting punishment.' Mrs Powers may mean this desire to stop time as a reference to former slaveholders who wished for a return to slavery, thus suspending the natural historical movement of Black people from emancipation to full citizenship.

The two figures, the clock separating them like the tree and entwined serpent in classical representations of the fall of Adam and Eve, stand for another fall from God's grace: that of whites who enslaved Africans and justified their political and social system.

Beneath the two human figures is the hog Betts, a female figure described by Mrs Powers as 'independent,' who ran five hundred miles from Georgia to Virginia. As I said above, the textile designers of Dahomey commonly used animal figures in their wall hangings to symbolize African kings. I take Betts as such a symbolic representation, a metaphor for a Black woman. Her five-hundred-mile flight is meant to inform us that she was a runaway slave, and that Betts became free on her own account.

The penultimate frame continues the creation of the animals.

The final frame is Mrs Powers' representation of the crucifixion of Christ, another biblical assurance of the ultimate redemption of men and women by God, an echo of the first frame in the quilt. The Roman crosses of the crucifixion, like the Kongo crosses which are motifs in the frame depicting the story of Job, promise a continuity of life

for the righteous, and a deliverance from the powers of the *beast* of Revelation. In one sense it is a hopeful ending to the journey represented by the Second Bible Quilt; in another sense it is dismal, suggesting that only the death of the Son of God can redeem the casualties of the slavocracy.

<div align="center">VI</div>

> When I plant my garden, I like to plant potatoes when the nights are dark, when the moon is old. And I like to plant my beans when the sign is in the Twins, that's in the arms. You plant your potatoes when the sign is in the feet. Plant cabbage when the sign's in the head, when it's light.
>
> *Viola King Barnett*

Viola King Barnett is one of the older Black women of North Carolina whose histories and testimonies make up the book *Hope and Dignity*.[52] One thing is clear; with very few exceptions, these women expect a private relationship with God which takes precedence over all other relationships.

It is a truism in American culture and society that older Black women have been among the most supportive of the church, have been consistent voices in the maintenance of its discipline and ethics, extraordinary advocates of tolerance and patience. But this is not the whole truth at all.

I see Viola King Barnett alone in her garden, constructing, organizing her plantings, designing her rows according to the signs in the heavens, like an African gardener. I see a line of descent from other Black women to Mrs Barnett. A line in which African belief systems coexist with Afro-American Christianity.

As I mentioned above, it has struck me again and again while working on this essay, that substantial power, particularly power to do with the spiritual and with life and death, was assumed by and given to Nana Bukúu – 'a superlative warrior, utterly fearless'; Yemoja – an 'arbiter of her people's happiness and a militant witch'; Oshun – 'she greets the most important matter in the water'; the composers of the funeral and death songs, the dancers of the womb dance. This female authority came with African men and women to the New World and the slave communities. In the content of their minds and memories. It was embodied in Grandy Nanny. Harriet Tubman. Sojourner Truth. Big Lucy. Mammy Pleasants. Harriet Powers.

When discussing, examining, analyzing any part of Afro-American history or culture it is necessary always to keep in mind the fact that racism is a primary reality; it is racism that creates the conditions under which Afro-Americans do anything in American culture. It is like trying to work and live and create in an enormous astrodome. Racism creates an unnatural atmosphere, as does the closed-circuit air supply of the astrodome. The dome is always there. Not as visible at some times as at others – but ever present. The atmosphere in the astrodome may seem to change, to freshen, but that is basically an illusion, controlled by those who control the opening and closing of the dome.

Ironically, it was because of segregation – one manifestation of racism in America – that African culture was able to survive in some form among Black Americans. Unlike other Americans, who were able to assimilate to some extent into the dominant culture,

Afro-Americans have not for the most part had assimilation as an option. So African-ism survives, and it gives strength and depth to Black life. But because of racism, some of the truly *wonderful* aspects of African philosophy will never enter the mainstream of America. That may be, as I suggested above, the American tragedy.

Notes

1 Irene V. Jackson, 'Black women and music: a survey from Africa to the New World', in *The Black Woman Cross-culturally*, ed. Filomena Chioma Steady (Cambridge, MA: Schenkman, 1981), pp. 383–4.
2 Ibid.
3 Kenneth Bilby and Filomena Chioma Steady, 'Black women and survival: a Maroon case', in *The Black Woman Cross-culturally*, pp. 458–60.
4 Lorraine Hansberry, interview with Mike Wallace, on 'Art and the black revolution', Caedmon Records.
5 Betye Saar, interview with Houston Conwill, *Black Art*, 3 (1979): 14.
6 Bilby and Steady, 'Black women and survival', p. 459.
7 Jackson, 'Black women and music', pp. 383–4.
8 Alice Walker, *The Color Purple* (New York: Harcourt Brace, 1982), pp. 166–8.
9 Hansberry, speech, 1964, quoted by Julian Mayfield, 'Lorraine Hansberry: a woman for all seasons', *Freedomways (Lorraine Hansberry: Art of Thunder, Vision of Light)*, 19 (4) (1964): 266.
10 Walker, *The Color Purple*, pp. 224–5.
11 *Miami Herald*, Los Angeles Times Service, 15 June 1981. I am indebted to Audre Lorde for sending me this clipping.
12 Robert Farris Thompson, *Flash of the Spirit* (New York: Random House, 1983), p. 68.
13 Ibid., p. 72.
14 Ibid., p. 74.
15 C. L. R. James, 'The Atlantic slave trade', in *The Future in the Present: Selected Writings* (Westport, CT: Lawrence Hill, 1980), p. 236.
16 Ibid.
17 Ibid., pp. 243–4.
18 Ibid., p. 239.
19 Ibid., p. 253.
20 Maud Cuney Hare, 'The source', in *The Negro in Music and Art*, ed. Lindsay Patterson, International Library of Negro Life and History (Washington, DC: Publishers Company), p. 22.
21 Jackson, 'Black women and music', p. 386.
22 Hare, 'The source', p. 22.
23 Despite her activity as a spy for the Union army, and her role as a leader of her people – or perhaps because of the latter – Harriet Tubman was denied a federal pension even though numerous petitions were made on her account. Following Billie Holiday's adoption of 'Strange Fruit' as somewhat of a signature tune, she was arrested and imprisoned for heroin possession; as a result she lost her cabaret license, which was never reinstated. Nina Simone has been charged by the Internal Revenue Service to the tune (no pun intended) of $100,000.
24 James Baldwin, 'Lorraine Hansberry at the summit', *Freedomways*, p. 272.
25 Thompson, *Flash of the Spirit*, p. 5.
26 Norma Jean and Carole Darden, *Spoonbread and Strawberry Wine* (New York: Fawcett Crest, 1978), p. 28.
27 Ibid., p. 30.
28 Thompson, *Flash of the Spirit*, p. 5.
29 Ibid., pp. 5–6.

30 Ibid., p. 6.
31 Ibid., p. 7.
32 Marie Jeane Adams, 'The Harriet Powers pictorial quilts', *Black Art*, 3 (4) (1979): 12–28.
33 Ibid., p. 25.
34 Thompson, *Flash of the Spirit*, p. 34.
35 Ibid., p. 245.
36 Ibid., p. 247.
37 The Greek cross is a recurrent motif in Harriet Powers' First Bible Quilt.
38 Thompson, *Flash of the Spirit*, p. 108.
39 Ibid., p. 109.
40 Ibid., p. 104.
41 Adams, 'The Harriet Powers pictorial quilts', p. 18.
42 Zora Neale Hurston, *Tell my Horse* (Philadelphia: Lippincott, 1938), pp. 138–40.
43 Zora Neale Hurston, *Moses: Man of the Mountain* (Philadelphia: Lippincott, 1939), pp. 7–8.
Thompson, *Flash of the Spirit*, pp. 176–7.
44 Sarah Bradford, *Harriet Tubman: The Moses of her People*, reprint (Secaucus, NJ: Citadel Press,
1974), pp. 118–19.
45 Thompson, *Flash of the Spirit*, p. 176.
46 Ibid., p. 9.
47 Ibid.
48 Ibid., pp. 7–9.
49 Ibid., p. 85.
50 Ibid., p. 86.
51 Ibid., p. 85.
52 *Hope and Dignity: Older Black Women of the South*, narratives by Emily Herring Wilson, pho-
tographs by Susan Mullally (Philadelphia: Temple University Press, 1983), p. 29. This entire book is
of great importance in understanding the religious beliefs of older Black women.

9.2 Creativity

Women: A Journal of Liberation, 'Editorial' (1970)

From *Women: A Journal of Liberation*, 2 (1) (1970), p. 1.

[. . .] The artist has traditionally held a special place – he has been called 'prophet' often, for it is thought that the artist creates a new vision of the world for us. We want to insist here that the artist is not prophet; the artist creates an *original* work, but that original work is the product of an age; it is not independent of the society that the artist lives in. When we view the artist not as a prophet, but only as a good worker or creator in the field of paint, words, stone, then we make a beginning toward a new understanding of art.

But art as we know it today, self-expression through the media of painting, composing, writing or dancing, is just *one* form of creativity – one that everyone should be able to utilize. We should all be taught the skills of these forms of self-expression and we should all know that our feelings are important and worthy of sharing with others. Then creativity becomes something possible in *whatever* field human beings put their hands and their minds to. We can talk about living artistically, communicating with creativity and beauty in our relationships with other people.

We mean by creativity the process of producing in joy, of producing in a totally non-alienated way, whether it be producing a car that functions well, or producing a women's liberation journal. The collective endeavor that we all (you readers included) engage in, year round, to get four issues of this journal to press has started us thinking about collectivity and the possibilities it offers as an artistic instrument. We have already said that we deny the old myth of the 'genius' artist who, ahead of her/his time, foresees and then suggests to the rest of us the vision of a new world. We said that artists receive in abundance the ideas and mood of their time; they are dependent, though not completely, upon their society. And just as we deny this view of the artist as prophet and replace it with the view of artist as a historically and culturally grounded creature, so too we want to deny the view of art as *individual expression*, and replace it with the view which we consider truest: that art is *social* expression. As we struggle to

change society now, our art is part of that struggle and expresses that struggle in such things as political posters and guerrilla theater.

It is clear that the art of our new society must convey a new political message. Lords and ladies will no longer pose before regal palaces while servant girls tend to them. Nor will our art exalt the 'famous' individuals who rise above the rest of the people and then forget them. More of our artistic expression will be in groups; it will convey messages which change people's lives; it will be useful and helpful, not simply 'culture on a shelf;' the artistic skills will be passed along from person to person and not confined to a small group of people. Art must be part of the everyday life of every person, placed where everyone can enjoy it – in the streets, on buses, in factories and in schools and offices. In Russia, because it is believed that people have the right to have beauty all around them, the subway stations are decorated with mosaics and paintings. In Cuba, poster art and film making are given high priority because they can reach so many people.

But how do we develop this kind of artistically free community? There certainly are prerequisites: a socialist economy, planned around human needs rather than profits; an egalitarian community where the need to be superior to other people doesn't exist, but is replaced by a genuine respect for all people, as equals, capable of accomplishing anything collectively. [. . .]

Hélène Cixous, 'The Laugh of the Medusa' (1975)

From *Signs*, 1 (4) (1976), pp. 875–893, trans. Keith Cohen and Paula Cohen (originally published in French 1975); reprinted in *New French Feminisms*, ed. Elaine Marks and Isabelle de Courtivron (Cambridge, MA: University of Massachusetts Press, 1981), pp. 245–264.

I shall speak about women's writing: about *what it will do*. Woman must write her self: must write about women and bring women to writing, from which they have been driven away as violently as from their bodies – for the same reasons, by the same law, with the same fatal goal. Woman must put herself into the text – as into the world and into history – by her own movement.

The future must no longer be determined by the past. I do not deny that the effects of the past are still with us. But I refuse to strengthen them by repeating them, to confer upon them an irremovability the equivalent of destiny, to confuse the biological and the cultural. Anticipation is imperative.

Since these reflections are taking shape in an area just on the point of being discovered, they necessarily bear the mark of our time – a time during which the new breaks away from the old, and, more precisely, the (feminine) new from the old (*la nouvelle de l'ancien*). Thus, as there are no grounds for establishing a discourse, but rather an arid millennial ground to break, what I say has at least two sides and two aims: to break up, to destroy; and to foresee the unforeseeable, to project.

I write this as a woman, toward women. When I say 'woman,' I'm speaking of woman in her inevitable struggle against conventional man; and of a universal woman subject who must bring women to their senses and to their meaning in history. But first it must be said that in spite of the enormity of the repression that has kept them in the 'dark' – that dark which people have been trying to make them accept as their attribute – there is, at this time, no general woman, no one typical woman. What they have *in common* I will say. But what strikes me is the infinite richness of their individual constitutions: you can't talk about *a* female sexuality, uniform, homogeneous, classifiable into codes – any more than you can talk about one unconscious resembling another. Women's imaginary is inexhaustible, like music, painting, writing: their stream of phantasms is incredible.

I have been amazed more than once by a description a woman gave me of a world all her own which she had been secretly haunting since early childhood. A world of searching, the elaboration of a knowledge, on the basis of a systematic experimentation with the bodily functions, a passionate and precise interrogation of her erotogeneity. This practice, extraordinarily rich and inventive, in particular as concerns masturbation, is prolonged or accompanied by a production of forms, a veritable aesthetic activity, each stage of rapture inscribing a resonant vision, a composition, something beautiful. Beauty will no longer be forbidden.

I wished that woman would write and proclaim this unique empire so that other women, other unacknowledged sovereigns, might exclaim: I, too, overflow; my desires have invented new desires, my body knows unheard-of songs. Time and again I, too, have felt so full of luminous torrents that I could burst – burst with forms much more beautiful than those which are put up in frames and sold for a stinking fortune. And I, too, said nothing, showed nothing; I didn't open my mouth, I didn't repaint my half of the world. I was ashamed. I was afraid, and I swallowed my shame and my fear. I said to myself: You are mad! What's the meaning of these waves, these floods, these outbursts? Where is the ebullient, infinite woman who, immersed as she was in her naïveté, kept in the dark about herself, led into self-disdain by the great arm of parental-conjugal phallocentrism, hasn't been ashamed of her strength? Who, surprised and horrified by the fantastic tumult of her drives (for she was made to believe that a well-adjusted normal woman has a . . . divine composure), hasn't accused herself of being a monster? Who, feeling a funny desire stirring inside her (to sing, to write, to dare to speak, in short, to bring out something new), hasn't thought she was sick? Well, her shameful sickness is that she resists death, that she makes trouble.

And why don't you write? Write! Writing is for you, you are for you; your body is yours, take it. I know why you haven't written. (And why I didn't write before the age of twenty-seven.) Because writing is at once too high, too great for you, it's reserved for the great – that is for 'great men'; and it's 'silly.' Besides, you've written a little, but in secret. And it wasn't good, because it was in secret, and because you punished yourself for writing, because you didn't go all the way, or because you wrote, irresistibly, as when we would masturbate in secret, not to go further, but to attenuate the tension a bit, just enough to take the edge off. And then as soon as we come, we go and make ourselves feel guilty – so as to be forgiven; or to forget, to bury it until the next time.

Write, let no one hold you back, let nothing stop you: not man; not the imbecilic capitalist machinery, in which publishing houses are the crafty, obsequious relayers of

imperatives handed down by an economy that works against us and off our backs; and not *yourself*. Smug-faced readers, managing editors, and big bosses don't like the true texts of women – female-sexed texts. That kind scares them.

I write woman: woman must write woman. And man, man. So only an oblique consideration will be found here of man; it's up to him to say where his masculinity and femininity are at: this will concern us once men have opened their eyes and seen themselves clearly.[1]

Now women return from afar, from always: from 'without,' from the heath where witches are kept alive; from below, from beyond 'culture'; from their childhood which men have been trying desperately to make them forget, condemning it to 'eternal rest.' The little girls and their 'ill-mannered' bodies immured, well-preserved, intact unto themselves, in the mirror. Frigidified. But are they ever seething underneath! What an effort it takes – there's no end to it – for the sex cops to bar their threatening return. Such a display of forces on both sides that the struggle has for centuries been immobilized in the trembling equilibrium of a deadlock.

Here they are, returning, arriving over and again, because the unconscious is impregnable. They have wandered around in circles, confined to the narrow room in which they've been given a deadly brain-washing. You can incarcerate them, slow them down, get away with the old Apartheid routine, but for a time only. As soon as they begin to speak, at the same time as they're taught their name, they can be taught that their territory is black: because you are Africa, you are black. Your continent is dark. Dark is dangerous. You can't see anything in the dark, you're afraid. Don't move, you might fall. Most of all, don't go into the forest. And so we have internalized this horror of the dark.

Men have committed the greatest crime against women. Insidiously, violently, they have led them to hate women, to be their own enemies, to mobilize their immense strength against themselves, to be the executants of their virile needs. They have made for women an antinarcissism! A narcissism which loves itself only to be loved for what women haven't got! They have constructed the infamous logic of antilove.

We the precocious, we the repressed of culture, our lovely mouths gagged with pollen, our wind knocked out of us, we the labyrinths, the ladders, the trampled spaces, the bevies – we are black and we are beautiful.

We're stormy, and that which is ours breaks loose from us without our fearing any debilitation. Our glances, our smiles, are spent; laughs exude from all our mouths; our blood flows and we extend ourselves without ever reaching an end; we never hold back our thoughts, our signs, our writing; and we're not afraid of lacking.

What happiness for us who are omitted, brushed aside at the scene of inheritances; we inspire ourselves and we expire without running out of breath, we are everywhere!

From now on, who, if we say so, can say no to us? We've come back from always.

It is time to liberate the New Woman from the Old by coming to know her – by loving her for getting by, for getting beyond the Old without delay, by going out ahead of what the New Woman will be, as an arrow quits the bow with a movement that gathers and separates the vibrations musically, in order to be more than her self.

I say that we must, for, with a few rare exceptions, there has not yet been any writing that inscribes femininity; exceptions so rare, in fact, that, after plowing through litera-

ture across languages, cultures, and ages,[2] one can only be startled at this vain scouting mission. It is well known that the number of women writers (while having increased very slightly from the nineteenth century on) has always been ridiculously small. This is a useless and deceptive fact unless from their species of female writers we do not first deduct the immense majority whose workmanship is in no way different from male writing, and which either obscures women or reproduces the classic representations of women (as sensitive – intuitive – dreamy, etc.).[3]

Let me insert here a parenthetical remark. I mean it when I speak of male writing. I maintain unequivocally that there is such a thing as *marked* writing; that, until now, far more extensively and repressively than is ever suspected or admitted, writing has been run by a libidinal and cultural – hence political, typically masculine – economy; that this is a locus where the repression of women has been perpetuated, over and over, more or less consciously, and in a manner that's frightening since it's often hidden or adorned with the mystifying charms of fiction; that this locus has grossly exaggerated all the signs of sexual opposition (and not sexual difference), where woman has never *her* turn to speak – this being all the more serious and unpardonable in that writing is precisely *the very possibility of change*, the space that can serve as a springboard for subversive thought, the precursory movement of a transformation of social and cultural structures.

[. . .]

She must write her self, because this is the invention of a *new insurgent* writing which, when the moment of her liberation has come, will allow her to carry out the indispensable ruptures and transformations in her history, first at two levels that cannot be separated.

(*a*) Individually. By writing her self, woman will return to the body which has been more than confiscated from her, which has been turned into the uncanny stranger on display – the ailing or dead figure, which so often turns out to be the nasty companion, the cause and location of inhibitions. Censor the body and you censor breath and speech at the same time.

Write your self. Your body must be heard. Only then will the immense resources of the unconscious spring forth. Our naphtha will spread, throughout the world, without dollars – black or gold – nonassessed values that will change the rules of the old game.

To write. An act which will not only 'realize' the decensored relation of woman to her sexuality, to her womanly being, giving her access to her native strength; it will give her back her goods, her pleasures, her organs, her immense bodily territories which have been kept under seal; it will tear her away from the superegoized structure in which she has always occupied the place reserved for the guilty (guilty of everything, guilty at every turn: for having desires, for not having any; for being frigid, for being 'too hot'; for not being both at once; for being too motherly and not enough; for having children and for not having any; for nursing and for not nursing . . .) – tear her away by means of this research, this job of analysis and illumination, this emancipation of the marvelous text of her self that she must urgently learn to speak. A woman without a body, dumb, blind, can't possibly be a good fighter. She is reduced to being the servant of the militant male, his shadow. We must kill the false woman who is preventing the live one from breathing. Inscribe the breath of the whole woman.

(*b*) An act that will also be marked by woman's *seizing* the occasion to *speak*, hence her shattering entry into history, which has always been based *on her suppression*. To write and thus to forge for herself the anti-logos weapon. To become *at will* the taker and initiator, for her own right, in every symbolic system, in every political process.

It is time for women to start scoring their feats in written and oral language.

Every woman has known the torment of getting up to speak. Her heart racing, at times entirely lost for words, ground and language slipping away – that's how daring a feat, how great a transgression it is for a woman to speak – even just open her mouth – in public. A double distress, for even if she transgresses, her words fall almost always upon the deaf male ear, which hears in language only that which speaks in the masculine.

It is by writing, from and toward women, and by taking up the challenge of speech which has been governed by the phallus, that women will confirm women in a place other than that which is reserved in and by the symbolic, that is, in a place other than silence. Women should break out of the snare of silence. They shouldn't be conned into accepting a domain which is the margin or the harem.

Listen to a woman speak at a public gathering (if she hasn't painfully lost her wind). She doesn't 'speak,' she throws her trembling body forward; she lets go of herself, she flies; all of her passes into her voice, and it's with her body that she vitally supports the 'logic' of her speech. Her flesh speaks true. She lays herself bare. In fact, she physically materializes what she's thinking; she signifies it with her body. In a certain way she *inscribes* what she's saying, because she doesn't deny her drives the intractable and impassioned part they have in speaking. Her speech, even when 'theoretical' or political, is never simple or linear or 'objectified,' generalized: she draws her story into history.

There is not that scission, that division made by the common man between the logic of oral speech and the logic of the text, bound as he is by his antiquated relation – servile, calculating – to mastery. From which proceeds the niggardly lip service which engages only the tiniest part of the body, plus the mask.

In women's speech, as in their writing, that element which never stops resonation, which, once we've been permeated by it, profoundly and imperceptibly touched by it, retains the power of moving us – that element is the song: first music from the first voice of love which is alive in every woman. Why this privileged relationship with the voice? Because no woman stockpiles as many defenses for countering the drives as does a man. You don't build walls around yourself, you don't forego pleasure as 'wisely' as he. Even if phallic mystification has generally contaminated good relationships, a woman is never far from 'mother' (I mean outside her role functions: the 'mother' as nonname and as source of goods.) There is always within her at least a little of that good mother's milk. She writes in white ink.

Woman for women – There always remains in woman that force which produces/is produced by the other – in particular, the other woman. *In* her, matrix, cradler; herself giver as her mother and child; she is her own sister–daughter. You might object, 'What about she who is the hysterical offspring of a bad mother?' Everything will be changed once woman gives woman to the other woman. There is hidden and always ready in woman the source; the locus for the other. The mother, too, is a metaphor. It is

necessary and sufficient that the best of herself be given to woman by another woman for her to be able to love herself and return in love the body that was 'born' to her. Touch me, caress me, you the living no-name, give me my self as myself. The relation to the 'mother,' in terms of intense pleasure and violence, is curtailed no more than the relation to childhood (the child that she was, that she is, that she makes, remakes, undoes, there at the point where, the same, she mothers herself). Text: my body – shot through with streams of song; I don't mean the overbearing, clutchy 'mother' but, rather, what touches you, the equivoice that affects you, fills your breast with an urge to come to language and launches your force; the rhythm that laughs you; the intimate recipient who makes all metaphors possible and desirable; body (body? bodies?), no more describable than god, the soul, or the Other; that part of you that leaves a space between yourself and urges you to inscribe in language your woman's style. In women there is always more or less of the mother who makes everything all right, who nourishes, and who stands up against separation; a force that will not be cut off but will knock the wind out of the codes. We will rethink womankind beginning with every form and every period of her body. The Americans remind us, 'We are all Lesbians': that is, don't denigrate woman, don't make of her what men have made of you.

Because the 'economy' of her drives is prodigious, she cannot fail, in seizing the occasion to speak, to transform directly and indirectly *all* systems of exchange based on masculine thrift. Her libido will produce far more radical effects of political and social change than some might like to think.

[. . .]

It is impossible to *define* a feminine practice of writing, and this is an impossibility that will remain, for this practice can never be theorized, enclosed, coded – which doesn't mean that it doesn't exist. But it will always surpass the discourse that regulates the phallocentric system; it does and will take place in areas other than those subordinated to philosophico-theoretical domination. It will be conceived of only by subjects who are breakers of automatisms, by peripheral figures that no authority can ever subjugate.

[. . .]

The Dark Continent is neither dark nor unexplorable – It is still unexplored only because we've been made to believe that it was too dark to be explorable. And because they want to make us believe that what interests us is the white continent, with its monuments to Lack. And we believed. They riveted us between two horrifying myths: between the Medusa and the abyss. That would be enough to set half the world laughing, except that it's still going on. For the phallologocentric sublation[4] is with us, and it's militant, regenerating the old patterns, anchored in the dogma of castration. They haven't changed a thing: they've theorized their desire for reality! Let the priests tremble, we're going to show them our sexts!

Too bad for them if they fall apart upon discovering that women aren't men, or that the mother doesn't have one. But isn't this fear convenient for them? Wouldn't the worst be, isn't the worst, in truth, that women aren't castrated, that they have only to stop listening to the Sirens (for the Sirens were men) for history to change its meaning? You only have to look at the Medusa straight on to see her. And she's not deadly. She's beautiful and she's laughing.

Men say that there are two unrepresentable things: death and the feminine sex. That's because they need femininity to be associated with death; it's the jitters that give

them a hard-on! for themselves! They need to be afraid of us. Look at the trembling Perseuses moving backward toward us, clad in apotropes. What lovely backs! Not another minute to lose. Let's get out of here.

Let's hurry: the continent is not impenetrably dark. I've been there often. I was overjoyed one day to run into Jean Genet. It was in *Pompes funèbres*.[5] He had come there led by his Jean. There are some men (all too few) who aren't afraid of femininity.

Almost everything is yet to be written by women about femininity: about their sexuality, that is, its infinite and mobile complexity, about their eroticization, sudden turn-ons of a certain minuscule–immense area of their bodies; not about destiny, but about the adventure of such and such a drive, about trips, crossings, trudges, abrupt and gradual awakenings, discoveries of a zone at one time timorous and soon to be forth-right. A woman's body, with its thousand and one thresholds of ardor – once, by smash-ing yokes and censors, she lets it articulate the profusion of meanings that run through it in every direction – will make the old single-grooved mother tongue reverberate with more than one language.

We've been turned away from our bodies, shamefully taught to ignore them, to strike them with that stupid sexual modesty; we've been made victims of the old fool's game: each one will love the other sex. I'll give you your body and you'll give me mine. But who are the men who give women the body that women blindly yield to them? Why so few texts? Because so few women have as yet won back their body. Women must write through their bodies, they must invent the impregnable language that will wreck par-titions, classes, and rhetorics, regulations and codes, they must submerge, cut through, get beyond the ultimate reserve-discourse, including the one that laughs at the very idea of pronouncing the word 'silence,' the one that, aiming for the impossible, stops short before the word 'impossible' and writes it as 'the end.'

Such is the strength of women that, sweeping away syntax, breaking that famous thread (just a tiny little thread, they say) which acts for men as a surrogate umbilical cord, assuring them – otherwise they couldn't come – that the old lady is always right behind them, watching them make phallus, women will go right up to the impossible.

When the 'repressed' of their culture and their society returns, it's an explosive, *utterly* destructive, staggering return, with a force never yet unleashed and equal to the most forbidding of suppressions. For when the Phallic period comes to an end, women will have been either annihilated or borne up to the highest and most violent incandescence. Muffled throughout their history, they have lived in dreams, in bodies (though muted), in silences, in aphonic revolts.

And with such force in their fragility: a fragility, a vulnerability, equal to their incom-parable intensity. Fortunately, they haven't sublimated; they've saved their skin, their energy. They haven't worked at liquidating the impasse of lives without futures. They have furiously inhabited these sumptuous bodies: admirable hysterics who made Freud succumb to many voluptuous moments impossible to confess, bombarding his Mosaic statue with their carnal and passionate body words, haunting him with their inaudible and thundering denunciations, dazzling, more than naked underneath the seven veils of modesty. Those who, with a single word of the body, have inscribed the vertiginous immensity of a history which is sprung like an arrow from the whole history of men and from biblico-capitalist society, are the women, the supplicants of yesterday, who

come as forebears of the new women, after whom no intersubjective relation will ever be the same. You, Dora, you the indomitable, the poetic body, you are the true 'mistress' of the Signifier. Before long your efficacity will be seen at work when your speech is no longer suppressed, its point turned in against your breast, but written out over against the other.

In body – More so than men who are coaxed toward social success, toward sublimation, women are body. More body, hence more writing. For a long time it has been in body that women have responded to persecution, to the familial-conjugal enterprise of domestication, to the repeated attempts at castrating them. Those who have turned their tongues 10,000 times seven times before not speaking are either dead from it or more familiar with their tongues and their mouths than anyone else. Now, I-woman am going to blow up the Law: an explosion henceforth possible and ineluctable; let it be done, right now, *in* language.

Let us not be trapped by an analysis still encumbered with the old automatisms. It's not to be feared that language conceals an invincible adversary, because it's the language of men and their grammar. We mustn't leave them a single place that's any more theirs alone than we are.

If woman has always functioned 'within' the discourse of man, a signifier that has always referred back to the opposite signifier which annihilates its specific energy and diminishes or stifles its very different sounds, it is time for her to dislocate this 'within,' to explode it, turn it around, and seize it; to make it hers, containing it, taking it in her own mouth, biting that tongue with her very own teeth to invent for herself a language to get inside of. And you'll see with what ease she will spring forth from that 'within' – the 'within' where once she so drowsily crouched – to overflow at the lips she will cover the foam.

Nor is the point to appropriate their instruments, their concepts, their places, or to begrudge them their position of mastery. Just because there's a risk of identification doesn't mean that we'll succumb. Let's leave it to the worriers, to masculine anxiety and its obsession with how to dominate the way things work – knowing 'how it works' in order to 'make it work.' For us the point is not to take possession in order to internalize or manipulate, but rather to dash through and to 'fly.'[6]

Flying is woman's gesture – flying in language and making it fly. We have all learned the art of flying and its numerous techniques; for centuries we've been able to possess anything only by flying; we've lived in flight, stealing away, finding, when desired, narrow passageways, hidden crossovers. It's no accident that *voler* has a double meaning, that it plays on each of them and thus throws off the agents of sense. It's no accident: women take after birds and robbers just as robbers take after women and birds. They (*illes*)[7] go by, fly the coop, take pleasure in jumbling the order of space, in disorienting it, in changing around the furniture, dislocating things and values, breaking them all up, emptying structures, and turning propriety upside down. [. . .]

Notes

1 Men still have everything to say about their sexuality, and everything to write. For what they have said so far, for the most part, stems from the opposition activity/passivity from the power relation between a fantasized obligatory virility meant to invade, to colonize, and the consequential phantasm

of woman as a 'dark continent' to penetrate and to 'pacify.' (We know what 'pacify' means in terms of scotomizing the other and misrecognizing the self.) Conquering her, they've made haste to depart from her borders, to get out of sight, out of body. The way man has of getting out of himself and into her whom he takes not for the other but for his own, deprives him, he knows, of his own bodily territory. One can understand how man, confusing himself with his penis and rushing in for the attack, might feel resentment and fear of being 'taken' by the woman, of being lost in her, absorbed or alone.

2 I am speaking here only of the place 'reserved' for women by the Western world.

3 Which works, then, might be called feminine? I'll just point out some examples: one would have to give them full readings to bring out what is pervasively feminine in their significance. Which I shall do elsewhere. In France (have you noted our infinite poverty in this field? – the Anglo-Saxon countries have shown resources of distinctly greater consequence), leafing through what's come out of the twentieth century – and it's not much – the only inscriptions of femininity that I have seen were by Colette, Marguerite Duras, . . . and Jean Genet.

4 Standard English term for the Hegelian *Aufhebung*, the French *la relève*.

5 Jean Genet, *Pompes funèbres* (Paris: privately published, 1948), p. 185.

6 Also, 'to steal.' Both meanings of the verb *voler* are played on, as the text itself explains in the following paragraph (translator's note).

7 *Illes* is a fusion of the masculine pronoun *ils*, which refers back to birds and robbers, with the feminine pronoun *elles*, which refers to women (translator's note).

bell hooks, 'Women Artists: The Creative Process' (1995)

From bell hooks, *Art on my Mind: Visual Politics* (New York: The New Press, 1995), pp. 125–132.

I am a girl who dreams of leisure, always have. Reverie has always been necessary to my existence. I have needed long hours where I am stretched out, wearing silks, satins, and cashmeres, just alone with myself, embraced by the beauty around me. I have always been a girl for fibers, for textiles, and for the feel of comforting cloth against my skin. When I have adorned myself just so, I am ready for the awesome task of just lingering, spending uninterrupted time with my thoughts, dreams, and intense yearnings, often the kind that, like unrequited love, go unfulfilled. Lately, in the midst of that solitude, I find myself writing, spinning words together in my head so as not to lose or forget the insights, the sharp moments of clarity that come during this quiet time, that surface amid the luxurious smells of expensive French lemon verbena soap and fruity perfume, a book in my hand.

More often than not I end up breaking the reverie to reach for pen and paper, to write. Writing for me is never a moment of reverie; it's always work. Writing is my passion. But it is not an easy passion. It does not shelter or comfort me. Words try me – work me as though I am caught in a moment of spirit possession where forces beyond my control inhabit and take me, sometimes against my will, to places, landscapes of thoughts and ideas, I never wanted to journey to or see. I have never been a girl for travel. Always one wedded to the couch, the back porch, the swing, I want to see the world standing still. My thoughts are movements, my ideas, my adventures. If I travel

somewhere, it is often just too much; I feel bombarded, too many sensations, overloaded, I break down. 'Girl,' I tell my sweetest friend, who often worries about how much time I spend shut away, confined, in the midst of solitude, 'I understand Emily [Dickinson]: she stayed home to collect her thoughts – to work undisturbed.'

I think often and deeply about women and work, about what it means to have the luxury of time – time spent collecting one's thoughts, time to work undisturbed. This time is space for contemplation and reverie. It enhances our capacity to create. Work for women artists is never just the moment when we write, or do other art, like painting, photography, paste-up, or mixed media. In the fullest sense, it is also the time spent in contemplation and preparation. This solitary space is sometimes a place where dreams and visions enter and sometimes a place where nothing happens. Yet it is as necessary to active work as water is to growing things. It is this stillness, this quietude, needed for the continued nurturance of any devotion to artistic practice – to one's work – that remains a space women (irrespective of race, class, nationality, etc.) struggle to find in our lives. Our need for this uninterrupted, undisturbed space is often far more threatening to those who watch us enter it than is that space which is a moment of concrete production (for the writer, that moment when she is putting the words on paper, or, for the painter, that moment when she takes material in hand). We have yet to create a culture so utterly transformed by feminist practice that it would be common sense that the nurturance of brilliance or the creation of a sustained body of work fundamentally requires such undisturbed hours. In such a world it would make perfect sense for women who devote themselves to artistic practice to rightfully claim such space.

Long after the contemporary feminist movement stirred up questions about great art and female genius, compelling folks to rethink the nature of gender and artistic prac- tice, to look at women's art with respect and full recognition, we still must confront the issues of gender and work with respect to the politics of making space and finding time to do what we women artists do. Most artistic women I know feel utterly overextended. We are working to make money (since we have all long abandoned the notion that men would support us while we make art – if we ever thought that – or that patrons would recognize the inequities of history and make reparations granting us time and material support), to take care of ourselves and our nonpatriarchal families. We spend inordinate amounts of time doing the political work (both theoretical and practical) to keep in place those changes brought about by the feminist movement that are enabling more women than ever before to do artistic work. And we spend much time trying to figure out how to use our time wisely. We worry about not giving enough of our care and personhood to loved ones. Many of us still labor with the underlying fear that if we care too much about art, we will be companionless, alone. And some of us who have companions or children make sure that when we come home there are no visible signs of our artistic selves present. Many women artists clear workspace, do not display work, so as to erase all signs of their passion for something so transcendental as art. Despite feminist thinking and practice, women continue to feel conflicted about the allocation of time, energy, engagement, and passion. Though important, it is not overly reassur- ing that some of us have managed to fit everything into the schedule. Because of this, we now know that making everything fit is no guarantee that we will mature as artists and thinkers. Some of us fear that all of this tightly controlled scheduling is also con-

stricting and limiting our imaginations, shutting down our dreams and visions, so that we enter a different psychic imprisonment. No longer bound by sexist, racist, or class constraints that tell us we cannot be artists, cannot create great and compelling work, we remain bound by limitations on our imaginations.

It has not been my experience that I can dream, think, and create my best when weary, overworked, and stressed out. Many years ago I decided that if I wanted to know the conditions and circumstances that led men to greatness I should study their lives and compare them with the lives of women. I read the biographies of men across race, class, and nationality whom our culture has declared great or significant creative thinkers and artists. I found that folks in these men's lives (parents, friends, lovers, etc.) both expected and accepted that they would need space and time apart for the workings of the everyday to blossom, for them to engage in necessary renewal of spirit. For the most part, their biographies and autobiographies revealed that these men did not have to spend an inordinate number of hours justifying their need for contemplation, for time to be alone, to revel in quietude, to work undisturbed. Adrienne Rich comments on the need for this time in her compelling book *What Is Found There: Notebooks on Poetry and Politics*, and she emphasizes that such time is often 'guiltily seized.' She continues:

> Most, if not all, of the names we know in North American poetry are the names of people who have had some access to freedom in time – that privilege of some which is actually a necessity for all. The struggle to limit the working day is a sacred struggle for the worker's freedom in time . . . Yet every work generation has to reclaim that freedom in time, and many are brutally thwarted in the effort. Capitalism is based on the abridgement of that freedom.

Most women artists, including myself, are also salaried workers in areas not directly related to their art. I still dream of the day when I can stop teaching and devote time to writing and making art. Most women artists are still struggling to find time. Even though the feminist movement led to the opening of class opportunities that have enabled individual successful women to claim this time, these opportunities are still rare. These lone individuals were and are often well situated by their class, race, upbringing, education, or milieu to receive the benefits of these opportunities.

I grew up in a large working-class Southern black patriarchal family, with many sisters and one brother, and my experience of emerging from that context as a potentially gifted artist/creator has always served as the groundwork of my consistent consideration of the impact of class, race, and gender on female creativity and artistic production. Most women I encounter (with the exception of a privileged few) feel that we are still struggling against enormous odds to transform both this culture and our everyday lives so that our creativity can be nurtured in a sustained manner. Respect for the intensity of that struggle must lead us to continue to make a public context for discussion, debate, theorizing, and for the institutionalization of strategies and practices that continue to critically interrogate female creativity and artistic production from a feminist standpoint. These days I am often asked by women, particularly women of color, how it is I find the time to write so much. I find time by sacrificing other involvements and engagements. Living alone without children helps makes that

sacrifice possible. Like many women who have been passionately devoted to artistic practice, I find that devotion is often seen by others as 'suspect,' as though the very fact of writing so much must mean that I am really a monstrous self, hiding some horrible disaffection for life, for human contact. Sexism generates this response to women who are passionately devoted to work. We are all impressed by men who devote their lives to artistic practice. I recall the wonder with which I first took the male German poet Rilke to be one of my artistic spiritual mentors and guides. His confessional writing made solitude seem like a necessary ritual for artistic self-actualization. When I read writing about him, literary criticism, biography, the thoughts of other writers whom his work had inspired, no one seemed to find his devotion suspect. It was seen as a sign of his genius, essential to the cultivation of brilliance. His devotion to artistic practice was never viewed as suspect or monstrous, but simply, as essential to his growth and development.

Growing up black, female, and working-class without the guidance of many well-meaning grown-ups, I chose my mentors from those individuals whose work touched my spirit. Naïvely unaware of the politics of gender in the world of culture, I felt I could be as faithful to the examples set for me by white male writers/artists as I was to those of Emily Dickinson, Lorraine Hansberry, or James Baldwin. My only longtime companion, whom I left years ago, continues to write and publish poetry. A professor of literature, he brought into my life an awareness of the importance of discipline and devotion. We were both poets, sharing a mutual fascination for works by white male poets of the Black Mountain School. We poured over the writings of Charles Olson, William Carlos Williams, and Robert Duncan. Through his research he developed a friendship with Robert Duncan. White, male, gay, Robert and his lover, Jess, represented for me an ideal relationship. They placed art at the center of life and structured a mutually satisfying relationship around it. I learned from their example. They gave themselves 'time' to create and were supported by patrons and admirers. Jess, who still works alone in his studio, was my primary mentor. He was the one who often shut himself away from an interfering world, enclosed himself in a world of art. Seeing Jess gave me a courageous and constructive example. He never seemed to care what others thought of him or his work. Unlike Robert, who occasionally mocked my devotion to artistic practice in the typical sexist manner, Jess always reassured me that I could fashion for myself a world in which I could create.

Given the politics of race, gender, and class, it is not surprising that so many of the models of artistic discipline I drew upon to guide my work were white and male. I knew that I needed guidance because of the difficulty I had constructing a confident identity as an artist. In my younger years, I found myself struggling with an inability to see projects through to their end. I habitually abandoned art work before it was done, never quite finishing pieces I was writing. Discipline was an important issue. I had to find a way to break through the barriers that were leading me to abandon work, had to learn to complete it. I practiced discipline by following the example of chosen mentors. Long before Frida Kahlo became the pop cultural icon that she is today, I was fascinated by her relationship to painting – the way she continued to work even when she was in great physical pain. As is the case with contemporary artists such as the Afro-Caribbean American painter Jean-Michel Basquiat, Kahlo's relationship to art risks being submerged by the cannibalistic, voyeuristic obsession with her personal life, the details of

her love affairs, and her abuse of alcohol and drugs. While I, too, am drawn to the hedonistic passion that colored her relationship to daily life, I remain most fascinated by her relationship to work, by the young woman who, after suffering intense surgery, could proudly declare, 'I haven't died and I have something to live for: painting.' Perhaps there will come a day when Kahlo's hedonistic lifestyle will be talked about as merely a constructed backdrop, a mask or persona she created to hide the intensity of a woman driven by love of art. Intuitively, and then later politically, she must have understood how monstrous and threatening she might have appeared to sexist cultures everywhere had she made it more evident that art was always the driving obsession, always the primary longing, the primal quest.

From the example of Kahlo, I saw the necessity for sustained work. Learning from artists from diverse cultural backgrounds and experiences, I was determined to create a world for myself where my creativity could be respected and sustained. It is a world still in the making. Yet each year of my life, I find myself with more undisturbed, uninterrupted time. When I decided to accept a smaller salary and teach part-time, it was to give myself more time. Again, this choice required sacrifice, a commitment to living simply. Yet these are the choices women artists must make if we want more time to contemplate, more time to work. Women artists cannot wait for ideal circumstances to be in place before we find the time to do the work we are called to do; we have to create oppositionally, work against the grain. Each of us must invent alternative strategies that enable us to move against and beyond the barriers that stand in our way. I often find that other women are among that group of people who see female devotion to work as suspect. Whether such women speak from positions of repressed rage or envy, it is clear that we need to do more feminist consciousness raising about the importance of women affirming one another in our efforts to construct uninterrupted undisturbed spaces wherein we can contemplate and work with passion and abandon.

Consciousness-raising groups, gatherings, and public meetings need to become a central aspect of feminist practice again. Women need spaces where we can explore intimately and deeply all aspects of female experience, including our relationship to artistic production. Even though most feminists these days are aware of issues of race, class, and sexual practices, of our differences, we tend to confront these issues only superficially. Women have yet to create the context, both politically and socially, where our understanding of the politics of difference not only transforms our individual lives (and we have yet to really speak about those transformations) but also alters how we work with others in public, in institutions, in galleries, etc. For example: When will white female art historians and cultural critics who structure their careers focusing on work by women and men of color share how this cultural practice changes who they are in the world in a way that extends beyond the making of individual professional success? When will they speak and write about how this work changes how they interact with people of color? When will all of us interrogate issues of race and racism in relation to our notions of artistic excellence, looking at the ways we think about color, how we use images in works? How many artists truly politicize difference by interrogating their choices? Working alone in her studio, the African-American painter Emma Amos strives to critically interrogate the way in which race, racism, and white supremacy actually determine what colors we choose to use in paintings, the colors we make human bodies. Issues of class are raised by works such as Eunice Lipton's *Alias, Olympia*. To what

extent does her privileged class and nationality affect how she interprets the life and history of a white working-class woman? These are the types of discussion that must emerge if we are to understand the complexity of our differences, if we are to create a cultural context where meaningful solidarity between women artists can be strengthened. When such strengthening occurs, the art world in which we work will expand and become more affirming.

Many folks assume that feminism has already changed the social context in which women artists produce work. They mistake greater involvement in the marketplace with the formation of a liberatory space where women can create meaningful, compelling, 'great' art and have that art be fully recognized. The 'commodification' of difference often leads to the false assumption that works by people of color and marginalized white women are 'hot' right now and able to garner a measure of recognition and reward that they may or may not deserve. The impact such thinking has on our work is that it often encourages marginalized artists to feel we must do our work quickly, strike while the iron is hot, or risk being ignored forever. If we write, we are encouraged to write in the same manner as those who have made the big money and achieved the big success. If, say, we take photographs, we are encouraged to keep producing the image that folks most want to see and buy. This commodification for an undiscerning marketplace seeks to confine, limit, and even destroy our artistic freedom and practice. We must be wary of seduction by the superficial and rare possibility of gaining immediate recognition and regard that may grant us some measure of attention in a manner that continues to marginalize us and set us apart. Women must dare to remain vigilant, preserving the integrity of self and of the work.

As women artists expressing solidarity across differences, we must forge ahead, creating spaces where our work can be seen and evaluated according to standards that reflect our sense of artistic merit. As we strive to enter the mainstream art world, we must feel empowered to vigilantly guard the representation of the woman as artist so that it is never again devalued. Fundamentally, we must create the space for feminist intervention without surrendering our primary concern, which is a devotion to making art, a devotion intense and rewarding enough that it is the path leading to our freedom and fulfillment.

Bibliography

The selection in this bibliography follows the pattern of the texts in this book. It contains few reviews or texts on individual artists. The sheer amount of work on art by women makes that prohibitive. The aim was to select items with feminist intent, implications or frameworks. Also, the bibliography is of English-language texts. The exception is francophone Canadian/Quebecois writing, which has had a close and profound influence upon and interchange with anglophone Canadian writing, and has therefore been included. For an international list, including non-English-language books and catalogues, see the *n. paradoxa* website (<http://web.ukonline.co.uk/members/n.paradoxa/index.htm>).

General

Bad Girls (London: ICA, 1993).

Bad Girls (New York: New Museum of Contemporary Art; Cambridge, MA: MIT Press, 1994).

Events: En Foco (New York: Heresies Collective, New Museum of Contemporary Art, 1983).

NowHere (Louisiana Revy: Louisiana Museum for Moderne Kunst, 1996).

Sense and Sensibility (Nottingham: Midland Group, 1983).

Women and the Arts Bibliography/Les femmes et les arts bibliographie (Ottawa, Ont.: Canadian Conference of the Arts, 1986).

Anderson, Janet A., *Women in the Fine Arts: A Bibliography and Illustration Guide* (Jefferson, NC: McFarland, 1991).

Appleton, Gil, *Women in the Arts: A Study by the Research Advisory Group of the Women and Arts Project* (North Sydney, NSW: Policy and Planning, Australia Council, 1983).

Arbour, Rose-Marie, et al., *Art et féminism* (Montreal: Musée d'art contemporain, 1982).

Arbour, Rose-Marie, Paquin, Nycole and Carani, Marie, *Création/femmes* (Quebec: Galerie d'art du Grand Théâtre de Qébec, 1989).

Attfield, Judy and Kirkham, Pat (eds), *A View from the Interior: Feminism, Women and Design* (London: The Women's Press, 1989; 2nd edn, 1995).

Bachmann, Donna and Piland, Sherry, *Women Artists: An Historical, Contemporary and Feminist Bibliography* (Metuchen, NJ: Scarecrow Press, 1978).

Baker, Houston A., Diawara, Manthia and Lindeborg, Ruth H. Black (eds), *British Cultural Studies: A Reader* (Chicago: University of Chicago Press, 1996).

Barrett, Michèle and Phillips, Anne (eds), *Destabilizing Theory: Contemporary Feminist Debates* (Cambridge: Polity Press, 1992).

Beckett, Jane, 'Danger at the margins', *Women's Art Magazine*, 55 (1993): 4–7.

Bee, Susan and Schor, Mira (eds), *M/E/A/N/I/N/G: An Anthology of Artists' Writings, Theory, and Criticism* (Durham, NC: Duke University Press, 2000).

Belvo, Hazel, *WARM: A Landmark Exhibition* (Minneapolis, MN: Women's Art Registery of Minnesota, 1984).

Betterton, Rosemary (ed.), *Looking On: Images of Femininity in the Visual Arts and Media* (London: Pandora Press, 1987).

Bobo, Jacqueline (ed.) *Black Feminist Cultural Criticism* (Oxford: Blackwell, 2001).

Bobo, Jacqueline, *Black Women Film and Video Artists* (New York: Routledge, 1998).

Borzello, Frances and Ledwidge, Natacha, *Women Artists: A Graphic Guide* (London: Camden Press, 1986).

Bradley, Jessica and Johnstone, Lesley (eds), *Sightlines: Reading Contemporary Canadian Art* (Montreal: Artextes Editions, 1994).

Broude, Norma and Garrard, Mary D., *The Power of Feminist Art: The American Movement of the 1970s, History and Impact* (New York: Harry N. Abrams, 1994).

Brunt, Rosalind and Rowan, Caroline (eds), *Feminism, Culture and Politics* (London: Lawrence and Wishart, 1982).

Bullock, Graham R., *Feminist Art and Design: A Bibliography* (Hull: Art and Design Library, HCHE, 1986).

Calvert, Gill, et al., *Pandora's Box* (Rochdale: Rochdale Art Gallery, 1984).

Cheney, Liana De Girolami, Faxon, Alicia Craig and Russo, Kathleen Lucey, *Self-portraits: Women Painters* (Aldershot: Ashgate, 2000).

Chiarmonte, Paula L., *Women Artists in the US: A Selective Bibliography and Resource Guide in the Fine and Decorative Arts* (Boston, MA: G. K. Hall, 1990).

Chicago, Judy, *The Birth Project* (Garden City, NY: Doubleday, 1985).

Chicago, Judy, *The Dinner Party: Judy Chicago* (Boston, MA: Boston Women's Art Alliance, 1979).

Chicago, Judy, *The Dinner Party: A Symbol of our Heritage* (Garden City, NY: Doubleday/Anchor, 1986).

Chicago, Judy, *Embroidering our Heritage: The Dinner Party Needlework* (Garden City, NY: Doubleday/Anchor, 1980).

Coleman, Debra, Danze, Elizabeth, and Henderson, Carol (eds), *Architecture and Feminism* (New York: Princeton Architectural Press, 1996).

COSAW Women's Collective, *Like a House on Fire: Contemporary Women's Writing, Art and Photography from South Africa* (Fordsaw, SA: COSAW Publishing, 1994).

Craig, Christine, *The Changing Status of Women in the Arts: A Preliminary Reference* (Kingston, Jamaica: Women's Bureau, 1975).

Dines, Gail and Humez, Jean M., *Gender, Race and Class in Media: A Text-reader* (Thousand Oaks, CA: Sage, 1995).

Dotterer, Ronald L. and Bowers, Susan (eds), *Politics, Gender, and the Arts: Women, the Arts, and Society* (Selinsgrove, PA: Susquehanna University Press, 1992).

Dotterer, Ronald L. and Bowers, Susan (eds), *Sexuality, the Female Gaze, and the Arts: Women, the Arts, and Society* (Selinsgrove, PA: Susquehanna University Press, 1992).

Dunford Penny, *A Biographical Dictionary of Women Artists in Europe and America since 1850* (London: Harvester Wheatsheaf, 1990).

Elinor, Gillian, et al. (eds), *Women and Craft* (London: The Women's Press, 1988).

Falk, Lorne and Fischer, Barbara (eds), *The Event Horizon: Essays on Hope, Sexuality, Social Space, and Media(tion) in Art* (Toronto, Ont.: Coach House Press; Walter Phillips Gallery, 1987).

Farris, Phoebe (ed.), *Women Artists of Color: A Bio-critical Sourcebook to 20th Century Artists in the Americas* (Westport, CT: Greenwood Press, 1999).

Foster, Hal (ed.), *Discussions in Contemporary Culture, vol. 1* (Seattle: Dia Art Foundation/Bay Press, 1991).

Foster, Stephen, *The Seventh Wave* (Southampton: John Hansard Gallery, 1994).

Fusco, Coco (ed.) *Corpus Delecti: Performance Art in the Americas* (New York: Routledge, 1999).

Gale, Peggy and Steele, Lisa (eds), *Video Re/view* (Toronto: Art Metropole and VTape, 1996).

Gaze, Delia (ed.), *Dictionary of Women Artists* (London: Fitzroy Dearborn, 1997).

Grossberg, Lawrence, Nelson, Cary and Treichler, Paula (eds), *Cultural Studies* (London: Routledge, 1992).

Gubar, Susan, *Critical Condition: Feminism at the Turn of the Century* (New York: Columbia University Press, 2000).

Hedges, Elaine and Wendt, Ingrid, *In her own Image: Women Working in the Arts* (New York: Feminist Press, 1980).

Henkes, Robert, *The Art of Black American Women: Works of Twenty-four Artists of the Twentieth Century* (Jefferson, NC: McFarland, 1993).

Hess, Thomas and Baker, Elizabeth (eds), *Art and Sexual Politics: Why Have There Been No Great Women Artists?* (London: Macmillan, 1973).

Hine, Darlene Clark and Thompson, Kathleen, *Facts on File Encyclopedia of Black Women in America, vol. 3: Dance, Sports, and Visual Arts* (New York: Facts on File, 1997).

Hogan, Susan (ed.), *Feminist Approaches to Art Therapy* (London: Routledge, 1997).

Huet, Leen, Neetens, Wim and Seresia, Marijke (eds), *An Unexpected Journey: Vrouw en Kunst – Woman and Art* (Antwerp: Gynaika, 1996).

Isaak, Jo Anna, *Feminism and Contemporary Art: The Revolutionary Power of Women's Laughter* (London: Routledge, 1996).

Isaak, Jo Anna (ed.), *Laughter Ten Years After* (Geneva, NY: Hobart and William Smith College Press, 1995).

Johnson, Deborah and Oliver, Wendy (eds), *Women Making Art: Women in the Visual, Literary, and Performing Arts since 1960* (New York: Peter Lang, 2000).

Jones, Amelia (ed.), *Sexual Politics: Judy Chicago's Dinner Party in Feminist Art History* (Los Angeles: Armand Hammer Museum of Art, UCLA, 1996).

Juno, Andrea and Vale, V. (eds), *Angry Women* (San Francisco: RE/Search Publications, 1991).

Kent, Sarah and Morreau, Jackie (eds), *Women's Images of Men* (London: Writers and Readers, 1984).

Kerr, Joan and Holder, Jo (eds), *Past Present: The National Women's Art Anthology* (Sydney: Craftsman House, 1999).

King Hammond, Leslie (ed.), *Gumbo Ya Ya: Anthology of Contemporary African American Women Artists* (New York: Midmarch, 1995).

Kirby, Sandy, *Sight Lines: Women's Art and Feminist Perpectives in Australia* (East Roseville, NSW: Craftsman House, 1992).

Krasilovsky, Alexis-Rafael, 'Feminism in the arts: an interim bibliography', *Artforum*, 10 (June 1972): 72–5.

Kruger, Barbara and Mariani, P. (eds), *Remaking History* (Seattle: Bay Press, 1989).

LaDuke, Betty, *Companeras: Women, Art, and Social Change in Latin America* (San Francisco: City Lights Books, 1985).

Langer, Cassandra, *Feminist Art Criticism: An Annotated Bibliography* (New York: G. K. Hall, 1993).

de Lauretis, Theresa (ed.), *Feminist Studies/Critical Studies* (Basingstoke: Macmillan, 1986).

Linker, Kate, 'Eluding definition: contemporary thought and feminist artists', *Artforum*, 23 (4) (1984): 61–7.

Lippard, Lucy, *c.7,500: An Exhibition* (Valencia, CA: California Institute of the Arts, 1973).

Lippard, Lucy, *From the Center: Feminist Essays on Women's Art* (New York: E. P. Dutton, 1976).

Lippard, Lucy, *Twenty-six Contemporary Women Artists* (Ridgefield, CT: Aldrich Museum of Contemporary Art, 1971).

Lloyd, Alison, Kapoor, Kamala and Biswas, Sutapa, *Inside Out: Contemporary Women Artists of India* (Middlesborough: Middlesborough Art Gallery, 1995–6).

Loeb, Judy, *Feminist Collage: Educating Women in the Visual Arts* (New York: Columbia University Teachers College Press, 1979).

Lyle, Cindy, Sylvia Moore and Cynthia Navaretta (eds), *Women Artists of the World* (New York: Midmarch Associates, 1984).

Marks, Elaine and de Courtivron, Isabelle (eds), *New French Feminisms* (University of Massachusetts Press, 1980).

Marsh, Anne, *Body and Self: Performance Art in Australia, 1969–1992* (Australia: Oxford University Press, 1993).

Miller, Nikki, *Feminisms: An Exhibition of 27 Women Artists* (Perth: PICA, 1992).

Mirzoeff, Nicholas, *The Visual Culture Reader* (London: Routledge, 1998).

Moore, Catriona (ed.), *Dissonance: Feminism and the Arts 1970–90* (St Leonards, NSW: Allen and Unwin, 1994).

Neumaier, Diane (ed.), *Reframings: New American Feminist Photographers* (Philadelphia: Temple University Press, 1995).

Olin, Ferris and Miller, Barbara B., 'Women and the visual arts: a bibliography', *Women's Studies Quarterly*, special issue: Teaching about Women and the Visual Arts, 15 (1–2) (1987): 62–6.

Parker, Rozsika, *The Subversive Stitch: Embroidery and the Making of the Feminine* (London: The Women's Press, 1984).

Perry, Gill (ed.), *Gender and Art* (New Haven, CT: Yale University Press in association with The Open University, 1999).

Petteys, Chris, *Dictionary of Women Artists* (Boston, MA: G. K. Hall, 1984).

Piland, Sherry, *Women Artists: An Historical, Contemporary and Feminist Bibliography*, 2nd edn (Metuchen, NJ: Scarecrow Press, 1994).

Pollock, Griselda (ed.), *Generations and Geographies in the Visual Arts: Feminist Readings* (London: Routledge, 1996).

Puerto, Cecilia, *Latin American Women Artists: Kahlo and Look Who Else. A Selective Annotated Bibliography* (Westport, CT: Art Reference Collection, n. 21, 1996).

Raven, Arlene, *At Home* (Long Beach, CA: Long Beach Museum of Art, 1983).

Robinson, Hilary (ed.), *Visibly Female: Feminism and Art Today – An Anthology* (London: Camden Press, 1987; New York: Universe, 1988).

Roth, Moira, *Difference, Indifference: Essays, Interviews and Performances* (G + B Arts International, 1998).

Roth, Moira et al., *Connecting Conversations: Interviews with 28 Bay Area Women Artists* (Oakland, CA: Eucalyptus Press, 1988).

Saxenhuber, Hedwig et al. (eds), *Oh Boy, It's a Girl! Feminismen in der Kunst* (Munich: Kunstverein Munchen, 1994).

Schor, Mira et al., 'Contemporary feminism: art practice, theory, and activism – an intergenerational perspective', *Art Journal*, 58 (4) (1999): 8–29.

Schor, Naomi, *Bad Objects: Essays Popular and Unpopular* (Durham, NC: Duke University Press, 1995).

Shimbun, Asahi (ed.), *Gender Beyond Memory: The Works of Contemporary Women Artists* (Tokyo: Metropolitan Museum of Photography, 1996).

Skeggs, Beverley (ed.), *Feminist Cultural Theory: Process and Production* (Manchester: Manchester University Press, 1995).

Slatkin, Wendy, *Women Artists in History: From Antiquity to the 20th Century* (Englewood Cliffs, NJ: Prentice-Hall, 1985).

Squiers, Carol (ed.), *The Critical Image: Essays on Contemporary Photography* (London: Lawrence and Wishart, 1991).

Vergine, Lee, 'From Italy: struggles of women artists', *Art and Artists*, 12 (August 1977): 39–41.

Wolff, Janet, *Women's Knowledge and Women's Art* (Nathan, Qld: Institute for Cultural Policy Studies, 1989).

de Zegher, M. Catherine (ed.), *Inside the Visible: An Elliptical Traverse of 20th Century Art in, of, and from the Feminine* (Cambridge, MA: MIT Press, 1996).

Journal Special Issues

Allen Memorial Art Museum Bulletin (Oberlin, Ohio: Oberlin College, Allen Memorial Art Museum), supplement: Women and the Media: New Video, 41 (1983–4).
Art and Artists (October 1973).
Art and Australia, 32 (3) (1995).
Art Criticism, 65 (September 1979).
Art Journal, 35 (4) (1976); (Feminist Art Criticism), 50 (2) (1990); (We're Here: Gay and Lesbian Presence in Art and Art History), 55 (Winter 1996); (Contemporary Feminism: Art Practice, Theory, and Activism – An Intergenerational Perspective, ed. Mira Schor et al.), 58 (4) (2000).
Artlink, 14 (1) (1995).
Artnews (Women's Liberation, Women Artists, and Art History), 69 (9) (1971).
Artweek (Focus on the Women's Art Movement), 21 (5) (1990).
Canadian Woman Studies/Les cahiers de la femme (Feminism and visual art/le feminisme et l'art visuel), 11 (1) (1990).
Differences (More Gender Trouble: Feminism Meets Queer Theory), 6 (2–3) (1994).
Drama Review (Suzanne Lacy), 32 (1) (1988).
Everywoman (Miss Chicago and the California Girls), 2 (7) issue 18 (7 May 1971).
Feminist Review (Cultural Politics), 18 (Winter 1984).
Hypatia (Feminist Aesthetics), 5 (2) (1990).
Issues in Architecture, Art and Design (Jewish Women in Visual Culture), 5 (1) (1997).
Journal of Homosexuality, 27 (1–2) (1994).
October (Questions of Feminism), 71 (1995).
Oxford Art Journal, 3 (1) (1980); 18 (2) (1995).
Southern Quarterly (Art and Feminism), 17 (2) (1979).
Studio International (Women's Issue), 193 (987) (1977).
Tema Celeste (The Question of Gender in Art, Part 1), 37/38 (1992); (The Question of Gender in Art, Part 2), 39 (1993).
Visual Dialog, 1 (2), 2 (3).
Walt (Feminism at CalArts: The Ideal Persists), 3 (1) (1983).
Women's Studies (Women Artists on Women Artists), 6 (1) (1978).
Women's Studies Quarterly (Teaching about Women and the Visual Arts), 15 (1–2) (1987).

Documenting the Movement

Feminist Directions: 1970/1996: Robin Mitchell, Mira Schor, Faith Wilding, Nancy Youdelman (Riverside, CA: Regents of the University of California, 1996).
From History to Action: An Exhibition in Celebration of the Tenth Anniversary of the Woman's Building (Los Angeles: The Woman's Building, 1984).
Instabili: La Question du Sujet/The Question of Subject – Celebrating 15 Years (Montreal: La Centrale [Galerie Powerhouse], 1990).
'Kunstlerinnen: Women Artists International 1877–1977', *Spare Rib*, 59 (1977): 35–7.
Make (Special Issue: Twenty Years of Women's Art [anniversary of the Women's Art Library]), 81 (1998).
More than Minimal: Feminism and Abstraction in the 70s (Waltham, MA: Rose Art Museum, Brandeis University, 1996).
Overview 1972–1977 (New York: AIR Gallery, 1977–8).

'See Red Poster Collective', *Spare Rib*, 98 (1980): 52–5.

What Ever Happened to the Women Artists' Movement? (New York: Womanart Enterprises, 1977).

Women's Art History Collective, 'Women Artists Collective Information Centre', *Studio*, 192 (September 1976): 196–7.

Ader, Alison and Church, Julia, *True Bird Grit: A Book about Canberra Women in the Arts, 1982–1983* (Australia, Canberra: Acme Ink, 1982).

Allen, Catherine, Chiti, Judith and Hill, Linda, *Transformations: Women in Art 70s–80s* (New York: Feminist Art Institute, 1981).

Alloway, Lawrence, 'Post-masculine art: women artists 1970–1980', *Art Journal*, 39 (4) (1980): 295–7.

Alloway, Lawrence, 'Women's art in the '70s', *Art in America*, 64 (3) (1976): 64–72.

Applebroog, Ida et al., 'The women's movement in art, 1986', *Arts Magazine*, 61 (1) (1986): 54–7.

Arbour, Rose-Marie, 'Quelques hypothèses pour une histoire de l'art des femmes, 1965–1985', in *Le Monde selon Graffe*, ed. Pierre Ayot and Madeleine Forcier (Montreal: Éditions Graff, 1987), pp. 575–85.

Batten, Juliet, 'The women's art movement', *Broadsheet*, 136 (1986): 36–40.

Beckman, Laurel 'The problem with role models: contextualizing So Cal 1970's FemArtBooks and the matter with contemporary practice', *Journal of Artists' Books* (Fall 1997): 28–30.

Berman, Avis, 'A decade of progress: but could a female Chardin make a living?', *Artnews*, 78 (1980): 73–9.

Blake, Nayland (ed.), *In a Different Light: Visual Culture, Sexual Identity, Queer Practice* (San Francisco: City Lights, 1995).

Brown, Kay, 'The emergence of black women artists: the 1970s, New York', *International Review of African-American Art*, 15 (1) (1998): 45–9.

Burke, Janine, 'Anima', *Art and Australia*, 32 (3) (1995): 338–43.

Burke, Janine, *Field of Vision: A Decade of Change – Women's Art in the Seventies* (Victoria: Viking/Penguin, 1990).

Doll, Nancy, 'Seventeen years and still counting: the view from New England', *Women Artists News*, 12 (1) (1987): 6, 36–7.

Dougherty, Cecilia, 'Stories from a generation: early video at the LA Woman's Building', *Afterimage*, 26 (1) (1998): 8–11.

DuPlessis, Rachel Blau and Snitow, Ann (eds), *The Feminist Memoir Project: Voices from Liberation* (New York: Three Rivers Press, 1998).

English, Priscilla, 'An interview with two artists from Womanhouse', *New Woman*, 1 (9) (1972): 36–43.

Ewington, Julie, 'Frames of reference', *Art and Text*, 41 (1992): 30–1.

Gaff, Jackie, 'The Women's Free Art Alliance', *Artscribe*, 6 (April 1977): 46.

Gagnon, Lise, 'Québec 70–80: À travers la photographie, les femmes et l'identité', *Esse*, 16 (1990): 52–9.

Gagnon, Monika, 'Work in progress: Canadian women in the visual arts 1975–1987', in *Work in Progress: Building Feminist Culture*, ed. by Rhea Tregebov (Toronto: The Women's Press, 1987), pp. 101–27.

Glueck, Grace, 'Women artists '80: a matter of redefining the whole relationship between art and society', *Artnews*, 79 (8) (1980): 58–63.

Goodall, Phil, 'Feministo, art and parcel of the WLM' (Phil Goodall interviewed by Lynn Alderson and Sophie Laws), *Trouble and Strife*, 5 (1985): 51–6.

Gordon, Juliette, 'The history of our WAR from beginnings to today or, life under fire in the art world dear workers', *Manhattan Tribune* (2 May 1970).

Hanley, JoAnn and Wooster, Ann-Sargent, *The First Generation: Women and Video, 1970–1975* (New York: Independent Curators, 1993).

Harrison, Margaret, 'Notes on feminist art in Britain 1970–77', *Studio International*, 193 (987) (1977): 212–20.

Himid, Lubaina, 'Mapping: a decade of black women artists 1980–1990', in *Passion: Discourses on Blackwomen's Creativity*, ed. by Maud Sulter (Hebden Bridge: Urban Fox Press, 1990), pp. 63–72.

Hladki, Janice and Holmes, Ann, 'Collecting our thoughts: a history of the Women's Cultural Building Collective', *Matriart*, 7 (3) (1998): 8–11.

Jobling, Paul, *Bodies of Experience: Gender and Identity in Women's Photography since 1970* (London: Scarlet Press, 1997).

Karras, Maria, *The Woman's Building, Chicago, 1893; The Woman's Building, Los Angeles, 1973* (Los Angeles: Women's Community Press, 1975).

Kent, Jane (ed.), *Setting the Pace: The Women's Art Movement 1980–1983* (Adelaide: Women's Art Movement, 1984).

Kimball, Gayle (ed.), *Women's Culture: The Women's Renaissance of the Seventies* (Metuchen, NJ: Scarecrow Press, 1981).

Larson, Kay, 'For the first time women are leading not following', *Artnews* (October 1980): 64–72.

Larson, Kay, 'We've come a long way . . . maybe', *Artnews*, 96 (May 1997): 138–9.

Lippard, Lucy, 'In the flesh: looking back and talking back', *Women's Art Magazine*, 54 (1993): 4–9.

Lippard, Lucy, 'Sweeping exchanges: the contribution of feminism to the art of the 1970s', *Art Journal*, 41 (1–2) (1980): 362–5; reprinted in *The Pink Glass Swan: Selected Feminist Essays on Art* (New York: The New Press, 1995), pp. 171–82.

McRobbie, Angela, 'Women and the arts into the 1990s', *Alba: Scotland's Visual Arts Magazine* (April 1991): 4–12.

Meyer, Laura, 'From finish fetish to feminism: Judy Chicago's Dinner Party in California art history', in *Sexual Politics: Judy Chicago's Dinner Party in Feminist Art History*, ed. Amelia Jones (Los Angeles: Armand Hammer Museum of Art, UCLA, 1996), pp. 48–74.

Miller, Nikki, *Feminisms: An Exhibition of 27 Women Artists* (Perth: Perth Institute of Contemporary Art, 1992).

Moore, Catriona, 'Cunts with attitude', *Art and Text*, 46 (1993): 34–7.

Moore, Catriona, *Indecent Exposures: Twenty years of Australian Feminist Photography* (St Leonards, NSW: Allen and Unwin with the Power Institute of Fine Arts, 1994).

Moore, Catriona, 'Supermodels: women artists enter the mainstream', in *What is Appropriation? An Anthology of Critical Writings on Australian Art in the 1980s and 1990s*, ed. Rex Butler (Brisbane: Institute of Modern Art and Power Publications, 1996), pp. 261–70.

Moore, Sylvia (ed.), *Yesterday and Today: California Women Artists* (New York: Midmarch, 1989).

Morreau, Jacqueline and Elwes, Kate, 'Lighting a candle', in *Women's Images of Men*, ed. Sarah Kent and Jacqueline Morreau (London: Writers and Readers, 1984), pp. 22–6.

Nemser, Cindy, 'The women artists movement', *Feminist Art Journal*, 2 (4) (1973): 8–10.

Nochlin, Linda et al., 'The woman artists' movement: an assessment', *Womanart*, 1 (3) (1977): 26–39.

NSW Women and Arts, *The Growth of Women's Art: From Manifesto to Polemics* (NSW: D West, Government Printer, 1983).

O'Dell, Kathy, *Kate Millett, Sculptor: The First 38 Years*, (Catonsville, MD: Fine Arts Gallery, University of Maryland, 1997).

Parker, Rosie, 'The story of art groups', *Spare Rib*, 95 (1980): 50–1.

Parker, Rozsika and Pollock, Griselda, '*Old Mistresses: Women, Art and Ideology*: the book's genesis in the Art History Collective', *Spare Rib*, 113 (1981): 52–3.

Pollock, Griselda, 'Issue: an exhibition of social strategies by women artists', *Spare Rib*, 103 (1981): 49–51.

Raven, Arlene, *The New Culture: Women Artists of the Seventies* (Terre Haute, Indiana: Turman Gallery, Indiana State University, 1984).

Raven, Arlene, 'Two decades of the feminist art movement', *Ms*, 3 (1) (1992): 68–73.

Raven, Arlene, *Women Look at Women: Feminist Art for the Eighties* (Allentown, PA: Muhlenberg College, 1981).

Raven, Arlene and Pieniadz, Jean, 'Words of honor: contributions of a feminist art critic', *Women and Therapy*, 17 (3–4) (1995): 383–9.

Robins, Corinne, 'The AIR Gallery: 1972–1978', in *Overview 1971–1977: An Exhibition in Two Parts* (New York: AIR Gallery, 1978), unpaginated.

Rosen, Randy and Brawer, Catherine C. (eds), *Making their Mark: Women Artists Move into the Mainstream 1970–1985* (New York: Abbeville Press, 1989).

Rosenberg, Avis Lang, 'Women artists and the Canadian artworld: a survey', *Criteria: A Critical Review of the Arts*, 4 (2) (1978): 13–18.

Roth, Moira, *The Amazing Decade: Women and Performance Art in America 1970–1980* (Los Angeles: Astro Artz, 1983).

Roth, Moira, 'Performance art in 1980s: a turn of events', *Studio International*, 195 (June 1982): 16–24.

Schapiro, Miriam, 'An interview with Miriam Schapiro', interview by Christy Sheffield Sanford and Enid Shomer, *Women Artists News*, 11 (2) (1986): 22–6.

Schapiro, Miriam, 'Recalling Womanhouse', *Women's Studies Quarterly*, special issue: Teaching about Women and the Visual Arts, 15 (1–2) (1987): 25–30.

Schapiro, Miriam and Wilding, Faith, 'Cunts/quilts/consciousness', *Heresies*, 24 (1989): 6–13.

Schor, Mira, 'Amnesiac return', *Tema Celeste*, 37–8 (1992): 16–17.

Siegel, Jeanne, *Art Talk: The Early 80s* (New York: Da Capo Press, 1988).

Siegel, Judy, *Mutiny and the Mainstream: Talk that Changed Art, 1975–1990* (New York: Midmarch, 1992).

Skiles, Jacqueline, 'More coast-to-coast ferment: protest and politics in the feminist art movement of the 1970s: summary of 1980 panel discussion', *Women Artists News*, 16–17 (1991–2): 140–1.

Spires, Randi, 'Feminism and art in Toronto: a five-year overview', *Artnews*, 13 (2) (1987): 29–33.

Tenhaaf, Nell, 'A history or a way of knowing', *Matriart*, 4 (1) (1993): 4–9.

Walker, Caryn Faure, *Ecstacy, Ecstacy, Ecstacy, She Said: Women's Art in Britain – A Partial View* (Manchester: Corner House, 1994).

WAM (Women's Art Movement), *The Women's Show, Adelaide, 1977* (Adelaide: Experimental Art Foundation, 1978).

Waugh, Phyllis Waugh, 'Feminist art in Toronto, 1984: a survey', *Resources for Feminist Research/Documentation sur la recherche féministe*, 13 (4) (1984): 5–6.

Wilding, Faith, *By our own Hands: The Women Artist's Movement* (Santa Monica: Double X, 1977).

Wilding, Faith, 'The feminist art programs at Fresno and Calarts, 1970–75', in *The Power of Feminist Art: The American Movement of the 1970s, History and Impact*, ed. Norma Broude and Mary D. Garrard (New York: Harry N. Abrams, 1994), pp. 140–57.

Williams, Carol, 'A working chronology of feminist cultural activities and events in Vancouver: 1970–1990', in *Vancouver Anthology: The Institutional Politics of Art*, ed. Stan Douglas (Vancouver: Talonbooks, 1991), pp. 170–205.

Wolverton, Terry, 'The women's art movement today', *Artweek*, 21 (5) (1990): 20–1.

Women Artists in Revolution, *A Documentary Herstory of Women Artists in Revolution* (Women Artists in Revolution, 1971).

Women's Interart Center, *A Documentary Herstory of Women Artists in Revolution (Part 2)* (Pittsburgh: Know Inc., 1973).

Women's Work, *Women's Work: Two Years in the Life of a Women Artists Group* (London: Brixton Art Gallery, 1986).

Chapter 1

'Appendix 1: what is women's art?', in *Women Artists in Manitoba*, ed. Sharron Corne (Manitoba: Arts and Letters Committee, Provincial Council of Manitoba, 1981), pp. 26–7, 33.

Baker, Elizabeth, 'Sexual art-politics', in *Art and Sexual Politics: Women's Liberation, Women Artists and Art History*, ed. Thomas Hess and Elizabeth Baker (New York: Macmillan, 1973), pp. 108–19.

de Beauvoir, Simone, 'Dreams, fears, idols', in *The Second Sex* (Harmondsworth: Penguin, 1972; first pub. France, 1949).

Bigwood, Carol, *Earth Muse: Feminism, Nature, and Art* (Philadelphia, PA: Temple University Press, 1993), pp. 125–51.

Bociurkiw, Marusia, 'Women, culture, and inaudibility', *Fuse* (Summer 1984): 47–54.

Bonner, Frances et al. (eds), *Imagining Women: Cultural Representations and Gender* (Cambridge: Polity Press, 1992).

Bordo, Susan, *Unbearable Weight: Feminism, Western Culture, and the Body* (Berkeley, CA: University of California Press, 1993).

Butler, Judith, *Gender Trouble: Feminism and the Subversion of Identity* (London: Routledge, 1990).

Cixous, Hélène and Clément, Catherine, *The Newly Born Woman* (Manchester: Manchester University Press, 1986).

Colomina, Beatriz (ed.), *Sexuality and Space* (New York: Princeton Architectural Press, 1992).

Cutting Edge: The Women's Research Group (ed.), *Desire by Design: Body, Territories and New Technologies* (New York: I. B. Taurus, 1999).

Faludi, Susan, *Backlash: The Undeclared War against Women* (New York: Crown, 1991).

Figes, Eva, *Patriarchal Attitudes* (London: Faber, 1970).

Fuenmayor, Jesús, Haug, Kate and Ward, Frazer (eds), *Dirt and Domesticity: Constructions of the Feminine* (New York: Whitney Museum of American Art, 1992).

Greer, Germaine, *The Whole Woman* (London: Doubleday, 1999).

Guerrilla Girls, *The Guerrilla Girls' Bedside Companion to the History of Western Art* (Harmondsworth: Penguin, 1998).

Gwyn, Sandra, 'Women in the arts in Canada', *Communiqué*, 8 (1975): 3–5, 43–4.

Haraway, Donna, 'A cyborg manifesto: science, technology, and socialist-feminism in the late twentieth century', in *Simians, Cyborgs, and Women: The Reinvention of Nature* (London: Free Association Books, 1991), pp. 141–81, 243–8.

Haraway, Donna, 'A manifesto for cyborgs: science, technology, and socialist-feminism in the 1980s', *Socialist Review*, 15 (2) (1985): 65–108; reprinted in *Feminism/Postmodernism*, ed. Linda Nicholson (London: Routledge, 1990).

Holzer, Jenny, 'Truisms' (1977–82), in *Writing/Schriften* (Ostfldern-Ruit: Cantz, 1996), unpaginated.

hooks, bell, 'The oppositional gaze', in *Black Looks: Race and Representaton* (Boston, MA: South End Press, 1992), pp. 115–31.

hooks, bell, *Yearning: Race, Gender, and Cultural Politics* (Boston, MA: South End Press, 1990).

Irigaray, Luce, *This Sex which is Not One* (Ithaca, NY: Cornell University Press, 1985).

Jardine, Alice and Smith, Paul (eds), *Men in Feminism* (London: Methuen, 1989).

Kauffman, Linda S., *Bad Girls and Sick Boys: Fantasies in Contemporary Art and Culture* (Berkeley, CA: University of California Press, 1998).

Kirkham, Pat (ed.), *The Gendered Object* (Manchester: Manchester University Press, 1996).

Klein, Yvonne, 'A position paper in support of a sexual-equality clause in ANNPAC/RACA's membership criteria', *Parallélogramme*, 8 (5) (1983): 20–1.

Kristeva, Julia, 'Women's time' (1979), *Signs*, 7 (1) (1981): 13–35; reprinted in *The Kristeva Reader*, ed. Toril Moi (Oxford: Blackwell, 1986), pp. 187–213.

Labowitz, Leslie and Lacy, Suzanne, 'Mass media, popular culture, and fine art: images of violence against women', in *Social Works*, ed. Nancy Buchanan (Los Angeles: Los Angeles Institute of Contemporary Art, 1979), pp. 26–31.

de Lauretis, Theresa, *Technologies of Gender: Essays on Theory, Film and Fiction* (Basingstoke: Macmillan, 1987).

McRobbie, Angela, *In the Culture Society: Art, Fashion, and Popular Music* (London: Routledge, 1999).

Meskimmon, Marsha, *Engendering the City: Women Artists and Urban Space* (London: Scarlet Press, 1997).

Metzger, Deena, 'In her image', *Heresies*, 2 (1977): 2–11.

Millett, Kate, *Sexual Politics* (London: Virago, 1977; first pub. 1971).

Morgan, Robin, 'Art and feminism: a one-act whimsical amusement on all that matters', in *Going Too Far: The Personal Chronical of a Feminist* (New York: Vintage Books, 1978), pp. 265–89.

Morgan, Robin, 'Defining women's culture: interview with Robin Morgan', interview by Gayle Kimball, in *Women's Culture: The Women's Renaissance of the Seventies*, ed. Gayle Kimball (Metuchen, NJ: Scarecrow Press, 1981), pp. 30–40.

Oakley, Ann, *Sex, Gender and Society* (London: Temple Smith, 1972).

Parker, Rozsika, 'Art of course has no sex, but artists do', *Spare Rib*, 25 (1974): 34–5.

Parmar, Pratibha, 'Hateful contraries: media images of Asian women', *Ten-8*, 16 (1984): 72–8.

Plant, Sadie, *Zeros and Ones: Digital Women and the New Technocultures* (London: Fourth Estate, 1997).

Probyn, Elspeth, *Sexing the Self: Gendered Positions in Cultural Studies* (London: Routledge, 1993).

Raven, Arlene, *Picture This, or, Why is Art Important?* (Houston: The Judy Chicago Word and Image Network, 1982).

Riley, Denise, *Am I that Name?: Feminism and the Category of 'Women' in History* (London: Macmillan, 1988).

Segal, Lynne, *Why Feminism? Gender, Psychology, Politics* (Cambridge: Polity Press, 1999).

Showalter, Elaine, *Hystories: Hysterical Epidemics and Modern Media* (New York: Columbia University Press, 1997).

Stich, Sidra (ed.), *New World (Dis)Order* (Northern California Council of the National Museum of Women, 1993).

Tenhaaf, Nell, 'The trough of the wave: sexism and feminism', *Vanguard*, 13 (7) (1984): 15–18.

Threadgold, Terry and Cranny-Francis, Anne (eds), *Feminine, Masculine and Representation* (Sydney: Allen and Unwin, 1990).

Van Den Bosch, Annette and Beal, Alison, *Ghosts in the Machine: Women and Cultural Policy in Canada and Australia* (Toronto: Garamond Press, 1998).

Wayne, June, 'The male artist as a stereotypical female', *Art Journal*, 32 (4) (1973): 414–16.

Weeks, Jeffrey, *Sex, Politics and Society: The Regulation of Sexuality since 1800* (London: Longman, 1981).

Williamson, Judith, *Consuming Passions: The Dynamics of Popular Culture* (London: Marion Boyars, 1986).

Chapter 2

Art and Ideology (New York: Museum of Contemporary Art, 1984).

Issue (London: ICA, 1980).

Power Plays: Sue Coe, Jacqueline Morreau, Marisa Rueda (London: Jacqueline Morreau and Marisa Rueda in conjunction with an exhibition at Bluecoat Gallery, Liverpool, 1983).

The Wild Art Show, Long Island City (New York: PS1, 1982).

Women in the Arts: A Strategy for Action (North Sydney, NSW: Australia Council, 1984).

Women's Studies in Art and Art History: Descriptions of Current Courses with Other Related Information, 2nd edn (New York: Women's Caucus for Art, 1975).

Abrahams, Linda, 'Who counts and who's counting', *Matriart*, 5 (1) (1994): 6–9.

Ad Hoc Committee of Women Artists, *Rip-off File* (New York: Ad Hoc Committee of Women Artists, 1973).

Alpern, Mildred, 'Cultural view of gender in works of art and contemporary advertisements: an approach for the high school classroom', *Women's Studies Quarterly*, 10 (4) (1982): 16–19.

Ament, Elizabeth A., 'Using feminist perspectives in art education', *Art Education*, 51 (5) (1998): 56.

Amos, Emma, 'Some dos and donts for black women artists', *Heresies*, 15 (1982): 17.

Arbour, Rose-Marie, 'Les expositions collectives: un bilan', in *Exposition Actuelles I*, ed. Elaine Steinberg-Kraut (Montreal: Air Canada/Le Comité Ad Hoc, 1983), pp. 38–47.

Azélie (Artand, Zee), 'Risquer ce texte la question se lancée: est-ce que je m'identifié femme quand je crée?', *Cahiers des arts visuels au Québec*, 4(13) (1982): 29–30.

Barber, Fionna, 'Could do better . . . The Hyde and women's art', *Circa*, 58 (1991): 34–7.

Barndt, Deborah, 'About absences and silences: the community(ies) in Jo Spence's legacy', *Matriart*, 7 (3) (1998): 33–6.

Barnett, Pennina, 'Artists and racism', *Artists Newsletter* (December 1987): 24–5.

Becker, Carol, *The Invisible Drama: Women and the Anxiety of Change* (Golden, CO: Fulcrum, 1990).

Becker, Carol, *Social Responsibility and the Place of the Artist in Society* (Chicago, IL: Lake View Press, 1990).

Becker, Carol (ed.), *The Subversive Imagination: Artists, Society, and Responsibility* (New York: Routledge, 1994).

Becker, Carol, *Zones of Contention: Essays on Art, Institutions, Gender, and Anxiety* (New York: State University of New York Press, 1996).

Berg, Ann and Sjöö, Monica, 'Images of Womanpower 71: arts manifesto' (1971); reprinted in *Mama! Women Artists Together*, ed. Mama Collective (Birmingham: Mama Collective/Arts Lab Press, 1977), p. 5.

Biswas, Sutapa, Edge, Sarah and Slattery, Claire, *Along the Lines of Resistance: An Exhibition of Contemporary Feminist Art* (Barnsley: Cooper Gallery, 1988).

Blackwell, Erin, 'Object into subjects: the illustrated woman', Second Annual Conference of Feminist Activism and Art: Center for the Arts at Yerba Buena Gardens, San Francisco, 1994, *Art Papers*, 18 (July/August 1994): 36–40.

Bociurkiw, Marusia, 'Je me souviens: a response to the Montreal killings', *Fuse* (Spring 1990): 7–10.

Borsa, Joan, *Making Space* (Vancouver: Presentation House Gallery, 1988), pp. 5–7.

Bourgeois, Gail, 'Coming and going and never far away', *Matriart*, 7 (3) (1998): 20–5.

Brand, Peggy Zeglin, 'Revising the aesthetic-nonaesthetic distinction: the aesthetic value of activist art', in *Feminism and Tradition in Aesthetics*, ed. Peggy Zeglin Brand and Carolyn Korsmeyer (University Park, PA: Pennsylvania State University Press, 1995), pp. 245–72.

Brodsky, Judy, 'The Women's Caucus for Art', *Women's Studies Newsletter*, 5 (1–2) (1977): 13–15.

Brookner, Jackie, 'Feminism and students of the 80s and 90s', *Art Journal*, 50 (1991): 11–13.

Broude, Norma and Garrard, Mary D., 'Feminist art history and the academy', *Women's Studies Quarterly*, 15 (1–2) (1987): 10–16.

Brown, Betty Ann (ed.), *Expanding Circles: Women, Art and Community* (New York: Midmarch, 1996).

Brown, Betty Ann, 'Hope for the '90s', *Artweek*, 21 (5) (1990): 22–3.

Brown, Betty Ann and Say, Elizabeth, *Communitas: The Feminist Art of Community Building* (Northridge, CA: Art Galleries, California State University, 1992).

Brown, Kay, '"Where we at" black women artists', *Feminist Art Journal*, 1 (1) (1972): 25.

Brunsdon, Charlotte, 'Pedagogies of the feminine: feminist teaching and women's genre', *Screen*, 32 (4) (1991): 364–81.

Buchanan, Nancy (ed.), *Social Works* (Los Angeles: Los Angeles Institute of Contemporary Art, 1979), pp. 38–7.

Burnham, Linda Frye and Durland, Steven (eds), *The Citizen Artist: 20 Years of Art in the Public Arena – An Anthology from High Performance Magazine* (Gardiner, NY: Critical Press, 1998).

Callen, Anthea, 'A beginning time: three women artists look at experience of art college', *Spare Rib*, 44 (1976).

Campbell, Mary Schmidt, 'Beyond individuals', *Museum News* (July/August 1990), pp. 37–40.

Castanis, Muriel, 'Behind every artist there's a penis', *Village Voice* (19 March 1970).

Chapman, Gretel, 'Women and the visual arts', *Female Studies*, 5 (1972): 38–9.

Chen, Margaret and Kennedy-Kish, Banakonda, 'The Women on Site Exhibition: a question of censorship, or: is the question censorship?', *Artviews*, 13 (4) (1987): 6–7.

Chicago, Judy, 'Let sisterhood be powerful', *Womanspace*, 1 (1) (1973): 4.

Chicago, Judy, *Through the Flower: My Struggle as a Woman Artist* (London: The Women's Press, 1977).

Chicago, Judy and Schapiro, Miriam, 'Feminist art program', *Art Journal*, 31 (1) (1971): 48.

Chicago, Judy and Schapiro, Miriam (eds), *Womanhouse* (Los Angeles: California Institute of the Arts, 1972).

Church Gibson, Pamela and Gibson, Roma (eds), *Dirty Looks: Women, Pornography, Power* (London: British Film Institute, 1993).

Cohn, Terri, 'Guerrilla Girls West', *Artweek*, 21 (5) (1990): 24–5.

Coe, Sue, 'Police state: an interview with Sue Coe', *Spare Rib*, 199 (1989): 39–42.

Collins, Georgia, 'Feminist approaches to art education', *Journal of Aesthetic Education*, 15 (2) (1981): 83–94.

Collins, Georgia, 'Women and art: the problem of status', *Studies in Art Education*, 21 (1) (1979): 57–64.

Collins, Georgia and Sandell, Renee (eds), *Gender Issues in Art Education: Content, Contexts, and Strategies* (Reston, Va.: National Art Education Association, 1996).

Collins, Georgia and Sandell, Renee, *Women, Art, and Education* (Reston, Va.: National Art Education Association, 1984).

Conley, Christine, 'In from the cold: feminism and art in Edmonton', *Parallélogramme*, 11 (3) (1986): 12–18.

Cousineau, Marie-Hélène, 'Inuit women's video', in *Video re/View*, ed. Peggy Gale and Lisa Steele (Montreal: Art Metropole and VTape, 1996), pp. 64–8.

Couture, Francine and Lemerise, Suzanne, 'L'art des femmes: "La partie n'est pas gagnée!" ', *Possibles*, 7 (1) (1982): 29–44.

Cromwell-Tollenaar, Fay, 'Equity: fact or fiction', *Matriart*, 5 (1) (1994): 20–2.

Dagg, Anne Innis, *The 50% Solution: Why Should Women Pay for Men's Culture?* (Waterloo, Ont.: Otter Press, 1986).

Davis, Gayle R., 'Visibility: the slide registry of Nova Scotia Women Artists', *Canadian Woman Studies/Les cahiers de la femme*, 3 (3) (1982): 52–3.

Denison, Sarah, *Women on Site* (Toronto: A Space, 1987).

Diamond, Sara, 'Art after the coup: interventions by Chilean women', *Fuse* (March–April 1988), pp. 15–24.

Dietrich, Linda and Smith-Hurd, Diane, 'Feminist approaches to the survey', *Art Journal*, 54 (3) (1995): 44–7.

Dosser, Diana, Nunn, Pamela Gerrish and Spender, Dale, 'To claim an education', papers given at WAC Conference, 1982, *Feminist Art News*, 10 (1983): 4–8.

Dubin, Steven C., *Arresting Images: Impolitic Art and Uncivil Actions* (London: Routledge, 1992).

Dyer, Susan Y., 'From phone zaps to fax zaps: Women's Action Coalition', *Women's Art Magazine*, 53 (1993): 11–13.

Edge, Sarah, 'Censorship and freedom of speech: concepts of individual freedom', *Feminist Art News*, 3 (8) (1991): 22–4.

Editorial Group, 'From the Editorial Group', *Heresies*, 4 (Winter 1978): 2.

Elinor, Gillian and Matlow, Erica, 'Art education', *Feminist Review*, 18 (1984): 127–8.

Farrell, Audrey, 'Judy Chicago: exploitation or art?', *Art Criticism*, 10 (2) (1995): 94–106.

Felshin, Nina (ed.), *But is it Art? The Spirit of Art as Activism* (Seattle: Bay Press, 1995).

Feminist Art Program (ed.), 'Letters to a young woman artist', *Anonymous was a Woman: A Documentation of the Women's Art Festival; A Collection of Letters to Young Women Artists* (Valencia: Feminist Art Program, California Institute of the Arts, 1974).

Feminists against Censorship, *Pornography and Feminism: The Case against Censorship* (London: Lawrence and Wishart, 1991).

Fine, Elsa Honig, Gellman, Lola B. and Loeb, Judy (eds) *Women's Studies and the Arts* (New York: Women's Caucus for Art, 1973).

Fowler, Joan, 'Women Artists Action Group seminar', *Circa*, 41 (1988): 26–7.

Fowler, Rowena, 'Why did suffragettes attack works of art?', *Journal of Women's History*, 2 (3) (1991): 109–25.

Frueh, Joanna, *Erotic Faculties* (Berkeley, CA: University of California Press, 1996).

Gablik, Suzi, *The Re-enchantment of Art* (London: Thames and Hudson, 1991).

Gablik, Suzi, 'You don't have to have a penis to be a genius: the Guerrilla Girls have infiltrated the American art world', *Women's Art Magazine*, 60 (1994): 6–11.

Gagnon, Monica, 'Women's work', *Parachute*, 50 (1988): 61–2.

Gamman, Lorraine, 'Are you being served with a mask: ten years later on the Guerrilla Girls', *Women's Art Magazine*, 66 (1995): 20–2.

Garber, Elizabeth, 'Implications of feminist art criticism for art education', *Studies in Art Education*, 32 (1) (1990): 17–26.

Gourlay, Sheena, 'Women's art programmes on the prairies', *Parallélogramme*, 11 (3) (1986): 11.

Guerrilla Girls, *The Banana Report: The Guerrilla Girls Review the Whitney* (New York: The Clocktower, 1987).

Guerrilla Girls (with an essay by Whitney Chadwick), *Confessions of the Guerrilla Girls* (London: Pandora Press, 1995).

Hagaman, Sally, 'Feminist inquiry in art history, art criticism, and aesthetics: an overview for education', *Studies in Art Education*, 32 (1) (1990): 27–35.

Hare, Susan, 'Excerpt from a submission to the Royal Commission on Aboriginal Affairs', *Matriart*, 2 (1) (1991): 10–11.

Hart, Lynda, 'Karen Finley's dirty work: censorship, homophobia, and the NEA', *Genders*, 14 (1992): 1–15.

hooks, bell, 'Art on my mind', in *Art on my Mind: Visual Politics* (New York: The New Press, 1995), pp. 1–9.

Iskin, Ruth, 'The fine art of social change', in *Social Works*, ed. Nancy Buchanan (Los Angeles: Los Angeles Institute of Contemporary Art, 1979), pp. 8–16.

Iskin, Ruth, 'Institutions of women's culture: interview with Ruth Iskin', interview by Gayle Kimball, in *Women's Culture: The Women's Renaissance of the Seventies*, ed. Gayle Kimball (Metuchen, NJ: Scarecrow Press, 1981), pp. 280–91.

Iskin, Ruth, 'A space of our own, it's meanings and implications', *Womanspace*, 1 (1) (1973): 8–10.

Ivinski, Pamela A., 'Women who turn the gaze around', *Print*, 47 (1993): 36–43.

Jacobsen, C., 'Redefining censorship, art and politics – a feminist view', *Art Journal*, 50 (4) (1991): 42–55.

Johnston, Claire, 'Women's cinema as counter-culture', *Screen Pamphlet*, 2 (March 1973); reprinted in *Feminism and Film*, ed. E. Ann Kaplan (Oxford: Oxford University Press, 2000), pp. 22–33.

Kabat, Jennifer, 'Entrapment', in *The Subject of Rape*, ed. Monica Chau et al. (New York: Whitney Museum of American Art, 1993), pp. 65–77.

Kalbfleish, Jane, 'See Jane play, see Dick (run)', *Border/lines*, 22 (1991): 32–7.

Kantaroff, Maryon, 'Purpose', in *Woman as Viewer* (Winnipeg: Committee for Women Artists/ Winnepeg Art Gallery, 1975), pp. 3–7.

Kaplan, Janet, 'We interrupt this reading . . .', *M/E/A/N/I/N/G*, 8 (1990): 36–9.

Karibian, Leah, 'Survival in the arts: a survey', *Women's Art Magazine*, 38 (1991): 12–14.

Kelly, Mary, *Social Process – Collaborative Action: Mary Kelly 1970–75* (Vancouver: Charles H. Scott Gallery, 1997).

Krikorian, Tamara et al., 'Women's exhibitions', *Aspects*, 13 (1980), unpaginated.

Labowitz, Leslie, 'Developing a feminist media strategy', *Heresies*, 9 (1980): 28–31.

Labowitz, Leslie and Lacy, Suzanne, 'Feminist artists: developing a media strategy for the movement', in *Fight Back! Feminist Resistance to Male Violence*, ed. Frédérique Delacoste and Felice Newman (Minneapolis, MN: Cleis Press, 1981), pp. 266–72.

Lacy, Suzanne, 'The forest and the trees', *Heresies*, 4 (3) (1982): 62–3.

Lacy, Suzanne (ed.), *Mapping the Terrain: New Genre Public Art* (Seattle: Bay Press, 1995).

Lacy, Suzanne, 'In mourning and in rage (with analysis aforethought)', in *Femicide: The Politics of Woman Killing*, ed. Jill Radford and Diana E. H. Russell (New York: Twayne, 1992), pp. 317–24.

Langer, Sandra, 'The mythology of success: a gynaesthetic reading', *WARM Journal*, 5 (3) (1984): 4–5.

Langer, Sandra, 'Salving our wounds: maternal patronizing and the women's movement', *Redact*, 1 (1) (1984): 111–14.

Lederer, Carrie J. and the Guerrilla Girls, *Guerrilla Girls Talk Back: The First Five Years – A Retrospective, 1985–1990* (San Rafael, CA: Falkirk Cultural Center, 1991).

Linker, Kate, 'Forum', *Artforum*, 21 (8) (1983): 2–3.

Lippard, Lucy, *Get the Message? A Decade of Art for Social Change* (New York: E.P. Dutton, 1984).

Lippard, Lucy, 'A note on the politics and aesthetics of a women's show', in *Women Choose Women* (New York: Women in the Arts/The New York Cultural Center, 1973), pp. 6–7.

Lippard, Lucy, *On the Beaten Track: Tourism, Art and Place* (New York: The New Press; London: I. B. Tauris, 1999).

Lippard, Lucy, 'Sexual politics art style', *Art in America*, 59 (September/October 1971): 19–20; longer version in *From the Center: Feminist Essays on Women's Art* (New York: E. P. Dutton, 1976), pp. 28–37.

Lippard, Lucy, 'Some propaganda for propaganda', *Heresies*, 9 (1980): 35–9; reprinted in *The Pink Glass Swan: Selected Feminist Essays on Art* (New York: The New Press, 1995), pp. 139–49.

Lippard, Lucy, 'Trojan horses: activist art and power', in *Art Theory and Criticism: An Anthology of Formalist, AvantGarde, Contextualist and Post-Modernist Thought*, ed. Sally Everett (Jefferson, NC: McFarland, 1991), pp. 185–203; reprinted in *Art after Modernism: Rethinking Representation*, ed. Brian Wallis (New York: New Museum of Contemporary Art, 1984).

Lippard, Lucy, 'The women artist's movement – what next?', in *From the Center: Feminist Essays on Women's Art* (New York: E. P. Dutton, 1976), pp. 139–48; reprinted in *The Pink Glass Swan: Selected Feminist Essays on Art* (New York: The New Press, 1995), pp. 80–3.

Lippard, Lucy, 'Why separate women's art?', *Art and Artists*, 8 (7) (1973): 8–9.

López, Yolanda M. and Roth, Moira, 'Social protest: racism and sexism', in *The Power of Feminist Art: The American Movement of the 1970s, History and Impact*, ed. Norma Broude and Mary D. Garrard (New York: Harry N. Abrams, 1994), pp. 140–57.

Lubell, Ellen, 'Women march on MOMA', *Village Voice* (19 June 1984).

McQuiston, Liz, *Suffragettes to She-devils: Women's Liberation and Beyond* (London: Phaidon, 1997).

Mama Collective (ed.), *Mama! Women Artists Together* (Birmingham: Mama Collective/Arts Lab Press, 1977).

Marmer, Nancy, 'Womanspace: a creative battle for equality in the art world' *Artnews*, 72 (6) (1973): 38–9.

Marsh, Anne, 'Art and society: an analysis of community art', in *Live Art: Australia and America*, ed. Anne Marsh and Jane Kent (Adelaide: Anne Marsh and Jane Kent, 1984), pp. 39–45.

Marter, Joan, 'Strategies for women in art', *Women's Studies Quarterly*, special issue: Teaching about Women and the Visual Arts, 15 (1–2) (1987): 51–3.

Moore, Catriona, 'The art of political correctness', *Art and Text*, 41 (1992): 32–9.

Moore, Liz et al. (eds), *Toward a Revolutionary Feminist Art* (Bristol: Liz Moore et al., 1973).

Muller, Viana, 'Liberating the artists: black women take over', *Women: A Journal of Liberation*, 2 (1) (1970): 46–7.

Needham, Wilma, 'Women and peace: on visual art and resistance', in *Women and Peace: Resource Book* (Halifax, Nova Scotia: Voice of Women, 1987), pp. 4–8.

Nickel, Michelle, 'Some perspectives on women's alternative art centres', *Parallélogramme*, 7 (5) (1982): 9–10.

Nochlin, Linda, 'How can feminism in the arts implement cultural change', *Arts in Society*, (Spring/Summer 1974): 81–9.

Nochlin Pommer, Linda, 'The image of women in the 19th and 20th centuries', *Female Studies*, 2 (1970): 163–5.

O'Connor, Ailsa, *Unfinished Work: Articles and Notes on Women and the Politics of Art* (Victoria, Australia: Greenhouse Publications, 1982).

Ollie, Jennifer and Tuer, Dot, 'Censorship in Canada: case history Ontario', *Vanguard*, 15 (3) (1986): 30–3.

O'Neill, Beverley, 'Feminism and art: the focus of Womanspace', *Womanspace*, 1 (1) (1973): 11–13.

Parker, Rozsika, 'Censored', *Spare Rib*, 54 (1977): 43–5; reprinted in *Looking On: Images of Femininity in the Visual Arts and Media*, ed. Rosemary Betterton (London: Pandora Press, 1987), pp. 254–8.

Parker, Rozsika, 'A piece of the pie?', *Spare Rib*, 74 (1978): 20–2.

Parker, Rozsika, 'Portrait of the artist as housewife', *Spare Rib*, 60 (1977): 5–8.

Parker, Rozsika, 'Women artists take action', *Spare Rib*, 13 (1973).

Patterson, Katherine J., 'Pornography law as censorship: linguistic control as (hetero)sexist harness', *Feminist Issues*, 14 (2) (1994): 91–115.

Permar, Roxane, 'Fragile territories: women and power in art education', *Make: The Magazine of Women's Art*, 77 (1997): 6–7.

Philp, Andrea, 'Women's work: a report on Manitoba Artists for Women's Art', *Parallélogramme*, 11 (3) (1986): 19–21.

Pike, Bev, with Driscoll, Kathy, 'Painting a collective herstory: Manitoba Artists for Women's Art', *Fuse* (Fall 1990): 15–17.

Pindell, Howardena, 'Sticks and stones' (1988), in *The Heart of Question: The Writings and Paintings of Howardena Pindell* (New York: Midmarch, 1997), pp. 29–31.

Piper, Adrian, *Out of Order, Out of Sight*, 2 vols (Harvard, MA: MIT Press, 1996).

Pollock, Griselda, 'Feminism, femininity and the Hayward Annual Exhibition 1978', *Feminist Review*, 3 (1979): 33–55.

Pollock, Griselda, 'History and position of the contemporary woman artist', *Aspects*, 28 (1984).

Poteet, Susan K., 'Powerhouse: Montreal women's gallery', *Branching Out: Canadian Magazine for Women*, 2 (5) (1975): 19–21.

Prost, Viviane, 'D'une coopérative artistique: Powerhouse', *Possibles*, 4 (1) (1979): 163–6.

Raven, Arlene, *Art in the Public Interest* (Ann Arbor: UMI Research Press, 1989, 1992).

Raven, Arlene, *Crossing Over: Feminism and Art of Social Concern* (Ann Arbor: UMI Research Press, 1988).

Raven, Arlene, 'We did not move from theory/we moved to the sorest wounds', in *RAPE* (Columbus, Ohio: Ohio State University Gallery of Fine Art, 1985), pp. 5–12.

Reimer, Priscilla, 'Supporting women's art in Manitoba', *Parallélogramme*, 18 (2) (1992): 32–40.

Rice, Shelley, 'One critic's survival kit for the 1980s', in *Women Look at Women: Feminist Art for the '80s*, ed. Linda Weintraub (Allentown, PA: Center for the Arts, Muhlenberg College, 1981), pp. 42–5.

Ringgold, Faith, 'The Gedok Show and the lady left', *Feminist Art Journal*, 1 (2) (1972): 8, 20.

Ritchie, Christina, 'Fuck yous, I'm going to bingo!', *Parallélogramme*, 8 (4) (1983): 37–47.

Robinson, Hilary, 'Within the pale in *From Beyond the Pale*: the construction of femininity in the curating of an exhibition season at the Irish Museum of Modern Art, Dublin', *Journal of Gender Studies*, 6 (3) (1997): 255–67.

Robinson, Hilary, 'The women's movement in art education', *Circa*, 89 (1999) (supplement on art education): 6–7.

Robinson, Jane, 'Women, cultural work and the cod moratorium', *Parallélogramme*, 20 (4) (1995): 21–8.

Rosenberg, Avis Lang, 'Anatomy of a situation: off the wall at the BC Artists Show', *Centerfold* (October/November 1979): 48–9.

Rosengarten, Linda, 'On the subject of rape', *LAICA Journal*, 15 (1977): 48–50.

Rosler, Martha, 'The birth and death of the viewer: on the public function of art', in *Discussions in Contemporary Culture*, ed. Hal Foster (Seattle: Dia Art Foundation/Bay Press, 1991), pp. 9–15.

Rosler, Martha, *Positions in the Life World* (Cambridge, MA: MIT Press; Birmingham: Ikon Gallery; Vienna: Generali Foundation, 1998).

Rosler, Martha and Wallis, Brian (eds), *If You Lived Here: The City in Art, Theory, and Social Activism* (Seattle: Bay Press, 1991).

Ross, Christine, 'History of a rupture', in *Sightlines: Reading Contemporary Canadian Art*, ed. Jessica Bradley and Lesley Johnstone (Montreal: Artextes Editions, 1994), pp. 168–97.

Ross, Christine, 'What's at stake at the Musée du Québec: "femmes-forces"', *Vanguard*, 17 (1) (1988): 42–4.

Sandell, Renee, 'Feminist art education: an analysis of the women's movement as an educational force', *Studies in Art Education*, 20 (2) (1979): 18–28.

Schapiro, Mimi, 'Our beginning', *Womanspace*, 1 (1) (1973): 7.

Schneemann, Carolee, 'From an unsent letter to Allan Kaprow', in *More than Meat Joy: Performance Works and Selected Writings* (New Paltz, NY: Documentext, 1974; 2nd edn, 1997), pp. 195–8.

Schor, Mira, 'Girls will be girls', *Artforum*, 29 (1) (1990): 124–7.

Schor, Mira, 'Troubleshooters', *Artforum*, 28 (10) (1990): 17–18.

Seaman, Patricia, 'Women on site', *Parachute*, 49 (1987–8): 38.

Seigel, Judy, 'Women in the arts – gallery action', *Feminist Art Journal*, 3 (1) (1974): 7, 25.

Shaver-Crandell, Annie, 'Let MoMA Know/WAVE demonstration', *Women's Caucus for Art, New York City Chapter Information* (August/September 1984), unpaginated.

Shaver-Crandell, Annie, 'Woman perceived: on teaching the imagery of women in art', *Women's Studies Quarterly*, special Issue: Teaching about Women and the Visual Arts, 15 (1–2) (1987): 54–5.

Sjöö, Monica, 'Feminist art and patriarchal culture: a contradiction', in *Toward a Revolutionary Feminist Art*, ed. Liz Moore et al. (Bristol: Liz Moore et al., 1973), pp. 1–4.

Skelton, Pam, 'Women and art education', *NATFHE Journal* (National Association of Teachers of Further and Higher Education) (May/June, 1985): 18–20.

Skiles, Jacqueline, 'Addendum: some notes on our founding and herstory', in *A Documentary Herstory of Women Artists in Revolution*, ed. Women's Interart Center (Pittsburgh: Know Inc., 1973), pp. 71–4.

Skiles, Jacqueline, *The Woman Artist's Movement* (Pittsburg, PA: Know Inc., 1972).

Spero, Nancy, 'The Whitney and women', *The Art Gallery* (January 1971): 26–7.

Stamerra, Joanne, 'Erasing sexism from MoMA', *Womanart*, 1 (1) (1976): 12–13.

Steele, Lisa, 'Affirmative action: women's presentations to the committee', *Fuse* (August/September 1981): 202–3.

Steele, Lisa, 'Women's cultural building: putting the practice before the architecture', *Fuse* (May/June 1982).

Steyn, Juliet, 'The women's peace mural', *Aspects* (Spring 1986), unpaginated.

Stoke, Christine, 'The Daylesford embroidered banner project', *Lip* (1984): 6–13.

Tamblyn, Christine, 'The river of swill: feminist art, sexual codes and censorship', *Afterimage*, 18 (October 1990): 10–13.

Tenhaaf, Nell, 'Powerhouse gallery: a statement', *Centerfold* (February/March 1979): 122–3.

Trucco, Terry, 'Where are the women museum directors?', *Art News*, 76 (February 1977): 52–7.

Tucker, Marcia, 'Common ground', *Museum News* (July/August 1990): 44–6.

Vance, Carole S. 'Issues and commentary: feminist fundamentalism, women against images', *Art in America*, 81 (September 1993): 35–7.

Vogel, Lise, 'Women, art, and feminism: syllabus' and 'An analysis', *Female Studies*, 7 (1973): 42–53.

van Wagner, Judy K. C., *Women Shaping Art: Profiles of Power* (New York: Praeger, 1984).

Walsh, Val, '"Walking on the ice": women, art education and art', *Journal of Art and Design Education*, 9 (2) (1990): 147–61.

Walsh, Val, 'Women up against art/education: history or practice?', *Drawing Fire: Journal of the National Association for Fine Art Education*, 2 (3) (1998): 17–23.

Weekes, Ann Owens, 'Students' self-image: representations of women in "high" art and popular culture', *Woman's Art Journal*, 13 (2) (1992–3): 32–8.

White, Barbara Erlich, 'A 1974 perspective: why women's studies in art and art history?', *Art Journal*, 35 (4) (1976): 340–4.

Williams, Linda, *Hard Core: Power, Pleasure and the Frenzy of the Visible* (Berkeley, CA: University of California Press, 1989; London: Pandora Press, 1990).

Withers, Josephine, 'The Guerrilla Girls', *Feminist Studies*, 14 (2) (1988): 284–300.

Women's Caucus for Art, 'Women's Caucus for Art statement of purpose', *Women's Caucus for Art, New York City Chapter Information* (August/September 1984), unpaginated.

Women's Workshop, 'Women's Workshop/Artist's Union', *Spare Rib*, 29 (1974).

Yeo, Marian, 'Murdered by misogyny: Lin Gibson's response to the Montreal massacre', *Canadian Woman Studies/Les cahiers de la femme*, 12 (1) (1991): 8–11.

Zaleski, Jean, 'Jurying: innovations by women in the arts', *Feminist Collage: Educating Women in the Visual Arts*, ed. Judy Loeb (New York: Columbia University Teachers College Press, 1979), pp. 241–6.

Chapter 3

'Excerpts from an invitational seminar on the life and work of Emily Carr', *Collapse*, 2 (1996): 78–121.

Irish Women Artists from the 18th Century to the Present Day (Dublin: National Gallery of Ireland, 1987).

Trouble in the Archives (Bloomington, IN: Indiana University Press, 1992) (also published as *Differences*, 4 (3) (1992).

Adler, Kathleen and Pointon, Marcia, *The Body Imaged: Human Form and Visual Culture since the Renaissance* (Cambridge: Cambridge University Press, 1993).

Alloway, Lawrence:, 'Women's art and the failure of art criticism', *Art Criticism*, 1 (Winter 1980): 55.

Alpers, Svetlana, 'Art history and its exclusions', in *Feminism and Art History: Questioning the Litany*, ed. Norma Broude and Mary D. Garrard (New York: Harper and Row, 1982), pp. 183–99.

Andreae, Janice, 'Reading three texts/projects by Carol Laing', *Matriart*, 7 (1–2) (1997): 8–17.

Arbour, Rose-Marie and Lemerise, Suzanne, 'The role of Quebec women in the plastic arts of the last thirty years', *Vie des Arts*, 20 (78) (1975): 65–7.

Baranik, Rudolf et al. ('The Catalog Committee'), *The Anti-catalog* (New York: The Catalog Committee, 1977).

Barber, Fionna, 'Feminist writings and art practice', *Circa*, 40 (1988): 33–5.

Barzman, Karen-Edis, 'Beyond the canon: feminists, postmodernism, and the history of art', *Journal of Aesthetics and Art Criticism*, 52 (3) (1994): 327–39.

Bashkirtseff, Marie, *The Journals of Marie Bashkirtseff* (London: Virago, 1984).

Bawden, Anne C. and Greenaway, W. K., 'Women in art and art history', *Atlantis: A Women's Studies Journal/Revue des études sur la femme*, 2 (2), pt 2 (Spring 1977): 143–50.

Bettelheim, Judith, 'Art history outside the canon: finding an ethnographic methodology for feminist art history', *Artweek* (8 February 1990): 25.

Bluestone, Natalie Harris (ed.), *Double Vision: Perspectives on Gender and the Visual Arts* (Cranbury, NJ: Associated University Presses, 1995).

Bontemps, Arna Alexander and Fonvielle-Bontemps, Jacqueline, 'African-American women artists: an historical perspective', *Sage*, 4 (1) (1987): 17–24.

Borzello, Frances, *The Artist's Model* (London: Junction Books, 1982).

Borzello, Frances, *Seeing Ourselves: Women's Self-portraits* (London: Thames and Hudson, 1998).

Breitling, Gisela, 'Speech, silence and the discourse of art: on conventions of speech and feminine consciousness', in *Feminist Aesthetics*, ed. Gisela Ecker (London: The Women's Press, 1985), pp. 162–74.

Broude, Norma, 'Degas's "misogyny"', *Art Bulletin*, 59 (March 1977): 95–107.

Broude, Norma, *Impressionism: A Feminist Reading – The Gendering of Art, Science, and Nature in the Nineteenth Century* (New York: Rizzoli, 1991).

Broude, Norma and Garrard, Mary D., 'Discussion: an exchange on "The Feminist Critique of Art History"', *Art Bulletin*, 71 (1989): 124–6.

Broude, Norma and Garrard, Mary D. (eds), *The Expanding Discourse: Feminism and Art History* (New York: Icon Editions, 1992).

Broude, Norma and Garrard, Mary D. (eds), *Feminism and Art History: Questioning the Litany* (New York: Harper and Row, 1982).

Buhler Lynes, Barbara, 'The language of criticism: Georgia O'Keeffe', *Women's Art Magazine*, 51 (1993): 4–19.

Burke, Janine, 'Feminist art criticism', in *The Women's Show, Adelaide 1977*, ed. Women's Art Movement (Adelaide: Experimental Art Foundation, 1978), pp. 61–2.

Burke, Janine, 'Sense and sensibility: women's art and feminist criticism' (1978), in *Dissonance: Feminism and the Arts 1970–1990*, ed. Catriona Moore (St Leonards, NSW: Allen and Unwin, 1994), pp. 52–6.

Callen, Anthea, *The Angel in the Studio: Women in the Arts and Crafts Movement* (London: Astragal, 1979).

Callen, Anthea, 'Sexual division of labor in the arts and craft movement', *Woman's Art Journal* (Fall 1984): 1–6.

Chadwick, Whitney, 'Balancing acts: reflections on postminimalism and gender in the 1970s', in *More than Minimal: Feminism and Abstraction in the '70s*, (Hanover, NH: Brandeis University, The Rose Art Museum, 1996).

Chadwick, Whitney, *Women, Art and Society* (London: Thames and Hudson, 1989; 2nd edn 1996).

Chadwick, Whitney, *Women Artists and the Surrealist Movement* (London: Thames and Hudson, 1985).

Chadwick, Whitney and de Courtivron, Isabelle (eds), *Significant Others: Creativity and Intimate Partnership* (London: Thames and Hudson, 1993).

Chave, Anna, 'O'Keeffe and the masculine gaze', *Art in America*, 78 (1990): 115–25.

Cherry, Deborah, 'Flowers in the desert', *Women's Art Magazine*, 52 (1993): 18–21.

Cherry, Deborah, *Painting Women: Victorian Women Artists* (London: Routledge, 1993).

Cherry, Deborah and Pollock, Griselda, 'Patriarchal power and the Pre-Raphaelites', *Art History*, 7 (4) (December 1984): 480–95.

Cherry, Deborah and Pollock, Griselda, 'Woman as sign in Pre-Raphaelite literature: a study of the representation of Elizabeth Siddall', *Art History*, 7 (2) (June 1984): 206–27.

Comini, Alessandra, 'Art history, revisionism, and some holy cows', *Arts Magazine*, 54 (June 1980): 96–100.

Comini, Alessandra, 'Titles can be troublesome: misinterpretations in male art criticism', *Art Criticism*, 1 (2) (1979): 50–4.

Coombs, Annie and Nead, Lynda, 'No more "old master" narratives', *Art Monthly*, 123 (1989): 15–17.

Cottingham, Laura, *Seeing through the Seventies: Essays on Feminism and Art* (Amsterdam: G + B Arts International, 2000).

Deepwell, Katy, 'Mapping feminism is necessary', *Siksi* 12 (4) (1997): 88–9.

Deepwell, Katy (ed.), *New Feminist Art Criticism: Critical Strategies* (Manchester: Manchester University Press, 1995).

Deepwell, Katy, *Ten Decades: Careers of Ten Women Artists Born 1897–1906* (Norwich: Norwich Gallery, 1992).

Deepwell, Katy (ed.), *Women Artists and Modernism* (Manchester: Manchester University Press, 1998).

Dobie, Elizabeth Ann, 'Interweaving feminist frameworks', *Journal of Aesthetics and Art Criticism*, 48 (Fall 1990): 381–94.

Doumato, Linda, 'The literature of woman in art', *Oxford Art Journal*, 3 (1) (1980): 74–7.

Doy, Gen, *Women and Visual Culture in Nineteenth-century France*, 1800–1852 (Leicester: Leicester University Press, 1998).

Duncan, Carol, *The Aesthetics of Power: Essays in Critical Art History* (Cambridge: Cambridge University Press, 1993).

Duncan, Carol, 'The esthetics of power in modern erotic art', *Heresies*, 1 (January 1977): 46–50; reprinted in *Feminist Art Criticism: An Anthology*, ed. Arlene Raven, Cassandra Langer and Joanna Frueh (London: UMI Research Press; New York, Icon Editions, 1988), pp. 59–70.

Duncan, Carol, 'Virility and male domination in early twentieth century vanguard art', *Artforum*, 12 (4) (1974).

Duncan, Carol, 'When greatness is a box of Wheaties', *Artforum* (October 1975): 60–4.

Edwards, Steve, *Art and its Histories: A Reader* (New Haven, CT: Yale University Press in association with the Open University, 1999).

Fer, Briony, *On Abstract Art* (New Haven, CT: Yale University Press, 1997).

Fine, Elsa Honig, *Women and Art: A History of Women Painters and Sculptors from the Renaissance to the Twentieth Century* (London: Allanheld and Schram/Prior, 1978).

Frueh, Joanna, 'A chorus of women's voices', *New Art Examiner* (May 1988): 25–7.

Frueh, Joanna, 'The dangerous sex: art language and power', *Women Artists News*, 10 (5) (September 1985): 6–7, 11.

Frueh, Joanna, Langer, Cassandra and Raven, Arlene (eds), *New Feminist Criticism: Art, Identity, Action* (New York: HarperCollins, 1994).

Gabhart, Ann and Broun, Elizabeth, 'Old mistresses: women artists of the past', *The Walters Art Gallery Bulletin* (special issue), 24 (7) (1972), unpaginated.

Garb, Tamar, *Sisters of the Brush: Women's Artistic Culture in Late Nineteenth Century Paris* (New Haven, CT: Yale University Press, 1994).

Garb, Tamar, 'Unpicking the seams of her disguise: self-representation in the work of Marie Bashkirtseff', *Block*, 13 (1987): 79–86.

Garrard, Mary D., *Artemisia Gentileschi around 1622: The Shaping and Reshaping of an Artistic Identity* (Berkeley, CA: University of California Press, 2000).

Garrard, Mary D., *Artemisia Gentileschi: The Image of the Female Hero in Italian Baroque Art* (Princeton, NJ: Princeton University Press, 1988).

Garrard, Mary D., 'Artemisia Gentileschi's self-portrait as the allegory of painting', *Art Bulletin*, 62 (March 1980): 97–112.

Garrard, Mary D., 'Feminism: has it changed art history?', *Heresies*, 4 (1978): 59–60.

Garrard, Mary D., '"Of men, women and art": some historical reflections', *Art Journal*, 35 (4) (1976): 324–9.

Gouma-Peterson, Thalia and Mathews, Patricia, 'The feminist critique of art history', *Art Bulletin*, 69 (September 1987): 327–57.

Gouma-Peterson, Thalia and Mathews, Patricia, 'Reply', *Art Bulletin*, 71 (March 1989): 126–7.

Greer, Germaine, *The Obstacle Race* (London: Weidenfeld and Nicolson, 1979).

Harris, Ann Sutherland and Nochlin, Linda, *Women Artists 1550–1950* (Los Angeles: Los Angeles County Musem of Art; New York: Alfred A. Knopf, 1978).

Havice, Christine, 'Feminist art history: a review essay', *Southern Quarterly*, 17 (2) (1979): 87–94.

Hess, Thomas and Nochlin, Linda (eds), *Woman as Sex Object: Studies in Erotic Art 1730–1970* (London: Allan Lane, 1973).

Hoorn, Jeanette (ed.), *Strange Women: Essays in Art and Gender* (Melbourne: Melbourne University Press, 1994).

Hudon, Christine, 'For a feminist approach to art history', *Canadian Woman Studies/Les cahiers de la femme*, 1 (3) (1979): 4–5.

Irigaray, Luce, 'The power of discourse and the subordination of the feminine', in *This Sex Which is Not One* (Ithaca, NY: Cornell University Press, 1985), pp. 76–85.

Iskin, Ruth, 'Selling, seduction, and soliciting the eye: Manet's bar at the Folies-Bergère', *Art Bulletin*, 77 (1) (1995): 25–44.

Jacobs, Frederika, *Defining the Renaissance Virtuosa* (Cambridge: Cambridge University Press, 1997).

Jolicoeur, Nicole, 'Of words, women, and art', in *Feminist toi-même, féministe quand même*, ed. Nicole Jolicoeur and Isabelle Bernier (Quebec: La Chambre Blanche, 1986), pp. 45–8.

Jones, Amelia, 'Modernist logic in feminist histories of art', *Camera Obscura*, 27 (September 1991): 149–65.

Jones, Amelia, 'Power and feminist art (history)', *Art History*, 18 (3) (September 1995): 435–59.

Jordanova, Ludmilla, 'Linda Nochlin's Lecture "Women, Art and Power"', in *Visual Theory: Painting and Interpretation*, ed. Norman Bryson, Michael Ann Holly and Keith Moxey (Cambridge: Polity Press, 1991), pp. 54–60.

Jordanova, Ludmilla, *Sexual Visions: Images of Gender in Science and Medicine in the 18th–20th Centuries* (Brighton: Harvester Wheatsheaf, 1989).

Kampen, Natalie B., 'Women's art: beginnings of a methodology', *Feminist Art Journal*, 1 (2) (Fall 1972): 10, 19.

Kampen, Natalie and Grossman, Elizabeth G., *Feminism and Methodology: Dynamics of Change in the History of Art and Architecture* (Wellesley, MA: Wellesley College Center for Research, 1983), pp. 1–9, 24–8.

Kendall, Richard and Pollock, Griselda (eds), *Dealing with Degas: Representations of Women and the Politics of Vision* (New York: Universe, 1992).

Kerr, Joan, *Heritage: The National Women's Art Book – 500 Australian Women Artists from Colonial Times to 1955* (Sydney: Craftsman House, 1995).

Kerr, Joan, 'National women's art exhibitions: three "firsts"', in *Past Present: The National Women's Art Anthology*, ed. Joan Kerr and Jo Holder (Sydney: Craftsman House, 1999), pp. 2–10.

Laing, Carol, 'How can we speak to painting?', *C Magazine*, 25 (1990): 19–24.

Langer, Cassandra L., 'Feminist art history: critique critiqued', *Women Artists News*, 12 (Fall/Winter 1987): 38, 62.

Langer, Cassandra L., 'Feminist art criticism: turning points and sticking places', *Art Journal*, 50 (2) (1991): 4–5, 21–8.

Langer, Sandra, 'Emerging feminist art history', *Art Criticism*, 1 (2) (1979): 66–84.

Langer, Sandra, 'Is there a new feminist criticism', *Women Artists News*, 10 (5) (1985): 4–5.

Lauter, Estella, 'Feminist interart criticism and American women artists – a contradiction in terms', *College Literature*, 19 (2) (1992): 98–105.

Lawrence, Cynthia (ed.), *Women and Art in Early Modern Europe: Patrons, Collectors, and Connoisseurs* (University Park, PA: Pennsylvania State University Press, 1997).

Leeks, Wendy, 'Ingres other-wise', *Oxford Art Journal*, 9 (1) (1996): 29–37.

Lippard, Lucy, 'On art and artists', interview by Kate Horsfield (1974), *Profile*, 1 (3) (1981): 1–8.

Lippard, Lucy, *The Pink Glass Swan: Selected Feminist Essays on Art* (New York: The New Press, 1995).

Lippard, Lucy, 'Projecting a feminist criticism', *Art Journal*, 35 (4) (1976): 337–9; excerpt from introduction to *From the Center: Feminist Essays on Women's Art* (New York: E. P. Dutton, 1976).

Lipton, Eunice, *Alias Olympia: A Woman's Search for Manet's Notorious Model and her own Desire* (New York: Charles Scribner's Sons, 1992).

Lomas, D. and Howell, R., 'Medical imagery in the art of Frida Kahlo', *British Medical Journal*, 299 (December 1989): 23–30.

McCoid, Catherine Hodge and McDermott, LeRoy D., 'Toward decolonizing gender: female vision in the Upper Paleolithic', *American Anthropologist*, 98 (2) (1996): 319–26.

Magenta, Muriel, 'Feminist art criticism: a political definition', *Woman Image Now: Arizona Women in Art*, 2 (April 1984): 12–18.

Mainardi, Pat, 'Quilts: the great American art', *Feminist Art Journal*, 2 (1) (1973): 1, 18–23; reprinted in *Feminism and Art History: Questioning the Litany*, ed. Norma Broude and Mary D. Garrard (New York: Harper and Row, 1982), pp. 331–46.

Marsh, Jan, *The Pre-Raphaelite Sisterhood* (London: Quartet Books, 1985).

Mathews, Patricia, 'Feminist art criticism: multiple voices and changing paradigms', *Art Criticism*, 5 (2) (1989): 1–34.

Mathews, Patricia, 'Gender analysis and the work of Meyer Schapiro', *Oxford Art Journal*, 17 (1) (1994): 81–91.

Meskimmon, Marsha, *We Weren't Modern Enough: Women Artists and the Limits of German Modernism* (Berkeley, CA: University of California Press, 1999).

Meskimmon, Marsha and West, Shearer (eds), *Visions of the 'Neue Frau': Women and the Visual Arts in Weimar Germany* (Aldershot: Scholar Press; Brookfield, Vt.: Ashgate, 1995).

Mitchell, Marilyn Hall, 'Sexist art criticism: Georgia O'Keeffe – a case study', *Signs*, 3 (3) (1978): 681–7.

Modleski, Tania, *Feminism without Women: Culture and Criticism in a 'Postfeminist' Age* (London: Routledge, 1991).

Mulvey, Laura and Wollen, Peter, *Frida Kahlo and Tina Modotti* (London: Whitechapel Art Gallery, 1982).

Nead, Lynda, 'Feminism, art history and cultural politics', in *The New Art History*, ed. Al Rees and Frances Borzello (London: Camden Press, 1986).

Nead, Lynda, *Myths of Sexuality: Representations of Women in Victorian Britain* (Oxford: Blackwell, 1988).

Neale, Margo, 'Past present continuous: the presentation and interpretation of indigenous art', in *Past Present: The National Women's Art Anthology*, ed. Joan Kerr and Jo Holder (Sydney: Craftsman House, 1999), pp. 20–9.

Nemser, Cindy, 'Analysis: critics of women's art', *Feminist Art Journal*, 1 (1971): 14.

Nemser, Cindy, 'Art criticism and women artists', *Journal of Aesthetic Education*, 7 (3) (1973): 73–83.

Nemser, Cindy, 'Art criticism and women artists', *Visual Dialog*, 1 (2) (1975–6): 4–6.

Nochlin, Linda, 'An interview with Linda Nochlin', interview by Carolyn A. Cotton and Barbara B. Miller, *Rutgers Art Review*, 6 (1985): 78–91.

Nochlin, Linda, *Representing Women* (New York: Thames and Hudson, 1999).

Nochlin, Linda, 'Starting from scratch', *Women's Art Magazine*, 61 (1994): 6–11.

Nochlin, Linda, 'Starting from scratch: the beginnings of feminist art history', in *The Power of Feminist Art: The American Movement of the 1970s, History and Impact*, ed. Norma Broude and Mary D. Garrard (New York: Harry N. Abrams, 1994), pp. 130–7.

Nochlin, Linda, 'Why have there been no great women artists?', *Artnews* (January 1971): 20–39, 67–71; reprinted in *Women, Art, and Power, and Other Essays* (London: Thames and Hudson, 1991), pp. 145–77.

Nochlin, Linda, *Women, Art, and Power, and Other Essays* (London: Thames and Hudson, 1991).

Nochlin, Linda, 'Women artists in the 20th century: issues, problems, controversies', *Studio* 193 (May/June 1977): 165–74.

Nunn, Pamela Gerrish, *Victorian Women Artists* (London: The Women's Press, 1987).

Ockman, Carol, *Ingres's Eroticized Bodies: Retracing the Serpentine Line* (New Haven, CT: Yale University Press, 1995).

Orenstein, Gloria Feman, 'Art history', *Signs*, 1 (2) (1975): 505–25.

Orton, Fred and Pollock, Griselda, *Avant-gardes and Partisans Reviewed* (Manchester: Manchester University Press, 1996).

Parker, Rozsika, 'Breaking the mould', *New Statesman* (2 November 1979): 681–2.

Parker, Rozsika, 'Portrait of the artist as a young woman: Marie Bashkirtseff', *Spare Rib*, 34 (1975): 32–5.

Parker, Rozsika, 'The word for embroidery was work', *Spare Rib*, 37 (1975): 41–5.

Parker, Rozsika and Pollock, Griselda, *Old Mistresses: Women, Art and Ideology* (London: Routledge and Kegan Paul, 1981).

Peers, Juliet, 'Place aux dames: women artists and historical memory', in *Past Present: The National Women's Art Anthology*, ed. Joan Kerr and Jo Holder (Sydney: Craftsman House, 1999), pp. 30–9.

Pindell, Howardena, 'Criticism/or/between the lines', in *The Heart of the Question: The Writings and Paintings of Howardena Pindell* (New York: Midmarch, 1997), pp. 81–3.

Pointon, Marcia, 'Interior portraits: women, physiology and the male artist', *Feminist Review*, 22 (1986): 5–22.

Pointon, Marcia, *Naked Authority: The Body in Western Painting 1830–1908* (Cambridge: Cambridge University Press, 1990).

Pointon, Marcia, *Strategies for Showing: Women, Possession and Representation in English Visual Culture 1665–1800* (Oxford: Oxford University Press, 1997).

Pollock, Griselda, *Avant-garde Gambits 1888–1893: Gender and the Colour of Art History* (London: Thames and Hudson, 1992).

Pollock, Griselda, 'The case of the missing women', in *The Point of Theory: Practices of Cultural Analysis*, ed. Mieke Bal and Inge Boer (Amsterdam: Amsterdam University Press, 1994), pp. 91–108.

Pollock, Griselda, 'Critical reflections', *Artforum*, 28 (6) (1990): 126–7.

Pollock, Griselda, *Differencing the Canon: Feminist Desire and the Writing of Art's Histories* (London: Routledge, 1999).

Pollock, Griselda, *Mary Cassatt: Painter of Modern Women* (New York: Thames and Hudson, 1998).

Pollock, Griselda, 'Painting, feminism, history', in *Destabilising Theory: Contemporary Feminist Debates*, ed. Michèle Barrett and Anne Phillips (Cambridge: Polity Press, 1992), pp. 138–76.

Pollock, Griselda, 'The politics of theory: generations and geographies in feminist theory and the histories of art', in *Generations and Geographies in the Visual Arts: Feminist Readings*, ed. Griselda Pollock (London: Routledge, 1996), pp. 3–21.

Pollock, Griselda, 'Theory, ideology, politics: art history and its myths', *Art Bulletin*, 78 (1996): 16–22.

Pollock, Griselda, 'Trouble in the archives: introduction', *Differences*, 4 (3) (1992): iii–xiv.

Pollock, Griselda, 'Underground women: art by women in the basement of the National Gallery', *Spare Rib*, 21 (1974): 36–8.

Pollock, Griselda, *Vision and Difference: Femininity, Feminism and the Histories of Art* (London: Routledge, 1988).

Pollock, Griselda, 'Vision, voice and power: feminist art history and marxism', *Block*, 6 (1982): 2–21.

Pollock, Griselda, 'Women, art and ideology; questions for feminist art historians', *Women's Art Journal*, 4 (1) (1983): 39–47; reprinted in *Visibly Female: Feminism and Art Today – An Anthology*, ed. Hilary Robinson (London, Camden Press, 1987; New York: Universe, 1988), pp. 203–21.

Rando, Flavia, 'Vermeer, Jane Gallop, and the other/woman: feminist theory, art history', *Art Journal*, 55 (4) (1996): 34–41.

Raven, Arlene, Langer, Cassandra and Frueh, Joanna (eds), *Feminist Art Criticism: An Anthology* (London: UMI Research Press; New York, Icon Editions, 1988).

Rees, A. L. and Borzello, Frances (eds), *The New Art History* (London: Camden Press, 1986).

Rickey, Carrie, 'Why women don't express themselves', *Village Voice* (2 November 1982).

Rogoff, Irit, 'Gossip as testimony: a postmodern signature', *Women's Art Magazine*, 67 (1995): 6–9; reprinted in *Generations and Geographies in the Visual Arts: Feminist Readings*, ed. Griselda Pollock (London: Routledge, 1996), pp. 58–65.

Rom, Cristine, 'One view: the feminist art journal', *Woman's Art Journal*, 2 (2) (Fall 1981/Winter 1982): 32–8.

Rosenberg, Avis Lang, 'Woman-as-other in the art of men', *Vanguard*, 3 (6) (August 1974): 5.

Russell, H. Diane, *Eva/Ave: Woman in Renaissance and Baroque Prints* (Washington: National Gallery of Art; New York: Feminist Press at the City University of New York, 1990).

Sawelson-Gorse, Naomi, *Women in Dada: Essays on Sex, Gender, and Identity* (Cambridge, MA: MIT Press, 1998).

Schor, Mira, 'Appropriated sexuality', *M/E/A/N/I/N/G*, 1 (1986): 8–17.

Schor, Mira, 'Patrilineage', *Art Journal*, 50 (2) (1991): 58–63; reprinted in *New Feminist Criticism: Art, Identity, Action*, ed. Joanna Frueh, Cassandra Langer and Arlene Raven (New York: HarperCollins, 1994), pp. 42–59.

Schwartz, Therese, 'They built women a bad art history', *Feminist Art Journal*, 2 (Fall 1973): 10–11, 22.

Seddon, Jill and Worden, Suzette (eds), *Women Designing: Redefining Design in Britain between the Wars* (Brighton: University of Brighton, 1994).

Sheriff, Mary D., *The Exceptional Woman: Elisabeth Vigée-Lebrun and the Cultural Politics of Art* (Chicago: Chicago University Press, 1996).

Sherman, Clare Richer, with Holcomb, Adele M., *Women as Interpreters of the Visual Arts 1820–1979* (Westport, CT: Greenwood Press, 1981).

Sherman, Daniel J. and Rogoff, Irit (eds), *Museum Culture: Histories, Discourses, Spectacles* (London: Routledge, 1994).

Simons, Patricia, 'Lesbian (in)visibility in Italian Renaissance culture: Diana and other cases of donna con donna', *Journal of Homosexuality*, 27 (1–2) (1994): 81–122.

Simons, Patricia, 'Women in frames: the gaze, the eye, the profile in Renaissance portraiture', *History Workshop*, 25 (1988): 4–30; reprinted in *The Expanding Discourse: Feminism and Art History*, ed. Norma Broude and Mary D. Garrard (New York: Icon Editions, 1992), pp. 39–57.

Sims, Lowery, 'Art: 19th century black women artists', *Easy Magazine* (January 1978): 32.

Solomon-Godeau, Abigail, 'Reconsidering erotic photography: notes for a project of historical salvage', *LAICA Journal*, 47 (5) (1987): 51–8.

Sontag, Susan, 'Women, the arts, and the politics of culture', *Salmagundi* (Fall 1975–Winter 1976): 28–48.

Tickner, Lisa, 'An introduction', *Women's Images of Men* (London: ICA, 1980).

Tickner, Lisa, 'The object of art history', *Art Bulletin*, 76 (September 1994): 404–7.

Tickner, Lisa, 'Pankhurst, Modersohn-Becker and the obstacle race', *Block*, 2 (1980): 24–39.

Tickner, Lisa, *The Spectacle of Women: Imagery of the Suffrage Campaign, 1907–14* (London: Chatto and Windus, 1987).

Tufts, Eleanor, 'Beyond Gardner, Gombrich and Janson: towards a total history of art', *Arts Magazine*, 55 (8) (1981): 150–4.

Tufts, Eleanor, *Our Hidden Heritage: Five Centuries of Women Artists* (London: Paddington Press, 1974).

Vogel, Lise, 'Erotica, the academy and art publishing: a review of *Woman as Sex Object: Studies in Erotic Art 1730–1970, New York 1972*', *Art Journal*, 35 (4) (1976): 378–85.

Vogel, Lise, 'Fine arts and feminism: the awakening consciousness', *Feminist Studies*, 2 (1) (1974): 23–37; reprinted in *Feminist Art Criticism: An Anthology*, ed. by Arlene Raven, Cassandra Langer and Joanna Frueh (London: UMI Research Press; New York, Icon Editions, 1988): 21–58.

Wallace, Michele, 'Negative images: towards a black feminist cultural criticism', in *Invisibility Blues: From Pop to Theory* (London: Verso, 1990), pp. 241–55.

Williams, Val, *Women Photographers: The Other Observers 1900 to the Present* (London: Marion Boyers, 1986).

Wilson, Judith, 'Hagar's daughters: social history, cultural heritage, and Afro-US women's art', in *Bearing Witness: Contemporary Works by African American Women Artists*, ed. Jontyle Theresa Robinson (New York: Rizzoli/Spelman College, 1996), pp. 95–112.

Wolff, Janet, 'The artist, the critic and the academic: feminism's problematic relationship with "theory"', in *New Feminist Art Criticism: Critical Strategies*, ed. Katy Deepwell (Manchester: Manchester University Press, 1995), pp. 14–19.

Wolff, Janet, 'The excursions of theory: feminist ambivalence in art practice', in *Theory Rules: Art as Theory, Theory and Art*, ed. Jody Berland, Will Straw and David Tomas (Toronto: YYZ Books, 1996), pp. 177–91.

Wolff, Janet, *Feminine Sentences: Essays in Women and Culture* (Cambridge: Polity Press, 1990).

Wolff, Janet, *Resident Alien: Feminist Cultural Criticism* (Cambridge: Polity Press, 1995).

Wolff, Janet, *The Social Production of Art* (Basingstoke: Macmillan, 1981).

Women Artists Collective, 'Women's art, 1877–1977', *Spare Rib*, 103 (1981).

Zelevansky, Lynn (ed.), *Sense and Sensibility: Women Artists and Minimalism in the Nineties* (New York: Museum of Modern Art, 1994).

Chapter 4

'Forum: what is female imagery?', *Ms*, 3 (11) (May 1975): 62–4, 80–3.

Barling, Marion, 'To be or not to be? Or, and from the darkness, let there be light: some thoughts on developing a feminist aesthetic', *Resources for Feminist Research/Documentation sur la recherche féministe*, 13 (4) (1984–6): 29.

Battersby, Christine, *Gender and Genius: Towards a Feminist Aesthetics* (London: The Women's Press, 1989).

Benjamin, Andrew and Osbourne, Peter (eds), *Thinking Art: Beyond Traditional Aesthetics* (London: ICA, 1991).

Bettelheim, Judith, 'Pattern painting: the new decorative – a Californian perspective', *Images and Issues* (March/April, 1983): 32–6.

Brand, Peggy Zeglin (ed.), *Beauty Matters* (Bloomington, IN: Indiana University Press, 2000).

Brand, Peggy Zeglin and Korsmeyer, Carolyn (eds), *Feminism and Tradition in Aesthetics* (University Park, PA: Pennsylvania State University Press, 1995).

Caputi, Mary, 'Identity and non-identity in aesthetic theory', *Differences*, 8 (3) (1996): 128–47.

Davis, Hilary E., 'The temptations and limitations of a feminist aesthetic', *Journal of Aesthetic Education*, 27 (1) (1993): 99–105.

Ecker, Gisela (ed.), *Feminist Aesthetics* (London: The Women's Press, 1985).

Felski, Rita, *Beyond Feminist Aesthetics: Feminist Literature and Social Change* (London: Hutchinson Radius, 1989).

Florence, Penny and Foster, Nicola (eds), *Differential Aesthetics: Art Practices and Philosophies – Towards New Feminist Understandings* (London: Ashgate Press, 2000).

Garber, Elizabeth, 'Feminism, aesthetics, and art education', *Studies in Art Education*, 33 (4) (1992): 210–25.

Gates, Eugene, 'The female voice: sexual aesthetics revisited', *Journal of Aesthetic Education*, 22 (Winter 1988): 58–68.

Hammond, Harmony, 'Monstrous beauty', in *Wrappings: Essays on Feminism, Art and the Martial Arts* (New York: Mussmann Bruce, 1984), pp. 87–93.

Hein, Hilde and Korsmeyer, Carolyn (eds), *Aesthetics in Feminist Perspective* (Bloomington, IN: Indiana University Press, 1993).

hooks, bell, 'Aesthetic inheritances: history worked by hand', in *Yearning: Race, Gender and Cultural Politics* (Boston: MA: South End Press, 1990), pp. 115–22.

hooks, bell, 'Beauty laid bare: aesthetics in the ordinary', in *Art on my Mind: Visual Politics* (New York: The New Press, 1995), pp. 119–24.

James, Julia, and Keeping, Sara, 'Discussing female aesthetics' (report from workshop at WAC Conference, 1982), *Feminist Art News*, 10 (1983): 12.

Korsmeyer, Carolyn, 'Philosophy, aesthetics, and feminist scholarship', in *Aesthetics in Feminist Perspective*, ed. Hilde Hein and Carolyn Korsmeyer (Bloomington, IN: Indiana University Press, 1993), pp. vii–xv.

Kraft, Selma, 'Cognitive function and women's art', *Woman's Art Journal* (Fall/Winter 1983–4): 5–9.

Krauss, Rosalind E., *Bachelors: Essays on Nine Women Bachelors who Challenged Masculinist Aesthetics* (Cambridge, MA: MIT Press, 1999).

McCormack, Thelma, 'In her place: issues in feminist aesthetics', *Vanguard*, 16 (3) (Summer 1987): 24–6.

Mainardi, Pat, 'Feminine sensibility: an analyisis', *Feminist Art Journal*, 1 (2) (1972): 10, 22.

Morse, Marcia, 'Feminist aesthetics and the spectrum of gender', *Philosophy East and West*, 42 (2) (1992): 287–95.

Nemser, Cindy, 'Art criticism and the gender prejudice', *Arts Magazine*, 46 (5) (March 1972): 44–6.

Piper, Adrian, 'A paradox of conscience: analytical philosophy and the ethics of contemporary art practice', *New Art Examiner* (April 1989): 27–31.

Piper, Adrian, 'Performance and the fetishism of the art object', *Vanguard*, 10 (2) (January 1982): 16–19.

Raven, Arlene, 'Women's art: the development of a theoretical perspective', *Womanspace*, 1 (1) (1973): 14–20.

Schaffer, Talia and Psomiades, Kathy Alexis (eds), *Women and British Aestheticism* (London: University Press of Virginia, 1999).

Schapiro, Miriam and Chicago, Judy, 'Female imagery', *Womanspace*, 1 (3) (1973): 11–14.

Schor, Naomi, *Reading in Detail: Aesthetics and the Feminine* (London: Methuen, 1987), pp. 11–22.

Stokes Sims, Lowery, 'The mirror, the other: the politics of aesthetics', *Artforum*, 28 (7) (1990): 111–15.

Wilding, Faith, 'Women artists and female imagery', *Everywoman*, 2 (7) (1972): 18–19.

Wolff, Janet, *Aesthetics and the Sociology of Art* (London: George Allen and Unwin, 1983).

Chapter 5

Division of Labor: Women's Work in Contemporary Art (Bronx, NY: Bronx Museum, 1995).
Frames of Reference: Aspects of Feminism and Art (Sydney: Artspace, 1991).
Semaine de la vidéo féministe québécoise (Québec: Ministère des Affaires Culturelles, 1982).
Sense and Sensibility in Feminist Art Practice (Nottingham: Midland Group, 1982).
Allen, Jan et al., *Femscript: Transcript of the Proceedings of the Symposium on Feminist Art Practice, 29 January 1995, Agnes Etherington Art Centre, Kingston, Ontario* (Kingston, Ont.: Organization of Kingston Women Artists, 1996).
Alloway, Lawrence, 'Women's art in the 70s', *Art in America*, 64 (1976): 64–72.
Arbour, Rose Marie, 'Femmes et production artistique: à propos de quelques événements récents', *Possibles*, 6 (3–4) (1982): 235–48.
Arbour, Rose Marie, 'L'art par amour', *Possibles*, 10 (3–4) (1986): 289–97.
Armatage, Kay, 'Feminist new narrative: shock troops or rear guard?', *Border/lines*, 6 (Winter 1986–7): 18–21.
Avgikos, Jan, 'Seeing with our bodies', *Tema Celeste*, 37–8 (1992): 38–43.
Baker, Bobby, 'Drawing on a mother's experience' (performance text), *n.paradoxa*, 5 (2000): 58–62.
Baert, Renée, 'Abandonment and grace: the architectural interventions of Martha Fleming and Lyne Lapointe', *Canadian Art*, 7 (1) (1990): 72–7.
Barnett, Pennina, *The Subversive Stitch* (Manchester: Cornerhouse Art Gallery, 1986).
Barry, Judith and Flitterman-Lewis, Sandy, 'Textual strategies: the politics of art-making', *Lip* (1981); edited version in *Screen* (Summer 1980); reprinted in *Visibly Female: Feminism and Art Today – An Anthology*, ed. Hilary Robinson (London: Camden Press, 1987), pp. 106–17; also in *Feminist Art Criticism: An Anthology*, ed. Arlene Raven, Cassandra Langer and Joanna Frueh (London: UMI Research Press; New York, Icon Editions, 1988), pp. 87–98; *Framing Feminism: Art and the Women's Movement 1970–1985*, ed. Rozsika Parker and Griselda Pollock (London: Pandora Press, 1987).
Barwell, Jenny and Binns, Vivienne, 'The development of a political view: a conversation between two women artists', *Lip* (1978–9): 43–9.
Batten, Juliet, 'What is a feminist artist?', *Broadsheet*, 110 (June 1983): 20–31.
Bell, Janis, 'Conversations with May Stevens', in *May Stevens: Ordinary/Extraordinary*, ed. Melisa Dabakis and Janis Bell (New York: Universe Books, 1988), pp. 35–42.
Betterton, Rosemary, 'Brushes with a feminist aesthetic', *Womens Art Magazine*, 66 (September/October 1995): 6–11.
Betterton, Rosemary, *(Dis)parities* (Sheffield: Mappin Gallery, 1993), unpaginated.
Bourgeois, Louise, 'Child abuse,' *Artforum*, 21 (4) (1982): 40–7.
Boyce, Sonia, 'The art of identity: Sonia Boyce interviewed by Manthia Diawara', *Transition*, 55 (1992): 192–201.
Boyce, Sonia, 'Something else', *Spare Rib*, 230 (1991–2): 32–5.
Burko, Diane et al., 'More on women's art: an exchange', *Art in America*, 64 (6) (1976): 11–23.
Butler, Sheila, 'More thoughts on painting', *C Magazine*, 21 (1991): 11–13.
Case, Sue-Ellen, *The Domain-matrix: Performing Lesbian at the End of Print Culture* (Bloomington, IN: Indiana University Press, 1996).
Chicago, Judy, 'Art, audience, and The Dinner Party', interview by Sandy Ballatore, *Images and Issues*, 1 (1) (1980): 36–9.
Chicago, Judy, 'The Dinner Party project: an interview with Judy Chicago', interview by Susan Rennie and Arlene Raven, *Chrysalis*, 4 (1977): 89–101.
Condé, Carol, 'Washing the dishes', *Fireweed*, 15 (1982): 41–5.
Cottingham, Laura, *How Many 'Bad' Feminists Does it Take to Change a Lightbulb?* (New York: Sixty Percent Solution, 1994).

Cottingham, Laura, 'Thoughts are things: what is a woman?', interview with Mary Kelly, *Contemporanea* (September 1990): 44–9.

Cousineau, Penny, ' "In my Fantasies, I'm the Man": Sophie Calle's true stories', *Parachute*, 82 (1996): 11–15.

Croft, Susan and MacDonald, Claire, 'Performing postures', *Women's Art Magazine*, 57 (March/April 1994): 9–12.

Dalton, Pen, 'Feminist art practice and the mass media: a "personal" account', *Women's Studies International Quarterly*, 3 (1) (1980): 55–7.

Damon, Betsy, 'The 7000 year old woman', *Heresies*, 3 (1977): 11–13.

Davies, Suzanne, 'Private and public: points of departure – the work of Margaret Harrison', *Lip* (1984): 20–4.

Davis, Tricia and Goodall, Phil, 'Personally and politically: feminist art practice', *Feminist Review*, 1 (1979): 21–35; reprinted in *Framing Feminism: Art and the Women's Movement* 1970–1985, ed. Rozsika Parker and Griselda Pollock (London: Pandora Press, 1987), pp. 293–302.

Dawkins, Heather, 'Cultural politics, social history and embroidery', *Vanguard*, 14 (7) (September 1985): 10–12.

Deepwell, Katy, 'In defence of the indefensible: feminism, painting and postmodernism', *Feminist Art News*, 2 (1987): 9–12.

Deepwell, Katy, 'Landscape and feminist art practices', *Women Artists' Slide Library Journal*, 27 (1989): 25–6.

Dubreuil-Blondin, Nicole, 'De quel centre? La situation paradoxale de l'art des femmes', *Galerie Jolliet Bulletin*, 5 (March 1981): 2, 15–16.

Elliott, Bridget, *Dangerous Goods: Feminist Visual Art Practices* (Edmonton: Edmonton Art Gallery, 1990).

Falkenstein, Michelle, 'What's so good about being bad?', *Art News*, 98 (10) (1999): 158–63.

Farris, Phoebe, 'Racializing gender: women photographers from the seventies to the millennium', *Camerawork*, 26 (2) (1999): 42–5.

Fleming, Martha, 'The production of meaning: Karl Beveridge and Carol Conde', *Block*, 8 (1983): 24–33; plus response in *Block*, 9 (1984): 14.

Florence, Penny and Reynolds, Dee (eds) *Feminist Subjects: Multi-media* (Manchester: Manchester University Press, 1995).

Forte, Jeanie, 'Women's performance art: feminism and postmodernism', *Theater Journal*, 40 (2) (1988): 217–35.

Fortnum, Rebecca and Houghton, Gill, 'Women and contemporary painting: re-presenting non-representation', *Women Artists' Slide Library Journal*, 28 (1989): 4–5.

Frueh, Joanna, Langer, Cassandra and Raven, Arlene (eds), *New Feminist Criticism: Art, Identity, Action* (New York: Icon Editions, 1994).

Fulton, Jean, 'A feminist resolution: the art of Nancy Spero', *New Art Examiner* (February 1989): 32–5.

Garrard, Rose, *Rose Garrard: Archiving my own History: Documentation of Works, 1969–1994* (Manchester: Cornerhouse; London: South London Gallery, 1994).

Grace, Helen, 'From the margins: a feminist essay on women's art', *Lip* (1981–2): 13–18.

Grzinic, Marina, 'Media and body politics', *n.paradoxa*, 2 (1998): 23–31.

Hammond, Harmony, 'Creating feminist works', in *Wrappings: Essays on Feminism, Art, and the Martial Arts* (New York: Mussmann Bruce, 1984), pp. 11–18.

Hammond, Harmony, 'Curator's statement', in *Home Work: The Domestic Environment Reflected in Work by Contemporary Women Artists* (Seneca Falls, NY: National Women's Hall of Fame, 1981), pp. 3–4.

Hammond, Harmony, 'Feminist abstract art: a political viewpoint', *Heresies*, 1 (1977): 66–70.

Harris, Geraldine, *Staging Femininities: Performance and Performativity* (Manchester: Manchester University Press, 1999).

Harrison, Margaret, 'Margaret Harrison', interview by Geoffrey Dunlop, in *Margaret Harrison: Work from Cumberland and Recent Work* (Carlisle: Carlisle Museum and Art Gallery, 1980), pp. 12–15.

Hart, Lynda and Phelan, Peggy (eds), *Acting Out: Feminist Performances* (Ann Arbor: University of Michigan Press, 1993).

Hershman, Lynn, 'Touch sensitivity and other forms of subversion: interactive artwork', *Leonardo*, 26 (5) (1993): 431–6.

Hershman Leeson, Lynn, *Clicking In: Hot Links to a Digital Culture* (Seattle: Bay Press, 1996).

Hiller, Susan, *Thinking about Art: Conversations with Susan Hiller*, ed. and intro. Barbara Einzig (Manchester: Manchester University Press, 1996).

hooks, bell, 'Talking art with Carrie Mae Weems', *Art on my Mind: Visual Politics* (New York: The New Press, 1995), pp. 74–93.

Hunter, Alexis, 'Feminist perceptions', *Artscribe*, 25 (October 1980): 25–9.

Isaak, Jo Anna, 'Seduction without desire', *Vanguard*, 16 (3) (1987): 11–14.

Isaak, Jo Anna, 'A work in comic courage: Nancy Spero', *Parachute*, 51 (June/August 1988): 11–15.

Jefferies, Janet, 'Text and textiles: weaving across the borderlines', in *New Feminist Art Criticism: Critical Strategies*, ed. Katy Deepwell (Manchester: Manchester University Press, 1995), pp. 164–73.

Kaneda, Shirley, 'Painting and its others', *Arts Magazine*, 65 (10) (1991): 58–64.

Kelly, Mary, *Interim* (Cambridge: Kettle's Yard, 1986).

Kelly, Mary, 'Mary Kelly interviewed by Terrence Maloon', *Artscribe*, 13 (1978): 16–19.

Kelly, Mary, 'Notes on reading the *Post-partum Document*', *Control Magazine*, 10 (1977): 10–12.

Kelly, Mary, *Post-partum Document* (London: Routledge and Kegan Paul, 1983).

Kelly, Mary, 'Sexual politics', in *Art and Politics: Proceedings of a Conference on Art and Politics Held on 15th and 16th April 1977*, ed. Brandon Taylor (Winchester: Winchester School of Art Press, 1980), pp. 66–75; reprinted in *Framing Feminism: Art and the Women's Movement 1970–1985*, ed. Rozsika Parker and Griselda Pollock (London: Pandora Press, 1987), pp. 303–12; Mary Kelly, *Imaging Desire* (Cambridge, MA: MIT Press, 1996), pp. 2–10.

Kelly, Mary, 'What is feminist art?', in *Towards Another Picture: An Anthology of Artist's Writings* (Nottingham: The Midland Group, 1977), pp. 226.

Kent, Sarah, 'Feminism and decadence', *Artscribe*, 47 (July/August 1984): 54–61.

Key, Joan, 'Models of painting practice: too much body?', in *New Feminist Art Criticism: Critical Strategies*, ed. Katy Deepwell (Manchester: Manchester University Press, 1995), pp. 153–61.

Kolbowski, Silvia, 'Legacies of critical practice in the 1980s', *Discussions in Contemporary Culture*, vol. 1, ed. Hal Foster (Seattle: Dia Art Foundation/Bay Press, 1991), pp. 99–103.

Kozloff, Joyce, *Interviews with Women in the Arts, Part 1* (New York: School of Visual Arts, 1975).

Kozloff, Joyce, *Interviews with Women in the Arts, Part 2* (New York: School of Visual Arts, 1976).

Kraft, Selina, 'Definition of feminist art or feminist definition of art?', in *Politics, Gender and the Arts: Women, the Arts and Society*, ed. Roland Dotterer and Susan Bowers (London: Associated University Press, 1992), pp. 11-18.

Kruger, Barbara, 'Repositioning, no repose', interview by Monica Gagnon, *Border/lines*, 2 (Spring 1985): 13–15.

Kuby, Lolette, 'The hoodwinking of the women's movement: Judy Chicago's Dinner Party', *Frontiers*, 6 (3) (1982): 127–9.

Lacy, Suzanne, 'Skeptical of the spectacle', *The Act*, 2 (4) (1990): 36–42.

Lacy, Suzanne and Lippard, Lucy, 'Political performance art', *Heresies*, 17 (1984): 22–5.

Langon, Ann R., 'Feminist art: what is it? where is it?', *Women Artists News*, 8 (5–6) (1983): 22.

Lavin, Maud, 'What's so bad about "bad girl" art?', *Ms*, 4 (5) (1994): 80–3.

Lippard, Lucy, 'Both sides now (a reprise)', *Heresies*, 24 (1989): 29–34: reprinted in *The Pink Glass Swan: Selected Feminist Essays on Art* (New York: The New Press, 1995), pp. 266–77.

Lippard, Lucy, 'Lacy: some of her own medicine', *Drama Review*, special issue, 32 (1) (1988): 71–6.

Lippard, Lucy, 'May Steven's Big Daddies', *Women's Studies*, 3 (1) (1975): 89–91.

Lippard, Lucy, *Six Years: The Dematerialization of the Art Object from 1966 to 1972* (Berkeley, CA: University of California Press, 1973).

Lippard, Lucy, 'Yvonne Rainer on feminism and her film', *Feminist Art Journal*, 4 (22) (1975): 5–11.

McDonald, Susan S., 'Making art: political and personal change', *WARM: A Landmark Exhibition*, ed. Hazel Blevo (Minneapolis, MN: Women's Art Registery of Minnesota, 1984), pp. 12–16.

Mansell, Alice, 'Towards a feminist visual practice', *Canadian Woman Studies/Les cahiers de la femme*, 11 (1) (Downsview, Ont.: York University, 1990), pp. 29–30.

Marsh, Anne and Kent, Jane (eds), *Live Art: Australia and America* (Adelaide: Anne Marsh and Jane Kent, 1984).

Mastai, Judith, 'Thou shalt not . . . the law of the mother', in *Women and Paint* (Saskatoon: Mendel Art Gallery, 1995), pp. 8–14.

Mayer, Mónica, 'On life and art as a feminist', *n.paradoxa* (online), 9 (1999).

Mellencamp, Patricia, *Indiscretions: Avantgarde Film, Video and Feminisms* (Bloomington, IN: Indiana University Press, 1990).

Meyer, Melissa and Schapiro, Miriam, 'Waste not, want not: an inquiry into what women saved and assembled: femmage', *Heresies*, 4 (1978): 66–9.

Miller, Lynn F. et al., *Lives and Works: Talks with Women Artists* (Metuchen, NJ: Scarecrow Press, 1981).

Millett, Kate, 'Kate Millett: interactions between sculpture and writing. Kate Millett interviewed by Holly O'Grady', *Feminist Art Journal*, 6 (1) (1977): 22–6.

Molesworth, Helen, 'House work and art work', *October*, 92 (2000): 71–97.

Mueller, Roswitha, *Valie Export: Fragments of the Imagination* (Bloomington, IN: Indiana University Press, 1994).

Myers, Terry R., 'The Mike Kelley problem', *New Art Examiner*, 21 (10) (1994): 24–9.

Nemser, Cindy, *Art Talk: Conversations with Twelve Women Artists* (New York: Charles Scribner's Sons, 1975).

Nemser, Cindy, 'Towards a feminist sensibility: contemporary trends in women's art', *Feminist Art Journal*, 5 (2) (1976): 19–23.

Nochlin, Linda, *Women Choose Women* (New York: New York Cultural Center, 1973).

O'Grady, Lorraine, 'Artist as art critic: interview with conceptualist Lorraine O'Grady', interview by Theo Davis, *Sojourner: The Women's Forum*, 22 (3) (1996): 25–8.

Parker, Rozsika, 'Feministo', *Studio International*, 193 (987) (1977): 181–3.

Parker, Rozsika, 'Portrait of the artist as housewife', *Spare Rib*, 60 (1977): 5–8.

Parker, Rozsika and Pollock, Griselda (eds), *Framing Feminism: Art and the Women's Movement 1970–1985* (London: Pandora Press, 1987).

Parmar, Pratibha, 'Cherry Smyth interviewed Pratibha Parmar', *Feminist Art News* 3 (5) (1990): 2–5.

Petherbridge, Deanna, 'Féminisme! C'est moi!', *Art Monthly*, 123 (1989): 6–9.

Piper, Adrian, 'Goodby to easy listening', in *Pretend* (New York: Exit Art/John Webber Gallery, 1990).

Piper, Adrian, 'Performance as social and cultural intervention: interview with Adrian Piper by Bruce Barber and Serge Guilbaut', *Parachute*, 24 (1981): 25–32.

Pollock, Griselda, 'Issue', *Spare Rib*, 103 (1981): 49–51.

Raven, Arlene, 'Feminist content in current female art', *Sister*, 6 (5) (1975): 10.

Raven, Arlene, 'A remarkable conjunction: feminism and performance art', in *Yesterday and Today: California Women Artists*, ed. Sylvia Moore (New York: Midmarch, 1989), pp. 242–8.

Rice, Shelley, 'Feminism and photography: trouble in paradise', *Afterimage*, 6 (March 1979): 5–7.

Ringgold, Faith, *We Flew over the Bridge: The Memoirs of Faith Ringgold* (Boston, MA: Little Brown, 1995).

Ringgold, Faith, 'The wild art show', *Woman's Art Journal*, 3 (1) (1982): 18–19.

Roberts, John, 'Fetishism, conceptualism, painting', *Art Monthly*, 82 (1984): 17–19.

Roberts, John, 'Painting and sexual difference', *Parachute*, 55 (1989): 25–31.

Robins, Corinne, 'Why we need "bad girls" rather than "good ones"', *M/E/A/N/I/N/G*, 8 (1990): 43–8.

Robinson, Hilary, 'The morphology of the mucous: Irigarayan possibilities in the material practice of art', in *Differential Aesthetics: Art Practices and Philosophies – Towards New Feminist Understandings*, ed. Penny Florence and Nicola Foster (London: Ashgate Press, 2000).

Robinson, Hilary (ed.), *Visibly Female: Feminism and Art Today – An Anthology* (London: Camden Press, 1987; New York: Universe, 1988).

Rosenbach, Ulrike, 'Un féminisme en évolution', an interview with Thérèse St-Gelais, *Parachute*, 57 (1990): 28–30.

Rosenbach, Ulrike, with Elizabeth Gower et al., 'Don't believe I'm an amazon', *Lip* (1980): 84–9.

Rosler, Martha, 'I'm thinking about making art about life . . .', in *Social Works*, ed. Nancy Buchanan (Los Angeles: Los Angeles Institute of Contemporary Art, 1979), pp. 35–7.

Rosler, Martha, 'The private and the public: feminist art in California', *Artforum*, 16 (1) (September 1977): 66–74.

Rosler, Martha, 'Untitled statement', in *Issue*, ed. Lucy Lippard (London: ICA, 1980), unpaginated.

Roth, Moira, 'The passion of Rachel Rosenthal', *Parachute*, 73 (1994): 22–8.

Roth, Moira, 'Visions and re-visions', *Artforum*, 19 (3) (1980): 36–45; reprinted in *Feminist Art Criticism: An Anthology*, ed. Arlene Raven, Cassandra Langer and Joanna Frueh (London: UMI Research Press; New York, Icon Editions, 1988), pp. 99–110.

Rothenberg, Diane, 'Social art/social action', *Drama Review*, Special Issue, 32 (1) (1988): 61–70.

Rowley, Sue, 'Going public, getting personal' in *Dissonance: Feminism and the Arts 1970–1990*, ed. Catriona Moore (St Leonards, NSW: Allen and Unwin, 1994), pp. 231–7.

Roy, Hélène, 'Question d'art, d'art féminin, d'art féminist ou autre', *Cahiers des arts visuels au Québec*, 4 (13) (Spring 1982): 7–10, 22.

Ruddick, Sara and Daniels, Pamela (ed.), *Working it Out: 23 Women Writers, Artists, Scientists and Scholars Talk about their Lives and Work* (New York: Pantheon, 1977).

Sauzeau Boetti, A., 'Negative capability as practice in women's art', *Studio International*, 191 (979) (1976): 24–5.

Sawchuk, Kim, 'Biological, not determinist: Nell Tenhaff's technological mutations', *Parachute*, 75 (1994): 11–17.

Schapiro, Miriam (ed.), *Art: A Woman's Sensibility* (Valencia: Feminist Art Program, California Institute of the Arts, 1975).

Schneemann, Carolee, *More than Meat Joy: Performance Works and Selected Writings* (New Paltz, NY: Documentext, 1979; 2nd edn, 1997).

Schor, Mira, 'Course proposal', *M/E/A/N/I/N/G*, 13 (1993): 20–3.

Schor, Mira, 'Painting as manual', *M/E/A/N/I/N/G*, 18 (1995): 31–41.

Schor, Mira, *Wet: On Painting, Feminism, and Art Culture* (Durham, NC: Duke University Press, 1997).

Slakin, Wendy (ed.), *The Voices of Women Artists* (Englewood Cliffs, NJ: Prentice-Hall, 1993).

Smith, Beryl K., Arbeiter, Joan and Swenson, Sally S. (eds), *Lives and Works: Talks with Women Artists*, vol. 2 (Lanham, MD: Scarecrow Press, 1999).

Solomon, Joan and Spence, Jo, *What Can a Woman Do with a Camera?: Photography for Women* (London: Scarlet Press, 1995).

Spence, Jo, *Cultural Sniping: The Art of Transgression* (London: Routledge, 1995).

Spence, Jo, *Putting Myself in the Picture: A Personal and Political Autobiography* (London: Camden Press, 1986, 2nd edn, 1988).

Spero, Nancy, 'Defying the death machine: an interview with Nancy Spero by Nicole Jolicoeur and Nell Tenhaff', *Parachute*, 39 (June/August 1985): 50–5.

Spero, Nancy, 'On art and artists', interview by Kate Horsfield (1982), *Profile*, 3 (1) (1983): 2–18.

Steele, Lisa, 'The Judy Chicago paradox: "after the party's over"', *Fuse* (September 1982): 94–5.

Stevens, May, 'Looking backward in order to look forwards: memoirs of a racist girlhood', *Heresies*, 15 (1982): 22–3.

Straayer, Chris, 'I say I am: feminist performance video in the '70s', *Afterimage*, 13 (4) (1985): 8–12.

Tabrizian, Mitra, 'The blues: an interview with Mitra Tabrizian discussing her latest work with Alex Noble', *Ten-8*, 25 (1987): 30–5.

Tickner, Lisa, 'Notes on feminism, femininity and women's art', *Lip* (1984): 14–18.

Tickner, Lisa, 'Sexual art politics: notes for a discussion', in *Art and Politics: Proceedings of a Conference on Art and Politics Held on 15th and 16th April 1977*, ed. Brandon Taylor (Winchester: Winchester School of Art Press, 1980), pp. 63–5.

Tuer, Dot, 'From the father's house: women's video and feminism's struggle with difference', *Fuses*, 48 (1987–8): 17–24.

Tufnell, Miranda and Crickmay, Chris, *Body, Space, Image: Notes Towards Improvisation and Performance* (London: Virago, 1990).

Wells, Liz (ed.), *Viewfindings: Women Photographers, 'Landscape' and Environment* (West of England: Available Light, 1994).

Wilding, Faith, 'Monstrous domesticity', *M/E/A/N/I/N/G*, 18 (1995): 3–16.

Willis, Deborah, 'Talking back: black women's visual liberation through photography', in *Transforming the Crown: African, Asian and Caribbean Artists in Britain, 1966–1996*, ed. Mora J. Beauchamp-Byrd and M. Franklin Sirmans (New York: Franklin H. Williams Caribbean Cultural Center/African Diaspora Institute, 1997), pp. 63–8.

Willis, Holly, 'Cyberwomen: feminist strategies in multimedia – CD-ROMs by women artists', *Artweek*, 28 (February 1997): 14–15.

Wilson, Judith, 'Lorraine O'Grady: critical interventions', in *Lorraine O'Grady: Photomontages* (New York: Intar Gallery, 1991), pp. 2–18.

Withers, Josephine, 'Eleanor Antin: allegory of the soul', *Feminist Studies*, 12 (1) (1986): 117–28.

Withers, Josephine, 'Revisioning our foremothers: reflections on the ordinary, extraordinary art of May Stevens', *Feminist Studies*, 13 (3) (1987): 485–512.

Chapter 6

American Visions/Visiones de las Americas: Artistic and Cultural Identity in the Western Hemisphere (New York: ACA Books in association with Arts International, 1994).

'Black women artists', *Spare Rib*, 188 (1988): 8–12.

Dialectics of Isolation: An Exhibition of Third World Women Artists of the United States (New York: AIR Gallery, 1980).

Issues in Architecture, Art and Design (special issue on Jewish Women in Visual Culture), 5 (1) (1997).

Joining Forces '1 + 1 = 3': A Two-part Collaborative Installation Exhibition by 'Where We At' Black Women Artists (New York: Muse Community Museum, 1986).

Relocating History: An Exhibition of Work by Seven Irish Women Artists (Belfast: Fenderesky Gallery at Queen's, 1993).

'Where We At' Black Women Artists: A Tapestry of Many Fine Threads (Brooklyn, NY: Where We At Black Women Artists, n.d.).

Ankori, Gannit, 'Yocheved Weinfeld's portraits of the self', *Woman's Art Journal*, 10 (1) (1989): 22–7.

Arnold, Marion, *Women and Art in South Africa* (Cape Town: David Philip, 1996).

Barber, Fionna, 'Territories of difference: Irish women artists in Britain', *Third Text*, 27 (1994): 65–75.

Barton, Christina and Lawler-Dormer, Deborah (eds), *Alter/Image: Feminism and Representation in New Zealand Art 1973–1993* (Wellington and Auckland: Wellington and Auckland City Art Gallery, 1993).

Beauchamp-Byrd, Mora J. and Sirmans, M. Franklin (eds), *Transforming the Crown: African, Asian and Caribbean Artists in Britain, 1966–1996* (New York: Franklin H. Williams Caribbean Cultural Center/African Diaspora Institute, 1997).

Beckett, Jane and Cherry, Deborah, 'Clues to events', in *The Point of Theory: Practices of Cultural Analysis*, ed. Mike Bal and Inge Boer (Amsterdam: Amsterdam University Press, 1994), pp. 48–55.

Bell, Diane, 'Aboriginal women: ritual and culture', Diane Bell interviewed by Lesley Dumbrell, *Lip* (1978–9): 5–9.

Billingslea-Brown, Alma Jean, *Crossing Borders through Folklore: African American Women's Fiction and Art* (Columbia: University of Missouri Press, 1999).

Blocker, Jane, 'Ana Mendieta and the politics of the Venus Negra', *Cultural Studies*, 12 (1) (1998): 31–50.

Blocker, Jane, *Where is Ana Mendieta?: Identity, Performativity, and Exile* (Durham, NC: Duke University Press, 1999).

Bloom, Lisa, *With Other Eyes: Looking at Race and Gender in Visual Culture* (Minneapolis, MN: University of Minnesota, 1999).

Bontemps, Arna Alexander, *Forever Free: Art by African-American Women 1862–1980* (Normal, IL and Alexandria, VA: Stephenson, 1980).

Burman, Chila, 'There have always been great blackwomen artists', in *Visibly Female: Feminism and Art Today – An Anthology*, ed. Hilary Robinson (London: Camden Press, 1987), pp. 195–9.

Bush, Corlann Gee, 'The way we weren't: images of women and men in cowboy art', *Frontiers*, 7 (3) (1984): 73–8.

Callaghan, Mary Hammond, 'Margaret Clarke's "Mary and Brigid, 1917": Mother Ireland in Irish art and nationalism', *Atlantis*, 22 (2) (1998): 99–111.

Campbell, Jean and Gaga, Doris Abra, 'Black on black art therapy: dreaming in colour', in *Feminist Approaches to Art Therapy*, ed. Susan Hogan (London: Routledge, 1997), pp. 216–76.

Cardinal-Schubert, Joane, 'Excerpts from speeches', *Matriart*, 2 (1) (1991): 9.

Cardinal-Schubert, Joane, 'Surviving as a native woman artist', *Canadian Woman Studies/Les cahiers de la femme*, 11 (1) (1990): 50–1.

Cliff, Michelle, 'Object into subject: some thoughts on the work of black women artists', *Heresies*, 4 (3) (1984): 34–40; reprinted in *Visibly Female: Feminism and Art Today – An Anthology*, ed. Hilary Robinson (London: Camden Press, 1987).

Cooks, B. R., 'See me now: contemporary black American women artists and their visual depictions of black Americans', *Camera Obscura*, 36 (1995): 67–83.

Cummins, Pauline, 'Unearthed' (performance text), *n.paradoxa*, 5 (2000): 71–2.

Dehejia, Vidya (ed.), *Representing the Body: Gender Issues in Indian Art* (New Delhi: Kali for Women in association with the Book Review Literary Trust, 1997).

Dinwara, Manthia, 'Black spectatorship: problems of identification and resistance', *Screen*, 29 (4) (1988): 66–76.

Dysart, Dinah and Fink, Hannah, *Asian Women Artists* (East Roseville, NSW: Craftsman House, 1996).

Farris-Dufrene, Phoebe M., *Voices of Color: Art and Society in the Americas* (Atlantic Highlands, NJ: Humanities Press, 1997).

Fowler, Joan, 'Speaking of gender . . . expressionism, feminism and sexuality', in *A New Tradition: Irish Art of the Eighties* (Dublin: Douglas Hyde Gallery, 1990), pp. 53–67.

Gagnon, Monika, 'Questions of difference', *Harbour*, 5 (1992): 36–42.

Gaines, Jane, 'White privilege and looking relations: race and gender in feminist film theory', *Screen*, 29 (4) (1988): 12–27.

Gates, Henry Louis (ed.), *Reading Black, Reading Feminist: A Critical Anthology* (New York: Meridian Books, 1990).

Golden, Thelma (ed.), *Black Male* (New York: Whitney Museum of American Art, 1994).

Grinnell, Jennifer and Conley, Alston (eds), *Re/dressing Cathleen: Contemporary Works from Irish Women Artists* (Boston: McMullen Museum of Art, Boston College, 1997).

Haar, Sandra, 'Passing over the practice: the problem of a Jewish art history', *Matriart*, 1 (3) (1991): 13–14.

Hammond, Harmony et al. (eds), *Women of Sweetgrass, Cedar, and Sage: Contemporary Art by Native American Women* (New York: Gallery of the American Indian Community House, 1985).

Hammond King, Leslie (ed.), *Gumbo Ya Ya: Anthology of Contemporary African American Women Artists* (New York: Midmarch, 1995).

Hashmi, Salima and Poovaya-Smith, Nima, *An Intelligent Rebellion: Women Artists of Pakistan* (Bradford: City of Bradford Metropolitan Council, 1994).

Hassan, Salah M. (ed.), *Gendered Visions: The Art of Contemporary African Women Artists* (Trenton, NJ: Africa World Press, 1997).

Haug, Kate, 'Myth and matriarchy: an analysis of the mammy stereotype', in *Dirt and Domesticity: Constructions of the Feminine*, ed. J. Fuenmayor et al. (New York: Whitney Museum of American Art, 1992), pp. 38–57.

Henry, Victoria, 'The personal is the political: Joane Cardinal-Schubert', *Artichoke*, 2 (2) (1991): 38–9.

Hezekiah, Gabrielle, 'Don't go to dat place and fool around like rich girls: black Canadian women filmmakers and video artists', *Cineaction*, 32 (1993): 68–75.

Higgins, Judith, 'Art from the edge, part 1', *Art in America*, 83 (12) (1995): 37–43.

Hiller, Susan (ed.), *The Myth of Primitivism: Perspectives on Art* (London: Routledge, 1991).

Himid, Lubaina (ed.), *The Thin Black Line* (London: ICA, 1985).

hooks, bell, *Art on my Mind: Visual Politics* (New York: The New Press, 1995).

Jim, Alice Ming Wai, 'An analysis and documentation of the 1989 exhibition "Black Wimmin: When and Where We Enter"', *RACAR (Revue d'art canadienne/Canadian Art Review)*, 23 (1–2) (1996): 71–83.

Jiwani, Yasmin, 'Making the invisible visible: reclaiming history and creating new definitions', *Parallélogramme*, 15 (4) (1990): 20–6.

Johnson, Claudette, 'Issues surrounding the representation of the naked body of a woman', *Feminist Art News*, 3 (8) (1991): 12–13.

Johnson, Vivien, 'Is there a gender issue in aboriginal art?', *Art and Australia*, 32 (3) (1995): 350–7.

Kim, Elaine H., '"Bad women": Asian American visual artists Hanh Thi Pham, Hung Liu, and Yong Soon Min', *Feminist Studies*, 22 (3) (1996): 573–602.

Kirker, Anne, *New Zealand Women Artists: A Survey of 150 Years* (East Roseville, NSW: Craftsman House, 1986).

LaDuke, Betty, *Africa through the Eyes of Women Artists* (Trenton, NJ: Africa World Press, 1991).

LaDuke, Betty, *Africa: Women's Art, Women's Lives* (Trenton, NJ: Africa World Press, 1997).

LaDuke, Betty, 'Yolanda Lopez: breaking Chicana stereotypes', *Feminist Studies*, 20 (1) (1994): 117–30.

Laiwan, 'Notes against difference', *Parallélogramme*, 19 (1) (1993): 22–30.

Lamoureux, Johanne, *Seeing in Tongues: A Narrative of Language and Visual Arts in Quebec* (Vancouver: Morris and Helen Belkin Art Gallery, 1995), pp. 1–19.

Lamy, Suzanne, 'La femme, le Québec et les arts plastiques', *Comuniqué*, 8 (May 1987): 29–31.

Lewis, Reina, *Gendering Orientalism: Race, Femininity, and Representation* (London: Routledge, 1996).

Lewis, Samella S., *Art: African-American* (New York: Harcourt Brace Jovanovich, 1978).

Lippard, Lucy, *The Lure of the Local: Senses of Place in a Multicentered Society* (New York: The New Press, 1997).

Lippard, Lucy, *Mixed Blessings: New Art in a Multicultural America* (New York: Pantheon Books, 1990).

Lippard, Lucy (ed.), *Partial Recall: Photographs of Native North Americans* (New York: The New Press, 1992).

Lippard, Lucy, 'Turning the mirrors around: the pre-face', *American Art*, 5 (1–2) (1991): 23–35.

Loftus, Belinda, 'Mother Ireland and the troubles: artist, model and reality', *Circa*, 1 (November/December 1981): 9–13.

Longley, Edna, *From Cathleen to Anorexia: The Breakdown of Irelands* (Dublin: Attic Press, 1990).

McIntosh, Peggy, 'White privilege and male privilege: a personal account of coming to see correspondences through work in women's studies' (1988), in *Race, Class, and Gender: An Anthology*, ed. Margaret L. Anderson and Patricia Hill Collins (Belmont: Wadsworth, 1995), pp. 76–87.

MacKay, Gillian, 'Lady Oracle: Jane Ash Poitras and the First Nations phenomenon', *Canadian Art*, 11 (3) (1994): 75–81.

Madill, Shirley J-R. (ed.), *Identity/Identities* (Winnipeg: Winnipeg Art Gallery, 1988).

Maestro, Lani, 'Kindling fires/planting forests: living with racism in Canada', *Parallélogramme*, 13 (3) (1988): 19–23.

Marsh, Anne, 'Performing histories and the myth of place: a female menace', *n.paradoxa*, 3 (1999): 6–13.

Mullin, Molly, 'Representation of history, Irish feminism, and the politics of difference', *Feminist Studies*, 17 (1) (Spring 1991): 29–50.

Nash, Catherine, 'Reclaiming vision: looking at landscape and the body', *Gender, Place and Culture*, 3 (2) (1996): 149–69.

Nash, Catherine, 'Remapping the body/land: new cartographies of identity, gender, and landscape in Ireland', in *Writing Women and Space: Colonial and Post-colonial Geographies*, ed. Alison Blunt and Gillian Rose (London: Guilford Press, 1994), pp. 227–50.

Nelson, Charmaine, *Through An-other's Eyes: White Canadian Artists – Black Female Subjects/Le regard de l'autre: artistes canadiens blancs – sujets féminins noirs* (Oshawa, Ont.: Robert McLaughlin Gallery, 1998).

Ní Dhomhnaill, Nuala, 'What foremothers?', *Poetry Ireland Review*, 36 (1993): 18–31.

Nochlin, Linda and Garb, Tamar (eds), *The Jew in the Text: Modernity and the Construction of Identity* (London: Thames and Hudson, 1995).

O'Grady, Lorraine, 'Olympia's maid: reclaiming black female subjectivity', in *New Feminist Criticism: Art, Identity, Action*, ed. Joanna Frueh, Cassandra Langer and Arlene Raven (New York: Harper Collins, 1994), pp. 152–70.

Perkins, Hetti, *Aboriginal Women's Exhibition* (Sydney: Art Gallery of New South Wales, 1991).

Philip, Marlene Nourbese, 'Whose listening? Artists, audiences, and language', *Fuse* (September 1988): 15–24.

Pindell, Howardena, 'Art world racism: a documentation', *New Art Examiner* (March 1989): 32–6.

Pindell, Howardena, 'Diaspora/realities/strategies', *n.paradoxa* (online), 7 (July 1998).

Pindell, Howardena, 'Free, white and 21' (1992), in *The Heart of the Question: The Writings and Paintings of Howardena Pindell* (New York: Midmarch Press, 1997), pp. 65–9.

Pindell, Howardena, 'Introduction', in *Autobiography: In her own Image*, ed. Inverna Lockpez (New York: INTAR Latin American Gallery, 1988), pp. 8–9.

Piper, Adrian, 'Adrian Piper's open letter to Donald Kuspit', *Real Life Magazine*, 17–18 (Winter 1987–8): 2–11.

Piper, Adrian, 'The critique of pure racism', interview by Maurice Berger, *Afterimage*, 18 (3) (October 1990): 5–9.

Piper, Adrian, 'Passing for white, passing for black', *Transition*, 56 (1992): 4–32.

Piper, Adrian, 'Political self-portrait no. 2', *Heresies*, 8 (1979): 37–8.

Pollock, Griselda, 'Is feminism to Judaism as modernity is to tradition?', in *Rubies and Rebels: Jewish Female Identity in Contemporary British Art*, ed. Monica Bohm-Ducken and Vera Grodzinski (London: Lund Humphries, 1996), pp. 15–27.

Pollock, Griselda, 'The presence of the future: feminine and Jewish difference: intricate but I hope not incoherent thoughts on identity and art', *Issues in Architecture, Art and Design*, 5 (1) (1997): 37–63.

Quick-To-See Smith, Jaune, 'Women of sweetgrass, cedar, and sage', *Women's Studies Quarterly*, special issue on Teaching about Women and the Visual Arts, 15 (1–2) (Spring/Summer 1987): 35–7.

Robinson, Hilary, 'Disruptive women artists: an Irigarayan reading of Irish visual culture', *Irish Studies Review*, 8 (1) (2000): 57–72.

Robinson, Hilary, 'Irish/woman/artwork: selective readings', *Feminist Review*, 50 (1995): 89–110.

Robinson, Jontyle Theresa (ed.), *Bearing Witness: Contemporary Works by African-American Women Artists* (New York: Rizzoli/Spelman College, 1996).

Rogoff, Irit, 'Daughters of sunshine: diasporic impulses and gendered identities', *Issues in Architecture, Art and Design*, 5 (1) (1997–8): 82–98.

Rogoff, Irit, *Terra Infirma: Geography's Visual Culture* (London: Routledge, 2000).

Rowley, Sue, 'Someday, somewhere: women and nation in international art', *Artlink*, 14 (1) (1995): 16–18.

Seaton, Beth, 'Indian princesses and cowgirls: stereotypes from the frontier/Rebecca Belmore', *Parachute*, 69 (January/March 1993): 41–2.

Shohat, Ella (ed.), *Talking Visions: Multicultural Feminism in a Transnational Age* (New York: New Museum of Contemporary Art; Cambridge, MA: MIT Press, 1998).

Soussloff, Catherine M. (ed.), *Jewish Identity in Modern Art History* (Berkeley, CA: University of California Press, 1999).

Spires, Randi, 'Joyce Wieland: true matriot love', *Matriart*, 2 (4) (1992): 3–9.

Spivak, Gayatri Chakravorty, *In Other Worlds: Essays in Cultural Politics* (London: Routledge, 1988).

Spivak, Gayatri Chakravorty, *The Post-colonial Critic: Interviews, Strategies, Dialogues*, ed. Sarah Harasym (London: Routledge, 1990).

Stevens, May, *Irish Art: Pauline Cummins, Mary Duffy, Alanna O'Kelly* (New York: WAAG, 1987).

Steyn, Juliet (ed.), *Other than Identity: The Subject, Politics and Art* (Manchester: Manchester University Press, 1997).

Sujir, Leila, 'On being female and (half) Asian in an art world narrative', *Artichoke*, 4 (2–3) (1992): 12–19.

Sulter, Maud, 'Passion: blackwomen's creativity – an interview with Maud Sulter', *Spare Rib*, 220 (1991): 6–10.

Sulter, Maud (ed.), *Passion: Discourses on Blackwomen's Creativity* (Hebden Bridge: Urban Fox Press, 1990).

Szakacs, Devinis, and Kopf, Vicki (eds), *Next Generation: Southern Black Aesthetic* (Winston-Salem, NC: Southeastern Center for Contemporary Art, 1990).

Tawadros, Gilane, 'Beyond the boundary: the work of three black women artists in Britain', *Third Text*, 8–9 (1989): 121–50.

Tawadros, Gilane, 'Other Britains, other Britons', *Aperture*, 113 (1988): 45–6.

Tesfagiorgis, Freida High, 'Afrofemcentrism and its fruition in the art of Elizabeth Catlett and Faith Ringgold', *Sage*, 4 (1) (1987): 25–9.

Todd, Loretta, 'Notes on appropriation', *Parallélogramme*, 16 (1) (1991): 24–32.

Tuer, Dot, 'To speak of difference', *Parachute*, 43 (1986): 41–3.

Walker, Alice, 'In search of our mothers' gardens' (1974), in *In Search of our Mothers' Gardens: Womanist Prose* (San Diego: Harcourt Brace, 1983), pp. 231–43.

Wallace, Michele, *Invisibility Blues: From Pop to Theory* (London: Verso, 1990).

Wieland, Joyce, *True Patriot Love/Veritable amour patriotique* (Ontario: National Gallery of Canada, 1971).

Wilson, Judith, 'Beauty rites: towards an anatomy of culture in African American women's art', *International Review of African American Art*, 11 (3) (1994): 11–17.

Zastrow, Leona M., 'American Indian women as art educators', in *Women Art Educators*, ed. Enid Zimmerman and Mary Ann Stankiewicz (Bloomington, IN: Indiana University, 1982), pp. 88–95.

Chapter 7

Adams, Parveen, *The Emptiness of the Image: Psychoanalysis and Sexual Differences* (London: Routledge, 1996).

Adams, Parveen and Cowie, Elizabeth (eds), *The Woman in Question* (London: Verso, 1990).

Adelman, Shonagh, 'Five feminist videotapes: redefining the female subject', *C Magazine*, 21 (1991): 24–32.

Allen, Jan, *The Female Imaginary* (Kingston, Ont.: Agnes Etherington Art Centre, 1994), pp. 7–22.

Andre, Linda, 'The politics of postmodern photography', *Minnesota Review*, 23 (1984).

Appignanesi, Lisa (ed.), *Desire* (London: ICA, 1984).

Appignanesi, Lisa, *Ideas from France: The Legacy of French Theory* (London: ICA, 1985).

Apter, Emily, 'Out of the closet: Mary Kelly's corpus (1984–85)', *Art Journal*, 54 (1) (1995): 66–70.

Baert, Renée, 'Subjects on the threshold: problems with pronouns', in *Mirror Machine: Video and Identity*, ed. Jannine Marchessault (Toronto: YYZ Books, 1995), pp. 187–202.

Banning, Kass, Longfellow, Brenda and Williamson, Janice, 'Bad sisters in the Big Apple: feminist film theory', *Border/lines*, 2 (1985): 8–9.

Barker, Francis, Hulme, Peter and Iversen, Margaret (eds), *Postmodernism and the Re-reading of Modernity* (Manchester: Manchester University Press, 1992).

Beckett, Jane and Cherry, Deborah, 'Sorties: ways out from behind the veil of representation', *Feminist Art News*, 3 (4) (1990): 3–5.

Berger, John, *Ways of Seeing*, chapter 3 (London: Penguin, 1972), pp. 45–64.

Berland, Jody, Straw, Will and Tomas, David (eds), *Theory Rules: Art as Theory, Theory and Art* (Toronto: YYZ Books, 1996).

Betterton, Rosemary, 'Introduction: feminism, femininity and representation', *Looking On: Images of Femininity in the Visual Arts and Media* (London: Pandora, 1987), pp. 1–17.

Braidotti, Rosi, 'Body images and the pornography of representation', *Journal of Gender Studies*, 1 (2) (1991): 148–50.

Brennan, Theresa (ed.), *Between Feminism and Psychoanalysis* (London: Routledge, 1989).

Brettle, Jane and Rice, Sally, *Public Bodies – Private States: New Views on Photography, Representation and Gender* (Manchester: Manchester University Press, 1994).

Brooks, Rosetta, 'Woman visible: women invisible', *Studio International*, 193 (987) (1977): 208–12.

Burgin, Victor, Donald, James and Kaplan, Cora (eds), *Formations of Fantasy* (London: Methuen, 1986).

Burt, Helene, 'Beyond practice: a postmodern feminist perspective on art therapy research', *Art Therapy: Journal of the American Art Therapy Association*, 13 (1) (1996): 12–19.

Butler, Susan, 'Subject-to-change', *Women's Art Magazine*, 59 (1994): 23–6.

Cameron, Dan, 'Post-feminism', *FlashArt*, 132 (February–March 1987): 80–3.

Chadwick, Whitney, 'Fetishizing fashion/fetishizing culture: Man Ray's Noire et Blanche', *Oxford Art Journal*, 18 (2) (1995): 3–17; reprinted in *Women and Dada*, ed. Naomi Sawelson-Gorse (Cambridge, MA: MIT Press, 1999), pp. 294–329.

Copjec, Joan, 'In lieu of essence: an exposition of a photographic work by Silvia Kolbowski', *Block*, 7 (1982): 27–31.

Cottingham, Laura, 'The feminine de-mystique: gender, power, and irony in '80s art', *FlashArt*, 147 (1989): 91–5.

Cottingham, Laura, 'Feminism versus masculinism', *Tema Celeste*, 39 (1993): 64–7.

Cowie, Elizabeth, 'Woman as sign', *m/f*, 1 (1978): 49–63.

Cruz, Marcia, 'Black woman, white image', *Border/lines*, 27 (1993): 3–4.

Dent, Tory, 'Alreadymade "female"', *Parachute*, 76 (1994): 20–4.

Déry, Louise, 'Avant-propos', *Corps et Jouissances: Regardes de femmes* (Rimouski, Quebec: Musée regional de Rimouski, 1986), unpaginated.

Desmond, Jane, 'Mapping identity onto the body', *Women and Performance: A Journal of Feminist Theory*, 6 (2) (1993): 102–27.

Dinwara, Manthia, 'The nature of mother in dreaming rivers', *Third Text*, 13 (1990–91): 73–84.

Doane, Mary Ann, 'Film and the masquerade: theorizing the female spectator', *Screen*, 23 (3–4) (1982): 17–32; reprinted in *Femmes Fatales: Feminism, Film Theory, Psychoanalysis* (New York: Routledge, 1991).

Docherty, Thomas (ed.), *Postmodernism: A Reader* (New York: Columbia University Press, 1993).

Doy, Gen, *Seeing and Conciousness: Women, Class, and Representation* (Oxford: Berg, 1990).

Drucker, Johanna, 'Visual pleasure: a feminist perspective', *M/E/A/N/I/N/G*, 11 (1992): 3–11.

Dubreuil-Blondin, Nicole, 'Et in academia ego', *Parachute*, 60 (1990): 44–5.

Dubreuil-Blondin, Nicole, 'Feminism and modernism: paradoxes', in *Modernism and Modernity: The Vancouver Conference Papers*, ed. Benjamin Buchloh, Serge Guilbaut and David Solkin (Halifax: The Press of the Nova Scotia School of Art and Design, 1983), pp. 195–211.

Dubreuil-Blondin, Nicole, 'The land art of American women: the return of content to post-modern art', *Opus International*, 8 (Spring 1983): 16–23.

Duncan, Carol, 'The MoMA's hot mamas', *Art Journal*, 48 (Summer 1989): 71–8.

Dworkin, Andrea, *Pornography: Men Possessing Women* (London: The Women's Press, 1981), pp. 17–18.

Eiblmayr, Silvia et al. (eds), *Die verletzte Diva: Hysterie, Korper, Technik in der Kunst des 20. Jahrhunderts/The Wounded Diva: Hysteria, Body and Technique in Twentieth Century Art* (Cologne: Oktagon, 2000).

Elliott, Bridget and Wallace, Jo-Ann, *Women Artists and Writers: Modernist (Im)positionings* (New York: Routledge, 1994).

Ellis, John, 'Photography/pornography/art/pornography', *Screen*, 21 (1) (1980): 81–108.

Elsby, Kristen (ed.), *Difficult Territory: A Postfeminist Project* (Woolloomooloo, NSW: Artspace Visual Arts Centre, 1997).

Ettinger, Bracha Lichtenberg, 'Matrix: beyond the phallus', *Women's Art Magazine*, 56 (1994): 12–15.

Ettinger, Bracha Lichtenberg, 'Matrix and metamorphosis', *Differences*, 4 (3) (1992): 176–208.

Ettinger, Bracha Lichtenberg, *The Matrixial Gaze* (Leeds: Feminist Arts and Histories Network, 1995).

Ewington, Julie, 'Fragmentation and feminism: the critical discourses of postmodernism', *Art and Text*, 7 (1982): 61–73.

Ewington, Julie, 'Past the post: postmodernism and postfeminism', in *150 Victorian Women Artists*, ed. Women 150 (Melbourne: Visual Arts Board of the Australia Council, 1985).

Fletcher, John, 'Versions of masquerade', *Screen*, 29 (3) (1988): 43–70.

Foster, Hal (ed.), *The Anti-Aesthetic* (Seattle: Bay Press, 1983); also published as *Postmodern Culture* (London: Pluto Press, 1985).

Fuss, Diana, *Essentially Speaking: Feminism, Nature and Difference* (London: Routledge, 1989).

Gagnon, Monika, 'Text scientiae (the enlacing of knowledge): Mary Kelly's corpus', *C Magazine*, 10 (1986): 24–33.

Garb, Tamar, *Bodies of Modernity: Figure and Flesh in Fin-de-siècle France* (London: Thames and Hudson, 1998).

Garrard, Mary D., 'Feminist art and the essentialism controversy', *C. R.: The Centennial Review*, 39 (3) (1995): 468–92.

Gourlay, Sheena, 'Penser la realité autrement: notes on the work of Nicole Jolicoeur', *Matriart*, 3 (4) (1993): 4–11.

Griffin, Gabriele (ed.), *Difference in View: Women and Modernism* (London: Taylor and Francis, 1994).

Grosz, Elizabeth, 'Conclusion: a note on essentialism and difference', in *Feminist Knowledge: Critique and Construct*, ed. Sneja Gunew (London: Routledge, 1990), pp. 332–44.

Grosz, Elizabeth, 'Feminist theory and the politics of art' in *Dissonance: Feminism and the Arts 1970–90*, ed. Catriona Moore (St Leonards, NSW: Allen and Unwin, 1994), pp. 139–53.

Grosz, Elizabeth, 'Inscriptions and body-maps: representations and the corporeal', in *Feminine, Masculine and Representation*, ed. Terry Threadgold and Anne Cranny-Francis (Sydney: Allen and Unwin, 1990), pp. 62–74, 273–5.

Heath, Stephen, *Representation and Sexual Difference* (Oxford: Blackwell, 1989).

Hiller, Susan, 'Susan Hiller: resisting representation', interview by Annette van den Bosch, *Artscribe*, 46 (1984): 44–8.

Himid, Lubaina, 'In the woodpile: black women artists and the modern woman', *Feminist Art News*, 3 (4) (1990): 2–3.

Huyssen, Andreas, 'Mapping the postmodern', in Andreas Huyssen, *After the Great Divide: Modernism, Mass Culture, Postmodernism* (Bloomington, IN: Indiana University Press, 1986), pp. 179–221; reprinted in *Feminism/Postmodernism*, ed. Linda Nicholson (London: Routledge, 1990), pp. 234–77.

Huyssen, Andreas, 'Mass culture as woman: modernism's other' (1986), in *Art Theory and Criticism: An Anthology of Formalist, AvantGarde, Contextualist and Postmodernist Thought*, ed. Sally Everett (Jefferson, NC: McFarland, 1991), pp. 228–42.

Isaak, Jo-Anna, 'Our mother tongue: the Post Partum Document', *Vanguard*, 11 (3) (1982): 14–17.

Iversen, Margaret, 'The deflationary impulse: postmodernism, feminism, and the anti-aesthetic', in *Thinking Art: Beyond Traditional Aesthetics*, ed. Andrew Benjamin and Peter Osbourne (London: ICA, 1991), pp. 81–93.

Iversen, Margaret, 'Fashioning feminine identity', *Art International*, 2 (1988): 52–7.

Jacobus, Mary, *First Things: The Maternal Imaginary in Literature, Art, and Psychoanalysis* (New York: Routledge, 1995).

Jardine, Alice, *Gynesis: Configurations of Woman and Modernity* (Ithaca, NY: Cornell University Press, 1985).

Jolicoeur, Nicole, 'Combustion lente', *Possibles*, 14 (1) (1990): 9–19.

Jones, Amelia, *Body Art: Performing the Subject* (Minneapolis, MN: University of Minnesota Press, 1998).

Kappeler, Susanne, *The Pornography of Representation* (Cambridge: Polity Press, 1986).

Kelly, Mary, 'Beyond the purloined image', *Block*, 9 (1983): 68–72; reprinted in *Imaging Desire* (Cambridge, MA: MIT Press, 1996), pp. 107–14.

Kelly, Mary, *Imaging Desire* (Cambridge, MA: MIT Press, 1996).

Kelly, Mary, 'Interview with Mary Kelly', interview by Jennifer Fisher, *Parachute*, 55 (1989): 32–5.

Kelly, Mary, 'Reviewing modernist criticism', *Screen*, 22 (3) (1981): 41–62; reprinted in *Imaging Desire* (Cambridge, MA: MIT Press, 1996), pp. 80–106.

King, Catherine, 'The politics of representation: a democracy of the gaze', in *Imagining Women: Cultural Representations and Gender*, ed. Francis Bonner et al. (Cambridge: Polity Press, 1992), pp. 131–9.

Klinger, Linda S., 'Where's the artist? Feminist practice and poststructural theories of authorship', *Art Journal*, 50 (2) (1991): 39–47.

Kolbowski, Sylvia, 'Feminism and art and psychoanalysis: some questions regarding the third term', *Parallélogramme*, 10 (4) (1985): 56–60.

Krauss, Rosalind E., *The Optical Unconscious* (Cambridge, MA: MIT Press, 1993).

Kristeva, Julia, *Powers of Horror* (New York: Columbia University Press, 1982).

Kuhn, Annette, *The Power of the Image: Essays on Representation and Sexuality* (London: Routledge and Kegan Paul, 1985).

de Lauretis, Theresa, 'Sexual indifference and lesbian representation', *Theatre Journal*, 40 (2) (1988): 155–77.

Lee, Rosa, 'Resisting amnesia: feminism, painting and postmodernism', *Feminist Review*, 26 (1987): 5–28.

Linker, Kate (ed.), *Difference* (London: ICA, 1985).

Lippard, Lucy, 'Both sides now (essentialists versus deconstructivists in feminist art and theory)', *Heresies*, 6 (4) (1989): 29–34.

Lomax, Yve, *Writing the Image: An Adventure with Art and Theory* (New York: I. B. Tauris, 2000).

McGee, Micki, 'Narcissism, femininism, and video art: some solutions to a problem in representation', *Heresies*, 12 (1981): 88–91.

Marchessault, Jannine, 'Is the dead author a woman? Some thoughts on feminist authorship', *Parallélogramme*, 15 (4) (1990): 10–18.

de Marneffe, Daphne, 'Looking and listening: construction of clinical knowledge in Charcot and Freud', *Signs*, 17 (1) (1991): 71–111.

Marshment, Margaret, 'The picture is political: representation of women in contemporary popular culture', in *Introducing Women's Studies*, ed. D. Richardson and V. Robinson (London: Macmillan, 1993), pp. 123–50.

Marter, Joan, 'Three women artists married to early modernists: Sonia Delaunay-Terk, Sophie Tauber-Arp, and Marguerite Thompson Zorach', *Arts Magazine*, 54 (September 1979): 88–95.

Mavor, Carol, *Becoming: The Photographs of Clementia, Viscountess Hawarden* (Durham, NC: Duke University Press, 1999).

Melville, Stephen, 'The time of exposure: self-portraiture in Cindy Sherman', *Arts Magazine* (January 1986): 17–21.

Mercer, Kobena, with Spivak, Gayatri, Rose, Jacqueline and McRobbie, Angela, 'Sexual identities: questions of difference', *Undercut*, 7 (1988): 19–30.

Moi, Toril, *Sexual/Textual Politics: Feminist Literary Theory* (London: Methuen, 1985).

Morris, Meagan, *The Pirate's Fiancée: Feminism, Reading, Postmodernism* (London: Verso, 1988).

Mulvey, Laura, *Fetishism and Curiosity* (London: British Film Institute; Bloomington, IN: Indiana University Press, 1996).

Mulvey, Laura, *Visual and Other Pleasures* (Basingstoke: Macmillan, 1989).

Nicholson, Linda, *Feminism/Postmodernism* (London: Routledge, 1990).

Nixon, Mignon, 'Bad enough mother; uses of the body in some contemporary feminist art practices through a Kleinian framework', *October*, 71 (1995): 70–92.

Noble, Andrea, 'Tina Modotti and the politics of signature', *Women: A Cultural Review*, 6 (3) (1995): 287–95.

Owens, Craig, 'The discourse of others: feminists and postmodernism', in *The Anti-Aesthetic*, ed. Hal Foster (Seattle: Bay Press, 1983), pp. 57–82; also published as *Postmodern Culture* (London: Pluto Press, 1985).

Owens, Craig, 'Honor, power and the love of women', *Art in America*, 71 (January 1983): 7.

Pajaczkowska, Claire, 'Structure and pleasure', *Block*, 9 (1983): 4–13.

Partington, Angela, *Feminist Art and Avant-gardism* (Birmingham: Centre for Contemporary Cultural Studies, University of Birmingham, 1986).

Perron, Mireille, 'When Medusa smiles', *Parallélogramme*, 14 (4) (1989): 12–18.

Perry, Gill, *Women Artists and the Parisian Avant-garde* (Manchester: Manchester University Press, 1995).

Phelan, Peggy, 'Feminist theory, poststructuralism, and performance', *TDR*, 32 (1) (1988): 107–27.

Phelan, Peggy, *Unmarked: The Politics of Performance* (London: Routledge, 1993).

Pollock, Griselda, 'Missing women: rethinking early thoughts on images of women', in *The Critical Image: Essays on Contemporary Photography*, ed. Carol Squiers (London: Lawrence and Wishart, 1991), pp. 202–19.

Pollock, Griselda, 'Modernity and the spaces of femininity', in *Vision and Difference: Femininity, Feminism and the Histories of Art* (London: Routledge, 1988).

Pollock, Griselda, 'Pollock on Greenberg', *Art Monthly*, 178 (1994): 14–18.

Pollock, Griselda, 'What's the difference? Feminism, representation and sexuality', *Aspects* (Spring 1986), unpaginated.

Pollock, Griselda, 'What's wrong with images of women?', *Screen Education*, 24 (1977): 25–33; reprinted in *Framing Feminism: Art and the Women's Movement 1970–1985*, ed. Rozsika Parker and Griselda Pollock (London: Pandora Press, 1987), pp. 132–8.

Pollock, Griselda, 'With my own eyes: fetishism, the labouring body and the colour of its sex', *Art History*, 17 (3) (1994): 342–82.

Rando, Flavia, 'The essential representation of woman', *Art Journal*, 50 (2) (1991): 48–52.

Reus, Theresa Gomez, 'Performing the (post-modern) dance of gender: Nancy Spero and images of women', *Journal of Gender Studies*, 2 (1) (1993): 45–55.

Rice, Shelley and Gumpert, Lynn, *Inverted Odysseys: Claude Cahun, Maya Deren, and Cindy Sherman* (Cambridge, MA: MIT Press, 1999).

Riviere, Joan, 'Womanliness as a masquerade', in *Formations of Fantasy*, ed. Victor Burgin et al. (London: Methuen, 1986), pp. 35–44.

Robinson, Hilary, 'Louise Bourgeois's "cells": gesturing towards the mother', in *Museum of Modern Art Papers, vol. 1: Louise Bourgeois*, ed. Ian Cole (Oxford: Museum of Modern Art, 1996), pp. 21–30.

Robinson, Hilary, 'She looks at her looking for him: viewing the voyeur: female visual pleasure in Sophie Calle's *Suite vénitienne*', *Women's Art Magazine*, 69 (1996): 5–9.

Rose, Jacqueline, *Sexuality in the Field of Vision* (London: Verso, 1986).

Rose, Jacqueline, 'Sexuality and vision: some questions', in *Vision and Visuality*, ed. Hal Foster (Seattle: Bay Press, 1988), pp. 115–27.

Roth, Charlene, 'Parafeminism', *Artweek*, 27 (7) (1996): 18–19.

Rouch, Jean et al., 'Culture and representation', *Undercut*, 17 (1988).

Schor, Mira, 'From liberation to lack', *Heresies*, 6 (4) (1989): 15–21.

Schor, Naomi and Weed, Elizabeth (eds), *The Essential Difference* (Bloomington, IN: Indiana University Press, 1994).

Sherlock, Maureen P., 'A dangerous age: the mid-life crisis of postmodern feminism', *Arts Magazine*, 65 (1) (1990): 70–4.

Smith, Terry, 'From the margins: modernity and the case of Frida Kahlo', *Block*, 8 (1983): 11–23.

Smith, Terry, 'Further thoughts on Frida Kahlo', *Block*, 9 (1983): 34–7.

Solomon-Godeau, Abigail, *Male Trouble: A Crisis in Representation* (New York: Thames and Hudson, 1997).

Stam, Robert, Burgoyne, Robert and Flitterman-Lewis, Sandy (eds), *New Vocabularies in Film Semiotics: Structuralism, Post-structuralism and Beyond* (London: Routledge, 1992).

Suleiman, Susan Rubin, *Risking Who One Is: Encounters with Contemporary Art and Literature* (Cambridge, MA: Harvard University Press, 1994).

Suleiman, Susan Rubin, *Subversive Intent: Gender, Politics and the Avant-garde* (Cambridge, MA: Harvard University Press, 1990).

Tickner, Lisa, 'Allen Jones in retrospect: a serpentine view', *Block*, 1 (1979): 39–45.

Tickner, Lisa, 'Men's work? Masculinity and modernism', *Differences*, 4 (3) (1992): 1–37.

Tickner, Lisa, *Modern Life and Modern Subjects: British Art in the Early Twentieth Century* (New Haven, CT: Yale University Press, 2000).

Topliss, Helen, *Modernism and Feminism: Australian Women Artists, 1900–1940* (East Roseville, NSW: Craftsman House, 1996).

Tuer, Dot, 'From the father's house: women's video and feminism's struggle with difference', *Fuses*, 48 (1987–8): 17–24.

Ussher, Jane M., 'The masculine gaze: framing "woman" in art and film', in *Fantasies of Femininity: Reframing the Boundaries of Sex* (London: Penguin, 1997), pp. 104–77.

Wagner, Anne, *Three Artists (Three Women): Modernism and the Art of Hesse, Krasner and O'Keeffe* (Berkeley, CA: University of California Press, 1996).

Wallace, Michele, 'Modernism, postmodernism, and the problem of the visual in Afro-American culture', in *Aesthetics in Feminist Perspective*, ed. Hilde Hein and Carolyn Korsmeyer (Bloomington, IN: Indiana University Press, 1993), pp. 205–17.

Weedon, Chris, *Feminist Practice and Poststructuralist Theory* (Oxford: Blackwell, 1987).

Wolff, Janet, 'The invisible flâneuse: women and the literature of modernity', *Theory, Culture and Society*, 2 (3) (1985): 37–46; reprinted in *Feminine Sentences: Essays on Women and Culture* (Cambridge: Polity Press, 1990), pp. 34–50.

Wolff, Janet, *Feminine Sentences: Essays on Women and Culture* (Cambridge: Polity Press, 1990).

Wolff, Janet, 'Women at the Whitney, 1910–30: feminism/sociology/aesthetics', *Modernism–Modernity*, 6 (3) (1999): 117–38.

Wright, Elizabeth (ed.), *Feminism and Psychoanalysis: A Critical Dictionary* (Oxford: Blackwell, 1992).

Chapter 8

About Time (London: ICA, 1980).

Women's Images of Men (London: ICA, 1980).

Abelove, Henry, Barale, Michèle and Halperin, David (eds), *Lesbian and Gay Studies Reader* (London: Routledge, 1993).

Adams, Parveen, 'The three (dis)graces', *New Formations*, 19 (1993): 130–8.

Adelman, Shonagh, 'Girrly pictures', *Border/lines*, 37 (1995): 28–32.

Allara, Pamela, '"Mater" of fact: Alice Neel's pregnant nudes', *American Art*, 8 (2) (1994): 7–31.

Alloway, Lawrence et al., 'Letter to the editor', *Artforum*, 13 (4) (1975): 9.

Arbour, Rose-Marie, 'Pour un corps différent', *Corps et Jouissances: Regardes de femmes* (Rimouski, Quebec: Musée regional de Rimouski, 1986), unpaginated.

Armatage, Kay, 'The feminine body: Joyce Wieland's Water Sark', *Canadian Woman Studies/Les cahiers de la femme*, 8 (1) (1987): 84–8.

Ashburn, Elizabeth, *Lesbian Art: An Encounter with Power* (East Roseville, NSW: Craftsman House, 1996).

Augustine, Karen/Miranda, 'Bizarre women, exotic bodies and outrageous sex: or, if Annie Sprinkle was a black ho she wouldn't be all that', *Border/lines*, 32 (1994): 22–4.

Bailey, Buseje, 'Lesbian art and identity', *Matriart*, 1 (2) (1990): 7–8.

Benglis, Lynda, 'Lynda Benglis in conversation with France Morin', *Parachute*, 6 (1977): 9–11.

Betterton, Rosemary, 'How do women look? The female nude in the work of Susanne Valadon', *Feminist Review*, 19 (1985): 3–24; reprinted in *Visibly Female: Feminism and Art Today – An Anthology*, ed. Hilary Robinson (London: Camden Press, 1987), pp. 250–71; *Looking On: Images*

of Femininity in the Visual Arts and Media, ed. Rosemary Betterton (London: Pandora Press, 1987).

Betterton, Rosemary, *An Intimate Distance: Women, Artists and the Body* (London: Routledge, 1996).

Blair, Jennifer, 'Smashing icons: Vancouver feminist video art and the female body', *C Magazine*, 46 (Fall 1994): 43–50.

Blake, Nayland (ed.), *In a Different Light: Visual Culture, Sexual Identity, Queer Practice* (San Francisco: City Lights Books, 1995), pp. 64–6.

Bociurkiw, Marusia, 'Territories of the forbidden: lesbian culture, sex, and censorship', *Fuse* (March–April 1988): 27–32.

Boffin, Tessa and Fraser, Jean (eds), *Stolen Glances: Lesbians take Photographs* (London: Pandora Press, 1991).

Boffin, Tessa and Gupta, Sunil, *Ecstatic Antibodies: Resisting the AIDS Mythology* (New York: Rivers Oram Press, 1990).

Bonney, Claire, 'The nude photograph: some female perspectives', *Women's Art Journal* (Fall 1985): 9–14.

Bower, Marion, 'Daring to speak its name: the relationship of women to pornography', *Feminist Review*, 24 (October 1986).

Bright, Deborah, *Photography and Sexuality: The Passionate Camera* (London: Routledge, 1997).

Bright, Susie and Posener, Jill (ed.) *Nothing but the Girl: The Blatant Lesbian Image* (London: Cassell, 1996).

Burkard, Lene, Justesen, Kirsten and Ohrt, Karen (eds), *Kroppen Som Membran/Body as Membrane* (Odense: Kunsthallen, 1996).

Butler, Judith, *Bodies that Matter: On the Discursive Limits of 'Sex'* (London: Routledge, 1993).

Butler, Judith, 'The body you want', interview by Liz Kotz, *Artforum*, 31, (3) (1992): 82–9.

Butler, Susan, *New Perspectives on the Nude* (Cardiff: ffotogallery, 1983).

Cameron, Dan, 'Reverse backlash: Sue Williams' black comedy of manners', *Artforum*, 31 (3) (1992): 71–3.

Campbell, Colin, 'Lesbians on the loose', *Fuse* (Spring 1987): 21–4.

Carter, Erica and Watney, Simon (eds), *Taking Liberties: AIDS and Cultural Politics* (London: Serpent's Tail, 1989).

Caughie, John, et al., *The Sexual Subject: A Screen Reader in Sexuality* (London: Routledge, 1992).

Chadwick, Whitney and Ades, Dawn (eds), *Mirror Images: Women, Surrealism, and Self-representation* (Cambridge, MA: MIT Press, 1998).

Chau, Monica, et al. (eds), *The Subject of Rape* (New York: Whitney Museum of American Art, 1993), pp. 79–85.

Cooper, Emmanuel, *The Sexual Perspective: Homosexuality and Art in the Last 100 Years in the West* (London: Routledge and Kegan Paul, 1986; 2nd edn, 1994).

Corinne, Tee, 'Artist's statement: on sexual art', *Feminist Studies*, 19 (2) (1993): 369–76.

Corinne, Tee, *Cunt Coloring Book: Drawings* (San Francisco: Last Gasp, 1988, rev. edn).

Coward, Rosalind, *Female Desire: Women's Sexuality Today* (London: Paladin Books, 1984).

Crimp, Douglas and Rolston, Adam, *AIDS Demo Graphics* (Seattle: Bay Press, 1990).

Davis, Kathy, '"My body is my art": cosmetic surgery as feminist utopia?', *European Journal of Women's Studies*, 4 (1) (1997): 23–37.

Deepwell, Katy, 'Sassy, or not?', *Siksi: Nordic Art Review*, 11 (4) (1996): 88–90.

Duffy, Mary, 'Redressing the balance', *Feminist Art News*, 3 (8) (1991): 15–18.

Dyer, Richard, *Now You See It: Studies in Lesbian and Gay Film* (London: Routledge, 1990).

Felshin, Nina, 'Women's work: a lineage, 1966–94', *Art Journal*, 54 (1) (1995): 71–85.

Ford, Simon, 'Subject and (sex) object: Cosey Fanny Tutti and her works for magazines', *Make*, 80 (1998): 2–7.

Friis-Hansen, Dana, 'Yayoi Kusama's feminism', *Art and Text*, 49 (1994): 48–55.

Frueh, Joanna, 'Has the body lost its mind?', *High Performance* (Summer 1989): 44–7.

Fryer Davidov, Judith, *Women's Camera Work: Self/Body/Other in American Visual Culture* (Durham, NC: Duke University Press, 1998).

Gale, Peggy, 'Lisa Steele: looking very closely', *Parachute*, 2 (1976): 30–1.

Gallop, Jane, *Thinking Through the Body* (New York: Columbia University Press, 1988).

Goodman, Lizbeth, 'Sexuality and autobiography in performance (art)', *Women: A Cultural Review*, 5 (2) (1994): 123–36.

Gossy, Mary, 'Gals and dolls: playing with some lesbian pornography', *Art Papers*, 18 (6) (1994): 21–4.

Grover, Jan Zita, 'Dykes in context', *Ten-8*, 30 (1988): 38–47.

Grover, Jan Zita, 'Dykes in context: some problems in minority representation', in *The Contest of Meaning: Critical Histories of Photography*, ed. Richard Bolton (Cambridge, MA: MIT Press, 1989), pp. 162–203.

Hammond, Harmony, *Lesbian Art in America: A Contemporary History* (New York: Rizzoli, 2000).

Hammond, Harmony, 'Lesbian artists', in *Wrappings: Essays on Feminism, Art, and the Martial Arts* (New York: Mussmann Bruce, 1984), pp. 40–1.

Hammond, Harmony, 'A lesbian show', in *In a Different Light: Visual Culture, Sexual Identity, Queer Practice*, ed. Nayland Blake (San Francisco: City Lights, 1995), pp. 45–9.

Hammond, Harmony and Lord, Catherine, *Gender, Fucked* (Seattle, WA: Center on Contemporary Art, 1996).

Himid, Lubaina, 'We will be', in *Looking On: Images of Femininity in the Visual Arts and Media*, ed. Rosemary Betterton (London: Pandora Press, 1987), pp. 259–66.

Horne, Peter and Lewis, Reina (eds), *Outlooks: Lesbian and Gay Sexualities in Visual Cultures* (London: Routledge, 1996).

Houser, Craig, Jones, Leslie C. and Taylor, Simon, *Abject Art: Repulsion and Desire in American Art* (New York: Whitney Museum of American Art, 1993).

Isaak, Jo-Anna, 'Mothers of invention', in *Mothers of Invention* (Geneva, NY: Houghton House Gallery, Hobart and William Smith Colleges, 1989), unpaginated.

Iskin, Ruth, 'Sexual and self-imagery in art: male and female', *Womanspace*, 1 (3) (1973): 4–10, 14.

Jackson, Phyllis J., '(In)forming the visual: (re)presenting women of African descent', *International Review of African American Art*, 14 (3) (1997): 31–7.

Jones, Amelia, 'Intra-Venus and Hannah Wilke's feminist narcissism', in *Hannah Wilke: Intra Venus* (New York: Ronald Feldman Fine Arts, 1995), pp. 4–13, 47.

Jones, Amelia and Stephenson, Andrew (eds), *Performing the Body/Performing the Text* (London: Routledge, 1999).

Jones, Kellie, 'In their own image', *Artforum*, 29 (30) (1990): 133–8.

Kipnis, Laura, 'Female transgression', in *Resolution*, ed. Michael Renov and Erika Suderburg (Minneapolis, MN: University of Minnesota Press, 1996), pp. 333–45.

Kirshner, Judith Russi, 'A narrative of women's experience', *Art Criticism*, 6 (1) (1989): 20–31.

Klein, Jennie, 'Tell all: new lesbian narratives', *New Art Examiner*, 27 (9) (2000): 18–23.

Kwinter, Kerri and Mason, Joyce, 'Alter Eros: was it good for you?', *Fuse* (Summer 1984): 45–53.

Lesbian and Gay Historical Society of San Diego, *Lesbian and Gay Contributions to the Arts* (San Diego, CA: Lesbian and Gay Historical Society of San Diego, 1994).

Lewis, Reina, 'Dis-Graceful images: Della Grace and lesbian sado-masochism', *Feminist Review*, 46 (1994): 76–91.

Linker, Kate, 'Ex-posing the female model, or, the woman who poses for money', *Parachute*, 40 (1985): 16–17.

Lippard, Lucy, 'The pains and pleasures of rebirth: European and American women's body art', *Art in America*, 64 (3) (1976): 72–81; reprinted in *From the Center: Feminist Essays on Women's Art* (New York: E. P. Dutton, 1976); and *The Pink Glass Swan: Selected Feminist Essays on Art* (New York: The New Press, 1995), pp. 99–113.

Lippard, Lucy, 'Transformation art', *Ms*, 4 (4) (1975): 33–9.

Lipton, Eunice, 'Representing sexuality in women artists' biographies', *Journal of Sex Research* (February 1990): 81–93.

Liu, Catherine, 'In the realm of the senses', *FlashArt* (October 1988): 100–101, 123.

Longfellow, Brenda, 'Sex/textual politics: tracing the imaginary in the films of Valie Export', *Border/lines*, 4 (1985–6): 11–13.

Lord, Catherine, 'Down there: toys in Babeland', *Art and Text*, 46 (1993): 30–1.

MacDowall, Cyndra, 'Sapphic scenes', *Fuse* (1991): 25–39.

McPherson, Heather (ed.), *Spiral 7: A Collection of Lesbian Art and Writing from Aotearoa New Zealand* (Wellington: Spiral, 1992).

Malchiodi, Cathy A., 'Invasive art: art as empowerment for women with breast cancer', in *Feminist Approaches to Art Therapy*, ed. Susan Hogan (London: Routledge, 1997), pp. 49–64.

Maritime, Mickey, et al., 'Letters to the editor', *Artforum*, 13 (7) (1975): 8–9.

Martin, Rosy, 'Looking and reflecting: returning the gaze, re-enacting memories and imagining the future through phototherapy', in *Feminist Approaches to Art Therapy*, ed. Susan Hogan (London: Routledge, 1997), pp. 150–76.

Martin, Rosy, 'Unwind the ties that bind', in *Forbidden Subjects: Self Portraits by Lesbian Artists* (Vancouver: Gallerie Publications, 1992), pp. 71–2.

Martin, Rosy, 'You (never) can tell: phototherapy, memory, and subjectivity', *Blackflash*, 14 (3) (1996): 4–8.

Meskimmon, Marsha, *The Art of Reflection: Women Artists' Self-portraiture in the Twentieth Century* (London: Scarlet Press, 1996).

Mills, Josephine, '100 years of homosexuality, curated by Doug Townsend', *Blackflash*, 10 (3) (1992): 5–6, 12–14.

Nead, Lynda, *The Female Nude: Art, Obscenity and Sexuality* (London: Routledge, 1992).

Nemser, Cindy, 'Four artists of sensuality', *Arts Magazine*, 49 (7) (1975): 73–5.

Nemser, Cindy, 'Linda Benglis: a case of sexual nostalgia', *Feminist Art Journal*, 3 (4) (1974–5): 7, 23.

Nochlin, Linda, 'Painted women', *Art in America*, 86 (11) (1998): 106–11.

Oishi, Eve, 'Uses of the erotic: sexuality and difference in lesbian film and video', *Art Papers*, 18 (6) (1994): 25–8.

Orlan, '"I do not want to look like . . .": Orlan on becoming-Orlan', *Women's Art Magazine*, 64 (1995): 5–10.

Parker, Rozsika, 'About time', *Spare Rib*, 102 (1981): 48.

Parker, Rozsika, 'Images of men', *Spare Rib*, 99 (1980): 5–8; reprinted in *Framing Feminism: Art and the Women's Movement* 1970–1985, ed. Rozsika Parker and Griselda Pollock (London: Pandora Press, 1987), pp. 220–23.

Pattynama, Pamela, 'Image and pose', *Ten-8*, 30 (1988): 26–37.

Pointon, Marcia, *Naked Authority: The Body in Western Painting 1830–1908* (Cambridge: Cambridge University Press, 1990).

Pollock, Griselda, 'Old bones and cocktail dresses: Louise Bourgeois and the question of age', *Oxford Art Journal*, 22 (2) (1999): 71–100.

Rand, Erica, 'Lesbian sightings: scoping for dykes in Boucher and Cosmo', *Journal of Homosexuality*, 27 (1–2) (1994): 123–39.

Rand, Erica, 'Women and other women', *Art Journal*, 50 (2) (1991): 29–34.

Raven, Arlene, 'Los Angeles lesbian arts', *Art Papers*, 18 (6) (1994): 6–8.

Raven, Arlene, 'Star studded', *High Performance*, 28 (1984); reprinted in *Art Theory and Criticism: An Anthology of Formalist, Avantgarde, Contextualist and Postmodernist Thought*, ed. Sally Everett (Jefferson, NC: McFarland, 1991), pp. 204–14.

Raven, Arlene and Iskin, Ruth, 'Through the peephole: toward a lesbian sensibility in art', *Chrysalis*, 4 (1977): 19–31.

Robinson, Hilary, 'Whose beauty? Women, art and intersubjectivity in Luce Irigaray's writings', in *Beauty Matters*, ed. Peg Zeglin Brand (Bloomington, IN: Indiana University Press, 2000), pp. 224–51.

Rosler, Martha, 'She sees in herself a new woman everyday', *Heresies*, 2 (1977): 90–1.

Ross, Christine, 'Redefinitions of abjection in contemporary performances of the female body', *Res*, 31 (1997): 149–56.

Roth, Martha, 'Notes toward a feminist performance aesthetic', *Women and Performance: A Journal of Feminist Theory*, 1 (1) (1983): 5–24.

Saslow, James M., *Bibliography of Gay and Lesbian Art* (New York: College Art Association, Gay and Lesbian Caucus, 1994).

Scheck, Sandra, *Lesbians and the Arts: A Bibliography and Research Guide* (Washington, DC: Library and Research Center, National Museum of Women in the Arts, 1995).

Schneider, Rebecca, *The Explicit Body in Performance* (London: Routledge, 1997).

Semmel, Joan and Kingsley, April, 'Sexual imagery in women's art', *Woman's Art Journal*, 1 (1) (1980): 1–6.

Sieglohr, Ulrike, *Focus on the Maternal: Female Subjectivity and Images of Motherhood* (London: Scarlet Press, 1998).

Smith, Anne Marie, 'Girls on video: fear and loathing and the search for pleasure', *The Body Politic* (July 1986): 25–7.

Smyth, Cherry, *Damn Fine Art by New Lesbian Artists* (London: Cassell, 1996).

Spence, Jo, 'Marks of struggle', interview by David Hevey, *Women's Art Magazine*, 47 (July/August 1992): 8–11.

Spence, Jo, 'The picture of health?', *Spare Rib*, 1 (63) (1986): 19–24.

Spero, Nancy, 'Sky goddess, Egyptian acrobat', *Artforum*, 26 (7) (1988): 103–5.

Steele, Lisa, 'Freedom, sex and power: interview with Charlotte Bunch', *Fuse* (January–February 1983): 232–7.

Stiles, Kristine, 'The empty slogan of self-representation', *Siksi*, 12 (1) (1997): 87–90.

Suleiman, Susan Rubin (ed.), *The Female Body in Western Culture: Contemporary Perspectives* (Cambridge, MA: Harvard University Press, 1986).

Taylor, Jocelyn, 'I seek to steal the sexual body', *Art Papers*, 18 (6) (1994): 29–31.

Tenneson Cohen, Joyce, *Insights: Self-portraits by Women* (London: Gordon Fraser, 1979).

Tickner, Lisa, 'The body politic: female sexuality and women artists since 1970', *Art History*, 1 (2) (1978): 236–49; reprinted in *Framing Feminism: Art and the Women's Movement 1970–1985*, ed. Rozsika Parker and Griselda Pollock (London: Pandora Press, 1987), pp. 263–76; *Looking On: Images of Femininity in the Visual Arts and Media*, ed. Rosemary Betterton (London: Pandora Press, 1987).

Tickner, Lisa, 'Nancy Spero: images of women and *la peinture féminine*', in *Nancy Spero* (London: ICA, 1987), pp. 5–8.

Tuer, Dot, 'Perspectives of the body in Canadian video art', *C Magazine*, 36 (1993): 29–36.

Tuer, Dot, 'Video in drag: trans-sexing the feminine', *Parallélogramme*, 12 (3) (1987): 24–9.

Vespry, Anne, 'Issues of body image in lesbian (and feminist) comics', *Matriart*, 3 (3) (1993): 31–2.

Walters, Margaret, *The Nude Male* (London: Penguin, 1978).

Warner, Marina, *Monuments and Maidens: The Allegory of the Female Form* (London: Weidenfeld and Nicolson, 1985).

Wilson, Judith, 'Beauty rites: towards an anatomy of culture in African American women's art', *International Review of African American Art*, 11 (3) (1994): 11–17, 47–55.

Chapter 9

Anderson, Pamela Sue, *A Feminist Philosophy of Religion* (Oxford: Blackwell, 1998).

Apostolos-Cappadona, Diane and Ebersole, Lucinda, *Women, Creativity, and the Arts: Critical and Autobiographical Perspectives* (New York: Continuum, 1995).

Asphodel, 'Woman magic', *Spare Rib*, 110 (1981): 50–3.

Baring, Anne and Cashford, Jules, *The Myth of the Goddess: Evolution of an Image* (London: Viking, 1991).

de Beauvoir, Simone, 'Women and creativity' (1966), in *French Feminist Thought: A Reader*, ed. Toril Moi (Oxford: Blackwell, 1987).

von Braun, Christina, 'Engendering the imago, imaging gender', *n.paradoxa*, 5 (2000): 74–82.

Burnham, Jack, 'Mary Beth Edelson's great goddess', *Arts Magazine*, 60 (3) (1985): 75–8.

Christ, Carol P., *Rebirth of the Goddess: Finding Meaning in Feminist Spirituality* (London: Routledge, 1997).

Christ, Carol P. and Plaskow, Judith (eds), *Womanspirit Rising: A Feminist Reader in Religion* (San Francisco: Harper and Row, 1979; 2nd edn, 1992).

Condren, Mary, *The Serpent and the Goddess: Women, Religion and Power in Celtic Ireland* (San Francisco: Harper and Row, 1989).

Daly, Mary, *Gyn/ecology: The Metaethics of Radical Feminism* (Boston, MA: Beacon Press, 1978).

Daly, Mary, *Pure Lust: Elemental Feminist Philosophy* (London: The Women's Press, 1984).

Denes, Agnes et al., 'Developing creativity', *Arts in Society*, 2 (1) (1974): 37–41.

Diamond, Sara, 'Art, gender and class: creativity and social constraints', *Parallélogramme*, 10 (4) (1985): 51–5, 76.

Edelson, Mary Beth, 'Goddess imagery in ritual', interview by Gayle Kimball, *Women's Culture: The Women's Renaissance of the Seventies*, ed. Gayle Kimball (Metuchen, NJ: Scarecrow Press, 1981), pp. 91–105.

Edelson, Mary Beth, 'Mary Beth Edelson on saving the world', *Art Criticism*, 2 (3) (1986): 49–54.

Edelson, Mary Beth, *Woman Rising* (Mary Beth Edelson, 1975).

Exum, J. Cheryl, *Plotted, Shot, and Painted: Cultural Representations of Biblical Women* (Sheffield: Sheffield Academic Press, 1996).

Gimbutas, Maria, *The Language of the Goddess* (San Francisco: Harper and Row, 1989).

Kavaler-Adler, Susan, *The Compulsion to Create: A Psychoanalytic Study of Women Artists* (London: Routledge, 1993).

Kristeva, Julia, 'Stabat mater' (1977), in *The Kristeva Reader*, ed. Toril Moi (Oxford: Blackwell, 1986), pp. 161–86.

Langer, Sandra L., 'The sister chapel: towards a feminist iconography, with a commentary by Ilse Greenstein', *The Southern Quarterly*, 17 (2) (1979): 28–41.

Lijn, Liliane, 'Imagine the goddess! A rebirth of the female archetype in sculpture', *Leonardo*, 20 (2) (1987): 123–30.

Lippard, Lucy, *Overlay: Contemporary Art and the Art of Prehistory* (New York: Pantheon Books, 1983).

Lippard, Lucy, 'Quite contrary: body, nature and ritual in women's art', *Chrysalis*, 2 (1977): 30–47.

Lorde, Audre, 'The erotic as power', *Chrysalis*, 9 (1979): 29–31; reprinted in *Sister Outsider: Essays and Speeches* (Freedom, CA: Crossing Press, 1984), pp. 53–9.

Montano, Linda, 'On art and artists', interview by Lyn Blumenthal (1983), *Profile*, 4 (6) (1984): 2–25.

Montano, Linda, 'Spirituality and art', *Women Artists News*, 10 (3) (1985): 8.

Moulton, Carlyn, 'Image, symbol, and sacrament: religious language and *The Dinner Party*', *Fireweed*, 15 (1982): 19–25.

O'Faolain, Julia and Martines, Lauro, *Not in God's Image: Women in History* (London: Maurice Temple Smith, 1973).

Orenstein, Gloria Feman, 'Creation and healing: an empowering relationship for women artists', *Women's Studies International Forum*, 8 (5) (1987): 439–58.

Orenstein, Gloria Feman, 'Methodology of the marvelous', *Matriart*, 6 (1) (1996): 26–35.

Orenstein, Gloria Feman, 'From occultation to politicization: the evolution of the goddess image in contemporary feminist art', in *The Green Stubborn Bud: Women's Culture at Century's Close*, ed. Kathryn F. Clarenbach and Edward L. Kamarck (Metuchen, NJ: Scarecrow Press, 1987), pp. 39–59.

Orenstein, Gloria Feman, 'The reemergence of the archetype of the great goddess in art by contemporary women', *Heresies*, 5 (1978): 74–84; reprinted in *Feminist Art Criticism: An Anthology*, ed. Arlene Raven, Cassandra Langer and Joanna Frueh (London: UMI Research Press; New York, Icon Editions, 1988), pp. 71–86; *Visibly Female: Feminism and Art Today – An Anthology*, ed. Hilary Robinson (London, Camden Press, 1987; New York: Universe, 1988), pp. 158–70.

Orenstein, Gloria Feman, 'The sister chapel: a travelling homage to heroines', *Womanart*, 1 (3) (1977): 12–21.

Page, Barbara, 'Pourquoi la femme ne crée-t-elles pas?: La création féminine et les réalisatrices Allemandes', *Parachute*, 37 (1984–5): 9–13.

Raven, Arlene, 'The art of the altar', *Lady-Unique-Inclination-of the Night* (Autumn 1983): 29–41.

Raven, Arlene, 'The circle: ritual and the occult in women's performance art', *New Art Examiner* (November 1980): 8–9.

Rieger, Marylyn Partridge, 'Creative women: their potential, personality, and productivity', *Canadian Woman Studies/Les cahiers de la femme*, 1 (3) (1979): 16–61.

Saunders, L. (ed.) *Glancing Fires: An Investigation into Women's Creativity* (London: The Women's Press, 1987).

Sjöö, Monica, 'Some thoughts about our exhibition of "women's art" at the Swiss Cottage Library in London, 7–28 April, 1973' (1973); reprinted in Monica Sjöö (ed.), *Women Are the Real Left* (Bristol: Monica Sjöö, 1979), pp. 15–16.

Sjöö, Monica and Mor, Barbara, *The Great Cosmic Mother of All* (London: Rainbow Press, 1981).

Suleiman, Susan Rubin and Bauman, Raquel Portillo, 'Motherhood and identity politics: an exchange', in *Risking Who One is: Encounters with Contemporary Art and Literature* (Cambridge, MA: Harvard University Press, 1994), pp. 55–63.

Synder Ott, Joelynn, *Women and Creativity* (Millbrae, CA: Les Femmes, 1978).

Turner, Kay, 'Contemporary feminist rituals', *Heresies*, 2 (1) (1982): 20–6.

Warner, Marina, *Alone of All her Sex: The Myth and the Cult of the Virgin Mary* (London: Picador, 1976).

Web-based Information

There is much information available through the Web. This is a sample of some useful and reliable sources. Many of these pages have links to further information and sites: see in particular the *n.paradoxa* site.

Web-based bibliographies

Carla Williams' Library (mainly African American, photography, and feminist cultural studies): http://www.carlagirl.net/library.html

Annotated Bibliography of Feminist Aesthetics in the Literary, Performing and Visual Arts 1970–1990, compiled by Linda Krumholz and Estella Lauter: http://www.inform.umd.edu/EdRes/Topic/WomensStudies/Bibliographies/AestheticsBiblio/performance-arts

Karla Huebner's Feminist Art History Bibliography: http://ourworld.compuserve.com/homepages/
 karlahuebner/bib.htm
n.paradoxa: An International List of Books and Articles on Contemporary Feminist Art Practice:
 http://web.ukonline.co.uk/n.paradoxa/books.htm
Women's Studies Resources: Art and Performance (University of Iowa): http://bailiwick.lib.uiowa.edu/
 wstudies/art.html

Web-based resources

Allgirls.net (Germany): http://www.blinx.de/allgirls/
Art Sites: History of Women Artists (USA): http://www.expage.com/page/ssh
Artnode: 69 Feminist Artists (Denmark): http://www.artnode.dk/inserts/an_reload.html
Axis Foundation for Gender and the Arts (Holland): http://www.axisvm.nl/
Bildweschel: Umbrella Organization for Women/Media Arts/Culture (Germany): http://
 www.internetfrauen.w4w.net/bildwechsel/start_us.html
City of Women (Slovenia): http://www.sigov.si/uzp/city/
Distinguished Women of Past and Present: Art (USA): http://www.DistinguishedWomen.com/
 subject/art.html
Feminist Art Worksite (Los Angeles, USA): http://www.calarts.edu/~thefword/index.html
Frauen Museum (Bonn, Germany): http://www.frauenmuseum.textur.com/
Glasgow Women's Library (Scotland): http://www.womens-library.org.uk/
Guerrilla Girls (USA): http://www.guerrillagirls.com/
Lesbians in the Visual Arts (USA): http://www.lesbianarts.org/
National Museum of Women in the Arts (Washington, USA): http://www.nmwa.org/
Native American Women Artists (USA): http://www.heard.org/exhibits/watchfuleyes/bio/html
NONA: Multimedia Women's Center (Zagreb, Croatia): http://www.videodocument.org/nona/
n.paradoxa (London, Britain): http://web.ukonline.co.uk/members/n.paradoxa/
Old Boys Network (cyberfeminism, international): http://www.obn.org/
Queer Cultural Center (USA): http://www.queerculturalcenter.org/
Sonoma State University Women Artists Archive (USA): http://libweb.sonoma.edu/special/
 waa/default.html
Through the Flower (USA): http://www.judychicago.com/
Varo Registry (USA) (the Varo Registry runs the Feminist Art History Listserve and the Women
 Artists Listserve, which can be accessed through this site): http://www.varoregistry.com/
Women Artists in History (USA): http://www.wendy.com/women/artists.html
Womenhouse (USA): http://cmp1.ucr.edu/womenhouse/
Women's Art Library (London, England; publishers of *Make*): http://web.ukonline.co.uk/
 womensart.lib/
Women's Art Register (Melbourne, Australia): http://yarranet.net.au/womar/womar1.htm
Women's Art Resource Centre (Toronto, Canada; publishers of *Matriart*): http://www.warc.net/
Women's Caucus for Art (USA): http://www.nationalwca.com/
World's Women On-line (USA): http://wwol.inre.asu.edu/intro.html

Index